1001

Photoshop® Tips

ANDY ANDERSON

CONTRIBUTING EDITOR
KRIS JAMSA, PH.D., M.B.A.

Check the Web for Updates:

To check for updates or corrections relevant to this book and/or CD-ROM visit our updates page on the Web at **http://www.prima-tech.com/support.**

Send Us Your Comments:

To comment on this book or any other PRIMA TECH title, visit our reader response page on the Web at **http://www.prima-tech.com/comments.**

How to Order:

For information on quantity discounts, contact the publisher: Prima Publishing, P.O. Box 1260BK, Rocklin, CA 95677-1260; (916) 787-7000. On your letterhead, include information concerning the intended use of the books and the number of books you want to purchase.

A Division of Prima Publishing

Prima Publishing and colophon are registered trademarks of Prima Communications, Inc. PRIMA TECH is a trademark of Prima Communications, Inc., Roseville, California 95661.

Publisher:	Stacy L. Hiquet
Managing Editor:	Sandy Doell
Associate Marketing Manager:	Jennifer Breece
Book Production:	Argosy
Technical Reviewer:	Bob Breece
Cover Design:	Prima Design Team

ISBN: 0-7615-2751-6

Library of Congress Catalog Card Number: 2001111675

Printed in the United States of America

01 02 03 04 05 II 10 9 8 7 6 5 4 3 2 1

About the Author

Andy Anderson is formerly the director of a four-state school system where he designed, wrote, and implemented curriculum dealing with computer science, graphics, and the Internet. As a university lecturer in Alabama and at Wichita State University, Andy has used his unique talents to teach programming languages such as COBOL, BASIC, and Fortran, as well as computer graphics, animation, and Web design techniques.

He is the owner of One-of-a-Kind Productions, Inc., a company specializing in speeches, advertising, and multimedia training tools. He holds several degrees including physics, education and history.

Contents at a Glance

PHOTOSHOP BASICS .*1–70*

QUICK VIEW OF THE PHOTOSHOP TOOLBOX .*71–94*

WORKING ON A PHOTOSHOP DOCUMENT .*95–116*

IMPORTING DOCUMENTS INTO PHOTOSHOP .*117–122*

MOVING BEYOND THE BASICS .*123–170*

WORKING WITH PHOTOSHOP GRADIENTS .*171–180*

WORKING WITH OPTIONS, COMMANDS, AND ADJUSTMENTS*181–235*

UNDERSTANDING COLOR SPACE IN PHOTOSHOP .*236–262*

MODIFYING AND MOVING PHOTOSHOP IMAGES .*263–409*

WORKING WITH ACTIONS .*410–426*

USING PHOTOSHOP'S AUTOMATE COMMANDS .*427–431*

WORKING WITH CHANNELS .*432–463*

USING PATHS IN PHOTOSHOP .*464–486*

WORKING WITH THE STYLES PALETTE .*487–491*

USING PHOTOSHOP FILTERS .*492–540*

MANAGING COLOR IN PHOTOSHOP .*541–585*

WORKING WITH PHOTOSHOP'S MEASUREMENT SYSTEMS*586–588*

SCANNING, RESTORING, AND MANIPULATING IMAGES*589–651*

WORKING WITH TEXT IN PHOTOSHOP .*652–688*

SAVING AND PRINTING PHOTOSHOP FILES .*689–721*

PHOTOSHOP, IMAGEREADY, AND THE INTERNET .*722–881*

CREATING SPECIAL EFFECTS .*882–915*

USING PHOTOSHOP'S ADDITIONAL PLUG-INS .*916–919*

ADDITIONAL PHOTOSHOP ISSUES .*920–1001*

INDEX

Contents

Photoshop Basics

Setting Up a New Photoshop Document1

Finding a Misplaced Image on Your
Hard Drive (Macintosh Only) .2

Saving Your Image Files and Quitting Photoshop3

Choosing the Correct Compression Scheme to Fit the File4

Opening Illustrator Files in Photoshop5

Opening Images Saved in the Kodak CD Format6

Understanding Raster Image Programs7

Working in Photoshop's RGB Color Space8

Working in Photoshop's CMYK Color Space9

Working in Photoshop's Grayscale Color Space10

Setting Up Photoshop's Color Settings11

Working with Fonts in Photoshop12

Understanding How Photoshop Transforms an Image13

Opening Photoshop Along with Other Adobe Programs14

Running Photoshop with Virtual Memory15

Understanding How Photoshop Uses Your Hard Drive
and RAM Memory .16

Keeping Photoshop an Efficient and Fast-Running Program . . .17

Assigning RAM Memory to Photoshop18

Displaying File and Image Information19

Performing a Quick Print Preview in Photoshop20

Retrieving Information from a Photoshop Document21

Choosing the Correct Interpolation Method22

Understanding the Settings Files in Photoshop23

Controlling Photoshop by Restoring the Settings Files24

Saving Separate Setting Files for Special Occasions
(Macintosh Only) .25

Performing Updates to Photoshop Online26

Setting Up Preferences for Online Help27

Choosing an Additional Plug-in Folder Within Photoshop . . .28

Determining Which Color-Selection Method is Best29

Placing PostScript Files Using the Anti-alias Option30

Using Short Pantone Names with Photoshop Images31

Saving Palette Locations in Photoshop32

Setting the Save File Options Within Photoshop33

Using the File Extension Option .34

Choosing Upper- or Lower-case File Names35

Knowing When to Maximize Backwards Compatibility36

Saving Photoshop Channels in Grayscale or Color37

Using the Pixel Doubling Option .38

Understanding When to Use Diffusion Dither39

When to Use Export Clipboard Option40

Choosing the Correct Painting Cursor41

Using Columns in Photoshop .42

Measuring Images in Points .43

Working with Video LUT Animation44

Using More Than One Scratch Disk45

Determining the Correct Cache Levels Setting46

How Image Cache Affects the Histogram47

Reasoning Behind Registration .48

Selecting Tools in Photoshop .49

Using Plug-in Modules .50

Working with Computer Monitors and Color Depth51

Using the Predefined Color Settings Within Photoshop52

Changing Photoshop's Screen Display Mode53

Using Photoshop's Document Window54

Moving Around in an Image Using the Navigator Palette55

Changing Image Size Using the Pull-Down Menu56

Calibrating Monitor Color Using the Adobe Gamma Utility . . 57

Controlling Toolbar and Palette Visibility58

Working with the Document Status Window59

Creating Customized Photoshop Palettes60

Saving Files with Image Previews61

Manually Choosing Colors with the Color Picker62

Quickly Accessing Information with Context-Sensitive Menus 63

Changing Photoshop's Tool Icons64

Using the New Options Bar in Photoshop65

Viewing Pop-up Palettes in Photoshop66

Renaming Pop-up Palette Items .67

Linking Palettes Together .68

Docking Palettes Together .69

Quickly Resetting the Positions of Palettes and Dialog Boxes . .70

Quick View of the Photoshop Toolbox

The Marquee Tools .71

The Move Tool .72

The Lasso Tools .73

The Magic Wand Tool .74

The Cropping Tool .75

The Slice Tool .76

The Airbrush Tool .77

The Paintbrush and Pencil Tools .78

The Clone and Pattern Stamp Tools79

The History and Art History Brush Tools80

The Eraser Tools .81

The Gradient Tool .82

The Focus Tools .83

The Toning Tools .84

The Path Tools .85

The Type Tool .86

The Pen Tools .87

The Drawing Tools .88

The Notes Tools .89

The Eyedropper Tool .90

The Hand Tool .91

The Zoom Tool .92

The Quick Mask Option .93

The Foreground and Background Colors94

Working on a Photoshop Document

Using Pop-up Sliders95
Using the Info Palette96
Working with 8-bit and 16-bit Channels97
Repurposing Images98
Inserting Digital Copyright Information into a
Photoshop Image99
Working with Contact Sheets100
Modifying Tool Settings with the Options Bar101
Creating Personalized Picture Packages102
Generating Guides in Photoshop103
Setting Up a Grid in a Document Window104
Working with DPI and PPI105
Changing Grid Preferences106
Selecting the Correct Halftone Screen Frequency107
Understanding Dot Gain and Ink Coverage108
Choosing a Particular Width and Height
Measurement System109
Determining When an Image Contains
Too Much Resolution110
Choosing the Correct Color Space111
Opening Preexisting Images112
Determining Resolution Based on Final Output113
Increasing the Resolution of an Image
by Changing Image Size114
Using the Place Option to Import Images into Photoshop115
Selecting Anti-aliased for PostScript Images116

Importing Documents into Photoshop

Importing Multi-Page PDF Files into Photoshop117
Importing a PDF Image Directly into Photoshop118
Importing Images Directly from a Scan119
Importing Anti-alias PICT Files (Macintosh Only)120
Importing Annotations121
Importing PICT Resources (Macintosh Only)122

Moving Beyond the Basics

Using Layer Styles with the Drawing Tools123
Working with the Polygon Lasso Tool124
Creating Shapes with the Custom Shape Tool125
Creating Arrowhead Lines126
Using the Shape Layer and Work Path Options
with the Drawing Tools127
Selecting Options for the Drawing Tools from the
Options Bar128
Defining and Saving Custom Shapes Using Paths129
Understanding the Clone Stamp Tool130
Working with the Pattern Stamp Tool131
Determining What Compression Scheme to Use132
Creating and Saving Patterns133
Working with the Slice Tool134
Using the Save for Web Feature with a Sliced Image135
Using the Standard Lasso Tool136
Understanding the Magnetic Lasso Tool137

Using Photoshop's New Drawing Tools138
Using the Magnetic Pen Tool139
Changing the Magnetic Pen Tool Options140
Using the Magnetic Pen Tool141
Going Beyond Undo with the History Brush142
Using the History Brush with a Transparent Layer143
Creating a Painterly Effect with the Art History Brush144
Using the Color Range Command145
Using the Measure Tool to Straighten an Image146
Working with the Smudge Tool147
Creating Fast Backgrounds Using Filters148
Understanding How the Shear Tool Operates149
Curving Text onto a Surface Using Shear150
Working with Quick Mask151
Understanding Masks in Photoshop152
Combining Quick Mask with Traditional Selection Methods .153
Creating Vector Paths with the Pen Tool154
Adding, Subtracting, and Converting Anchor Points
on a Pen Path155
Using the Freeform Pen Tool to Create a Work Path156
Converting Pen Paths into Permanent Paths157
Using the Blur Tool158
Correcting Dust and Scratches with the Blur Tool159
Blending Two Objects Together with the Blur Tool160
Choosing the Fill161
Using the Burn Tool to Restore Blown-Out Highlights
in an Image162
Controlling Ink Saturation with the Sponge Tool163
Using the Eyedropper Tool164
Working with the Magic Eraser165
Understanding the Paint Bucket Tool166
Controlling the Paint Bucket167
Using the Background Eraser168
Using the Standard Eraser Tool169
Understanding How the Magic Wand Works170

Working with Photoshop Gradients

Controlling Filters with Gradients171
Working with the Gradient Options172
Using Gradients with Layer Blending Modes173
Creating a Gradient Fill Layer174
Creating Custom Gradients175
Loading and Creating Custom Gradient Palettes176
Controlling the Transparency of a Gradient with Layers177
Creating a Gradient from Colors Within an Image178
Creating a Multicolor Wash179
Reducing "Stepped" Gradients with Noise
and Gaussian Blur180

Working with Options, Commands, and Adjustments

Using the Contiguous Option with the Magic Wand181
Controlling Selection Information with Tolerance182
Using the Zoom Tool Correctly183

Changing the View of an Image Using Percentages184

Defining a New Brush with a Circle185

Defining a New Brush from Drawn Objects186

Loading Additional Brushes .187

Defining the Brush Palette .188

Defining a "Sparkle" with a Brush189

Painting Using the Behind Blending Mode190

Using Brush Dynamics .191

Working with the Hue, Saturation, and Color
Blending Modes .192

Warping Text .193

Using Wet Edges with the Brush Tools194

Temporarily Modifying Individual Brush Styles195

Using a Drawing Tablet with the Brush Tools196

Changing the Fade Rate of a Brush to Produce Comet Tails . .197

Using the Equalize Option .198

Working with Threshold to Control Image Pixels199

Understanding the Posterize Option200

Understanding How the Levels Command Adjusts an Image .201

Using the Eyedroppers in Levels to Balance an Image202

Controlling Output with the Levels Output Sliders203

Working with Auto Levels .204

Understanding How the Curves Command Adjusts an Image .205

Using the Color Balance Command206

Working with Brightness and Contrast207

Understanding the Hue/Saturation Command208

Using Desaturate to Remove the Color from an Image209

Using Replace Color .210

Understanding the Selective Color Command211

Working with the Channel Mixer Command212

Converting an Image to Grayscale Using Channel Mixer . . .213

Using the Channel Mixer Presets214

Using the Gradient Map Command215

Converting an Grayscale Image Using the Invert Command . .216

Understanding the Difference Between Pressure,
Opacity, and Exposure .217

Creating Text in Photoshop 6.0218

Using Posterize to Control the Number of
Colors in an Image .219

Using the Variations Command .220

Selecting a Foreground and Background Color Swatch221

Understanding the Difference Between the Paintbrush
and the Airbrush .222

Creating a Calligraphic Brush .223

Creating a Dotted-Line Brush .224

Modifying Tool Options .225

Drawing Lines and Shapes .226

Manipulating Shapes with Free Transform227

Using Auto Erase with the Pencil Tool228

Using the Magic Eraser Tool to Remove an
Unwanted Background .229

Modifying a Photoshop Brush to Create a New Brush230

Loading and Saving Custom Swatch Palettes231

Painting an Image Using the Fill Command232

Controlling Your Work with Layers233

Using Blending Modes to Influence the Painting Tools234

Creating Realistic Shadows with Your Paintbrush235

Understanding Color Space in Photoshop

Changing Color in an Image with the Paintbrush236

Understanding How Photoshop Manages Color237

Understanding Additive and Subtractive Color Space238

Understanding Color Models and Color Modes239

Measuring the White Point of Your Monitor240

Calibrating or Characterizing Your
Monitor... Which is Best? .241

Using RGB Color Mode .242

Adjusting RGB Images for Cross-Platform Display243

Using CMYK Mode .244

Using Lab Mode .245

Using Grayscale Mode .246

Using Bitmap Mode .247

Working with Profile Mismatch .248

Understanding ICC Profiles .249

Converting RGB Images to CMYK250

Performing a Profile-to-Profile Conversion of a
Photoshop Image .251

Understanding Color Management252

Understanding Printer Color Management253

Converting a Document's Profile254

Converting a Document into Another Color Mode255

Converting an Image to Grayscale Using Lab Color256

Understanding the Basics of Spot Color Channels257

Creating a Spot Color Plate in Photoshop258

Painting on a Spot Color Channel259

Preparing Images for Television .260

Editing Photoshop's Color Settings261

Choosing the Correct Dither Option for
8-Bit Indexed Color .262

Modifying and Moving Photoshop Images

Modifying an Image with the Duplicate Command263

Using Apply Image .264

Understanding the Calculations Command265

Working with the Add and Subtract Blending Modes266

Using Calculations to Blend Layers267

Working with the Move Tool .268

Changing an Image Using Image Size269

Adjusting the Canvas Size .270

Rotating the Canvas .271

Using the Cropping Tool .272

Cropping the Image Without the Cropping Tool273

Expanding the Canvas Using the Cropping Tool274

Using the Trim Command to Crop an Image275

Using the Histogram to Examine an Image276

Using the Liquify Command .277

Freezing and Thawing Areas of an Image278

Working with Photoshop's Airbrush Tool279
Selection Methods .280
Creating a Rectangular or Elliptical Selection Using Ratio . . .281
Working with the Marquee Tools .282
Working with the Lasso Tools .283
Using the Magic Wand .284
Making Selections with the Pen Tool285
Converting Selections into Paths .286
Using the Move Tool Options .287
Using New View to Control Image Editing288
Determining When to Use the Extract Command289
Using Photoshop's Sharpen Tool .290
Using the Extract Tool Options .291
Adjusting Selections Numerically .292
Modifying Selections Manually .293
Expanding a Selection .294
Contracting a Selection .295
Smoothing a Selection .296
Hiding Selection Borders While Working297
Using Transform Selection on a Selection298
Working with Free Transform to Create a
Freestanding Shadow .299
Removing Moiré Patterns from a Scanned Image300
Choosing a Source for a Kodak CD File301
Choosing a Destination for a Kodak CD File302
Using Grow and Similar to Influence a Selection303
Understanding How Feathering Operates304
Feathering a Selection to Create a Vignette Border305
Working with the Foreground and
Background Color Swatches .306
Saving a Selection as a Permanent Channel307
Using the Direct Selection Tool .308
Creating Selections from Channels309
Using the Stroke Command .310
Using the Load Selection Command311
Creating a Layer Clipping Path .312
Applying a Style to a Layer Clipping Path313
Editing a Layer Clipping Path .314
Using Selections to Control the Effects of
Filters and Adjustments .315
Understanding How Photoshop Looks at Color Correction . .316
Creating a Border from a Selection317
Using Color Balance to Tint an Image318
Using Curves to Adjust an Image .319
Registering a Digimarc Watermark320
Applying a Digimarc Watermark to an Image321
Understanding Adjustment Layers .322
Using Multiple Adjustment Layers Creatively323
Merging Adjustment Layers .324
Using Masks with Adjustment Layers325
Combining Blending Modes with Adjustment Layers326
Working Smart with Adjustment Layers327
Setting the Highlights and Shadows Within an Image328

Info Palette Shortcuts .329
Setting Color Measurement Points
with the Eyedropper Tool .330
Using an Adjustment Layer to Correct a Lens Flare331
Increasing or Decreasing Shadows Using Selective Color . . .332
Using the Hue/Saturation Command to Apply
Color to an Image .333
Removing Selective Areas of Color with the
Desaturate Command .334
Changing the Eyedropper Sample Rate
for Greater Accuracy .335
Correcting Red Eye in an Image .336
Creating a Customized Pattern .337
Adjusting the Color in an Image Using Channel Mixer338
Using Photoshop's Trap Option .339
Using the Fill Command with a Customized Pattern340
Understanding the Concept of Layers341
Restacking Layers .342
Hiding and Showing Layers .343
How Multiple Layers Relate to a Documents's File Size344
Working with the Blend If Option to Create Transparency . . .345
Backgrounds vs. Layers .346
Working with a Layered Document File347
Viewing and Selecting Layers .348
Adding Layers to an Image from Another Document349
Using the Auto Select Layer Option350
Quickly Selecting Nontransparent Areas on a Layer351
Quickly Masking Transparent Areas of a Layer352
Distributing Linked Layers .353
Aligning Linked Layers .354
Aligning a Layer to a Selection Marquee355
Linking Layers Together .356
Controlling a Layer's Opacity .357
Locking a Layer .358
Preserving a Layer's Transparency .359
Selecting the Visible Part Within a Layer360
Blending Mode Concepts .361
Working with the Hard Light
and Soft Light Blending Modes .362
Using the Color Burn and Color Dodge Blending Modes . . .363
Using the Lighten and Darken Blending Modes364
Using the Dissolve Blending Mode365
Applying the Screen and Overlay Blending Modes366
Using the Difference and Exclusion Blending Modes367
Using the Hue, Saturation, Color,
and Luminosity Blending Modes .368
Using the Normal Blending Mode .369
Controlling Adjustment Layers with Built-in Masks370
Understanding When to Merge Adjustment Layers371
Managing Adjustment Layers .372
Flattening Layers Within Photoshop373
Merging Layers .374
Merging the Visible Layers .375
Making a Pixel-to-Pixel Copy of a Layer376

Copying an Element Within a Layer377

Using Clipping Groups to Control the Effect of
Adjustment Layers .378

Using a Clipping Group to Create Exotic Edges379

Creating Layer Sets .380

Working with Layer Properties .381

Applying a Layer Effect .382

Moving Layer Effects with Drag and Drop383

Applying Global Light to a Multilayered Effect384

Converting Effects Layers into Regular Layers385

Creating a Layer Mask .386

Editing a Layer Mask .387

Duplicating a Layer Mask .388

Linking and Unlinking Layer Masks389

Using Pass Though with a Layer Set390

Creating Perspective with Layer Effects391

Understanding Layer Divisions .392

Creating Layer Effects via Copy and Paste393

Converting a Background into a Layer394

Sampling Image Information from All Layers395

Using Layers to Create a Magnifying Lens Effect396

Understanding How History Operates397

Creating a Snapshot .398

Using Linear or Nonlinear Histories399

Painting with a Snapshot .400

Using Multiple Undos .401

Creating a New Document from a History State402

How the History Palette Impacts Memory403

Filling a Selection with a History State404

Dragging History States Between Document Windows405

Stepping Through the History States406

Duplicating a History State .407

Creating a Snapshot from a Previous History State408

Using Erase to History .409

Working with Actions

Using the Actions Palette .410

Creating a New Action .411

Working with the Playback Options412

Opening and Closing Action Sets413

Converting an Action into a Button414

Modifying an Existing Action .415

Using Batch Processing to Speed Up Your Work416

Excluding or Including the Playback of a Command417

Recording an Action Using Different Dialog Settings418

Saving Individual Actions into a Set419

Saving Sets into Folders .420

Inserting Menu Items into an Action421

Inserting Stop Commands into an Action422

Placing Commands into an Action423

Activating a Modal Control in an Action424

Copying and Moving Steps Between Actions425

Nesting Actions Together .426

Using Photoshop's Automate Commands

Using Conditional Mode Change427

Creating Multiple Images with the Picture
Package Command .428

Converting PDF Documents into Photoshop Files429

Generating a Contact Sheet from a Group of
Photoshop Images .430

Converting a Photoshop Command into an Action431

Working with Channels

Understanding Channels and Their Role in Photoshop432

Understanding Channels and
Their Relationship to File Size .433

Working with Native Channels and Alpha Masks434

Mixing Channels .435

Viewing Channels .436

Changing the Display of the Channel Palette437

Editing Channels .438

Editing the Black Channel of a CMYK Image439

Rearranging the Stacking Order of Channels440

Merging Multiple Channels .441

How Channels Are Used to Define Color442

Creating a New Channel .443

Using Photoshop's Paintbrush Tools on a Channel444

Using Channels to Hold Difficult Selections445

Modifying a Channel Using Filters446

Working with Channels to Sharpen an Image447

Creating a Painted Look with Channels and Filters448

Creating Spot Color Channels for Text449

Converting a Channel into a Spot Color Channel450

Using Channels with Quick Mask451

Converting a Channel into Tracing Paper452

Creating a Selection with Your Paintbrush453

Saving Selections with the Save Selection Command454

Turning a Channel into a Selection455

Loading Multiple Channels as Selections456

Changing Channel Options .457

Quickly Removing Channel Selections.458

Splitting Channels into Individual Images459

Duplicating a Channel .460

Influencing the Intensity of a Filter Using Channels461

Removing Moiré with Channels .462

Accenting Areas of an Image Using Channels463

Using Paths in Photoshop

Understanding Paths .464

Working with Anchor Points .465

Drawing Tips When Using the Pen Tool466

Creating a New Path .467

Using the Pen Tool to Create a Path468

Combining Multiple Paths .469

Using Photoshop's Selection Tools470

Aligning and Distributing Paths .471

Understanding Work Paths .472

Creating Paths from Selections .473

Understanding Tolerance .474

Creating Selections from Vector Paths475

Creating Transparency with a Clipping Path476

Setting Up for Transparency .477

Saving Files with Clipping Paths .478

Using Paths with the Stroke Command479

Creating Awesome Neon Using Paths480

Using Paths to Control Drawing and Editing Tools481

Applying Color to a Vector Path .482

Applying a Fill Using a Vector Path483

Adding to an Existing Path .484

Copying a Path into the Same Image485

Moving a Path into Another Photoshop Document486

Working with the Styles Palette

Creating Styles from Layers .487

Applying Styles to Text .488

Applying Styles to Selections .489

Applying a Style to a Layer .490

Saving and Loading Style Sheets491

Using Photoshop Filters

Previewing and Applying Filters .492

Understanding How Filters Are Applied493

Working with Despeckle .494

Using the Median Filter .495

Working with the High Pass Filter on an Image496

Using the Minimum/Maximum Filters on Channels497

Using Photoshop's Cutout Filter to Create Artwork498

Working with the Tiles Filter .499

Using the Torn Edges Filter .500

Applying an Artificial Grain to an Image501

Making Filters Appear Natural .502

Pushing Filters to the Maximum .503

Using Texture Mapping .504

Creating Custom Texture Maps .505

Working with Customized Texture Maps506

Using Graduated Values with the Mosaic Filter507

Blending Filter Effects .508

Using the Torn Edge Filter to Enhance an Image509

Loading Images as Texture Maps510

Defining the Distortion Area with the Displace Filter511

Understanding How to Apply Filters512

Improving the Performance of Memory-Intensive Filters513

Working with the Artistic Filters .514

Understanding the Pixelate Facet Filter515

Using the Blur and Blur More Filters516

Understanding the Brush Strokes Filter517

Working with the Distort Filters .518

Using the Noise Filters .519

Applying the Pixelate Filters .520

Removing the White Halo from an Image Using Defringe . . .521

Helping Out a Resized Image .522

Resetting Values Within a Dialog Box523

Applying Unsharp Mask .524

Using the Render Filters .525

Using the Sketch Filters .526

Working with the Stylize Filters .527

Using Texture Patchwork .528

Using the Spherize Filter .529

Working with the Fade Command530

Using the Lighting Effects Filter .531

Creating a Spotlight to Emphasize an Image Area532

Working with Smart Blur .533

Understanding the Dither Box Filter534

Using Polar Coordinates .535

Working with 3D Transformation .536

Choosing the Correct Render Option in 3D Transform537

Creating Custom Filters .538

Applying Filter Effects to Separate Channels539

Using Difference Clouds and Levels to Create Lightning540

Managing Color in Photoshop

Selecting Colors with the Swatches Palette541

Selecting Colors Using the Eyedropper Tool542

Using Photoshop's Color Spectrum543

Choosing Colors by Their Numeric Values544

Using Lab Color to Preserve Image Color545

Working with Pantone Colors .546

Adding Individual Colors to the Swatches Palette547

Using the Background Eraser to Erase the Edge of an Image .548

Selecting Color with the Foreground Color Button549

Comparing Corrections in CMYK and RGB Color Space550

Using the Web Safe Color Sliders551

Converting Colors into Hexadecimal Values552

Creating Web Safe Colors from the RGB Color Palette553

Understanding the Color Wheel .554

Using Dry Brush and Lighting Effects to Produce a Painting .555

Using Polar Coordinates to Create a Zoom Effect556

Using the Adobe Color Picker to Select Web Colors557

Using a Hard Proof to Check for Consistent Color558

Creating an ICC Monitor Profile .559

Assigning an ICC Color Profile to a Photoshop Document . . .560

Previewing Color Adjustments .561

Viewing the Color Values of Pixels562

Simulating a Television Image .563

Creating a Star Field with Noise .564

Adjusting Overlapping Spot Colors565

Using a Displacement Map to Distort Text566

Using Photoshop's Color Sliders .567

Creating a Custom Color Palette from a Photoshop Image . . .568

Using Color Management with Printed Output569

Selecting Soft Proofing Colors .570

Matching On-Screen Images to a Color Proof571

Viewing an Image On-Screen to Evaluate Color Quality572

Creating a Noise Gradient .573

Embedding Color Profiles into an Image574

Sorting the Color Table for Optimum Results (ImageReady) .575

Creating an Optimized Color Table (ImageReady)576

Working with Background Transparency
in an Image (ImageReady) .577

Locking Colors into an Image Table (ImageReady)578

Understanding Color Depth and GIF Images579

Using the Hue/Saturation Command580

Using Selection to Influence the Replace Color Command . . .581

Using the Gradient Map Command to Create a Sepia
Image .582

Understanding Native Color Channels583

Creating Selections with Channel Shortcuts584

Working on the Internet .585

Working with Photoshop's Measurement Systems

Additional Measuring Units .586

Using Photoshop's Measurement Units587

Changing Measurement Units on the Fly588

Scanning, Restoring, and Manipulating Images

Scanning an Old Image into Photoshop589

Working Smart to Eliminate Common Scanning Mistakes . . .590

Choosing the Correct Color Space for Scanning Old Images . .591

Identifying Low and High Key Images592

Determining the Best Resolution593

Scanning Directly into Photoshop594

Using the History to Revert to Previous History States595

Steps for Scanning Success .596

Scanning Images for the Monitor597

Using the Smudge Tool to Blend Pixels598

Fixing Dust and Scratches .599

Using the History Brush to Creatively Edit an Image600

Using the Dodge Tool to Control Image Exposure601

Using the Sponge Tool to Control Color Saturation602

Using the Dust & Scratches Filter with the History Brush . . .603

Creating Customized Photo-Restoration Brushes604

Using the Clone Stamp Tool .605

Using the Clone Stamp Tool Between Two Images606

Controlling the Clone Stamp Tool Using Multiple Layers607

Moving Information Between Open Documents and
Making It Look Realistic .608

Selecting Information with the Clone Stamp Tool609

Using the Right Color Space .610

Removing Fringe Pixels .611

Removing Fringe Pixels Using the Blend If Options612

Using Curves to Correct High Key Images613

Using the Levels Dialog Box to Adjust the
Midtones of an Image .614

Basic Steps for Correcting Images615

Loading and Saving Curves Adjustments616

Correcting Images with Heavy Foreground Shadows617

Using Target Values to Set Highlights and Shadows618

Using Threshold to Identify Blackpoint and
Whitepoint in an Image .619

Correcting Color Using the Individual Color Plates620

Finding an Image's Midpoint .621

Making Quick Overall Adjustments to an Image622

Using Levels to Adjust Color .623

Using the Brightness/Contrast Command624

Using the Auto Levels Command625

Using the Auto Contrast Command626

Sharpening an Image .627

Using the Info Palette to Identify the Tonal
Range of an Image .628

Using Levels to Set Highlights, Shadow, and Midtones629

Using the Variations Command .630

Using the Desaturate Command631

Using the Invert Command .632

Using the Equalize Command .633

Using the Threshold Command .634

Colorizing a Black and White Image635

Adjusting Screen Shots for Print636

Applying a Tint to an Image .637

Using Layers to Add Additional Objects to an Image638

Using the Posterize Command .639

Using Blending Modes to Reconstruct Faded Images640

Using Curves to Increase the Contrast in an Image641

Blending Two Images Together .642

Correcting and Matching the Color Tone of an Image643

Reducing Blemishes with Smart Blur644

Creating the Illusion of a Slide-Mounted Image645

Putting a Corner Curl on an Image646

Creating a Bevel on Any Object with a Gradient647

Creating a Scan Line Effect with Patterns and Channels648

Generating a Carved Look to an Image649

Changing Weather in an Image... Making It Rain650

Enhancing Shadows in Four-Color Printing Presses651

Working with Text in Photoshop

Understanding How Photoshop Processes Type652

Working with the Type Mask Tool653

Gaining Flexibility with Type Layers654

Working with Text and Filters .655

Using Text Masks .656

Curving Text in Photoshop .657

Manipulating Text Images .658

Manipulating Text Images with Clipping Groups659

Creating 3-D Text with Layer Effects660

Working with Text and Graphics in Screen View661

Using Type Masks to Create Embossed Text662

Selecting a Font .663
Sharpening Text .664
Converting Text into a Freeform Shape with Filters665
Creating a Work Path from Type666
Adjusting Text Using Kerning, Tracking and Leading667
Working with Hyphenation Options668
Working with Character Options669
Creating a Multicolor Glow for Text670
Extruding Liquid Type from an Image671
Changing the Perspective of Text to Create a Sense of
Depth .672
Creating a Beaded Outline Out of Text673
Making Quick Chrome Bevels with Text674
Creating Text with a Soft Glow .675
Identifying Text with Multiple Stroke Gines676
Creating Text with a Background Light Burst677
Creating a Drop-Shadow Back Screen for Type678
Screening Text Against a Background
Using Adjustment Layers .679
Creating Type that Fades Across the Image680
Using Type as a Spot Channel .681
Choosing the Correct File Type for Images
with Spot Color Channels .682
Moving Layers Between Documents683
Controlling a Paint Bucket Fill with Layers684
The Photoshop Format .685
Working with Shape Layers .686
Working with Layer Blending Modes687
Choosing Between RGB and CMYK Color
Space for Your Output .688

Saving and Printing Photoshop Files
Placing an Image into Adobe Illustrator689
Exporting Paths into Adobe Illustrator690
Saving an Image Using the CompuServe GIF Format691
Choosing the Correct Palette Type for an Indexed File692
Opening EPS files .693
Importing Illustrator Files as Paths694
JPEG, GIF and PNG: The Formats of the Internet695
Creating QuickTime Movies from Animated GIF Files696
Using the Save As a Copy Option697
Saving an RGB Image as a BMP or PICT Image698
Printing Directly from Photoshop Using Default
Printing Options .699
Using Photoshop's Printing Options700
Printing a Color Image to a Black-and-White Printer701
Printing to a PostScript Color Printer702
Preparing Images with Clipping Paths for an Imagesetter703
Transferring Images to QuarkXpress704
Transferring an Image to a Film Recorder705
Copying Images into Macromedia Director706
Transferring Photoshop Images into Adobe After Effects707
Preparing Images for Screen Display708

Setting Up Printer's Marks Within an Image709
Adjusting Images to Conform to a Web Safe Palette710
Deciding File Formats Based on Final Output711
Printing an Image to a PostScript File712
Selecting and Transferring Halftone Screen Attributes713
Using the Proof Setup Option .714
Printing a Portion of an Image .715
Changing the Print Encoding of an Image716
Printing Vector Images .717
Saving and Loading Custom Color-Management Settings718
Using Color Management Between
Photoshop and Illustrator .719
Understanding Color Mnagement's Role in Printing720
Printing Using Color Traps for Press721

Photoshop, ImageReady, and the Internet
Creating a GIF Animation from a Multi-Layered PS Image . . .722
Cropping an Image for the Web .723
Using the Trim Command in ImageReady724
Exporting Images Using ImageReady725
Viewing Cross-Platform Differences on Your Monitor726
Adjusting the Gamma of an Image Using ImageReady727
Optimizing an Image by File Size728
Understanding File Compression in ImageReady729
Creating Your Own Optimization Settings730
Using the Optimize Settings for a JPEG Image731
Using the Optimize Setting for a GIF Image732
Using the Optimize Setting for a PNG-8 Image733
Using the Optimize Setting for a PNG-24 Image734
Printing Spot Color Channels .735
Blending RGB Colors Using the Gamma Option736
Creating a Master Image .737
Regenerating ImageReady's Color Space738
Outputting to the Web .739
Printing a Grayscale Image with a Pantone Tint740
Using Web Snap to Convert an Image into a
Web Safe Palette .741
Setting Up Web Safe Artwork When Using Photoshop742
Creating a Custom Palette for Indexed Images743
Using a Custom Color Table .744
Applying a Gradient to a GIF Image745
Adjusting the Color Picker to Display Web Colors746
Previewing the Dither of a Web Image747
Converting a Image into Web Safe Colors
with the Click of a Button .748
Recompressing a Compressed Image749
Previewing an Image in a Browser Using Photoshop750
Selecting the Correct Fill Color When
Converting an Image to Transparent751
Using Onion Skinning on a GIF Animation752
Creating a "Frame" Look to a Web Page by
Creating Directional Tiles .753
Reducing the File Size of a JPEG Image754

Reducing the File Size of a GIF Image755
Reducing the File Size of a PNG Image756
Preparing an Illustrator File for Placement into ImageReady .757
Converting a QuickTime Movie into an
Animated GIF Using ImageReady758
Using the Tile Maker Filter to Create Seamless Backgrounds .759
Editing ImageReady Animation Files760
Using the Layers Palette as a Storyboard761
Making Flat-Color Areas Safe for the Web762
Creating the Illusion of Movement in an Animated GIF763
Making an Animation Fade In and Out764
Using Channels to Apply GIF Optimization Settings765
Using Channels to Apply JPEG Optimization Settings766
Using Hexadecimal Values in a Web Color System767
Optimizing Individual Image Slices768
Using a Temporary Droplet and Using It in ImageReady769
Creating Permanent Droplets .770
Applying a Droplet to a Graphic .771
Including an Action in a Photoshop Droplet772
Creating a JavaScript Rollover .773
Using JavaScript Rollovers with Sliced Images774
Working with 2-up and 4-up Views775
Using Various File Formats with a Sliced Image776
Using Logos for Web Backgrounds777
Creating 3-D Buttons with Copy and Paste778
Editing Colors Within an ImageReady Color Table779
Creating a Master Color Palette .780
Creating a JavaScript Rollover in Photoshop781
Cropping Web Animations .782
Using the Tween Option to Create Smooth Animation783
Using Tween with Layer Effects .784
Using Tween to Fade Animation .785
Resizing an Animated GIF File .786
Forcing a Rollover to Trigger an Animation Sequence787
Creating Background Transparency in GIF and PNG Images .788
Applying Layer Effects Within ImageReady789
Modifying a Layer Effect in ImageReady790
Choosing a Frame Disposal Method Within an Animation . . .791
Creating an Image with a Matted Background792
Identifying Non-Web Colors Using ImageReady793
Creating Seamless Background Images Using the
Offset Option .794
Determining Whether a Background Is Really Seamless . . . 795
Creating a Seamless Background Using a Photograph796
Using a Full-Screen Image as a Background797
Creating a Browser Size Template .798
Moving a Photoshop Image into ImageReady799
Working with Transparency in the GIF Format800
Creating an Image Map .801
Moving ImageReady Rollovers into GoLive802
Moving ImageReady Rollovers into Generic
Web-Editing Programs .803

Choosing GoLive or ImageReady When
Saving Web Images .804
Performing a Digital Emboss with Lighting Effects805
Working with Sliced Images .806
Working with Type in ImageReady807
Moving Type from Photoshop into ImageReady808
Linking Slices in a Web Image .809
Attaching the Alt Tag to a Sliced Image810
Compressing QuickTime Movies .811
Designing a Web Interface .812
Using Photoshop to Create an Interactive Button List . . . 813
Building an Interactive Button List Using ImageReady814
Understanding Dithering in a Web Image815
Printing ImageReady Documents .816
Applying a Custom Dither Pattern to a
Web Background Image .817
Creating a Web Image Gallery .818
Assigning Transparency to an Indexed Color Image Using
Photoshop's Color Table Command819
Moving Photoshop Images into Adobe LiveMotion820
Creating Ragged Text Using Layer Masks821
Saving Recurring Web Settings .822
Opening Photoshop Files as Animations823
Creating Animations from Separate Images824
Changing the Size of Background Tiles to Produce
Different Effects .825
Reasoning for Using Web Safe Colors826
Making GIF Images Small .827
Making JPEG Images Small .828
Converting from Grayscale to Bitmap829
Changing Image Size Using Save for Web830
Locking Colors Using Save for Web831
Using Layers to Generate Motion in a Photoshop Image832
Understanding Black Point Compensation833
Converting to Indexed Color .834
Specifying the Correct Indexed Color Palette835
Changing the Bit Depth of an Indexed Color Image836
Forcing Colors Using Indexed Color837
Choosing the Correct Dither Options for an
Indexed Color Palette .838
Editing Specific Colors Within the Indexed Color Palette839
Working with Color-Matching Options for an
Indexed Color Image .840
Changing the Colors of a Simple Background Image841
Working in Lab Color Mode .842
Choosing an Index Color Table .843
Understanding Raster and Vector Images844
Converting Bitmap Images into Halftone Images845
Working with Additional Bitmap Conversion Options846
Working with Monotone Images .847
Manipulating Duotone Images .848
Changing the Curves of a Duotone Image849
Converting an Image to Multichannels850

Using the Original and Optimized Views in ImageReady851
Understanding the JPEG File Format852
Understanding the GIF File Format853
Understanding the PNG-8 and PNG-24 File Formats854
Exporting a Duotone Image into Another Application855
Saving Files with the DCS Format for Color Separations . . .856
Printing the Color Separation Plates857
Working with Color Separation Tables858
Saving a PDF File .859
Embedding ICC Profiles into PDF Graphics860
Understanding File Formats and Color Spaces861
Choosing Size and Color Space for Presentations862
Using Quick Mask for Complicated Transparency Effects . . .863
Compression of Graphics .864
Creating a Soft-Edged Shadow in a GIF Transparent Image . .865
Applying Filters with the History Brush866
Using Duotone and Noise to Create the Appearance
of Age in an Image .867
Using Gaussian Blur to Create a Sense of Depth
in an Image .868
Weaving Color and Black and White into the Same Image . . .869
Using Filter Techniques to Attract Attention870
Using the Screen Blending Mode to Generate Transparency . .871
Creating Textured Backgrounds .872
Creating a Photo Collage with Layer Masks 873
Creating Brushed-Metal Text .874
Applying a Chrome Look to Text .875
Creating a Metallic Texture .876
Applying a Futuristic Look to Text877
Creating a Mound Button .878
Applying Rust to a Background Surface879
Converting Common-Looking Text to Gold880
Creating a Multicolor Pushbutton for the Internet881

Creating Special Effects

Creating a Studio Backdrop .882
Designing Realistic Screw Heads .883
Designing a Logo Pattern .884
Creating a Spherical Shadow .885
Creating a Shadow in Front of an Object886
Working with Cast Shadows .887
Creating a Shadow on a Curved Surface888
Creating Quick Neon .889
Colorizing Line Art .890
Creating Beads on a String .891
Wrapping an Image Around a Sphere892
Creating a Stone Background .893
Creating Realistic Water Droplets on an Image894
Working with the Lens Flare Filter895
Creating a Moveable Lens Flare on a Separate Layer896
Creating a Chiseled Edge .897
Creating Credit-Card Text with the Effects Layers898

Using the Pastels Filter with the History Brush899
Creating a Colorized Mezzotint .900
Using the Audio Annotation Tool .901
Ghosting an Image to Generate Attention902
Softening an Image Using Multiple Layers903
Solarizing an Image .904
Creating an Assembled Image from Multiple Layers905
Using Lens Flare to Create a 3-D Globe906
Using Multiple Colors to Create a Text Glow907
Using the Gradient Tool to Generate Spheres908
Using Threshold to Create a Pen-and-Ink Drawing909
Creating Separate Layers from Layer Effects910
Using the Global Angle Command911
Understanding the Visual Perception Created
by Offset Shadows .912
Understanding Adobe's Open Architecture Programming913
Working with the Layer Style Dialog Box
to Create a Shadow .914
Using Pinch to Control Barrel Distortion915

Using Photoshop's Additional Plug-ins

Using the Scratch Compression Plug-in916
Working with Unlimited Clipboard Size917
Installing the Unlimited Preview Plug-in918
Using the Force VM Compression Plug-in919

Additional Photoshop Issues

Working with Text Annotations .920
Experimenting with the Use All Layers Option921
Creating Quick Marbleized Text .922
Working with Color Reproduction Basics923
Creating Wire-Frame Text .924
Recognizing Colors That Will Not Print925
Quickly Editing Out-of-Gamut Colors926
Working with the Twain Interface .927
Adjusting the Dot Gain of a Grayscale Image928
Quickly Removing Color Casts Introduced by a Scanner929
Using Lab Color to Sharpen an RGB Image930
Why Scanned Images Appear Dull931
Using Transform on Linked Layers932
Flipping Photoshop Images .933
Managing Your Workflow .934
Creating Carved Text .935
Choosing Serif or Sans Serif Fonts936
Indexing Your Images Using Contact Sheets937
Redefining an Image Using Columns938
Previewing Fill Modes .939
Using Drag-and-Drop to Copy Between Applications940
Using Drag-and-Drop to Copy Information with a Layer941
Using the Paste Into Command .942
Using the Cut and Copy Commands, and Their Effect
on RAM Memory .943
Cropping Pixels Outside the Viewable Image944

Using Clipboard Memory to Copy Between Applications945

Using the Scale Tool Correctly .946

Using De-interlace to Remove Horizontal Line Jitter947

Using a Table to Determine Scan Resolutions948

Switching to the NTSC Color Palette for Television949

Reducing Print Size Without Reducing Image Quality950

Using the Jump To Button .951

Resetting Preferences in ImageReady952

Adding Applications to the Jump To Button953

Using Automatic Update with the Jump To Option954

Changing an Image's Print Dimensions955

Monitoring Work in Progress .956

Changing Photoshop Screen Mode for Color Correction957

Creating 3-D Packaging .958

Creating Realistic Shadows for 3-D Packaging959

Backlighting an Image .960

Fixing the Edges of a Motion-Blurred Object961

Creating Finely Chiseled Text .962

Viewing the Effects of a Feather Using Quick Mask963

Creating Backgrounds with Depth Using the Lighting
Effects Filter .964

Correcting Out-of-Gamut Colors with the Sponge Tool965

Creating a Cool-Looking Web Interface966

Creating Spherical Buttons .967

Adding Depth with Drop Shadows968

Creating Custom Shadows Without Using Layer Effects969

Getting Started with WebDAV .970

Operating in the WebDAV Environment971

Choosing Options for WebDAV .972

Viewing and Working with Copyright Information973

Converting an Animation into an Image
Suitable for Printing .974

Simulating Motion in an Image .975

Focusing Attention Using Adjustment Layers976

Moving Photoshop's Brushes Palette977

Understanding Object Linking (Windows Only)978

Creating a Pill-Shaped Button .979

Creating a Smooth Selection Using Noise980

Creating a Transparent Image for PowerPoint981

Locating the Exact Center of a Graphic Image982

Quickly Opening and Closing Layers in Photoshop983

Determining the Dynamic Range of a Scanner984

Viewing Images Intended for the Internet985

Previewing Images in a Browser .986

Updating Existing HTML Files .987

Creating a Hybrid Graphic in ImageReady988

Reducing Step Gradients with Noise989

Customizing an Action to Create a New Photoshop
Document .990

Using Merge Visible to Lock Layer Effects991

Adding the GIF89a Format to Photoshop 6.0992

Creating an Instant Neon Glow .993

Setting Text on Fire .994

Creating Wild Backgrounds with the Gradient Tool995

Creating Stacked Text .996

Restoring the Input Setting in the New Dialog box997

Creating a Unique Lens Flare .998

Finding the Big Electric Cat .999

Making Things Explode .1000

Wrapping Text Around a Globe .1001

Index

Setting Up a New Photoshop Document

Using Photoshop, you can create high-resolution, four-color graphics (images that generate a color palette by mixing the colors cyan, magenta, yellow, and black) designed for magazines, or you can produce low-resolution images with a specified color palette for fast-loading Web graphics. Each Photoshop image is like a fingerprint and requires its own unique setup. As a designer, you should always start a project in Photoshop with a thorough understanding of exactly where the graphic images are going to be used.

To create a new graphic in Photoshop, select the File menu New option. Photoshop will display the New dialog box, as shown in Figure 1.1.

Figure 1.1 Using the Photoshop New dialog box lets you specify an image's characteristics.

The New dialog box is where the characteristics of a new document are first specified. Using the New dialog box, you can set the following options:

- **Width** and **Height:** Width and height should be decided based on the image's final destination. You can crop an image (reduce the number of pixels in a Photoshop graphic) without affecting the quality of the final document; however, increasing the size of a graphic image is a different story. It forces Photoshop to insert additional pixels into the image. Since the additional pixels add dots of color, not actual image detail, enlarging a Photoshop graphic after being opened will flatten large areas of color and obscure image details.

- **Resolution:** Photoshop measures resolution in an image by the number of pixels contained in a linear inch. You can lower resolution after opening the image in Photoshop; however, increasing the resolution will only add additional dots of color, not additional detail. If you are uncertain about the final destination of the image, always choose a resolution higher than you think you will need, as discussed in Tip 113, "Determining Resolution Based on Final Output."

- **Mode:** The New dialog box defines color space as the image's mode. All Photoshop graphics are created within a specific color space (Bitmap, Grayscale, RGB, CMYK, or Lab). Changing into a different color space after opening the document can shift the color space of an image and force you into unnecessary and time-wasting color correction, as discussed in Tip 111, "Choosing the Correct Color Space."

2 *Finding a Misplaced Image on Your Hard Drive (Macintosh Only)*

In Tip 3, "Saving Your Image Files and Quitting Photoshop," you will learn to how to save a current Photoshop image to a file by specifying the file's name and type. In addition, Photoshop lets you specify the folder where the file will be stored.

Saving your Photoshop graphics into organized folders will make you (or someone else) more efficient by reducing the amount of time spent searching the disk for the image file. Unfortunately, sooner or later everyone manages to misplace a file. Do not despair. Photoshop can help you find that missing graphic file with ease.

To locate a missing file, perform the following steps:

1. Select the File menu Open option. Photoshop will display the Open dialog box.

2. Within the Open dialog box, click your mouse on the Find button. Photoshop will display the Find dialog box, as shown in Figure 2.1.

3. Within the Find dialog box, type the name of the missing file into the file name input field.

4. Click your mouse on the OK button or press Enter.

Figure 2.1 Use the Find dialog box to locate misplaced files.

Photoshop will begin searching for the file on all hard drives and disks currently attached to your computer, so if you are working with multiple disks or a RAID system, this may take a minute or two.

If you receive the error message "No matching files were found," Photoshop was unable to find a file with the exact file name you typed into the Find dialog box. Repeat the previous steps, making sure you typed the file name correctly. As you type the file name, you can use either upper- or lowercase letters. The Photoshop Find command is not case-sensitive.

If you do not remember the entire file name, type the portion of the name you remember into the Find dialog box input field and click your mouse on the OK button. Photoshop will begin displaying, one at a time, the names of all files containing the typed characters. If the highlighted file name is not the correct one, click your mouse on the Find Again button until Photoshop highlights the correct file name. Then click your mouse on the Open button, and Photoshop will display the selected graphic.

3 *Saving Your Image Files and Quitting Photoshop*

Like most programs, sooner or later when you use Photoshop, you are going to want to stop working and end the day. Photoshop will not let you exit the program without ensuring you have saved all open graphic files. Exactly how Photoshop saves a file directly relates to what you were doing to the image before you clicked your mouse on the Save button.

The following list briefly describes your options when you save a file within Photoshop:

- **Saving a new file:** Select the File menu Save option. If this is your first save of the file, Photoshop will open the Save As dialog box, as shown in Figure 3.1, and prompt you to name the file, choose the image's format, and choose which folder on the disk you want to store the image file.

Figure 3.1 *The Save As dialog box opens the first time you save a file in Photoshop.*

- **Saving a file that has been saved once:** If you have previously saved the file, selecting the File menu Save option will automatically save the file back to its original location on disk, with the same name and format you assigned to the image the first time it was opened in Photoshop. When you save a graphic a second time, Photoshop, without prompt or warning, will automatically delete the original image and replace the document on disk with the current working version.

- **Using Save As:** Choosing File menu Save As when working in a new or previously saved image forces Photoshop into displaying the Save As dialog box, previously shown in Figure 3.1, and gives you the ability to change the file's name, saved location on disk, and document format.

- **Using Save As and renaming the file:** It is a good idea to occasionally perform a Save As (select the File menu Save As option) and rename the file. You might, for example, add a number to the end of the file name that tracks the current version of that particular graphic image. If you named your file *image.tif*, you might, with each succeeding Save As, change the name to *image1.tif, image2.tif*, and so on. Performing a File menu Save As and renaming the file will not overwrite the original saved image on disk, but it will create a copy of the graphic with a new name. You now have an evolution of your design as you continue to work, and if the need arises, you (or someone else) have a quick way to return to an earlier version of the image.

Note: Choosing Save As from the File menu in Photoshop 6.0 gives you the option to save a copy of the file and include alpha channels and multiple layers as well as annotations and spot colors. Several of the tips in this book discuss these options in greater detail.

4 *Choosing the Correct Compression Scheme to Fit the File*

Graphic images tend to be very large, especially where Photoshop is concerned. When you save a Photoshop file to disk, consider compressing the image. Photoshop will make the file smaller, and smaller images take up less space on your hard drive.

Compression schemes fall into two major categories: compression that permanently removes information from the file (lossey) and compression that reduces file size without removing information (lossless). Unless you are working on graphics destined for the Internet or projects in which image size is an important consideration, you should always choose lossless compression methods to save your files.

The following list describes the major compression schemes available within Photoshop:

Photoshop compression: When you save an image using the Photoshop format (files saved with the *.psd* extension), you are using Photoshop's native format. Understand that Photoshop compression is lossless (that's a good thing). Photoshop is also automatically compressing the image when you save it to disk by 20 percent or more.

To save an image using Photoshop's native format, perform these steps:

1. Select the File menu Save As option. Photoshop will display the Save As dialog box, as shown previously in Figure 3.1.

2. Within the Save As dialog box, click your mouse on the Format pop-up box. Photoshop will display a list of your file format options.

3. From the displayed list, click your mouse on the desired format. The list of options will collapse, and the Format option box will now display the file format you selected.

4. Within the Save As dialog box, click your mouse on the Save button. Photoshop will save the image to disk.

Saving an image in native format defines the image as a Photoshop graphic and lets you use features available only to Photoshop, such as multiple layers and transparent pixels. However, since most programs do not support these features, graphics saved in Photoshop native format have limited movement outside of Photoshop. Programs such as QuarkXPress, PageMaker, and PowerPoint cannot open a graphic with the *.psd* extension.

LZW compression: Lemple-Zif-Welch (I strongly suggest calling it LZW) compression is the compression method used by Photoshop to save Tagged Image Files (files saved with the *.tif* extension). Unlike the Photoshop native format, files saved as *.tif* images are more accessible by other programs such as QuarkXPress, PageMaker, InDesign, and PowerPoint. LZW compression is lossless and can shrink a file saved to disk by 50 percent or more. This makes LZW compression an excellent choice for saving large sets of Photoshop images to disks or rewriteable CDs.

To save a file with LZW compression, perform these steps:

1. Select the File menu Save As option. Photoshop will display the Save As dialog box.

2. Within the Save As dialog box, click your mouse on the Format pop-up box. Photoshop will display a list of your file format options.

3. Within the Format options list, click on the TIFF format option. The list of options will collapse, and the TIFF file format will be displayed in the Format option box.

4. Within the Save As dialog box, click your mouse on the Save button. Photoshop will display the TIFF Options dialog box, as shown in Figure 4.1.

5. Within the TIFF Options dialog box, click on the LZW option and click the OK button. Photoshop will save the file to disk.

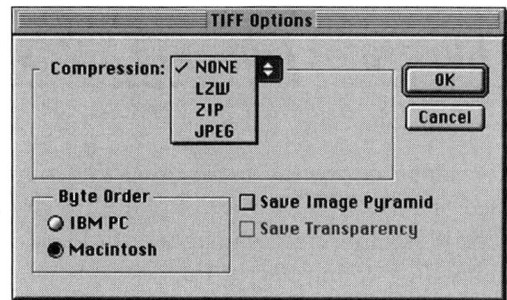

Figure 4.1 Saving files in the TIFF format allows for several compression methods.

Zipping a file in Photoshop: The Zip file compression method has been used on graphic files for years but was confined to the Windows format. Over the last few years, however, the popularity of Zip compression caused its migration to the Macintosh platform. Photoshop 6.0 is one of the first programs to include the Zip compression option as part of saving a Tagged Image File (*.tif*).

> *Note: To use JPEG compression in Photoshop for Windows, select the extended TIFF save options in the Preferences dialog box.*

Like LZW compression, the Zip compression scheme is lossless, but it can save even more space on your hard drive than using LZW compression.

To save a file using Zip compression, perform these steps:

1. Select the File menu Save As option. Photoshop will display the Save As dialog box.

2. Click your mouse on the Format pop-up box. Photoshop will display a list of your file format options.

3. Within the Format options list, click on the TIFF format option. The list of options will collapse, and the TIFF file format will be displayed in the Format option box.

4. Within the Save dialog box, click your mouse on the Save button. In turn, Photoshop will display the TIFF Options dialog box.

5. Within the TIFF Options dialog box, click your mouse on the ZIP option and click the OK button. Photoshop will save the image to disk.

Files saved with Photoshop 6.0 Zip compression can be reopened in Photoshop 6.0 without problem. Unfortunately, if you do not have Photoshop 6.0, you will need an additional program to compress and decompress the image. It is important to note that these additional compression programs operate independently of Photoshop and require the image to have been previously saved by Photoshop to disk. Exercise care when moving zipped images between computers; ensure that the file's recipient has access to the necessary programs to decompress the image.

JPEG compression: You probably noticed a third compression option in the TIFF options dialog box called JPEG compression. The JPEG compression scheme is discussed in greater detail in Tip 828, "Making JPEG Images Small." JPEG compression is used extensively for presentation and Web graphics, but care must be exercised because JPEG (*Joint Photographic Experts Group*) compression is lossey. JPEG compresses an image by permanently removing image information (the quality of the image will suffer when viewed or printed), and after you save the file, Photoshop cannot recover the lost information. It will be gone forever.

Note: To use JPEG compression in Photoshop for Windows, select the extended TIFF save options in the Preferences dialog box.

5 *Opening Illustrator Files in Photoshop*

Adobe Illustrator is Photoshop's co-worker program in the computer design industry. While Photoshop handles images composed of a group, or *raster*, of pixels (as discussed in Tip 7, "Understanding Raster Image Programs"), Adobe Illustrator creates images out of vector or mathematical shapes (as explained in Tip 844, "Understanding Raster and Vector Images").

Since most graphic images are defined as *vector* or *raster*, owning both Photoshop and Illustrator gives you the ability to open and manipulate almost any graphic image. As a designer, that gives you a lot of control and flexibility.

To open an Adobe Illustrator graphic, you must first use Photoshop to convert the image into an acceptable format. Fortunately, this conversion process is quick and painless because Photoshop performs all the work for you.

To work on an Adobe Illustrator image in Photoshop, use one of the following options:

- **Use your mouse to drag it:** If you have Photoshop and Illustrator open at the same time, click your mouse on the Illustrator object you want to move and drag the image to any open Photoshop graphic window. Photoshop automatically creates a new layer and encloses the image within a bounding box. (A bounding box is a square or rectangle surrounding the Illustrator image with visible handles on the corners and sides of the box.) As long as the bounding box is visible, you can click your mouse on the bounding box handles and resize and/or rotate the Illustrator image to the desired size. When you are ready, press the Enter key and Photoshop will convert the image. The open Photoshop document will automatically determine the resolution and color space of the converted Illustrator image.

- **Using the File menu Place option:** This method is great if you do not have enough computing power to open Photoshop and Illustrator at the same time. Use Photoshop to open a graphics file (select the File menu Open option) and, once the image is open, select the File menu Place option. Photoshop will open the Place dialog box, as shown in Figure 5.1. Locate the desired Illustrator graphic and click your mouse on the Place button. Photoshop creates a new layer and displays the Illustrator graphic within a bounding box, as discussed in the previous option. Use your mouse to drag it. Resize the image and press Enter when you like what you see. Photoshop will then convert the Illustrator vector image (a mathematical object) into a raster image (a graphic composed of pixels) with the resolution and color space of the open Photoshop document.

Figure 5.1 Select the correct Illustrator graphic and click your mouse on the Place button.

- **Using the File menu Open option:** Let's say you need to convert an Adobe Illustrator graphic, but you do not want to insert the image into an existing Photoshop document. Open Photoshop and select File menu Open. Photoshop will display the Open dialog box. Select the Illustrator graphic file by clicking your mouse on the correct file name and then click your mouse on the Open button. Photoshop will display the Rasterize Generic EPS Format dialog box, as shown in Figure 5.2. Because you are not moving or placing this Illustrator graphic into a preexisting Photoshop image, you must define the conversion process. The width, height, resolution, and color space of the image are all modifiable input fields. To change the image's characteristics, click your mouse in the desired input field and change the default information. Most Illustrator graphics default to CMYK color space. If this is not correct, click your mouse on the pop-up button and choose the desired color space. The option for Constrained Proportions, if checked, lets you change the width or height of the image without stretching the image out of proportion. For more information on the Anti-aliased option, read Tip 116, "Selecting Anti-aliased for Postscript Images."

Figure 5.2 Use the Rasterize dialog box to define the characteristics of the Illustrator file.

⑥ *Opening Images Saved in the Kodak CD Format*

When you are working with your own photographs, you have one of two choices to open them in Photoshop. You can scan them yourself, or you can let someone else do it for you. Say you have a bunch of original negatives or slides that you need to open in Photoshop. The problem, however, is you do not have a negative/slide scanner. Do not despair. Take your negatives or slides to a local photo lab and ask them to transfer the images to a Kodak Photo CD. The photo lab will use Kodak's proprietary hardware and software to scan the images and write them to a CD. The Kodak format is unique in that it saves each image as a separate file (called an image pac); however, when you open the image in Photoshop, you can choose between six different file sizes and nine different output resolutions.

The advantages to saving an image in the Kodak format are:

1. You do not have to spend your time and equipment resources scanning the images (very time-consuming).

2. The equipment used to create the scanned image is typically beyond the financial reach of most designers (high-end drum and flatbed scanners).

3. The images are not platform-specific. Regardless of whether you use a Macintosh or Windows computer, Photoshop will let you open the images and edit them.

4. Images saved in the Kodak format are easy to store. You can save up to 120 Kodak formatted images on a single CD.

5. They are relatively inexpensive, running about 75 cents per image.

To open a Kodak Photo CD image, insert the CD into your computer's CD reader, launch Photoshop, and then perform these steps:

1. Select the File menu Open option. Photoshop will display the Open dialog box.

2. From the file list, click your mouse on the desired file name and then click your mouse on the Open button. Photoshop will display the Kodak CD dialog box.

3. Click your mouse on the Pixel Size pop-up input field. Photoshop will display the six pixel size options.

4. Click your mouse on the selected pixel size. The pixel size options window will collapse and will display your choice in the Pixel Size input field box.

5. In the Photo CD dialog box, click your mouse on the Profile pop-up input field. Photoshop will display a list of profile options. From the listed options, click on the closest match to the image's source and click the OK button. See Tip 301, "Choosing a Source for a Kodak CD File." In the Photo CD dialog box, click your mouse on the Resolution pop-up input field. Photoshop will display a list of the resolution options. From the listed options, click on the target resolution (the final output resolution of the image when it is printed or displayed) and click the OK button. See Tip 302, "Choosing a Destination for a Kodak CD File."

7. In the Photo CD dialog box, click your mouse on the Color Space pop-up input field. Photoshop will display a list of the color space options. From the listed options, click on the closest match to the final output device and click the OK button. See Tip 288, "Using New View to Control Image Editing," for more information on this process.

8. Click the OK button. Photoshop will open a window containing the image. You can now edit the image as you would any other open Photoshop graphic.

7 *Understanding Raster Image Programs*

All images opened in Photoshop, regardless of their file format, are raster images (resolution dependent). Photoshop defines raster images as a grouping, or *raster,* of pixels that defines the detail of the viewable image, as shown in Figure 7.1.

When you open an image in Photoshop, the resolution of the image controls how many pixels the image contains (its raster size) and therefore the amount of detail the image will contain when it is opened in Photoshop.

When you use Photoshop to adjust or resize an image, the resolution of the image gives Photoshop the information it needs to make the adjustments correctly. While it is not as easy as saying more resolution is better, photographic images scanned at higher resolutions will color correct, light balance, and resize better than images scanned at lower resolutions. See Tip 110, "Determining When an Image Contains Too Much Resolution."

Figure 7.1 *Enlarging a section of a Photoshop image demonstrates that all Photoshop images are composed of a grouping, or raster, of pixels.*

8 *Working in Photoshop's RGB Color Space*

The RGB color space is the color space of your computer monitor. When you are working on an open image in Photoshop and the image is in the RGB color space, the colors viewed on your monitor will use varying percentages of red, green, and blue to display the graphic image. Since your monitor does not require an external light source to display color (but rather projects the color to your eyes), the RGB color space is defined as "additive" color.

Photoshop defines the red, green, and blue components of a graphic image on separate plates called channels, as shown in Figure 8.1. (For more information on channels, see Tip 432, "Understanding Channels and Their Role".) Photoshop maintains a separate channel for each of the three-color components of an image. It then mixes those three channels of red, green, and blue into what is defined in Photoshop as the composite channel.

In Photoshop, what determines the maximum number of colors an image can generate is the number of bits per pixel. A normal RGB image is composed of a 24-bit pixel and has the capacity to generate 16.7 million separate colors.

Figure 8.1 *Photoshop divides an RGB image into its separate color components of red, green and blue.*

9 *Working in Photoshop's CMYK Color Space*

Photoshop creates all the colors within a CMYK image by mixing cyan, magenta, yellow, and black. CMYK is the color space of the print world. As discussed in the preceding tip, Photoshop divides the colors, in this case CMYK colors, and places them onto separate plates called channels, as shown in Figure 9.1. Since Photoshop uses the CMYK color space for printed output, not for displaying the image on a monitor, the only way to correctly view a Photoshop CMYK graphic is to print the image using the File menu Print option. For more information on printing, see Tip 699, "Printing Directly from Photoshop Using Default Printing Options."

Figure 9.1 Photoshop separates a CMYK color image into separate plates or channels of cyan, magenta, yellow, and black.

Once Photoshop has transferred the image from computer screen to printed document, the color space of the graphic switches from additive to subtractive. In other words, light from an external source will strike the paper and bounce up to your eyes. Depending on the type of paper (color, surface texture) and type of inks used, some of the light source's spectrum of color will be absorbed or subtracted from the light. What is left is viewed by your eyes as the colors of the graphic image, hence the term "subtractive" color.

Unlike RGB color space, the maximum number of colors a CMYK image can generate is not determined by pixel depth (refer to the preceding tip). The maximum number of colors in a Photoshop CMYK image will be determined by where the graphic is to be printed. Understand that the number of printable colors in a CMYK image will be determined by the paper stock and inks being used, not by what you see on your computer monitor. See Tip 253, "Understanding Printer Color Management," for more information on printed color.

When you open Photoshop and view a CMYK image, Photoshop is attempting to readjust the CMYK subtractive color space to view correctly on an additive monitor (refer to the preceding tip for information on additive color space). Unfortunately, Photoshop and your monitor cannot do a perfect job of displaying CMYK color space to your eyes. Therefore, you should take care when viewing a CMYK image on your computer monitor. Understand that what you see is not necessarily what you are going to get.

10 *Working in Photoshop's Grayscale Color Space*

In Photoshop, the grayscale color space (Photoshop defines grayscale as a color space), contrary to its name, is not just used for black-and-white images. In fact, the grayscale color space can be used to convert an image into shades of any definable color. The important thing to understand about grayscale is the word "scale." Grayscale images can use any color and shade, or "scale" that color across the image. An example would be the aging of a graphic image by converting the shades of gray in a grayscale image into shades of sepia by the use of a duotone, as discussed in Tip 637, "Applying a Tint to an Image."

Since a grayscale image has only one color (black), Photoshop only creates one 8-bit channel, as shown in Figure 10.1. (See Tip 432, "Understanding Channels and Their Role," for more information on channels.) The limitation of a grayscale image is the maximum shades of color it can generate. In Photoshop, a grayscale image of 8 bits can only generate 256 separate shades of color. See Tip 442, "How Channels Are Used to Define Color," for information on how Photoshop determines the number of colors in an image by the number of bits.

Figure 10.1 A Photoshop grayscale image has one channel or color, defined as black. Grayscale images produce a maximum of 256 shades of gray.

11 *Setting Up Photoshop's Color Settings*
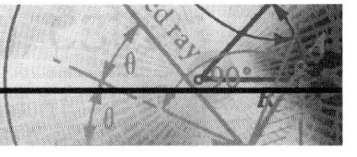

Adobe greatly simplified the workload of setting up color management in Photoshop 6.0 by moving most of the controls into a single Color Settings dialog box. Rather than make you set each option individually, Photoshop now supplies you with a predefined list of color management settings. If, however, the predefined settings do not fit your particular design workflow, you can customize the settings to fit any project.

To manage Photoshop's color settings, launch Photoshop and choose the Edit menu Color Settings option. Photoshop will display the Color Settings dialog box. Click on the Settings pop-up button. Photoshop will display a list of the predefined color settings:

- **Custom:** Lets you customize all the options in the Color Settings dialog box to fit a workflow outside the predefined settings.

- **Color Management Off:** Use if the Photoshop graphics are destined for on-screen presentations or documents designed to be viewed on a computer monitor.

- **ColorSync Workflow:** Use on Macintosh systems that will not be transferred to Windows. ColorSync Workflow performs color management based on the Macintosh-based ColorSync Color Management System (CMS).

- **Emulate Photoshop 4:** If you have a large collection of Photoshop 4.0 images and you need to preserve the color profile of those graphics, select this option.

- **Europe Prepress Defaults:** For use with graphics destined to be printed on European presses.

- **Japan Prepress Defaults:** For use with graphics destined to be printed on Japanese presses.

- **US Prepress Defaults:** For use with graphics destined to be printed on presses in America.

- **Web Graphics Defaults:** For use on graphics destined for the World Wide Web.

Click on the option that best fits your workflow. The predefined settings list will collapse, and the Settings button will display your choice. Click the OK button. The Color Settings dialog box will close, and you are now ready to work.

Keep in mind that you must make changes to the Color Settings dialog box *before* opening or creating any files within Photoshop.

> *Note: High-end printing performed by a service bureau or publishing house may require you to create a custom set of color settings. If you plan to use these settings again, click on the Save button in the Color Settings dialog box and save the custom settings.*

To save a customized set of color settings, launch Photoshop and perform the following steps:

1. Choose the Edit menu Color Settings option. Photoshop will display the Color Settings dialog box.

2. Within the Color Settings dialog box, click on the individual pop-up input fields and make specific changes to the displayed options.

3. Within the Color Settings dialog box, click on the Save button. Photoshop will display the Save dialog box, as shown in Figure 11.1.

4. In the Save dialog box, describe the file by selecting with your mouse the default file name "untitled" and then typing in a descriptive name. Choose a new folder in which to store the file or keep the default location of Settings (recommended).

5. In the Save dialog box, click the Save button. Photoshop will close the Save dialog box.

6. In the Color Settings dialog box, click the OK button. Photoshop will close the Color Settings dialog box, and you can now begin work.

Figure 11.1 The Color Settings Save dialog box defines the name and storage location of all customized color settings files.

To load a previously saved options file, launch Photoshop and perform the following steps:

1. Choose the Edit menu Color Settings option. Photoshop will display the Color Settings dialog box.

2. In the Color Settings dialog box, click on the Load button. Photoshop will display the Load dialog box.

3. In the Load dialog box, select the correct folder and then select with your mouse the correct file name. Finally, click the Load button. Photoshop will close the Load dialog box.

4. In the Color Settings dialog box, click the OK button. Photoshop makes the changes to the Color Settings and closes the dialog box. You are now ready to work.

12 *Working with Fonts in Photoshop*

Photoshop handles fonts differently than normal text-processing programs. Whereas programs such as QuarkXPress, PageMaker, and even Microsoft Word handle text as a vector or mathematical shape, Photoshop converts text into a raster image, as discussed in Tip 652, "Understanding How Photoshop Processes Type." The difference between Photoshop and other text-processing programs is best illustrated when you print the graphic file.

In order to print a text-based document (non-Photoshop), you will need to have the correct font loaded on your computer. When you select the print option, the text-based program will access the font file and instruct the printer to print the document based on the information in that specific font file. Without that file, the printer will substitute another font or, in worst-case scenarios, print the text with a jagged, hard-to-read appearance.

When you print a Photoshop image containing text, the printer does not rely on the font file because Photoshop converted the text into pixels, so the font file is not required. This means you can move a Photoshop document to any computer and print the file without regard to the fonts loaded on that machine. Unfortunately, once Photoshop converts the text into image pixels, you cannot make even simple changes to the text like correcting a misspelled word or changing the font type.

Note: There are two ways to force Photoshop into converting vector text into pixels: You can convert the text by selecting the text layer and choosing the Layer menu Rasterize Type option, or you can flatten the image (combine all of Photoshop's layers into one single layer or background). In either case, once you have saved a rasterized or flattened file in Photoshop, you can never reopen the graphic and adjust the text.

13 *Understanding How Photoshop Transforms an Image*

In Tip 7, "Understanding Raster Image Programs," you learned that Photoshop was a raster-based program, or a program that defines an image as a group of pixels. Each pixel in a Photoshop image defines a piece of the image, so the more pixels there are in a Photoshop image, the more pieces, or detail, the image contains. In Photoshop, you measure the raster size of an image by its resolution.

Keep in mind that when you transform, or resize, an image, Photoshop does not enlarge or contract the image pixels; it will add or subtract pixels. Say you have an image three pixels wide by three pixels tall. Since image pixels are square, they fit together like bricks in a wall. Therefore, an image that's three by three would actually contain nine pixels (three times three equals nine pixels).

Photoshop defines the process of adding pixels to a Photoshop image as interpolation, and there are three choices for the interpolation of a Photoshop image:

- **Nearest Neighbor:** This generates or subtracts image pixels by comparing the pixels to their nearest neighbor, as shown in Figure 13.1. This method is fast, but it delivers an image with poor image quality.

Figure 13.1 Of the choices, the Nearest Neighbor interpolation method is the simplest and least effective method of transforming an image.

- **Bilinear:** Bilinear is a tradeoff between speed and quality. This method uses the pixels surrounding an image to the left, right, top, and bottom, as illustrated in Figure 13.2. Photoshop takes the values of those surrounding pixels and divides by four. The results of that calculation determine the colors of the new pixels.

- **Bicubic:** The Bicubic method is the best but the slowest of the three. Not only does it analyze the pixels like it does in the Bilinear method, it goes a step further by accessing the diagonal pixels, as shown in Figure 13.3. All the pixels are then averaged together. The result might take longer than the other two methods, but it will be the best possible.

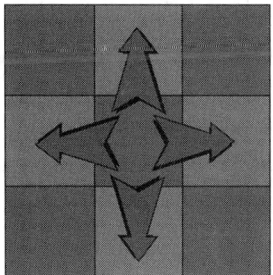

Figure 13.2 Bilinear interpolation is a tradeoff on speed versus quality.

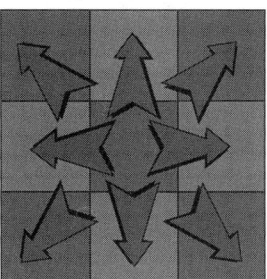

Figure 13.3 The Bicubic interpolation method works the hardest to give you the best possible image.
Unless there is a specific reason to sacrifice quality for the sake of speed, always use the Bicubic interpolation method.

To choose an interpolation method, launch Photoshop and perform these steps:

1. Choose the Edit menu Preferences-General option. Photoshop will display the General Preferences dialog box.

2. Click on the Interpolation pop-up input button. Photoshop will display your three interpolation choices.

3. Click on the selected interpolation method. The pop-up box will collapse, and the Interpolation button will display your choice.

4. Within the General Preferences dialog box, click OK. Photoshop will register your changes and close the Preferences dialog box.

14 *Opening Photoshop Along with Other Adobe Programs*

Photoshop is a fantastic program, but it cannot do everything... at least not yet. Say you need to work on an image in Photoshop and move the image into ImageReady. You could save the file by selecting the File menu Save option and then close Photoshop. Then you could launch ImageReady and select the File menu Open option, select the Photoshop file, and click your mouse on the Open button. It will work, but it consumes a lot of time. There is an easier way if you have enough computing horsepower to pull it off: Open both programs at the same time and then move from one program to another.

Two important system requirements for using Photoshop with other programs are:

- **Speed:** The clock speed of your computer processor is measured in millions of instructions per second (MIPS). The average computer system sold today runs at 500 MIPS or higher, and the fastest run at over a billion. The "clock speed" of a computer is the most common term used in the computer industry to describe a computer's speed. You should have a computer running at a clock speed

of 300 or higher. Slower clock speeds will work, but you will be disappointed in how slow the system performs with multiple open programs.

- **RAM memory:** Random access memory (RAM) is where your computer performs all of its work and is measured in millions of bytes (MB). The absolute minimum needed for opening Photoshop with other programs is 128MB of RAM, but 256MB will give you better performance and will let you perform more work in the same amount of time. And saving time is what it is all about.

Photoshop gives you another distinct advantage when you use it with other Adobe programs like Illustrator and InDesign. You can click and drag graphic items between programs (use your mouse to drag them). Refer to Tip 5, "Opening Illustrator Files in Photoshop," to understand how to move graphic items between different Adobe products.

15 *Running Photoshop with Virtual Memory*

One point of frustration with Photoshop users (mostly Macintosh) is whether to use virtual memory. Prior to version 6.0, Photoshop always advised users to run with virtual memory disabled. The reasoning behind this is that Photoshop handles its own memory through the program, not through the operating system.

Unfortunately, some programs actually run better with virtual memory turned on, and a few programs *require* that it be on to run. This has never been a point of contention with Windows users, and with the release of Photoshop 6.0, Macintosh users can relax as well. Photoshop running on the newer Macintosh computers (G series and higher) now runs fine with virtual memory turned on.

On Windows computers, let Windows manage the virtual memory settings. On Macintosh computers, turn virtual memory on and set it to its lowest settings.

To activate virtual memory on a Macintosh:

1. Click on the Apple button and choose the Control Panels Memory option. The Macintosh operating system will display the Memory dialog box, as shown in Figure 15.1.

Figure 15.1 The Memory dialog box controls the Photoshop's virtual memory option.

2. Click on the Virtual Memory On button.

3. Click on the button in the upper-left corner of the Memory dialog box to close the box. Finally, restart your computer. Virtual memory is now activated.

To activate virtual memory in Windows, perform these steps:

1. On the desktop, right click your mouse on your My Computer icon.

2. From the pull-down menu, click on the Properties option. Windows will display the hard-drive System Properties dialog box.

3. Click on the Performance tab. Windows will display the hard-drive Systems Properties Performance options. Click on the Virtual Memory button. Windows will display the current Virtual Memory settings, as shown in Figure 15.2.

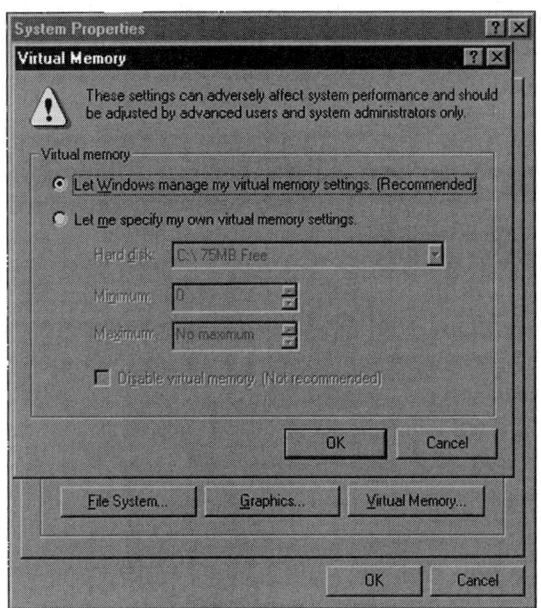

Figure 15.2 The Virtual Memory dialog box controls the use of virtual memory within the Windows operating system.

4. Choose the option to let Windows manage virtual memory and click the OK button.

5. Restart Windows and virtual memory is controlled by the Windows operating system.

Note: Windows users should never disable virtual memory.

16 *Understanding How Photoshop Uses Your Hard Drive and RAM Memory*

Photoshop is a resource-intensive program. When Photoshop is open on your computer, it requires a significant amount of random access memory (RAM) as well as space on your hard drive. (Photoshop defines the hard drive as the *scratch disk*.) Making Photoshop perform operations faster involves a thorough understanding of how the program balances its need for RAM memory and space on your hard drive.

• **Random access memory:** When you launch Photoshop, you are operating the program within RAM memory on your computer. Think of RAM memory as the workplace on your computer. When you

launch Photoshop and open a graphic file, your computer attempts to load the Photoshop program and any open graphic files into RAM memory. If you do not have enough RAM memory, your computer is forced to substitute your computer hard drive. Since your hard drive is a poor substitute for RAM memory, operations performed in Photoshop will slow down.

Photoshop requires a minimum of 12MB of RAM; however, Photoshop requires more than just the minimum requirements to run efficiently. Adobe recommends assigning 32MB of RAM, and that is just to get started. On average, you should have 32MB of RAM plus five times the size of any open graphic files. For more information on determining file size, refer to Tip 19, "Displaying File and Image Information." Assume you opened a 10MB graphic file in Photoshop. Photoshop will require 32MB of RAM plus five times ten, or an additional 50MB of RAM memory for the graphic file. That makes a grand total of 82MB of RAM memory. For more information on RAM memory, refer to Tip 18, "Assigning RAM Memory to Photoshop."

- **Hard drive:** When you work in Photoshop, there is a constant "dance" going on inside your computer between RAM memory and the hard drive. Photoshop is working within RAM memory and, at the same time, writing operations to your computer hard drive.

You learned in the preceding list item that Photoshop requires plenty of RAM memory, but to work efficiently, Photoshop also requires five times the file size (in available space on the hard drive) of any open graphic files. If, for example, you open a 20MB graphic file in Photoshop, not only will you need 132MB of RAM memory (100MB for the file, 32MB for Photoshop), but at least 100MB free disk space on your hard drive. Give it any less and Photoshop will display a dialog box and the error message "Out of Scratch Disk Space." For more information on determining file size, see Tip 19, "Displaying File and Image Information."

17 Keeping Photoshop an Efficient and Fast-Running Program

In Tip 16, you learned that Photoshop requires space on your hard drive to operate, but Photoshop uses the hard drive for more than just a simple storage area. When you work within Photoshop, as you open documents, save files, delete files, and launch other graphic programs, your hard drive gets quite a workout. As you create or resave Photoshop image files to your hard drive, the computer attempts to find one single area to write the file. As your hard drive gets full, instead of saving the graphic file in one nice continuous stream of data, the Photoshop image file is split into sections and saved in several different locations on your hard drive. The process of breaking files apart is called fragmentation. Since it takes Photoshop longer to open and save a fragmented graphic file, Photoshop becomes less efficient. Photoshop slows down, and you slow down with it.

The solution is to have a lot of free open space on your hard drive available to Photoshop. Not only will having a lot of available space on your hard drive help Photoshop run faster, keeping that space cleaned up is also important.

Photoshop users operating on the Windows platform need to clean up their hard drives on a weekly basis by performing a defragmentation. Keep in mind that the defragmentation utility is part of the Windows operating system, not Photoshop.

To use the Disk Defragmenter utility, close all open programs and perform these steps:

1. Double-click on the My Computer icon located on your desktop. Windows will open a window displaying the contents of your computer, including icons representing all attached hard drives.

2. Right-click on the hard drive icon holding the Photoshop application (normally this would be drive C). Windows will display a list of options.

3. Click on the Properties option. Windows will display the Properties dialog box.

4. Within the Properties dialog box, click on the Tools tab. Windows will display the tool options, as shown in Figure 17.1.

Figure 17.1 The Tools tab supplies information on when you last defragmented your hard drive.

5. Within the Tools tab, the Defragment Status option will display how much time has elapsed since your last defragmentation.

6. Click on the Defragment Now button. Windows will display a dialog box showing you the progress of the defragment utility in percentage complete, as shown in Figure 17.2.

> *Note: If this is the first time you have used a defragment utility on your hard drive, the process may take 30 minutes or longer.)*

Figure 17.2 The Defragmentation dialog box displays information on the status of the operation.

7. When the defragment utility has completed, click the OK button in the Properties dialog box.

8. Restart your computer by clicking on the Start button and selecting the Shutdown option. Click on the Restart button and then click the OK button. Windows will restart, and you are now ready to resume work with a defragmented (faster) hard drive.

> *Note: Macintosh users do not have a built-in defragment utility, so the purchase of a third-party software application is required to defragment a Macintosh hard drive. This author recommends purchasing a hard drive utility application like Norton Utilities and performing the*

Speed Disk utility. The process is similar to the defragment utility offered in Windows, and a regular application of Speed Disk will help your hard drive perform more efficiently.

Note: Here is something to take into account when your hard drive fills up. Photoshop will not allocate more RAM memory to Photoshop program operations than you have in available contiguous hard drive space. Let's say you assign 200MB of RAM to Photoshop, but your hard drive is getting full, and you only have 80MB of contiguous hard drive space available. Photoshop will only allocate 80MB of RAM for program use so you should keep an eye on that hard drive.

18 Assigning RAM Memory to Photoshop

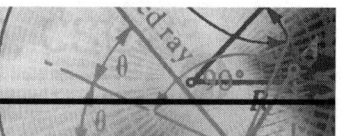

You learned in Tip 16, "Understanding How Photoshop Uses Your Hard Drive and RAM Memory," that Photoshop requires a lot of RAM memory, so it is important to know how much RAM memory is installed on your computer. Assume you are working in Photoshop on a 25MB graphic image. You learned in Tip 16 that Photoshop requires five times the size of the graphic image in available RAM memory plus 32MB for Photoshop. However, Photoshop is not the only application running on your computer. Your operating system (Macintosh or Windows) is also running and consuming RAM memory, and you may have other graphic image programs open like ImageReady or Illustrator. To determine how much RAM memory you need, use this checklist:

- Adobe Photoshop: 32MB RAM

- Open graphic file: Five times the image file size

- Operating system: 10 or 12MB RAM (Macintosh or Windows)

- Additional open programs: Check the user manual of the open application

According to the preceding calculations, if you are opening a 25MB graphic file in Photoshop and will be working with Adobe Illustrator at the same time, you will need almost 200MB of RAM memory installed on your computer.

Photoshop (25MB) graphic file (125MB) + operating system (12MB) + Illustrator (25MB) = 187MB

While you can operate with less RAM memory, Photoshop will perform operations slower because you do not have enough working space (RAM memory) for Photoshop to perform its operations.

To determine how much RAM memory is installed on your computer, Windows users perform these steps:

1. Right-click on your computer icon (located on the Windows desktop) and select the Properties option from the pop-up list. Windows will open the Properties dialog box.

2. Within the Properties dialog box, click on the Performance tab. Windows will display the performance status of your computer, as shown in Figure 18.1.

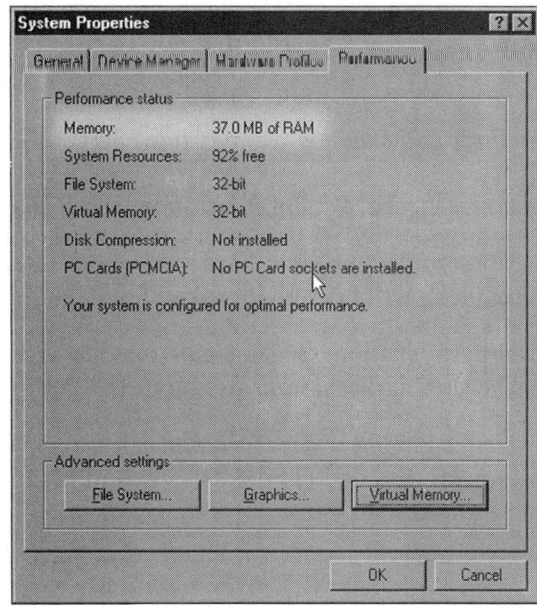

Figure 18.1 Displaying the Properties dialog box Performance tab.

3. The memory option will display the current amount of RAM memory installed. Based on the preceding calculation, this number should meet or exceed your RAM memory requirements.

4. When you are finished, click the OK button to collapse the Properties dialog box.

To determine how much RAM memory is installed on your computer, Macintosh users perform these steps:

1. Close all active programs.

2. Click on the Apple button and select About This Computer from the pop-up list of options.

3. Macintosh will display the About This Computer dialog box, as shown in Figure 18.2.

Figure 18.2 Displaying the About This Computer dialog box on a Macintosh.

4. Within the About This Computer dialog box, Built-in Memory displays the total installed RAM memory on your computer.

5. When you are finished, click on the close button, located in the upper-left corner of the About This Computer dialog box.

If you do not have enough RAM memory, either install or have installed additional RAM modules. For more information on installing RAM modules on your computer, consult your computer users manual or contact the manufacturer.

Windows users: Let the operating system handle the allocation of memory to Photoshop. All you must do is follow the steps in this section to verify that you have enough RAM memory.

Macintosh users: You will need to allocate a specific amount of memory to Photoshop.

To allocate RAM memory to a Macintosh application, perform these steps:

1. Make sure Photoshop is closed. Within Photoshop, select the File menu Quit option.

2. Open the Applications folder on your hard drive and double-click on the folder named Adobe Photoshop 6.0. Macintosh will open the Adobe Photoshop 6.0 Applications folder.

3. Within the Photoshop Applications folder, locate the file named Adobe Photoshop 6.0 and click once on the file name. The icon darkens, indicating that the Photoshop application file is selected.

4. From the desktop, select File menu Get Info and select the Memory option. Macintosh will display the Adobe Photoshop 6.0 Info dialog box, as shown in Figure 18.3.

Figure 18.3 The Photoshop Info dialog box.

5. The Adobe Photoshop dialog box lists the suggested, minimum, and preferred RAM memory sizes for the Photoshop program. Click in the Preferred Size input field and, based on your calculation of needed RAM memory (refer to the previous discussion), type in the correct amount of RAM.

6. When you are finished, click on the close button, located in the upper-left corner of the Adobe Photoshop Info dialog box. The dialog box will close, and the changes to RAM memory will be recorded.

The next time you open Photoshop, it will allocate RAM memory based on your changes to the Photoshop Info dialog box.

Macintosh users: Since you are allocating the RAM memory to Photoshop, make sure the total RAM assigned to Photoshop does not exceed the total RAM memory available on your computer.

19 *Displaying File and Image Information*

As you learned in Tip 16, "Understanding How Photoshop Uses Your Hard Drive and RAM Memory," assigning RAM memory and organizing your hard drive are necessary steps toward making Photoshop an efficient program. However, after you open an image within Photoshop, the program gives you a way to observe the characteristics of any open graphic file.

Each open graphic in Photoshop comes with its own information dialog box, as shown in Figure 19.1.

Photoshop lets you view six different areas of information specifically related to the open graphic. To select any one of the six areas of document information, click on the black triangle located to the right of the information dialog box and choose one of the following options:

- **Document size:** The information field displays two numbers separated by a right slash, as shown in Figure 19.2. The number on the left represents the "flattened" size of the file at its current resolution and color space. The number on the right represents the size of the current image as you add additional layers. For more information on how Photoshop flattens an image, refer to Tip 373, "Flattening Layers Within Photoshop."

Figure 19.1 The information dialog box displays information about the characteristics of any open graphic files in Photoshop.

Figure 19.2 The document size option displays the flattened and unflattened size of the open graphic file.

- **Scratch size:** The information field displays two numbers separated by a right slash, as shown in Figure 19.3. The number on the left represents the amount of physical RAM memory needed to efficiently process the open graphic. The number on the right represents the amount of available RAM memory available to Photoshop. To work efficiently, the number on the left (the amount of RAM Photoshop needs) should be smaller than the number on the right (the amount of RAM that is available).

*Figure 19.3 The scratch size option displays the amount of RAM memory required
by the open graphic file and how much total RAM memory is available.*

- **Efficiency:** The information field displays a numerical percentage, as shown in Figure 19.4. This number represents the percentage of Photoshop operations being performed using RAM memory. When Photoshop does not have sufficient quantities of RAM memory, a low numerical percentage indicates that Photoshop is substituting hard drive space for RAM memory. Refer to Tip 18, "Assigning RAM Memory to Photoshop," for information on how lack of RAM memory affects the performance of Photoshop.

Figure 19.4 *The efficiency option displays, in percentage, the number of operations performed to a graphic file within RAM memory.*

- **Timing:** The information field displays a single number, as shown in Figure 19.5. The timing option records in seconds how long it took to complete the last operation. Timing does not record an overall average of work completed on an open graphic, but how long it took to complete a particular operation or filter; it then resets itself and records the next operation.

Figure 19.5 *The timing option displays, in seconds, the amount of time required for every modification to a graphic file within Photoshop.*

Note: Timing does more than inform you how long it took to complete a particular Photoshop operation; it also records the amount of time it took you to perform all the steps. If you open the Gaussian Blur dialog box and take five minutes to decide the amount of blur to enter into the blur input field, and when you click the OK button it only takes Photoshop 10 seconds to actually perform the Gaussian Blur, the timing option will display five minutes and ten seconds (the amount of time it took to perform the Gaussian Blur plus the amount of time you took to think about it).

- **Current tool:** Choosing this option will display the name of the current tool in the information dialog box, as shown in Figure 19.6. Its value to the experienced designer is of limited use, but new users of the program might benefit if they are confused as to tool names.

Figure 19.6 *The current tool option displays the name and shortcut key for the selected tool.*

Note: If you see a copyright symbol (©) displayed in the information dialog box, then the graphic has been designated by the designer as copyrighted material. For additional information on Photoshop's copyright option, refer to Tip 99, "Inserting Digital Copyright Information into a Photoshop Image."

20 Performing a Quick Print Preview in Photoshop

In Tip 19, "Displaying File and Image Information," you learned how to keep a watchful eye on any open graphic file by accessing the information dialog box. That's not all the informational dialog can do for you, however; it can also give you a quick preview of how your document will print. To get a quick preview of any open graphic file in Photoshop, click and hold on the information dialog box. Photoshop will display a pop-up box showing you a square with an "X" (representing the graphic image) on top of a white square (representing the sheet of paper), as shown in Figure 20.1. In this figure, the quick print preview not only displays the image as it will be printed, it also displays visual information such as crop marks and calibration bars.

Figure 20.1 The quick print preview option displays image placement, the location of crop marks, and other printer information.

Unless you modify the printing options in Photoshop, the quick print preview will display the image centered on the paper, without crop marks or calibration bars. To modify print placement and to add crop marks and calibration bars, refer to Tip 709, "Setting Up Printer's Marks Within an Image."

21 Retrieving Information from a Photoshop Document

You learned in Tip 19, "Displaying File and Image Information," and Tip 20, "Performing a Quick Print Preview in Photoshop," that the information dialog box within Photoshop can help you manage and print a graphic file. However, there are two more features within the information dialog box that will help you identify the characteristics of any open Photoshop graphic file.

To display the dimensions, number of channels, color and resolution information within an open Photoshop graphic, perform these steps:

1. Press and hold the Alt key and click with your mouse on the information dialog box, as shown in Figure 21.1.

2. Photoshop will display information about the width and height of the open graphic, the number of channels it holds, the color space of the document, and a very important piece of information, the resolution of the image measured in pixels per linear inch.

3. Releasing the mouse will automatically close the information box.

To display the image tile information within an open Photoshop graphic, perform these steps:

1. Press and hold the Command key (Ctrl key for Windows users) and click on the information dialog box, as shown in Figure 21.2.

2. Photoshop will display information regarding the number of tiles contained within the open graphic file and the number of pixels per tile.

3. Releasing the mouse will automatically close the information box.

Note: Tiles are how Photoshop stores digital information within a graphic. You may have noticed that, when Photoshop opens or redraws a graphic image, it redraws the image in blocks from the upper-left to the lower-right corner of the image window.

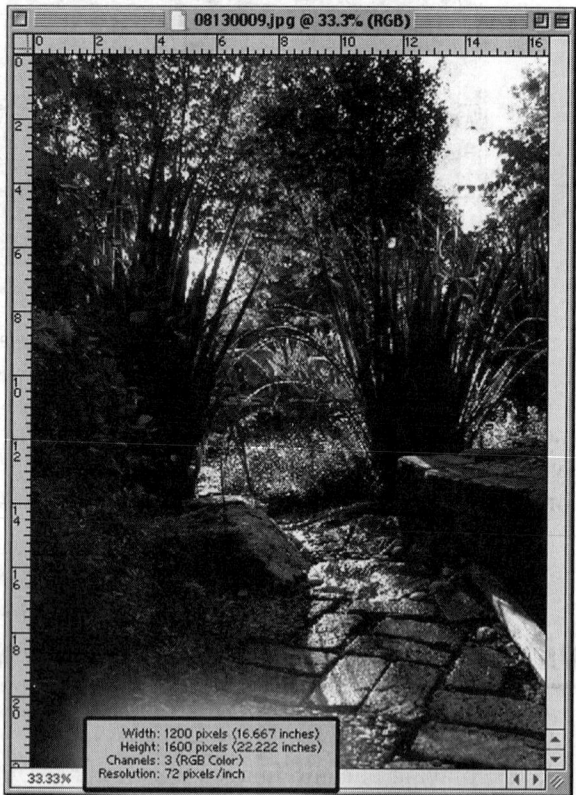

Figure 21.1 Clicking on the information dialog box while holding down the Alt key displays important information about the characteristics of a graphic file.

Figure 21.2 Tile information can be displayed within a Photoshop graphic by clicking on the information dialog box while holding down the Command key.

22 *Choosing the Correct Interpolation Method*

When you increase the size of a graphic within Photoshop, the program does not increase the width and height of the image by enlarging or stretching the pixels in the image. Photoshop leaves the pixels the same size and inserts additional pixels of color to fill in the enlarged image. Photoshop defines the process of adding pixels to an enlarged image as interpolation. In Tip 13, "Understanding How Photoshop Transforms an Image," you learned that Photoshop has three interpolation methods: Nearest Neighbor, Bilinear, and Bicubic. Understand that the Bicubic method is the slowest but produces the best results.

Although Adobe recommends working with Bicubic interpolation, circumstances might dictate that you choose one of the other two methods. Refer to Tip 13, "Understanding How Photoshop Transforms an Image," for detailed information on how Photoshop performs each interpolation method.

To change to another interpolation method, perform these steps:

1. Select the Edit menu Preferences-General option. Photoshop will display the general Preferences dialog box.

2. Click on the Interpolation button to display the three interpolation choices.

3. Click on the desired option. The dialog box will collapse and display your selected option. Click the OK button. Photoshop will close the Preferences dialog box, and you are ready to work.

- **Nearest Neighbor:** Since Nearest Neighbor only checks the color information of the adjacent pixels, this method, if used at all, works with images that are enlarged in multiples of two (100 percent enlarged to 200 percent, 400 percent, and so on). The Nearest Neighbor option will also quickly enlarge a bitmap image. Since bitmap images are two colors (black and white), the Nearest Neighbor option can quickly enlarge a bitmap image and will retain the overall quality of the original (smaller) image.

- **Bilinear:** The Bilinear interpolation method adds pixels to an enlarged image by examining the color information of the surrounding vertical and horizontal pixels. While not as detailed as Bicubic, Bilinear can quickly transform large billboard-size images, in which quality can be sacrificed for the sake of production time.

Note: In both cases, switching from the Bicubic interpolation method is a decision made to increase production workflow, not final image quality. If possible, use the Bicubic interpolation method for the best image quality and use the other two methods only when time constraints make it absolutely necessary. In addition, it is not necessary to restart Photoshop after switching interpolation methods.

23 Understanding the Settings Files in Photoshop

When you work in Photoshop, you constantly make changes to the program. In a single work session, you might rearrange the palette locations, change tool options, and modify program preferences. Then the next time you launch Photoshop and begin to work on a graphic image, all the previous changes made to the program are still in effect. Photoshop keeps track of all your changes within a set of settings files. Every time Photoshop opens, it reads the settings files and sets up the program to conform to the information contained within those files.

Before Photoshop 6.0, there were three settings files:

- General Preferences
- Color Settings
- Actions Preferences

In Photoshop 6.0, Adobe has modified the settings files to match the complexity of the program. Photoshop now has separate settings files controlling custom shapes, gradients, brushes, patterns, and styles as well as the original three.

24 *Controlling Photoshop by Restoring the Settings Files*

You learned in Tip 23, that Photoshop tracks modifications to tools, palettes, and preferences by storing that information within the settings files. Photoshop reads settings files every time the program opens, and that is where a problem can occur because the settings files can become corrupt.

Since Photoshop relies heavily on those files, having a corrupted settings file can cause Photoshop to behave erratically or even crash. If you are experiencing unusual system lockups and crashes when you open Photoshop, you just may have a corrupted settings file.

If you suspect you have a corrupt settings file and you are using Photoshop for Windows, perform the following steps:

1. Open the Photoshop program.

2. As the program is opening, press and hold Alt+Control+Shift. Photoshop will display a dialog box with the option "Are you sure you want to Restore your Preferences?".

3. Click on the OK button. The program will finish loading, and your preferences are reset.

If you suspect you have a corrupt settings file and you are using Photoshop for Macintosh, perform the following steps:

1. Close all open programs.

2. Open the Preferences folder located within the System folder and open the Adobe Photoshop 6 Settings folder.

3. Drag the file named Adobe Photoshop 6 Prefs to the Trash.

When you restart Photoshop, the program will open with a new general Preferences file.

25 *Saving Separate Setting Files for Special Occasions (Macintosh Only)*

Photoshop is a versatile program. It lets you work on images for the Web or images destined for a high-end print job. Each job is unique and requires that Photoshop have a unique set of preferences. In Tip 23, "Understanding the Settings Files in Photoshop," you learned that adjustments to preferences are stored in separate files for access by Photoshop. You can create separate settings files and then use them in Photoshop when needed. This can save you hours of time setting and resetting the preferences for each type of Photoshop job.

To create a set of specialized preference files, perform the following steps:

1. Open Photoshop.

2. Select the Edit menu Preferences-General option. Photoshop will display the general Preferences dialog box.

3. Work through the preferences, setting them to fit your particular workflow requirements.

4. When you are finished, click the OK button. Photoshop will close the Preferences dialog box.

5. Close Photoshop.

6. Open the Preferences folder located within the System folder.

7. Locate and right-click your mouse on the folder named Adobe Photoshop 6 Settings. From the fly-out menu, select the Duplicate option. The Macintosh operating system will duplicate the folder and name it Adobe Photoshop 6 Settings copy.

8. Rename the copied preference folder to match the workflow with names like Web Design Settings or Four-Color Press Settings.

Repeat the preceding steps by making copies of specific Photoshop settings for different workflow requirements. When you need to change the preferences within Photoshop, perform these steps:

1. Open the Preferences folder located within the System folder.

2. Open the Adobe Photoshop 6 Settings folder and the modified settings folder that fits your new workflow (such as Web Design Settings folder).

3. Drag and copy the files from the modified folder into the original Adobe Photoshop 6 Settings folder. To copy all the files within a folder, select the folder containing the files you want to copy and press ⌘+A (Select All). Then hold the Alt key while clicking and dragging the selected file names into the new folder.

4. A dialog box will display, indicating that you are overwriting the files in the Settings folder. Click the OK button. The copied files will overwrite the old files.

5. Open Photoshop. The program will now operate with the modified setting files.

If you work in Photoshop with various workflow requirements, this can be a real timesaver.

> *Note: Although the procedure of saving settings files is similar within the Windows operating system, since the files are maintained in the Registry, the process of modifying the Windows Registry file can be more time-consuming than opening Photoshop and manually changing the preferences.*

26 *Performing Updates to Photoshop Online*

Adobe Photoshop, as a graphics program, is constantly changing. When Photoshop 6.0 was released to the public, it went through a stringent test phase to weed out the obvious bugs and problems. Unfortunately, Adobe is not perfect, and programs are released to the public that contain errors. Adobe handles this problem by creating patches to the program that are designed to fix the errors that slipped by the beta testers. All of these bug fixes are available for download 24 hours a day at the Adobe Web site: **www.adobe.com.**

Photoshop makes this process even easier by allowing you to perform updates from the Web site directly into Photoshop. To update Photoshop online, perform these steps:

1. Open Adobe Photoshop.

2. Click on the top icon in the Photoshop toolbar, as shown in Figure 26.1.

Figure 26.1 Access Adobe Online by clicking on the topmost icon in the toolbar.

3. Photoshop will display the Adobe Online dialog box, as shown in Figure 26.2.

Figure 26.2 The Adobe Online dialog box gives you access to the online update features.

4. Click on the Refresh button. Photoshop will access its online update facilities. If your program requires updating, Adobe will automatically download the necessary files to your computer, as shown in Figure 26.3.

Figure 26.3 Photoshop displays all files as they download.

5. When the last download finishes, click on the Close button in the Adobe Online dialog box.

6. Close and restart Photoshop. You are now working with the updated program.

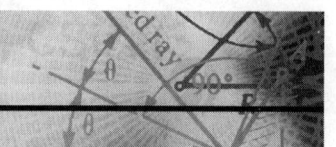

27 *Setting Up Preferences for Online Help*

In Tip 26, you learned that Photoshop can be updated directly from within the program with the click of a button. However, the update option can also be set up to perform updates on a regular basis. To configure Photoshop for automatic online updates, perform these steps:

1. Open Adobe Photoshop and click on the top icon in the Photoshop toolbar (refer to Figure 26.1).

2. Photoshop will display the Adobe Online dialog box (refer to Figure 26.2).

3. Click the Preferences button. Photoshop will display the Adobe Online Preferences dialog box, as shown in Figure 27.1.

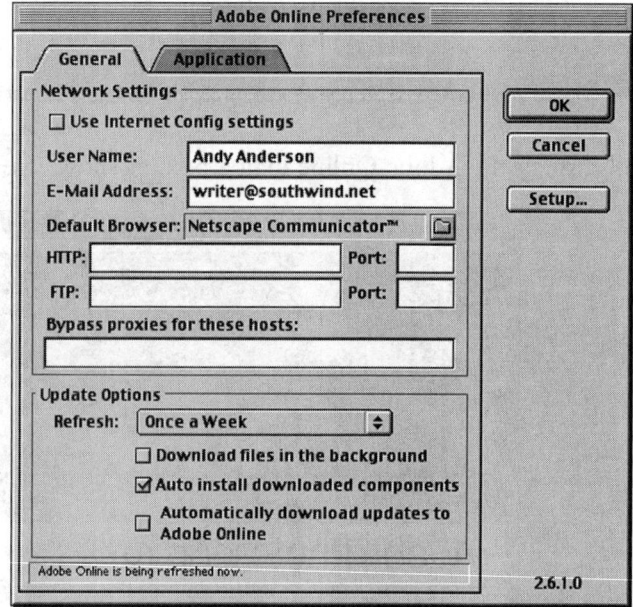

Figure 27.1 The Adobe Online Preferences dialog box lets you choose how often updates are performed.

4. Click on the Refresh button to display a listing of your Refresh pop-up list.

5. Click to select how often you want to refresh Photoshop and click the OK button. Photoshop will close the Online Preferences.

6. Click on the Close button in the Adobe Online dialog box. Photoshop will close the dialog box.

Based on your selection, Photoshop will now check the Adobe Web site on a regular basis and will update the program accordingly.

28 *Choosing an Additional Plug-in Folder Within Photoshop*

Adobe Photoshop comes packaged with a huge amount of photographic and special-effect filters. You can also purchase special-effect filters from various companies. (Hint: There are many free filters available for download from various Photoshop Web sites.) Adobe Photoshop filters are small files called plug-in modules. When Photoshop is opened, these filters connect (plug in) to the program, enhancing its capabilities. Adobe Photoshop places all of its default plug-ins (those plug-ins that come with the program) within a folder named Plug-ins, located inside the Adobe Photoshop 6.0 application folder.

The Plug-ins folder is fine for the default Photoshop plug-ins, but if you are the type of Photoshop user who purchases additional plug-ins and filters and then places them all within the default Plug-Ins folder, watch out.

When you launch Photoshop, the program will load all of the plug-ins within the default folder whether you use them or not, and that can consume a lot of your precious RAM memory. Since Photoshop needs a lot of RAM memory to operate, this can cause Photoshop to slow down and even lock up.

The solution ... Help Photoshop run faster by separating your plug-ins into job-specific folders (such as Web Image Plug-ins, Painting Effects Plug-ins, and so on) and then opening a specific plug-ins folder when you launch the Photoshop program.

To choose an additional plug-ins folder, perform these steps:

1. Open Photoshop while holding down the ⌘+Alt keys. Photoshop will display the Choose an additional Plug-Ins folder dialog box, as shown in Figure 28.1.

Figure 28.1 Pressing ⌘+Alt while opening Photoshop will display the Choose an additional Plug-Ins folder dialog box.

2. Locate the additional plug-ins folder and select it by clicking on the folder name.

3. Click on the Choose button. Photoshop will close the dialog box and finish opening the program.

4. You are now working in Photoshop with an additional plug-ins folder.

29 *Determining Which Color-Selection Method Is Best*

Adobe Photoshop allows you to use one of two color-selection methods. To choose a color-selection method, perform these steps within Photoshop:

1. Choose Edit menu Preferences from the pull-down menu and select the General Preferences option. Photoshop will display the Preferences dialog box.

2. Click on the Color Picker option to display your choices, as displayed in Figure 29.1.

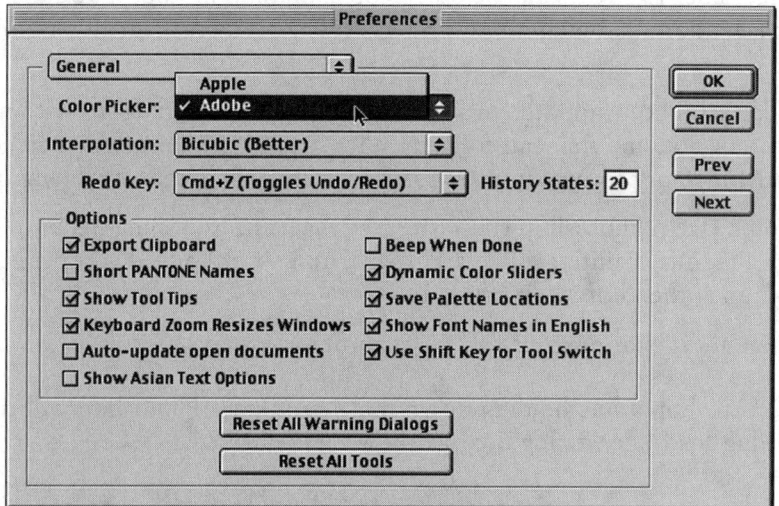

Figure 29.1 *The Color Picker options as displayed in the Preferences dialog box.*

Note: Windows users will see Photoshop and Windows as their two choices. Macintosh users will see Photoshop and Apple as their two choices.

3. Choose your Color Picker by clicking on one of the available options and then click the OK button. Photoshop will close the Preferences dialog box, and you are ready to work.

Whether you use Macintosh or Windows, this author recommends that you choose Photoshop as your color-selection method for several reasons:

- The Photoshop Color Picker is cross-platform compatible (Macintosh/Windows friendly).

- It will reproduce color accurately between Photoshop and other Adobe programs.

- It will give you a warning when you select a color that is out of the range of your printing device or, in the case of Web graphics, when the colors fall outside the Web-safe color palette.

30 *Placing PostScript Files Using the Anti-alias Option*

Photoshop uses the Anti-alias option to remove the jagged edges that appear around placed PostScript files (PDF and EPS). While smooth-looking edges are a desirable effect for most placed PostScript images, the same is not true for small text files and sharp line drawings.

If you are intending to place a small PostScript text file (a font size of 12 points or lower) or sharp line drawing into a Photoshop document, you should turn off the Anti-alias option.

To turn off Anti-alias within Photoshop, perform these steps:

1. Select the Edit menu Preferences option and choose General Preferences. Photoshop will display the Preferences dialog box, as shown in Figure 30.1.

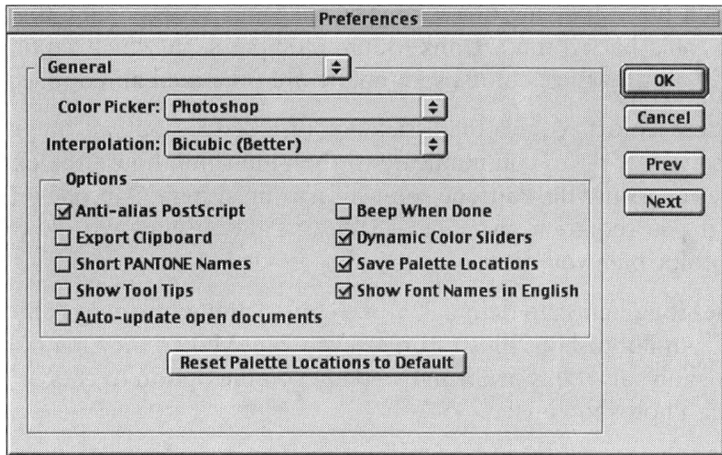

Figure 30.1 The Preferences dialog box and the Anti-alias PostScript option.

2. Click on the check mark next to the Anti-alias PostScript option to deselect it.

3. Click the OK button. Photoshop will close the Preferences dialog box, and you can continue working in Photoshop.

Figure 30.2 illustrates the difference between turning Anti-alias on or off. As you can see, leaving Anti-alias on will distort small text and make it difficult to read.

Figure 30.2 Leaving the Anti-alias option on will adversely affect small text files.

Note: Since the Anti-alias PostScript option is within the General Preferences, it is a part of the Photoshop program and will remain off until changed.

31 *Using Short Pantone Names with Photoshop Images*

Photoshop is capable of producing high-end, four-color images (images printed by mixing cyan, magenta, yellow, and black inks) and images with spot colors. Spot colors are one or more image ink plates with each plate applying one ink. Typically, spot colors define the color of text on a poster or a specific color for a background. Unlike four-color press, in which mixing cyan, magenta, yellow, and black produces all the image colors, spot colors are premixed and applied with each plate.

Images with spot colors require the assistance of a service bureau or publishing house with high-end printing presses. In order to communicate to the publishing house the exact color needed for that spot color plate, designers use the Pantone color-measuring system. Pantone measures color the same way for everyone, so if you require a particular shade of Pantone blue, you know the printer will understand exactly what color blue you need.

Photoshop uses long names to define Pantone colors, and while long Pantone names are fine if you print your images from Photoshop, Illustrator, or even PageMaker, they may not work for a high-end service bureau. Photoshop solves this problem by giving you the option to choose short names to define Pantone colors within a Photoshop image.

To use short Pantone names within a Photoshop image, performing these steps:

1. Select Edit menu Preferences and choose the General Preferences option. Photoshop will display the Preferences dialog box, as shown in Figure 31.1.

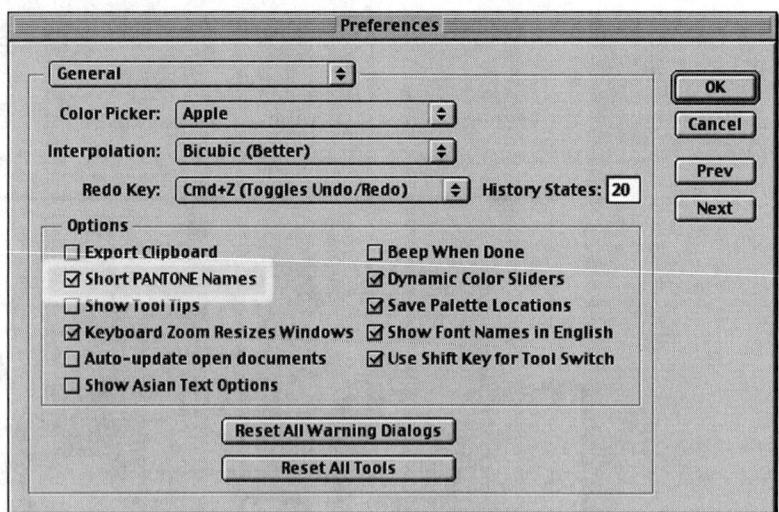

Figure 31.1 Selecting the Short PANTONE Names option lets Photoshop use more industry-compatible names.

2. Locate the Short PANTONE Names option and verify that there is a check mark in the activation box located to the left of the option. If not, click once within the check box to activate the option. You should now see a check mark in the activation box.

3. Click the OK button. Photoshop will close the Preferences dialog box, and you are ready to design Photoshop images with short Pantone names.

32 *Saving Palette Locations in Photoshop*

When you work within Photoshop, the program will let you redesign the location of all the palettes. Assume you use the Swatches palette and the Styles palette at the same time; however, since they are located within the same palette, you constantly click between the Swatches and Styles tabs. You need to see both palettes at the same time, so you click on the Styles tab and drag the Styles option into the palette holding History and Actions. Now you can view the Swatches palette and the Styles palette at the same time without having to click back and forth. Unfortunately, the next time you open Photoshop, all the palettes are back in their original positions.

The answer to this problem is simple: You instruct Photoshop to save the new location of the palettes. To save palette locations within Photoshop, perform these steps:

1. Select Edit menu Preferences and choose the General Preferences option. Photoshop will display the Preferences dialog box, as shown in Figure 32.1.

2. Locate the Save Palette Locations option and click once in the check box to activate the option (clicking will insert a check mark into the activation box).

3. Click the OK button. Photoshop will close the General Preferences dialog box, and you are ready to work in Photoshop.

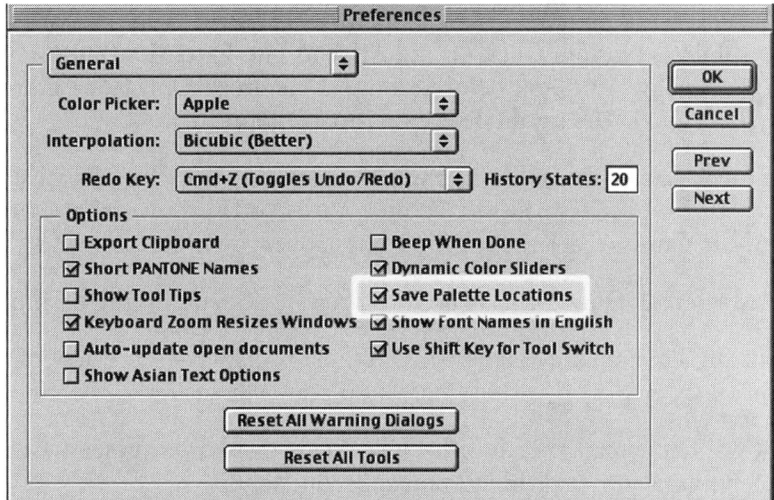

Figure 32.1 The Save Palette Locations option is located in the Preferences dialog box.

33 *Setting the Save File Options Within Photoshop*

When you save a graphic in Photoshop, you decide on an individual basis certain image characteristics such as resolution, height and width, and color space. Photoshop will also let you assign certain default characteristics to images every time you save a file.

To modify the default image characteristics, perform these steps:

1. Select Edit menu Preferences and choose the Saving Files option. Photoshop will display the Preferences dialog box, as shown in Figure 33.1.

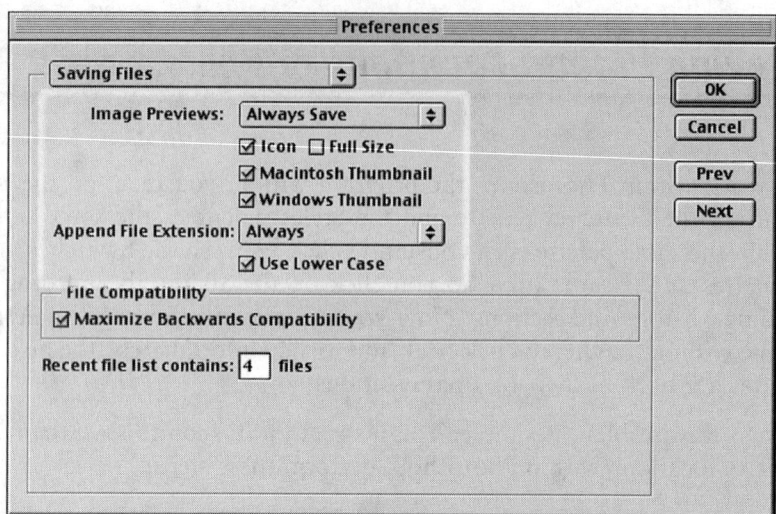

Figure 33.1 *The default settings for saving graphic images are located in the Saving Files section of the Preferences dialog box.*

2. Make your selections from the available options and click the OK button. Photoshop will close the Saving Files dialog box, and you are ready to work.

- **Image Previews:** Click on the Image Previews button and choose between Never Save, Always Save, and Ask Before Saving.

- **Append File Extension:** Click on the Append File Extension button and choose between Always Save, Never Save, and Ask Before Saving (Macintosh Only). For more information on file extensions, see Tip 34, "Using the File Extension Option."

- **Use Lower Case:** Computer operating systems are not case-sensitive, but the Internet is. If you work with images destined for Web pages, select Use Lower Case. For more information on the case of file names, see Tip 35, "Choosing Upper- or Lowercase File Names."

- **Icon** (Macintosh Only): This is used to preview an icon on the desktop of your computer.

- **Macintosh Thumbnail** (Macintosh Only): This displays a preview of the graphic when using the File menu Open option within Photoshop on a Macintosh.

- **Windows Thumbnail** (Macintosh Only): This displays a preview of the graphic when using the File menu Open option within Photoshop on Windows.

- **Full Size** (Macintosh Only): This is used by layout programs to display the image onscreen.

Note: If your Photoshop work is primarily with images that will be used on the Internet, deselect the Icon, Macintosh Thumbnail, Windows Thumbnail, and Full Size options. These options will increase the image size of a saved graphic by 5k to 7k. Although that additional size is not significant to the printing of an image, it is important when you are saving images destined for the World Wide Web.

34 *Using the File Extension Option*

The file extension follows the file name and describes the format of the saved graphic image. File extensions begin with a period and are three characters in length.

The file name *image.jpg*, with *.jpg* being the extension, indicates that the file is saved as a compressed graphic (Joint Photographic Experts Group). Each file format has its own three-letter designation.

The Append File Extension option mentioned in Tip 33 is important for two reasons: cross-platform compatibility and Internet graphic images.

- **Cross-platform compatibility**: Designers today seldom work within one operating system. You will design graphic images using Photoshop for Windows and then give them to someone who works with Photoshop on a Macintosh. If you work within one operation system, file extensions will not be a problem, but if you move between Macintosh and Windows, then not using an extension defining the format of the file will cause problems. Photoshop for Windows may not recognize your Macintosh image, and this forces you into manually selecting the format to open the graphic.

- **Internet graphic images**: Although the World Wide Web is changing, file extensions are still important to the Internet. One of the most common reasons for broken links to Internet graphics is failure to add the file extension. Always use a file extension on graphics saved for viewing on the Internet.

To automatically save Photoshop graphics with a file extension, refer to Tip 33 and select the Always Save option from the Append File Extension drop-down list.

35 *Choosing Upper- or Lowercase File Names*

Choosing upper- or lowercase letters is important if your images are destined for the Internet. In Tip 33, "Setting the Save File Options Within Photoshop," you learned that you can define the case of a saved file. In the Photoshop preferences, you have a choice between upper- or lowercase. Although it does not matter which one you choose, studies show that UPPERCASE words are harder to read than lowercase lettering.

When you design Web pages, the name of the file as defined in the Web page must be in the same case letters as the actual file name. If you saved a file in Photoshop with the name *UPPER.JPG* and you defined it in the Web page as *upper.jpg* or *Upper.jpg*, your Web page will display a broken image link. To save yourself the hassle of trying to remember what you did when you saved the file, instruct Photoshop to always save the files in upper- or lowercase.

To instruct Photoshop to save files in upper- or lowercase, refer to Tip 33 and choose Use Upper Case or Use Lower Case in response to the File Extension option.

36 Knowing When to Maximize Backwards Compatibility

Photoshop is one of the few programs on the market that lets a user create documents and then open them in earlier versions of the program, even versions that do not support layers. Photoshop performs this trick within General Preferences. It is an option called Maximize Backwards Compatibility. However, unless you plan to open Photoshop 6.0 images in earlier versions of Photoshop, you need to deselect this option. Turning the Maximize Backwards Compatibility option off will reduce the size of a saved Photoshop graphic by 20 percent or more.

To turn off the Maximize Backwards Compatibility option, perform these steps:

1. Select Edit menu Preferences and choose the Saving Files options within the Preferences dialog box. Photoshop will display the Saving Files option dialog box, as shown in Figure 36.1.

2. Deselect Maximize Backwards Compatibility option if it has been checked.

3. When all modifications are complete, click the OK button. Photoshop will close the Saving Files options within the Preferences dialog box, and you are ready to work.

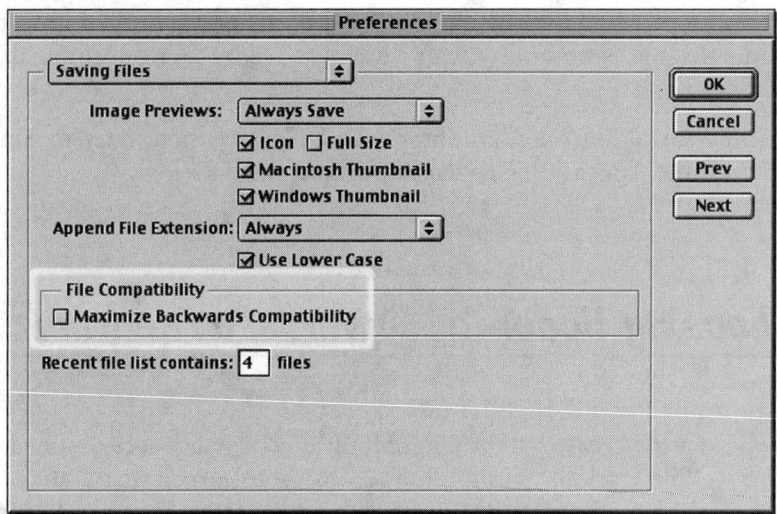

Figure 36.1 Turning off the Maximize Backwards Compatibility option saves file size.

From this point forward, saving a graphic image in Photoshop will reduce the file size by 20 percent, and that can save space on your hard drive. Photoshop reduces file size by removing the composite image from the file. The composite image is a flattened version of your graphic image. This flattened image is what lets Photoshop open your graphic file in versions of Photoshop that do not support multiple layers.

37 Saving Photoshop Channels in Grayscale or Color

The Channels palette within Photoshop displays visual information on the percentage of ink used within a graphic image. Clicking on the tab named Channels activates the Channels dialog box, as shown in Figure 37.1.

Say you are editing an RGB image within Photoshop. (RGB images mix the additive colors red, green, and blue to display the colors within the image.) When you click on the Channels palette tab, you will notice three separate channels named Red, Green, and Blue. A fourth item, named RGB, is not an ink channel but a composite.

Clicking on the composite channel (RGB) causes Photoshop to mix all the inks within the graphic, and your monitor will display the image in full color.

Clicking on an individual channel name (Red, Green, or Blue) will activate that individual channel, and the visible image on your monitor will change to a representation of the image in shades of gray.

By default, individual channels display color in shades of gray. The darker the shade of gray, the less that particular ink is used to produce the colors within the image. For more information on channels, see Tip 432, "Understanding Channels and Their Role."

When working within Photoshop, you have the choice of viewing the channels in shades of gray (default) or in shades of color. In other words, the red channel will display ink distribution in shades of red, the green channel in green, and the blue channel in blue. It is important to note that changing from shades of gray into shades of color in no way affects the way the channels work or how the image will print. It only affects how you view the channels on your monitor.

Figure 37.1 The Channels palette displays the percentage of ink used within an image.

If you want to view Photoshop channels in color, perform these steps:

1. Select Edit menu Preferences and choose the Display and Cursors options within the Preferences dialog box. Photoshop will display the Display & Cursors dialog box, as shown in Figure 37.2.

2. Locate the Color Channels in Color option and click in the activation box. You should see a check mark in the box. (The activation box is a toggle switch; clicking within the box will activate or deactivate the option.)

3. Click the OK button and Photoshop will close the Display & Cursors dialog box.

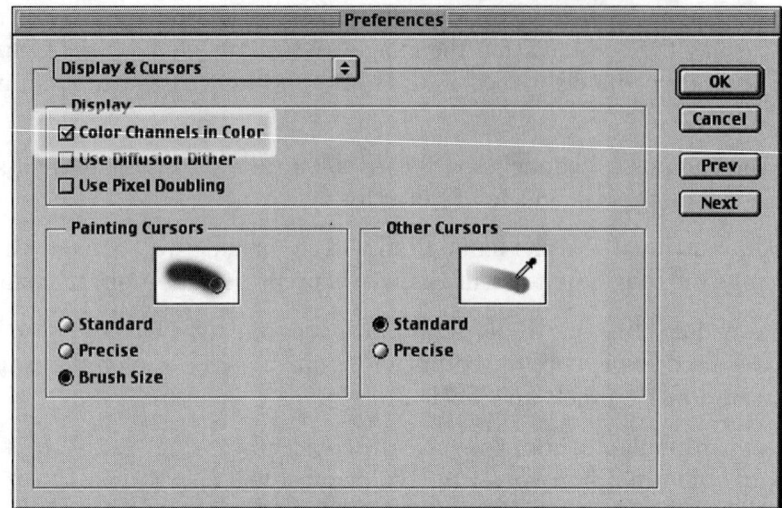

Figure 37.2 Select the Color Channels in Color option to display image information in color.

38 *Using the Pixel Doubling Option*

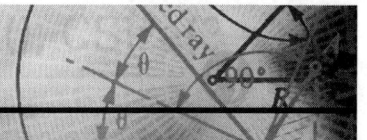

To work faster in Photoshop without damaging the image, select the Use Pixel Doubling option in the Photoshop preferences. The Use Pixel Doubling option works when you move image information within a Photoshop document. Let's say you select and move an area of an open image. Normally, the information you see displayed as you click and drag is at the same resolution as the original image. Displaying a full-resolution copy of the information requires Photoshop to use memory and processor time. In high-resolution images, this can make moving large areas of a graphic a slow and tedious job.

If Use Pixel Doubling is selected, Photoshop reduces the resolution of the moved image and restores the image to full resolution when you complete the move. You work faster without compromising the quality of the image.

To activate Use Pixel Doubling, perform these steps:

1. Select Edit menu Preferences and choose the Display & Cursors option. Photoshop will display the Display & Cursors dialog box, as shown in Figure 38.1.

2. Locate the Use Pixel Doubling option and click in the activation box located to the left of the option. You should now see a check mark in the box. (The activation box is a toggle switch; clicking within the box will activate or deactivate the option.)

3. Click the OK button. Photoshop will close the Display & Cursors dialog box, and you are ready to work.

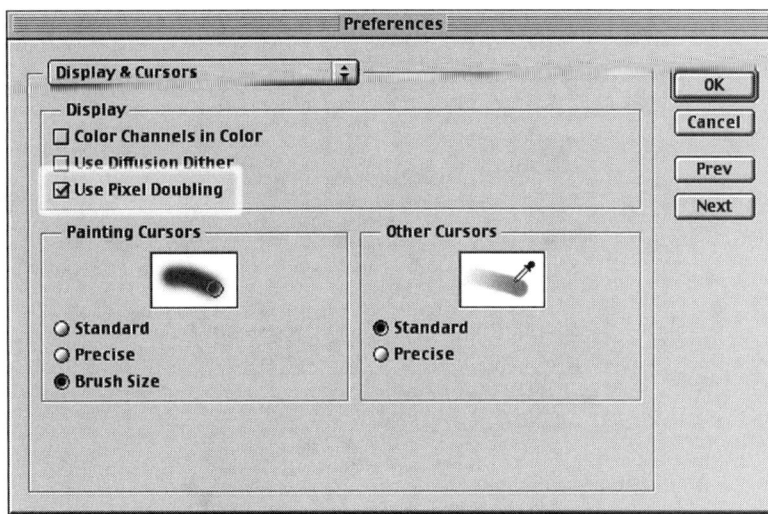

Figure 38.1 Activating the Use Pixel Doubling option will save you time when moving digital information.

39 *Understanding When to Use Diffusion Dither*

Photoshop uses a color lookup table to store and display the colors used in an open graphic image. If your monitor only supports 256 colors, Adobe Photoshop uses a technique called dithering to mix pixels of available colors to simulate colors not currently available.

By default, Adobe Photoshop uses pattern dithering, which can result in a distinctive pattern of darker or lighter areas in the image. In contrast, diffusion dithering eliminates this distinctive patterning by using the surrounding pixels in the mix of pixel color. However, if you scroll or edit a portion of the displayed image, diffusion dithering can cause incorrect color information to display on your monitor. Keep in mind that dithering effects appear only onscreen, not in print.

If your monitor only displays 256 colors and you choose to use diffusion dithering, perform these steps:

1. Select Edit menu Preferences and choose the Display & Cursors option. Photoshop will display the Display & Cursors dialog box, as shown in Figure 39.1.

2. Locate the Use Diffusion Dither option and click in the activation box. You should see a check mark in the box. (The activation box is a toggle switch; clicking within the box will activate or deactivate the option.)

3. Click the OK button. Photoshop will close the Display & Cursors dialog box.

> **Note:** *If your monitor is capable of displaying millions of colors (24-bit color), then you do not need to use the Use Diffusion Dither option.*

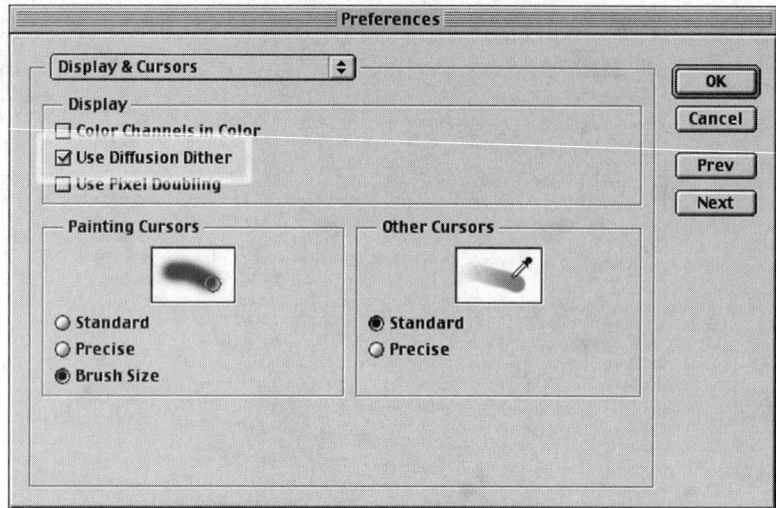

Figure 39.1 The Use Diffusion Dither option is located within the Display & Cursors dialog box.

40 *When to Use the Export Clipboard Option*

When you select all or part of an open Photoshop graphic and use the Edit menu Save option, you are storing that information in Clipboard memory. Clipboard memory is a portion of your computer's RAM memory, so the larger the area you save, the more RAM memory is used and the less is available to Photoshop. The Export Clipboard option, when selected, preserves anything saved in Clipboard memory, even after Photoshop is closed.

One reason you would want to use the Export Clipboard option would be moving information between graphic programs. You can open a graphic file in Photoshop, select an area of the image, and perform an Edit menu Copy. That digital information is not stored within the Clipboard or RAM memory. Now you close Photoshop, open a second graphic program, and perform an Edit menu Paste. The digital information you previously copied in Photoshop is now pasted into the newly opened graphic program. If you perform this operation on a regular basis, then you will need to select the Export Clipboard option.

If, however, you do not need to copy and paste information in the preceding manner, you need to turn off the Export Clipboard option.

Turning off Export Clipboard forces Photoshop to erase all digital information from the Clipboard every time Photoshop is closed. This frees up precious RAM memory and lets your computer and other programs run more efficiently.

To view and change the status of the Export Clipboard option, perform these steps:

1. Select the Edit menu Preferences option and choose General Preferences. Photoshop will display the General Preferences dialog box.

2. Locate the Export Clipboard option, as shown in Figure 40.1. The box to the left of the option displays its current state. If there is a check mark in the box, Export Clipboard is active, and your Clipboard memory is saved when Photoshop is closed. If the box is empty, your Clipboard is purged every time Photoshop is closed.

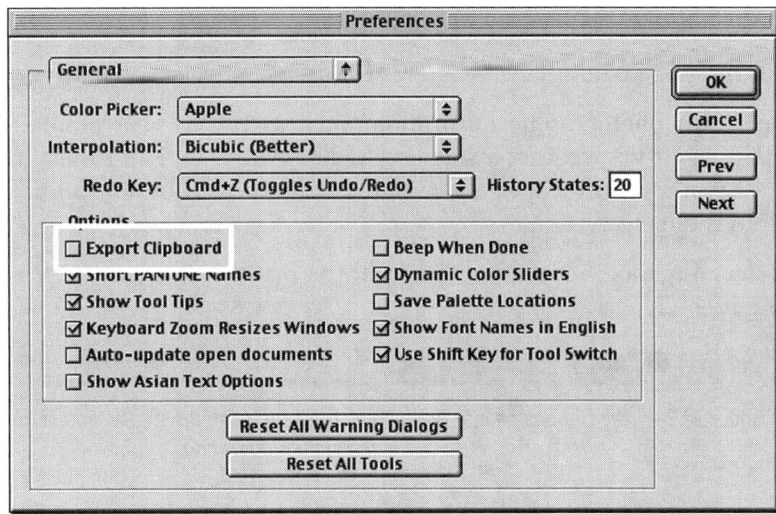

Figure 40.1 *The Export Clipboard option, when selected, saves information in the Clipboard for use by other programs.*

3. When you have made your changes, click the OK button. Photoshop will close the General Preferences dialog box, and your changes are recorded.

41 *Choosing the Correct Painting Cursor*

Choosing a painting cursor may not seem very exciting, but it is important to remember that the Brush palette in Photoshop is used for more than just applying paint to a Photoshop image. The Brush palette in Photoshop controls everything from photographic restoration to stroking a border color around a graphic image.

Figure 41.1 *The Brush palette in Photoshop controls more than just the paintbrushes.*

These are the tools in Photoshop that use the Brush palette:

- Airbrush tool

- Paintbrush/Pencil tools

- Rubber Stamp/Pattern Stamp

- History Brush/Art Brush

- Regular/Background/Magic Eraser tools

- Blur/Sharpen/Smudge tools

- Dodge/Burn/Sponge tools

Tools that perform photographic restoration, such as the Rubber Stamp, Blur/Sharpen/Smudge, and Dodge/Burn/Sponge tools, require a soft brush. The Airbrush, Paintbrush, and Eraser tools, depending on the type of work performed, might require a hard brush for sharp line drawing or a soft brush to blend inks into the image.

When you select any tool that requires a brush, the Brush palette will appear on the Options palette, as shown in Figure 41.2.

Figure 41.2 The Options palette will display the Brush palette for all Photoshop tools using brushes to control their operation.

Clicking on the default brush displays the characteristics of that brush.

Clicking on the down-arrow button, located to the right of the default brush, will display a listing of available brushes. To change the default brush, click on the desired brush and it becomes the default brush. For more information on Photoshop brushes, see Tip 188, "Defining the Brush Palette," and Tip 230, "Modifying a Photoshop Brush to Create a New Brush."

42 *Using Columns in Photoshop*

Layout programs such as QuarkXpress, InDesign, and PageMaker use column width to specify the size of a graphic image. Also, newspapers and many book publishers require images to be measured in column width.

If it proves necessary to define an image using column width, Photoshop lets you use a similar method to define the size of a graphic image.

To define columns as your default measuring system, perform these steps:

1. Select Edit menu Preferences and choose the Units and Rulers option. Photoshop will display the Units & Rulers options within the Preferences dialog box, as shown in Figure 42.1.

2. Choose the correct Width and Gutter sizes by clicking within the Width and Gutter input boxes.

3. When you have completed your changes, click the OK button.

4. With Photoshop open, select the File menu New option. Photoshop will display the New dialog box, as shown in Figure 42.2.

5. Click the Width button, choose columns from the pop-up menu, and choose the number of columns for the image.

6. Click the OK button. Photoshop will close the New dialog box.

Your new canvas now displays graphic images with a column width, as defined within the Units & Rulers dialog box. For more information on the use of columns, see Tip 938, "Redefining an Image Using Columns."

Figure 42.1 The column width and gutter of a graphic image are defined within the Units & Rulers dialog box.

Figure 42.2 Choose the columns option to measure a graphic image in columns.

43 *Measuring Images in Points*

Some service bureaus and printers require that graphic images be measured in points. This is especially true when working with images overlaid with PostScript type. Photoshop lets the user define an image using points; however, it is important to know what point measuring system your service bureau is using.

If your service bureau requires that graphic images be measured in points, ask if they are using the PostScript or Traditional measuring system. The PostScript system uses 72 points per linear inch, and the traditional system uses 72.27 points per linear inch. The difference may seem trivial until you are required to overlay PostScript text on a Photoshop graphic.

To select a point measuring system within Photoshop, perform these steps:

1. Select Edit menu Preferences and choose the Units & Rulers option. Photoshop will open the Units & Rulers dialog box, as shown in Figure 43.1.

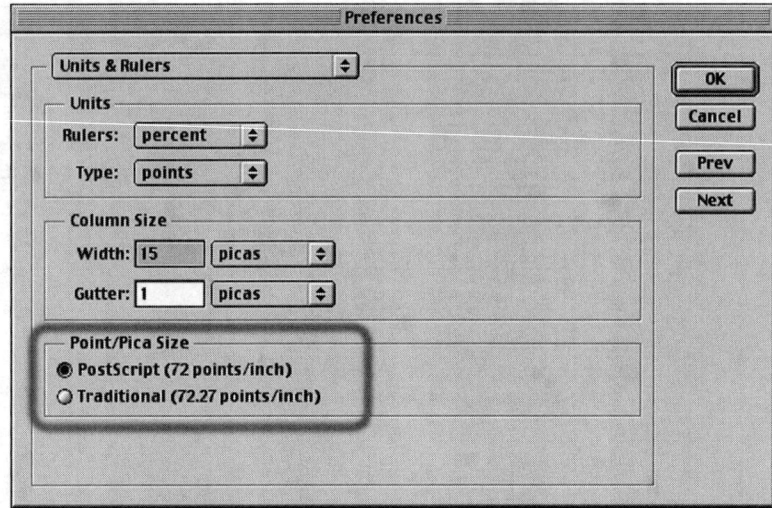

Figure 43.1 The Point/Pica Size option is located within the Units & Rulers dialog box.

2. From the Point/Pica Size option, select PostScript or Traditional measuring.

3. After making your changes, click the OK button.

Changes made to the Point/Pica Size option will affect all future graphic images opened within Photoshop that use points as the default measuring system.

44 *Working with Video LUT Animation*

Most of the filters and adjustments within Photoshop come with a Preview option, as shown in Figure 44.1. The Preview option displays edited information on the monitor through a video lookup table. The video lookup table is where Photoshop stores information on the colors used in the open graphic image. When the Preview option is active in a filter or adjustment dialog box, you can see the changes made to the image before accepting them. The Preview option uses the video lookup table to display changes to the image.

When using the video lookup table option, it is important to understand its limitations:

- For video LUT animation to work in 24-bit color mode with Windows, you must install a color table animation extension, supplied by your video card manufacturer.

- Video LUT animation will cause problems in the Macintosh operating system if you are using a 24-bit or 32-bit video card for which certain color QuickDraw commands have not been properly implemented. If you have a problem, you will need to contact your video card manufacturer for ROM updates. You should also reset the video mode and turn off the Video LUT Animation option in the Display Preferences dialog box.

Photoshop 6.0 solves the problem of video LUT animation by making the selection for you. In previous versions of Photoshop, the option to choose video LUT animation is made within the Display & Cursors options within the Preferences dialog box. Photoshop 6.0 removed this option and activates video LUT animation based on your computer hardware.

Figure 44.1 The Preview option within most Photoshop filters and adjustments allows you to directly view changes made to an image.

45 *Using More Than One Scratch Disk*

In Tip 16, "Understanding How Photoshop Uses Your Hard Drive and RAM Memory," you learned that Photoshop needs RAM memory and access to your hard drive. Since access to the hard drive (defined as the scratch disk) is so important to Photoshop, Adobe lets you assign up to four hard drives to be used as additional scratch disks.

If you have an additional hard drive attached to your computer, assigning it as the scratch disk can, depending on the speed of the new drive, increase disk access speeds by 20 percent or more.

> *Note: Never assign a network hard drive as your scratch disk. Network hard drives are notoriously slow. Instead of speeding up Photoshop, a network hard drive will actually slow Photoshop down. Always use a hard drive attached to your computer as a scratch disk.*

To assign an additional scratch disk to Photoshop, perform these steps:

1. Select Edit menu Preferences and choose the Plug-Ins & Scratch Disks option. Photoshop will open the Plug-Ins & Scratch Disks dialog box, as shown in Figure 45.1.

Figure 45.1 Photoshop lets the user select up to four scratch disks.

2. Click on the First button to see a list of available hard drives, as shown in Figure 45.2.

Figure 45.2 Clicking on the Scratch Disk buttons will list all available hard drives.

3. Choose the appropriate drive. Photoshop will display the name of the selected hard drive to the right of the First option. If you have additional drives, you can select up to four scratch disks.

4. When you have completed your changes, click the OK button. Photoshop will record your changes and close the Plug-Ins & Scratch Disks dialog box. It is not necessary to restart Photoshop; the changes to scratch disks are immediate.

46 *Determining the Correct Cache Levels Setting*

The Cache Levels option specifies to Photoshop the number of screen redraws allowed for each open graphic image. Cache Levels speeds up the redraw of high-resolution images within Photoshop by using low-resolution images to update the graphic image as you work.

The Image Cache can be any number from 1 to 8. Choosing the number 1 disables the image cache and significantly slows the redraw of high-resolution images.

Choosing a number from 2 through 8 lets Photoshop create and cache (store in memory) from 1 to 7 extra low-resolution images. Photoshop uses these low-resolution images and quickly redraws the graphic as you work.

Although creating several low-resolution images can speed up graphic editing, the higher the cache level, the longer it will take to open an image in Photoshop, and the more RAM memory will be used to store the image information.

To view and modify the Image Cache, perform these steps:

1. Select Edit menu Preferences and choose the Image Cache option. Photoshop will display the Memory & Image Cache (Image Cache: Macintosh) option within the Preferences dialog box, as shown in Figure 46.1.

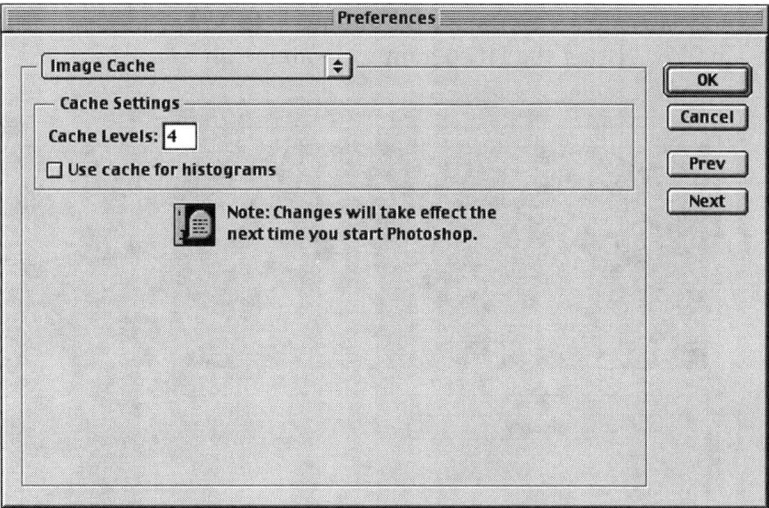

Figure 46.1 *The Cache Levels option controls the number of screen redraws available to Photoshop.*

2. Click in the Cache Levels input field and type a number from 1 to 8.

3. When you have completed all changes, click the OK button. Photoshop will record your changes to the cache levels and will close the dialog box. You do not need to restart Photoshop; the changes are immediate.

The following are some recommendations for Image Cache based on the pixel dimensions of a graphic opened within Photoshop.

- 192×192 1 cache level

- 384×384 2 cache levels

- 768×768 3 cache levels

- 1,536×1,536 4 cache levels

- 3,072×3,072 5 cache levels

- 6,144×6,144 6 cache levels

- 12,288×12,288 7 cache levels

- Higher 8 cache levels

For more information on determining the pixel dimensions of a Photoshop image, see Tip 269, "Changing an Image Using Image Size."

47 *How Image Cache Affects the Histogram*

In the preceding tip, you learned that increasing cache levels can increase your performance when editing Photoshop images. There is one other option within the Image Cache dialog box that will influence the onscreen image: the Use cache for histograms option (refer to Figure 46.1).

When you open an image in Photoshop and choose Image menu Histogram, the program will display a histogram of the current image. The histogram displays in a graph format the number of pixels in the open image and their brightness, as shown in Figure 47.1. For more information on the use of the histogram, see Tip 276, "Using the Histogram to Examine an Image."

Figure 47.1 *Turning off Use cache for histograms gives you a more accurate view of image information.*

By default, Photoshop leaves the Use cache for histograms option selected; however, I recommend that you turn off this option.

When you select the Use cache for histograms option (refer to Figure 46.1), Photoshop displays the histogram by using a representative sample of the image pixels as they are currently displayed on your monitor.

Understand that editing an image in Photoshop at any view size other than 100 percent forces Photoshop to add or subtract image pixels from the displayed graphic. This means the histogram will not be accurate unless you view the image at exactly 100 percent.

When you turn off the Use cache for histogram option, you force Photoshop to reanalyze the original pixel information of an image, not the image as viewed on your monitor. This will give you an accurate histogram every time. Since the histogram is indispensable for photographic restoration, turning off Use cache for histograms is the best way to work.

To modify the Use cache for histograms option, perform these steps.

1. Select Edit menu Preferences and choose the Image Cache option. Photoshop will display the Image Cache dialog box (refer to Figure 46.1).

2. Click in the input box located to the left of the Use cache for histogram option. The input box is a toggle switch; clicking within the box will add or remove a check mark.

3. When you have completed your changes, click the OK button. Photoshop will record the changes and close the Image Cache dialog box. You do not need to restart Photoshop.

48 *Reasoning Behind Registration*

Now is a good time to address an area of Photoshop that many designers ignore: product registration. Photoshop, like all computer programs, changes constantly. Therefore, some day soon we will all be using Adobe Photoshop 9 and Adobe Illustrator 10. Not only do products evolve, mistakes and bugs get into programs that are released to the public (can you believe it?).

When you register Photoshop, Adobe sends you notices of updates and problems. Most fixes and patches to Photoshop are free to registered users.

Photoshop also lets you protect your digital images using a Digimarc watermark. Protecting your images also involves registering Photoshop. For more information on creating Digimarc watermarks, see Tip 99, "Inserting Digital Copyright Information into a Photoshop Image."

When you install Photoshop for the first time, you will be prompted to fill out the registration information. To do this, you will need your registration number. In fact, you will not be able to load Photoshop without that important piece of information.

You have the option of sending the registration information directly to Adobe over the Internet, or you can choose to print out the form and mail it. Whatever method you choose, stop and take the time to register Photoshop.

> *Note: It's not a bad idea to go through your hard drive and create a paper list of every program you own, the version currently in use, and the registration number. That way, if you need to reinstall a program, you will not have to hunt around to find that information.*

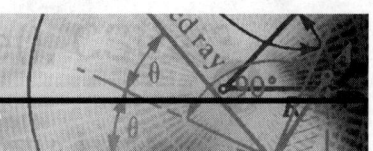

49 *Selecting Tools in Photoshop*

The 33 buttons on the Photoshop toolbar give you access to 51 tools and a host of other options.

There are a number of ways to access the tools on the Photoshop toolbar. You can select by clicking on the desired tool. You also can select tools with the use of a single keystroke (see Figure 49.1).

Figure 49.1 *The toolbar gives the user access to all of the tools within Photoshop.*

A button containing a unique graphic visually describes each of the tools. If you have the Tool Tips option selected within General Preferences, Photoshop will display a small box next to each tool with the name and shortcut keystroke associated with the tool (see Figure 49.2).

Figure 49.2 *Photoshop tools tips identify each tool and include the shortcut keystroke.*

Some of the tools have a small black triangle located in the lower-right corner of the tool button. The triangle indicates that more tools hidden within the button.

Clicking and holding your mouse on a button containing a small black triangle will cause Photoshop to display a pop-up box showing all additional tools, as shown in Figure 49.3. Clicking on one of the pop-up box options will make that the default tool.

Figure 49.3 Photoshop groups tools together on the toolbar to save space on your monitor.

Using a combination of mouse clicks and shortcut keystrokes can increase your efficiency while working in Photoshop and will let you do more work in the same amount of time.

50 *Using Plug-in Modules*

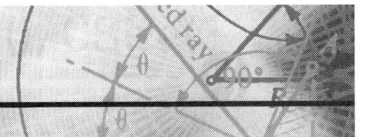

Using plug-in modules in Photoshop increases what the program is capable of doing. Photoshop uses an open architecture that lets designers plug in additional features. In Photoshop, plug-ins are located under the Filter option on the pull-down menu.

You can purchase additional plug-ins from third-party vendors such as Extensis and Kai, and many other plug-ins are downloadable free on the Internet.

Plug-ins are designed by programmers and designer/programmers and are essentially computer code that tells Photoshop to perform a certain sequence of instructions. The results can be anything from converting the size of an image to high-end photographic restoration, all with the click of a button.

Installing additional plug-ins involves following the instructions that came with the plug-in. In most cases, this means placing the plug-in into a specific folder so that Photoshop can access it.

If you use a lot of additional plug-ins, you may have noticed that Photoshop takes longer to open. That is because all plug-ins, regardless of whether they are being used or not, are loaded when Photoshop opens.

If you are experiencing slowdowns in Photoshop due to excessive use of plug-ins, try separating plug-ins according to use and only load the ones you need.

To load a select set of plug-ins, perform these steps:

1. Select Edit menu Preferences and choose the Plug-Ins & Scratch Disks option. Photoshop will display the Plug-Ins & Scratch Disks dialog box, as shown in Figure 50.1

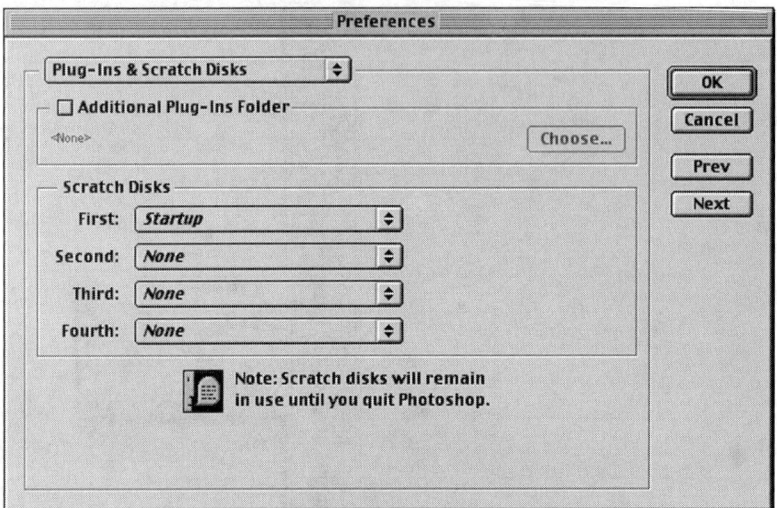

Figure 50.1 The Plug-Ins & Scratch Disks dialog box.

2. Click to insert a check mark into the Additional Plug-Ins Folder option. Photoshop will open a dialog box and let you choose the folder containing the additional plug-ins, as shown in Figure 50.2. Click on the correct folder name and click the Open button. Photoshop will record your selection and close the selection dialog box.

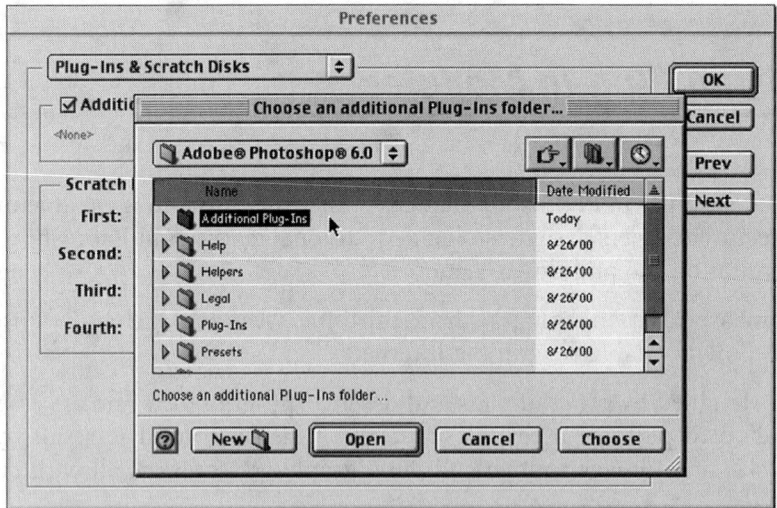

Figure 50.2 To add functionality to Photoshop, select an additional plug-in folder.

3. Click on the OK button.

Note: You can only select and use one additional plug-in folder at a time. If you need to change to another plug-in folder, repeat steps 1 through 3.

51 _Working with Computer Monitors and Color Depth_

The color depth of a monitor determines the number of colors the screen can display at any one time. Since Photoshop uses a computer monitor to display the colors in a graphic image, it is important to understand the color depth of your particular monitor.

With very few exceptions, computer monitors are capable of displaying multiple color depths. To determine how many colors your monitor is displaying, if you are using a Windows PC, perform these steps:

1. Close Photoshop and any open programs.

2. Click on the Windows Start button. Windows will display a pop-up menu of selectable items.

3. Move your mouse cursor over the item named Settings, and a secondary pop-up menu will appear. Click on the Control Panel option. Windows will open the Control Panel folder, as shown in Figure 51.1.

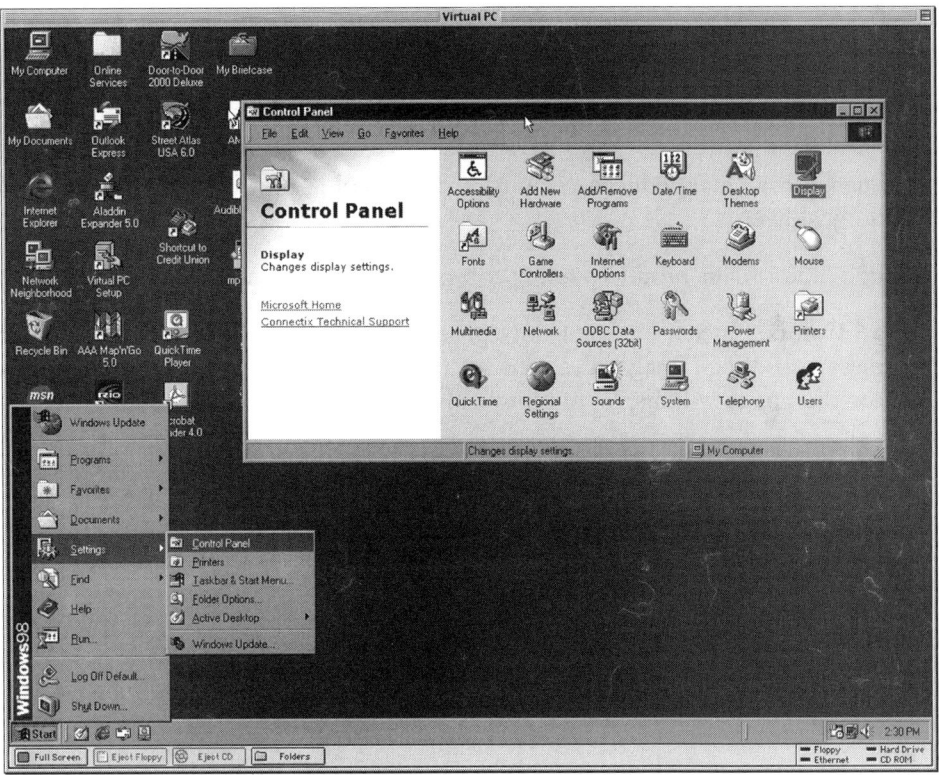

Figure 51.1 You will find the monitor Display program in the Control Panel window.

4. Locate the program named Display and double-click on the icon. Windows will open the Display Properties dialog box.

5. Select the Settings tab, then click on the Colors input box. Depending on your monitor, you will see several options, as shown in Figure 51.2.

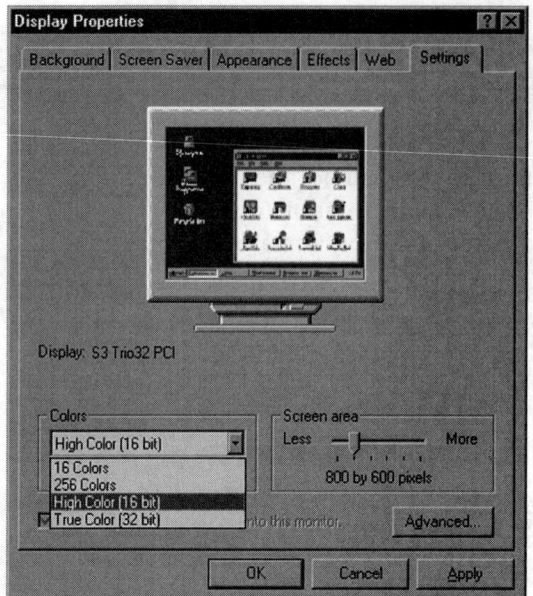

Figure 51.2 The Display dialog box describes the characteristics of your monitor and gives you the option to modify them.

6. Click to select one of the options and click the OK button. Note: In some cases, you may be required to restart Windows to effect the selected display changes.

- **True Color:** This produces the most accurate color, but the redraw rates in Photoshop are considerably slower.

- **High Color:** This produces fewer colors; however, the redraw rates in Photoshop will be faster.

- **256 Colors:** Since 8-bit color only produces 256 colors, it is difficult to work in this color space unless you design images destined for the Internet. This color space will give you a good idea of how the image will display on low-end monitors.

- **16 Colors:** As for 4-bit (or 16) color, it has limited use. One application of 4-bit color is to change to that color space when you are working in nongraphic programs on your laptop computer. The low color depth will decrease the strain on your laptop batteries and give you more run time between charges.

Note: Changing the color depth of your monitor does not affect how the file will be saved or printed. It only affects the view of the image on you monitor.

52 *Using the Predefined Color Settings Within Photoshop*

By introducing a new, easy-to-understand Color Settings dialog box, as shown in Figure 52.1, Photoshop 6.0 has gone a long way toward simplifying color management for the graphic designer.

Figure 52.1 The new Color Settings dialog box in Photoshop 6.0.

Each of the predefined configurations will embed a color management profile within each saved Photoshop graphic image. That profile describes to the computer what system created the graphic and the best way to output the image.

To modify the predefined Color Settings preferences, perform these steps:

1. Select the Edit menu Color Settings option. Photoshop will display the Color Settings dialog box.

2. Click on the Settings button, located at the top of the dialog box. Photoshop will display a list of predefined options.

There are eight predefined color settings options. Choose the one that best fits your current workflow conditions.

- **Color Management Off:** Use for graphics destined for video or an on-screen presentation.

- **ColorSync Workflow:** A Macintosh color management system used to preserve color information. The ColorSync Workflow option will not work on a computer running the Windows operating system.

- **Emulate Photoshop 4:** If you open Photoshop 4.0 graphic images in Photoshop 6.0, this option will preserve the image colors by converting the graphic using the Photoshop 4 color space.

- **Europe Prepress Defaults:** Use if Europe is the destination of your graphic images. This option emulates conditions found in most service bureaus in Europe.

- **Japan Prepress Defaults:** Useful if your images are printed in Japan. This option emulates conditions found in most service bureaus in Japan.

- **Photoshop 5.0 Default Spaces:** Use this option if you move graphics from Photoshop 5.0 into Photoshop 6.0. Photoshop will convert the image using the Photoshop 5.0 color space.

- **U.S. Prepress Defaults:** Useful if your images print in the United States. This option emulates conditions found in most service bureaus in the United States.

- **Web Graphics Default:** If you are designing graphics for display on the Internet, use this option. Web Graphics Default takes into account the variety of monitors on the market and modifies the graphic image to display it best.

When you have completed your changes, click the OK button.

Note: Modifying color settings is not a one-time event. Every time your workflow changes, reflect those changes by modifying the color settings.

53 *Changing Photoshop's Screen Display Mode*

When you open a graphic image within Photoshop, the image displays against the background of your monitor. On computers running Macintosh or the Windows operating system, that may mean viewing the image on a multicolored desktop cluttered with icons and open folders. Photoshop helps by giving you three ways to view your graphic images; these can be selected using the Screen Mode buttons.

The buttons to change the screen mode are located near the bottom of the toolbar, as in Figure 53.1.

Screen Mode buttons

Figure 53.1 The Screen Mode buttons are located near the bottom of the Photoshop toolbar.

To change the screen mode, perform these steps:

1. Open a graphic image in Photoshop.

2. To change the screen display, click on one of the screen mode buttons shown in Figure 53.1.

 - **Standard Mode:** Standard Mode (the leftmost button) displays graphic images within a window containing a title bar and scroll bars. The default background and all palettes and menus are still visible.

 - **Full Screen Mode with Menu Bar:** Full Screen Mode with Menu Bar (the middle button) centers the image against a gray background. The graphic window title bar and scroll bars are removed.

 - **Full Screen Mode:** Full Screen Mode (the rightmost button) centers the graphic image on your monitor against a black background. The graphic window title bar and scroll bars are removed.

Note: *Pressing the Tab key in any screen mode will temporarily remove the tool bar and palettes from the screen. Pressing the Tab key a second time will restore them to their previous positions on the monitor.*

54 *Using Photoshop's Document Window*

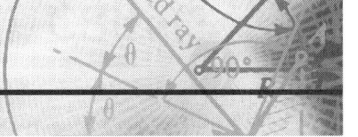

Images viewed in Photoshop appear within a document window. Depending on what screen mode you are currently using (refer to Tip 53), you may see a document window with or without a title bar and scroll bars.

Photoshop lets you open multiple windows of a single graphic file and display them at different views. One way to use this feature is to open a graphic file for editing, open a second document window, and enlarge a segment of the image that requires editing. You can edit the enlarged image while viewing the results of your editing on the whole image in the other document window, as shown in Figure 54.1.

Figure 54.1 Opening two views of an image lets you view the affects of your editing on the whole image.

To open multiple views of the same image within Photoshop, perform these steps:

1. Select the File menu Open option and choose a graphic image. Photoshop will open your graphic image and display it within a document window.

2. Select the View menu New View option. Photoshop will open a second document window, displaying a copy of the original image. Although the document windows contain the same image, each window can be controlled separately.

3. To make one of the document windows active, click on one of the two windows. The title bar of the other document window will turn gray (indicating that it is no longer active).

4. Select the Zoom tool from your toolbar. Enlarge an area of the active document window by moving over the area to be enlarged with your Zoom tool and clicking with your mouse. Each click of your mouse will enlarge the graphic image. Note that the Zoom tool will not affect the inactive document window. For more information on the Zoom tool, see Tip 183, "Using the Zoom Tool Correctly."

5. You can now use your editing tools on the document window containing the enlarged image while, at the same time, viewing the affects of your change to the original.

6. When you have completed your changes, close the new document window by clicking on the close button in the upper-left corner of the document window. Photoshop will close the document window, and you now have your original image, complete with all the editing changes.

55 *Moving Around in an Image Using the Navigator Palette*

When you open an image within Photoshop, you have several ways to change the image view size and to move into different areas of the image. One handy way to navigate within an image is to use the Navigator palette, as shown in Figure 55.1.

Figure 55.1 The Navigator palette in Photoshop.

To resize an image using the Navigator palette, use one of these methods:

Note: If your Navigator palette is not visible, select the Window menu Show Navigator option. Photoshop will then display the Navigator palette.

- **Using the Navigator palette slider:** At the bottom of the Navigator palette is a small triangular slider, as shown in Figure 55.2. Clicking and dragging right or left on the slider will increase or decrease the view size of the image.

- **Using the Navigator input field:** In the lower-left corner of the Navigator palette is the view size input field. Click inside this input field to select and change the number. View sizes range from 0.066% to 1600%.

- **Using the zoom in/out buttons:** Located to the left and right of the Navigator zoom slider are two buttons (they resemble mountains). The button on the left reduces the view, and the button on the right increases the view.

To navigate within an image using the Navigator palette, use this method:

- **Using the proxy preview area:** The Navigator palette contains a small preview of your graphic image. When you enlarge a graphic image, the document window will display the image at the specified view size; however, the preview area of the Navigator palette will always display the entire image.

 As an image is enlarged, a small rectangle appears in the preview area of the Navigator palette. That rectangle defines the viewable image as displayed by the document window (see Figure 55.3).

Figure 55.2 The Navigator palette lets you resize an image by using a slider, buttons, or an input field.

Figure 55.3 The Navigator palette displays the entire image and the area visible within the document window.

To change the view of an image within the document window, perform these steps:

1. Move your mouse into the preview area of the Navigator palette. When your mouse cursor enters the rectangle defining the viewable area, it will change into a hand icon, as shown in Figure 55.3.

2. To move the view box, click and drag your mouse. Moving the view box moves the visible area of the image as displayed within the document window.

Note: Use of the Navigator palette does not require the selection of a specific tool from the Photoshop toolbar. Whenever you drag your cursor over the Navigator palette, you will have full access.

56 *Changing Image Size Using the Pull-Down Menu*

In the preceding tip, you learned how to change the viewing size of a graphic image using the Navigator palette. Photoshop actually gives you several ways to control the image view size.

When you first open an image in Photoshop, the program will reduce the view size of the graphic to fit the monitor.

To change the view size of an image, select the View pull-down menu. Photoshop will display a list of view options, as shown in Figure 56.1.

Figure 56.1 View options as displayed from Photoshop's pull-down menu.

- **Zoom In:** Increases the view size of the image, up to 1600 percent.

- **Zoom Out:** Decreases the view size of the image, down to 0.066 percent.

- **Fit on Screen:** Resizes the active image to the available space on your monitor.

Note: The Fit on Screen option takes into account Photoshop's toolbox and palettes and places the image accordingly.

- **Actual Pixels:** Produces a view size of the image based on the width and height of the image in pixels. The current resolution of your monitor will influence how the image displays.

- **Print Size:** Produces a view size of the image based on the current ruler measurements (inches, picas, and so on), not the number of pixels in the image. This is useful to view an approximation of the image size when printed.

Note: The view of the image on your computer monitor does not influence the output of the image to print.

57 *Calibrating Monitor Color Using the Adobe Gamma Utility*

Let's say you begin with a color photograph that needs to be printed. First you scan the image, then you work on the image within Photoshop, and finally you send the image out to print. If your scanner, monitor, and printer are incorrectly calibrated, the image will print with incorrect color values. Without some help, this can make color management in Photoshop a tricky business.

Photoshop contains a helper program that will assist you in calibrating your monitor. It is called the Adobe Gamma program. The Adobe Gamma program is loaded when you install Photoshop on your computer and resides within the Photoshop application folder.

Here's how to load the Adobe Gamma program:

In the Windows operating system, click on the Start button. Move your cursor over the Settings option and click on Control Panel to open the Control Panel folder. Locate the Adobe Gamma utility and double-click to launch the program.

In the Macintosh operating system, click on the Apple icon and move your cursor down to the Control Panels option. Locate and click once on Adobe Gamma to launch the program.

You will see the Adobe Gamma dialog box, as shown in Figure 57.1.

Figure 57.1 *The Adobe Gamma program adjusts the colors on your computer monitor to fit your workflow.*

If you have never calibrated your monitor, choose the Step by Step option and click on the Next button. The Adobe Gamma utility will take you through a series of screens. At each screen, you will stop and evaluate your monitor by adjusting the contrast, colors, and white point of the monitor.

To advance to the next screen, click on the Next button. To return to a previous screen, click on the Back button. Click the Cancel button if you wish to end the calibration session without changing your monitor.

When you have completed all the adjustments and you are on the last screen, click on the Finish button. The Adobe Gamma Utility will open a dialog box and let you save the newly-created calibration file.

Give your new profile a name and click the Save button. Adobe Gamma will record your changes to the color settings of your monitor and will close the dialog box. You are now ready to work.

Note: To take into account aging monitors and the accidental resetting of brightness and contrast monitor controls, the Adobe Gamma program should be run on a monthly basis.

58 Controlling Toolbar and Palette Visibility

When you open Photoshop, the program displays a toolbox and 13 palettes. Regardless of the size of your monitor, these windows will eventually get in the way of your work, and no matter how hard you try, you cannot work under an open palette.

If you need additional working space in Photoshop, press the Tab key on your keyboard. The Tab key, when pressed, will remove all Photoshop palettes and the toolbox from the monitor. You can still work on the open image, and all your tools still function but without the screen clutter. To restore all palettes and the toolbox, press the Tab key again. The Tab key functions as a toggle switch, turning the palettes and toolbar on and off as needed.

If you want to remove the palettes without removing the toolbox, hold the Shift key down while pressing the Tab key. This removes the palettes without removing the toolbox. Hold the Shift key while pressing the Tab key a second time to restore the palettes to the screen. The Shift and Tab keys function as a toggle switch, turning the palettes on and off as needed.

59 Working with the Document Status Window

In Tip 19, "Displaying File and Image Information," you learned that the status bar in Photoshop contains information about the current image. In Photoshop for Windows, the status bar is located at the bottom to the monitor, directly above the Start button. In Photoshop for Macintosh, the status bar is attached to the bottom of the document window.

To hide the status bar in Photoshop for Windows, select the Window menu Hide Status Bar option. Photoshop will remove the status bar from the monitor and give you more room to work.

To return the status bar to the screen, select the Window menu Show Status Bar option. Photoshop will redisplay the status bar.

Note: This feature is only available in Photoshop running with the Windows operating system.

60 *Creating Customized Photoshop Palettes*

When you open Photoshop for the first time after installing the program, the palettes and toolbox appear in their default positions, as shown in Figure 60.1.

Figure 60.1 In their default locations, Photoshop palettes appear along the right side of the monitor and the toolbox on the left.

In Photoshop, you have the ability not only to change the positions of the palettes on the screen, but also to move individual palette tabs to create your own customized palettes. This procedure can save you editing time by organizing the information on your screen.

If you want to move the Swatches palette tab into the group palette containing the History and Actions tabs, open Photoshop and perform these steps:

1. Make sure all palettes are visible.

2. Click and hold on the Swatches tab.

3. Drag the Swatches tab out of the palette and place it in the palette containing the History and Actions tabs. When you release your mouse, the Swatches tab relocates to the other palette, as shown in Figure 60.2.

Figure 60.2 Clicking and dragging on a palette tab lets you create customized groups.

To ensure that changes made to your palettes are permanent, perform these steps:

1. Select Edit menu Preferences and choose the General Preferences option. Photoshop will display the General Preferences dialog box, as shown in Figure 60.3.

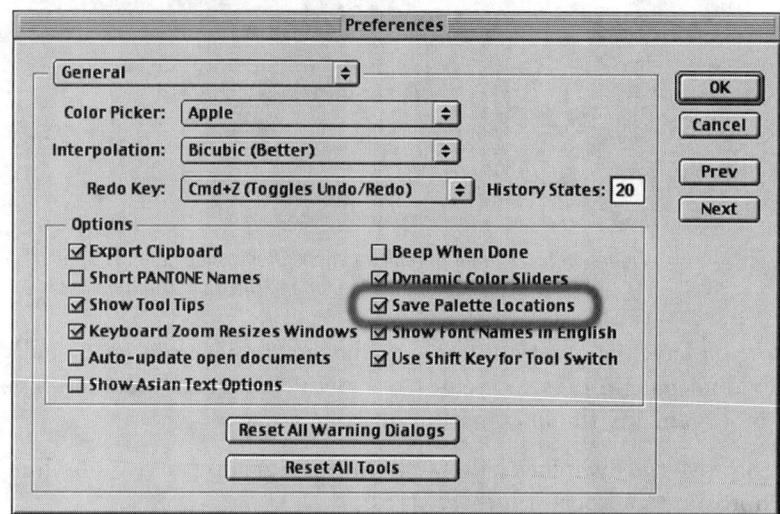

Figure 60.3. The Save Palette Locations option preserves the changes you make to palettes and groups.

2. The input box to the left of the Save Palette Locations option should have a check mark in it. If it does not contain a check mark, click once in the input field.

3. Click the OK button within the General Preferences dialog box. Photoshop will close the dialog box.

Now, when you close Photoshop and reopen the program, your palette locations will be preserved.

Note: If you change palette locations and groups but you want Photoshop to reopen using the default layout, perform the preceding steps but do not select the Save Palette Locations option. This will force Photoshop to open the same way every time, regardless of how you manipulate the palettes during a work session.

61 *Saving Files with Image Previews*

When saving a graphic image (File menu Save), Photoshop lets you save the file with or without an image preview.

Your operating system (Macintosh or Windows) uses image previews to display a small thumbnail of the image. Layout programs such as PageMaker and InDesign use image previews to display a low-resolution image for placement on the page. Photoshop also uses image previews to display a thumbnail image in the Open dialog box, as shown in Figures 61.1, 61.2, and 61.3.

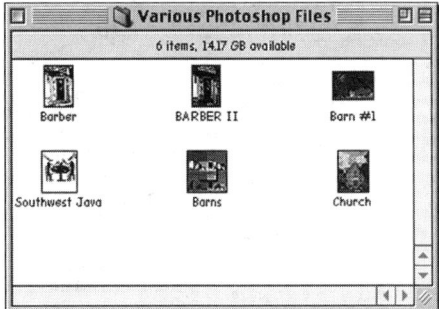

Figure 61.1 Graphics saved in Photoshop with an image preview are used by your operating system.

The characteristics of image previews are determined in Photoshop by accessing the Preference options. To modify the image preview settings, perform these steps:

1. Select Edit menu Preferences and choose the Saving Files option. Photoshop will display the Saving Files options in the Preferences dialog box, as shown in Figure 61.4.

2. Click on the Image Previews button. Photoshop will display three choices:

 • **Never Save:** Image previews are never saved with the image.

 • **Always Save:** Image previews are always saved with the image.

 • **Ask When Saving:** Every time a file is saved, Photoshop will ask if you want to save the image with a preview.

In the Macintosh operating system, you have several preview choices:

 • **Icon:** This lets the files be used as a preview icon on your desktop.

 • **Macintosh Thumbnail:** This is used to display a preview of the image in the Open dialog box in Photoshop for Macintosh.

 • **Windows Thumbnail:** This is used to display a preview of the image in the Open dialog box in Photoshop for Windows.

 • **Full Size:** This is used to open a preview image in layout programs that can only display low-resolution placement images.

3. When you have completed making your changes, click the OK button. Photoshop will record your changes to the Image Previews option and will close the dialog box. You are now ready to work.

Figure 61.2 Layout programs use image previews to display a low-resolution placement graphic.

Figure 61.3 Photoshop uses image previews to display a thumbnail of the image in the Open dialog box.

Figure 61.4 The Saving Files options in Photoshop preferences.

62 *Manually Choosing Colors with the Color Picker*

In Tip 29, "Determining Which Color-Selection Method Is Best," you learned that Photoshop lets you choose between your operating system's color picker and the built-in color picker inside Photoshop.

To use the color picker within Photoshop, click on the Foreground or Background color swatch on the toolbox, in turn, Photoshop displays the Color Picker dialog box, as shown in Figure 62.1.

Figure 62.1 Click on the Foreground or Background color swatch to open the Color Picker dialog box.

The Adobe Color Picker displays a large box of color, called the color field, and a vertical box to the right, called the color slider. The color slider shows the range of color available for the selected color mode (RGB, CMYK, and so on) and resembles a vertical rainbow. The large color field box represents the saturation of the color selected on the color slider.

You click on the color slider to choose your color. The two triangular sliders positioned on either side of the color slider point to the selected color. Once you have selected a color, determine the saturation

of the color by clicking in the large color field box. The small circle within the color field indicates the current saturation level of the color. The color rectangle to the right of the color slider indicates the new color in the top half and the original color in the bottom half (refer to Figure 62.1).

Photoshop will also warn you when the color you have selected is outside of the printable range. When you see a warning sign, as shown in Figure 62.2, the color you have selected will not print within the CMYK color space (refer to Tip 9, "Working in Photoshop's CMYK Color Space").

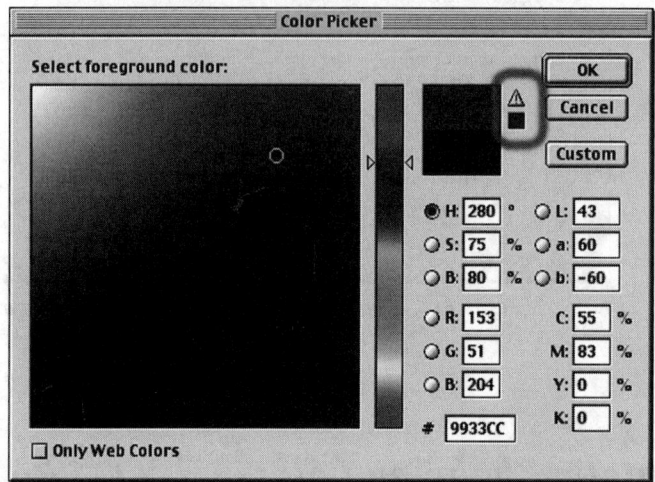

Figure 62.2 *The warning icon, shown within the red rectangle, indicates a color outside the range of four-color (CMYK) printing.*

To choose the closest color that will print, click on the warning icon. The Color Picker will move you to the closest printable color, and the warning icon will disappear.

After selecting your color, click the OK button. Photoshop will close the Color Picker dialog box, and your color is ready for use. If you originally clicked on the Foreground color box, that color has not changed to your selected color. If you originally clicked on the Background color box, that color has now changed to your selected color. For information on how to save selected colors, see Tip 547, "Adding Individual Colors to the Swatches Palette."

63 *Quickly Accessing Information with Context-Sensitive Menus*

Photoshop 6.0 expanded its use of context-sensitive menus throughout the program. To access a context-sensitive menu, move your cursor over a graphic or tool and right-click your mouse. Depending on the tool you have selected and where you click, Photoshop will display a pop-up menu with selectable items.

Say you've selected the Paintbrush tool and you need to modify the brush or change to a different blending mode. Move your cursor over the image and right-click your mouse. You will see a context-sensitive menu appear, as shown in Figure 63.1.

The Photoshop program contains numerous context-sensitive menus, all designed to speed up your photo-editing work.

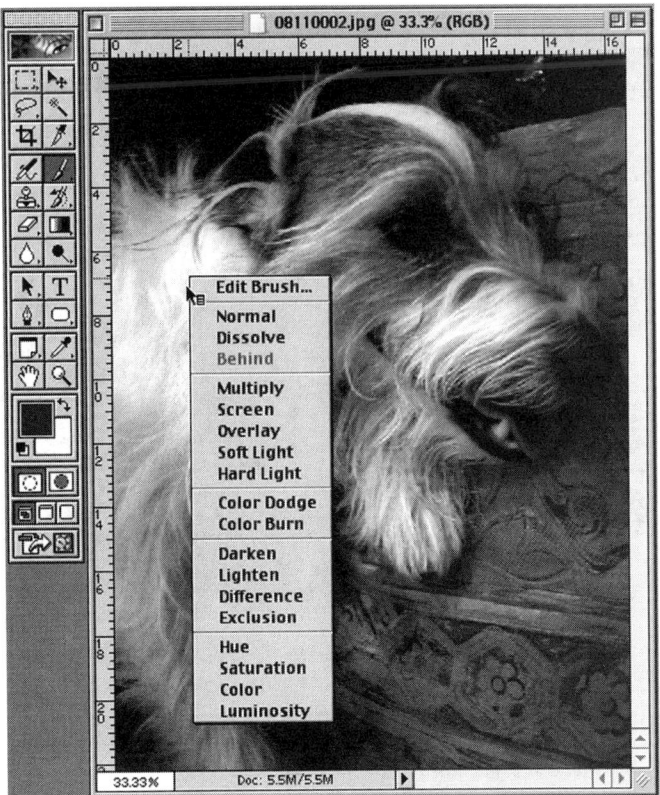

Figure 63.1 Right-clicking your mouse while using the Paintbrush displays a context-sensitive menu.

64 *Changing Photoshop's Tool Icons*

Photoshop assigns each tool an icon that resembles the icons as displayed on the toolbox. When you select and use a tool from the toolbox, your mouse cursor changes to an icon of the selected tool. Say you choose the Paintbrush tool. As soon as you select the tool from the toolbox, the cursor will resemble the Paintbrush icon on the toolbox, as shown in Figure 64.1.

While the Paintbrush icon may describe what tool you are currently using, it does little to describe how the tool works and where the hotspot of the tool is located. The hotspot defines the part of the tool icon that performs the work.

Knowing where the hotspot is located on a tool tells you where to position that tool before you start working. Without that information, you may sample the wrong area of an image with the Eyedropper or paint the wrong pixels with the Paintbrush.

Photoshop lets you choose the types of icons you want to use. To change your tool icons, perform these steps:

1. Select Edit menu Preferences and choose the Display & Cursors option. Photoshop will open the Display & Cursors options, as shown in Figure 64.2.

Figure 64.1 Selecting the Paintbrush from the toolbox changes your cursor to resemble a Paintbrush.

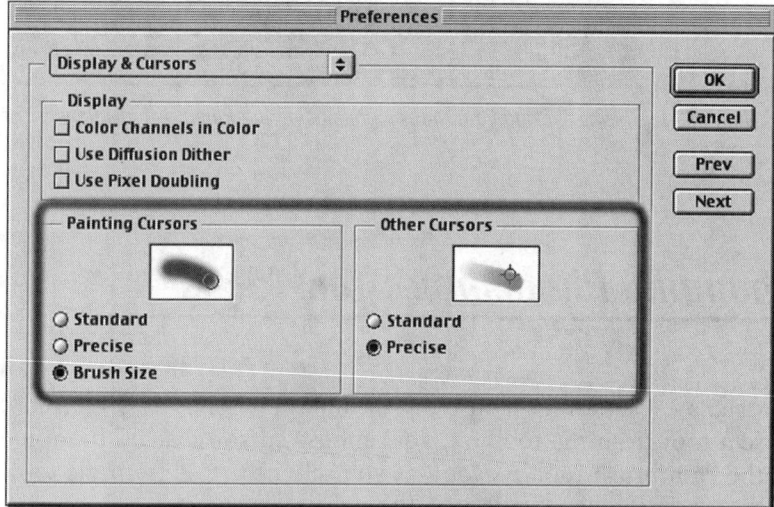

Figure 64.2 Modification of Photoshop's cursors is accomplished through the
Display & Cursor options in the Preferences dialog box.

Painting Cursors

- **Standard:** Choose this option to display your cursors with the same icon as displayed in the toolbox.

- **Precise:** Choose this option to display a crosshair icon for all your painting tools.

- **Brush Size:** Choose this option to display a small circle, indicating the size of brush used.

Other Cursors

- **Standard:** Choose this option to display all the tools, with the exception of the painting cursors, with the same icon as displayed on the toolbox.

- **Precise:** Choose this option to display all the tools, with the exception of the painting cursors, with a crosshair icon.

2. To make your selections, click on the radio buttons located to the left of each option.

3. When you have completed your changes, click OK.

Note: A quick way to switch from standard tool icons to precise icons is to press the Cap Lock key on your keyboard. Pressing the Cap Lock key changes standard tool icons into Precise icons. Pressing the Cap Lock key a second time returns the Precise icons back to Standard icons.

65 *Using the New Options Bar in Photoshop*

Photoshop made a major improvement in version 6.0 when it redesigned and moved the Options palette. The Options bar is located at the top of the Photoshop window, directly under the pull-down menu (see Figure 65.1), and it replaces the old Options palette.

Figure 65.1 In Photoshop, the Options bar displays the characteristics of the selected tool.

The Options bar supplies all the characteristics associated with a particular tool. Say you have the Paintbrush selected and you need to change the brush size. Adobe removed the brushes from their old palette location and attached them to the Options bar. Now, every time you use a tool that requires a brush size, the brushes are located on the Options bar, as shown in Figure 65.2.

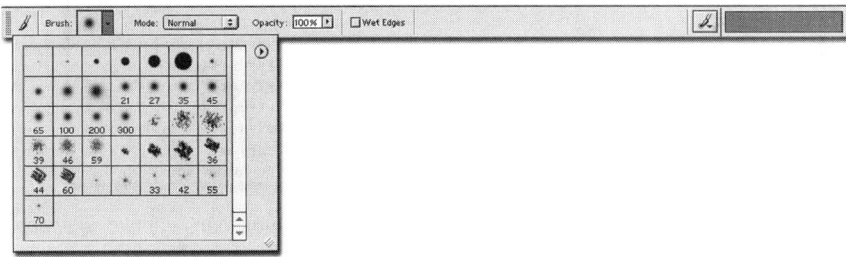

Figure 65.2 The Brush palette is now located on the Options bar.

Adobe added a few new features to the Options bar like Brush Dynamics (see Tip 191, "Using Brush Dynamics") and palette docking (see Tip 69, "Docking Palettes Together").

We have been using the same Options palette for 10 years, but now it is in a more accessible area and is packed with added power.

66 *Viewing Pop-up Palettes in Photoshop*

The pop-up palettes in Photoshop provide you with easy access to libraries of brushes, patterns, swatches, contours, and shapes. All of the pop-up palettes open with default settings. To fit your work-flow needs, you can customize pop-up palettes by changing the view of the palettes. You can even add additional library items to each palette to increase their usability.

If you are working with the Swatches palette in Photoshop and you want to change to a different color palette, perform these steps:

1. To select the Swatches palette, click on the Swatches tab, shown in Figure 66.1. If the Swatches palette is not visible, select Window menu Show Swatches Palette.

Figure 66.1 The Swatches palette in Photoshop.

2. Click on the triangle in the upper-right corner of the Swatches palette. You will see a pop-up menu, as shown in Figure 66.2.

Figure 66.2 Clicking on the triangle button will open a pop-up menu containing options for the Swatches palette.

3. Choose one of the 16 preset color palettes or click the Load Swatches option to load your own customized color palettes. For more information on creating customized color palettes, see Tip 568, "Creating a Custom Color Palette from a Photoshop Image."

4. When you choose a new color palette, Photoshop will prompt you to change or append the new palette, as shown in Figure 66.3.

Figure 66.3 When you open a new color palette in the Swatches palette, you have the option of adding the new palette to the existing color palette (Append) or replacing the old color palette with the new one (OK).

Photoshop Basics 77

5. If you choose the Append option, Photoshop will add the new color palette to the end of the existing palette. If you want to replace the existing color palette with the new palette, click the OK button. In either case, Photoshop will close the dialog box and display your choice in the Swatches palette.

Photoshop will also let you change the view of the pop-up palettes. If you want to view the information in the Styles palette by the name of the style instead of by viewing an icon, perform these steps:

1. To select the Styles palette, click on the Styles tab, shown in Figure 66.4. If the Styles palette is not visible, select Window menu Show Styles Palette.

Figure 66.4 The Styles palette, viewed using small icons.

2. Click on the triangle in the upper-right corner of the Styles palette. You will see a pop-up menu, as shown in Figure 66.5.

Figure 66.5 Clicking on the triangle button will open a pop-up menu containing options for the Styles palette.

3. The view selections available for the Styles palette are Text Only, Small Thumbnail, Large Thumbnail, Small List, and Large List. Click on a different view option. The Styles palette will change to reflect your change, as shown in Figure 66.6.

Figure 66.6 The Styles palette using the view option Small List.

Note: The available options to change the view of pop-up palettes will vary with the different pop-up palettes.

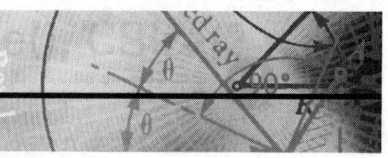

67 *Renaming Pop-up Palette Items*

In Tip 66 you learned how to change the icons in pop-up palettes to text. To help you further define palette items, Photoshop lets you rename any pop-up menu item.

To rename an item within the Styles pop-up menu, perform these steps:

1. To select the Styles palette, click on the Styles tab, shown in Figure 67.1. If the Styles palette is not visible, select Window menu View Styles palette.

Figure 67.1 *The Styles palette in Photoshop.*

2. Right-click (Macintosh: Ctrl-click) on the style you want to change. You will see a pop-up menu.

3. Click on the Rename Style option. Photoshop will open the Style Name dialog box, as shown in Figure 67.2. Click in the input field and rename the style. When you are finished, click the OK button. Your style now has a new name.

Figure 67.2 *The Style Name dialog box lets you rename any icon within the Styles palette.*

Note: All of the pop-up palettes in Photoshop let you choose between viewing the items as icons or as text.

68 *Linking Palettes Together*

In Tip 60, "Creating Customized Photoshop Palettes," you learned that you can create groups of palette tabs by dragging an item tab from one group into another. Photoshop 6.0 gives you a way to not only create palette groups but to lock palettes together, so although they are still separate groups, they will move and resize as a single unit.

If you want to group the Layers/Channels/Paths palette group with the History/Actions palette group, perform these steps:

1. Locate the Layer/Channels/Paths group and the History/Actions group. One at a time, click on the title bars of each group and drag them to the middle of your screen, as shown in Figure 68.1.

Figure 68.1 Moving the two palette groups to the middle of the screen will make the job of linking them together easier.

2. Click on the Layers tab and drag it out of the Layers/Channels/Paths group. (To link palettes together, you need to move one item tab at a time.) Drag the Layers tab into the History/Actions group until your cursor is touching either the History or Actions tab, as shown in Figure 68.2.

Figure 68.2 Drag the item tab on top of one of the tabs in the second group.

3. When you release your mouse, the Layer tab will appear by itself in a palette directly under the History/Actions palette. You have just linked the two palettes together.

4. Finally, one at a time, click and drag the Channels and Paths tabs into the center of the Layers palette. You now have two separate palettes linked together, as shown in Figure 68.3.

Figure 68.3 Linking the Layers/Channels/Paths and History/Actions palettes lets you move and resize the two palettes as a single unit.

69 *Docking Palettes Together*

Linking palettes (refer to Tip 68) and grouping item tabs (refer to Tip 60, "Creating Customized Photoshop Palettes") are two ways to improve the organization and workflow within Photoshop. However, Photoshop 6.0 gives you one more way to organize your palettes: by docking them together.

Let's say you are working on a project that requires heavy use of Layers and Swatches, and you want easy access to these palettes. Docking palettes together requires the use of the new Options bar in Photoshop. The gray area to the right of the Options bar is the docking area for palettes, as shown in Figure 69.1.

Figure 69.1 The docking area on the Options bar is the gray area on the far right. Use this area to move any combination of palette tabs.

To dock the Layers and Swatches palettes, perform these steps:

1. Locate the Options bar. If the Options bar is not visible, select Window menu View Options.

2. Click, one at time, on the Layers and Swatches tabs and drag them into the gray docking area on the Options bar, as shown in Figure 69.2. When you release your mouse, the Layers and Swatches palette tabs are now within the docking station.

3. To open the Layers or Swatches palettes, click on the tab name displayed in the Options bar docking area. The palette will open, giving you access to all its features.

Figure 69.2 Moving palette tabs into the docking station gives you easy access
to the tools you need to get the job done quickly.

70 Quickly Resetting the Positions of Palettes and Dialog Boxes

The last several tips dealt with reorganizing and moving palettes and dialog boxes. As previously discussed, the positions of open palettes and dialog boxes are saved when you exit the application. In Photoshop, you can always start with default palette positions or restore default positions at any time, as discussed in Tip 60, "Creating Customized Photoshop Palettes."

Photoshop gives you a way to restore all palettes and moveable dialog boxes back to the default positions. To do this, select the Window menu Reset Palette Locations option. All palettes and dialog boxes will return to their original positions.

> *Note: When you choose the Window menu Reset Palette Locations option, all linked palettes are unlinked, and all palettes previously moved to the Options bar docking station are returned to their default palette locations. It is a great way to start a new project, with everything back in its original place.*

71 The Marquee Tools

The Marquee tools are selection tools; their purpose is to define a work area within an open image. When you open a graphic in Photoshop and use one of the selection tools, that selection is the only area of the image where you can work. All the tools, adjustments, and filters in Photoshop will only function within that defined area.

To select the Marquee tool, click on the Marquee button, located in the upper-left corner of the toolbox, as shown in Figure 71.1.

The Marquee tool is a grouped tool; clicking and holding your left mouse button on the Marquee tool reveals four selection tools: Rectangular, Elliptical, Single Row, and Single Column, as shown in Figure 71.2.

To change to a different Marquee tool, perform these steps:

1. Click and hold your mouse on the Marquee tool. Photoshop will open a pop-up box displaying the four Marquee tools, as shown in Figure 71.2.

Figure 71.1 The Marquee tool lets you make selections within an open graphic file.

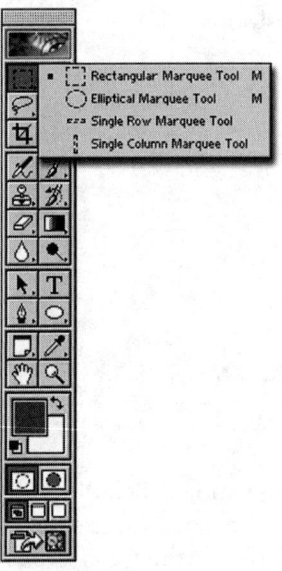

Figure 71.2 The Marquee tool is a group tool that lets you access four separate selection options.

2. Click on the Marquee tool you want to use. Photoshop will close the pop-up box, and your selection is now the default tool. For more information on selection techniques, see Tip 282, "Working with the Marquee Tools."

- **Rectangular Marquee:** Lets you create square or rectangular selections, as shown in Figure 71.3.

- **Elliptical Marquee:** Lets you create circular or oval selections, as shown in Figure 71.4.

- **Single Row Marquee:** Lets you create a selection based on a single horizontal pixel, as shown in Figure 71.5.

- **Single Column Marquee:** Lets you create a selection based on a single vertical pixel, as shown in Figure 71.6.

Figure 71.3 The Rectangular Marquee tool makes selections based on a square or rectangle.

Figure 71.4 The Elliptical Marquee tool selects information in the form or a circle or oval.

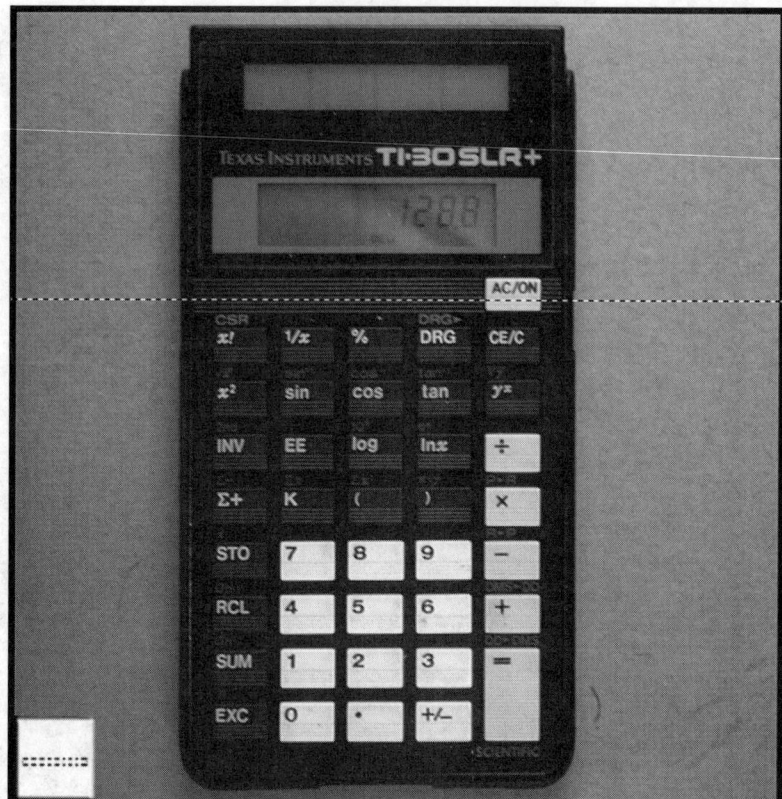

Figure 71.5 The Single Row Marquee tool selects a single row of pixels, left to right across the entire image.

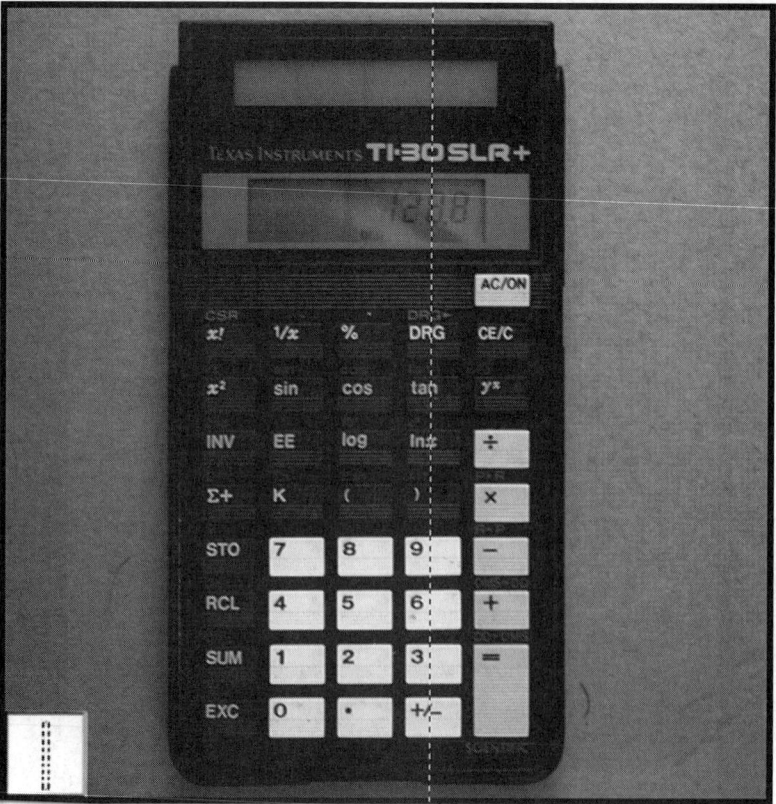

Figure 71.6 The Single Column Marquee tool selects a single column of pixels from the top to the bottom of the image.

72 *The Move Tool*

The Move tool moves pixel information within a Photoshop graphic. To select the Move tool, click on the Move tool button, located in the upper-right of the toolbox, as shown in Figure 72.1.

To use the Move tool, click and drag in the document window of an open Photoshop graphic.

Note: The Move tool works with or without a selection.

If you first select an area of a graphic image, the Move tool will only move the pixels within the selected area, as shown in Figure 72.2. If no pixels are selected within a graphic image, the Move tool will move the entire layer or background. For more information on moving information in Photoshop, see Tip 268, "Working with the Move Tool."

Figure 72.1 The Move tool lets you move pixel information within any open Photoshop image.

Figure 72.2 The Move tool will move all the pixels within a selected area.

73 *The Lasso Tools*

Photoshop provides you with three Lasso tools. Like the Marquee tools, the Lasso tools create selections within a Photoshop graphic.

To select the Lasso tool, click on the Lasso button on the toolbox, as shown in Figure 73.1.

Figure 73.1 The Lasso tool selects pixel information within a Photoshop graphic.

The Lasso tool is a grouped tool; clicking and holding your left mouse button on the Lasso tool reveals a pop-up menu with three tools: Lasso, Polygon Lasso, and Magnetic Lasso.

To change to a different Lasso tool, perform these steps:

1. Click and hold your mouse on the Lasso tool. Photoshop will open a pop-up menu displaying the three Lasso tools.

2. Click on the Lasso tool you want to use. Photoshop will close the pop-up box, and your selection is now the default tool.

 • **Standard Lasso:** Selects information based on the freeform movement of your mouse, as shown in Figure 73.2.

 • **Polygon Lasso:** Selects information by creating straight lines between user-defined points. Clicking your mouse in the document window sets an anchor point. Moving and clicking your mouse in another location sets another anchor point and draws a straight line between the points, as shown in Figure 73.3.

 • **Magnetic Lasso:** Selects information by looking for shifts in the brightness of the image, as shown in Figure 73.4.

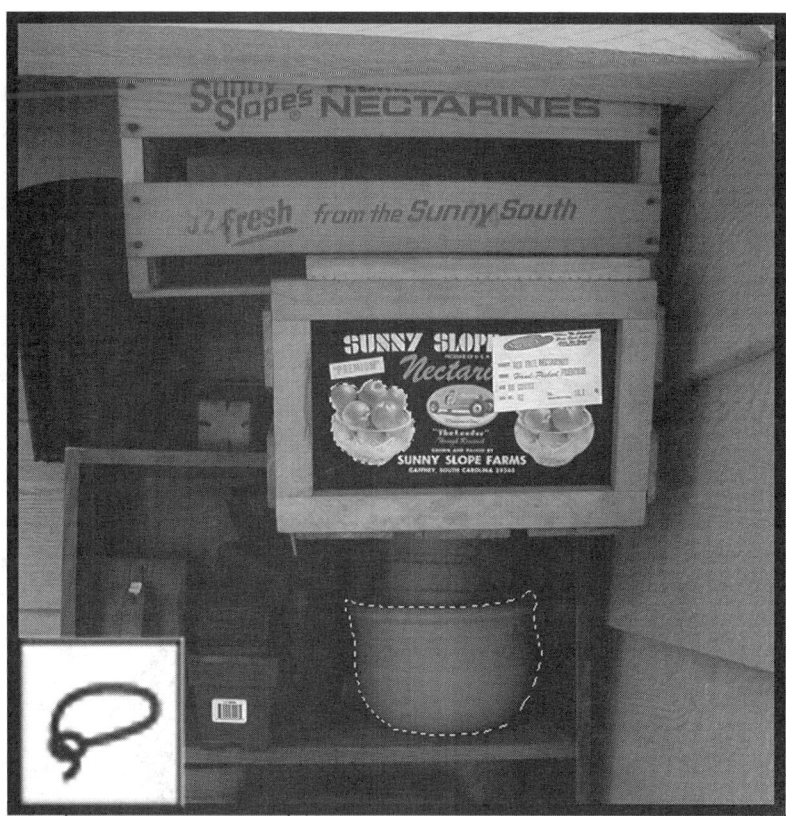

Figure 73.2 The freeform Lasso tool selects pixel information by clicking and dragging your mouse across the image (see Tip 136, "Using the Standard Lasso Tool").

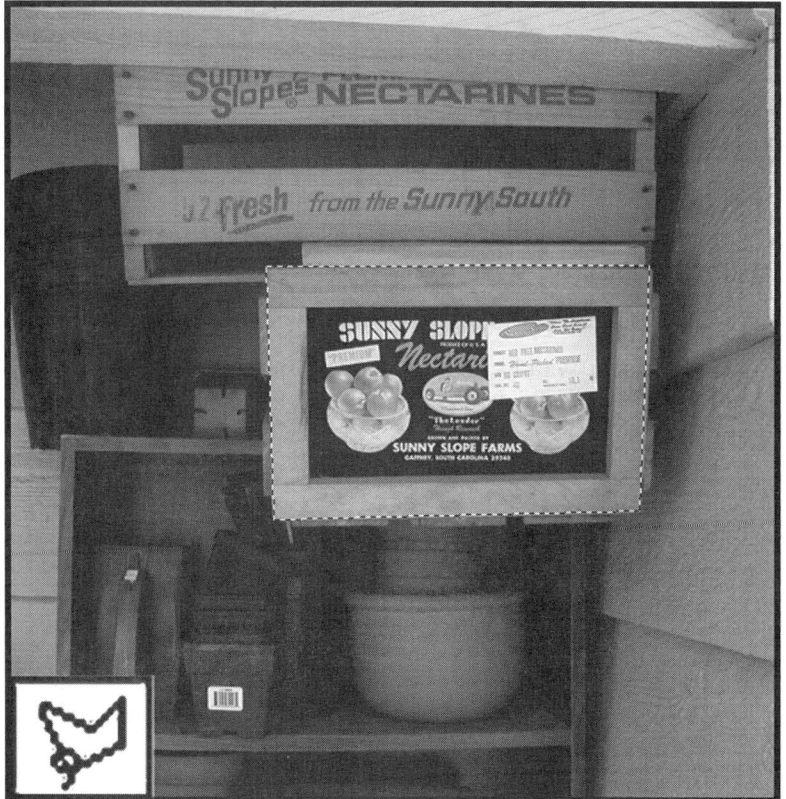

Figure 73.3 The Polygon Lasso tool selects pixel information by drawing straight lines between mouse clicks (see Tip 124, "Working with the Polygon Lasso Tool").

Figure 73.4 The Magnetic Lasso tool selects pixel information by the edge brightness of the image (see Tip 137, "Understanding the Magnetic Lasso Tool").

74 *The Magic Wand Tool*

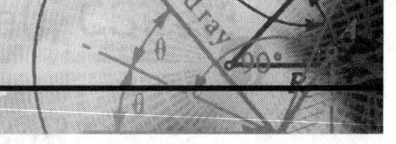

The Magic Wand tool is one of the most versatile selection tools within Photoshop. The Magic Wand selects information by the color brightness level of the pixels.

To select the Magic Wand tool, click on the Magic Wand button on the toolbox, as shown in Figure 74.1.

When you move the Magic Wand tool into the document and click your mouse, Photoshop samples the pixel under the Magic Wand and selects similar pixels based on the brightness of the sampled pixel, as shown in Figure 74.2.

Figure 74.1 The Magic Wand tool selects pixel information within a Photoshop graphic.

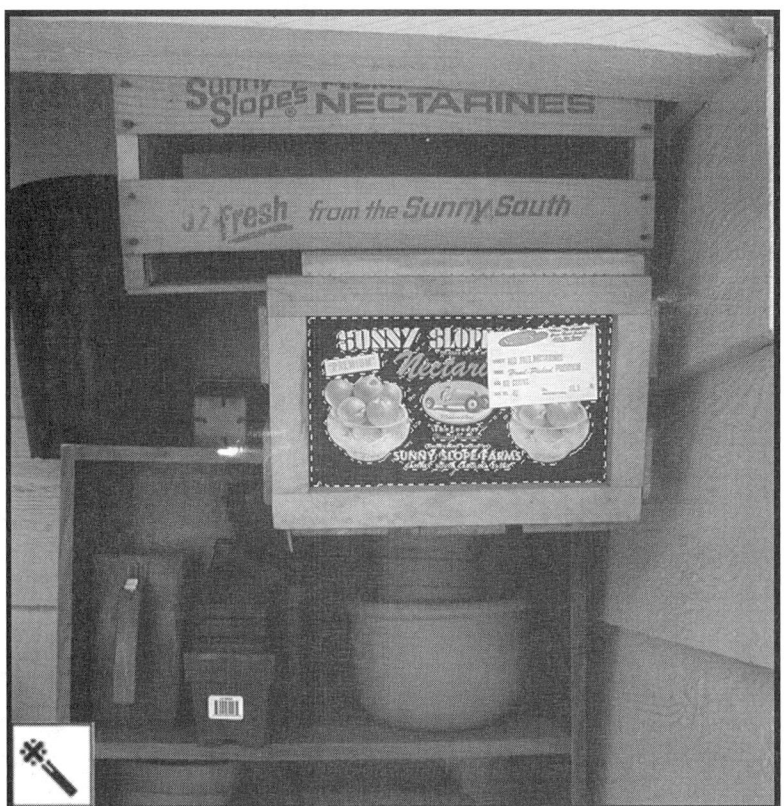

Figure 74.2 The Magic Wand Tool selects pixel information by the brightness of the pixels
(see Tip 170, "Understanding How the Magic Wand Works").

75 *The Cropping Tool*

The Cropping tool lets you draw a rectangular area by clicking and dragging your mouse over the image. When you press the Enter key, Photoshop will discard the pixels outside the selected rectangular area.

To select the Cropping tool, click on the Cropping tool button on the toolbox, as shown in Figure 75.1.

Figure 75.1 The Cropping tool removes pixel information from a Photoshop graphic.

To select information, move the Cropping tool into the document window and click and drag to define a rectangular or square area, as shown in Figure 75.2.

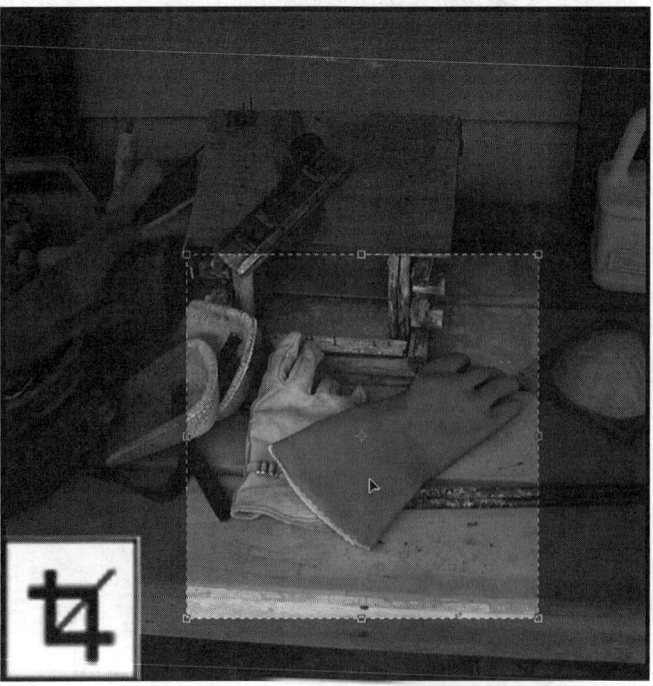

Figure 75.2 The Cropping tool redefines the image by removing pixel information from the image (see Tip 272, "Using the Cropping Tool").

76 *The Slice Tool*

Adobe introduced a new tool in Photoshop 6.0 called the Slice tool. The Slice tool divides a graphic image into separate image pieces, each saved with a distinct file name. Later, the pieces can be reassembled into a whole image. The technique of slicing an image is used primarily on large images destined for the Internet. However, the technique of slicing an image has recently been used for large display images and banners.

The Slice tool is located on the toolbox, as shown in Figure 76.1.

Figure 76.1 The Slice tool divides a single image into several separate images.

To select the Slice tool, click on the Slice tool icon shown in Figure 76.1. Slices are created within a Photoshop graphic by dragging the Slice tool across the image, shown in Figure 76.2. When sliced images are used in conjunction with the Save for Web feature, Photoshop will save your sliced images and generate the HTML table for reassembling them into a Web page. See Tip 135, "Using the Save for Web Feature with a Sliced Image."

Figure 76.2 The Slice tool divides a single Photoshop graphic into separate images
(see Tip 134, "Working with the Slice Tool").

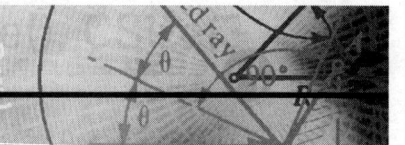

77 *The Airbrush Tool*

Airbrush is one of three tools in Photoshop that physically paints onto a Photoshop image. To select the Airbrush tool, click on the Airbrush icon shown in Figure 77.1.

Figure 77.1 The Airbrush tool in the Photoshop toolbox.

As with all painting tools, the Airbrush tool uses the predefined shape of a brush to apply the ink to the image (see Tip 230, "Modifying a Photoshop Brush to Create a New Brush").

After selecting a brush shape, you apply color to the image by clicking and dragging your cursor across the image, shown in Figure 77.2. The color of the brush is determined by the current foreground color (see Tip 549, "Selecting Color with the Foreground Color Button").

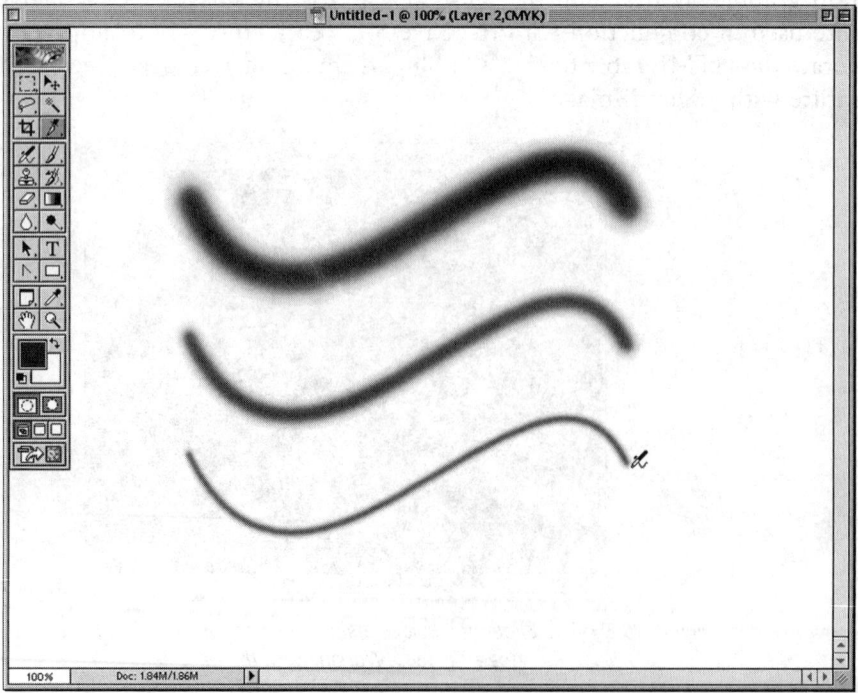

Figure 77.2 The Airbrush tool paints color into a Photoshop image (see Tip 279, "Working with Photoshop's Airbrush Tool").

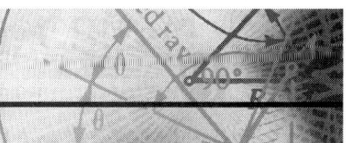

78 *The Paintbrush and Pencil Tools*

The Paintbrush tool, like the Airbrush tool (refer to the preceding tip), applies a specific color of ink to the image. To select the Paintbrush tool, click on the Paintbrush icon in the toolbox, as shown in Figure 78.1.

Figure 78.1 The Paintbrush tool in the Photoshop toolbox.

The Paintbrush tool is a group tool. Clicking and holding your mouse button on the Paintbrush icon displays a pop-up menu, which displays two choices: the Paintbrush tools and the Pencil tools, as shown in Figure 78.2. Clicking on the Paintbrush or the Pencil tool makes it the default tool.

Figure 78.2 The Paintbrush and Pencil tool apply color to the screen, based on the current foreground color.

After selecting a brush shape, you apply color to the image by clicking and dragging your cursor across the image. The current Foreground color determines the color of the brush (see Tip 549, "Selecting Color with the Foreground Color Button").

The Paintbrush and Pencil tools apply ink to the screen using an opacity setting. Ink is applied to the image by a predefined percentage (see Figure 78.3). So long as you hold down the mouse button as you drag the paintbrush across the image, the opacity of the ink will remain the same (see Tip 191, "Using Brush Dynamics").

Figure 78.3 The Paintbrush tool applies color to an image, based on an Opacity setting from zero to 100 percent.

79 *The Clone and Pattern Stamp Tools*

The Clone Stamp tool is one of the most widely used photographic restoration tools in the Photoshop toolbox. In a sense it is a paintbrush, but it does not paint solid colors; it actually paints image information. To select the Clone Stamp tool, click on the Clone Stamp icon in the Photoshop toolbox, as shown in Figure 79.1.

Figure 79.1 The Clone Stamp tool in the Photoshop toolbox.

The Stamp tool icon is a group tool. Clicking and holding your mouse on the Stamp tool opens a pop-up menu displaying the Clone and Pattern Stamp tools, as shown in Figure 79.2. Select a default tool by clicking on the Clone Stamp tool or the Pattern Stamp tool.

Figure 79.2 The Clone and Pattern Stamp tools.

- **The Clone Stamp tool:** Click and drag your mouse across the image to transfer pixel information from one point in the image to another. The Clone Stamp tool uses options and the size and shape of the current brush to control the area of modification, shown in Figure 79.3 (see Tip 605, "Using the Clone Stamp Tool").

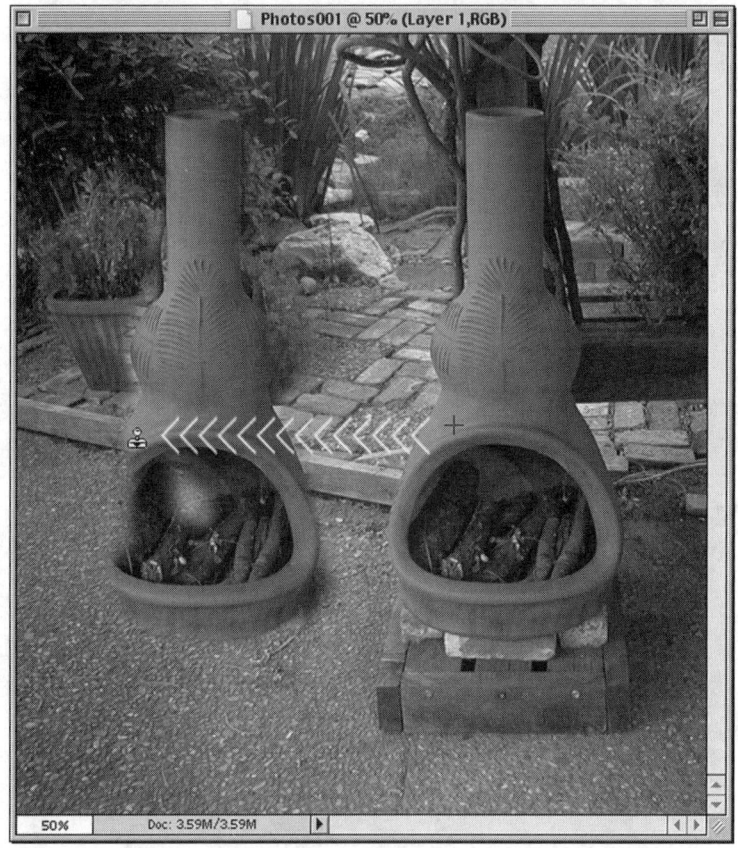

Figure 79.3 The Clone Stamp tool paints image information.

- **The Pattern Stamp tool:** The Pattern Stamp paints a Photoshop image with a saved pattern. This tool uses options and the size and shape of the current brush to control the area of modification, as shown in Figure 79.4 (see Tip 131, "Working with the Pattern Stamp Tool").

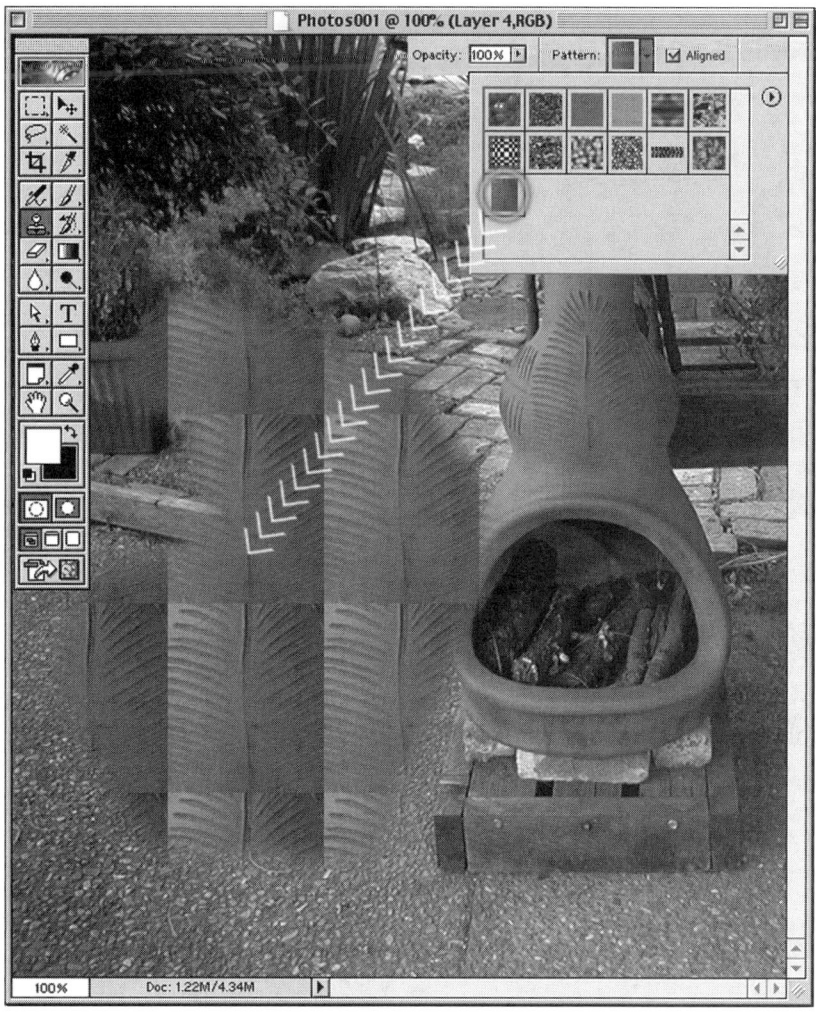

Figure 79.4 The Pattern Stamp tool paints the image with a previously saved pattern.

80 *The History and Art History Brush Tools*

The History tools work in conjunction with the History palette to paint using saved states of an image (see Tip 404, "Filling a Selection with a History State"). To select the History Brush tool, select the History Brush icon in the Photoshop toolbox, as shown in Figure 80.1.

Figure 80.1 The History Brush tool in the Photoshop toolbox.

The History Brush tool is a grouped tool. Clicking and holding your mouse on the History Brush opens a pop-up menu displaying the History and Art History Brush tools, as shown in Figure 80.2. Select a default tool by clicking on the History or Art Brush options. Photoshop will close the pop-up menu, and the option you clicked on will become the default tool.

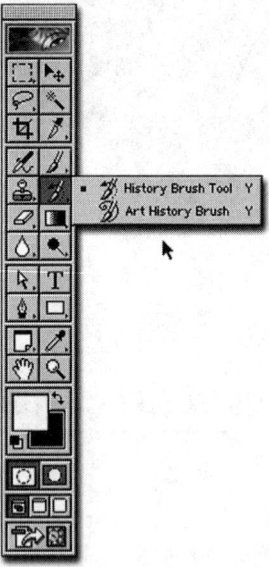

Figure 80.2 The History and Art History Brush tools.

- **The History Brush:** Paints pixel information into a Photoshop image based on a saved history state (see Figure 80.3). The History Brush uses the History palette, the Options bar, and the size and shape of the current brush to control the area of modification (see Tip 600, "Using the History Brush to Creatively Edit an Image").

- **The Art History Brush:** Like the History Brush, the Art History Brush paints pixel information into an image based on a saved history state, but it modifies the pixel information to give the image a "painterly" look (see Figure 80.4). The Art History Brush uses the History palette, the Options bar, and the size and shape of the current brush to control the area of modification (see Tip 144, "Creating a Painterly Effect with the Art History Brush").

Figure 80.3 The History Brush paints information from a History state.

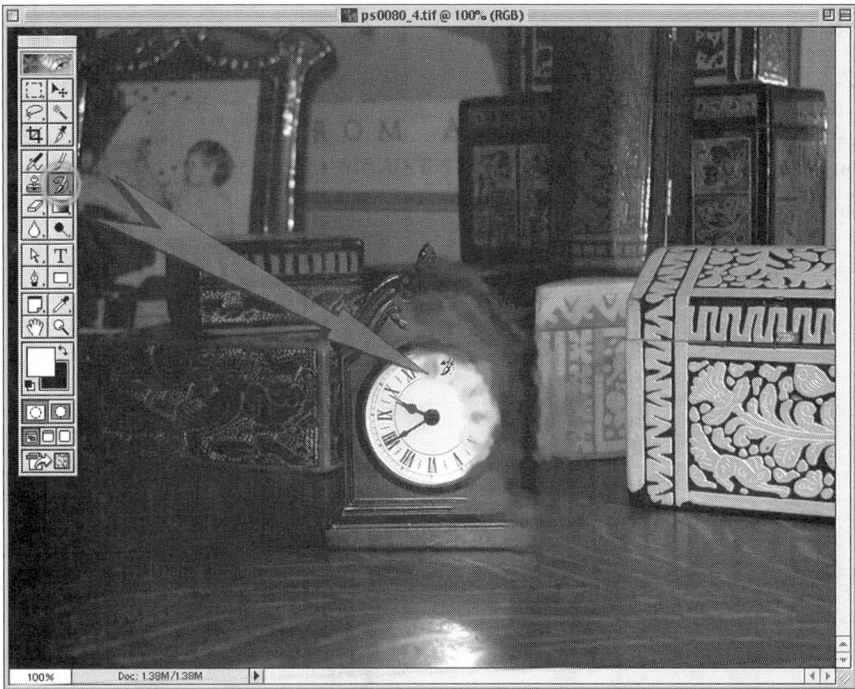

Figure 80.4 The Art History Brush gives a Photoshop image a painterly look.

81 *The Eraser Tools*

Photoshop comes equipped with three Eraser tools: standard, Background, and Magic. To select the default eraser tool, click on the Eraser icon shown in Figure 81.1.

Figure 81.1 The Eraser tool icon, in the Photoshop toolbox.

The Eraser tool is a grouped tool. To change from the default eraser, click and hold on the Eraser icon in the Photoshop toolbox. Photoshop will display a pop-up menu with three eraser choices, as shown in Figure 81.2. Click on one of the menu items to change the default eraser.

Figure 81.2 Clicking and holding on the Eraser icon displays all three eraser options.

- **Eraser:** To erase pixel information, click and drag your mouse across the image. If the image is on a background, the standard Eraser will fill in the erased information with the current background color, as shown in Figure 81.3 (see Tip 169, "Using the Standard Eraser Tool").

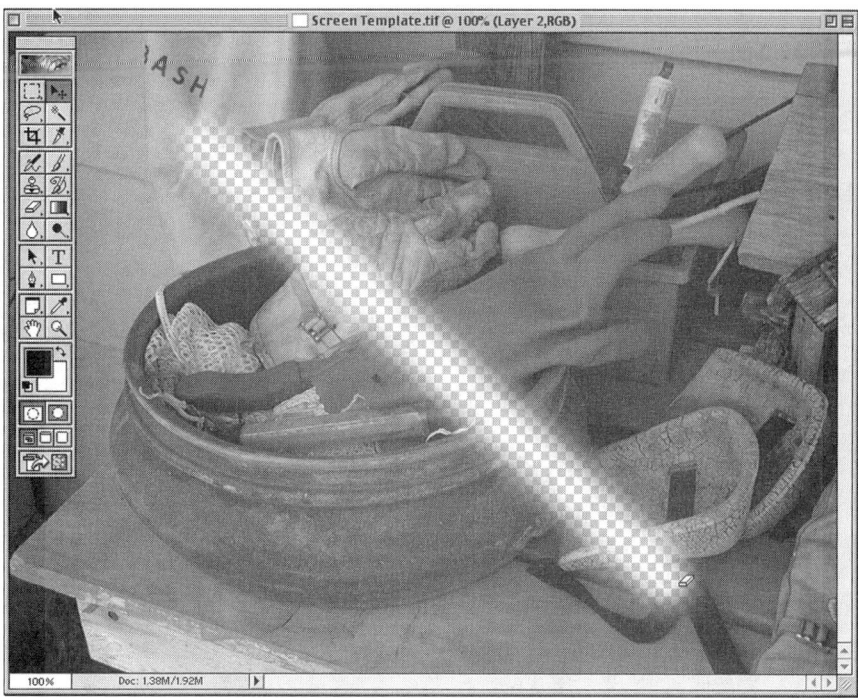

Figure 81.3 The standard Eraser tool.

- **Background Eraser:** To erase pixel information on a Background, click and drag your mouse across the image. The Background automatically converts into a layer, and the pixels erase to transparent, as shown in Figure 81.4 (see Tip 168, "Using the Background Eraser").

Figure 81.4 The Background Eraser tool.

- **Magic Eraser:** Erases pixel information within an image if the image is a Background, by clicking once on the image. The pixels erase by color brightness and convert to transparent, as shown in Figure 81.5 (see Tip 165, "Working with the Magic Eraser").

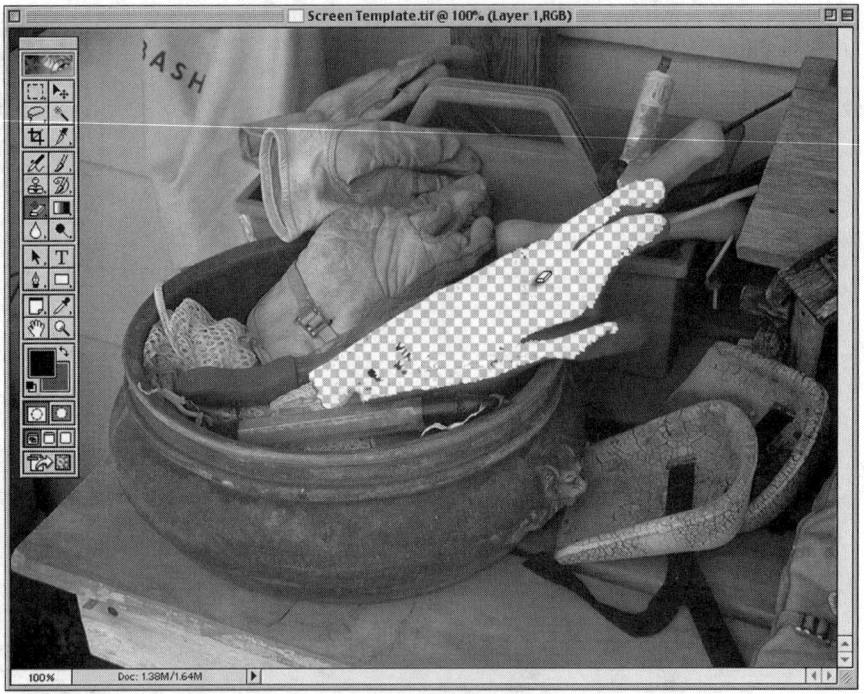

Figure 81.5 The Magic Eraser tool.

82 *The Gradient Tool*

The Gradient tool in Photoshop applies two or more colors to an image in a gradient pattern. To select the Gradient tool, click on the Gradient icon in the Photoshop toolbox, as shown in Figure 82.1.

Figure 82.1 The Gradient tool in the Photoshop toolbox.

The Gradient tool is a grouped tool. To change from the Gradient tool, click and hold on the Gradient icon in the Photoshop toolbox. Photoshop will display a pop-up menu with two choices. Click on one of the menu items to select the Gradient tool or the Paint Bucket tool.

- **Gradient:** Apply a gradient of two or more colors by clicking and dragging your mouse across the image, as shown in Figure 82.2 (see Tip 172, "Working with the Gradient Options").

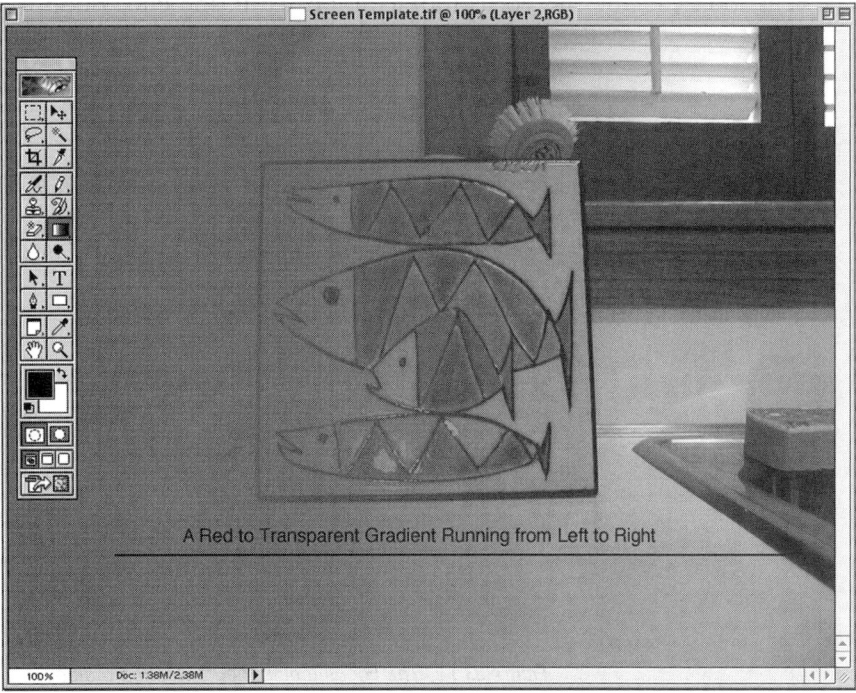

Figure 82.2 The Gradient tool in Photoshop.

- **Paint Bucket:** Apply a single color to an image by clicking once within the image, as shown in Figure 82.3 (see Tip 166, "Understanding the Paint Bucket Tool").

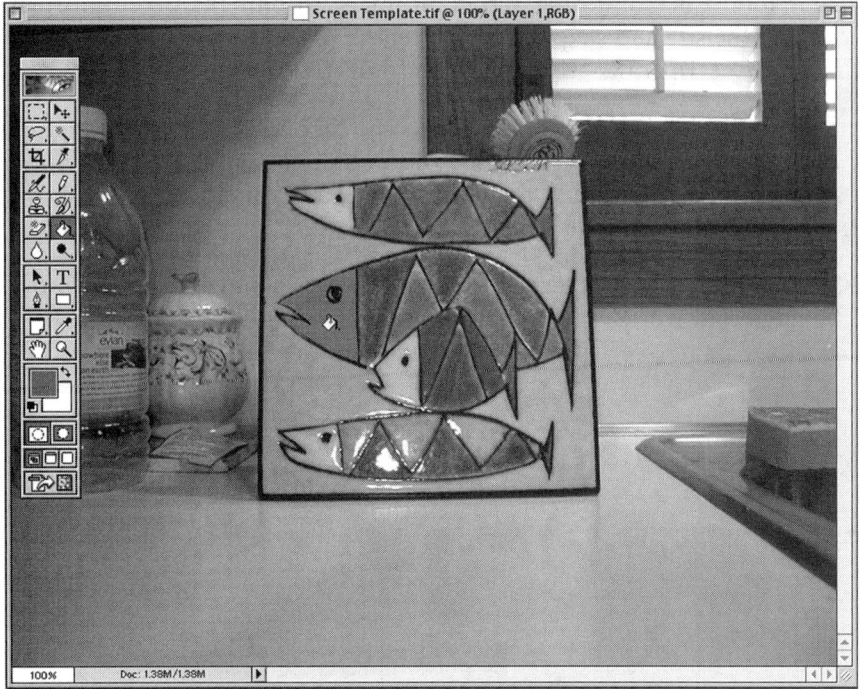

Figure 82.3 The Paint Bucket tool in Photoshop.

83 *The Focus Tools*

The Photoshop toolbox contains three Focus grouped tools: Blur, Sharpen, and Smudge. To select the default Focus tool, click on the Focus tool icon located in the Photoshop toolbox, as shown in Figure 83.1.

Figure 83.1 The Focus tool in the Photoshop toolbox.

The Focus tool is a grouped tool. To view the Focus tool options, click and hold on the Focus tool. Photoshop will open a pop-up menu displaying your three choices. Click on one of the choices. Photoshop will close the pop-up menu, and your selected tool will now be the default tool.

- **The Blur tool:** Click and drag across an image to blur the pixel information. The Blur tool uses options and the size and shape of the current brush to control the area of modification, as shown in Figure 83.2 (see Tip 158, "Using the Blur Tool").

- **The Sharpen tool:** Click and drag across an image to sharpen the pixel information. The Sharpen tool attempts to do the exact opposite of the Blur tool. The Sharpen tool uses options and the size and shape of the current brush to control the area of modification, as shown in Figure 83.3 (see Tip 290, "Using Photoshop's Sharpen Tool").

- **The Smudge tool:** Click and drag across an image to smudge the pixel information (see Figure 83.4). The Smudge tool works in the same way as dragging your finger across a wet canvas to produce streaks in the paint (see Tip 147, "Working with the Smudge Tool").

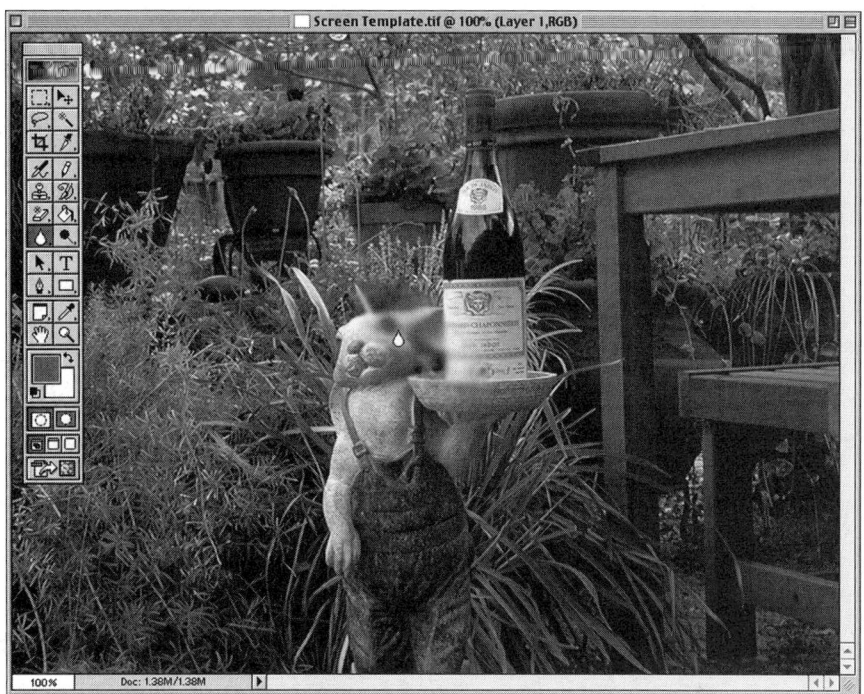

Figure 83.2 The Blur tool gives a visual impression of an out-of-focus image.

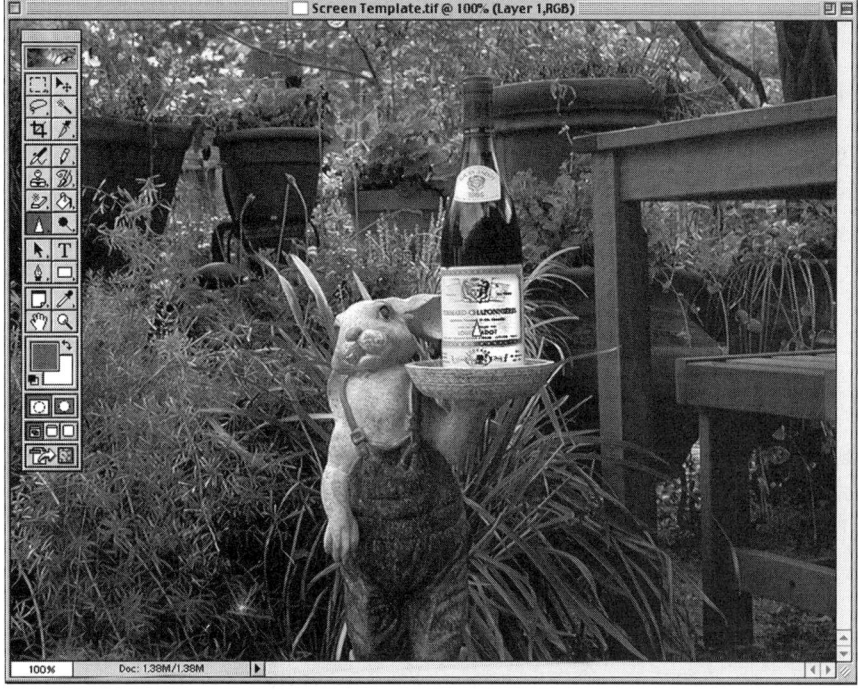

Figure 83.3 The Sharpen tool visually sharpens image information.

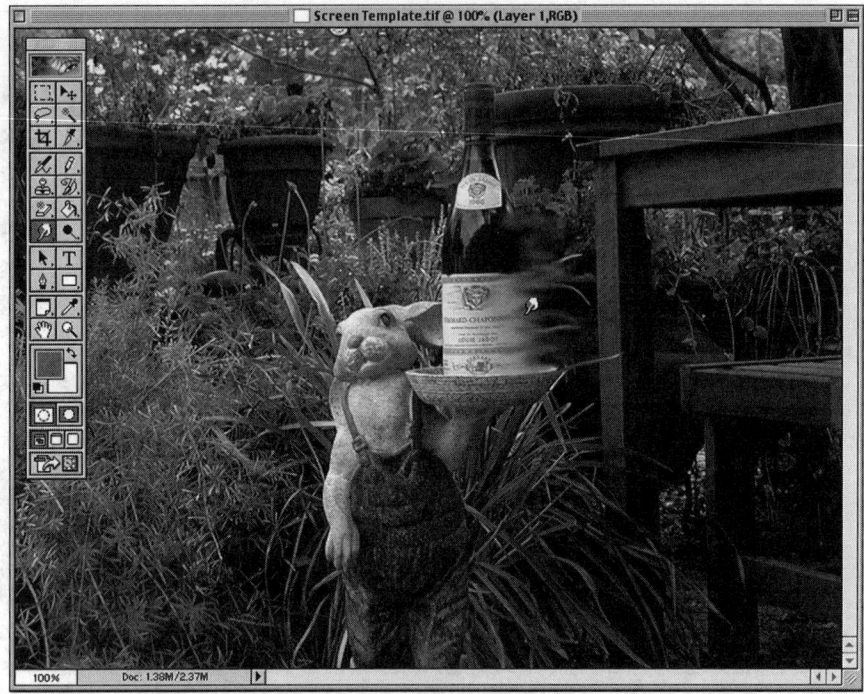

Figure 83.4 The Smudge tool smears pixels as if they were wet paint.

84 *The Toning Tools*

The Photoshop toolbox contains three Toning tools: Dodge, Burn, and Sponge. To select the default Toning tool, click on the Toning tool icon on the Photoshop toolbox, as shown in Figure 84.1.

Figure 84.1 The Toning tool in the Photoshop toolbox.

The Toning tool is a grouped tool. To view the Toning tool options, click and hold on the Toning tool. Photoshop will open a pop-up menu displaying your three choices, as shown in Figure 84.2. Select an option by clicking on one of the choices. Photoshop will close the pop-up menu, and your selected tool will now be the default tool.

Figure 84.2 The Toning tool options as displayed in the Photoshop toolbox.

- **The Dodge tool:** Click and drag your mouse across a portion of a graphic image to lighten the pixel information. The Dodge tool uses options and the size and shape of the current brush to control the area of modification as shown in Figure 84.3 (see Tip 601, "Using the Dodge Tool to Control Image Exposure").

Figure 84.3 The Dodge tool lightens pixel information.

- **The Burn tool:** Click and drag your mouse across a portion of a graphic image to darken the pixel information. The Burn tool uses options and the size and shape of the current brush to control the area of modification, as shown in Figure 84.4. (See Tip 162, "Using the Burn Tool to Restore Blown-Out Highlights in an Image.")

Figure 84.4 The Burn tool darkens pixel information.

- **The Sponge tool:** The Sponge tool increases or decreases the saturation of the colors in a Photoshop image. Use the Sponge tool by clicking and dragging across the graphic image. The Sponge tool uses options and the size and shape of the current brush to control the area of modification, as shown in Figure 84.5 (see Tip 602, "Using the Sponge Tool to Control Color Saturation").

Figure 84.5 The Sponge tool increases or decreases the color saturation of pixel information.

85 *The Path Tools*

Photoshop 6.0 contains two Path tools: Path Component and Direction Selection. The Path tools let you select and/or modify a previously created path (see Tip 154, "Creating Vector Paths with the Pen Tool").

To select the default Path tool, click on the Path tool icon on the Photoshop toolbox, as shown in Figure 85.1.

The Path tool is a grouped tool. To view the Path tool options, click and hold on the Path tool. Photoshop will open a pop-up menu displaying your two choices, as shown in Figure 85.2.

Figure 85.1 The Path tool in the Photoshop toolbox.

Figure 85.2 The Path tool options as displayed in the Photoshop toolbox.

Select an option by clicking on one of the choices. Photoshop will close the pop-up menu, and your selected tool will now be the default tool.

- **The Path Component Selection tool:** Click and drag any Photoshop path to move the entire path to a different position as shown in Figure 85.3.

- **The Direct Selection tool:** Click and drag on any anchor point within a Photoshop path to control that individual point, as shown in Figure 85.4. (See Tip 308, "Using the Direct Selection Tool.")

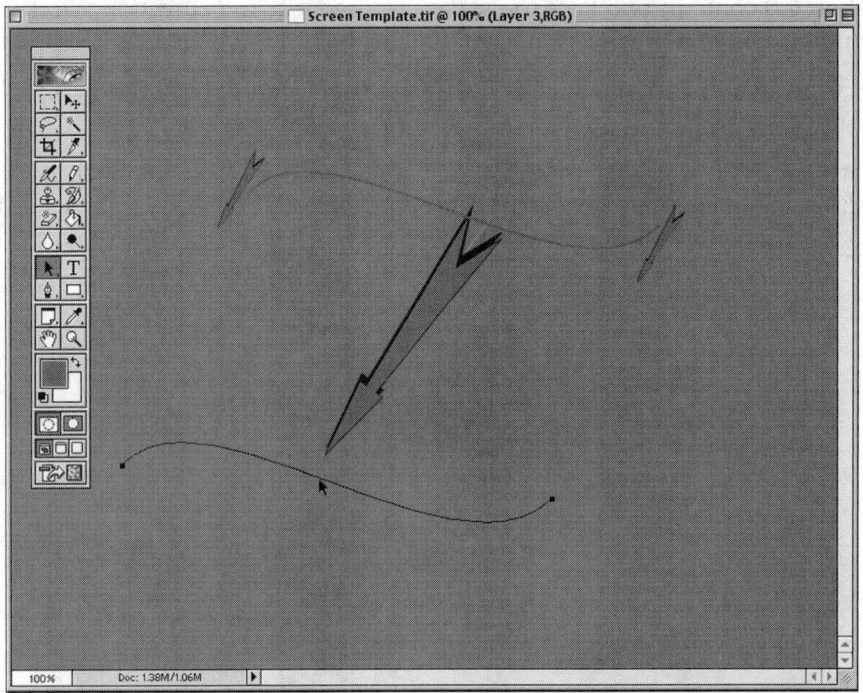

Figure 85.3 The Path Component tool in Photoshop lets you select and move any path.

Figure 85.4 The Direct Selection tool in Photoshop lets you select and move individual anchor points on a path.

86 *The Type Tool*

Photoshop 6.0 contains a new, more powerful typing tool. Not only can you place text into any open Photoshop image, you can also use text as a mask or path and even warp text into any shape you desire. To select the Type tool, click on the Type icon in the Photoshop toolbox, as shown in Figure 86.1.

Figure 86.1 The Type tool in the Photoshop toolbox.

When selecting the Type tool, your cursor resembles an I-beam. To create type, select the Type tool and click within a Photoshop image. Using your keyboard, type the text directly in the document window.

Once placed within a Photoshop document, text can be bent and curved to create a variety of special effects, as shown in Figure 86.2. (See Tip 193, "Warping Text.")

Figure 86.2 The Type tool with the new Text Warp feature lets you adjust straight text to fit just about any shape.

87 *The Pen Tools*

The Pen tool in Photoshop lets you create vector-based paths within a raster-based program. Refer to Tip 7, "Understanding Raster Image Programs," for a better understanding of how Photoshop creates a graphic image.

There are five Pen tools in the Photoshop toolbox: Pen Tool, Freeform Pen Tool, Add Anchor Point Tool, Delete Anchor Point Tool, and Convert Pen Point Tool. To select the default Pen tool, click on the Pen tool icon, as shown in Figure 87.1.

Figure 87.1 The Pen tool icon in the Photoshop toolbox.

The Pen tool is a grouped tool. Clicking and holding your mouse button on the Pen tool icon opens a pop-up menu that displays five options. Clicking on one of the options makes it the default tool.

- **The Standard Pen tool:** Creates vector pen paths within a Photoshop image. Clicking creates a single anchor point. Moving to another position within the same image and clicking a second time connects the points together with a path (see Tip 466, "Drawing Tips When Using the Pen Tool").

- **The Freeform Pen tool:** To use the Freeform Pen tool, click and drag your mouse within a Photoshop image. The Freeform Pen tool creates a vector line based on the shape you draw (see Tip 156, "Using the Freeform Pen Tool to Create a Work Path").

- **The Add Anchor Point tool:** The Add Anchor Point tool adds anchor points to a preexisting pen path. Move your cursor over a path segment and click your mouse somewhere on the path to add an anchor point (see Tip 465, "Working with Anchor Points").

- **The Delete Anchor Point tool:** The Delete Anchor Point tool deletes anchor points from a preexisting pen path. To delete an anchor point, move your cursor over an anchor point and click your mouse once (again, see Tip 465).

- **The Convert Point tool:** The Convert Point tool converts straight anchor points into curved anchor points. For more information on converting anchor points, see Tip 155, "Adding, Subtracting and Converting Anchor Points on a Pen Path."

88 *The Drawing Tools*

The Drawing tools are new to Photoshop 6.0. There are six drawing tools in the Photoshop toolbox: Rectangle, Rounded Rectangle, Ellipse, Polygon, Line, and Custom Shape. To select the default Drawing tool, click on the Drawing tool icon, as shown in Figure 88.1.

Figure 88.1 The Drawing tool in the Photoshop toolbox.

The Drawing tool is a group tool. Clicking and holding your mouse button on the Drawing tool icon opens a pop-up menu that displays six options. Clicking on one of the options makes it the default tool.

- **The Rectangle, Rounded Rectangle, Ellipse, and Polygon tools:** Create predefined shapes filled with the default Foreground color or as a shape layer or work path. For additional information on the standard drawing tools, see Tip 138, "Using Photoshop's New Drawing Tools."

- **The Line tool:** Draws straight lines within a Photoshop image. The size and color of the line are determined by the current brush and Foreground color.

- **The Custom Shape tool:** Lets you draw with customized shapes such as arrows, text balloons, and a variety of others (see Tip 125, "Creating Shapes with the Custom Shape Tool").

89 *The Notes Tools*

New to Photoshop 6.0, the Notes tool lets you create an audio or text note and save it with the file. Use notes to pass information concerning a graphic image to another designer or printing instructions to a service bureau. To select the default Notes tool, click on the Notes tool icon, as shown in Figure 89.1.

The Notes tool is a group tool. Clicking and holding your mouse button on the Notes tool icon opens a pop-up menu that displays two options: the Notes tool and the Audio Annotation tool. Clicking on one of the two options will make it the default tool.

Figure 89.1 The Notes tool in the Photoshop toolbox.

- **The Notes tool**: To create a text note, select the Notes tool and click once within a graphic image. Photoshop will open a text dialog box. You can now type and attach a text message directly to the image file (see Tip 920, "Working with Text Annotations").

- **The Audio Annotation tool**: The Audio Annotation tool lets you create an audio note and attach it to a Photoshop graphic image. To create an audio note, select the Audio Annotation tool and click once within a graphic image. Photoshop will open the Audio dialog box. The Audio dialog box lets the user create and save a message and attach it to the current image (see Tip 901, "Using the Audio Annotation Tool").

90 *The Eyedropper Tool*

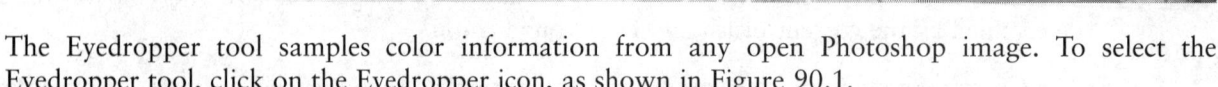

The Eyedropper tool samples color information from any open Photoshop image. To select the Eyedropper tool, click on the Eyedropper icon, as shown in Figure 90.1.

To use the Eyedropper tool to select a sample color, click once within a Photoshop image. The area sampled becomes the foreground color in the Photoshop toolbox, as shown in Figure 90.2.

Note: To use the Eyedropper to change the Background color, click on the image with the Eyedropper tool while holding down the Alt key. Photoshop will change the background color to the sampled color (see Tip 542, "Selecting Colors Using the Eyedropper Tool").

Figure 90.1 The Eyedropper tool in the Photoshop toolbox.

Figure 90.2 The Eyedropper tool selects color information within a Photoshop graphic.

91 *The Hand Tool*

The Hand tool in Photoshop lets you move the viewable area of an image within a document window without using the scroll bars. To select the Hand tool, click on the Hand icon, as shown in Figure 91.1.

Figure 91.1 The Hand tool icon in the Photoshop toolbox.

To use the Hand tool, select the Hand icon from the Photoshop toolbox and click and drag within a Photoshop document window. This lets you view different portions of an enlarged image without resizing the document window, as shown in Figure 91.2.

Figure 91.2 The Hand tool moves an image within the document window.

92 *The Zoom Tool*

The Zoom tool in Photoshop lets you change the view size of an open Photoshop document. To select the Zoom tool, click on the Zoom icon, as shown in Figure 92.1.

Figure 92.1 The Zoom tool icon in the Photoshop toolbox.

To expand the view size of an image, select the Zoom tool from the toolbox and click once within an open Photoshop image. With each mouse click, the image will expand until reaching a maximum view size of 1600 percent.

To lower the view size of an image, select the Zoom tool and click once while holding down the Alt key. Each subsequent Alt+click will lower the image size. The minimum view size will vary depending on the actual size of the open image. See Tip 183, "Using the Zoom Tool Correctly."

Figure 92.2 The Zoom tool increases or decreases the view size of an image.

93 *The Quick Mask Option*

The Quick Mask option in Photoshop is a selection method. However, unlike some of Photoshop's selection methods requiring the tracing of the image, the Quick Mask option makes a selection by using the Paintbrush tools. To select the Quick Mask option, click on the Quick Mask icon, as shown in Figure 93.1.

To select pixel information within a document using the Quick Mask method, select the Quick Mask icon in the Photoshop toolbox. Now select your Paintbrush tool and choose a brush size. See Tip 453, "Creating a Selection with Your Paintbrush."

Clicking and dragging a black paintbrush across an image in Quick Mask mode produces, by default, a 50-percent red overlay. The areas painted in red become the selected areas of the image, as shown in Figure 93.2.

Figure 93.1 The Quick Mask icon in the Photoshop toolbox.

To view the image as a selection, click on the Standard Edit button in your toolbox, as shown in Figure 93.2. Photoshop will change the red-colored areas of the image into dotted-line selections, as shown in Figure 93.3.

To reedit an image, click on the Quick Mask icon (refer to Figure 93.1) and continue painting. If you need to erase a portion of the selection area, choose white as your painting color. For more information on using the Quick Mask mode, see Tip 151, "Working with Quick Mask."

Figure 93.2 The red areas within the document window represent the selected areas of the image.

Figure 93.3 The Standard Edit mode icon in the Photoshop toolbox.

94 *The Foreground and Background Colors*

The Foreground and Background color boxes are located near the bottom of the toolbox, as shown in Figure 94.1. The Foreground color box (the one on the left) overlaps the Background color box (the one on the right).

Figure 94.1 The Foreground and Background color boxes in the Photoshop toolbox.

The Foreground color swatch represents the current painting color. All of the painting tools in Photoshop use the foreground color, as shown in Figure 94.2.

Figure 94.2 The Foreground color box defines the current painting color in Photoshop.

The background color swatch works with a Background in the Layers palette. When you erase pixel information on a Background, you cannot change the pixels to transparent; instead, Photoshop fills (not erases) the pixel information you are deleting with the current background color, as shown in Figure 94.3. For more information on foreground and background colors, see Tip 306, "Working with the Foreground and Background Color Swatches."

Figure 94.3 The Background color box defines the fill color used when erasing pixel information within a Background.

95 *Using Pop-up Sliders*

Pop-up sliders appear throughout Photoshop. They define the level of opacity of the Paintbrush tool, the exposure of the Dodge and Burn tools, and the sensitivity of the Magic Wand. Pop-up sliders are composed of a horizontal bar with a triangular slider underneath, as shown in Figure 95.1.

Figure 95.1 The Pop-up input box on the Paintbrush Options bar.

To activate a pop-up slider, click on the small black triangle located to the right of the input box. Photoshop will open the slider box, as shown in Figure 95.2.

Figure 95.2 Clicking the small black triangle to the right of the input box opens the pop-up slider.

- **Manually changing the pop-up input field data:** Select the current number in the pop-up input box. Using your keyboard, type a new number and press the Enter key.

- **The pop-up slider tool:** Click on the triangle located to the right of the pop-up input field. Photoshop will display a horizontal bar with a small triangle underneath. Click and drag the slider left or right to change the input data. Press the Enter key when finished.

• **Using the keyboard to control pop-up input field data:** Follow the steps in the preceding bullet to activate the pop-up slider; however, instead of clicking and dragging the triangle left and right, use the arrow keys on your keyboard. Pressing the right or left arrow keys increases or decreases the current number in the input field by one. Pressing the Shift key with the left or right arrow keys increases or decreases the number in the input field by 10. When you have finished changing the input field number, press the Enter key.

96 *Using the Info Palette*

The Info palette in Photoshop displays detailed color information on any open Photoshop document. To access the Info palette, open Photoshop, locate the palettes on the right side of the Photoshop window, and click on the Info tab. If you do not see the Info tab, select the Window menu View Info option. Photoshop will display the Info palette, as shown in Figure 96.1.

Figure 96.1 The Info palette displays color and position information on the active Photoshop document.

To use the Info palette, make sure the Info palette is visible and move your mouse cursor over the image. Regardless of the tool you are using, the Info palette will display information on the graphic image.

• **Color Information:** By default, the upper-left portion of the Info palette will display RGB color information, and the upper-right portion displays CMYK color information. The color information displayed in the Info palette represents the sample of the image directly under your mouse cursor. For more information on the RGB and CMYK color spaces, refer to Tip 8, "Working in Photoshop's RGB Color Space," and Tip 9, "Working in Photoshop's CMYK Color Space."

• **Cursor Position Information:** The bottom-left portion of the Info palette displays the precise X/Y coordinates of the mouse cursor in the default measurement system of inches.

• **Measurement Information:** The bottom-right portion of the Info palette displays measurement information when you use the Measure tool or any of the drawing tools. When you use any drawing tool, the Info palette will display information concerning the width and height of the drawn shape in the default measurement system of inches.

To change the characteristics of the Info palette, perform these steps:

1. Click on the black triangle in the upper-right portion of the Info palette. Photoshop will open a pop-up menu, as shown in Figure 96.2.

Figure 96.2 The pop-up menu displays a list of available options for the Info palette.

2. With the pop-up menu open, click on Palette Options. Photoshop will open the Info Options dialog box, as shown in Figure 96.3.

3. To change how color information displays in the Info palette, click on the First Color Readout and Second Color Readout buttons. Photoshop will display a pop-up menu showing your color options, as shown in Figure 96.4. Click on one of the options to change to a different color measuring system.

Figure 96.3 The Info Options dialog box lets you change the characteristics of the Info palette.

4. To change the measurement system for the mouse and the drawing tools, click on the Ruler Units button. Photoshop will display a pop-up menu showing the available measuring options. Click on one of the options to change to a different measurement system.

Figure 96.4 The Info Palette options for displaying color information.

5. When you have completed your changes, click the OK button.

97 *Working with 8-bit and 16-bit Channels*

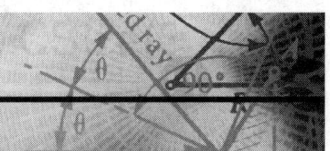

Photoshop's ability to display color and modify an image depends on the number of bits each pixel contains.

A normal Photoshop image contains 8-bit color channels. That translates into a 24-bit image, or 16.7 million displayable colors. To increase the number of displayable colors in a graphic image, Photoshop needs more bits assigned to each pixel.

To change a Photoshop image from 8-bit to 16 pixels—and give it the ability to display billions of colors—perform these steps:

1. Open a graphic image in Photoshop.

2. Select Image menu Mode and choose the 16 Bits/Channel option. Photoshop will change the active image to 16-bit channels.

3. To change or return an image to 8-bit channels, select Image menu Mode and choose the 8 Bits/Channel option. Photoshop will convert/return the image to 8-bit channels.

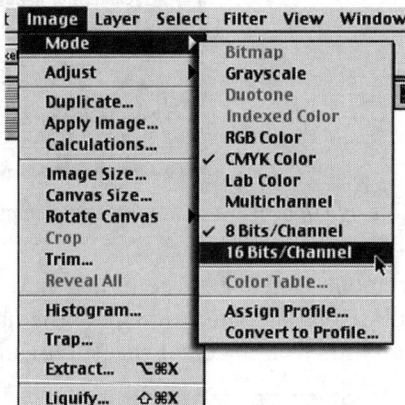

Figure 97.1 Choose 16-bit channels to use billions of colors in Photoshop.

Note: Bitmap, Indexed Color, and Multichannel graphics cannot use 16-bit channels.

98 *Repurposing Images*

Photoshop has the capability to create a single image that may find its way into several different areas. You might choose to use an image on a Web page and save the image for later display in a brochure or for use in a television commercial. The major concern with images used for different purposes is how to save them.

The Internet uses the JPEG (*Joint Photographic Experts Group*), GIF (*Graphics Interchange Format*), and the PNG (*Portable Network Graphic*) formats. Resolutions for Internet graphics default to 72 pixels per inch, and the color space will be RGB.

Print graphics have much higher resolutions and use the TIFF (*Tagged Image Format*) and EPS (*Encapsulated PostScript*) formats. Color space can (and does) vary; however, most high-end color jobs print in the CMYK color space.

Finally, television has its own set of standards to contend with, like resolutions of 96 pixels per inch and a color space modified for the NTSC (*National Television Systems Committee*) color space.

It is not necessary to scan and save three separate images because one format is modifiable for all three purposes.

Say you need to scan an image and prepare it for use on the Internet, but you want to save the image in a format that will let you work in a variety of different ways. Although there is no universal, do-all format, here are some suggestions for saving and storing images:

- **Scan the image at 300 dpi**: In most cases, 300 dpi is a high enough resolution to cover even four-color (CMYK) print jobs, and if the image needs to be transferred to the Internet or television, you can reduce the resolution with ease.

- **Choose the TIFF file format**: TIFF is as close to a universal format as you can get. TIFF images transfer into any other format, and there is hardly a program on the market that will not open a TIFF file. They will even transfer from Macintosh to Windows and vice versa.

- **Choose the RGB color space**: The RGB (red, green, and blue) color space holds up to 16.7 million colors and will translate into any other format. This gives you enough color information to do whatever you need to get the job done.

There you have it. With a little work, an RGB, TIFF image saved at 300dpi is transferable into almost any needed format.

99 *Inserting Digital Copyright Information into a Photoshop Image*

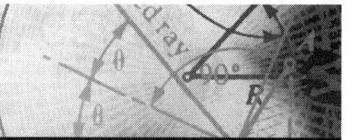

Photoshop gives you the ability to protect your images with a digital watermark. A digital watermark contains information on the creator and the type of image. Digital watermarks embed into the pixel information of the image and are not part of the normal text information saved with a file. Using digital watermarks gives you the ability to track your files and to prove ownership of an image, should the need arise.

To tag your images with a digital watermark, perform these steps:

1. Open an image in Photoshop.

2. Select Filter menu Digimarc and choose the Embed Watermark option. Photoshop will open the Embed Watermark dialog box, as shown in Figure 99.1. You will have to register with Digimarc before embedding a watermark (see Tip 320, "Registering a Digimarc Watermark").

Figure 99.1 The Embed Watermark dialog box lets you assign a watermark to an image.

3. Watermark information includes the copyright year, image attributes, the target output, and the durability of the watermark.

- **Copyright Year:** Type the year you created the image into the input field.

- **Image Attributes:** Restricted, Do Not Copy, and Adult are the options available in Image Attributes. It is to be noted that selecting the Restricted or Do Not Copy options does not prevent the image from being copied; it simply defines the characteristics of the image.

- **Target Output:** Monitor, Web, and Print are the available options. Defining the graphic as a Web graphic does not change the image; it only defines how you designed the graphic.

- **Watermark Durability:** A Digimarc watermark embeds within the pixel information of a saved graphic image. Increasing the durability of the watermark embeds the information deeper into the image, making it harder for someone to remove the watermark without destroying the image.

4. Click the OK button after completing all your changes. Photoshop will embed the watermark into the image and close the dialog box.

Note: Photoshop will inform the user of a copyrighted image that it contains a digital watermark. Although this does not prevent someone from using your images, it identifies the image as legally your image.

100 *Working with Contact Sheets*

Photoshop can save you lots of time by letting you organize graphic images into folders and printing a contact sheet of the images. A contact sheet contains thumbnails of all the graphics within a folder, and it is an excellent way to view collections of graphics without having to look at them one at a time on your monitor.

To create a contact sheet from a group of images, perform these steps:

1. Gather a group of graphic image files into a single folder.

2. Open Photoshop.

3. Select File menu Automate and choose the Contact Sheet II option. Photoshop will open the Contact Sheet II dialog box, as shown in Figure 100.1.

4. Click the Choose button to select the folder containing your graphic images. If the folder contains additional folders and you want to include them in the contact sheet, click to place a check mark in the Sub Folder input box.

5. To change the Width, Height, Resolution, and Color Space of the contact sheet, click in the input fields and type in the new measurements.

6. In the Thumbnails option, you can choose to display the images Across First (left to right) or Down First (top to bottom), and you can select how many images you want to print per column and row.

7. If you want to use file names as captions, click to place a check mark in the input box to the left of the Use Filenames as Captions option.

8. When you have completed entering the information, click the OK button within the Contact Sheet II dialog box. Photoshop will close the dialog box and begin creating your contact sheet.

9. The contact sheet will display on your monitor as a Photoshop graphic. To print the contact sheet, select File menu Print from the pull-down menu.

Figure 100.1 The Contact Sheet II dialog box lets you create a contact sheet of the images within a folder.

Figure 100.2 A contact sheet created in Photoshop using the Contact Sheet II option.

101 *Modifying Tool Settings with the Options Bar*

Each tool in the Photoshop toolbox uses options to control its behavior. The Options bar, as shown in Figure 101.1, gives you the ability to change the default characteristics of a tool.

Figure 101.1 The Options bar (shown here for the Paintbrush) gives you control of every tool in the Photoshop toolbox.

The Options bar is new to Photoshop 6.0. It is a combination of the old Photoshop Options palette combined with powerful new settings. For all tools that require a brush size, the Options bar now includes the brushes along with the tool, as shown in Figure 101.2, and the Dynamic option controls how a brush performs with a drawing tablet, as shown in Figure 101.3. Refer to Tip 196, "Using a Drawing Tablet with the Brush Tools."

Figure 101.2 The Brush options are now part of the Options bar.

Figure 101.3 The Brush Dynamics option controls how the Photoshop tools perform with a drawing tablet.

102 *Creating Personalized Picture Packages*

The Picture Package option in Photoshop lets you take a single image and print it in a standard photographic package of Wallet Size, 3.5 × 5, 5 × 7, 8 × 10, or any combination you desire. To set up an image for a picture package, perform these steps:

1. Open an image in Photoshop.

2. Select File menu Automate and choose the Picture Package option. In turn, Photoshop will open the Picture Package dialog box, as shown in Figure 102.1.

3. Choose one of the options in the Picture Package dialog box.

 - **Source Image:** Click on the Choose button to select a specific graphic or the Use Frontmost Document option to select the graphic image currently open in Photoshop.

 - **Document Layout:** Click on the Layout button. In turn, Photoshop will display a pop-up menu showing the layout options. Click to select the desired layout.

 - **Document Resolution:** Click in the Resolution input field to change the resolution. Refer to Tip 113, "Determining Resolution Based on Final Output."

 - **Document Mode:** Click on the Mode button to change the color space of the picture package. Refer to Tip 111, "Choosing the Correct Color Space."

4. Click the OK button to create the picture package. In turn, Photoshop will create a graphic image according to your specifications. To print the Picture Package, select Print from the File menu.

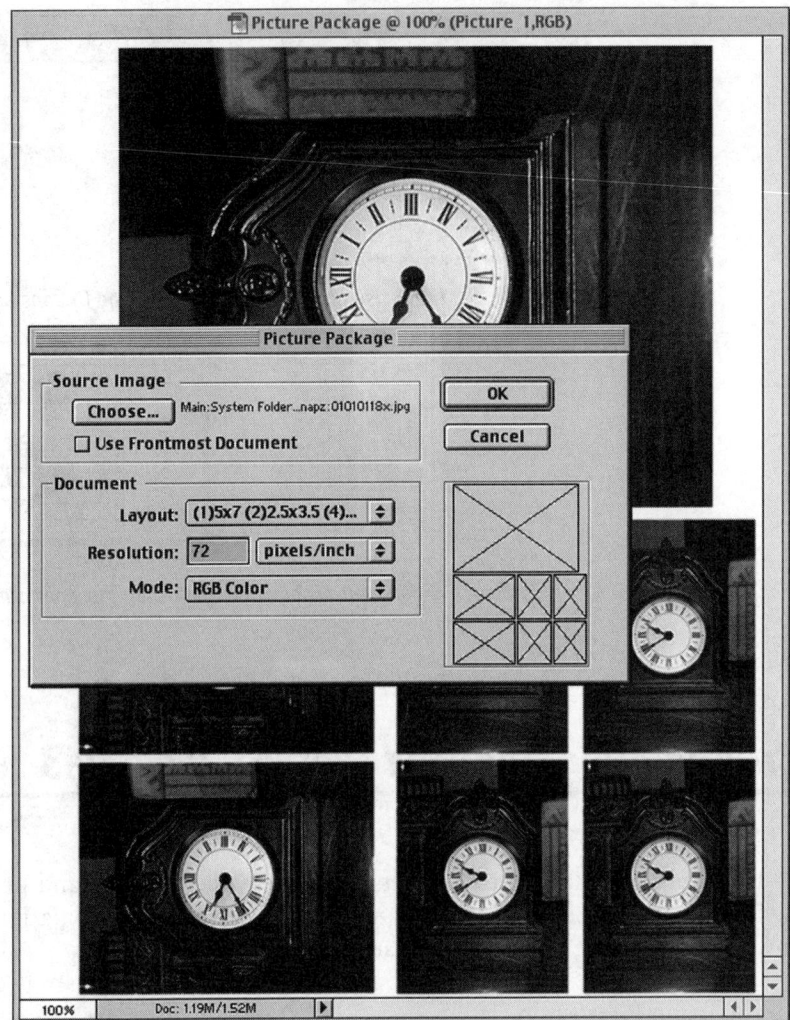

Figure 102.1 The Picture Package option in Photoshop lets you control how your image will print.

103 *Generating Guides in Photoshop*

Photoshop lets you create vertical or horizontal guidelines. Designers use guides for a variety of purposes, mostly related to the alignment of graphic information within a Photoshop document. The guidelines in Photoshop conform to the Ruler Bar. If you open a Photoshop document and the ruler bar is not visible, select View menu and choose Show Ruler from the pull-down menu.

To place a horizontal or vertical guide line in a Photoshop document, move your cursor into the ruler bar and click and drag your mouse back into the document. Your mouse cursor now carries a horizontal or vertical line into the document and sets the guideline when you release your mouse, as shown in Figure 103.1.

Figure 103.1 Clicking in the ruler bar and dragging into a Photoshop document produces a vertical or horizontal guide.

- To lock all guides, select the View menu and choose Lock Guides from the pull-down menu. In turn, a check mark will appear next to the Lock Guides option, indicating that all Photoshop guides are now locked.

- To unlock guides, select the View menu Lock Guides option. In turn, the check mark next to the Lock Guides option will be removed, indicating that all Photoshop guides are now unlocked.

- To move a guide, select the Move tool from the toolbox. Make sure the guidelines are not locked, touch the guide you want to move, and click and drag the guide to move it. Release your mouse when the guideline is repositioned.

- To remove a guide, select the Move tool from the toolbox. Touch the guide you want to remove, drag the guide back into the ruler bar, and release your mouse. The guide is removed from the document window.

- To remove all guides, select the View menu Clear Guides option. All the guides will be removed from the Photoshop document.

- To force an object to snap to the guide lines, select View menu Snap To. In turn, Photoshop will open a fly-out menu. Verify that there is a check mark next to the Guide option. If there is not a check mark, click once on the Guides option to activate Snap to Guides. In turn, the menu will close, and when you move a graphic in Photoshop, it will snap to the nearest guideline.

- To convert a horizontal guide into a vertical guide or a vertical guide into a horizontal guide, click on a guide and press and hold the Alt key. In turn, a horizontal guide will convert to a vertical guide, and vice versa. Release your mouse and then release the Alt key. The guideline is converted.

- To position a guide by the marks on your ruler bar, click and drag the guide while holding down the Shift key. The guide will move according to the tic marks on your ruler bar.

To set a guide based on a specific measurement, perform these steps:

1. Select the View menu New Guide option. Photoshop will open the New Guide dialog box, as shown in Figure 103.2.

2. Select a horizontal or vertical guide by clicking on the corresponding Vertical or Horizontal radio button.

Figure 103.2 The New Guide dialog box in Photoshop lets you create a guide based on a specific measurement.

3. Click in the Position input field and enter the measurement for the guide line.

4. When you are finished, click the OK button. Your guideline will be placed in the document window.

104 Setting Up a Grid in a Document Window

In the preceding tip, you learned how to create guide lines. Photoshop will also let you set up a grid. The grid, by default, is a series of boxes drawn in the document window. Like guide lines, the grid helps in aligning pieces of a graphic image.

To create a grid in Photoshop, open a graphic image, select View menu Show, and choose Grid from the fly-out menu. Photoshop will display a grid pattern across the document window, as shown in Figure 104.1.

Unlike guide lines, the grid option creates a fixed pattern of lines intersecting within the document window. It is to be noted, however, that the grid does not print and is only visible while the image is within the Photoshop document window.

- To cause items to snap to the grid, select View menu Snap To. Photoshop will open a fly-out menu displaying the Snap To options. If the Grid option does not display a check mark, click once on the Grid option. In turn, Photoshop will close the menu, and moved items within the Photoshop document window will now snap to the grid marks.

- To disable the Snap To option, select View menu Snap To from the pull-down menu. Photoshop will open a fly-out menu displaying the Snap To choices. Click once on the Grid option. As a result, Photoshop will close the pull-down menu, and the moved items within the Photoshop document window will no longer snap to the grid marks.

- To temporarily remove the grid from the document window, select the View menu Show Extras option. Photoshop will close the menu, and the grid will be removed from the document window.

- To view the grid, select the View menu Show Extras option. Photoshop will close the menu, and the grid will be removed from the document window.

Note: The Grid option is not a document option but a program option. If you choose to display a grid within a document window, all documents opened within Photoshop from that point forward will display a grid until you turn off the Grid option.

Figure 104.1 The Grid option in Photoshop lays a grid pattern on your image and is useful for image alignment.

105 *Working with DPI and PPI*

The terms dpi (*dots per inch*) and ppi (*pixels per inch*) are used to describe the information contained within a graphic image. If you have a graphic image containing 150 ppi, this means that the image holds 150 dots of ink per linear (not square) inch. Each dot of ink represents a piece of the detail of the whole image. While dpi and ppi are sometimes used interchangeably, they represent two different areas of the digital image industry.

- **DPI (dots per inch)**: The term dpi is used to indicate the amount of information in a linear inch sent to an output device, typically a color or black-and-white inkjet or laser printer. All printers print with a resolution, and that resolution is defined in the number of physical dots of ink the printer is capable of printing per linear inch.

- **PPI (pixels per inch)**: The term ppi describes the number of physical dots of information contained within a digital image. If you scan an image at a resolution of 1200 ppi, this means that the digital image is stored on your computer with 1200 physical dots of information per linear inch. When you work on the image in Photoshop, you are working with an image that has 1200 dots of information per linear inch. However, when you print to an output device that is only capable of printing at 600 dpi, you will lose half of the pixel information.

Remember that the ppi or dpi of an image does not indicate how large the image will be when it is sent to a printer. Photoshop measures the output size of an image in width and height (refer to Tip 109, "Choosing a Particular Width and Height Measurement System"), not in resolution, as shown in Figure 105.1.

Figure 105.1 The pixels in an image represent the physical information contained in the document.

106 *Changing Grid Preferences*

In Tip 104, "Setting Up a Grid in a Document Window," you learned that the grid option in Photoshop assists in the alignment of image information. To further enhance the effectiveness of the grid, Photoshop lets you redefine the characteristics of the grid.

To modify the characteristics of the grid, perform these steps:

1. Select Edit menu Preferences, and choose the Guides & Grid option from the pull-down menu. Photoshop will then open the Guides & Grid dialog box, as shown in Figure 106.1

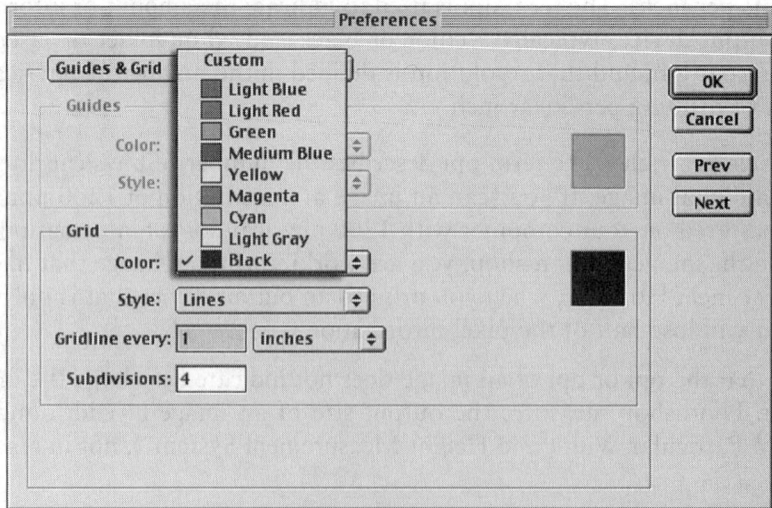

Figure 106.1 The Guides & Grid dialog box lets you change the layout of the grid in Photoshop.

2. Click on the Grid Color button. Photoshop will display a list of color options. Click on a color to change the default grid color.

3. Click on the Grid Style button. Photoshop will display a list of style options for the grid lines. Select an option to change the default grid style.

4. Click in the Gridline every input field and type a number to change the default spacing for the major gridlines.

5. Click on the Gridline measurement button. Photoshop will display a list of available gridline measuring options. Select one of the measurement options to change from the default.

6. Click in the Subdivisions input field and type a number to change the frequency of minor gridlines.

7. When you have finished making changes, click the OK button in the Grid & Guides dialog box.

107 *Selecting the Correct Halftone Screen Frequency*

In Tip 105, "Working with DPI and PPI," you learned that the resolution of an image controls the overall quality of the final printed product. The higher the resolution of an image, the more pixels it contains and the more information is available for detail, but the larger the file size. Large files take longer to open in Photoshop, screen redraws are slower, and images printed with too much resolution will not print better; they will just be bigger. On the other hand, images scanned at too low of a resolution will produce poor output quality.

Before selecting a resolution for your high-end printout, call your print shop and ask what halftone screen frequency it plans to use. Once you have that information, work with these rules:

- **Grayscale images:** The resolution of a grayscale image is one and a half times the output screen frequency. If your printer uses a 133-line screen, the final resolution of your image is 200. Anything less will affect the quality of the image; anything more is wasted digital information.

- **Color images:** The final resolution of a color image is twice the screen frequency of the output device. If your image to print is on a 133-line screen printer, the resolution of the image is 266. Anything less will affect the quality of the image; anything more is wasted digital information.

- **Line art:** Line art prints better at higher resolutions. When you print line art, the final resolution should be from 600 to 800 pixels per inch.

Using higher resolutions than those suggested will only produce a larger file size and a slower print time, not a better image.

108 *Understanding Dot Gain and Ink Coverage*

The dot gain of an image refers to the undesirable spreading of inks on low-quality papers. Dot gains range from 0 percent for high-end, slick, magazine paper stock to 20 percent or higher for low-end paper stock such as newspapers and brochures. Since your monitor uses pixels and not dots of ink, the dot gain of a printed image causes the document to look darker than it originally appeared on your monitor. Photoshop lets you compensate the monitor image to simulate the dot gain of paper. To change the dot gain of a Photoshop image, perform these steps:

1. Check with your print shop to find out the dot gain of the output paper.

2. Open Photoshop.

3. Select the Edit menu and choose Color Settings from the pull-down menu. The Color Settings dialog box will open, as shown in Figure 108.1.

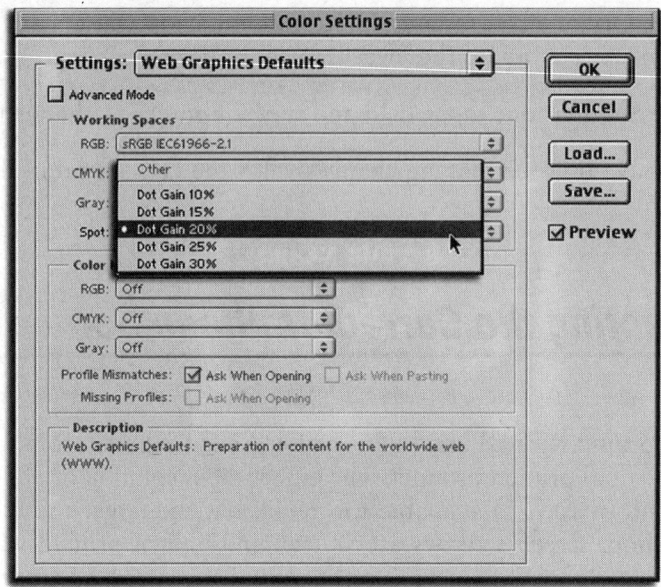

Figure 108.1 The Color Settings dialog box gives you the option to adjust the dot gain of Photoshop's document window.

4. Click the Spot button in the Working Spaces section of the Color Settings dialog box. Photoshop will display a list of dot gain options, as shown in Figure 108.1. Select one of the dot gain presets or click on the Custom option to enter a unique dot gain.

5. Click the OK button in the Color Settings dialog box when you have completed your changes.

Note: Changing the dot gain of an image using the Color Setting dialog box changes the default color settings for the program. All new documents opened in Photoshop will use these settings.

109 *Choosing a Particular Width and Height Measurement System*

All graphics have a width and a height. Photoshop measures images in two ways: by the ruler bar or by to total number of pixels in the image. Which measurement system you use depends on the output of the image.

- To send the image to print, use the inches or pica measurement system.

- To send the image to display on the Web, use the pixels measurement system.

By default, the ruler bar in Photoshop displays width and height information in inches. If you open an image in Photoshop and the ruler bar is not visible in the document window, select View menu, and choose Show Rulers from the pull-down menu. Photoshop will display the ruler bar, as shown in Figure 109.1.

Figure 109.1 The ruler bar in the Photoshop document window displays information on the width and height of the open Photoshop image.

To change the ruler bar to another measuring system, perform these steps:

1. Open a graphic image in Photoshop.

2. Move your mouse cursor into the horizontal or vertical ruler bar and right-click (Macintosh: Ctrl+click) your mouse. Photoshop will open a pop-up menu with a list of measurement options, as shown in Figure 109.2.

3. Click on one of the measuring options. Photoshop will close the pop-up menu, and your ruler bar will display the width and height of the image according to your choice.

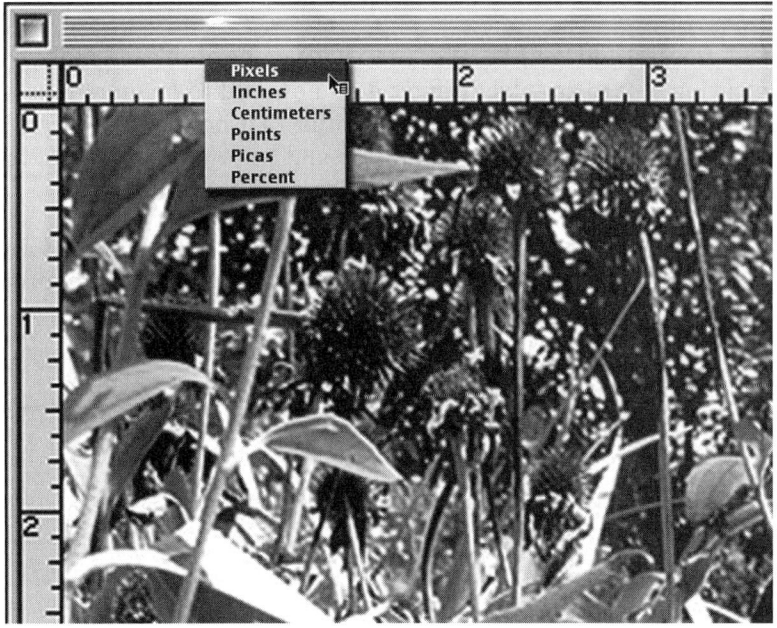

Figure 109.2 Right-clicking your mouse in the Photoshop ruler bar lets you choose a new image measurement system.

110 *Determining When an Image Contains Too Much Resolution*

Image quality is determined by how many pixels a graphic image contains. In Photoshop, pixel information is measured in resolution. The greater the resolution of a Photoshop image, the more pixels the image contains and therefore the more information present, as shown in Figure 110.1.

Figure 110.1 Using the correct output resolution means the difference between a good image and a great image.

Photoshop measures resolution in linear not square inches. A 5-by-5-inch graphic image with a resolution of 150 pixels per inch contains 562,500 total pixels. Each pixel represents a single dot of ink that collectively makes up the image.

In Tip 107, "Selecting the Correct Halftone Screen Frequency," you learned at what resolutions to save an image when outputting to a high-end printing press. However, when you are working with inkjet printers, the formulas for the resolution of an image change.

- **Color and grayscale images:** Because of the dot gains of ink on paper, the final output resolution of an image being sent to an inkjet printer does not need to be more than half the output resolution of the printer device. Say you have an inkjet print that prints at 600 dpi. In most cases, the final output resolution of the Photoshop graphic should not exceed 300 dpi. In most cases, using a higher resolution will only produce a larger file size, not a better image.

- **Line art images:** Line art images require high resolutions. Print images at 600 dpi to achieve fine lines in your printout. In most cases, using a higher resolution will only produce a larger file size, not a better image.

111 *Choosing the Correct Color Space*

Photoshop supplies you with seven color spaces. Each color space defines the mix of inks within a graphic image. For a document to print or display at its best, it is important to work in the right color space.

To convert an image into a different color space, perform these steps:

1. Open a graphic image in Photoshop.

2. Select Image menu and choose Mode from the pull-down menu. Photoshop will display a pop-up menu with your color mode options. Click on one of the mode options to change the color mode of the graphic image.

 - **Bitmap:** The Bitmap color space consists of a single bit pixel and is capable of displaying a maximum of two colors. Bitmap files are extremely small and therefore are capable of producing high-resolution images with a small file size. For this reason, they are used for the scanning and printing of line-art and single-color sketches. Line art requires a high resolution for smooth printing. Bitmap images can be scanned at 600 ppi or higher and still maintain a small file size, as shown in Figure 111.1.

 - **Grayscale:** Grayscale images contain an 8-bit pixel and are capable of producing a maximum of 256 steps of gray. Although it is limited in the number of gray steps it can produce, the grayscale color space is used to print black and white drawings and photographs, as shown in Figure 111.2.

 - **Duotone:** A duotone image is similar to a grayscale image in that it contains 8-bit pixels and is capable of producing 256 steps of color. However, unlike the grayscale mode, a duotone image can be scaled with any shade of color. The Duotone mode is used to produce images tinted with a particular color, as shown in Figure 111.3.

Figure 111.1 Bitmap images create small, high-resolution images that are ideal for sketches and line-art drawings.

Figure 111.2 The grayscale mode works with black and white drawings and photographs.

Figure 111.3 The duotone mode lets you change the overall tint of a photographic image.

- **Indexed Color:** Like the Grayscale and Duotone modes, Indexed Color images are composed of an 8-bit pixel. However, the major difference between Grayscale and Duotone is the ability of an Indexed color image to display 256 separate colors, not a color scale. Indexed color images, because of their reduced size from normal 24-bit color images, are used to prepare color images for display on the Internet or in computer slide presentations like PowerPoint and iShell, as shown in Figure 111.4.

- **RGB:** The RGB color mode displays all the colors within an image using a mix of red, green, and blue pixels. Since each color pixel is made up of 8 bits, an RGB image contains a 24-bit color pixel ($3 \times 8 = 24$). A 24-bit color image is capable of producing one of 16.7 million colors per pixel. The RGB mode is the color space of your monitor. Color images display best on a computer monitor if they are in the RGB color space. Also, many inkjet printers use the RGB color space (check with your printer manufacturer) and will print at their best if left in RGB color space, as shown in Figure 111.5.

Figure 111.4 Indexed color images have small file sizes compared to a normal RGB image.

Figure 111.5 RGB is the color space of your computer monitor and many inkjet printers.

- **CMYK:** The CMYK color mode displays color information using a mix of cyan, magenta, yellow, and black pixels. Since each color pixel is made up of 8 bits, a CMYK image contains a 32-bit pixel (8×4 = 32). CMYK color mode is the color space of paper. Images destined for high-end printing on a four-color print press use the CMYK color space, as shown in Figure 111.6.

- **Lab Color:** The Lab color mode is the only device-independent color space within Photoshop. Lab color is a 24-bit, 3-pixel color system, so it is the same size as an RGB image. While applications for Lab color vary, a primary use of Lab color is for the transfer of RGB color image between different versions of Photoshop and different graphic programs. See Tip 245, "Using Lab Mode."

Note: For more information on how the number of bits influences the color of an image, see Tip 442, "How Channels Are Used to Define Color."

Figure 111.6 The CMYK color space is used for printing to four-color print presses.

११२ _Opening Preexisting Images_

The majority of the work done in Photoshop is done to preexisting images. When an image is reopened in Photoshop, it will have a preselected format, resolution, and color space. To open a preexisting image, perform these steps:

1. Select File menu Open. Photoshop will display the Open dialog box, as shown in Figure 112.1.

 - **Show:** The Show button lets you select what file format you want to see displayed. Click on the Show button to display a list of format options. Choose a particular file format by clicking on the selected choice. Photoshop will close the Show options, and the window will only display the selected file format.

 - **Hide/Show Preview (Macintosh only):** Click on the Show or Hide Preview button to show or hide an image preview.

 - **Format:** The Format button displays the format of the currently selected graphic file.

 - **Find (Macintosh only):** Click on the Find button to locate a missing file by its name. Refer to Tip 2, "Finding a Misplaced Image on Your Hard Drive (Macintosh Only)."

2. When you see the name of the correct file displayed within the Open dialog box, select the file name and press the Open button. The selected file will be opened.

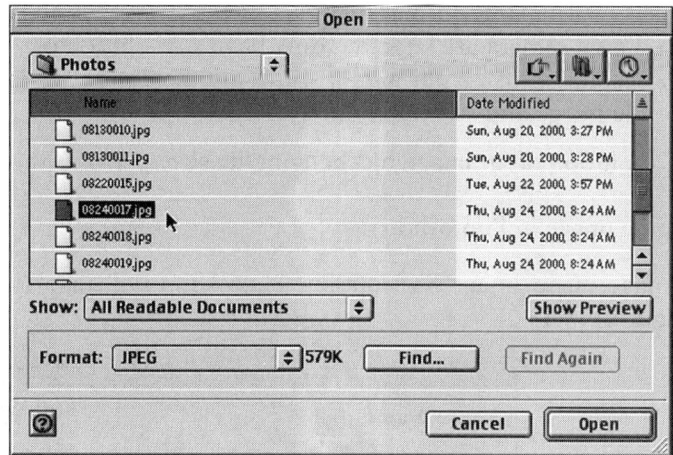

Figure 112.1 The Open dialog box in Photoshop lets you choose a graphic image file for editing within Photoshop.

113 *Determining Resolution Based on Final Output*

When you edit an image in Photoshop, it is important to know where the graphic image is to be printed or displayed. The resolution of the image, as well as its color space and size, are all determined by the final output of the image. In Photoshop, the resolution of an image is very important to the quality of the final output.

Images output to the Internet or used in multimedia projects are saved with low resolutions of 72 to 96 ppi. However, working on a 72-ppi image does not give Photoshop enough pixel information, and the final image quality will suffer. Typically, you will scan and work at higher resolutions and then reduce the image resolution as a final step before saving the file.

When you scan an image into Photoshop at a higher resolution, the scan resolution should be a number that is evenly divisible into the final output resolution. If you are working on an image that will be displayed on the Internet, this means that you will save the image with a final resolution of 72 ppi. When you scan the image at a higher resolution, that resolution should be 144 not 150, or 288 not 300. The scan resolutions of 144 and 288 are evenly divisible into 72 (the final output resolution).

114 *Increasing the Resolution of an Image by Changing Image Size*

It is important to understand that increasing the resolution of an image within Photoshop will have no effect on the detail of the image. Increasing resolution in an open Photoshop graphic will simply add more pixels to the image, not more detail. Refer to Tip 22, "Choosing the Correct Interpolation Method."

There is a way to increase the resolution of an image in Photoshop and still maintain good-quality output, but it requires that you change the size of the image.

This method works best on large-format images, like those taken with digital cameras. Typically, images produced from a digital camera are large but only have a resolution of 72 ppi. If you open a digital camera image with a resolution of 72 ppi with a width and height of 16 × 22 inches, you need to increase the resolution of the image and still maintain quality.

To increase the resolution of an image by changing its size, perform these steps:

1. Open a graphic image in Photoshop.

2. Select the Image menu Image Size option. Photoshop will display the Image Size dialog box, as shown in Figure 114.1.

Figure 114.1 The Image Size dialog box lets you change the resolution, width, and height of a Photoshop image.

- **Constrain Proportions:** To select this option, make sure there is a check mark in the Constrain Proportions option. If there is not, click in the input box.

- **Resample:** To deselect this option, remove the check mark from the Resample Image option by clicking in the input box.

You can change the resolution of the image in two ways: by changing the width and height of the image or by adjusting the resolution.

- **Width and Height:** Click on the Width field, type in a smaller number, and press the Enter key. With the Resample Image option deselected, decreasing the width and/or height of the image forces Photoshop into compressing the image pixels into a smaller area, thus increasing the resolution of the image and preserving the quality.

- **Resolution:** If you need a specific resolution, click in the Resolution field, type in a larger number, and press the Enter key. With the Resample Image option deselected, increasing the resolution of the image forces Photoshop into reducing the width and height of the image to fit the new resolution. You now have a quality image with a higher resolution.

The trick is to turn off the Resample option. When Resample is on (a check mark in the input box) and you increase the resolution of the image, Photoshop will not change the image size. Instead, it will begin to add pixels to the image. This only increases the number of pixels in the image, not the overall detail. When Resample is off (no check mark in the input box), Photoshop does not add or subtract pixels but changes the image size to match the new resolution.

115 *Using the Place Option to Import Images into Photoshop*

The Place command lets you import Adobe Illustrator, PDF, and EPS files containing vector art into an open Photoshop image.

To place an Adobe Illustrator, PDF, or EPS file, perform these steps:

1. Open a Photoshop graphic in Photoshop (File menu Open).

2. Select the File menu Place command. Photoshop will open the Place dialog box, as shown in Figure 115.1.

Figure 115.1 *The Place option in Photoshop lets you insert an Adobe Illustrator, PDF, or EPS file into an open Photoshop document window.*

3. The Place dialog box will display all available Illustrator, PDF, and EPS files. Choose the correct image and click the Place button. Photoshop will then close the Place dialog box and insert the image into a bounding box within a separate layer in the open document window.

4. To resize the image, click and drag on one of the adjustment boxes, located on the corners and sides of the placed image, as shown in Figure 115.2.

5. When you have finished adjusting the graphic image, press the Enter key. Photoshop will remove the bounding box, and the image is now placed within the Photoshop document window.

Figure 115.2 The placed graphic can be resized by clicking and dragging on any of the adjustment boxes.

116 *Selecting Anti-aliased for PostScript Images*

In Tip 115 you learned how to place Adobe Illustrator, PDF, and EPS files into Photoshop. It is also possible to directly open an EPS file without placing it into an existing Photoshop document window.

To open an Illustrator or generic EPS file, perform these steps:

1. Select File menu and choose Open from the pull-down menu. Photoshop will display the File Open dialog box.

2. Select the Illustrator or generic EPS file. Refer to Tip 112, "Opening Preexisting Images." Photoshop will open the Rasterize Generic EPS Format dialog box, as shown in Figure 116.1.

Figure 116.1 The Rasterize Generic EPS Format dialog box lets you modify the characteristics of the image file.

The following options are available in the Rasterize Generic EPS Format dialog box.

- **Width/Height:** Photoshop will insert the default values for the PDF file. Click in the input fields to modify the width and height of the converted PDF document.

- **Resolution:** PDF files are created in the EPS (*Encapsulated PostScript*) format and are therefore resolution-independent. Click in the Resolution input field to choose the correct resolution for the converted PDF document, based on the final resolution.

- **Mode:** Click on the Mode button and choose the correct color space from the available options, based on the final output.

- **Anti-aliased:** Click to insert a check mark in the Anti-aliased input box to select this vector conversion option.

- **Constrain Proportions:** Click to insert a check mark in the Constrain Proportions input box to maintain the width and height proportions of the PDF document.

Note: The Anti-aliased option is useful for converting vector graphics and giving the images an overall smooth appearance. However, the Anti-aliased option should be disabled (remove the check mark from the Anti-aliased input box) when converting small vector text. Smoothing vector text can render the text unreadable, as shown in Figure 116.2.

Figure 116.2 The Anti-aliased option, when applied to small text, makes the text difficult to read.

117 *Importing Multi-Page PDF Files into Photoshop*

PDFs (*Portable Document Files*) are quickly becoming the most popular format for transferring graphic and text information between all types of computers and operating systems. PDF files are used for everything from simple one-page documents to massive multi-page manuals. Photoshop lets you import multi-page PDF documents directly into Photoshop.

To open a PDF document, perform these steps:

1. Open Photoshop, select File menu Automate, and choose the Multi-Page PDF to PSD option.

2. Photoshop will display the Open dialog box. Select the correct file by clicking once on the file name and then pressing the Enter key.

3. In turn, Photoshop will close the Open dialog box and display the Convert Multi-Page PDF to PSD dialog box, as shown in Figure 117.1

The following options are available when opening a PDF document file in Photoshop.

- **Source PDF:** Click the Source PDF button and Photoshop will display the Choose Source dialog box. Select the correct PDF file by clicking once on the file name and then clicking the OK button.

- **Page Range:** Choose All to open all the pages within the PDF document or click in the From/To input fields to select a range of pages within the PDF document.

- **Output Options:** PDF files are created in the EPS format and are therefore resolution-independent. Click in the Resolution input field to choose the correct resolution for the converted PDF document, based on the final resolution.

Figure 117.1 The Convert Multi-Page PDF to PSD dialog box lets you open and modify the characteristics of a PDF file.

- **Mode:** Click on the Mode button and choose the correct color space from the available options, based on the final output.

- **Anti-aliased:** Click in the Anti-aliased input box to select this vector conversion option. For more information on Anti-aliased, refer to Tip 116.

- **Base Name:** Click in the Base Name input field and type in a file name for the converted PDF file.

- **Choose:** Click the Choose button and Photoshop will display the Choose Folder dialog box. Select the correct destination folder by clicking on the correct folder name and then click the OK button.

After making all your modifications, click the OK button within the Convert Multi-Page PDF to PSD dialog box. In turn, Photoshop will close the dialog box and open the PDF file in a Photoshop document window.

Note: Since PDF documents are heavily text oriented, using the Anti-aliased option, may produce text that is difficult to read, especially if the text size falls below 12 points.

118 *Importing a PDF Image Directly into Photoshop*

In the preceding tip, you learned that by selecting File menu Automate and choosing the Multi-Page PDF to PSD option, Photoshop can convert and open a multi-page PDF file. However, if the PDF file is a single page, you can directly convert and open the file.

To open a single-page PDF file, perform these steps:

1. Open Photoshop and select the File menu Open option. Photoshop will display the Open dialog box.

2. Select the single-page PDF file by clicking once on the file name and then clicking the Open button.

3. In turn, Photoshop will close the Open dialog box and open the Rasterize Generic PDF Format dialog box, as shown in Figure 118.1.

Rasterize Generic PDF Format

Image Size: 1.85M

Width: 11 inches

Height: 8.5 inches

Resolution: 72 pixels/inch

Mode: CMYK Color

☑ Anti-aliased ☑ Constrain Proportions

OK

Cancel

Figure 118.1 The Rasterize Generic PDF Format dialog box lets you customize the conversion process.

The following options are available for opening a single-page PDF file.

- **Width/Height:** Photoshop will insert the default values for the PDF file. Click in the input fields to modify the width and height of the converted PDF document.

- **Resolution:** PDF files are created in the EPS format and are therefore resolution-independent. Click in the Resolution input field to choose the correct resolution for the converted PDF document, based on the final resolution.

- **Mode:** Click on the Mode button and choose the correct color space from the available options, based on the final output.

- **Anti-aliased:** Insert a check mark in the Anti-aliased input box to select this vector conversion option. For more information on Anti-aliased, refer to Tip 116, "Selecting Anti-aliased for PostScript Images."

- **Constrain Proportions:** Insert a check mark in the Constrain Proportions input box to maintain the width and height proportions of the PDF document.

When you have completed all your modifications, click the OK button. In turn, Photoshop will close the Rasterize Generic PDF Format dialog box and open the converted PDF document within a Photoshop document window.

119 *Importing Images Directly from a Scan*

Scanning images for editing in Photoshop is a common practice. In fact, Photoshop lets you scan an image directly into a document window. To scan images directly into Photoshop, perform these steps:

1. Open Photoshop, select File menu Import, and choose the Twain Acquire option.

2. Photoshop will open your scanner software, as shown in Figure 119.1. Each scanner uses its own software. For more information on how your scanner software operates, consult your scanner operations manual.

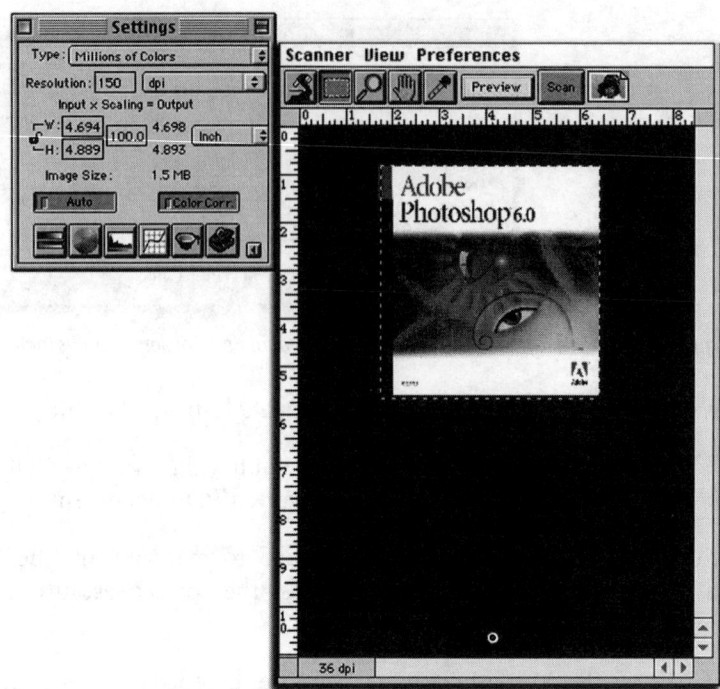

Figure 119.1 A typical scanner software interface, accessed through the Photoshop Twain Acquire option.

3. Perform a standard scan according to your particular scan software, as shown in Figure 119.1.

4. After you have completed the scan, instead of saving the file, Photoshop will open the image directly into a document window, ready to edit.

> *Note: To open and work with your scanner, you will need a plug-in file provided by the scanner manufacturer. If you are experiencing difficulty in accessing your scanner, contact the scanner manufacturer. It is the responsibility of the manufacturer, not Adobe, to ensure that their scanners interface successfully with Photoshop.*

120 *Importing Anti-alias PICT Files (Macintosh Only)*

Photoshop lets you import object-oriented PICT files created in programs like MacDraw and Canvas. The Import anti-alias feature creates smooth-edged PICT files that can then be transferred into any other format or color mode. It is important to note that the entire PICT file must be held in the computer's memory for the Import Anti-alias feature to operate. That makes it difficult to import large PICT files without a lot of RAM memory (256MB or higher).

To import an anti-aliased PICT file on a Macintosh, perform these steps:

1. Open Photoshop, select File menu Import, and choose the Anti-aliased PICT option. Photoshop will display the Open dialog box, as shown in Figure 120.1.

Figure 120.1 The Open dialog box in Photoshop.

2. Select the correct PICT file by clicking once on the file name and then on the Open button. In turn, Photoshop will close the Open File dialog box and open the Anti-Aliased PICT dialog box, as shown in Figure 120.2.

Figure 120.2 The Anti-Aliased PICT dialog box lets you define the characteristics of an object-oriented PICT file before opening the document.

The following options are available for opening an anti-aliased PICT file.

- **Width/Height:** Photoshop will open the dialog box with default values assigned to the image width and height. Click in the Width and/or Height fields to change the default values, based on the final output of the image.

- **Mode:** You have two options for the color of the image: RGB (red, green, and blue) and Grayscale. Click on one of the radio buttons located to the left of the mode options to change to a different color space.

- **Constrain Proportions:** Insert a check mark in the Constrain Proportions input box to maintain the width and height proportions of the document.

3. When all changes have been made, click the OK button. In turn, Photoshop will close the Anti-Aliased PICT dialog box and open the PICT image in a document window.

Note: If you do not want to apply anti-aliasing to an object-oriented PICT file, use File menu Open instead of File menu Import.

121 *Importing Annotations*

Photoshop 6.0, includes a new feature, the ability to create text annotations. Text annotations give you the ability to record detailed instructions and save them with the document. For example, you can create a text note (refer to Tip 920, "Working with Text Annotations"), and then move that note into another Photoshop document, as shown in Figure 121.1.

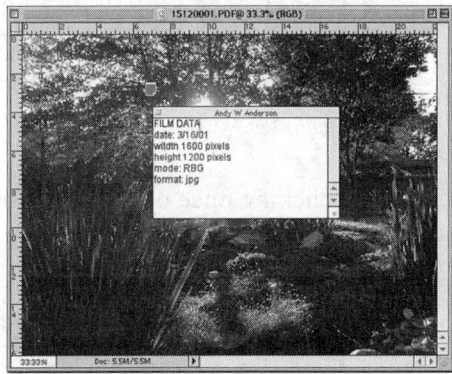

Figure 121.1 A Photoshop document containing a text annotation.

To move a Photoshop annotation note from one document into another, open the new document in Photoshop, and perform these steps:

1. Select the File menu, select Import, and choose Annotation from the fly-out menu. In turn, Photoshop displays the Open dialog box, as shown in Figure 121.2.

2. Select the Photoshop file containing the annotation.

3. Click the Load button. Photoshop examines the document and copies all annotations into the active document.

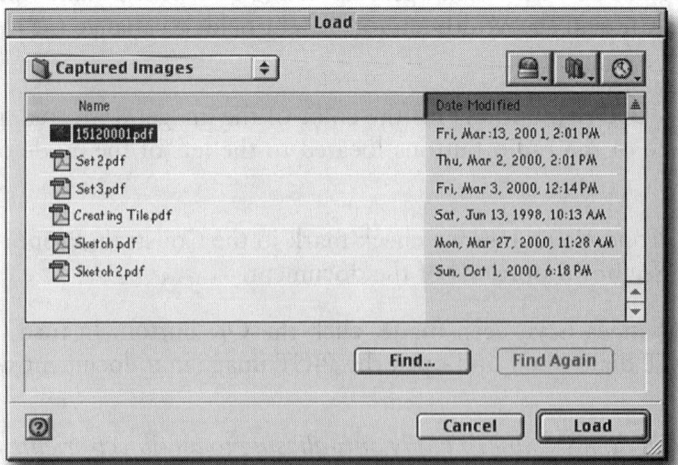

Figure 121.2 The Open dialog box lets you select a Photoshop document and import any annotations.

Note: The "Load" document must contain at least one annotation. If the document does not contain any annotations, Photoshop warns you in an Alert box that it was unable to move any notes.

122 *Importing PICT Resources (Macintosh Only)*

The PICT Resource option is unique to the Macintosh platform. A PICT resource is graphic information like the splash plate for a program or the graphics used by the program to illustrate special features.

To select a specific PICT Resource from a Macintosh file, perform these steps:

1. Select File menu Import and choose the PICT Resource option. Photoshop will display the Open dialog box, as shown in Figure 122.1.

Figure 122.1 *The Open dialog box lets you choose the PICT resource from the open list of file names.*

2. Select the PICT Resource file by clicking once on the file name and then clicking the Open button. Photoshop will close the Open File dialog box and open the PICT Resource dialog box, as shown in Figure 122.2.

Figure 122.2 *The PICT Resource dialog box displays the available resource images for the selected file.*

3. The PICT Resource dialog box displays the number of resource images within the selected file. Click on the left and right double arrows to preview the resource images.

4. When the preview box displays the correct resource, click the OK button. Photoshop will close the PICT Resource dialog box and open the selected resource.

Once the resource opens in a Photoshop document window, it is ready to be edited and saved as a normal Photoshop image or to be resaved as a PICT Resource.

123 *Using Layer Styles with the Drawing Tools*

New to Photoshop 6, the Drawing tools let you create filled objects like "rounded" corner boxes, arrows, and stars. For more information on using the Drawing tools, see Tip 138, "Using Photoshop's New Drawing Tools."

The Layer Styles palette is also new to Photoshop 6 and lets you create multilayer effects and save them as a clickable button. You can then apply precreated layer effects to new Photoshop graphic elements with the click of a button. For more information on creating styles, see Tip 487, "Creating Styles from Layers."

To apply a layer style to a drawn shape, perform these steps:

1. Open a graphic in Photoshop and create a new layer. See Tip 341, "Understanding the Concept of Layers."

2. Click and hold your mouse on the Drawing tool, located in the toolbox. Photoshop will display a pop-up menu displaying the drawing tool choices, as shown in Figure 123.1.

Figure 123.1 The Drawing tools in the Photoshop toolbox.

3. Click to choose one of the drawing tools. Photoshop will close the pop-up menu, and you are ready to draw.

4. Click and drag inside the document window to create a new shape based on your selected drawing tool. Release the mouse when the shape is the correct size.

5. Click on the Styles tab to display the Styles palette, as shown in Figure 123.2.

6. Make sure the layer containing your newly drawn shape is selected. Now move to the Styles palette and select a style by clicking on one of the style buttons. Photoshop will change the current layer to reflect the defined style, and your shape will change.

Note: Drawn shapes combined with layer effects make excellent Web buttons, and using the Styles palette to apply the layer effect makes the process accurate and fast.

Figure 123.2 The Styles palette displays icons representing all the available styles.

124 *Working with the Polygon Lasso Tool*

The Polygon Lasso is a selection tool that will let you create selections based on straight lines.

To use the Polygon Lasso, go to the Photoshop toolbox and click and hold your mouse on the Lasso icon. Photoshop will display a pop-up box displaying the lasso options, as shown in Figure 124.1.

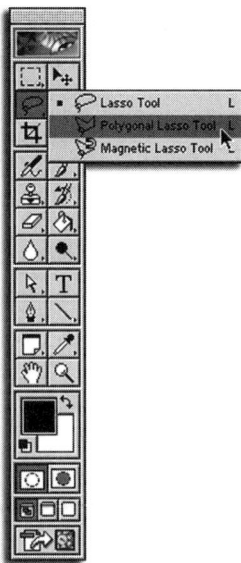

Figure 124.1 The Lasso tool options in the Photoshop toolbox.

To use the Polygon Lasso, perform these steps:

1. Click on the Polygon Lasso option. Photoshop will close the Lasso options, and the Polygon Lasso is now the default Lasso tool.

2. Move into the Photoshop document window with the Lasso tool. Position your mouse cursor where you want to begin selecting and click once.

3. Photoshop will create an anchor point. As you move your mouse cursor, you will see a straight line extending out from the anchor point, as shown in Figure 124.2.

Figure 124.2 The Polygon Lasso creates straight lines between anchor points to create a selection.

4. Move your cursor to where you want to place a second anchor point and click your mouse. Photoshop will draw a straight line between the two anchor points.

5. Move your cursor around the document window and click once for each additional anchor point. Photoshop will continue to add straight-line segments between each anchor point.

6. When you want to close the shape, double-click your mouse or place your mouse cursor over the starting anchor point and click once. In either case, Photoshop will close the selection, as shown in Figure 124.3.

Figure 124.3 The Polygon Lasso creates selections in a Photoshop document based on straight lines.

Here are some additional features of the Polygon Lasso:

- Holding down the CTRL (Command key: Macintosh) while clicking once will automatically close off the Polygon shape.

- Holding down the Shift key while drawing with the Polygon Lasso will force the tool to draw 90 and 45 degree lines between anchor points.

- Holding down the Alt key (Option key: Macintosh) while clicking and dragging will let you create freeform lines instead of straight lines between anchor points.

125 *Creating Shapes with the Custom Shape Tool*

A cool new tool in Photoshop is the Custom Shape drawing tool. The Custom Shape tool creates shapes that go far beyond the box shapes Photoshop users are accustomed to drawing.

To use the Custom Shape drawing tool, perform these steps:

1. Click and hold your mouse on the Drawing tool icon in the Photoshop toolbox. Photoshop will display the drawing tool choices, as shown in Figure 125.1.

Figure 125.1 The Custom Drawing tools icon in the Photoshop toolbox.

2. Click on the Custom Shape Tool option. Photoshop will close the Drawing tool options, and the Custom Shape option is now the default drawing tool.

3. To draw a custom shape, go to the Options bar (located under the pull-down menu) and click on the Shape icon. Photoshop will open a pop-up box, displaying all the available shape choices, as shown in Figure 125.2.

4. Click on the shape you want to draw and return to the Photoshop document window. (The Shape pop-up box will not close until you begin using the Shape tool.)

Figure 125.2 The custom shape options, located on the Options bar.

5. To draw the selected shape, click and drag your mouse in the document window. Release your mouse to set the shape in the document window.

Here are some additional features of the Custom Shape drawing tool:

- Hold the Shift key to force Photoshop to draw the custom shape using constrained proportions.

- Hold the Alt key to draw the selected shape from the center out.

- For information on how to create your own custom shapes, see Tip 129, "Defining and Saving Custom Shapes Using Paths."

126 *Creating Arrowhead Lines*

Arrowhead lines are very useful in Photoshop. They are used to create pointers that emphasize a particular element of a Photoshop document, or they can be linked with a text box to explain something of importance to the viewer of your image.

To create an arrowhead line, perform these steps:

1. Open a graphic image in Photoshop.

2. To select the Line tool, right-click (or click and hold your mouse) on the Drawing tool icon in the Photoshop toolbox. Photoshop will display a fly-out menu showing the Drawing tool options, as shown in Figure 126.1.

3. To select the Line tool, click on the Line tool option. Photoshop will close the Drawing tools fly-out options, and the Line tool is now the default drawing tool.

4. To select the arrowhead options, go to the Options bar (located at the top of the screen) and click on the black triangle located to the right of the drawing tool icons, as shown in Figure 126.2. Photoshop will open the Arrowheads dialog box.

Figure 126.1 The Line tool option in the Photoshop toolbox.

Figure 126.2 The Arrowheads dialog box lets you convert a simple line into an arrowhead line.

The following options are available when creating arrowhead lines.

- **Weight:** The weight of the line in pixels refers to the thickness of the line. See Figure 126.3.

Figure 126.3 The Weight option defines the thickness of a drawn line.

- **Start/End:** The Start and End options define the location of the arrowhead in relation to the line. Start places the arrowhead at the beginning of the drawn line. End places the arrowhead at the end of the drawn line. Click to place a check mark next to one or both of the options. (A check mark indicates the option is selected.)

- **Width/Length:** The Width and Length options refer to the thickness and length of the arrowhead, not the total length of the line. Click in the Width and Length input boxes to define the arrowhead. The Width and Length options are a percentage of the Weight of the line.

• **Concavity:** The concavity of the line defines how the shape of the arrowhead merges with the shaft, as shown in Figure 126.4. Click in the input box to define the concavity of the arrowhead. Concavity is defined as a percentage from –50% to +50%.

Figure 126.4 The Concavity option defines the final shape of the arrowhead.

5. After defining the arrowhead, click and drag your mouse in the document window to create an arrowhead line.

Note: To draw a 90- or 45-degree arrowhead line, hold the Shift key while drawing the line.

127 *Using the Shape Layer and Work Path Options with the Drawing Tools*

In Tip 125, "Creating Shapes with the Custom Shape Tool," you learned how to use the new drawing tools in Photoshop; however, the new drawing tools will do more than simply paint a shape into a Photoshop document window. Using any of the drawing tools, Photoshop lets you create specialized shape layers and instant work paths.

Shape layers create instant clipping paths around any drawn shape, and the Work Path option creates a work path in the Paths palette instead of a filled shape.

To draw a shape layer or work path, perform these steps:

1. Using Tip 125 as your guide, set up Photoshop to create a customized or regular shape by selecting one of the drawing tools, but don't draw the shape yet.

2. Located on the left side of the Options bar (see Figure 127.1) are three icons. Clicking on one of the three icons controls what type of shape you draw.

Figure 127.1 The Options bar displays button icons that control the type of shape you draw.

3. The Options bar displays three icons.

- Select the left icon to draw a shape layer

- Select the middle icon to create a work path out of your shape.

- Select the right icon to create a foreground colored, filled shape, as discussed in Tip 125.

4. Move your mouse cursor into the document window and click and drag your mouse to create the selected shape. The creation of clipping paths and work paths has never been simpler. For more information on clipping paths, see Tip 478, "Saving Files with Clipping Paths."

128 *Selecting Options for the Drawing Tools from the Options Bar*

When you are using the drawing tools in Photoshop, you will eventually need to draw a shape with more precision than just a simple click and drag. Photoshop lets you modify the characteristics of each of the drawing tools to control the final shape.

To change the characteristics of a drawing tool, perform these steps:

1. To select one of the drawing tools, refer to Tip 125, "Creating Shapes with the Custom Shape Tool."

2. Go to the Options bar after selecting a drawing tool. The Options bar displays an icon for each of the drawing tools.

3. Select the tool you want to modify by clicking on the specific tool icon.

4. Click on the black triangle, located at the end of the drawing tool icons. Photoshop will open a dialog box displaying the current state of the tool, as shown in Figure 128.1.

Figure 128.1 *The Options bar in Photoshop displays the characteristics of all the drawing tools in Photoshop.*

The Rectangle, Rounded, Ellipse, and Custom Shape tools have the following options.

- **Unconstrained:** This is the default for all the drawing tools. Unconstrained lets you design a shape by clicking and dragging. Releasing the mouse sets the shape of the object.

- **Square:** This performs the same function as holding down the Shift key while using any of the drawing tools. The Square option forces you into drawing shapes that are perfectly square. The Ellipse tool uses the term "rounded" to indicate drawing with a perfect circle.

- **Fixed Size:** Click in the input boxes to define an exact width and height for the drawn shapes.

- **Proportional:** Click in the input boxes to define a proportional size for the drawn shape such as 2 to 1, or 3 to 5. Say you use the ratio of 2 to 1; when you draw the shape, the width will always be twice the height of the drawn shape.

- **From Center:** This performs the same function as holding down the Alt key while using any of the drawing tools. The From Center option draws the shape from the center outward instead of dragging from a corner.

Note: Once modified, the Shape tools will retain their new characteristics until changed or reset.

129 Defining and Saving Custom Shapes Using Paths

In Tip 125, "Creating Shapes with the Custom Shape Tool," you learned how to use the Custom Shape tool to select and draw predefined shapes. However, eventually you will need to draw a shape that is not a part of the predefined set. Photoshop lets you create your own customized shapes from paths.

Say you need to create a custom shape that resembles two interlocking squares. To create your own customized double-square shape, perform these steps:

1. Open a new document window in Photoshop. The size and resolution of the new document are not important.

2. Select the Rectangular Marquee tool and, while holding down the Shift key, click in the document window and draw a square. See Tip 282, "Working with the Marquee Tools." You need to see a selection square similar to Figure 129.1.

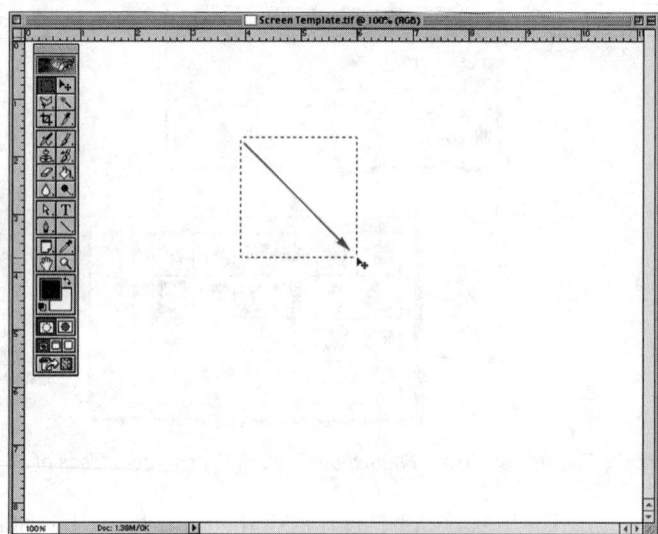

Figure 129.1 Using the Rectangular Marquee tool, click and drag a square in the document window.

3. Hold down the Shift key and draw a second, interlocking square, similar to Figure 129.2.

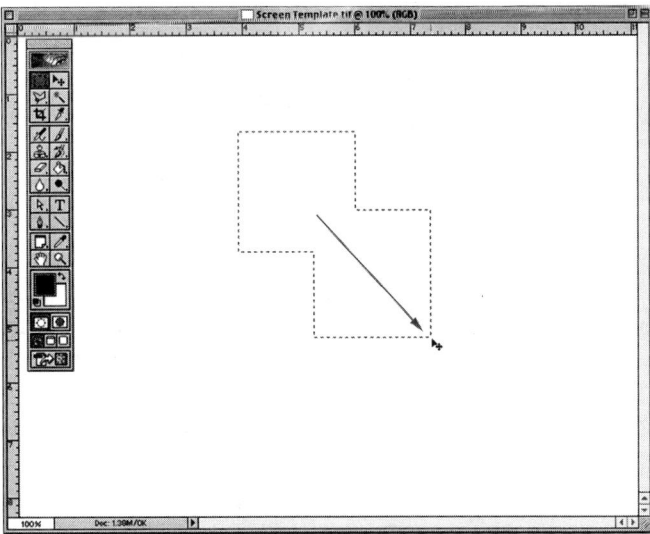

Figure 129.2 Holding the Shift key and dragging with the Rectangular Marquee tool adds to the previous selection.

4. Click on the Paths tab to display the Paths palette, as shown in Figure 129.3.

Figure 129.3 The Paths palette in Photoshop.

5. Click on the black triangle in the upper-right corner of the Paths palette. Photoshop will display a fly-out menu showing the Paths options, as shown in Figure 129.4.

Figure 129.4 The fly-out menu displays the available options on the Paths palette.

6. Click on the Make Work Path option. Photoshop will close the fly-out menu and display the Make Work Path dialog box, as shown in Figure 129.5.

Figure 129.5 The Tolerance option controls the relative smoothness of the path.

7. Click in the input box to change the Tolerance option. Tolerance is a decimal number from 0.5 to 10. The higher the number, the more Photoshop will attempt to smooth out a jagged path. Since we want the custom shape to be exactly what we selected, change the Tolerance number to 0.5 and click the OK button. In turn, Photoshop will close the Tolerance dialog box and create the work path, as shown in Figure 129.6. For more information on the Tolerance option, see Tip 474, "Understanding Tolerance."

Figure 129.6 The work path is created after selecting the correct Tolerance option.

8. Select the Drawing tool icon from the Photoshop toolbox, as referred to in Tip 125. It does not matter which one of the individual drawing tools is selected; just select the drawing tool icon.

9. Move your mouse into the document window containing the newly created path and right-click your mouse to open a context-sensitive menu. Click on the Define Custom Shape option. Photoshop will close the context-sensitive menu and open the Shape Name dialog box, as shown in Figure 129.7.

Figure 129.7 The Shape Name dialog box defines the name of the newly created custom shape.

10. Click in the Name input field, type a name for the new shape, and click the OK button.

11. Photoshop will close the Shape Name dialog box, and your new shape is now available for use. Refer to Tip 125 for information on how to use your new shape.

130 *Understanding the Clone Stamp Tool*

One of the most powerful tools for photographic restoration is Photoshop's Clone Stamp tool. The Clone Stamp (sometimes referred to as the Rubber Stamp) is a paintbrush that copies digital information from one portion of an image and paints that information over another portion of the image. The Clone Stamp can be used to remove a scratch from an image or to replace large portions of a damaged graphic. For image restoration, there is no tool quite like the Clone Stamp.

If you need to repair a graphic image that contains damaged areas, use the Clone Stamp tool and perform these steps:

1. Open the damaged image in a document window.

2. Right-click (Macintosh: Ctrl+click) on the Clone Stamp icon to display a fly-out menu of the Stamp options, as shown in Figure 130.1.

Figure 130.1 The Stamp options in the Photoshop toolbox.

3. Click on the Clone Stamp option. Photoshop will close the fly-out options, and the Clone Stamp is now the default tool.

4. Move to the Options bar and click on the black triangle located next to the Brush option. Photoshop will display the Brush palette. Select a brush size from the Brush palette, as shown in Figure 130.2.

5. Move your cursor into the document window. You need to identify to the Clone Stamp tool what pixels you want to paint. To do this, move your cursor directly over the pixels, hold down the Alt key, and click once. This defines what pixels the Clone Stamp tool will use. This process is called defining the aligned point.

6. Move your cursor over the area that needs painting. Click and drag your mouse in small circles over the area. The Clone Stamp will copy pixels from the aligned point and paint them over where you moved the Clone Stamp.

Figure 130.2 The Brush palette, located on the Options bar.

Repeat steps 5 and 6 to Clone Stamp from different areas of the image. With a little practice, you will be able to do fantastic work in restoring old photographic images. For more information on how to use the Clone Stamp tool, see Tip 605, "Using the Clone Stamp Tool," and Tip 607, "Controlling the Clone Stamp Tool Using Multiple Layers."

131 *Working with the Pattern Stamp Tool*

Photoshop has two stamp tools: the Clone Stamp and the Pattern Stamp. In the preceding tip, you learned the primary operation of the Clone Stamp tool. The Pattern Stamp performs a completely different function. It takes a predefined pattern and lets you use that pattern within any open Photoshop document window.

To use the Pattern Stamp, perform these steps:

1. Open a New or preexisting image in Photoshop. In this example, you will use the pattern from the predefined pattern set.

2. To select the Pattern Stamp, right-click (or click and hold your mouse) on the Stamp icon in the Photoshop toolbox. Photoshop will display the Stamp tool options in a fly-out menu, as shown in Figure 131.1.

3. Select the Pattern Stamp tool by clicking on the option once. Photoshop will close the fly-out menu, and the Pattern Stamp is now the default Stamp tool.

Figure 131.1 The Stamp options in the Photoshop toolbox.

4. Move your cursor to the right side of the Options bar and click on the Patterns button. Photoshop will display a pop-up box, showing all available patterns. Click once on a specific icon to select that pattern.

5. Choose the correct size brush by moving to the left side of the Options bar and clicking once on the black triangle next to the Brush icon. Photoshop will display the Brush dialog box, showing all available brush options. Click once on a specific icon to select a brush.

6. To use the Pattern Stamp, move your mouse cursor into the document window. Apply the pattern by clicking and dragging your mouse. Depending on the size and shape of the brush, Photoshop will paint the selected pattern into the document window, as shown in Figure 131.2.

Figure 131.2 The Pattern Stamp lets you create consistent patterns and use them on multiple Photoshop images.

Note: *The Pattern Stamp is not new to Photoshop; however, the ability to use predefined patterns is new. Having the ability to create and save patterns helps give images a consistent look and saves you the time of having to re-create often-used patterns. For information on how to create and save your own patterns, see Tip 133, "Creating and Saving Patterns."*

132 *Determining What Compression Scheme to Use*

Saving files in Photoshop can be a tricky business. For instance, compression of image data will make a file smaller but can also damage the image in the process. In Tip 4, "Choosing the Correct Compression Scheme to Fit the File," you learned about the different compression schemes. A compression scheme might fit the Photoshop image file, but you also need to know the final destination of the image. This table helps define how the different compression schemes work.

Image Output	GIF	JPG	LZW	PKZIP	PNG
Slide presentations	x	x			
PDF documents	x	x			
Image storage			x	x	
Computer to computer			x	x	
Web images	x	x			x
Interactive CDs	x	x			x
Live motion (Web animation)				x	

Note: If your images are being used in a slide presentation program like PowerPoint or Director, the images need to be small enough to load quickly yet still maintain a good visual quality. Compressing images using LZW compression is not recommended. LZW compression does not damage the file, but compressing and uncompressing the images during a presentation will task the processor on your computer and cause images to open with a jerky movement. Presentations with jerky animation are commonly said to have the "jitters." Avoid the jitters by avoiding LZW compression.

Note: Although the .jpg extension is commonly thought of as a file format, it is actually a compression scheme used primarily to save Internet graphics.

133 *Creating and Saving Patterns*

In Tip 131, "Working with the Pattern Stamp Tool," you learned how to select predesigned patterns and apply them to a Photoshop document. In Photoshop 6.0, you can work with patterns of your own creation and save them for future use. Patterns can be a freeform graphic created in a new document window, a piece or section of an open photograph, or a scanned image.

To create and save your own pattern, perform these steps:

1. Open a new document window in Photoshop by selecting File menu New. Photoshop will display the New dialog box. For this example, you will create a new 1 × 1 inch document with a Resolution of 150 and a Mode of RGB color, as shown in Figure 133.1.

Figure 133.1 Set up the New dialog box to create a new pattern.

2. Click the OK button in the New dialog box. Photoshop will close the New dialog box and open your document window.

3. Select the Paintbrush from the toolbox and create a design, as shown in Figure 133.2. Refer to Tip 78, "The Paintbrush and Pencil Tools." The design you create is not important. Be creative.

Figure 133.2 Creating a design with the Paintbrush tool.

4. When the design is complete, select the Rectangular Marquee tool from the toolbox and draw a selection square around your design. Refer to Tip 71, "The Marquee Tools." If you want your pattern contained within a perfect square, hold the Shift key down while using the Rectangular Marquee tool.

5. With the pattern area selected, Choose Edit menu Define Pattern. Photoshop will open the Pattern Name dialog box.

6. Define the new pattern by clicking in the Pattern Name input field and typing in the name of the new pattern.

7. Click the OK button. Photoshop will close the Define Pattern dialog box, and your new pattern is now available from the Pattern Picker, as shown in Figure 133.3.

Figure 133.3 The Pattern Picker displays all the available patterns for the Pattern Stamp.

134 *Working with the Slice Tool*

In its bid to become more Web friendly, Photoshop 6.0 added an image-slicing tool to its toolbox. Now the slicing of images does not require moving the graphic into ImageReady.

To perform image slicing within Photoshop, perform these steps:

1. Open a graphic image in Photoshop.

2. Click and hold your mouse (or right-click) on the Slice tool in the Photoshop toolbox. Photoshop will display the two available slicing tools, as shown in Figure 134.1. Click once on the Slice tool option to make it the default tool.

3. Move the Slice tool into the document window and click and drag the tool across the image to create a slice. Release the mouse to complete the slice. Photoshop will define the dragged area as a slice, as shown in Figure 134.2.

4. Depending on where you created your first slice, Photoshop will further divide the image into separate pieces for future placement into an HTML table.

5. To create more slices within the image, click and drag the Slice tool a second time across the image. Photoshop will define and number the new slice.

6. Create as many slices as you need by clicking and dragging the Slice tool across the image.

Figure 134.1 The Slice tool in the Photoshop toolbox.

Figure 134.2 Dragging the Slice tool across a Photoshop image creates a slice.

Note: When you create a sliced image within Photoshop, you generate User Slices and Photoshop Slices. The Slice tool creates User Slices as you click and drag across the image. However, since Photoshop creates the image for display within an HTML table, it must further divide the graphic; these extra slices are defined as Photoshop Slices. User Slices use the color blue to identify themselves, and Photoshop Slices are defined in gray.

135 *Using the Save for Web Feature with a Sliced Image*

In the preceding tip, you learned that Photoshop 6.0 lets you create a sliced image without moving into ImageReady. Once the image is sliced, it needs to be saved as a sliced table image. Selecting File menu Save will not save the image as a sliced document; you will need to use the Save for Web feature.

To save a sliced image for use on the Internet, perform these steps:

1. Create a sliced image within a Photoshop document window. Refer to Tip 134.

2. Select File menu Save for Web. Photoshop will open the Save for Web dialog box, as shown in Figure 135.1.

3. The Save for Web dialog box lets you view the sliced image with the original uncompressed image in the upper-left and three versions of the image in various states of compression, as shown in Figure 135.2.

Figure 135.1 *The Save for Web dialog box in Photoshop.*

Figure 135.2 The Save for Web dialog box in Photoshop lets you define the characteristics of the Web image.

4. Click on the image preview you want to use and click the OK button. Photoshop will open the Save Optimized As dialog box, as shown in Figure 135.3. For more information on sliced image compression, see Tip 768, "Optimizing Individual Image Slices."

*Figure 135.3 The Save Optimized As dialog box lets you name
and define the characteristics of the sliced image.*

5. Select one of the format options by clicking on the Format button and selecting from the three options. You have the choice of creating the HTML (HTML only), just saving the sliced images (Images Only), or saving the HTML and the images (HTML and Images).

After making your Format selection, click the OK button. Photoshop will close the Save Optimized As dialog box and save your sliced image file.

Note: When you save a sliced image using the Format option HTML and Images, Photoshop saves a folder named Images containing all of the sliced images along with an HTML document containing the HTML code to create a zero-border table and display all of the saved images.

136 *Using the Standard Lasso Tool*

The standard Lasso is a general-purpose selection tool that selects pixel information in a document window using the freeform movements of your mouse. Unlike other selection tools that select information by color or brightness level, the standard Lasso is yours to control and, in many cases, will select pixel information when no other selection method will work.

To select the standard Lasso tool, click on and hold (or right-click on) the Lasso icon in the Photoshop toolbox. Photoshop will display a fly-out menu with your three Lasso options, as shown in Figure 136.1. Click on the Lasso tool option to make it the default selection tool.

Figure 136.1 The Lasso tool options in the Photoshop toolbox.

To use the standard Lasso, move into a Photoshop document window and click and drag your mouse. As you drag, a visible line will follow the movement of your mouse; this line defines the selection area. Release the mouse when your selection is complete. Photoshop will close off the area and turn the line into a standard dotted-line selection, as shown in Figure 136.2.

*Figure 136.2 The standard Lasso tool creates selections based on the movement
of your mouse within the document window.*

The Options bar in Photoshop 6.0 contains features that previously required the use of shortcut keys, as shown in Figure 136.3.

Figure 136.3 The Options bar in Photoshop 6.0 lets you change the characteristics of the standard Lasso tool.

When the standard Lasso tool is selected, the left side of the Options bar displays four new buttons that will help you maximize your selection performance. Clicking on any one of the buttons produces these changes to the Lasso tool:

- **New Selection (default):** Creates a new selection area each time you use the Lasso tool.

- **Add to Selection:** Adds to a previously created selection each time you use the Lasso tool.

- **Subtract From Selection:** Lets you remove previously selected areas from the document window by clicking and dragging your mouse over a selection.

- **Intersect With Selection:** To use this option, first draw a selection area in the document window. Next select Intersect With Selection and draw another selection area, overlapping the previous selection. Photoshop will create a selection based on the overlapped area.

The Options bar now includes an option to feather the selected area. The Feather option gives your selection a softer edge, as shown in Figure 136.4. Feathering measures in pixels; therefore, the resolution of the open graphic image determines the overall effect of feathering. To change the Feather option, click your mouse in the Feather input field and enter a number from 0 to 250 (refer to Figure 136.3).

The final option available on the Options bar is Anti-aliased. The Anti-aliased option, when checked, helps soften the edges of a selection by coating the jagged edge of a selection with soft transitional colors. The effect is to help the eye smoothly blend the selection into the background, as shown in Figure 136.5.

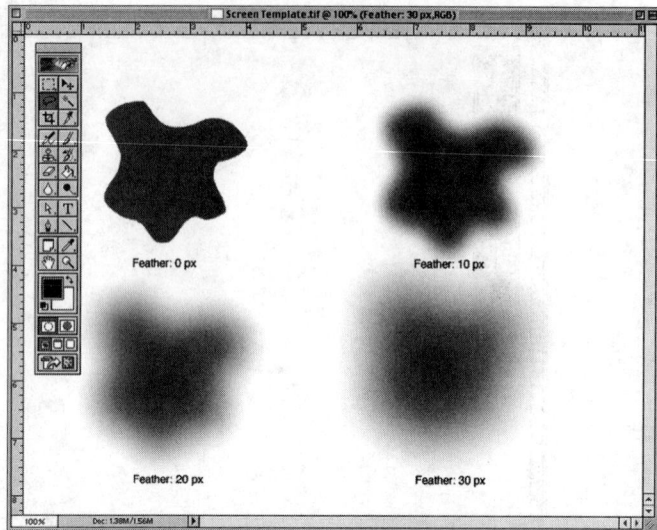

Figure 136.4 Using the Feather option with the Lasso tool produces a softer edge to a selection line.

Figure 136.5 The Anti-aliased option gives a selected image a visual softness and reduces the jagged appearance of the graphic.

137 Understanding the Magnetic Lasso Tool

The Magnetic Lasso is an excellent selection tool for images containing a definable edge to the selection. To select the Magnetic Lasso tool, click on and hold (or right-click on) the Lasso icon in the Photoshop

toolbox. Photoshop will display a fly-out menu with your three Lasso options, as shown in Figure 137.1. Click on the Magnetic Lasso tool option to make it the default selection tool.

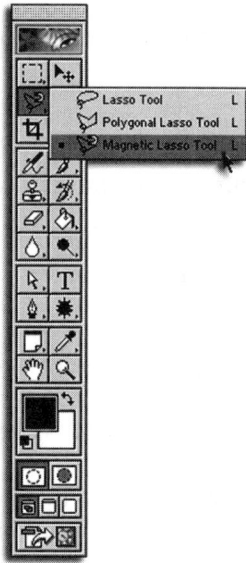

Figure 137.1 The Magnetic Lasso tool option in the Photoshop toolbox.

To use the Magnetic Lasso tool, open a graphic image in Photoshop, move the Magnetic Lasso tool into the document window, and perform these steps:

1. Visually identify what you want to select and move the Magnetic Lasso to the edge of the selection. Click once on the selection edge, as shown in Figure 137.2. Clicking your mouse identifies the edge of the selection and lets the Magnetic Lasso follow the edge of the image.

2. Move your mouse to trace the selection, keeping close to the edge of the object. The Magnetic Lasso follows your movement and stays locked to the edge of the selection.

3. To complete the selection, move your mouse cursor back to the original starting point of your selection or double-click. Photoshop will close the selection.

Figure 137.2 The Magnetic Lasso makes a selection by following the edge of the area you want to select.

With the Magnetic Lasso selected, the Options bar displays information on the characteristics of the default tool, as shown in Figure 137.3.

Figure 137.3 The Options bar lets you change the characteristics of the Magnetic Lasso tool.

- **Width:** The Width option defines the sensitivity of the Magnetic Lasso. Increasing the Width option decreases the sensitivity of the Magnetic Lasso and lets your mouse drift further away from the selection edge. Click in the Width input field and type a number from 1 to 40 to change the Width option.

- **Edge Contrast:** The Edge Contrast option defines the amount of contrast shift that defines the edge of the selection. The higher the number, the less sensitive the Magnetic Lasso is to a contrast shift. Click in the Edge Contrast input field and type in a number from 1 to 100 to change the Edge option.

- **Frequency:** During the selection process, as you drag your mouse along the edge of the image, the Magnetic Lasso creates temporary anchor points along the selection path. If you want to erase part of the selection edge, the anchor point is as far back as you can go. The Frequency option lets you control how closely the anchor points attach to the selection line. The higher the number, the further apart the anchor points are spaced on the line; the smaller the number, the closer they are on the selection line. Click in the Frequency input box and type a number from 0 to 100 to change the Frequency option.

- **Stylus Pressure:** If you are working with a drawing tablet, select or deselect Stylus Pressure. When selected, an increase in stylus pressure causes the width option to decrease.

When the Magnetic Lasso tool is selected, the left side of the Options bar displays four new buttons that will help you maximize your selection performance. Clicking on any one of the buttons produces these changes to the Magnetic Lasso tool:

- **New Selection (default):** Creates a new selection area each time you use the Magnetic Lasso tool within a document window.

- **Add to Selection:** Adds to a previously created selection each time you use the Magnetic Lasso tool within a document window.

- **Subtract From Selection:** Lets you remove previously selected areas from the document window by clicking and dragging your mouse.

- **Intersect With Selection:** Draw a selection area in the document window. Next select Intersect With Selection and draw another selection area, overlapping the previous selection. Photoshop will create a selection based on the overlapped area.

The Options bar also includes an option to feather the selected area. The Feather option measures in pixels; therefore, the resolution of the open graphic determines its overall effect on an image. To change the Feather option, click in the Feather input field and type in a number from 0 to 250 (refer to Figure 137.3). The Feather option gives your selection a softer edge, as shown in Figure 137.4.

The final option available on the Option bar is Anti-aliased. The Anti-aliased option, when checked, helps soften the edges of a selection by adding pixels to the selection's jagged edge and then coating the jagged edge with soft colors. The effect helps the eye blend the selection into the background, as shown in Figure 137.5.

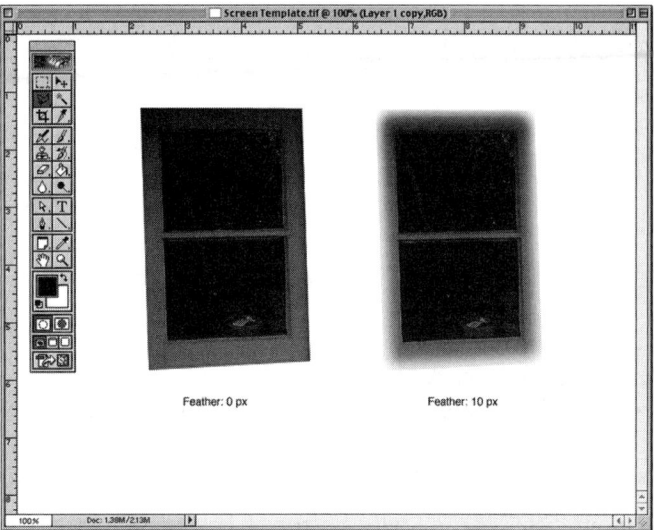

Figure 137.4 Using the Feather option with the Magnetic Lasso tool produces a softer edge to a selection line.

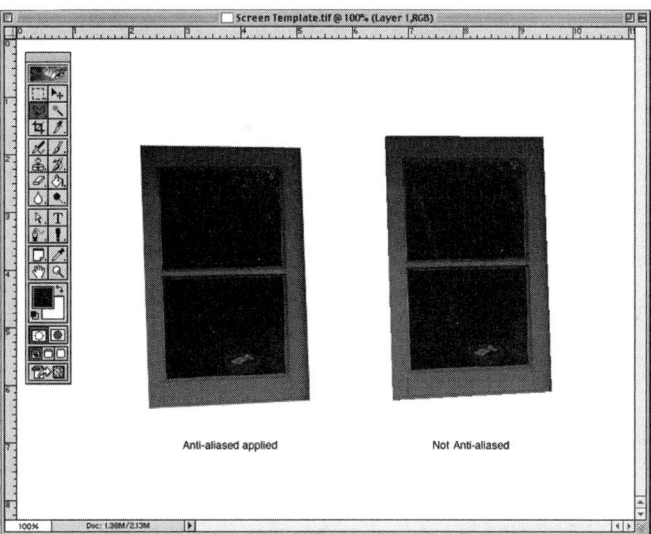

Figure 137.5 The Anti-aliased option, when used in conjunction with the Magnetic Lasso, gives a selected image a visual softness and reduces the jagged appearance of the graphic.

138 *Using Photoshop's New Drawing Tools*

Often asked for and finally here, the new Drawing tools in Photoshop give you ability to create everything from boxes with rounded corners to exotic special shapes.

To select a drawing tool, click on the Drawing tool icon, as shown in Figure 138.1 (refer to Tip 88, "The Drawing Tools").

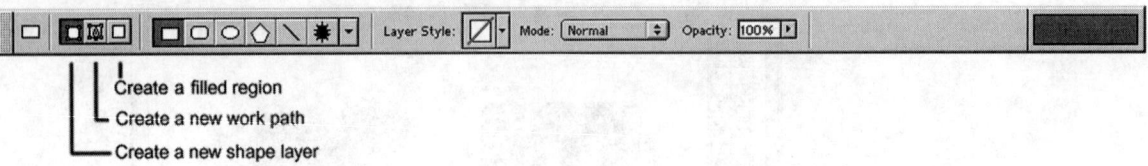

Create a filled region
Create a new work path
Create a new shape layer

Figure 138.1 The Drawing tools options on the Options bar.

With a Drawing tool selected, the left side of the Options bar displays three options for how the drawing tools work.

- **Create a New Shape Layer:** A shape layer is a fill layer containing a clipping path. The fill layer defines the color of the shape; the layer-clipping path defines the geometric outline of the shape. You can change the color and other attributes of a shape by editing its fill layer and applying layer styles. To create a shape layer, click on the Shape Layer icon, as shown in Figure 138.1.

The Options bar now displays the Styles button. Click on the Styles button. Photoshop will display the Styles palette, as shown in Figure 138.2.

Figure 138.2 The Styles palette located on Photoshop's Option bar.

Click to select a style from the Styles palette. Move into the document window of an open Photoshop image and draw a shape by clicking and dragging your mouse. Release the mouse to complete the shape. Photoshop will create a shape layer, as shown in Figure 138.3.

Figure 138.3 A shape layer containing a graphic image created with Photoshop's new drawing tools.

- **Create a New Work Path**: The Create a New Work Path option, as shown in Figure 138.1, creates a work path from a drawn object.

 Select a drawing tool from the toolbox and click on the Create a New Work Path option on the Option bar (refer to Figure 138.1). When you draw a shape with any of the drawing tools, Photoshop will automatically create a work path in the Paths palette, as shown in Figure 138.4. For more information on work paths, see Tip 472, "Understanding Work Paths."

Figure 138.4 The Paths palette in Photoshop contains the work path from a drawn shape.

- **Create a Filled Region**: The third option, Create a Filled Region (shown in Figure 138.1), lets you create any shape and fill the shape in with the current foreground color, as shown in Figure 138.5.

Figure 138.5 The Create a Filled Region option, when used in conjunction with the drawing tools, creates a shape filled with the default foreground color.

139 *Using the Magnetic Pen Tool*

The Magnetic Pen is an option of the Freeform Pen tool. The Magnetic Pen lets you draw a path that snaps to the edges of defined areas in your image. You can define the range and sensitivity of the snapping behavior as well as the complexity of the resulting path. The Magnetic Pen and Magnetic Lasso tools share many of the same options.

To use the Magnetic Pen tool, click and hold (or right-click) your mouse on the Pen tool icon in the Photoshop toolbox. Photoshop will open a fly-out menu displaying the Pen tool options, as shown in Figure 139.1. Click on the Freeform Pen Tool option to make it the default tool.

The Options bar displays the default options for the Pen tool. On the Options bar, select the Magnetic option by clicking in the check mark input box, as shown in Figure 139.2.

The Magnetic Pen tool works in the same way as the Magnetic Lasso, by selecting a path based on the edge contrast of the image pixels. Visually identify what you want to select and move the Magnetic Pen to the edge of the selection. Click once on the selection edge, as shown in Figure 139.3. Clicking your mouse identifies the edge of the selection and lets the Magnetic Pen trace the edge of the image as you move your mouse.

Figure 139.1 Clicking on the Freeform Pen Tool icon in the Photoshop toolbox makes it the default tool.

Figure 139.2 The Options bar in Photoshop lets you change the characteristics of the Freeform Pen tool.

Figure 139.3 The Magnetic Pen makes a selection by tracing the edge of the area you want to select.

Move your mouse to trace the area you want selected, keeping close to the edge of the image. The Magnetic Pen follows your movement and stays locked to the edge of the selection. If the line drawn by

the Magnetic Pen begins to drift away from the selection edge, click once to set an additional anchor point. If you do not click your mouse, the Magnetic Pen tool will place anchor points along the line based on the default settings.

To complete the selection, move your mouse cursor back to the original starting point of your selection or double-click. Photoshop will close the selection.

The difference between the Magnetic Lasso and the Magnetic Pen tool is what it draws. The Magnetic Lasso draws a standard, dotted-line selection area, while the Magnetic Pen creates a work path in the Paths palette.

Tips on using the Magnetic Pen tool:

- If the Magnetic Pen does not snap to the desired edge, click once to add a fastening point manually and to keep the border from moving.

- Press and hold the Alt key while dragging your mouse to draw a freehand path.

- Press and hold the Alt key and click to draw straight-line segments.

- Press Enter to end an open path. (Pressing the Enter key creates a straight line between the last and beginning points of the pen shape.)

- Double-click to close the path with a magnetic line segment.

- Press and hold the Alt key and double-click to close the path with a straight segment.

140 *Changing the Magnetic Pen Tool Options*

When you select the Pen tool, the Options bar displays the default settings of the Pen tool, as shown in Figure 140.1. To change how the Pen tool performs, change the default options.

Figure 140.1 The Pen tool default options, as displayed in the Options bar.

- **Resetting the Tool:** Click on the Pen icon, located on the far left of the toolbar (see Figure 140.1). Photoshop will open a fly-out menu that gives you the option to reset either the current tool or all tools in the Photoshop toolbox back to their default values.

- **Shape Layer or Work Path:** The two buttons located to the right of the Pen icon decide what the Pen tool will draw. Clicking the left button creates a shape layer, and clicking the right button creates a work path.

- **Curve Fit:** This controls how sensitive the final path is to the movement of your mouse. Click in the Curve Fit input field and type a value between 0.5 and 10.0 pixels. A higher value creates a simpler path with fewer anchor points.

Activating the Magnetic option changes the tool into the Magnetic Pen. Select the Magnetic option by clicking in the check mark input box. Then click on the button to the right of the Magnetic option to change the characteristics of the Magnetic Pen tool.

- **Width**: The Width option defines the sensitivity of the Magnetic Pen. Increasing the value of the Width option decreases the sensitivity of the Magnetic Pen and lets your mouse drift further away from the selection edge. Click in the Width input field and type a number from 1 to 40 to change the Width option.

- **Contrast**: The Contrast option defines the amount of contrast shift that defines the edge of the selection. The higher the number, the less sensitive the Magnetic Pen is to a contrast shift on the edge of the image selection. Click in the Contrast input field and type in a number from 1 to 100 to change the Contrast option.

- **Frequency**: During the selection process, as you drag your mouse along the edge of the image, the Magnetic Pen creates temporary anchor points along the selection path. If you want to back up on the selection edge, the anchor point is as far back as you can go. The Frequency option lets you control how closely the anchor points attach to the selection line. The higher the number, the further apart the anchor points are spaced on the line; the smaller the number, the closer they are on the selection line. Click in the Frequency input box and type a number from 0 to 100 to change the Frequency option.

- **Stylus Pressure:** If you are working with a drawing tablet, select or deselect Stylus Pressure. When selected, an increase in stylus pressure causes the width option to decrease.

141 *Using the Magnetic Pen Tool*

Since the Magnetic Pen tool traces an image based on a shift in contrast, images with good contrast will produce better results than poor or soft-focused images, as shown in Figure 141.1.

Figure 141.1 The Magnetic Pen tool works better with high-contrast images.

If you are experiencing difficulty making good selections with the Magnetic Pen, try adding a Curves or Levels adjustment layer to boost image contrast, as shown in Figure 141.2. For more information on adjustment layers, see Tip 322, "Understanding Adjustment Layers."

Figure 141.2 Use of an adjustment layer temporarily boosts the contrast of the image and makes selection with the Magnetic Pen easier.

When you finish tracing the selection with the Magnetic Pen, delete the adjustment layer. Deleting the adjustment layer returns your image to its original condition and preserves your selection.

Another successful way to use the Magnetic Pen is within one of the image color channels (see Tip 432, "Understanding Channels and Their Role"). Select the channel that gives you the best contrast on the edge of the object you want to trace and use the Magnetic Pen on that channel, as shown in Figure 141.3.

Figure 141.3 Using the Magnetic Pen within a color channel gives you control over the selection.

When you complete the selection, return to the composite image (again, see Tip 432). You now have a precise selection.

142 *Going Beyond Undo with the History Brush*

When you first open an image in Photoshop, the program takes a snapshot of the image. The snapshot image is a copy of the file when first opened; this includes the image's original color space and resolution. Photoshop saves this snapshot in the History palette, as shown in Figure 142.1.

Figure 142.1 The History palette holds a snapshot of a graphic image for future use by the History brush.

When the History brush is selected (refer to Tip 80, "The History and Art History Brush Tools"), the tool uses the snapshot of the original state of the image and paints image information back into the document window.

The History brush is an excellent tool to use when restoring portions of an image and the Undo option isn't available. (The Undo option in Photoshop, by default, goes back 20 steps.) Figure 142.2 illustrates using the History brush to restore portions of an edited image.

Figure 142.2 The History brush repaints image information based on the snapshot of the original image.

The History brush, as with all drawing tools in Photoshop, draws in the document window based on the size and shape of the brush. When the History brush is selected, the Options bar displays a button that lets you select the correct brush size, as shown in Figure 142.3.

Note: Although the History brush will do far more than simply restore original image information, it is a great thing to remember when you need to correct an editing mistake and that mistake goes beyond the limitations of a simple Undo.

Figure 142.3 The size and shape of the brush controls how the History brush tool works.

143 *Using the History Brush with a Transparent Layer*

In the preceding tip, you learned that the History brush works by using a snapshot of the original image. While this can be a tremendous timesaving feature, you can further control the process by adding transparent layers to your image and using the History brush in these layers.

To use the History brush with a transparent layer, perform these steps:

1. Open an image within a Photoshop document window.

2. Select the History brush (refer to Tip 80, "The History and Art History Brush Tools").

3. Create a new layer directly above the original image, as shown in Figure 143.1. For more information on creating new layers in Photoshop, see Tip 233, "Controlling Your Work with Layers."

4. With the new layer selected, use the History brush (refer to the preceding tip) to paint back-image information. Since you are painting within a transparent layer, you maintain control over the image.

5. You can move or change the opacity or blending mode of the layer at any time. Moreover, if what you painted is completely wrong, you can simply delete the transparent layer and start again.

Using the History brush is a tremendous timesaver. When combined with additional transparent layers, the History brush gives you the control needed to create the best possible image in the shortest possible timeframe.

Figure 143.1 Creating transparent layers for use with the History brush gives you control over the final image.

144 *Creating a Painterly Effect with the Art History Brush*

Along with the History brush, Photoshop includes the Art History brush. The History brush is a grouped tool. Refer to Tip 80, "The History and Art History Brush Tools," to select the Art History brush.

The Art History brush is controlled by the size and shape of the brush (refer to the preceding tip) and creates the illusion of a painted image by further controlling the tool's various options.

To control the characteristics of the Art History brush, select the brush and go to the Options bar, as shown in Figure 144.1.

Figure 144.1 The Art History options control how the Art History brush paints the original image.

- **Resetting the Tool:** Click on the Art History icon, located on the far left of the toolbar (see Figure 144.1). Photoshop will open a fly-out menu that gives you the option to reset either the current tool or all tools in the Photoshop toolbox back to their default values.

- **Brush:** Select the brush size you want to use.

- **Mode:** The Art History brush works with different blending modes to produce different effects on the image. See Tip 234, "Using Blending Modes to Influence the Painting Tools," for more information on blending modes.

- **Opacity:** Click in the Opacity input box and enter an opacity value from 1 to 100, or click the black triangle to the right of the input box and use the triangular slider to change the opacity. The higher the number, the more opaque the painting effect.

- **Style:** Click on the Style button to display a list of styles available for the Art History brush. Click on the style you want to use.

- **Fidelity:** This determines how closely the Art History brush uses the original colors from the image. Click in the Fidelity input box and enter an value from 0 to 100, or click the black triangle to the right of the input box and use the triangular slider to change the value. The higher the number, the closer the Art History colors will resemble the original image colors.

- **Area:** The Area option defines the area covered by the Art History brush. The greater the size, the larger the covered area and the more numerous the strokes. Click in the Area input box and enter a value from 0 to 500 pixels to change the value.

- **Spacing:** The Spacing option defines where the Art History paint strokes are applied. A low spacing tolerance lets you paint unlimited strokes anywhere in the image. A high spacing tolerance limits your paint strokes to areas that differ considerably from the color in the original image. Click in the Spacing input box and enter a value from 0 to 100, or click the black triangle to the right of the input box and use the triangular slider to change the value.

- **Brush Dynamics:** To understand how brush dynamics are used in conjunction with a drawing tablet, see Tip 191, "Using Brush Dynamics."

When you have completed all your modifications to the Art History options, move into the document window. Create brush strokes by clicking and dragging within the document window.

Note: To further control the painting process, refer to Tip 143, "Using the History Brush with a Transparent Layer." The Art History brush works within a transparent layer, just like the History brush. This will give you total control over your image and will save you time when you want to go back and correct previously unnoticed errors.

145 *Using the Color Range Command*

Several of the tools within the Photoshop toolbox deal with the selection of pixel information and, depending on the image, perform their tasks quite well. However, Photoshop gives you more ways to select digital information than simply using the standard toolbox tools.

Another way to select is using the Color Range option. To use the color range selection method, perform these steps:

1. Open an image within Photoshop.

2. Choose Select menu Color Range. Photoshop will open the Color Range dialog box, as shown in Figure 145.1.

Figure 145.1 The Color Range dialog box lets you select pixel information based on the brightness and colors of the original image.

3. Click on the Select button. Photoshop will open a fly-out menu displaying all your color selection options. Click to choose a selection method. In this example, you will be using the Sampled Colors option.

4. The Color Range dialog box, by default, displays a preview image of the open graphic. You can choose to display a preview of the selection or view the original image. In this example, click to choose Image. The Color Range dialog box will display a full-color preview of the original open document.

 At the bottom of the Color Range dialog box is the Selection Preview option. Click to display a preview option.

 • **None:** There is no preview of the selection in the open document window.

 • **Grayscale:** The selected areas of the image appear as grayscale within the image document window.

 • **Black or White Matte:** Displays the selection as a black or white matte within the image document window.

 • **Quickmask:** Displays the selection as a semitransparent layer of color. (The default color for Quickmask is red.)

5. Choose the option that best helps you identify the selection in the document window. For this example, choose White Matte.

6. Photoshop displays all selection information with a white matte overlay within the document window, as shown in Figure 145.2.

7. Move your mouse cursor into the preview of the image within the Color Range dialog box. Your cursor now resembles an eyedropper. Click once on a color. The original document window changes to reflect your selection of color information.

8. You can adjust the range of colors within the selection by using the Fuzziness slider at the top of the Color Range dialog box. Increase or decrease the value of the Fuzziness option by clicking in the input field and typing a value of 0 to 200 or by clicking and dragging the triangular slider located under the Fuzziness input box. Decreasing the value decreases the range of colors selected; increasing the number increases the range of color selected.

Figure 145.2 The Color Range dialog box with White Matte as the Selection Preview.

9. By default, the Color Range dialog box lets you select one color at a time. Clicking a second time in the image preview resets the color range to the newly sampled area. To add or subtract colors from the range of selected colors, click the plus or minus eyedropper, located on the right side of the Color Range dialog box (refer to Figure 145.1).

10. When you have made your color range selection, click the OK button. Photoshop will close the Color Range dialog box and remove the white matte from the document window. Photoshop converts the white matte into a selected area based on color.

> *Note: You can focus the Color Range option by roughly selecting an area within the graphic image before opening the Color Range dialog box. The Color Range selection will only occur within the previously selected area.*

> *Note: On the right side of the Color Range dialog box is the Invert option (refer to Figure 145.1). If you want to reverse the selection, place a check mark in the Invert option by clicking in the Invert input field. When you click the OK button, the selection area will be reversed.*

146 *Using the Measure Tool to Straighten an Image*

Scanning images requires placing the media on the scanner bed. Typically, the image lays square; however, there are times when the scan is not perfect, and the image winds up at an angle, as shown in Figure 146.1. Normally, you rescan the image, making sure it is lying square on the scanner bed. However, what about an image received from a client or an original image that no longer is available, as is common with old photographs?

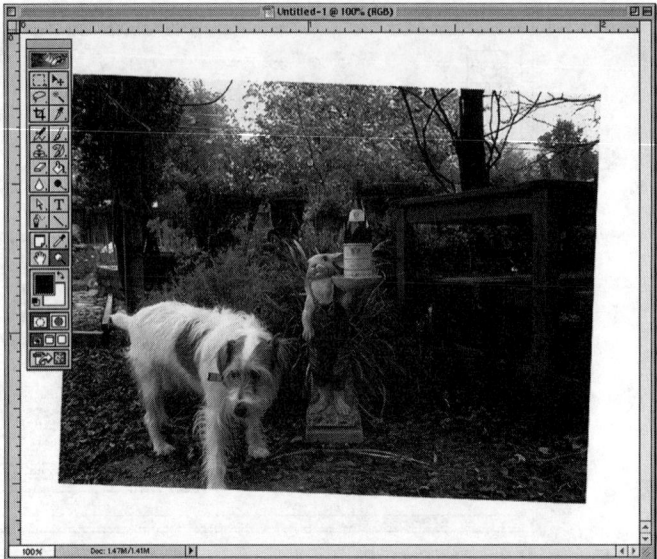

Figure 146.1 Images not placed square on the scanner bed produce an angled graphic that needs correction.

To straighten an image, perform these steps:

1. Open the image in Photoshop.

2. Select the Measure tool from the Photoshop toolbox. The Measure tool is grouped with the Eyedropper tools. Click and hold (or right-click) your mouse on the Eyedropper tool, as shown in Figure 146.2. Photoshop will open a fly-out menu. Click on the Measure tool option to make it the default tool.

Figure 146.2 The Measure tool is grouped with the Eyedropper tools in the Photoshop toolbox.

3. Click on the Info tab to display the Info palette, as shown in Figure 146.3.

Figure 146.3 The Info palette displays information on the open Photoshop document.

4. With the Measure tool selected, move to the upper-left corner of the document window. Next click and drag the Measure tool to the right, exactly copying the angle of the mis-registered photograph. Release the mouse when the angle matches the angle of the frame, as shown in Figure 146.4.

Figure 146.4 The Measure tool measures distance and angles within a Photoshop document window.

Note: *The Info palette now records the angle of the line you drew with the Measure tool, as shown in Figure 146.4.*

5. Select Image menu Rotate Canvas and choose Arbitrary from the fly-out menu. Photoshop will open the Rotate Canvas dialog box. The angle recorded by the Measure tool automatically inserts into the Angle text box, as shown in Figure 146.5.

Figure 146.5 The Rotate Canvas dialog box automatically records the angle of the Measure tool.

6. Choose CCW (Counter-Clockwise) as the rotation method and click the OK button. Photoshop will close the Rotate Canvas dialog box and rotate the image. Since the angle defined by the Measure tool is exactly the angle needed to straighten the image, the graphic corrects itself, as shown in Figure 146.6.

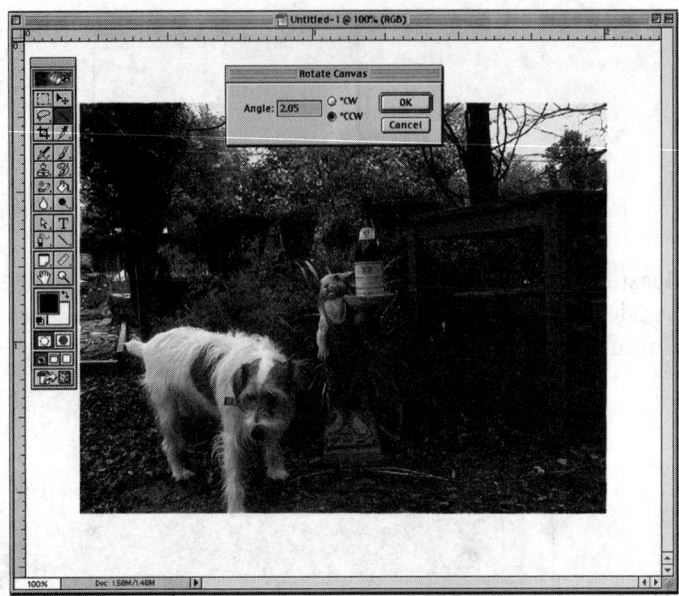

Figure 146.6 The Measure tool, along with the Rotate can command, successfully corrected a mis-registered scan.

147 *Working with the Smudge Tool*

The Smudge tool reproduces the action of moving your finger through wet paint. The action begins when you click your mouse and ends when you release the mouse button.

To select the Smudge tool, click and hold (or right-click) your mouse on the Focus tool icon. Photoshop will open a fly-out menu displaying the Focus tool options, as shown in Figure 147.1. Click on the Smudge Tool option to make it the default tool.

These options are available from the Options bar when using the Smudge tool, as shown in Figure 147.2.

Figure 147.1 The Focus tools in the Photoshop toolbox.

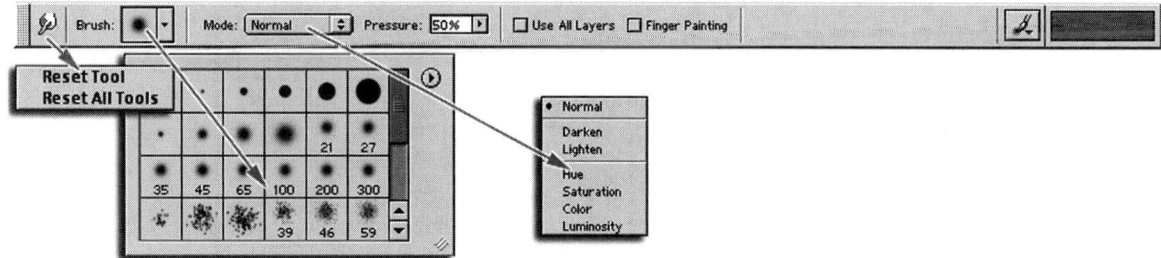

Figure 147.2 The Smudge tool options in the Options bBar control the characteristics of the Smudge tool.

- **Resetting the Tool:** Click on the Smudge tool icon, located on the far left of the toolbar (see Figure 147.2). Photoshop will open a fly-out menu that gives you the option to reset the current tool, or all tools in the Photoshop toolbox, back to its default value.

- **Brush:** Select the brush size you want by clicking on the black triangle located to the right of the Brush icon. Photoshop will display all available brush sizes. Click to choose a brush.

- **Mode:** The Smudge tool works with different blending modes to produce different effects on the image. See Tip 234, "Using Blending Modes to Influence the Painting Tools," for more information on blending modes.

- **Pressure:** The Smudge tool pressure refers to the intensity of the smudge effect. Click in the Pressure input box and enter a value from 1 to 100, or click the black triangle to the right of the input box and drag the slider left or right. The higher the value, the more intense the effect.

- **Use All Layers:** When checked, the Smudge tool uses the colors from all underlying layers. When unchecked, the Smudge tool only uses the colors within the active layers.

- **Finger Painting:** When checked, the Smudge tool uses the foreground color when you first click and drag your mouse. When unchecked, the Smudge tool uses the colors directly under the mouse cursor.

- **Brush Dynamics:** Click the Paintbrush icon on the right side of the Options bar to access the Brush Dynamics options. For more information on brush dynamics, see Tip 191, "Using Brush Dynamics."

148 *Creating Fast Backgrounds Using Filters*

There are occasions when you are looking for that special background to use on a Web site or as a background for a poster or brochure. You've looked through all the standard clip art, and nothing seems to fit want you want. Why not make your own backgrounds using a blank canvas and the creative filters within Photoshop?

To create a background that does not draw attention away from the image, perform these steps.

1. Select File menu New. Photoshop will open the New dialog box, as shown in Figure 148.1.

Figure 148.1 The New dialog box in Photoshop defines the characteristics of the new document.

2. Create a new document with these characteristics:

 • Width and Height: 5 inches

 • Resolution: 150 pixels/inch

 • Mode: RGB Color

 • Contents: White

3. After you enter the changes, click the OK button. Photoshop will close the New dialog box and open the new document.

4. Click on the Swatches tab to open the Swatches palette, as shown in Figure 148.2.

Figure 148.2 The Swatches palette in Photoshop displays the default color palette.

5. Move your cursor into the Swatches palette until the cursor icon changes into an eyedropper tool. Clicking within the Swatches palette will automatically change the default foreground color in the toolbox. Move the eyedropper over one of the light blues and click once. Photoshop will change the default color to blue, as shown in Figure 148.3.

6. Hold down the Alt key (Option on Macintosh) and press the Delete key. Photoshop will fill the document with the default foreground color of blue.

7. Select Filter menu Noise and choose Add Noise. Photoshop will open the Add Noise dialog box, as shown in Figure 148.4.

8. In the Add Noise dialog box, click in the Amount field and enter a value of 30, or click and drag the triangular slider left or right until the Amount field changes to a value of 30.

9. Click to select Uniform Distribution.

Figure 148.3 The Swatches palette controls your default painting colors.

10. Do not place a check mark in the Monochromatic input box. (To add or remove a check mark, click in the input box to the left of the Monochromatic option.)

11. Click the OK button. Photoshop will close the Add Noise dialog box and perform the noise filter on the image, as shown in Figure 148.5.

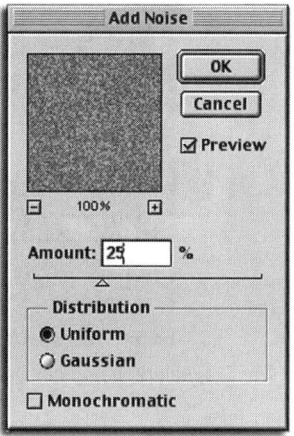

Figure 148.4 The Add Noise dialog box in Photoshop.

Figure 148.5 The Noise filter applied to the image.

12. Select Filter menu Texture and choose the Craquelure option. Photoshop will open the Craquelure dialog box, as shown in Figure 148.6.

Figure 148.6 The Craquelure dialog box controls the effects of the filter operation.

13. Modify the Craquelure options by clicking in the input fields and typing in a value or by dragging the triangular sliders located under the options left or right.

- Crack Spacing: 15

- Crack Depth: 6

- Crack Brightness: 9

14. Click on the OK button. Photoshop will close the Craquelure dialog box and perform the filter operation on the image, as shown in Figure 148.7.

Figure 148.7 The background image after application of the Craquelure filter.

This is just one of thousands of filter combinations that produce great backgrounds. Experiment, have some fun, and see what you can produce.

149 *Understanding How the Shear Tool Operates*

The Shear tool distorts an image along a curved line defined by the Shear dialog box. To use the Shear tool, perform these steps:

1. Open an image in Photoshop.

2. Select Filter menu Distort and choose the Shear option. Photoshop will open the Shear dialog box, as shown in Figure 149.1

3. The grid in the upper-left of the Shear dialog box controls the amount of shearing applied to the image. To add a point to the grid line, move your mouse into the grid and click once on the center vertical line. Photoshop will add an anchor point to the line. Click and drag the new anchor point left or right to shear the image. When you release your mouse, the effect of the shear displays in the image preview box, as shown in Figure 149.2.

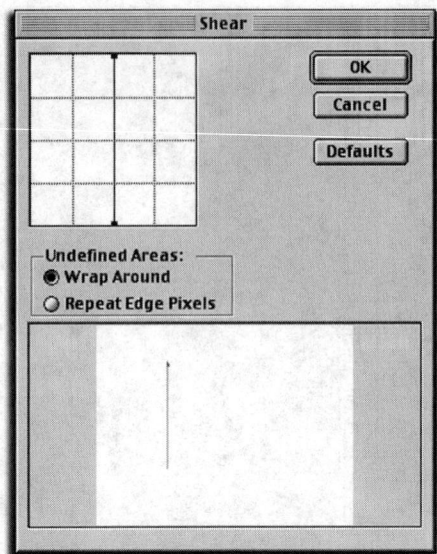

Figure 149.1 The Shear dialog box controls the characteristics of the Shear tool.

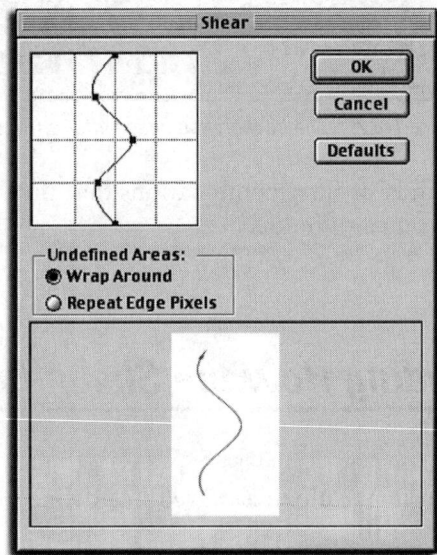

Figure 149.2 The grid in the Shear dialog box controls the amount of shearing applied to the image.

4. The only option available in the Shear dialog box is the Undefined Areas option. This option controls how Photoshop fills in the wrapped areas of the sheared image. The Wrap Around option will move the pixels pushed off the image and wrap them around to the opposite side. The Repeat Edge Pixels option will extend the colors of the pixels along the image's edge in the direction specified by the shear operation. Choose one of these options by clicking on the one of the two radio buttons.

5. Click the OK button to apply the shear to the image as shown in Figure 149.3, or click the Defaults button to reset the grid and start again.

Note: You can control the Shear tool by selecting an area of the image before selecting the Shear filter.

Figure 149.3 The Shear filter applied to a Photoshop image.

150 *Curving Text onto a Surface Using Shear*

The Shear tool is a special effects filter that bends image information along a predetermined grid line. In the preceding tip, you learned how the Shear filter works. Here is a practical application of why you would want to use the Shear tool: to bend text to fit a curved surface.

To bend text to fit a curved surface, perform these steps:

1. Open an image in Photoshop. In this example, you have a blank coffee cup, and you want to place text on its curved surface, as shown in Figure 150.1.

2. Click to select the Type tool in the Photoshop toolbox and create the text, as shown in Figure 150.2. For more information on creating text, see Tip 654, "Gaining Flexibility with Type Layers."

3. With the text layer selected, choose Edit menu Transform and select Rotate 90 CCW. Photoshop will rotate the text layer 90 degrees counterclockwise. This is necessary since the Shear filter only bends image information left or right.

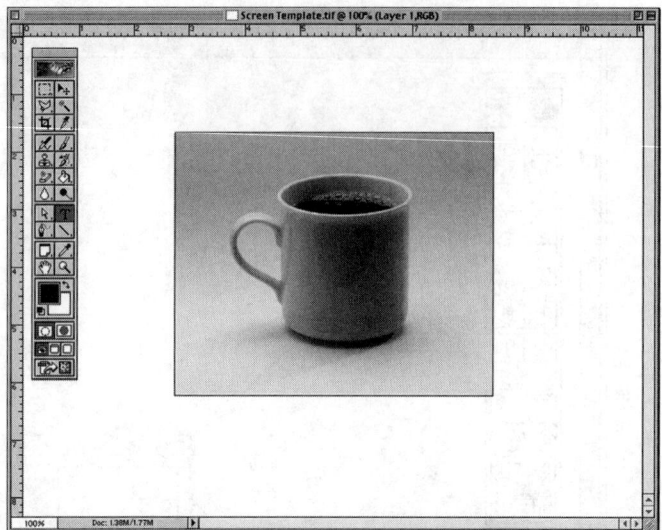

Figure 150.1 This coffee cup image needs the addition of some curved text.

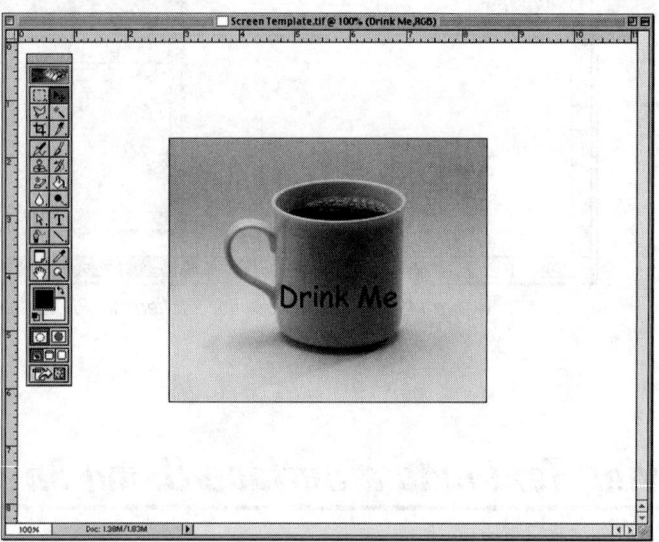

Figure 150.2 The text needs a curve to fit the surface of the cup.

4. With the text layer selected, select Filter menu Distort and choose the Shear option. Photoshop will open a warning dialog box, informing you that filters cannot be applied to a text layer and asking your permission to rasterize the layer. Click the OK button. Photoshop opens the Shear dialog box. For information on using the Shear filter, refer to the preceding tip. For greater control with the Shear filter, choose the Rectangular Marquee tool and create a selection around the text. Remember to include enough horizontal space between the text and the selection edge to contain the shearing of the text.

5. Move your cursor into the grid box and click once in the middle of the center vertical line. Photoshop will add an anchor point to the line. Click the new anchor point and drag it one-half grid line to the right, as shown in Figure 150.3. This will curve the text to the right.

6. Click the OK button. Photoshop will close the Shear dialog box and perform the Shear operation to the text.

7. Select Edit menu Transform and choose the Rotate 90 CW option. Photoshop will rotate the text back to its original horizontal position. Use the Move tool and place the text over the cup, as shown in Figure 150.4.

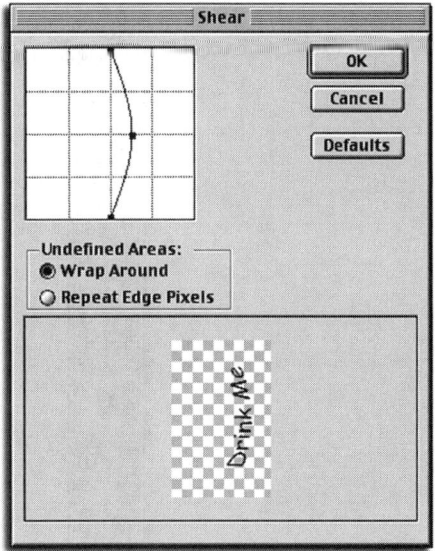

Figure 150.3 The Shear tool bends the image to the right, creating a curved look to the text.

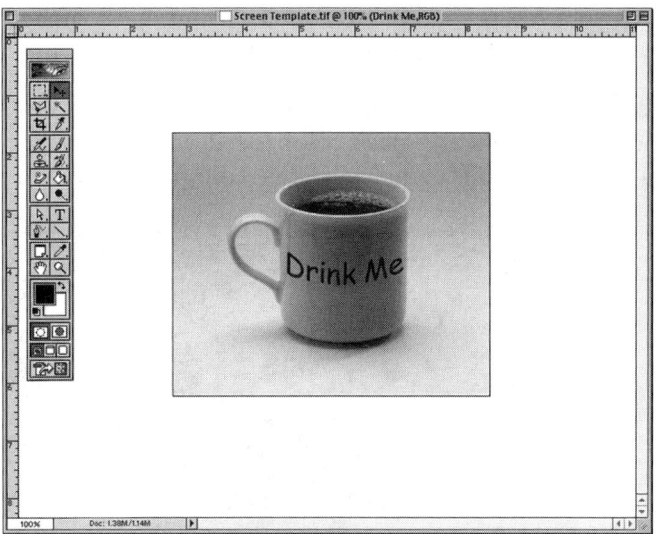

Figure 150.4 The curved text is applied to the surface of the cup.

151 *Working with Quick Mask*

The Quick Mask mode lets you select portions of a Photoshop image by using your paintbrush instead of the standard selection tools. To edit an image in Quick Mask mode, perform these steps:

1. Open an image in Photoshop.

2. Select the Paintbrush tool from the toolbox by clicking on the Paintbrush icon. For more information on using the Paintbrush tool, refer to Tip 78, "The Paintbrush and Pencil Tools."

3. Enter Quick Mask mode by clicking on the Quick Mask icon in the toolbox, as shown in Figure 151.1.

Figure 151.1 Clicking on the Quick Mask icon lets you select image areas with your paintbrush.

4. Select black as your foreground painting color. Painting the image with black, white, or a shade of gray creates a mask. By default, black masks the image and white unmasks the image.

5. Paint the area of the image you want to mask by clicking and dragging your mouse within the document window. By default, the mask color is red with 55 percent opacity. Continue painting until the area you want masked is completely covered in red, as shown in Figure 151.2.

Figure 151.2 The Quick Mask paints with an overlay of red.

6. To translate the mask back into a selection, click on the Standard Mode icon located to the left of the Quick Mask button (refer to Figure 151.1). The red overlay will turn into a standard selection defined by a dotted line, as shown in Figure 151.3.

Figure 151.3 *The Standard Mode translates the red mask into a standard dotted-line selection.*

7. To remove selection areas using Quick Mask, click the Quick Mask icon and paint the image using white. The white color will remove the red overlay from the image and accordingly reduce the mask. Return to standard editing mode by clicking the Standard Mode icon to view the results.

8. To modify the Quick Mask settings, double-click on the Quick Mask icon in the toolbox. Photoshop will open the Quick Mask Options dialog box, as shown in Figure 151.4.

Figure 151.4 *The Quick Mask Options dialog box controls the characteristics of the Quick Mask.*

- **Color Indicates:** This lets you choose whether the mask color indicates the mask or the area selected. Click on a radio button to make your choice.

- **Color:** The default mask color is red; however, if you want to change the mask color, click on the color box. Photoshop will open the Color Picker dialog box, as shown in Figure 151.5. Choose a new color by clicking within the color box and then clicking the OK button.

- **Opacity:** The Opacity option lets you change the transparency of the mask color. Click in the Opacity input field and enter a value from 0 to 100.

Figure 151.5 *The Color Picker in Photoshop lets you choose the color used to create the mask.*

152 *Understanding Masks in Photoshop*

Many features in Photoshop use a mask to control what they do. Masks produce an effect on an image in two ways: by using black and white or by using transparency. Quick Masks, Channel Masks, and Layer Masks all work with black and white or a shade of gray to determine the masked area. Clipping Groups (another form of image masking) use transparency to define the mask.

Clipping Groups and Layer Masks make areas of an image temporarily transparent. This lets you work on a complicated design like a photo collage without first erasing any of the pixel information. That gives you control and flexibility over time.

Quick Masks and Channel Masks do not make areas of an image transparent; instead, the mask transforms into a standard dotted-line selection. Since the selected area within a document window defines your workspace, Quick Masks and Channel Masks let you make complicated selections with ease.

Masks help create exotic borders around images (see Tip 379, "Using a Clipping Group to Create Exotic Edges"), and they can control the effect of a filter (see Tip 171, "Controlling Filters with Gradients").

Masks are a big part of Photoshop. Understanding how masks function gives you insight into how Photoshop operates.

153 *Combining Quick Mask with Traditional Selection Methods*

In Tip 151, "Working with Quick Mask," you learned how to work with the Quick Mask tool; however, the Quick Mask tool is best used when it is combined with other selection methods. If you have a selection to make in an image, instead of directly going into Quick Mask, try roughing the selection out with the Lasso tool or possibly the Magic Wand, as shown in Figure 153.1.

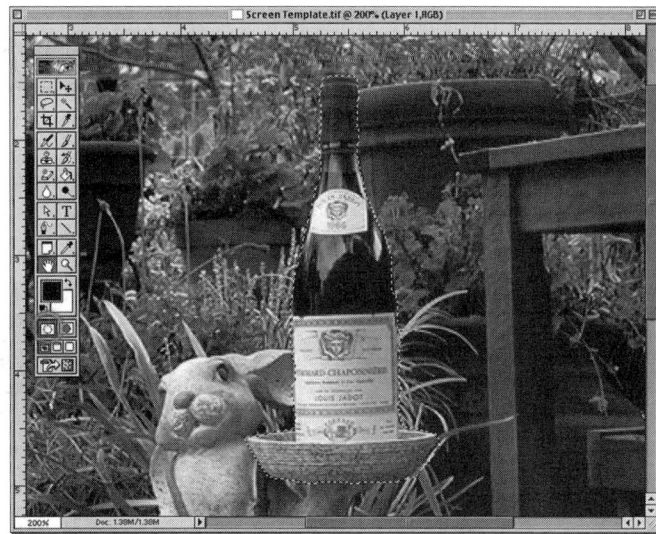

Figure 153.1 Using the Lasso tool to rough out the selection.

To edit the image, perform these steps:

1. Enter Quick Mask mode by clicking on the Quick Mask icon. Photoshop will display the image with a red (the default color) overlay, as shown in Figure 153.2. The areas of the image not overlaid with red indicate the selected areas.

2. Choose your paintbrush and paint the mask according to Tip 151. Painting the image in Quick Mask gives you the control you need to select difficult areas.

3. To view your work as a dotted-line selection, click the Standard Mode icon in the toolbox (refer to Tip 151). Photoshop transforms the painted mask into a selection.

4. Switch between Standard and Quick Mask modes to refine the selection.

Using standard editing tools along with Quick Mask gives you the ability to make complicated selections with speed and accuracy.

Figure 153.2 Using the Quick Mask mode, complete the selection by masking and unmasking the image using your paintbrush.

154 *Creating Vector Paths with the Pen Tool*

Photoshop contains a new and improved Pen tool that lets you create complicated vector-based paths. Vector paths are composed of straight or curved anchor points that are connected together with line segments, as shown in Figure 154.1.

Figure 154.1 Vector paths are segment lines connected together by anchor points.

To use the Pen tool, perform these steps:

1. Open an image in Photoshop.

2. To display the Pen tool options, click and hold (or right-click) your mouse on the Pen tool icon in the Photoshop toolbox. Photoshop will open a fly-out menu displaying the available options, as shown in Figure 154.2. Click on the Pen tool option to make it the default tool.

Figure 154.2 The Pen tool options in the Photoshop toolbox.

When you first move the Pen tool into the document window, you see a small "x" located at the bottom right of the tool. This indicates that the pen path is a new path and is not connected to another preexisting path. The Pen tool displays several icons to inform you of what will happen when you click your mouse.

- An "x" in the lower-right corner of the Pen icon indicates a new pen path. Clicking once within a document window will start a new path by creating the first anchor point.

- A "/" in the lower-right corner of the Pen icon indicates that your cursor is over an existing anchor point. Clicking once will connect an anchor point to the segment and will let you continue creating the shape.

- An "o" in the lower-right corner of the Pen icon indicates that you have moved over the first anchor point in the shape. Clicking once will close the shape and let you begin creating another path.

- A "+" in the lower-right corner of the Pen icon indicates that you have moved over a segment line (the line between anchor points). Clicking once adds an anchor point to the segment line.

- A "−" in the lower-right corner of the Pen icon indicates that you are over an existing anchor point. Clicking once will remove that anchor point from the vector shape.

- If you do not see an identifying icon in the lower-right corner of the Pen tool, clicking once will create another anchor point connected by a segment path to the previous anchor point.

Click once with the Pen tool to create a straight anchor point. Segment lines between straight anchor points will be straight lines, as shown in Figure 154.3.

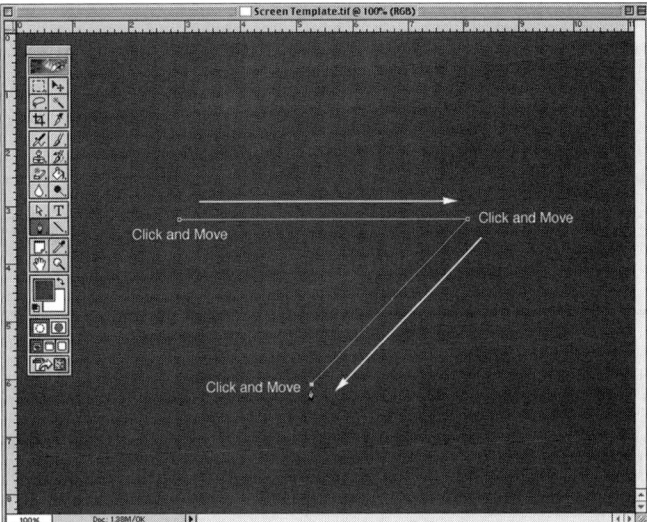

Figure 154.3 Clicking once with the Pen tool creates a straight-line anchor point.

3. Click and drag with the Pen tool to create a curved anchor point. As you drag your mouse, two lines pull away in opposite directions from the anchor point. These lines extending outward from the anchor point are the direction lines. Direction lines control the bend of the segment.

4. Depending on how much you drag your mouse, segment lines connecting curved anchor points will bend, as shown in Figure 154.4. Using curved anchor points is the secret to creating segment lines that wrap around curved images.

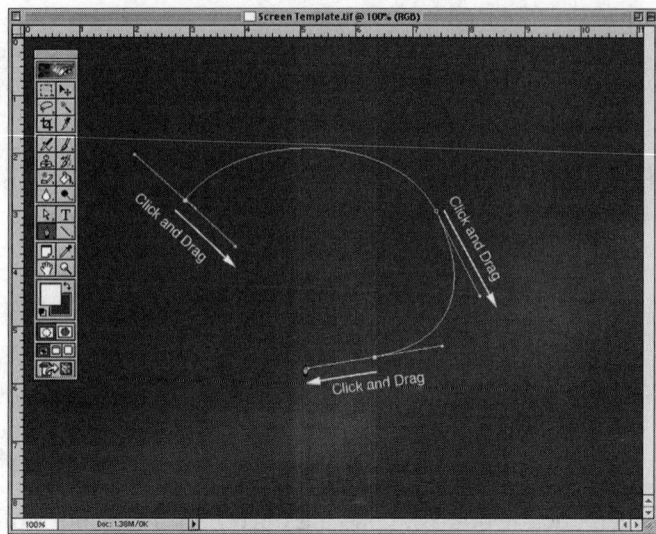

Figure 154.4 Curved anchor points create curved segment lines.

Pen paths perform many functions in Photoshop:

- Pen paths create clipping paths around images to generate a transparent edge. See Tip 478, "Saving Files with Clipping Paths."

- Pen paths convert easily into complicated selections. See Tip 475, "Creating Selections from Vector Paths."

- Pen paths create stroked or filled areas within a Photoshop image. See Tip 479, "Using Paths with the Stroke Command."

155 *Adding, Subtracting, and Converting Anchor Points on a Pen Path*

In the preceding tip, you learned about the basic functions of the Pen tool. You can add, subtract, and create straight or curved anchor points. However, once the shape closes, you lose the ability to modify the shape with the Pen tool. Fortunately, Photoshop also thought of this and gave us additional tools to modify an existing path.

To modify an existing path, click and hold (or right-click) your mouse on the Pen tool icon in the Photoshop toolbox. Photoshop will display the Pen tool options. Three of the Pen options help control a shape after it is closed.

- **Add Anchor Point tool:** Adds anchor points to an existing pen path. Move the Add tool over any segment line (the line connecting anchor points) and click once to add a new anchor point.

- **Delete Anchor Point tool:** Deletes anchor points on an existing pen path. Move the Delete tool over an existing pen point and click once to delete the anchor point. Photoshop will compensate the shape by snapping the segment lines to the remaining anchor points.

- **Convert Anchor Point tool:** Converts straight anchor points to curved anchor points and vice versa. Click once on a curved anchor point to convert it back to a straight anchor point. The direction lines will snap back to the anchor, and the lines extending out from the point will be straight. To convert a straight anchor point to a curved anchor point, move over an existing straight anchor and click and drag your mouse.

The Convert Anchor Point tool will also let you click on the direction lines to further control the bend of the line segment, as shown in Figure 155.1.

Figure 155.1 The Convert Anchor Point tool lets you control the bend and shape of the segment lines within a vector path.

156 *Using the Freeform Pen Tool to Create a Work Path*

The Freeform Pen tool lets you draw lines within a Photoshop document, based on the movement of your mouse. The Freeform Pen tool is similar to the Magnetic Pen tool (refer to Tip 139, "Using the Magnetic Pen Tool"); however, the Freeform Pen does not snap to an edge color.

To use the Freeform Pen tool, perform these steps:

1. Open a graphic image in Photoshop.

2. Click and hold (or right-click) your mouse on the Pen tool icon in the Photoshop toolbox. Photoshop will open a fly-out menu containing the Pen tool options, as shown in Figure 156.1. Click on the Freeform Pen Tool option to make it the default tool.

3. To draw a Freeform Pen path, move your cursor into the document window and click and drag your mouse. As you move, Photoshop draws a vector path based on the movement of your mouse, as shown in Figure 156.2.

4. To close the shape, drag the pen cursor to the starting anchor point and release the mouse. Photoshop will create a closed work path.

5. To create an open shape, release your mouse anywhere within the document window except on the starting anchor point. Photoshop will create an open work path.

Figure 156.1 The Pen tool options on the Photoshop toolbox.

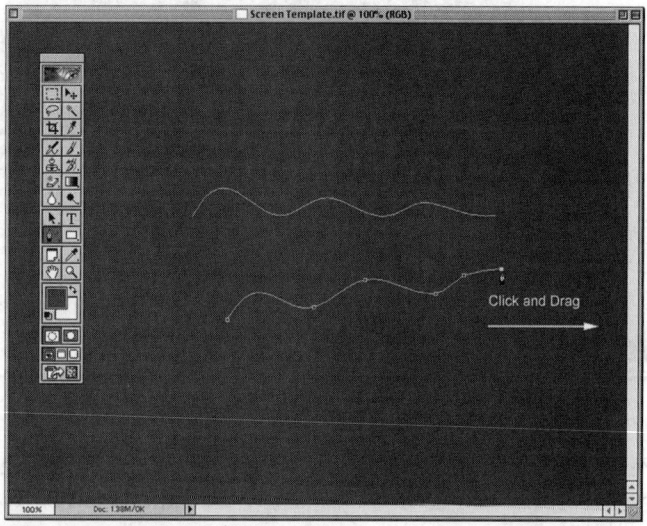

Figure 156.2 The Freeform Pen tool draws a vector path based on the movement of your mouse.

6. When you are using the Freeform Pen tool, you have several options available from the Options bar, as shown in Figure 156.3.

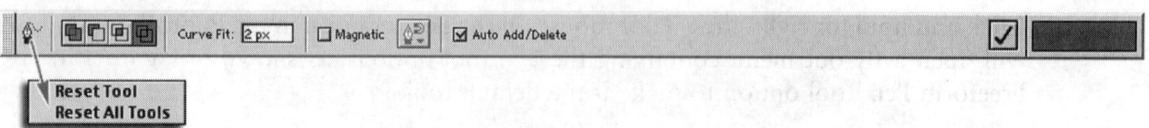

Figure 156.3 The Options bar displays the available options for the Freeform Pen tool.

- **Resetting the Tool:** Click on the Freeform Pen tool icon located on the far left of the toolbar (refer to Figure 156.2). Photoshop will open a fly-out menu that gives you the option to reset either the current tool or all tools in the Photoshop toolbox back to their default values.

- **Create a New Shape Layer:** This is the first button to the right of the Tool Reset option. When this option is active, paths drawn with the Freeform Pen tool convert automatically into shape layers. For more information on Shape layers, see Tip 686, "Working with Shape Layers."

- **Create a New Work Path (default):** This is the second button to the right of the Tool Reset option. When this option is active, paths drawn with the Freeform Pen tool convert into Photoshop work paths.

- **Curve Fit:** Controls how sensitive the final path is to the movements of your mouse. Click in the Curve Fit input box and enter a value from 0.5 to 10.0. The higher the value, the fewer anchor points are used to create the work path.

- **Magnetic:** Selection of the Magnetic option converts the Freeform Pen tool into the Magnetic Pen tool (refer to Tip 139, "Using the Magnetic Pen Tool").

- **Auto Add/Delete:** Select this option when you want to add or delete anchor points from a work path using the Freeform Pen tool. Move over a path segment (the straight or curved line connecting two anchor points) with the Freeform Pen tool and click to add an anchor point. Move over an existing anchor point and click to remove that anchor point from the work path.

Note: You cannot control the addition of anchor points while you are using the Freeform Pen tool; however, once the work path is completed, it can be modified just like any other Photoshop work path. For information on modifying a path, see Tip 308, "Using the Direct Selection Tool."

157 *Converting Pen Paths into Permanent Paths*

When you draw using any of the Pen tools, you create a temporary work path. All work paths are stored in the Paths palette. Photoshop only lets you have one work path in a document. If you begin creating a new work path without saving the old path, Photoshop will automatically delete the old path and replace it with the new one. Therefore, it is important to understand that you can save paths.

To convert a temporary work path into a permanent path, perform these steps:

1. Open the Paths palette. To view the Paths palette, click on the Paths tab. Photoshop will display the Paths palette, as shown in Figure 157.1. If you do not see the Paths tab, select Window menu View Paths to open the Paths palette.

Figure 157.1 Clicking on the Paths tab activates the Paths palette and displays a list of all available paths.

2. In the Paths palette, locate the path named "Work Path." Double-click on the Work Path. Photoshop will open the Save Path dialog box, as shown in Figure 157.2.

Figure 157.2 Enter a name into the Save Path dialog box to permanently save the work path.

3. Click in the Name input field and enter a name for the work path. Click the OK button when you are finished. Photoshop will close the Save Path dialog box, and your path is now a permanent part of the image.

4. Creating another path with any of the Pen tools automatically creates another Work Path in the Paths palette. If you want to save this path, repeat the preceding steps.

158 *Using the Blur Tool*

The Blur tool is one of a group of tools defined as Focus tools. While the Blur tool makes a great approximation of blurring an image, it is important to understand what happens to an image when you use the Blur tool. Using the Blur tool on an image does not create a true out-of-focus image. That can only be achieved in a darkroom using the original image. The Blur tool creates the illusion of focus by softly feathering image colors; feathering the colors within an image creates the illusion of the image being out of focus.

To use the Blur tool, perform these steps:

1. Open an image in Photoshop.

2. Click and hold (or right-click) your mouse on the Focus tool icon. Photoshop will display the Focus tool options, as shown in Figure 158.1. Click on the Blur option to make it the default tool.

3. Move your cursor into the document window and click and drag your mouse over the area you want to take out of focus. The more you move the Blur tool over an area, the more intense the effect. Release your mouse to end the blur process.

4. When you are using the Blur tool, you have several options available from the Options bar, as shown in Figure 158.2. Modifying these options changes the way the Blur tool performs.

 • **Resetting the Tool:** Click on the Blur tool icon located on the far left of the toolbar (see Figure 158.2). Photoshop will open a fly-out menu that gives you the option to reset either the current tool or all tools in the Photoshop toolbox back to their default values.

 • **Brush:** The size and shape of the brush control the area blurred within an image. To change to another brush size, click on the black triangle located to the right of the brush icon. Photoshop will open the brush palette. Click on a brush to make it the default brush. For more information on using the Brush palette, see Tip 188, "Defining the Brush Palette."

Figure 158.1 The Focus tool options in the Photoshop toolbox.

Figure 158.2 The Options bar displays the available options for the Blur tool.

- **Mode:** Click on the Mode button to display a list of available blending modes. Clicking on one of the available options changes the default blending mode of the Blur tool. For more information on blending modes, see Tip 234, "Using Blending Modes to Influence the Painting Tools."

- **Pressure:** The Pressure option does not influence what the Blur tool does, only how long it takes for the tool to work. Click in the Pressure input box and type in a value from 1 to 100, or click the black triangle to the right of the input box and drag the slider left or right. The higher the value, the faster the tool works.

- **Use All Layers:** Selecting this option causes the Blur tool to blend pixel information from all visible layers. Deselect this option if you only want to blur the pixels in the active layer.

- **Brush Dynamics:** Brush Dynamics help link a pressure-sensitive drawing tablet to Photoshop. For more information on brush dynamics, see Tip 191, "Using Brush Dynamics."

159 *Correcting Dust and Scratches with the Blur Tool*

The Blur tool is one of those great Photoshop tools that can perform multiple functions. Its primary function is, of course, to give the visual impression of a blurred image. However, it can do many more

jobs such as helping remove dust and scratches from an old image. The Blur tool does its best job of removing dust and scratches in areas that do not contain a lot of image detail.

To use the Blur tool to remove dust and scratches from an image, perform these steps:

1. Open an image in Photoshop that contains dust and scratches.

2. Click and hold (or right-click) your mouse on the Focus tool option in the Photoshop toolbox. Photoshop will display the Focus tool options (refer to Figure 158.1 in the preceding tip). Click on the Blur tool option to make it the default tool.

3. When you use the Blur tool, you have several options available from the Options bar, as shown in Figure 158.2 in the preceding tip. To remove dust and scratches, make these changes to the Blur options:

 • **Resetting the Tool:** Click on the Blur tool icon located on the far left of the toolbar (refer to Figure 158.2). Photoshop will open a fly-out menu that gives you the option to reset either the current tool or all tools in the Photoshop toolbox back to their default values. Click the Reset Tool option to reset the Blur tool back to its default values.

 • **Brush:** Removing dust and scratches requires a small, soft brush. Click on the black triangle located to the right of the Brush icon. Photoshop will open the Brush palette. Click on one of the small, soft brushes in the second row, as shown in Figure 159.1.

Figure 159.1 For removal of dust and scratches, choose one of the small, soft brushes in the second row.

 • **Mode:** Click on the Mode button. Photoshop will display the Mode options. Click on the Darken option, as shown in Figure 159.2.

4. To remove dust and scratches from the image, move your mouse cursor over a scratch. Click and drag your mouse, making small circular motions, until the scratch blends into the image, as shown in Figure 159.3.

Note: To remove dark scratches from an image, click on the Mode button in the Options bar and select Lighten.

Note: Image areas containing detail require more aggressive techniques such as using the Clone Stamp (see Tip 605, "Using the Clone Stamp Tool").

Figure 159.2 Choose Darken as the Mode for the Blur tool.

Figure 159.3 Using the Blur tool can greatly simplify the process of removing dust and scratches from an image.

160 *Blending Two Objects Together with the Blur Tool*

In the preceding tip, you learned how the Blur tool works to restore images containing dust and scratches. Here is another way to use this versatile tool: to visually blend two or more objects into the same Photoshop document.

Photographic documents do not contain knife-edges because the colors between two objects will blend slightly; this is called fractualization of the image's color space. What this describes is the natural tendency of the edge colors of an image to blend into the background. Images with sharp edges have what is called a cut, copy, and paste look to them.

When you create a multi-layered document in Photoshop, like a photo collage, you move several images from different Photoshop documents into one single document window. To give the image the appear-

ance of blending the graphic images together, use the Blur tool on the edge of the image to soften its transition.

To use the Blur tool to create a blended effect, perform these steps:

1. Open or create a multilayer document containing several objects, as shown in Figure 160.1. For more information on combining two or more images into one Photoshop document, see Tip 683, "Moving Layers Between Documents."

Figure 160.1 *The sharp edges of the image in the separate layer makes the images appear to have a cut, copy, and paste appearance.*

2. Select the Blur tool from the Photoshop toolbox (refer to Tip 158, "Using the Blur Tool").

3. When you use the Blur tool to soften the transition of objects, you will need to modify the characteristics of the Blur tool, as shown in Figure 158.2.

 • **Resetting the Tool:** Click on the Blur tool icon located on the far left of the toolbar (refer to Figure 158.2). Photoshop will open a fly-out menu that gives you the option to reset the current tool, or all tools in the Photoshop toolbox, back to its default value.

 • **Brush:** Softening the edge of a graphic requires a soft brush. Click on the black triangle located to the right of the Brush icon. Photoshop will open the Brush palette. Click on one of the small, soft brushes in the second row, as shown in Figure 159.1 in the preceding tip.

 • **Use All Layers:** This is the trick to making the transition look natural. Click in the Use All Layers input box to activate this option.

4. Select the layer containing the image you want to blend. See Tip 348, "Viewing and Selecting Layers," for more information on selecting layers.

5. Move your mouse cursor over the edge of the image and, using small round strokes, move along the edge. Since you selected the Use All Layers option, the Blur tool will use the active layer containing the graphic and the underlying layer containing the background to blend the image pixels, as shown in Figure 160.2.

Figure 160.2 The Blur tool makes images appear more natural by blending the edge pixels to create a smooth visual transition.

161 *Choosing the Fill*

In Photoshop, the Fill command is a versatile tool that lets you select and area of an image and fill that area with a color or even a predefined pattern.

To use the Fill option on a Photoshop image, perform these steps:

1. Open a graphic image in Photoshop.

2. Choose a selection tool and select the areas of the image that you want to fill, as shown in Figure 161.1. See Tip 280, "Selection Methods," for more information on selection techniques.

Figure 161.1 Selecting areas of an image before using the Fill command controls what areas of the image change.

3. Select the Edit menu Fill command. Photoshop will open the Fill dialog box, as shown in Figure 161.2.

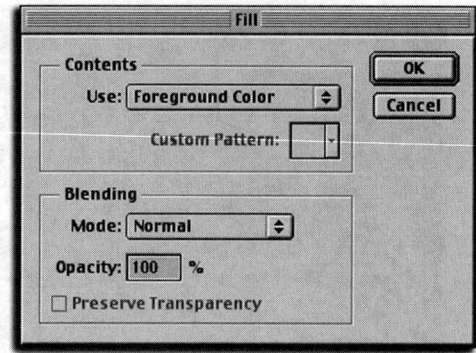

Figure 161.2 The Fill dialog box controls how the fill color or pattern applies to the image.

4. Several options available from the Fill dialog box to control how the fill applies to the image. Click the Use button to display a list of available color or pattern options.

- **Foreground Color:** Click this option to fill the selected area with the current foreground color.

- **Background Color:** Click this option to fill the selected area with the current background color.

- **Custom Pattern:** This option makes available a Custom Pattern button. Click the Custom Pattern button to display a list of all available patterns. Select a pattern by clicking once on the desired pattern.

- **History:** Click this option to fill the selected area with the current History state. For more information on History states, see Tip 404, "Filling a Selection with a History State."

- **Black:** Click this option to fill the selected area with the color black.

- **50% Gray:** Click this option to fill the selected area with 50% gray.

- **White:** Click this option to fill the selected area with the color white.

- **Mode:** Click the Mode button to display a list of Blending Mode options. Click to select a different blending mode. For more information on blending modes, see Tip 687, "Working with Layer Blending Modes."

- **Opacity:** This defines the transparency of the fill in a percentage. Click in the input field and enter a value from 1 to 100. The lower the number, the more transparent the image fill.

- **Preserve Transparency:** Select this option when you want to protect all the transparent pixels within a Photoshop image. When selected (placing a check mark in the input box) the Fill command will not work on the transparent pixels in a layer.

5. Click the OK button to perform the Fill command. Photoshop will close the Fill dialog box and perform the fill operation, as shown in Figure 161.3.

Note: It is not necessary to select areas of an image before performing a fill. Using the Fill command on a layer without any selected areas will cause the Fill command to fill the entire layer. The selection process gives you control over where the fill occurs.

Figure 161.3 Clicking the OK button in the Fill dialog box causes Photoshop to perform the fill.

162 *Using the Burn Tool to Restore Blown-Out Highlights in an Image*

The Photoshop toolbox contains two Toning tools: the Dodge tool and the Burn tool. These tools alternately lighten or darken pixel information within a graphic image and are very useful for correcting underexposed and overexposed photos.

You may have an image in which some of the highlights appear too bright, as in Figure 162.1.

Figure 162.1 To correct excessive highlights in an image, use the Burn tool.

To work with the Burn tool, perform these steps:

1. Open an image containing excessive highlight areas.

2. Click and hold (or right-click your mouse) on the Toning tool icon. Photoshop will display a fly-out menu with a list of options. Click on the Burn tool option to make it the default tool.

3. There are several options available in the Options bar to help you control the Burn tool, as shown in Figure 162.2.

Figure 162.2 *The Options bar controls the characteristics of the Burn tool.*

- **Resetting the Tool:** Click on the Burn tool icon located on the far left of the toolbar (see Figure 162.2). Photoshop will open a fly-out menu that gives you the option to reset either the current tool or all tools in the Photoshop toolbox back to their default values. Click on the Reset Tool option to reset the Burn tool.

- **Brush:** The size and shape of the brush control the area affected by the Burn tool. To change to another brush size, click on the black triangle located to the right of the Brush icon. Photoshop will open the Brush palette. Click on a brush to make it the default brush. The Burn tool performs best when using a soft brush. For more information on using the Brush palette, see Tip 188, "Defining the Brush Palette."

- **Range:** The Range option selects the brightness range of the pixels to change. Choose Midtones to affect the middle range of grays. Choose Shadows to affect the darker areas of the image. Choose Highlights to affect the lighter areas of the image. Unless the image contains an unusual amount of dark or light pixels, leave this option on Midtones.

- **Exposure:** The Exposure option does not influence what the Burn tool does, only how long it takes for the tool to perform the operation. Click in the Exposure input box and type in a value from 1 to 100, or click the black triangle to the right of the input box and drag the slider left or right. The higher the value, the faster the tool works.

- **Brush Dynamics:** Brush Dynamics help link a pressure-sensitive drawing tablet to the Burn tool. For more information on brush dynamics, see Tip 191, "Using Brush Dynamics."

4. Move the Burn tool into the document window and click and drag your mouse over the highlights you want to darken. To produce a good visual effect, use smooth circular motions and release the mouse occasionally to see how the work is progressing.

5. The size and shape of the brush control the area affected by the Burn tool; however, time also controls the Burn tool. Moving the tool slowly over an area will cause more darkening of the pixel data than moving quickly across the same area. In addition, brush strokes will always overlap. The area of overlap will receive more darkening than areas not overlapped, as shown in Figure 162.3.

Figure 162.3 *Correcting image highlights requires a steady hand and a thorough knowledge of the Burn tool.*

163 *Controlling Ink Saturation with the Sponge Tool*

The Sponge tool controls the saturation of the inks within an image. You may have an image that contains areas requiring additional saturation of the inks, as shown in Figure 163.1.

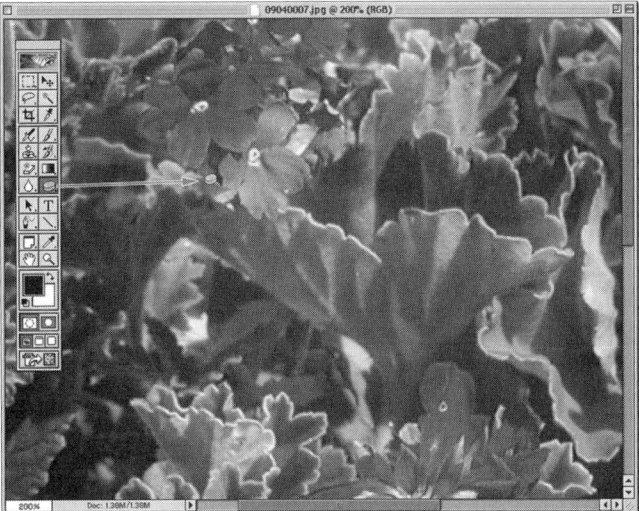

Figure 163.1 *To increase or decrease the saturation of the inks within an image, use the Sponge tool.*

To increase or decrease the saturation of the inks in an image, perform these steps:

1. Open the image in Photoshop.

2. Click and hold (or right-click) your mouse on the Toning tool icon. Photoshop will display a fly-out menu with the Toning tool options, as shown in Figure 163.2. Click on the Sponge tool option to make it the default tool.

Figure 163.2 The Toning tools in the Photoshop toolbox.

3. The Options bar displays the options for controlling the characteristics of the Sponge tool, as shown in Figure 163.3.

Figure 163.3 The Options bar controls the characteristics of the Sponge tool.

- **Resetting the Tool:** Click on the Sponge tool icon located on the far left of the toolbar (see Figure 163.3). Photoshop will open a fly-out menu that gives you the option to reset either the current tool or all tools in the Photoshop toolbox back to their default values. Click on the Reset Tool option to reset the Sponge tool.

- **Brush:** The size and shape of the brush control the area affected by the Sponge tool. To change to another brush size, click on the black triangle located to the right of the Brush icon. Photoshop will open the Brush palette. Click on a brush to make it the default brush. The Sponge tool performs best when using a soft brush. For more information on using the Brush palette, see Tip 188, "Defining the Brush Palette."

- **Desaturate/Saturate:** Click the Mode button and select Desaturate to reduce the saturation of the inks within an image, or select Saturate to increase the saturation of the inks within an image. In this example, you are using the Saturate option.

- **Pressure:** The Pressure option does not influence what the Sponge tool does, only how long it takes for the tool to perform the operation. Click in the Pressure input box and type in a value from 1 to 100, or click the black triangle to the right of the input box and drag the slider left or right. The higher the value, the faster the tool works.

- **Brush Dynamics:** Brush Dynamics help link a pressure-sensitive drawing tablet to the Sponge tool. For more information on brush dynamics, see Tip 191, "Using Brush Dynamics."

4. Move the Sponge tool into the document window and place it over the pixels requiring saturation. Click and drag your mouse in a circular motion. One technique is to start in the middle of the affected area and drag your mouse in a clockwise or counterclockwise spiral.

5. The size and shape of the brush control the area affected by the Sponge tool; however, time also controls the Sponge tool. Moving the Sponge tool slowly over an area will cause the effect to be more pronounced than moving quickly across the same area. In addition, brush strokes will always overlap. The area of overlap will receive more application of the tool than areas not overlapped.

A proper understanding of the Sponge tool will result in images with restored color, as shown in Figure 163.4.

Figure 163.4 The Sponge tool restores the balance of color within an image by increasing or decreasing the saturation of the inks.

164 *Using the Eyedropper Tool*

The Eyedropper tool samples color within any open document window and transfers that color to the foreground or background color in the Photoshop toolbox. You use the eyedropper by clicking once inside a Photoshop image. The point at which you clicked the mouse cursor becomes the sample point for the color selection.

To select the Eyedropper tool, click and hold (or right-click) your mouse on the Eyedropper icon in the Photoshop toolbox. Photoshop will display the Eyedropper options, as shown in Figure 164.1. Click on the Eyedropper tool option to make it the default tool.

With the Eyedropper tool selected, the Options bar displays the available options for the tool, as shown in Figure 164.2.

Figure 164.1 The Eyedropper options in the Photoshop toolbox.

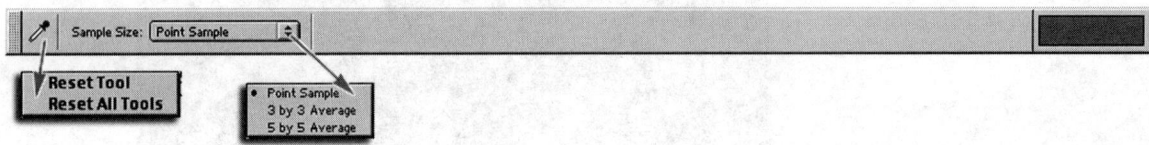

Figure 164.2 The Options bar displays the options available for the Eyedropper tool.

- **Resetting the Tool:** Click on the Eyedropper tool icon, located on the far left of the toolbar (refer to Figure 164.2). Photoshop will open a fly-out menu that gives you the option to reset either the current tool or all tools in the Photoshop toolbox back to their default values. Click on the Reset Tool option to reset the Eyedropper tool.

- **Point Sample:** Click on the Sample Size button and select Point Sample to sample the pixel directly under the mouse cursor.

- **3 by 3 Average:** Click on the Sample Size button and select 3 by 3 Average to average a grid of pixels 3 wide by 3 tall, or 9 pixels.

- **5 by 5 Average:** Click on the Sample Size button and select 5 by 5 Average to average a grid of pixels 5 wide by 5 tall, or 25 pixels.

If you choose one of the Average sample methods, the Eyedropper uses your mouse click as the center point of the averaged area. It then adds all the pixel values together to arrive at the correct color.

By default, clicking with the Eyedropper tool changes the foreground color. To change the background color with the Eyedropper tool, hold the Alt key (the Option key on Macintosh) and click the Eyedropper tool within a document window. The background color will change instead of the foreground color.

165 *Working with the Magic Eraser*

The Magic Eraser works by changing all similar pixels within a Photoshop image. If you select the Magic Eraser and click inside an image layer, the Magic Eraser will erase (make transparent) all similar pixels. If the image is in a background, Photoshop will convert the background into a layer before erasing the pixel information.

The Magic Eraser is a sampling tool. Clicking within the image with the Magic Eraser generates the sample pixel. The Eraser tool then uses that sample to control what pixels to erase.

To use the Magic Eraser, perform these steps:

1. Open a Photoshop graphic image.

2. Click and hold (or right-click) your mouse on the Eraser icon in the Photoshop toolbox. Photoshop will display the Eraser tool options, as shown in Figure 165.1. Click on the Magic Eraser Tool option to make it the default tool.

Figure 165.1 The Eraser options in the Photoshop toolbox.

3. With the Magic Eraser selected, the Options bar displays all available options to control the characteristics of the tool, as shown in Figure 165.2.

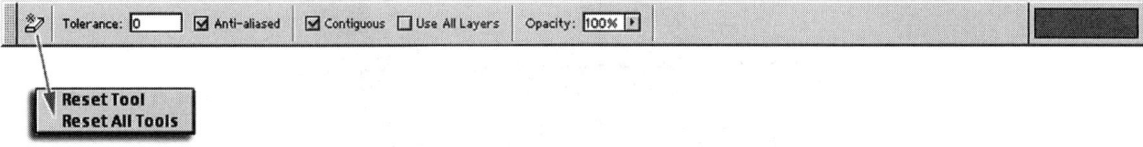

Figure 165.2 The Options bar displays the options available for the Magic Eraser tool.

- **Resetting the Tool:** Click on the Magic Eraser icon located on the far left of the toolbar (see Figure 165.2). Photoshop will open a fly-out menu that gives you the option to reset either the current tool or all tools in the Photoshop toolbox back to their default values. Click on the Reset Tool option to reset the Magic Eraser tool.

- **Tolerance:** The Tolerance option controls the number of pixels erased. Each pixel in a Photoshop image contains a brightness number of 0 to 255. When you click within a Photoshop document, the pixel directly under the Magic Eraser becomes the sample. The Tolerance option decides how many steps of brightness to erase based on the sample pixel. Click in the Tolerance field and enter a number from 0 to 255. The higher the number, the more pixels (steps of brightness) the Magic Eraser will select.

- **Anti-aliased:** The Anti-aliased option creates a visually smooth eraser by softening the edge where erasing occurs. To create an exact (jagged) eraser, deselect this option. To deselect the Anti-aliased option, click once in the input box to remove the check mark.

- **Contiguous:** Deselecting the Contiguous option (removing the check mark from the input box) causes the Magic Eraser to erase all pixels of similar value throughout the image, as shown in Figure 165.3. Selecting the Contiguous option erases an area surrounding the sample pixel (where you clicked the mouse), as shown in Figure 165.4.

Figure 165.3 Using the Magic Eraser tool with the Contiguous setting not selected will erase all pixels within the defined range throughout the image.

Figure 165.4 The same image with the Contiguous option selected only affects the pixels surrounding the sampled area.

- **Use All Layers:** The Use All Layers option, if selected (by placing a check mark in the input box), will erase all pixels of similar value in every visible layer. If Usc All Layers is deselected (by removing the check mark from the input box), only the active layer will be affected.

- **Opacity:** The Opacity option controls the transparency of the erased pixels. An Opacity setting of 100 (default) completely erases the selected pixels. Enter a value from 1 to 100. The lower the value, the less transparent the remaining pixels of the erased area will be.

166 *Understanding the Paint Bucket Tool*

The Paint Bucket tool shares a similar feature with the Magic Eraser and the Magic Wand: They all use a Tolerance value to determine how they perform. The Magic Eraser erases areas of an image based on color value, the Magic Wand selects areas of an image based on color value, and the Paint Bucket fills areas of an image with color based on color value.

When you select the Paint Bucket tool and click inside a Photoshop image, the Paint Bucket samples the pixel directly under the Paint Bucket and records its color value. The color values of pixels range from 0 to 255. Photoshop compares the color value of the sampled pixel to the Tolerance setting in the Options bar, as shown in Figure 166.1.

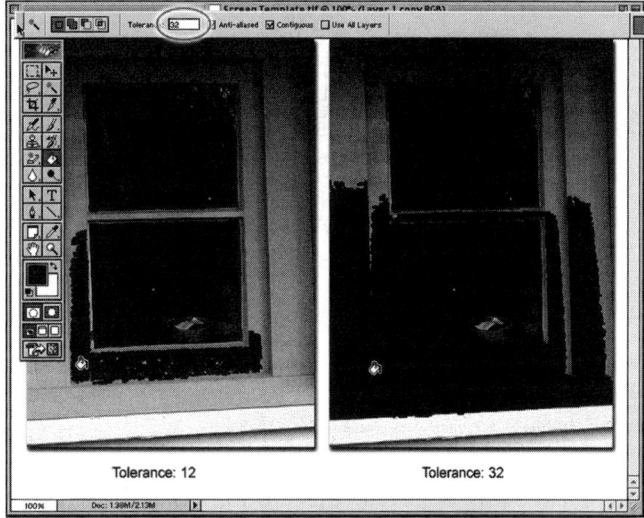

Figure 166.1 When using the Paint Bucket, the Tolerance setting controls the amount of fill applied to the image.

The Paint Bucket fills an area with color information based on the Tolerance setting. When the color value of the image pixels exceeds the Tolerance setting, the Paint Bucket stops performing the fill.

Note: Color value is only one of the components that define the color of a pixel. Sometimes referred to as "brightness," the color value measures the brightness of the pixel from black (0) to white (255).

167 *Controlling the Paint Bucket*

In the preceding tip, you learned how the Paint Bucket performs its fill; however, understanding how to control the Paint Bucket makes this a valuable timesaving tool.

To select the Paint Bucket tool, perform these steps:

1. Click and hold (or right-click) your mouse on the Paint Bucket icon in the Photoshop toolbox. Photoshop will display the available options for the icon, as shown in Figure 167.1. Click on the Paint Bucket option to make it the default tool.

Figure 167.1 The Paint Bucket options, located on the Photoshop toolbox.

Note: In Photoshop 6.0, the Paint Bucket and Gradient tools are grouped together under the same button in the Photoshop toolbox. Depending on what tool you used last, you will see either the Paint Bucket or the Gradient tool.

2. With the Paint Bucket tool selected, the Options bar displays all available options for the Paint Bucket, as shown in Figure 167.2. Changing the Paint Bucket options lets you control exactly how the tool performs.

 • **Resetting the Tool:** Click on the Paint Bucket tool icon located on the far left of the toolbar (see Figure 167.2). Photoshop will open a fly-out menu that gives you the option to reset either the current tool or all tools in the Photoshop toolbox back to their default values. Click on the Reset Tool option to reset the Paint Bucket tool.

 • **Fill:** Choose between using the foreground color or a predefined pattern by clicking on the Fill button and selecting Foreground or Pattern.

 • **Pattern:** If you selected Pattern as the Fill option, the Pattern option becomes available. Click on the Pattern button to choose a predefined pattern.

 • **Mode:** Click the Mode button to display a list of available blending modes. For more information on blending modes, see Tip 687, "Working with Layer Blending Modes."

Figure 167.2 The Options bar displays the available options for the Paint Bucket tool.

- **Opacity:** The Opacity option controls the transparency of the painted pixels. An Opacity setting of 100 (default) completely paints over the selected pixels. Enter a value from 1 to 100. The lower the value, the less the image pixels will be affected by the Paint Bucket.

- **Tolerance:** The Tolerance option controls the number of pixels affected by the Paint Bucket. Each pixel in a Photoshop image contains a color value of 0 to 255. When you click within a Photoshop document, the pixel directly under the Paint Bucket becomes the sample. The Tolerance option decides how many steps of color value to paint based on the sample pixel. Click in the Tolerance field and enter a number from 0 to 255. The higher the number, the more pixels (color values) the Paint Bucket will select.

- **Anti-aliased:** The Anti-aliased option creates a visually smooth image by softening the edge where painting occurs. To create an exact (jagged) Paint Bucket fill, deselect this option. To deselect the Anti-aliased option, click once in the input box to remove the check mark.

- **Contiguous:** The Contiguous option selects an area surrounding the sample pixel (where you clicked the mouse). Deselecting the Contiguous option (removing the check mark from the input box) causes the Paint Bucket to select all pixels of similar value throughout the image.

- **All Layers:** The All Layers option influences the color value of the sampled pixel. When you select the All Layers option, the Paint Bucket tool will sample the pixel under the cursor in the active layer and all underlying layers. When the option is deselected (default), the Paint Bucket will only sample the pixels in the active layer.

For more information on controlling the Paint Bucket, see Tip 684, "Controlling a Paint Bucket Fill with Layers."

168 *Using the Background Eraser*

The Background Eraser lets you erase pixels to transparency. Since backgrounds cannot contain transparent pixels, using the Background Eraser on a Background automatically converts the background into a layer.

The Background Eraser is not a simple eraser; it is a powerful tool that assists you in making complicated erasers within a Photoshop image while at the same time protecting other portions of the image.

The Background Eraser works by sampling the image. When you select the Background Eraser and click inside a Photoshop graphic, the Background Eraser samples the color value of the pixel directly under the cursor. That value is then used to determine the pixels to erase and those to preserve.

To select the Background Eraser tool, click and hold (or right-click) your mouse on the Eraser icon in the Photoshop toolbox. Photoshop will display the Eraser tool options within a fly-out menu, as shown in Figure 168.1. Click on the Background Eraser Tool to make it your default tool.

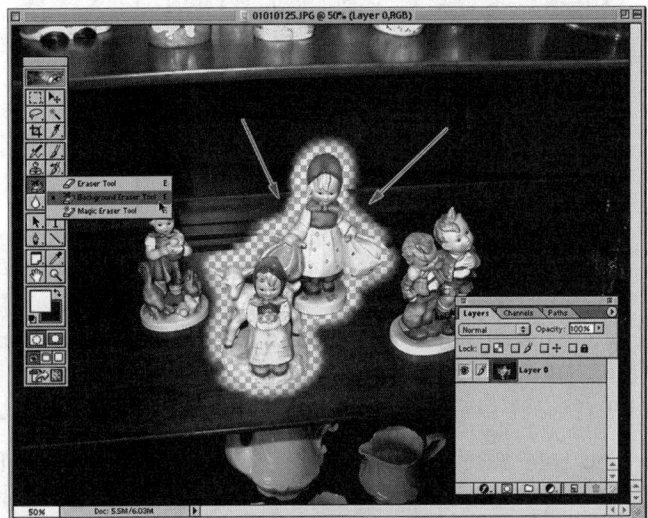

Figure 168.1 The Eraser options in the Photoshop toolbox.

With the Background Eraser selected, the Options bar displays all available options for the tool, as shown in Figure 168.2.

Figure 168.2 The Options bar displays the available options for changing the characteristics of the Background Eraser tool.

- **Resetting the Tool:** Click on the Background Eraser tool icon located on the far left of the toolbar (see Figure 168.2). Photoshop will open a fly-out menu that gives you the option to reset either the current tool or all tools in the Photoshop toolbox back to their default values. Click on the Reset Tool option to reset the Background Eraser tool.

- **Brush:** The size and shape of the brush control the area affected by the Background Eraser tool. To change to another brush size, click on the black triangle located to the right of the Brush icon. Photoshop will open the Brush palette. Click on a brush to make it the default brush. For more information on using the Brush palette, see Tip 188, "Defining the Brush Palette."

- **Limits:** Click on the Limits button to display the available choices. Discontiguous erases all sampled pixels wherever they occur in the graphic image. Contiguous erases the sampled color and all other similar pixels that connect to one another. Find Edges erases the sample pixels while preserving the sharpness of shape edges.

- **Tolerance:** Click in the Tolerance input field and type a value from 0 to 100, or click the black triangle to the right of the input box and drag the slider left or right. The Tolerance field is directly linked to the color value of the pixels in the image. The higher the value in the Tolerance field, the more pixels are erased by the Background Eraser; the lower the value, the fewer pixels are erased.

- **Protect Foreground Color:** Selecting this option prevents the Background Eraser from erasing any colors in an image that match the current color in the Foreground Swatch box.

- **Sampling:** Click on the Sampling button and choose a sampling method. The Continuous option continually samples the pixels under the cursor as you drag you mouse. The Once option will only sample the pixels the first time you click your mouse. The Background Swatch option only erases pixels matching the Background color box.

- **Brush Dynamics:** Brush Dynamics help link a pressure-sensitive drawing tablet to the Background Eraser tool. For more information on brush dynamics, see Tip 191, "Using Brush Dynamics."

After modifying the Background Eraser options, move your cursor into the document and position the Background Eraser icon directly over the pixels you want to erase. Your Background Eraser resembles a round cursor with a plus sign at the center. The plus sign represents from where the cursor will sample the colors in the image. Click and drag your mouse in the image to perform the erase operation. Clicking and dragging again within the image resamples the pixel information. Remember that the Background Eraser erases image information based on the sample pixel.

For more information on using the Background Eraser tool, see Tip 548, "Using the Background Eraser to Erase the Edge of an Image."

169 *Using the Standard Eraser Tool*

There has always been an Eraser tool in Photoshop, and although the other eraser tools may have more flexibility and power, the standard Eraser performs several standard eraser functions.

The standard Eraser tool erases or paints areas of a Photoshop image. If you click and drag the eraser tool within a Background, it will paint the current Background color over the erased portions of the image. If you click and drag the Eraser tool within a layer, it will convert the selected pixels to transparent.

To select the Eraser tool, perform these steps:

1. Click and hold (or right-click) your mouse on the Eraser icon. Photoshop will display the Eraser options in a fly-out menu.

2. Select the Eraser tool from the available options. You control the Eraser tool by selecting from the available options on the Options bar, as shown in Figure 169.1.

Figure 169.1 The Options bar displays the available options for the Eraser tool.

- **Resetting the Tool:** Click on the Eraser tool icon located on the far left of the toolbar (see Figure 169.1). Photoshop will open a fly-out menu that gives you the option to reset either the current tool or all tools in the Photoshop toolbox back to their default values. Click on the Reset Tool option to reset the Eraser tool.

- **Brush:** The size and shape of the brush control the area affected by the Eraser tool. To change to another brush size, click on the black triangle located to the right of the Brush icon. Photoshop will open the Brush palette. Click on a brush to make it the default brush. See Tip 188, "Defining the Brush Palette," for more information on using the Brush palette.

- **Mode:** The Eraser tool works by emulating one of three painting tools: the Paintbrush, Airbrush, or Pencil. Click on the Mode button to select one of these three options. The forth option, Block, erases areas of an image based on a square cube, not a round paintbrush. Selecting the Block option disables the Brush palette and the Opacity settings.

- **Opacity:** The Opacity option controls the transparency of the erased pixels. An Opacity setting of 100 (default) completely erases the selected pixels. Enter a value from 1 to 100.

- **Wet Edges:** The Wet Edges option simulates moving the Eraser tool through an image containing wet paint. The effect softens the edge of the erased area in the same way that wet paint would bleed back onto a canvas.

- **Erase to History:** The Erase to History option changes the Eraser tool into a paintbrush that paints using the current History State.

- **Brush Dynamics:** Brush Dynamics help link a pressure-sensitive drawing tablet to the Eraser tool. For more information on brush dynamics, see Tip 191, "Using Brush Dynamics."

170 *Understanding How the Magic Wand Works*

The Magic Wand is one of those indispensable Photoshop tools that, if used correctly, make complicated selections a snap.

The Magic Wand selects information within a Photoshop image by the color value of the sampled pixel. When you move the Magic Wand cursor into the image and click once, you create the sample pixel. The Magic Wand uses the sample pixel to determine how much pixel information to select.

To select the Magic Wand, click once on the Magic Wand icon in the Photoshop toolbox, as shown in Figure 170.1.

The Options bar displays all the available options for the Magic Wand tool, as shown in Figure 170.2. You control the Magic Wand by modifying one or more of these options.

Figure 170.1 Clicking on the Magic Wand icon makes it the default tool.

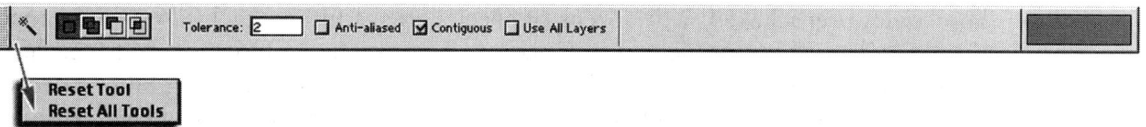

Figure 170.2 The Magic Wand options on the Options bar.

- **Resetting the Tool:** Click on the Magic Wand icon located on the far left of the toolbar (see Figure 170.2). Photoshop will open a fly-out menu that gives you the option to reset either the current tool or all tools in the Photoshop toolbox back to their default values. Click on the Reset Tool option to reset the Magic Wand tool.

The next four buttons control how the Magic Wand adds or subtracts pixels to an existing selection (refer to Figure 170.2). Moving from left to right, these are the available options.

- **New Selection (default):** With this button selected, each use of the Magic Wand within an image creates a new selection.

- **Add to Selection:** Each click of the Magic Wand within an image adds pixels to the previous selection.

- **Subtract from Selection:** Each new click of the Magic Wand within an image subtracts pixels from the previous selection.

- **Intersect with Selection:** Clicking the Magic Wand within an image containing a previous selection generates a new selection based on an intersection of the two.

Once you have selected how the Magic Wand adds or subtracts pixel information, select from the following options to further define the actions of the tool.

- **Tolerance:** The Tolerance option controls the number of pixels selected. Each pixel in a Photoshop image contains a brightness number of 0 to 255. When you click within a Photoshop document, the pixel directly under the Magic Wand becomes the sample. The Tolerance option decides how many steps of color value to select based on the sample pixel. Click in the Tolerance field and enter a number from 0 to 255. The higher the number, the more pixels (color values) the Magic Wand will select.

- **Anti-aliased:** The Anti-aliased option creates a visually smooth selection by feathering the edge where selection occurs. To create an exact (jagged) selection, deselect this option. To deselect the Anti-aliased option, click once in the input box to remove the check mark.

- **Contiguous:** The Contiguous option selects an area surrounding the sample pixel (where you clicked the mouse). Deselecting the Contiguous option (removing the check mark from the input box) causes the Magic Wand to select all pixels of similar value throughout the image.

- **Use All Layers:** The Use All Layers option, if selected (by placing a check mark in the input box), will create the sample pixel based on the active layer and any visible layers under the active layer. If Use All Layers is deselected (by removing the check mark from the input box), the sample pixel is selected from the active layer.

For more information on the use of the Magic Wand, see Tip 284, "Using the Magic Wand."

171 *Controlling Filters with Gradients*

Photoshop comes prepackaged with dozens of special effects filters. Each filter, when applied, changes or modifies the pixels in a graphic image. Once you have applied a filter to an image, the effect of that filter is controllable by the use of the Fade command (see Tip 508, "Blending Filter Effects"). However, the area affected by a filter is controllable by first selecting an area of an image with one of Photoshop's selection tools and then applying the filter, as demonstrated in Figure 171.1.

Figure 171.1 Selecting a specific area of an image controls where the effects of a filter are applied.

The trick here is to understand that selections do not have to be 100 percent opaque. For instance, you can feather the edge of a selection to produce a softer edge. When a filter encounters an area that is not 100 percent selected, it reduces the effect of the filter based on the percentage of the image area selected, as shown in Figure 171.2. If an area within an image is 50 percent selected, the maximum effect of the filter is 50 percent.

Figure 171.2 Feathering softens the jagged edge of a selection.

There are several ways in Photoshop to reduce the opacity of a selected area, but one of the most versatile ways is to use the Gradient tool and blending modes. This effect is called a three-layer filter or a filter sandwich.

Say you have a photo and you want to apply a Gaussian blur; however, you do not want the entire image to receive the blur filter, just a portion. A filter sandwich will produce the effect you want without changing the image pixels, and it will still give you control to modify the image at a later time.

To create a filter sandwich, perform these steps:

1. Open a photo in Photoshop.

2. Make a copy of the image layer by clicking and dragging the layer icon over the New Layer button, as demonstrated in Tip 376, "Making a Pixel-to-Pixel Copy of a Layer." The Layers palette now displays two layers: the original image and an exact copy, as shown in Figure 171.3.

Figure 171.3 The Layers palette in Photoshop displays an icon for each layer within the active document.

3. To simplify the process, you will rename the individual layers. Double-click on the bottom layer in the Layers palette. Photoshop will open the Layer dialog box. Click in the Layer Name field and type the name "original." Click the OK button. Photoshop will close the Layer dialog box, and the layer's name changes to "original."

4. Repeat the naming process for the top layer and name it "duplicate."

In the Layers palette, select the bottom layer (original) by clicking once on the layer name.

5. Render the top layer transparent by clicking on the layer's visibility icon, as shown in Figure 171.4. Although the image will not change, the top layer is now transparent.

Figure 171.4 The eye icon within the Layers palette controls the layer's visibility.

6. Now you need to do something to the original layer. Select the Image menu Adjust option and choose Threshold. Photoshop will display the Threshold dialog box, as shown in Figure 171.5.

Figure 171.5 The Threshold dialog box controls the amount of black and white applied to the active layer or selection.

7. The Threshold option changes the image by defining the pixels as either black or white. Click in the Threshold Level input box and enter a number from 0 to 255, or click and drag the triangular slider to the left or right. Increasing the threshold increases the number of black pixels in the image; decreasing the number increases the number of white pixels. Select a threshold that divides the image into black and white. In this example, you decreased the threshold value to 125 as shown in Figure 171.5.

8. With the bottom layer selected, click on the new layer icon to create a new layer. See Tip 233, "Controlling Your Work with Layers." Photoshop will create a new transparent layer directly above the active layer. You now have a new layer "sandwiched" in between your original layer and duplicate layer, as shown in Figure 171.6.

Figure 171.6 The new layer you created separates the top layer from the bottom layer.

9. In the Layers palette, right-click your mouse on the new layer. Photoshop will open the Layer Styles dialog box. Click in the Layer Name field and rename the layer to "gradient." Click on the OK button to the close the Layer Styles dialog box and record the name change.

10. Select the middle layer (gradient) by clicking once on the layer's name. This layer is going to control the visual blending process.

11. From the toolbox, select the Gradient tool. Refer to Tip 82, "The Gradient Tool," and set your default colors to black and white by pressing the letter "D" on your keyboard.

12. Move your mouse cursor to the upper-left corner of the document window, drag down to the lower-right corner, and release your mouse. The Gradient tool paints with a gradient of black to white, as shown in Figure 171.7.

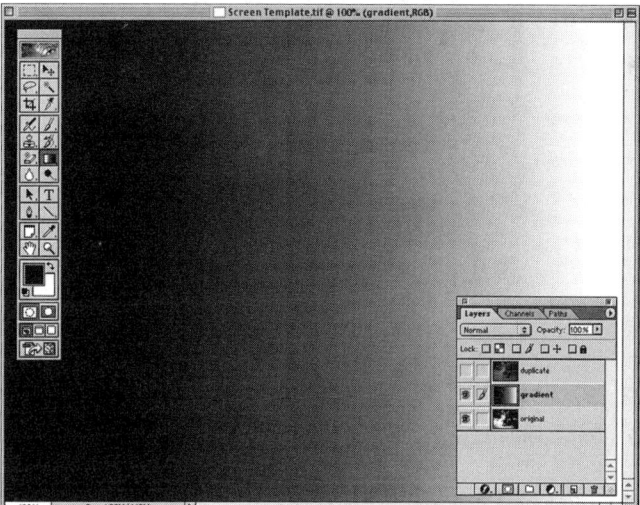

Figure 171.7 Clicking and dragging the Gradient tool across the document window creates a black-to-white gradient.

13. Select the top layer (duplicate) by clicking on the layer name in the Layers palette.

14. Locate the Blending Mode button in the top left of the Layers palette (it should currently say Normal). This button controls the blending mode of the layer. Click the Blending Mode button. Photoshop will display a list of available blending modes. Click and choose Multiply. Photoshop will use the gradient layer to control the visible image. The visible image fades from right to left. The visible parts of the image correspond to the white areas of the gradient mask. The areas of the image fading to black, correspond to the areas of the gradient layer moving toward black, as shown in Figure 171.8.

Figure 171.8 The Multiply blending mode works with the gradient layer to display a portion of the image.

15. Now, here's the trick that will restore the left portion of the image. Click once on the gradient layer. Click the Blending Mode button and choose the Screen option. The bottom-right portion of the image will display the image you changed to threshold and will fade it into the original image, as shown in Figure 171.9.

Figure 171.9 The combination of blending modes and the gradient layer controls what you see of the two images.

As you can see, the blending modes of Multiply and Screen acted on the "sandwiched" gradient layer to produce the effect of combining two separate layers. You can control what areas of each image are visible by using the Gradient tool to redraw the gradient layer.

172 *Working with the Gradient Options*

The Gradient tool in Photoshop lets you create gradual blends using two or more colors. Clicking and dragging the Gradient tool across a graphic image controls the length and direction of the gradient fill.

To select the Gradient tool, click on the Gradient tool icon in the Photoshop toolbox, as shown in Figure 172.1.

Figure 172.1 The Gradient tool icon in the Photoshop toolbox.

Note: *The Gradient tool is grouped with the Paint Bucket tool. If you see the Paint Bucket tool instead of the Gradient tool, click and hold (or right-click) your mouse on the Paint Bucket tool. Photoshop will display a fly-out menu with the Paint Bucket and Gradient tool options. Click on the Gradient tool option to make it the default tool.*

With the Gradient tool selected, the Options bar displays the available options used to control the tool, as shown in Figure 172.2.

Figure 172.2 The Options bar displays the available options for the Gradient tool.

- **Resetting the Tool:** Click on the Gradient tool icon located on the far left of the Options bar (see Figure 172.2). Photoshop will open a fly-out menu giving you the option to reset either the current tool or all tools in the Photoshop toolbox back to their default values. Click on the Reset Tool option to reset the Gradient tool.

- **Gradient Picker:** Click on the black triangle located to the right of the Gradient Picker button. Photoshop will display a list of all available gradients, as shown in Figure 172.2. Click on a gradient to make it the default gradient.

Figure 172.2 The Gradient Picker displays a list of all available gradient options.

- **Gradient Selector:** Click on one of the Gradient Selector buttons to select a linear, radial, angled, reflected, or diamond gradient, as shown in Figure 172.3.

Linear Angled Diamond

Radial Reflected

Figure 172.3 Select a gradient from the available options.

- **Mode:** Click on the Mode button. Photoshop will display a list of all available blending modes. For more information on blending modes, see Tip 173, "Using Gradients with Layer Blending Modes."

- **Opacity:** The Opacity option controls the transparency of the gradient pixels. Setting the opacity to 100 percent (the default) completely paints over the selected pixels. Select a value from 1 to 100. The lower the value, the less the image pixels will be affected by the Paint Bucket.

- **Reverse:** Selecting the Reverse option (by placing a check mark in the Reverse input box) reverses the gradient colors 180 degrees. Say you create a linear gradient from black to white; selecting the Reverse option draws the gradient from white to black.

- **Dither:** Selecting the Dither option (by placing a check mark in the Dither input box) softens the color transition of the gradient fill. Dithering mixes the pixels of all available colors to simulate a softer transition between the colors created in the gradient fill. The Dither option helps reduce banding in a gradient fill.

- **Transparency:** Selecting the Transparency option (by placing a check mark in the Transparency input box) lets the Gradient tool use transparent pixels as part of the gradient fill. If left unchecked, the Gradient tool fills whole image areas with a solid color. Since transparent pixels are a feature of a layer and not a background, the Transparency option does not work on a background.

173 *Using Gradients with Layer Blending Modes*

In the preceding tip, you leaned how to control the Gradient tool with the use of the Options bar. One of the interesting techniques to use with the Gradient tool is combining it with a different blending mode.

Refer to the preceding tip and select the Gradient tool. On the Options bar, click on the Mode button. Photoshop displays a list of available blending modes, as shown in Figure 173.1.

Figure 173.1 The available blending modes for the Gradient tool.

Blending Mode options control how the Gradient tool interacts with the pixels within a graphic image. The default mode of Normal causes the Gradient tool to perform without interaction with the image pixels. Say you choose to place a linear gradient of black to white on an image. With Normal selected as the blending mode, the gradient fill will completely cover the image pixels. When you choose a different blending mode, the pixels within the image react with the colors used in the gradient fill, producing a completely different result.

One creative way to use the Mode option is to fade an image from color to black and white.

Refer to the preceding tip to select the Gradient tool and perform these steps:

1. Click on the Gradient tool icon located on the far left of the Options bar. Photoshop will open a fly-out menu giving you the option to reset either the current tool or all tools in the Photoshop toolbox back to their default values. Click on the Reset Tool option to reset the Gradient tool.

2. In the Options bar, click on the black triangle located to the right of the Gradient Picker to display a list of preset gradients. (Refer to Figure 172.2.)

3. Select the black to transparent linear gradient (the second gradient option in the top row) by clicking it once.

4. Click on the Mode button. Photoshop displays a list of available blending modes. Click on Color to make it the default-blending mode.

5. Move your cursor into the document window and click and drag your mouse from the top left of the image down to the bottom right, as shown in Figure 173.2.

Figure 173.2 Clicking and dragging the Gradient tool across the image with the Color blending mode selected.

6. When you release the mouse, the image changes. The top left of the graphic image is now black and white and slowly fades back into color.

7. The Color blending mode forces the image pixels to take on the hue and saturation of the gradient color while maintaining their own luminance. Since you blended the image using black, the image areas covered with the black gradient converted into shades (luminance) of black and white. The areas covered by the transparent part of the gradient did not change and, therefore, maintained their original color.

You can vary the effect by choosing a different gradient, varying the length and direction of the gradient stroke, or changing the blending color.

174 *Creating a Gradient Fill Layer*

In the preceding tip, you learned how to create a special effect by using the Gradient tool with the Blending Mode option. The one restriction to changing the blending mode of the Gradient tool is a fundamental lack of control over the image pixels. Using the Gradient tool on an image layer changes the pixels of the image, and your future options of controlling the image are limited.

You can produce the same effects of the Gradient tool by using a separate layer.

Using the preceding tip, select and set up the Gradient tool for a black to transparent fill, but do not create the fill before performing these additional steps:

1. Create a new layer directly above the layer containing the image to which you want to apply the gradient. See Tip 233, "Controlling Your Work with Layers." Your Layers palette now contains a blank layer, as shown in Figure 174.1.

Figure 174.1 Clicking on the New Layer icon creates a new layer in the Layers palette.

2. Now, with the new layer selected, click and drag your Gradient tool from the top left of the document window to the lower right. The Gradient tool creates a gradient of black to transparent pixels, as shown in Figure 174.2.

Figure 174.2 The Gradient tool applied to the new layer.

3. In the Layers palette, click on the Layer Blending Mode button. Photoshop displays a list of available layer blending modes, as shown in Figure 174.3.

Figure 174.3 The Layer Blending Mode button displays all available blending modes.

4. Click to choose the Color blending mode. The blending mode options will close, and the image within the document window changes. The areas previously displayed as solid black now display as black and white, as shown in Figure 174.4.

Figure 174.4 The layer blending mode Color converts the solid black pixels in the gradient fill layer to shades of gray within the image.

Although the visual effect is the same as applying the Gradient tool directly to the image pixels, the difference is control. Since the gradient fill is contained within a separate layer, you have control over the image.

This method also gives you a way to experiment with different blending modes without actually changing the image pixels.

175 *Creating Custom Gradients*

In the preceding tip, you learned how to use the Gradient tool with the preset gradient options. Photoshop 6.0 comes with sophisticated gradient editing tools that lets you create new gradients or edit existing gradients.

To access the Gradient Editor, perform these steps:

1. Select the Gradient tool by referring to Tip 172, "Working with the Gradient Options."

2. Move your mouse into the Options bar and click once on the visible gradient, not the black triangle. Photoshop will open the Gradient Editor dialog box, as shown in Figure 175.1.

Figure 175.1 The Gradient Editor dialog box lets you create or modify gradients.

3. To create a new gradient, first select a preset gradient that most closely matches the appearance you are looking for in your new gradient.

4. You can modify a gradient using the Gradient Editor options:

 • **Name:** Click in the Name input field and enter the name of the gradient.

 • **Gradient Type:** Click on the Gradient Type button to choose a Solid or Noise gradient. For this example, select the Solid option.

 • **Smoothness:** Click in the Smoothness input field and enter a value of 0 to 100 to control the blend of the gradient colors. The higher the value, the smoother the transition of the gradient colors. This option helps to reduce the "stepped" appearance of some gradients.

 • **Gradient Window:** The Gradient window, located directly below the Smoothness option, contains a visual display of the new gradient.

 • **Opacity Stops:** Located directly above the Gradient window, the Opacity Stops control the transparency of the gradient colors. Click on an existing Opacity Stop to edit that stop or click directly above the Gradient window to create a new Opacity Stop, as shown in Figure 175.2.

Figure 175.2 The Opacity Stops control the transparency of the gradient color.

To edit an Opacity Stop, click once on one of the existing Opacity Stops. The Opacity and Location options become available, as shown in Figure 175.2.

- **Opacity:** Click in the Opacity field and enter a value from 0 to 100 to change the opacity of the gradient. The lower the number, the greater the transparency of the color.

- **Location:** Click in the Location field and enter a value from 0 to 100 to change the horizontal location of the Opacity Stop, or manually click and drag the Opacity icon left or right.

- **Color Stops:** The Color Stop icons represent the physical colors used in the gradient. The Color Stop icons are located directly under the Gradient window, as shown in Figure 175.3.

 To modify a Color Stop, click on one of the existing Color Stop icons. The Color and Location options become available, as shown in Figure 175.3. To create a new Color Stop, click once directly below the Gradient window.

- **Color:** Click within the Color input field. Photoshop will open the Color Picker dialog box, as shown in Figure 175.4.

 Select a color from the Color Picker dialog box and then click the OK button. Photoshop will close the Color Picker dialog box, and the selected color is now the default color of the selected Color Stop. You can also select a color directly from the Swatches palette by moving your mouse into the Photoshop Swatches palette and clicking on a color.

- **Location:** Click in the Location field and enter a value from 0 to 100 to change the horizontal location of the Color Stop, or manually click and drag the Color Stop icon left or right.

- **Midpoint Icons:** Located directly between the Color Stops and the Opacity Stops are the Midpoint icons. These small diamond-shaped icons control the midpoint for blending two Color Stops or the transparency between two Opacity Stops. Click on the Midpoint icons and drag the icons left or right to control how the gradient colors and the transparency of the colors interact with the gradient.

Figure 175.3 The Color Stop icons define the physical colors used in the gradient.

Figure 175.4 The Color Picker dialog box lets you change the color of the selected Color Stop.

5. When you have made all your changes to the new gradient, click on the New button within the Gradient dialog box. Photoshop creates a new gradient icon.

6. Click on the OK button to record the changes. The new gradient is now selectable from the Gradient Presets.

176 *Loading and Creating Custom Gradient Palettes*

In the preceding tip, you learned how to create your own custom gradients. When you create a custom gradient, it becomes a permanent part of the Gradient Presets. The Presets are available every time you open Photoshop. Therefore, it is a good idea to create and save custom sets of gradients and load them when needed.

To save a set of custom gradients, perform these steps:

1. Access the Gradient Editor (refer to the preceding tip) and create a custom set of gradients.

2. Click on the Save button in the Gradient Editor dialog box. Photoshop will display the Save dialog box, as shown in Figure 176.1.

Figure 176.1 The Save dialog box lets you save custom gradient palettes.

3. Click in the Name field, enter a name for the gradient palette, and click the Save button. Photoshop will close the dialog box and save the custom palette.

Note: It is a good idea to save all your custom palettes within the same folder. This will make it easier to locate them when needed.

4. To load a previously saved gradient set, open the Gradient Editor dialog box (again, refer to the preceding tip) and click on the Load button. Photoshop displays the Load dialog box, as shown in Figure 176.2.

Figure 176.2 The Load dialog box lets you select and use a previously created set of custom gradients.

5. Locate the folder containing the custom gradient and click once on the gradient file name.

6. Click once on the Load button. Photoshop will close the Load dialog box and append the custom gradient file onto the existing Presets.

177 *Controlling the Transparency of a Gradient with Layers*

In Tip 175, "Creating Custom Gradients," you learned how to control the transparency of the colors within a gradient fill. However, using the Gradient Editor to control color transparency causes you to lose a measure of control over the image. Instead, you achieve a higher degree of control by doing the gradient fill within a separate layer.

Refer to Tip 174, "Creating a Gradient Fill Layer," and create the same gradient fill layer with one exception: Do not change the blending mode of the new layer to Color. Leave the layer blending mode on Normal.

You will see an image similar to Figure 177.1. The upper-left areas of the image are covered by the black gradient color.

Figure 177.1 The Gradient tool applied to a separate layer.

The Layers palette controls the opacity of each layer. With the gradient layer selected, click in the Opacity input field and enter a number from 0 to 100 to control the opacity of the gradient layer, or click on the black triangle located to the right of the Opacity input field and drag the slider left or right. The lower the opacity value, the more transparent the layer becomes, as shown in Figure 177.2.

Figure 177.2 The Opacity option on the Layers palette controls the transparency of the pixels within that layer.

Using a layer to control opacity, as opposed to creating a gradient with a semitransparent color, gives you more control over the final project.

178 *Creating a Gradient from Colors Within an Image*

In Tip 175, "Creating Custom Gradients," you learned how to create a custom gradient. The Gradient Editor lets you choose colors from Photoshop's Color Picker or from the Swatches palette. However, you can also select colors directly from the document window of any open graphic image.

To select the colors for a custom gradient directly from a document image, open a graphic file in Photoshop and, performing the steps in Tip 175, open and create a new gradient.

Click on the Color Stop of the gradient color you want to change and move your mouse cursor into the open graphic image. Your cursor turns into an eyedropper tool. Click anywhere within the graphic. The Color Stop changes to the selected color, as shown in Figure 178.1.

Figure 178.1 Clicking within the document window changes the color of the selected Color Stop.

To record the change, click the OK button in the Gradient Editor. Photoshop will close the dialog box and record the change to the gradient.

> *Note: The ability to choose a color from the open document window is true for any open document. If you have two separate graphic images open, the Gradient Editor will let you select a color from either of the open graphic images.*

179 *Creating a Multicolor Wash*

You can use the Gradient tool to create a multicolored wash. A multicolored wash is several applications of the Gradient tool within a single layer.

To create a multicolored wash, perform these steps:

1. Open a graphic image in Photoshop.

2. Select the Gradient tool and choose the black to transparent preset gradient. (Refer to Tip 174, "Creating a Gradient Fill Layer.")

3. Create a new layer by clicking on the New Layer button in the Layers palette, as shown in Figure 179.1.

Figure 179.1 Clicking on the New Layer icon automatically creates a new (transparent) layer in the Layers palette.

4. With the new layer selected, move the Gradient tool to the upper-left corner of the document window, click and drag toward the center of the graphic, and release the mouse. The Gradient tool paints a fading black from the upper left to the center, as shown in Figure 179.2.

Figure 179.2 The first application of the gradient tool applies a wash of black from the upper left to the center of the image.

5. Next move to the upper-right corner of the image, drag the Gradient tool toward the center of the image, and release. Repeat this process in all the corners of the image. Each time you apply the Gradient tool in a corner, the area washes with black and creates a custom vignette around the image, as shown in Figure 179.3.

You can vary the effect by dragging longer or shorter strokes with the Gradient tool and by using different gradients.

Note: When selecting your gradient, make sure you choose a gradient that fades to transparency.

Figure 179.3 Multiple uses of the Gradient tool create a custom vignette around an image.

180 *Reducing "Stepped" Gradients with Noise and Gaussian Blur*

One of the biggest problems in creating a smooth gradient is the "stepped" look some gradient patterns produce, as shown in Figure 180.1.

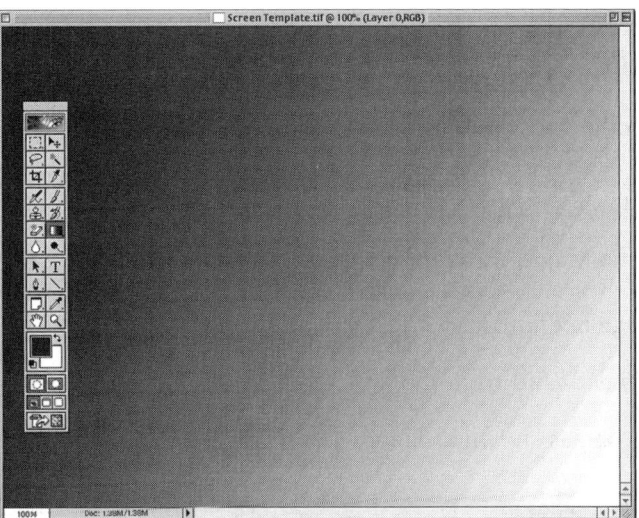

Figure 180.1 The stepped appearance of some gradient patterns is due to the use of wrong colors or the lack of displayable colors on your monitor.

One way to help gradients appear smooth is to increase the Smoothing option for the gradient, as referred to in Tip 175, "Creating Custom Gradients."

Another way is to introduce a Gaussian Blur to the gradient. To smooth a gradient with a Gaussian Blur, perform these steps:

1. Select the layer containing the gradient, as shown in Figure 180.1.

2. Select Filter menu Blur and choose the Gaussian Blur filter. Photoshop will open the Gaussian Blur dialog box. Click on the triangular slider located under the Radius input field and drag it left or right to increase or decrease the amount of blur within the image. Work with the slider, dragging left or right, until the stepped appearance of the gradient disappears, as shown in Figure 180.2.

Figure 180.2 Using Gaussian Blur will reduce the "stepped" appearance of the gradient.

181 *Using the Contiguous Option with the Magic Wand*

In Tip 170, "Understanding How the Magic Wand Works," you learned that the Magic Wand is a unique selection tool that bases a selection on a sample of the image. The Magic Wand extends out from the sample pixel and selects pixels if they fall within the Magic Wand's Tolerance range, as explained in Tip 182, "Controlling Selection Information with Tolerance."

The Magic Wand, by default, confines its selection to a single area; however, you can use the Magic Wand to select all pixels within an image that fall within the sample Tolerance range.

To change how the Magic Wand makes its selection, perform these steps:

1. Open an image in Photoshop.

2. Select the Magic Wand from the toolbox (refer to Tip 74, "The Magic Wand Tool").

3. The Options bar, as shown in Figure 181.1, displays the available options for the Magic Wand.

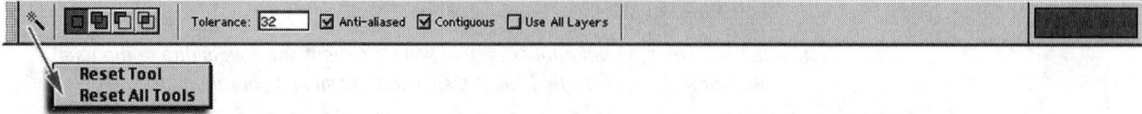

Figure 181.1 The Options bar controls the characteristics of the Magic Wand.

4. Click once on the Magic Wand icon located at the left of the Options bar. The Reset options will display within a pop-up menu. Click on the Reset Tool option to reset the Magic Wand option to its default value.

5. The Contiguous option controls how the Magic Wand selects pixel information. The check mark in the input box to the left of the Contiguous option indicates that it is the default state.

6. When you select the Contiguous option, the Magic Wand only selects pixels connected to the sample, as shown in Figure 181.2.

Figure 181.2 When you select the Contiguous option, you restrain the Magic Wand into selecting pixels connected to the sample pixel.

7. Clicking and removing the check mark from the Contiguous option lets the Magic Wand select pixel information anywhere within the document, as shown in Figure 181.3.

Figure 181.3 With the Contiguous option deselected, the Magic Wand selects pixels throughout the image that match the sample.

182 *Controlling Selection Information with Tolerance*

When using the Magic Wand, you select pixels based on their match with the sample pixel. You create a sample pixel by clicking once with the Magic Wand within an image. Wherever you clicked the Magic Wand becomes the sample pixel. The Magic Wand then expands out and identifies the pixels that match the sample. You create sample matches with the Tolerance option, which is located in the Magic Wand options, as shown in Figure 182.1.

Figure 182.1 The Tolerance option controls the amount of pixel information selected by the Magic Wand.

It is a simple fact of Photoshop that all pixels are numeric values. You see a color, and that color, when mixed with all the other colors in a digital image, becomes a photograph. Photoshop only sees a number, a mathematical value, and that is how Photoshop identifies the pixels. The value assigned to the tolerance is any number from 0 to 255. The higher the number, the more pixels the Magic Wand selects. If you type the value 255 into the Tolerance option, you will select every visible pixel in the image, regardless of its color.

To change the tolerance of the Magic Wand tool, click in the Tolerance input box and enter a number from 0 to 255. The Tolerance value can be changed while working with the tool.

Say you make a selection using the Magic Wand and you want to add to the selection. If you hold the Shift key down while sampling a different area of the image, the Magic Wand will add that pixel information to the selection. However, what if the tolerance of the Magic Wand is set too high, and you select more than you want? First, press CTRL + Z (Command + Z: Macintosh) to undo the previous selection, then click in the Tolerance input field on the Magic Wand options and lower the number. Next return to the image and Shift+click on the image. The new selection is added to the previous selection, based on the new tolerance.

183 *Using the Zoom Tool Correctly*

Photoshop's Zoom tool changes the view size of an image without affecting the graphic's print or display size. The obvious use of the Zoom tool is to expand the image to make selection and editing work easier. Here are some tips on the use of the Zoom tool:

- To expand the image, click once with the Zoom tool within the document window. The image increases in size. Note that the expansion of the image centers on where you clicked the Zoom tool.

- To contract the image, press and hold the Alt key and click once with the Zoom tool within the document widow. Note that the contraction of the image centers on where you clicked the Zoom tool.

- To resize the document window to fit the expansion or contraction of the image, click to select the Resize Windows To Fit option, as shown in Figure 183.1.

Figure 183.1 *The Resize Windows To Fit option causes Photoshop to resize the document window to fit the current size of the graphic image.*

- To expand a specific section of an image, click and drag your mouse. The Zoom tool draws a selection marquee. When you release the mouse, the Zoom area fits the selection marquee, as shown in Figure 183.2.

- To view the image at actual pixel size, double-click on the Zoom tool icon in the toolbox. The image will expand to 100 percent view.

Remember, the Zoom tool only changes the size of the viewable image; it does not affect how the image will print or display.

Figure 183.2 Clicking and dragging the Zoom tool creates a selection marquee that defines the magnified area of the image.

184 *Changing the View of an Image Using Percentages*

The Zoom tool is not the only way to change the view of an image. The bottom-left corner of the document window contains an input box that displays the current view size of the image, as shown in Figure 184.1.

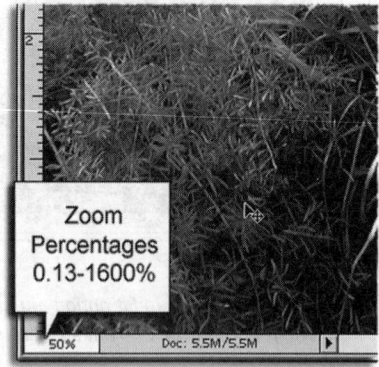

Figure 184.1 The View input box in the lower-left corner of the document window lets you change the view size of the image by entering a percentage.

To change the view size, click in the View input box, type in a number from 0.13 to 1600 percent, and press the Enter key. The View input box lets you type in a fractional number, if needed, such as 144.6 percent, or you can even insert a ratio such as 4:1, as shown in Figure 184.2.

Figure 184.2 The View input box lets you enter a zoom ratio as opposed to a view percentage.

A 4:1 ratio would display the image at 400 percent; a 1:4 ratio would display the image at 25 percent.

Using the View input box gives you absolute control over the size of the image as it is viewed on your monitor.

185 *Defining a New Brush with a Circle*

The Brush palette is an important part of the Photoshop program. Many tools, not just the Paintbrush tool, use brushes to complete their work. Photo restoration would be impossible without the use of the Dodge and Burn tools as well as the Clone Stamp, just to name a few. Eventually, you are going to get into a situation in which the standard brushes do not fit what you need. Do not try to make do using what is available. Make your own brushes to fit virtually any painting or editing situation.

To create a new brush, select any of the Photoshop tools that use a brush. In this example, you will select the Paintbrush from the Photoshop toolbox. Refer to Tip 78, "The Paintbrush and Pencil Tools," for more information on selecting the Paintbrush.

In the Options bar, click on the black triangle located to the right of the Brush icon. Photoshop will open the Brush palette, as shown in Figure 185.1.

Figure 185.1 Clicking on the black triangle opens the Brush palette and displays all available Photoshop brushes.

Click on the triangle button in the upper-right corner of the Brush palette (see Figure 185.1). Photoshop opens a fly-out menu displaying the Brush palette options. Click on the New Brush option. Photoshop opens the New Brush dialog box. Choose from the available options to create a new brush.

- **Name:** Click in the Name input box and give your new brush a name.

- **Diameter:** Click on the triangle slider located under the Diameter option and drag left or right to choose a size for your new brush. Brush sizes range from 1 to 999 pixels.

- **Hardness:** Click on the triangle slider located under the Hardness option and drag left or right to choose a hardness for your new brush. The hardness of the brush measures in a percentage from 0 to 100 percent. The higher the percentage, the sharper the color of the brush appears. The lower the percentage, the more feathered (soft looking) the brush, as shown in Figure 185.2.

Figure 185.2 The Hardness option determines how soft the brush appears when used within a document window.

- **Spacing:** Click on the triangle slider located under the Spacing option and drag left or right to choose a spacing for your new brush. The spacing of the brush determines how solid the brush appears. Brushes measure spacing as a percentage from 1 to 999 percent. A spacing of 1 to 25 percent creates a visually solid brush stroke. By copying the shape of the brush on top of itself, the brush resembles a solid shape as the brush drags across the layer. Higher spacing values create a dotted-line effect when the brush is used, as shown in Figure 185.3.

- **Angle:** Click in the Angle input box to change the angle of the drawn shape. Values range from 0 to 180 degrees. Changing the angle of a brush is useless unless the roundness of the brush is also changed.

- **Roundness:** Click in the Roundness input box to change the roundness of the drawn shape. Values range from 0 to 100 percent. Changing the roundness takes the brush shape out of round and, when combined with the Angle option, creates some very convincing calligraphic brushes, as shown in Figure 185.4.

After completing your changes, click the OK button. Photoshop will close the New Brush dialog box, and your new brush is available from the Brush palette.

Figure 185.3 The Spacing option causes the brush shape to appear solid or broken.

Figure 185.4 The angle and roundness of a brush influence the shape of the brush.

Note: *When you create a new brush, it becomes available to all tools requiring the use of a brush. New brushes are not confined to the open graphic image; they are available to any Photoshop document.*

186 *Defining a New Brush from Drawn Objects*

In the preceding tip, you learned how to create a brush from a standard circle. However, Photoshop lets you create a brush from any shape. To create a brush from a drawn object, perform these steps:

1. Select File menu New and create a new document. In this example, you will create a new document with a Width and Height of 5 inches, a Resolution of 150, and a color mode of RGB. Choose White

for the content and click the OK button. Photoshop will close the New dialog box and open a new document window.

2. Press the letter "D" on your keyboard to change the foreground and background colors to black and white.

3. Select the Paintbrush tool and draw a brush shape on the screen. Refer to Tip 78, "The Paintbrush and Pencil Tools," for information on using the Paintbrush tool.

4. Select the Rectangular Marquee selection tool from the toolbox. Refer to Tip 71, "The Marquee Tools," for information on using the Marquee tool. Draw a rectangle defining the area you want to use as a new brush, as shown in Figure 186.1.

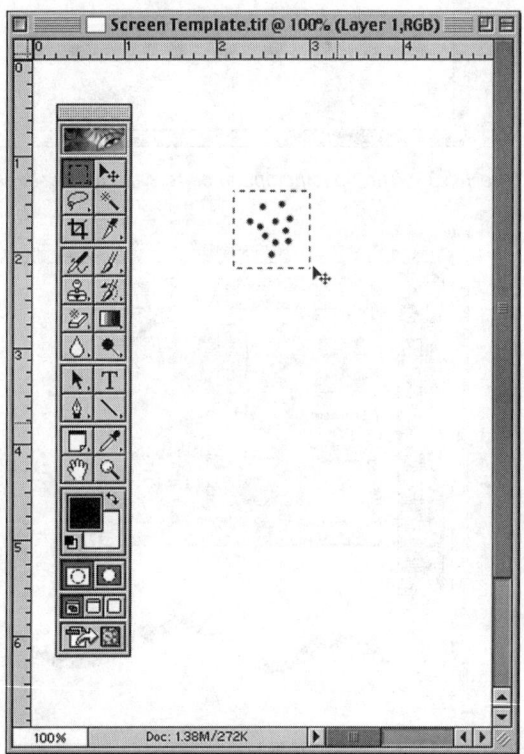

Figure 186.1 Use the Rectangular Marquee tool to select the brush shape.

5. Select Edit menu Define Brush. Photoshop will open the Brush Name dialog box. Click in the Name input field and enter the name of the new brush, as shown in Figure 186.2.

6. Click the OK button. Photoshop will close the Brush Name dialog box. Your new brush is now available from the Brush palette. Brushes created and placed in the brush palette become available to all tools in Photoshop that require a brush.

Figure 186.2 *Enter the name of the new brush in the Brush Name dialog box.*

187 *Loading Additional Brushes*

In the preceding two tips, you learned how to create brushes out of simple circles or drawn shapes. Since new brushes become a part of the brush palette, it will not be long before you have amassed a huge assortment of brushes. Rather than having to deal with a large brush palette, you can create separate brush palettes and load them when necessary.

To create a custom Brush palette, refer to the two preceding tips, create a set of new brushes, and follow these steps:

1. Choose a tool from the toolbox that requires the use of the brush palette. In this example, you will select the Paintbrush tool. Refer to Tip 78, "The Paintbrush and Pencil Tools," for more information on the Paintbrush.

2. In the Options bar, click on the black triangle located to the right of the Brush icon. Photoshop will open the Brush palette (refer to Figure 185.1).

3. Click on the triangle button located in the upper-right corner of the Brush palette (again, refer to Figure 185.1). Photoshop will open a fly-out menu with the brush palette options. Click on the Save Brushes option. Photoshop will open the Save dialog box, as shown in Figure 187.1.

4. Click in the Name input field, type a name for the brush set, and click on the Save button. Photoshop will close the Save dialog box and save your new Brush palette.

5. To load a preexisting Brush palette, repeat step 3 to open the Brush options and then select Load Brushes. Photoshop will open the Load dialog box. Locate the folder containing the brush set and click once on the file name to select it, as shown in Figure 187.2.

Figure 187.1 The Save dialog box lets you define and save custom palettes.

Figure 187.2 The Load dialog box lets you select a preexisting Brush palette.

Click the OK button. Photoshop will close the Load dialog box and append the brushes to the Brush palette.

188 *Defining the Brush Palette*

In Photoshop 6.0, you can control the default Brush palette using the Preset Manager. The Preset Manger lets you add, subtract, or modify the brushes in the default set.

To access the Preset Manager, select Edit menu Preset Manager. Photoshop will open the Preset Manager dialog box, as shown in Figure 188.1.

Figure 188.1 The Preset Manager dialog box controls all the default palettes in Photoshop 6.0.

Click on the Preset Type button. The Preset Manager displays a list of all available palettes, as shown in Figure 188.2.

Figure 188.2 The Preset Type button displays a list of all the palettes within Photoshop 6.0.

Click on the Brushes option. Photoshop displays the default Brush palette (refer to Figure 188.1).

- To delete a specific brush, click on that brush icon and click the Delete button. The Preset Manager deletes the selected brush.

- To rename a specific brush, click on a brush icon and click the Rename button. The Preset Manager opens the Brush Name dialog box. To change the default name, click in the Name input field, enter the new name, and click the OK button. The Preset Manager closes the Brush Name dialog box and renames the brush.

- To load a preexisting Brush palette, click on the Load button. The Preset Manager will open the Load dialog box. Locate the folder containing the brush set and click once on the file name to select it (refer to Figure 187.2).

- To change the view of the brush icons or to load a one of Photoshop's additional Brush palettes, click on the triangle button located to the left of the Done button. The Preset Manager will open a fly-out menu with the available Brush options. Click to change the view of the brush icons or click on one of Photoshop's brush sets, as shown in Figure 188.3.

Figure 188.3 Changing the view of the icon to list as text.

Changes made within the Preset Manager to the Brush palette affect the display of the Brush palette throughout Photoshop.

189 *Defining a "Sparkle" with a Brush*

Placing a highlight on a graphic image is easy when you have the right brush for the job. To create a sparkle brush, perform these steps:

1. Select File menu New and create a new document. In this example, you will create a new document with a Width and Height of 5 inches, a Resolution of 150, and a color mode of RGB. Choose Transparent for the content and click the OK button. Photoshop will close the New dialog box and open a new document window.

2. Press the letter "D" on your keyboard to set the foreground and background colors to black and white.

3. Using your Paintbrush and a soft brush, draw a small cross shape, as shown in Figure 189.1.

4. You need to save this brush into your Brush palette. Define the cross shape by using your Rectangular Marquee tool to select the cross (refer to Tip 186, "Defining a New Brush from Drawn Objects"). The new Sparkle brush is a part of your default Brush palette. Select File menu Close. Select Do Not Save when asked to save the new file.

5. Select File menu Open. Photoshop will open the Open dialog box. Select a graphic image that needs a sparkle by clicking once on the file name and clicking on the Open button. Photoshop will open the graphic image.

6. Press the letter "D" on your keyboard and then press the letter "X". The letter "D" will set the foreground and background colors to black and white, and the letter "X" will reverse the two colors. Your brush painting color is now white, as shown in Figure 189.2.

Figure 189.1 *Create a small cross shape with your Paintbrush tool.*

Figure 189.2 *By setting the foreground color swatch to white, all the painting tools in Photoshop will now paint with white.*

7. Select the Paintbrush from the Brush palette and choose the Sparkle brush, as shown in Figure 189.3.

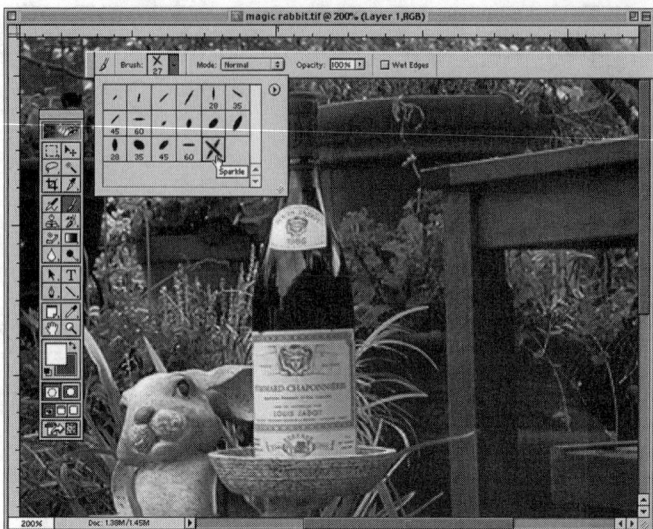

Figure 189.3 Click on the Sparkle brush to make it the default brush.

8. Now move the brush into the document window and click the mouse where you want to apply a sparkle, as shown in Figure 189.4.

Figure 189.4 The Sparkle brush applied to the graphic image.

Note: To further control the Sparkle brush, create a new layer (see Tip 233, "Controlling Your Work with Layers") and apply the Sparkle brush within the new layer. Using the Sparkle brush in new layer gives you control to edit or move the brush without changing the image.

190 *Painting Using the Behind Blending Mode*

In the preceding three tips, you learned how to create new brushes and apply them to an image. Another important way to control the Paintbrush is with the Blending Mode options.

To use the Paintbrush with blending modes, select the Paintbrush from the toolbox (refer to Tip 78, "The Paintbrush and Pencil Tools").

Click on the Mode button located in the Options bar. The Options bar will display the Mode options, as shown in Figure 190.1.

Figure 190.1 Clicking the Mode button displays all the available options for the Paintbrush.

Click on the Behind option. The Options bar will close the Mode options and make Behind the default mode.

When selecting Behind as the default blending mode for the Paintbrush, the only areas that accept paint in a document window are those with transparent pixels. For this reason, the Behind option is ideal for creating custom shadow effects.

To create a custom shadow effect, select the Paintbrush, choose Behind as the blending mode, and perform these steps:

1. Select File menu Open. Photoshop will display the Open dialog box. Select an image on which you want to paint a custom shadow and click the Open button. Photoshop will open the selected graphic file, as shown in Figure 190.2.

2. In the Paintbrush Options bar, change the Opacity of the Paintbrush to 60 percent, as shown in Figure 190.3.

3. Move the Paintbrush into the document window and click and drag the brush down the left side and bottom of the graphic, as shown in Figure 190.4.

Figure 190.2 *A graphic image containing an object surrounded by transparent pixels.*

Figure 190.3 *The Opacity option for the Paintbrush controls the opacity of the painted stroke.*

Figure 190.4 The Paintbrush with the Behind option selected only paints on the transparent pixels of the image.

The Behind option restricts what the Paintbrush can paint within an image. It will only let the brush work in areas of the image containing transparent pixels. Controlling the brush in this manner helps you create great-looking custom shadows.

191 *Using Brush Dynamics*

One of the new features in Photoshop 6.0 is the introduction of Brush Dynamics. Brush Dynamics are available for all of Photoshop's drawing (Paintbrush, Airbrush, and Pencil) tools as well as for image-editing (Clone Stamp, Pattern Stamp, History Brush, Eraser, Blur, Sharpen, Smudge, Dodge, Burn, and Sponge) tools. Brush Dynamics control how the brush tools apply ink to the screen or how the image editing tools modify the image.

When you select a tool with brush dynamics, you will see the Brush Dynamics icon located on the far right of the Options bar, as shown in Figure 191.1.

Figure 191.1 Brush Dynamics are available for all brushes and image-editing tools.

To access brush dynamics, select a tool from the toolbox that uses brush dynamics and click once on the Brush Dynamics button (see Figure 191.1). The Options bar will open the Brush Dynamics dialog box, as shown in Figure 191.2.

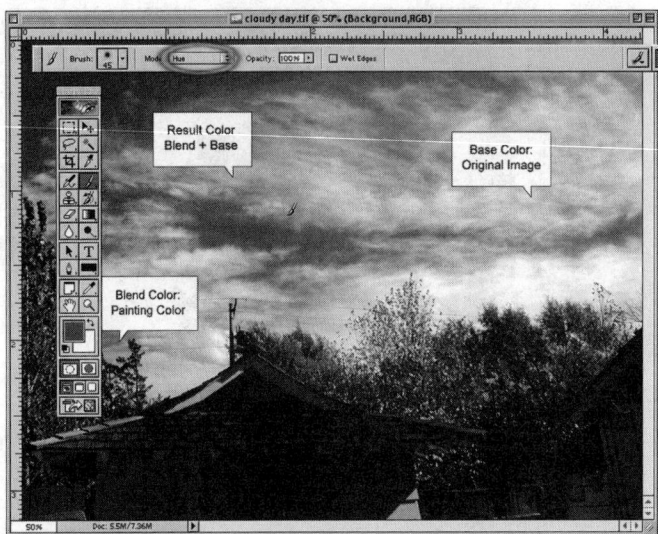

Figure 191.2 The Brush Dynamics dialog box, shown here displaying the available options for the Paintbrush.

The selection of a tool determines the available Dynamic Brush options.

- **Size:** The Size option controls the size of the tool as measured by a specific brush size. Click on the Size button to display three options: Off, Fade, and Stylus. Select Off to control the brush size with the standard Brush palette. Select Fade to control the size of the brush in steps.

- **Opacity:** The Opacity option controls the transparency of the tool. Click on the Opacity button to display three options: Off, Fade, and Stylus. Select Off to control the opacity of the tool with the standard opacity slider. Select Fade to control the opacity of the tool in steps. Select Stylus to dynamically control the tool with a drawing tablet.

- **Color:** The Color option controls the color of the brush tool. Click on the Color button to display three choices: Off, Fade, and Stylus. Select Off to control the color of the brush tool with the Foreground Color Swatch. Select Fade to fade the brush color from the Foreground to the Background color swatch by steps. Select Stylus to dynamically control the brush color with a drawing tablet.

- **Pressure:** The Pressure option controls the Dodge, Burn, Sponge, and Airbrush tools. Click on the Pressure option to display three choices: Off, Fade, and Stylus. Select Off to control the Pressure of the tool by the standard Pressure or Exposure sliders. Select Fade to control the Pressure of the tool in measured steps. Select Stylus to dynamically control the tool with a drawing tablet.

192 *Working with the Hue, Saturation, and Color Blending Modes*

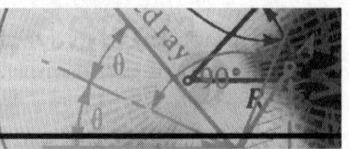

Blending modes control how pixels in the image are affected by a painting or editing tool. When using the blending mode options, you are working with and changing three areas of an image: the base color (the original color of the image), the blend color (the color applied with the painting or editing tool), and the result color (the color resulting from the blend), as shown in Figure 192.1.

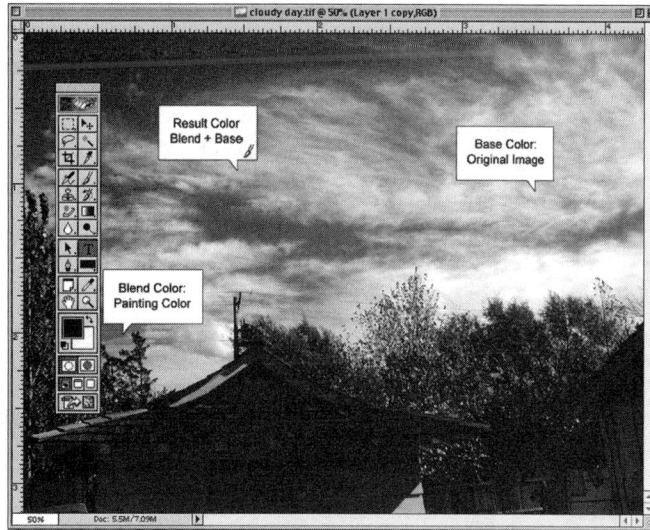

Figure 192.1 All image pixels within a graphic consist of three items: hue, saturation, and luminance.

- **Hue:** When you use the Hue blending mode, Photoshop preserves the hue of the blend color and mixes it with the luminance and saturation of the base color, as shown in Figure 192.2.

Figure 192.2 The Hue blending mode mixes the hue of the blending color with the saturation and luminance of the base color.

- **Saturation:** When you use the Saturation blending mode, Photoshop preserves the saturation of the blend color and mixes it with the luminance and hue of the base color. If the area painted contains gray pixels, there is no change to the image, as shown in Figure 192.3.

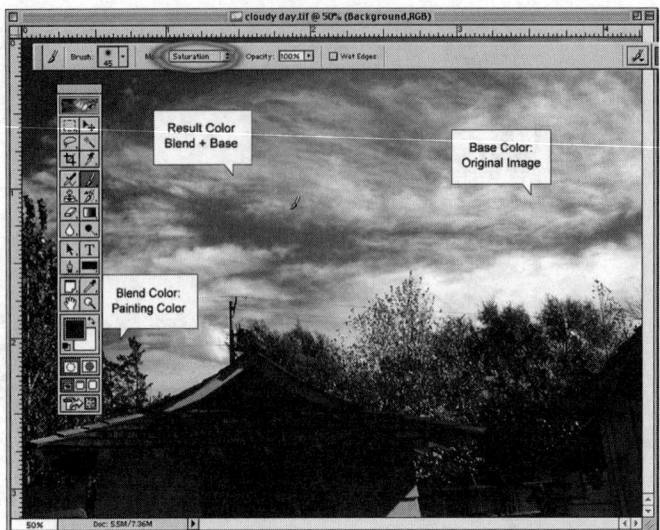

Figure 192.3 The Saturation blending mode mixes the saturation of the blending
color with the hue and luminance of the base color.

- **Color:** When you use the Color blending mode, Photoshop preserves the hue and saturation of the blend color and mixes them with the luminance of the base color. Using black as the blend color creates black and white images from color images, as shown in Figure 192.4.

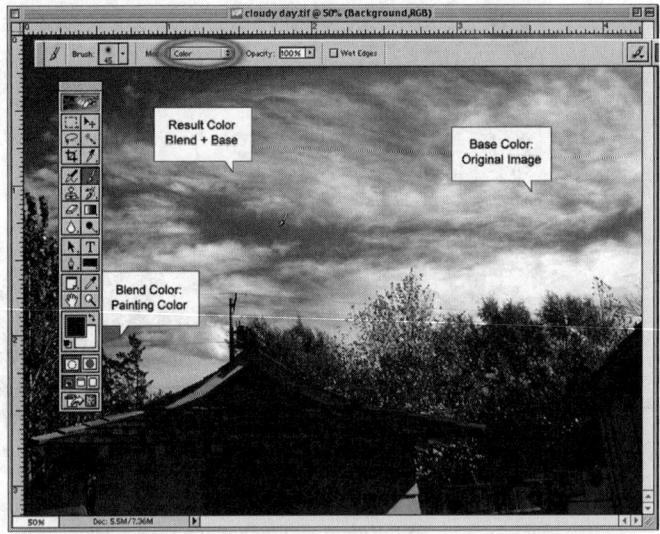

Figure 192.4 The Color blending mode mixes the hue and saturation of the blending
color with the luminance of the base color.

Not only do the blending mode options control what you paint, they control how you paint. For more information on use of blending modes, see Tip 234, "Using Blending Modes to Influence the Painting Tools."

193 *Warping Text*

With the release of Photoshop 6.0, the ability to warp text is now here. The Warp Text option lets you bend and curve text based on several options.

To use the Warp Text option, perform these steps.

1. Select the Type tool and create some text within an open Photoshop document. For more information on creating text in Photoshop, see Tip 218, "Creating Text in Photoshop 6.0."

2. Click on the Warp Text button located on the right side of the Options bar, as shown in Figure 193.1.

Figure 193.1 The Warp Text button in the Photoshop Options bar.

3. Photoshop will open the Warp Text dialog box, as shown in Figure 193.2.

Figure 193.2 The Warp Text dialog box lets you control the application of the warp to the text.

- **Style:** Click on the Style button. The Warp Text dialog box will display a list of available options, as shown in Figure 193.3.

Figure 193.3 The Style options control the type of warp applied to the text.

- **Horizontal/Vertical:** Select an option by clicking on one of the two radio buttons. The Horizontal and Vertical options control whether the warp is applied to text horizontally or vertically. The Horizontal option is best applied to text running left to right, and the Vertical option is best applied to text running up and down, as shown in Figure 193.4.

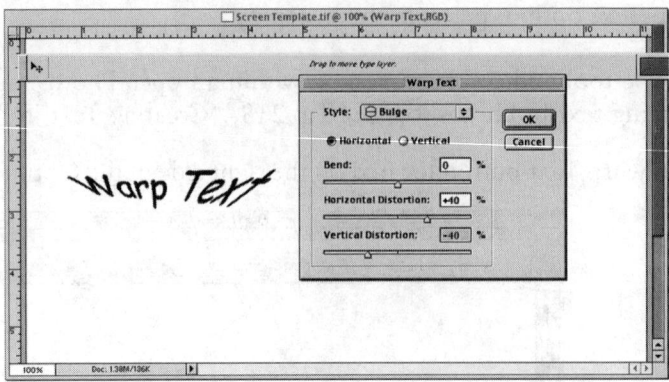

Figure 193.4 Text with the Bulge style selected and applied horizontally and vertically.

- **Bend:** Controls the physical amount of bend applied to the text based on the Warp style, as shown in Figure 193.5. Click on the triangular slider and drag it left or right, or click in the Bend input field and enter a value from +100 to –100 percent.

Figure 193.5 The Bend options as applied to text using the Flag style.

- **Horizontal Distortion:** Controls the amount of horizontal distortion applied to the text based on the Warp style, as shown in Figure 193.6. Click on the triangular slider and drag it left or right, or click in the Horizontal Distortion input field and enter a value from +100 to –100 percent.

Figure 193.6 The Horizontal Distortion option applied to text using the Flag style.

- **Vertical Distortion:** Controls the amount of vertical distortion applied to the text based on the current Warp style, as shown in Figure 193.7. Click on the triangular slider and drag it left or right, or click in the Vertical Distortion input field and enter a value from +100 to –100 percent.

Figure 193.7 The Vertical Distortion option applied to text using the Flag style.

To apply the Warp to the text, click the OK button after you have made your changes. Photoshop will close the Warp Text dialog box and record your changes to the text.

194 *Using Wet Edges with the Brush Tools*

The Wet Edges option is a watercolor effect commonly called a "wash." When Wet Edges is selected, the brush tools react the same way a wet brush reacts when dragged over a watercolor: Color builds up at the edges of the brush and, depending on the default foreground color, will wash the image with a semi-transparent color.

To use the Wet Edges option, click in the toolbox and select the Paintbrush tool. For more information on selecting and using the Paintbrush, refer to Tip 78, "The Paintbrush and Pencil Tools."

Move into the Options bar and select the Wet Edges option by clicking in the Wet Edges check mark box, as shown in Figure 194.1.

Figure 194.1 The Wet Edges option in the Paintbrush options.

Move into an open Photoshop graphic and begin painting by clicking and dragging the Paintbrush across the image. The central portion of the brushstroke will tint the image (based on the foreground color swatch) and thicken the color along the edges of the stroke, as shown in Figure 194.2.

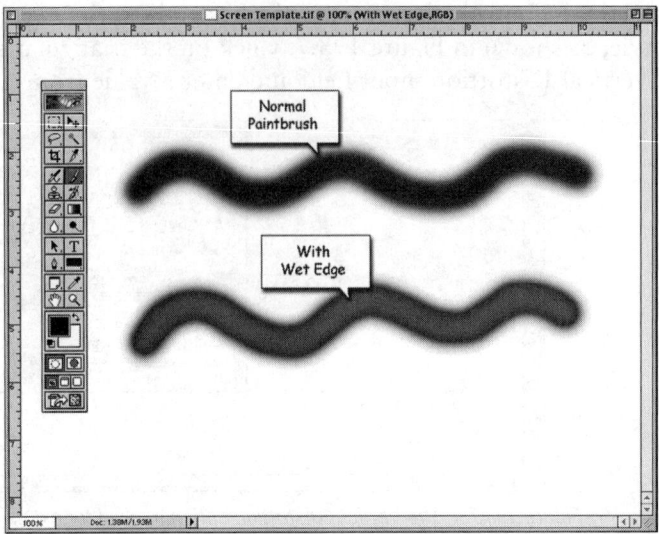

Figure 194.2 The Wet Edges option applied to a photographic image.

195 *Temporarily Modifying Individual Brush Styles*

You learned in Tip 185, "Defining a New Brush with a Circle," that you can create an unlimited number of brushes. However, there are times when you want to create a single-use brush. Photoshop 6.0 lets you create a temporary brush from any of your existing brushes. The brush will be usable for as long as needed but will not be saved within the Brush palette.

To create a one-time-only brush, perform these steps:

1. Open a document in Photoshop and select any of the tools that use the Brush palette. For this example, you will select the Airbrush tool. For more information on selecting and using the Airbrush tool, refer to Tip 77, "The Airbrush Tool."

2. When you select the Airbrush tool, the Options bar displays all the available options, as shown in Figure 195.1.

Figure 195.1 The Options bar displays all the options for the Airbrush tool.

3. Click on the Airbrush icon at the far left of the Options bar (see Figure 195.1) and select the Reset Tool option to reset the Airbrush to its default values.

4. Click once on the Brush icon button. Photoshop will open a dialog box containing the options for the default brush, as shown in Figure 195.2.

Figure 195.2 The options displayed for the default brush let you temporarily modify the characteristics of the brush.

Note: Do not click on the black triangle to the right of the Brush icon. Clicking on the black triangle will only open the Brush palette and let you select a brush.

5. Make your changes to the brush by modifying the available options. For more information on modifying the characteristics of a brush, refer to Tip 185, "Defining a New Brush with a Circle."

6. To use the modified brush, move directly into the document window and begin using the brush. The Brush icon displays your modified brush for as long as you need its use.

7. To remove the temporary brush, click on the black triangle to the right of the Brush icon. Photoshop will open the Brush palette, as shown in Figure 195.3.

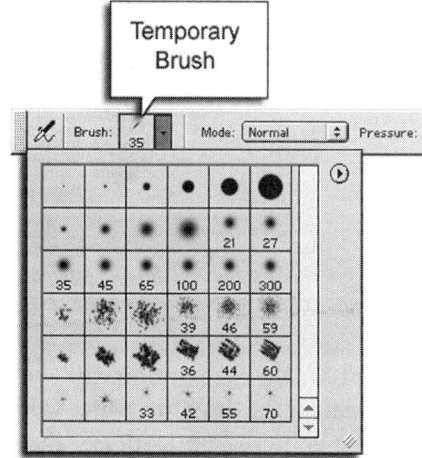

Figure 195.3 The Brush palette displays all the available brushes in Photoshop.

8. You will notice that your temporary brush does not appear in the Brush palette. Click to select another brush. The newly selected brush becomes the default brush, and your temporary brush is deleted.

196 *Using a Drawing Tablet with the Brush Tools*

One of the advantages of using Photoshop is its ability to link to a drawing tablet. Drawing tablets translate the movement and pressure of the pen to the tablet to give you tremendous control over Photoshop's tools.

To use a drawing tablet, you must first connect the drawing tablet to your computer and load the supplied software to control the tablet. Consult your drawing tablet's user guide for the proper way to connect your drawing tablet.

Once the drawing tablet is connected, you must instruct Photoshop to use the new device. Select each drawing and editing tool and modify the tool's Brush Dynamics. For more information on how to change the Brush Dynamics of a tool, refer to Tip 191, "Using Brush Dynamics."

To connect the drawing and editing tools to the drawing tablet, you must use the Stylus option within Brush Dynamics (again, refer to Tip 191).

- **Opacity:** When Stylus is selected for the Opacity option, the transparency of the drawing tools and the effect of the editing tools are controlled by the pressure applied with the pen tool to the drawing tablet's surface. The harder the pen is pressed against the tablet, the more solid the color or the more the effect of the editing tool is applied to the image. A lighter touch with the pen produces a more transparent drawing color or less application of a particular editing tool, as shown in Figure 196.1.

Figure 196.1 The pressure of the pen against the tablet surface controls the transparency of the drawing tools and the application of the editing tools.

- **Size:** When Stylus is selected for the Size option, the width of the brush or editing tool is controlled by the pressure of the pen against the drawing tablet. The harder the pen is pressed against the tablet, the wider the brush size. The lighter the pressure of the pen against the tablet, the smaller the brush size, as shown in Figure 196.2.

Figure 196.2 The size of the brush is controlled by the pressure of the pen against the surface of the tablet.

- **Color:** When Stylus is selected for the Color option, the color of the drawing tool is influenced by the pressure of the pen against the drawing tablet. The Color option uses the foreground and background color swatches. When the pen is pressed harder against the surface of the drawing tablet, the color of the drawing tool moves toward the background color. When less pressure is applied, the color of the drawing tool moves toward the foreground color, as shown in Figure 196.3.

Figure 196.3 The color of the drawing tool is influenced by the pressure of the pen against the surface of the drawing tablet.

Using a drawing tablet with Photoshop gives you greater control than just using your mouse.

197 *Changing the Fade Rate of a Brush to Produce Comet Tails*

The Fade rate option on the Paintbrush controls the rate at which the brush runs out of ink. To change the Fade rate of the Brush tool, perform these steps:

1. Open a graphic image in Photoshop, as shown in Figure 197.1. You are going to use the Fade option to create a comet tail in the night sky.

Figure 197.1 Using the Fade option, you can create realistic comet tails in the night sky.

2. Select the Paintbrush tool from the Photoshop toolbox. For more information on selecting and using the Paintbrush, refer to Tip 78, "The Paintbrush and Pencil Tools."

3. The Options bar displays all the available options for the Paintbrush tool, as shown in Figure 197.2.

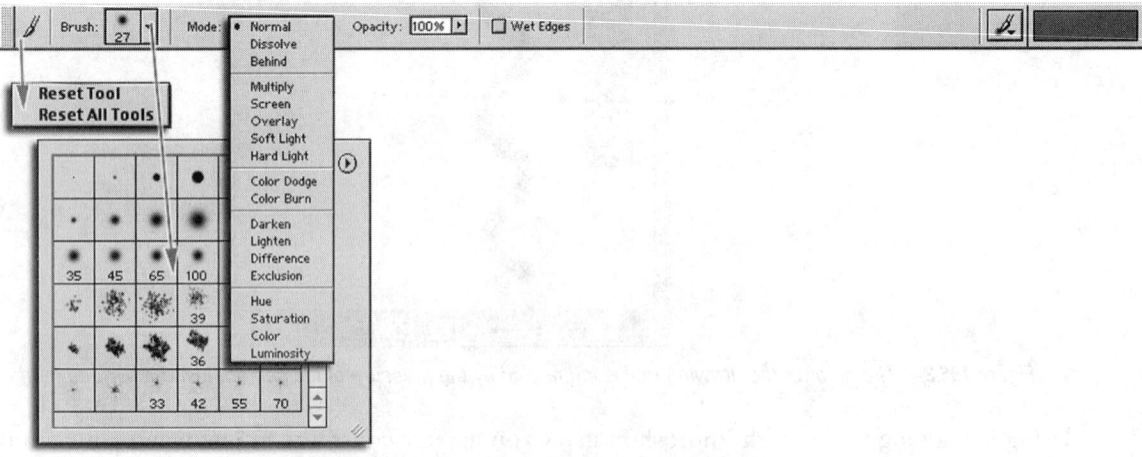

Figure 197.2 The Options bar displaying the Paintbrush options.

4. Click on the Paintbrush icon at the far left of the Options bar (see Figure 197.2) and select the Reset Tool option to reset the Paintbrush to its default values.

5. Click on the black triangle to the right of the Brush button. Photoshop will open a dialog box displaying all available brushes. Click on the 27-pixel soft brush, as shown in Figure 197.3.

Figure 197.3 The Brush palette in the Paintbrush Options bar.

6. Click the Brush Dynamics button located on the far right of the Options bar (refer to Figure 197.2). Photoshop will display the Brush Dynamics for the Paintbrush, as shown in Figure 197.4.

Figure 197.4 The Brush Dynamics dialog box displaying the Paintbrush options.

7. Click on the Opacity button and select Fade from the pop-up list. Click in the Steps input field and type in the number 25. This will cause the Paintbrush to fade from the foreground color swatch to transparent in 55 steps.

8. Press the letter "D" on your keyboard to default your foreground and background color swatches to black and white.

9. Press the letter "X" on your keyboard to reverse the foreground and background color swatches. You are now painting with white.

10. Move into the image area and, somewhere in the evening sky, click and drag your mouse upward. The point that you first clicked on will be 100-percent white. As you drag your mouse, the white will begin to fade (turn transparent) and in 25 steps will disappear. The effect looks strikingly like a comet tail, as shown in Figure 197.5.

Figure 197.5 The Fade option applied to a white Paintbrush gives the impression of a comet tail in the night sky.

198 *Using the Equalize Option*

The Equalize command redistributes the brightness values of the pixels in an image so that they more evenly represent the entire range of brightness levels. When the Equalize command is applied to an image, Photoshop locates the lightest and darkest pixels within the image and assigns them the values of white and black. It then attempts to remap the image based on the new values of white and black.

To use the Equalize command, select Image menu Adjust and select the Equalize option from the fly-out menu. Photoshop will perform the Equalize command to the open document.

The Equalize command performs well on overexposed or underexposed scanned images when the image contains a good balance between light and dark pixels, as shown in Figure 198.1.

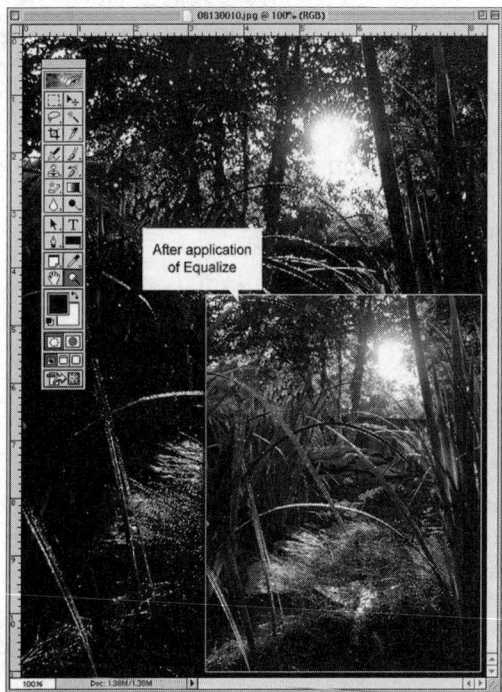

Figure 198.1 This scanned image is too dark. Applying the Equalize command easily corrects this type of image problem.

Equalize does not work as well on images that do not contain representative black or white pixels, as shown in Figure 198.2.

To assist the Equalize command in selecting the correct light and dark image pixels, perform these steps:

1. Select an area of the image before choosing the Equalize command, as shown in Figure 198.3. Choose an area of the image that you feel represents a good distribution of light and dark pixels.

Figure 198.2 This image is too dark. However, since the image does not contain a good example of white, the Equalize command over compensates the exposure.

Figure 198.3 Selecting an area of the image before choosing Equalize helps control the process.

2. Select Image menu Adjust and choose the Equalize option from the fly-out menu. Photoshop will open the Equalize dialog box, as shown in Figure 198.4.

Figure 198.4 The Equalize dialog box controls how the representative light and dark pixels are selected.

3. Select the Equalize entire image based on selected area option by clicking on the radio button to the left of the option.

4. Click the OK button. The Equalize command will use the selected area to determine the correct light and dark pixels and will equalize the image based on that information, as shown in Figure 198.5.

Figure 198.5 Selecting an area of the image with a representative sample of light and dark pixels helps the Equalize command correct the image.

199 *Working with Threshold to Control Image Pixels*

The Threshold command converts grayscale or color images into high-contrast, black-and-white images. Threshold bases its conversion on the luminance values of the image pixels. Every pixel in a Photoshop image contains a luminance from 0 to 255. The higher the luminance, the lighter the color or shade of gray of the pixel.

To use the Threshold command, perform these steps:

1. Open an image in Photoshop, as shown in Figure 199.1.

Figure 199.1 An image in Photoshop before conversion with the Threshold command.

2. Select Image menu Adjust and select the Threshold option from the fly-out menu. Photoshop will open the Threshold dialog box, as shown in Figure 199.2.

Figure 199.2 The Threshold dialog box displays a graph of the luminance of the pixels within the active image.

3. Click on the triangular slider located under the graph and drag it to the left or right. Dragging the slider to the right increases the Threshold Level and increases the number of pixels assigned the color black. Dragging the slider to the left decreases the Threshold Level and increases the number of pixels assigned the color white, as shown in Figure 199.3.

Figure 199.3 The Threshold slider determines the number of black and white pixels within the active Photoshop image.

4. Click the OK button to confirm your Threshold settings. Photoshop will convert the image and close the Threshold dialog box.

Note: The Threshold command can be saved as a History state and used for creating a special effect image.

200 *Understanding the Posterize Option*

Photoshop's Posterize command lets you choose a specific number of colors or brightness values (for grayscale images) assigned to a Photoshop image. Posterize works with the image's channels to produce the available colors. Say you choose a Posterize value of 2 in an RGB (image colors are selected by mixing red, green, and blue); the image will contain six colors: two for the red channel, two for the green channel, and two for the blue channel.

To use the Posterize command, perform these steps:

1. Open a graphic image in Photoshop, as shown in Figure 200.1.

Figure 200.1 A typical graphic image before applying the Posterize command.

2. Select Image menu Adjust and choose the Posterize option from the fly-out menu. Photoshop will open the Posterize dialog box, as shown in Figure 200.2.

Figure 200.2 The Posterize dialog box controls the number of colors assigned to a Photoshop image.

3. Click in the Levels field and enter a value from 2 to 255. The lower the value, the fewer colors are assigned to the image; the higher the value, the more colors are assigned to the image, as shown in Figure 200.3.

Figure 200.3 The Posterize command with the Preview option selected lets you view the final image.

4. To confirm the modification to the image, click the OK button. Photoshop will record your changes to the image and close the Posterize dialog box.

201 Understanding How the Levels Command Adjusts an Image

The Levels command is one of the more powerful image-editing tools in Photoshop. It lets you adjust the tonal range and color balance of a graphic image in three areas: shadows, midtones, and highlights. To use the Levels command, open an image that needs tonal or color balance adjustments and perform these steps:

1. Select Image menu Adjust and choose Levels from the fly-out menu. Photoshop will open the Levels dialog box, as shown in Figure 201.1.

Figure 201.1 The Levels dialog box displays a histogram or bar chart of the pixels within the active image.

2. The Levels dialog box displays a graph of the image information, called a histogram. The histogram is a physical representation of the brightness of the pixels within the active image. Therefore, the histogram is a vertical bar chart with each of the bars representing how many of each luminance pixel exists within the active image. A normal histogram representing an average image will have pixel information spread out across the entire work area, as shown in Figure 201.2.

3. When an image becomes overexposed or underexposed, the image pixels are compressed into a smaller area, as shown in Figure 201.3.

4. Under the histogram is a slider bar containing three triangular sliders (see Figure 201.3). The black slider represents the shadow areas, the gray slider represents the midtones, and the white slider represents the highlights of the image.

5. Restoration of an image is accomplished by stretching the histogram data to fit the data window. You uncompress the Levels histogram by moving the triangular sliders to fit the visible data, as shown in Figure 201.4.

Figure 201.2 The histogram of an average image contains a sampling of pixel data across the shadow, midtones, and highlight areas of the image.

Figure 201.3 The Levels palette showing compressed pixel information.

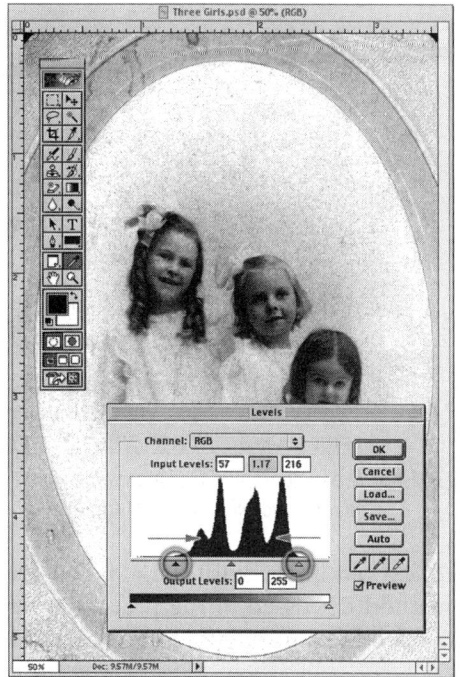

Figure 201.4 Moving the triangular sliders to fit the visible histogram uncompresses the image data and restores the image.

6. To make the Levels adjustments permanent, click the OK button in the Levels dialog box. Photoshop will close the Levels dialog box and apply the adjustments to the image.

It is perhaps too easy to say that all photographs will improve with the simple moving of the sliders, but in many cases, that's all that is necessary to restore an image to printable form.

For more information on using the Levels sliders, see Tip 629, "Using Levels to Set Highlights, Shadows, and Midtones."

202 *Using the Eyedroppers in Levels to Balance an Image*

In the preceding tip, you learned how to use the Levels dialog box to adjust the quality of an image by reassigning the value of the shadows, midtones, and highlights. You accomplish image adjustment by clicking on the adjustment sliders, located directly under the histogram, and moving them to fit the histogram data (refer to the preceding tip).

There are times, however, when the use of the input sliders does not produce the results you are after. When this happens, the image contains large areas of nondetail dark or light pixels. Say you scan an image with a large white border. The histogram cannot distinguish between white border pixels and detail highlights within the image. Therefore, the Levels dialog box displays a histogram with incorrect highlight data, as shown in Figure 202.1.

*Figure 202.1 The histogram of an image containing a large white border; it shows
an incorrect placement of the highlights of the image.*

The same would be true of an old image with dark, faded areas. The histogram would show incorrect shadow data. Using the method discussed in the preceding tip to correct an image with large amounts of nondetail black or white produces unsatisfactory results, as shown in Figure 202.2.

*Figure 202.2 An image containing large areas of nondetail black or white makes it difficult
to correct the image using only the highlight and shadow input sliders.*

To correct an image with excessive white or dark areas, open a graphic image in Photoshop and perform these steps:

1. Select Image menu Adjust and choose Levels from the fly-out menu. Photoshop will open the Levels dialog box (refer to Figure 202.2).

2. Start by moving the shadow and highlight input sliders toward the center of the image data, as shown in Figure 202.3.

3. Click once on the black eyedropper tool in the Levels dialog box and move your cursor into the document window. Your cursor resembles an eyedropper. Choose an area of the image containing dark pixels with some detail (not black pixels) and click to sample the pixels. Photoshop will readjust the shadow areas of the image to match the sample, as shown in Figure 202.4.

Figure 202.3 Moving the shadow and highlight input sliders inward helps identify the image information and prepares the way for use of the eyedropper tools.

Figure 202.4 Clicking once with the black eyedropper identifies the shadow areas of the active Photoshop image.

4. Click once on the white eyedropper tool in the Levels dialog box and move your cursor into the document window. Your cursor resembles an eyedropper. Choose an area of the image containing light pixels that contain some detail (not pure white) and click to sample the pixels. Photoshop will readjust the highlight areas of the image to match the sample, as shown in Figure 202.5.

Figure 202.5 Clicking once with the white eyedropper identifies the highlight areas of the active Photoshop image.

Using a combination of input sliders and the eyedroppers gives the best results when attempting to adjust the tonal range of an image.

Note: Adjusting the tonal range of a color image with the Levels command typically introduces a color cast to the image. To correct the color cast of an image, see Tip 641, "Using Curves to Increase the Contrast in an Image."

203 *Controlling Output with the Levels Output Sliders*

In Tip 201, "Understanding How the Levels Command Adjusts an Image," you learned how to control the shadows, midtones, and highlights using the Levels input sliders. The Levels output sliders, as shown in Figure 203.1, control the percentage of ink assigned to each pixel.

Figure 203.1 The Levels output sliders control the percentage of ink to an image when sent to an output device.

When sending a Photoshop image to a printing device, the type of paper used influences the dot gain of the inks. Dot gain defines the percentage of the ink that spreads into the fibers of the paper. The lower the quality of the paper, the more dot gain of the inks. Say you are sending an image to a publisher for eventual printing in a newspaper. The average dot gain of newspaper is 18 percent. When the inks representing the image strike the paper, they expand out 18 percent. That means the image will be 18 percent darker, and you will lose 18 percent of the detail in the image. In images containing dark, heavy shadow areas, the ink dots may blend together and result in a heavy loss of image detail, as shown in Figure 203.2.

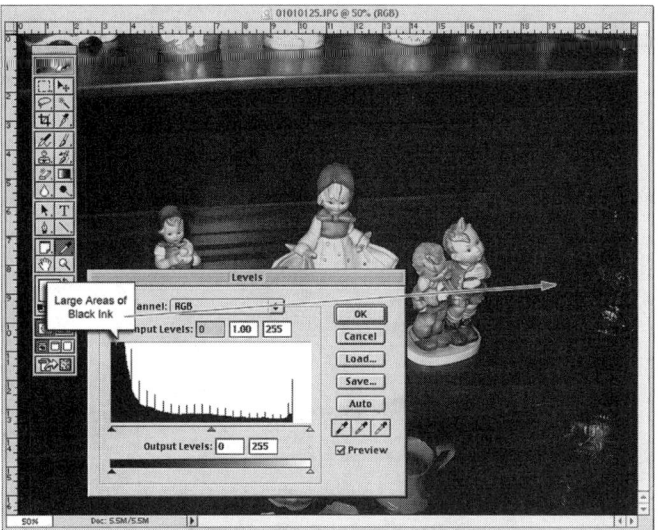

Figure 203.2 Images containing dark shadow areas will lose some or all of their detail when printed on high-dot-gain papers.

The Levels output sliders adjust the percentages of ink assigned to each pixel and help correct excessive dot gain. To use the Levels output sliders to control ink dot gain, open an image in Photoshop and perform these steps:

1. Select Image menu Adjust and choose the Levels option from the fly-out menu. Photoshop will open the Levels dialog box (refer to Figure 203.1).

2. To reduce the dot gain of an image in the shadow areas, click on the black output slider and drag it to the right, as shown in Figure 203.3. Photoshop lowers the percentage of ink used to print the darker image pixels and reduces the effect produced by high-dot-gain papers.

Figure 203.3 Dragging the black output slider to the right of the Output Levels data field reduces the percentage of ink used to print the image.

Note: The amount of ink reduction is determined by several factors: the type of paper, the inks used, and the printer or press. New soy-based inks and fiber-reduced papers are changing how you work with ink reduction. A general rule of thumb is that the numerical step reduction is half the physical dot gain of the paper. Say you are printing an image on 18-percent dot-gain paper. Your numerical reduction of ink using the black output slider is between 8 to 12 percent, as shown in Figure 203.4. However, always contact the newspaper or printing house assigned to the job and ask them for a recommendation.

Figure 203.4 The average ink reduction performed on an image printing on 18-percent dot-gain paper.

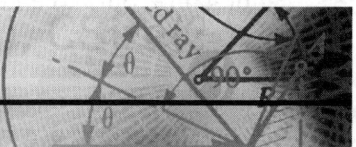

204 *Working with Auto Levels*

The Auto Levels command corrects the tonal quality of an image by automatically adjusting the Level input sliders (see Tip 201, "Understanding How the Levels Command Adjusts an Image"). The Auto Levels command appears in two places within Photoshop:

- Select Image menu Adjust and select Auto Levels from the fly-out menu. Photoshop executes the Auto Levels command on the active document or selection.

- Select Image menu Adjust and select Levels from the fly-out menu. Photoshop will open the Levels dialog box. Click on the Auto button. Photoshop will execute the Auto Levels command to the active document or selection and will leave the Levels dialog box open, as shown in Figure 204.1.

Figure 204.1 Clicking on the Auto button causes Photoshop to perform an Auto Levels command to the active image or selection and leaves the Levels dialog box open for further adjustments to the image.

In both instances, the Auto Level command is automatically executed.

The Auto Levels command moves the Levels sliders automatically to set highlights and shadows. It defines the lightest and darkest pixels in each color channel as white and black and then redistributes intermediate pixel values proportionately. Because Auto Levels adjusts each color channel individually, it may remove or introduce colorcasts. By default, Auto Levels clips the white and black pixels by 0.5 percent; that is, it ignores the first 0.5 percent of either extreme (white or black) when identifying the lightest and darkest pixels in the image. This ensures that white and black values are based on representative rather than extreme pixel values.

Note: Auto Levels will only give good results when an image contains an average distribution of pixels from white to black. However, adjusting an image using Levels or Curves is still the best way to perform image correction.

205 *Understanding How the Curves Command Adjusts an Image*

The Curves command works to redistribute the saturation of the inks within an image. The Curves command is similar to the Levels command (refer to Tip 201, "Understanding How the Levels Command Adjusts an Image") in that they both control image information based on the tonal range of the pixels.

To open the Curves dialog box, select Image menu Adjust and select the Curves option from the fly-out menu. Photoshop displays the Curves dialog box, as shown in Figure 205.1.

Figure 205.1 Working on the principle of a graph, the Curves dialog box redistributes the tonal range and the ink saturation of an image.

The diagonal line running from the lower left to the upper right of the Curves graph indicates the current state of the image. When the Curves dialog box opens for the first time, the image displays a null curve line, as shown in Figure 205.1. The Curves command operates on the principle of a graph with the horizontal plot defining the tonal range and the vertical plot defining the ink saturation. A null curve indicates the normal tonal range of the image; changing (bending) the null curve line changes the distribution of inks within the image.

Clicking on the null graph line creates an additional edit point. To modify the tonal range or color saturation of the inks within an image, click on the graph line to create an edit point and drag to move it to another position, as shown in Figure 205.2.

Clicking on an edit point and dragging left or right controls the tonal range of the pixels within the active image. Clicking on an edit point and dragging up or down controls the saturation of the inks within the active image.

Figure 205.2 Clicking and dragging on an edit point lets you change
the tonal range or ink saturation of the image.

The Curves dialog box first opens with two edit points (refer to Figure 205.1). Clicking and dragging the two points in toward the center of the graph redefines the shadows and highlights of the image just as the Levels command performs correction on the shadows and highlights of an image (again, refer to Tip 201).

The advantage of the Curves command is its ability to generate more edit points. Clicking and dragging your mouse on the Curves graph line lets you add up to 15 edit points. Each one of these individual points can adjust the tonal range and ink saturation of the active image, as shown in Figure 205.3.

Figure 205.3 Adding edit points to the graph line lets you precisely control the inks within the image.

206 *Using the Color Balance Command*

The Color Balance command does not have the control of the Curves or Levels command; however, it is useful for generalized color correction of an image.

To use the Color Balance command, select Image menu Adjust and choose Color Balance from the fly-out menu. Photoshop displays the Color Balance dialog box, as shown in Figure 206.1.

Figure 206.1 The Color Balance dialog box helps with generalized color balancing of an image.

The Color Balance dialog box contains several options:

- **Color Balance:** Click and drag the triangular sliders left or right, or click in the Color Levels input fields and enter a value from –100 to 100. Negative numbers (moving the sliders to the left) generate more cyan, magenta, or yellow within the active image, and positive numbers (moving the sliders to the right) generate more red, green, or blue within the active image.

- **Tone Balance:** Click on the radio buttons and individually adjust the Shadows, Midtones, or Highlights of the active image. Normally, 80 percent of an image is contained within the midtones range, with the image slowly falling off into the highlights and shadows.

- **Preserve Luminosity:** Click in the check box input field to activate the Preserve Luminosity option. Activating this option preserves the brightness of the image pixels and helps maintain the tonal balance of the image. Select this option when performing color correction to an image to maintain the brightness values of the pixels.

The Color Balance option has limited use when it comes to color correction. If you scan a photograph containing a green cast, the Color Balance command is a quick way to remove unwanted colorcasts. To balance the image, select Midtones and click to place a check mark in the Preserve Luminosity option. Next click and drag the Magenta/Green slider toward Magenta (to the left). Adding more magenta to the image (the opposite of green) changes the ink saturation of the graphic and corrects the image, as shown in Figure 206.2.

Figure 206.2 Correcting an image with a green color cast is a snap using the Color Balance command.

The Color Balance command is useful for general color correction to an image; however, the Curves and Levels commands are still the powerhouse tools for performing complicated image correction.

To learn how to use the Color Balance command to color tint an RGB image, see Tip 318, "Using Color Balance to Tint an Image."

207 *Working with Brightness and Contrast*

Another of Photoshop's tools used in modifying an image is the Brightness/Contrast command. The Brightness/Contrast command makes simple adjustments to the tonal range of the active image, but it should never be used on photographs. The Brightness/Contrast command provides linear adjustment to the image pixels, and by nature, photographs are nonlinear.

To select the Brightness/Contrast dialog box, select Image menu Adjust and choose the Brightness/Contrast option from the fly-out menu. Photoshop displays the Brightness/Contrast dialog box, as shown in Figure 207.1.

Figure 207.1 The Brightness/Contrast dialog box modifies the pixels within an image using a linear format.

- **Brightness:** To modify the brightness of the image pixels, click and drag the triangular Brightness slider to the left or right, or click in the input field and enter a value between –100 and 100. Increasing the Brightness (dragging the slider to the right) increases the brightness of the image pixels on a linear basis, as shown in Figure 207.2.

Figure 207.2 Moving the Brightness slider to the left or right makes a linear adjustment to the pixels and produces an overall dark and muddy image.

- **Contrast:** To modify the contrast of the image pixels, click and drag the triangular Contrast slider to the left or right, or click in the input field and enter a value between –100 and 100. Increasing the Contrast (dragging the slider to the right) increases the contrast in the image on a linear basis, as shown in Figure 207.3.

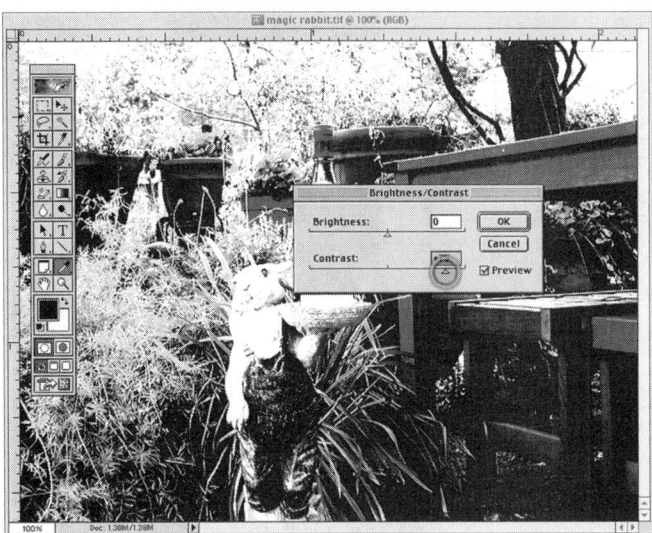

Figure 207.3 Moving the Contrast slider to left or right makes a linear adjustment to the pixels and reduces the number of visible colors within the image.

The Brightness/Contrast dialog box will not work on a photograph because photographs do not fade in a linear fashion. When an image fades, the digital information within the image begins to compress. When digital information compresses, it draws the highlights and shadows of the image toward the midtones (nonlinear); therefore, shadow areas become lighter and highlights become darker. Brightness/Contrast cannot correct a compressed (nonlinear) image because it moves all the pixels in one direction (linear).

Use Brightness/Contrast to modify a piece of clipart or a drawing, but when it comes to changing and modifying a photographic image, always use the Levels and Curves commands. Unlike Brightness/Contrast, Levels and Curves perform nonlinear image adjustment.

208 *Understanding the Hue/Saturation Command*

The Hue/Saturation command lets you adjust the hue, saturation, and lightness of an image by adjusting the pixels in relation to a standard color wheel, as shown in Figure 208.1.

Figure 208.1 The Hue/Saturation dialog box adjusts the color of an image based on the HSL color wheel.

To select the Hue/Saturation command, select Image menu Adjust and choose Hue/Saturation from the fly-out menu. Photoshop displays the Hue/Saturation dialog box, as shown in Figure 208.2.

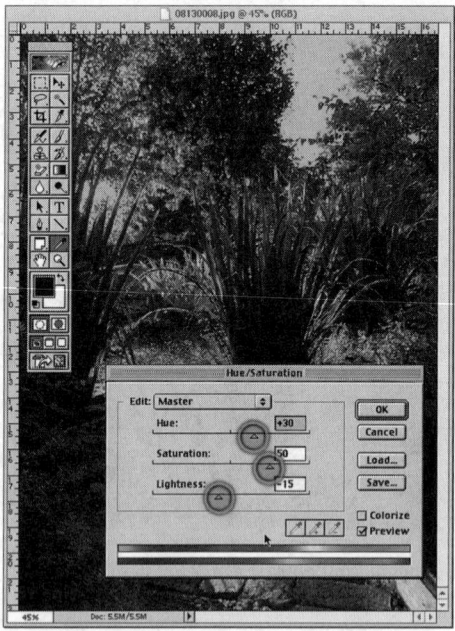

Figure 208.2 The Hue/Saturation dialog box in Photoshop lets you modify the overall color composition of a graphic image.

To modify an image, choose from the available options:

- **Edit:** Click on the Edit button to display a list of available color spaces. Selecting Master (default) selects all the colors within an image and changes the hue, saturation, and lightness of the image. Select an individual color by clicking on the Edit button and choosing a single color to edit.

- **Hue:** The Hue option represents the color of the pixel. Click and drag the Hue slider left or right, or click in the Hue input box and enter a number from −180 to 180. The value of Hue represents a move around the color wheel. A positive number indicates clockwise rotation, and a negative number represents a counterclockwise rotation.

- **Saturation:** The Saturation option represents the percentage of color (Hue) of the pixels. Click and drag the Saturation slider to the left or right, or click in the Saturation input field and enter a value from –100 to 100. The higher the value, the more saturated the ink. Changing the Saturation value to –100 completely desaturates the colors and produces a grayscale image.

- **Lightness:** To change the lightness value of the pixels, click and drag the Lightness slider to the left or right, or click in the Lightness input field and type a value from –100 to 100. The higher the value, the lighter the image; the lower the value, the darker the image.

- **Colorize:** The Colorize option, if selected, paints the image with an overall color cast. Click in the Colorize check mark box to add a color cast the image. The foreground color swatch determines the initial position of the Hue slider, as shown in Figure 208.3.

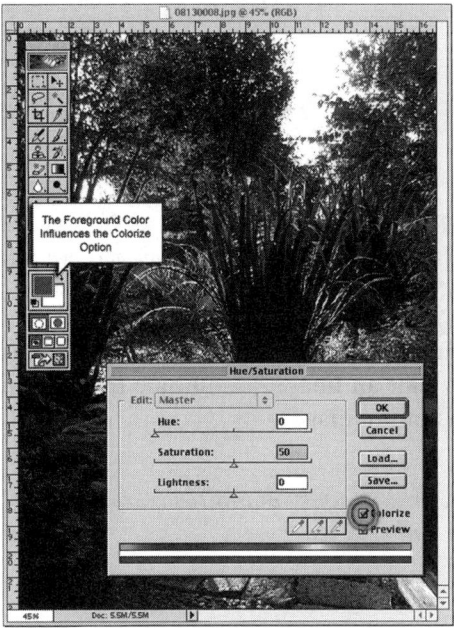

Figure 208.3 When using the Colorize option, the foreground color swatch determines the initial placement of the Hue slider.

Note: You can also use the Colorize option to add color to a grayscale image converted to RGB, or to an RGB image, to make it look like a duotone. For more information on using the Hue/Saturation command, see Tip 333, "Using the Hue/Saturation Command to Apply Color to an Image."

209 *Using Desaturate to Remove the Color from an Image*

The Desaturate command converts a color image to a grayscale image without changing the image's original color mode.

To use the Desaturate command, select Image menu Adjust and choose Desaturate from the fly-out menu. The Desaturate command automatically converts the image to grayscale by equalizing the values of the red, green, and blue pixels and, at the same time, preserving their luminosity, as shown in Figure 209.1.

Figure 209.1 *The Desaturate command converts an image to grayscale without changing the color mode of the original image.*

Use the Desaturate command before introducing a color cast to an image, as discussed in Tip 318, "Using Color Balance to Tint an Image." Combine the Desaturate command with the History brush to colorize selected portions of an image.

> *Note: If you are working with a multi-layered image, the Desaturate command converts the selected layer only.*

210 *Using Replace Color*

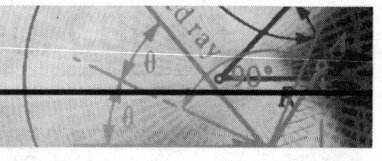

The Replace Color command is similar to the Color Range command (refer to Tip 145, "Using the Color Range Command") with one major exception. The Color Range command lets you create selections based on specific colors, and the Replace Color command lets you change the hue, saturation, and brightness of the image pixels based on a specific color or colors.

To use the Replace Color command, perform these steps:

1. Open an image within Photoshop.

2. Choose Image menu Adjust and select Replace Color from the fly-out menu. Photoshop will open the Replace Color dialog box, as shown in Figure 210.1.

3. The Replace Color dialog box, by default, displays a preview image of the open graphic. You can choose to display a preview of the selected colors, or you can choose to view the original image. In this example, click on the radio button to the left of Selection to choose the Selection option. The Replace Color dialog box will display a black-and-white preview mask of the original open document, as shown in Figure 210.1.

Figure 210.1 The Replace Color dialog box lets you change the hue, saturation, and brightness of the image pixels.

4. Move your mouse cursor into the preview of the image within the Replace Color dialog box. Your cursor now resembles an eyedropper. Click once within the image. The black-and-white preview changes to reflect your selection of color information. The white areas of the preview mask represent the selected areas of the document, as shown in Figure 210.2.

Figure 210.2 Clicking within the document window defines the selected colors in the image.

5. You can adjust the range of colors within the selection by using the Fuzziness slider, located at the top of the Replace Color dialog box. Increase or decrease the value of the Fuzziness option by clicking in the input field and typing a value of 0 to 200 or by clicking and dragging the triangular slider located under the Fuzziness input box. Decreasing the value decreases the range of colors selected; increasing the number increases the range of color selected.

6. By default, the Replace Color dialog box lets you select one color at a time within the active image. Clicking a second time in the Image Preview resets the color range to the newly sampled area. To add or subtract colors from the range of selected colors, click the plus or minus eyedropper, located on the right-side of the Color Range dialog box (refer to Figure 210.1). Clicking on the plus eyedropper lets you add colors to the range of selected colors. Clicking on the minus eyedropper removes colors from the range of selected colors. Select an eyedropper tool and move into the original image. Each time you click your mouse within the image, you create a sample for the Replace Color command.

When you have made your selection, modify the hue, saturation, and lightness of the selected image pixels by moving the Transform sliders located in the Replace Color dialog box.

- **Hue:** The Hue option represents the color of the pixel. Click and drag the Hue slider left or right, or click in the Hue input field and enter a number from –180 to 180. The value of Hue represents a move around the color wheel. A positive number indicates clockwise rotation and a negative number represents a counterclockwise rotation.

- **Saturation:** The Saturation option represents the percentage of color (Hue) of the pixels. Click and drag the Saturation slider to the left or right, or click in the Saturation input field and enter a value from –100 to 100. The higher the value, the more saturated the ink. Changing the Saturation value to –100 completely desaturates the colors and produces a grayscale image.

- **Lightness:** To change the lightness value of the pixels, click and drag the Lightness slider to the left or right, or click in the Lightness input field and type a value from –100 to 100. The higher the value, the lighter the image; the lower the value, the darker the image.

When you complete your color adjustments to the image, click the OK button. Photoshop will close the Replace Color dialog box and record your changes.

Note: You can further define where the Replace Color command operates by selecting an area within the graphic image before opening the Replace Color dialog box.

211 *Understanding the Selective Color Command*

Selective color correction is a technique used by high-end scanners and separation programs to increase or decrease the amount of process colors in each of the additive and subtractive primary color components in an image. Selective Color uses CMYK (cyan, magenta, yellow, and black) colors to correct an image; however you can use Selective Color on an RGB (red, green, and blue) image as well.

To use the Selective Color command on a Photoshop document, select the composite channel in the Channels palette. Selective Color requires selection of the composite channel (see Tip 432, "Understanding Channels and Their Role").

Select Image menu Adjust and choose the Selective Color command. Photoshop displays the Selective Color dialog box, as shown in Figure 211.1.

Figure 211.1 The Selective Color dialog box controls the percentage of process colors applied to a high-end image.

The Selective Color dialog box lets you increase or decrease the amount of a specific process ink selectively, without affecting any other primary colors in the image.

To decrease one color component in the image while leaving the other color components unaltered, perform these steps:

1. Select Image menu Adjust and choose the Selective Color option from the fly-out menu. Photoshop displays the Selective Color dialog box, as shown in Figure 211.1.

2. Click on the Colors button to display a list of the additive and subtractive color sets, including whites, neutrals and blacks. In this example, click on Greens to make it the default color set.

3. Click on the Relative radio button to make it the default method. The Relative option adjusts the color of the image based on the relative value of the ink. Say you start with a pixel that is 50 percent cyan, and you move the Cyan slider to the right until the cyan input field displays 10. You have increased the cyan in the image by 5 percent because 10 percent of 50 percent is 5 percent, as shown in Figure 211.2.

Figure 211.2 The Selective Color dialog box is being used to increase cyan in the green component of an image without affecting any other color components.

4. Click the OK button to close the Selective Color dialog box and record your changes to the image.

Using the Selective Color command on an image redefines the color values within an image; however, changing color values is a decision usually made by those printing the final image, not by you. Service bureaus and printing companies use specific presses, papers, and inks. The operator of the press determines specific ink modifications made to a high-end document, and he bases this on his own specific way of using his presses. Always check with the company producing the final output for recommendations on changing the colors within an image.

212 *Working with the Channel Mixer Command*

The Channel Mixer command lets you modify a color channel using a combination of the current color channels. The Channel Mixer, by nature, lets you make color adjustments to an image, create grayscale images from a color photo, or even generate sepia-tone images.

To use the Channel Mixer on an open Photoshop document, select Image menu Adjust and choose Channel Mixer from the fly-out menu. Photoshop displays the Channel Mixer dialog box, as shown in Figure 212.1.

*Figure 212.1 The Channel Mixer dialog box controls the color in an image by adding or
subtracting portions of the available color channels.*

Select from the available options to modify the active image.

- **Output Channel:** Click on the Output Channel button to display the available channels in the active image, as shown in Figure 212.2. Click once on a channel name (cyan, magenta, yellow, or black) to make it the default channel.

Figure 212.2 The Output Channel button displays all the available channels in the active document.

- **Source Channels:** The Source Channels display information on the percentage of each channel used by the Channel Mixer. The Source Channels display information based on the current Output Channel. By default, Source Channels display 100 percent of the selected Output Channel and zero percent for all other channels. If you select the Red channel as the Output channel, the Red channel displays 100 percent, and the green and the blue channels default to zero. To add or subtract the mix of a particular channel, click and drag the sliders to the left or right, or click in the Source Channels input boxes and enter a value from –200 to 200. The higher the value, the more that particular channel mixes with the default Output Channel. Since a channel represents a particular ink color, adding or subtracting a channel adds or subtracts that channel color from the active image.

- **Constant:** The Constant option adds a layer of varying opacity to the selected Output Channel. Click and drag the triangular Constant slider left or right, or click in the Constant input field and enter a value from –100 to 100. Negative values (dragging the slider to the left) create a black channel; positive values (dragging the slider to the right) create a white channel. This Constant option acts as a mask, increasing or decreasing the overall effect of the channel mixing command.

- **Monochrome:** Selecting the Monochrome option applies same setting in the selected Output Channel to all the channels, in essence creating a black and white image. Click once on the Monochrome option to select it and then click again to deselect the option, giving you the ability to create a hand-tinted appearance. See Tip 338, "Adjusting the Color in an Image Using Channel Mixer."

213 *Converting an Image to Grayscale Using Channel Mixer*

In the preceding tip, you learned how the Channel Mixer command uses the available channels in a document to colorize or change the image. The Channel Mixer is also an excellent way to convert an image to grayscale. To convert an open color image to grayscale, perform these steps:

1. Select Image menu Adjust and choose the Channel Mixer option from the fly-out menu. Photoshop displays the Channel Mixer dialog box (refer to Figure 212.1).

2. Click to select the Monochrome option. The Channel Mixer converts the image into shades of gray. The Output Channel option displays Gray, as shown in Figure 213.1.

3. For a grayscale image with a harder look, add more green and blue to the image by dragging the Green and Blue channel sliders to the right or by clicking in the respective input fields and entering the values. At the same time, lower the Constant percentage (drag the slider to the left or enter a negative value) to compensate, as shown in Figure 213.2.

4. Click the OK button to close the Channel Mixer dialog box and record your changes.

Figure 213.1 Clicking the Monochrome option converts a color image to grayscale.

Figure 213.2 Create a grayscale image with a higher contrast by increasing Green and Blue and lowering the Constant value.

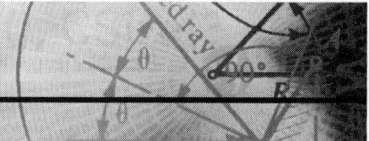

214 *Using the Channel Mixer Presets*

You learned in the preceding tip how the Channel Mixer option works to modify an image to grayscale with the click of a button. Photoshop also lets you choose from a variety of Channel Mixer preset options. To use one of the Channel Mixer presets, open an image in Photoshop and perform these steps:

1. Select Image menu Adjust and choose the Channel Mixer option from the fly-out menu. Photoshop displays the Channel Mixer dialog box, as shown in Figure 214.1.

Figure 214.1 The Channel Mixer dialog box, displaying channel information for a four-color document.

2. Click on the Load button in the Channel Mixer dialog box. Photoshop displays the Load dialog box, as shown in Figure 214.2.

Figure 214.2 The Load dialog box lets you choose from the Channel Mixer presets.

3. Click to select one of the presets and click the OK button. Photoshop closes the Load dialog box and inserts the selected preset into the Channel Mixer dialog box, as shown in Figure 214.3.

Figure 214.3 The Channel Mixer dialog box with the color2.cha preset loaded, creating the effect of a sepia-toned image.

4. When you have completed your changes, click the OK button. Photoshop closes the Channel Mixer dialog box and records your changes.

215 *Using the Gradient Map Command*

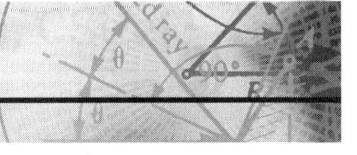

The Gradient Map command works with an existing image and maps the grayscale range of the image (the brightness of the pixels) to a preselected gradient fill. When a Gradient Map merges with an image, the shadow, midtone, and highlight areas of the image map to the shadow, midtone, and highlight areas of the gradient map.

You can create your own gradient maps or select from Photoshop's preset gradient maps. To use the Gradient Map option on an open Photoshop image, perform these steps:

1. Select Image menu Adjust and choose the Gradient Map option from the fly-out menu. Photoshop displays the Gradient Map dialog box, as shown in Figure 215.1.

2. To change the default gradient, click on the black triangle located to the right of the gradient preview. Photoshop displays the gradient picker. Clicking on a gradient swatch automatically changes the gradient used to create the map, as shown in Figure 215.2.

3. To create a new gradient map from a preexisting swatch, click once to select a gradient from the presets. Then click once on the sample of the gradient located at the top of the Gradient Map dialog box. Photoshop displays the Gradient Editor dialog box, as shown in Figure 215.3.

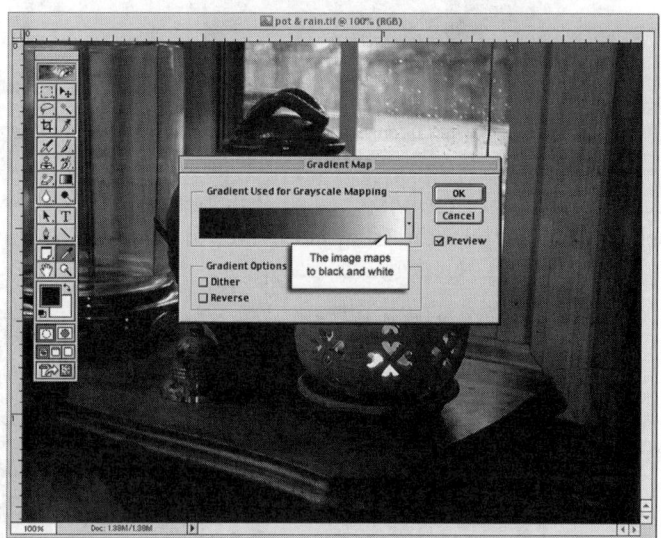

Figure 215.1 The Gradient Map dialog box maps the brightness of the image pixels with the colors in the gradient map.

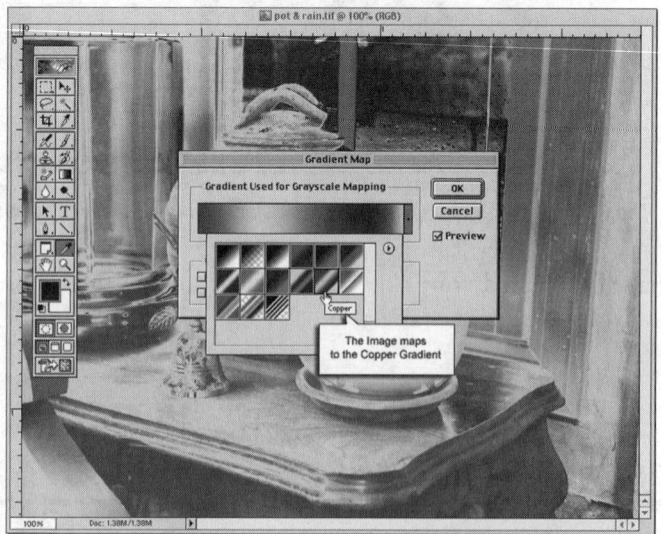

Figure 215.2 Clicking on a gradient swatch changes the gradient map used to convert the image.

Figure 215.3 The Gradient Editor dialog box lets you create your own gradients for use as image maps.

4. Using the information in Tip 178, "Creating a Gradient from Colors Within an Image," create a new gradient.

5. Click the New button in the Gradient Editor dialog box to save the new gradient. Then click the OK button to close the Gradient Editor and return to the Gradient Map dialog box. Your new gradient is now listed at the bottom of the gradient presets ready for use.

6. Click the OK button to close the Gradient Map dialog box and record your changes.

216 *Converting a Grayscale Image Using the Invert Command*

The Invert command inverts the colors in an image. Choosing the Invert Command automatically reverses the image pixels, converting a normal black and white image into a negative. The Invert command converts an entire image or a previously selected portion of an image.

Each pixel within a black and white image contains a brightness value from 0 to 255. Zero represents black and 255 represents white. All the values between 0 and 255 represent shades of gray. When the invert command executes, the 0 brightness pixels convert to 255, and a pixel with a value of 10 would convert to a value of 245.

To change a grayscale image using the Invert command, select Image menu Adjust and choose the Invert option from the fly-out menu. Photoshop automatically converts the image or the selected portion of the image, as shown in Figure 216.1.

Note: Because color print film contains an orange mask in its base, the Invert command cannot make accurate positive images from scanned color negatives.

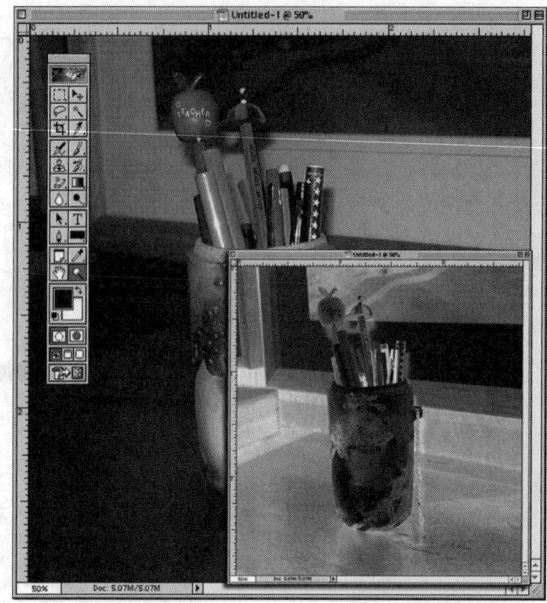

Figure 216.1 The Invert command applies to the entire image or to a previously selected portion of an image.

217 Understanding the Difference Between Pressure, Opacity, and Exposure

When you use any of Photoshop's 15 painting and image-editing tools, the Options bar lists one of three ways in which the tool performs its work: Pressure, Exposure, or Opacity.

The Airbrush, Blur, Sharpen, Smudge, and Sponge tools use Pressure to control what they do to an image. The Dodge and Burn tools use Exposure to control their work. In addition, the Paintbrush, Pencil, Clone Stamp, Pattern Stamp, History Brush, Art History Brush, Eraser, and Gradient tool all use an Opacity setting.

The difference between the three options is how the tool changes the image.

- **Opacity:** Clicking and dragging your mouse controls tools that use the Opacity setting. If you set the opacity setting to 50 percent and then you click and drag your mouse over the image, as long as you continue to hold the mouse button down, the image will receive a 50 percent application of the given tool—no more, no less. Releasing the mouse and clicking a second time applies another 50 percent to the image. You maintain control over the default tool by holding down the mouse button, as shown in Figure 217.1.

- **Exposure/Pressure:** Tools that use Exposure and Pressure operate with more than a mouse click. They also modify an image based on the speed at which the tool drags across the image and the overlap of the brush stroke, as shown in Figure 217.2.

Figure 217.1 Clicking and holding the mouse button controls the application of all tools using the Opacity setting.

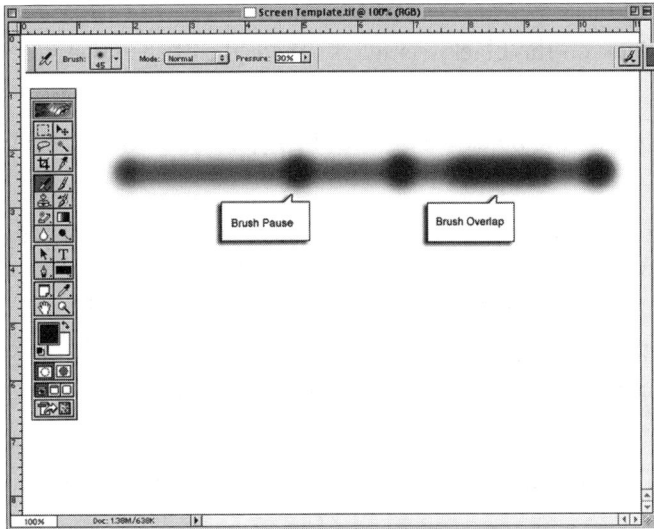

Figure 217.2 Tools using the Exposure or Pressure option change image data based on the speed at which the brush moves over the image and the overlap of the brush strokes.

218 *Creating Text in Photoshop 6.0*

Before Photoshop version 6.0, designers typed words into a dialog box and inserted them into the document. When the document printed, the text converted to a raster image and became subject to the resolution of the printed document. It goes without saying that Photoshop was not a typing program.

With the release of Photoshop 6.0, all that has changed. You type text directly into the document window in a type layer, and the text retains its vector format when printed. New features now let you warp and bend text to fit a specific shape.

To create text in Photoshop 6.0, select the Type Tool from the Photoshop toolbox. The Options bar will display the options available for the Type Tool, as shown in Figure 218.1.

Figure 218.1 Selecting the Type Tool from the Photoshop toolbox causes the Options bar to display all the available typing options.

Modify the Type Tool by choosing from the available options on the Options bar:

- **Reset Option:** Click on the Type icon, located on the far left of the Options bar, to reset the current tool (or to reset all tools) back to its default settings.

- **Type Layer/Mask Font:** Click on the Text Layer button or the Mask Font button (refer to Figure 218.1) to type text directly into a layer or to create a mask out of a font. For more information on using the Mask Type tool, see Tip 653, "Working with the Type Mask Tool."

- **Horizontal/Vertical Type:** Click on the Horizontal or Vertical buttons to generate horizontal or vertical type or type masks.

- **Font Family:** Click on the black triangle to the right of the font box to select from the list of available fonts.

- **Font Style:** Click on the black triangle to the right of the style box to select from the available font styles.

- **Font Size:** Click on the black triangle to the right of the font size box to set the size (in points) of the type.

- **Anti-aliasing Method:** Click on the Anti-aliasing button to display a list of available anti-aliasing methods. The Crisp option creates a hard, sometimes ragged appearance to text, while the Smooth option helps to smooth out the visual appearance of the text.

- **Left/Center/Right Alignment:** Click on the Left Align, Center Align, or Right Align button to format the structure of multiline text layers to left, center, or right alignment.

- **Text Color:** Click the text color box to display the Color Picker dialog box (refer to Tip 62, "Manually Choosing Colors with the Color Picker") to choose a default type color.

- **Warped Text:** Click the Text Warp button to modifying any preexisting type. Refer to Tip 193, "Warping Text," for more information on warping text.

- **Palettes:** Click the Palettes button to display the Paragraph and Character dialog boxes. For more information on using the Paragraph and Character palettes, see Tip 672, "Working with Paragraph and Character Options" and Tip 669, "Working with Character Options."

After selecting from the available options, move your cursor into the document window and begin typing, as shown in Figure 218.2.

To modify preexisting text, select the text using the Type Tool and modify it using the preceding options.

Figure 218.2 The Type Tool in Photoshop creates text directly in the document window.

219 *Using Posterize to Control the Number of Colors in an Image*

The Posterize command lets you specify the number of tonal levels (or brightness values) for each channel in an image and then maps the image pixels to the closest matching level. The visual result is the reduction of available color in the active image.

To use the Posterize command on an open image, perform these steps:

1. Select Image menu Adjust and choose the Posterize option from the fly-out menu. Photoshop displays the Posterize dialog box, as shown in Figure 219.1.

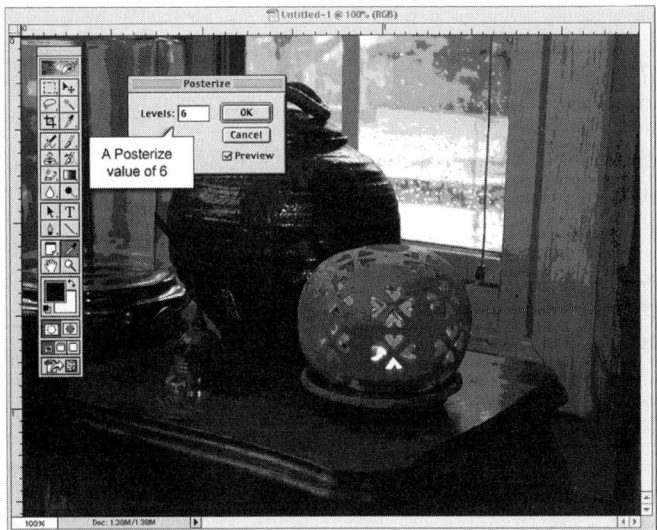

Figure 219.1 The Posterize command controls the number of visible colors within an image by controlling the tonal steps of each channel.

2. Click in the Levels input box and type a number from 2 to 255. The Levels number controls the number of tonal steps assigned to each channel. Since an RGB image (red, green, and blue) contains three separate channels, using a Levels number of two creates six viewable colors in the image: two for red, two for green, and two for blue, as shown in Figure 219.2.

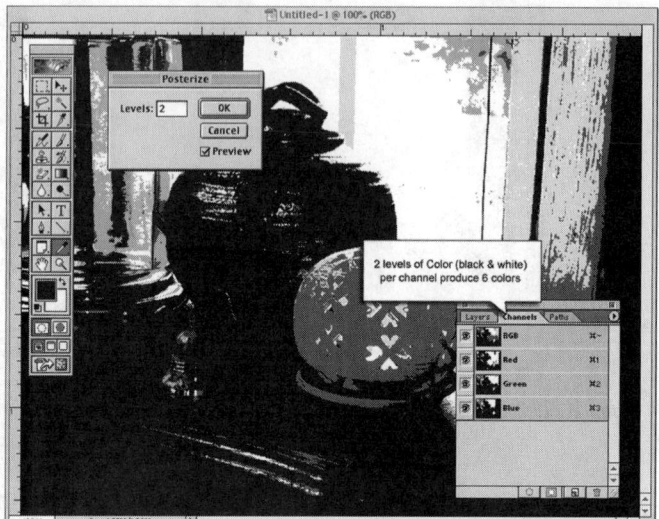

Figure 219.2 Using a Levels value of 2 creates a tonal value of two (black and white) per channel and a total of six colors within the active image.

3. Click OK to close the Posterize dialog box and record the changes to the image.

The Posterize command is useful for creating special effects such as large, flat areas of color within a graphic image. The effects of the Posterize command are most visible when reducing the number of gray levels in a grayscale image, but it also produces interesting effects within a color image.

220 *Using the Variations Command*

The Variations command adjusts the color balance, contrast, and/or saturation of the active image by displaying thumbnails of the image in various stages of color correction and ink saturation. The Variations command is useful for average images that do not require precise color adjustments.

To access the Variations command on an open Photoshop image, select Image menu Adjust and choose the Variations option from the fly-out menu. Photoshop displays the Variations dialog box, as shown in Figure 220.1.

Choose from the available options to modify an image:

- **Original/Current Pick:** The two thumbnails in the upper left of the Variations dialog box show the original image and compare it to the changed image. During the course of making changes to the image, clicking on the Original thumbnail restores the image to its original settings.

- **Image Adjustment:** Click on the radio buttons to modify the Shadows, Midtones, Highlights, or Saturation of the inks in the active image.

- **Fine/Coarse:** Click on the triangular slider and move it left or right to increase (Coarse) or decrease (Fine) the amount of each adjustment. The finer the setting, the more clicks per adjustment thumbnail are required to produce a change in the image.

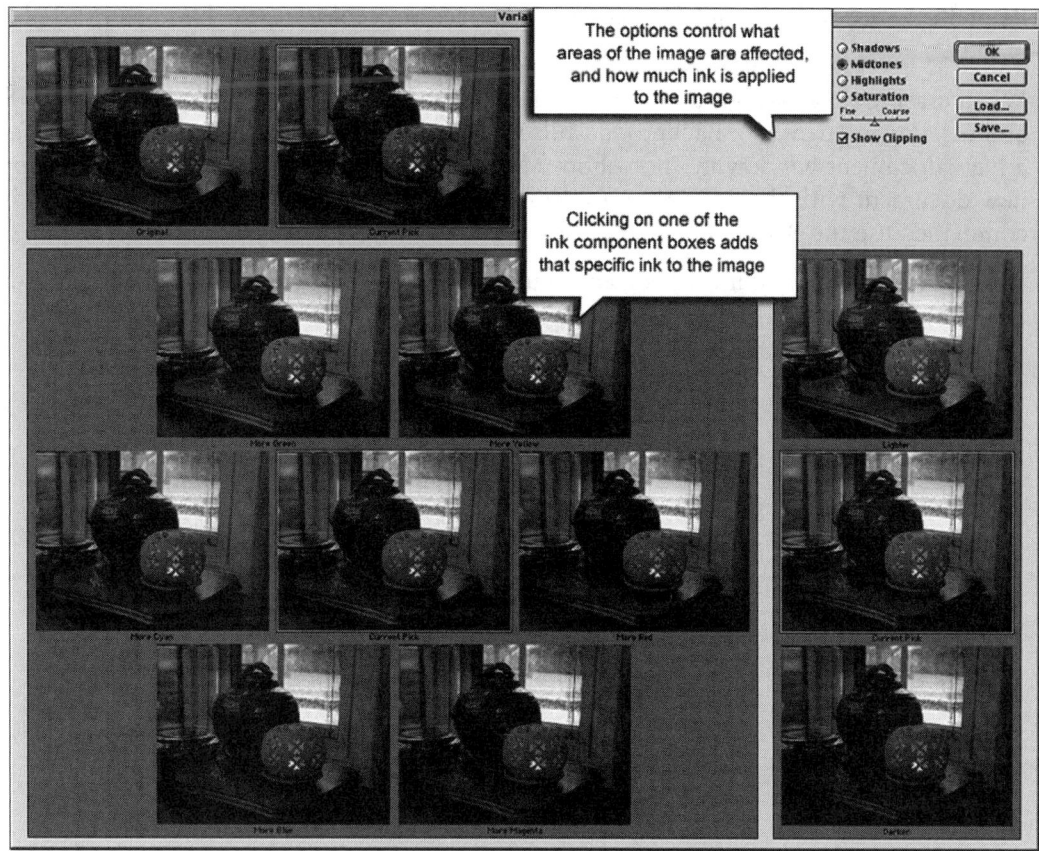

Figure 220.1 Clicking on the thumbnails in the Variations dialog box controls the color balance, contrast and/or saturation of the active image.

- **Show Clipping:** Click in the Show Clipping box to select this option. When selecting the Show Clipping option, the image previews display a neon color over the areas of the image that, due to the adjustments made to the image, convert the pixels to pure black or white.

- **Variation Adjustments:** Click on the thumbnails surrounding the Current Pick thumbnail to add a color adjustment to the image. Clicking on Green, for example, adds an adjustment of green to the current pick based on the Image Adjustment and Fine/Coarse options. The more times you click on the Green thumbnail (or any other thumbnail), the more the image colors will shift. Clicking on the Lighter and Darker thumbnails adjusts the brightness values of the pixels. Each time you click a thumbnail, the changes display in the Current Pick thumbnails.

Although using the Variations option helps in the adjustment of images with simple color and contrast problems, the best way to correct the color and tonal range of an image is using the Levels and Curves commands.

221 *Selecting a Foreground and Background Color Swatch*

Photoshop's Foreground Color Swatch performs multiple tasks in Photoshop: The Airbrush and Paintbrush tools use the Foreground Color Swatch as their painting color; the Pencil tool draws lines using that color. However, the brushes are not the only tools to use the Foreground Color Swatch: The

Paint Bucket, Gradient, and Shapes tools also use this color, as do Photoshop's Fill and Stroke commands.

When erasing on a Background, the Standard Eraser tool uses the Background Color Swatch. Selecting and deleting an area on a Background fills the deleted area with the Background color. When you open a New document window in Photoshop (File menu New), Photoshop gives you the option of filling the new document with the Background Color Swatch. In addition, Photoshop's Fill Gradient tool and Fill commands use the Background Color Swatch.

With all this popularity, it is important to understand the best way to select colors for the Color Swatch, as shown in Figure 221.1.

Figure 221.1 The Color Swatch displays the current Foreground and Background color swatches.

- **Default Colors:** To set the Foreground and Background colors to their default values of black and white, click on the small black and white icon located in the lower-left corner of the color swatches box.

- **Reversing Colors:** To reverse the current Foreground and Background colors, click on the small bent arrow in the upper-right corner of the color swatches box.

- **Swatches Palette:** Clicking once on any color in the Swatches palette automatically changes the default Foreground Color Swatch. Holding down the Alt (Macintosh: Option) key and clicking on a color in the Swatches palette automatically changes the Background Color Swatch.

- **Color Palette:** The Color palette contains a small icon representing the Foreground and Background Color Swatches. Click on the Foreground or Background icon to select the Foreground or Background Color Swatch and click and drag the color sliders in the Color palette to change the selected color swatch, as shown in Figure 221.2. For more information on the Color palette, see Tip 231, "Loading and Saving Custom Swatch Palettes."

- **The Eyedropper Tool:** Selecting the Eyedropper tool and clicking on a color in an open Photoshop image automatically changes the Background Color Swatch. Holding down the Alt (Macintosh: Option) key and clicking on a color with the Eyedropper tool automatically changes the Foreground Color Swatch, as shown in Figure 221.3.

Figure 221.2 Modifying a color in the Color palette changes the Foreground or Background Color Swatch.

- **The Foreground and Background Color Swatches:** Clicking once on the Foreground or Background Color Swatches (refer to Figure 221.1) automatically opens the Color Picker and lets you choose a standard color or a custom color, as shown in Figure 221.4. For more information on using the Color Picker dialog box, see Tip 62, "Manually Choosing Colors with the Color Picker."

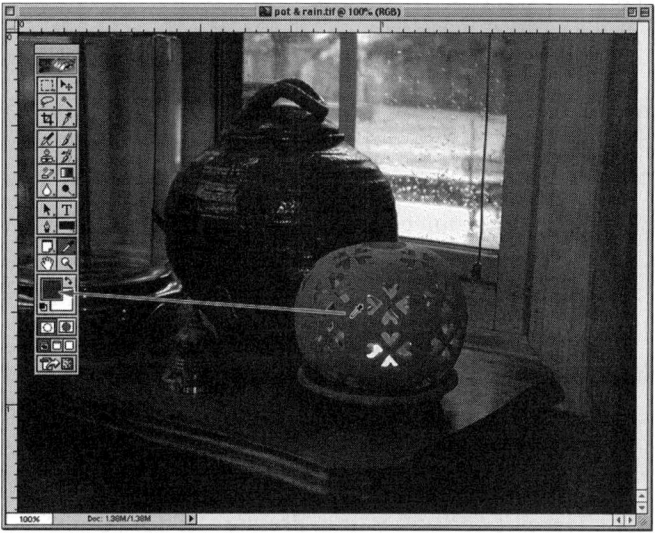

Figure 221.3 The Eyedropper tool selects Foreground and Background Color Swatches from any open Photoshop document.

Figure 221.4 Clicking on the Foreground or Background Color Swatch automatically opens the Color Picker dialog box and lets you select a standard or custom color.

222 Understanding the Difference Between the Paintbrush and the Airbrush

The Airbrush and Paintbrush tools work in a similar fashion: They both use the Foreground color as their painting color, and they both use the same brushes to apply the ink to the image. The one major difference between the Airbrush and Paintbrush tools is the application of the ink to the screen.

The Airbrush tool performs in much the same way as an airbrush performs in the hands of a natural media artist. As a natural media artist moves the airbrush, the brush applies a layer of ink to the canvas. If the artist moves slowly or overlaps a stroke, more ink is applied. Conversely, moving faster with an airbrush produces a stroke with less ink.

When you use the Airbrush tool in Photoshop, the tool works using a Pressure option (refer to Tip 217, "Understanding the Difference Between Pressure, Opacity, and Exposure"). The Pressure of the tool influences how much ink applies to the document. Moving the Photoshop Airbrush in faster strokes and overlapping strokes creates the look and feel of a real airbrush, as shown in Figure 222.1.

The Paintbrush tool does not perform with a Pressure option; it instead uses Opacity (again, refer to Tip 217). Opacity controls the brush using the mouse as an on/off switch. When you use the Paintbrush and drag the brush across the document window, the mouse controls the percentage of ink applied to the image. Clicking and holding the mouse down while using a 30-percent opaque paintbrush produces a 30-percent application of color to the image. No matter how many times you go over an area, the opacity will not exceed 30 percent. If you release and then click the mouse while moving over a painted area, the Paintbrush tool will add an additional 30 percent of color to the image, as shown in Figure 222.2.

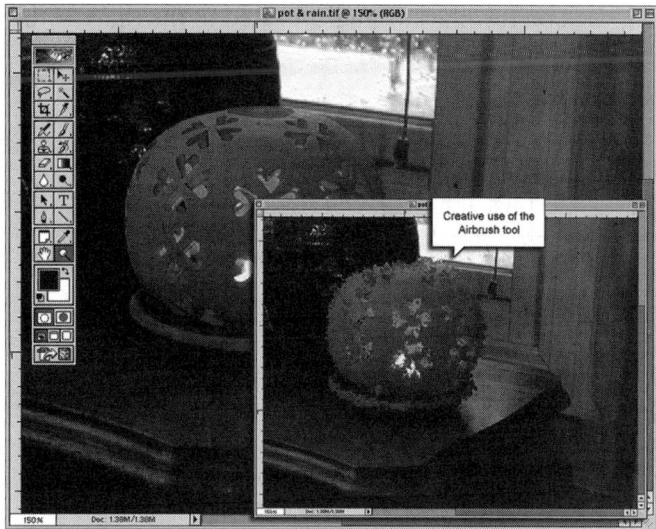

Figure 222.1 Using the Airbrush tool creates the illusion of working with a real airbrush.

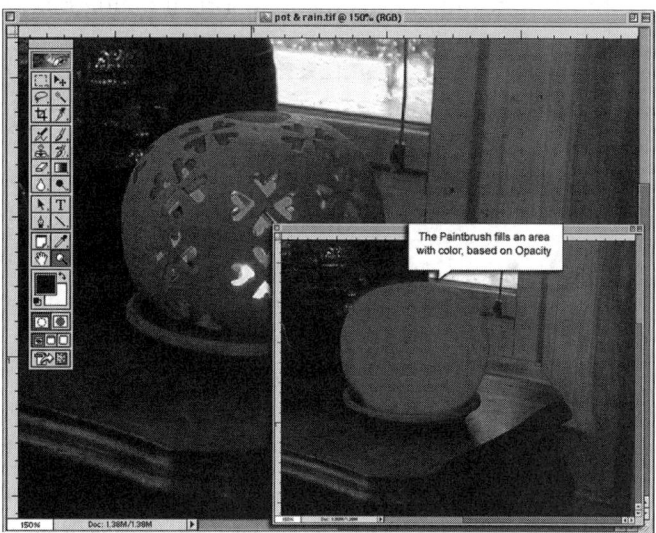

Figure 222.2 The Paintbrush enables you to control ink distribution by clicking and holding the mouse button. As long as you hold down the mouse button, the opacity of the Paintbrush remains constant.

The Paintbrush tool is excellent for filling an area of an image with a specific opacity color. As long as you continue to hold down the mouse button as you drag the Paintbrush, the opacity of the brush color remains constant.

223 *Creating a Calligraphic Brush*

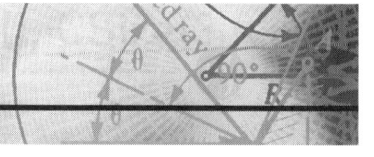

In Tip 185, "Defining a New Brush with a Circle," you learned how to create new circular brushes. Photoshop also lets you create calligraphic brushes and then use them to create everything from special effects to calligraphic lettering.

To create a new calligraphic brush, select any of the Photoshop tools that use a brush. In this example, you will select the Paintbrush from the Photoshop toolbox. Refer to Tip 78, "The Paintbrush and Pencil Tool," for more information on selecting the Paintbrush.

In the Options bar, click on the black triangle located to the right of the Brush icon. Photoshop will open the Brush palette, as shown in Figure 223.1.

Figure 223.1 *Clicking on the black triangle opens the Brush palette and displays all available Photoshop brushes.*

Click on the round button with a triangle symbol located in the upper-right corner of the Brush palette (refer to Figure 223.1). Photoshop opens a fly-out menu displaying the Brush palette options. Click on the New Brush Option. Photoshop opens the New Brush dialog box, as shown in Figure 223.2.

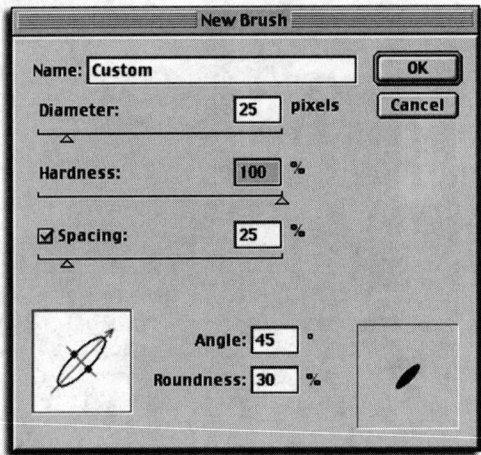

Figure 223.2 *The New Brush options define the characteristics of a new brush.*

- **Name:** Click in the Name input field and enter a name for the new brush; type Calligraphic 1 for the brush name.

- **Diameter:** Click on the triangle slider located under the Diameter option and drag left or right to choose a size for your new brush. Brush sizes range from 1 to 999 pixels; choose a diameter of 25 pixels.

- **Hardness:** Click on the triangle slider located under the Hardness option and drag left or right to choose a hardness for your new brush. Calligraphic brushes require a hard brush; choose 100 percent hardness.

- **Spacing:** Click on the triangle slider located under the Spacing option and drag left or right to choose a spacing for your new brush. Calligraphic brushes require a solid spacing; choose 25 percent for the value of spacing.

- **Angle:** Click in the Angle input box to change the angle of the drawn shape. Values range from –180 to 180 degrees. Change the angle of the brush to 45 degrees.

- **Roundness:** Click in the Roundness input box to change the roundness of the drawn shape. Values range from 0 to 100 percent. Change the roundness of the brush to 30 percent.

Click the OK button in the New Brush dialog box. Photoshop closes the New Brush dialog box and saves your new brush in the Brush palette, as shown in Figure 223.3.

Figure 223.3 *The new calligraphic brush is now part of the Brush palette and is available for use.*

224 *Creating a Dotted-Line Brush*

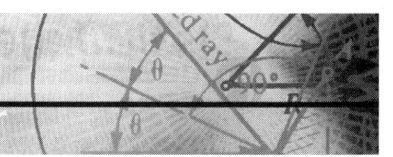

In the preceding tip, you learned how to create a calligraphic brush; however, it is just as easy to create a brush that generates a dotted line. Referring to the preceding tip, create a brush with these characteristics.

- **Name:** Dotted Line 1

- **Diameter:** 25 pixels

- **Hardness:** 50 percent

- **Spacing:** 250 percent

- **Angle:** 0 degrees

- **Roundness:** 0 percent

Click the OK button to save the new brush.

A default spacing of 25 percent creates a visual solid brush. Changing the spacing to 250 percent creates a brush that, when dragged across the document, creates a copy of itself every 250 percent, as shown in Figure 224.1.

Figure 224.1 Changing the spacing of a brush creates a dotted line based on the percentage of the spacing.

Note: Holding down the Shift key while dragging the brush across the document creates a perfectly straight line.

225 Modifying Tool Options

It is important to understand that modifying the tools in Photoshop can help with the design of a project. You do not need to use the standard brushes; you can make your own to fit the job at hand. You can also modify the Pressure option of the Airbrush and the Opacity option of the Paintbrush. With the click of a button, you can change the blending mode of your tools as well as assign them to work with your drawing tablet.

It is just as important to understand that changing tool options changes them for the program, not the open document file. Photoshop records all modifications made to the tools and records them in a preference file. The next time Photoshop opens, all the tools reset to the way they were last used.

To reset all the tools in Photoshop back to their default values, perform these steps:

1. Open Adobe Photoshop

2. Click on the icon at the far left of the Options bar to display the Tool Reset pop-up menu, as shown in Figure 225.1 (it does not matter what tool is selected).

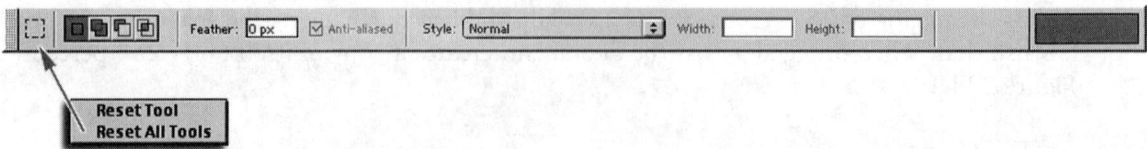

Figure 225.1 Clicking on the icon at the far left of the Options bar opens the Tool Reset pop-up menu.

3. Click on Reset All Tools. Photoshop resets all the tool options in Photoshop back to their default values, and you are ready to work.

226 *Drawing Lines and Shapes*

In Tip 125, "Creating Shapes with the Custom Shape Tool," you learned that the Custom Shape tool draws Shaped Layers, Custom Paths, and Filled Regions. Filled Regions are Custom Shapes, created and filled with the current Foreground Color Swatch.

To use the Custom Shapes tool to draw a filled shape, perform these steps.

1. Click and hold your mouse on the Drawing Shape tool in the Photoshop toolbox. Photoshop will display a fly-out menu with the Drawing Shape options, as shown in Figure 226.1.

Figure 226.1 The Drawing Shape options displayed in the Photoshop toolbox.

2. Click on the Custom Shape tool option. Photoshop closes the fly-out menu and makes the Custom Shape the default tool.

3. The Options bar now displays all the options available for the Custom Shape tool, as shown in Figure 226.2.

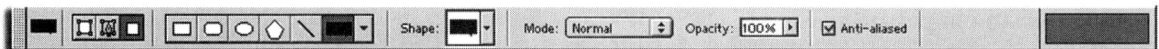

Figure 226.2 The Options bar displays all the available options for the Custom Shape tool.

4. The first set of buttons on the left of the Options bar (refer to Figure 226.2) lets you choose what type of shape you want to draw. Click on the right-most button to select Filled Region as the drawing type.

5. Click on the Shape button to display a list of available shapes, as shown in Figure 226.3.

Figure 226.3 The Shape button on the Options bar displays all available custom shapes.

6. Click to choose the heart shape. Photoshop makes the heart the default drawing shape.

7. Create a new layer in Photoshop (see Tip 233, "Controlling Your Work with Layers").

8. Move your cursor into the document window and click and drag your mouse to draw the shape. When you release your mouse, the shape fills with the default Foreground Color, as shown in Figure 226.4.

Figure 226.4 Clicking and dragging your mouse draws a custom, filled shape in the new layer.

To control the shape, perform one or more of these options:

- **Shift Key:** Hold down the Shift key while drawing the shape to keep the width and height of the shape in perspective.

- **Alt (Macintosh: Option) Key:** Press the Alt (Macintosh: Option) key to select a new fill color from the document window. Clicking your mouse within the document changes the Foreground Color. Release the Alt (Macintosh: Option) key and click and drag your mouse to create the shape.

- **Alt (Macintosh: Option) Key:** To draw the shape from the center out, first click and hold your mouse and then press and hold the Alt (Macintosh: Option) key. The shape draws out from the center of where you first clicked.

227 *Manipulating Shapes with Free Transform*

In the preceding tip, you learned how to select and draw a shape using the Custom Shape tool. Once you have drawn a shape, you may need to modify it to fit a particular size or dimensional shape. Photoshop lets you change a previously drawn, filled shape with the use of the Free Transform command.

To modify a custom shape, perform the steps in the preceding tip to draw a shape in a new layer and select Edit menu Free Transform. Photoshop places a bounding box around the shape, as shown in Figure 227.1.

Figure 227.1 The Free Transform command creates an editable bounding box around the custom shape.

Choose one or more of these options to modify the shape:

- Move your mouse over one of the handles in any of the four corners until it resembles a diagonal double arrow and drag in or out to expand or contract the shape.

- Move your mouse over one of the handles in any of the four corners until it resembles a diagonal double arrow and drag in or out while holding down the Shift key to proportionally expand or contract the shape.

- Move your mouse over one of the handles in any of the four corners until it resembles a diagonal double arrow and drag in or out while holding down the Alt key to expand or contract the shape from the center.

- Move your mouse over one of the middle handles until it resembles a vertical or horizontal double arrow and drag in or out to change the width or height of the shape.

- Move your mouse outside the bounding box created by the Free Transform command until it resembles a curved double arrow and then drag your mouse to rotate the shape.

- Move your mouse over any handle and drag your mouse while holding down the CTRL key (Command key: Macintosh) to change the perspective of the shape.

Press the Enter key to exit the Free Transform command and record the changes to the shape.

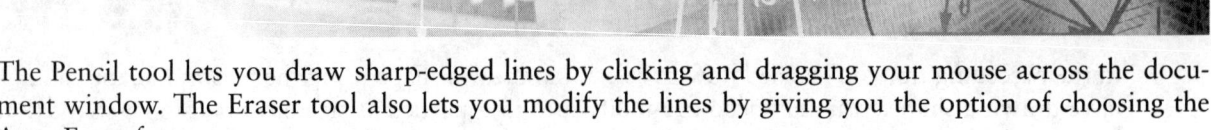

228 *Using Auto Erase with the Pencil Tool*

The Pencil tool lets you draw sharp-edged lines by clicking and dragging your mouse across the document window. The Eraser tool also lets you modify the lines by giving you the option of choosing the Auto Erase feature.

To use the Auto Erase feature with the Pencil tool, select the Pencil tool from the toolbox (refer to Tip 78, "The Paintbrush and Pencil Tools"). The Options bar displays all the available options for the Pencil tool, as shown in Figure 228.1.

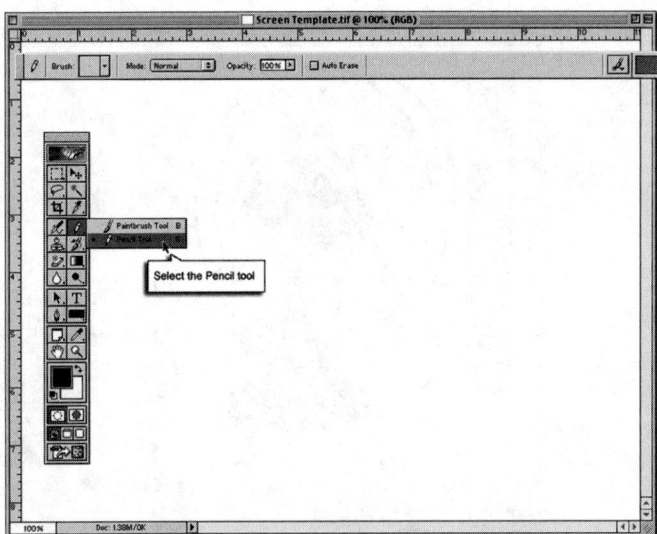

Figure 228.1 The Options bar controls the characteristics of the Pencil tool.

Click in the Auto Erase input box to select the option (refer to Figure 228.1). To deselect the Auto Erase option, click once again in the input box to remove the check mark.

The Auto Erase feature lets you erase portions of a previously drawn line; however, it does not erase the line. It paints over the line with the background color. If the background of your document is white and the background color swatch is white, the visual effect is that of erasing the line, as shown in Figure 228.2. If, however, the background of your image and the background color swatch are not the same, the effect is that of painting a second color line over the first line.

1. Open an existing or new document in Photoshop.

2. Select the Pencil tool and choose a foreground and background color (refer to Tip 221, "Selecting a Foreground and Background Color Swatch").

3. Click in the document and drag to draw a line. The line appears in the foreground color. Now move away from the original line and click and drag again with the Pencil tool. A second line draws within the document using the foreground color.

4. To erase a portion of the line, move your mouse over the portion of the line you want to erase and click and drag your mouse. As you drag your mouse, it paints the image with the background color. If the background color is the same as the background in the document, the effect of visually erasing the line is achieved, as shown in Figure 228.2.

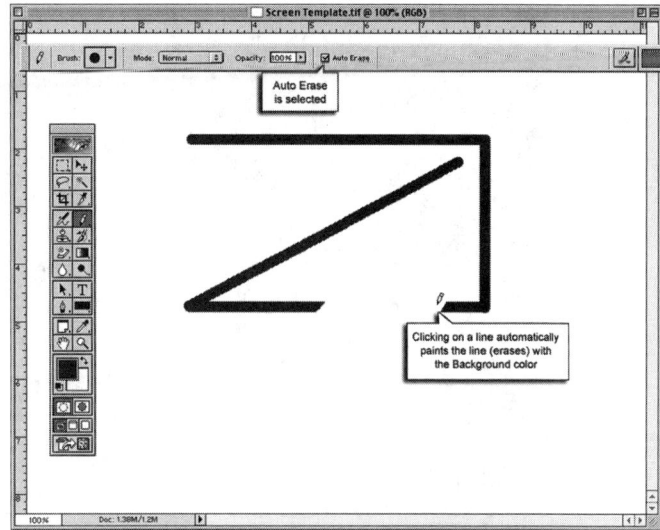

Figure 228.2 The Auto Erase feature deletes a previously drawn line by painting over the old line with the current background color swatch.

The Auto Erase feature keys to where the mouse is positioned before clicking and dragging. If your mouse is over a previously drawn line, the Pencil tool paints over (erases) the line using the background color. If your mouse is positioned over any other area of the document, it draws a line based on the foreground color.

229 *Using the Magic Eraser Tool to Remove an Unwanted Background*

In Tip 165, "Working with the Magic Eraser," you learned how the Magic Eraser operates to remove pixels from an image. The Magic Eraser works based on the tolerance of the image pixels. Clicking in the document with the Magic Eraser identifies the pixel under the mouse as the sample. The Magic Eraser then selects and deletes pixels within the image based on how you set the options of the tool.

To use the Magic Eraser to remove an unwanted background, perform these steps:

1. Open an image in Photoshop, as shown in Figure 229.1.

2. Select the Magic Eraser from the toolbox (again, refer to Tip 165).

3. The Options bar displays all the available options for the Magic Eraser, as shown in Figure 229.2.

Figure 229.1 In this image, you want to remove the background surrounding the dog.

Figure 229.2 The Options bar displays the available options for the Magic Eraser.

- **Resetting the Tool:** Click on the Magic Eraser icon located on the far left of the toolbar (refer to Figure 229.2). Photoshop will open a fly-out menu that gives you the option to reset either the current tool or all tools in the Photoshop toolbox back to their default values. Click on the Reset Tool option to reset the Magic Eraser tool.

- **Tolerance:** The Tolerance option controls the number of pixels erased. Each pixel in a Photoshop image contains a brightness number of 0 to 255. When you click within a Photoshop document, the pixel directly under the Magic Eraser becomes the sample. The Tolerance option decides how many steps of brightness to erase based on the sample pixel. Click in the Tolerance field and enter a number from 0 to 255. The higher the number, the more pixels (steps of brightness) the Magic Eraser will select. Leave the Tolerance value set to 32.

- **Anti-aliased:** The Anti-aliased option creates a visually smooth eraser by softening the edge where erasing occurs. To create an exact (jagged) eraser, deselect this option. To deselect the Anti-aliased option, click once in the input box to remove the check mark. Click again in the Anti-aliased input box to re-enable the option.

- **Contiguous:** The Contiguous option erases an area surrounding the sample pixel (where you clicked). Deselecting the Contiguous option (removing the check mark from the input box) causes the Magic Eraser to erase all pixels of similar value throughout the image. Leave this option selected.

- **Use All Layers:** The Use All Layers option, if selected (by placing a check mark in the input box), will erase all pixels of similar value in every visible layer. If Use All Layers is unselected (by removing the check mark from the input box), only the active layer is affected. Leave this option unselected.

- **Opacity:** The Opacity option controls the transparency of the erased pixels. An Opacity setting of 100 (default) completely erases the selected pixels. Enter a value from 1 to 100. The lower the value, the less transparent will be the erased pixels. Leave this value set to 100 percent.

4. Move the Magic Eraser into the image and click once on the background. Based on the settings of the Magic Eraser, a portion of the image erases to transparent.

5. Move around the background, clicking your mouse to remove more of the image pixels until the entire background is eliminated, as shown in Figure 229.3.

Figure 229.3 The Magic Eraser successfully eliminated the background from the image.

The Magic Eraser works best when the pixels it erases are distinctly different from the other image pixels. To make complicated selections easy, see Tip 289, "Determining When to Use the Extract Command," and Tip 445, "Using Channels to Hold Difficult Selections."

Note: You will use this image to complete the steps in Tip 232. Therefore you may wish to save the image for future reference.

230 *Modifying a Photoshop Brush to Create a New Brush*

In Tip 186, "Defining a New Brush from Drawn Objects," you learned how to create a new brush from a previously drawn object. The one restriction to creating shapes from objects is the inability to resize the brush. Creating brushes from circles gives you the option to reform the size of the brush from 1 to 999 pixels; when you draw your own shape, you are stuck the original size the shape.

If you want to resize a brush shape in Photoshop, perform these steps:

1. Open a New document in Photoshop (File menu New) and use these options:

 • **Width:** 5 inches

 • **Height:** 5 inches

 • **Resolution:** 150 pixels/inch

 • **Mode:** RGB Color

 • **Contents:** Transparent

2. Click the OK button to open the new document.

3. Select the Paintbrush tool from the toolbox (refer to Tip 78, "The Paintbrush and Pencil Tools").

4. From the Options bar, click on the small black triangle located to the right of the Brush button. Photoshop displays a palette with all the available brushes, as shown in Figure 230.1.

Figure 230.1 The Brush palette displays all the available brushes.

5. Click on the brush you want to resize. Photoshop makes it the default brush shape.

6. Press the letter "D" on your keyboard to default your foreground and background colors to black and white (always create a brush in black or a shade of gray).

7. Move your Paintbrush into the document window and click your mouse once. Photoshop places a single copy of the paintbrush (in black) into the empty document.

8. Select Edit menu Free Transform. Photoshop creates a bounding box around your brush shape. Modify the shape using the information in Tip 227, "Manipulating Shapes with Free Transform."

9. When you have completed modifications to the brush, select Edit menu Define Brush. Photoshop displays a small thumbnail of the new brush inside the Brush Name dialog box, as shown in Figure 230.2.

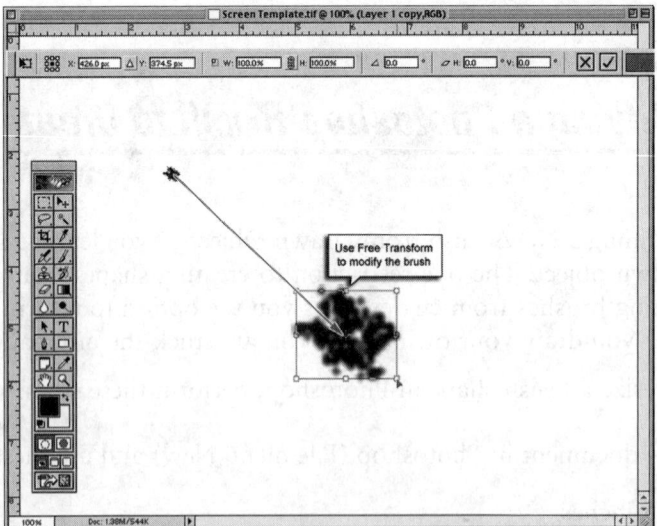

Figure 230.2 The Brush Name dialog box displays the new brush and lets you assign a name.

10. Click in the Name input field and enter a name for the new brush. Click the OK button to close the Brush Name dialog box and save the new brush in the Brush palette.

Your new brush is now accessible by any tool that uses the Brush palette.

231 | *Loading and Saving Custom Swatch Palettes*

The default Swatch palette in Photoshop displays typical mix colors and grayscale swatches, as shown in Figure 231.1.

Figure 231.1 *The default Swatch palette in Photoshop.*

There are times, however, when the default colors are not what you need for the job. In that case, create your own swatch palettes and then save and load them when necessary.

To create a custom Swatch palette, first click on the Swatches tab to view the current Swatch palettes (refer to Figure 231.1). If the Swatches tab is not visible, select Window menu Show Swatches.

Delete all the swatches you do not want as part of your custom palette by holding down the CTRL key (Command key: Macintosh) and clicking one at a time on the color swatches you want to remove from the palette, as shown in Figure 231.2.

Figure 231.2 *Clicking on a color swatch while holding down the CTRL key (Command key: Macintosh) automatically removes that color from the current palette.*

Add individual process or custom colors to the modified Swatch palette by performing the steps in Tip 547, "Adding Individual Colors to the Swatches Palette."

When you have completed adding swatches to the palette, click on the triangular button in the upper-right corner of the Swatches palette. Photoshop displays a fly-out menu containing the Swatches palette options, as shown in Figure 231.3.

Click on the Save Swatches option. Photoshop displays the Save dialog box, as shown in Figure 231.4.

Click in the Name field, enter a name for your palette, and click the Save Button. Photoshop closes the Save dialog box and saves your customized Swatches palette.

To use a previously saved palette, click on triangular button in the upper-right corner of the Swatches palette. Photoshop displays the available options, as shown in Figure 231.3.

Click on the Load Swatches button. Photoshop opens the Load dialog box. Select your customized Swatches palette from the available list and click the Load button. Photoshop closes the Load dialog box and loads your customized Swatches palette.

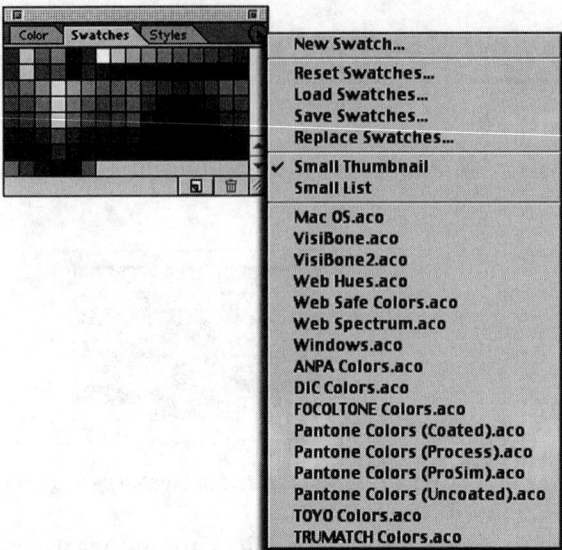

Figure 231.3 *The Options menu for the Swatches palette.*

Figure 231.4 *The Save dialog box lets you name and save customized swatch palettes.*

To reset the Swatches palette back to the default colors, click on the triangular button in the upper-right corner of the Swatches palette. Photoshop displays the available options, as shown in Figure 231.3.

Click on the Reset Swatches option. Photoshop displays a warning dialog box asking, "Replace current color swatches with the default colors?" Click the OK button to replace the colors or click Append to add the default color to the current palette.

232 *Painting an Image Using the Fill Command*

Photoshop includes a powerful feature that lets you use a current selection as a guide for filling an area with a color, pattern, or history state. For this example, you will replace the background of the image in

Tip 229, "Using the Magic Eraser Tool to Remove an Unwanted Background." In that tip, you learned how to use the Magic Eraser to remove pixel information from the image. In this tip, you will replace that erased data with a fill background, as shown in Figure 232.1.

Figure 232.1 The image from Tip 229 requires a new background.

To use the Fill command with a selection, open an image and perform these steps:

1. Reset all Photoshop tools to their default values (refer to Tip 225, "Modifying Tool Options").

2. Select the Magic Wand and click once in the transparent area. Since you clicked on a transparent pixel, the Magic Wand will select all the transparent pixels in the background, as shown in Figure 232.2.

Figure 232.2 The Magic Wand selects all the transparent pixels and creates an area usable by the Fill command.

3. Select Edit menu Fill. Photoshop opens the Fill dialog box, as shown in Figure 232.3.

Figure 232.3 The Fill dialog box controls how Photoshop performs a fill.

Control the Fill command from the available options:

- **Contents:** Click to choose a fill option. Choose from Foreground Color, Background Color, Pattern, History, Black, 50% Gray, or White.

- **Custom Pattern:** If you choose Pattern as your Fill option, the Custom Pattern option becomes available. Click on the Custom Pattern button to display a list of available patterns and click on a specific pattern to make it the default fill pattern.

- **Blending:** The Fill option lets you choose a blending mode for the fill color or pattern. Click on the Mode button to choose from the available options. See Tip 234, "Using Blending Modes to Influence the Painting Tools."

- **Opacity:** Click in the Opacity input field and enter a value between 1 and 100 to change the opacity of the fill. The higher the value, the more opaque the fill.

- **Preserve Transparency:** When selected, Preserve Transparency protects the transparent pixels from being colored by the Fill command.

Note: Since the background layer does not support transparency, the Preserve Transparency option is not available.

4. Click the OK button to apply the fill to the image, as shown in Figure 232.4.

Figure 232.4 The Fill command applied to the background of the image.

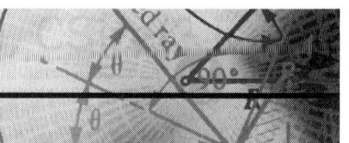

233 *Controlling Your Work with Layers*

Controlling layers in Photoshop gives you total control of your document. Photoshop lets you create transparent layers and perform editing operations to an image within those layers.

The tools in Photoshop that let you perform multilayer editing are the Clone and Pattern Stamp tools and the Blur, Sharpen, and Dodge tools. When selecting any of these tools, the Options bar displays the Use All Layers option.

To use any of these editing tools, open a document in Photoshop (File menu Open) and perform these steps:

1. Create a new layer directly above the image layer, by clicking the Create New Layer icon at the bottom of the Layers palette.

Figure 233.1 Creating a new layer directly above the image layer gives you editing control over the document.

2. Click on the Blur tool (refer to Tip 83, "The Focus Tools").

3. Reset the Blur tool to its default settings (refer to Tip 225, "Modifying Tool Options").

4. In the Options bar, click on the Use All Layers option, as shown in Figure 233.2.

5. Determine in the Layers palette that the newly created layer is selected.

6. Click and drag your cursor over the area of the image you want to blur. The image pixels begin to blur, as shown in Figure 233.2.

Since you are working in a separate layer, the effects of the blur are not applied to the original image. If you do not like how the work is progressing, you can choose to erase part of the information in the edit layer or delete the entire layer and start over again. Choosing the Use All Layers option and editing the image in a separate layer gives you control and flexibility over time.

To make your changes to the image permanent, click on the triangular button in the upper-right corner of the Layers palette. Photoshop displays a pop-up menu showing all available layer options. Click on the Flatten Image option to combine your editing layer with the image layer. Your editing changes are now a permanent part of the image.

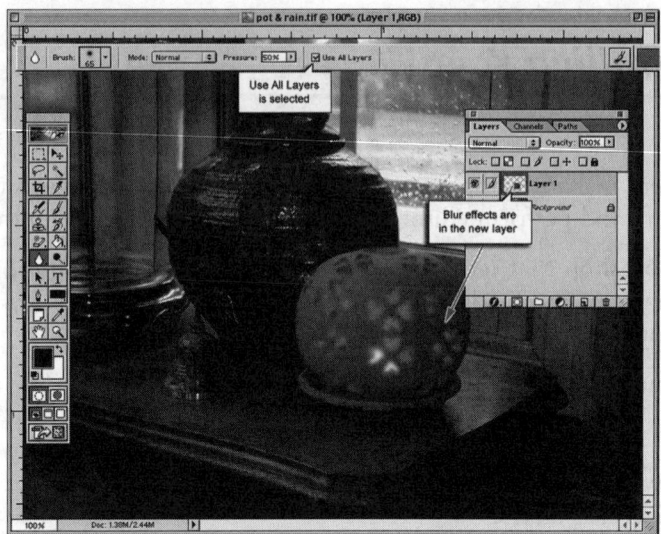

Figure 233.2 Using the Blur tool in a separate layer gives you total control over image editing.

234 *Using Blending Modes to Influence the Painting Tools*

You can modify Photoshop's painting tools to paint the image based on a calculation or blending mode. The Blending Mode option is available for all of Photoshop's painting tools. When you have a painting tool selected, click on the Mode button in the Options bar to display a list of all available Blending Mode options, as shown in Figure 234.1.

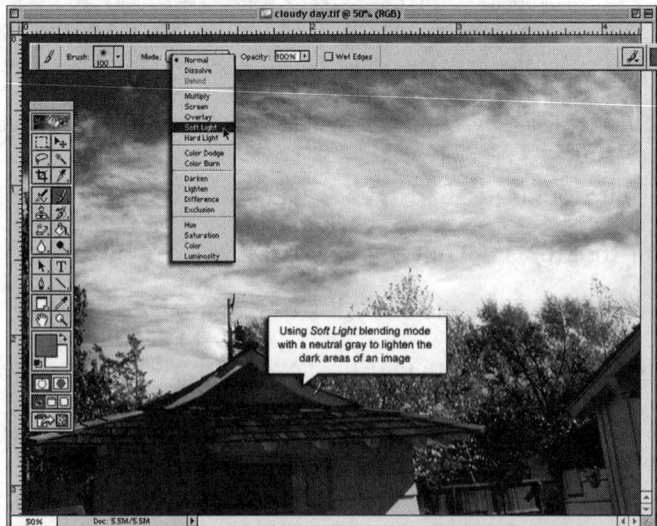

Figure 234.1 The Blending Mode options let you make creative use of the painting tools.

When referring to the various blending modes, these terms are used to describe the colors:

- **Base color:** The original colors in the image.

- **Blend color:** The painting color (Foreground Color Swatch).

- **Result color:** The result of the blending of the Base and Blend colors.

The Blending Mode options available to the painting tools are:

- **Dissolve:** The Dissolve option edits or paints each pixel in the active layer using the blend color. The result color is a random replacement of the pixels with the base color or the blend color, depending on the opacity at any pixel location. This mode works best with the Paintbrush or Airbrush tool and a large brush, and it displays a ragged appearance to the image colors.

- **Behind:** The Behind option edits or paints the transparent part of a layer with the blend color. All areas of a layer containing pixels with color are locked out to the Behind option.

- **Multiply:** The Multiply option looks at the color information in each channel and multiplies the base color by the blend color. The result color is always a darker color. Multiplying any color with black produces black. Multiplying any color with white leaves the color unchanged. When you paint with a color other than black or white, additional strokes with a painting tool produce darker and darker colors.

- **Screen:** The Screen option examines each channel's color information and multiplies the opposite of the blend and base colors. The result color is always a lighter color. Screening with black leaves the color unchanged. Screening with white produces white.

- **Overlay:** The Overlay option multiplies or screens the colors, depending on the base color. Patterns or colors overlay the existing pixels while preserving the highlights and shadows of the base color.

- **Soft Light:** The Soft Light option darkens or lightens the colors, depending on the blend color. If the blend color is lighter than 50 percent gray, the image is lightened. If the blend color is darker than 50 percent gray, the image darkens. Painting with pure black or white produces a distinctly darker or lighter area but does not result in pure black or white.

- **Hard Light:** The Hard Light option multiplies or screens the colors, depending on the blend color. If the blend color is lighter than 50 percent gray, the image lightens. If the blend color is darker than 50 percent gray, the image is darkened.

- **Color Dodge:** The Color Dodge option examines the color information in each channel and brightens the base color to reflect the blend color. Blending with black produces no change.

- **Color Burn:** The Color Burn option examines the color information in each channel and darkens the base color to reflect the blend color. Blending with white produces no change.

- **Darken:** The Darken option examines the color information in each channel and selects the base or blend color (whichever is darker) as the result color.

- **Lighten:** The Lighten option examines the color information in each channel and selects the base or blend color (whichever is lighter) as the result color.

- **Difference:** The Difference option examines the color information in each channel and subtracts either the blend color from the base color or the base color from the blend color, depending on which has the greater brightness value.

- **Exclusion:** The Exclusion option creates an effect similar to but lower in contrast than the Difference option. Blending with white inverts the base color values. Blending with black produces no change.

- **Hue:** The Hue option creates a result color with the luminance and saturation of the base color and the hue of the blend color.

- **Saturation:** The Saturation option creates a result color with the luminance and hue of the base color and the saturation of the blend color.

- **Color:** The Color option creates a result color with the luminance of the base color and the hue and saturation of the blend color. This preserves the gray levels in the image and is useful for coloring monochrome images and for tinting color images.

- **Luminosity:** The Luminosity option creates a result color with the hue and saturation of the base color and the luminance of the blend color. This mode generates the opposite effect from that of the Color option.

235 *Creating Realistic Shadows with Your Paintbrush*

Creating realistic shadows in Photoshop involves more than the simple click of a button. With the release of Photoshop 5.0, Adobe created new Effects Layers that let you create shadows, bevels, and embosses with the click of a button. However, designers created shadow and emboss effects long before version 5.0 was released to the public.

Creating a realistic shadow involves understanding how your eyes interpret three-dimensional information. Painting 3-D information on a flat surface requires lightening and darkening areas of the image to generate the visual effect of depth. Say you want to create a 3-D tile effect without using the Effects Layers in Photoshop.

To generate a shadow on an image using your paintbrush, create a new document in Photoshop (File menu New). Create the new document with the following options.

- **Width:** 5 inches

- **Height:** 5 inches

- **Resolution:** 150 pixels/inch

- **Mode:** RGB

- **Contents:** Transparent

To create the 3-D tile, perform these steps:

1. Select the Rectangular Marquee tool and draw a square on the screen, as shown in Figure 235.1 (refer to Tip 71, "The Marquee Tools").

2. Click on a swatch color in the Swatches palette. The Foreground Color Swatch changes to match your selection.

3. Select the Paint Bucket from the toolbox and click once inside the selection to fill the square with the Foreground color, as shown in Figure 235.2.

4. Select the Paintbrush tool from the toolbox and set the Opacity of the paintbrush to 50 percent, as shown in Figure 235.3.

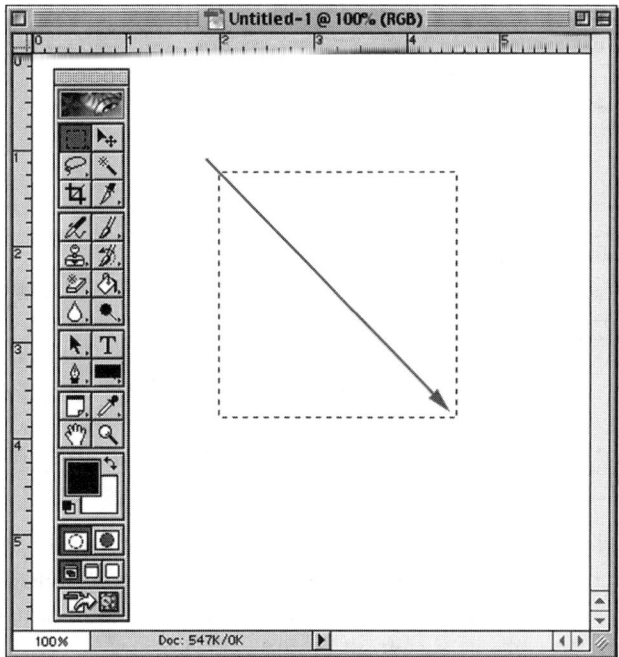

Figure 235.1 Create a square selection in the document window using the Rectangular Marquee tool.

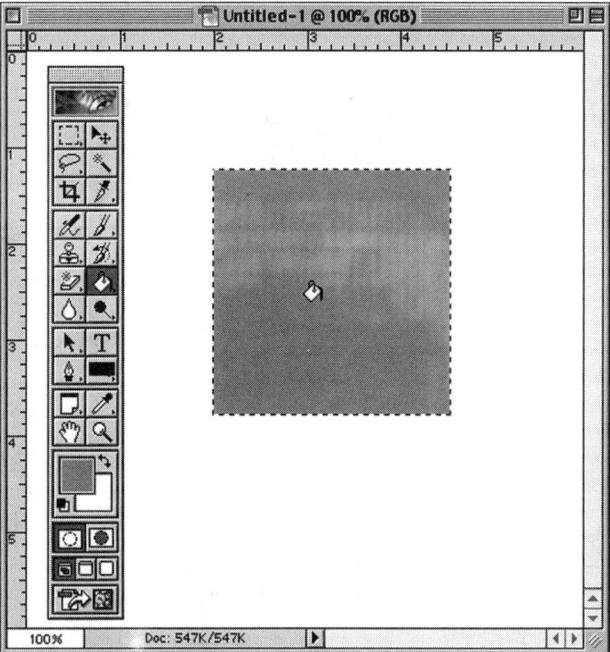

Figure 235.2 Clicking with the Paint Bucket tool inside the selected area fills the area with the Foreground color.

Figure 235.3 Setting the Opacity of the paintbrush to 50 percent reduces the application of the brush color to the image.

5. On the Options bar, click on the black triangle to the right of the Brush button. Photoshop displays a list of available brushes. Click to choose the 27-pixel Soft Round brush, as shown in Figure 235.4.

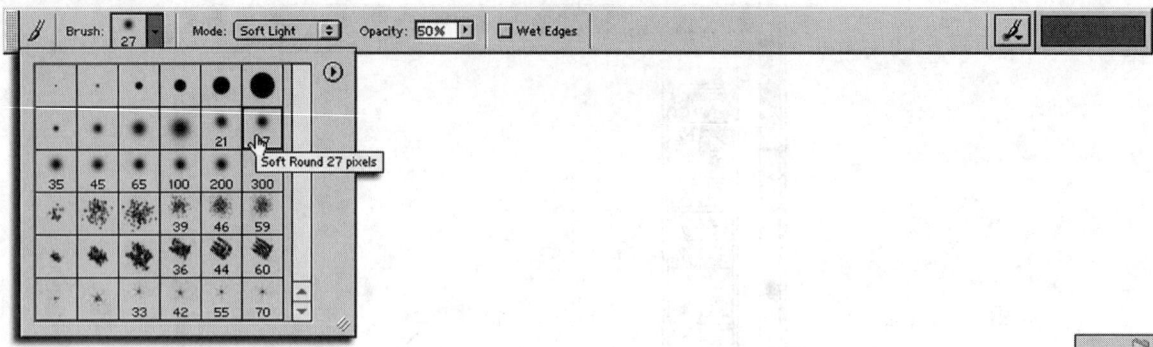

Figure 235.4 Select the 27-pixel Soft Round brush in the Brush palette.

6. Press the letter "D" on your keyboard to default the Foreground and Background colors to black and white.

7. Move the paintbrush into the document window and (with the square still selected) position your mouse in the upper-right corner of the image and drag straight down. Hint: To create a straight line, hold down the Shift key while you drag the mouse. The right side of the tile has a dark streak running from top to bottom, as shown in Figure 235.5.

Figure 235.5 Dragging the 50 percent paintbrush down the right side of the square produces a darker, shade-like look to the edge of the image.

8. Create another brush stroke exactly like the previous stoke, except run left to right across the bottom of the image.

9. Press the letter "X" on your keyboard to reverse your Foreground and Background colors to white and black.

10. Click with your white paintbrush in the upper-left corner of the square and drag to the right while holding down the Shift key.

11. Click with your white paintbrush in the upper-left corner of the square and drag down. The right and bottom sides of the square are dark and the top and left sides are light, as shown in Figure 235.5.

You have created a 3-D square using only your paintbrush. Knowing how the 3-D process operates gives you control over an image that no single button will ever provide.

236 *Changing Color in an Image with the Paintbrush*

A versatile way to convert portions of an image to black and white is with the Paintbrush tool and blending modes.

To paint out areas of an image to black and white, perform these steps:

1. Select the Paintbrush from the toolbox. Refer to Tip 78, "The Paintbrush and Pencil Tools."

2. Press the letter "D" on the keyboard to default the Foreground and Background colors to black and white.

3. Click on the Paintbrush icon at the far left of the Options bar and reset the Paintbrush to its default settings (refer to Tip 225, "Modifying Tool Options").

4. Click on the Mode button in the Options bar and change the blending mode of the Paintbrush to Color, as shown in Figure 236.1.

Figure 236.1 Changing the Mode to Color lets you selectively paint out areas of the image to black and white.

5. Click on the black triangle to the right of the Brush button. Photoshop displays a list of available brushes. Select a medium-size, soft brush from the palette.

6. Move into the image with your Paintbrush and drag the brush over the areas of the image you want to turn into grayscale. The Color blending mode chosen for the paintbrush removes the hue and saturation of the image pixels and replaces them with the painting color. Since the painting color is black, the image pixels convert into shades of gray, as shown in Figure 236.2.

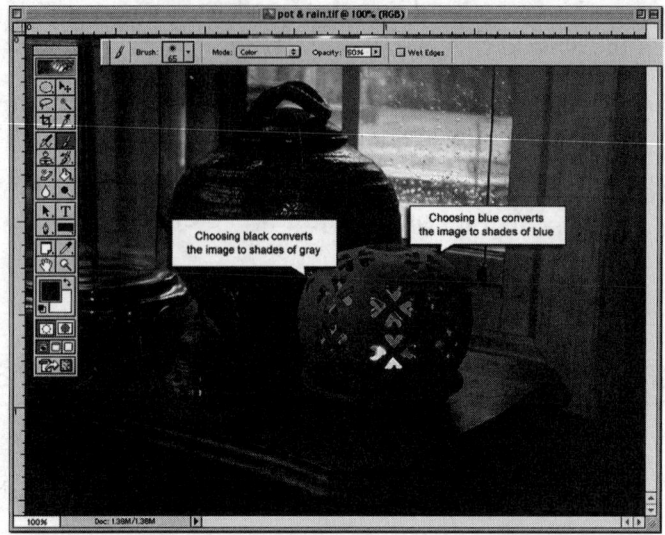

Figure 236.2 Painting with black as the Foreground color and using the Color blending mode causes painted areas of the image to convert into shades of gray.

237 Understanding How Photoshop Manages Color

Color management is important to a Photoshop image because of the different devices a graphic has to pass through before the final output. Photoshop is constantly improving the way it deals with color.

Color-matching problems result from input and output devices and software that use different color spaces or the same color spaces using different definitions. The obvious way to correct this problem is to use a universal color management system.

A color management system (CMS) compares the color space that created the image to the color space in which the same image is output. A good color management system makes the necessary adjustments to the image so that the final output is as consistent as possible among different devices.

Note: Do not confuse color management with color adjustment or color correction. The best color management system in the world will not correct an image that was saved with color problems.

Photoshop follows a color management workflow based on conventions developed by the International Color Consortium (ICC), and as the computer industry evolves, more and more software and hardware vendors are complying with this standard.

Several items are needed if color management is to be successful:

- **A good color management engine:** Several companies have developed different ways to tackle color management. To provide you with a choice, a color management system lets you choose a color management engine that represents the approach you want to use. Sometimes called the color management module (CMM), the color management engine is the part of the CMS that does the work of reading and translating colors between different color spaces.

- **Color definition**: Each pixel in an image document has a set of color definitions that describe that pixel's color mode. However, the actual appearance of the pixel may vary when output to or displayed on different devices because each device has a particular way of translating the raw numbers into visual color. That is why an image displayed on your monitor may look totally different when sent to an output device such as an ink-jet printer. The hardware device has no idea how to print or display the information.

- **Color profiles:** An ICC workflow (the one used by Photoshop) uses color profiles to determine how each color in a document translates. When you create a new document in Photoshop, you have the option of attaching a color profile to that image. Documents in Photoshop without associated profiles are known as untagged and contain color without a definition of how that color is to display or print. When working with untagged documents, Photoshop uses the current working-space profile to display and edit colors.

Refer to Tip 11, "Setting up Photoshop's Color Settings," for more information on how to use color management with a Photoshop document.

Note: Color management is an evolving technology. In some cases, the output hardware or software does not yet support the level of color management supported by Photoshop. As time passes this will change, and managing color before color management came of age will be one of those bedtime stories you use to frighten your grandchildren.

238 *Understanding Additive and Subtractive Color Space*

The RGB (red, green, and blue) color model is defined as additive color. A large percentage of the visible spectrum can be represented by mixing the colors red, green, and blue. Since red, green, and blue colors combine to create white, they are defined as additive colors. Adding 100 percent red, green, and blue together creates white, as shown in Figure 238.1.

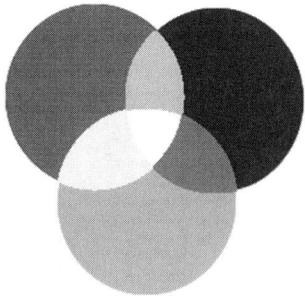

Figure 238.1 Adding 100 percent red, green, and blue creates white; in other words, all the color is reflected back to your eyes.

Your monitor displays the visible colors you see by projecting them out to your eyes. You do not need an external light source bouncing off the monitor to view a Photoshop graphic image as you would to view an image on a piece of paper. Actually, external light sources adversely affect what you see on your screen. To combat this problem, computer designers create hoods for their monitors and work in semilighted rooms to reduce the effect of an external light source.

The opposite side of the color world is the CMYK model (cyan, magenta, yellow, and black). Defined as subtractive color, it is based on the light-absorbing quality of ink printed on paper. As a light source strikes translucent inks, part of the color within the light source is absorbed and part reflects back to

your eyes. The part that reflects back to your eyes is the visible spectrum of light that you see, as shown in Figure 238.2.

Figure 238.2 *Subtractive color (cyan, magenta, yellow, and black) requires an external light to reflect off the image source. What is left of the colors (subtractive) is bounced back up to your eyes.*

The subtractive color space requires an external light source to view the document. In fact, it would be impossible to view any subtractive color image without one.

In theory, pure cyan, magenta, and yellow combine to absorb all color and produce a pure black. However, all printing inks contain some measure of impurities; therefore, the three inks when combined actually produce a muddy brown. Black is added as a fourth ink to produce deep shadows and rich blacks. Combining cyan, magenta, yellow, and black to reproduce color is called four-color process printing.

The subtractive (cyan, magenta, and yellow) and additive (red, green, and blue) colors are complementary colors because each pair of subtractive colors creates an additive color, and each pair of additive colors creates a subtractive color, as shown in Figure 238.3.

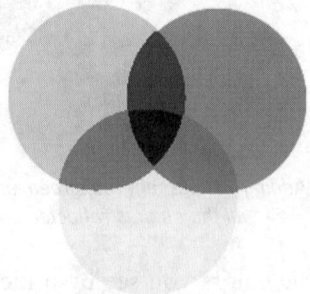

Figure 238.3 *Additive and subtractive colors, when combined in pairs, produce their complementary color.*

239 *Understanding Color Models and Color Modes*

Photoshop uses six color modes to display images: Duotone, Indexed color, RGB, CMYK, HSB, and Lab color. Color modes determine the color model used by Photoshop to display and output the image to print. Photoshop bases its color modes on established models for describing and reproducing color.

The color models available in Photoshop are:

- **RGB:** The RGB (red, green, and blue) color model consists of three channels of color. A normal RGB image consists of a 24-bit pixel capable of generating 16.7 million separate colors per pixel. The RGB color mode has changed over the years, and caution should be exercised when moving an RGB image into another editing program. Refer to the preceding tip for more information on the RGB color model.

- **CMYK:** The CMYK (cyan, magenta, yellow, and black) color model consists of four channels of color. A normal CMYK image contains a 32-bit pixel. However, the number of colors created depends on the palette chosen for printing. In most cases, the number of colors reproducible in CMYK fall into the thousands. CMYK is the color model of the professional press and four-color printing. Refer to the preceding tip for more information on the CMYK color model.

- **HSB:** The HSB (hue, saturation, and brightness) color model consists of three channels of color information. The Hue channel describes the image color, the Saturation channel describes the percentage of color applied to the image, and the Brightness channel describes the light and dark value of the pixel. The HSB model is based on the human perception of color as it exists in the real world. The HSB model is available for use in Photoshop; however, there is no specific HSB color mode to choose from in selecting or opening a new document.

- **Lab:** The Lab (lightness, a, and b) color model is based on the model proposed by the Commission Internationale d'Eclairage (CIE) in 1931 as an international standard for color measurement. In 1976, this model was refined and named CIE L*a*b. Later the asterisks were dropped and the model was named simply Lab. Lab color is considered device independent and measures color equally between scanners, monitors, and printers. Its three channels consist of a lightness channel measuring the light and dark values of each pixel, an "a" channel measuring color from green to red, and a "b" channel measuring color from blue to yellow.

- **Duotone:** The Duotone model is specific to Photoshop. It consists of a single 8-bit channel and is therefore capable of generating a maximum of 256 shades of color. The Duotone color model is used for creating color tints to black and white images without the large file sizes generated by RGB (red, green, and blue) color models. See Tip 637, "Applying a Tint to an Image," for more information on using the Duotone color model.

- **Indexed color:** The Indexed color model consists of a single 8-bit channel and, unlike the Duotone model, is capable of generating a maximum of 256 separate colors, not shades of a color. The Indexed color model is used to create small color images for display on the Internet, or for graphic images for use in computer presentations. For more information on using the Indexed color model, see Tip 834, "Converting to Indexed Color."

240 *Measuring the White Point of Your Monitor*

In Tip 57, "Calibrating Monitor Color Using the Adobe Gamma Utility," you learned how to calibrate your monitor using the built-in Gamma program. When you use the Adobe Gamma program, you are creating an ICC color profile that matches your images to your monitor. To create a correct color profile, you will need to know the white point of your monitor. The white point of a monitor is set by the manufacturer; however, the age of a monitor can subtly change the white point value and shift the colors on your monitor. To measure the white point on your monitor, open the Adobe Gamma utility (refer to Tip 57), as shown in Figure 240.1.

Figure 240.1 The Adobe Gamma utility lets you create an ICC color profile for your monitor.

Perform these steps:

1. Click and select the Step By Step Assistant.

2. Click the Next button five times until the Adobe Gamma Assistant displays the white point page, as shown in Figure 240.2.

3. Click the Measure button and read the Adobe Gamma instructions before clicking the Next button.

4. When you click the Next button, the screen goes black and you see three squares on the monitor, as shown in Figure 240.3.

5. Click on the square that best represents a neutral gray. Continue clicking squares until the most neutral gray square appears in the center of the three. When you click on the center gray square, the Adobe Gamma returns to the white point dialog box and displays a Hardware White Point.

6. Refer to Tip 57 to finish creating a profile for your computer monitor.

Note: Monitors change as they age. This can alter the profile you set up and cause shifts in color. It is recommended that you check your monitor on a monthly basis.

Figure 240.2 The Adobe Gamma Assistant lets you create a white point by measuring the current state of your monitor.

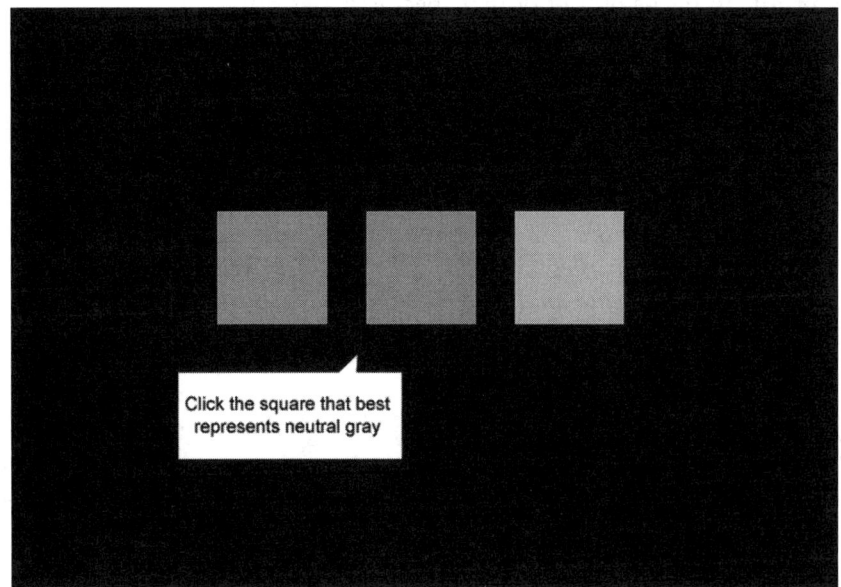

Figure 240.3 Clicking on the most neutral gray box helps set the white point on your monitor.

241 *Calibrating or Characterizing your Monitor . . . Which is Best?*

In Tip 57, "Calibrating Monitor Color Using the Adobe Gamma Utility," you learned how to calibrate your monitor to display color. The Adobe Gamma software is a profiling program that brings your computer into compliance with a predefined industry standard. Publishing houses and service bureaus then use that standard to reproduce accurate color.

However, not everyone sends his or her work to a publishing house or a high-end service bureau. If your work involves ink-jet and laser printers more than a four-color press, then characterizing your monitor may provide a better solution to your color needs. Characterizing your monitor describes how the monitor is currently reproducing color, based on your monitor and output printing devices.

In Tip 57, you calibrated your monitor by going through a series of screens and answering questions about your workflow. In doing so, you created an ICC profile that defines your system to anyone who wants to output your graphic images accurately. You *calibrated* your monitor to the industry standard.

When you *characterize* a monitor, you adjust the system to fit your workflow, and that workflow may not fit a particular industry standard. Instead of calibrating your monitor to an industry standard, you can characterize it to match your output.

Say you are experiencing problems adjusting the monitor color of an image to your inkjet printer. The image looks satisfactory on your monitor, but the color on your inkjet printer is off enough to cause problems. Using the information in Tip 57, readjust your monitor (using the Adobe Gamma utility) to create a profile to fit the output of that specific inkjet printer.

Understand that you are readjusting the colors on your monitor to fit a particular workflow. Images designed with a characterized monitor profile may not be printed accurately by high-end presses or service bureaus. However, if your workflow does not involve the world of presses and publishers, this may be the way to generate consistently accurate color.

Note: When you use the Adobe Gamma utility, you are not stuck with one workflow. You can create multiple profiles to match specific jobs. Create a profile to match workflow to an inkjet printer and create another profile to match the high-end four-color press.

242 *Using RGB Color Mode*

The RGB color mode mixes red, green, and blue inks to produce color (refer to Tip 238, "Understanding Additive and Subtractive Color Space"). RGB is the color mode of your computer monitor.

The uses for RGB color mode are:

- **Monitor display:** Since RGB color is the color space of your monitor, any images destined for display on a computer monitor should be edited in the RGB color mode. Online documents, PDFs (Portable Document Files), Web graphics, and any document viewed on a monitor should be designed using the RGB color mode.

- **Presentations:** Projection systems used in conjunction with computer presentation software project digital information using RGB color. When you design the graphics for your next computerized presentation, design them in RGB color.

- **Print:** Many inkjet and laser color printers output using RGB colors. Check the user manual that came with your printer. If it prints using RGB inks, design and output your images using RGB color.

243 *Adjusting RGB Images for Cross-Platform Display*

When you create a graphic image in Photoshop, the way the image displays on a monitor involves many factors, one of them being the operating system. You may have noticed that an image displayed on a Macintosh computer looks different than the same image displayed on a Windows computer, as shown in Figure 243.1.

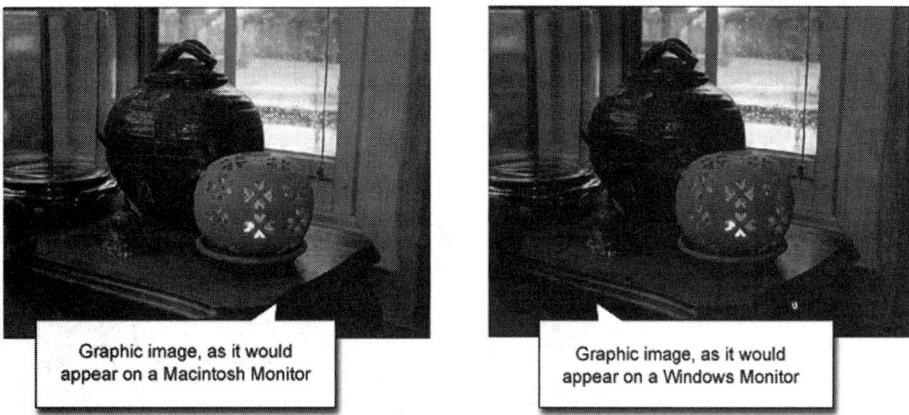

Figure 243.1 *Displaying images on Macintosh and Windows computers causes a shift the graphics color table and gamma.*

Each pixel within an image defines color using a color number. When displaying the image on your monitor, the color number tells the computer what colors to use. The Windows and Macintosh operating systems use different color tables, and this can cause a shift in the color of an image.

The gamma of the monitor defines the midpoint between light and dark. Macintosh monitors average a 1.8 gamma, and Windows monitors average a 2.2 gamma. This translates into the image appearing 15 to 20 percent darker when designed in Photoshop for Macintosh and displayed in Windows. Images designed in Photoshop for Windows and displayed on a Macintosh display 15 to 20 percent lighter.

Ideally, the solution would be to design one image for the Macintosh and a second image for Windows. However, in many cases (such as Web graphics), you do not know who will be viewing your images and what operating system they will be using.

Another solution is to index the colors in the image to match the Web Safe color table, as discussed in Tip 834, "Converting to Indexed Color." However, most photographs cannot be converted into the Web Safe color palette because they lose too many colors, as shown if Figure 243.2. In addition, this does not address the problem with the gamma of the image.

Photoshop lets you view your images using the color table and gamma of the other operating system, and this helps point out potential problems. To view an image using the color table and gamma of another operating system, select View menu Proof Setup and select Macintosh RGB or Windows RGB, depending on your current operating system.

Figure 243.2 Indexing the color in an image solves the color table problem but has limited success when applied to large graphic images.

If you work in Photoshop for Windows and choose Macintosh RGB, the visible image shifts into the color table and gamma of a Macintosh monitor. If you work in Photoshop for Macintosh and choose Windows RGB, the visible image shifts into the color table and gamma of a Windows monitor, as shown in Figure 243.3.

Figure 243.3 Using the Proof Setup option of Macintosh RGB alerts you to any potential cross-platform problems.

If, after testing, the image is not satisfactory, use the Curves and Levels commands to make your adjustments.

For more information on using Curves, see Tip 319, "Using Curves to Adjust an Image."

To learn more about adjusting an image using Levels, see Tip 629, "Using Levels to Set Highlights, Shadows, and Midtones."

244 *Using CMYK Mode*

The CMYK color mode mixes cyan, magenta, yellow, and black to produce the colors in the image (refer to Tip 238, "Understanding Additive and Subtractive Color Space").

The uses for CMYK color mode are:

- **Prepress:** The process of dividing an image into its color components (cyan, magenta, yellow, and black), creating separate plates for each color, and then printing the image is called four-color printing. Most high-end work requires images in CMYK color.

- **Process color:** Four-color printing presses require a specific mix of inks called process color inks. Process color inks are a universal way to measure ink, and they ensure that the colors in the final output match the original image. The most widely used process color system in the United States is the Pantone Color Matching System. For more information on the Pantone Color Matching System, see Tip 546, "Working with Pantone Colors."

- **Postscript printers:** CMYK colors output better to a Postscript printer with a RIP (Raster Image Processor). Although these printers do not separate the colors in the image like a four-color press does, they interpret and work best with process colors. If you own a Postscript printer with a RIP (inkjet or laser), use CMYK colors with process colors to produce consistent color output.

245 *Using Lab Mode*

The Lab color mode mixes ink differently than CMYK (cyan, magenta, yellow, and black) or RGB (red, green, and blue) color modes. Lab color uses three variables to mix color:

- **Variable l:** This variable measures the value of the pixel from black to white.

- **Variable a:** This variable measures the ink in the image from green to red.

- **Variable b:** This variable measures the ink in the image from blue to yellow.

Shifting the lightness and darkness (l), green to red (a), and blue to yellow (b) values produces all the colors in a Lab image.

Lab color is device-independent color. All software and hardware using the Lab color mode use the same values to define the colors. Refer to Tip 239, "Understanding Color Models and Color Modes," for more information on Lab color.

Uses for the Lab color space are:

- **Transporting an image:** Since all image-editing software uses the same version of Lab color, it is an excellent way to move an image from one image-editing program into another while preserving the colors space of the original graphic. For more information on using Lab to move a graphic image, see Tip 545, "Using Lab Color to Preserve Image Color."

- **Image sharpening:** Use Lab color to sharpen an RGB image without loss of color or detail. See Tip 524, "Applying Unsharp Mask."

- **Converting to grayscale:** Use Lab color to convert an RGB image into a perfect grayscale image. See Tip 256, "Converting an Image to Grayscale Using Lab Color."

246 *Using Grayscale Mode*

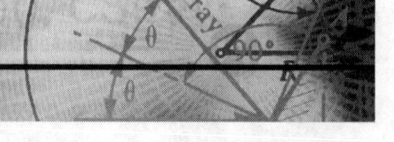

The Grayscale mode does not mix color; instead, each 8-bit pixel is assigned a number from 0 to 255. A pixel assigned a value of 0 is black, and a pixel assigned a value of 255 is white. The values 1 to 254 represent shades of gray.

Uses for the Grayscale mode are:

- **Image conversion:** Photoshop uses the Grayscale mode as an intermediate step. Images converted into the Duotone and Bitmap modes must be converted into the Grayscale mode first.

- **Grayscale printing:** Most designers have moved away from the Grayscale mode, even for the printing of black and white images. The problem exists in the size of the pixel. An 8-bit pixel only generates 254 shades of gray within an image. RGB images are two thirds larger; however, they generate over 16.7 million variations per pixel. Base your decision to use a particular color space on the final size of the image file (Web graphics have to be small), the equipment you are using (larger files take longer to work on), and any requirements or restrictions of your output device.

247 *Using Bitmap Mode*

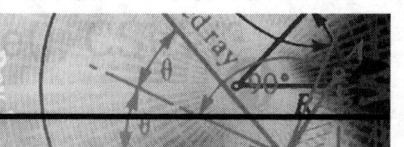

Bitmap mode produces an image with 1-bit pixels. Bitmap images produce small file sizes; however, because each pixel contains only one bit, you are restricted as to what you can do with Bitmap images.

Uses for the Bitmap mode are:

- **Halftone images:** In traditional print production, placing a halftone screen between a piece of film and the image and then exposing the film produces a halftone. When you use the Bitmap mode, you can select to convert the image into a halftone. For more information on this process, see Tip 845, "Converting Bitmap Images into Halftone Images."

- **Printing sketches and line art:** If you are working with fine sketches or a line art drawing, the major problem is the jagged appearance of the image when it prints. Typically, this is due to the resolution of the image. Low resolutions produce a jagged appearance to the lines. Converting the image to Bitmap and raising the resolution (300 ppi or higher) produces a small file size (1-bit pixels do not take up a lot of space) and a smooth printed image. For more information on Bitmap files, see Tip 844, "Understanding Raster and Vector Images."

248 *Working with Profile Mismatch*

Photoshop and other image-editing programs let you embed (or tag) an image with a color profile and save the profile with the image. A profile is a definition of the system and color space that created the image. For more information on creating a profile for your Photoshop images, refer to Tip 11, "Setting Up Photoshop's Color Settings."

When Photoshop opens a tagged graphic, it reads the profile before opening the image. If the profile matches the current color space, Photoshop opens the image and you are ready to work. If the color space of the graphic is different from the operating color space, a mismatch occurs and Photoshop opens the Embedded Profile Mismatch dialog box, as shown in Figure 248.1.

Figure 248.1 A profile mismatch occurs when the color profile of the image does not match the current working space of your monitor.

The Embedded Profile Mismatch dialog box gives you three choices:

- **Use the embedded profile (instead of the working space):** Use this option when you want to preserve the color working space of the original document. This will cause color problems if the image is printed on a four-color press (cyan, magenta, yellow, and black) and the working space of your monitor is calibrated to the press.

- **Convert document's colors to the working space:** Use this option when you want to change the color space of the document to the working color space of your monitor. Use this option if the image is printed on a four-color press (cyan, magenta, yellow, and black) and the working space of your monitor is calibrated to the press.

- **Discard the embedded profile (don't color manage):** Using this option removes the color profile from the image and does not embed a color profile into the image when it is saved.

To open the image, select from the available options and click the OK button. Photoshop will close the Embedded Profile Mismatch dialog box and open the image.

To close the image file without working on it, click on the Cancel button. Photoshop will close the Embedded Profile Mismatch dialog box and will not open the image.

For more information on using color profiles with Photoshop, refer to Tip 11, "Setting Up Photoshop's Color Settings," and see Tip 249, "Understanding ICC Profiles."

249 *Understanding ICC Profiles*

The International Color Consortium created the ICC Color Profile. In essence, it is a standard throughout the professional press industry for how colors print and even how they display on your monitor.

Using the Adobe Gamma utility (refer to Tip 57, "Calibrating Monitor Color Using the Adobe Gamma Utility") creates an ICC profile matching your hardware, as shown in Figure 249.1.

Figure 249.1 ICC profiles standardize color and help give you consistent results.

Photoshop, your monitor, and various output devices from Postscript printers to high-end four-color presses use this profile to manage the color of the image. This movement of an image from editing to printing is defined as your workflow.

As a computer designer using Photoshop, proper calibration helps eliminate color cast in your monitor, makes your monitor's midtones and grays as neutral as possible, and standardizes image display across different monitors.

> *Note: Although Adobe Gamma is an effective calibration and profiling utility, hardware utilities are more precise. If you have a hardware utility that generates ICC-compliant profiles, use that instead of Adobe Gamma. Also, be sure to use only one calibration utility to display your profile; using multiple utilities can result in incorrect color.*

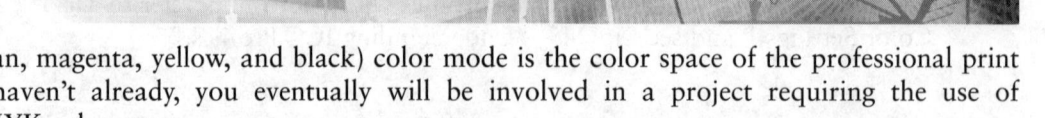

250 *Converting RGB Images to CMYK*

The CMYK (cyan, magenta, yellow, and black) color mode is the color space of the professional print world. If you haven't already, you eventually will be involved in a project requiring the use of Photoshop's CMYK color space.

The RGB color space is everywhere: Most scanners create images using the RGB color space, digital cameras supply you with images in RGB color, and most CD clip art is in the RGB color space. There are exceptions to every rule, but eventually you will open an RGB image in Photoshop that is destined to be output as CMYK.

If you are working on an RGB image and the output of that image is CMYK, it is not necessary to convert the image immediately. Here are three reasons to edit the image as RGB and convert it at the end of the project:

1. **Size:** CMYK images are 25 percent larger than their RGB counterparts. A larger file size translates into a longer working time. Remember, the larger the file size, the longer Photoshop takes to perform editing operations.

2. **Monitor color space:** Your monitor displays color using three pixels of red, green, and blue. You can temporally view an image in CMYK color space (select View menu Proof Setup and choose CMYK working space), but understand that your monitor cannot accurately show you the CMYK color space. It is only a close approximation.

3. **Editing:** Many of the editing features in Photoshop are disabled when you work in the CMYK color space, giving you less control over the final image, as shown in Figure 250.1.

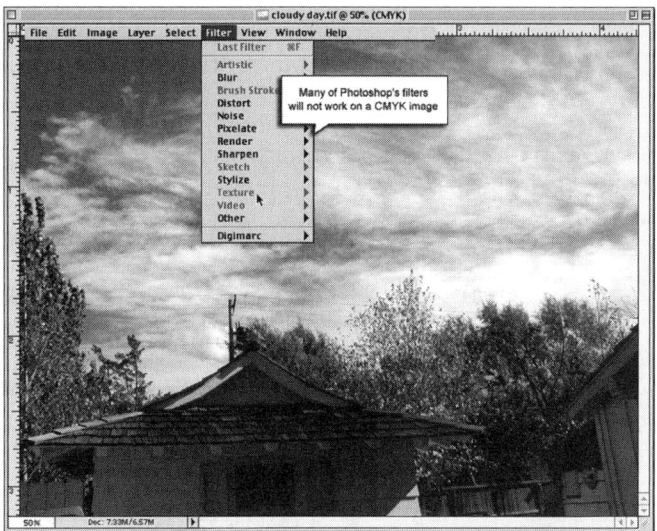

Figure 250.1 Many of Photoshop's filters and adjustments will not work when you edit an image in the CMYK color space.

If the original image is an RGB image, it is best to stay within the RGB color space and convert the final image into CMYK at or near the end of the project.

For more information on using RGB and CMYK to edit an image, see Tip 550, "Comparing Corrections in CMYK and RGB Color Space."

251 *Performing a Profile-to-Profile Conversion of a Photoshop Image*

When you assign a profile to an image, you are instructing other computers and output devices about the color table and system of the originating system.

The Profile-to-Profile conversion option lets you convert a document's colors into a different color profile or insert a different color profile into a Photoshop graphic without converting the profile of the original document. If, for example, you need to prepare a document for printing on a different output device, you would use the Profile-to-Profile option to perform the operation.

To perform a Profile-to-Profile conversion of a Photoshop image, select Image menu Mode and choose Assign Profile from the pull-down menu. Photoshop opens the Assign Profile dialog box, as shown in Figure 251.1.

Figure 251.1 The Assign Profile dialog box lets you change the current color profile of the open document.

- **Don't Color Manage This Document:** Choose this option when you want to remove a profile from the current document.

- **Working:** Choose this option to change the profile of the open document to Photoshop's current working space.

- **Profile:** Choose this option to assign a different color profile to the open document and then click on the Profile button to display a list of available color profile options, as shown in Figure 251.2.

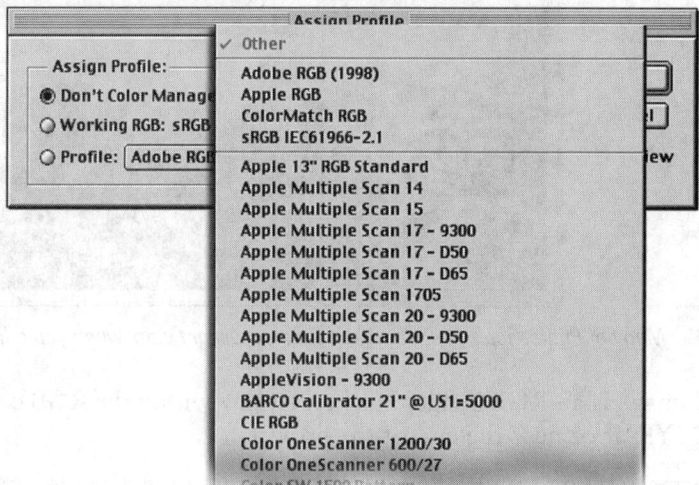

Figure 251.2 Clicking the Profile option lets you choose from a list of available color profiles.

Click the OK button in the Assign Profile dialog box to record your changes to the open document.

252 *Understanding Color Management*

Color management of a document involves knowing the final output of the document. When you work on an image in Photoshop, the document passes through several devices: It may come from a digital camera or scanner, then be displayed on a monitor, and finally be output to a monitor or printer. The Input-Processing-Output flow must be controlled; otherwise, the color within the image will shift as the document passes from one device to another.

Color management is not to be confused with color correction or color adjustment. Color management is an evolving technology that controls what an image will look like from input, through processing, and then to the final output of the image.

A color management system (CMS) works with the image to produce consistent color throughout the editing process. Photoshop uses the color management system supported by the International Color

Consortium (ICC). Since most high-end layout programs such as QuarkXPress and InDesign use the ICC color management system, this gives you a reliable way to maintain the color integrity of the image.

Understand that each pixel in a color document is assigned a number that describes the pixel's color. However, color numbers may be interpreted differently by your monitor or output-printing device. Photoshop's color management system, working with an ICC color profile, works to describe a pixel's color and then accurately translate that color information to monitors, printers, and printing presses.

Photoshop lets you control the color within an image by defining the default color working space. Refer to Tip 11, "Setting Up Photoshop's Color Settings," for more information on setting up Photoshop's working space. After setting up the default color working space, you then assign a profile to the image. Refer to the previous tip for more information on assigning a profile to an image.

Color management is an evolving, not-yet-perfect way of preserving the color integrity of your Photoshop documents. It is recommended that you keep up with the changes in the CMS industry by accessing the Adobe Web site at **www.adobe.com**.

253 _Understanding Printer Color Management_

When you view an image, the colors you see are dependent on the output device. Monitors operate in a different color space than printers, and different printers use different color spaces. Photoshop gives you a way to control the output of the printed document. This gives you a way to print an accurate image without changing the color profile of the document. Refer to Tip 251, "Performing a Profile-to-Profile Conversion of a Photoshop Image," for more information on changing the color profile of a document.

To work with the color management settings of your printer, choose the File menu and select Print Options from the pull-down menu. Photoshop will display the Print Options dialog box. Click to select Show More Options, as shown in Figure 253.1.

Figure 253.1 Selecting Print Options from the File menu displays the Print Options dialog box.

Click on the Output button and select Color Management from the available list of options. Photoshop will display the Color Management options, as shown in Figure 253.2.

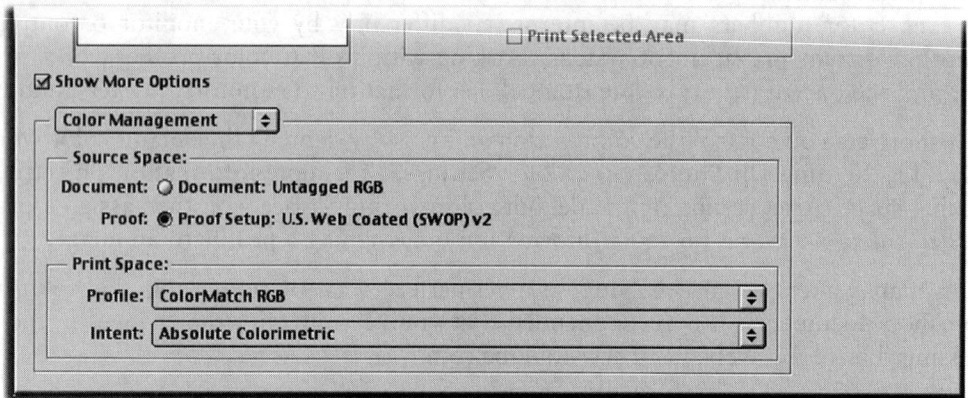

Figure 253.2 The Color Management options in the Print Options dialog box.

- **Document:** Choose the Document option to print the image in the default color space.

- **Proof:** Choose the Proof option to create a proof image. For more information on setting up a document for proof printing, see Tip 714, "Using the Proof Setup Option."

Profile:

- **Same as Source:** Choose this option to print the document using the document's default profile.

- **PostScript Color Management:** Choose this option to send the image to a PostScript printer along with the document's default color profile.

- **Printer Color Management:** Choose this option to send the image to a non-PostScript printer along with the document's default color profile.

- **Print Options:** Select the option that matches your output device.

Intent:

- **Perceptual:** Attempts to preserve the visual relationship between colors in a way that is natural to the human eye. This option works well with photographic images.

- **Saturation:** Attempts to create vivid color in a printed document at the expense of accurate color. This intent works well with business graphics, where bright, not accurate, colors are needed.

- **Absolute Colorimetric:** Attempts to maintain color accuracy at the expense of preserving relationships between colors. Absolute Colorimetric works well on images printed with less color than contained in the original image.

- **Relative Colorimetric:** Compares the white point of the source color space to that of the destination color space and shifts all colors accordingly. Like the Perceptual option, Relative Colorimetric works well on photographic images.

Click the OK button in the Print Options dialog box to record your changes to the image. When you print the image (File menu Print), the document prints using your new print options.

Note: Modifying the print options will not change the default color space of the document. It will only affect the document when sent to a printer.

254 *Converting a Document's Profile*

In Tip 251, "Performing a Profile-to-Profile Conversion of a Photoshop Image," you learned how to convert the colors in an image without removing the document's default color profile. However, there are times when you want to change the profile of an image permanently. To change a document profile, select Image menu Mode and choose Convert to Profile from the fly-out menu. Photoshop will display the Convert to Profile dialog box, as shown in Figure 254.1.

- **Source Space:** Describes the default color space of the open document.

- **Destination Space:** Click the Profile button and choose the color space you want to use to convert the open document.

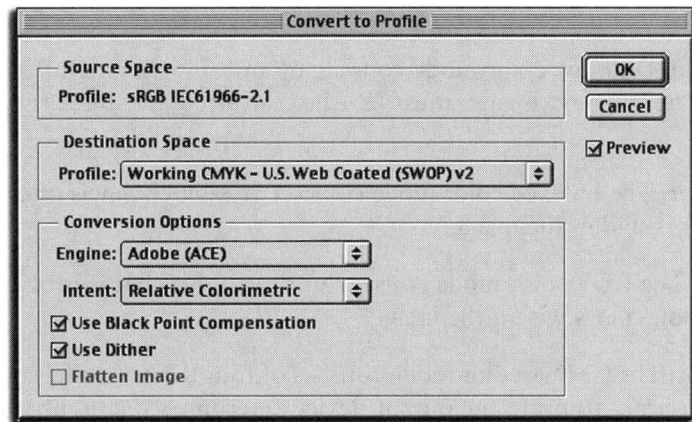

Figure 254.1 *The Convert to Profile dialog box lets you permanently convert a Photoshop document from one color profile to another color profile.*

Conversion Options:

- **Engine:** The color engine specifies the management system used to convert the image. The Adobe (ACE) is the color engine used by Photoshop.

- **Intent:** Describe the intent of the output image. Refer to the preceding tip for more information on the Intent option.

- **Use Black Point Compensation:** Choosing this option maps the full dynamic color range of the source image to the full dynamic range of the output device. If the black point of the source space is lighter than the output device, it can result in blocked or gray shadows in the printed image. However, when the black point of the source is darker than that of the output device, choosing this option helps balance the midtones of the image.

- **Use Dither:** Choosing this option helps achieve a visual color match to the original document by blending inks to display colors not reproducible on the output device. Choose this option when the output device has a smaller color space than the source document.

- **Flatten Image:** This option is available when working on multi-layered documents. Choosing this option converts a multi-layered Photoshop document into a single layer.

255 *Converting a Document into Another Color Mode*

When you first open a document in Photoshop, the image is defined by its original color mode. The color mode of a document tells Photoshop the color space, the number of channels, and the available colors the image is capable of producing.

The available color modes in Photoshop are:

- **Bitmap:** The Bitmap color mode consists of a single 1-bit channel of color capable of producing a black and white image. Images must first be converted into Grayscale before using the Bitmap color mode.

- **Grayscale:** The Grayscale color mode consists of an 8-bit channel of color capable of producing 256 steps of gray.

- **Duotone:** The Duotone color mode consists of an 8-bit channel of color capable of producing 256 steps or shades of color. Images must first be converted into the Grayscale color mode before using Duotone.

- **Indexed color:** The Indexed color mode consists of 8-bit channels of color capable of generating 256 separate colors within the image.

- **RGB color:** The RGB color mode consists of three 8-bit channels of color capable of generating up to 16.7 million colors within the image.

- **CMYK color:** The CMYK color mode consists of four 8-bit channels of color. Since the CMYK color mode is for output to print, the output device determines the number of printable colors.

- **Lab color:** The Lab color mode consists of three 8-bit channels of color. Lab color is a device-independent method of measuring color within an image.

To change an image into a different color mode, select Image menu Mode and choose one of the preceding options from the fly-out menu.

> *Note: Changing the color mode of an image permanently changes the colors within the image. If, for example, you want to convert an RGB (red, green, and blue) image to grayscale, selecting Image menu Mode and choosing Grayscale will permanently remove the color information from the image. There is no option in Photoshop to return an image to its original color mode. Therefore, it is recommended that you make a copy of your image and convert the copy into another color mode. Once an image is converted and saved, there is no way to reverse the procedure.*

256 *Converting an Image to Grayscale Using Lab Color*

Converting color images into black and white images is a common practice in Photoshop. As described in the preceding tip, selecting Image menu Mode and choosing Grayscale from the pull-down menu automatically converts a color image into shades of gray. However, converting an RGB image (red, green, and blue) directly into a grayscale image is not the best method to use. A better way to convert an RGB image to grayscale is to take an intermediate step by using Lab color.

The conversion process involves how RGB and Lab modes mix color. In the RGB color mode, three channels mixing red, green, and blue inks produces all the colors within the image. When you convert an RGB image directly into grayscale, this usually produces overly dark shadow areas in the converted image.

The Lab mode works with three channels, defined as Lightness, Lab a, and Lab b. The Lab a and Lab b channels determine the inks and saturation of the colors. The Lightness channel determines the brightness of the color from light to dark.

To convert an RGB image using the Lab method, perform these steps:

1. Open an RGB image in Photoshop.

2. Select Image menu Mode and choose Lab Color from the fly-out menu. Photoshop displays the image in Lab color, as shown in Figure 256.1.

Figure 256.1 An image converted into Lab color displays the document using three channels: Lightness, Lab a, and Lab b.

3. Click and drag the Lab b channel to the trash, as shown in Figure 256.2. Note: When you drag the Lab b channel to the trash, Photoshop converts the two remaining channel names into Alpha 1 (Lightness), and Alpha 2 (Lab a). Click and drag the Alpha 2 channel to the trash and leave the Alpha 1 channel.

Figure 256.2 Remove the Lab a and Lab b channels from the document by dragging them to the trash.

4. This leaves only the Alpha 1 (Lightness) channel in the Channels palette. Since the Alpha 1 channel describes the brightness of the pixels from dark to light, you have a perfect grayscale image, as shown in Figure 256.3.

5. Select Image menu Mode and choose Grayscale from the fly-out menu. You now have a grayscale image containing the correct amount of highlights and shadows.

Figure 256.3 Removing the Lab a and Lab b channels generates a grayscale image with the correct amount of highlights and shadows.

257 *Understanding the Basics of Spot Color Channels*

All Photoshop images have one or more channels. Photoshop stores information about the color elements of an image in its channels. Photoshop defines additional channels as Alpha channels, and images can contain up to 24 channels, as shown in Figure 257.1.

Figure 257.1 The Channels palette displays all the available channels for the active document.

Think of channels as the plates used in color processing, with each channel (plate) applying a layer of color on the printing press. Photoshop uses the additional channels (Alpha channels) to store and edit masks or to create spot color channels, as shown in Figure 257.2.

Figure 257.2 Photoshop lets you create spot color channels to store specific color printing information.

In a normal four-color job, passing the document through a printing press creates the colors in the image. The printing press has four drums, one for each of the printing colors: cyan, magenta, yellow, and black. The color drums each apply color to the document; different applications of cyan, magenta, yellow, and black produce all the visible colors within the image.

Spot color channels apply a premixed color to a document using a single plate, as shown in Figure 257.3.

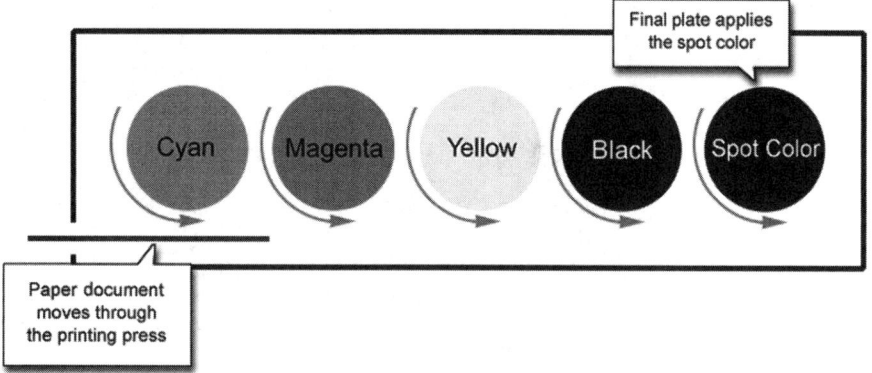

Figure 257.3 A four-color press using a spot color plate.

Note: Spot channels create bright areas of color normally not reproducible using normal four-color methods. Spot channels are also used to generate a varnish over a portion of the image. Applying a varnish creates a shiny or matte look to predefined areas of the image.

258 *Creating a Spot Color Plate in Photoshop*

In the preceding tip, you learned about spot color channels in Photoshop. To create a spot color channel, open a document in Photoshop and perform these steps:

1. If the Channels palette is not visible, select the Window menu and select View Channels from the pull-down menu. Photoshop will display the Channels palette, as shown in Figure 258.1.

Figure 258.1 The Channels palette displays all channels in the open document.

2. Using standard selection techniques, select an area of the image. The selected area is used to define the area covered by the spot color. In this example, the Type Mask tool was used to create a spot channel, as shown in Figure 258.2.

Figure 258.2 The Type Mask tool creates the selected area used to create a spot color channel.

3. Click on the triangular button in the upper-right corner of the Channels palette. Photoshop displays the Channels option in a fly-out menu. Select the New Spot Channel option. Photoshop displays the New Spot Channel dialog box, as shown in Figure 258.3.

4. Click the Color box in the New Spot Channel dialog box. Photoshop displays the Color Picker dialog box. Click the Custom button in the Color Picker dialog box to display Photoshop's custom color sets, as shown in Figure 258.4.

5. Select a color from the available options and click the OK button. Photoshop closes the Color Picker dialog box and records your changes, as shown in Figure 258.5.

6. The Solidity option only affects what you see displayed on the screen. It does not affect how the spot color prints. Enter a number from 0 to 100 to change the solidity of the color.

7. Click the OK button. Photoshop creates a new spot channel, as shown in Figure 258.6.

Figure 258.3 The New Spot Channel dialog box identifies the characteristics of the spot channel.

Figure 258.4 The Custom Picker dialog box displays all the standard color measuring systems.

Figure 258.5 Choosing a color from the Color Picker displays the color in the selected portions of the image.

Figure 258.6 The new spot channel is visible in the Channels palette.

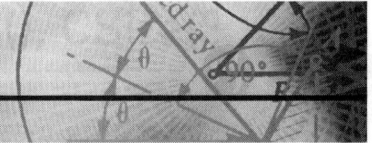

259 *Painting on a Spot Color Channel*

In the preceding tip, you learned how to create a spot color channel. You can edit spot color channels to reflect a change in the printing of the document without having to re-create the channel.

To edit a spot color channel, open a document containing spot color channels and perform these steps:

1. If the Channels palette is not visible, select the Window menu and select View Channels from the pull-down menu. Photoshop will display the Channels palette (refer to Figure 258.6 in the preceding tip).

2. In the Channels palette, click once on the name of the spot color channel. Photoshop will deactivate all the channels except the one you clicked on, as shown in Figure 259.1.

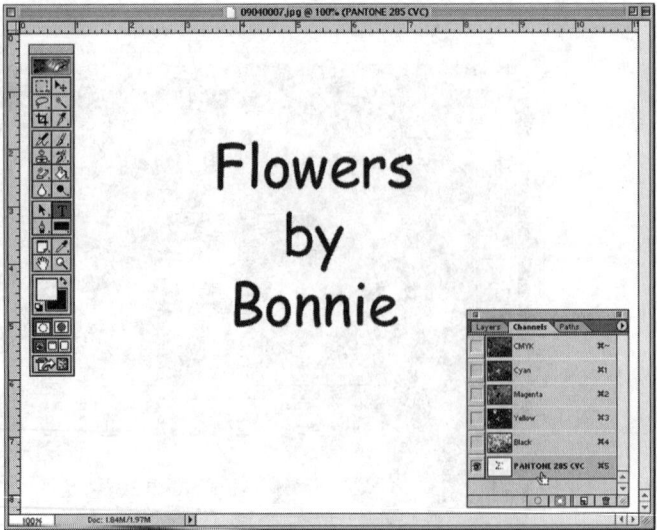

Figure 259.1 Clicking on the spot color channel activates that channel.

3. Select the Paintbrush tool from the toolbox. Spot color channels, like any other channels, are masks for the inks in the image. Masks use black, white, and shades of gray to determine the amount of ink applied to the spot color. Black means 100 percent of the spot color's ink is applied to the document. Painting with a 50-percent gray applies 50 percent the ink, as shown in Figure 259.2. The shade of gray you paint with determines the amount of the spot color applied by the printing press. In this example, a line was added under the owner's name.

Figure 259.2 Painting on a mask defines the area and density of the spot color.

4. Save the image (File menu Save) when you complete the changes. The document is saved with the modified spot color mask.

260 *Preparing Images for Television*

Images destined for television screens require a specific color space and resolution to display correctly. The color space of most television images is RGB (red, green, and blue); however, the normal RGB color space has a wider gamut (more colors) than that of a television screen. To prepare a document for television, first open the image in Photoshop, select Filter menu Video, and then choose NTSC Colors from the fly-out menu, as shown in Figure 260.1.

Figure 260.1 Choosing the NTSC color filter readjusts the colors in the image to display correctly on a television screen.

The NTSC (National Television Standards Commission) option defines the gamut (viewable colors) that the average television screen in the United States displays. Choosing this option remaps the colors and creates an image acceptable to television monitors.

Another consideration for images designed for television screens is the De-Interlace option. While using De-Interlace is not as important to single-frame images, it causes problems with moving images or animation when displayed on a television screen.

Television screens are interlaced; they display the image by displaying every other scan line (scan lines run left to right across the television monitor) of the image and alternate back and forth, as shown in Figure 260.2.

This switching back and forth between scan lines causes the image to "jitter," or bounce, on the television screen. This is especially apparent when images contain long horizontal lines. The lines appear to bounce up and down (jitter).

Figure 260.2 Interlaced video displays the image with two passes of alternating scan lines.

To de-interlace an image, open the document in Photoshop, select Filter menu Video, and choose De-Interlace from the fly-out menu. Photoshop will open the De-Interlace dialog box, as shown in Figure 260.3.

Figure 260.3 The De-Interlace dialog box helps prepare an image for display on a television screen.

- **Eliminate Odd/Even Fields:** You have a choice of eliminating the odd or even fields within the document. Most images display better by eliminating the odd field. However, check with the television studio and get its advice.

- **Create New Fields by Duplication/Interpolation:** If your image contains horizontal lines, choose the Interpolation method. Photographic images display better with the Duplication method.

Click the OK button to close the De-Interlace dialog box and record your changes to the original image.

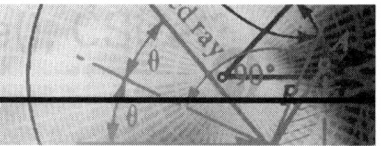

261 *Editing Photoshop's Color Settings*

In Tip 11, "Setting Up Photoshop's Color Settings," you learned how to create a working space based on Photoshop's predefined settings. The Color Settings dialog box also lets you create a customized workspace to fit a specific workflow.

To create a customized color settings file, open Photoshop, select the Edit menu, and choose Color Settings from the pull-down menu. Photoshop will open the Color Settings dialog box, as shown in Figure 261.1.

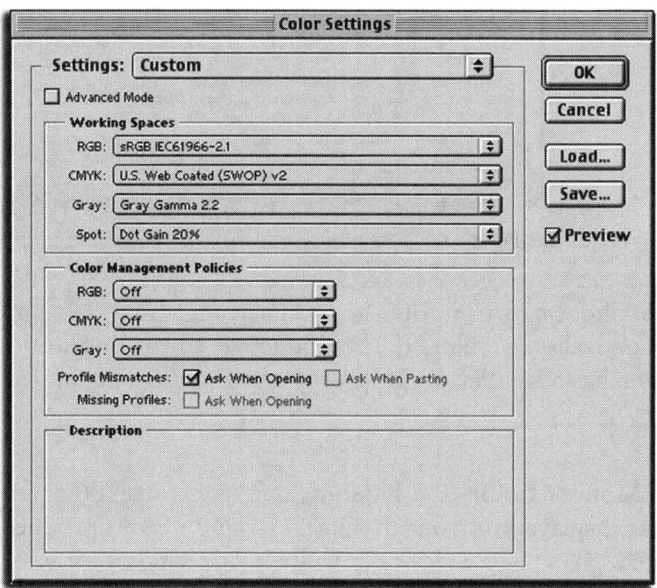

Figure 261.1 The Color Settings dialog box lets you create a customized workflow.

Click in the Advanced Mode check box to access the Advanced Mode settings, as shown in Figure 261.2.

For information on customizing the Working Spaces and Color Management Policies sections, refer to Tip 11.

Conversion Options:

- **Engine:** The conversion engine specifies what color management system Photoshop uses to convert graphics between color spaces. The Adobe (ACE) is recommended for most users.

- **Intent:** Refer to Tip 253, "Understanding Printer Color Management," for more information on setting the Intent of an image.

- **Use Black Point Compensation:** Choosing this option maps the full dynamic color range of the source image to the full dynamic range of the output device. If the black point of the source space is lighter than the output device, it can result in blocked or gray shadows in the printed image. However, when the black point of the source is darker than that of the output device, choosing this option helps balance the midtones of the image.

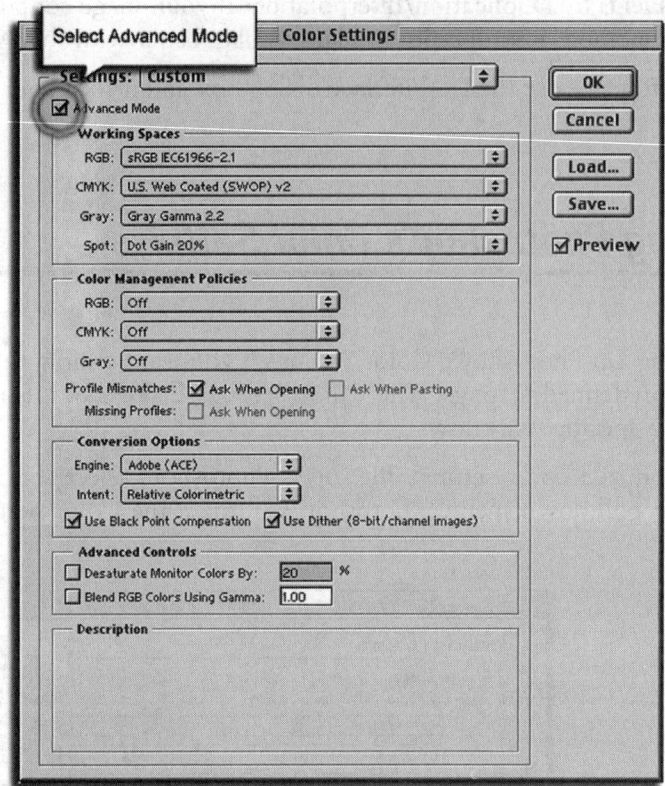

Figure 261.2 Selecting the Advanced Mode option gives you access to Photoshop's advanced color settings.

- **Use Dither:** Choosing this option helps achieve a visual color match to the original document by blending inks to display colors not reproducible on the output device. Choose this option when the output device has a smaller color space than the source document.

Advanced Controls:

- **Desaturate Monitor Colors By:** Enter a value from 0 to 100 to influence the color saturation of the document as displayed on your monitor. A value of 100 produces a grayscale image. This option, when selected, gives you an idea of how the image will appear when output to devices using a smaller gamut of color (fewer printable colors).

- **Blend RGB Colors Using Gamma:** Select this option to blend the colors within an image. A blending gamma of 1 matches the blending gamma of most applications and will produce images with the fewest edge artifacts.

When you have completed your changes to the Color Settings dialog box, click on the Save button. Photoshop opens the Save dialog box, as shown in Figure 261.3.

Click in the Name input field to identify the file and click the Save button to save the new color settings file to the hard drive.

To access a previously saved settings file, open Photoshop, select the Edit menu, and choose Color Settings from the pull-down menu. Photoshop will open the Color Settings dialog box. Click on the Load button. Photoshop will open the Load dialog box, as shown in Figure 261.4.

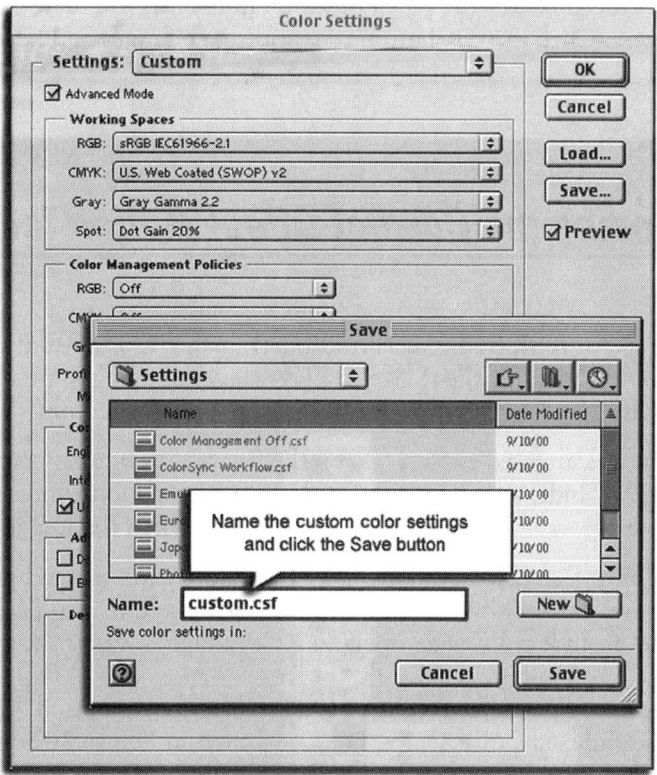

Figure 261.3 Clicking the Save button lets you save your customized color settings.

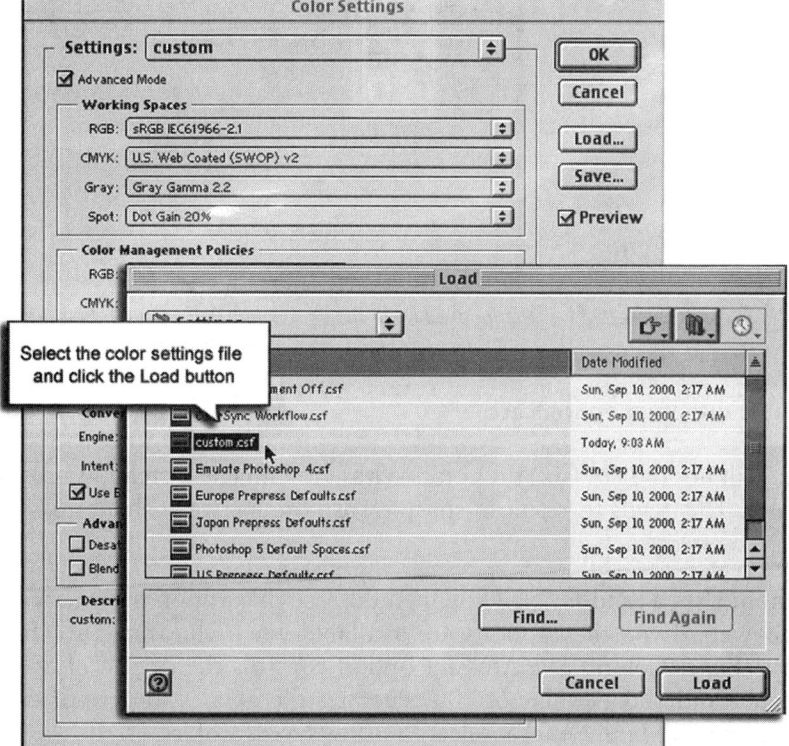

Figure 261.4 The Load dialog box lets you select a previously saved color settings file.

Select the correct file and click the Open button. Photoshop will load the color settings file into the Color Settings dialog box. Click the OK button to record the changes and begin work using your newly loaded settings file.

262 *Choosing the Correct Dither Option for 8-Bit Indexed Color*

When you convert an RGB (red, green, and blue) image into Indexed color mode, you are significantly reducing the amount of color the image displays. Indexed images are capable of producing a maximum of 256 colors, while RGB images produce up to 16.7 million colors.

Indexed color images are used extensively on the Internet because of their small size. However, when you convert an image to Indexed color (see Tip 834, "Converting to Indexed Color"), the reduction of the number of visible colors in the image causes problems when the image is viewed.

The Indexed color option helps visually blend the colors in an image by using dithering. Dithering, when selected, blends available colors within the indexed image to simulate the missing colors. To select a dither option for an Indexed image, open an RGB image in Photoshop and perform these steps:

1. Select Image menu Mode and choose the Indexed Color option from the fly-out menu. Photoshop will open the Indexed Color dialog box, as shown in Figure 262.1.

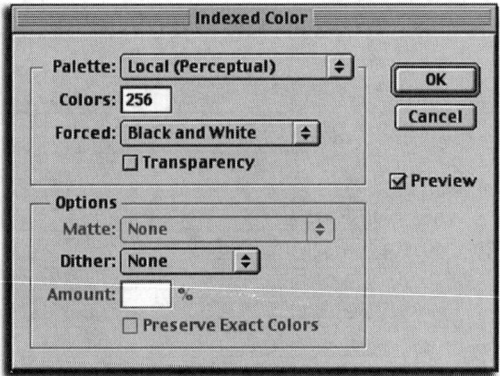

Figure 262.1 The Indexed Color dialog box lets you select a dithering option that will visually blend the colors within the image.

The available dithering options are:

- **None:** Will not dither (mix) the colors within the image; instead, it uses the color closest to the missing color. This tends to result in sharp transitions between shades of color in the image, creating a posterized effect.

- **Diffusion:** Uses a random blending method. Use this option to preserve fine lines and text in images for the Web. Two other options are available when choosing the Diffusion option: Amount and Preserve Exact Colors. The Amount option controls the degree of color blending. Type in a value between 1 and 100. A value of 100 generates the greatest degree of color dithering. To protect the exact colors within the image, select Preserve Exact Colors.

- **Pattern:** Uses a more structured blending method than the Diffusion option. Although useful for clip art images, the Pattern option produces photographs with a more structured, less realistic appearance.

- **Noise:** Noise helps reduce seam patterns along the edges of divided images. Choose this option if you plan to slice the image for placement in an HTML table.

2. Choose the Preview option to view the results of your dithering selection directly on the image, as shown in Figure 262.2.

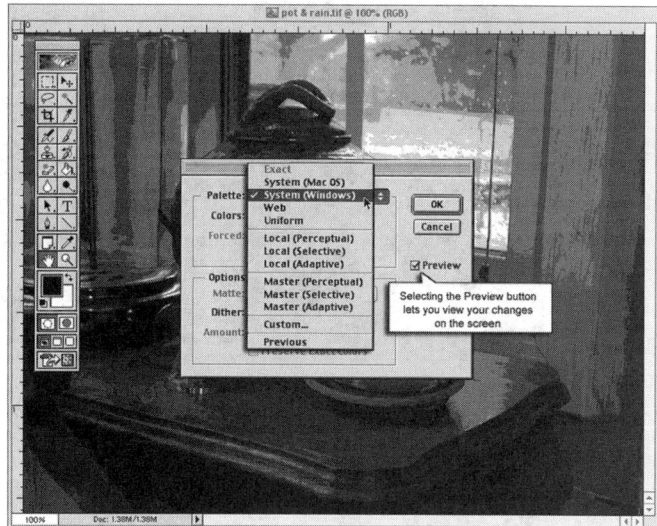

Figure 262.2 The Preview button lets you view the results of the dithering directly on the image.

3. Click the OK button to close the Indexed Color dialog box and record your changes to the image.

263 *Modifying an Image with the Duplicate Command*

The Duplicate command lets you create an exact copy of an image—including all layers, channels, and editing effects—without saving the file to disk. Using the Duplicate command creates a copy of the image in RAM (Random Access Memory). This gives you the ability to modify a copy of the image without having to save the file to disk.

To use the Duplicate command, open an image in Photoshop and perform these steps:

1. Select Image menu Duplicate. Photoshop will open the Duplicate Image dialog box, as shown in Figure 263.1.

2. Click in the As input field and type a name for the duplicate image.

3. The Duplicate Merged Layers Only option is available for multi-layered documents. Selecting this option creates a single-layered file. Not selecting this option preserves the individual layers of the original document.

4. Click the OK button. Photoshop closes the Duplicate Image dialog box and creates a copy of the original image in RAM. You can now work and edit the image just like any other Photoshop document.

5. To save the duplicate image, select the File menu and choose the Close command from the pull-down menu. Photoshop will ask you if you want to save the changes to the file, as shown in Figure 263.2.

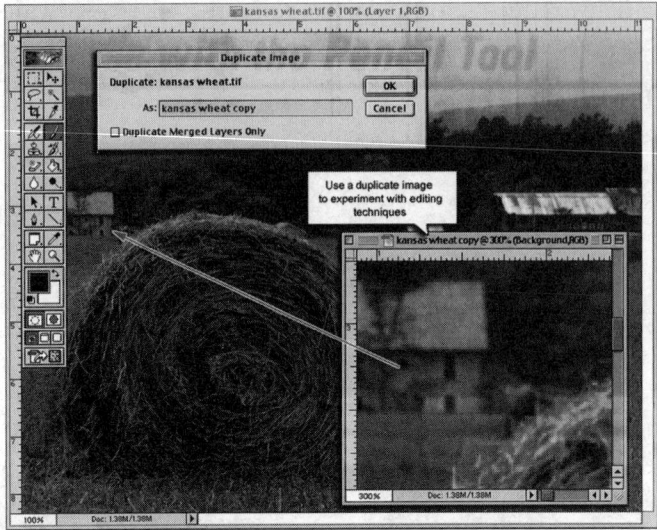

Figure 263.1 The Duplicate command lets you create a copy of an image without first saving the document to your hard drive.

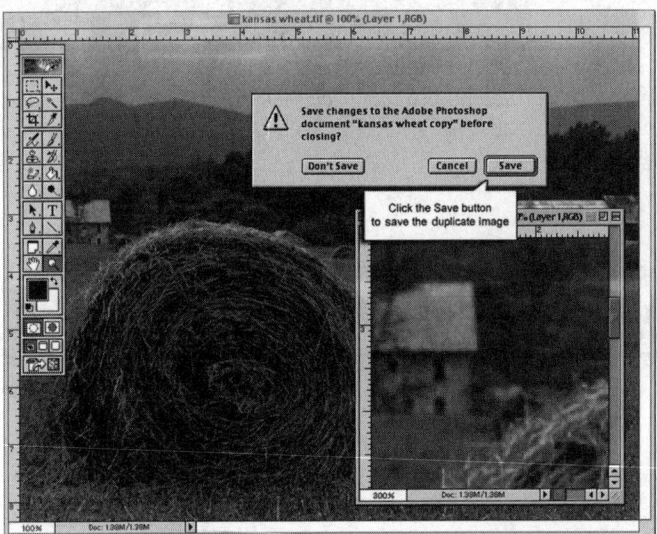

Figure 263.2 The Save dialog box lets you permanently save the changes made to the duplicate file.

6. Click the Save button. Photoshop opens the Save dialog box.

7. Name the file and click the Save button. Photoshop will record the changes to the file and close the Save dialog box.

264 *Using Apply Image*

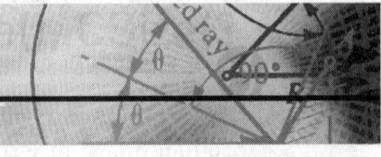

The Apply Image command lets you modify images in much the same way as using blending modes with multiple layers. The main advantage of the Apply Image command is its ability to blend layers and channels between two open images.

To use the Apply Image command on two images, both documents must have the same pixel dimensions. For more information on viewing or changing the pixel dimensions of a Photoshop document, see Tip 269, "Changing an Image Using Image Size."

To use Apply Image on two documents, open two documents in Photoshop (File menu Open) and perform these steps:

1. Select the Image menu and choose Apply Image from the pull-down menu. Photoshop will open the Apply Image dialog box, as shown in Figure 264.1.

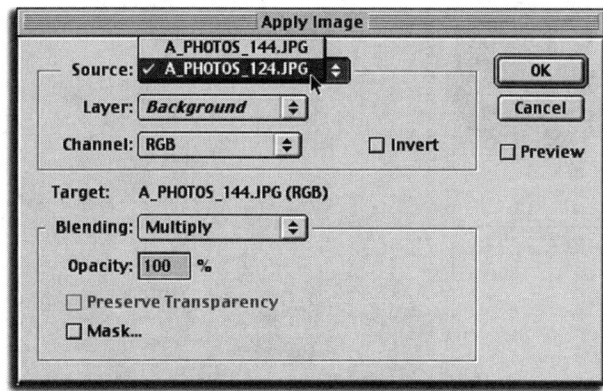

Figure 264.1 The Apply Image dialog box lets you blend the layers and channels of one image into the layers and channels of another image.

2. Click on the Source button to choose the source image. The available choices are any open Photoshop documents that have the same pixel dimensions (width and height) as the target image.

3. Click on the Layer button to choose a specific layer within the source document. If the image does not contain multiple layers, this option will not be available.

4. Click on the Channel option to choose from the available channels in the source document. Choosing the top option (called the composite channel) uses all the channels for the blending operation.

5. The Target option defaults to the active document window.

6. Click on the Blending option to apply a blending mode change to the target image. If you have the Preview option selected, you can view the changes to the original image.

7. Click in the Opacity field and enter a value between 1 and 100 to control the amount of the blending mode applied to the target image. A value of 100 applies 100 percent of the blending mode to the target image, as shown in Figure 264.2.

8. If your target image contains transparent areas, click to select the Preserve Transparency option to prevent the transparent areas of the target image from being affected by the blending mode.

9. Click on the Mask option to apply the blending mode to the target document through a mask. A mask can be another layer within the target or source document, or it can be a separate document. Select the image containing the mask, the layer, and the channel, as shown in Figure 264.3.

10. Click the OK button to record your changes to the target document, as shown in Figure 264.4.

Figure 264.2 The Multiply mode applied to the target image produces a mix of the source and target documents.

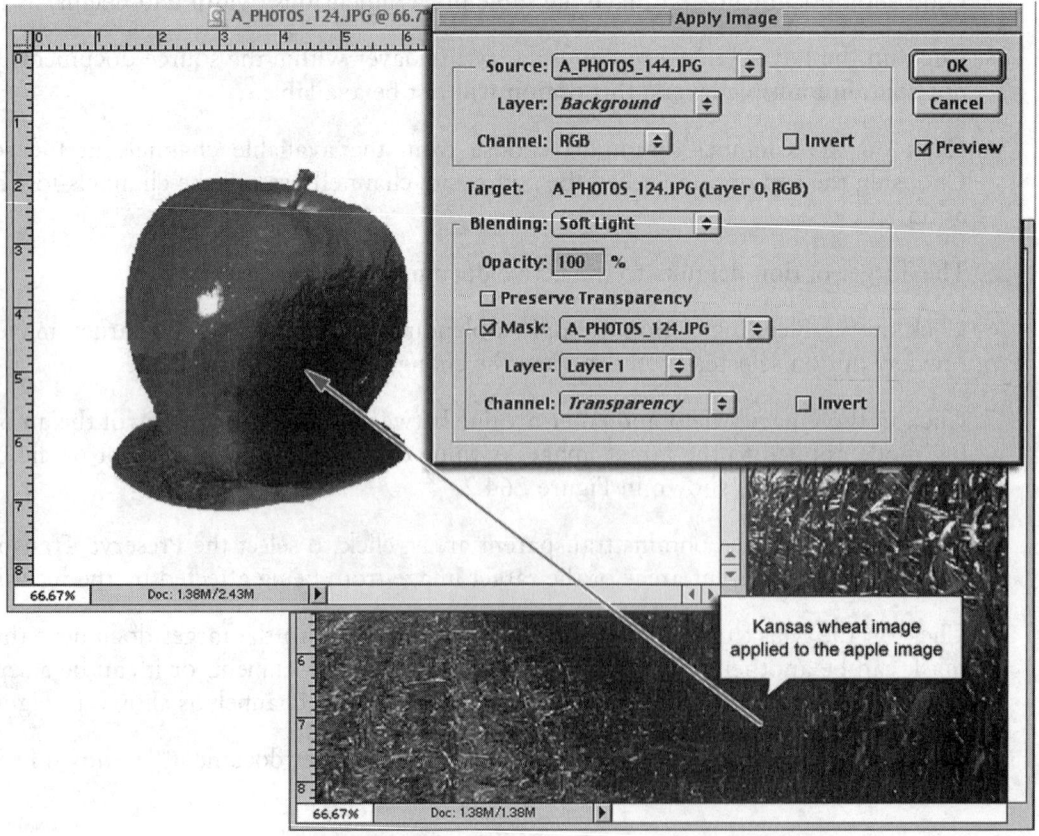

Kansas wheat image applied to the apple image

Figure 264.3 Using Apply Image with a third document containing a mask.

Figure 264.4 The Apply Image command used on a Photoshop document.

265 *Understanding the Calculations Command*

The Calculations command lets you blend the channels from one or more source images. You can then apply the results to a new image or to a new channel or selection in the active image.

All the images used with the Calculations command must have the same pixel dimensions. For more information on viewing or changing the pixel dimensions of a Photoshop document, see Tip 269, "Changing an Image Using Image Size."

To use the Calculations command, open two or more Photoshop documents and perform these steps:

1. Select the Image menu and choose the Calculations command. Photoshop will open the Calculations dialog box, as shown in Figure 265.1.

2. Click on the Source 1 button to select the source document.

3. Click on the Layer button to select a specific layer within the source document. If the source document does not contain multiple layers, the Layer option will not be available.

4. Click on the Channel button to select a specific channel from the source document. The number of available channels is determined by the color mode of the source document.

5. Click on the Source 2, Layer, and Channel buttons to select the second document, the specific layer, and the channel used in the blending process.

6. Click on the Blending option to choose the blending mode for the two documents.

7. Click in the Opacity field and enter a value from 1 to 100 to control the amount of blending applied to the result image. A value of 100 applies 100 percent of the blending mode to the target image.

Figure 265.1 The Calculations dialog box lets you blend the channels from one or more source images.

8. Click on the Mask option to apply the blending mode to the source document through a mask. A mask can be another layer within the source document, or it can be a separate document.

9. Click on the Result button to choose the destination of the Calculations command. The Result can be a new channel or a selection within the Source 1 document, or you can choose to create a new document based on the Calculations command.

Click on the OK button to close the Calculations command and record your changes, as shown in Figure 265.2.

Figure 265.2 The Calculations command applied to a source document.

266 *Working with the Add and Subtract Blending Modes*

In the preceding two tips, you learned how to use the Apply Image and Calculations commands to create a new image from a combination of two or more Photoshop documents. The blending modes available for Calculations and Apply Image contain two new options: Add and Subtract.

The Add blending mode adds the values of two channels, and the Subtract blending mode subtracts the values of two channels. Two additional options are available when you choose the Add or Subtract blending modes: Offset and Scale, as shown in Figure 266.1.

- **Offset:** Click in the Offset input field and enter a value from 255 to –255. The Offset value lightens or darkens the pixels in the destination channel by any brightness value between 255 and –255. Negative values darken the image; positive values lighten the image.

- **Scale:** Click in the Scale input field and enter a value from 1.000 to 2.000. Entering a higher Scale value darkens the image, as shown in Figure 266.2.

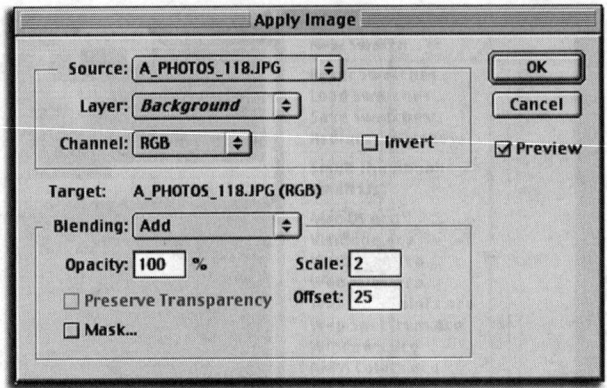

Figure 266.1 The Add and Subtract blending modes modify the image by increasing or decreasing the values of the two selected channels.

Figure 266.2 The Scale value further lightens or darkens the source image.

Click the OK button in the Apply Image or Calculations dialog box to close the dialog box and record your changes to the original image.

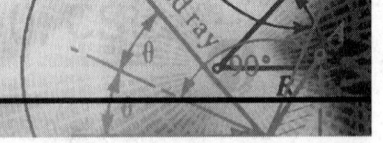

267 *Using Calculations to Blend Layers*

The Calculations and Apply Image commands use the layers and channels from two or more Photoshop documents to produce an image that is a combination of the two source documents. However, the Calculations command blends pixel values to produce a grayscale image, whereas the Apply Image command works with the color values of the pixels.

The Calculations command can be used to create a grayscale document from one or more open Photoshop images.

To create a grayscale image, open a color document in Photoshop and perform these steps:

1. Select the Image menu and choose the Calculations command. Photoshop opens the Calculations dialog box, as shown in Figure 267.1.

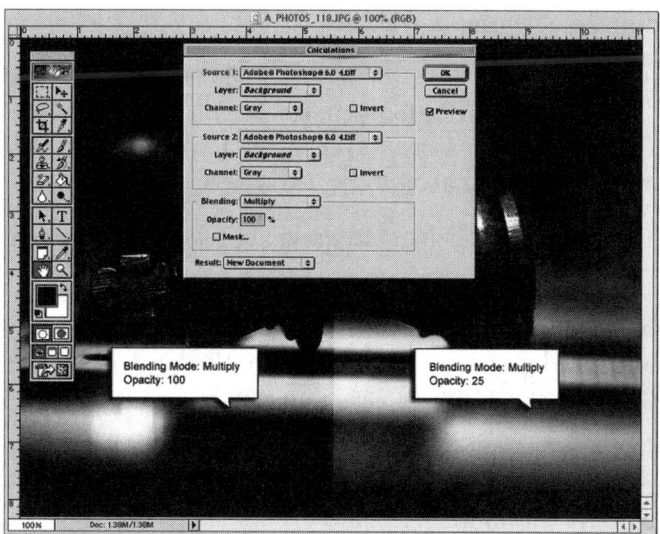

Figure 267.1 The Calculations dialog box lets you convert a color document into a specialized grayscale image.

2. The Source 1 button displays the active document. This option is not modifiable.

3. Click on the Layer button to choose the layer you want to convert to grayscale. If you do not have a multi-layered document, this option will not be available.

4. Click on the Channel button and choose the Gray channel option.

5. The Source 2 input fields must display the same options as Source 1.

6. Click on the Blending button and choose Normal to create a standard grayscale image. To darken the image, choose the Multiply option; to lighten the image, choose the Screen option.

7. If the image appears too dark or too light, click in the Opacity input field and enter a value from 1 to 100 to modify the effects of the Screen and Multiply blending modes.

8. Click in the Result field, choose New Document, and click the OK button. Photoshop closes the Calculations dialog box and opens a new document containing the modified image.

Note: While there are other ways to produce a grayscale image, using the Calculations dialog box gives you more creative control over the final image.

268 *Working with the Move Tool*

The Move tool is not a very exciting tool; however, you would not get very far in Photoshop without its existence. The Move tool moves information inside a document window or between documents.

To use the Move tool, open a document in Photoshop and select the Move tool from the Photoshop toolbox. Refer to Tip 72, "The Move Tool," for information on selecting the Move tool.

Here are some tips for using the Move tool:

- Clicking and dragging in a layer moves the entire layer.

- Clicking and dragging within a selected area moves only the selected area.

- Clicking and dragging in a layer or selection while holding down the Alt key (Macintosh: Option key) creates a copy of the selection or layer. If you move an entire layer, Photoshop automatically places the copied layer into a new layer in the Layers palette. If you are copy/moving a selection, Photoshop leaves the copied area in the active layer.

- Using the Shift key while clicking and dragging a layer or selection forces the move to be 90 or 45 degrees.

- The Move tool is linked to the arrow keys on your keyboard. Pressing the arrow keys moves a layer or selection one pixel at a time. Holding down the Shift key while using the arrow keys moves the active layer or selected area ten pixels at a time.

- Choosing the Select menu and choosing Transform Selection from the pull-down menu creates a bounding box around a previously selected area and lets you modify the selection box without changing the pixels within the selection.

- Clicking and dragging a layer or selection into another open document window creates a copy of the selection or layer in the other document.

269 *Changing an Image Using Image Size*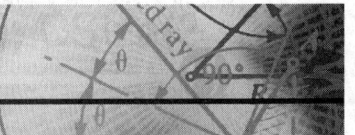

The Image Size dialog box lets you modify the width, height, and resolution of an open Photoshop image.

To use the Image Size dialog box, open a graphic image in Photoshop, select the Image menu, and choose Image Size from the pull-down menu. Photoshop will display the Image Size dialog box, as shown in Figure 269.1.

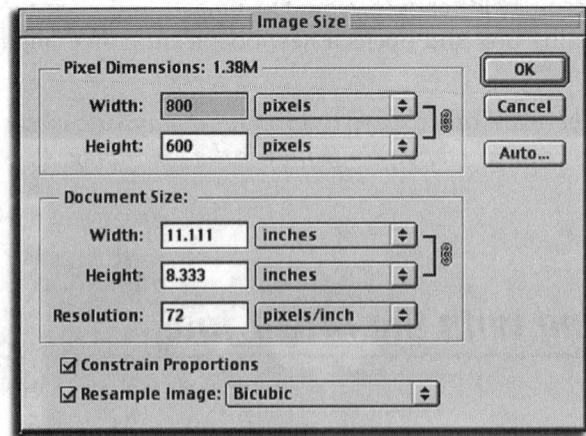

Figure 269.1 *The Image Size dialog box lets you change the width, height, and resolution of a Photoshop document.*

- **Pixel Dimensions:** Displays the current size of the image file. When adjustments are made to the file, the Pixel Dimensions field displays the original and new size of the image.

- **Width and Height:** Click in the Width and Height input fields to change the image size in pixels. Use these measurements when creating images for the Internet or computerized slide presentations. Click on the Width and Height measurement buttons to record image size changes in pixels or a percentage of the active document.

- **Document Size:** Click in the Width and Height fields to change the image size. Click on the Width and Height measurement buttons to change the measurement option to inches, centimeters, points, picas, columns, or a percentage of the active document. Use the Document Size options when preparing an image for output to paper.

- **Resolution:** Click in the Resolution input field to change the resolution of the image.

- **Constrain Proportions:** Choose the Constrain Proportions option to keep the width and height dimensions of the image in proportion. When the Constrain Proportions option is selected, changing the width automatically modifies the height to keep the image in proportion.

- **Resample Image:** When the Resample Image option is selected, changing the width and height of the image does not change the image's resolution. Instead, it forces Photoshop to resample the image and add or remove pixels to accommodate the new size of the document. When Resample Image is not selected, the number of pixels within the document does not change. Therefore, lowering the width and/or height of an image will increase the image's resolution. Raising the width and height of the image decreases the image's resolution. When Resample Image is selected, Photoshop adds or subtracts pixels from the image using one of three interpolation methods. Click on the Resample Image button to select from Bicubic, Bilinear, or Nearest Neighbor. For more information on resample methods, refer to Tip 22, "Choosing the Correct Interpolation Method."

- **Auto:** Click on the Auto button. Photoshop opens the Auto Resolution dialog box. The Auto Resolution dialog box is used to generate an image with the best resolution to use with printing presses. Presses measure the resolution of an image using a line screen. Type in the press's line screen in inches or centimeters and choose Draft, Good, or Best. The Best option is used for the image sent to the printing press. Use the Good and Draft options to create images for proofing. Click the OK button to record your changes to the Image Size dialog box.

When you finish making changes, click the OK button. Photoshop will close the Image Size dialog box and record your changes to the open image.

270 _Adjusting the Canvas Size_

The Canvas Size command lets you modify the width and height of the document canvas without changing the width and height of the graphic image.

To modify the document canvas, open a graphic in Photoshop, select the Image menu, and choose the Canvas Size option from the pull-down menu. Photoshop will open the Canvas Size dialog box, as shown in Figure 270.1.

- **Current Size:** Displays the current size, width, and height of the document.

- **New Size:** Displays the size of the document based on the changes to its width and height.

- **Width and Height:** Click in the input fields to change the width and height of the document. Click on the Width and Height measurement buttons to change to pixels, inches, centimeters, points, picas, or a percentage of the original document.

Figure 270.1 The Canvas Size dialog box lets you change the width and height of a document without changing the width or height of the graphic.

- **Anchor:** Click on one of the nine position boxes to determine where the existing image is positioned on the new canvas. Clicking on the center box expands the canvas equally around the original image. Clicking on any of the outer boxes positions the original image in that sector and expands the new canvas based on the box you clicked.

Click the OK button to close the Canvas Size dialog box and record your changes to the document.

Note: Choosing a canvas size that is smaller than the original image will force Photoshop to remove (clip) portions of the image. A better way to crop an image is using the Cropping tool. For more information on cropping an image, refer to Tip 75, "The Cropping Tool."

271 *Rotating the Canvas*

The Rotate Canvas command lets you rotate or flip an entire image. The Rotate Canvas option works on the entire document window. It does not work on individual layers or selections. To rotate an image, open a graphic in Photoshop, select Image menu Rotate Canvas, and choose from the following options:

- **180 degrees:** Choosing this option rotates the document 180 degrees.

- **90 degrees CW:** Choosing this option rotates the document 90 degrees clockwise.

- **90 degrees CCW:** Choosing this option rotates the document 90 degrees counterclockwise.

- **Arbitrary:** Choosing this option opens the dialog box shown in Figure 271.1. Click in the Angle input field and type a value from 0 to 360. Then choose clockwise (CW) or counter clockwise (CCW). Click OK to perform the rotation.

- **Flip Horizontal:** Choosing this option flips (not rotates) the graphic from top to bottom and creates a horizontal mirror image of the original document.

- **Flip Vertical:** Choosing this option flips (not rotates) the graphic from left to right and creates a vertical mirror image of the original document.

Figure 271.1 The Rotate Canvas dialog box lets you choose a rotation value from 0 to 360 degrees.

272 *Using the Cropping Tool*

Photoshop's Cropping tool lets you select a portion of an image by using a rectangular selection tool. To crop a portion of an image, select the Cropping tool from the toolbox (refer to Tip 75, "The Cropping Tool").

The Cropping tool performs like the rectangular selection tool. Click and drag your cursor in the selection window, creating a rectangular selection. When you release the mouse, a bounding box with handles defines the cropped area, and a cropping shield covers the rest of the image, as shown in Figure 272.1.

Figure 272.1 An editable bounding box defines the cropped area of a document.

The Options bar defines the characteristics of the Cropping tool, as shown in Figure 272.2.

Figure 272.2 The Options bar defines the characteristics of the Cropping tool.

Click in the Width, Height, and Resolution input fields (see Figure 272.2) and enter the final width, height, and resolution values of the cropped area.

Click the Front Image button to insert the current width, height, and resolution of the active document into the Width, Height, and Resolution input fields.

Click the Clear button to reset the input fields.

Once an area is selected, the Options bar changes to display new options, as shown in Figure 272.3.

Figure 272.3 The Options bar displays new options to help define the cropped area of the image.

- **Shield cropped area:** Select this option to shield the cropped areas of the graphic with a mask.

- **Color:** Click on the Color option to change the color of the shield.

- **Opacity:** Click in the Opacity input box and enter a value from 1 to 100 to change the transparency of the shield. A value of 100 creates an opaque shield.

- **Perspective:** Clicking on the Perspective option lets you change the perspective of the cropped area by clicking and dragging individual handles to create a nonrectangular area.

- **Cropped Area:** Choose Delete to remove the image information outside the cropped area. Choose Hide to preserve the areas outside the bounding box.

You can resize the bounding box by clicking and dragging on the bounding box handles.

- Click and drag the vertical or horizontal handles to change the height or width of the bounding box. When your cursor is positioned over a vertical or horizontal handle, the cursor icon changes to a vertical or horizontal line.

- Click and drag the corner handles to change the width and height of the selected corner. Holding down the Shift key maintains the original proportions of the cropped area. When your cursor is positioned over a corner handle, the cursor icon changes to a diagonal line.

- Rotate the cropped area by moving the cursor outside the bounding box until your cursor resembles a bent arrow and then clicking and dragging your mouse.

- Move the cropped area by clicking and dragging from inside the bounding box.

Perform the crop by double-clicking inside the bounding box, by pressing the Enter key, or by clicking the check mark icon in the Options bar (refer to Figure 272.3).

273 *Cropping the Image Without the Cropping Tool*

In the preceding tip, you learned how to reduce the size of an image by selecting a specific area of an image with the Cropping tool. While the Cropping tool gives you the most control over what you want to remove from the original image, the Rectangular Marquee tool can also be used as a cropping tool. For more information on selecting and using the Marquee tools, refer to Tip 71, "The Marquee Tools."

To crop an image using the Rectangular Marquee tool, open a graphic image in Photoshop and perform these steps:

1. Define an area of the image by clicking and dragging the Marquee tool across the document window, as shown in Figure 273.1.

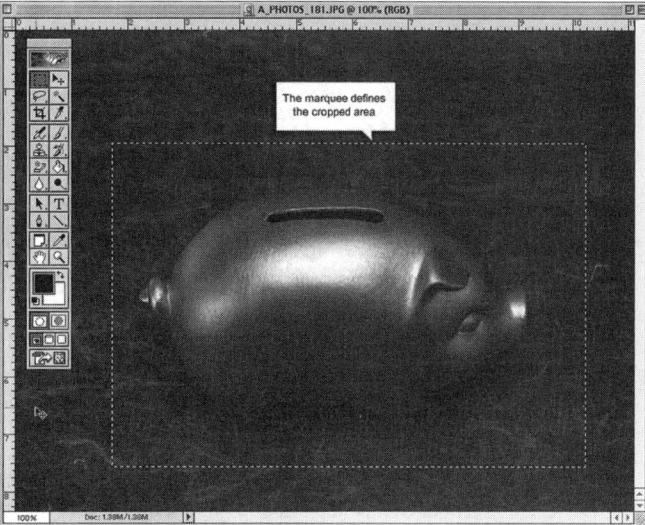

Figure 273.1 Dragging the Marquee tool across the image defines the cropped area.

2. Select the Image menu and choose the Crop option from the pull-down menu. Photoshop will crop the image by eliminating all the areas outside the selection boundary, as shown in Figure 273.2.

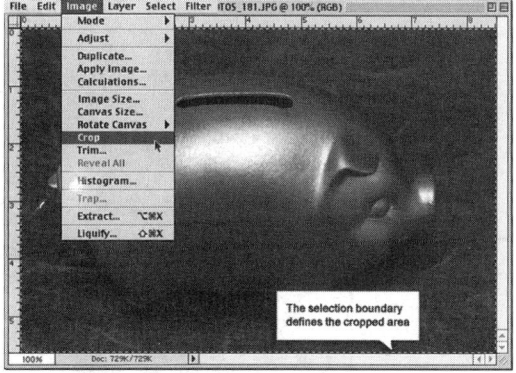

Figure 273.2 The selection boundary defines the area remaining after the Crop command is executed.

274 *Expanding the Canvas Using the Cropping Tool*

In Tip 270, "Adjusting the Canvas Size," you learned how to increase or decrease the canvas size of a Photoshop graphic. Another way to increase the size of the canvas is by using the Cropping tool.

To expand the size of the canvas, perform these steps:

1. Open a graphic in Photoshop and expand the size of the document window by clicking in the lower-right corner of the document window and dragging outward. A gray area surrounds the image, as shown in Figure 274.1.

Figure 274.1 Clicking and dragging from the lower-right corner of the document window expands the size of the window, not the graphic.

2. Select the Cropping tool (refer to Tip 272, "Using the Cropping Tool"). Click and drag your mouse across the document from the upper-left to the lower-right corner of the document window, as shown in Figure 274.2.

Figure 274.2 Click and drag across the document window to select the entire image.

3. To expand the canvas, move your cursor over one of the cropping handles and drag outward into the gray area surrounding the image, as shown in Figure 274.3.

Figure 274.3 Clicking and dragging the cropping handles redefines the shape of the cropped area.

Press the Enter key or double-click the mouse within the bounding box to set the expansion. The canvas size expands to fit the size of the bounding box, as shown in Figure 274.4.

Figure 274.4 The canvas size expands to fit the size defined by the bounding box.

275 *Using the Trim Command to Crop an Image*

New to Photoshop 6.0, the Trim command lets you crop an image by using the transparency or color of the pixels on the edge of the image. The Trim command is best used to remove solid colors or borders surrounding a scanned image, as shown in Figure 275.1.

*Figure 275.1 The Trim command works best on images containing solid-color
borders that need to be removed from the image.*

To use the Trim command, open an image in Photoshop, select the Image menu, and choose the Trim
option from the pull-down menu. Photoshop will display the Trim dialog box, as shown in Figure 275.2.

Figure 275.2 The Trim dialog box lets you control how an image is cropped.

The Trim dialog box uses one of three options to decide what pixels to remove from the image:

- **Transparent Pixels:** Choose this option to trim away transparency at the edges of the image, leaving
 the smallest image containing nontransparent pixels.

- **Top Left Pixel Color:** Choose this option to remove an area from the edge of the image based on the
 color of the upper-left pixel.

- **Bottom Right Pixel Color:** Choose this option to remove an area from the edge of the image based
 on the color of the lower-right pixel.

Select one or more areas to trim from the image:

- **Top:** Choose this option to trim the top pixels from the image.

- **Bottom:** Choose this option to trim the bottom pixels from the image.

- **Left:** Choose this option to trim the left pixels from the image.

- **Right:** Choose this option to trim the right pixels from the image.

See Figures 275.3 and 275.4 for examples of the Trim command.

Figure 275.3 The Trim command executed using top and right as the trim areas.

Figure 275.4 The Trim commands executed using top, bottom, right, and left as trim areas.

276 *Using the Histogram to Examine an Image*

Image editing in Photoshop requires a graphic that contains a sufficient amount of detail. Using the Histogram command supplies you with the information you need to perform image editing.

To use the Histogram command, open an image in Photoshop, select the Image menu, and choose the Histogram command from the pull-down menu. Photoshop will open the Histogram dialog box, as shown in Figure 276.1.

Figure 276.1 The Histogram dialog box supplies you with information on the amount of detail in the active image.

- **The x-axis (horizontal):** Represents the color values of the pixels from the darkest (on the left side of the graph) to the brightest (on the far right side of the graph).

- **The y-axis (vertical):** Represents the percentage of each pixel within the document. Since each pixel within an image contains a brightness value from 0 (black) to 255 (white), think of the histogram as a 256 vertical bar spreadsheet, describing how many of each value pixel are contained within the image.

- **Channel:** Click on the Channel button to display a list of available channels. Click to select one of the available channels to view the histogram data for that particular color. If you are working on a grayscale image, the Channel option is not available.

- **Mean:** The average brightness values for all the pixels in the image.

- **Std Dev:** The Standard Deviation represents how widely the pixels vary from the brightest to the darkest. A Deviation value of 0 would indicate no deviation in the pixel values, and the graphic would be one solid color.

- **Median:** Shows the middle value in the total range of color values within the image. The Median value falls in the range of 0 (black) to 255 (white). An acceptable median value for an average image is anywhere from 115–140.

- **Pixels:** Represents the total number of pixels used in the image.

- **Level:** Move your cursor into the histogram and move left to right across the graph. The Level field displays the value of the pixel directly under your mouse cursor. Level values range from 0 (shadows) on the far left of the histogram to 255 (highlights) on the far right of the histogram.

- **Count:** When you move your cursor across the histogram, the Level field displays the brightness value of the pixel directly under your cursor. The Count field displays how many of the pixels in the image make up that particular value.

- **Percentile:** Displays, in percentage, the number of pixels counted from the far left of the histogram to the current position of your mouse cursor. The Percentile field will increase as you move your cursor toward the right of the histogram.

- **Cache Level:** Displays the setting for the image cache. Refer to Tip 47, "How Image Cache Affects the Histogram."

Images with good detail have a histogram that contains sufficient detail across the x-axis, as shown in Figure 276.2.

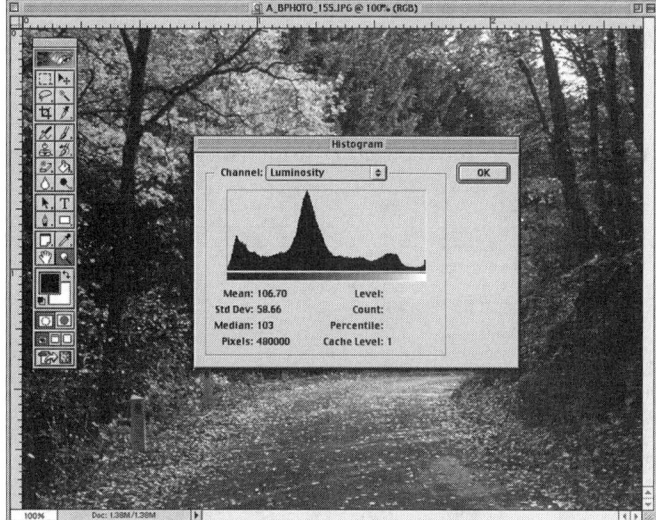

Figure 276.2 This image contains good detail in the shadow, midtones, and highlights.

Images in which the histogram displays gaps in the x-axis are poor candidates for image editing, as shown in Figure 276.3.

Figure 276.3 This histogram contains major gaps in the highlight and midtone areas of the image.
This lack of detail makes image editing difficult.

The histogram command should be used every time you scan or open an image in Photoshop to determine the quality and detail of the graphic.

277 *Using the Liquify Command*

New to Photoshop 6.0, the Liquify command lets you manipulate an image as if areas of the image were melting. The Liquify command works with all images in Photoshop with the exception of images in Bitmap, Lab, or Duotone color modes.

To use the Liquify command, open a Photoshop image, select the Image menu, and choose the Liquify command from the pull-down menu. Photoshop will open the Liquify dialog box, as shown in Figure 277.1

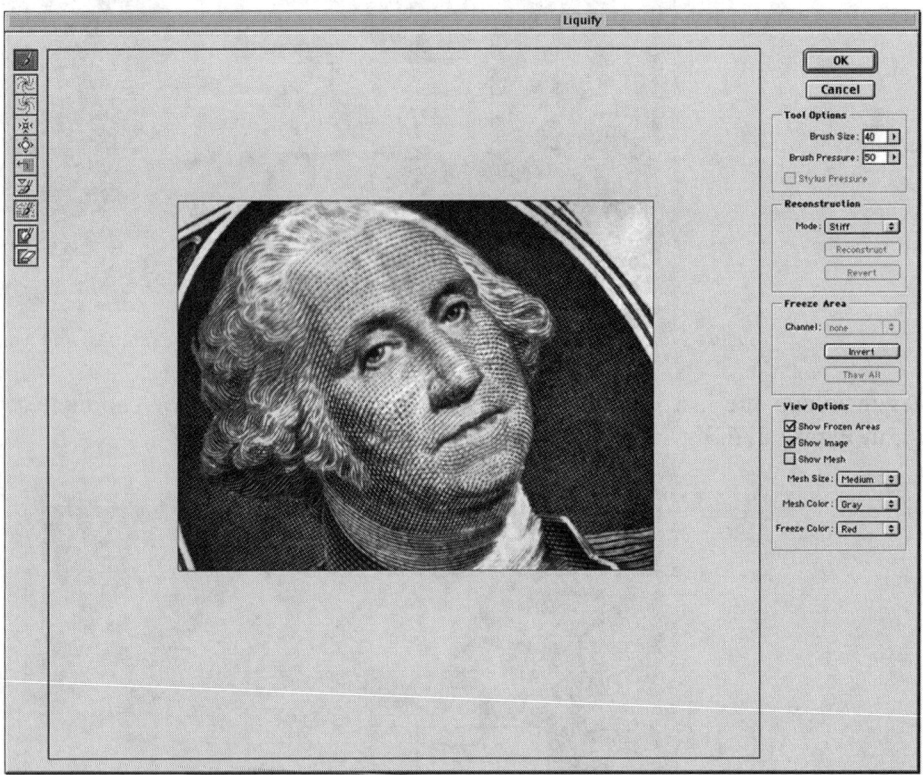

Figure 277.1 The Liquify command lets you manipulate an image as if areas of the image were melting.

Tool Options:

- **Brush Size:** Click in the Brush Size input field and enter a value from 1 to 150. Brush sizes are measured in pixels. The larger the value, the larger the brush size.

- **Brush Pressure:** Click in the Brush Pressure input field and enter a value from 1 to 100. The higher the value, the more intensely the Liquify effect is applied to the image.

Reconstruction:

- **Mode:** Click on the Mode button to chose a Liquify mode. Each of the reconstruction modes affects how the Liquify tools work on the image. For example, using the Revert mode with the Reconstruct tool restores previously distorted areas of the image back to their original color and shape.

- **Reconstruct:** The Reconstruct button restores portions of an image affected by the Liquify command. The overall visual effect restores the central regions of the image while maintaining a percentage of the distortion effect along the edges of the image.

- **Revert:** Clicking on the Revert button restores the image to its original shape.

- **Freeze Area:** See Tip 278, "Freezing and Thawing Areas of an Image."

View Options:

- **Show Frozen Areas:** Displays a mask over the frozen areas of the image (see Tip 278).

- **Show Image:** Select this option when the Show Mesh option is selected to display the image underneath the mesh.

- **Show Mesh:** Displays a grid over the image. If Show Image is not selected, the mesh displays against a solid gray background.

- **Mesh Size:** Click the Mesh Size button to change the size of the mesh.

- **Mesh Color:** Click the Mesh Color button to change the color of the mesh.

- **Freeze Color:** Click the Freeze Color button to change the color of the frozen areas of the image (see Tip 278).

The Liquify tools are located on the left side of the Liquify dialog box (refer to Figure 277.1).

- **Warp Tool:** Select this tool and click and drag across the image. The pixels push ahead of the brush and mix with the original pixels to create a melted look to the image, as shown in Figure 277.2.

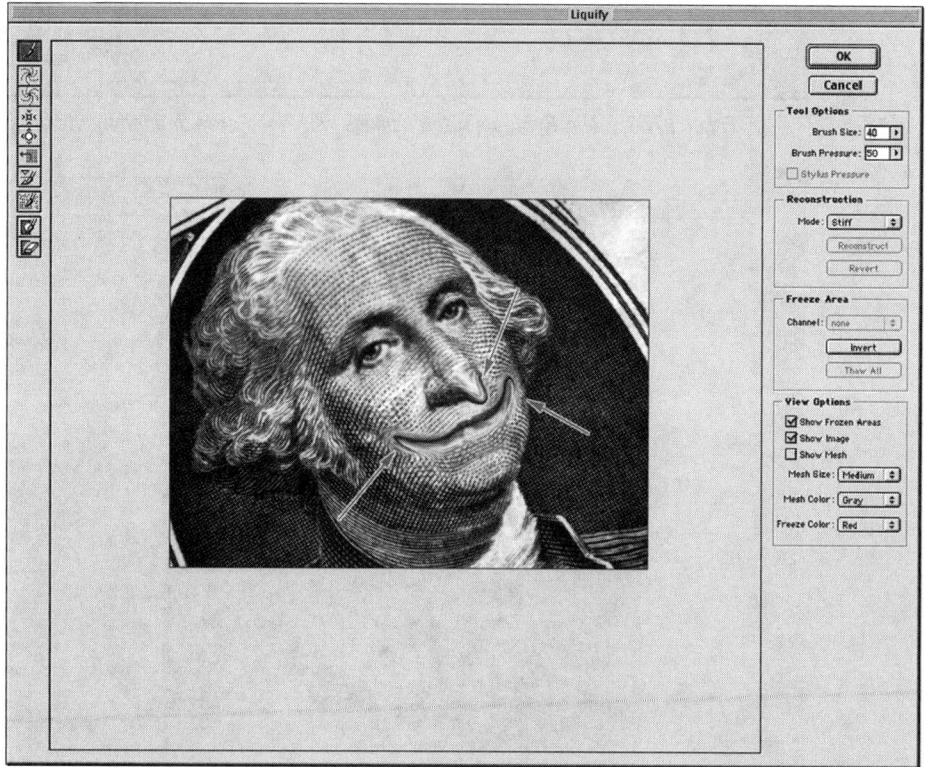

Figure 277.2 The Warp tool changes the image pixels to create a melted look to the image.

- **Twirl Clockwise:** When this tool is used, the pixels in the area defined by the Brush Size rotate clockwise. Release the mouse button to end the Twirl effect, as shown in Figure 277.3.

- **Twirl Counter Clockwise:** When this tool is used, the pixels in the area defined by the Brush Size are rotated counterclockwise. Release the mouse button to end the Twirl effect.

- **Pucker:** Click and hold down the mouse button to drag pixels inward toward the center of the brush size, as shown in Figure 277.4.

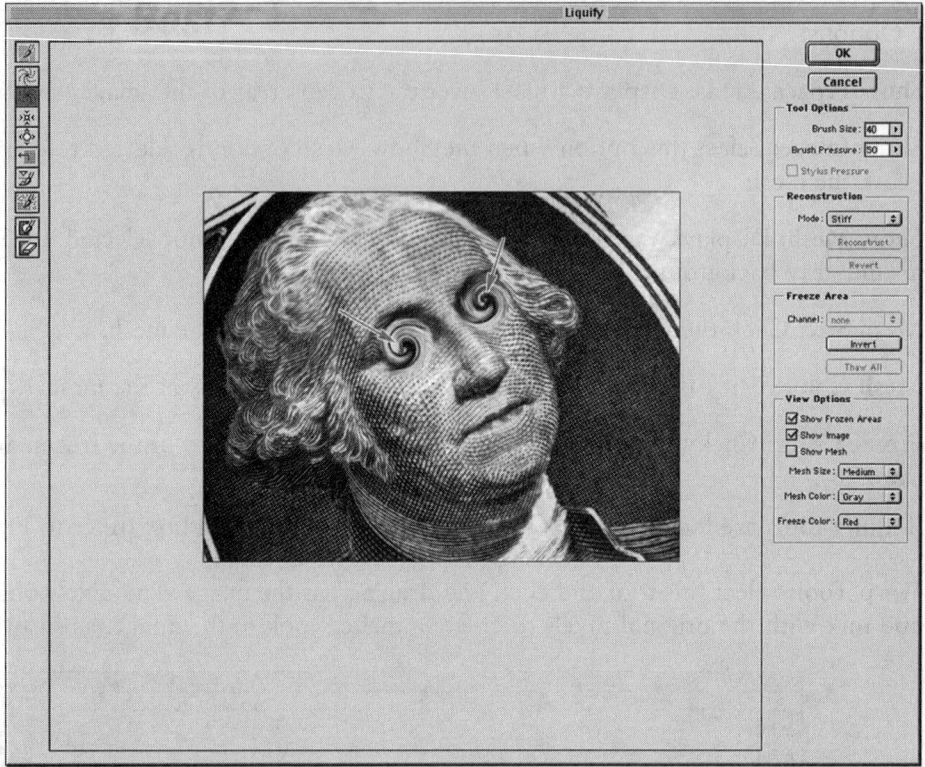

Figure 277.3 The Twirl tool rotates pixels within the area defined by the brush size.

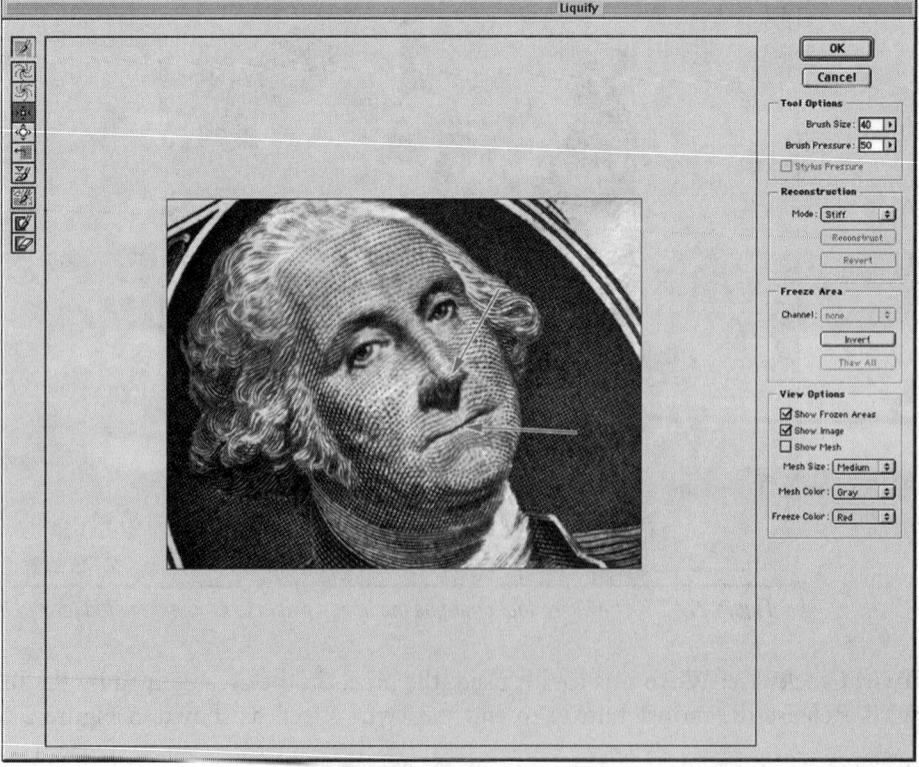

Figure 277.4 The Pucker tool drags pixels toward the center of the area defined by the brush size.

- **Bloat:** Click and hold down the mouse button to move pixels away from the center of the brush, as shown in Figure 277.5.

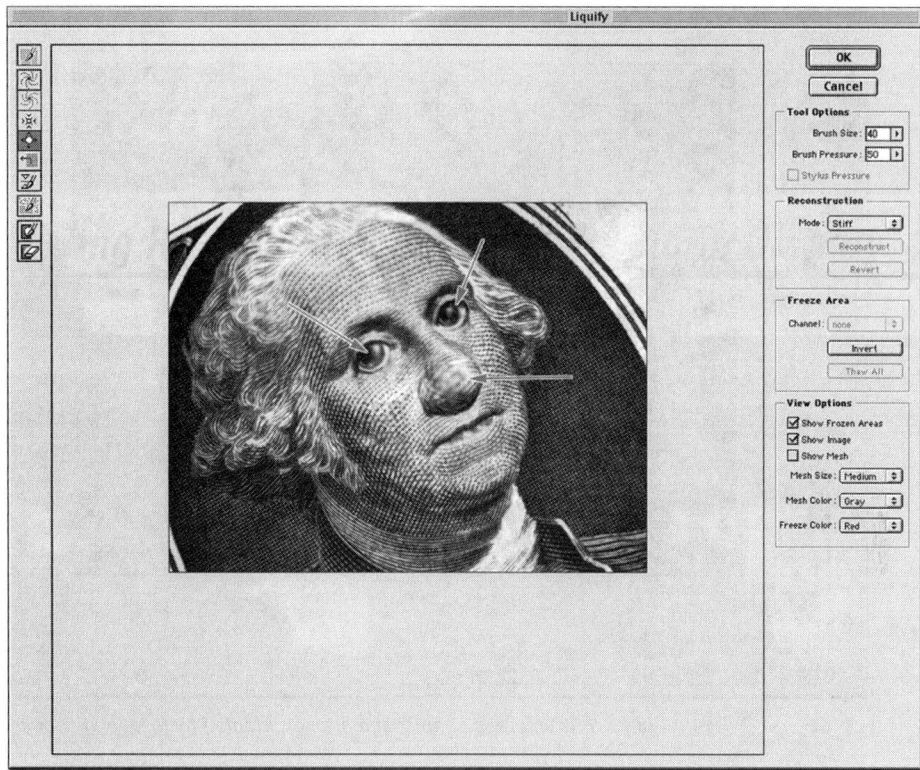

Figure 277.5 The Bloat command pushes pixels out from the center of the area of the brush size, creating a bloated look to the image.

- **Shift Pixels:** Click and drag your cursor across the image to move pixels under the cursor perpendicular to the direction of movement.

- **Reflection:** Click and drag your cursor to reflect the area perpendicular to the direction of the stroke.

- **Reconstruct:** The Reconstruct tool restores the image back to its original look. When used with the Revert mode, the tool restores the image back to its original look, paint stroke by paint stroke. When the Reconstruct tool is used with reconstruction modes other than Revert, the restoration effect is less striking.

- **Freeze and Thaw tools:** See Tip 278 for information on freezing and thawing an image.

Click the OK button to close the Liquify dialog box and record your changes to the original image.

278 *Freezing and Thawing Areas of an Image*

In the preceding tip, you learned how to use the Liquify command to create special effects. You can further control the Liquify command by freezing areas of the image. The Liquify command does not affect the frozen areas of an image. You can define frozen areas of an image in one of two ways: by creating a mask within a channel or by painting the areas of the image you want to freeze, as shown in Figure 278.1.

Figure 278.1 Frozen areas of an image are not affected by the Liquify command.

To use the channel method for freezing an image, open a Photoshop graphic and create a channel mask. For more information on creating channel masks, see Tip 434, "Working with Native Channels and Alpha Masks." Select the Image menu and choose the Liquify command from the pull-down menu.

To use the channel mask to freeze a portion of the image, perform these steps:

1. In View Options, select Show Frozen Areas by clicking in the input box to the right of the option.

2. Click the Channel button in the Freeze Area and select your newly created mask channel. The mask appears as a semitransparent area, covering the image as shown in Figure 278.2.

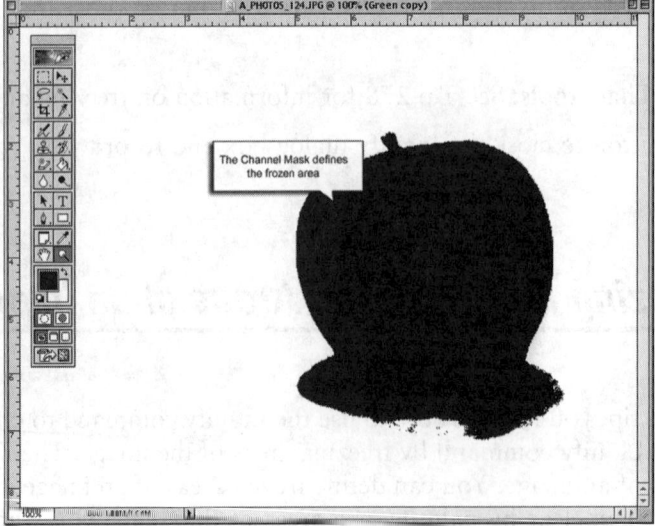

Figure 278.2 The newly created channel mask protects those areas of the image from the effects of the Liquify command.

3. Modify the image using the Liquify tools (refer to the preceding tip). The masked areas are not affected by the Liquify commands, as shown in Figure 278.3.

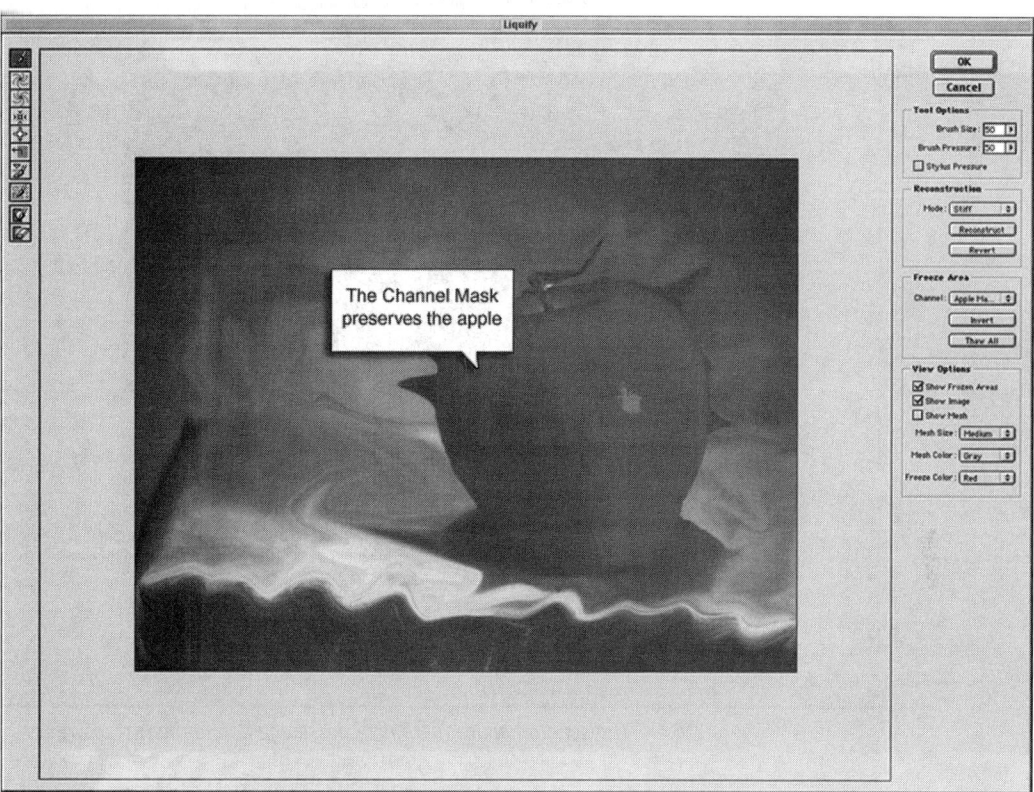

Figure 278.3 The mask isolates portions of the image and prevents them from being modified by the Liquify command.

4. Click the OK button to close the Liquify dialog box and record your changes to the image.

To freeze areas of an image without creating a channel mask, perform these steps:

1. Open an image in Photoshop, select the Image menu, and choose the Liquify command. Photoshop will open the Liquify dialog box (refer to Figure 278.1).

2. Select the Freeze tool from the Liquify toolbox (refer to Figure 278.1). When you drag your mouse across the image, you create a semitransparent area. Those semitransparent areas are the frozen areas of the image, as shown in Figure 278.4.

3. To erase portions of the frozen image, click on the Thaw tool (located directly under the Freeze tool) and click and drag over the semitransparent areas of the image. By erasing portions of the mask, you make those areas available to the Liquify command.

4. After painting the mask, use the Liquify tools on the image (refer to the preceding tip) and click the OK button to record your changes to the original image.

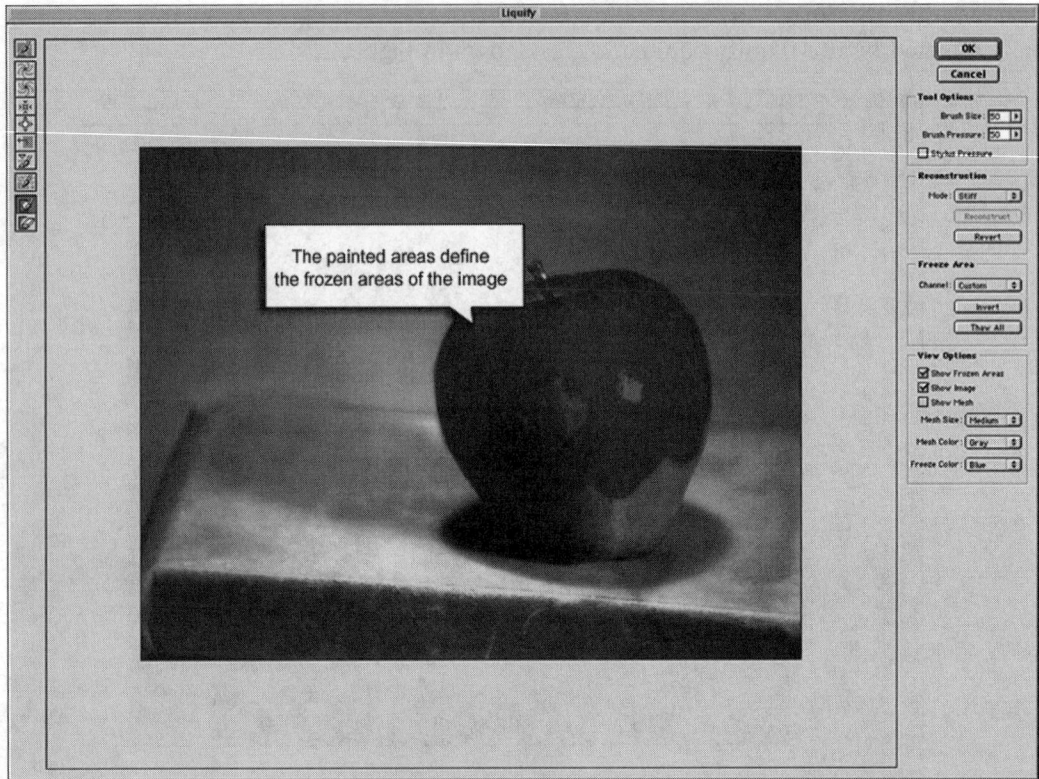

Figure 278.4 The semitransparent areas of the image define the frozen areas.

279 *Working with Photoshop's Airbrush Tool*

Photoshop's Airbrush tool simulates the paint strokes made by a mechanical airbrush. Although the Airbrush tool applies ink to the image, it does so differently than all the other painting tools in Photoshop.

As discussed in Tip 222, "Understanding the Difference Between the Paintbrush and the Airbrush," the Airbrush uses a Pressure option to apply ink to the screen. Unlike with the Paintbrush, the application of ink onto the graphic is affected by both the speed of the brush as it is dragged across the image and the overlapping of brush strokes. For this reason, the Airbrush is harder to control and requires technique and skill.

When used in conjunction with a drawing tablet, Photoshop's Airbrush tool simulates the effect of using a real airbrush. Refer to Tip 196, "Using a Drawing Tablet with the Brush Tools," for more information on setting up a drawing tablet with Photoshop.

To use the Airbrush with a drawing tablet, select the Airbrush from the toolbox and click on the Brush Dynamics button in the Options bar, as shown in Figure 279.1.

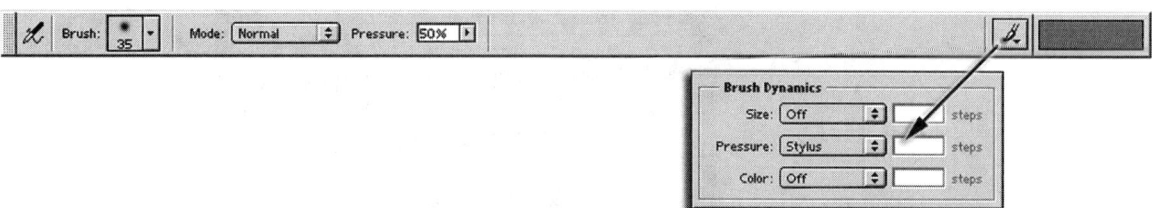

Figure 279.1 *The Brush Dynamics option lets you set up a drawing tablet with your Airbrush tool.*

- **Size:** Click the Size button and select the Stylus option to link the size of the Airbrush to the pressure exerted by the drawing tool against the tablet, as shown in Figure 279.2.

Figure 279.2 *The Size option controls the relative size of the brush based on the pressure of the stylus against the drawing tablet.*

- **Pressure:** Click the Pressure button and select the Stylus option to link the transparency of the Airbrush to the pressure exerted by the drawing tool against the tablet, as shown in Figure 279.3.

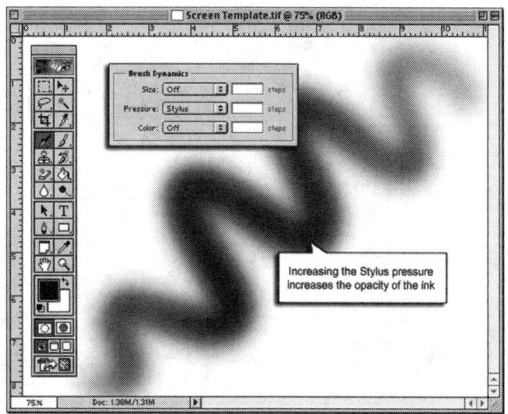

Figure 279.3 *The Pressure option controls the transparency of the brush based on the pressure of the stylus against the drawing tablet.*

- **Color:** Click the Color button and select the Stylus option to link the color used by the Airbrush to the pressure exerted by the drawing tool against the tablet. The color shifts between the Foreground and Background Color Swatches. Lighter pressure reveals more of the Foreground color, and heavier pressure of the stylus against the tablet reveals more of the Background color, as shown if Figure 279.4.

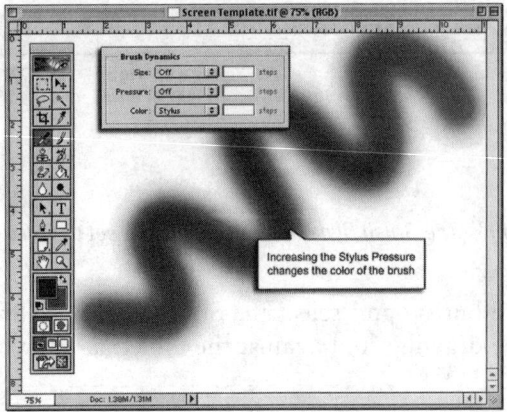

Figure 279.4 The Color option controls the color of the brush based on the pressure of the stylus against the drawing tablet.

280 *Selection Methods*

Selection is the name of the game in Photoshop. Say you need to remove a background from an image or want to perform image editing on a portion of the image. When you select an area within a Photoshop image, you are defining your work area. Nothing happens outside of the selected area, as shown in Figure 280.1.

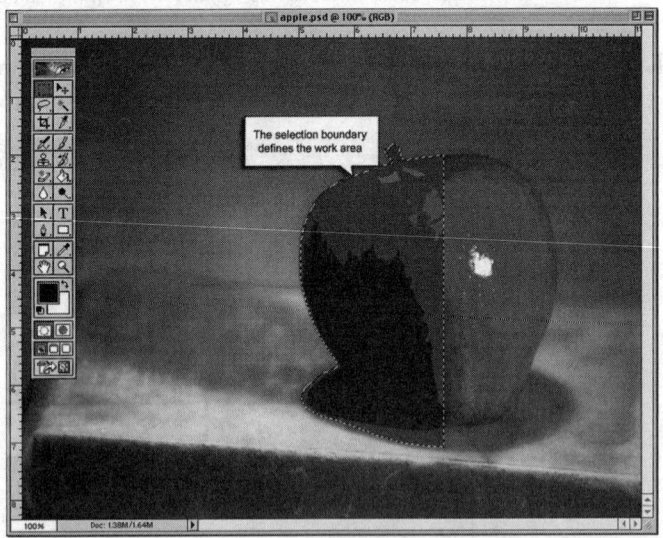

Figure 280.1 Selecting an area of an image defines your work area.

When you select an area of a graphic image, examine your tools and choose the best tool to perform the job.

- **Standard selection tools:** The Marquee and Lasso tools work when none of the other selection techniques will do the job. Image information or specific colors do not control the selection; the Marquee and Lasso tools direct a selection by clicking and dragging within the image. Refer to Tip 71, "The Marquee Tools," and Tip 73, "The Lasso Tools," for more information on these tools.

- **Magic Wand:** The Magic Wand tool selects information by a variation in the luminosity of the pixels in the image. Choose the Magic Wand when you want to select areas of the image containing similar brightness levels. See Tip 284, "Using the Magic Wand," for more information on using this tool.

- **Magnetic Lasso:** The Magnetic Lasso tool creates a selection by selecting pixel information along a definable edge. Use the Magnetic Lasso when the area you want to select is surrounded by a definable shift of color or brightness. Refer to Tip 137, "Understanding the Magnetic Lasso Tool," for more information on using this tool.

- **Quick Mask:** The Quick Mask option creates a selection by painting the image with a semitransparent area of color. Use the Quick Mask option to touch up a selection. Refer to Tip 151, "Working with Quick Mask," for more information on using this selection tool.

- **Selection masks:** You can make complicated selections easy by using a selection mask within a channel. Selection masks, like Quick Masks, identify the selected area by painting the mask. Use this option when you have a color channel that closely matches what you want to select. Refer to Tip 152, "Understanding Masks in Photoshop," for more information on this selection tool.

- **Extract:** The Extract option lets you paint over the selected area and then extracts the image out of the original document. Use this option when you are selecting hair or fine lines. See Tip 289, "Determining When to Use the Extract Command," for more information on this selection tool.

- **Color Range:** The Color Range option lets you select areas of an image based on color. Use this option when you want to select areas out of an image that contain similar color values. Refer to Tip 145, "Using the Color Range Command," for more information on using this selection tool.

The idea is not to learn one way to select information but to understand how Photoshop can best perform the selection. Knowing how to quickly select pixel information within a Photoshop document helps you become more efficient and lets you get more work accomplished in the same amount of time.

281 *Creating a Rectangular or Elliptical Selection Using Ratio*

In the preceding tip, you learned that selection of information within a document defines the working area. The Marquee tools perform a selection by drawing a rectangle or elliptical area around the pixels. The shape of the marquee is determined by how you drag the tool over the image. There are times when the area you need to select matches a predefined set of measurements. Photoshop lets you assign an aspect ratio or choose a specific size for the selection.

To create a predefined selection using the Marquee tools, perform these steps:

1. Open a graphic image in Photoshop.

2. Select the Rectangular or Elliptical Marquee tool. Refer to Tip 71, "The Marquee Tools."

3. Click on the Style button in the Options bar to display a list of available options, as shown in Figure 281.1.

Figure 281.1 The Style button on the Options bar lets you control the aspect ratio or width and height of the selection area.

4. Select Constrained Aspect Ratio and type a value of 2 in the Width input field and 1 in the Height input field. When you click and drag your mouse over the image, the selection will be twice as wide as it is tall, as shown in Figure 281.2.

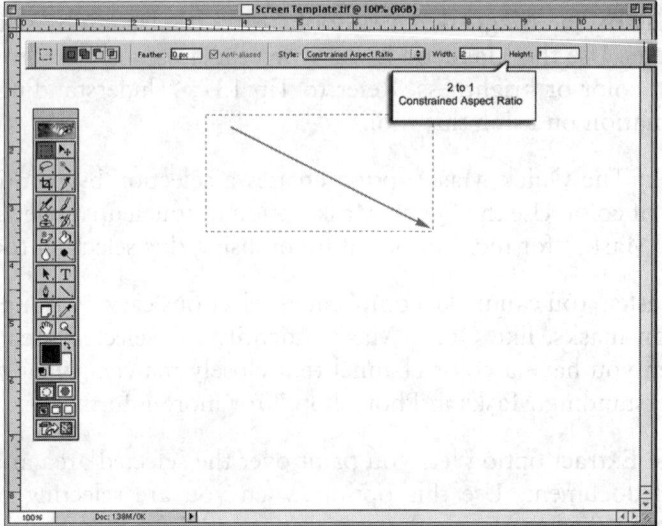

Figure 281.2 The Constrained Aspect Ratio option controls the relative size of the selection.

5. Select Fixed Size and enter a width and height to control the size of the selected area. For example, entering values of 2 inches for Height and 2 inches for Width would select an area exactly 2 inches by 2 inches. When you use the Fixed Size option, it is not necessary to drag your mouse over the image; just click once and the selection tool will draw a marquee based on the values entered for the Width and Height options, as shown in Figure 281.3.

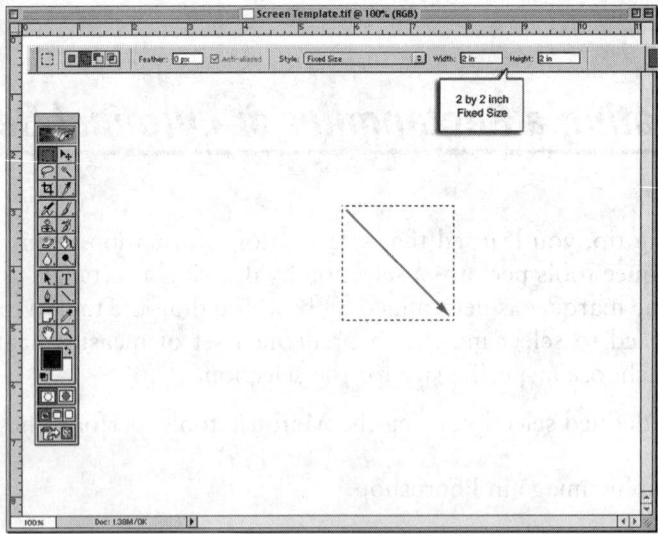

Figure 281.3 The Fixed Size option draws a rectangle or ellipse matching the Width and Height input fields.

282 *Working with the Marquee Tools*

In the preceding tip, you learned that you can control the Marquee tools to fit a particular size or aspect ratio. However, the Options bar gives you several ways to control the Marquee tools, as shown in Figure 282.1.

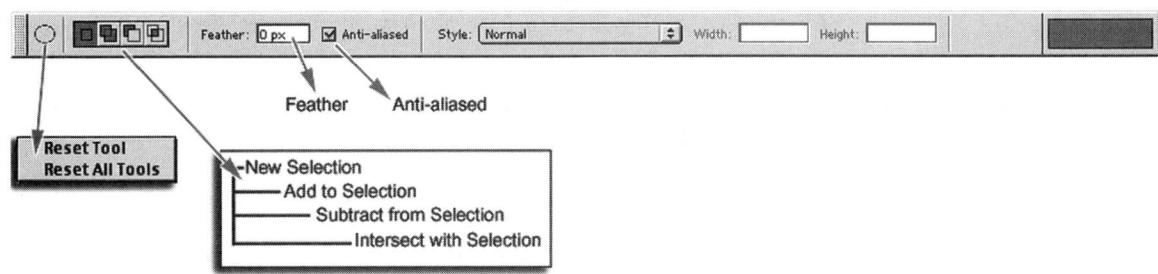

Figure 282.1 The Options bar defines the characteristics of the Marquee tools.

- **Reset Tools:** Click on the Marquee icon located at the far left of the Options bar and select the Reset Tool option. Photoshop resets the Marquee options to their default values.

- **New selection:** Click the New selection button (refer to Figure 282.1) to create a new selection.

- **Add to selection:** Click the Add to selection button (refer to Figure 282.1) to add to an existing selection.

- **Subtract from selection:** Click the Subtract from selection button (refer to Figure 282.1) to subtract from an existing selection.

- **Intersect with selection:** Click the Intersect with selection button to create a new selection based on the intersection of the Marquee tool with an existing selection.

- **Feather:** Click in the Feather input field and enter a value from 0 to 250. The higher the value, the more feathered the edge of the selection.

- **Anti-aliased (elliptical marquee only):** Click in the Anti-aliased check box to select this option. The Anti-aliased option creates a visually smooth selection by slightly feathering the selection edge.

283 *Working with the Lasso Tools*

The Lassos are true freeform selection tools. Unlike the Marquee tools or any of the other selection tools in Photoshop, the Lasso tools are the only tools directly controlled by the movement of your mouse across the image. The Lasso tool does not select by color or the brightness of the pixels; it moves where you move and selects any pixels in any shape within the document window. It may not be the most sophisticated way to make a selection; however, the Lasso tools can sometimes select information when no other selection method will work.

When you are using the Lasso tools, the Options bar gives you several options to control how the tools works, as shown in Figure 283.1.

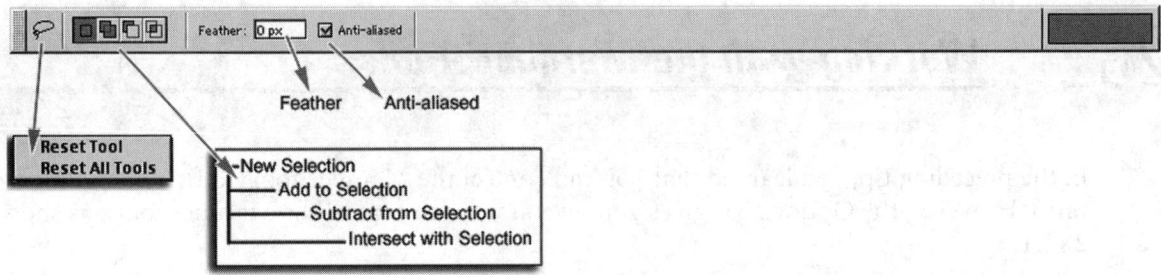

Figure 283.1 The Options bar defines the characteristics of the Lasso tools.

- **Reset Tools:** Click on the Lasso icon located at the far left of the Options bar and select the Reset Tool option. Photoshop resets the Lasso options to their default values.

- **New Selection:** Click the New Selection button (refer to Figure 283.1) to create a new selection.

- **Add to Selection:** Click the Add to Selection button (refer to Figure 283.1) to add to an existing selection.

- **Subtract from Selection:** Click the Subtract from selection button (refer to Figure 283.1) to subtract from an existing selection.

- **Intersect with Selection:** Click the Intersect with selection button to create a new selection based on the intersection of the Lasso tool with an existing selection.

- **Feather:** Click in the Feather input field and enter a value from 0 to 250. The higher the value, the more feathered the edge of the selection.

- **Anti-aliased:** Click in the Anti-aliased check box to select this option. The Anti-aliased option creates a visually smooth selection by slightly feathering the selection edge.

To use the Lasso tool, click and drag within the document window. As you drag the mouse across the document, the movement of your mouse creates a freeform selection.

To create straight lines while using the Freeform Lasso, hold the Alt key (Option key: Macintosh). The Freeform Lasso temporarily transforms into the Polygon Lasso. Click once and move (do not drag) to another position and click again. Photoshop creates a straight line between the two points. Continue to click and move to create more straight points. Release the Mouse and Alt key (Option key: Macintosh) to close the selection.

> *Note: Converting the Freeform Lasso temporarily into the Polygon Lasso only works when there are no previous selections within the active document window.*

Releasing the mouse automatically closes the selection border, as shown in Figure 283.2.

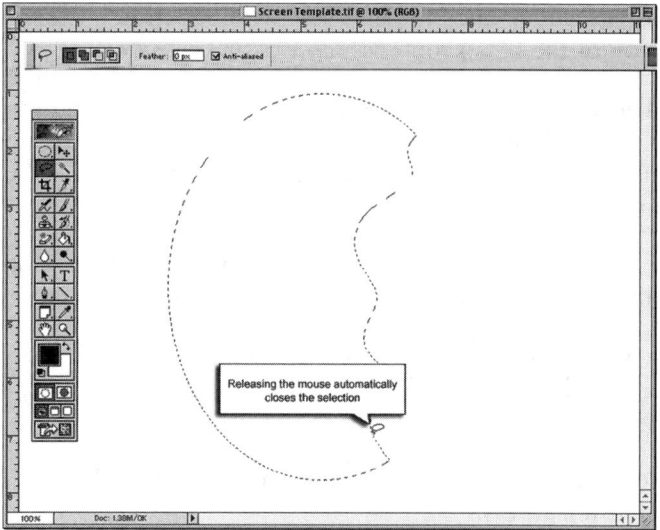

Figure 283.2 *Releasing the mouse automatically closes off the selection border.*

284 *Using the Magic Wand*

The Magic Wand tool creates selection borders based on the luminosity of the sample pixels. The Magic Wand tool does not function like the Marquee and Lasso tools; you do not drag the mouse across the image.

Selection with the Magic Wand is accomplished by clicking once on the document. The pixels directly under the mouse create a sample, and the Magic Wand expands outward, selecting pixels that match the sample. The Magic Wand options control how the tool performs selections, as shown in Figure 284.1.

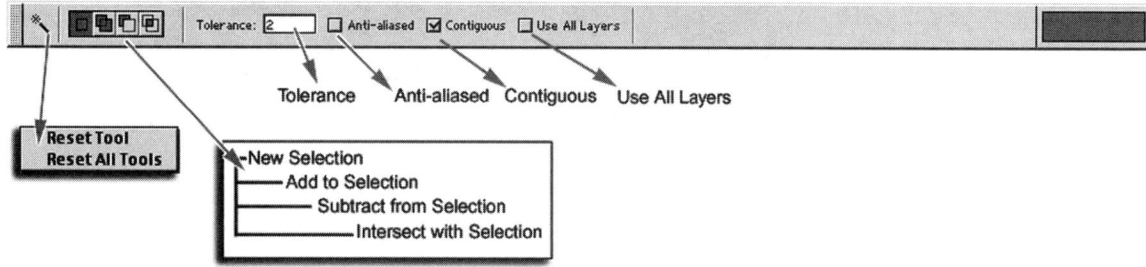

Figure 284.1 *The Options bar controls the selection characteristics of the Magic Wand.*

- **Reset Tools:** Click on the Magic Wand icon located at the far left of the Options bar and select the Reset Tool option. Photoshop resets the Magic Wand options to their default values.

- **New Selection:** Click the New Selection button (refer to Figure 284.1) to create a new selection.

- **Add to Selection:** Click the Add to Selection button (refer to Figure 284.1) to add to an existing selection.

- **Subtract from Selection:** Click the Subtract from Selection button (refer to Figure 284.1) to subtract from an existing selection.

- **Intersect with Selection:** Click the Intersect with Selection button to create a new selection based on the intersection of the Lasso tool with an existing selection.

- **Tolerance:** The Tolerance of the Magic Wand influences the number of pixels selected by the Magic Wand. Click in the Tolerance field and type a value from 0 to 255. The higher the value, the more pixel information is included in the selection. Refer to Tip 182, "Controlling Selection Information with Tolerance."

- **Anti-aliased:** Click in the Anti-aliased check box to select this option. The Anti-aliased option creates a visually smooth selection by slightly feathering the selection edge.

- **Contiguous:** When the Contiguous option is selected, the Magic Wand only selects pixels adjacent to the sample pixel. When the Contiguous option is not selected, the Magic Wand selects all pixels matching the sample pixel throughout the image.

- **Use All Layers:** When the Use All Layers option is selected, the Magic Wand selects pixel information from all visible layers.

To use the Magic Wand, click once within a document. Then, depending on the options, the Magic Wand selects pixels within the image, as shown in Figure 284.2.

Figure 284.2 The Magic Wand selects pixels based on their luminosity.

285 *Making Selections with the Pen Tool*

One more way to create a selection is to create a pen path using one of the Pen tools. The Pen tools create sharper selections due to the fact they are vector tools. To create a selection based on a pen path, open a graphic in Photoshop and perform these steps:

1. Select the Pen tool from the toolbox and draw a path, as shown in Figure 285.1. See Tip 466, "Drawing Tips When Using the Pen Tool."

2. Select the Window menu and choose Show Paths from the pull-down menu. Photoshop will display the Paths palette, as shown in Figure 285.2.

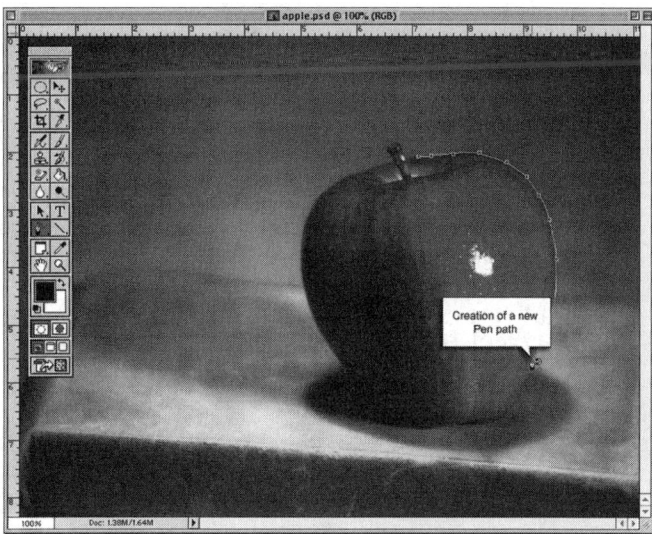

Figure 285.1 A pen path created using the Freeform Pen tool.

Figure 285.2 The Paths palette in Photoshop.

3. The Paths palette contains a work path containing the pen path (refer to Figure 285.2).

4. Click on the black triangular button located in the upper-right corner of the Paths palette. Photoshop will open a fly-out menu displaying the Path options, as shown in Figure 285.3.

5. Select Make Selection from the fly-out menu. Photoshop will open the Make Selection dialog box, as shown in Figure 285.4.

 • **Feather Radius:** Click the Feather Radius input box and enter a value from 0 to 250. The higher the value, the more feathered the selection border.

 • **Anti-aliased:** Click in the Anti-aliased check box to select this option. The Anti-aliased option creates a visually smooth selection by slightly feathering the selection edge.

 • **Operation:** Choose to add, subtract, or intersect with a previous selection. If this is your first selection, the only available option is New Selection.

6. Click the OK button to close the Make Selection dialog box and convert the pen path into a selection, as shown in Figure 285.5.

Figure 285.3 Clicking on the black triangular button displays the available Paths options.

Figure 285.4 The Make Selection dialog box describes the characteristics of the selection.

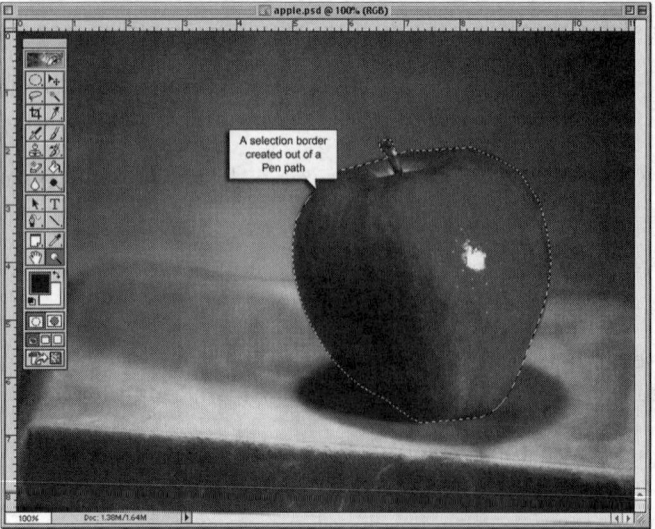

Figure 285.5 The pen path is converted into a selection border.

286 *Converting Selections into Paths*

In the preceding tip, you learned how to convert a pen path into a selection. Photoshop also lets you convert selections into paths.

To convert a selection into a path, open a Photoshop document and perform these steps.

1. Using any one of the standard selection tools, create a selection within the image, as shown in Figure 286.1.

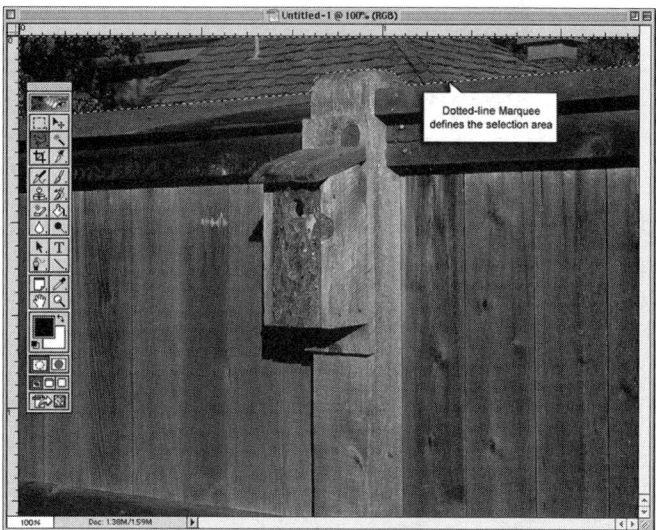

Figure 286.1 A Photoshop image containing a selection boundary.

2. Select the Window menu and choose Show Paths from the pull-down menu. Photoshop will display the Paths palette, as shown in Figure 286.2.

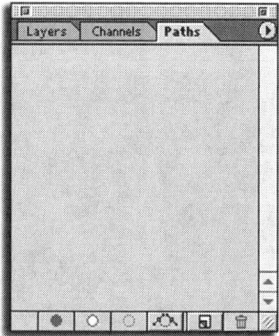

Figure 286.2 The Paths palette in Photoshop.

3. Click on the black triangular button located in the upper-right corner of the Paths palette. Photoshop will open a fly-out menu displaying the Path options, as shown in Figure 286.3.

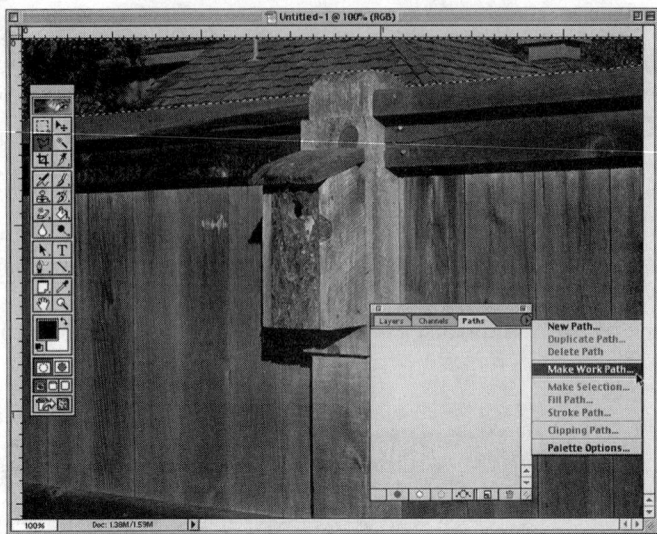

Figure 286.3 Clicking on the black triangular button displays the available Paths options.

4. Select Make Work Path from the fly-out menu. Photoshop will open the Make Work Path dialog box, as shown in Figure 286.4.

Figure 286.4 The Make Work Path dialog box in Photoshop.

5. Click in the Tolerance input field and enter a value from 0.5 to 10. The Tolerance option defines the complexity of the path. The higher the value, the less complex the path. Higher values make the shape smoother by reducing the number of anchor points in the path.

6. Click the OK button. Photoshop closes the Make Work Path dialog box and creates the path, as shown in Figure 286.5.

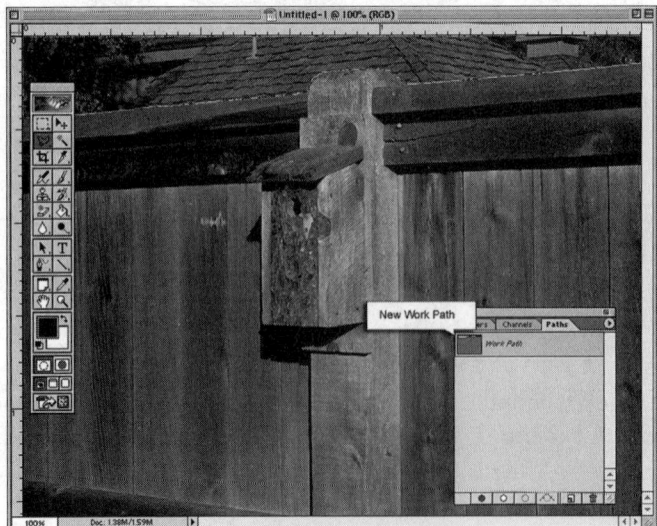

Figure 286.5 The Paths palette contains a work path based on your selection.

287 *Using the Move Tool Options*

In Tip 268, "Working with the Move Tool," you learned how the Move tool is used to reposition layers and selections. Photoshop 6.0 contains several new options for using the Move tool.

Open an image in Photoshop and create a selection on the image using any of the standard selection tools. Select the Move tool in the Photoshop toolbox, as shown in Figure 287.1.

Figure 287.1 The Options bar controls the operation of the Move tool.

- **Reset Tools:** Click on the Move tool icon located at the far left of the Options bar and select the Reset Tool option. Photoshop resets the Move tool options to their default values.

- **Auto Select Layer:** Select this option when you are working in a multi-layered document. The Move tool will select the topmost layer containing visible pixels under the cursor and not just within the selected layer.

- **Show Bounding Box:** When this option is selected, a bounding box surrounds all selection borders. The bounding box contains handles that let you adjust the pixels within the selection area, as shown in Figure 287.2.

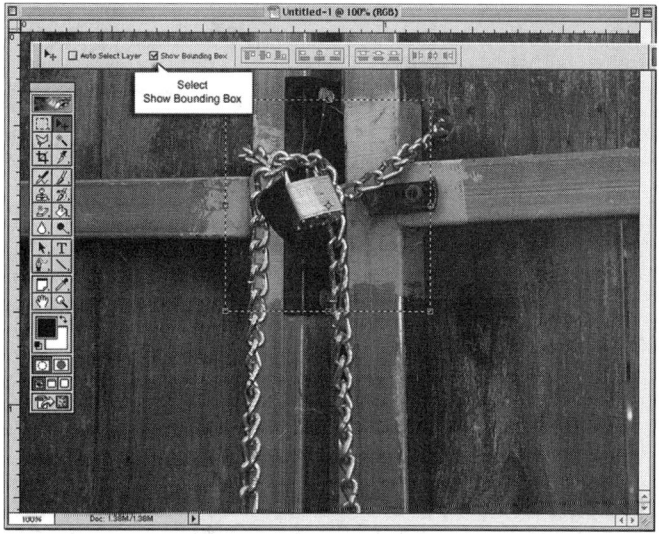

Figure 287.2 The Show bounding Box option, when selected, creates an adjustable bounding box around the selection.

- **Layer Alignment:** Link two or more layers together and use the Layer Alignment options to align the layers to left, center, or right and top, middle, or bottom (see Tip 355, "Aligning a Layer to a Selection Marquee"), as shown in Figure 287.3.

Figure 287.3 The Align options let you align two or more grouped layers.

- **Distribute Layers:** Link three or more layers together and use the Distribute Layers options to distribute layers to the top, vertical, or bottom edge and the left, horizontal, or right edge (see Tip 353, "Distributing Linked Layers"), as shown in Figure 287.4.

Figure 287.4 The Distribute options let you distribute the pixel information in three or more linked layers.

288 *Using New View to Control Image Editing*

When you edit an image in Photoshop, you work at various resolutions. For example, you zoom into a small portion of an image, perform some editing, and then zoom back out to view the results. Moving back and forth between view sizes can be frustrating and time consuming. A better way to work is with the New View command.

The New View command lets you create a second, editable version of the original document window. You can zoom into the new document window, make editing changes to the image, and view the results in the original document window.

To use the New View feature, open a graphic image in Photoshop and perform these steps:

1. Select the View menu and choose New View from the pull-down menu. Photoshop creates a second document window containing a working copy of the original image, as shown in Figure 288.1.

2. Use your Zoom tool to increase the view of the new document window. For more information on using the Zoom tool, refer to Tip 92, "The Zoom Tool."

3. Perform image editing within the new document window and watch the effects of your editing on the original image, as shown in Figure 288.2.

Figure 288.1 The New View command creates a copy of the original image in a second document window.

4. After completing your editing changes, select the File menu and choose the Close command. Photoshop will close the new document window. Since the new document window is a working copy of the original image, Photoshop will not ask you to save the file.

Figure 288.2 Changes made within the new document window are reflected in the original image.

289 *Determining When to Use the Extract Command*

The Extract command provides an advanced way to remove an object from its background. The Extract command makes easy work of removing simple shapes from a background. However, it can also remove complicated shapes like hair or soft-edged objects from a background with a minimum of work.

To use the Extract command, open a graphic image in Photoshop, select the Image menu, and choose Extract from the pull-down menu. Photoshop will open the Extract dialog box, as shown in Figure 289.1.

Tool Options:

- **Brush Size:** Click the Brush Size input field and enter a value from 1 to 999. The higher the value, the larger the brush size. The Highlight tool uses the brush size to paint around the border of the selected image. Use small brushes for images with sharp edges and larger brushes for hair or soft edges.

- **Highlight:** Click on the Highlight button to change the highlight color. Changing the highlight color does not affect the performance of the Extract command, but in some cases, it makes the highlight easier to identify.

- **Fill:** Click on the Fill button to change the fill color. Changing the fill color does not affect the performance of the Extract command, but in some cases, it makes the fill easier to identify.

- **Smart Highlighting:** Select the Smart Highlighting option when highlighting an object with a well-defined edge.

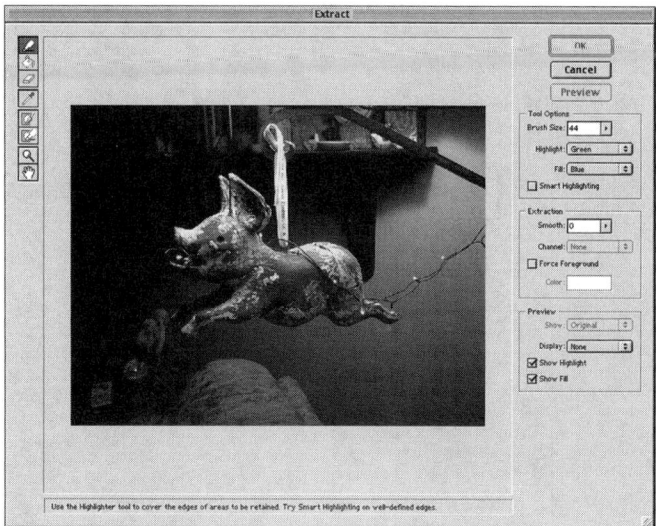

Figure 289.1 The Extract command lets you remove simple and complicated shapes from the background.

Extraction:

- **Smooth:** Enter a value from 0 to 100 in the Smooth input field. The higher the value, the smoother the edge of the extraction. Start an extraction using a value of 0. If the extraction produces sharp blocky edges, increase the value until you achieve the best results. The best way to clean up small problems with the edge of a selection is to use the Edge Touchup tool, discussed later in this tip.

- **Channel:** If you created a selection mask in an Alpha channel, the Extract tool lets you use the mask to define the extraction area. Click on the Channel button and select your channel mask. If you did not create a channel mask, the Channel option will not be available. For more information on creating channel masks, see Tip 434, "Working with Native Channels and Alpha Masks."

- **Force Foreground:** When objects are especially complicated, select the entire object using the Highlighter tool and then select the Force Foreground option. Use the Eyedropper from the Extract tools menu and click inside the highlighted area to select the foreground color. Click the Preview button to view the extraction.

Preview:

- **Show:** Click the Show button to display the original image or the results of the extraction.

- **Display:** Click the Display option to choose how to display the background area after the extraction.

- **Show Highlight/Fill:** Select Show Highlight and/or Show Fill to display the highlight and/or fill over the original image.

The Extraction tools:

- **Highlighter tool:** The Highlighter tool works with the brush size and the Highlighter color to paint the edge of your selection. Select this tool first and define the edge of your selected area, as shown in Figure 289.2.

- **Fill tool:** Use the Fill tool to fill the area of the image enclosed by the Highlighter tool, as shown in Figure 289.3.

- **Eraser tool:** The Eraser tool edits the image by erasing portions of the highlight or fill area.

- **Eyedropper:** The Eyedropper tool is used in conjunction with the Force Background option to help to extract the image.

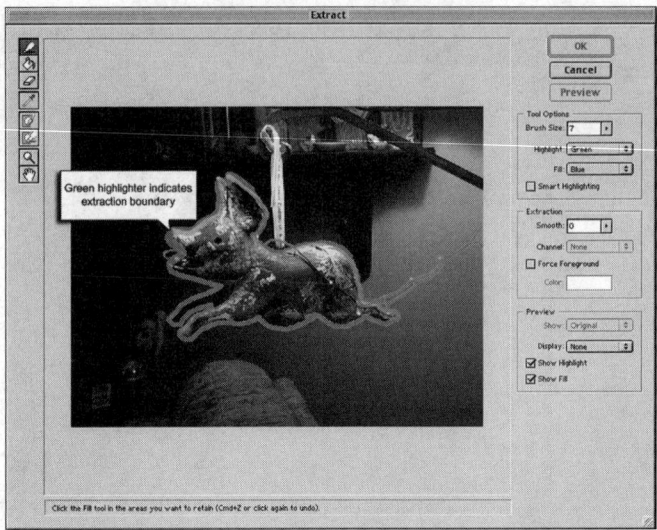

Figure 289.2 The Highlighter tool defines the edge of the selection.

- **Cleanup tool:** After performing the extraction, the Cleanup tool helps restore portions of the edge of the image that were not removed during the extraction process. The Cleanup tool is only available during a preview of the extraction.

- **Edge Touchup tool:** The Edge Touchup tool helps restore parts of the edge lost during the extraction process. The Edge Touchup tool is only available during a preview of the extraction.

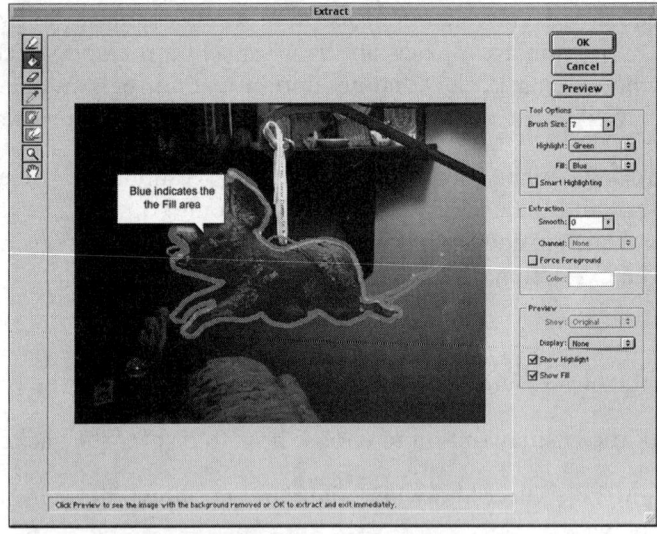

Figure 289.3 The Fill tool fills in the area of the image enclosed by the Highlighter tool and defines the extracted image.

- **Zoom tool:** The Zoom tool in Extract performs exactly like the Zoom tool in the Photoshop toolbox. Use the Zoom tool to increase or decrease the view of the preview image. For more information on using the Zoom tool, refer to Tip 92, "The Zoom Tool."

- **Hand tool:** When you zoom in to an image, the Hand tool lets you move the image within the preview window.

When you have selected the area of the image to be extracted, click on the Preview button to view the image, as shown in Figure 289.4.

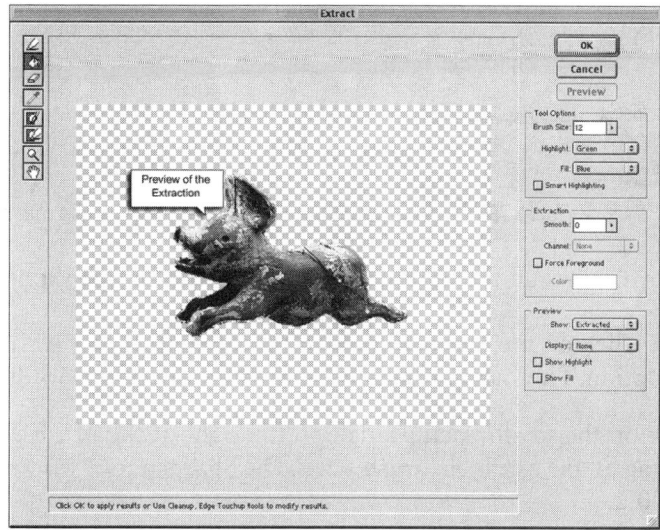

Figure 289.4 The Preview button lets you view the extraction process before recording the results to the original image.

If there are any modifications to be made to the image, choose the appropriate tools and correct the image. Click the OK button to close the Extract dialog box as shown in Figure 289.5

Figure 289.5 The Extract command successfully removed the background from this image.

290 *Using Photoshop's Sharpen Tool*

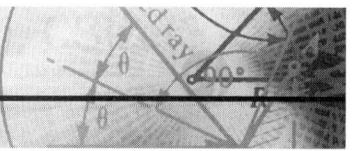

Photoshop's toolbox contains three focus tools: Smudge, Blur, and Sharpen. The Sharpen tool works to sharpen an image by reducing the number of steps of luminosity between the highlights and shadows of the image.

To use the Sharpen tool, open a graphic image in Photoshop. To select the Sharpen tool, click and hold (or right-click) your mouse on the Focus tool icon. Photoshop will open the Focus tool options. Click on the Sharpen tool option to select that tool, as shown in Figure 290.1.

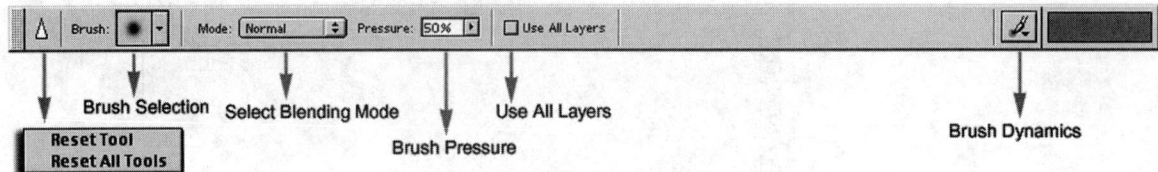

Figure 290.1 Clicking on the Sharpen tool icon makes that the default tool.

The Options bar displays all the options available for the Sharpen tool (see Figure 290.1).

- **Reset Tools:** Click on the Sharpen tool icon located at the far left of the Options bar and select the Reset Tool option. Photoshop resets the Sharpen tool options to their default values.

- **Brush:** Click on the small black triangle to the right of the brush icon. Photoshop displays a dialog box displaying all the available brush sizes. The Sharpen tool works best with a soft brush, as shown in Figure 290.2.

- **Mode:** Click on the Mode button to choose from the available blending modes. See Tip 687, "Working with Layer Blending Modes," for more information on how blending modes influence the Sharpen tool.

Figure 290.2 Choose a soft brush from the Brush palette to make the sharpening tool appear more natural.

- **Pressure:** Click in the Pressure input field and enter a value from 1 to 100. The greater the value, the faster the Sharpen tool changes the image.

- **Use All Layers:** When this option is selected, the Sharpen tool uses all the pixels in the visible layers, not just pixels in the selected layer. For more information on using this feature, see Tip 921, "Experimenting with Use All Layers Option."

To use the Sharpen tool, move into the document with the Sharpen tool. Click and drag your mouse over the areas to sharpen. The more you drag over an area, the more the Sharpen tool modifies the image, as shown in Figure 290.3.

Figure 290.3 Dragging the Sharpen tool over an area of a document creates a visual sharpness to an image.

291 *Using the Extract Tool Options*

In Tip 289, "Determining When to Use the Extract Command," you learned how the Extract command removes information from an image. In this example, you will remove a complicated background from an image using the Extract tool and the History brush.

To work with the Extract tool and the History brush, follow these steps:

1. Open an image in Photoshop, select the Image menu, and choose the Extract command from the pull-down menu. Photoshop will open the Extract dialog box, as shown in Figure 291.1.

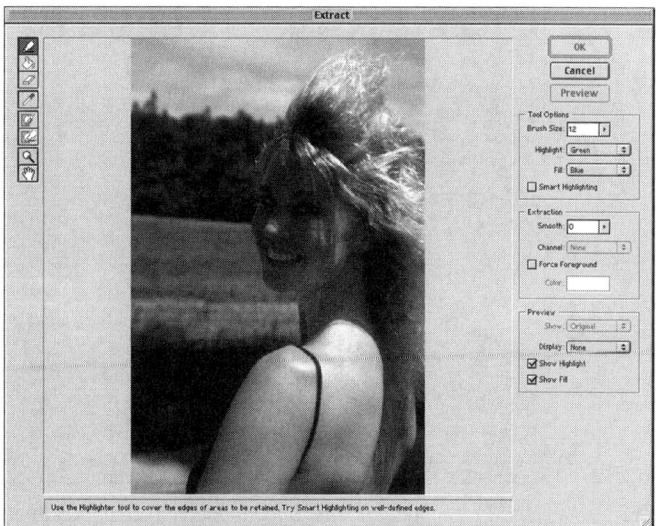

Figure 291.1 The Extract dialog box helps in removing complicated backgrounds from an image.

In this example, the image contains both soft and well-defined edges.

2. Select the Highlighter tool with a 20-pixel brush and choose Smart Highlighting (refer to Tip 289). Use the Highlight tool to define the edges of the image, as shown in Figure 291.2.

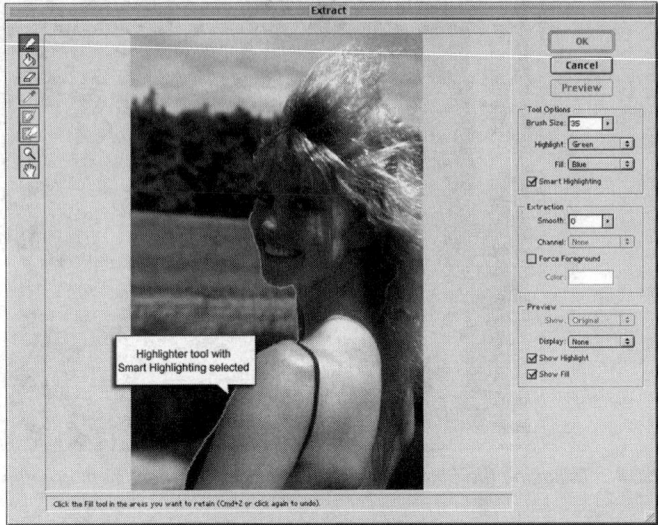

Figure 291.2 *Using the Highlighter tool with the Smart Highlighting option selected automatically controls the diameter of the brush.*

3. With the Highlighter tool selected, deselect the Smart Highlighting option, and change the brush size to 40 pixels. Since you want to retain the smooth look to the soft-edged areas of the image, enter a value of 20 in the Smooth option (refer to Tip 289). Use the Highlighter tool to paint the soft-edged areas of the image, as shown in Figure 291.3.

4. Select the Fill tool and click once in the center of the area enclosed by the Highlighter. Photoshop fills the enclosed area, as shown in Figure 291.4.

5. Click the Preview button. The Extract command removes the background from the image; however, the extraction process may leave some gaps in the image, as shown in Figure 291.5.

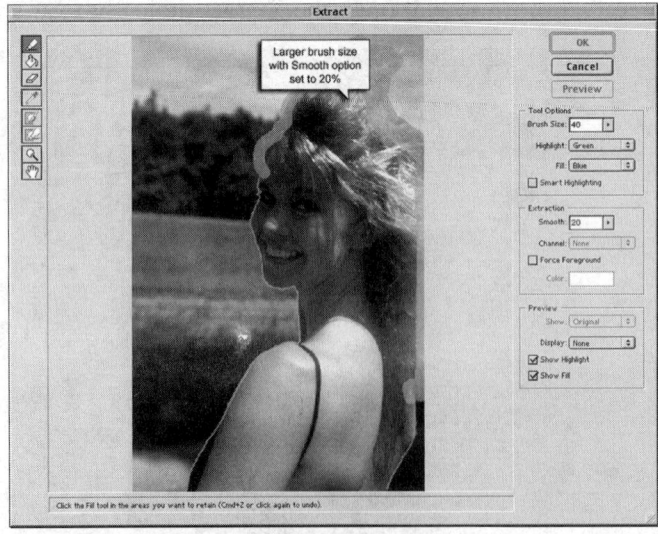

Figure 291.3 *Using the Highlighter with the Smooth option at 20 percent helps soften the edges of the image.*

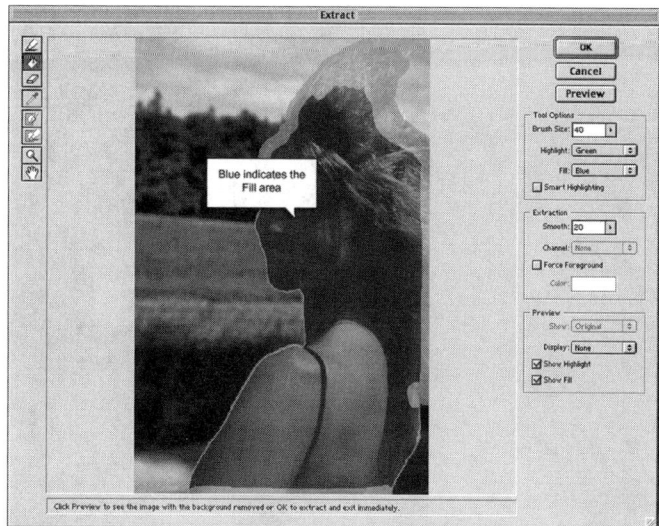

Figure 291.4 The Fill tool (blue) fills the area enclosed by the Highlighter (green).

Figure 291.5 The preview of the extraction shows missing areas around the edge of the image.

6. At this point, you could use the Cleanup and Edge Touchup tools. In this case, however, it's faster to use the History brush.

 Click the OK button. Photoshop will close the Extract dialog boxes and save your changes to the original image. Now select the History brush from the toolbox, as shown in Figure 291.6.

7. Choose a medium-size, soft brush from the Options bar. Refer to Tip 142, "Going Beyond Undo with the History Brush," for more information on the operation of the History brush.

8. Using the History brush, move over the deleted portions of the extraction and paint them back into the image, as shown in Figure 291.7.

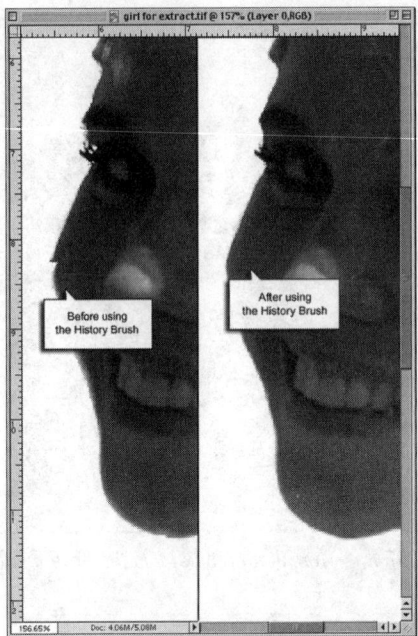

Figure 291.6 *The History brush makes the final modifications to the image.*

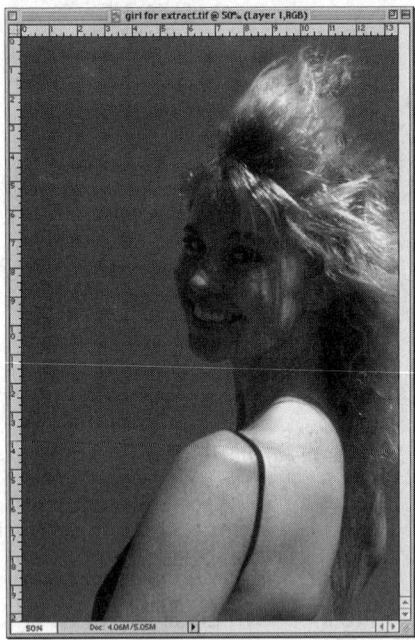

Figure 291.7 *The History brush restores the deleted portions of the image.*

Note: Combining the Extract command with the History brush is an excellent way to remove an image from its background quickly.

292 *Adjusting Selections Numerically*

In Tip 226, "Drawing Lines and Shapes," you learned how to use the Free Transform command. The Free Transform command lets you move or resize an image by visually examining the image. However, there are times when you want to modify a selected area by changing the dimensions of the selection to fit a specific size.

1. To modify a selection by the numbers, open a graphic image in Photoshop.

2. Choose the area of the image you want to modify. Refer to Tip 280, "Selection Methods," for more information on selection.

3. Select Choose the Edit menu and select Free Transform from the pull-down menu. Photoshop changes the Options bar and places a modifiable border around the selection, as shown in Figure 292.1.

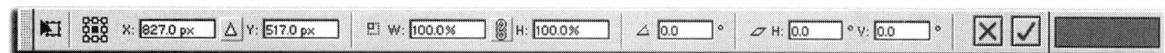

Figure 292.1 The Options bar in Free Transform mode controls the characteristics of the transform.

- **Reset Tools:** The Transform command is not a tool; therefore, the Reset Tools option is not available.

- **Reference Point Location:** The proxy box, located on the left end of the Options bar (refer to Figure 292.1), contains eight white squares and one black square. The black square represents the reference point for the image. When the center square is selected, the image rotates and resizes from the center out. When the image is moved, the Reference Point represents the X and Y (horizontal and vertical) coordinates of the image. Click on any of the white squares to change the reference point of the selected area.

- **X coordinate:** Click in the X coordinate input field to change the horizontal position of the selected pixels.

- **Y coordinate:** Click in the Y coordinate input field to change the vertical position of the selected pixels.

- **Relative Position:** Click the small triangular button between the X and Y coordinate fields to change a relative measurement system. The Relative Position option, when selected, measures distance from the original placement of the image. When Relative Position is selected, the X and Y coordinate fields change to 0. Moving the image changes the X and Y coordinates relative to the image's original position.

- **Width and Height:** Click in the Width and Height input fields and enter a value from –2000 to 2000 percent.

- **Maintain Aspect Ratio:** Click the chain icon, located between the Width and Height input fields to maintain the original proportions of the image.

- **Set Rotation:** Click in the Set Rotation input field and enter a value from –180 to 180 degrees. Choosing a value other than 0 rotates the selected pixels.

- **Set Horizontal Skew:** Click in the Horizontal Skew field and enter a value from –180 to 180 degrees. Choosing a value other than 0 skews the selected pixels.

- **Set Vertical Skew:** Click in the Vertical Skew field and enter a value from −180 to 180 degrees. Choosing a value other than 0 skews the selected pixels.

- **"X":** Click on the "X" button to cancel the transform operation.

- **Checkmark:** Click on the Checkmark button to perform the transform operation.

293 *Modifying Selections Manually*

In the preceding tip, you learned how to change a selected area using precise measurements. Photoshop also lets you manipulate an image using the Transform and Free Transform commands.

1. To modify a selection manually, open a Photoshop image and, using traditional selection methods, select a portion of the image. Refer to Tip 280, "Selection Methods," for more information on selection.

2. Select the Choose Edit menu and select Free Transform from the pull-down menu. Photoshop places a modifiable border around the selection, as shown in Figure 293.1.

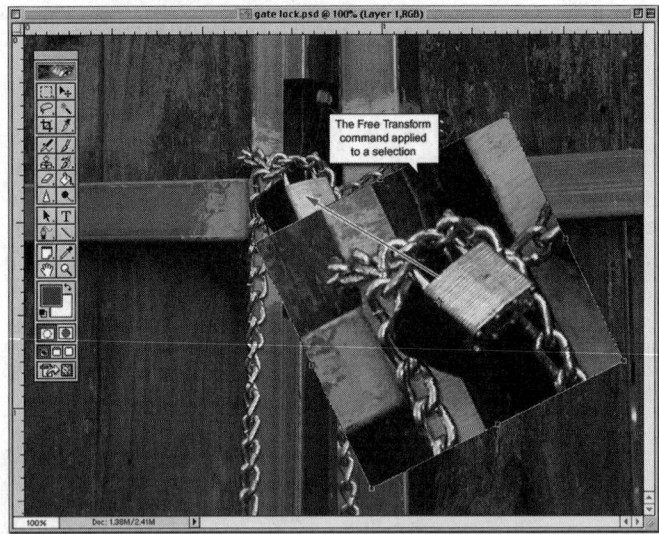

Figure 293.1 Choosing the Free Transform command places a modifiable selection boundary around a selection.

3. Move your mouse cursor over any of corner handles. Your cursor changes to a double-arrow diagonal line.

- Click and drag toward the center of the selection to reduce the image size.

- Click and drag away from the center of the selection to increase the image size.

- Hold down the Shift key while dragging the mouse to maintain the aspect ratio of the original image.

- Hold down the Alt (Macintosh: Option) key to expand or contract the image from the relative center of the selected area.

- Hold down the Ctrl (Macintosh: Command) key to change the perspective of a single corner of the selected area.

4. Move your mouse cursor over any of the middle handles. Your cursor changes to a double-arrow horizontal or vertical line.

- Click and drag toward the center of the selection to reduce the image size from the selected horizontal or vertical handles.

- Click and drag away from the center of the selection to increase the image size from the selected horizontal or vertical handles.

- Hold down the Ctrl (Macintosh: Command) key to skew the selected pixels.

- Hold down the Ctrl (Macintosh: Command) key and the Shift key to constrain the skew operation to horizontal or vertical, depending on the chosen handle.

5. Move your cursor outside the transform bounding box. Your cursor changes to a bent double arrow.

- Click and drag to rotate the selected pixels.

- Click and drag while holding down the Shift key to constrain the rotation value to 15 degree increments.

6. Move your mouse into the transform bounding box. Your cursor changes to a solid black arrow.

- Click and drag to move the selected pixels.

- Click and drag while holding down the Shift key to constrain the move to 90 or 45 degrees.

7. To permanently change the transformed selection, double-click or press the Enter key. Photoshop removes the transform bounding box and records your changes to the selected pixels.

294 *Expanding a Selection*

Photoshop gives you the ability to expand a selection area without modifying the pixels within the selection.

To expand a selection, open a graphic image in Photoshop and perform these steps:

1. Choose the area of the image you want to modify by choosing from Photoshop's available selection tools. Refer to Tip 280, "Selection Methods," for more information on selection.

2. Choose Modify from the Select menu and choose Expand from the list of available options. Photoshop opens the Expand Selection dialog box, as shown in Figure 294.1.

3. Click in the Expand By input field and enter a value from 1 to 100 pixels. The larger the value, the more the selection marquee expands. In this example, the image expands by 20 pixels.

4. Click the OK button. Photoshop closes the Expand Selection dialog box and expands the selection marquee by the input value, as shown in Figure 294.2.

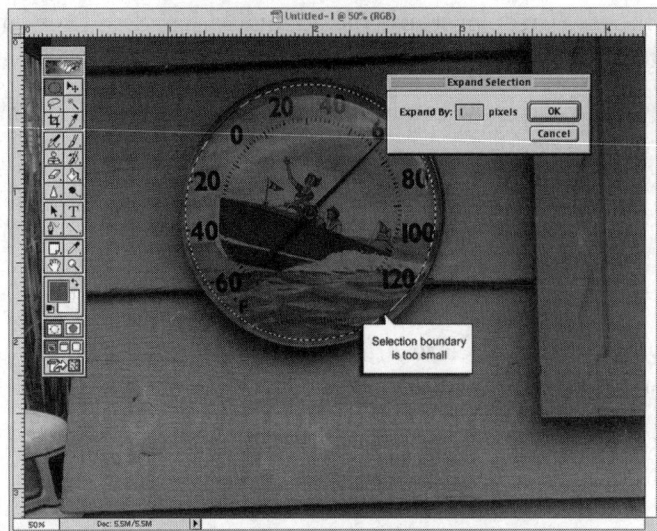

Figure 294.1 The Expand Selection dialog box controls the expansion of the selection marquee.

Figure 294.2 The selection marquee expands without modifying the image pixels.

Note: The expansion command increases the size of the image equally around the selection border, regardless of the shape of the selection marquee. In square marquees, this causes the corners of the expanded marquee to loose their 90-degree corners.

295 *Contracting a Selection*

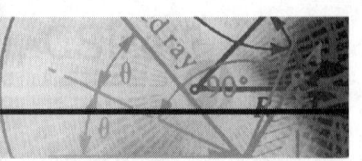

Photoshop gives you the ability to reduce the size of a selection area without modifying the pixels within the selection.

To reduce a selection, open a graphic image in Photoshop and perform these steps:

1. Choose the area of the image you want to modify. Refer to Tip 280, "Selection Methods," for more information on selection.

2. Choose Modify from the Select menu and choose Contract from the list of available options. Photoshop opens the Contract Selection dialog box, as shown in Figure 295.1.

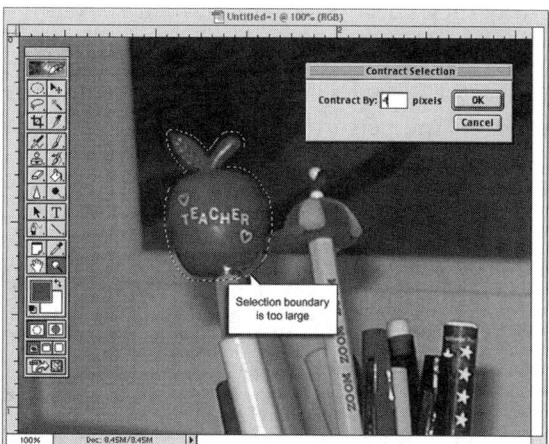

Figure 295.1 The Contract Selection dialog box controls the reduction of the selection marquee.

3. Click in the Contract By input field and enter a value from 1 to 100 pixels. The larger the value, the more the selection marquee contracts. In this example, the selection marquee contracts by 25 pixels.

4. Click the OK button. Photoshop closes the Contract Selection dialog box and reduces the selection marquee by the input value, as shown in Figure 295.2.

Figure 295.2 The selection marquee contracts without modifying the image pixels.

Note: Unlike Expand, the Contract command does not modify the corners of rectangular selections.

296 *Smoothing a Selection*

When you select pixel information using the Rectangular or Square Marquee tools, the selection edges are always smooth curved or straight lines. The same cannot be said for the Lasso and Magic Wand tools. Because of the way they select information, their selection marquees are, many times, too jagged to use.

If you want to smooth out a jagged selection marquee without modifying the selected pixels, open a graphic image in Photoshop and perform these steps:

1. Use the Magic Wand or Freeform Lasso to create a selection boundary, as shown in Figure 296.1.

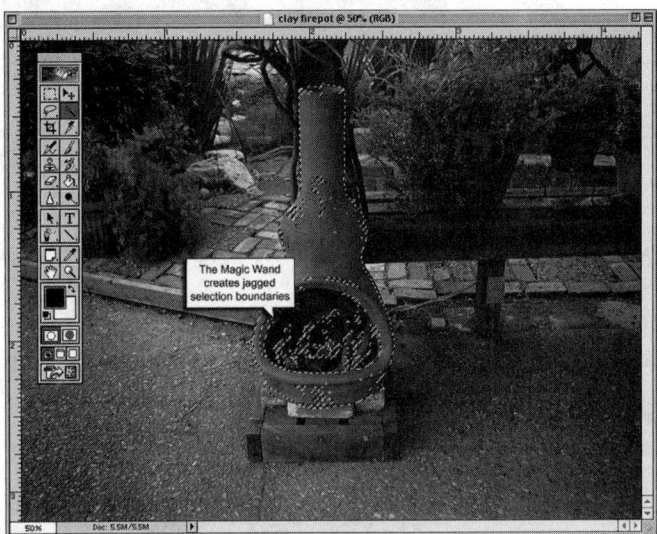

Figure 296.1 *The Freeform Lasso and the Magic Wand create jagged selection boundaries.*

2. Choose Modify from the Select menu and choose Smooth from the fly-out menu. Photoshop opens the Smooth Selection dialog box, as shown in Figure 296.2.

Figure 296.2 *The Smooth Selection dialog box lets you smooth a jagged selection border without modifying the image pixels.*

3. Click in the Sample Radius input field and input a value from 1 to 100.

4. Click the OK button. Photoshop searches for unselected pixels within the input value range. If most of the pixels in the value range are selected, any unselected pixels are added to the selection. If most pixels are unselected, any selected pixels are removed from the selection. This helps select stray areas within an image and smooth out the selection edge, as shown in Figure 296.3.

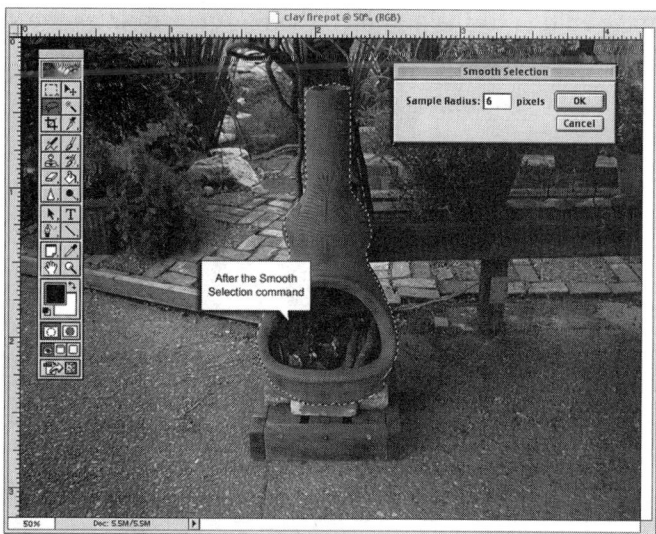

Figure 296.3 *The Smooth command smoothes the edge of the selection border.*

297 *Hiding Selection Borders While Working*

One of the hindrances to image editing within a selection is the distraction of the selection marquee. That dotted line places a barrier between you and the image pixels, making it difficult to evaluate the editing until you remove the border. Unfortunately, by then it may be too late. Photoshop gives you a way to conduct editing within a selection border while temporarily making the selection marquee invisible.

To work on a selected area of an image without the distraction of the selection border, open a graphic image in Photoshop and make a selection around an editing area. In this example, the background needs to be lightened, as shown in Figure 297.1.

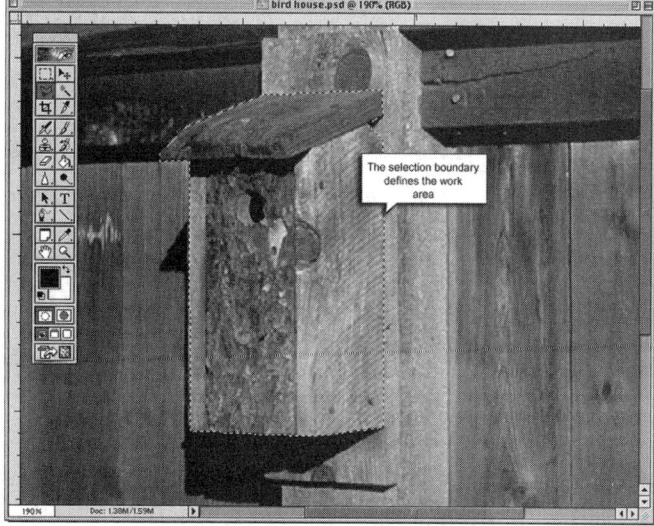

Figure 297.1 *The selection of the background in this image lets you control the effects of editing.*

Select the View menu and choose Show Extras from the pull-down menu. Photoshop removes the selection marquee from the document window.

Next perform image editing to the graphic. The marquee isolates the selected pixels but is not distracting your work. You can see exactly what is happening to the image, as shown in Figure 297.2.

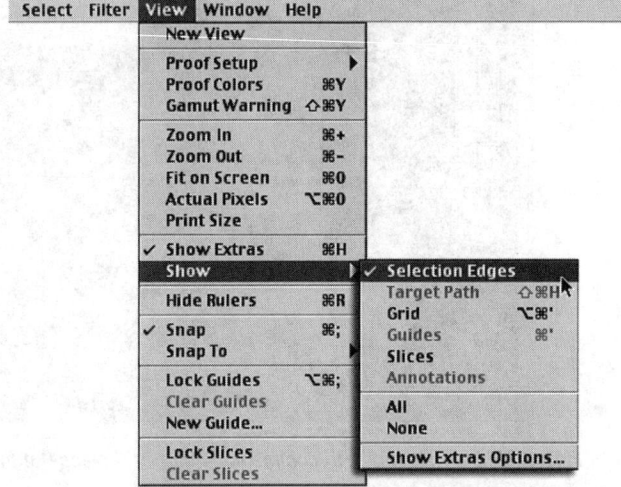

Figure 297.2 Editing an image is simpler when the selection marquee is invisible.

To make the selection marquee visible, select the View menu and choose Show Extras from the pull-down menu. Photoshop restores the selection marquee to the image, as shown in Figure 297.3

Figure 297.3 Being able to toggle the selection marquee helps when performing complicated image editing.

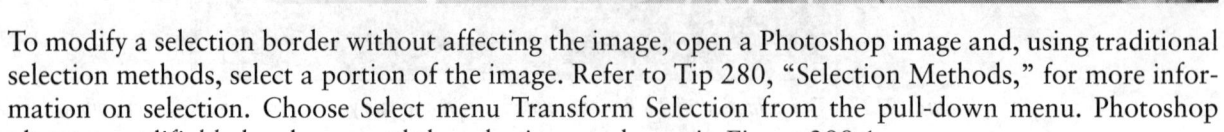

298 *Using Transform Selection on a Selection*

To modify a selection border without affecting the image, open a Photoshop image and, using traditional selection methods, select a portion of the image. Refer to Tip 280, "Selection Methods," for more information on selection. Choose Select menu Transform Selection from the pull-down menu. Photoshop places a modifiable border around the selection, as shown in Figure 298.1.

Figure 298.1 Choosing the Transform Selection command places a modifiable selection boundary around a selection.

Move your mouse cursor over any of the corner handles. Your cursor changes to a double-arrow diagonal line.

- Click and drag toward the center of the selection to reduce the selection marquee.

- Click and drag away from the center of the selection to increase the selection marquee.

- Hold down the Shift key while dragging with the mouse to maintain the aspect ratio of the original selection marquee.

- Hold down the Alt (Macintosh: Option) key to expand or contract the selection marquee from the relative center of the selection.

- Hold down the Ctrl (Macintosh: Command) key to change the perspective of a single corner of the selection marquee.

Move your mouse cursor over any of the middle handles. Your cursor changes to a double-arrow horizontal or vertical line.

- Click and drag toward the center of the selection to reduce the selection marquee from the selected horizontal or vertical handles.

- Click and drag away from the center of the selection to increase the selection marquee from the selected horizontal or vertical handles.

- Hold down the Command key to skew the selection marquee.

- Hold down the Command key and the Shift key to constrain the skew operation on the selection marquee to horizontal or vertical, depending on the chosen handle.

Move your cursor outside the selection marquee. Your cursor changes to a bent double arrow.

- Click and drag to rotate the selection marquee.

- Click and drag while holding down the Shift key to constrain the rotation value to 15-degree increments.

Move your mouse into the selection marquee. Your cursor changes to a solid black arrow.

- Click and drag to move the selection marquee.

- Click and drag while holding down the Shift key to constrain the move to 90 or 45 degrees.

Note: The Transform Selection command is similar to the Free Transform command (refer to Tip 293, "Modifying Selections Manually") with one exception. The Free Transform command modifies the pixels within the selection boundary, and the Transform Selection command only modifies the marquee.

299 *Working with Free Transform to Create a Freestanding Shadow*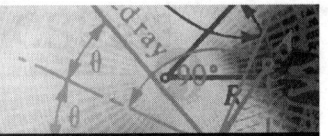

In Tip 293, "Modifying Selections Manually," you learned how to modify a selection. In this tip, you will use Free Transform to create a object shadow.

To create a freestanding shadow, perform these steps:

1. Select the File menu and choose the New command from the pull-down menu. Photoshop will open the New dialog box, as shown in Figure 299.1.

Figure 299.1 The New dialog box describes the characteristics of a new document.

2. Create a new document with these options:

 • **Width:** 5 inches

 • **Height:** 5 inches

 • **Resolution:** 150 pixels/inch

 • **Mode:** RGB

 • **Contents:** White

3. Click the OK button. Photoshop closes the New dialog box and opens a new document window.

4. If the Layers palette is not visible, select the Window menu and choose View Layers from the pull-down menu. Click on the New Layer icon at the bottom of the Layers palette and create a new layer, as shown in Figure 299.2.

Figure 299.2 *Clicking on the New Layer icon automatically creates a new layer directly above the selected layer and names it Layer 1.*

5. Right-click on the name (Layer 1) of the new layer. Photoshop displays the available options for Layer 1. Select the Layer Properties option. Photoshop opens the Layer Properties dialog box, as shown in Figure 299.3.

Figure 299.3 *The Layer Properties dialog box lets you rename a new layer.*

6. Click in the Name input field and enter the name "box." Click the OK button to close the dialog box and the new layer is named "box."

7. Select your Rectangular Marquee tool and create a square selection on the screen, as shown in Figure 299.4. For more information on using the Rectangular Marquee tool, refer to Tip 71, "The Marquee Tools."

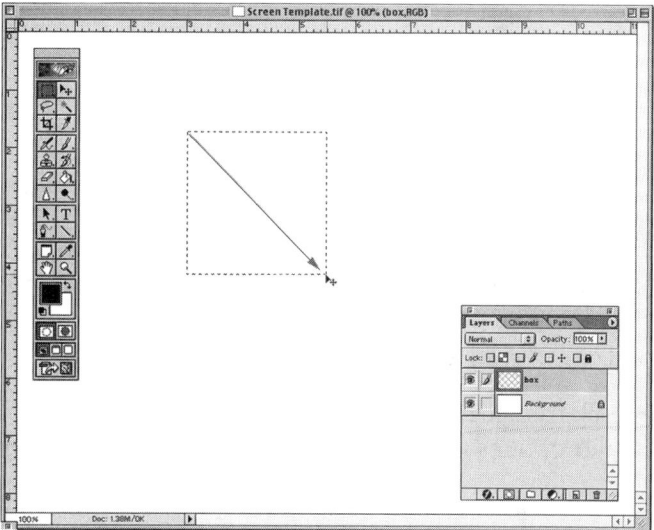

Figure 299.4 *Draw a square marquee in the new layer.*

8. If the Swatches palette is not visible, select the Window menu and choose Show Swatches from the pull-down menu. Move your cursor into the Swatches palette. Your cursor resembles an eyedropper. Click on a color swatch to select a color for your box. In this example, a blue color was selected, as shown in Figure 299.5.

Figure 299.5 Clicking on a color in the Swatches palette makes that color the foreground color.

9. Select the Paint Bucket from the toolbox and click once within the selection marquee. The selection area fills with the Foreground color swatch, as shown in Figure 299.6.

Figure 299.6 The Paint Bucket tool fills an area with the current foreground color.

10. Select the box layer in the Layers palette.

11. Click on the black triangular button in the upper-right corner of the Layers palette. Photoshop displays the available options for the Layers palette.

12. Select the Duplicate Layer option. Photoshop opens the Duplicate Layer dialog box, as shown in Figure 299.7.

Figure 299.7 The Duplicate Layer options let you make a copy of the selected layer.

13. Click in the Duplicate Box As input field, enter the name "shadow," and click the OK button. Photoshop creates a duplicate of the box layer and names it "shadow."

14. Press the letter "D" on your keyboard to default the Foreground and Background colors to black and white.

15. The selection marquee is still visible in the document window. Select the Paint Bucket tool and click once in the center of the selection marquee. The selected area will go black. You now have two layers sitting exactly on top of each other.

16. Press Ctrl + D (Macintosh: Command+D) on your keyboard to deselect the rectangular marquee.

17. Select the Shadow layer by clicking once on the name shadow in the Layers palette.

18. Select Filter menu Blur and choose Gaussian Blur from the fly-out menu. Photoshop opens the Gaussian Blur dialog box, as shown in Figure 299.8.

Figure 299.8 The Gaussian Blur dialog box controls the amount of blur within a layer or selection.

19. In the Radius input field, enter a value of 20, and then click the OK button. Photoshop closes the Gaussian Blur dialog box and records your changes to the shadow layer.

20. Reposition the shadow layer by clicking on the name "shadow" and dragging the layer underneath the box layer, as shown in Figure 299.9.

Figure 299.9 Clicking and dragging on a layer lets you reposition the layer within the Layers palette.

21. Select the shadow layer by clicking once on the name "shadow."

22. Select the Edit menu and choose Free Transform from the pull-down menu. Photoshop places an editable bounding box around the shadow box, as shown in Figure 299.10.

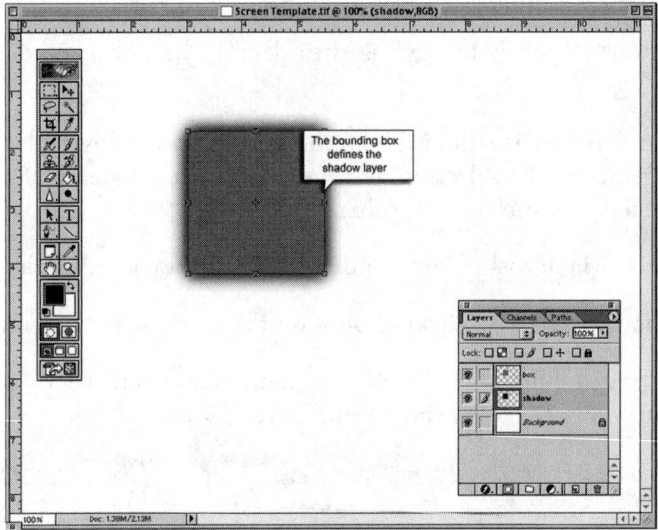

Figure 299.10 The Free Transform command places an editable bounding box around the image in the shadow layer.

23. Hold down the Ctrl (Macintosh: Command) key and click and drag the top middle handle on the bounding box down and to the right, as shown in Figure 299.11. Then press the Enter key, or click the check mark in the Options bar to complete the Free Transform command.

24. To complete the effect, lower the opacity of the shadow layer by selecting the shadow layer, clicking the Opacity input field, and entering a value of 80. That will lower the opacity of the shadow layer, as shown in Figure 299.12.

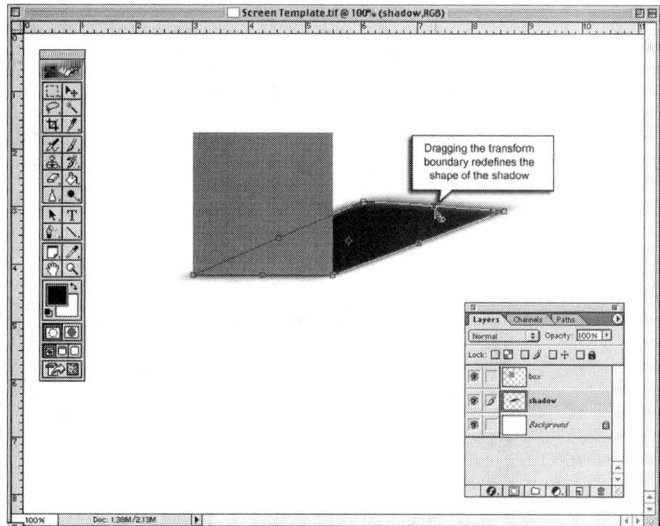

Figure 299.11 Using the Command key with Free Transform lets you skew the shadow layer to resemble a freestanding shadow.

Figure 299.12 Lowering the opacity of the shadow layer makes the layer resemble a shadow behind the box.

300 *Removing Moiré Patterns from a Scanned Image*

One problem encountered when scanning an image is the generation of moiré patterns. Moiré patterns are those annoying repeating patterns that occur in a scanned image when the optical array of the scanner does not match the pattern or colors used in the image, as shown in Figure 300.1.

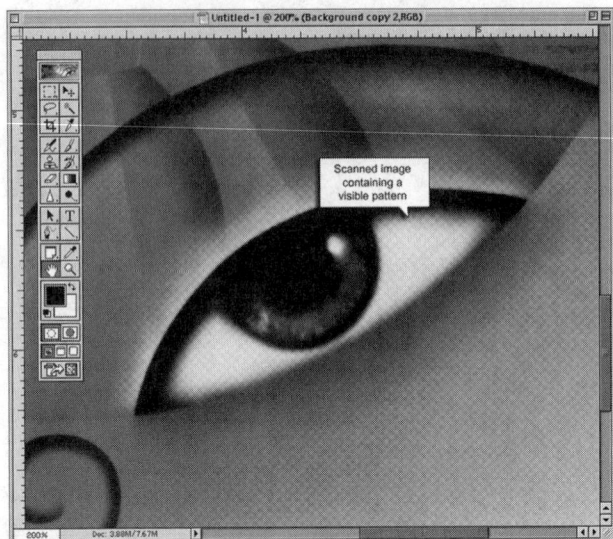

Figure 300.1 Moiré patterns are created when the optical array of the scanner
does not match the pattern or color of the scanned image.

Moiré patterns are correctable by rotating the image on the scanner bed. To correct an image containing a moiré pattern, lay the graphic on the scanner bed at a 45-degree angle and rescan.

When you open the graphic image in Photoshop (File menu Open), the moiré pattern is gone, as shown in Figure 300.2.

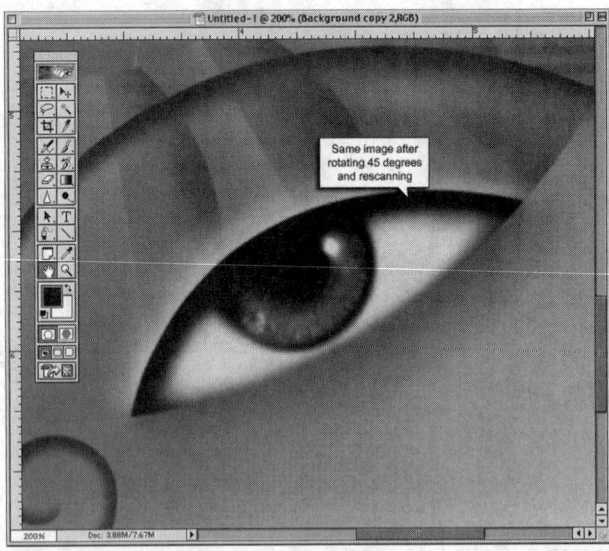

Figure 300.2 Rotating the image on the scanner bed by 45 degrees corrects most moiré patterns in an image.

Note: If the image still contains an undesirable moiré pattern, make sure you are scanning the image within the optical resolution of the scanner. Increasing the scan resolution above the optical resolution forces the scanner to add pixels (interpolate) of color to the image, and this can cause moiré patterns to appear. Check the scanner user's manual to determine the optical resolution of your scanner.

301 *Choosing a Source for a Kodak CD File*

The Kodak Photo CD format is a popular way to produce high-quality scans of your negatives. In fact, most film-processing labs offer the option of placing your images on a CD when you send your film off for processing. The Kodak CD format is a proprietary format that gives you a high-quality scan of your images without an investment in additional scanners and software.

When you request your images in the Kodak CD format, you receive a CD containing the scanned images. To open a file scanned in the Kodak CD format, it is necessary to answer some questions as to the identity of the source document.

To open an image scanned in the Kodak CD format, place the CD in your drive, open Photoshop, and perform these steps:

1. Select the File menu and choose Open from the pull-down menu. Photoshop displays the Open dialog box, as shown in Figure 301.1.

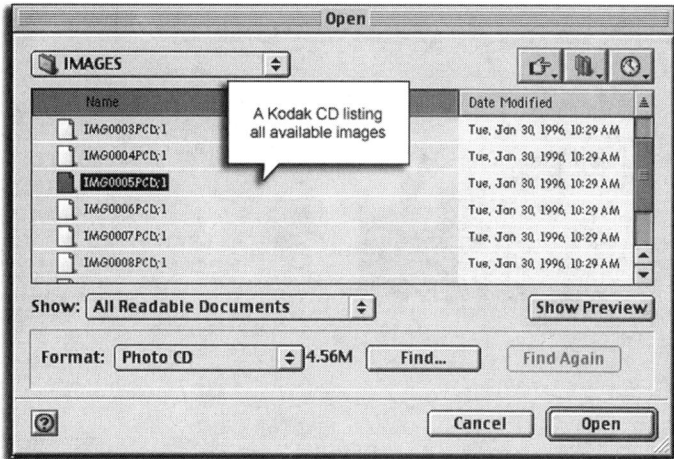

Figure 301.1 Select the Kodak CD image from the list of available files.

2. Select the correct file name and click the Open button. Photoshop closes the dialog box and opens the Kodak PCD Format dialog box, as shown in Figure 301.2.

3. Click on the Pixel Size button to choose the input size of the document, as shown in Figure 301.3. The number of pixels within the document influences the quality of the image. The higher the pixel count, the larger the image and the more information is available to Photoshop.

4. Click the Profile button to determine the profile of the input document, see Figure 301.3.

5. Click the OK button. Photoshop closes the Kodak PCD Format dialog box and opens the image in Photoshop. Once the image is open, treat it just like any other Photoshop document.

Note: For information on setting up the destination image, see the next tip.

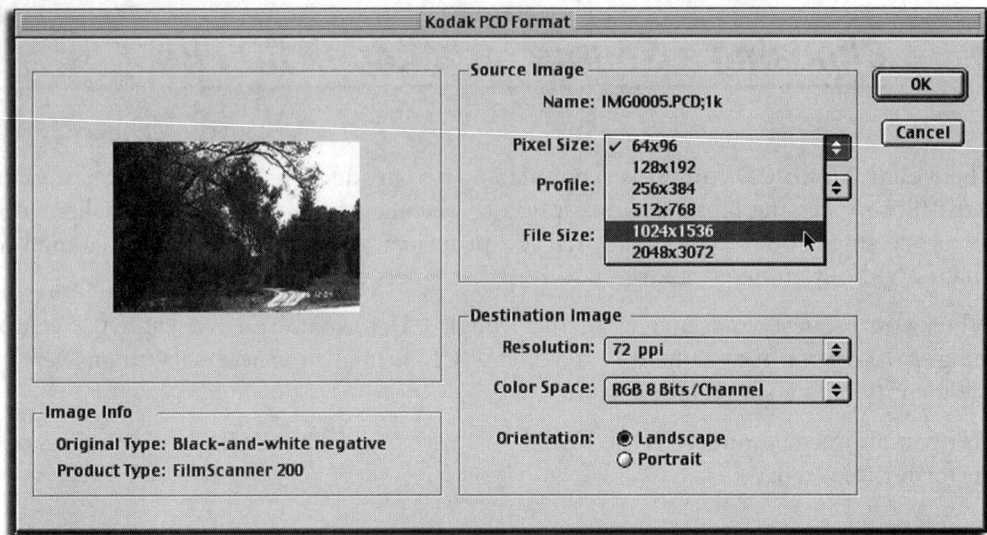

Figure 301.2 *The Kodak PCD Format dialog box describes the characteristics of the image file.*

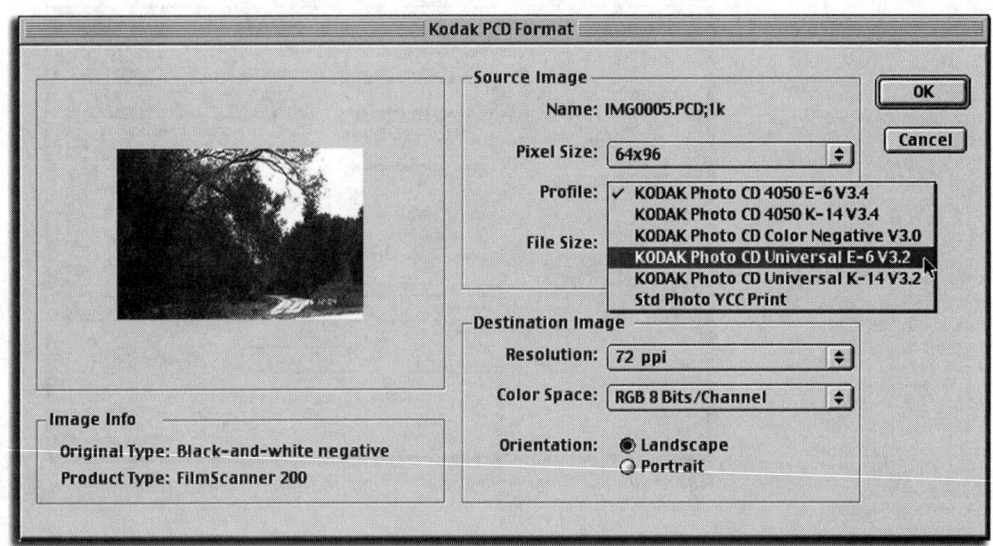

Figure 301.3 *The Pixel Size button lets you determine the input size of the image.*

302 *Choosing a Destination for a Kodak CD File*

In the preceding tip, you learned about the Kodak CD format and how to select a source document.

To open an image scanned in the Kodak CD format, place the CD in your drive, open Photoshop, and perform these steps:

1. Select the File menu and choose Open from the pull-down menu. Photoshop displays the Open dialog box, as shown in Figure 302.1.

2. Select the correct file name and click the Open button. Photoshop closes the dialog box and opens the Kodak PCD Format dialog box, as shown in Figure 302.2.

3. Click on the Resolution option to display a list of available resolutions, as shown in Figure 302.3. The resolution of the image is directly related to the pixel size of the image (refer to the preceding tip). The destination resolution determines the number of pixels in a linear inch. For example, if the Pixel Size is 72×72 and the Resolution is 144ppi, the image would occupy a print area of one-half inch (72 goes into 144 twice).

Figure 302.1 Select the Kodak CD image from the list of available files.

Figure 302.2 The Kodak PCD Format dialog box describes the characteristics of the image file.

4. Click the Color Space option to choose from the available color spaces, as shown in Figure 302.4. RGB 8 Bits/Channel and LAB 8-Bits/Channel produce millions of colors within the document. RGB 16 Bits/Channel and LAB 16-Bits/Channel create a document capable of producing billions of colors.

5. Click the OK button. Photoshop closes the Kodak PCD dialog box and opens the image within a document window. Once the image is open, you can use it as you would any other Photoshop document.

Note: Photoshop can open and edit images saved in the Kodak PCD format, but it cannot save files as Kodak PCD documents.

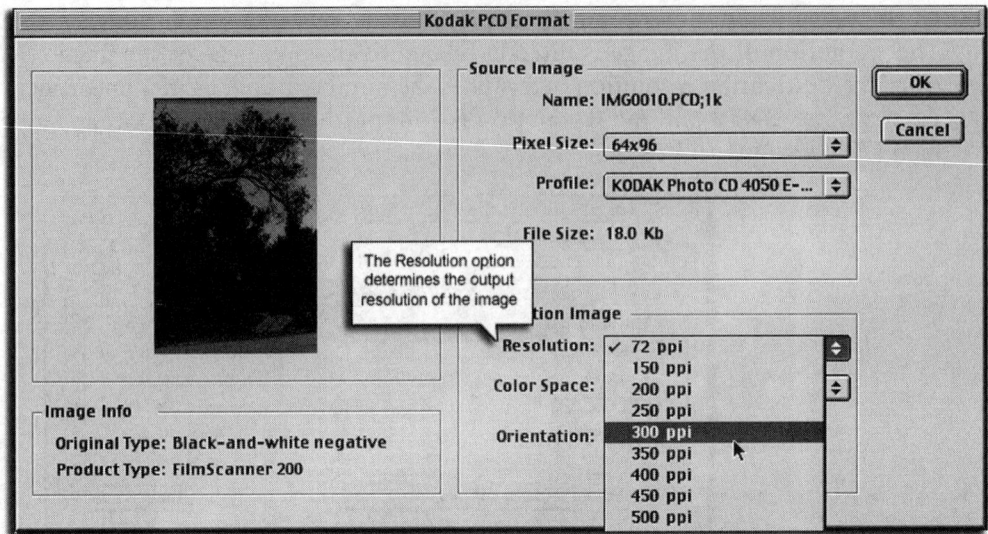

Figure 302.3 The Resolution of the image determines how many pixels are output within a linear inch.

Figure 302.4 Clicking the Color Space button lets you select from the available color spaces.

303 *Using Grow and Similar to Influence a Selection*

When you use any of the selection tools in Photoshop, you create a work area. Photoshop uses the work area to control where image editing takes place within the document. All of Photoshop's editing tools work within the selection area. Selected areas of an image are defined by a dotted line, sometimes referred to as a marching ant marquee. In Tip 294, "Expanding a Selection," and Tip 295, "Contracting a Selection," you learned how to modify a previous selection area. It is also possible to modify a previous selection by using the Command and Alt (Macintosh: Option) keys. Refer to Tip 136, "Using the Standard Lasso Tool."

Photoshop gives you two commands to help with the selection of information in a document: Grow and Similar. The Grow and Similar commands work with an existing selection to select additional pixels.

The Grow and Similar commands work in conjunction with the Tolerance setting of the Magic Wand. To change the Tolerance setting, select the Magic Wand tool and click in the Tolerance input field, as shown in Figure 303.1.

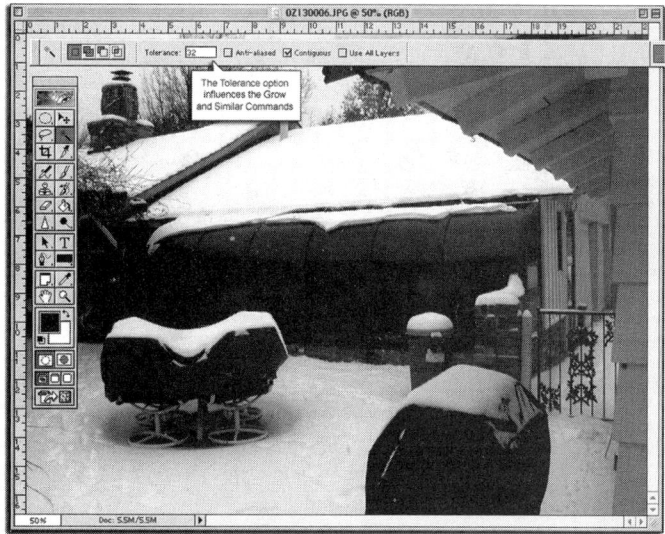

Figure 303.1 The Tolerance setting on the Magic Wand controls the Grow and Similar commands regardless of the selection tool.

Tolerance values range from 0 to 255. The higher the Tolerance value, the greater the selection range and the more pixel information selected. For more information on selecting a Tolerance setting, refer to Tip 182, "Controlling Selection Information with Tolerance."

To use the Grow command, select an area of an image with any selection tool. Choose the Select menu and choose the Grow command from the pull-down menu. Photoshop selects more pixel information within the image based on the area selected and the Tolerance setting; the Grow command expands the selection outward, as shown in Figure 303.2.

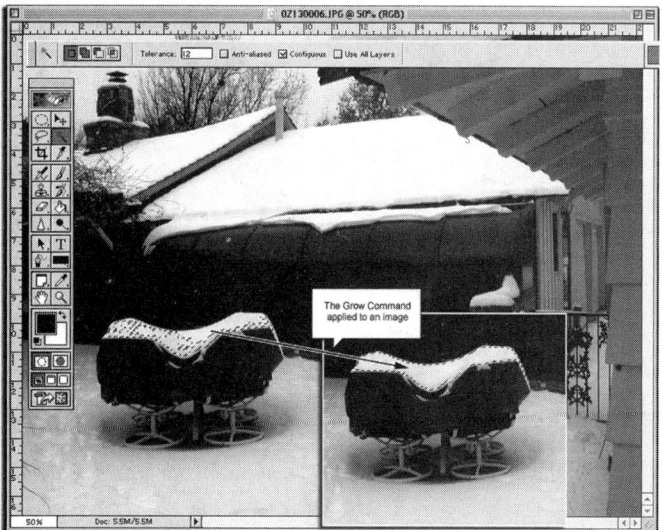

Figure 303.2 The Grow command expands the selection area outward from the original selection area.

To use the Similar command, select an area of an image using any selection tool. Choose the Select menu and choose the Similar command from the pull-down menu. Photoshop selects pixels throughout the document based on the pixels contained within the original selection area and the Tolerance setting, as shown in Figure 303.3.

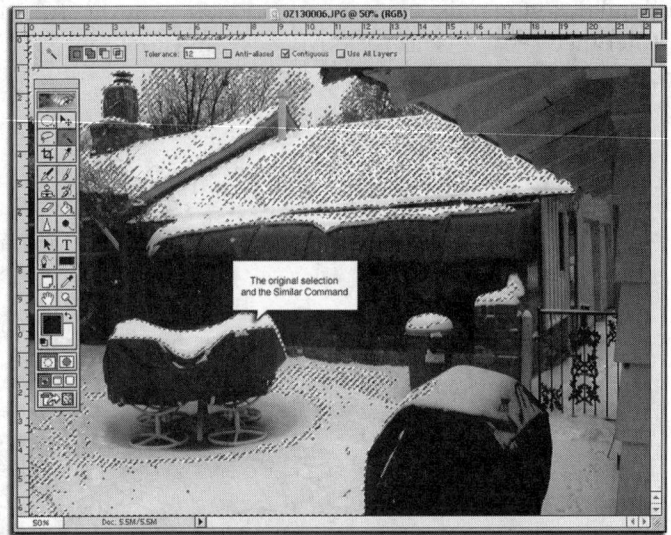

Figure 303.3 The Similar command uses the pixels within an existing selection
and selects matching pixels throughout the document.

304 *Understanding How Feathering Operates*

The feathering option works in conjunction with a selection marquee to produce a softer visual appearance to a selection. Selection tools create sharp-edged marquees, as shown in Figure 304.1.

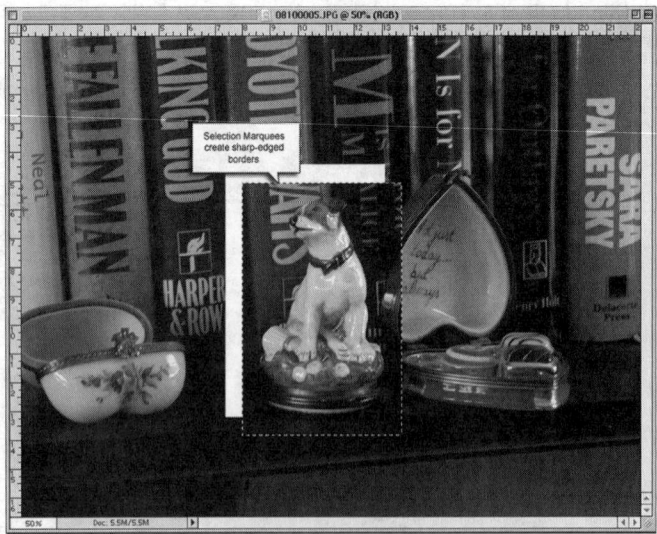

Figure 304.1 Selection tools create sharp edges between the area selected and the isolated pixels of the image.

Softer selection borders create a visual transition for image editing and color correction. To create a softer selection border, use any of the selection tools to create a selection marquee. Choose the Select menu and choose the Feather command from the pull-down menu. Photoshop opens the Feather Selection dialog box, as shown in Figure 304.2.

Figure 304.2 The Feather Selection dialog box sets the amount of feathering applied to a selection border.

Click in the Feather Radius input field and enter a value from 0.2 to 250. It is important to understand that the input value represents a radius, not a diameter. Therefore, a Feather Radius value of 25 actually creates a feather on the edge of the selection of 50 (25 pixels inside the selection marquee and 25 pixels outside the selection marquee), as shown in Figure 304.3.

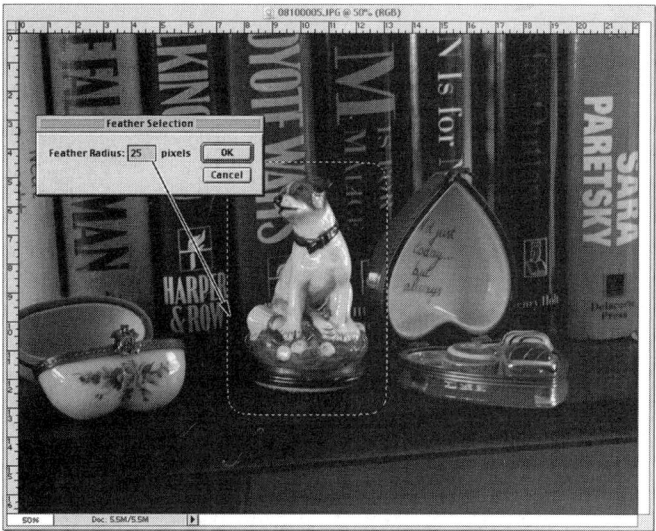

Figure 304.3 A Feather Radius of 25 creates a feathering diameter of 50 pixels.

The Feather command operates by reducing the opacity of the pixels as they move away from the center of the selection until the transparency of the edge pixels is 0, as shown in Figure 304.4.

Figure 304.4 The Feather command operates by slowly reducing the opacity of the pixels within the feather zone.

305 *Feathering a Selection to Create a Vignette Border*

In the preceding tip, you learned how to use the Feather command to create a visually soft selection edge. In this example, you will use the Feather command to create a soft vignette around an image.

To create a soft vignette, open an image in Photoshop and perform these steps:

1. Select the Elliptical Marquee and create an oval selection within the document window, as shown in Figure 305.1. For more information on using the Marquee tools, refer to Tip 71, "The Marquee Tools."

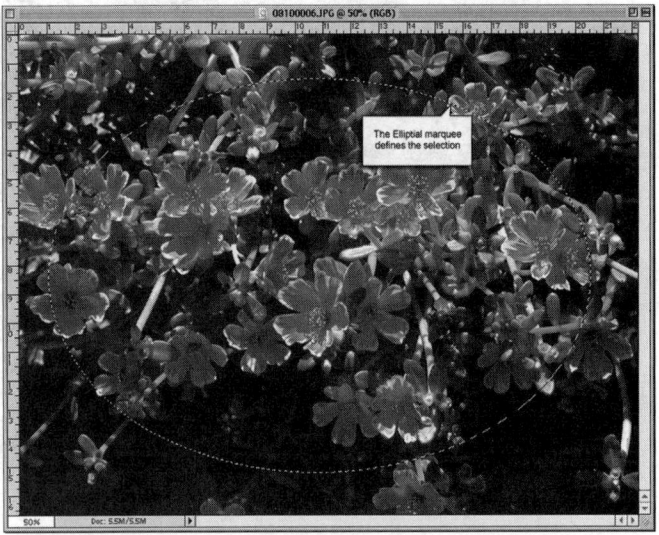

Figure 305.1 As you drag your mouse across the document window, the Elliptical Marquee tool creates an oval selection area.

2. Choose the Select menu and choose the Feather command from the pull-down menu. Photoshop opens the Feather Selection dialog box, as shown in Figure 305.2.

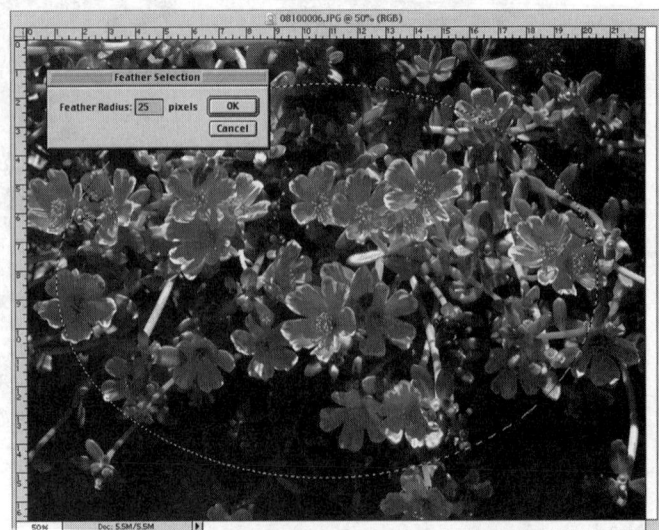

Figure 305.2 The Feather Selection dialog box defines the amount of feathering applied to the selection border.

3. In the Feather Radius input field, enter a value from 0.2 to 250. In this example, a value of 25 was used.

4. Click the OK button. Photoshop closes the Feather dialog box and applies the feather to the selection.

5. Choose the Select menu and choose the Inverse command from the pull-down menu. Photoshop reveres the selection area.

6. Press the Delete key on your keyboard. Photoshop deletes all the pixels in the selection area, creating a soft vignette around your image, as shown in Figure 305.3.

Figure 305.3 Pressing the Delete key removes all the pixels within the selection area and creates a soft vignette.

Note: If the vignette is created on a background, the deleted areas are filled with the current background color. If the vignette is created on a layer, the deleted areas are converted to transparent pixels.

306 *Working with the Foreground and Background Color Swatches*

The Foreground and Background Color Swatches control the painting and fill colors used by Photoshop. They are located at the bottom of the toolbox, as shown in Figure 306.1.

The Foreground color controls the Brush tools, the Paint Bucket, the color of typed text, and the first color used in a foreground-to-background gradient. It is also an option in the Fill commands.

The Background color controls the standard Eraser tool and the Delete command when used on a background. The Background color is also an option in the Fill commands and is the last color used in a foreground-to-background gradient.

Selecting and changing the Foreground and Background Color Swatches is accomplished in several ways (refer to Tip 221, "Selecting a Foreground and Background Color Swatch"). You can reset the color swatches to a default of black and white by pressing the letter "D" on your keyboard or by clicking on the default button, located to the lower left of the swatch boxes, as shown in Figure 306.2.

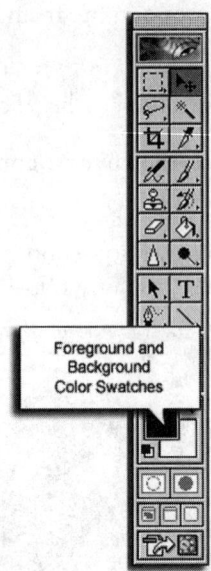

Figure 306.1 The Foreground and Background Color Swatches in the Photoshop toolbox.

Figure 306.2 The default button resets the Foreground and Background Color Swatches to black and white.

To reverse the color swatches, press the letter "X" on your keyboard or click on the reverse button, located to the upper right of the swatch boxes, as shown in Figure 306.3.

Figure 306.3 The reverse button reverses the position of the color swatch boxes.

307 *Saving a Selection as a Permanent Channel*

When you create a selection within a document, the selection marquee exists only as long as the document is open and you do not perform some other Photoshop operation. There are times when you need to save a selection. Saving a selection gives you access to the selection at a later time. For example, you could create a selection area, close Photoshop, and reopen the document. If you saved the selection area as a channel, it is still available.

To save a selection, open a document in Photoshop and perform these steps:

1. Create a selection using any of Photoshop's selection tools. For more information on selections, refer to Tip 280, "Selection Methods." The Photoshop document contains a selection marquee, as shown in Figure 307.1.

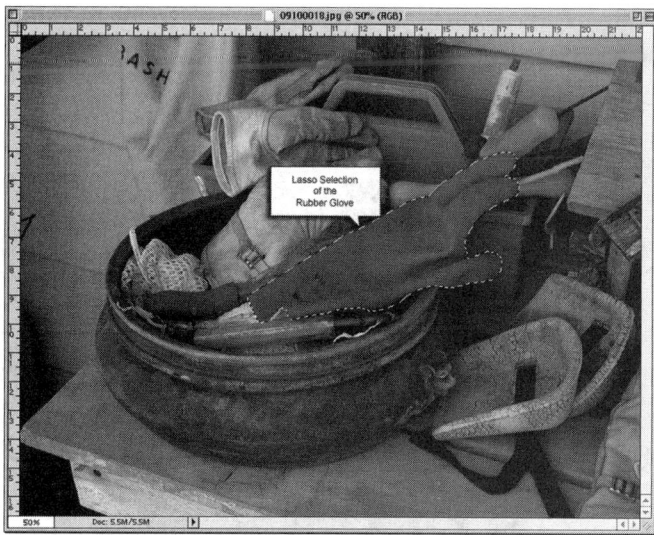

Figure 307.1 A selection marquee created using the Lasso tool.

2. If the Channels palette is not visible, select the Window menu and choose Show Channels from the pull-down menu. Photoshop displays the Channels palette, as shown in Figure 307.2.

Figure 307.2 The Channels palette displays a list of all available channels.

3. Click on the Create New Channels icon at the bottom of the Channels palette. The document window changes to solid black, as shown in Figure 307.3.

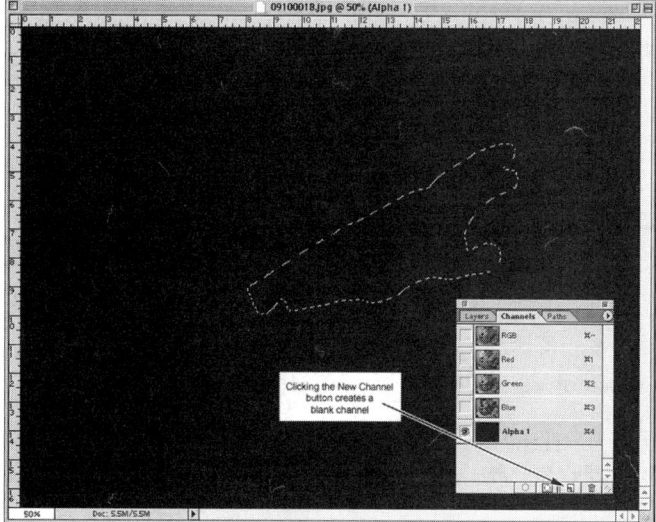

Figure 307.3 A new channel displays as black within the document window.

4. Make sure your background color swatch is white (refer to the preceding tip for setting the foreground and background color swatches).

5. Press the Delete key on your keyboard. The selected areas of the image change to white, as shown in Figure 307.4.

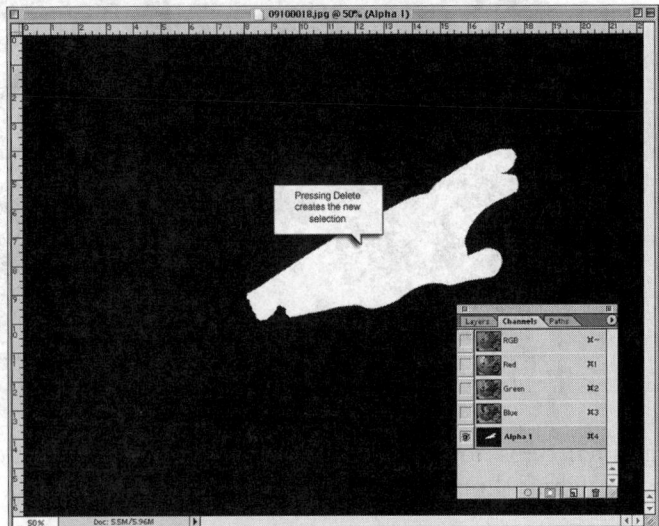

Figure 307.4 The white areas of the new channel define the selected areas of the image.

When you save the image as a *.tif* or *.psd* document, the additional channels are saved with the image, giving you access to your selection whenever needed.

Note: For information on creating a selection from a previously saved channel, see Tip 309, "Creating Selections from Channels."

308 *Using the Direct Selection Tool*

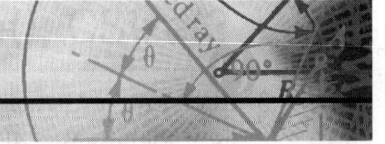

The Photoshop toolbox contains two tools that let you modify a previously created path: the Path Component and Direct Selection tools. Both of these tools help you adjust the anchor points within a path. For more information on creating a path, refer to Tip 154, "Creating Vector Paths with the Pen Tool."

To use the Direct Selection tool, open a document containing a previously created path, and perform these steps:

1. If the Paths palette is not visible, select the Window menu and choose Show Paths from the pull-down menu. Photoshop displays the Paths palette, as shown in Figure 308.1.

2. Select the path you want to modify by clicking once on the path name. The path becomes visible in the document window, as shown in Figure 308.2.

3. Click and hold (or right-click) on the Selection tool. Photoshop displays a pop-up menu displaying the selection tools. Select the Direct Selection option to make that the default tool, as shown in Figure 308.3.

4. Vector paths are composed of anchor points, direction lines, and path segments, as shown in Figure 308.4.

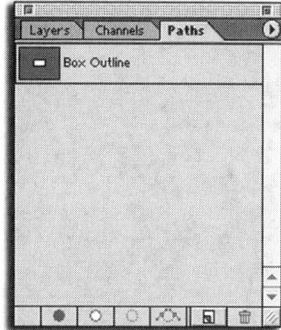

Figure 308.1 The Paths palette displays a list of all available paths within the active document.

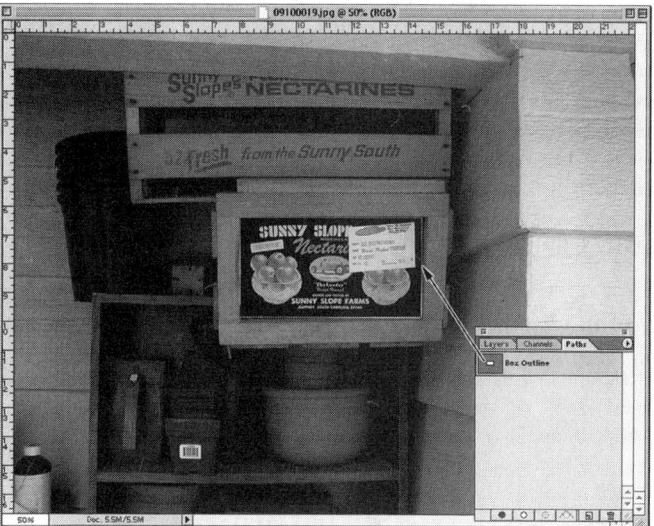

Figure 308.2 Clicking on a path in the Paths palette displays the path in the document window.

Figure 308.3 Clicking on the Direct Selection option makes it the default tool.

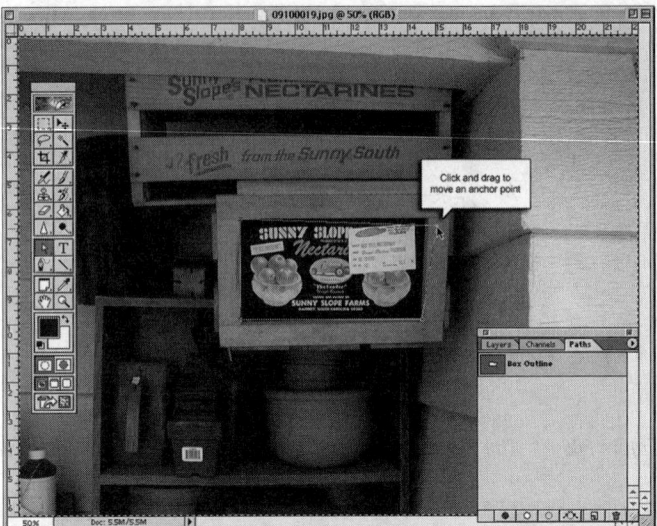

Figure 308.4 The components that comprise a vector path are anchor points, direction lines, and path segments.

5. Click on an anchor point to move the anchor point to a different location.

6. Click on a direction line to change the shape of the line segment.

7. Click on a path segment to move an entire segment.

Note: As you modify the path with the Direct Selection tool, changes are automatically recorded to the shape. When you save the document, the modifications are saved with the image.

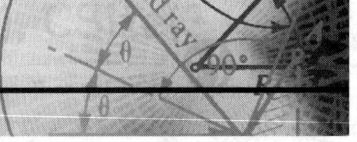

309 *Creating Selections from Channels*

In Tip 307, "Saving a Selection as a Permanent Channel," you learned how to create a selection and save it as an alpha channel. Channels define a selection by using black, white, and shades of gray to define the selection area. To reconvert a channel into a selection, open a document containing a saved channel selection and perform these steps:

1. If the Channels palette is not visible, select the Window menu and choose Show Channels from the pull-down menu. Photoshop displays the Channels palette, as shown in Figure 309.1.

2. Move your cursor over the channel containing the selection you want to reactivate. Your cursor resembles a hand with the index finger pointing upward.

3. Hold down the Ctrl (Macintosh: Command) key. Your cursor displays a small square to the right of the hand icon. Click once with your mouse. Your document window now redisplays the selection exactly as you originally created it, as shown in Figure 309.2.

Figure 309.1 The Channels palette displays a list of all available channels.

Figure 309.2 Clicking on an alpha channel while holding down the Ctrl
(Macintosh: Command) key converts the channel into a selection.

310 *Using the Stroke Command*

The Stroke command in Photoshop works with a previously selected area. When the Stroke command is executed, Photoshop paints the selection marquee with a color. You decide the width and specific location of the stroke by modifying the information in the Stroke dialog box.

To use the Stroke command, open a document in Photoshop and perform these steps:

1. Use one of your selection tools to create a marquee. The dotted line defining the selection area is what the Stroke command uses to define the stroke, as shown in Figure 310.1.

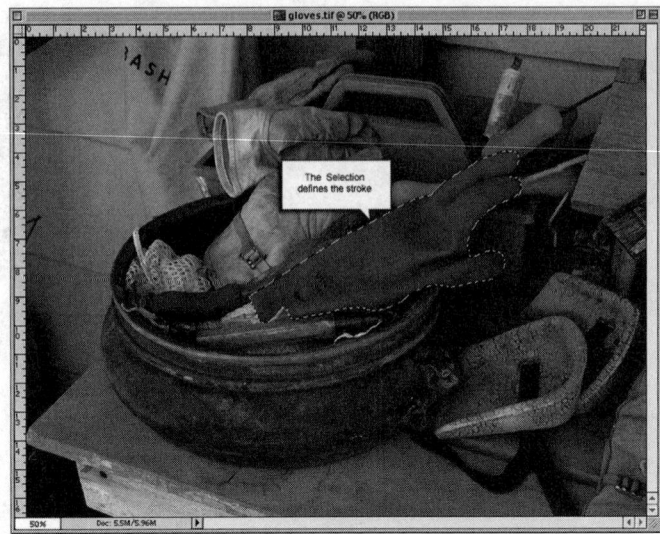

Figure 310.1 The dotted line marquee defines where the Stroke command draws the stroke.

2. Select the Edit menu and choose the Stroke command from the pull-down menu. Photoshop opens the Stroke dialog box, as shown in Figure 310.2.

Figure 310.2 The Stroke dialog box defines the characteristics of the line.

- **Stroke Width:** In the Width input field, enter a value from 1 to 250 pixels.

- **Stroke Color:** The Stroke Color defaults to the current Foreground color swatch. Click in the Color box to open the Photoshop Color Picker dialog box. Choose a color from it and click the OK button. The Color Picker dialog box closes, and the Stroke color changes. For more information on selecting color, see Tip 62, "Manually Choosing Colors with the Color Picker."

- **Location:** Click on one of the three radio buttons to draw the stroke on the inside, center, or outside of the dotted-line marquee.

- **Blending Mode:** Click on the blending Mode button to select from the available blending modes. For more information on using the blending modes with the Stroke command, see Tip 687, "Working with Layer Blending Modes."

- **Opacity:** In the Opacity field, enter a value from 1 to 100. The lower the value, the more transparent the color and blending mode of the stroke.

- **Preserve Transparency:** Select the Preserve Transparency check box to activate this option. When Preserve Transparency is selected, the areas of a layer containing transparent pixels are locked and cannot be modified.

3. Make your changes to the Stroke options and click the OK button. Photoshop closes the Stroke dialog box and performs the Stroke command, as shown in Figure 310.3.

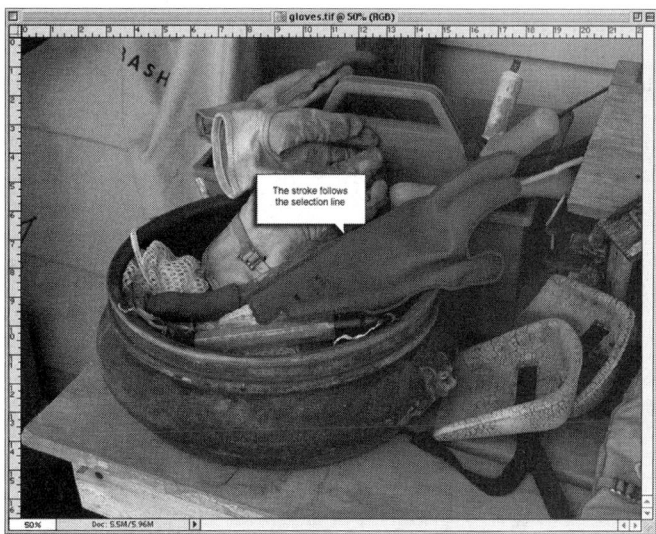

Figure 310.3 The Stroke command executed on a marquee selection.

311 *Using the Load Selection Command*

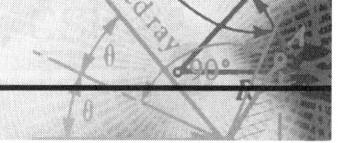

In Tip 309, "Creating Selections from Channels," you learned how to convert an alpha channel into a selection. When you convert a channel into a selection using the technique in Tip 309, all the white areas of the channel are selected, and all the black areas are masked. Photoshop gives you a way to control the selection process by using the Load Selection command.

To use the Load Selection command, open a Photoshop image containing a selection saved as a channel, and perform these steps:

1. Choose the Select menu and choose Load Selection from the pull-down menu. Photoshop opens the Load Selection dialog box, as shown in Figure 311.1.

Figure 311.1 The Load Selection dialog box lets you control the application of the selection to the image.

2. The options in the Load Selection dialog box help you control the selection process:

- **Document:** Click the Document option and select the Photoshop document containing the Alpha channel mask. The Document list contains the names of all open Photoshop documents. If you only have one document open, this option will not be available.

- **Channel:** Click the Channel option and select the channel containing the mask. The Channel list contains the names of all the Alpha channels within the selected document.

- **Invert:** Select the Invert check box. The Invert option reverses the selection area.

- **Operation:** Click on one of the radio buttons to Add, Subtract, or Intersect the channel mask with a previous selection. New Selection is the only option to choose if no other selection marquees exist in the document.

3. Click the OK button. Photoshop closes the Load Selection dialog box and creates a selection, as shown in Figure 311.2.

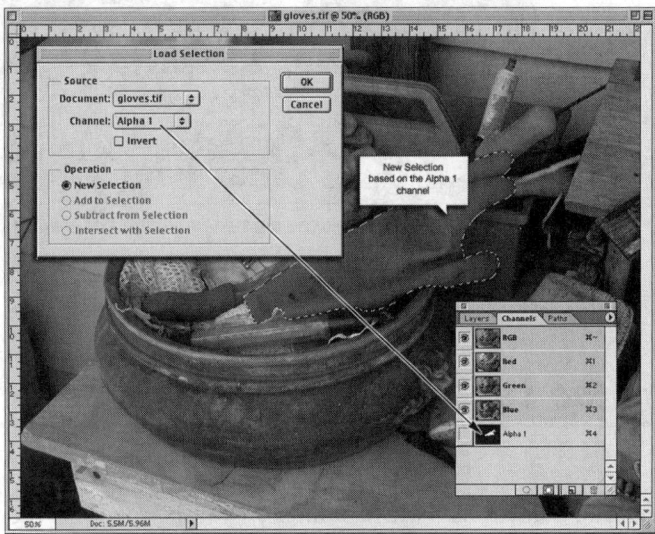

Figure 311.2 The Load Selection command generates selections based on Alpha channel masks.

312 *Creating a Layer Clipping Path*

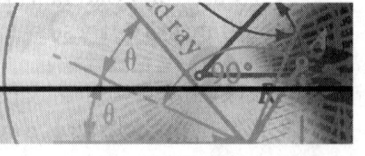

Photoshop uses Layer clipping paths in conjunction with the new drawing tools to create sharp-edged shapes. Layer clipping paths are ideal for creating 3-D buttons and interfaces for Web sites and interactive media.

A Layer clipping path consists of a layer with an attached clipping path, as shown in Figure 312.1.

Figure 312.1 A Layer clipping path defines the shape and look of the layer information.

To create a Layer clipping path, open Photoshop and perform these steps:

1. Select the File menu and choose New from the pull-down menu. Photoshop will open the New dialog box, as shown in Figure 312.2.

Figure 312.2 The New dialog box defines the characteristics of the new document.

2. Create a new document with these parameters:

 * **Width:** 3 inches

 * **Height:** 3 inches

 * **Resolution:** 72 pixels/inch

 * **Mode:** RGB

 * **Contents:** White

3. Click the OK button. Photoshop closes the New dialog box and opens the new document.

4. Move your cursor into the toolbox and click and hold (or right-click) on the Drawing tools icon. Photoshop displays a list of available Drawing tools. Select the Rounded Rectangle tool, as shown in Figure 312.3.

Figure 312.3 The Drawing tool options in the Photoshop toolbox.

5. Click the Create New Shape Layer button in the Options bar, as shown in Figure 312.4.

Figure 312.4 The New Shape Layer button creates shapes with a Layer clipping path.

6. Press the letter "D" on your keyboard. Photoshop defaults the Foreground and Background Color Swatches to black and white.

7. Click and drag the Rounded Rectangle tool across the document window. Photoshop creates a bounding box, defining the shape. Release the mouse when you see a shape similar to Figure 312.5.

Figure 312.5 Clicking and dragging your mouse across the document window creates a rectangular shape.

8. Photoshop creates a new layer with a clipping path, as shown in Figure 312.6.

Figure 312.6 *The Layers palette displays a new layer containing a clipping path.*

313 *Applying a Style to a Layer Clipping Path*

In the preceding tip, you learned how to create a Layer clipping path. Layer clipping paths generate shapes by creating a vector path along with the layer (refer to Figure 312.6 in the previous tip). The clipping path portion of the layer defines the visual shape of the object.

When you initially create a Layer clipping path, the path fills with the current foreground color. Once a Layer clipping path is created, you cannot use any of standard editing tools such as the Gradient or Brush tools; however, you can use the Styles palette to apply a predesigned style to the Layer clipping path.

To apply a style, create a Layer clipping path (refer to the preceding tip) and perform these steps:

1. If the Styles palette is not visible, select the Window menu and choose Show Styles from the pull-down menu. Photoshop opens the Styles palette, as shown in Figure 313.1.

Figure 313.1 *The Styles palette displays a list of all available styles.*

2. With the Layer containing the clipping path selected, click on one of the available styles in the Styles palette. Photoshop applies the style to the Layer clipping path, as shown in Figure 313.2.

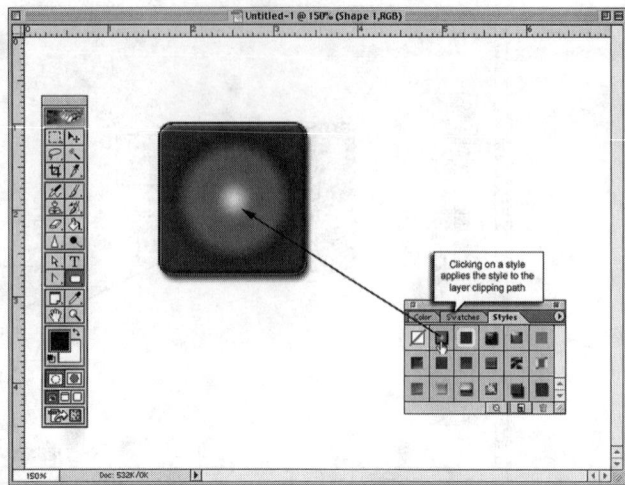

Figure 313.2 Click on a style button to apply that style to the Layer clipping group.

3. To apply another style to the Layer clipping group, click on another style button.

4. To remove a style from a Layer clipping group, click on the Default Style button in the upper-left corner of the Styles palette (refer to Figure 313.2). (The Default Style button has a diagonal line running through it.)

For more information on creating your own styles, see Tip 487, "Creating Styles from Layers."

314 *Editing a Layer Clipping Path*

In the preceding two tips, you learned how to create and apply a style to a Layer clipping path. There are times, however, when you want to redesign the shape created by the clipping path. Photoshop creates clipping paths using vector shapes, and vector shares are modifiable just like any other vector path.

To modify a Layer clipping path, create a Layer clipping path (refer to Tip 312, "Creating a Layer Clipping Path") and perform these steps:

1. Select the Direct Selection tool from the Photoshop toolbox (refer to Tip 308, "Using the Direct Selection Tool").

2. The Direct Selection tool lets you select individual anchor points within a vector shape and modify the points by clicking and dragging your mouse, as shown in Figure 314.1 and 314.2.

Note: If needed, you can add or subtract anchor points by using the Add Anchor Point and Delete Anchor Point tools. For more information on adding and deleting anchor points from an existing vector shape, see Tip 465, "Working with Anchor Points."

Figure 314.1 The Direct Selection tool lets you modify the anchor points within a vector shape.

Figure 314.2 In this example, clicking and dragging every other anchor point creates a star shape with varying size points.

315 *Using Selections to Control the Effects of Filters and Adjustments*

In most cases, when you perform image editing on a Photoshop image or create a special effect, you will work on a particular portion of the image. The selection tools not only define the work area for your paintbrushes and other tools in the toolbox, they also control the application of a particular filter or adjustment.

One of the more common photographic problems is when you shoot a photo in which the foreground elements are in shadow and the background is in hard light. Typically, the foreground elements are correctly exposed; however, the background is overexposed, producing a light area lacking in detail.

In this example, the image in Figure 315.1 contains an overexposed background. Using the Levels dialog box, you will lighten the background in this overexposed image without modifying the foreground elements.

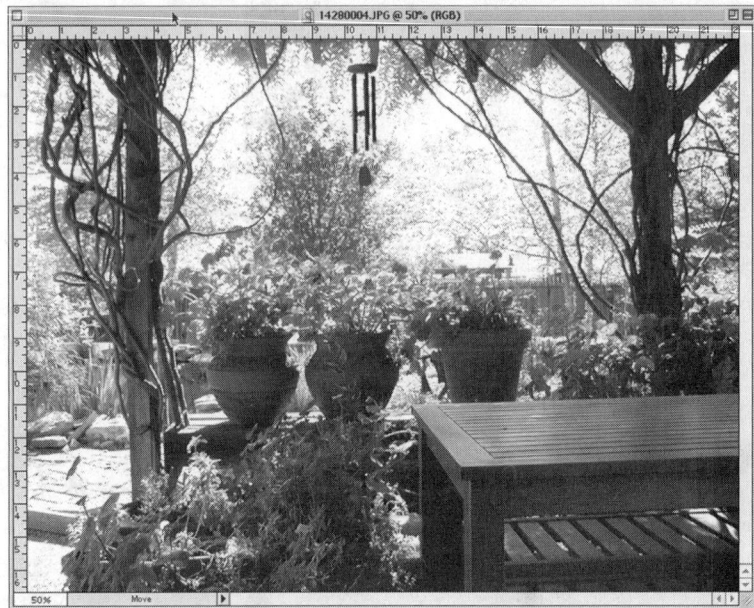

Figure 315.1 The overexposed background creates an out-of-balance image.

To lighten the background of the Photoshop image, perform these steps:

1. Using the standard selection tools, select the areas of the image that you want to modify. In this example, the Lasso tool selects the overexposed areas of the background, as shown in Figure 315.2.

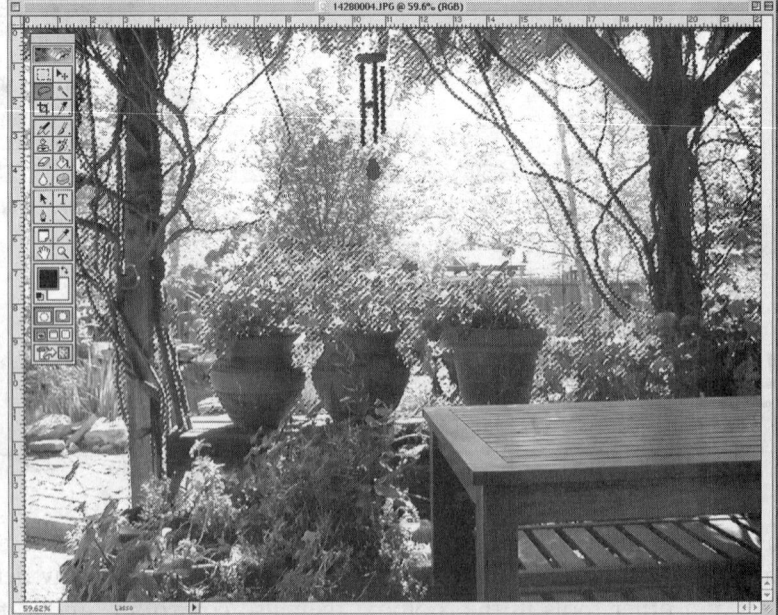

Figure 315.2 Use the Lasso tool to select the overexposed areas of the image.

2. Choose the Select menu and choose Feather from the pull-down menu. Photoshop opens the Feather Selection dialog box, as shown in Figure 315.3.

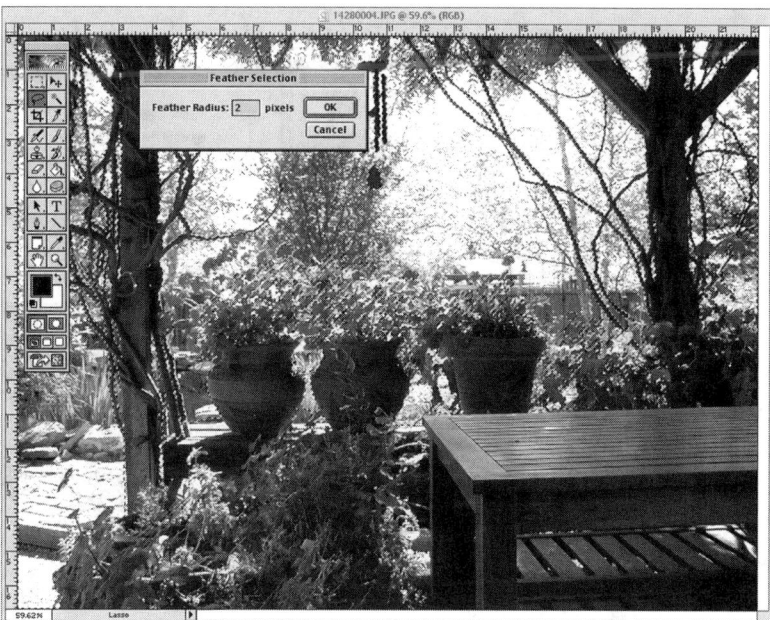

Figure 315.3 The Feather Selection dialog box controls the transparency of the pixels along the edge of the selection marquee.

3. In the Feather Radius input box, enter a value of 2, and click the OK button. Photoshop closes the Feather Selection dialog box and applies the feather to the selection. Using the Feathering command softens the edge of the selection marquee and helps blend the adjustment into the image.

4. Select Image menu Adjust and choose Levels from the fly-out menu. Photoshop opens the Levels dialog box, as shown in Figure 315.4.

Figure 315.4 The Levels dialog box defines the brightness values of the pixels within the selected area of the image.

5. Correct the image by moving the shadow and midtone input sliders to fit the Levels histogram data, as shown in Figure 315.5.

6. Click the OK button to close the Levels dialog box and record your changes to the image, as shown in Figure 315.6.

Note: For more information on using the Levels command, refer to Tip 201, "Understanding How the Levels Command Adjusts an Image."

Figure 315.5 The Levels command performs image correction within the area defined by the selection marquee.

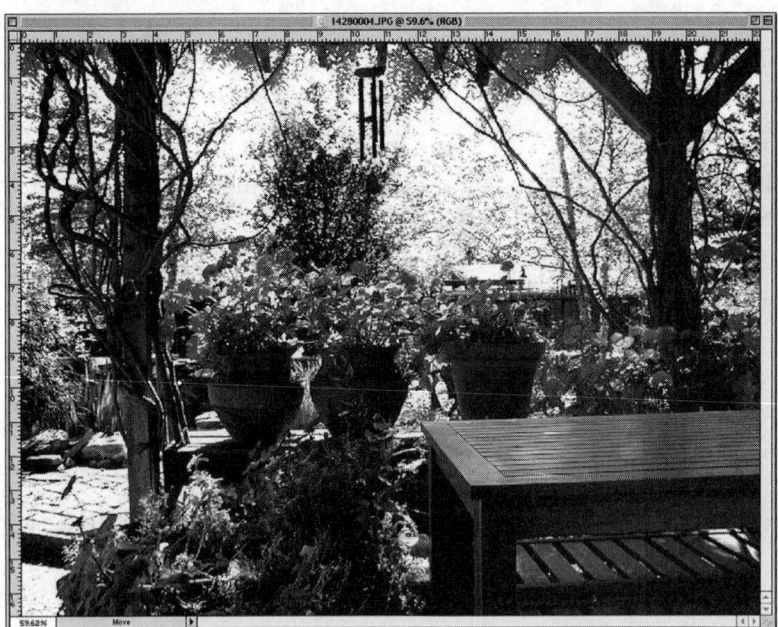

Figure 315.6 The image now displays the correct exposure for the foreground and background elements.

316 *Understanding How Photoshop Looks at Color Correction*

When you perform color correction to an image in Photoshop, you are working on three levels:

- **Monitor:** Your monitor displays color information based on how it was calibrated.
- **Visual:** People view color in different ways.

- **Output:** The final image—whether it is viewed on a monitor or sent to a printer.

The first thing to realize is that color management systems (CMSs) do not color correct an image; they only give a basis for where to start. For more information on color management systems, see Tip 569, "Using Color Management with Printed Output."

Many things influence what you see on your monitor:

- **Windows:** The color and intensity of the lighting sources around your monitor influence what colors your eyes see. If your monitor is positioned near a window, the sunlight in the morning contains a different color spectrum than at noon or in the evening. Keep your monitor away from windows or reduce the effects of the light coming through the window with shades or blinds.

- **Internal light sources:** The light sources used around your workspace should not be overpowering. Strong light sources reflect off your monitor and influence what you see. Choose subdued lighting that does not directly reflect off the screen. Do not turn lights on or off. Use the same lighting all the time.

- **Use neutral colors:** The colors of the walls in your studio reflect off the monitor and influence what you see. Choose neutral colors to limit the effect.

- **Clothing:** The color of the clothing you wear will influence the colors you perceive on your monitor. Choose neutral colors for your clothing.

- **Screen backgrounds:** Eliminate fancy multicolored backgrounds and screen savers. Use a middle gray background for your monitor.

The suggestion here is not to paint the walls in your studio black and always wear dark clothing, but to be aware that your surroundings influence what you see on your monitor and therefore affect how you perceive color. Consistency in how you work is the key to working with color.

317 *Creating a Border from a Selection*

When you create a selection in Photoshop using one of the selection tools (refer to Tip 280, "Selection Methods"), you see a dotted-line marquee. The areas enclosed by the dotted line define the working area, as shown in Figure 317.1.

Figure 317.1 The dotted line enclosing a selection defines Photoshop's work area.

Photoshop lets you create a border from a selection. To make a border out of a previous selection, open a Photoshop graphic and perform these steps:

1. Choose a selection tool and create a selection within the document. In this example, the Rectangular Marquee tool was used to create a rectangular selection, as shown in Figure 317.2.

Figure 317.2 The Rectangular Marquee tool creates a selection by clicking and dragging your mouse across the document.

2. Choose the Select menu, then select Modify and choose the Border command from the fly-out menu. Photoshop displays the Border Selection dialog box, as shown in Figure 317.3.

Figure 317.3 The Border Selection dialog box controls the characteristics of the border.

3. Click in the Width input field and enter a value from 1 to 200. The higher the value, the greater the width of the selection border.

4. Click the OK button to close the Border Selection dialog box and record your changes to the selection, as shown in Figure 317.4.

Figure 317.4 The Border Selection command converts a selection into a border.

Borders define the workspace within the image and are used just like any other selection. In this example, the border was filled with a solid color to create an outline, or border, around the image, as shown in Figure 317.5.

Figure 317.5 The selection border filled with a solid color creates the effect of a neon border running around the image.

318 *Using Color Balance to Tint an Image*

Photoshop gives you a variety of ways to influence the colors within an image. One of these ways is to use the Color Balance command. The Color Balance command modifies an image by influencing the balance between colors (refer to Tip 206, "Using the Color Balance Command").

To create an image with a sepia tint, open a graphic image in Photoshop and perform these steps:

1. Select the Image menu, then select Adjust and choose the Desaturate command from the fly-out menu. Photoshop converts the colors within the image into shades of gray. Note: If the image is in grayscale mode, this step is not necessary.

2. Convert the image into the CMYK color space by selecting the Image menu, then Mode and choosing the CMYK option from the fly-out menu. Note: If the image is already a CMYK graphic, this step in not necessary.

3. Select the Image menu, then select Adjust and choose Color Balance from the fly-out menu. Photoshop opens the Color Balance dialog box, as shown in Figure 318.1.

4. Click in the Preserve Luminosity check box to select the Preserve Luminosity option.

5. Click and select the Shadows option.

6. Click and drag the Cyan/Red slider until the Color Levels input field reads +95, the Magenta/Green slider reads +5, and the Yellow/Blue slider reads –20, as shown in Figure 318.2.

Figure 318.1 The Color Balance dialog box influences the color relationships within the image.

Figure 318.2 Selecting the Shadows option in Tone Balance influences the dark pixels within the image.

7. Select the Midtones option. The Color Levels input fields reset to 0.

8. Click and drag the Cyan/Red slider to +70, as shown in Figure 318.3.

Figure 318.3 The Midtone option influences the middle brightness range within the image.

9. Select the Highlights option. The Color Levels input fields reset to 0.

10. Click and drag the Cyan/Red slider to +30 and the Yellow/Blue slider to −15, as shown in Figure 318.4.

Figure 318.4 The Highlights option influences the lighter pixels within the image.

11. Click the OK button to close the Color Balance dialog box and record your changes to the image.

319 *Using Curves to Adjust an Image*

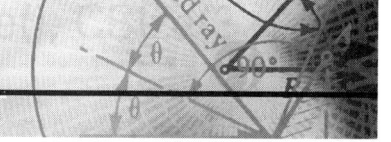

In the preceding tip, you learned how to tint an image using the Color Balance command. The Color Balance command modifies an image's color by the relationship between colors on a standard color wheel. The Curves command performs a similar function by shifting the colors in an image (refer to Tip 205, "Understanding How the Curves Command Adjusts an Image").

To access the Curves dialog box, open a graphic image in Photoshop, choose the Image menu, then select Adjust, and choose Curves from the fly-out menu. Photoshop opens the Curves dialog box, as shown in Figure 319.1.

Curves does not remove color from an image; it only changes the values of the inks based on the standard color wheel. In the standard color wheel, each color is balanced by a second color. In an RGB image, red is balanced with cyan, green is balanced with magenta, and blue is balanced with yellow.

In the Curves dialog box, the graph represents the saturation of the inks within the image. The vertical bar of the graph represents the percentage of saturation from 0 to 100 percent, and the horizontal bar represents the pixels within the image from dark (left) to light (right). The line on the graph represents the distribution of the inks within the image.

To influence a particular area of the color wheel, such as the color green, click on the Channel list and select Green from the pop-up menu, as shown in Figure 319.2.

Clicking on the graph line sets a movable point, as shown in Figure 319.3.

Figure 319.1 The Curves dialog box influences the saturation of ink within an image.

Figure 319.2 Clicking on the Channel list lets you select a particular color within the image.

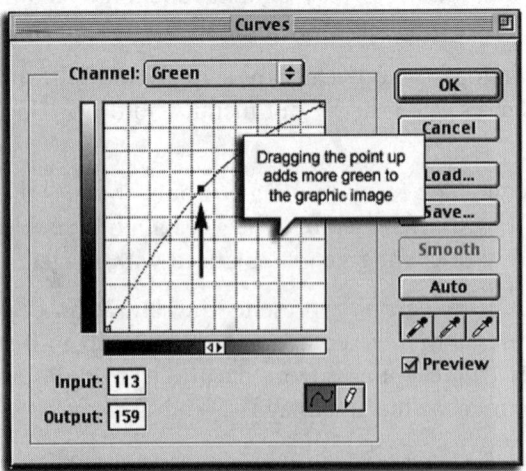

Figure 319.3 Clicking and dragging on a point moves the line and redistributes the inks within the image.

When you click and drag on an edit point in the Curves dialog box, you add (not remove) color. For example, if you click and drag a midtone edit point (refer to Figure 319.3) in the Green channel, dragging up adds more green to the image. Dragging the point down, however, does not remove the green; it adds magenta (the opposite of green), as shown in Figure 319.4.

Figure 319.4 *Moving edit points in the Curves dialog box changes the mixing of the colors.*

Understanding how the Curves command operates is fundamental to understanding how color correction is performed within Photoshop.

320 *Registering a Digimarc Watermark*

When you create a graphic image, the image becomes your intellectual property. The U.S. Government views graphics the same way it views words on paper. You have the legal right to copyright all of your creative efforts, and Photoshop gives you a way to prove the images are actually yours by creating a Digimarc watermark.

To use a Digimarc watermark, you must first register and purchase the watermark from the Digimarc Corporation.

To register with Digimarc, open a graphic image in Photoshop and perform these steps:

1. From the Filter menu, choose Digimarc and select Embed Watermark from the fly-out menu. Photoshop opens the Embed Watermark dialog box, as shown in Figure 320.1.

2. Click on the Personalize button. Photoshop opens the Personalize Creator ID dialog box. If you have an Internet account, click the Register button to access the Digimarc Web site, as shown in Figure 320.2.

3. Once you have registered your watermark, enter the number into the Creator ID dialog box and click the OK button. Photoshop closes the Personalize Creator ID dialog box.

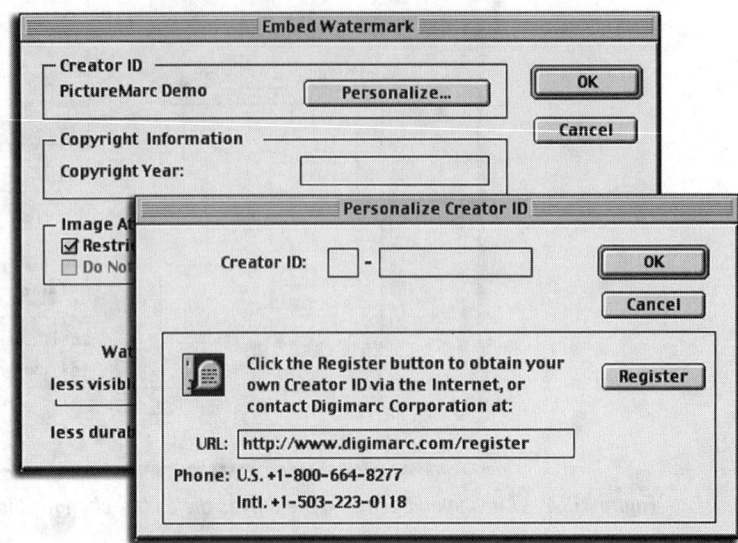

Figure 320.1 The Embed Watermark dialog box lets you purchase a Digimarc watermark.

Figure 320.2 The Digimarc Web site lets you register a unique ID that identifies your images as yours.

321 *Applying a Digimarc Watermark to an Image*

In the preceding tip, you learned how to activate the Digimarc watermark. Once this is accomplished, you can then apply the watermark to your images. Once you embed a Digimarc watermark into an image, it cannot be removed. Since the watermark is actually part of the image, watermarks are still detectable even after scanning the image.

The Digimarc watermark is embedded into the pixel information of the open graphic image, and it identifies that image as your intellectual property. To embed a Digimarc watermark, open a graphic image within Photoshop and perform these steps:

1. From the Filter menu, choose Digimarc and select Embed Watermark from the fly-out menu. Photoshop opens the Embed Watermark dialog box, as shown in Figure 321.1.

Figure 321.1 *The Embed Watermark dialog box controls the characteristics of the embedded watermark.*

2. Control the type of watermark by choosing from the available options:

- **Creator ID:** The Creator ID displays your Digimarc ID. Note: If you have not registered for a Creator ID, the Change button displays the word "Personalize." Click the Personalize button and refer to the preceding tip to register your Creator ID.

- **Copyright Information:** Click in the Copyright Year input field and enter the year the image was produced. Note: Copyright does not require a month or day, only the creation year of the image.

- **Image Attributes:** Select from the available options: Restricted, Do Not Copy, and Adult Content. Note: These options do not prevent someone from copying the image.

- **Target Output:** Click on the Target Output pull-down list and select Monitor, Web, or Print. Note: Selecting these options does not change the image.

- **Watermark Durability:** In the Watermark Durability input box, enter a value of 1 to 4. The higher the number, the more durable the watermark. More visible watermarks appear as visible noise within an image; less visible watermarks are less visible to the eye.

3. Click the OK button to close the Embed Watermark dialog box and record the changes to the image.

Note: Less visible watermarks easily become damaged when applying filters and adjustments to the image. Watermarks using higher visibility are harder to damage. Use lower visibility settings when working on fine artwork and graphics and use higher settings for images saved for the Internet.

322 *Understanding Adjustment Layers*

Photoshop introduced Adjustment layers in version 4.0 of the program. Adjustment layers give you control over the final look of the image by postponing the application of the adjustment to the image. When you use an Adjustment layer, the Adjustment layer holds the changes to the image. As long as the

Adjustment layer is separate from the image, the changes stay separate until you merge or flatten the layers. Adjustment layers control how the image is changed and when the changes are applied to the image.

To create a new Adjustment layer, open a graphic in Photoshop, select Layer menu New Adjustment Layer, and choose from the available options on the fly-out menu. Alternatively, you can choose the Create New Adjustment Layer button, as shown in Figure 322.1.

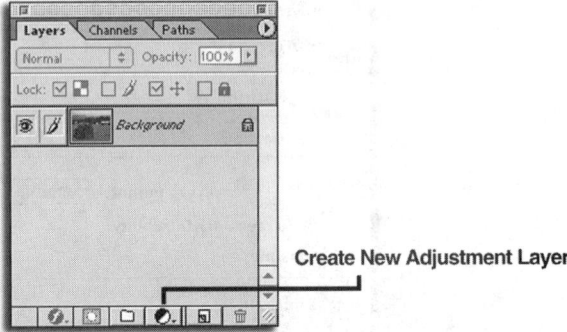

Create New Adjustment Layer

Figure 322.1 The Create New Adjustment Layer button gives you access to all of Photoshop's adjustment layers.

For example, you can use the Levels command as an Adjustment layer. Adjustment layers hold the modifications to the image, as shown in Figure 322.2.

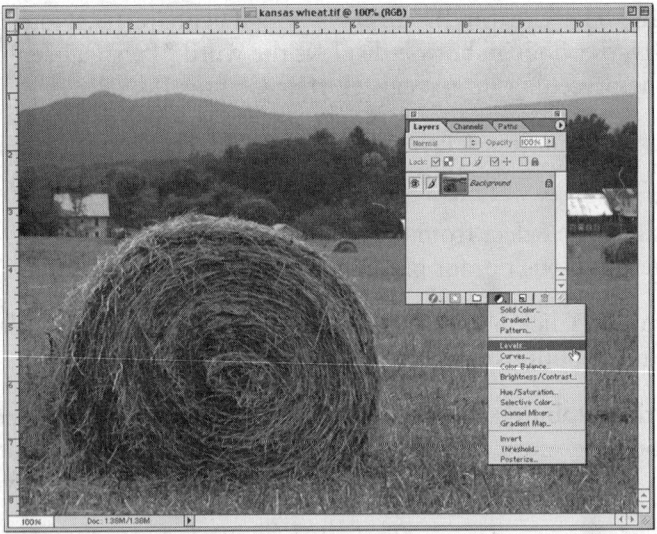

Figure 322.2 The Levels dialog box, used with an Adjustment layer, controls when the changes to the image are applied.

Adjustment layers are not graphic layers; they do not contain image information. They are the filters by which the document is viewed. If you choose, for example, the Posterize Adjustment layer, the original image does not change. However, the Adjustment layer visually displays the image based on the settings in the Adjustment layer, as shown in Figure 322.3.

After creating an Adjustment layer, changes are made by double-clicking on the Adjustment layer.

Figure 322.3 The Posterize Adjustment layer controls the visual display of the image without changing the original image.

323 *Using Multiple Adjustment Layers Creatively*

In the preceding tip, you learned how to create an Adjustment layer. Adjustment layers can be used in very creative ways. For example, you can reduce the steps of color within an image and, at the same time, convert the image to grayscale. Although you know what you want to do to the image, you are not exactly sure what the final image should look like.

Using Adjustment layers creatively, open an image in Photoshop and perform these steps:

1. Select Layer menu New Adjustment Layer and choose Posterize from the fly-out menu. Photoshop opens the Posterize dialog box, as shown in Figure 323.1.

Figure 323.1 The Posterize command controls the steps assigned to each color.

2. In the Levels input box, enter a value from 2 to 255. The higher the value, the more steps are assigned to each color. In this example, the value of 6 was chosen.

3. Click the OK button. Photoshop closes the Posterize dialog box.

4. Select Layer menu New Adjustment Layer and choose Hue/Saturation from the fly-out menu. Photoshop opens the Hue/Saturation dialog box, as shown in Figure 323.2.

Figure 323.2 The Hue/Saturation dialog box controls the percentage of color applied to an image.

5. In the Saturation input box, enter a value from –100 to +100. In this example, a value of –100 was chosen. A value of –100 removes all of the color within the image and converts the graphic into grayscale.

6. Click the OK button. Photoshop closes the Hue/Saturation dialog box and records your changes to the image (refer to Figure 323.2).

7. To make changes to the Hue/Saturation or Posterize dialog boxes, double-click your mouse on the layer to reopen the appropriate dialog box.

Using Posterize and Hue/Saturation within Adjustment layers gives you total control over the image. You can use as many Adjustment layers as needed to create the effect you want. You can even use more than one of each Adjustment layer.

Multiple Adjustment layers do not significantly increase the size of the file. All they do is give you control over the final image.

324 *Merging Adjustment Layers*

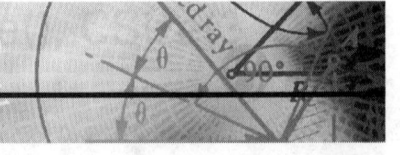

In the preceding tip, you learned how to use multiple Adjustment layers to create special effects. When you create an Adjustment layer, Photoshop creates a new element in the Layers palette. Each Adjustment generates a new layer, as shown in Figure 324.1.

Complicated designs generate many Adjustment layers. You can control the number of Adjustment layers in the Layers palette by merging selected layers together.

Say, for example, you are working on a graphic containing several Adjustment layers, as shown in Figure 324.2. To merge the Curves and Posterize layers in Figure 324.2, perform these steps:

Figure 324.1 The Layers palette contains a separate layer for each Adjustment layer.

1. Move your cursor into the Layers palette and click once on the Curves layer. The Curves layer becomes the selected layer.

2. Click on the small black triangle in the upper-right corner of the Layers palette. Photoshop opens a fly-out menu containing all the available options.

3. Select Merge Down from the fly-out menu. Photoshop merges the selected layer (Curves) into the layer directly underneath (Posterize), as shown in Figure 324.3.

Figure 324.2 Complicated graphic designs can generate many Adjustment layers.

To merge the Curves and Levels Adjustment layers in Figure 324.3, perform these steps:

1. Click once on the visibility icons for all the layers you do not want to merge, as shown in Figure 324.4. The visibility icon is a toggle switch, and clicking in the box turns the layer's visibility on or off. When the visibility icon is off, the layer cannot be modified or merged.

Figure 324.3 The Merge Down command merges two layers together.

Figure 324.4 Clicking on the visibility icon turns the selected layer off or on.

2. Click on the small black triangle in the upper-right corner of the Layers palette. Photoshop opens a fly-out menu containing all the available options.

3. Select Merge Visible from the fly-out menu. Photoshop merges all visible layers together, as shown in Figure 324.5.

Figure 324.5 The Merge Visible command merges all visible layers.

Note: *When using the Merge Visible command, one of the visible layers must be selected for the command to perform.*

325 *Using Masks with Adjustment Layers*

In the preceding tip, you learned how to merge an Adjustment layer. Not only does an Adjustment layer give you control as to when the adjustments are applied to the image; it also works with an adjustment mask.

Adjustment layers are comprised of two elements: the adjustment and the mask. The adjustment portion of the layer controls the type of adjustment (Levels, Posterize, etc.), and the mask portion of the layer controls where the adjustment is applied to the image, as shown in Figure 325.1.

Figure 325.1 Adjustment layers contain an adjustment and a mask.

For example, to remove some but not all of the color from a graphic, open an image in Photoshop and perform these steps:

1. Select Layer menu New Adjustment Layer and choose Hue/Saturation from the fly-out menu. Photoshop opens the Hue/Saturation dialog box, as shown in Figure 325.2.

Figure 325.2 The Hue/Saturation dialog box controls the linear saturation of the colors within an image.

2. In the Saturation input box, enter a value of –100. You also could drag the Saturation slider all the way to the left, as shown in Figure 325.3. The image loses all of its color.

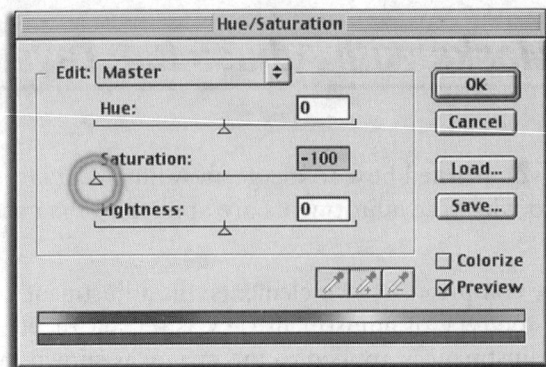

Figure 325.3 Moving the Saturation slider to the left reduces the saturation of the inks within the image.

3. Click the OK button. Photoshop closes the Hue/Saturation dialog box and records the changes to the image, as shown in Figure 325.4.

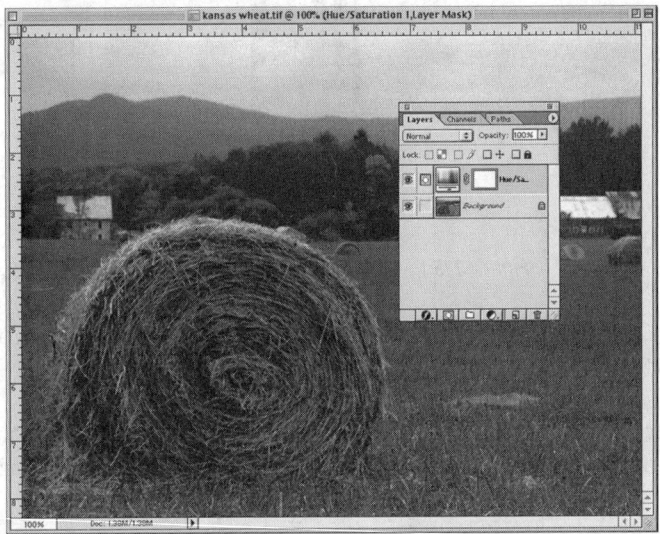

Figure 325.4 The Hue/Saturation Adjustment layer applied to the image.

4. Press the letter "D" on your keyboard to default the colors of your toolbox to white and black. Now press the letter "X" to reverse the colors to black and white.

5. Select the Paintbrush and choose a large soft brush. For more information on using the Paintbrush, refer to Tip 78, "The Paintbrush and Pencil Tools."

6. Click once on the Hue/Saturation layer to make it the selected layer.

7. Using your black paintbrush, paint over the areas of the image you want to restore to color. Photoshop returns the original color to the painted areas of the image, as shown in Figure 325.5.

When you use a paintbrush on an Adjustment layer, the areas containing black paint are masked. Conversely, using white paint on an Adjustment layer reveals the effects of the adjustment. Painting in a shade of gray partially reveals the effects of the adjustment, depending on the density of gray. The darker the shade of gray, the more masked the effect; the lighter the shade of gray, the more the effect is revealed.

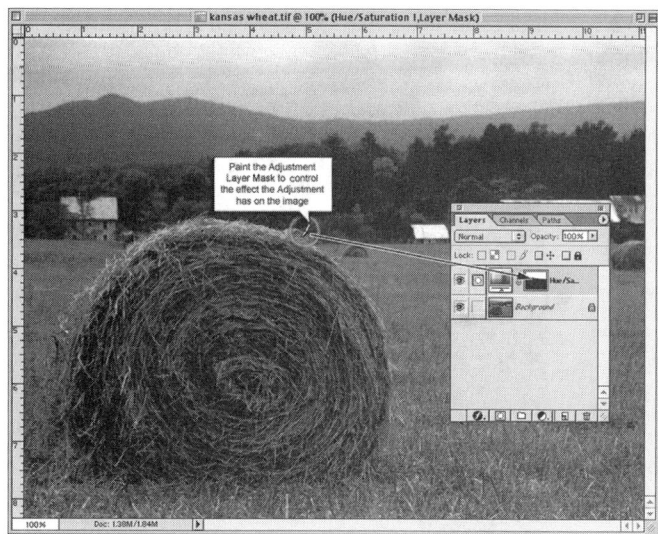

Figure 325.5 Painting an Adjustment layer with black masks the effects of the adjustment to the image.

326 *Combining Blending Modes with Adjustment Layers*

In Tip 323, "Using Multiple Adjustment Layers Creatively," you learned how to work with multiple Adjustment layers. You can combine Adjustment layers with Blending modes to modify how the Adjustment layer performs. For more information on Blending modes, see Tip 687, "Working with Layer Blending Modes."

Say, for example, you open a washed-out image in Photoshop, as shown in Figure 326.1.

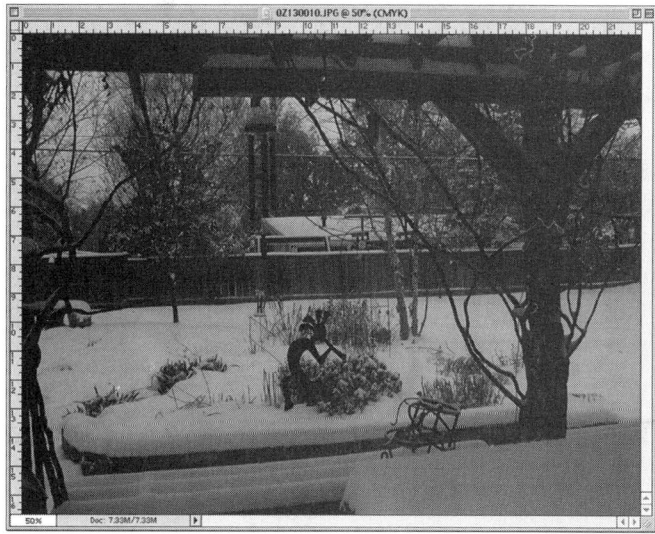

Figure 326.1 The open image contains washed-out highlights.

Washed-out images are common on overcast days when there is not enough sunlight to bring out the colors in the image. You want more saturation in the colors.

To use the Blending mode option with an Adjustment layer to correct this image, perform these steps:

1. Refer to Tip 322, "Understanding Adjustment Layers," and create a new Levels Adjustment layer, as shown in Figure 326.2.

Figure 326.2 The Levels Adjustment layer in the Layers palette.

2. Click the OK button to close the Levels dialog box.

3. Move your mouse into the Layers palette and click on the Blending mode button. Photoshop displays the Blending mode options, as shown in Figure 326.3.

Figure 326.3 The Blending mode options control how the Adjustment layer performs.

4. Select the Hard Light blending mode option. Photoshop closes the Blending mode options and applies the Hard Light option to the image, as shown in Figure 326.4.

Note: The Hard Light blending mode gives the visual appearance of shining a bright spotlight on the image.

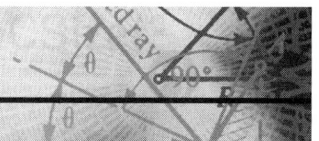

Figure 326.4 The Hard Light blending mode helps eliminate the washed-out appearance of the image.

327 *Working Smart with Adjustment Layers*

In the preceding four tips, you learned how to create and use Adjustment layers. Adjustment layers are a tremendously versatile tool for visually adjusting an image. Here are a few points to remember about adjustment layers:

- **Size:** Using Adjustment layers does not increase the size of a file. Normal layers contain visual pixels of information. Adjustment layers contain numerical data that instruct Photoshop how to visually change the image.

- **Flexibility:** Since Adjustment layers do not physically change the image, you have the control you need to experiment. Adjustment layers are saved with the image. Therefore, you can make adjustments to an image, save the file, and then reopen the image. The Adjustment layers stay separated from the image until you merge or flatten the layers.

- **Masks:** Adjustment layers come with their own layer masks (refer to Tip 325, "Using Masks with Adjustment Layers"). Layer masks control the areas of the image modified by the Adjustment layer.

- **Portability:** You can move an Adjustment layer from one document window into another open document. To move an adjustment layer between two open documents, click and drag the Adjustment layer from the Layers palette into the document window of another open graphic.

- **Position:** When you use Adjustment layers, their position within the Layers palette influences the adjustment. Moving up and down within the Layers palette changes how the Adjustment layer affects the visual image.

Using Adjustment commands is about control and flexibility: total control over the image at any stage of development and the flexibility to experiment.

328 *Setting the Highlights and Shadows Within an Image*

When you perform color correction on an image, one of the first things you want to do is set the highlights and shadows within the image. Identify and assign the highlights and shadows to the lightest and darkest areas within the image.

When you identify the lightest and darkest areas within an image, do not use areas devoid of information, such as pure black or pure white. Identify highlights and shadows as printable areas of the image, areas that contain some information. For instance, a pure white area on the image would not print any ink, and a pure black area would print pure black. Look for highlights and shadows containing information.

To set the highlights and shadows within an image, perform these steps:

1. Select the Eyedropper tool from the toolbox (refer to Tip 90, "The Eyedropper Tool").

2. Move your mouse into the Options bar and click the Sample Size button. Photoshop displays the Sample Size options, as shown in Figure 328.1.

Figure 328.1 The Sample Size options control how the Eyedropper samples color within the image.

3. Select 3 by 3 Average from the Sample Size options.

4. Select the Window menu and choose Show Info from the pull-down menu. Photoshop displays the Info palette.

5. Select Image menu Adjust and choose Curves from the fly-out menu. Photoshop opens the Curves dialog box, as shown in Figure 328.2.

Figure 328.2 The Curves dialog box sets the highlights and shadows within the active image.

6. Position the Curves dialog box so that you can see the Info palette and the entire image (see Figure 328.3).

7. Move your cursor around the document window until you identify the highlight areas of the image. The highlights are identified by their numeric values in the Info palette. If you are looking at the RGB portion of the Info palette, look for high numeric values. RGB numeric values range from 0 to 255. When you identify the image highlight, record the X and Y coordinates, as shown in Figure 328.3.

Figure 328.3 Record the X and Y coordinates of the image highlight.

8. Move your cursor around the document window until you identify the shadow areas of the image. The shadows are identified by their numeric values in the Info palette. If you are looking at the RGB portion of the Info palette, look for low numeric values. When you identify the image shadow, record the X and Y coordinates, as shown in Figure 328.4.

Figure 328.4 Record the X and Y coordinates of the shadow area of the image.

9. Double-click on the white eyedropper in the Curves dialog box. Photoshop opens the Color Picker. To correctly print an image onto white paper, change the RGB input values to 244, 244, 244, as shown in Figure 328.5. Click the OK button to close the Color Picker and record your changes to the Curves dialog box.

Figure 328.5 Changing the input values for the white eyedropper defines the highlight value for printing on white paper.

10. Double-click on the black eyedropper in the Curves dialog box to open the Color Picker. To correctly print an image onto white paper, change the RGB input values to 10, 10, 10, as shown in Figure 328.6. Click the OK button to close the Color Picker and record your changes to the Curves dialog box.

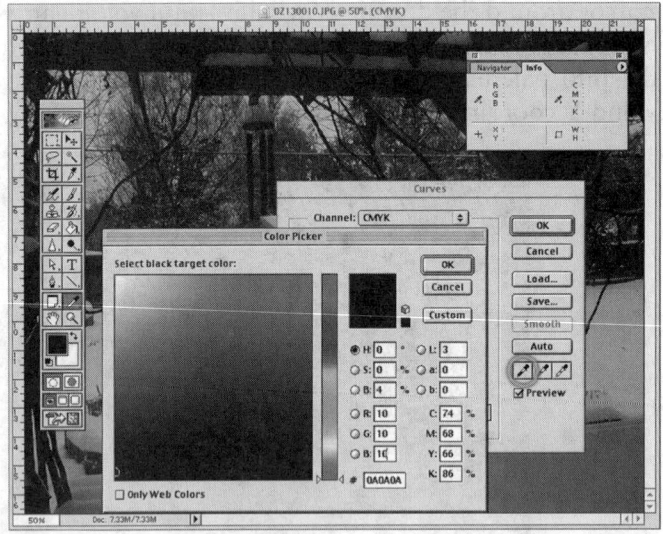

Figure 328.6 Changing the input values for the black eyedropper defines the shadow value for printing on white paper.

11. Click once on the white eyedropper and move your mouse into the document window. Using the X and Y coordinates you recorded for the highlight of the image, move your cursor over the highlight and click your mouse. Photoshop resets the highlight value within the image.

12. Click once on the black eyedropper and move your mouse into the document window. Using the X and Y coordinates you recorded for the shadow of the image, move your cursor over the shadow and click your mouse. Photoshop resets the shadow value within the image.

13. Once the highlight and shadow areas of the image are correctly set, the tonal range of the image readjusts and corrects the image, as shown in Figure 328.7.

Figure 328.7 The final image with corrected highlights and shadows.

14. If you made an error as to the location of the highlight and shadow areas of the image, hold down the Alt (Macintosh: Option) key to change the Cancel button to the Reset button. Click the Reset button and try again.

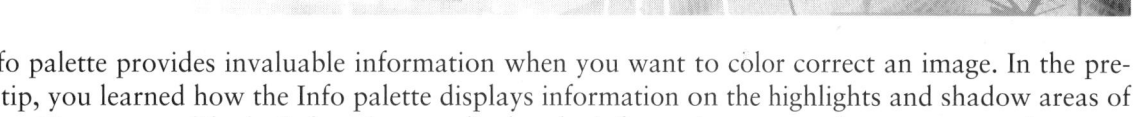

329 *Info Palette Shortcuts*

The Info palette provides invaluable information when you want to color correct an image. In the preceding tip, you learned how the Info palette displays information on the highlights and shadow areas of an image. You can modify the Info palette to display the information you need to correct any image.

The Info palette is divided into four sections. The top left and right sections display color information. The lower left displays X and Y coordinates that display the current position of your mouse. The bottom right displays width and height information.

The default options are RGB (top left), CMYK (top right), and X and Y coordinates and width and height measurements in inches, as shown in Figure 329.1.

Figure 329.1 The Info palette displays information on the current color state of the active image.

To quickly change the displayable options in the Info palette:

- **Color space:** To change the two available color spaces, click on one of the two Eyedropper icons. Photoshop displays the color mode options, as shown in Figure 329.2.

Figure 329.2 Click once on an Eyedropper icon to display a list of available color spaces.

To change to a different color space, click on one of the available options, as shown in Figure 329.3.

Figure 329.3 Clicking on the HSB color space changes the top left box.

- **X and Y coordinates:** Click on the plus sign icon to display a list of available measuring systems, as shown in Figure 329.4.

Figure 329.4 Changing the measurement system affects the X and Y coordinates and the width and height measurements.

330 Setting Color Measurement Points with the Eyedropper Tool

When you perform color correction on an image, it is important to know how much the pixels shifted from their original values. Photoshop lets you select measurement points within an image and monitor their changes.

To set color measurement points within an image, perform these steps:

1. Click and hold (or right-click) your mouse on the Eyedropper tool. Photoshop displays a list of available Eyedropper tools, as shown in Figure 330.1.

Figure 330.1 The Eyedropper tools in the Photoshop toolbox.

2. Click on the Color Sampler tool to make it the default eyedropper.

3. If the Info palette is not visible, select the Window menu and choose Show Info from the pull-down menu.

4. Move the Color Sampler eyedropper into the document window and click once to sample a portion of the image. The Info palette creates a box displaying the color value of the sample. To change to another color space, click on the Eyedropper icon and choose from the available options.

5. Click within the document to create additional sample points (maximum of four). Each time you click within the image, the Info palette creates another sample box, as shown in Figure 330.2.

Figure 330.2 The Color Sampler tool creates samples within the Info dialog box.

6. To move an existing sample point, click on the point and drag it to another position within the document window.

7. To delete an existing sample point, click on the point and drag it outside the document window.

8. When you modify an image using Levels or Curves, the sample point within the Info dialog box displays two values. The value on the left represents the original sample, and the value on the right represents the shift in the sample, as shown in Figure 330.3.

Figure 330.3 The Info palette displays information on the original and shifted values of the sampled pixels.

331 *Using an Adjustment Layer to Correct Lens Flare*

Occasionally, you take a Photograph that contains a bright halo of light. Light halos, or lens flares, are created when a strong light source bounces off the camera's lens, creating a halo of light. If the area encompassing the lens flare contains information, there is an easy way to correct the problem using a Levels Adjustment layer and the built-in mask.

To correct a lens flare in an image, perform these steps:

1. Select Layer menu New Adjustment Layer and choose Levels from the fly-out menu. Photoshop opens the Levels dialog box, as shown in Figure 331.1.

Figure 331.1 The Levels dialog box controls the brightness of the pixels in the image.

2. Click the middle Input Levels slider (the gray slider) and drag it to the right. As you drag the slider to the right, the image begins to darken. Continue dragging the slider to the right until the lens flare appears normal.

3. Click the OK button to close the Levels dialog box and record your changes to the image, as shown in Figure 331.2.

Figure 331.2 The Levels command corrects the lens flare but leaves the rest of the image too dark.

4. Press the letter "D" on your keyboard to change the default of the Foreground and Background colors to black and white.

5. Select the Paintbrush from the toolbox and select a medium-size, soft brush. Refer to Tip 78, "The Paintbrush and Pencil Tools."

6. Click once on the Levels Adjustment layer to make it the default layer.

7. Using your Paintbrush tool, paint with black to expose the original image. The color black acts like a mask to the Levels Adjustment layer. By painting with black around the outside of the lens flare, the original image is revealed, as shown in Figure 331.3.

Figure 331.3 The layer mask restores selected portions of the image to their original state.

8. Paint around the edges of the lens flare until the original image is restored (the black areas of the mask). The Levels Adjustment layer darkens the flare (the unpainted, or white, areas of the mask), as shown in Figure 331.4.

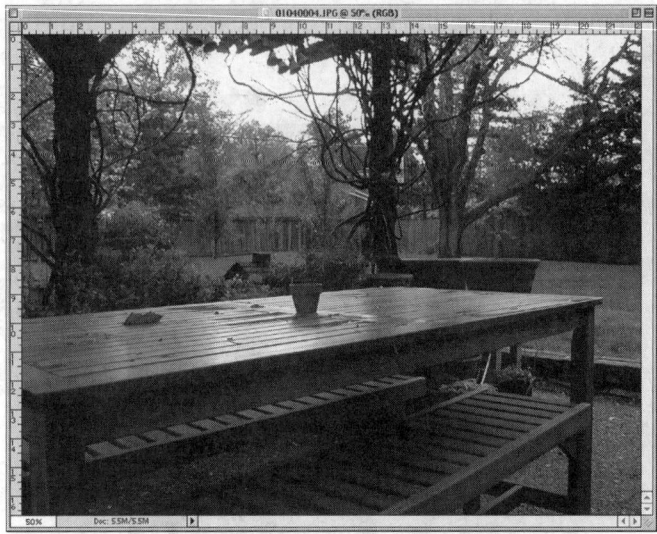

Figure 331.4 The Levels Adjustment layer and accompanying mask successfully removed the lens flare from the image.

332 *Increasing or Decreasing Shadows Using Selective Color*

In Tip 211, "Understanding the Selective Color Command," you learned how Selective Color controls output to a printing press. Selective Color works by increasing or decreasing a particular color within a document. Sometimes the shadows in an image look washed out. This is typically due to an overcast day or an indoor photograph without any strong lighting. Strong shadows help to emphasize elements within an image and make an otherwise dull image appear bolder.

To increase the shadow areas of an open Photoshop image, perform these steps:

1. Select Image menu Adjust and choose Selective Color from the fly-out menu. Photoshop opens the Selective Color dialog box, as shown in Figure 332.1.

2. Click once on the Colors option at the top of the Selective Color dialog box. Photoshop displays a list of available color selections, as shown in Figure 332.2.

3. Click on the Black option to make it the default color.

4. Click on the Relative radio button to make it the default method. The Relative option adjusts the color of the image based on the relative value of the ink. Say you start with a pixel that is 50 percent cyan and you move the Cyan slider to the right until the cyan input field displays +10. You have increased the cyan in the image by 5 percent because 10 percent of 50 percent is 5 percent.

5. Click on the Black triangular slider and drag the slider to the right to increase the black in the image. The farther you drag the black slider to the right, the darker the shadows.

6. Click the OK button to close the Selective Color dialog box and record your changes to the image.

Figure 332.1 The Selective Color command controls color by adding or subtracting specific colors from the image.

Figure 332.2 Clicking on the Colors option displays a list of all available color options.

Note: *When you increase the black in an image, black is added to an image on an increasing scale from the midtones to the dark shadows. This is not necessarily a bad thing because most images with dull shadows also contain washed out colors. Adding black to the image helps bring out the colors within the image and at the same time strengthens the shadows.*

333 *Using the Hue/Saturation Command to Apply Color to an Image*

Photoshop gives you several ways to change the overall color of an image: everything from using customized paintbrushes (Tip 635, "Colorizing a Black and White Image") to creating a duotone (Tip 848, "Manipulating Duotone Images"). However, one of the easier ways to add a tint to an image is by using

the Hue/Saturation command. The Hue/Saturation command works with images in the RGB, CMYK, Indexed, and Lab color spaces.

To apply a sepia tint to an image, perform these steps:

1. Select a brown or sepia color as your foreground color. If you are having difficulty locating a brown color, the default color set on the Swatches palette contains a series of brown colors, as shown in Figure 333.1.

Figure 333.1 The default Swatches palette contains a series of brown swatches.

2. Click on one of the brown swatches. Photoshop makes that swatch the foreground color.

3. Select the Image menu, then select Adjust and choose Hue/Saturation from the fly-out menu. Photoshop opens the Hue/Saturation dialog box, as shown in Figure 333.2.

Figure 333.2 The Hue/Saturation dialog box.

4. Select the Colorize check box. Photoshop colorizes the image based on the current foreground color, as shown in Figure 333.3.

5. Use the Saturation and Lightness sliders to control the intensity of the color.

6. Click the OK button to close the Hue/Saturation dialog box and record your changes to the image.

Figure 333.3 The Colorize option tints the image based on the current foreground color.

334 *Removing Selective Areas of Color with the Desaturate Command*

In advertising, getting the buyer's attention is the name of the game. Color is an excellent way to attract attention, but sometimes a lack of color can attract a wandering eye and focus the reader's attention.

One simple way to remove color from selective areas of an image is to use the Desaturate command within a selected area. In Figure 334.1, you want to remove the color from the surrounding areas of the image without changing the interior colors of the image.

Figure 334.1 To attract attention to the central area of the image you want to remove color from selective portions of the image.

Using your selection tools, select the areas of the image where you want the color removed. In this example, the Standard Lasso tool selected all the outer areas of the image (refer to Tip 280, "Selection Methods").

In order to make the selection edge blend in with the Desaturate command, choose the Select menu and choose the Feather command from the pull-down menu. Photoshop opens the Feather Selection dialog box, as shown in Figure 334.2.

Figure 334.2 The Feather Selection dialog box controls the visual sharpness of the selection edge.

In the Feather Radius input box, enter a value of 2, and click the OK button. Photoshop closes the Feather dialog box and records the changes to the image. A value of 2 creates a softer visual look to the edge of the selection.

Select Image menu Adjust and choose Desaturate from the fly-out menu. Photoshop removes the color from all the selected areas of the image, as shown in Figure 334.3.

Figure 334.3 The Desaturate command removes color from the selected areas of the image.

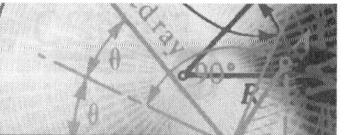

335 *Changing the Eyedropper Sample Rate for Greater Accuracy*

The Eyedropper tool is a sampler. When you click the Eyedropper within an open document, it takes a sample of the pixels and records that information in the Info palette.

To change the selection method used by the Eyedropper tool, open a graphic image in Photoshop and select the Eyedropper tool from the toolbox. Refer to Tip 90, "The Eyedropper Tool."

Click the Sample Size in the Options bar. Photoshop displays a list of available sampling options, as shown in Figure 335.1.

Figure 335.1 The Sample Size options control how the Eyedropper tool samples colors within an image.

- **Point Sample:** The Point Sample option samples the Hue, Saturation, and Brightness of the pixel directly under the eyedropper. Use Point Sample when an exact color match is required, as in selection of text or background colors.

- **3 by 3 Average:** Choose the 3 by 3 Average option to select the shadows and highlights within an image. The 3 by 3 Average option select a grid of pixels 3 tall by 3 wide and creates and averages the color of all nine pixels within the grid.

- **5 by 5 Average:** Choose the 5 by 5 Average option for large color areas in which an average of the color is more important than the selection of a specific color. The 5 by 5 Average option selects a grid of pixels 5 tall by 5 wide and creates and averages the color of all 25 pixels within the grid.

> *Note: When you sample an area of an image with the Eyedropper tool, Photoshop places the results of the sample in the Info dialog box and changes the foreground color in the toolbox to reflect the sampled area.*

336 *Correcting Red Eye in an Image*

We have all faced the problem of eliminating red eye from an image. Red eye occurs when a camera flash bounces inside your eye and reflects back to the camera. The red color of the blood vessels in your eye produces what we call "red eye."

Today's cameras come with options to reduce red eye, but the process is not always perfect, and sooner or later you will have to deal with an image containing red eye.

Some of the techniques to remove red eye involve removing all the color from the surrounding area and, in effect, grayscaling the red out of the eye. While this effect works, it is better if you try to restore the original color of the person's (or animal's) eye.

In Figure 336.1, the right eye of the model suffers from red eye. Removing the red from the right eye would eliminate one problem and create another.

Figure 336.1 The picture is perfect except for the red in the right eye of the model.

To eliminate the red eye in this image, you will use a technique used in Tip 333, "Using the Hue/Saturation Command to Apply Color to an Image."

1. Select the Eyedropper tool and set the Sample Size to a 3 by 3 Average (refer to the preceding tip).

2. Click the eyedropper on the color of the left eye. The color of the eye becomes the default foreground color.

3. Using the Elliptical selection tool, select the right eye, which contains the red (refer to Tip 71, "The Marquee Tools").

4. Select Image menu Adjust and choose Hue/Saturation from the fly-out menu. Photoshop opens the Hue/Saturation dialog box.

5. Click on the Colorize option. The selected area of the eye colorizes to match the foreground color.

6. Click and drag the Saturation slider left or right to increase or decrease the saturation of the ink.

7. Click OK to close the Hue/Saturation dialog box and record your changes to the image, as shown in Figure 336.2.

Figure 336.2 The Colorize option in the Hue/Saturation dialog box successfully corrected the red eye in the image.

337 *Creating a Customized Pattern*

Photoshop 6.0 comes with several sets of preset patterns. You can use patterns to create tiled Web sites, to fill areas of an image with a specific pattern, or simply to create a light background for a brochure or newsletter. While the preset patterns are useful, eventually you will want to create your own customized patterns.

To create a customized pattern, open Photoshop and perform these steps:

1. Select the File menu and select New from the pull-down menu. Photoshop opens the New dialog box, as shown in Figure 337.1.

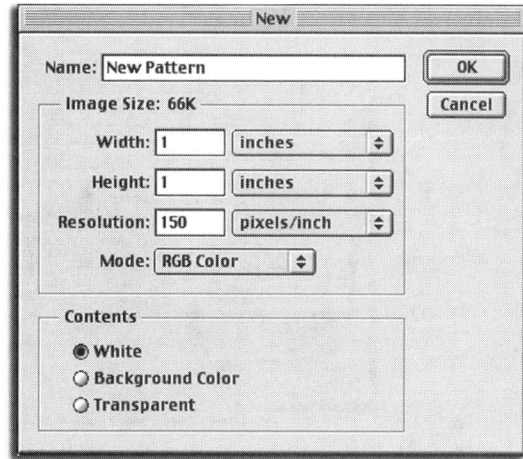

Figure 337.1 The New dialog box in Photoshop lets you define the characteristics of the new document.

2. Create a new file with the following characteristics:

 - **Width and Height:** 1 inch

 - **Resolution:** 150 pixels/inch

 - **Mode:** RGB

 - **Contents:** White

3. Click the OK button. Photoshop closes the New dialog box and creates a new document according to your specifications.

4. Create a pattern within the document window, as shown in Figure 337.2.

Figure 337.2 Creating a design within the document window.

5. Select the Edit menu and choose Define Pattern from the pull-down menu. Photoshop opens the Pattern Name dialog box, as shown in Figure 337.3.

Figure 337.3 You can define the name of the new pattern in the Pattern Name dialog box.

6. In the Name input field, type the name of the new pattern. Pattern names are limited to 32 alphabetic or numeric characters.

7. Click the OK button. Photoshop closes the Pattern Name dialog box and saves your pattern in the Custom Pattern palette, as shown in Figure 337.4.

Figure 337.4 The Custom Pattern palette displays thumbnails of all available patterns.

For information on applying a customized pattern to an image, see Tip 340, "Using the Fill Command with a Customized Pattern."

338 *Adjusting the Color in an Image Using Channel Mixer*

The Channel Mixer command controls the color in an image by adding or subtracting inks from individual channels (refer to Tip 212, "Working with the Channel Mixer Command"). The Channel Mixer command is unique in that it does not mix the colors between channels; it simply increases or decreases a particular channel's ink. While this gives you complete control over the ink within an image, it makes it difficult to control the final look of the image without a thorough knowledge of the color wheel. For this reason, the Channel Mixer is not used extensively for color correction but for color tinting.

To color tint an image using the Channel Mixer command, open a graphic image in Photoshop and perform these steps:

1. Select the Image menu, then select Adjust and choose Channel Mixer from the pull-down menu. Photoshop opens the Channel Mixer dialog box, as shown in Figure 338.1.

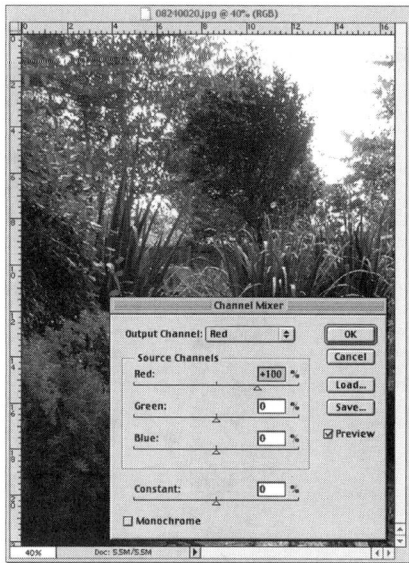

Figure 338.1 *The Channel Mixer modifies an image by adding or subtracting the inks in the individual color channels.*

2. Select the Monochrome check box. Photoshop converts the image into shades of gray.

3. Select the Monochrome check box again to remove the check mark. The graphic remains a grayscale image, as shown in Figure 338.2.

4. Click on the Output Channel option and choose from the available options. If the image is CMYK, the options are cyan, magenta, yellow, and black. If the image is RGB, the options are red, green, or blue, as shown in Figure 338.3.

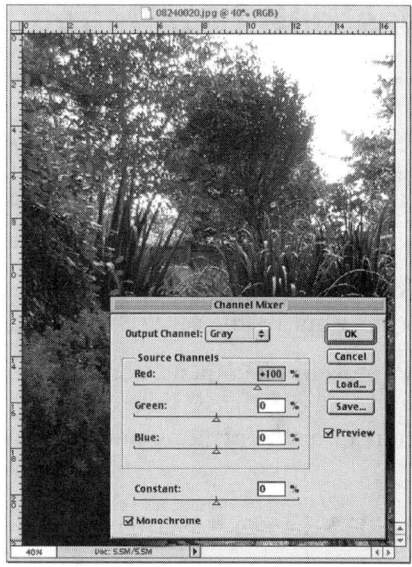

Figure 338.2 *Selecting and then deselecting the Monochrome option coverts the colors into shades of gray.*

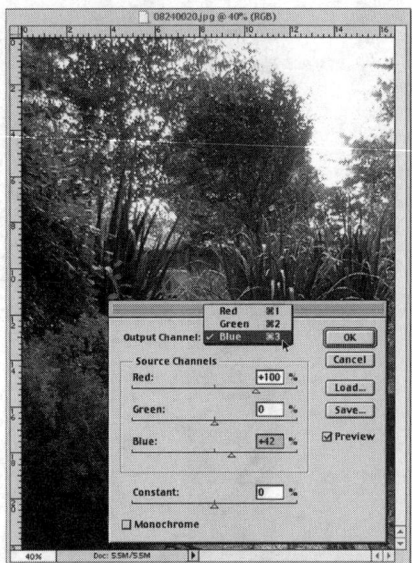

Figure 338.3 The Output Channel button displays a list of all available color channels.

5. To change the overall tint of the image, click the color sliders (either red, green, and blue or cyan, magenta, yellow, and black) and drag them left or right. Moving the sliders to the right increases the named color, and moving the sliders to the left decreases the named color.

6. Click the OK button to close the Channel Mixer dialog box and record your changes to the image.

339 *Using Photoshop's Trap Option*

After you have converted an image to CMYK, you can adjust the color trap. Trap is the overlap needed to ensure that a slight misalignment or movement of the plates while printing does not affect the final appearance of the print job. If different colors in your image touch, you need to overprint them slightly to prevent tiny gaps from appearing when the image is printed.

Trapping is the technique of overprinting two colors. The trapping of the colors within an image is not controlled by a specific formula but by the service bureau performing the final printing of the image.

To create a trap within a Photoshop document, perform these steps:

1. Contact your service bureau or the printing house performing the final print and ask how much to set the trap.

2. If the graphic is not a CMYK image, select the Image menu, then choose Mode and choose CMYK from the fly-out menu. Photoshop converts the inks in the image to CMYK (cyan, magenta, yellow, and black).

3. Select the Image menu and choose Trap from the pull-down menu. Photoshop opens the Trap dialog box, as shown in Figure 339.1.

Figure 339.1 *The Trap dialog box controls the overlapping of colors to control the misalignment of the plates on a four-color (CMYK) printing press.*

4. Click in the Width input field and enter the value given to you by your service bureau.

5. Click on the measurement option and select the option recommended by your service bureau, as shown in Figure 339.2.

Figure 339.2 *The measurement option displays a list of available measuring options.*

6. Click the OK button to close the Trap dialog box and record the changes to the image.

Note: The Trap option is only available for CMYK images and only works on images printed on a printing press. Printing presses use separate plates to define the colors within the image.

340 *Using the Fill Command with a Customized Pattern*

The Fill command lets you fill a layer or a selected area with a color, history state, or pattern. Patterns are saved designs that are applied to the image in a grid-like pattern. If you imagine a wall made up of perfectly square or rectangular bricks, you have a good idea of how patterns are applied to a Photoshop image.

In Figure 340.1, you want to modify the background by changing the wallpaper. To fill the background with a Customized pattern, perform these steps:

1. Select the areas of the image you want to change. In this example, the Lasso tools were used to select the wallpaper background (refer to Tip 280, "Selection Methods").

2. Select the Edit menu and choose the Fill option from the pull-down menu. Photoshop opens the Fill dialog box, as shown in Figure 340.1.

Figure 340.1 The Fill dialog box lets you fill a layer or selected area with a color, History State, or pattern.

3. Click on the Use option and select Pattern from the available options.

4. Click on the Custom Pattern option to display a list of available options, as shown in Figure 340.2.

Figure 340.2 The Custom Pattern option displays a list of available patterns.

5. Choose a pattern. In this example, a custom pattern was selected. To learn more about creating customized patterns, refer to Tip 337, "Creating a Customized Pattern."

6. Click the OK button. Photoshop closes the Fill dialog box and fills the selected area with the custom pattern, as shown in Figure 340.3.

Note: Depending on the selection, feathering the selection before applying the Fill command can help blend the fill pattern into the original image.

Figure 340.3 The Fill command filled the selected area with the custom pattern.

341 *Understanding the Concept of Layers*

When layers were introduced to Photoshop in version 3.0, it changed how designers work. Before layers, designers made changes to an image by painting or applying a filter directly to the image. Although this process worked, it limited what you could do, and it limited the control you had over the image. To apply a simple shadow to a graphic, you had to paint the shadow directly onto the image.

Layers changed everything. Now, creating a shadow is as simple as creating a layer and applying the shadow to the layer. Color corrections, adjustments, and even filters are now applied to separate layers, giving you total control over the creative process.

Layers, by definition, are separate pieces of clear plastic. Each layer has the ability to hold its own set of inks or adjustments. In Photoshop, you have regular layers, Adjustment layers, Effects layers, Fill layers, and Text layers.

- **Regular layers:** Regular layers are thin sheets of clear plastic. Each sheet lays directly over the original image. Layers are where everything happens in Photoshop. When you create a new layer, all of your painting tools apply ink within the selected layer, filters, and adjustments occur within the selected layer, and everything in Photoshop is accomplished on a layer-to-layer basis. Layers are created and selected from the Layers palette, as shown in Figure 341.1.

Figure 341.1 Clicking the New Layer icon automatically generates a new layer.

- **Adjustment layers:** Photoshop uses Adjustment layers to control image editing. When you use an Adjustment layer, you do not modify the original image; all adjustments occur within the specific Adjustment layer. The available options for Adjustment layers are Levels, Curves, Color Balance, Brightness/Contrast, Hue/Saturation, Selective Color, Channel Mixer, Gradient Map, Invert, Threshold, and Posterize. Adjustment layers are created and selected from the Layers palette, as shown in Figure 341.2.

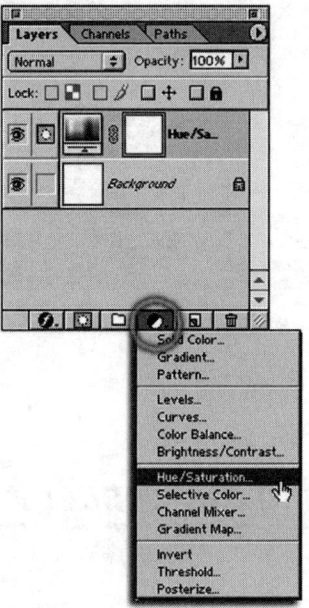

Figure 341.2 Click the New Fill/Adjustment Layer icon to generate a new Adjustment layer.

- **Effects layers:** Effects layers apply special effects to a layer without having to create the effects from scratch. The available options for Effects layers are Drop Shadow, Inner Shadow, Outer Glow, Inner Glow, Bevel and Emboss, Satin, Color Overlay, Gradient Overlay, Pattern Overlay, and Stroke. Effects layers are created and selected from the Layers palette, as shown in Figure 341.3.

Figure 341.3 Clicking the Add a layer style icon generates a new Effects layer.

- **Fill layers:** Fill layers are regular layers with an applied fill. The available options for Fill layers are Solid Color, Gradient, and Pattern. Fill layers are created and selected from the Layers palette, as shown in Figure 341.4.

Figure 341.4 Click the New Fill/Adjustment Layer icon to generate a new Fill layer.

- **Text layers:** Photoshop generates text within Text layers. Text, when entered into a Text layer, can be retyped or modified, giving you total control. Text layers are automatically created when you select the Type tool and click in the document window, as shown in Figure 341.5.

Figure 341.5 Selecting the Type tool and clicking within the document window automatically creates a new Text layer.

342 *Restacking Layers*

When you create a layer in Photoshop (refer to the preceding tip), the new layer appears in the Layers palette directly above the previously selected layer. This holds true for whatever type of layer you create. If you plan correctly, you always select the layer directly below where you want the new layer to appear, as shown in Figure 342.1.

Photoshop lets you create up to 8,000 layers, so no matter how careful you are, eventually you will want to change the stacking order of the layers within the Layers palette.

To change the position of a layer within the Layers palette, click and drag the layer up or down. When you see a dark line appear beneath the layer you want to drag under, release your mouse. Photoshop will move the selected layer to the new position, as shown in Figure 342.2.

Figure 342.1 New layers appear directly above the previously selected layer.

Figure 342.2 Clicking and dragging a layer lets you move it to another position within the Layers palette.

Note: *You cannot drag a layer below the background. See Tip 346, "Backgrounds vs. Layers," for information on the differences between the background and layers.*

343 *Hiding and Showing Layers*

Complicated Photoshop images require numerous layers. You have Adjustment layers, Text layers, and Effects layers all combined to create the final graphic images. There are times when you need to work on a particular layer without the distraction of the other layers.

To show or temporarily hide a layer within Photoshop, click on the Layer Visibility icon, as shown in Figure 343.1.

Thing to remember about hidden layers:

- The Visibility icon is a toggle switch. Clicking on the icon changes the state of the layer from visible to hidden.

- If a layer is hidden, it cannot be edited even if the layer is selected.

- When an Adjustment layer is hidden, the effects of the adjustment are removed from the visible image.

Figure 343.1 The Visibility icon controls when the layer is visible or hidden.

- When you choose Flatten Image from the Layers palette options, Photoshop opens a warning box and asks you if you want to discard the hidden layers. If you choose OK, Photoshop flattens the image and removes all the hidden layers.

- If you select a hidden layer, Photoshop automatically makes the layer visible.

344 *How Multiple Layers Relate to a Document's File Size*

One very important item to remember about adding layers to a Photoshop file is that additional layers increase the size of the file. When you create a new layer using the New Layer icon (refer to Tip 341, "Understanding the Concept of Layers"), the file size does not increase because the new layer does not contain any digital information.

Say, for example, you create a new layer in a Photoshop document. The image size remains the same, as shown in Figure 344.1.

Photoshop increases the size of the file only after you add elements to the layer. In Figure 344.2, the Paintbrush tool was used to create a white line across the new layer. The paint stroke added information to the image, and Photoshop increased the file size to store that new information.

When you fill an additional layer with a solid color, Photoshop does not increase the size of the file. Since you are doubling the amount of digital information in the image, you would expect Photoshop to double the size of the file. The exact opposite is true. When you create a new layer containing a solid color, the file size does not increase.

Photoshop stores digital information in the same way GIF images are compressed (see Tip 729, "Understanding File Compression in ImageReady"). When you add information to the image, such as the paint stroke in Figure 344.2, Photoshop stores the data based on the number of colors and the area filled with the paint. When you fill a layer with a single color, although there may be tens of thousands of pixels within the image, Photoshop only has to remember what one pixel looks like. It then fills the entire layer using that template, as shown in Figure 344.3.

Note: Although creativity knows no boundaries, understand that graphics with fewer colors create smaller file sizes, and that will help when you create graphics for computerized slide presentations and Web graphics.

Figure 344.1 Creating a new blank layer in Photoshop does not increase the size of the file.

Figure 344.2 When information in the form of a paint stroke is added to the new layer, the document file size is increased.

Figure 344.3 Filling a layer with a solid color does not increase the file size of the document.

345 *Working with the Blend If Option to Create Transparency*

A unique feature of a layer is the ability to temporarily create transparent areas without actually erasing the original pixels. You can combine two layers together: One layer contains a lightning strike and the other layer contains some clouds, as shown in Figure 345.1.

Figure 345.1 Two layers that contain nontransparent pixels.

To remove the blue sky from the lightning layer without erasing the pixels, double-click on the lightning layer. Photoshop opens the Layer Style dialog box, as shown in Figure 345.2.

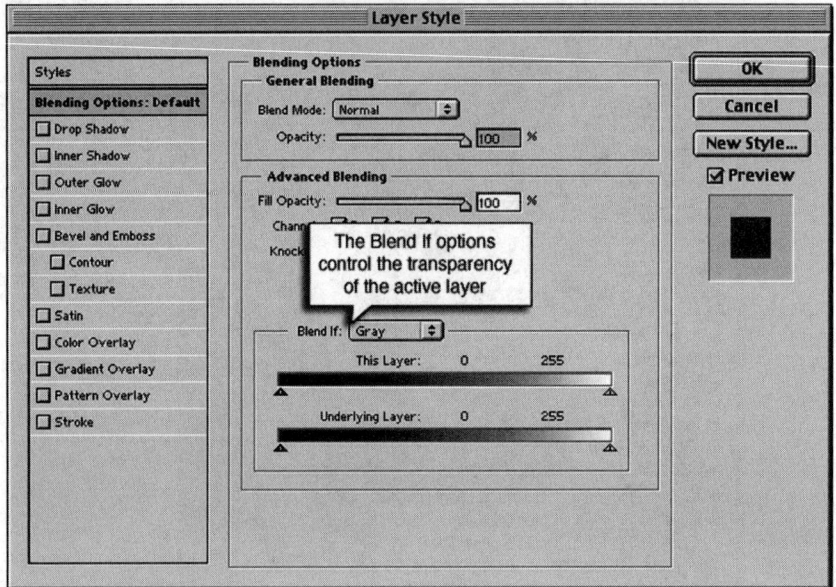

Figure 345.2 The Layer Style dialog box controls the transparency of the pixels within the selected layer.

The Blend If options, located at the bottom of the Layer Style dialog box, control the transparency of the pixels within the selected layer. Photoshop controls the pixels by referencing the luminosity of each pixel. Each pixel in Photoshop contains a number that indicates its brightness. The brightness, or luminosity, of the pixel is a value from 0 to 255. A value of 0 indicates a black pixel, and a value of 255 indicates a white pixel. Values of 2 to 244 indicate brightness of the pixel. In a black and white image, the values 2 to 244 indicate shades of gray; in a color image, they indicate a shade of a particular color.

Click on the Blend If button. Photoshop displays a list of available options, as shown in Figure 345.3.

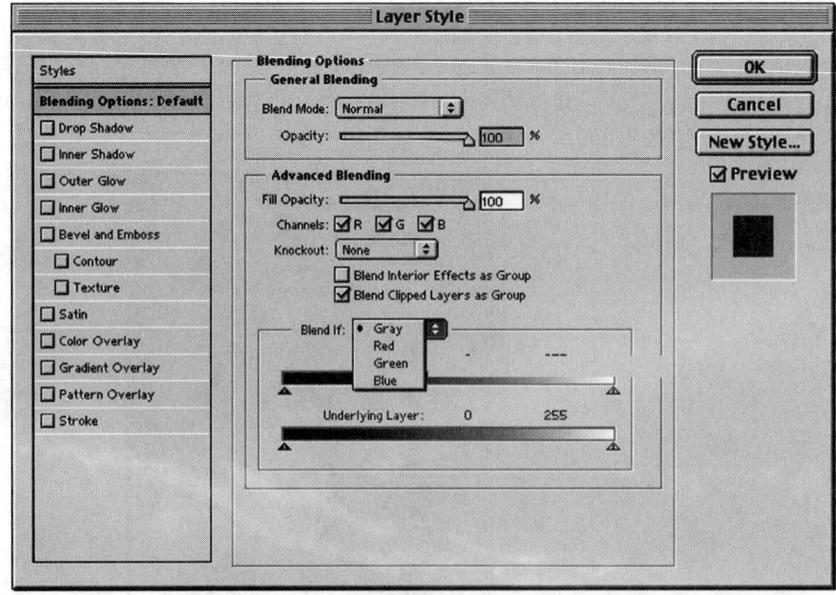

Figure 345.3 The Blend If button displays a list of available blending options.

In Figure 345.3, the available blending options are Gray, Red, Green, and Blue. Images saved in different color modes display options based on their channels. If you open a CMYK (cyan, magenta, yellow, and black) color image, the available Blend If options are gray, cyan, magenta, yellow, and black.

When you select the Gray Blend If option, Photoshop uses luminosity to determine what pixels to make transparent. When you choose a specific color, Photoshop uses the values of the pixels based on the specific color channel.

In this example, you want to eliminate pixels based on their brightness, so the Gray option is selected.

To make the darker image pixels transparent, click on the black triangle slider located underneath the This Layer option and drag it to the right. As you drag the black slider to the right, the zero input field increases and the dark pixels representing the sky become transparent. Keep dragging the black slider to the right until all the dark pixels (the sky) become transparent, as shown in Figure 345.4.

Figure 345.4 Clicking and dragging the black slider to the right causes the dark image pixels to go transparent.

In Figure 345.4, the Input value of the black slider is 183. This instructs Photoshop to make all pixels with a value of 0 to 183 transparent. Every pixel from 184 through 255 remains visible. If you want to make the lighter-value pixels transparent (in this example, the lightning), move the white triangular slider to the left.

Notice that there are two grayscale sliders, This Layer and Underlying Layer (refer to Figure 345.2). In the preceding example, you used the This Layer option to control the visibility of the pixels in the lightning layer. The Underlying Layer option also controls the pixels in the lightning layer but not by the luminosity of the pixels in the lightning layer. Underlying Layer controls the visibility of the pixels in the lightning layer based on the pixels in the underlying layer.

Say you want the lightning to come out of the clouds as opposed to laying on top of the clouds (refer to Figure 345.2). To make the lightning go into the clouds, click on the white triangular slider located under the Underlying Layer option and drag it to the left. As you drag the slider to the left, the lightning laying directly over the white clouds becomes transparent, as shown in Figure 345.5.

Note: *The Blend If option gives you control over what you see without erasing the image. This is just one more way in which Photoshop gives you the control you need to be creative.*

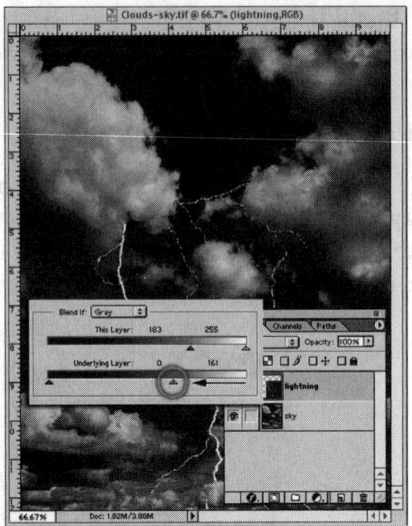

Figure 345.5 The Underlying Layer option controls the visibility of the pixels in the lightning layer
based on the luminosity of the pixels in the underlying layer.

346 Backgrounds vs. Layers

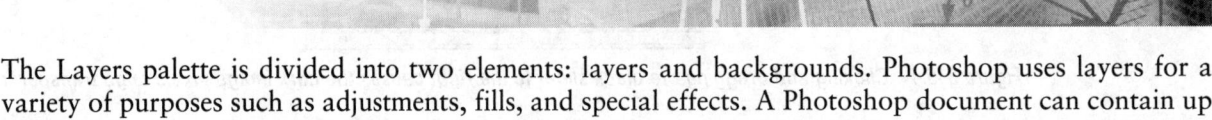

The Layers palette is divided into two elements: layers and backgrounds. Photoshop uses layers for a variety of purposes such as adjustments, fills, and special effects. A Photoshop document can contain up to 8,000 layers, and each one layer represents a single element of the whole image.

Backgrounds are unique to a graphic image; Photoshop allows for a maximum of one background. Backgrounds cannot be special effects layers, and they cannot be moved. If your Photoshop document contains a background, it will be the bottom layer in the Layers palette. Backgrounds share some similarities with layers: Editing and painting tools work on layers and backgrounds. Filters also work in a similar fashion when applied to a layer or a background. The major difference between a background and a layer is that a background cannot contain transparent pixels.

When you select the Eraser tool from the Photoshop toolbox and erase a portion of a background, the pixels fill with the Background Color Swatch, as shown in Figure 346.1.

When you use the Eraser tool on a layer, the image pixels convert to transparent, as shown in Figure 346.2.

Figure 346.1 Using the Eraser tool in a background fills the erased pixels with the current Background Color Swatch.

Figure 346.2 Using the Eraser tool in a layer converts the erased pixels to transparent.

347 *Working with a Layered Document File*

In Tip 344, "How Multiple Layers Relate to a Document's File Size," you learned that the more layers there are in a Photoshop image, the larger the document's file size. Since larger file sizes require more time for Photoshop to process, it is important to plan out any complicated Photoshop document.

Things to remember about working with layers:

- Blank layers do not consume file space; it is what is in the layer that increases the size of the file.

- Adjustment layers do not increase the size of a Photoshop document.

- When generating special effects such as bevels and shadows, using Photoshop's Effects layers takes up less file space than creating the special effects from scratch.

- When you work on a complicated multi-layered document, create portions of the image in separate document files and combine the layers together at the end of the project (see Tip 349, "Adding Layers to an Image from Another Document").

- Combine multiple layers together to save space (see Tip 375, "Merging the Visible Layers").

- To save time, try experimenting with complicated filters and adjustments on low-resolution versions of the original image. When you get the effect you want, apply the filter or adjustment to the original image.

- CMYK files are larger than RGB files. If possible, work on the image using the RGB color mode and convert the image to CMYK at or near the end of the project.

All of these tips do not make for a better graphic image; however, since file size relates to processing time, working smart enables you to get more done in the same amount of time.

348 *Viewing and Selecting Layers*

When you work with multiple layers in a Photoshop document, be aware that the transparent areas of the image let you see through to the underlying layers. When setting up a Photoshop document, the Layers palette displays the image layers in a top-down perspective. You take the position of looking through the layers from the top through to the bottom. To select a layer, click once on the layer element in the Layers palette, as shown in Figure 348.1.

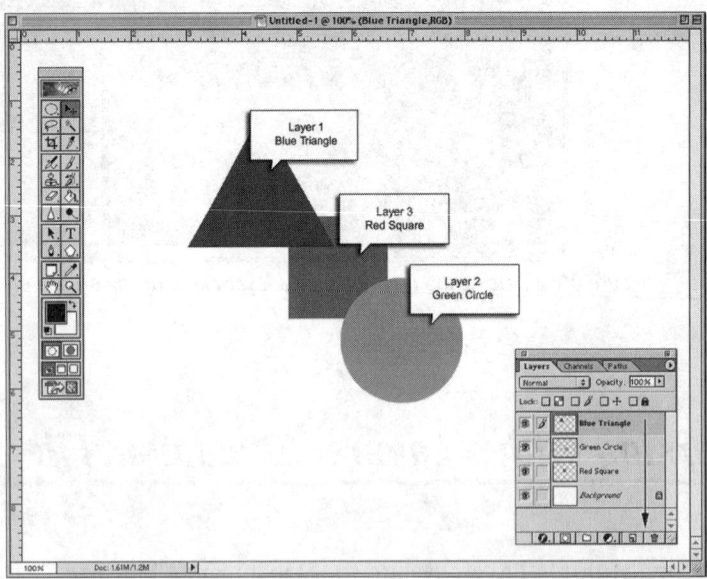

Figure 348.1 The Layers palette displays all layers using a top-down perspective.

When you create a new layer, the Layers palette creates a new element that describes the position and type of layer. The stacking order of the layer is determined by its physical position within the Layers palette, and the layer type is determined by special icons assigned to the layers, as shown in Figure 348.2.

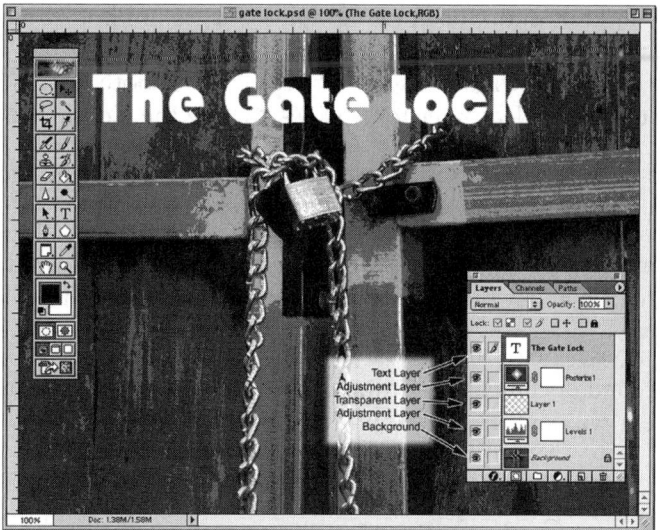

Figure 348.2 The Layers palette displays each layer's position and type.

At the far left of the layer element, a small thumbnail illustrates what is contained within the layer. To change a layer thumbnail, click on the black triangle in the upper-right corner of the Layers palette. Photoshop displays the Layers palette options. Select Palette Options and Photoshop displays the Layers Palette Options dialog box, as shown in Figure 348.3.

Figure 348.3 The Layers Palette Options dialog box controls the characteristics of the layer thumbnail.

Select the Palette Options radio buttons to change the size of the thumbnail or select None to remove all of the thumbnails from the palette. Since the layer thumbnail requires time to display, the larger the thumbnail selected, the longer it takes Photoshop to display the information in the Layers palette.

349 *Adding Layers to an Image from Another Document*

One of the great advantages to working in Photoshop is the ability to move layers between two open document windows. The ability to move image layers between document windows gives you control over your work and lets you add elements to an existing graphic image with ease.

To move a layer in Photoshop, open two graphic images in Photoshop, and perform these steps:

1. Position the document windows so you have access to both images. Reduce the view size of the document windows if needed (refer to Tip 183, "Using the Zoom Tool Correctly").

2. If the Layers palette is not visible, select the Window menu and choose Show Layers from the pull-down menu. Photoshop opens the Layers palette.

3. Click once in the document window containing the layer you want to move. The Layers palette displays information about the selected document window, as shown in Figure 349.1.

4. Move your mouse cursor into the Layers palette, click once on the layer you want to move, and drag it into the second document window. Photoshop automatically creates a copy of the layer in the second document window, as shown in Figure 349.2.

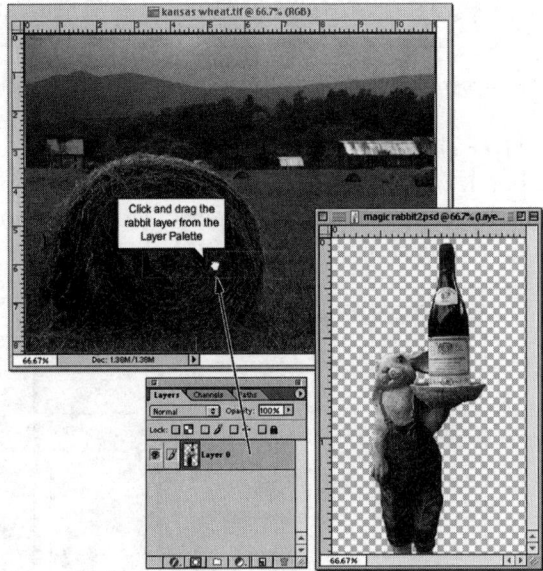

Figure 349.1 The Layers palette displays the layers within the active document window.

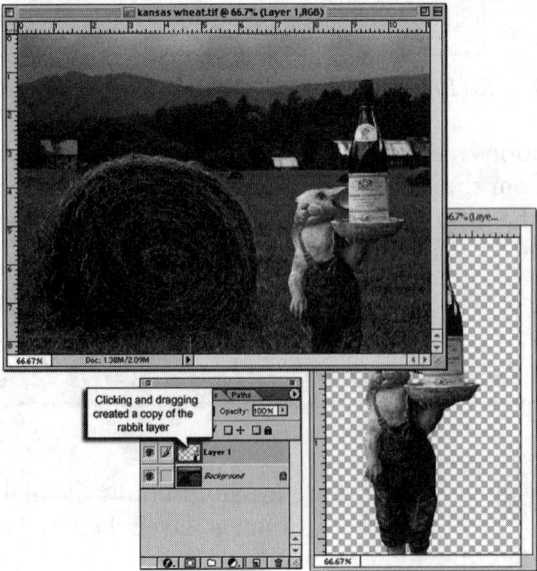

*Figure 349.2 Clicking and dragging a layer from the Layers palette into another open
document window automatically creates a copy of the layer.*

When moving a layer into another document window:

- The two document windows do not have to be the same width and height.

- The two document windows do not have to have the same resolution. If you drag a layer with a resolution of 150ppi into a document window with a resolution of 300ppi, the copied layer appears half the size of the original. If you drag a layer into a document with a lower resolution, the copied image increases in size, depending on the difference in resolution between the two document windows.

- The two documents do not have to be in the same color mode. If you drag a layer from an RGB document into a CMYK document, the moved layer takes on the color mode of the receiving document and automatically converts to CMYK.

- If you hold down the Enter key when you drag a layer, the copied layer centers itself within the new document window.

350 *Using the Auto Select Layer Option*

Photoshop uses the concept of a working layer. When you select the Paintbrush tool and drag it across the document window or when you apply a filter or adjustment, the changes to the image occur within the active layer. When you work in a multi-layered Photoshop document, it is important to keep an eye on the Layers palette. Otherwise you might realize, too late, that the work you did to the image was applied to the wrong layer.

Photoshop 6.0 takes you a step closer to working faster and smarter with an option called Auto Select Layer. To access the Auto Select Layer option, choose the Move tool from the Photoshop toolbox and click in the Auto Select Layer check box, as shown in Figure 350.1.

Figure 350.1 The Auto Select Layer option lets you select and move graphic information within a Photoshop multi-layered document.

When you click on any visible item within the document window, the Auto Select Layer option selects the layer containing the visible item, as shown in Figure 350.2.

In Figure 350.2, the document window contains three layers, each holding a visible element. With the Auto Select Layer option selected, clicking once on the red square selects the Red Square layer, clicking once on the green circle selects the Green Circle layer, and clicking on the Blue Triangle selects the blue triangle layer. Once the item is selected, you can click and drag your mouse to reposition the item.

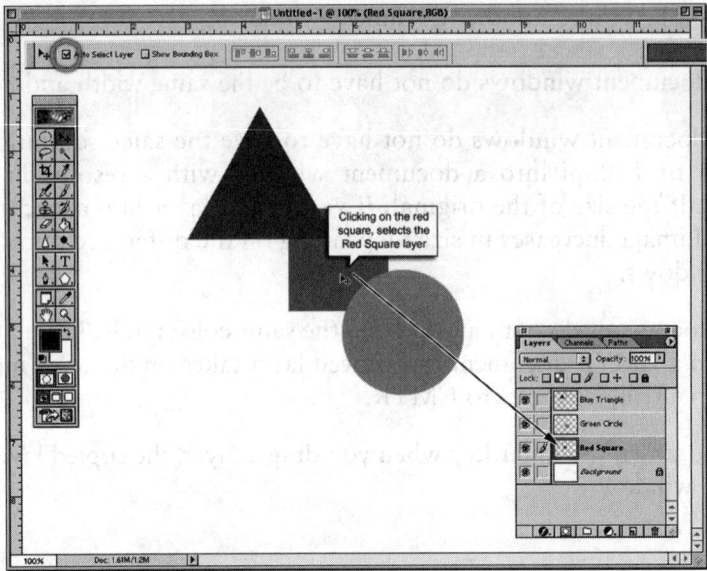

Figure 350.2 Clicking on a visible piece of information within a multi-layered document automatically selects the layer holding that information.

351 *Quickly Selecting Nontransparent Areas on a Layer*

Images in a Photoshop layer are composed of digital information and transparent pixels. The digital information is the visible portion of the layer. The pixels in the visible portion of an image have color information assigned to them. You see an image or a piece of clip art within the layer; Photoshop sees pixels assigned a particular color and brightness. The pixels in the layer that do not have any color or brightness information assigned to them are the transparent areas of the layer. Photoshop displays transparent pixels within an image by displaying a tablecloth pattern, as shown in Figure 351.1.

Figure 351.1 The tablecloth pattern defines the transparent areas of the layer.

To quickly select all the nontransparent areas of an image, open an image containing transparent and nontransparent areas (refer to Figure 351.1) and perform these steps:

1. If the Layers palette is not visible, select the Window menu and choose Show Layers from the pull-down menu. Photoshop displays the Layers palette.

2. Move your mouse cursor into the Layers palette, hold down the Ctrl (Macintosh: Command) key, and click once on the layer. Photoshop selects all the nontransparent pixels within the selected layer, as shown in Figure 351.2.

3. Once the nontransparent pixels are selected, that area becomes your work area. All editing and adjustments occur within that selected area.

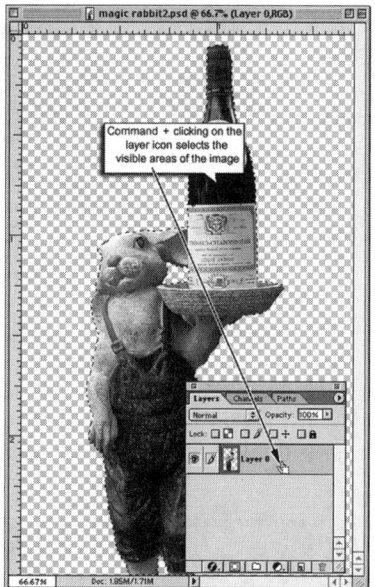

Figure 351.2 Clicking on a layer while holding down the Ctrl (Macintosh: Command) key selects all the nontransparent pixels within the layer.

352 *Quickly Masking Transparent Areas of a Layer*

In the preceding tip, you learned to quickly select the nontransparent areas of an image. Selected areas within a document window control the work area for all of Photoshop's tools and adjustments.

There are times, however, when you want to mask the nontransparent areas within a specific layer. Masking of nontransparent areas restricts what pixels are visible. Creating a mask over the nontransparent areas of an image gives you control to modify the entire layer while viewing a single area defined by the mask.

To create a mask over the transparent areas of an image, open a graphic containing transparent and nontransparent pixels and perform these steps:

1. Click on the selected layer while holding down the Ctrl (Macintosh: Command) key. Photoshop selects all the nontransparent areas of the layer (refer to the preceding tip).

2. Click on the Mask icon at the bottom left of the Layers palette. Photoshop creates a mask based on the unselected areas (transparent) of the image, as shown in Figure 352.1.

Figure 352.1 Clicking the Mask icon generates a mask over the nonselected portions of the layer.

3. Although the image appears the same, you now have a mask covering the transparent portions of the image.

4. Your painting and adjustment tools affect the entire image; however, you will only see the effects within the unmasked areas of the image, as shown in Figure 352.2.

Figure 352.2 Clicking and dragging a paintbrush across a layer containing a mask affects the entire image; however, the mask limits what is displayed.

For more information on using masks, refer to Tip 152, "Understanding Masks in Photoshop."

353 *Distributing Linked Layers*

When you work with multiple layers, each layer contains a piece of information. In a real sense, layers are puzzle pieces that, when assembled, create an image. There are times when you have several layers containing separate pieces, and you want to evenly distribute the information across the document window. Photoshop's Distribute options let you rearrange the visible pieces of an image.

The Distribute commands work with two or more layers that contain transparent and nontransparent information, as shown in Figure 353.1.

Figure 353.1 This image contains several layers, each one with a small visible object.

To evenly distribute the graphics within the layers, perform these steps:

1. Click in the link box to link all the individual layers together, as shown in Figure 353.2. For more information on linking layers, see Tip 356, "Linking Layers Together." Note: Since the background is, by default, locked, linking the background to another layer prevents you from using the redistribute action.

Figure 353.2 Clicking in the linking box of a layer links the layer to the currently selected layer.

2. Select the Move tool from the toolbox. The Options bar displays the options available for the Move tool. At the far right of the Options bar are the Align and Distribute buttons, as shown in Figure 353.3.

Figure 353.3 The Align and Distribute buttons let you rearrange the image information within all the linked layers.

3. Click on Distribute Vertical Centers. Photoshop distributes the items from top to bottom, as shown in Figure 353.4.

Figure 353.4 Clicking Distribute Vertical Centers equally distributes the space between graphics.

4. The Distribute Vertical Centers option measures the vertical distance between the top and bottom graphics and distributes the remaining graphics equally within that space.

5. To change the distance between the images, change the vertical position of the top and bottom graphics before selecting the Distribute Vertical Centers option.

Using the Distribute options gives you control over the pixels in a Photoshop document in a way once reserved for object-oriented programs like Adobe Illustrator. Although all Photoshop layers contain the same number of pixels, the Distribute options work only on the visible portions of the layer.

354 *Aligning Linked Layers*

In the preceding tip, you learned how to distribute images contained within separate layers. Photoshop also lets you align the visible parts of an image using the vertical and horizontal align options.

Figure 354.1 shows several layers containing different graphic images. You want to vertically align the items within the layers.

To align the graphics in Figure 354.1, perform these steps:

1. Click in the link box to link all the individual layers together, as shown in Figure 354.2. For more information on linking layers, see Tip 356, "Linking Layers Together."

2. Select the Move tool from the toolbox. The Options bar displays the options available for the Move tool. At the far right of the Options bar are the Align and Distribute buttons, as shown in Figure 354.3.

3. Click on the Align horizontal centers button (see Figure 354.3). Photoshop aligns the graphic images according to the horizontal centers of each graphic image, as shown in Figure 354.4.

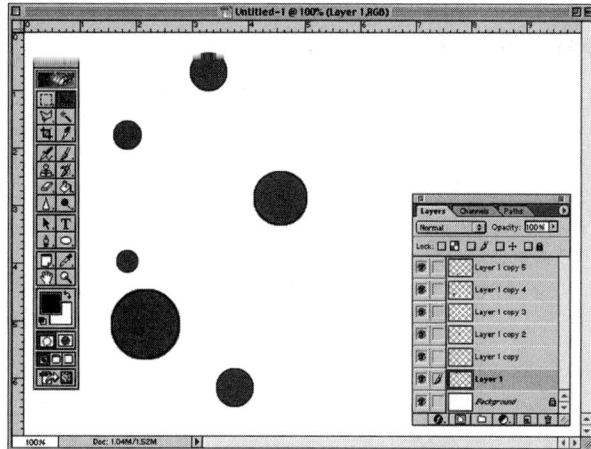

Figure 354.1 The elements within this image require vertical alignment.

Figure 354.2 Clicking in the link box of a layer links the layer to the currently selected layer.

Figure 354.3 The Align and Distribute buttons let you rearrange the image information within all the linked layers.

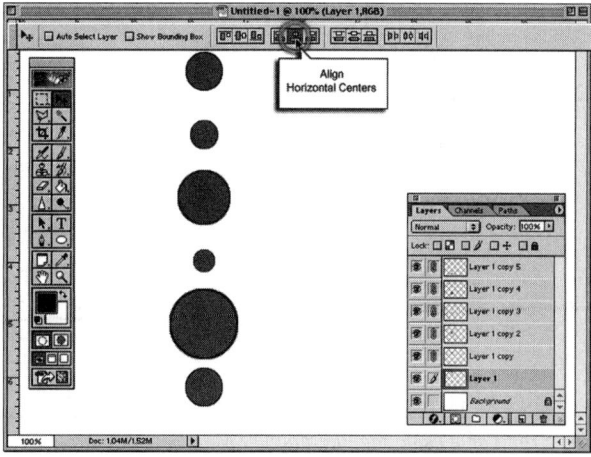

Figure 354.4 Clicking the Align Horizontal Centers button aligns the objects in all the linked layers.

4. If you want to align the linked images to the left or right edge, click on the Align Left or Align Right Edges buttons, as shown in Figure 354.5.

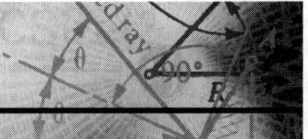

Figure 354.5 The images after choosing the Align Left Edges option.

355 *Aligning a Layer to a Selection Marquee*

In the preceding tip, you learned how to align a group of linked layers. Not only can you align image information based on a group of linked layers, you can also align layers to a selection marquee.

To align layers using a selection marquee, perform these steps:

1. Using the Rectangular Marquee tool, draw a rectangle within the document window. In this example, you want to align the layer elements to the four corners of the rectangle, as shown in Figure 355.1.

Figure 355.1 Drawing a rectangle using the Rectangular Marquee tool forms the basis for the alignment of the layer graphics.

2. Select the Move tool from the toolbox. The Options bar displays the options available for the Move tool. At the far right of the Options bar are the Align and Distribute buttons, as shown in Figure 355.2.

Figure 355.2 The Align and Distribute buttons let you rearrange the image information within all the linked layers.

3. Click once on the layer named top-left. This selects the top-left layer. Click on the Align Top Edges button and then click once on the Align Left Edges button (refer to Figure 354.3). Photoshop aligns the graphic images to the top left edge of the selection marquee, as shown in Figure 355.3.

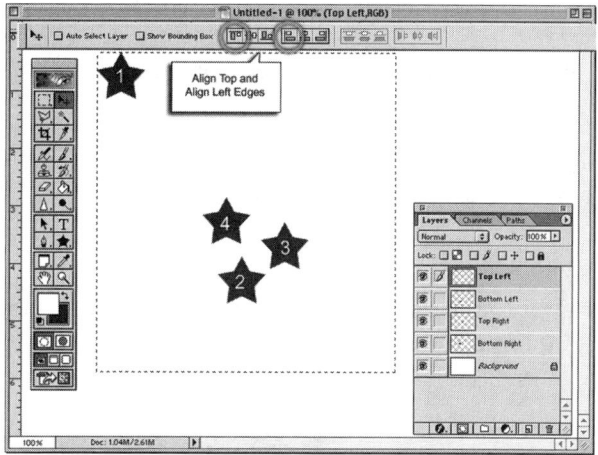

Figure 355.3 Clicking the Align top edges and Align left edges buttons aligns the selected layer to the top left edge of the selection marquee.

4. Click once on the layer named top-right to select the top-right layer. Click on the Align Top Edges button and then click once on the Align Right Edges button (refer to Figure 354.3). Photoshop aligns the graphic images to the top right edge of the selection marquee.

5. Click once on the layer named bottom left to select the bottom-left layer. Click on the Align Bottom Edges button and then click once on the Align Left Edges button (refer to Figure 354.3). Photoshop aligns the graphic images to the bottom-left edge of the selection marquee.

6. Click once on the layer named bottom-right to select the bottom-right layer. Click on the Align Bottom Edges button and then click once on the Align Right Edges button (refer to Figure 354.3). Photoshop aligns the graphic images to the bottom-right edge of the selection marquee and completes the alignment of all four layers, as shown in Figure 355.4.

Figure 355.4 The Alignment options aligned the four image layers to the four corners of the selection marquee.

356 *Linking Layers Together*

In Tip 353, "Distributing Linked Layers," and Tip 354, "Aligning Linked Layers," you learned how to align and distribute layers using the layer link option. The linking of layers lets you do more than align and distribute digital information.

To link two or more layers together, perform these steps:

1. Select the File menu, choose Open from the pull-down menu, and open a multi-layered graphic image in Photoshop.

2. If the Layers palette is not visible, select the Window menu and choose Show Layers from the pull-down menu. Photoshop displays the Layers palette.

3. Select a layer.

4. To link another layer to the selected layer, click once in the linking box. Photoshop links the selected layer to the second layer, as shown in Figure 356.1. Note: The Paintbrush icon will always be visible in the active layer.

Figure 356.1 Clicking in the linking box links the layer to the selected layer.

5. Click the linking box option of all the layers you want to link together. Linked layers do not have to be next to each other, as shown in Figure 356.2.

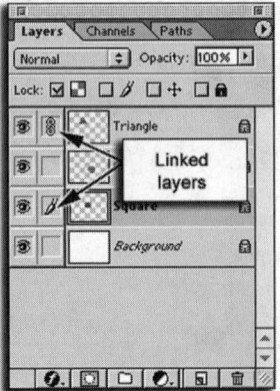

Figure 356.2 Linked layers do not have to be next to each other in the Layers palette.

6. Link layers when you need to:

- Align or distribute information in several layers.

- Move the information in two or more layers. Linking two or more layers together lets you select the Move tool and move the contents of all the linked layers.

357 *Controlling a Layer's Opacity*

While changing the opacity of a layer may not seem like such an exciting thing to do, it is a very important part of controlling a layer. Photoshop creates new layers with a default opacity of 100 percent, as shown in Figure 357.1.

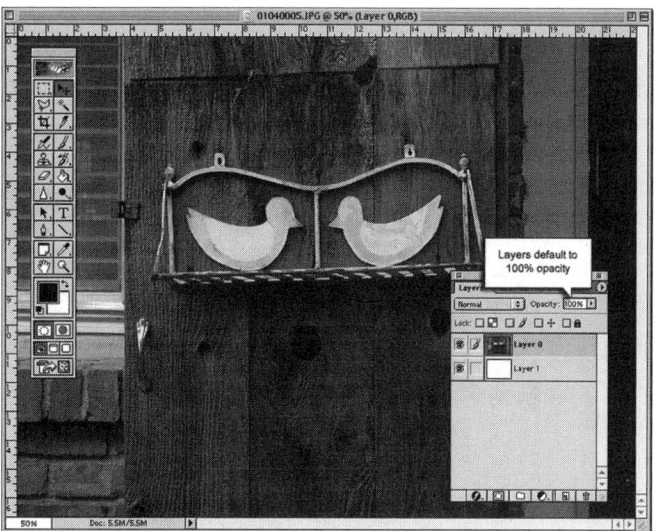

Figure 357.1 Photoshop creates a new layer with a default opacity of 100 percent.

To change the opacity of a layer, click in the Opacity input box and enter a value from 0 to 100 percent. The lower the value, the more transparent the layer.

- When you change the opacity of a layer, all the visible pixels within the active layer are equally affected.

- To change the opacity of a layer in predefined increments, click on the black triangle to the right of the Opacity input field, as shown in Figure 357.1. The Opacity slider opens under the Opacity input field, as show in Figure 357.2.

- Click on the triangular slider and drag it left or right to decrease or increase the opacity of a layer.

- Press the left or right arrow keys to decrease or increase the opacity of a layer, one percentage point at a time.

- Hold the Ctrl (Macintosh: Command) key and press the left or right arrow keys to decrease or increase the opacity of a layer, one percentage point at a time. Use the Shift key with the left or right arrow keys to increase the opacity of a layer by 10 percentage points at a time.

- Since background layers do not create transparent pixels, you cannot change the opacity of a background layer.

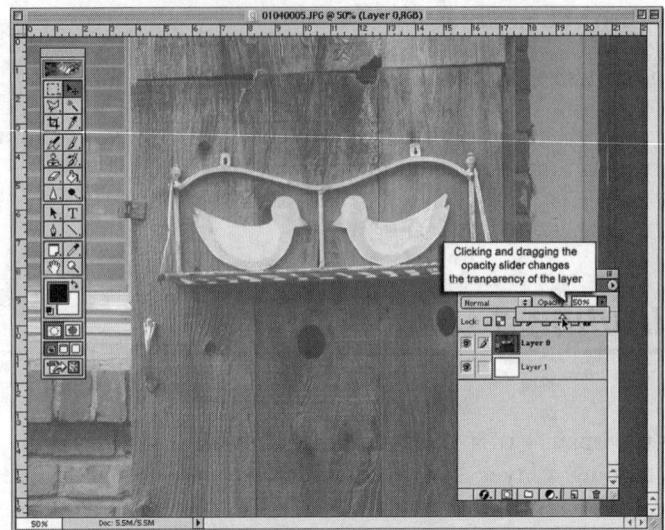

Figure 357.2 Clicking on the black triangle to the right of the Opacity input field opens the Opacity slider.

- When you change the transparency of a layer, the changes are not permanent until the layer is flattened, as shown in Figure 357.3.

Figure 357.3 Merging or flattening a layer makes changes to the opacity option permanent.

358 *Locking a Layer*

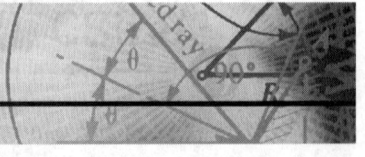

Photoshop 6.0 gives you several ways to lock the properties of a layer. When you lock a layer, you instruct Photoshop to preserve a certain portion of an image. To lock a layer, choose the Layers palette and select the layer you want to lock. If the Layers palette is not visible, select the Window menu, and choose Show Layers from the pull-down menu.

- **Lock Transparent Pixels:** To lock the transparent pixels within a layer, click on the Lock Transparent Pixels option in the Layers palette. When the Lock Transparent Pixels option is selected, Photoshop prevents any changes to the transparent pixels within the image, as shown in Figure 358.1.

Figure 358.1 The Lock Transparent Pixels option preserves the transparent pixels within the layer.

- **Lock Image Pixels:** The Lock Image Pixels option performs the opposite of Lock Transparent Pixels. When you select Lock Image Pixels, Photoshop protects all the pixels within the layer, as shown in Figure 358.2.

Figure 358.2 The Lock Image Pixels option preserves the pixels within the layer.

- **Lock Position:** When you select the Lock Position option, Photoshop lets your paint within the layer; however, you cannot use the Move tool to reposition the graphic information, as shown in Figure 358.3.

- **Lock All:** The Lock All option prevents any modification to the information within a layer. When you select Lock All, Photoshop prevents any changes to the visible and transparent pixels, and the image information cannot be moved, as shown in Figure 358.4. Choose this option when you want to protect a layer from accidental changes or movement.

Figure 358.3 The Lock Position option prevents the digital information within a layer from being moved.

Figure 358.4 The Lock All option prevents any changes or modifications to the information within a layer.

359 *Preserving a Layer's Transparency*

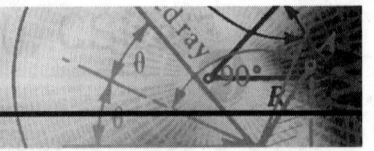

In the preceding tip, you learned how to lock a layer's transparency. When a layer's transparency is locked, Photoshop only lets you modify the pixels within the image that contain color information, and all the transparent pixels are protected from further modification.

The protection of transparent pixels has many applications, among them is the ability to create some unusual text patterns.

To create text with a unique pattern, perform these steps:

1. Select the File menu and choose New from the pull-down menu. Photoshop opens the New dialog box, as shown in Figure 359.1.

Figure 359.1 The New dialog box in Photoshop defines the characteristics of a new document.

2. Create a document with a Width and Height of 7 by 5 inches, a Resolution of 150 pixels/inch, and a Mode of RGB.

3. Select the Type tool and enter some text. For more information on the Type tool, refer to Tip 86, "The Type Tool."

4. Select the Layer menu, then choose Rasterize and choose Type from the fly-out menu. Photoshop converts the vector text into a rasterized image. You have to rasterize the text because Photoshop cannot perform the Fill command on a text layer.

5. Select the Preserve Transparency option on the text layer (refer to the preceding tip).

6. Select the Edit menu and choose the Fill option from the pull-down menu. Photoshop opens the Fill dialog box, as shown in Figure 359.2. For more information on using the Fill command, refer to Tip 232, "Painting an Image Using the Fill Command."

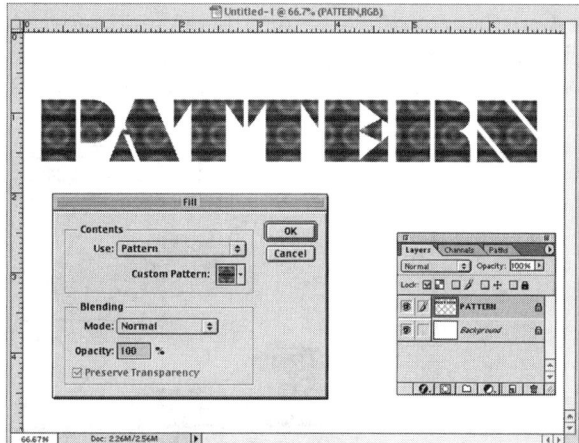

Figure 359.2 The Fill dialog box controls the pattern applied to the rasterized text.

7. Click on the Contents Use option. Photoshop displays a list of all available fill options. Choose Pattern from the pop-up menu.

8. Click on the Custom Pattern option and choose a pattern from the available options.

9. Click the OK button to close the Fill dialog box and record your changes to the text layer.

360 *Selecting the Visible Part Within a Layer*

In the preceding tip, you learned how to use the Preserve Transparency option to perform a Fill command on text. While the Preserve Transparency option protects the transparent pixels within an image, there are times when you need to quickly select the visible pixels within an image.

To select the visible pixels within a Photoshop document, open an image containing transparent and nontransparent pixels, as shown in Figure 360.1, and perform these steps:

Figure 360.1 A typical graphic image containing transparent and nontransparent pixel information.

1. If the Layers palette is not visible, select the Window menu and choose Show Layers from the pull-down menu. Photoshop displays the Layers palette.

2. Hold down the Ctrl (Macintosh: Command) key and move your mouse over the layer elements. Click once on the layer containing the image information you want to select. Photoshop selects all the visible pixels within the selected layer, as shown in Figure 360.2.

Figure 360.2 Holding down the Ctrl (Macintosh: Command) key and clicking on a layer selects all the visible pixels within the selected layer.

Note: When you hold down the Ctrl (Macintosh: Command) key and move your mouse into the Layers palette, the cursor resembles a small hand icon with a dotted-line square in the lower-right corner. When you click on a layer, all the visible pixels are selected.

361 *Blending Mode Concepts*

When you work with the Blending mode options in Photoshop, it is important to understand how Photoshop defines color.

Photoshop defines color pixels in three ways:

- **Hue:** The hue of a pixel is a value from 0 to 360 degrees. Hue defines the visible color of the image based on a standard color wheel.

- **Saturation:** The saturation of a pixel is a value from 0 to 100 percent. The saturation determines the percentage of ink color applied to the pixel. A value of 0 equals a pixel with color and produces a gray pixel. A value of 100 produces a totally saturated image pixel.

- **Luminosity:** The luminosity of an image pixel indicates its brightness. Photoshop uses a value from 0 to 255, with 0 being black and 255 white.

When you work with Blending modes, Photoshop uses three terms to define how the Blending mode operates:

- **Base color:** The base color defines the colors within the original image.

- **Blend color:** The blend color represents the painting color, or the current Foreground color in the toolbox.

- **Result color:** The result color is the new color created, as determined by the active Blending mode of the image.

Blending mode options are available for layers, as shown in Figure 361.1.

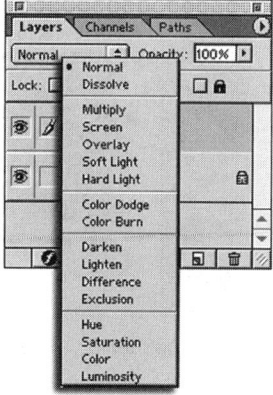

Figure 361.1 Blending mode options are available for all Photoshop layers.

The Blending mode options are also available for all of Photoshop's Brush and Pencil tools, as well as the Gradient and Paint Bucket tools. To access a Blending mode for one of Photoshop's tools, select the tool from the toolbox and click on the Mode button in the Options bar, as shown in Figure 361.2.

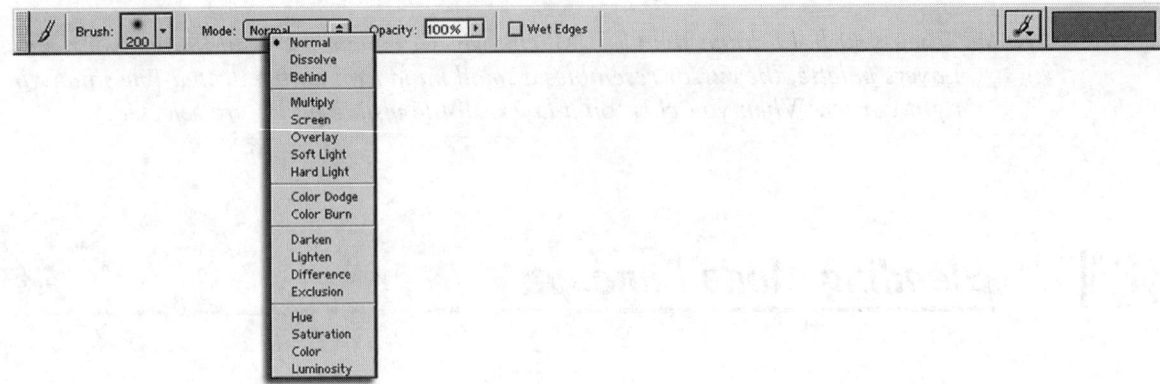

Figure 361.2 Blending mode options are available for all of Photoshop's drawing and editing tools.

362 Working with the Hard Light and Soft Light Blending Modes

The Soft and Hard Light Blending modes modify an image by changing the characteristics of the active tool or layer. The Soft and Hard Light Blending modes give the visual appearance of shining a soft or hard spotlight on the image.

The Soft and Hard Light Blending modes darken or lighten an area of an image, depending on the blending color (refer to the preceding tip). The blending color is represented by the Foreground color in Photoshop's toolbox, as shown in Figure 362.1.

Clicking a Color Swatch changes the default Foreground Color

Figure 362.1 The Foreground color in Photoshop's toolbox determines how the Soft Light Blending mode changes an image.

If the Foreground color is greater than 50 percent gray, the Blending mode darkens the pixels within the image. The higher the shade of gray, the darker the image pixels, as shown in Figure 362.2.

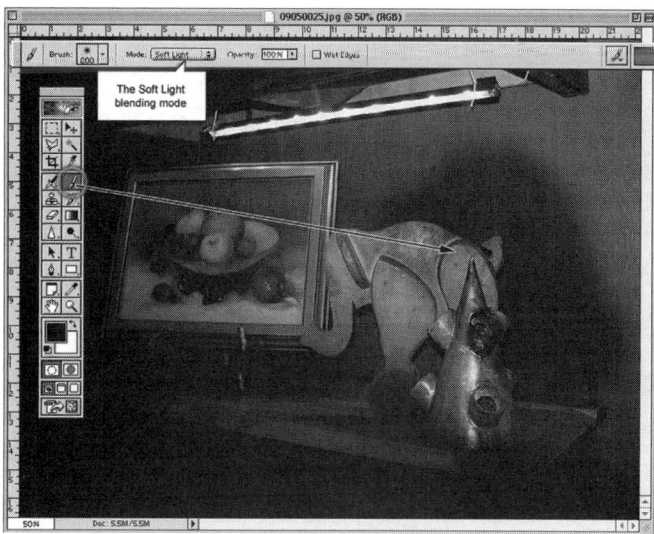

Figure 362.2 The darker the shades of gray, the more the image pixels darken.

If the Foreground color is less than 50 percent gray, the image pixels begin to lighten, as shown in Figure 362.3.

Note: A Foreground color of 50 percent gray produces no change within the image.

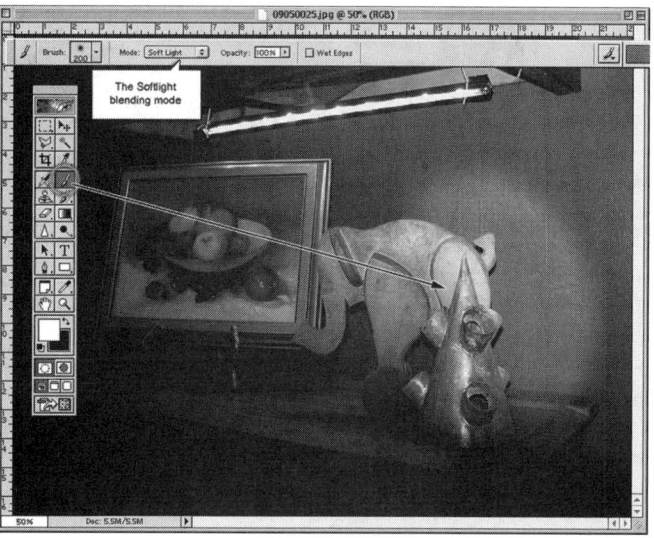

Figure 362.3 The lighter the shades of gray, the more the image pixels lighten.

363 *Using the Color Burn and Color Dodge Blending Modes*

The Color Burn Blending mode compares the base color (image pixels) with the blend color (painting color). Refer to Tip 361, "Blending Mode Concepts." Painting with white produces no change within the image. The Color Burn Blending mode darkens the image pixels to reflect the blend color, as shown in Figure 363.1.

Figure 363.1 The Color Burn Blending mode darkens the pixels within the image to reflect the painting, or blend, color.

The Color Dodge Blending mode compares the base color (image pixels) with the blend color (painting color) and lightens the image pixels to reflect the painting color, as shown in Figure 363.2. Painting with black produces no change within the image.

Figure 363.2 The Color Dodge Blending mode lightens the pixels within the image to reflect the painting, or blend, color.

364 *Using the Lighten and Darken Blending Modes*

When you use the Lighten Blending mode, Photoshop compares the base color (image pixels) with the blend color (painting color). Refer to Tip 361, "Blending Mode Concepts." Any pixels within the image that are darker than the blend color are replaced by the blend color. Any pixels lighter than the blend color do not change, as shown in Figure 364.1.

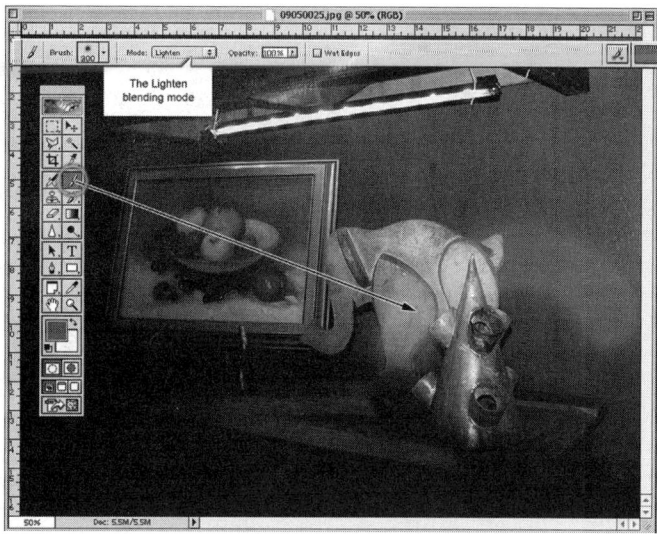

Figure 364.1 The Lighten Blending mode replaces the darker pixels within an image with the blend color.

When you use the Darken Blending mode, Photoshop compares the base color (image pixels) with the blend color (painting color). Any pixels within the image that are lighter than the blend color are replaced by the blend color. Any pixels darker than the blend color do not change, as shown in Figure 364.2.

Figure 364.2 The Darken Blending mode replaces the lighter pixels within an image with the blend color.

365 *Using the Dissolve Blending Mode*

The Dissolve Blending mode modifies an image by changing the characteristics of the active tool or layer (refer to Tip 361, "Blending Mode Concepts").

The Dissolve Blending mode replaces all the modified pixels within an image with the blend color (painting color). The effect randomly generates a replacement of the pixels, and this typically creates a ragged appearance to a paintbrush stroke. The effect works best when using a large Paintbrush, as shown in Figure 365.1.

Figure 365.1 The Dissolve Blending mode used with a large paintbrush creates a ragged appearance to the brush stroke.

366 *Applying the Screen and Overlay Blending Modes*

The Screen and Overlay Blending modes modify an image by changing the characteristics of the active tool or layer (refer to Tip 361, "Blending Mode Concepts").

The Screen Blending mode paints the image with an inverse of the base color (image pixels) and the blend color (painting color). The result is always a lighter color. Painting with black produces no change to the image. Any other painting color lightens the image and tints the overall colors within the graphic to match the blend color, as shown in Figure 366.1.

Figure 366.1 The Screen Blending mode lightens an image by examining the image pixels and the blend color and replacing the image pixels with an inverse of the two.

The Overlay Blending mode multiplies or screens the colors within the image, depending on the base color (painting color). The base color does not replace the blend color; it mixes with the blend color to

reflect the lightness or darkness of the original color. Using black with the Overlay Blending mode produces deeper shadows within an image and increases the contrast, as shown in Figure 366.2.

Figure 366.2 The Overlay Blending mode, used with black, increases shadows and improves contrast within an image.

367 *Using the Difference and Exclusion Blending Modes*

The Difference Blending mode works with the luminosity of the base (image pixels) and blend color (painting color). The luminosity of a pixel is a value from 0 to 255; the higher the value, the brighter the pixel. In a grayscale image, a pixel with a value of 0 is black, and a pixel with a value of 255 is white. Pixel values from 1 to 244 represent shades of gray. In a color image, the luminosity value of a pixel determines the brightness of the color.

When the luminosity of the base color is greater than the luminosity of the blend color, Photoshop subtracts the base color from the blend color. If the luminosity of the blend color is greater than the luminosity of the base color, Photoshop subtracts the blend color from the base color, as shown in Figure 367.1.

The Exclusion Blending mode creates a visual effect similar to the Difference Blending mode, but the visual effect is always lower in contrast, as shown in Figure 367.2.

> *Note: Since the Difference and Exclusion Blending modes create a new color by subtracting either the blend or base color from the original image, the final image colors are not based on a tinting of the image but on a subtraction from the color table.*

Figure 367.1 The Difference Blending mode creates a new image by subtracting one color (base or blend), depending on which color contains the greatest brightness value.

Figure 367.2 The Exclusion Blending mode creates a lower-contrast version of the Difference Blending mode.

368 *Using the Hue, Saturation, Color, and Luminosity Blending Modes*

The Hue, Saturation, Color, and Luminosity Blending modes modify an image by replacing one of the color components within a pixel (refer to Tip 361, "Blending Mode Concepts").

When you use the Hue Blending mode, Photoshop creates a result color by blending the Luminosity and Saturation of the base color with the Hue of the blend color, as shown in Figure 368.1.

Figure 368.1 The Hue Blending mode creates a new result color by blending characteristics of the original image pixels with the characteristics of the painting color.

When you use the Saturation Blending mode, Photoshop creates a result color by blending the Luminosity and Hue of the base color with the Saturation of the blend color, as shown in Figure 368.2.

When you use the Color Blending mode, Photoshop creates a result color by blending the Luminosity of the base color with the Hue and Saturation of the blend color, as shown in Figure 368.3.

Figure 368.2 The Saturation Blending mode creates a new result color by blending characteristics of the original image pixels with the characteristics of the painting color.

When you use the Luminosity Blending mode, Photoshop creates a new result color by blending the Hue and Saturation of the base color with the Luminosity of the blend color, as shown in Figure 368.4.

Figure 368.3 The Color Blending mode creates a new result color by blending characteristics of the original image pixels with the characteristics of the painting color.

Figure 368.4 The Luminosity Blending mode creates a new result color by blending characteristics of the original image pixels with the characteristics of the painting color.

369 *Using the Normal Blending Mode*

The default Blending mode for all of Photoshop's tools and layers is Normal. When you work with the Normal Blending mode, Photoshop defines the characteristics of the tool based on the normal world. Say, for example, you select the Paintbrush tool and choose to paint with sky blue. The Paintbrush paints the image with sky blue. It does not subtract or add a particular element of the image colors, and it does not screen or darken the pixels. It just paints with blue, as shown in Figure 369.1.

Figure 369.1 Using the Paintbrush with a Blending mode of Normal creates a stroke of paint based on the brush size and foreground color.

When you use the Blur or Sharpen tools, or any image-editing tool, the changes to the document are what you expect out of the tool if you used it in the normal world. It is only when you change to a different Blending mode that the characteristics of the tool change and you begin to see the creative part of using Blending modes.

When you work with any of Photoshop's editing and painting tools, do not just work using the Normal Blending mode. Experiment with different options. Logically understanding how the Blending modes change an image is the basis for being creative. Blend creative, right-brain thinking with logical information to produce the best results possible.

370 *Controlling Adjustment Layers with Built-in Masks*

Photoshop introduced Adjustment layers in version 4.0 and improved them with each new version of the program. In Photoshop 6.0, Adobe changed how you access Adjustment layers by placing a button on the bottom of the Layers palette. To select an Adjustment layer, click on the New Adjustment Layer button. Photoshop displays a list of available Adjustment Layer options, as shown in Figure 370.1.

Photoshop's adjustment options are available from the pull-down menu by selecting the Image menu, selecting Adjust and choosing from the available options on the fly-out menu. However, choosing to adjust an image with an Adjustment layer gives you flexibility and control over the image. When you choose an Adjustment layer, you make the adjustments within the layer, not the actual image. This gives you control over the final product and lets you change or modify the adjustments hours or even days later. For information on how Adjustment layers control an image, refer to Tip 322, "Understanding Adjustment Layers."

When you create an adjustment layer, a mask is applied to the image, and the application of the adjustment is applied though the mask, as shown in Figure 370.2.

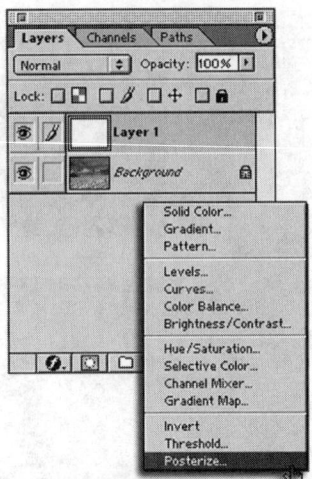

Figure 370.1 Clicking on the Adjustment Layers icon displays a list of available options.

Figure 370.2 Selecting the Posterize Adjustment layer applies a posterized effect across the entire image and automatically creates an adjustment mask.

Painting a mask with black or a shade of gray modifies the application of the Adjustment layer. To modify an Adjustment layer mask, perform these steps:

1. Select the layer you want to modify by clicking once on the Adjustment layer, as shown in Figure 370.3.

Figure 370.3 Select the Adjustment layer by clicking once on the layer name.

2. Select the Paintbrush from the toolbox. For more information on using the Paintbrush tool, refer to Tip 78, "The Paintbrush and Pencil Tools."

3. Choose black or a shade of gray for the painting color. The darker the shade of gray, the less effect the Adjustment layer has over the image. In this example, the color black was chosen. For more information on selecting colors, refer to Tip 221, "Selecting a Foreground and Background Color Swatch."

4. Move your painting cursor into the document window and drag it across the image. In this example, since the color black is the Foreground color, the image returns to normal where the paintbrush is applied, as shown in Figure 370.4.

The use of Adjustment layers gives you control over the image, and the use of Adjustment layers with masks gives you even more control over the final image.

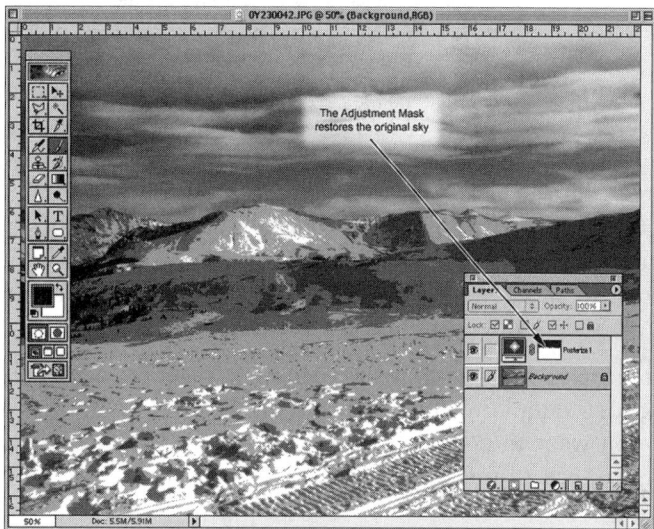

Figure 370.4 Selecting the Paintbrush tool and painting the mask with black effectively masks out the effects of the Posterize command and returns the image to normal.

371 *Understanding When to Merge Adjustment Layers*

In Tip 324, "Merging Adjustment Layers," you learned how to create and manage multiple Adjustment layers. Adjustment layers control various aspects of image editing by giving you flexibility and control over the final image.

When you merge Adjustment layers, you combine the image with the adjustments. Never merge the Adjustment layers into the image until you are sure you will not need to perform any changes to the Adjustment layer. For example, do not merge a Levels Adjustment layer with the image until you are sure the Levels Adjustment is perfect and does not require additional modification, as shown in Figure 371.1.

Figure 371.1 Do not merge the Levels Adjustment layer with the image until you are sure no additional Levels Adjustments are necessary.

Always merge the Adjustment layers into the image before converting to another color space. When you convert an image containing multiple Adjustment layers into another color space, Photoshop by default merges the Adjustment layer into one layer. If you do not merge the image layers together before converting the image into another color space, the calculation used by the converter produces a shift in the colors. This shift is most evident in highly saturated colors.

It is always best to merge the layers of a document together before converting the image into another color space. Say, for example, you completed editing an image in the RGB color space (red, green, and blue), and now you want to convert the image to the CMYK color space (cyan, magenta, yellow, and black). You will produce an image with greater color accuracy if you merge or flatten the image before converting the document.

Merging the Adjustment layers together before converting to another color space requires planning a project before starting. Knowing ahead of time that the image will be moved to another color space lets you decide when to create the Adjustment layers and when they need to be merged into the image.

372 *Managing Adjustment Layers*

When you work with Adjustment layers (refer to Tip 322, "Understanding Adjustment Layers"), the order in which the Adjustment layers are created determines how the effect is applied to the image.

Imagine looking down through a series of overhead transparencies; the order of the transparencies determines what you see. The same is true with Photoshop's Adjustment layers: The order determines the effect, as shown in Figure 372.1.

You can create Adjustment layers in a specific order, or you can move the layers into another position within the layer stack. To move an Adjustment layer to a different position within the layer stack, click on the Adjustment layer and drag up or down. Release your mouse when the layer is in the correct position within the stack, as shown in Figure 372.2.

Figure 372.1 The order of Adjustment layers determines the final image.

Figure 372.2 Clicking and dragging an Adjustment layer lets you move it to another position within the layer stack.

373 *Flattening Layers Within Photoshop*

A Photoshop 6.0 document can hold a maximum of 8,000 layers. Photoshop layers can be a combination of Adjustment layers, Fill and Content layers, and one Background. When you flatten a Photoshop document, you combine all the layers within the image into one background.

To flatten a Photoshop document, perform these steps:

1. If the Layers palette is not visible, select the Window menu and choose Show Layers from the pull-down menu. Photoshop displays the Layers palette, as shown in Figure 373.1.

Figure 373.1 The Layers palette displays a listing of all the layers within a Photoshop document.

2. Click on the black triangle in the upper right of the Layers palette. Photoshop displays the layer options in a fly-out menu, as shown in Figure 373.2.

Figure 373.2 Clicking on the black triangle displays a fly-out menu listing the layer options.

3. Click on Flatten Image. Photoshop combines all the image layers into a background layer, as shown in Figure 373.3.

Figure 373.3 The Flatten Image option combines all the layers within a Photoshop document into a single background layer.

Note: When you flatten a Photoshop document, you lose control over the individual layers. Flattening an image is performed at the end of a project or when the document size becomes too large. Once an image is flattened and saved, the individual layers can never be restored.

374 *Merging Layers*

In the preceding tip, you learned how to flatten an image. Flattening an image changes the image in two ways: It combines all the layers together, and it converts the layers into a Background.

In Photoshop, a Background is not movable, and the pixels cannot convert to transparent pixels (refer to Tip 346, "Backgrounds vs. Layers"). Say, for example, you have a multi-layered document that contains transparent areas, as shown in Figure 374.1.

Figure 374.1 A multi-layered document containing transparent pixels.

When you flatten a document, Photoshop paints the transparent areas of the image with the current Background color, as shown in Figure 374.2.

Figure 374.2 Using the Flatten Image option fills the transparent areas of an image with the current Background color.

To combine the layers of a Photoshop document without losing the transparent areas of the image, perform the steps in the preceding tip. However, instead of using the Flatten Image option in step 3, select Merge Visible, as shown in Figure 374.3.

Figure 374.3 Choosing Merge Visible from the layer options combines all the layers together while preserving the transparent areas of the image.

375 *Merging the Visible Layers*

In the preceding tip, you learned how to merge the layers of a Photoshop document without losing the transparent areas of the image. When you choose the Merge Visible option, you only merge the layers that are currently visible. In Photoshop, one way to manage the number of layers within a document is to merge some of the layers together.

Say, for example, you create a multi-layered document with a text-clipping group (see Tip 659, "Manipulating Text Images with Clipping Groups"). You want to combine the text layer with the clipping group, but you need the other layers within the document to remain separate, as shown in Figure 375.1.

To merge the text layer with the clipping-group layer, perform these steps:

1. If the Layers palette is not visible, select the Window menu and choose Show Layers from the pull-down menu. Photoshop displays the Layers palette, as shown in Figure 375.1.

2. Click on the Visibility icon to turn off (make invisible) all the layers you do not want to merge, as shown in Figure 375.2.

3. Click on the black triangle in the upper-right corner of the Layers palette. Photoshop displays a fly-out menu with the layer options (refer to Figure 375.2).

4. Click on the Merge Visible option. Photoshop merges the visible layers, as shown in Figure 375.3.

Figure 375.1 In this example, you only want to merge the text layer with its clipping group.

Figure 375.2 The Visibility icon controls the viewing state of the layer.

Figure 375.3 The Merge Visible option combines the visible layers without deleting or combining the nonvisible layers.

Note: Use the Merge Visible option to help manage the number of layers within a Photoshop document. The more layers, the larger the file size and the more time it takes Photoshop to complete operations. Work smart. Merge layers together to reduce the file size of the document.

376 *Making a Pixel-to-Pixel Copy of a Layer*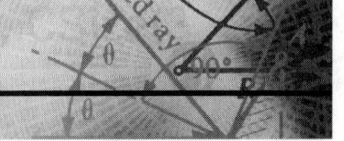

Photoshop gives you an easy way to make a pixel-to-pixel copy of a layer or Background. Say, for example, you create a document and want more than one copy of a particular layer, as shown in Figure 376.1.

Figure 376.1 The image requires another copy of Layer 2.

To create an exact copy of a layer or Background, perform these steps:

1. If the Layers palette is not visible, select the Window menu and choose Show Layers from the pull-down menu. Photoshop displays the Layers palette (see Figure 376.1).

2. Click and drag the layer over the New Layer icon. Photoshop creates a copy of the layer, as shown in Figure 376.2.

3. Select the Move tool from the toolbox and click and drag in the document window to move the copied image, as shown in Figure 376.3.

Figure 376.2 Clicking and dragging a layer over the New Layer icon creates an exact copy of the information within the layer.

Figure 376.3 Clicking and dragging with the Move tool lets you reposition the copied layer.

377 *Copying an Element Within a Layer*

In the preceding tip, you learned how to make an exact copy of a layer. When you drag a layer or Background over the New Layer icon, Photoshop creates a new layer with all of the data from the original layer. Say, however, you only want to create a new layer with a selected piece from another layer.

To create a new layer with a selected piece from another layer, perform these steps:

1. If the Layers palette is not visible, select the Window menu and choose Show Layers from the pull-down menu. Photoshop displays the Layers palette (refer to Figure 376.1).

2. Click and select the layer containing the digital information you want copied into another layer.

3. Using one of the selection tools, choose the area of the image you want to copy into a new layer. Refer to Tip 280, "Selection Methods," for more information on selection in Photoshop. In this example, a selection is made around the figurine on the left, as shown in Figure 377.1.

Figure 377.1 Selecting an area within an image defines the copied information.

4. Select the Edit menu and choose Copy from the pull-down menu.

5. Select the Edit menu and choose Paste from the pull-down menu. Photoshop places the copied pixels in a new layer, as shown in Figure 377.2.

Figure 377.2 The copied information is placed in a new layer, exactly on top of the original pixels.

6. Select the Move tool from the toolbox and click and drag in the document window to move the copied image, as shown in Figure 377.3.

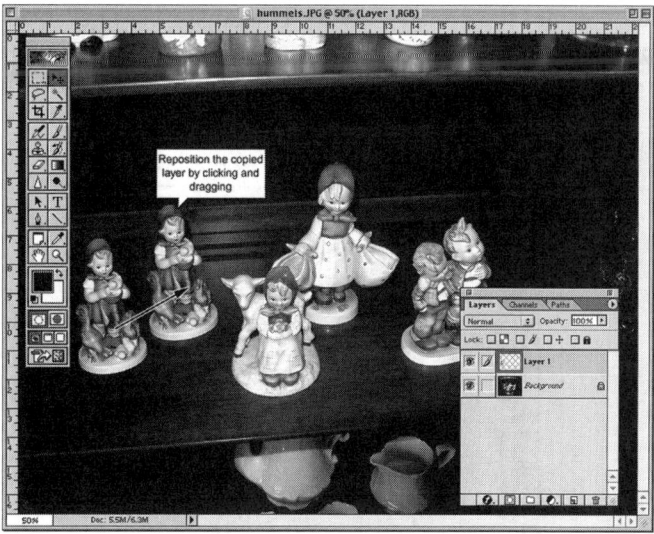

Figure 377.3 Clicking and dragging with the Move tool lets you reposition the copied information.

378 *Using Clipping Groups to Control the Effect of Adjustment Layers*

By default, the effects of an Adjustment layer are applied to all the underlying layers within a multi-layered document. There are times, however, when you want to apply an Adjustment layer to one layer without the effect changing the entire image, as shown in Figure 378.1.

Figure 378.1 Adjustment layers influence all the underlying layers within an image.

To control the effects of an Adjustment layer, use a clipping group. In Figure 378.1, the Levels Adjustment layer only needs to be applied to Layer 2. To control the effects of the Levels Adjustment layer, perform these steps.

1. If the Layers palette is not visible, select the Window menu and choose Show Layers from the pull-down menu. Photoshop displays the Layers palette (see Figure 378.1).

2. Move your cursor into the Layers palette. The cursor changes into a hand with a pointing index finger. Move the cursor until the tip of the index finger rests on the line separating the Adjustment layer from the layer directly below and press and hold down the Alt (Macintosh: Option) key. Photoshop changes the hand icon into the clipping group icon, as shown in Figure 378.2.

Figure 378.2 Holding down the Alt key and placing the cursor on the line separating the two layers produces the clipping group icon.

3. While the clipping group icon is visible, click once . Photoshop creates a clipping group between the two layers and controls the effect of the Adjustment layer, as shown in Figure 378.3.

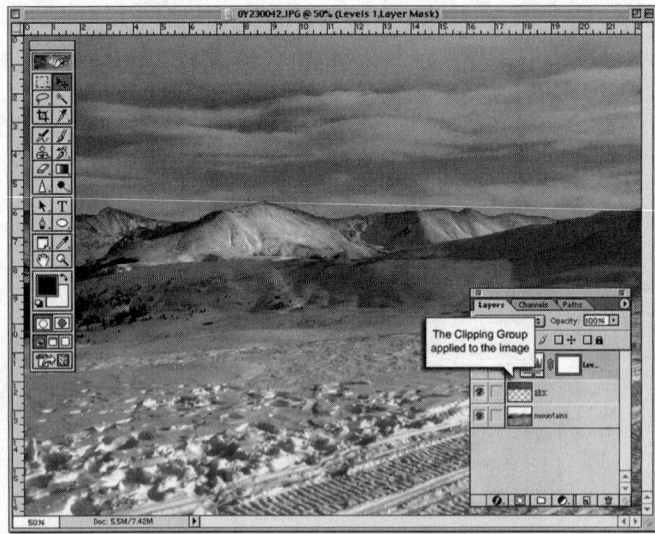

Figure 378.3 The clipping group applies the effect of the Levels Adjustment layer to the layers within the group.

Note: Clipping groups are composed of two or more layers. To deactivate a layer group, move your mouse over two layers grouped together, place your mouse cursor on the line separating the layers, hold down the Alt (Macintosh: Option) key, and click. Photoshop deactivates the clipping group.

379 *Using a Clipping Group to Create Exotic Edges*

In the preceding tip, you learned how a clipping group controls the application of an Adjustment layer. When you use clipping groups with normal layers of transparent and nontransparent pixels, a whole new creative door opens.

Say, for example, you want to create a photograph with more than a simple square-edged look. To create a more exotic edge to the image, open a graphic image in Photoshop and perform these steps:

1. If the Layers palette is not visible, select the Window menu and choose Show Layers from the pull-down menu. Photoshop displays the Layers palette. Click on the New Layer icon. Photoshop creates a new layer, as shown in Figure 379.1.

2. Using your painting tools, create a shape for your new image. In this example, the paintbrush was used to generate a ragged shape across the new layer. This area of nontransparent pixels defines the shape of the image, as shown in Figure 379.2. For more information on using Photoshop's painting tools, refer to Tip 78, "The Paintbrush and Pencil Tools."

Figure 379.1 Clicking on the New Layer icon generates a new transparent layer in the Layers palette.

3. Move your cursor into the Layers palette and click and drag the painted layer below the image, as shown in Figure 379.3.

4. Move your cursor into the Layers palette. The cursor changes into a hand with a pointing index finger. Move the cursor until the tip of the index finger rests on the line separating the two layers and press and hold down the Alt (Macintosh: Option) key. Photoshop changes the hand icon into the clipping group icon (refer to Figure 378.2).

5. While the clipping group icon is visible, click once. Photoshop creates a clipping group between the two layers, and the image displays within the painted area, as shown in Figure 379.4. Refer to the preceding tip for more information on creating clipping groups.

Figure 379.2 The Paintbrush tool created a nontransparent shape across the new layer.

Figure 379.3 Click and drag the painted layer below the image layer.

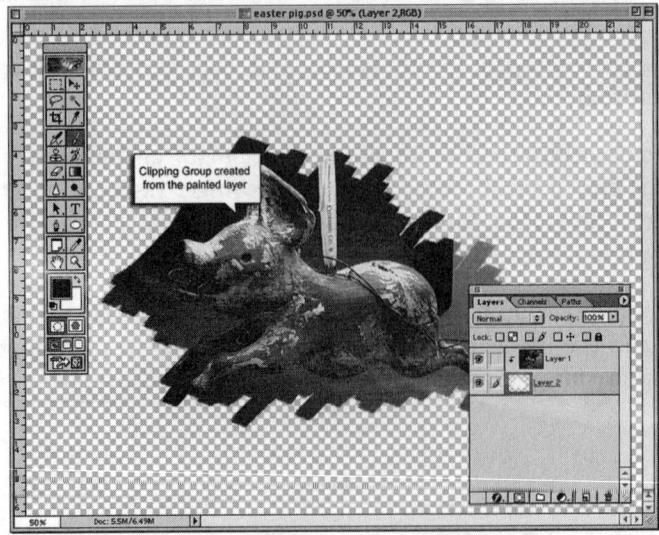

Figure 379.4 Photoshop creates a new image from the two images in the clipping group.

Note: A clipping group keys to the transparent and nontransparent areas of the painted layer. As you can see from Figure 379.4, the transparent areas of the painted layer clip the information from the image layer. Nontransparent areas of the painted layer display information from the image layer.

380 *Creating Layer Sets*

A great way to help manage images with multiple layers is to create layer sets. Layer sets help you organize groups or types of layers within a Photoshop document. To create a layer set, open a multi-layered document in Photoshop and perform these steps:

1. If the Layers palette is not visible, select the Window menu and choose Show Layers from the pull-down menu. Photoshop displays the Layers palette, as shown in Figure 380.1.

Figure 380.1 The Layers palette displays a listing of all the layers within the active Photoshop document.

2. Click the New Layer Set icon at the bottom of the Layers palette. Photoshop creates a new layer set, as shown in Figure 380.2.

3. Drag and drop the layers on top of the new set. Photoshop includes the dropped layer as part of the new set, as shown in Figure 380.3.

4. Drag as many layers as you want into the new set.

5. Once a new set is established, click on the small triangle to the left of the new set name to display or collapse the items within the set, as shown in Figure 380.4.

Figure 380.2 Clicking the New Layer Set icon generates a new layer set in Photoshop's Layers palette.

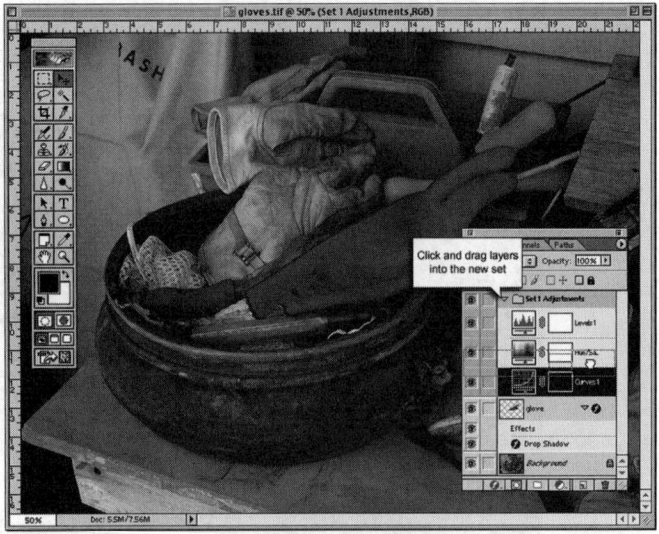

Figure 380.3 Dragging layers on top of the new set adds those layers to the set.

Figure 380.4 Clicking the white triangle collapses or displays all the layers within the set.

6. To move a layer out of the set, drag the layer back into the Layers palette. Photoshop moves the layer back into the standard Layers palette.

__Note:__ Layer sets are an organizational tool that helps you maintain control of the layers within a Photoshop document. Create as many sets as you need to organize your document.

381 *Working with Layer Properties*

When you create a new layer in Photoshop, by default, the new layer is positioned directly above the active layer. New layers appear in the Layers palette with the name Layer n, with "n" being the number of the layer.

Before version 6.0, you changed the name of a layer by moving your cursor into the Layers palette and double-clicking on the layer. Photoshop opened the Layer dialog box and let you change the name. In Photoshop 6.0, double-clicking on the layer opens the Layer Style dialog box, as shown in Figure 381.1.

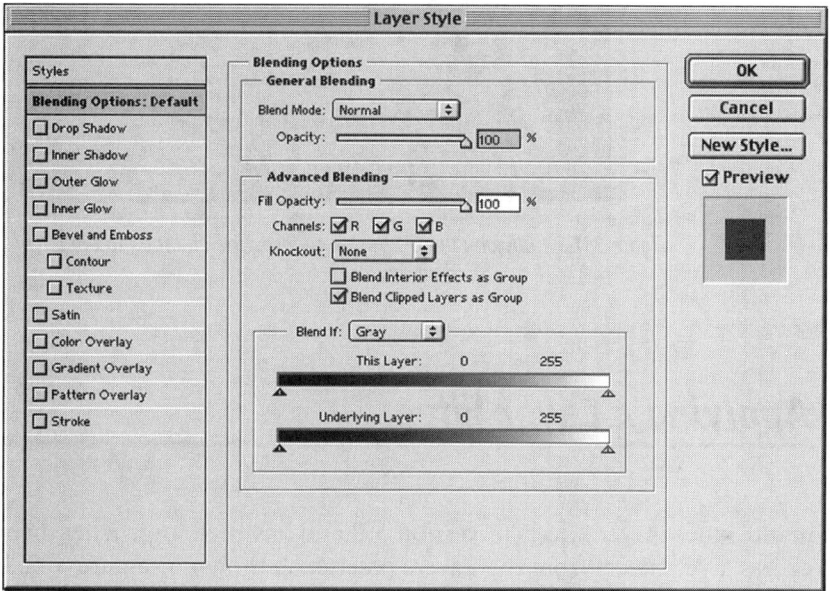

Figure 381.1 Double-clicking on a layer name in Photoshop 6.0 opens the Layer Style dialog box.

Notice that the Layer Style dialog box does not let you change the name of the layer.

To change a layer name in Photoshop 6.0, right-click (Macintosh: Command+click) on the layer name. Photoshop displays a pop-up menu with a list of layer options. Click on the Layer Properties option. Photoshop displays the Layer Properties dialog box, as shown in Figure 381.2.

Figure 381.2 The Layer Properties dialog box lets you change the name of an existing layer.

Click in the Name input field and enter a name for the new layer. Click the OK button to close the Layer Properties dialog box and rename the layer, as shown in Figure 381.3.

Figure 381.3 Clicking the OK button records the changes to the Layers palette.

382 Applying a Layer Effect

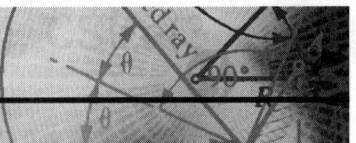

Photoshop introduced layer effects in version 5.0 and has been improving them ever since. In Photoshop 6.0, you access layer effects from the Layers palette, as shown in Figure 382.1.

Figure 382.1 Clicking the Layer Effects icon at the bottom of the Layers palette gives you access to Photoshop's layer effects.

Say, for example, you want to apply a drop shadow to a layer of text. For more information on creating text, refer to Tip 218, "Creating Text in Photoshop 6.0."

To add a drop shadow to text, perform these steps:

1. If the Layers palette is not visible, select the Window menu and choose Show Layers from the pull-down menu. Photoshop displays the Layers palette, as shown in Figure 382.2.

Figure 382.2 The Layers palette displays a visible list of all available layers within the active document.

2. Move your cursor into the Layers palette and click once on the layer containing the text. Photoshop makes the text layer the active layer (refer to Figure 382.2).

3. Click on the Layer Effect icon at the bottom of the Layers palette. Photoshop opens a pop-up menu displaying a list of all available layer effects (refer to Figure 382.1).

4. Click once on the Drop Shadow option. Photoshop opens the Layer Style dialog box with the Drop Shadow option selected, as shown in Figure 382.3.

Figure 382.3 The Layer Style dialog box controls the characteristics of Photoshop's layer effects.

5. Manipulating the controls in the Drop Shadow dialog box changes the characteristics of the text shadow. For more information on using layer effects to produce a shadow, see Tip 914, "Working with the Layer Style Dialog Box to Create a Shadow."

6. Click the OK button to close the Layer Style dialog box and record your changes to the image.

The left side of the Layer Style dialog box displays a list of all the available layer effects. Click on any of the Styles options to add an additional style to the text.

To deactivate a style, click in the check box to remove the check mark. Items in the Styles dialog box containing a check mark are applied to the image. Items without a check mark are not applied to the image.

383 *Moving Layer Effects with Drag and Drop*

In the preceding tip, you learned how to create a simple drop shadow. When you apply a layer effect to an image, the Layers palette displays a layer with the name of the effect, as shown in Figure 383.1.

Figure 383.1 When you apply a layer effect to a layer, Photoshop creates a separate layer identifying the effect and its position within the document.

When you created a drop shadow, Photoshop created a drop shadow layer and grouped it with the text layer. Every time you add an additional effect to a layer, Photoshop creates a new layer for the effect and groups it with the other effects, as shown in Figure 383.2.

Figure 383.2 Photoshop creates a new effects layer for every special effect and groups it with the previous effects.

Once you create an effect, it is a simple matter to copy that effect to any other layer within the document. To copy a layer effect to another layer within the active document, open a graphic image in Photoshop and perform these steps:

1. If the Layers palette is not visible, select the Window menu and choose Show Layers from the pull-down menu. Photoshop displays the Layers palette (refer to Figure 383.1).

2. In Figure 383.1, there are two layers. One layer (the text layer) has a drop shadow attached to the image; the other layer (the clock layer) requires the same drop shadow. Click on the Drop Shadow effects layer and drag and drop it on top of the clock layer. Photoshop creates a copy of the shadow layer and applies it to the clock layer, as shown in Figure 383.3.

Figure 383.3 Dragging and dropping an effect layer on top of another layer creates a copy of the effect.

384 *Applying Global Light to a Multilayered Effect*

When you work in the Layer Style dialog box, Photoshop creates special effects and styles. Several of the styles, like Drop Shadow and Bevel and Emboss, use a Global Light option, as shown in Figure 384.1.

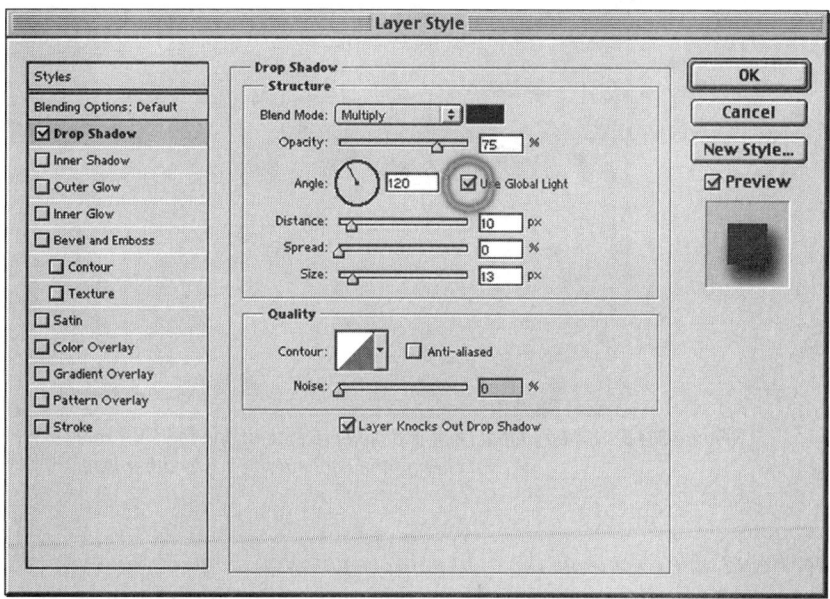

Figure 384.1 The Global Light option is available for all styles requiring an external light source such as Drop Shadow and Inner Shadow.

When you work with effects that use an external light source, the Angle option controls the direction of the light source (see Figure 384.1). With the Global Light option selected, Photoshop causes all layers containing special effects to use the same light source at the same angle.

A consistent light source is important to the perspective of the image. In the real world, shadows and light sources falling across bevels typically come from the same angle. Keeping the Global Light option selected forces the light sources to remain constant, as shown in Figure 384.2.

Figure 384.2 The Global Angle option forces all light sources on layer effects to come from the same direction.

When the Global Light option is not selected, the light source for each object is controlled independently of each layer effect, as shown in Figure 384.3.

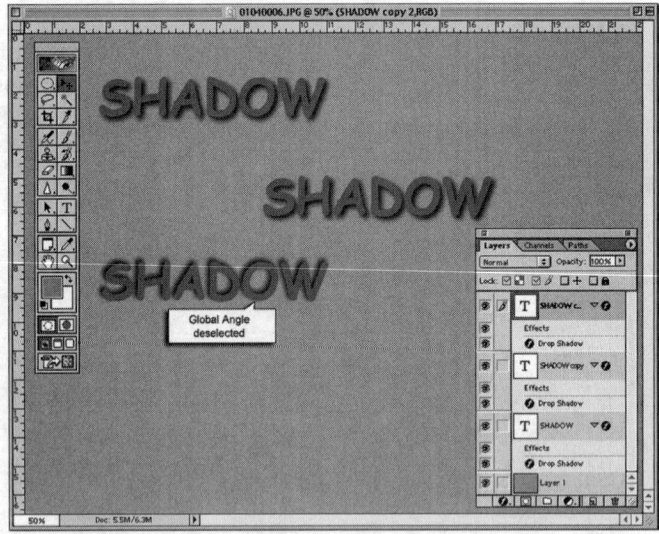

*Figure 384.3 When Global Light is deselected, changing the light source in one effect layer
will not change the light source in any other layer.*

Note: Being able to change the light sources within a single Photoshop document gives you creative freedom to do what you please; however, using multiple light sources moves you away from the real world and into the surrealistic world of special effects.

385 *Converting Effects Layers into Regular Layers*

In Tip 382, "Applying a Layer Effect," you learned how to add a layer effect to text, specifically a Drop Shadow to a text layer. In Tip 383, "Moving Layer Effects with Drag and Drop," you learned how to duplicate layer effects by dragging and dropping. There comes a time in the creative process when you've added several effects to a layer, and you want to combine the effects into the layer without flattening or merging all the image layers.

For example, you've created a multi-layered Photoshop document, and several of the layers have additional special effects layers attached to them, as shown in Figure 385.1.

Figure 385.1 A multi-layered Photoshop document with additional special effects layers.

Working on large, multi-layered documents is a confusing and time-consuming job. To bring order to the chaos, create layer sets (refer to Tip 380, "Creating Layer Sets") and combine some of the layers together.

If you have a large document, and you want to combine two of the layers, along with their respective special effects, perform these steps:

1. If the Layers palette is not visible, select the Window menu and choose Show Layers from the pull-down menu. Photoshop displays the Layers palette, see Figure 385.1.

2. Click on the Visibility icon and turn off (make invisible) all the layers except Layer 1 and Layer 1 copy (refer to Figure 385.1).

3. Click on the black triangle in the upper right of the Layers palette. Photoshop displays a fly-out menu with all the available layer options.

4. Click on the Merge Visible option. Photoshop merges (combines) the two special effects layers into one, as shown in Figure 385.2. Make sure you have one of the visible layers selected, or the Merge Visible option will not be available.

Note: Using Merge Visible to combine multiple layer effects into a single layer gives you a smaller, more manageable file. However, you lose the ability to further control the effects. Do not merge effect layers together until you are ready.

Figure 385.2 Selecting Merge Visible combines the special effects with the text layer.

386 Creating a Layer Mask

Layer masks are one of those features that make you glad you own Photoshop. Layer masks let you control the visible portions of an image without erasing or deleting pixel information.

To create a layer mask, open a Photoshop image and perform these steps:

1. If the Layers palette is not visible, select the Window menu and choose Show Layers from the pull-down menu. Photoshop displays the Layers palette, as shown in Figure 386.1.

Figure 386.1 The Layers palette displays a list of all the layers in the active document.

2. Click on the Layer Mask icon at the bottom of the Layers palette. Photoshop creates a layer mask and attaches it to the active layer, as shown in Figure 386.2. Note: You cannot create a layer mask on a background layer. You must first convert the background into a layer, as discussed in Tip 394, "Converting a Background into a Layer."

Figure 386.2 Clicking the Layer Mask icon creates a layer mask in the active layer.

3. To remove a layer mask from an image, click on the layer mask and drag the layer mask to the trash. Photoshop displays a dialog box asking if you want to apply or discard the layer mask, as shown in Figure 386.3.

Figure 386.3 Dragging the layer mask to the trash lets you apply or discard the mask.

Every layer within a Photoshop document can have its own layer mask. In the next tip, you will learn how to manipulate and edit a layer mask.

387 *Editing a Layer Mask*

In the preceding tip, you learned how to create a layer mask. However, not much happened to the image when you created the mask. Layer masks create transparent areas on an image by selecting a painting tool and painting with black, white, or a shade of gray.

When you create a new mask, the mask is white. The color white does not mask the graphic and lets you view the entire image. To mask the image, you need to paint the mask with black or a shade of gray. To edit a layer mask, open a Photoshop image and perform these steps:

1. If the Layers palette is not visible, select the Window menu and choose Show Layers from the pull-down menu. Photoshop displays the Layers palette.

2. Create a new layer mask (refer to the preceding tip).

3. When you create a layer mask, you essentially have two items within a single layer: the mask and the image. To edit the mask, click once on the mask, as shown in Figure 387.1.

Figure 387.1 Clicking on the layer mask activates the mask and lets you paint or mask the image.

4. Select the Paintbrush from the toolbox (refer to Tip 78, "The Paintbrush and Pencil Tools").

5. Select black as your painting color (refer to Tip 221, "Selecting a Foreground and Background Color Swatch").

6. Move your painting cursor into the document window and paint the areas of the image that you want transparent, as shown in Figure 387.2.

Figure 387.2 Using a black paintbrush on a layer masks changes the visible pixels in the image to transparent.

7. To restore image information, switch to the color white and paint the image. The white pixels remove the mask from the image, making the graphic visible, as shown in Figure 387.3.

8. Using a shade of gray creates a partial mask and generates semitransparent areas within the image.

> *Note: A mask is a powerful tool, letting you create transparency with the sweep of your paintbrush. Use masks on photo collages and where you want each layer assigned its own transparency layer mask.*

For more information on using masks, see Tip 642, "Blending Two Images Together."

Figure 387.3 *Painting the mask with the color white removes the mask from the image.*

388 *Duplicating a Layer Mask*

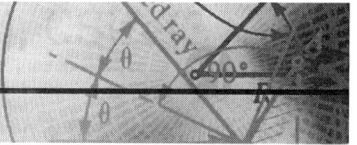

In the preceding two tips, you learned how to create, delete, and edit a layer mask. Once you create a layer mask, you might want to use the same mask on another layer.

To duplicate a layer mask, perform these steps:

1. Open a file containing a layer mask or create a layer mask on a new layer (refer to the preceding tip).

2. Move your cursor into the Layers palette, hold down the Ctrl key (Macintosh: Command key), and click on the layer mask, as shown in Figure 388.1.

Figure 388.1 *Holding down the Ctrl key (Macintosh: Command key) and clicking on the layer mask creates a selection from the black and white areas of the mask.*

3. Click on the layer to which you want to apply the mask. Photoshop selects the new layer.

4. Click on the Add Mask icon at the bottom of the Layers palette. Photoshop creates a copy of the original mask in the new layer, as shown in Figure 388.2.

Note: You cannot add a mask to a background layer.

Figure 388.2 Clicking on the Add Mask icon creates a mask based on the selected areas of the image.

Note: Being able to duplicate complicated masks saves time in the design process. Getting more work completed in the same amount of time makes you more efficient, and time is money in today's fast-paced world.

389 *Linking and Unlinking Layer Masks*

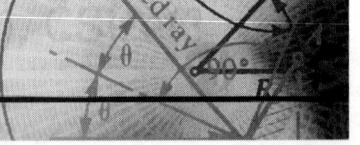

In Tip 386, "Creating a Layer Mask," you learned how to create a layer mask to control the transparency of an image layer. By default, when you create a layer mask, the mask links to the image. Moving the mask moves the image. In most cases, this is what you expect to happen; however, there are times when you want to move the image independent of the mask. To move the image and not the mask, you need to unlink the mask from the image.

To unlink a mask from the image, click on the chain icon located directly between the mask and the image, as shown in Figure 389.1.

Figure 389.1 Clicking on the chain icon separates the two layer elements and lets you move one independently from the other.

In this example, a multi-layered image displays a dog behind a window. The mask on the dog layer gives the appearance of the dog behind the window. To reposition the dog without moving the mask, perform these steps:

1. Click on the chain icon to separate the layer from the mask.

2. The mask layer contains two elements: a mask icon and an image icon. Click once on the image icon, as shown in Figure 389.2.

Figure 389.2 Clicking on the image icon selects the image and lets you move the image.

3. Select the Move tool from the toolbox.

4. Move the Move tool into the document window and click and drag to move the dog. The image of the dog moves without moving the mask, as shown in Figure 389.3.

Note: In many cases, such as photo collages, the image and mask move as a unit. However, when you need the image or mask to move independently, unchain the two layer items to achieve total control over the image.

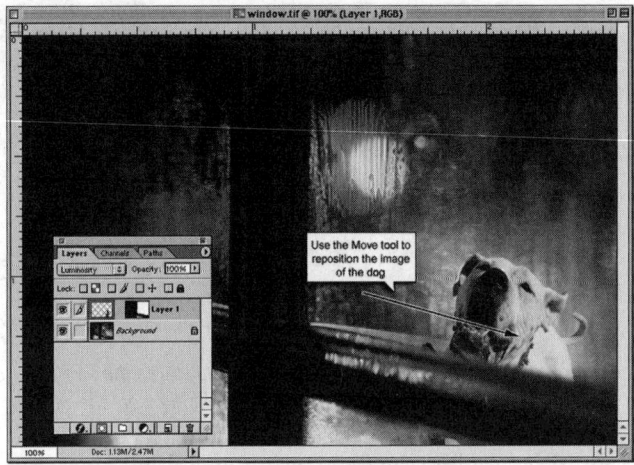

Figure 389.3 The unchained image of the dog is movable without moving the mask.

390 *Using Pass Through with a Layer Set*

In Tip 380, "Creating Layer Sets," you learned how to manage the Layers palette by creating individual layer sets and combining them into definable groups. When you create a new layer set, a new option called Pass Through is added to the blending modes, as shown in Figure 390.1.

Figure 390.1 The Pass Though option is only available when you create a layer set.

The Pass Through option works on a layer set containing Adjustment layers. When the Pass Through option is selected, the Adjustment layers within the set apply to all the layers within the image, regardless of whether they are part of the set or not, as shown in Figure 390.2.

To limit the effects of Adjustment layers to within the layer set, click on the Pass Through button. Photoshop displays the blending mode options. Click on the Normal option. Photoshop restricts the application of the Adjustment layers to within the layer set, as shown in Figure 390.3.

Figure 390.2 The Pass Through option takes the effects of all Adjustment layers within the layer set and applies the effects throughout the image.

Figure 390.3 Using the Normal blending mode option restricts the Adjustment layers from changing any image information outside the layer set.

391 *Creating Perspective with Layer Effects*

Three of Photoshop's layer effects help create perspective within an image: Drop Shadow, Inner Shadow, and Bevel and Emboss. The term "perspective" defines the ability to create 3-D shapes on a flat surface.

Drop Shadow uses a dark, blurred copy of the original object to create the illusion of a shadow, as shown in Figure 391.1.

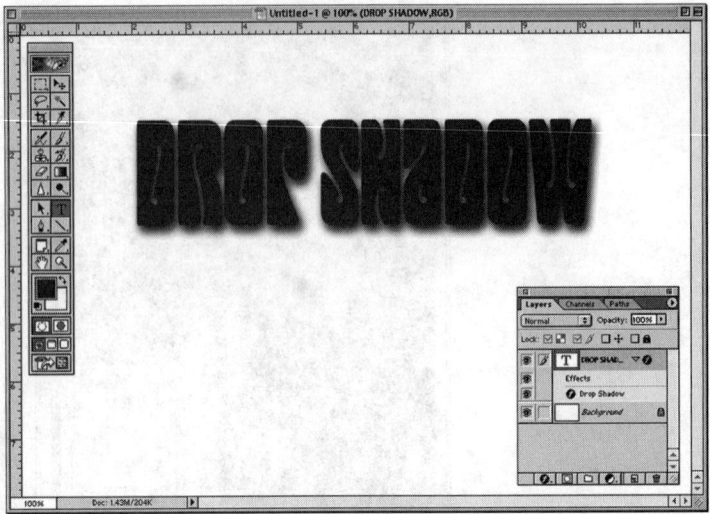

Figure 391.1 The Drop Shadow layer style creates the illusion of depth by offsetting
a dark, blurred copy of the original object.

Bevel and Emboss creates the illusion of three dimensions by lightening and darkening areas of the object, as shown in Figure 391.2.

Figure 391.2 The Bevel and Emboss layer style creates the illusion of three
dimensions by painting light and dark areas along the edges of the object.

Inner Shadow creates a sense of depth by painting a soft line along the inner edge of an object, as shown in Figure 391.3.

Note: For information on accessing and using layer effects, refer to Tip 382, "Applying a Layer Effect."

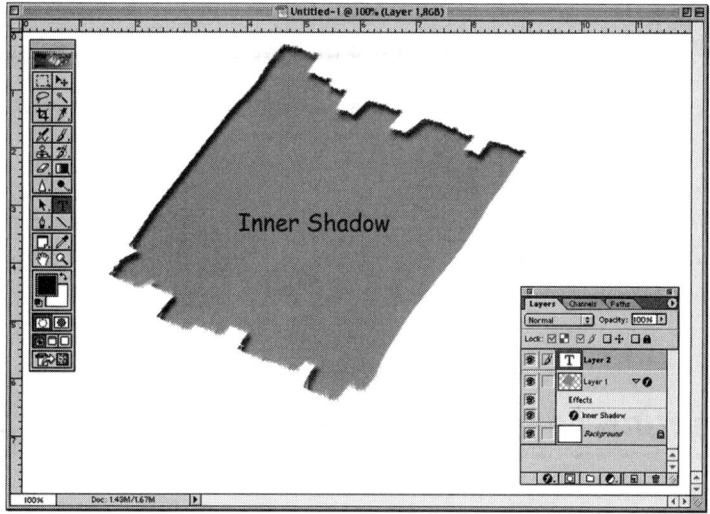

Figure 391.3 The Inner Shadow layer style creates the illusion of depth by painting a dark, soft line on the inner edge of the image.

392 *Understanding Layer Divisions*

If you own Photoshop 6.0, you have noticed that the Layers palette is different than in all previous versions of the program. Adobe revamped the Layers palette to give you more control over effects, Adjustment layers, and shape layers, as shown in Figure 392.1.

Figure 392.1 The Layers palette in Photoshop 6.0 gives you more control over layer effects and Adjustment layers.

- When you create a layer effect, Photoshop creates a layer to hold the effect. Double-click on the layer effect to access the Layer Style dialog box and reedit the effect (refer to Tip 382, "Applying a Layer Effect").

- The Adjustment layers are accessed from the Layers palette by clicking on the Adjustment Layer icon at the bottom of the Layers palette (refer to Figure 392.1). When you create a new Adjustment layer, Photoshop creates a new layer to hold the Adjustment (refer to Tip 322, "Understanding Adjustment Layers").

- Layer sets hold groups of layers like file folders hold groups of papers (refer to Tip 380, "Creating Layer Sets"). Layer sets let you organize the layers within a Photoshop document.

- Shape layers let you create unique shapes and modify the shapes with Pen tools (see Tip 686, "Working with Shape Layers").

Note: Photoshop 6.0 lets you create a maximum of 8,000 layers. However, with memory restraints and speed of work, a practical limit for most computers is 1,000 layers.

393 Creating Layer Effects via Copy and Paste

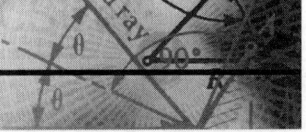

In Tip 383, "Moving Layers Effects with Drag and Drop," you learned how to copy a layer effect and transfer the effect to another layer. A second way to move a layer style is by performing a copy and paste.

To move a layer style by copy and paste, open a document containing a layer style and perform these steps:

1. Click on the Layer tab (or if the Layers palette is not visible, select the Window menu and choose Show Layers from the pull-down menu). Photoshop displays the Layers palette, as shown in Figure 393.1.

Figure 393.1 The Layers palette displays all the available layers and styles within the active document.

2. Move your mouse into the Layers palette and right-click (Macintosh: Command+click) on the layer style you want to copy. Photoshop displays a pop-up menu with the style options, as shown in Figure 393.2.

3. Select Copy Layer Style from the pop-up menu. Photoshop copies the layer style into memory.

4. Move your cursor over the layer you want to apply a style to and right-click (Macintosh: Command+click). Photoshop displays the style options pop-up menu (see Figure 393.2).

5. Select Paste Layer Style from the pop-up menu. Photoshop closes the pop-up menu and copies the style to the new layer, as shown in Figure 393.3.

Figure 393.2 The Layers pop-up menu displays all the options for controlling the characteristics of a layer style.

Figure 393.3 Using the Copy and Paste Layer Style option lets you move a style from one layer to another.

> **Note:** *Since Photoshop holds a style in memory, it is possible to copy and paste a layer style from one document to another. The style resides in memory until another style is copied or Photoshop is shut down.*

394 *Converting a Background into a Layer*

In Tip 346, "Backgrounds vs. Layers," you learned the difference between the two primary elements in a Photoshop document. Graphic images, when opened for the first time, are typically defined in the Layers palette as a Background. For example, images taken with a digital camera or scanned and then opened in Photoshop will open as a Background layer.

Since Backgrounds cannot be repositioned within the layer stack and the pixels within the image cannot be converted to transparent, Backgrounds have a limited use during the editing of a Photoshop document.

To convert a background into a layer, open the image in Photoshop and perform these steps:

1. Click on the Layer tab (or if the Layers palette is not visible, select the Window menu and choose Show Layers from the pull-down menu). Photoshop displays the Layers palette, as shown in Figure 394.1.

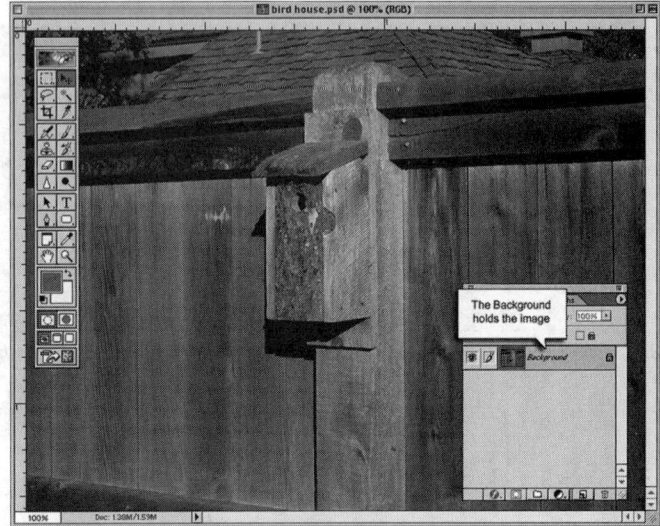

Figure 394.1 The Layers palette in Photoshop, defining the visible image as a Background.

2. Move your cursor into the Layers palette and double-click on the Background layer. Photoshop opens the New Layer dialog box, as shown in Figure 394.2.

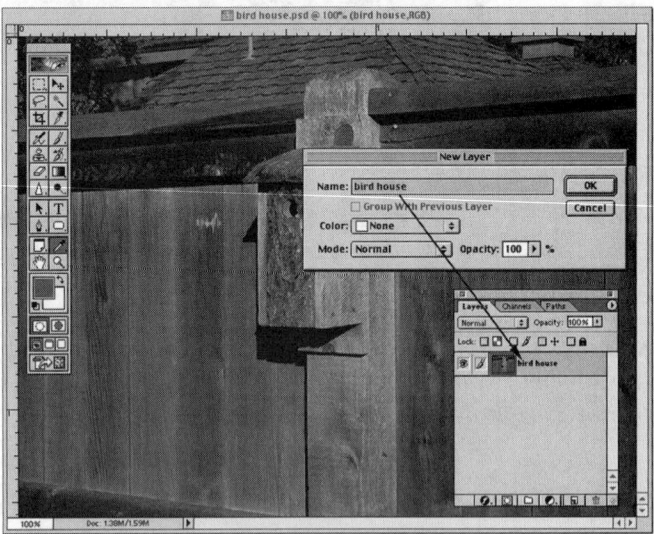

Figure 394.2 The New Layer dialog box lets you convert a Background into a layer.

3. Click in the Name input field and enter a name for the layer.

4. Click the OK button to close the New Layer dialog box and record your changes to the layer.

Note: Since the Background is now defined as a layer, you can convert the image pixels into transparent pixels and move the layer to any position within the layer stack.

395 *Sampling Image Information from All Layers*

When you use the Magic Wand tool, you sample and select digital information within a Photoshop document (refer to Tip 170, "Understanding How the Magic Wand Works"). The Magic Wand tool normally keys to the active layer. There are times, however, when you want to select digital information within a multi-layered document, and you want the Magic Wand to examine all the layers within the document at the same time.

To use the Magic Wand tool to select information in a multi-layered document, open the document in Photoshop and perform these steps:

1. Select the Magic Wand tool from the toolbox (refer to Tip 74, "The Magic Wand Tool").

2. Select the Use All Layers option in the Magic Wand options, as shown in Figure 395.1.

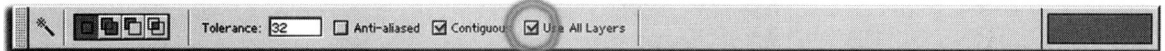

*Figure 395.1 The Use All Layers option lets the Magic Wand tool examine all the
layers in a Photoshop document, not just the active layer.*

3. Select the correct sample area of the image by moving the Magic Wand into the document and clicking once. Photoshop selects the pixels within the image based on the sample and selects all similar pixels throughout the image, regardless of the layer, as shown in Figure 395.2.

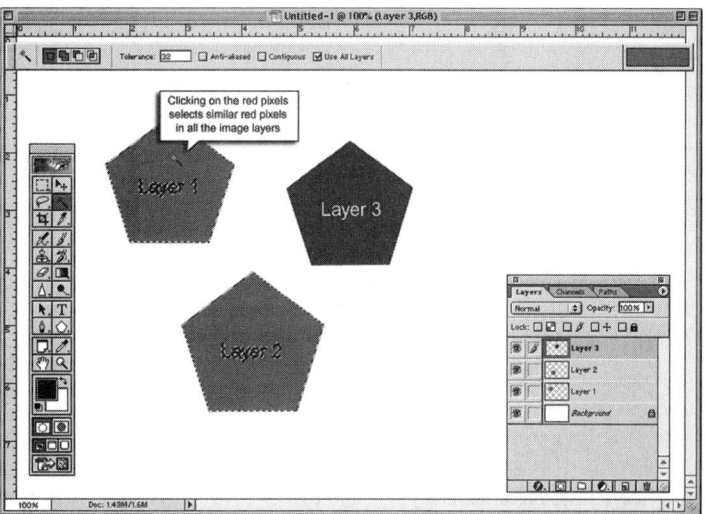

Figure 395.2 The Magic Wand selects pixels based on the sample throughout the image.

396 *Using Layers to Create a Magnifying Lens Effect*

In this tip, you will create the illusion of a magnifying glass enlarging a portion of an image.

To create a magnifying glass effect in Photoshop, open a graphic image and perform these steps:

1. Click on the Layer tab (or if the Layers palette is not visible, select the Window menu and choose Show Layers from the pull-down menu). Photoshop displays the Layers palette, as shown in Figure 396.1.

Figure 396.1 The Layers palette displays a list of all the layers within a Photoshop document.

2. Move your cursor into the Layers palette and make a copy of the image by clicking and dragging the layer over the New Layer icon. Photoshop creates a copy of the image layer, as shown in Figure 396.2. For more information on layer copies, refer to Tip 376, "Making a Pixel-to-Pixel Copy of a Layer."

Figure 396.2 Drag the original layer image over the New Layer icon to create an exact copy of the image.

3. Select Edit menu Transform and choose Scale from the fly-out menu. Photoshop displays the Scale options in the Options bar, as shown in Figure 396.3.

Figure 396.3 The Scale options, as displayed on Photoshop's Options bar.

4. Click in the Width and Height fields and enter a value of 150 percent. Press the Enter key twice to record the change to the image. Photoshop enlarges the image copy 150 percent, as shown in Figure 396.4.

Figure 396.4 The Scale option, by default, expands the image from the center out.

5. Click the New Layer Icon button at the bottom of the Layers palette to create a new layer, as shown in Figure 396.5.

Figure 396.5 Clicking on the New Layer icon creates a new layer directly above the active layer.

6. Select the Ellipse Tool and draw a round, filled circle in the new layer, as shown in Figure 396.6. For more information on using the Drawing tools, refer to Tip 138, "Using Photoshop's New Drawing Tools."

7. Next you will create a clipping group with the circle layer and the enlarged layer. Click and drag the layer containing the circle directly below the enlarged image layer, as shown in Figure 396.7.

Figure 396.6 To create a perfect circle with the Ellipse tool, hold down the Shift key while dragging the mouse.

Figure 396.7 Click and drag the layer containing the circle directly under the enlarged layer.

8. Create the clipping group by moving the hand icon cursor into the Layers palette until the cursor rests on the line between the enlarged layer and the circle layer. Then hold the Alt (Macintosh: Option) key and click, as shown in Figure 396.8.

Figure 396.8 Move the cursor to the line separating the image and the circle layer and Alt+click to create the clipping path.

9. Photoshop creates a clipping path based on the circle, as shown in Figure 396.9.

*Figure 396.9 By creating a clipping path based on the circle and enlarged layers,
you create the illusion of a magnifying glass.*

10. Click once on the layer containing the circle and select the Move tool from the toolbox. Next click and drag the circle around the image; stop when you have the correct position.

Note: You might combine the clipping group with the photographic image of a magnifying glass to complete the effect, as shown in Figure 396.10.

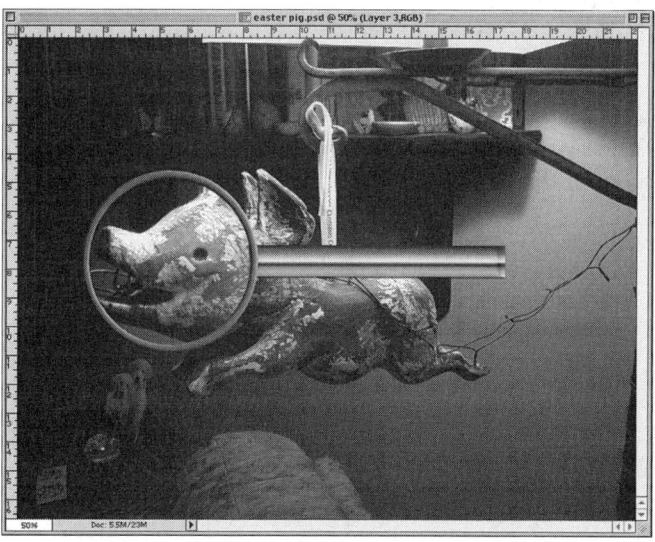

*Figure 396.10 Combining the clipping group with the image of a magnifying glass
completes the illusion of a magnifying glass moving over the image.*

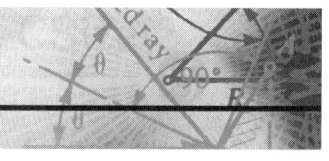

397 *Understanding How History Operates*

Photoshop introduced History in version 5 and totally changed how we use the program. The definition of Photoshop's History is control: control over an image, control over how you work on an image, and

control over image editing. With the introduction of History, Photoshop broke the single undo barrier. By default, History lets us return backwards through the last 20 operations.

Photoshop's History is broken down into two areas: a History brush and the History palette, as shown in Figure 397.1.

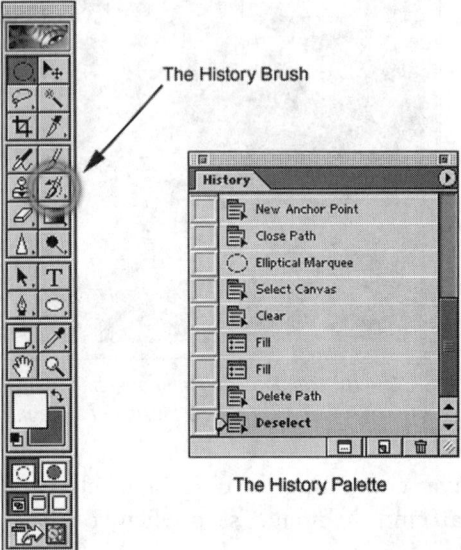

Figure 397.1 *The History brush and the History palette give the Photoshop designer total control over an image.*

When you first open an image in Photoshop, the History palette takes a snapshot of the image. The History brush uses that initial snapshot as a template to paint the image. When you use the History brush without modifying the snapshot, the brush automatically paints the image back into the document exactly the way it looked when first opened, regardless of the number of times you saved the file.

The History palette keeps a running total of the last 20 operations (called History states) performed in the document. When you click on a previous History state, Photoshop takes you back to that editing point and grays out all the steps after that point, as shown in Figure 397.2.

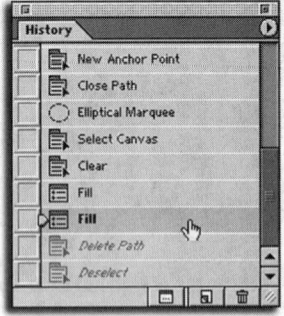

Figure 397.2 *Clicking on a previous History state in the History palette returns you to that point in the editing of the image.*

You cannot save a previous History with the document. Every time an image is opened in Photoshop, it starts with a new History palette. However, you can move items from the History palette between two open documents.

398 *Creating a Snapshot*

In the preceding tip, you learned how Photoshop automatically creates a snapshot of a document when first opened. The History brush, used to restore portions of an image to their original state, uses that snapshot. The History palette lets you create a snapshot of the image during any point in the design.

To create a snapshot of a document, open a document in Photoshop and perform these steps:

1. Click on the History tab, or select the Window menu and choose Show History from the pull-down menu. Photoshop displays the History palette, as shown in Figure 398.1.

Figure 398.1 The History palette displays all the History states in the active image.

2. Click on the black triangle in the upper-right corner of the History palette. Photoshop opens a pop-up menu displaying all available History options, as shown in Figure 398.2.

Figure 398.2 Clicking on the black triangle displays a pop-up menu with all the History palette options.

3. Select the New Snapshot option. Photoshop closes the pop-up menu and opens the New Snapshot dialog box, as shown in Figure 398.3.

4. Click in the Name input field and enter a unique name for the snapshot.

5. Click on the From option and create a snapshot from the Full Document (all layers), currently Merged layers, or the currently Active layer.

6. Click the OK button to close the New Snapshot dialog box and save the snapshot to the History palette, as shown in Figure 398.4.

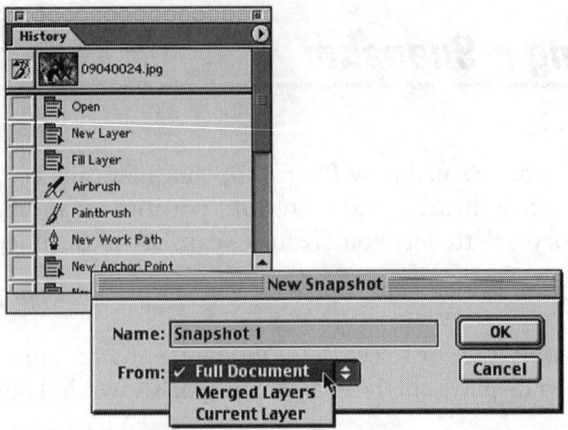

Figure 398.3 The New Snapshot dialog box defines the characteristics of the History snapshot.

Figure 398.4 The New Snapshot is stored in the History palette.

Note: *For more information on how to use a snapshot, see Tip 400, "Painting with a Snapshot."*

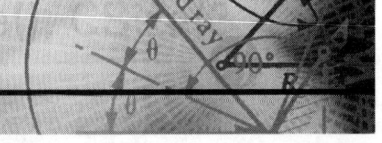

399 *Using Linear or Nonlinear Histories*

In Tip 397, "Understanding How History Operates," you learned how History works to record the individual editing steps within a document. When you click on a previous History state, by default, Photoshop undoes all the steps after the one you clicked. Say, for example, you create a document and perform 15 individual editing steps to the image, as shown in Figure 399.1.

When you click on History State 10, you undo states 11 through 15. By default, History works in a linear fashion, and clicking on a particular History state automatically grays out all the History states under the selected state, as shown in Figure 399.1. Once you perform a command or edit to the document, the grayed out History states are removed from the History palette.

To change the History palette to nonlinear, click on the black triangle in the upper-right corner of the History palette. Photoshop opens a pop-up menu displaying all available History options, as shown in Figure 399.3.

Select History Options from the pop-up menu. Photoshop displays the History Options dialog box. Click in the Allow Non-Linear History check box to select that option. Then click OK to close the History Options dialog box and record your changes to the History palette, as shown in Figure 399.4.

When you select the Allow Non-Linear History option, clicking a History state in the History palette only removes the selected state without deleting the subsequent states.

Figure 399.1 The History palette displaying 15 individual editing steps.

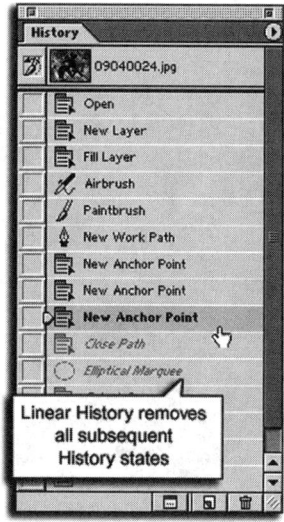

Figure 399.2 Clicking on History State 10 reverses the effects of step 11 and all subsequent History states.

Figure 399.3 Clicking the black triangle displays a list of all available History options.

Figure 399.4 With Allow Non-Linear History selected, you can remove specific states within the History palette.

400 *Painting with a Snapshot*

In Tip 398, "Creating a Snapshot," you learned how the History palette stores snapshots of the image during various stages of editing. Photoshop's History brush uses the History states in an image to paint the image.

Say, for example, you create a document in Photoshop with several different History states, as shown in Figure 400.1.

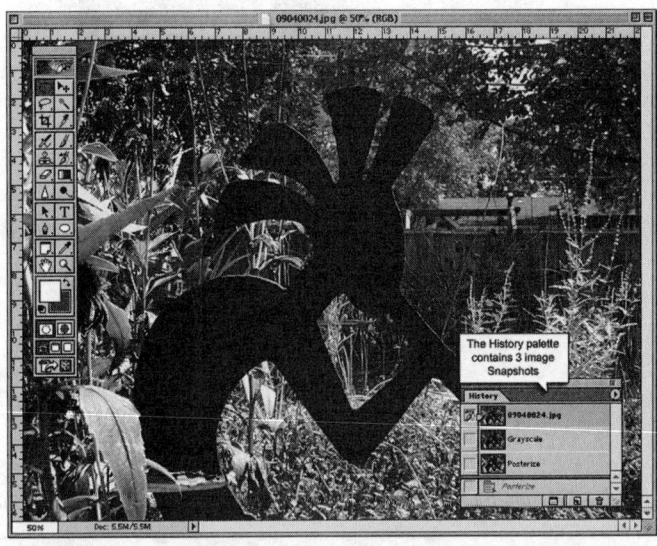

Figure 400.1 A Photoshop image with several saved History states.

To paint using a different History state, perform these steps:

1. Click on the History tab, or select the Window menu and choose Show History from the pull-down menu. Photoshop displays the History palette (see Figure 400.1).

2. Move your cursor into the History palette and select the snapshot you want to paint from by clicking to the far left of the snapshot name, as shown in Figure 400.2.

3. Select the History brush from the toolbox (refer to Tip 80, "The History and Art History Brush Tools").

4. Move the History brush into the image. Click and drag the History brush to paint from that particular History state, as shown in Figure 400.3.

Figure 400.2 Clicking to the far left of the snapshot chooses that snapshot as the one used by the History brush.

Figure 400.3 The History brush paints using a snapshot from the History palette.

401 *Using Multiple Undos*

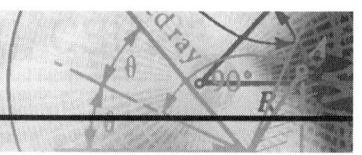

One of the great features of Photoshop since version 5 is the ability to perform multiple undos. Photoshop, by default, keeps a list of the last 20 operations in the History palette, as shown in Figure 401.1.

Photoshop defines the elements in the History palette as History states. Each state represents the graphic image at a previous development stage. To perform a single or multiple undo, move your mouse into the History palette and click once on one of the History states, as shown in Figure 401.2.

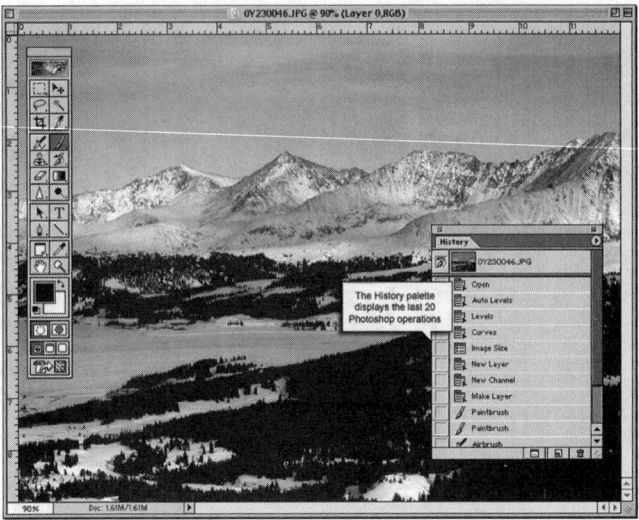

Figure 401.1 The History palette displays a list of the last 20 Photoshop operations.

Figure 401.2 Clicking on a History state lets you perform multiple undos.

When you click on a History state, all the History states below where you clicked turn gray. The further up the History list you click, the more States are undone. To reactivate a grayed-out History state, click once on the State. Photoshop will reactive that State and all previous History states.

To change the maximum number of allowable History states, select the Edit menu, then choose Preferences and choose General from the fly-out menu. Photoshop displays the General Preferences dialog box, as shown in Figure 401.3.

Click in the History states input box and enter a value from 1 to 100. Click the OK button to close the General Preferences dialog box and record your changes to the History palette.

> *Note: Increasing the number of History states increases the amount of RAM memory Photoshop needs to record all those additional History states. There are few circumstances in which you need more than 20 levels of undo (see Tip 403, "How the History Palette Impacts Memory").*

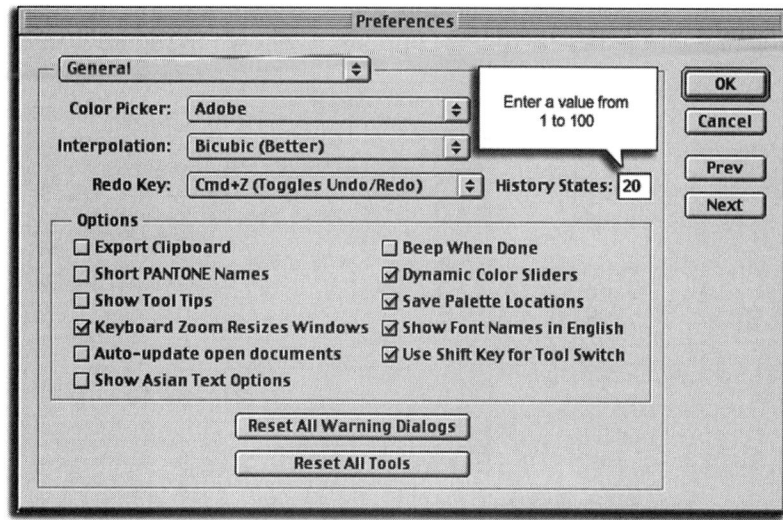

Figure 401.3 The General Preferences dialog box controls the maximum allowable History states.

402 *Creating a New Document from a History State*

In the preceding tip, you learned how the History palette lets you perform multiple undos. The History palette also lets you create a copy of an image from any visible History state.

For example, if you are working on a Photoshop image and you want to make a copy of the image based on a previous History state, perform these steps:

1. Click once on the History tab (or if the History palette is not visible, select the Window menu Show History from the pull-down menu). Photoshop displays the History palette, as shown in Figure 402.1.

Figure 402.1 The History palette displays a listing of the last 20 History states of the active document.

2. Click once on the History state you want to copy. Photoshop selects the History state.

3. Click on the black triangle in the upper-right corner of the History palette. Photoshop displays a fly-out menu with the History palette options, as shown in Figure 402.2.

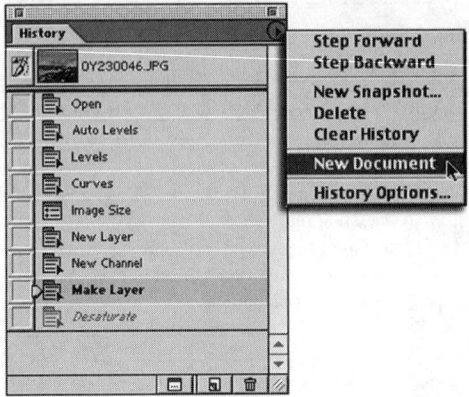

Figure 402.2 Clicking on the black triangle displays a list of all available History palette options.

4. Select New Document from the fly-out menu. Photoshop creates a new document based on the selected History state, as shown in Figure 402.3.

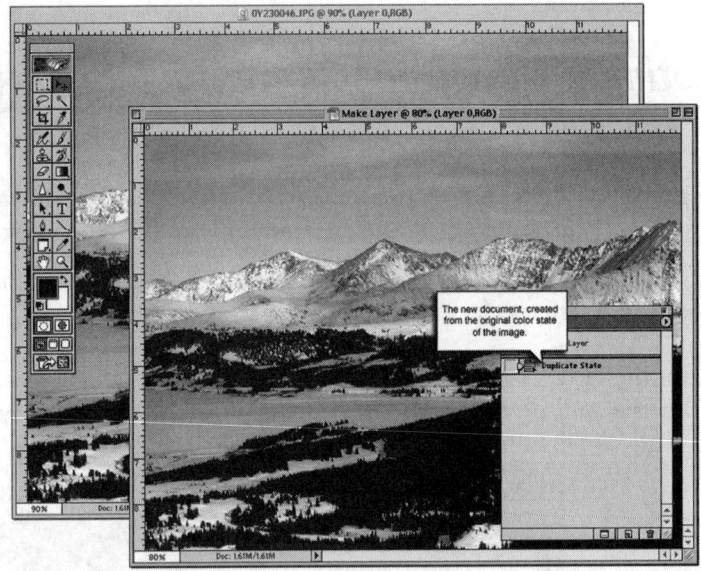

Figure 402.3 Selecting New Document creates a document based on the current History state.

403 *How the History Palette Impacts Memory*

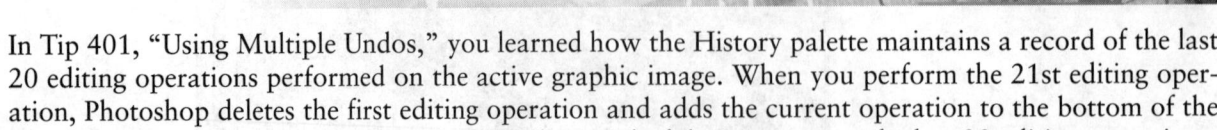

In Tip 401, "Using Multiple Undos," you learned how the History palette maintains a record of the last 20 editing operations performed on the active graphic image. When you perform the 21st editing operation, Photoshop deletes the first editing operation and adds the current operation to the bottom of the list. In this way, you have complete access and control of the image up to the last 20 editing operations.

Photoshop lets you control the number of History states by accessing General Preferences and changing the default number of History states (20) to any value from 1 to 100 (refer to Tip 401).

Increasing the number of History states has a negative effect on RAM memory. The more History states you use, the less RAM memory is available for Photoshop to perform its normal operations.

Each History state does not represent a screen shot of the image. Photoshop looks at the image, determines what changed from the previous History state, and saves that information in RAM memory.

When you click on a particular History state, Photoshop incorporates the changes back into the image. The price you pay for having the ability to perform multiple undos is a loss of RAM memory and a slower program.

One way to preserve a particular History state is to take a snapshot of the image (refer to Tip 398, "Creating a Snapshot." Creating snapshots of the image at important editing points lets you return to the image at that editing stage without increasing the number of available History states.

In fact, if a lack of available RAM memory is a problem, lower the number of History states to 5 or 10. Lowering the number of History states frees up more RAM memory for other operations and lets Photoshop perform normal operations faster.

404 *Filling a Selection with a History State*

In Tip 400, "Painting with a Snapshot," you learned how the History brush works with the History palette. While the History brush lets you "paint" an area of an image using a preselected History state, Photoshop also lets you "fill" an area of an image from a History state or snapshot.

To fill a preselected area of an image using a History state or snapshot, open the image in Photoshop and perform these steps:

1. Click once on the History tab (or, if the History palette is not visible, select the Window menu Show History from the pull-down menu). Photoshop displays the History palette, as shown in Figure 404.1.

2. Using Photoshop's selection tools, select the area of the image you want to fill, as shown in Figure 404.2. For more information on selection, refer to Tip 280, "Selection Methods."

Figure 404.1 The History palette displays a list of History states and snapshots for the active document.

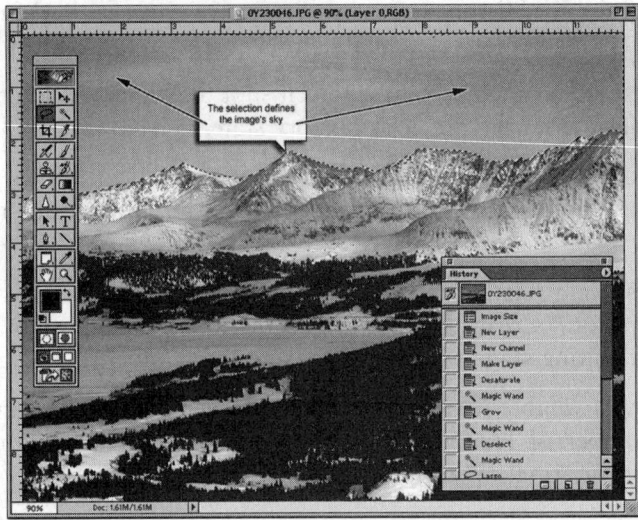

Figure 404.2 The selection defines the fill area.

3. Move your cursor into the History palette and click on the History state or snapshot you want to use for the Fill command, as shown in Figure 404.3.

Figure 404.3 Clicking to the left of the History state or snapshot selects that State for use by the Fill command.

4. Select the Edit menu and choose the Fill command from the pull-down menu. Photoshop opens the Fill dialog box, as shown in Figure 404.4.

Figure 404.4 The Fill dialog box controls the how the Fill command performs.

5. Click on the Contents Use button. Photoshop displays the Use options. Select Fill from the pop-up menu. Since you want the image to fill the selected area without changing the information, leave the Blending Mode option at Normal and leave the Opacity set to 100 percent (refer to Figure 404.4).

6. Click the OK button. Photoshop closes the Fill dialog box and fills the selected areas of the image with the selected snapshot, as shown in Figure 404.5.

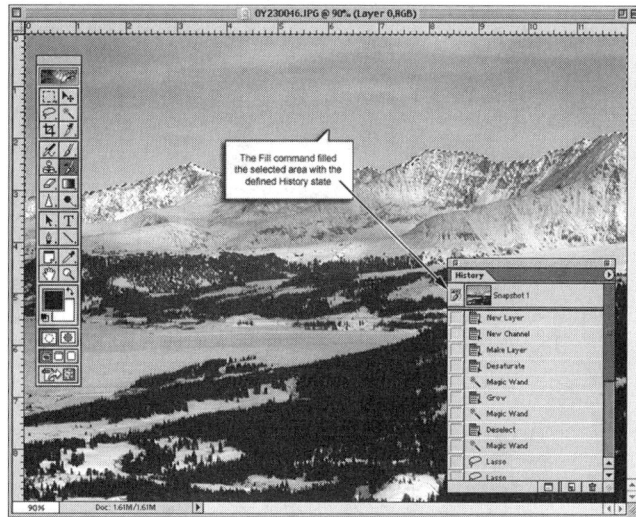

Figure 404.5 The final graphic with the selected areas of the image filled with a preselected Snapshot.

405 *Dragging History States Between Document Windows*

In Tip 402, "Creating a New Document from a History State," you learned how to use the History palette to create a new document based on a preselected History state or snapshot. Say, for example, you have an open document window and you want to move a particular History state or snapshot into the open document.

To move History states or Snapshots between documents, open two documents and perform these steps:

1. Click once on the History tab (or if the History palette is not visible, select the Window menu Show History from the pull-down menu). Photoshop displays the History palette, as shown in Figure 405.1.

2. The originating document contains the History state or snapshot you want to move. To select the originating document, click once inside the originating document window. Photoshop makes it the active document, and the History palette displays the History states and snapshots for that document.

3. Move your mouse into the History palette and click and drag a History state or snapshot from the History palette into the second document window, as shown in Figure 405.2.

Figure 405.1 The History palette displays a list of History states and snapshots for the active document.

Figure 405.2 Clicking and dragging a History state between documents copies that History state into the new document.

When you move History states or snapshots between open documents,

- The receiving document takes on the width, height, color space, and resolution of the moved Snapshot or History state.

- When you move a snapshot, Photoshop moves the image without any of the History states that were used to create the snapshot.

- When you move a History state into another document, that state and all previous states are copied into the new document.

Note: History states and Snapshots do not remain with a file. Once a document is saved and closed, reopening the document starts you with a blank History palette.

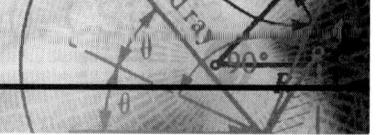

406 *Stepping Through the History States*

When you are working on an image, you can edit the image by moving up or down through the document's various History states. This is helpful when you are looking for a particular editing point or you just want to see the creation steps in your image one by one.

To step through the History states of an active image, perform these steps:

1. Click once on the History tab (or if the History palette is not visible, select the Window menu Show History from the pull-down menu). Photoshop displays the History palette, as shown in Figure 406.1.

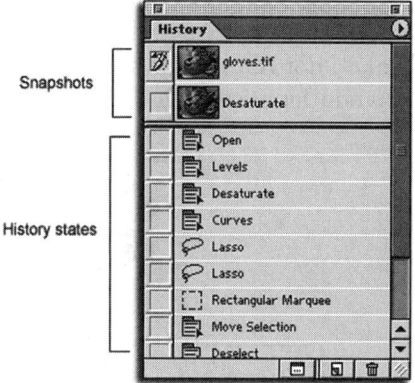

Figure 406.1 The History palette displays a list of History states and Snapshots for the active document.

2. Click on the black triangle in the upper-right corner of the History palette. Photoshop displays a fly-out menu with all the available History palette options.

3. Click on Step Forward or Step Backward to move up or down within the History palette.

4. To speed up the stepping process, use the shortcut keys for stepping: Ctrl+Shift+Z (Macintosh: Command+Shift+Z) to Step Forward and Ctrl+Alt+Z (Macintosh: Command+Option+Z) to Step Backward.

407 *Duplicating a History State*

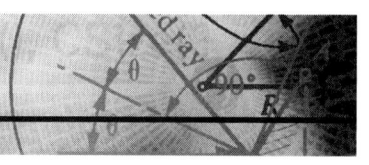

Since the editing instructions for each operation performed in Photoshop are contained within a History state, an important timesaver is the ability to duplicate a History state.

To duplicate a History state, open a document in Photoshop and perform these steps:

1. Click once on the History tab (or if the History palette is not visible, select the Window menu Show History from the pull-down menu). Photoshop displays the History palette, as shown in Figure 407.1.

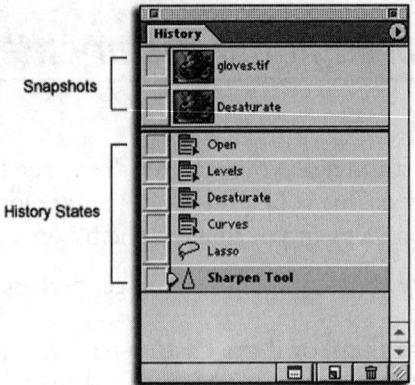

Figure 407.1 The History palette displays a list of History states and snapshots for the active document.

2. Move your cursor into the History palette and Alt+click (Macintosh: Option+click) on the History state you want to duplicate. Photoshop makes a duplicate of the History state and places it at the bottom of the list, as shown in Figure 407.2.

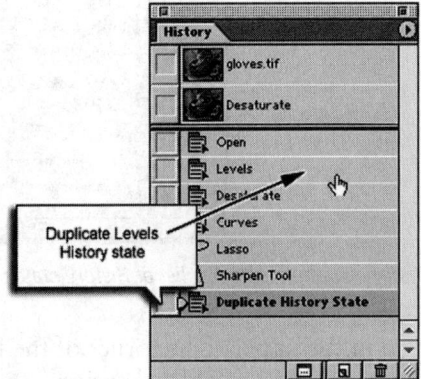

Figure 407.2 Alt+clicking on a History state duplicates that state at the bottom of the History list.

Note: Duplicating History states saves you time in the designing and editing process. Why go to the time-consuming expense of redoing an editing step when the History palette helps you do it with the click of a button?

408 Creating a Snapshot from a Previous History State

In Tip 398, "Creating a Snapshot," you learned how to create a snapshot of the current state of the image. The History palette lets you create a Snapshot of any available History state. To create a snapshot from a previous History state, perform these steps:

1. Click once on the History tab (or if the History palette is not visible, select the Window menu Show History from the pull-down menu). Photoshop displays the History palette, as shown in Figure 408.1.

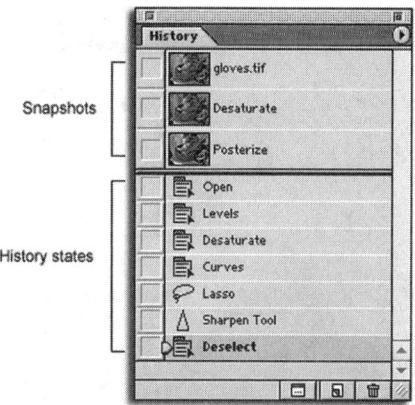

Figure 408.1 The History palette displays a list of History states and snapshots for the active document.

2. Move your mouse into the History palette and click once on the History state you want to convert into a snapshot. Photoshop selects the History state and reverts the image to that point in the editing process, as shown in Figure 408.2.

Figure 408.2 Clicking on a History state selects that particular point in the editing process.

3. Click on the black triangle in the upper-right corner of the History palette. Photoshop displays the options for the History palette in a fly-out menu.

4. Click once on the New Snapshot option. Photoshop opens the New Snapshot dialog box, as shown in Figure 408.3.

5. Click in the Name field and enter a name for the snapshot.

6. Click on the From button and choose Full Document, Merged Layers, or Current Layer.

7. Click the OK button. Photoshop closes the New Snapshot dialog box and creates the new snapshot, as shown in Figure 408.4.

Figure 408.3 The New Snapshot dialog box controls the name and characteristics of the snapshot.

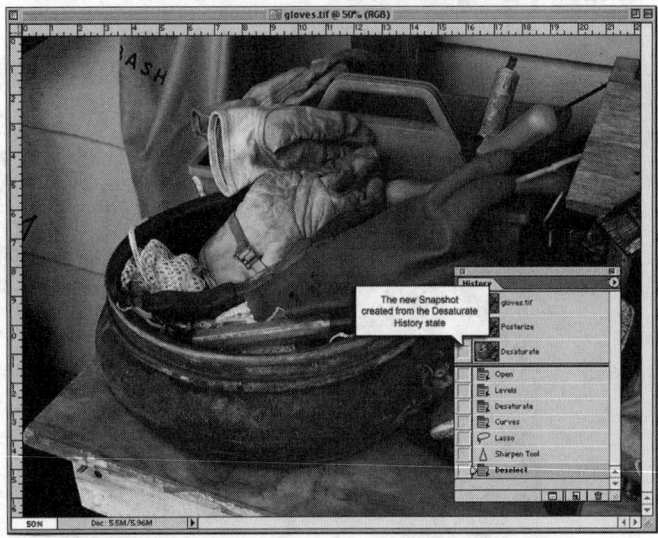

Figure 408.4 The History palette containing the New Snapshot.

8. Move your mouse into the History palette and click once on the last (bottom) History state to return the image to its most current state.

409 *Using Erase to History*

Photoshop introduced the History brush and the History palette in version 5; however, Photoshop gave designers a way to duplicate (in a small way) the effects of using the History brush long before Photoshop 5 hit the market.

Although the Erase to History option (Erase to Saved in pre-5 versions of the program) is still part of the Photoshop program, the History brush has all but eliminated its use.

To turn your Eraser tool into a History brush, open a Photoshop document and perform these steps:

1. Select the Eraser tool from the toolbox. For information on using the Eraser tool, refer to Tip 81, "The Eraser Tools." Photoshop displays the Eraser tool options in the Options bar, as shown in Figure 409.1.

Figure 409.1 The Eraser tool options in the Photoshop Options bar.

2. Click in the Erase to History check box. Photoshop places a check mark in the box. The Eraser tool is now a History brush.

3. Click within a Photoshop document and drag the Eraser tool across the image. The Eraser tool paints the image, just like the History brush, from the selected History state, as shown in Figure 409.2.

Figure 409.2 The Eraser tool acts like the History brush when the Erase to History option is selected.

Note: The Erase to History option is a holdover from the days before version 5. Back in Photoshop 3 and 4, Erase to History was the Erase to Saved option, and the Eraser tool restored the image back to the last saved version.

410 *Using the Actions Palette*

If you want to save time with repetitive operations, then the Actions palette is where you need to focus your attention. The Actions palette stores Photoshop editing operations into repeatable sequences.

Actions are not limited to the open document. Once you create and save an Action, it is available to any open Photoshop document. Photoshop comes with a set of preloaded Actions; however, you can create your own Actions from editing steps as you work on an image.

To perform an Action on an image, open a document in Photoshop and perform these steps:

1. Click on the Actions tab, or select the Window menu and choose Show Actions from the pull-down menu. Photoshop displays the Actions palette, as shown in Figure 410.1.

Default
Photoshop Actions —

Play Action

Figure 410.1 The Actions palette displays a list of all currently available Actions.

2. In this example, you will use one of Photoshop's preloaded Actions to create a vignette around the image. Using one of Photoshop's selection tools, create a selection border defining the vignette, as shown in Figure 410.2.

3. Move your mouse cursor into the Actions palette and click once on the Vignette (selection) option. Photoshop selects Vignette as the active Action.

4. To begin the Action, click once on the white triangle (the play button) located at the bottom of the Actions palette (refer to Figure 410.1).

5. Photoshop displays the Feather Selection dialog box, as shown in Figure 410.3.

Figure 410.2 The selection border defines the area used for creating the vignette.

Figure 410.3 The Feather Selection dialog box controls the amount of feathering applied to the vignette border.

6. Click in the Feather Radius input box and enter a feather value. In this example, a feather of 15 was selected. Click the OK button to continue the Action.

7. As you watch, Photoshop completes the Action by creating a vignette around the image based on the selection and feather option, as shown in Figure 410.4.

Figure 410.4 The final image containing a soft vignette.

Note: As you can see, Actions are a tremendous timesaver. When you edit an image in Photoshop, watch how you work and what you do. You can save time if you create Actions out of repetitive Photoshop operations. For more information on creating your own Actions, see Tip 411, "Creating a New Action."

411 *Creating a New Action*

In the preceding tip, you learned how Actions save valuable editing time. However, Photoshop goes beyond letting you select precreated Actions; it also lets you create your own Actions.

Creating an Action is similar to recording your voice with a cassette tape recorder. Once the information is recorded onto the tape, you can listen to the conversation again. New Actions are a combination of Photoshop operations assembled into a file. Once saved, that file can be used over and over again.

Say, for example, you want to create an Action to reduce the size of a digital camera image. You want the final image size to be as close to 5×7 as possible, with a color space of CMYK (cyan, magenta, yellow, and black).

To create an action, open an image and perform these steps:

1. If the Actions palette is not visible, click the Actions tab or select the Window menu and choose Show Actions from the pull-down menu. Photoshop displays the Actions palette, as shown in Figure 411.1.

2. Click the New Action icon at the bottom of the Actions palette. Photoshop opens the New Action dialog box, as shown in Figure 411.2.

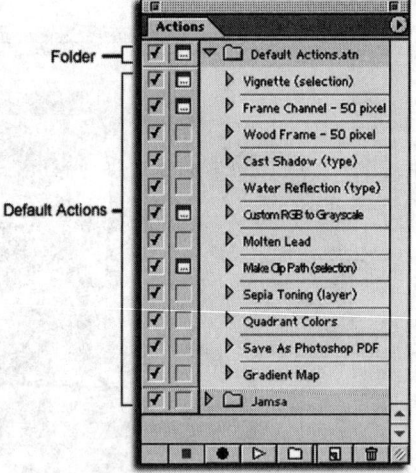

Figure 411.1 The Actions palette displays all the available Actions.

3. Click in the Name input field and enter a name for the Action. In this example, the name of the file is Reduction.

4. In this example, Set, Function Key, and Color are left at their default values, as shown in Figure 411.2.

5. Click the Record button. Photoshop closes the New Action dialog box and begins recording the Action.

6. Select the Image menu and choose Image Size from the pull-down menu. Photoshop opens the Image Size dialog box, as shown in Figure 411.3.

Figure 411.2 The New Action dialog box defines the initial characteristics of the file.

Figure 411.3 The Image Size dialog box defines the width, height, and resolution of the active image.

7. If you do not see a check mark in the Constrain Proportions and Resample Image options, click once in the input check boxes.

8. Click in the Document Size Width field and enter a value of 7. Since you selected the Constrain Proportions option, the Height field automatically changes.

9. Click the OK button. Photoshop closes the Image Size dialog box and resizes the image. The Actions palette records the Image size operation, as shown in Figure 411.4.

10. Select Image menu Mode and choose CMYK from the fly-out menu. Photoshop converts the color space of the image to CMYK and records the operation in the Actions palette.

11. Click the Stop Recording icon. Photoshop stops recording operations and saves a file named Reduction in the Actions palette, as shown in Figure 411.5.

The Image Size command recorded in the Reduction Action

Figure 411.4 The Action palette records the Image Size operation.

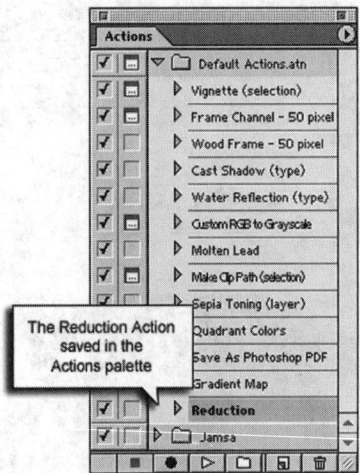

The Reduction Action saved in the Actions palette

Figure 411.5 Clicking the Stop Recording icon ends the Action and saves the file in the Actions palette.

Note: Once an Action is saved, it is useable by any open Photoshop document. For more information on running Actions, refer to Tip 410, "Using the Actions Palette."

412 *Working with the Playback Options*

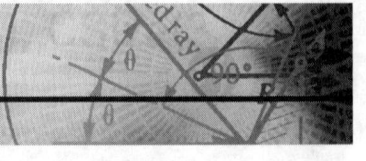

In Tip 410, "Using the Actions Palette," you learned how Actions work with Photoshop images. When you click the Play button, Photoshop performs the Action, step by step, until finished.

In Photoshop, the Playback options control the execution of the Action.

To access the Playback options, click on the black triangle in the upper-right corner of the Actions palette. Photoshop displays a fly-out menu with all the available Actions options, as shown in Figure 412.1.

Figure 412.1 Clicking the black triangle gives you access to the Actions palette options.

Click on Playback Options. Photoshop opens the Playback Options dialog box.

The available Playback options are:

- **Accelerated:** Select the Accelerated option by clicking once on the radio button to the left of the option. When selecting this option, Photoshop plays the selected action without pausing.

- **Step by Step:** Select the Step by Step option by clicking once on the radio button to the left of the option. When this option is selected, Photoshop redraws the screen after each step in the action. This option is useful if you want to watch how Photoshop performs each step of the Action.

- **Pause For:** Select the Pause For option by clicking once on the radio button to the left of the option. Then click in the Pause For input field and enter a value (in seconds) for how long you want Photoshop to pause between steps. The Pause For option is useful in a classroom situation in which you want the students to observe each step of the operation.

- **Pause for Audio Annotation:** Select Pause for Audio Annotation by clicking once in the check box to the left of the option. When selected, this option pauses an Action step until audio annotations play and then proceeds to the next step. If there are no audio annotations, the option is ignored.

Click the OK button in the Playback Options dialog box to close the dialog box and record your changes to the Actions palette.

413 *Opening and Closing Action Sets*

When you first open the Actions palette in Photoshop, you have access to the default Actions set. Photoshop comes with several sets of predesigned Actions. To open an additional set of Actions, perform these steps:

1. If the Actions palette is not visible, click the Actions tab or select the Window menu and choose Show Actions from the pull-down menu. Photoshop displays the Actions palette, as shown in Figure 413.1.

Figure 413.1 The Actions palette displays all the available Actions.

2. Click on the black triangle in the upper-right corner of the Actions palette. Photoshop displays a fly-out menu with all the available Actions options, as shown in Figure 413.2.

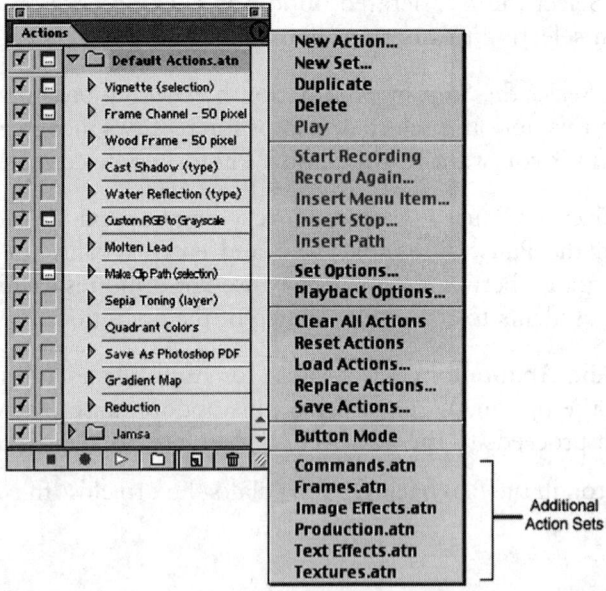

Figure 413.2 Clicking the black triangle gives you access to the Actions palette options.

3. At the bottom of the fly-out menu is a listing of all the available Action sets. Click on the set you want to activate. Photoshop adds the selected Actions to the Actions palette, as shown in Figure 413.3.

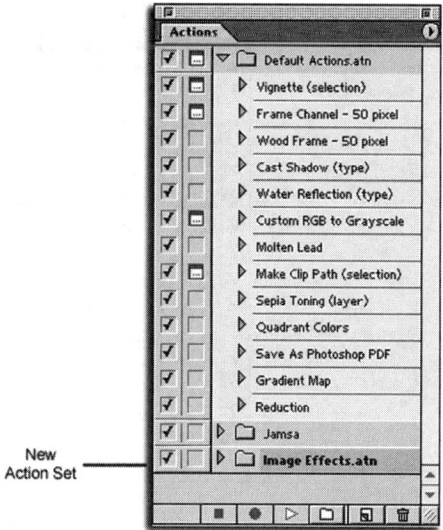

New
Action Set

Figure 413.3 The Actions palette displaying the default set and the newly selected set.

4. Click on the gray triangle to the left of the set name to view the enclosed Actions, as shown in Figure 413.4.

Click once
to expand set

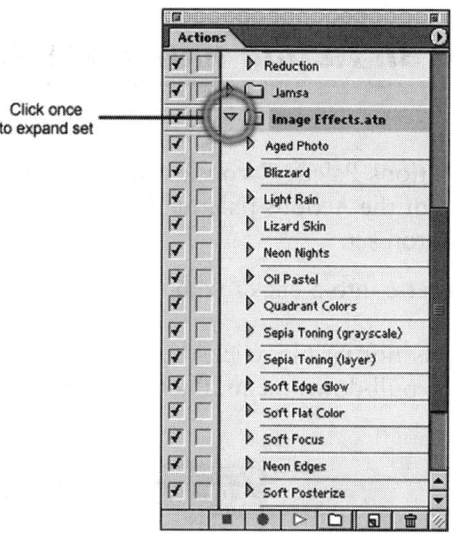

Figure 413.4 Clicking the gray triangle expands the new set and gives you access to the individual Actions.

5. To delete an individual Action or set, click and drag the Action or set to the Trash Can icon at the bottom of the Actions palette, as shown in Figure 413.5.

Note: If you delete an Action or set before saving the item into a folder, the deleted items are gone and cannot be retrieved. For more information on saving Action sets, see Tip 420, "Saving Sets into Folders."

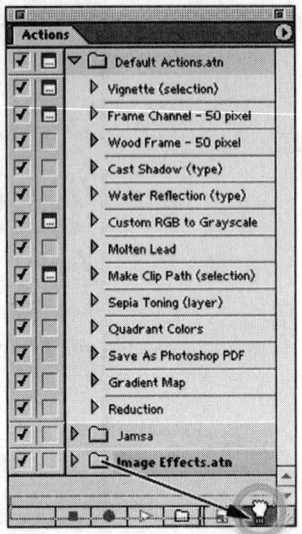

Figure 413.5 Clicking and dragging an Action or set to the Trash Can icon deletes the item from the Actions palette.

414 *Converting an Action into a Button*

In Tip 410, "Using the Actions Palette," you learned how to run an Action by clicking on the Action Play button at the bottom of the Actions palette. Photoshop gives you a simpler way to run Actions: by converting them into a button set.

To convert the Actions palette into a clickable button set, open Photoshop and perform these steps:

1. If the Actions palette is not visible, click the Actions tab or select the Window menu and choose Show Actions from the pull-down menu. Photoshop displays the Actions palette, as shown in Figure 414.1.

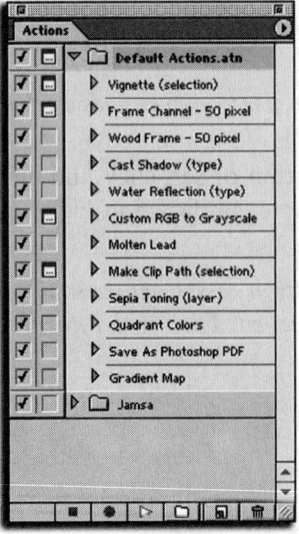

Figure 414.1 The Actions palette displays all the available Actions.

2. Click on the black triangle in the upper-right corner of the Actions palette. Photoshop displays a fly-out menu with all the available options, as shown in Figure 414.2.

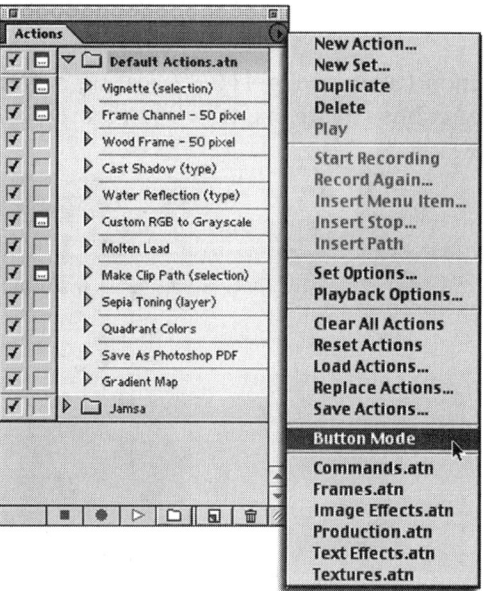

Figure 414.2 Clicking the black triangle gives you access to the Actions palette options.

3. Select Button Mode from the fly-out menu. Photoshop converts the Actions palette into a set of clickable buttons, as shown in Figure 414.3.

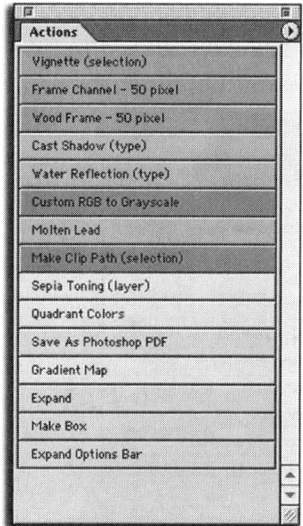

Figure 414.3 The Button Mode option converts the Actions palette into clickable items.

4. To select a particular Action, move your mouse cursor over the Action and click once. Photoshop performs the selected Action.

5. To turn off the Button Mode option, reselect the Actions options by clicking on the black triangle (refer to step 2) and click once on the Button Mode option. Photoshop returns the Actions palette to normal.

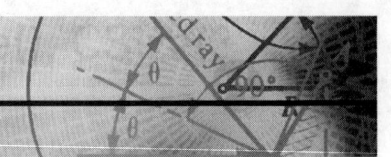

415 *Modifying an Existing Action*

Once you create an Action (refer to Tip 411, "Creating a New Action"), all the steps to perform the Action are listed in the Actions palette, as shown in Figure 415.1.

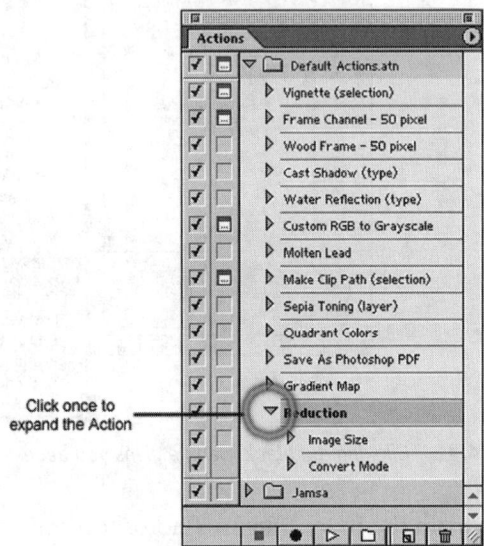

Click once to
expand the Action

Figure 415.1 Click the gray triangle to the left of an Action to display all the steps used to make that Action.

To remove a step from an Action, click and drag the step to the Trash Can icon at the bottom of the Actions palette, as shown in Figure 415.2.

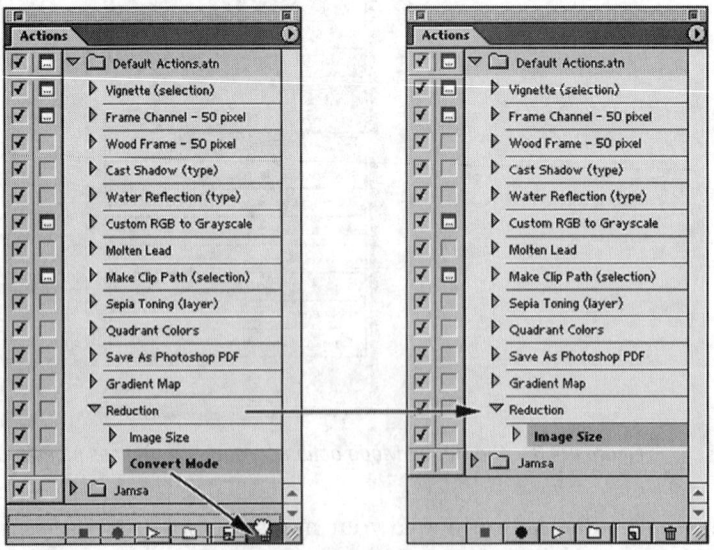

Figure 415.2 Clicking and dragging an Action step to the Trash Can deletes that step from the Action.

To modify an existing step, double-click on the step you want to modify. Photoshop opens the dialog box controlling that particular step. Say, for example, one of the steps in your Action requires Photoshop to perform a change to the width and height of the image.

Double-clicking on that step opens the Image Size dialog box, as shown in Figure 415.3.

Figure 415.3 Double-clicking on a step that requires a change to the image size opens the Image Size dialog box.

In this example, you make changes to the Image Size dialog box and click the OK button. Photoshop closes the Image Size dialog box and records the changes to the Action palette.

Photoshop records changes to the Action as you work; there is no need to perform an additional save operation. Once changes are set, use the modified Action as you would any other item in the Actions palette. Photoshop executes the Action using the newly added modifications. For more information on modifying an Action, see Tip 421, "Inserting Menu Items into an Action."

416 *Using Batch Processing to Speed Up Your Work*

One of the secrets to creating Actions is Photoshop's ability to use an Action to perform batch processing of several images. Say, for example, you have 25 digital images, and they all require the same change. Do not open the images one at a time and convert them; let Photoshop batch process the images. In Tip 411, "Creating a New Action," you created an Action to convert the size and color space of a digital image. Now you want to perform this Action on 25 images.

To batch process the 25 images, perform these steps:

1. Create a new folder on your hard drive and place all the original images in that folder, as shown in Figure 416.1.

2. If the Actions palette is not visible, click the Actions tab or select the Window menu and choose Show Actions from the pull-down menu. Photoshop displays the Actions palette, as shown in Figure 416.2.

3. Click once on the Reduction Action. Photoshop selects the Reduction Action.

4. Select File menu Automate and choose Batch from the fly-out menu. Photoshop displays the Batch dialog box, as shown in Figure 416.3.

Figure 416.1 A new folder containing all the graphic images.

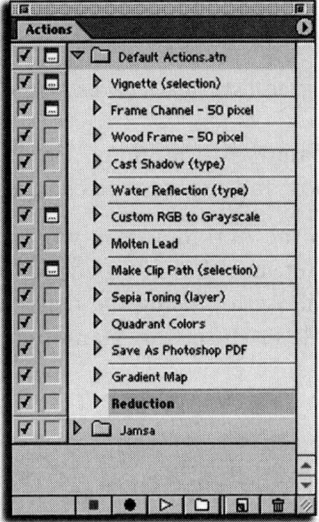

Figure 416.2 The Actions palette displays all the available Actions.

5. Since you preselected the Reduction Action, the Play section of the Batch dialog box displays the Set DefaultActions.atn and the Action Reduction. If you want to change the set, click on the Set option and select another action set.

6. Click the Choose button under the Source option. Photoshop displays the Choose a Batch Folder dialog box, as shown in Figure 416.4.

7. Select the digital images folder and click the Choose button. Photoshop closes the Choose a Batch Folder dialog box and selects the Ice Photos folder, as shown in Figure 416.5.

8. In this example, leave the Override Action "Open" Commands, Include All Subfolders, and Suppress Color Profile Warnings options unchecked.

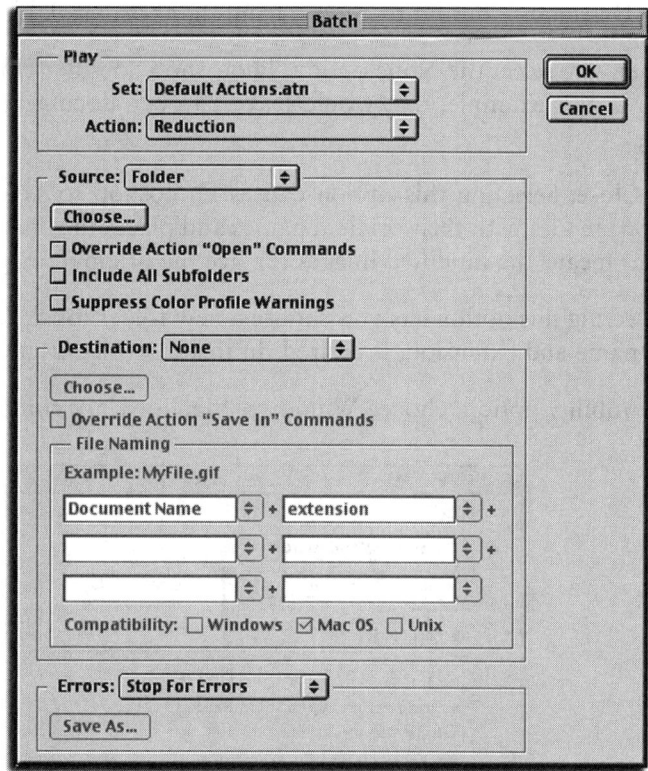

Figure 416.3 The Batch dialog box controls how batch processing is performed.

Figure 416.4 The Choose a Batch Folder dialog box lets you choose the folder containing the images you want to modify.

9. Click on the Destination button to choose from the three available options:

- **None:** When you select the None option, Photoshop does not close the document after it modifies the image. In this example, that would leave 25 open documents at the completion of the batch processing.

- **Save and Close:** Selecting this option causes Photoshop to save and close each file. Photoshop saves the image files with their original names and places the images back into their original source folder. That means the modified images replace the original images.

- **Folder:** Selecting this option lets you choose a new folder for the images, along with modifications to the file name and extension, if desired. In this case, the original images are not modified.

10. In the Compatibility option, choose Windows, Mac, or Unix compatibility.

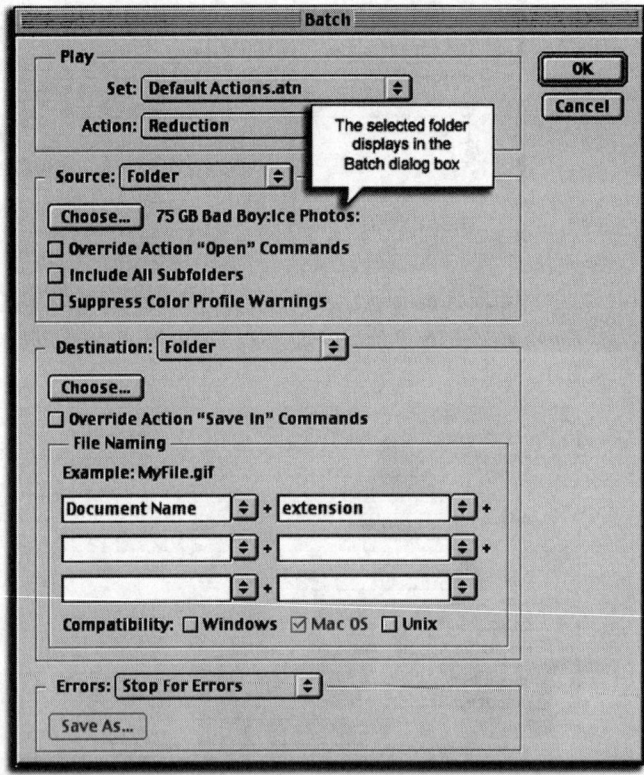

Figure 416.5 The Ice Photos folder contains all the images you want to batch process.

11. Click the Errors button and choose from the available options:

- **Stop for Errors:** Selecting this option causes Photoshop to stop batch processing every time it encounters an error.

- **Log Errors to File:** Selecting this option causes Photoshop to record any errors it encounters in a file. Click the Save As button to locate and identify the error file.

12. Click the OK button in the Batch dialog box. Photoshop closes the dialog box and processes all the images in the digital images folder.

417 *Excluding or Including the Playback of a Command*

When you create an Action, each Photoshop operation in the Action displays as a step in the Actions palette. To view the individual steps associated with an Action, click once on the gray triangle to the left of the Action name. The Actions palette displays, in list form, all the steps making up the Action.

For example, you want to use the Action created in Tip 411, "Creating a New Action"; however, you do not want the Action to convert the color space of the image to CMYK. To exclude that particular step, perform these steps:

1. If the Actions palette is not visible, click the Actions tab or select the Window menu and choose Show Actions from the pull-down menu. Photoshop displays the Actions palette, as shown in Figure 417.1.

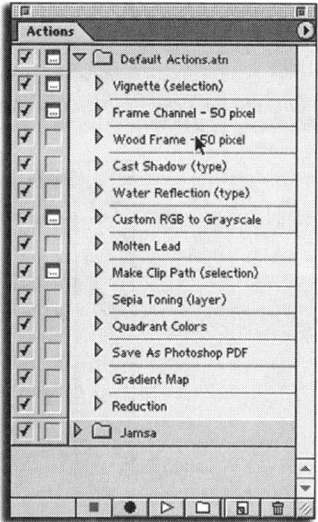

Figure 417.1 The Actions palette displays all the available Actions.

2. Click on the gray triangle to the left of the Reduction Action. The Actions palette displays a list of all the steps in the Reduction Action, as shown in Figure 417.2.

3. To the far left of each step there is a box with a black check mark (refer to Figure 417.2). The check mark indicates that the step is included in the Action. By default, all steps are included in the performance of an Action.

4. Click on the black check mark to the left of the Convert Mode step. The check mark is removed from the box, as shown in Figure 417.3.

5. When you play this Action (refer to Tip 410, "Using the Actions Palette"), the Action runs without the Convert Mode step changing the color space of the image to CMYK.

6. The check box located to the far left of each step is a toggle switch. Clicking in the box changes the state of any step from excluded (no check mark) to included (check mark).

Note: Controlling what steps are included or excluded within an Action gives you more control and flexibility over how an Action performs.

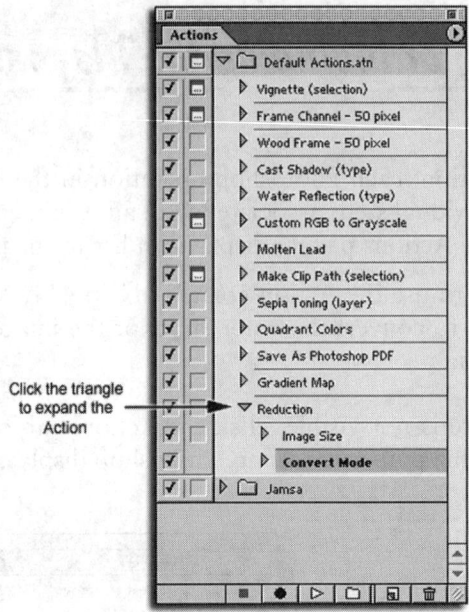

Click the triangle to expand the Action

Figure 417.2 Clicking the gray triangle displays all the steps in the Reduction Action.

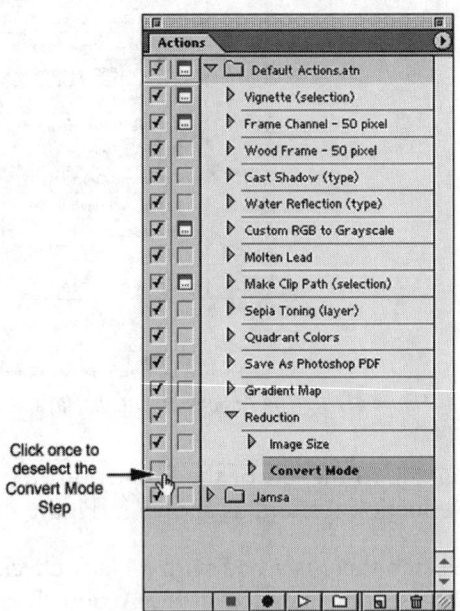

Click once to deselect the Convert Mode Step

Figure 417.3 Clicking on the black check mark removes the mark from the step and temporarily excludes that step from the Action.

418 *Recording an Action Using Different Dialog Settings*

When you record an Action, you record information into dialog boxes such as Image Size or Feather. Photoshop then saves those settings with the Action. The next time you use the Action, it repeats those same dialog settings.

For example, you have an Action called Convert that performs a Curves and Levels adjustment to an image and then saves the image at a resolution of 72ppi. You want a similar Action but with different settings to Levels and a final resolution of 133ppi.

To quickly create and modify an existing Action, perform these steps:

1. If the Actions palette is not visible, click the Actions tab or select the Window menu and choose Show Actions from the pull-down menu. Photoshop displays the Actions palette, as shown in Figure 418.1.

Figure 418.1 The Actions palette displays all the available Actions.

2. Click once on the Convert Action. Photoshop selects the Action.

3. Click on the black triangle in the upper-right corner of the Actions palette. Photoshop displays a fly-out menu with all the available options, as shown in Figure 418.2.

4. Select Duplicate from the fly-out menu. Photoshop creates a duplicate of the Convert Action and names it Convert copy.

5. Select the Action palette options (refer to step 3) and select Record Again from the fly-out menu. Photoshop begins replaying the Convert Action, stopping at each dialog box.

6. Since the Action uses the Levels, Curves, and Image Size dialog boxes, Photoshop stops and opens each of the dialog boxes, allowing you to make changes.

7. Click the OK button in the respective dialog boxes to continue through the Action.

8. The Convert copy is a new Action containing all the modifications you made to the dialog boxes.

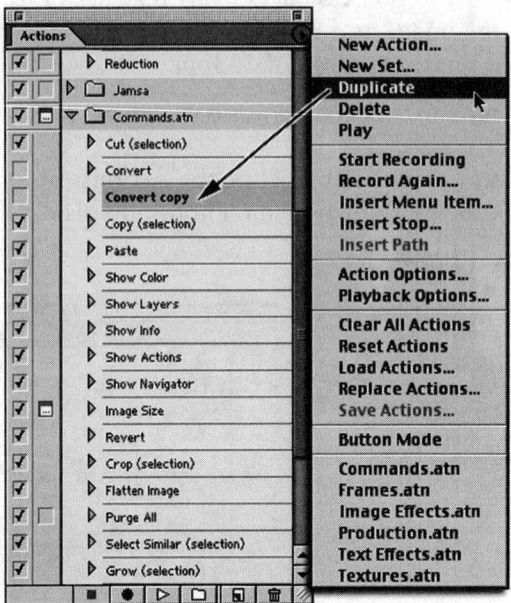

Figure 418.2 Clicking the black triangle gives you access to the Actions palette options.

419 *Saving Individual Actions into a Set*

When you create an Action, Photoshop by default places the saved file in the default Actions folder. Placing all of your Actions within one folder creates a confusing situation, sometimes taking precious minutes to locate the correct Action out of hundreds. The solution is to create specific folders, called sets, for your Actions and then organize your Actions into these sets.

To create a New Action set, perform these steps:

1. If the Actions palette is not visible, click the Actions tab or select the Window menu and choose Show Actions from the pull-down menu. Photoshop displays the Actions palette, as shown in Figure 419.1.

2. Click on the black triangle in the upper-right corner of the Actions palette. Photoshop displays a fly-out menu with all the available Actions options, as shown in Figure 419.2.

3. Click on New Set. Photoshop opens the New Set dialog box, as shown in Figure 419.3.

4. Click in the Name field and enter a name for the set. In this example, Special Actions is the name of the new set.

5 Click the OK button. Photoshop closes the New Set dialog box and creates a new set named Special Actions in the Actions palette, as shown in Figure 419.4.

Figure 419.1 The Actions palette displays all the available Actions.

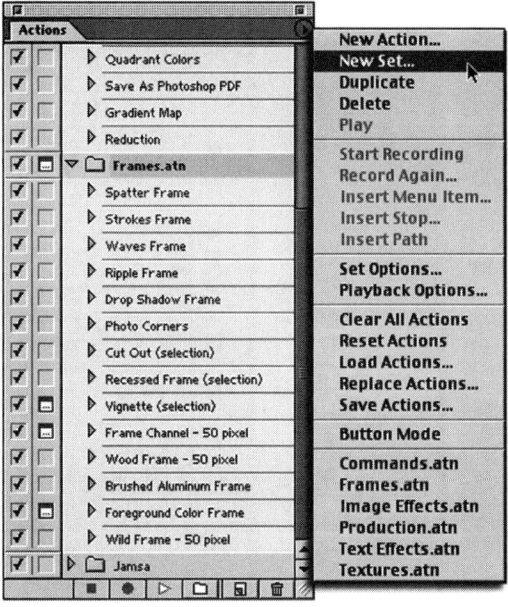

Figure 419.2 Clicking the black triangle gives you access to the Actions palette options.

Figure 419.3 The New Set dialog box defines the name of the Actions set.

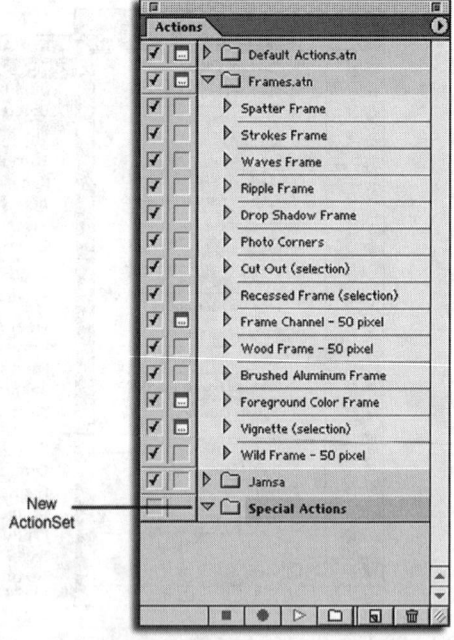

Figure 419.4 The newly created set is located in the Actions palette.

6. To add Actions to the new set, click and drag the Actions to the Special Actions folder. Photoshop moves (not copies) the Action into the new set, as shown in Figure 419.5.

Note: Creating new Action sets is a great organizing tip. Create and use Action sets to save time in the selection and playing of Actions.

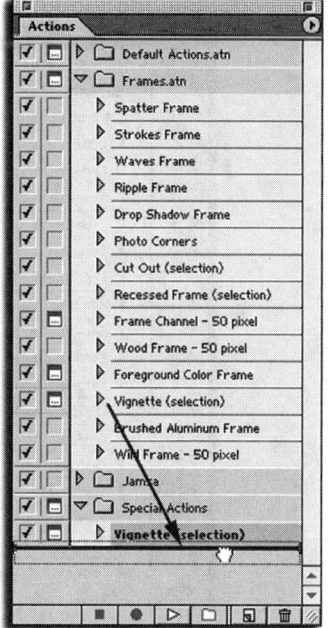

Figure 419.5 Clicking and dragging an Action over a set name moves that Action into the new set.

420 *Saving Sets into Folders*

In the preceding tip, you learned how to create a set and then move selected Actions into that set. When you create a new set in the Actions palette, the set and the Actions it contains are available every time you open Photoshop. However, you may not need those Actions every time you open Photoshop.

The Actions palette lets you create sets and then save them to a folder. Once you save a set into a folder, it can be deleted and reassessed whenever needed.

To save a set into a folder, open Photoshop and perform these steps:

1. If the Actions palette is not visible, click the Actions tab or select the Window menu and choose Show Actions from the pull-down menu. Photoshop displays the Actions palette, as shown in Figure 420.1.

2. Click on the black triangle in the upper-right corner of the Actions palette. Photoshop displays a fly-out menu with all the available Actions options, as shown in Figure 420.2.

3. Select Save Actions from the fly-out menu. Photoshop displays the Save dialog box, as shown in Figure 420.3.

4. Select the Folder where you want to store the Actions. Click the OK button to save the Action set and close the Save dialog box.

Figure 420.1 The Actions palette displays all the available Actions.

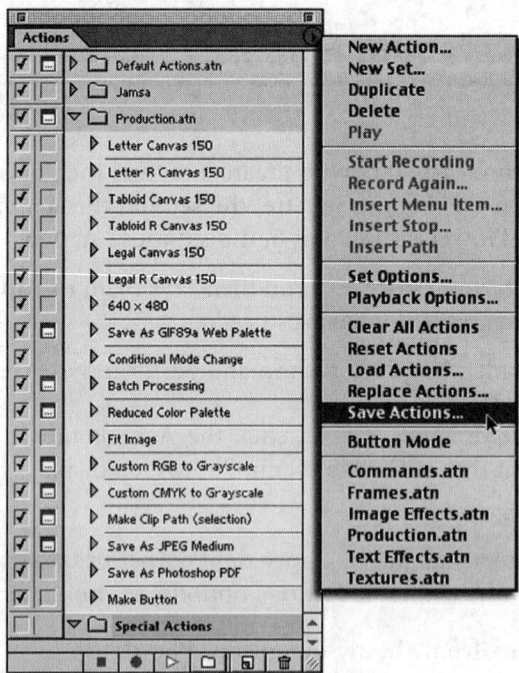

Figure 420.2 Clicking the black triangle gives you access to the Actions palette options.

Note: *Saving Actions sets into a folder gives you access to the Actions when needed. For more information on adding and deleting Action sets, refer to Tip 413, "Opening and Closing Action Sets."*

Figure 420.3 The Save dialog box defines the name and location of the Action set.

421 *Inserting Menu Items into an Action*

In Tip 415, "Modifying an Existing Action," you learned how to edit an existing Action by editing the steps within the Action file. You can also insert menu items into an existing Action.

For example, you've created an Action named Adjust that includes balancing the Levels and Curves in an image, and you want to add a Sharpen filter.

To add a menu item to an existing Action, perform these steps:

1. If the Actions palette is not visible, click the Actions tab or select the Window menu and choose Show Actions from the pull-down menu. Photoshop displays the Actions palette, as shown in Figure 421.1.

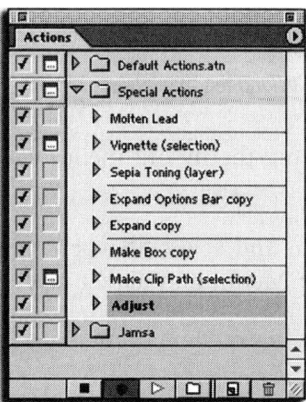

Figure 421.1 The Actions palette displays all the available Actions.

2. Click once on the Adjust Action. Photoshop selects the Adjust Action.

3. Click once on the gray triangle to the left of the Adjust Action. The Actions palette displays all the steps within the Adjust Action, as shown in Figure 421.2.

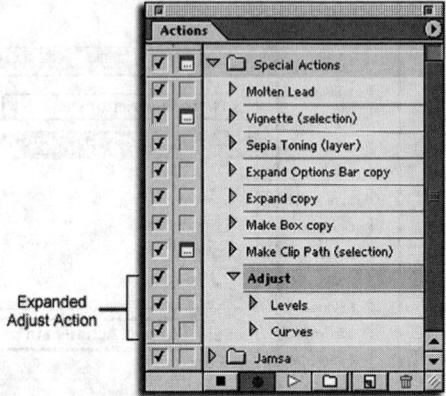

Figure 421.2 Clicking on the gray triangle displays all the steps within the Adjust Action file.

4. Click on the step directly above where you want to add the Sharpen filter. In this example, you want to add a sharpening filter after the Levels command.

5. Click on the black triangle in the upper-right corner of the Actions palette. Photoshop displays a fly-out menu with all the available Actions options, as shown in Figure 421.3.

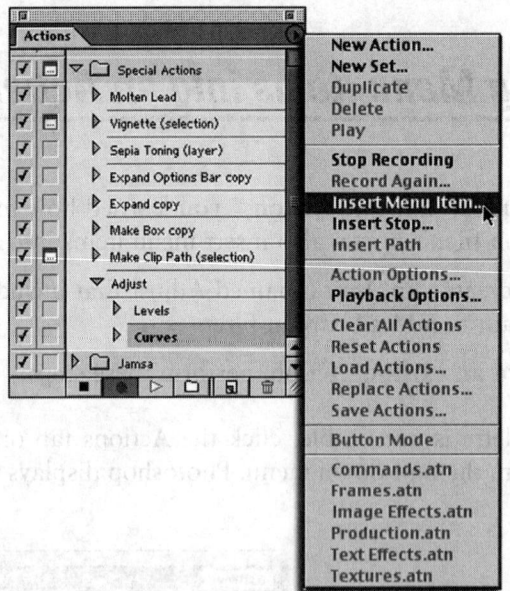

Figure 421.3 Clicking the black triangle gives you access to the Actions palette options.

6. Select Insert Menu Item from the fly-out menu. Photoshop opens the Insert Menu Item dialog box, as shown in Figure 421.4.

7. Select Filter menu Sharpen and select Sharpen Edges from the fly-out menu. Photoshop adds the Sharpen filter to the Insert Menu Item dialog box.

8. Click the OK button in the Insert Menu Item dialog box to record your changes to the Adjust Action, as shown in Figure 421.5.

Figure 421.4 The Insert Menu Item dialog box lets you add any available menu item to the selected Action.

Figure 421.5 The Insert Menu Item dialog box inserts the Sharpen Edges filter directly below the Levels step.

422 *Inserting Stop Commands into an Action*

In normal operation, an Action performs all of its steps without interaction. Some Actions, however, require certain conditions before they work correctly. When you insert a Stop command, the operation halts at the insertion point of the Stop into the Action and opens a dialog box. The dialog box contains information on what is required for the Action to complete.

Say, for example, you create an Action named Vignette that performs a soft vignette around an image. The Photoshop user must first create a selection on the image. Your Action uses that selection to define the vignette border. Therefore, you want to instruct the user to create the selection.

To insert a Stop into an Action, perform these steps:

1. If the Actions palette is not visible, click the Actions tab or select the Window menu and choose Show Actions from the pull-down menu. Photoshop displays the Actions palette, as shown in Figure 422.1.

2. Click once on the Action named Vignette. Photoshop selects the Vignette Action.

3. Click once on the gray triangle to the left of the Vignette Action. The Actions palette displays all the steps within the Vignette Action, as shown in Figure 422.2.

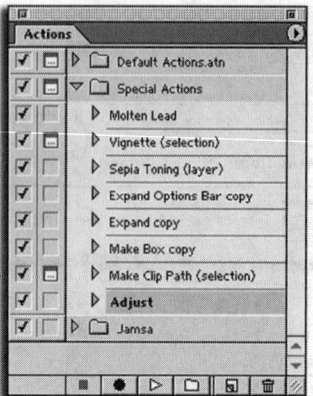

Figure 422.1 The Actions palette displays all the available Actions.

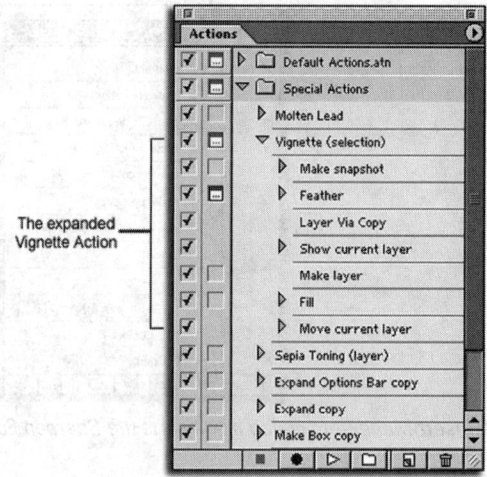

Figure 422.2 Clicking on the gray triangle displays all the steps within the Vignette Action.

4. Click on the step directly above where you want to add the Stop. In this example, you want to add it at the beginning of the file, so click on the first step in the Vignette Action.

5. Click on the black triangle in the upper-right corner of the Actions palette. Photoshop displays a fly-out menu with all the available Actions options, as shown in Figure 422.3.

6. Select Record Stop from the fly-out menu. Photoshop opens the Insert Stop dialog box, as shown in Figure 422.4.

7. Click in the Message field and type the message you want the user of the Action to see (refer to Figure 422.4).

8. Select the Allow Continue option by clicking once in the input box to the left of the option.

9. Click the OK button to insert the stop into the Vignette Action.

When you run the Vignette Action, the Stop command will halt the execution of the Action, display the message in a dialog box, and wait for a response by the user, as shown in Figure 422.5.

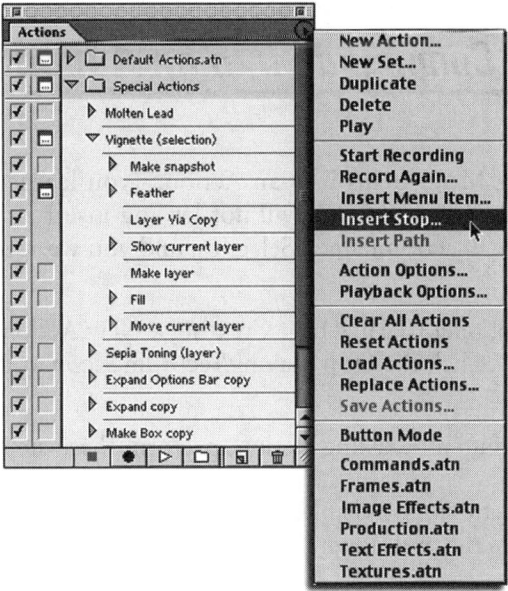

Figure 422.3 Clicking the black triangle gives you access to the Actions palette options.

Figure 422.4 The Record Stop dialog box lets you insert a message into an Action.

Figure 422.5 The inserted Stop command halts the program and waits for the user to respond.

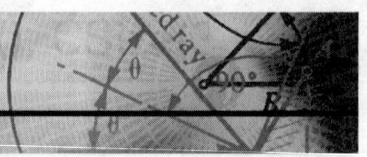

423 *Placing Commands into an Action*

In Tip 421, "Inserting Menu Items into an Action," you learned how to insert pull-down menu items into an existing Action. However, this will not let you insert a command or toolbox operation into an Action. Say you create an action named Selection and you want to insert a specific selection step into the Action.

To create a new action, refer to Tip 411, "Creating a New Action." Perform steps 1 through 5 and name the action "Selection." Click the Stop playing/recording icon at the bottom left of the Actions palette to save the action.

To insert a command into an existing Action, perform these steps:

1. If the Actions palette is not visible, click the Actions tab or select the Window menu and choose Show Actions from the pull-down menu. Photoshop displays the Actions palette, as shown in Figure 423.1.

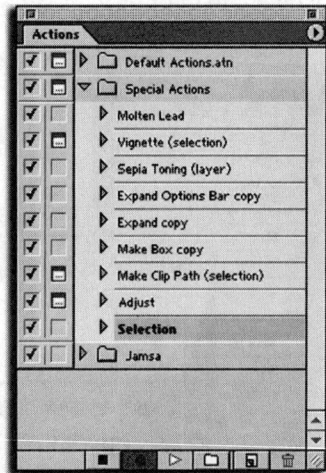

Figure 423.1 The Actions palette displays all the available Actions.

2. Click once on the Action named Selection. Photoshop selects the Selection Action.

3. Click once on the gray triangle to the left of the Selection Action. The Actions palette displays all the steps within the Action, as shown in Figure 423.2. In this example the action displays three commands: Make Snapshot, Convert Mode, and Levels.

4. Click on the step directly above where you want to add the selection command. In this example, you want to add the command directly under the Snapshot step. Click once on the Snapshot step.

5. Click on the black triangle in the upper-right corner of the Actions palette. Photoshop displays a fly-out menu with all the available Actions options, as shown in Figure 423.3.

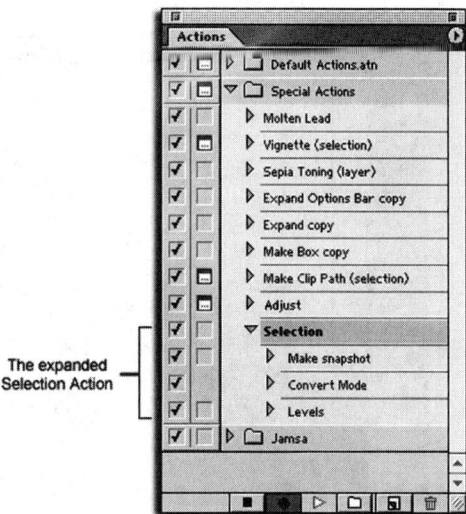

Figure 423.2 Clicking on the gray triangle displays all the steps within the Selection Action.

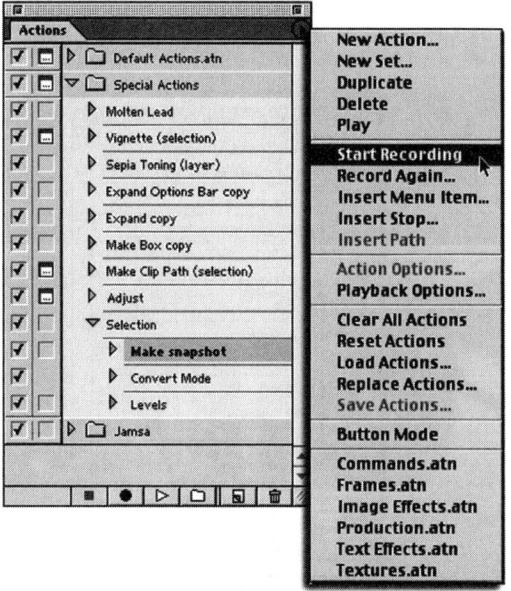

Figure 423.3 Clicking the black triangle gives you access to the Actions palette options.

6. Select Start Recording from the fly-out menu. Photoshop will record any new commands and insert them under the Snapshot step.

7. Select the Oval Marquee tool and create a round selection area on the image, as shown in Figure 423.4.

Figure 423.4 The Actions palette records the creation of the selection marquee.

8. Click the Stop Recording icon. Photoshop stops inserting commands into the Action, as shown in Figure 423.5.

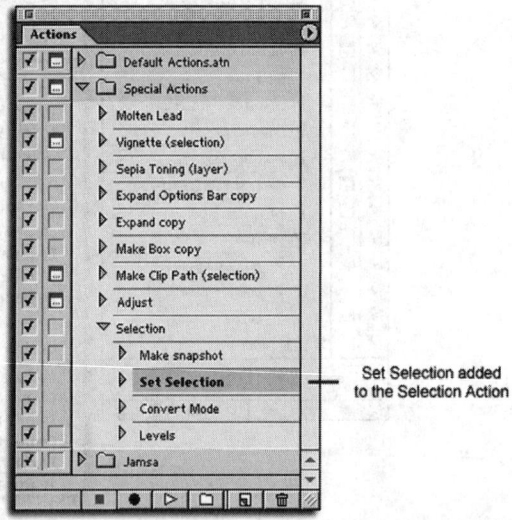

Set Selection added
to the Selection Action

Figure 423.5 Clicking the Stop Recording icon halts the insertion of additional commands.

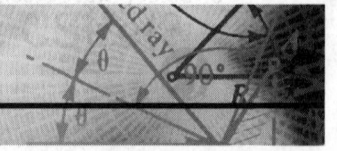

424 *Activating a Modal Control in an Action*

The modal controls within an Action let you stop the execution of the Action, make on-the-fly changes, and continue. Modal controls are available for all commands in Photoshop that require the use of a dialog box to input information.

Let's say you've created an Action named Digital Adjustment that converts an image taken with a digital camera. The operations performed on the image are Image Size, Image Resolution, and Levels. The Image Size and Resolution commands do not change; however, the adjustment to the Levels command depends on the image. You want to adjust the Levels within an image on a case-by-case basis.

To activate the modal control of an Action, perform these steps:

1. If the Actions palette is not visible, click the Actions tab or select the Window menu and choose Show Actions from the pull-down menu. Photoshop displays the Actions palette, as shown in Figure 424.1.

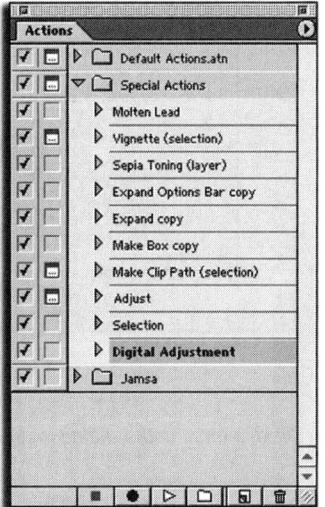

Figure 424.1 The Actions palette displays all the available Actions.

2. Click once on the Action named Digital Adjustment. Photoshop selects the Digital Adjustment Action.

3. Click once on the gray triangle to the left of the Digital Adjustment Action. The Actions palette displays all the steps within the Action, as shown in Figure 424.2.

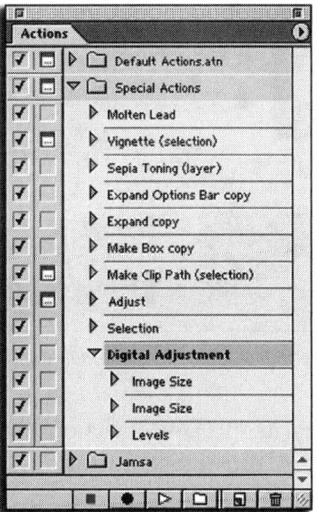

Figure 424.2 Clicking on the gray triangle displays all the steps within the Digital Adjustment Action.

4. Click once in the dialog control box to the left of the Levels command, as shown in Figure 424.3.

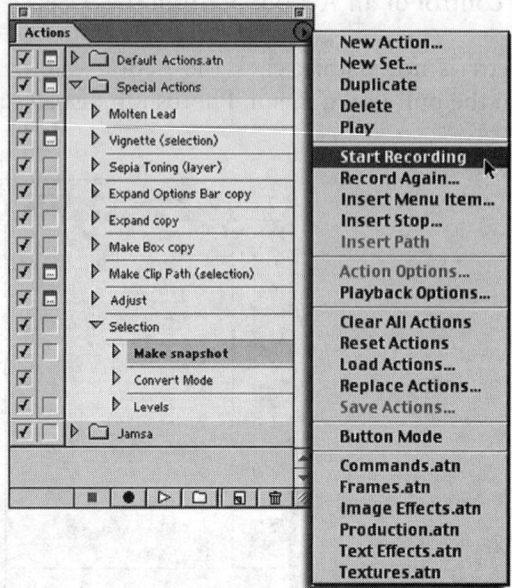

Figure 423.3 Clicking once in the dialog input box activates the modal control option.

5. Click the Action Play icon to run the Digital Adjustment Action. Photoshop halts the execution of the Action and opens the Levels dialog box, as shown in Figure 423.4.

Figure 423.4 The Digital Adjustment Action controls changes made in the Levels dialog box.

6. Make changes as necessary in the Levels dialog box and click the OK button. Photoshop resumes the execution of the Digital Adjustment Action.

> *Note: The modal control options are available on all Action steps in which information is entered into a dialog box.*

425 *Copying and Moving Steps Between Actions*

Since the same Actions palette is available every time you open an image in Photoshop, it is not necessary to copy Actions for specific documents. It is, however, important to know that you can click and drag individual steps between Actions if, for example, you create an Action with a specific step that would be useful in another Action.

To copy or move a step between two Actions, open the Actions palette and expand the Action out to see the individual steps (refer to step 3 of the preceding tip), as shown in Figure 425.1.

To move a step between two Actions, click on the step you want to move and drag it into the second Action. Release the mouse when the step is in the correct position in the stacking order, as shown in Figure 425.2.

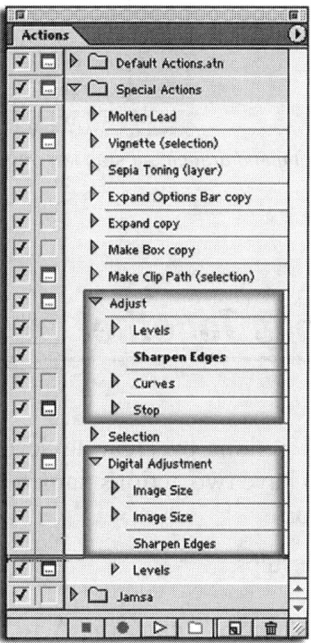

Figure 425.1 The Actions palette displaying two open Actions.

Note: To copy a step instead of moving it, hold down the Alt key (Macintosh: Option key) as you drag. Holding down the Alt key instructs Photoshop to create a copy of the step in the second Action file.

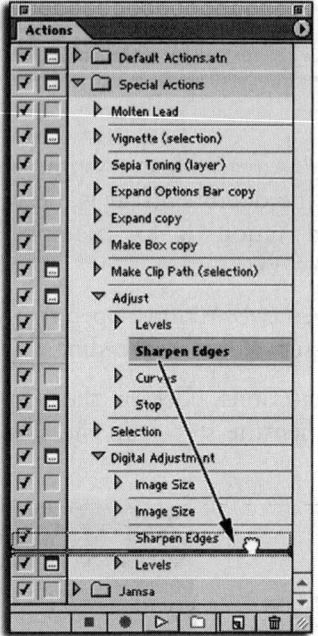

Figure 425.2 Clicking and dragging a step lets you move the step from one Action into another.

426 *Nesting Actions Together*

You can simplify complicated actions by creating several small actions and then nesting the actions together. Say, for example, you have two actions named original and nest, and you want to play the Nest action within the original action.

To nest Actions, perform these steps:

1. If the Actions palette is not visible, click the Actions tab or select the Window menu and choose Show Actions from the pull-down menu. Photoshop displays the Actions palette, as shown in Figure 426.1.

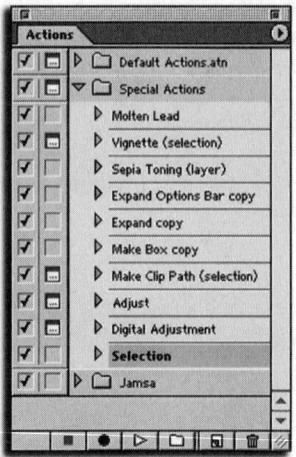

Figure 426.1 The Actions palette displays all the available actions.

2. Click once on the Adjust action. Photoshop selects the Adjust action.

3. Click once on the gray triangle to the left of the Adjust action. The Actions palette displays all the steps within the Adjust action, as shown in Figure 426.2.

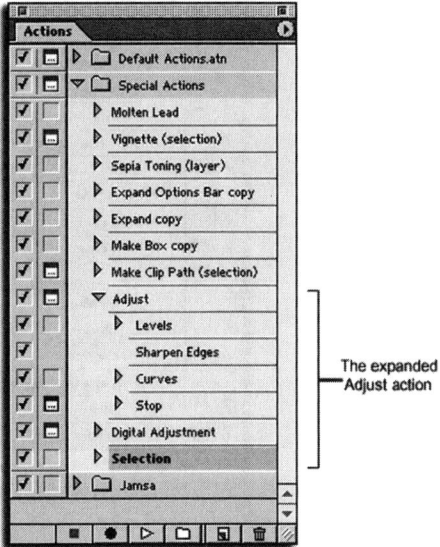

Figure 426.2 Clicking on the gray triangle displays all the steps within the Adjust action file.

4. Click on the step directly above where you want to nest the second action. In this example, you want the second action to execute after the Curves command. Therefore, click once on the Curves step.

5. Click on the black triangle in the upper-right corner of the Actions palette. Photoshop displays a fly-out menu with all the available Actions options, as shown in Figure 426.3.

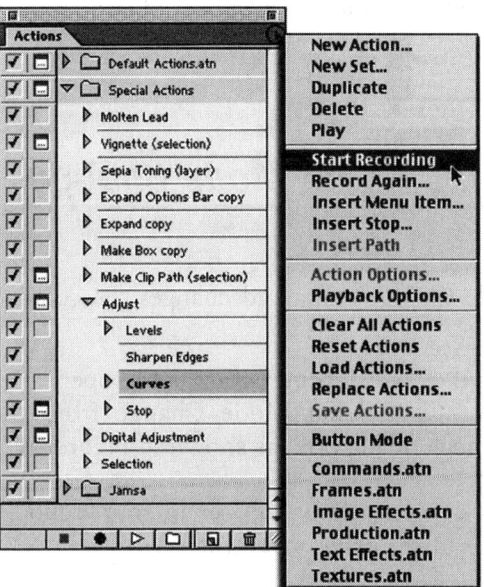

Figure 426.3 Clicking the black triangle gives you access to the Actions palette options.

6. Select Start Recording from the fly-out menu. Photoshop begins recording.

7. Click once on the Selection action to choose the Selection action.

8. Access the Actions palette options (refer to step 5) and select Play from the fly-out menu. Photoshop plays all the steps within the Selection action. The Adjust action now has a new step titled Play action "Selection," as shown in Figure 426.4.

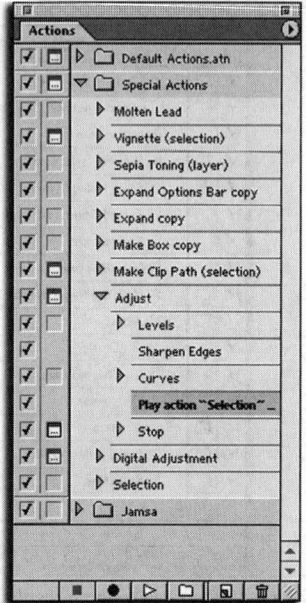

Figure 426.4 Clicking the Play button adds the nest action to the original action.

9. Access the Actions palette options (refer to step 5) and select Stop from the fly-out menu. Photoshop stops recording the action, and the Selection action is successfully added to the original action.

Note: Actions can include multiple nested actions. An action containing a nested item that is moved or deleted will not work, so plan ahead and organize your Actions palette.

427 *Using Conditional Mode Change*

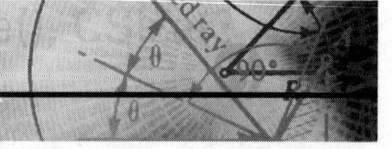

The Conditional Mode Change command changes the color space of an image based on the original color space of the image.

To use the Conditional Mode Change command, open an image in Photoshop, select File menu Automate, and choose Conditional Mode Change from the fly-out menu. Photoshop opens the Conditional Mode Change dialog box, as shown in Figure 427.1.

- **Source Mode:** Click to select any number of source modes. The Source Mode section defines the original color mode of the open document.

- **Target Mode:** Click on the Target Mode button and select from the available options. The Target Mode defines what color mode the image converts to, based on the color mode of the original image.

Note: The Conditional Mode Change command can be inserted into an action to convert images to the necessary color space before performing a particular action. Refer to Tip 410, "Using the Actions Palette."

Figure 427.1 The Conditional Mode Change dialog box lets you control the changing of an image into another color space.

428 *Creating Multiple Images with the Picture Package Command*

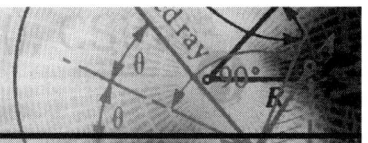

The Picture Package option lets you choose from a variety of output formats for your images. It resembles the photo options available from portrait studios.

To create a Picture Package from a Photoshop document, open the document in Photoshop, select File menu Automate, and choose Picture Package from the fly-out menu. Photoshop opens the Picture Package dialog box, as shown in Figure 428.1.

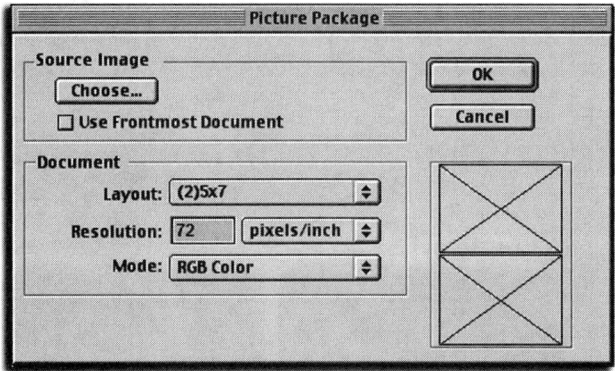

Figure 428.1 The Picture Package dialog box controls the characteristics of the output image.

- **Source Image:** Click the Choose button and select an image from a folder on your hard drive or click the Frontmost Document option to select the currently active image.

- **Document:** Click the Layout option and choose from the available layout options, as shown in Figure 428.2.

- **Resolution:** The Resolution option defines the resolution of the image used in the Picture Package. Click in the Resolution input box and enter a resolution for the final image.

- **Mode:** The Mode defines the color space of the Picture Package. Click on the Mode button and choose a color space from the available options.

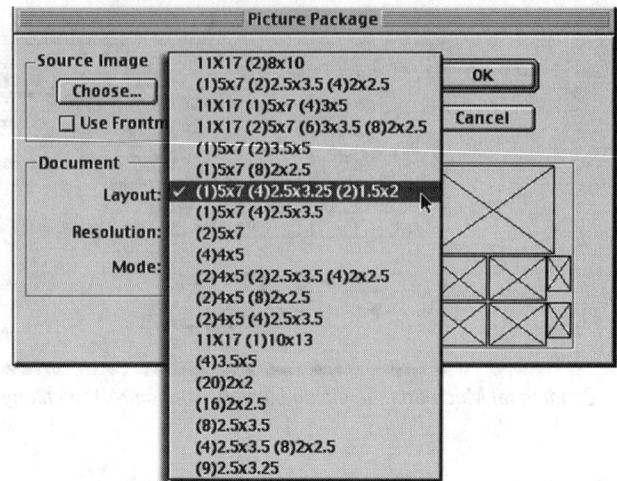

Figure 428.2 The Layout option defines the layout of the final picture package.

Click the OK button to close the Picture Package dialog box and create the Picture Package based on the selected options, as shown in Figure 428.3.

Figure 428.3 A completed Picture Package.

Note: Once Photoshop creates the Picture Package, you can edit and print the document just like any other Photoshop graphic image.

429 *Converting PDF Documents into Photoshop Files*

PDFs (Portable Document Files) are PostScript-generated documents. Since PostScript is used throughout the publishing, graphic arts, and printing industries, PDF documents can be opened on virtually any computer. While Photoshop cannot edit a PDF document, it can convert the image and then work on the converted document.

To convert a PDF document, open Photoshop, select File menu Automate, and choose Multi-Page PDF to PSD from the fly-out menu. Photoshop opens the Convert Multi-Page PDF to PSD dialog box, as shown in Figure 429.1.

Figure 429.1 The Convert Multi-Page PDF to PSD dialog box controls the conversion of the PDF document into a readable Photoshop document.

- **Source PDF:** Click on the Choose button. Photoshop opens the Select a PDF file to convert dialog box, as shown in Figure 429.2. Select the PDF document to convert and click the Open button.

- **Page Range:** If you are converting a multi-page PDF, select the range of pages to convert by clicking in the From and To input fields and entering the correct page numbers.

- **Output Resolution:** Click in the Resolution input box and enter a value for the output resolution of the converted PDF document.

- **Mode:** Click the Mode button and choose from the available color spaces. Regardless of the original color space of the PDF document, the Mode option defines the color space of the converted document.

- **Destination:** Click in the Base Name input field and enter the name of the converted PDF document.

- **Choose:** Click the Choose button and select a destination folder to save the converted PDF document.

Click the OK button to close the Convert Multi-Page PDF to PSD dialog box and convert the PDF file into a Photoshop document, as shown in Figure 429.3.

Figure 429.2 The Select a PDF file to convert dialog box lets you choose the PDF document to convert into a Photoshop document.

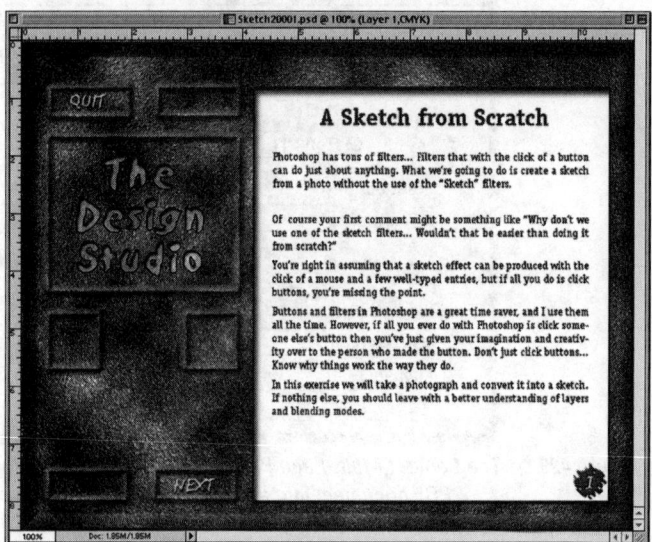

Figure 429.3 The Convert Multi-Page PDF to PSD dialog box converts the PDF file into a Photoshop document.

430 *Generating a Contact Sheet from a Group of Photoshop Images*

There is nothing more frustrating than trying to locate a particular image out of a group of documents. Say, for example, you've created a folder to hold the images from your digital camera, and you want to view all of the images on a photographic contact sheet.

To create a contact sheet, open Photoshop, select File menu Automate, and choose Contact Sheet II from the fly-out menu. Photoshop opens the Contact Sheet II dialog box, as shown in Figure 430.1.

- **Source Folder:** Click on the Source Folder button. Photoshop opens the Select Image Directory dialog box, as shown in Figure 430.2. Click the Choose button to record your selection to the Contact Sheet II dialog box.

- **Document Width/Height:** Click in the Width and Height input fields and enter the width and height of the contact sheet. This option defines the width and height of the output contact sheet, not the individual images.

- **Document Resolution:** Click in the Resolution input field and enter an output resolution for the printed contact sheet.

- **Document Mode:** Click on the Mode button and choose a color space for the output document.

- **Thumbnails Place:** Click the Place button and choose to arrange the thumbnails horizontally (from left to right) or vertically (from top to bottom).

- **Thumbnails Columns/Rows:** Click in the Columns and Rows input fields to choose how many images to place horizontally and vertically. Changing the number of images placed on the paper automatically adjusts the width and height of the individual images.

Figure 430.1 The Contact Sheet II dialog box defines the output of the printed contact sheet.

- **Use Filename As Caption:** Select this option to use the file name as a caption under each image.

- **Font:** Click the Font button and choose from the available fonts. Photoshop uses the font to print the caption for the image.

- **Font Size:** Click in the Font Size input field and select a point size. Photoshop uses the font size to print the caption for the image.

Click the OK button in the Contact Sheet II dialog box to create the contact sheet, as shown in Figure 430.3.

Figure 430.2 Click to select the folder containing the digital images.

Figure 430.3 A contact sheet created with the Contact Sheet II command.

431 *Converting a Photoshop Command into an Action*

As you learned in Tip 410, "Using the Actions Palette," Actions are tremendous timesavers because they let you assign repetitive tasks to the click of a button. Since Actions are simply Photoshop commands and menu items, you can create you own personal library of shortcut keys.

Say, for example, you want a special key assigned to Photoshop's Grow command (refer to Tip 303, "Using Grow and Similar to Influence a Selection").

To create a shortcut for the Grow command, open any document in Photoshop and perform these steps:

1. Use one of your selection tools to create a selection. It does not matter what tool you use or the shape of the selection, as shown in Figure 431.1.

Figure 431.1 Use a selection tool to create a selection marquee.

2. If the Actions palette is not visible, click the Actions tab or select the Window menu and choose Show Actions from the pull-down menu. Photoshop displays the Actions palette, as shown in Figure 431.2.

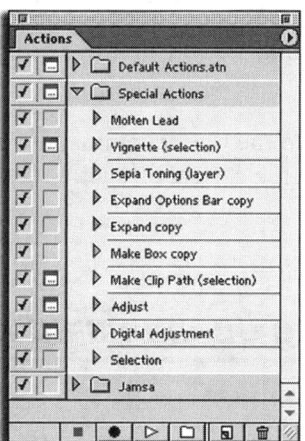

Figure 431.2 The Actions palette displays all the available Actions.

3. Click the Create New Action icon at the bottom of the Action palette. Photoshop opens the New Action dialog box, as shown in Figure 431.3.

Figure 431.3 Clicking the Create New Action icon opens the New Action dialog box.

4. In the Name input field, enter a Name for the Action (refer to Figure 431.3).

5. Click the Function Key button. Photoshop displays a list of available function keys, as shown in Figure 431.4.

Figure 431.4 Clicking the Function Key button displays all the available function keys.

6. Select one of the available function keys.

7. Click on the Shift or Command key check boxes to activate (place a check mark in) one or both of these options. Selecting Shift and/or Command requires you hold down that key(s) when pressing the function key.

8. Click the Record button in the New Action dialog box. Photoshop begins recording the Action.

9. Choose the Select menu and choose the Grow command from the pull-down menu.

10. Click on the Stop Recording button at the bottom left of the Actions palette. Photoshop stops recording the Action.

11. You now have a shortcut to the Grow command that you can access from the Actions palette (refer to Tip 410) or by pressing the assigned function key.

432 *Understanding Channels and Their Role in Photoshop*

Photoshop uses channels to store information about an image. To access the Channels palette, click the Channels tab or select the Window menu and choose Show Channels from the pull-down menu. Photoshop displays the Channels palette, as shown in Figure 432.1.

A new document opened in Photoshop contains a set of channels that define the image's color space. An RGB (red, green, and blue) image contains three channels, one each for the three colors. A CMYK image (cyan, magenta, yellow, and black) contains four channels, one each for the four colors. Each document contains a set of native channels defining the image's color space.

Photoshop creates channels with black, white, and shades of gray, and by default, the darker the shade of gray, the less color.

In the Red channel (refer to Figure 432.2), the darker the shade of gray in the red channel, the less red in the image. Each channel represents the percentage of colors applied to an image that, when mixed together, create the final colors within the graphic.

Figure 432.1 The Channels palette in Photoshop stores information about the active image.

The top channel in the Channels palette (refer to Figure 432.1) represents the composite or mixing channel. When you select the composite channel, the visible image in the document window represents all of the channels mixed together. When you click on an individual channel name, the visible image in the document window shifts to shades of gray, representing that particular channel's color percentages, as shown in Figure 432.3.

Figure 432.2 The Red channel in a typical Photoshop document.

In addition to Photoshop's native channels, the Channels palette also stores information on selection masks, called Alpha channels, and spot colors, called Spot Color channels.

For more information on Alpha channels, see Tip 445, "Using Channels to Hold Difficult Selections."

For more information on Spot Color channels, see Tip 450, "Converting a Channel into a Spot Color Channel."

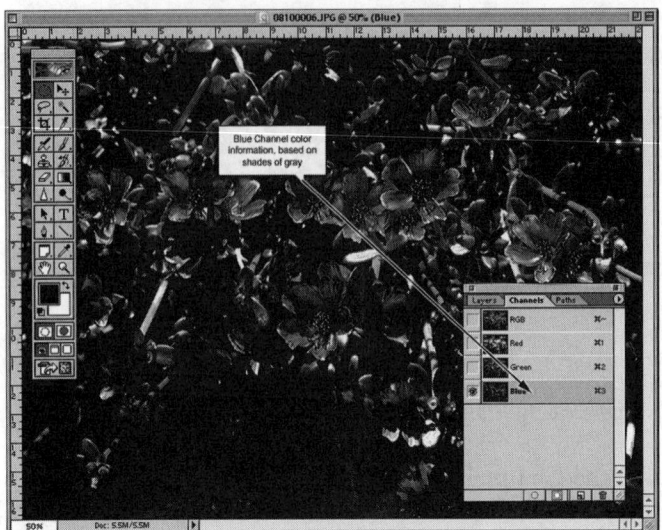

Figure 432.3 Clicking on an element in the Channels palette displays the color information for that particular channel.

433 Understanding Channels and Their Relationship to File Size

When you add additional channels to a Photoshop document (see Tip 443, "Creating a New Channel"), the effect on file size is not the same as adding new layers to the image (refer to Tip 344, "How Multiple Layers Relate to a Document's File Size").

Channels, by nature, are smaller than a layer. In an RGB (red, green, and blue) image, channels are one-third the size of a typical layer. In a CMYK (cyan, magenta, yellow, and black) image, channels are typically one-quarter the size of a layer.

The maximum number of channels available to any Photoshop image is 24, including the native channels. RGB images have the ability to generate 21 additional channels (3 native channels plus 21 additional channels equals 24), and a CMYK image with its 4 native channels generates an additional 20 channels.

The final size of a channel varies according to the amount of editing performed. A new Alpha channel without any editing does not increase the file size of the document. As you edit the mask (paint with black, white, and shades of gray), the image size increases until it reaches its maximum size, depending on the image's color space.

Note: Since additional channels contribute to the size of a document file, adding channels, like layers, will slow Photoshop's operations. Use channels, but only when necessary to the successful completion of your project.

434 *Working with Native Channels and Alpha Masks*

In Tip 432, "Understanding Channels and Their Role," you learned how channels work to create the viewable colors in a Photoshop image. Photoshop defines the original channels of a document as the Native channels, and additional channels are Alpha channels and Spot Color channels, as shown in Figure 434.1.

Figure 434.1 The Channels palette in Photoshop contains a combination of Native, Alpha, and Spot Color channels.

Native channels define the colors in the image, Alpha channels define selected areas within an image, and Spot Color channels define the application of a specific color within the image. Regardless the type of channel (Native, Alpha, or Spot Color), all channels operate using black, white, and shades of gray (refer to Tip 432).

You edit a channel by using your paintbrush tools and painting on the channel (see Tip 438, "Editing Channels").

When you paint with white on a Native color channel, you increase the color in that particular channel. When painting with white on an Alpha channel you create a selection, and painting with white on a Spot Color channel creates a spot color in the size and shape of the white painted area of the channel.

When you paint with shades of gray or black, you reduce the color in a Native channel and mask the gray-painted areas of an Alpha or Spot Color channel.

Separate in your mind the concepts of layers and channels. Channels, individually, do not represent the viewable image; they define the pieces of the image that, when assembled, create a full-color viewable document.

When you edit a layer, you work with all the channels combined. Painting purple on a layer affects all the Native (color) channels of that image, as shown in Figure 434.2.

Note: Channels are an important part of a Photoshop document. One of the keys to controlling an image is a firm understanding of channels and how they work with an image.

Figure 434.2 Painting on a layer affects all the channels within the document.

435 *Mixing Channels*

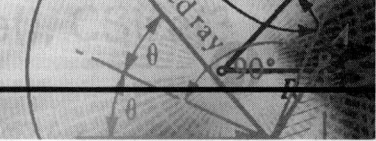

In Tip 338, "Adjusting the Color in an Image Using Channel Mixer," you learned how to correct the color in a Photoshop document using the Channel Mixer command.

The Channel Mixer command changes the balance of color in an image by modifying the shades of gray in the document's native color channels. Native channels define the image's color space by dividing the inks into three separate elements, as shown in Figure 435.1.

In the preceding tip, you learned that a Native color channel defines the percentage of ink using black, white, or a shade of gray. A typical Native color channel produces black, white, and 254 steps of gray. Each step of gray in a color channel represents a percentage of that channel's ink, as shown in Figure 435.2.

Figure 435.1 The native channels in Photoshop's Channels palette define the individual color inks within the active image.

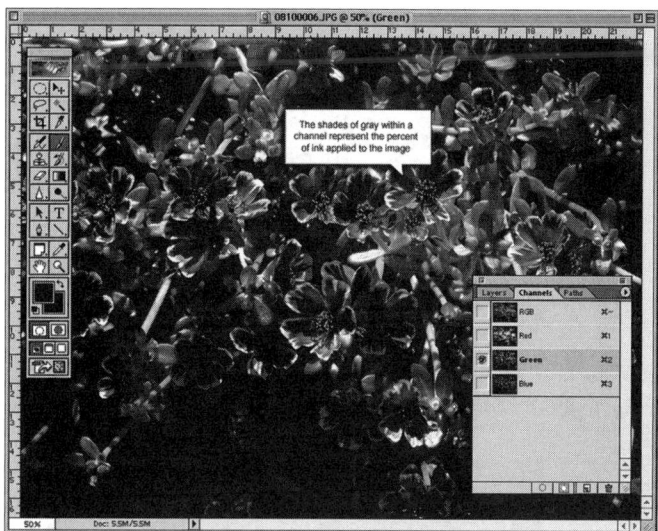

Figure 435.2 The shade of gray in a native channel represents a percentage of ink applied to the viewable image.

The color white represents 100 percent application of ink, the color black represents zero percent, and varying shades of gray represent incremental percentages of ink. By default, the darker shades of gray mean less ink, and lighter shades of gray indicate more ink. In Figure 435.2, the lighter areas of the channel indicate more green, and darker areas of the image indicate less green.

When Photoshop combines the Native color channels, it produces a full-color image. Photoshop mixes the digital information from the gray channels into ink colors. The resulting calculation combines the brightness of each color channel and produces pixels that are not defined as a shade of gray but with Hue, Saturation, and Luminosity (refer to Tip 192, "Working with the Hue, Saturation, and Color Blending Modes").

When you use the Channel Mixer command to mix the colors of an image, in reality, you are adjusting the shades of gray in Photoshop's Native color channels. Photoshop then recalculates the final color by combining the shade of gray from each of the three pixels.

436 *Viewing Channels*

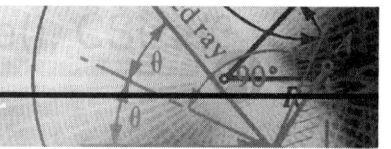

To view the channel information for an open Photoshop document, click the Channels tab or select the Window menu and choose Show Channels from the pull-down menu. Photoshop displays the Channels palette, as shown in Figure 436.1.

Figure 436.1 displays channel information for a typical CMYK (cyan, magenta, yellow, and black) Photoshop document.

To view a particular channel, click once on the channel name. Say, for example, you want to view the color information in the Magenta channel. Move your cursor into the Channels palette and click once on the Magenta channel. Photoshop deselects all the channels except Magenta, and the document window changes to display the Magenta channel, as shown in Figure 436.2.

Figure 436.1 The Channels palette in Photoshop stores information about the active image.

Figure 436.2 Clicking once on the Magenta channel selects that channel for viewing or editing.

The topmost channel (CMYK) is defined as the Composite channel. In reality, the Composite is not a channel. Clicking once on the Composite (CMYK) mixes all the color channels and produces a visible color image in the document window. The Composite channel defines the viewable and printable version of the color image, as shown in Figure 436.3.

Figure 436.3 The Composite channel defines the viewable and printable document.

Each channel has an Eye icon located to the far left of the channel name. Turning a channel eye icon on or off indicates whether the inks of the channel arc used to create the final color image. Say, for example, you want to view your image without the Black channel ink. Click on the Eye icon to the left of the Black channel. The visible image changes to a color image mixed with cyan, magenta, and yellow but no black, as shown in Figure 436.4.

Figure 436.4 Turning off the Eye icon next the Black channel displays a document mixed without the black ink.

437 *Changing the Display of the Channels Palette*

When you view the Channels palette for the first time, you see the default settings assigned by Photoshop for the display of the Channels palette.

To change the options of the Channels palette, click the Channels tab or select the Window menu and choose Show Channels from the pull-down menu. Photoshop displays the Channels palette, as shown in Figure 437.1.

Figure 437.1 The Channels palette in Photoshop stores information about the active image.

Click once on the black triangle in the upper-right corner of the Channels palette. Photoshop displays a fly-out menu listing all the available channel options, as shown in Figure 437.2.

Figure 437.2 The channel options control the characteristics of the Channels palette.

Click on Palette Options. Photoshop opens the Channels Palette Options dialog box, as shown in Figure 437.3.

Figure 437.3 The Channels Palette Options dialog box controls the size of the channel icons.

The only option available is the size of the palette thumbnails. Click to select from the available sizes or click None to view the Channels palette without thumbnails. Click the OK button to record your changes to the Channels palette, as shown in Figure 437.4.

Figure 437.4 The Channels palette with thumbnails turned off.

Note: *Since it takes time for Photoshop to create thumbnails, selecting None in the Channels Palette Options dialog box increases Photoshop's efficiency and frees up valuable processor time for other tasks.*

438 *Editing Channels*

In Tip 432, "Understanding Channels and Their Role," you learned how channels use shades of gray to define the colors within an image. To edit a channel in Photoshop, you paint the channel using any of Photoshop's painting or drawing tools.

Like the channels themselves, editing a channel requires painting the channel using a shade of gray. In fact, those are the only colors available to you when you edit a channel. When you open an image in Photoshop for the first time, the document window displays a full-color image. In other words, Photoshop mixes all the grayscale channels together to produce the color image. All of Photoshop's color palettes and color swatches display in color, as shown in Figure 438.1.

Figure 438.1 Opening an image in Photoshop for the first time displays a full-color image.

To edit the Black channel in Figure 438.1, move your cursor into the Channels palette and click once on the Black channel. Photoshop displays the Black channel in the document window, and the color palettes and color swatches convert to shades of gray, as shown in Figure 438.2.

Figure 438.2 Clicking on a channel displays the selected channel in the document window and converts Photoshop's default color swatches to shades of gray.

When you use Photoshop's painting tools on a color channel, you are readjusting the amount of that color as it applies to the overall colors in the image. Refer to Tip 78, "The Paintbrush and Pencil Tools," for more information on painting and editing with the brush tools.

439 *Editing the Black Channel of a CMYK Image*

In the preceding tip, you learned how to edit an individual channel of an image. Here is a way to edit the Black channel of a CMYK (cyan, magenta, yellow, and black) image to produce a special effect.

Open an RGB or CMYK color image in Photoshop and perform these steps:

1. If the image is not in CMYK color space, select Image menu Mode and choose CMYK from the fly-out menu. Photoshop converts the image to the CMYK color space.

2. To access the Channels palette, click the Channels tab or select the Window menu and choose Show Channels from the pull-down menu. Photoshop displays the Channels palette, as shown in Figure 439.1.

3. Move your cursor into the Channels palette and click once on the Black channel. Photoshop selects the Black channel, as shown in Figure 439.2.

4. Select Image menu Adjust and choose Levels from the fly-out menu. Photoshop opens the Levels dialog box, as shown in Figure 439.3.

Figure 439.1 *The Channels palette in Photoshop stores information about the active image.*

5. Click on the middle gray slider and drag it to the right. Photoshop darkens the pixels in the Black channel. Release the mouse when you have an image similar to Figure 439.4.

Figure 439.2 Clicking on the Black channel selects that channel for viewing and editing.

Figure 439.3 The Levels dialog box controls the pixel information in the Black channel.

Figure 439.4 Moving the gray Levels slider to the right darkens the pixels in the Black channel.

6. Click the OK button in the Levels dialog box to record your changes to the Black channel.

7. Move your cursor into the Channels palette and click once on the CMYK Composite channel. Photoshop mixes all the channel's images together, and the document window displays the new image, as shown in Figure 439.5.

Figure 439.5 Clicking on the Black channel combines all the channel images and produces a new image based on a darker Black channel.

Note: The Black channel in a CMYK image does not control the color in the image but it does control the amount of black applied to the dark and shadow areas. By increasing the black in a CMYK graphic, you create an image with a flatter, sketch-like appearance.

440 *Rearranging the Stacking Order of Channels*

In Tip 434, "Working with Native Channels and Alpha Masks," you learned that the Channels palette contains Native channels that define the colors of the original image. The Channels palette also contains user-created channels in the form of Alpha channels and Spot Color channels.

When you create a new channel, Photoshop deposits the channel under the color channels, as shown in Figure 440.1.

Unlike the Layers palette (refer to Tip 341, "Understanding the Concept of Layers"), when you create a new channel, it is always placed at the bottom of the Channels palette. Unfortunately, this is not always where you want the channel placed.

To display the Channels palette, click the Channels tab or select the Window menu and choose Show Channels from the pull-down menu. Photoshop displays the Channels palette (refer to Figure 440.1).

Composite Channel

Native Color Channels

Additional Alpha Channels

Figure 440.1 When you create a new channel, Photoshop places the channel at the bottom of the Channels palette.

To move a channel, first move your cursor into the Channels palette and place it above the channel you want to move. Next click and drag up or down in the stacking order. As you move through the Channels palette, a dark double line appears under the each channel. Release the mouse when the dark double line appears underneath the channel where you want to insert your channel. Photoshop moves your channel underneath the channel with the dark double line, as shown in Figure 440.2.

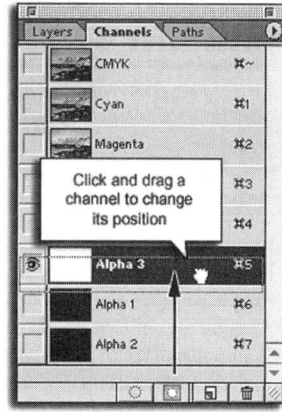

Click and drag a channel to change its position

Figure 440.2 Releasing the mouse moves the Alpha 3 channel directly under the black channel.

Note: You cannot change the stacking order of the document's Native color channels.

441 *Merging Multiple Channels*

Merging channels lets you combine multiple grayscale images into a single image. In fact, some scanners save a color image by scanning and saving separate grayscale images, one each for the red, green, and blue channels. The Merge Channels option lets you combine the images to produce a single graphic.

The Merge Channels option is only available if you have two or more grayscale images open, and the images have the same pixel dimensions.

To merge two or more grayscale images, perform these steps:

1. To access the Channels palette, click the Channels tab or select the Window menu and choose Show Channels from the pull-down menu. Photoshop displays the Channels palette, as shown in Figure 441.1.

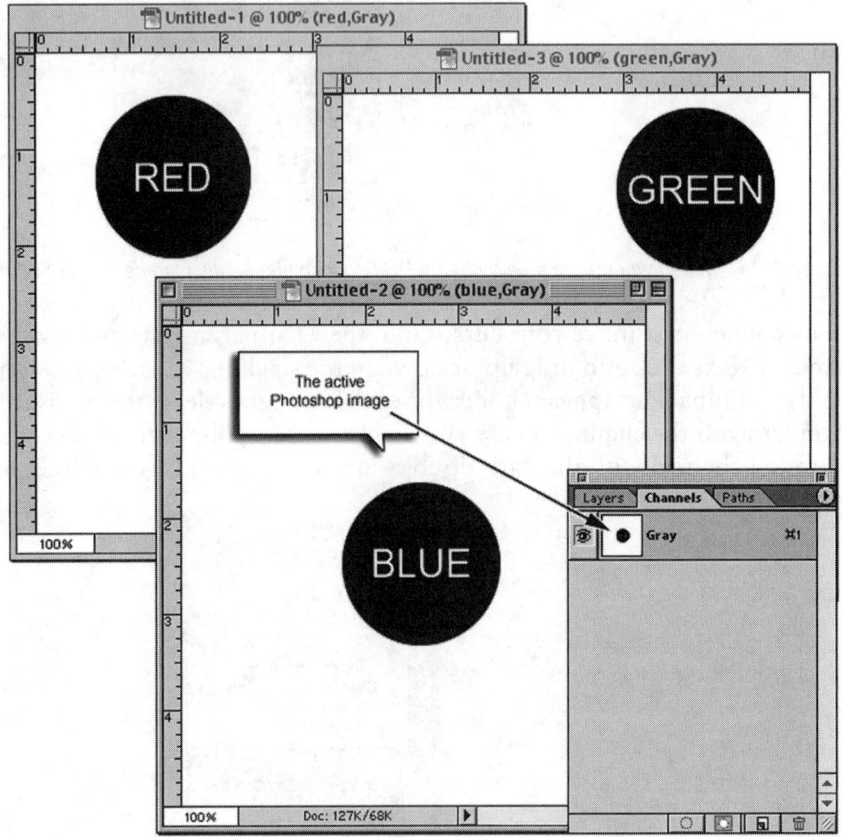

Figure 441.1 The Channels palette in Photoshop stores information about the active image.

2. Click once on the black triangle in the upper-right corner of the Channels palette. Photoshop opens the Channels palette options in a fly-out menu, as shown in Figure 441.2.

3. Select Merge Channels from the fly-out menu. Photoshop opens the Merge Channels dialog box, as shown in Figure 441.3.

Figure 441.2 The Channels options control the characteristics of the Channels palette.

Figure 441.3 The Merge Channels dialog box controls the merging of two or more Photoshop grayscale documents.

4. Click on the Mode button to select from the available options. In this example, the three grayscale documents are merged into a single RGB (red, green, and blue) image.

5. Click the OK button in the Merge Channels dialog box. Photoshop opens the Merge RGB Channels dialog box, as shown in Figure 441.4.

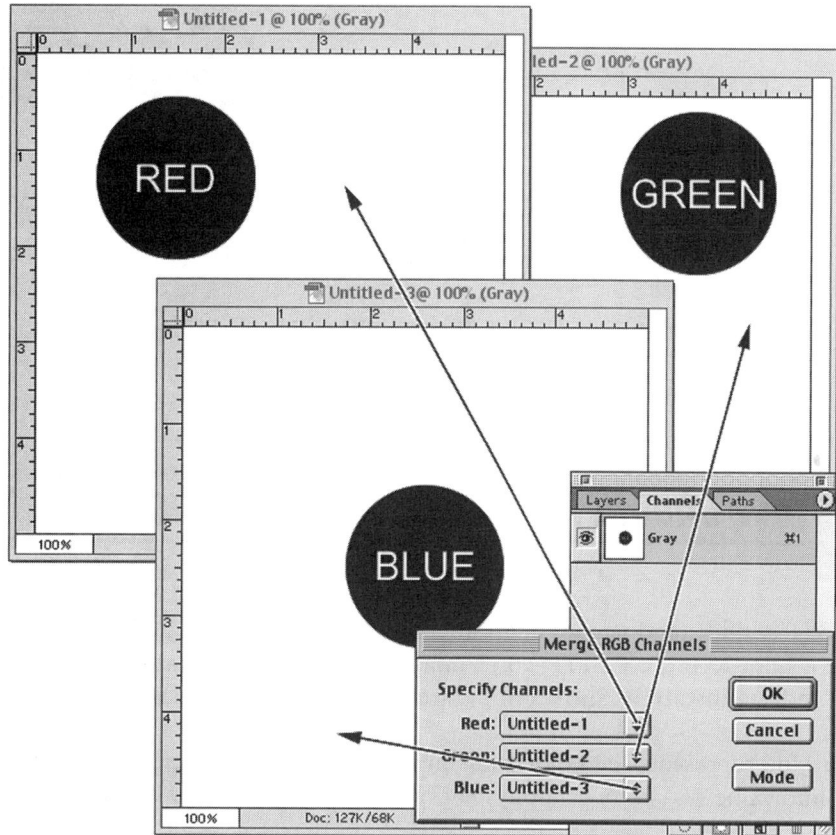

Figure 441.4 The Merge RGB Channels dialog box controls which grayscale image is assigned to each of the colors (Red, Green, and Blue).

6. Click on the Red, Green, and Blue buttons and assign one of the grayscale images to each of the color channels (refer to Figure 441.4).

7. Click the OK button in the Merge RGB Channels dialog box. Photoshop closes the dialog box and creates the new file, as shown in Figure 441.5.

Figure 441.5 The three grayscale images combine to create a single RGB color image.

For information on splitting a color image into separate grayscale images, see Tip 459, "Splitting Channels into Individual Images."

442 *How Channels Are Used to Define Color*

In Tip 432, "Understanding Channels and Their Role," you learned that Photoshop combines channels to create a Lab, RGB, or CMYK color image. Photoshop calculates the value of a color using hue, saturation, and luminosity, as shown in Figure 442.1.

- **Hue:** Hue represents the color transmitted through or reflected from an object to the viewer's eye. The hue value of a color is a physical number from 0 to 360 degrees.

- **Saturation:** The saturation of a color is the color's strength or purity and is represented by values from 0 (grayscale) to 100 percent (fully saturated).

- **Brightness:** Brightness represents the relative lightness of the color and is expressed in a value from 0 (black) to 100 percent (white).

The grayscale pixels of a channel only have one value: Luminosity. The luminosity of a pixel is a value range from 0 (black) to 255 (white). The values from 2 (light) to 255 (dark) represent shades of gray, as shown in Figure 442.2.

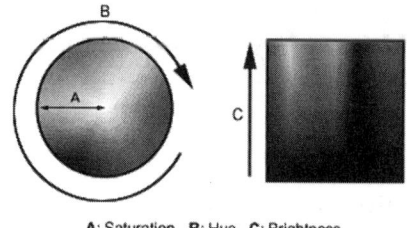

Figure 442.1 Hue, saturation, and luminosity as represented by a standard color wheel.

A: Saturation B: Hue C: Brightness

0 255

Figure 442.2 The Luminosity value of a grayscale pixel represents a shade of gray.

The reason the grayscale value of a channel pixel is limited to the values 0 to 256 is because of the pixel's bit depth. Every pixel in a Photoshop image is composed of bits (or switches), and each switch produces a 0 or 1, as shown in Figure 442.3.

8-bit
channel

Figure 442.3 The number of bits per pixel determines the shade of grayscale within each channel pixel.

Eight bits in a row produce a maximum of 256 possible combinations. Your eyes see a shade of gray; the computer sees a number from 0 to 256. When you combine the red, green, and blue channels of an RGB image, you have 24-bit pixels (8 bits per pixel multiplied by 3 equal 24 bits per pixel).

A 24-bit pixel produces a maximum of 16,777,216 possible combinations. Therefore, an RGB image is capable of producing 16,777,216 colors.

> **Note:** *Every color produced in a Photoshop color image is a product of a number. The more numbers available to a pixel, the more color it produces. Photoshop combines the pixels within each of the image's channels to produce the colors you see on your monitor and on paper.*

443 *Creating a New Channel*

When you open a graphic image in Photoshop, the Channels palette displays the Native color channels. You cannot create a new Native color channel; however, you can create channels to act as image masks.

To create a new channel, open an image in Photoshop and perform these steps:

1. To access the Channels palette, click the Channels tab or select the Window menu and choose Show Channels from the pull-down menu. Photoshop displays the Channels palette, as shown in Figure 443.1.

Figure 443.1 The Channels palette in Photoshop stores information about the active image.

2. Click on the New Channel icon located at the bottom of the Channels palette. Photoshop creates a new channel, and the visible image turns black, as shown in Figure 443.2.

Figure 443.2 Clicking the New Channel icon creates a new channel in the active Photoshop document.

3. When you create a new channel, Photoshop automatically selects the new channel (called an Alpha channel).

4. Select the Paintbrush tool from the toolbox, select a small soft brush, and select white as your painting color (refer to Tip 221, "Selecting a Foreground and Background Color Swatch").

5. Click and drag your white paintbrush from the upper-left corner of the image down to the lower right, as shown in Figure 443.3.

Figure 443.3 Clicking a dragging a white paintbrush across the image creates a diagonal white line in the channel.

6. Click once on the RBG channel (called the Composite channel). Photoshop activates all the color channels and displays the color image in the document window, as shown in Figure 443.4.

Figure 443.4 Clicking on the Composite channel activates all the color channels in the image.

Notice that the image did not change. When you edit an Alpha channel, you create a mask for the image. The white areas become selections, and the dark areas represent the image mask.

Click once on the Alpha 1 channel. Photoshop deactivates the color channels and returns you to the new channel. Experiment by painting on the mask in black, white, and shades of gray. You are not editing the colors in the image when you paint a mask; you are only creating selections.

Although this example does not illustrate how to use a channel as a selection, it gives you a good idea of how to use your paintbrushes to edit the channel. In the next tip, you will apply those skills to create a vignette around an image.

444 *Using Photoshop's Paintbrush Tools on a Channel*

In Tip 438, "Editing Channels," you learned how to modify the colors within an image by changing the grayscale information within an individual color channel. You can modify the information within a channel using any of Photoshop's adjustments or commands; however, the most versatile way to modify channel information is with the use of Photoshop's painting tools. For more information on using the Paintbrush tools, refer to Tip 78, "The Paintbrush and Pencil Tools."

To edit a channel using the Paintbrush tools, open a document in Photoshop and perform these steps:

1. To access the Channels palette, click the Channels tab or select the Window menu and choose Show Channels from the pull-down menu. Photoshop displays the Channels palette, as shown in Figure 444.1.

Figure 444.1 The Channels palette in Photoshop stores information about the active image.

2. Click on the New Channel icon at the bottom of the Channels palette. Photoshop creates a new channel, and the visible image turns black, as shown in Figure 444.2.

3. When you create a new channel, Photoshop automatically selects the new channel.

4. Select the Paintbrush tool from the toolbox, select a small soft brush, and select white as your painting color (refer to Tip 221, "Selecting a Foreground and Background Color Swatch").

Figure 444.2 Clicking the New Channel icon creates a new channel in the active Photoshop document.

5. Move your painting cursor into the document window. Position the cursor in the upper-left corner and click and drag your mouse to the upper-right corner. Now click and drag your white painting cursor around the edges of the channel until you see an image similar to Figure 444.3.

Figure 444.3 Clicking and dragging the white paintbrush around the edges of the images produces a black channel with white edges.

6. Click once on the Load Channel as Selection icon, located at the bottom left of the Channels palette. Photoshop creates a selection out of the white areas of the channel, as shown in Figure 444.4.

Figure 444.4 Clicking the Load Channel as Selection icon creates a selection from the white areas of the channel.

7. Click once on the RGB channel (called the Composite channel). Photoshop activates all the color channels, and the document window displays a color image with a selection border, as shown in Figure 444.5.

Figure 444.5 Clicking the Composite channel activates all the color channels and restores the color image to the document window.

8. Press the Delete key. Photoshop fills the selected pixels with the current background color. The document window now contains the image enclosed within a soft vignette, as shown in Figure 444.6.

Note: In order for the selection to be filled with the current background color, the graphic must first be flattened into a background layer. If you press the Delete key on a layer, Photoshop converts the selected pixels to transparent.

Figure 444.6 Pressing the Delete key encloses the image in a soft vignette.

445 *Using Channels to Hold Difficult Selections*

In the preceding tip, you learned how to use an Alpha channel to create a soft vignette around an image. Since an Alpha channel defines selected areas using shades of gray, channels are useful tools for temporarily holding difficult selections.

Say, for example, you begin the complicated selection of an image, and you want to stop. Maybe it is time for lunch, maybe you have a headache, maybe you are simply too tired to continue. However, you are half finished with the selection, and you do not want to start the selection process from the beginning. You would like to stop and then pick up later where you left off.

To use a channel to hold a selection, open a document in Photoshop, create a selection, and perform these steps:

1. To access the Channels palette, click the Channels tab or select the Window menu and choose Show Channels from the pull-down menu. Photoshop displays the Channels palette, as shown in Figure 445.1.

2. Click on the Create New Channel icon. Photoshop deactivates all the color channels and selects the new channel, as shown in Figure 445.2. Notice that the selection border is still visible.

3. If your background color swatch is not white, press the letter "D" on your keyboard to default the Foreground and Background color swatches to black and white. Then press the letter "X" until white appears as the background color swatch, as shown in Figure 445.3.

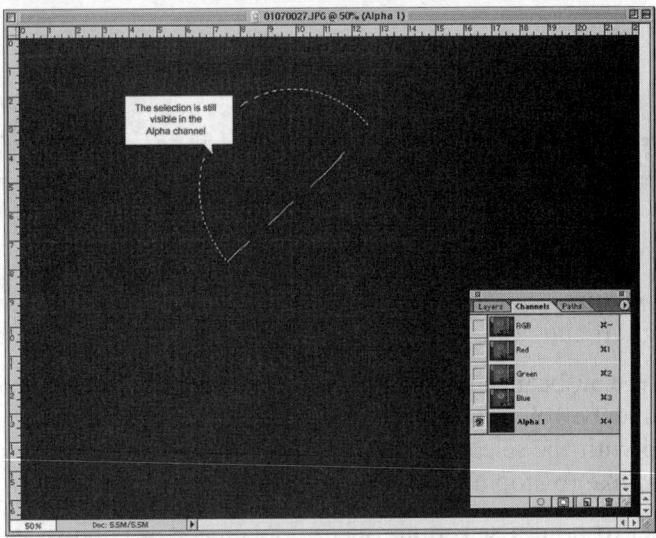

Figure 445.1 The document window contains a half-finished selection.

Figure 445.2 Clicking the New Channel icon creates a new channel.

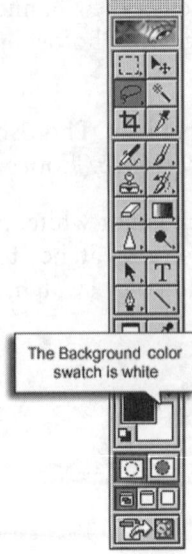

Figure 445.3 The Background color swatch is white.

4. Press the Delete key. Photoshop converts the selected areas of the new channel to white, as shown in Figure 445.4.

Figure 445.4 Pressing the Delete key converts the selected areas of the Alpha channel to white.

5. Press Ctrl+D (Macintosh: Command+D) to remove the selection marquee from the channel.

6. You now have an Alpha channel that contains the partial selection. To reactivate the selection and continue the selection process, click the Load Channel as Selection icon at the bottom left of the Channels palette, as shown in Figure 445.5.

Figure 445.5 Clicking the Load Channel as Selection icon converts the white areas of the Alpha channel into a selection.

7. To continue the selection process, click once on the Composite channel. Photoshop activates the color channels in the image. The color document is returned to the document window along with your selection marquee, as shown in Figure 445.6.

Figure 445.6 Clicking on the Composite channel activates all the color channels and returns the color image (with the selection marquee) to the document window.

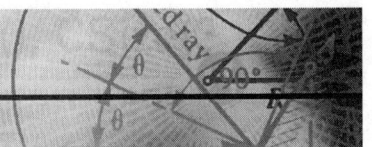

446 *Modifying a Channel Using Filters*

In Tip 444, "Using Photoshop's Paintbrush Tools on a Channel," you learned how to modify a channel information using Photoshop's painting tools. It is also possible to modify a channel using any of Photoshop's many filters. Say, for example, you want to create a soft vignette around an image, but unlike in Tip 444, you do not want to use the painting tools.

To create a soft vignette using channels, open a document in Photoshop and perform these steps:

1. To access the Channels palette, click the Channels tab or select the Window menu and choose Show Channels from the pull-down menu. Photoshop displays the Channels palette, as shown in Figure 446.1.

Figure 446.1 The Channels palette in Photoshop stores information about the active image.

2. Click on the New Channel icon located at the bottom of the Channels palette. Photoshop creates a new channel, and the visible image turns black.

3. Select the Elliptical Marquee tool from the toolbox and create an oval in the channel, as shown in Figure 446.2. For more information on the Elliptical tool, refer to Tip 71, "The Marquee Tools."

Figure 446.2 Clicking and dragging the Elliptical Marquee tool across the channel creates an oval selection.

4. Choose the Select menu and choose Inverse from the pull-down menu. Photoshop reverses the selection.

5. Choose the Select menu and choose Feather from the pull-down menu. Photoshop opens the Feather Selection dialog box, as shown in Figure 446.3. For more information on the Feather command, refer to Tip 304, "Understanding How Feathering Operates."

Figure 446.3 The Feather Selection dialog box controls the amount of feathering applied to a selection.

6. In the Feather Radius input field, enter a value of 25. Click the OK button in the Feather dialog box to apply the feather to the current selection.

7. If your background color swatch is not white, press the letter "D" on your keyboard to default the Foreground and Background color swatches to black and white. Then press the letter "X" until white appears as the background color swatch, as shown in Figure 446.4.

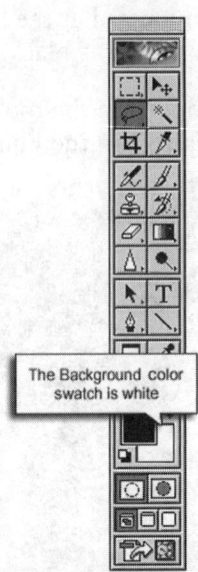

Figure 446.4 The Background color swatch is white.

8. Press the Delete key. Photoshop converts the selected areas of the Alpha channel to white, as shown in Figure 446.5.

Figure 446.5 Pressing the Delete key converts the selected areas of the Alpha channel to white.

9. Click once on the Load Channel as Selection icon, located at the bottom left of the Channels palette. Photoshop creates a selection out of the white areas of the channel, as shown in Figure 446.6.

Figure 446.6 *Clicking the Load Channel as Selection icon creates a selection from the white areas of the channel.*

10. Click once on the RGB channel (called the Composite channel). Photoshop activates all the color channels, and the document window displays a color image with a selection border, as shown in Figure 446.7.

Figure 446.7 *Clicking the Composite channel activates all the color channels and restores the color image to the document window.*

11. Press the Delete key. Photoshop fills the selected pixels with the current background color. The document window now contains the image enclosed within a soft vignette, as shown in Figure 446.8.

Figure 446.8 Pressing the Delete key encloses the image in a soft vignette.

447 *Working with Channels to Sharpen an Image*

In the preceding tip, you learned how to use channels and filters to create a soft vignette border around an image. Photoshop can use channels and filters to perform image editing. Say, for example, you want to sharpen a Photoshop image. The Photoshop program contains four sharpening filters: Sharpen, Sharpen Edges, Sharpen More, and Unsharp Mask. All four of these filters sharpen an image; however, combining channels and sharpen filters produces the best results.

To sharpen an image using channels and sharpen filters, open an image in Photoshop and perform these steps:

1. To access the Channels palette, click the Channels tab or select the Window menu and choose Show Channels from the pull-down menu. Photoshop displays the Channels palette, as shown in Figure 447.1.

Figure 447.1 The Channels palette displays all the channels for the active document.

2. Click one at a time on the Red, Green, and Blue channels and identify the channel that appears the most out of focus. In an RGB image, this typically is the Green channel, as shown in Figure 447.2.

Figure 447.2 *The Green channel appears more out of focus than the Red or the Blue channels.*

3. Click once on the Green channel to select it.

4. Select Filter menu Sharpen and choose Unsharp Mask from the fly-out menu. Photoshop opens the Unsharp Mask dialog box, as shown in Figure 447.3.

Figure 447.3 *The Unsharp Mask dialog box controls the sharpening of the Green channel.*

5. In the Amount, Radius, and Threshold fields, enter the values displayed in Figure 447.3. For more information on using Unsharp Mask, see Tip 627, "Sharpening an Image."

6. Click the OK button to apply the Unsharp Mask filter to the Green channel.

7. Click on the Composite channel. Photoshop activates the color channels and restores the color image to the document window, as shown in Figure 447.4.

Figure 447.4 Clicking on the RGB Composite image activates the color channels and restores the image.

Note: Performing an Unsharp Mask on a channel, as opposed to the entire image, gives you control over what pixels to modify and results in a better image.

448 Creating a Painted Look with Channels and Filters

Photoshop can combine channels and filters in creative ways to produce special effects. To create a painted look to an image, open an RGB image in Photoshop and perform these steps:

1. To access the Channels palette, click the Channels tab or select the Window menu and choose Show Channels from the pull-down menu. Photoshop displays the Channels palette, as shown in Figure 448.1.

Figure 448.1 The Channels palette displays all the channels for the active document.

2. Move your cursor into the Channels palette and select one of the channels, as shown in Figure 448.2.

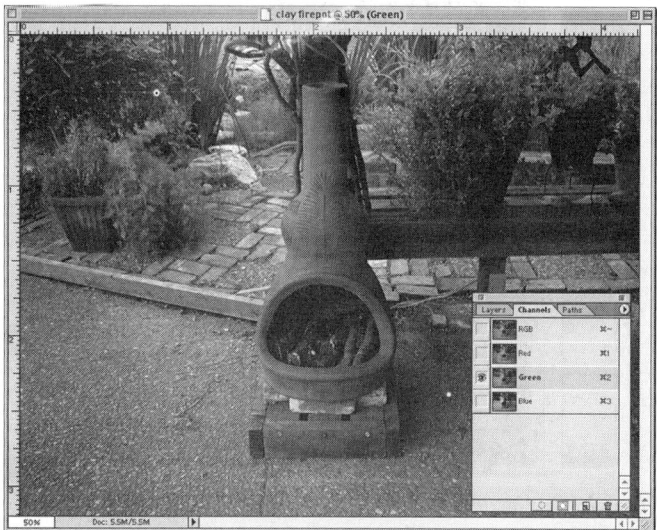

Figure 448.2 Clicking on the Green channel causes Photoshop to select the Green channel.

3. Select Filter menu Artistic and choose Cutout from the fly-out menu. Photoshop opens the Cutout dialog box, as shown in Figure 448.3.

Figure 448.3 The Cutout dialog box controls the effects of the Cutout filter.

4. In the No. of Levels, Edge Simplicity, and Edge Fidelity input fields, use the information supplied in Figure 448.3. For more information on using the Cutout command, see Tip 498, "Using Photoshop's Cutout Filter to Create Artwork."

5. Click the OK button in the Cutout dialog box to apply the changes to the Green channel.

6. Click on the Composite channel. Photoshop activates the color channels and restores the color image to the document window, as shown in Figure 448.4.

Figure 448.4 Clicking on the RGB Composite image activates the color channels and restores the image.

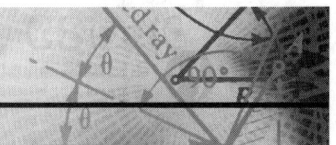

449 *Creating Spot Color Channels for Text*

Channels give you the ability to create specialized channels for spot colors. Spot Colors are channels for applying specific colors (usually Pantones) to an image. Say, for example, you want to create a poster using a Spot Color channel for the text. Open a document in Photoshop and perform these steps:

1. To access the Channels palette, click the Channels tab or select the Window menu and choose Show Channels from the pull-down menu. Photoshop displays the Channels palette, as shown in Figure 449.1.

Figure 449.1 The Channels palette displays all the channels for the active document.

2. Click on the black triangle in the upper-right corner of the Channels palette. Photoshop displays a fly-out menu containing the Channels palette options.

3. Select New Spot Channel from the fly-out menu. Photoshop displays the New Spot Channel dialog box, as shown in Figure 449.2.

Figure 449.2 The New Channel dialog box controls the ink color for the Spot channel.

4. Click once in the Color dialog box. Photoshop opens the Photoshop Custom Colors, as shown in Figure 449.3.

Figure 449.3 The Custom Colors dialog box lets you select the color to use with the Spot Color channel.

5. Select the correct color and click the OK button to record your change to the New Spot Color dialog box.

6. Click the OK button in the New Spot Color dialog box to apply the color to the Spot Color channel. Photoshop creates a new Spot Color channel, as shown in Figure 449.4.

Figure 449.4 The new Spot Color channel retains the name of the selected Pantone color.

7. If your Foreground color swatch is not white, press the letter "D" on your keyboard to default the Foreground and Background color swatches to black and white. Then press the letter "X" until white appears as the foreground color swatch.

8. Select the Type tool from the toolbox and type the text into the channel, as shown in Figure 449.5. For more information on creating text, refer to Tip 218, "Creating Text in Photoshop 6.0."

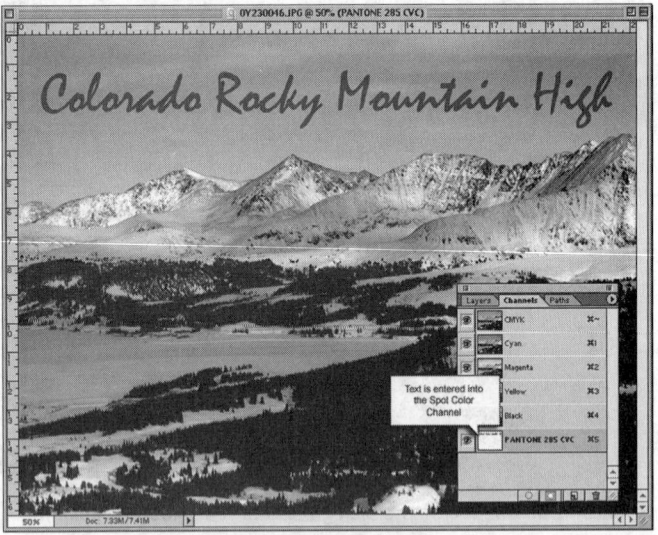

Figure 449.5 The Type tool types black text into the Spot Color channel.

Note: After creating the Spot Color channel, the image is ready to be saved and sent to the service bureau.

450 *Converting a Channel into a Spot Color Channel*

In the preceding tip, you learned how to create a Spot Color channel for text. Photoshop lets you convert an Alpha channel into a Spot Color channel. Say, for example, you create a channel containing a selection or group of text, and you want to convert the channel into a Spot Color channel.

To convert an Alpha channel into a Spot Color channel, open an image containing Alpha channels in Photoshop and perform these steps:

1. To access the Channels palette, click the Channels tab or select the Window menu and choose Show Channels from the pull-down menu. Photoshop displays the Channels palette, as shown in Figure 450.1.

Figure 450.1 The Channels palette displays all the channels for the active document.

2. Select the Alpha channel you want to convert into a Spot Color channel. In this example, the Alpha 2 channel was selected.

3. Click on the black triangle in the upper-right corner of the Channels palette. Photoshop displays a fly-out menu containing the Channels palette options.

4. Select Channel Options from the pull-down menu. Photoshop displays the Channel Options dialog box, as shown in Figure 450.2.

5. Click once in the Color swatch box. Photoshop opens the Photoshop Custom Colors, as shown in Figure 450.3.

6. Select the correct color and click the OK button to record your change to the Channel Optons dialog box.

7. Click the OK button in the Channel Option dialog box to apply the changes to the Alpha channel. Photoshop converts the Alpha channel into a Spot Color channel.

Note: Once the Spot Color channel is created, the document is ready to be saved and sent to the service bureau.

Figure 450.2 The Channels Options dialog box defines the characteristics of the Alpha channel.

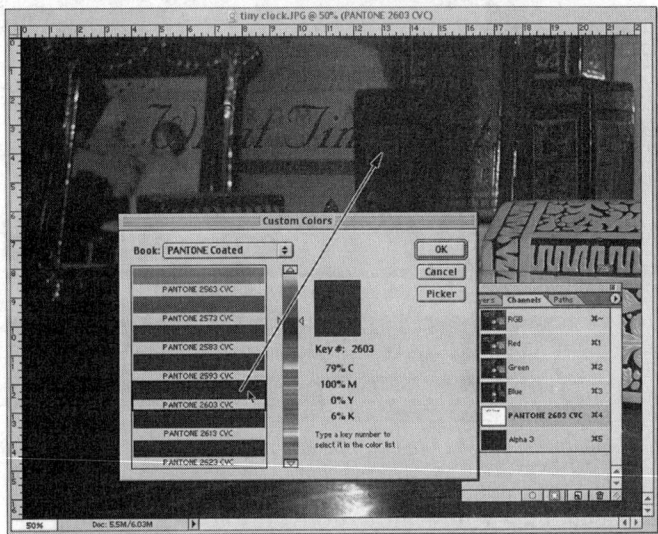

Figure 450.3 The Custom Colors dialog box lets you select the color to use with the Spot Color channel.

451 *Using Channels with Quick Mask*

In Tip 151, "Working with Quick Mask," you learned how to use the Quick Mask option to create a selection. When you work in Quick Mask mode, you use Photoshop's painting tools to create a selection within the active image. However, like any selection, using the Quick Mask option creates a temporary selection area that lasts only as long as the document is open.

Say, for example, you create a selection with Quick Mask, and you want to preserve the mask for use later in the editing process, as shown in Figure 451.1.

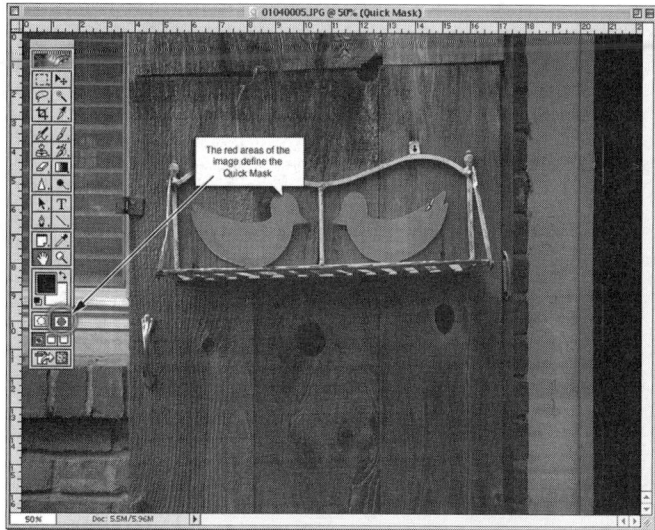

Figure 451.1 In Quick Mask, the red color represents the masked areas of the image.

To save a Quick Mask selection as a permanent channel, open an image, create a Quick Mask selection (refer to Tip 151), and perform these steps:

1. To access the Channels palette, click the Channels tab or select the Window menu and choose Show Channels from the pull-down menu. Photoshop displays the Channels palette, as shown in Figure 451.2.

Figure 451.2 The Channels palette in Photoshop stores information about the active image, including a temporary channel for the Quick Mask.

2. The Channels palette lists all the available channels in the active image, including a temporary channel named Quick Mask. The Quick Mask channel holds an image of the image mask you created using the Quick Mask option.

3. Click on the black triangle in the upper-right corner of the Channels palette. Photoshop displays a fly-out menu containing the Channels palette options.

4. Select Duplicate Channel from the fly-out menu. Photoshop opens the Duplicate Channel dialog box, as shown in Figure 451.3.

Figure 451.3 The Duplicate Channel option lets you create a copy of the Quick Mask and save it as a permanent channel.

5. In the Duplicate Quick Mask As input box, enter a descriptive name for the mask.

6. The Destination option lets you choose to copy the mask into a different document or to create a new document to hold the new channel. The default option for Destination is the original document. In this example, you want to leave the mask with the original document.

7. Click the OK button in the Duplicate Channel dialog box. Photoshop creates a permanent copy of the Quick Mask. You now have two channels in the Channels palette: the original Quick Mask (temporary) and a permanent copy of the Quick Mask.

Note: The original Quick Mask channel is temporary. It only exists while you work on the Quick Mask. When you exit Quick Mask mode (refer to Tip 151), the temporary channel deletes itself from the Channels palette.

452 *Converting a Channel into Tracing Paper*

In Tip 443, "Creating a New Channel," you learned how to create a new channel and how black, white, and shades of gray create selections within the new channel. When you create a new channel, the visible image in the document window turns completely black. Think of a new channel as a piece of opaque black paper laid over the image. When you paint on the mask with white or a shade of gray, you are exposing the image. Or if you use the analogy of a piece of black paper, you cut areas out of the masking paper, exposing the image, as shown in Figure 452.1.

The problem encountered with a channel mask is that a mask is opaque; you cannot see the underlying image, and therefore it is impossible to make a selection. To create a channel mask and create a selection as if you are using tracing paper, open an image in Photoshop and perform these steps:

1. To access the Channels palette, click the Channels tab or select the Window menu and choose Show Channels from the pull-down menu. Photoshop displays the Channels palette, as shown in Figure 452.2.

Figure 452.1 Painting on a channel mask is similar to creating a stencil from a black piece of paper.

Figure 452.2 The Channels palette displays all the channels for the active document.

2. Click on the Create New Channel icon. Photoshop deactivates all the color channels and selects the new channel. Notice that the visible image in the document window turns black, as shown in Figure 452.3.

Figure 452.3 Clicking the New Channel icon creates a new channel.

3. Move your cursor into the Channels palette and click once in the RGB channel visibility input box. Photoshop places an eye icon in the input box, as shown in Figure 452.4.

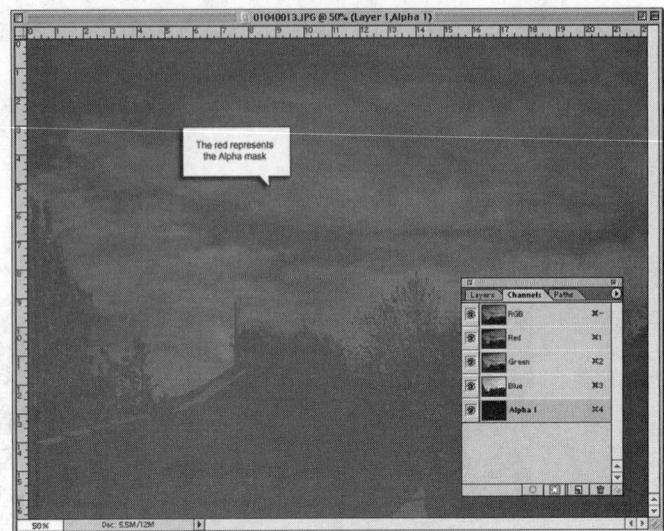

Figure 452.4 Clicking in the visibility input box reactivates the composite (RGB) layer.

4. The image in the document window displays with a red overlay. The red overlay represents the channel mask. Paint with black, white, or a shade of gray to mask or unmask the image.

5. To view the mask without the image, click once in the RGB channel visibility input box. Photoshop removes the eye icon from the input box, as shown in Figure 452.5.

Figure 452.5 Clicking on the visibility icon deactivates the composite (RGB)
channel and lets you view the mask without the image.

Note: To convert a channel mask into a selection, refer to Tip 309, "Creating Selections from Channels."

453 *Creating a Selection with Your Paintbrush*

In the preceding tip, you learned how to use the Channels palette to create a tracing paper image out of a channel. Channels and Quick Masks are excellent methods for making complicated selections easy. To create a selection using the Channels palette, open an image in Photoshop and perform these steps:

1. To access the Channels palette, click the Channels tab or select the Window menu and choose Show Channels from the pull-down menu. Photoshop displays the Channels palette, as shown in Figure 453.1.

Figure 453.1 The Channels palette displays all the channels for the active document.

2. Click on the New Channel icon located at the bottom of the Channels palette. Photoshop creates a new channel, and the visible image turns black.

3. If your background color swatch is not white, press the letter "D" on your keyboard to default the Foreground and Background color swatches to black and white. Then press the letter "X" until white appears as the foreground color, as shown in Figure 453.2.

Figure 453.2 The Background color swatch is white.

4. Select the Paintbrush tool from the toolbox and choose a medium size, hard-edged brush. For more information on working with the Paintbrush tools, refer to Tip 444, "Using Photoshop's Paintbrush Tools on a Channel."

5. Move your cursor into the Channels palette and click once in the RGB channel visibility input box. Photoshop places an eye icon in the input box, as shown in Figure 453.3.

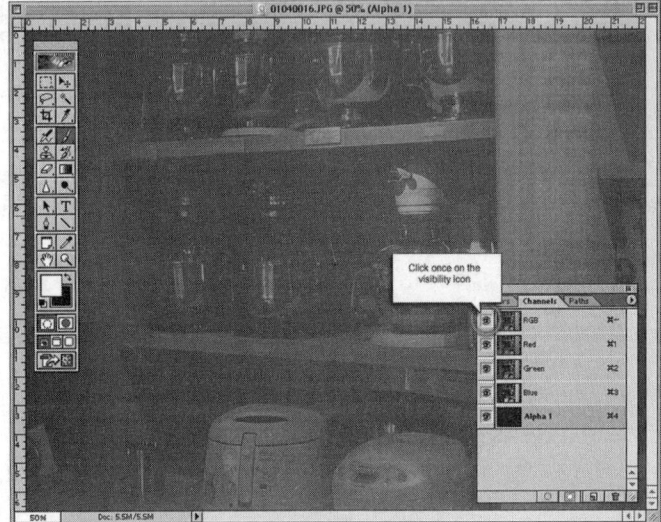

Figure 453.3 Clicking in the visibility input box reactivates the composite (RGB) layer.

6. The image in the document window displays with a red overlay. The red overlay represents the channel mask. Painting with black, white, or a shade of gray masks or unmasks the image (refer to Figure 453.3).

7. Using the white paintbrush, paint out (unmask) the areas of the image you want to select, as shown in Figure 453.4.

Figure 453.4 The white paintbrush unmasks areas of the image.

8. Paint the channel with black to mask areas of the visible image. Photoshop paints the image in a semitransparent red.

Note: To convert a channel mask into a selection, refer to Tip 309, "Creating Selections from Channels."

454 *Saving Selections with the Save Selection Command*

In Tip 451, "Using Channels with Quick Mask," you learned how to store Quick Mask selections using channels. In fact, any selection is convertible into a permanent selection with the use of the Save Selection command.

To convert a selection into a channel using Save Selection, open a document in Photoshop, create a selection area, and perform these steps:

1. To access the Channels palette, click the Channels tab or select the Window menu and choose Show Channels from the pull-down menu. Photoshop displays the Channels palette, as shown in Figure 454.1.

Figure 454.1 A Photoshop document with a selection defining a portion of the image.

2. Choose the Select menu and choose Save Selection from the pull-down menu. Photoshop opens the Save Selection dialog box, as shown in Figure 454.2.

3. The Document button determines in which Photoshop document to place the new selection channel. Click on the Document button to select from any open document or choose to place the selection channel into a new document.

4. The Channel button determines whether to place the selection within an existing channel or to create a new channel for the selection. Click on the Channel button to select a preexisting Alpha channel or select New to place the selection within a new channel.

5. In the Name input box, enter a name for the new channel. If you choose to place the selection within a new document, the Name field defines the name of the new document as well as the selection channel name.

Figure 454.2 The Save Selection dialog box controls the characteristics of the channel selection.

6. If you choose to place the selection within an existing channel, click a radio button to the left of the Operation options and choose to Replace, Add, Subtract, or Intersect the document selection with the existing channel.

7. Click the OK button to record your changes to the Channels palette, as shown in Figure 454.3.

Figure 454.3 The Channels palette contains a new channel based on the Save Selection command.

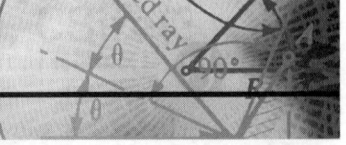

455 *Turning a Channel into a Selection*

In Tip 311, "Using the Load Selection Command," you learned how to use the Load Selection command to convert Alpha channel masks into a visible selection within the document window. The Load Selection command gives you total control over the final selection. However, there is a quicker way to convert an Alpha channel into a mask. Say, for example, you have a selection contained within an Alpha channel, and you simply want to apply the selection to the image.

To convert an Alpha channel into a selection, open a document containing an Alpha channel and perform these steps:

1. To access the Channels palette, click the Channels tab or select the Window menu and choose Show Channels from the pull-down menu. Photoshop displays the Channels palette, as shown in Figure 455.1.

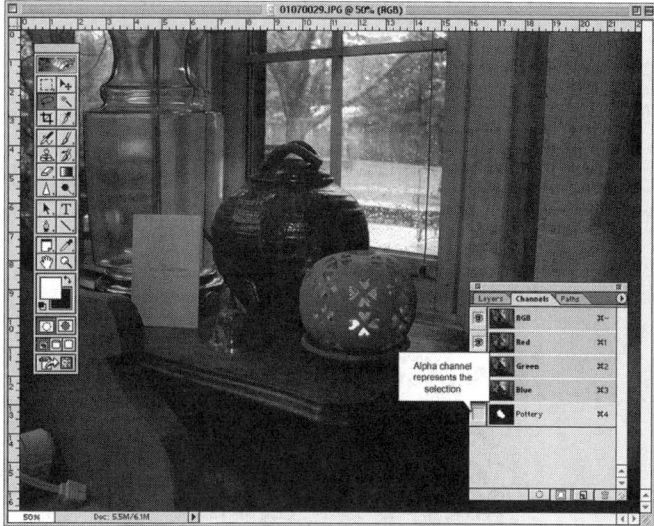

Figure 455.1 A Photoshop document with an Alpha channel.

2. Move your cursor into the Channels palette and above the channel you want to convert into a selection.

3. Hold down the Ctrl key (Macintosh: Command key). Your hand cursor now displays a small dotted square. Click your mouse and Photoshop converts the Alpha channel mask into a selection, as shown in Figure 455.2.

Figure 455.2 Ctrl+clicking on an Alpha channel mask converts the mask into a selection.

Note: *When you use the Ctrl+click method to convert an Alpha channel into a selection, you lose control of the Load Selection command. However, if you simply want to convert the Alpha channel into a selection, this is the most efficient way.*

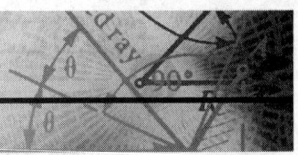

456 *Loading Multiple Channels as Selections*

In the preceding tip, you learned how to save selections into channels using the Save Selection command. Say, for example, you have a Photoshop document with several selections. You created the selections in separate channels to perform individual editing operations; however, you now want to combine the selections to apply a filter to the entire object.

To combine multiple selections, open a document containing several selections and perform these steps:

1. To access the Channels palette, click the Channels tab or select the Window menu and choose Show Channels from the pull-down menu. Photoshop displays the Channels palette, as shown in Figure 456.1.

Figure 456.1 A Photoshop document containing multiple Alpha channels.

2. Move your cursor into the Channels palette until the hand icon is directly above the channel you want to convert into a selection.

3. Hold down the Ctrl key (Macintosh: Command key). Your hand cursor now displays a small dotted square. Click your mouse and Photoshop converts the channel mask into a selection, as shown in Figure 456.2.

4. Move your hand icon cursor directly over the next channel you want to add to the selection. Hold down the Shift+Ctrl key (Macintosh: Shift+Command key). Your hand cursor now displays a small dotted square containing a plus sign. Click your mouse and Photoshop adds the channel mask to the existing selection, as shown in Figure 456.3.

Note: *Since you have the ability to combine selections, using separate channels to store portions of a selection gives you more control over the image.*

Figure 456.2 Ctrl+clicking on an Alpha channel mask converts the mask into a selection.

Figure 456.3 Holding down the Shift+Ctrl keys adds a channel mask to an existing selection.

457 *Changing Channel Options*

In Tip 452, "Converting a Channel into Tracing Paper," you learned how to edit a channel mask using the original image as a tracing paper template. When you first edit an image, the tracing paper appears red with a 50-percent transparency. Say, for example, you edit a document using the tracing paper option, and the original image is a shade of red. You want to change the color of the mask to help distinguish the mask from the image.

To change the color of the channel mask, open a document in Photoshop and perform these steps:

1. To access the Channels palette, click the Channels tab or select the Window menu and choose Show Channels from the pull-down menu. Photoshop displays the Channels palette.

2. Select the channel you want to edit and activate the tracing paper option (refer to Tip 452). Photoshop converts the black mask into a red overlay. The red mask makes it difficult to tell where the mask ends and the image begins, as shown in Figure 457.1.

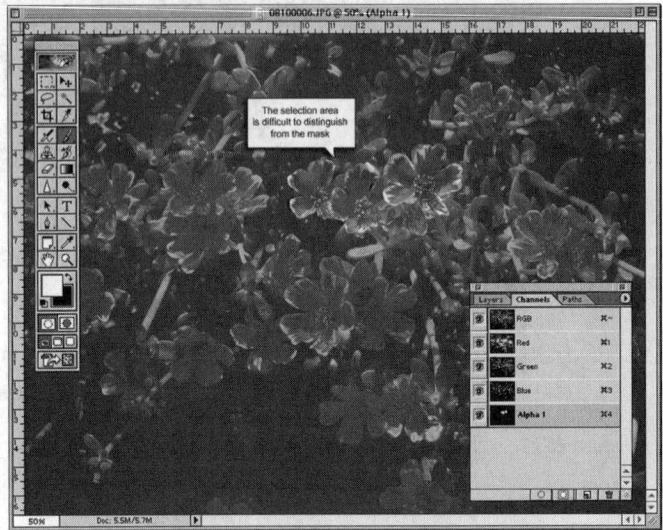

Figure 457.1 A Photoshop document with a tracing paper mask.

3. Click on the black triangle in the upper-right corner of the Channels palette. Photoshop displays a fly-out menu containing the Channels palette options.

4. Select Channel Options from the fly-out menu to display the Channel Options dialog box.

5. Click the Color swatch in the bottom-left corner of the Channel Options dialog box to open the Color Picker dialog box, as shown in 457.2.

Figure 457.2 The Color Picker dialog box lets you select a color for use with the mask.

6. Select a color from the available options and click the OK button to record your changes to the Channel Options dialog box. For more information on using Photoshop's Color Picker, refer to Tip 62, "Manually Choosing Colors with the Color Picker."

7. In the Opacity input box, enter a value from 0 to 100 percent. The higher the value, the darker the mask. At 0 percent, the mask is invisible; at 100 percent, the mask is opaque.

8. Select the radio button to the left of Masked Areas to make the painted areas of the image the masked areas. Select the radio button to the left of Selected Areas to make the painted areas of the image the selected areas. Refer to Tip 450, "Converting a Channel into a Spot Color Channel," for more information on using the Spot Color option.

9. Click the OK button to record your changes to the Alpha mask, as shown in Figure 457.3.

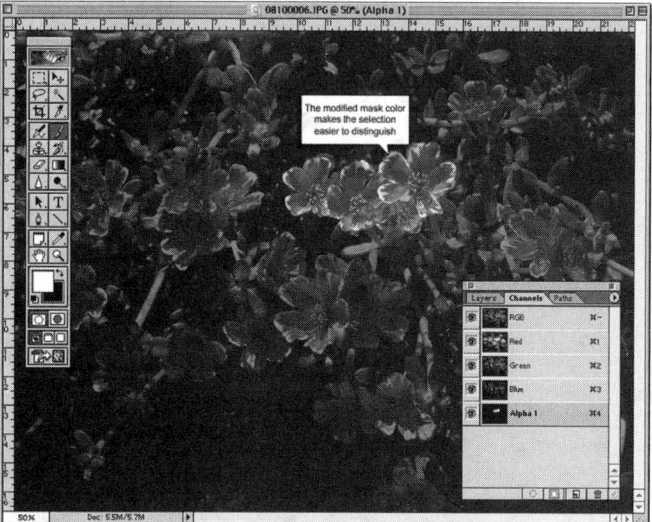

Figure 457.3 The Alpha mask after modifying Channel Options.

Note: Changes made to the Channel Options affect the masking options for all Photoshop documents.

458 *Quickly Removing Channel Selections*

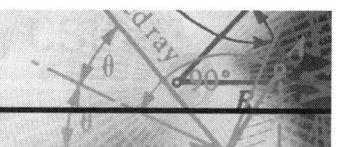

In Tip 456, "Loading Multiple Channels as Selections," you learned how to add more than one Alpha channel to a selection. Say, for example, you load several selections into a document, and you want to remove one or more of the selections.

To remove one or more selections from an image, open a document in Photoshop, create a multiple selection (refer to Tip 456), and perform these steps:

1. To access the Channels palette, click the Channels tab or select the Window menu and choose Show Channels from the pull-down menu. Photoshop displays the Channels palette, as shown in Figure 458.1.

2. Move your cursor into the Channels palette and move it above the channel you want to remove from the selection.

3. Hold down the Ctrl+Alt key (Macintosh: Command + Option key). Your hand cursor now displays a small dotted square with a negative sign. Click your mouse. Photoshop removes the Alpha channel mask from the selection, as shown in Figure 458.2.

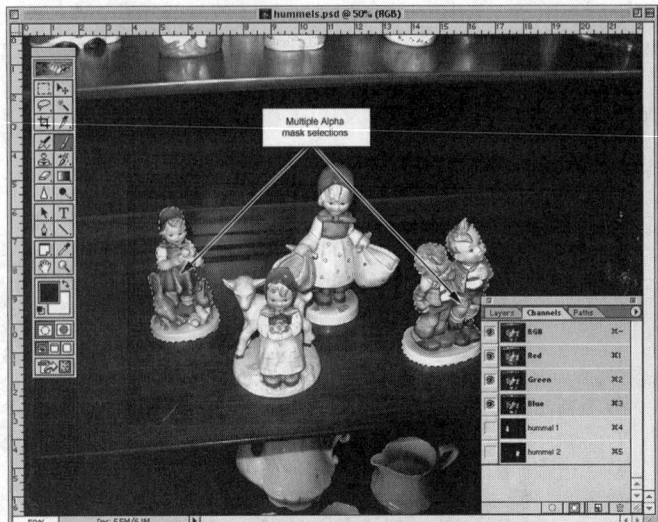

Figure 458.1 A Photoshop document containing multiple Alpha channel selections.

Figure 458.2 Alt+clicking on an Alpha channel mask removes the mask from the selection.

459 *Splitting Channels into Individual Images*

In Tip 441, "Merging Multiple Channels," you learned how to combine channels from several documents into one single document. Say, for example, you have a document and want to split the color channels into individual documents. Splitting the color channels of an image into separate documents is useful for moving large images between computers or for transmitting large documents over the Internet.

To separate the color channels of a Photoshop document, perform these steps:

1. To access the Channels palette, click the Channels tab or select the Window menu and choose Show Channels from the pull-down menu. Photoshop displays the Channels palette, as shown in Figure 459.1.

Figure 459.1 The Channels palette displays the image's native color channels.

2. Click on the black triangle in the upper-right corner of the Channels palette. Photoshop displays a fly-out menu containing the Channels palette options.

3. Select Split Channels from the fly-out menu. Photoshop creates a separate document for each channel in the original image, as shown in Figure 459.2.

Figure 459.2 Selecting the Split Channels command separates the channels in a Photoshop graphic into separate documents.

Note: *To reassemble the separate color channels into a single color document, refer to Tip 441, "Merging Multiple Channels."*

460 *Duplicating a Channel*

When you open a graphic image in Photoshop, the Channels palette displays a list of all the Color, Spot Color, and Alpha Mask channels in the document. Each channel is unique to that particular document. Say, for example, you want to create a duplicate copy of a channel in an open or new document.

To create a duplicate of a channel, open a Photoshop document and perform these steps:

1. To access the Channels palette, click the Channels tab or select the Window menu and choose Show Channels from the pull-down menu. Photoshop displays the Channels palette, as shown in Figure 460.1.

Figure 460.1 The Channels palette displaying the native color channels of the active document.

2. Click once on the channel you want to duplicate. Photoshop selects the channel. In this example, you selected the Red channel.

3. Click on the black triangle in the upper-right corner of the Channels palette. Photoshop displays a fly-out menu containing the Channels palette options.

4. Select Duplicate Channel from the fly-out menu. Photoshop opens the Duplicate Channel dialog box, as shown in Figure 460.2.

Figure 460.2 The Duplicate Channel dialog box controls the characteristics of the copied channel.

5. In the Duplicate As input box, enter a name for the channel copy. The default name is the original channel name plus the word copy.

6. Click on the Destination Document button. Photoshop displays a list of all currently open documents plus the New option. Select the New option to create a new document for the channel.

7. If you choose to duplicate the channel in a new document, click in the Name field and enter a name for the document.

8. Click the Invert button to reverse the black and white colors of the mask. Since the color of the mask determines the selection, choosing Invert reverses the selected areas of the mask.

9. Click OK to record your changes. In this example, you created a new document for the Red channel of an RGB image, as shown in Figure 460.3.

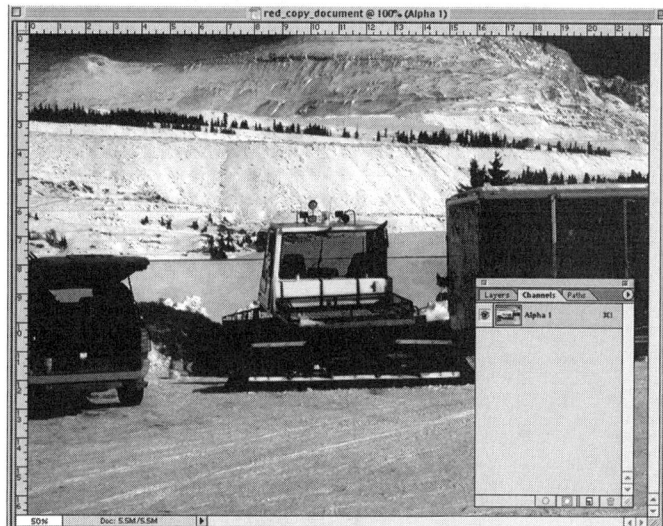

Figure 460.3 A new document created for the Red channel using the Duplicate Channel command.

461 *Influencing the Intensity of a Filter Using Channels*

A little-known tip concerning channels is their effect on the application of a filter or command. An Alpha channel mask represents a selected area of an image. By default, the black areas of a mask indicate the masked areas of the image, and the white areas of the mask represent the areas of the mask that are 100 percent selected. The trick is to use a shade of gray on the mask. When you paint the mask using 50 percent gray, the painted areas of the mask are only 50 percent selected. When you apply a filter or mask to the image, the filter applies at 50 percent.

To use an Alpha channel mask to influence a filter, open a document in Photoshop and perform these steps:

1. To access the Channels palette, click the Channels tab or select the Window menu and choose Show Channels from the pull-down menu. Photoshop displays the Channels palette, as shown in Figure 461.1.

2. Click on the New Channel icon located at the bottom of the Channels palette. Photoshop creates a new channel, and the visible image turns black, as shown in Figure 461.2.

Figure 461.1 The Channels palette in Photoshop stores color and masking information for the active image.

Figure 461.2 Clicking the New Channel icon creates a new channel in the active Photoshop document.

3. Select Photoshop's Gradient tool and create a black-to-white radial gradient across the channel, as shown in Figure 461.3. For more information on using the Gradient tool, refer to Tip 175, "Creating Custom Gradients."

4. Move your cursor into the Channels palette (the cursor changes to a hand icon) and click once on the Composite channel. In this example, click once on the RGB channel and Photoshop selects the Composite (RGB) channel.

5. Move your cursor above the channel you want to convert into a selection.

6. Hold down the Ctrl key (Macintosh: Command key). Your hand icon cursor now displays a small dotted square. Click your mouse and Photoshop converts the Alpha channel mask into a selection, as shown in Figure 461.4.

Figure 461.3 Clicking and dragging the Gradient tool across a channel creates a black-to-white mask.

Figure 461.4 Ctrl+clicking on an Alpha channel mask converts the mask into a selection.

7. Select the Filter menu, then choose Texture and choose Mosaic Tiles from the fly-out menu. Photoshop displays the Mosaic Tiles dialog box, as shown in Figure 461.5.

8. Choose the options from Figure 461.5 and click the OK button to record the Mosaic Tile filter to the document.

9. The Alpha mask controls the application of the filter. The black areas of the mask did not receive any mosaic tiles, and the areas of white received 100 percent application of the tiles. The areas of the mask defined by shades of gray received varying intensities of the mosaic filter depending on the particular shade of gray in the mask, as shown in Figure 461.6.

Figure 461.5 The Mosaic Tiles dialog box controls the application of the filter to the active Photoshop image.

Figure 461.6 The Mosaic Tile filter influenced the image based on the black, white, and shades of gray in the mask.

462 *Removing Moiré with Channels*
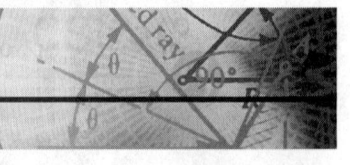

Images retrieved from newspapers and magazines typically create a moiré pattern in the scanned document, as shown in Figure 462.1.

Documents generate moiré patterns due to the four-color process used to create color images in magazines and the dot patterns used to generate black and white images in newspapers. Moiré patterns also appear in images that you resize. Moiré patterns are typically repeating patterns of color in normally solid areas of the image, refer to Figure 462.1.

Figure 462.1 A scanned image containing a moiré pattern.

To reduce or eliminate a moiré pattern in an image, open the graphic in Photoshop and perform these steps:

1. To access the Channels palette, click the Channels tab or select the Window menu and choose Show Channels from the pull-down menu. Photoshop displays the Channels palette.

2. Move your mouse cursor into the Channels palette and, one at a time, click on the Red, Green, and Blue channels. When you click on a channel, Photoshop deactivates all the other channels and displays the channel in the document window. Examine each channel and identify the channel in which the moiré pattern is most obvious. In this example, the Green channel contains the moiré pattern, as shown in Figure 462.2.

Figure 462.2 The Green channel contains the most obvious representation of the moiré pattern.

3. Select Filter menu Blur and choose Gaussian Blur from the fly-out menu. Photoshop opens the Gaussian Blur dialog box, as shown in Figure 462.3.

Figure 462.3 The Gaussian Blur dialog box controls the amount of blur applied to the image.

4. Using your mouse, drag the Gaussian Blur triangle slider left or right until the moiré pattern is lost in the blur. Click the OK button to apply the Gaussian blur to the image.

5. Select the Filter menu, select Sharpen and choose Unsharp Mask from the fly-out menu. Photoshop opens the Unsharp Mask dialog box, as shown in Figure 462.4.

Figure 462.4 The Unsharp Mask dialog box controls the amount of sharpening applied to the Green channel.

6. Using Tip 524, "Applying Unsharp Mask," sharpen the Green channel. Click OK to record the Unsharp Mask filter to the Green channel.

7. Click once on the Composite channel. In this example, the RGB channel is the Composite. Photoshop reactivates all the color channels, and the color image, without the moiré pattern, appears in the document window, as shown in Figure 462.5.

Figure 462.5 Performing a Gaussian Blur and Unsharp Mask on the Green channel removes the moiré pattern from the image.

463 *Accenting Areas of an Image Using Channels*

In Tip 461, "Influencing the Intensity of a Filter Using Channels," you learned how channels control the effect of a filter on an image. You can also use channels with Photoshop's commands and adjustments to create spectacular special effects. Say, for example, you want to use the Levels adjustment to create a spotlight or sunlight effect over a portion of an image.

To use channels to control the effect, open an image in Photoshop and perform these steps:

1. To access the Channels palette, click the Channels tab or select the Window menu and choose Show Channels from the pull-down menu. Photoshop displays the Channels palette, as shown in Figure 463.1.

Figure 463.1 The Channels palette in Photoshop stores color and masking information for the active image.

2. Click on the New Channel icon located at the bottom of the Channels palette. Photoshop creates a new channel, and the visible image turns black, as shown in Figure 463.2.

Figure 463.2 Clicking the New Channel icon creates a new channel in the active Photoshop document.

3. Select the Polygon Lasso from the toolbox and create a spotlight beam. For more information on using the Polygon Lasso, refer to Tip 124, "Working with the Polygon Lasso Tool." Note: To help design the shape of the spotlight beam, reactivate the composite channel by clicking once to the left of the RGB channel. This will reactivate the composite layers and let you view the image as you make your selection.

4. If your Background color swatch is not white, press the letter "D" on your keyboard to default the Foreground and Background color swatches to black and white. Then press the letter "X" until white appears as the Background color swatch.

5. Press the Delete key on your keyboard. The selected areas of the channel change to white, as shown in Figure 463.3.

Figure 463.3 Pressing the Delete key converts the areas of the image selected with the Polygon Lasso tool to white.

6. Select Filter menu Blur and choose Gaussian Blur from the fly-out menu. Photoshop opens the Gaussian Blur dialog box, as shown in Figure 463.4.

Figure 463.4 The Gaussian Blur dialog box controls the amount of blur applied to the image.

7. Press Ctrl+D (Macintosh: Command+D) on your keyboard. Photoshop removes the selection from the Alpha channel.

8. Click and drag the Gaussian Blur triangle slider left or right until the edges of the selection softly blur. In this example, a value of 25 is chosen. Click the OK button to apply the Gaussian blur to the Alpha channel, as shown in Figure 463.5.

Figure 463.5 The Gaussian Blur filter applies a soft blur to the edges of the light beam.

9. Click once on the Composite channel. In this example, the RGB channel is the Composite channel. Photoshop selects again all the color channels and displays the color image in the document window.

10. Move your cursor into the Channels palette and above the channel containing the light beam.

11. Hold down the Ctrl key (Macintosh: Command key). Your hand cursor now displays a small dotted square. Click your mouse and Photoshop converts the Alpha channel mask into a selection, as shown in Figure 463.6.

12. Select the Image menu, select Adjust, and choose Levels from the fly-out menu. Photoshop opens the Levels dialog box, as shown in Figure 463.7.

Figure 463.6 Ctrl+clicking on an Alpha channel mask converts the mask into a selection.

Figure 463.7 The Levels dialog box controls the dark-to-light tonal levels of the active image.

13. Click and drag the middle input slider to the left to lighten the selected areas of the image, as shown in Figure 463.8. For more information on using the Levels command, refer to Tip 201, "Understanding How the Levels Command Adjusts an Image."

Figure 463.8 Clicking and dragging the middle Levels slider to the right lightens the selected area of the image.

14. Choose Select menu and choose Inverse from the pull-down menu. Photoshop reverses the selected area.

15. Select the Image menu, choose Adjust and choose Levels from the fly-out menu. Photoshop opens the Levels dialog box (refer to Figure 463.7).

16. Click and drag the middle input slider to the right to darken the selected areas of the image. This helps gives emphasis to the lighted areas of the image, as shown in Figure 463.9.

Figure 463.9 Clicking and dragging the middle Levels slider to the rigt darkens the selected area of the image.

464 *Understanding Paths*

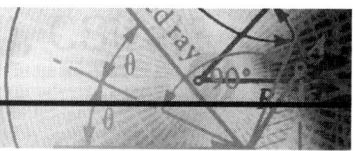

In Photoshop, the Layers palette controls the physical parts of an image, the Channels palette controls the colors and holds selections in Alpha channels, and the Paths palette holds all of Photoshop's vector-based paths. Photoshop defines the physical image as a grouping or raster of pixels. The resolution of an image determines how many pixels Photoshop uses to display and print the image (refer to Tip 114, "Increasing the Resolution of an Image by Changing Image Size").

The Paths palette does not use the resolution of an image to define a path; it uses vector, or mathematical, information.

When you create a shape in the Paths palette, Photoshop creates a mathematical formula to display that shape in the document window. Since Paths do not rely on resolution, resizing the image does not affect the path.

You create paths in Photoshop by using the Pen tools, by converting dotted-line selections, or by opening a path previously created by a vector program such as Adobe Illustrator.

To access the Paths palette, click the Paths tab or select the Window menu and choose Show Paths from the pull-down menu. Photoshop displays the Paths palette, as shown in Figure 464.1.

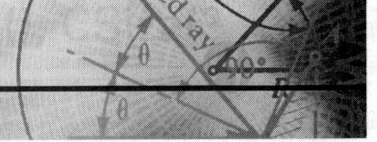

Figure 464.1 The Paths palette in Photoshop displays a list of all the available paths in the active document.

465 *Working with Anchor Points*

In the preceding tip, you learned how Photoshop defines a path. Paths are constructed using anchor points, and anchor points connect segment lines. In order to draw a line, you have to have at least two anchor points: one at the beginning and one at the end of the line, as shown in Figure 465.1.

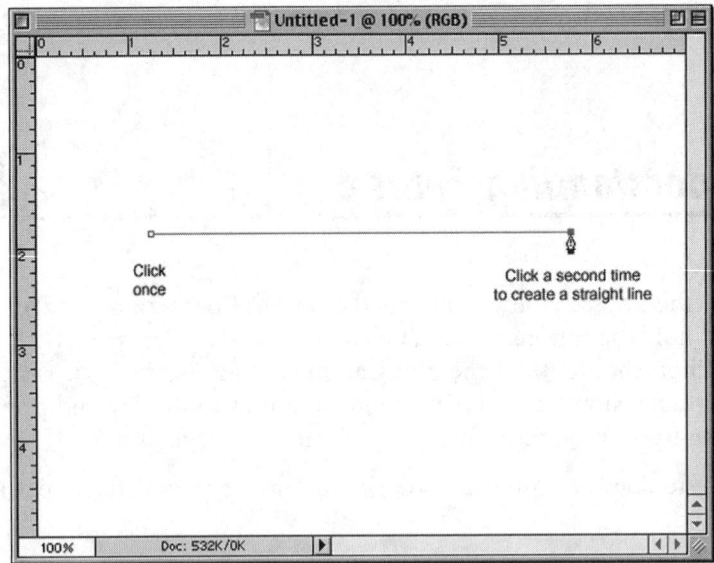

Figure 465.1 At least two anchor points define a straight line.

Anchor points can be straight or curved. When you use straight anchor points, the segment connecting the anchor points together is straight. When you use curved anchor points, the segment connecting the two points together curves, as shown in Figure 465.2.

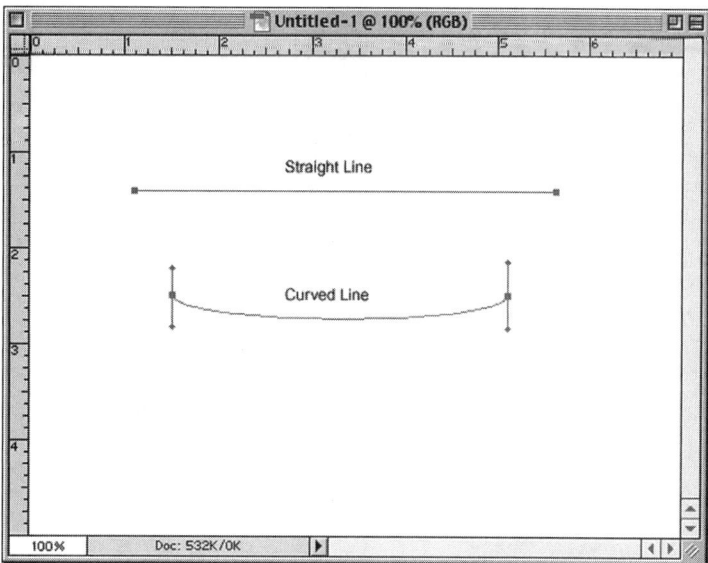

Figure 465.2 Anchor points can be straight or curved.

To create a path in Photoshop, open a document and perform these steps:

1. To access the Paths palette, click the Paths tab or select Window menu and choose Show Paths from the pull-down menu. Photoshop displays the Paths palette, as shown in Figure 465.3.

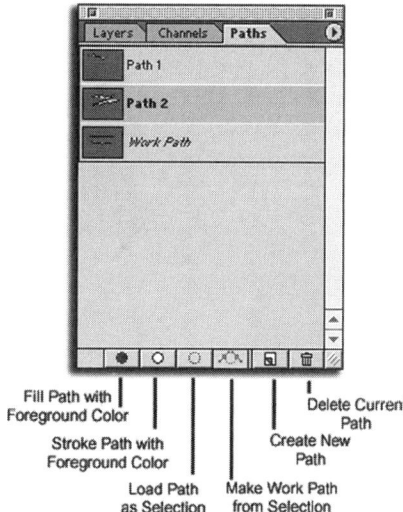

Figure 465.3 The Paths palette in Photoshop displays a list of all the available paths in the active document.

2. Select the Pen tool from the toolbox, as shown in Figure 465.4.

3. Move your Pen cursor into the document window and click. Photoshop creates a straight anchor point.

4. Move the Pen cursor down and to the right and click again. Photoshop creates a segment line connecting the two anchor points, as shown in Figure 465.5.

Figure 465.4 The Pen tool lets you create vector-based paths.

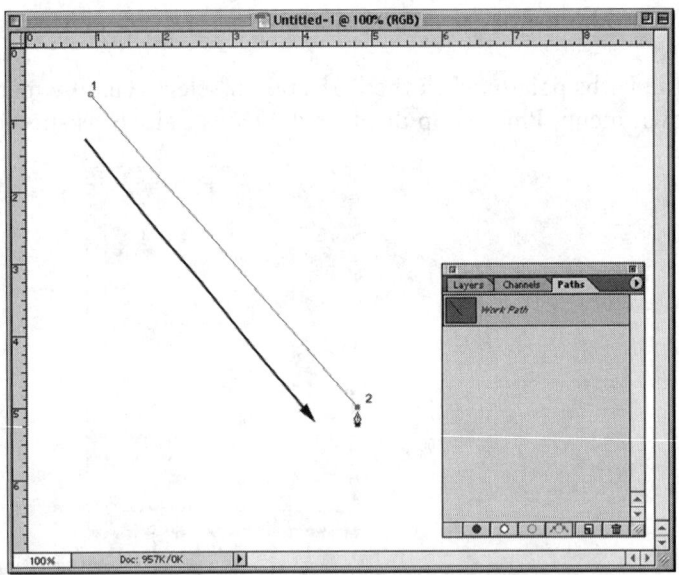

Figure 465.5 Clicking the Pen tool twice in the document window creates a straight segment line between the two anchor points.

5. Create a triangle by moving your Pen cursor straight up from your previous point until it is level with the first point and clicking once to set another anchor.

6. Move your Pen cursor over the starting anchor point and click once. Photoshop closes the shape and creates a triangle shape.

7. To create a curved anchor point, click and drag your mouse straight down. Photoshop creates a new anchor point with two direction lines, as shown in Figure 465.6.

8. Move to the right or left and click and drag the Pen tool straight up. Photoshop creates a curved segment line. The more you drag the anchor point up, the longer the direction lines become and the more curved the segment line, as shown in Figure 465.7. Release the mouse to stop the drawing process.

Figure 465.6 Clicking and dragging the Pen tool creates a curved anchor point with two direction lines.

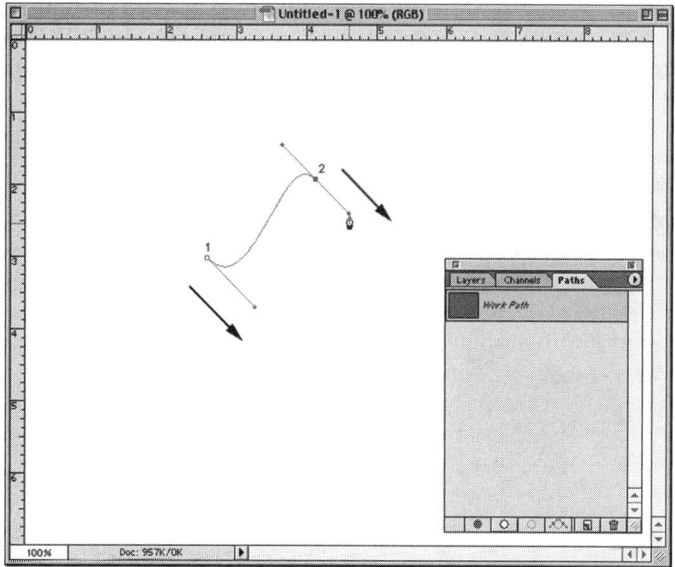

Figure 465.7 Clicking and dragging the Pen tool creates a curved segment line between two anchor points.

Note: *With its ability to draw straight and curved lines, the Pen tool, with some practice, is capable of drawing any desired shape.*

466 *Drawing Tips When Using the Pen Tool*

When using the Pen tool to create vector-based shapes:

- Hold the Shift key when clicking and dragging an anchor point. The Shift key constrains the direction lines to 90 or 45 degrees.

- Hold the Shift key when clicking to create a new anchor point. Say, for example, you want to create an anchor point directly to the left or right of the previous anchor point. Holding the Shift key constrains the new anchor point to be straight left or right of the previous anchor point.

- Hold the Shift key when clicking to create a new anchor point. Say, for example, you want to create an anchor point at an angle of 45 degrees from the previous anchor point. Holding the Shift key and moving up or down constrains the new anchor point to be 45 degrees from the previous anchor point.

- To relocate a previously created anchor point, click and hold the Ctrl key (Macintosh: Command key) and click and drag the anchor point to a new location. Holding the Ctrl key temporarily transforms the Pen tool into the Direct Selection tool.

- To change the curve on a curved segment line, hold the Ctrl key (Macintosh: Command key) and click and drag on the ends of the direction lines. Clicking on the end of a direction line while holding the Ctrl key lets you change the direction and length of the line, thereby changing the direction and curve of the segment.

- Click and drag with the Pen tool to create a new curved anchor point while holding the Alt key (Macintosh: Option key). Holding the Alt key creates an anchor point with only one direction line. Normally, clicking and dragging the Pen tool to create a curved anchor point creates a curve on both sides of the anchor point. When you hold the Alt key down and drag, the curved portion of the anchor point only affects the next anchor.

467 *Creating a New Path*

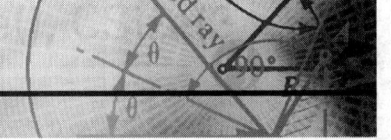

The Paths palette in Photoshop holds path elements. Each path element represents a path in Photoshop, as shown in Figure 467.1.

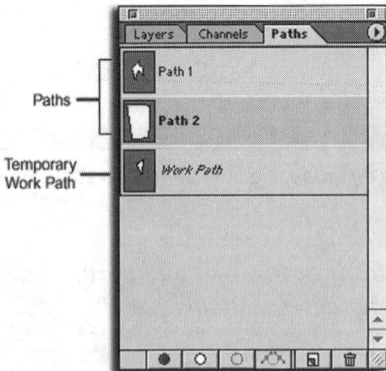

Figure 467.1 The Paths palette contains path elements that describe each of the paths in the active document.

To create a new path, open a Photoshop document and perform these steps:

1. To access the Paths palette, click the Paths tab or select the Window menu and choose Show Paths from the pull-down menu. Photoshop displays the Paths palette.

2. Move your mouse into the Paths palette and click the New Path icon at the bottom of the Paths palette. Photoshop creates a new path, as shown in Figure 467.2.

Figure 467.2 Clicking the New Path icon creates a new path in the Paths palette.

3. New Path elements do not contain a path; however, you can now use the Pen tools to create a path.

4. When you create a path (refer to Tip 465, "Working with Anchor Points"), Photoshop places the new path into the selected path in the Paths palette, as shown in Figure 467.3.

Figure 467.3 Photoshop places a new path into the active path element in the Paths palette.

5. If you select a Path element that already contains a path, using the Pen tool creates a new vector shape and adds that path to the existing one (refer to Tip 484, "Adding to an Existing Path").

468 *Using the Pen Tool to Create a Path*

In the preceding tip, you learned how to create a new path in Photoshop by clicking the New Path icon. When you click the New Path icon, Photoshop creates and names a new path: Path 1, Path 2, Path 3, etc. Another way to create a path is to select the Pen tool from the toolbox and begin creating a path.

To automatically generate a path in the Paths palette, open a document in Photoshop and perform these steps:

1. To access the Paths palette, click the Paths tab or select the Window menu and choose Show Paths from the pull-down menu. Photoshop displays the Paths palette, as shown in Figure 468.1.

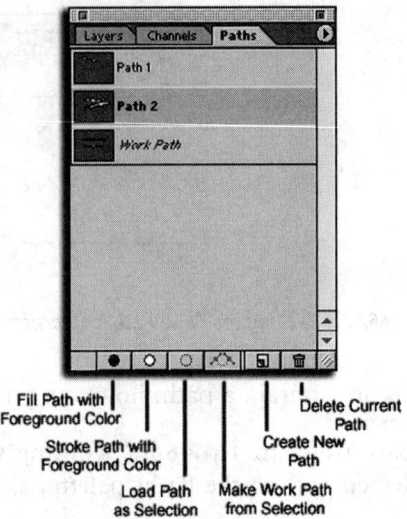

Figure 468.1 *The Paths palette in Photoshop displays a list of all the available paths in the active document.*

2. Select the Pen tool from the toolbox, as shown in Figure 468.2.

Figure 468.2 *The Pen tool lets you create vector-based paths.*

3. Move your Pen cursor into the document window and create a path (refer to Tip 465, "Working with Anchor Points"). Photoshop creates a work path in the Paths palette, as shown in Figure 468.3.

Figure 468.3 Creating a new path with the Pen tool automatically creates a new work path.

4. The Paths palette only supports one work path per document. To save the work path, double-click your mouse on the work path name. Photoshop opens the Save Path dialog box, as shown in Figure 468.4.

Figure 468.4 The Save Path dialog box lets you name a temporary work path.

5. In the Name input field, enter a name for the path. Click the OK button to record your changes to the Paths palette, as shown in Figure 468.5.

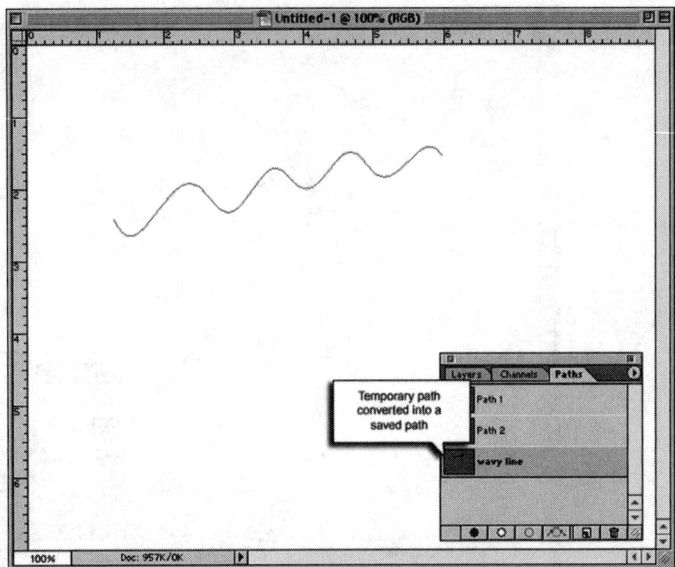

Figure 468.5 Naming a work path with the Save Path command permanently saves the path to the Paths palette.

469 *Combining Multiple Paths*

Photoshop lets you combine several paths together to form a new shape. Say, for example, you want to create a new shape from seven separate vector circles.

To create a new shape from two or more paths, open a new document in Photoshop and perform these steps:

1. To access the Paths palette, click the Paths tab or select the Window menu and choose Show Paths from the pull-down menu. Photoshop displays the Paths palette, as shown in Figure 469.1.

Figure 469.1 The Paths palette in Photoshop displays a list of all the available paths in the active document.

2. Click and hold your mouse on the Shape tool in Photoshop's toolbox. Photoshop displays a fly-out menu with all the available shape tools, as shown in Figure 469.2.

Figure 469.2 The Shape tool fly-out menu displays a list of all available shape tools.

3. Choose the Ellipse tool from the fly-out menu. Photoshop closes the fly-out menu and selects the Ellipse tool.

4. Choose Create a New Work Path from the Options bar, as shown in Figure 469.3 (refer to Tip 127, "Using the Shape Layer and Work Path Options with the Drawing Tools").

Figure 469.3 Choosing Create Work Path from the Options bar lets you create circular paths using the Ellipse tool.

5. Move the Ellipse tool into the document and draw three overlapping circles, similar to Figure 469.4.

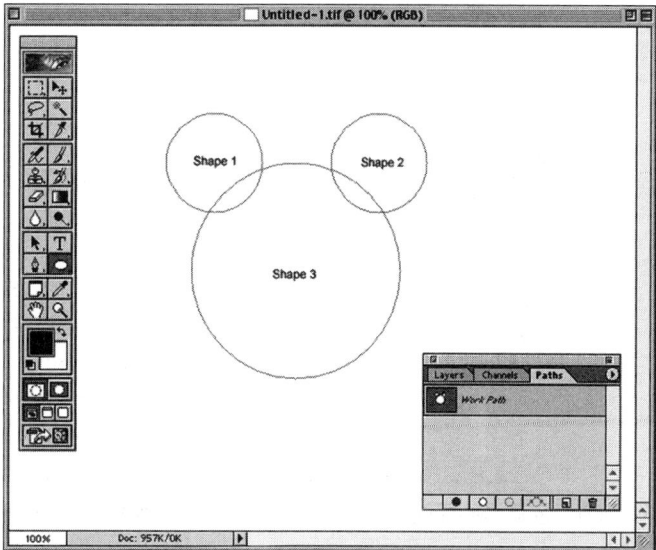

Figure 469.4 The Ellipse tool creates vector paths in the shape of ellipses or circles.

6. Click on the Selection tool in Photoshop's toolbox. Photoshop displays a fly-out menu with the available selection tools, as shown in Figure 469.5.

Figure 469.5 The Selection tool options in the Photoshop toolbox.

7. Choose the Path Component Selection tool. Photoshop closes the fly-out menu and selects the Path Component Selection tool.

8. If you need to move the separate circles, click with the Path Component tool and drag the circles into a new position.

9. Move the Path Component tool to the upper-left corner of the document window, then click and drag it down to the lower-right corner of the document window, and then release the mouse. Photoshop selects all the paths within the window, as shown in Figure 469.6.

Figure 469.6 Clicking and dragging the Path Component tool across the document window selects all the paths.

10. Select the Intersect shape areas option from the Options bar, as shown in Figure 469.7.

Figure 469.7 The Intersect shape areas option creates a new shape from two or more existing vector paths.

11. Click the Combine button in the Options bar (refer to Figure 469.7). Photoshop creates a new shape based on intersecting paths, as shown in Figure 469.8.

Figure 469.8 The Intersecting Paths option creates a new shape out of the three vector paths.

470 *Using Photoshop's Selection Tools*
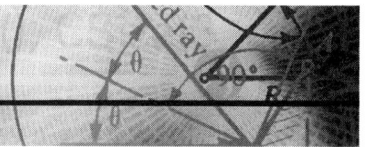

In Tip 465, "Working with Anchor Points," you learned that a new path in Photoshop is composed of anchor points and segment lines. You can reshape or move a vector pen path by choosing one of two tools: the Direct Selection tool or the Path Component Selection tool.

To access Photoshop's selection tools, click and hold your mouse on the Selection tool icon in the toolbox. Photoshop opens a fly-out menu displaying the selection tool options, as shown in Figure 470.1.

Figure 470.1 The Selection tool options in the Photoshop toolbox.

- **The Direct Selection tool:** The Direct Selection tool lets you select and move entire paths, as shown in Figure 470.2.

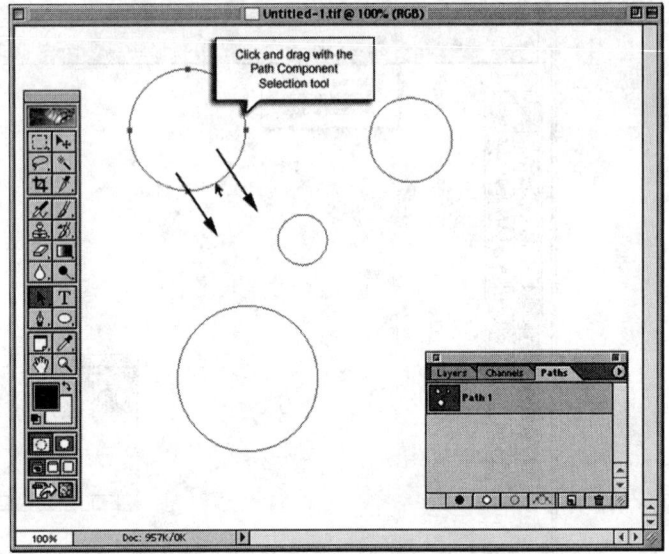

Figure 470.2 The Direct Selection tool lets you select and move entire paths.

- **The Path Component Selection tool:** The Path Component Selection tool lets you click and drag individual anchor points within a path, as shown in Figure 470.3.

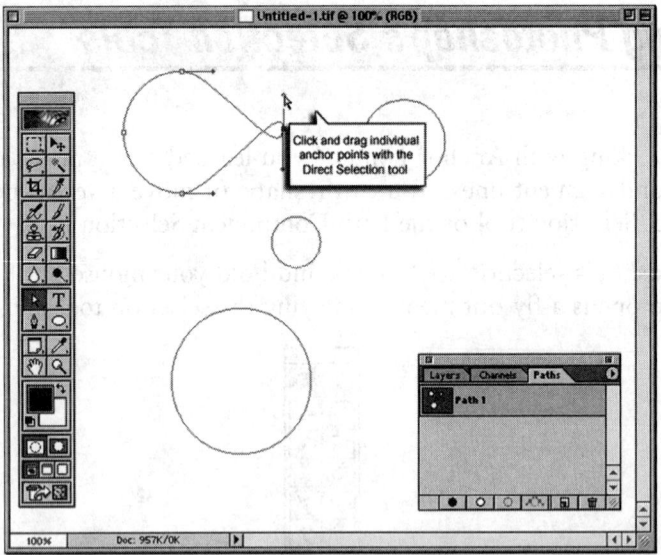

Figure 470.3 The Path Component Selection tool lets you select, move, and modify individual anchor points.

471 *Aligning and Distributing Paths*

In Tip 353, "Distributing Linked Layers," and Tip 354, "Aligning Linked Layers," you learned how to align and distribute graphic information between two or more layers. When you save a Path element in the Paths palette, that element can contain several paths, as shown in Figure 471.1.

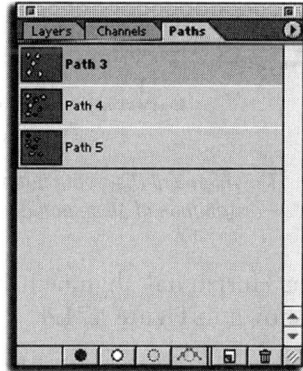

Figure 471.1 A saved path in the Paths palette can contain several separate paths.

Since vector-based paths are independent of each other, you do not perform alignment and distribution on two or more saved paths. To align or distribute paths, open or create a document containing multiple paths (refer to Figure 471.1) and perform these steps:

1. To access the Paths palette, click the Paths tab or select the Window menu and choose Show Paths from the pull-down menu. Photoshop displays the Paths palette, as shown in Figure 471.1.

2. Move your cursor into the Paths palette and click on the Path element containing the multiple paths. Photoshop selects the path, and the document window displays the vector-based objects (refer to Figure 471.1).

3. Click and hold your mouse on the Selection tool in Photoshop's toolbox. Photoshop displays a fly-out menu with all the available Selection tools, as shown in Figure 471.2.

Figure 471.2 The Selection tool fly-out menu displays a list of all available Selection tools.

4. Click once on the Path Component Selection tool. Photoshop closes the fly-out menu and selects the Path Component Selection tool.

5. Move the Path Component Selection tool to the upper-left corner of the document window and then click and drag it down to the lower-right corner of the document window. Photoshop draws a box enclosing all the elements in the document window.

6. Release your mouse to select all the vector-based objects in the document window. The Options bar now displays the Align and Distribute buttons, as shown in Figure 471.3.

Figure 471.3 The Align and Distribute buttons let you control the alignment and distribution of all selected vector-based objects.

7. Click on the Vertical and/or Horizontal alignment buttons to align the vector-based objects within the document window, as shown in Figure 471.4.

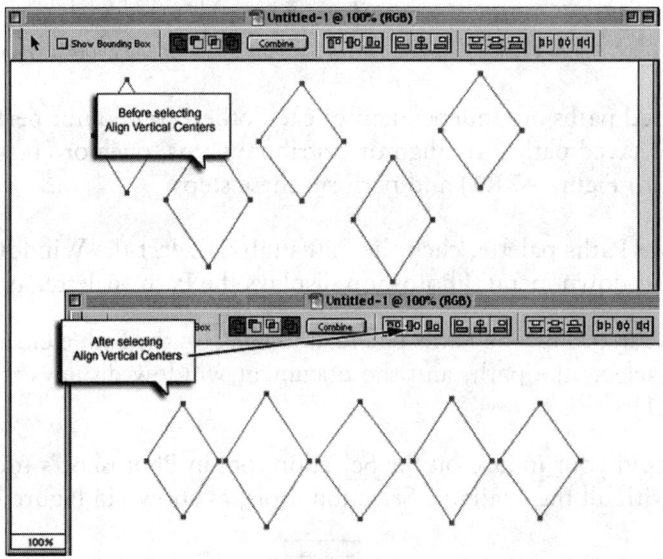

Figure 471.4 Clicking the Vertical and Horizontal alignment buttons aligns any selected vector-based objects within the document window.

8. Click on the Vertical and/or Horizontal distribution buttons to distribute the selected items within the document window, as shown in Figure 471.5.

Figure 471.5 Clicking the Vertical and Horizontal distribution buttons distributes any selected vector-based objects within the document window.

472 *Understanding Work Paths*

Photoshop displays two elements within the Paths palette: work paths and saved paths. Work paths are temporary items. In Tip 468, "Using the Pen Tool to Create a Path," you learned that Photoshop creates a work path when you create vector-based paths without first creating a Saved Path, as shown in Figure 472.1.

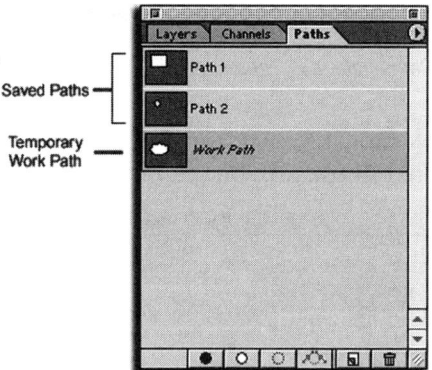

Figure 472.1 Photoshop inserts a vector-based object into a work path when there are no selected saved paths.

Here are some points on work paths:

- Photoshop only supports one work path.

- Convert a temporary work path into a permanent saved path by double-clicking on the work path's name. Photoshop opens the Name Path dialog box.

- Clipping paths require a saved path, not a work path (see Tip 476, "Creating Transparency with a Clipping Path").

- You do not create a work path. Photoshop creates a work path when you draw a vector-based shape without having a previously created saved path selected.

- If the Paths palette contains a work path and you create another path in the document window, Photoshop erases the previous work path and replaces it with one containing the newly created path.

- Photoshop always creates the work path at the bottom of the stacking order, and it cannot be moved.

473 *Creating Paths from Selections*

In Tip 468, "Using the Pen Tool to Create a Path," you learned how to generate paths by using Photoshop's Pen tools. You will create the most accurate paths with the Pen tools; however, Photoshop lets you create paths from selections.

To convert a selection into a path, open a Photoshop document and perform these steps:

1. To access the Paths palette, click the Paths tab or select the Window menu and choose Show Paths from the pull-down menu. Photoshop displays the Paths palette, as shown in Figure 473.1.

Figure 473.1 The Paths palette in Photoshop displays a list of all the available paths in the active document.

2. Using Photoshop's selection tools, create a selection within the document window, as shown in Figure 473.2. For more information on selection tools, refer to Tip 71, "The Marquee Tools."

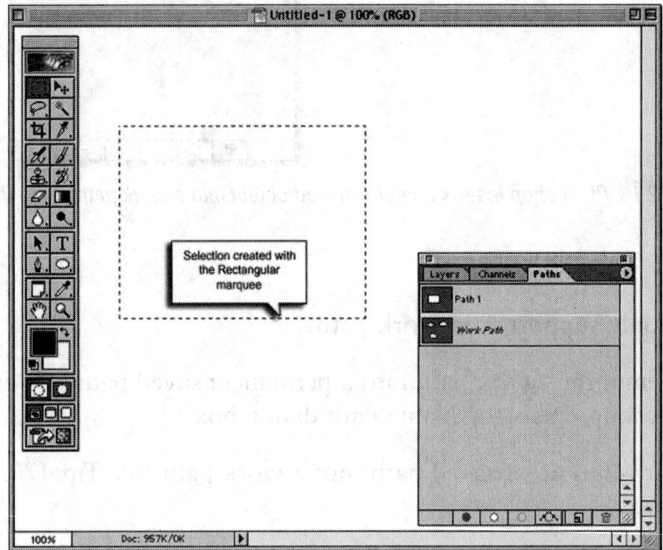

Figure 473.2 The Rectangular Marquee tool creates a box with 90-degree corners within the document window.

3. Move your mouse into the Paths palette and click the black triangle in the upper-right corner of the Paths palette. Photoshop displays a fly-out menu displaying the Paths options, as shown in Figure 473.3.

4. Select Make Work Path from the fly-out menu. Photoshop opens the Make Work Path dialog box, as shown in Figure 473.4.

Figure 473.3 Clicking the black triangle displays a fly-out menu with the Paths palette options.

Figure 473.4 The Make Work Path dialog box converts a selection into a path.

5. In the Tolerance input box, enter a value in decimal format from 0.5 to 10. The Tolerance field controls the smoothness of the converted path. The higher the value, the smoother the shape (see Tip 474, "Understanding Tolerance").

6. Click the OK button to apply the Tolerance to the selection. Photoshop converts the selection into a path and temporarily stores the path in a work path, as shown in Figure 473.5.

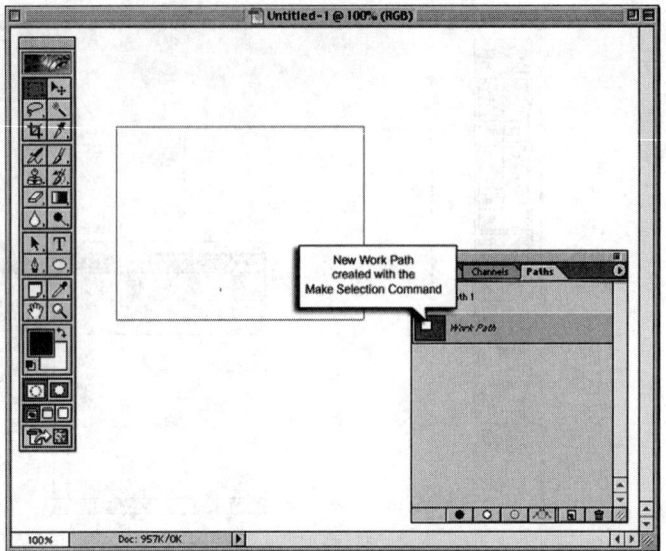

Figure 473.5 The newly converted selection is stored within a work path.

474 *Understanding Tolerance*

In the preceding tip, you learned how to convert a selection into a path. To convert an image based on pixels into a vector-based shape, Photoshop uses the Tolerance command (refer the preceding tip).

Photoshop uses the Tolerance value to convert the image shape into one based on anchor points and segment lines, as shown in Figure 474.1.

Figure 474.1 The Tolerance command instructs Photoshop how to convert a pixel-based image into a vector-based object.

Tolerance values are any decimal number from 0.5 to 10. When you enter a specific value into the Tolerance input field (refer to Figure 474.1), you are instructing Photoshop exactly how to make the conversion.

Creating a path requires knowledge of Photoshop's Pen tools plus the use of anchor points and segment lines (refer to Tip 465, "Working with Anchor Points"). When you convert a selection into a path, the Tolerance value helps to smooth out the shape. The higher the value entered into the Tolerance dialog box, the smoother the resulting vector shape. Photoshop smoothes vector shapes by creating them with fewer anchor points, as shown in Figure 474.2.

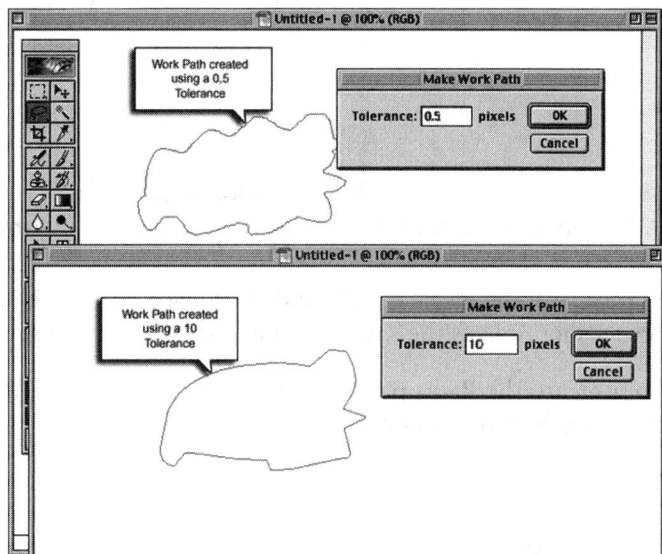

Figure 474.2 The higher the Tolerance value, the smoother (the fewer anchor points in) the converted shape.

Using a Tolerance value of 0.5 creates a path that closely resembles the original selection; however, the resulting path might contain hundreds of anchor points. Choosing a higher Tolerance value creates a path with less anchor points.

Note: Using low values in the Tolerance input field creates complicated paths with hundreds of anchor points. Complicated paths require more memory to work with and therefore will slow normal Photoshop editing operations. In addition, complicated paths require more memory to print. This results in slower printing times as well as possible printer lock ups.

475 *Creating Selections from Vector Paths*

In the preceding tip, you learned how to convert a selection into a vector path. Photoshop also lets you reverse the process and convert a path into a selection.

To convert a vector path into a selection, open a document containing one or more paths and perform these steps:

1. To access the Paths palette, click the Paths tab or select the Window menu and choose Show Paths from the pull-down menu. Photoshop displays the Paths palette, as shown in Figure 475.1.

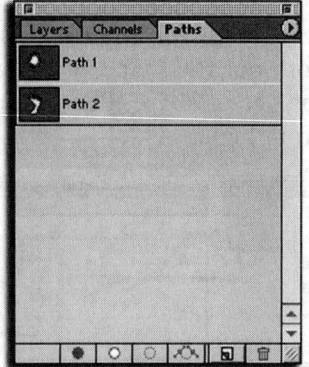

Figure 475.1 The Paths palette in Photoshop displays a list of all the available paths in the active document.

2. Move your mouse into the Paths palette and click once on the saved path you want to convert into a selection. Photoshop selects the saved path and displays it within the document window.

3. Move your mouse into the Paths palette and click the black triangle in the upper-right corner of the Paths palette. Photoshop displays a fly-out menu displaying the Paths options, as shown in Figure 475.2.

Figure 475.2 Clicking the black triangle displays a fly-out menu with the Paths palette options.

4. Choose Make Selection from the fly-out menu. Photoshop opens the Make Selection dialog box, as shown in Figure 475.3.

Figure 475.3 The Make Selection dialog box converts a path into a selection.

5. In the Feather Radius input field, enter a value from 0 to 250. The Feather Radius option controls the softness of the selection border. Refer to Tip 304, "Understanding How Feathering Operates," for more information on using the Feather command.

6. Click to select or deselect the Anti-aliased option. The Anti-aliased option creates a visually smooth selection (refer to Tip 116, "Selecting Anti-aliased for PostScript Images").

7. If the document window contains a previous selection, choose to Add, Subtract, or Intersect the converted vector path with the visible selection by clicking on the respective radio button. Clicking on a radio button selects that option and deselects all other selections in the Operation section.

8. Click the OK button to convert the vector path. Photoshop converts the vector path based on the Make Selection options and displays the selection within the document window, as shown in Figure 475.4.

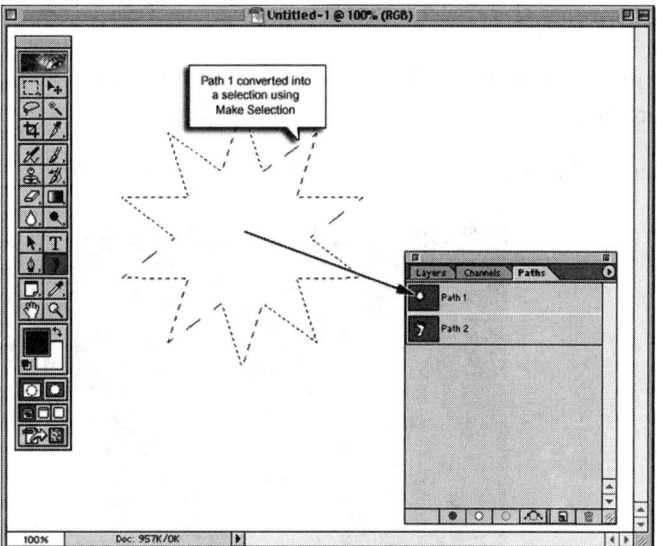

Figure 475.4 Clicking the OK button in the Make Selection dialog box converts the vector path into a selection.

476 *Creating Transparency with a Clipping Path*

Photoshop lets you create documents with transparent areas; however, when you move that image into another program (such as PageMaker, InDesign, or QuarkXPress) you lose the transparent areas. While the industry is constantly changing, most programs do not support Photoshop's transparency feature. For example, if you create an image in Photoshop, you can maintain the transparent areas of the image when you move it into another program.

To create a document with transparent areas, open a document in Photoshop and perform these steps:

1. To access the Paths palette, click the Paths tab or select the Window menu and choose Show Paths from the pull-down menu. Photoshop displays the Paths palette, as shown in Figure 476.1.

Figure 476.1 The Paths palette in Photoshop displays a list of all the available paths in the active document.

2. Move your mouse into the Paths palette and click the New Path icon at the bottom of the Paths palette. Photoshop creates a new path, as shown in Figure 476.2.

3. Select the Pen tool from the toolbox, as shown in Figure 476.3.

Figure 476.2 Clicking the New Path icon creates a new path in the Paths palette.

Figure 476.3 The Pen tool lets you create vector-based paths.

4. Move your Pen cursor into the document window and create a vector path around the area of the image you want to remain visible, as shown in Figure 476.4. Do not select the areas of the image that you want transparent.

Figure 476.4 The Pen tool creates a vector path around portions of the image.

5. Move your mouse into the Paths Palette and click the black triangle in the upper-right corner of the Paths palette. Photoshop opens a fly-out menu displaying the Paths options.

6. Choose Clipping Path from the fly-out menu. Photoshop opens the Clipping Path dialog box, as shown in Figure 476.5.

Figure 476.5 The Clipping Path dialog box creates an image with transparent areas.

7. Click on the Path button and choose the path that contains the vector-based path you just created.

8. In the Flatness input box, enter a value from 0.2 to 100 (see Tip 477, "Setting Up for Transparency"). A clipping path creates curved lines by connecting a series of straight-line segments. The higher the value, the fewer line segments are used to create the curved lines, as shown in Figure 476.5.

9. Click the OK button to apply the Clipping Path options to the Paths palette. Photoshop converts the original vector path into a clipping path, as shown in Figure 476.6.

Figure 476.6 A Paths palette containing a clipping path.

10. Select the File menu and choose Save As from the pull-down menu. Photoshop opens the Save As dialog box, as shown in Figure 476.7.

Figure 476.7 The Save As dialog box lets you save the image and the clipping path.

11. In the Name field, enter a name for the graphic image.

12. Click on the Format button. Photoshop displays a list of available formats. Choose the Photoshop EPS format from the pop-up menu. See Tip 478, "Saving Files with Clipping Paths," for information on saving an *.eps* document.

13. Click the Save button to save the graphic image and the clipping path. Photoshop saves the image into the designated folder and lets you use the image in other supporting programs, as shown in Figure 476.8.

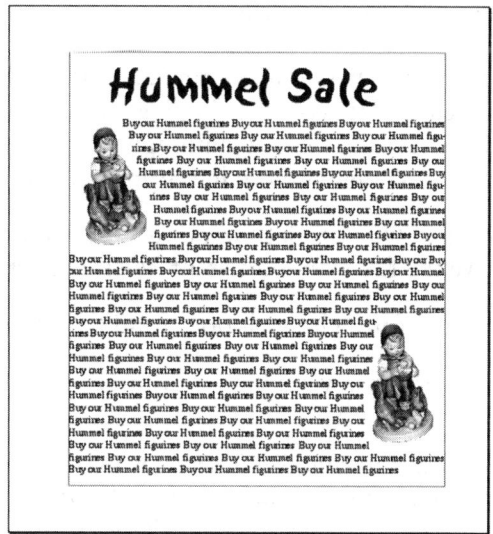

Figure 476.8 The saved image with transparent clipping path, displayed using Adobe PageMaker.

477 *Setting Up for Transparency*

In the preceding tip, you learned how to create an image with transparent areas using a clipping path. When you create a clipping path, you select a Tolerance value for the clipping path. The Tolerance value defines the number of line segments used to create the curved sections of the clipping path.

Photoshop creates curved lines by connecting groups of straight-line segments together, as shown in Figure 477.1.

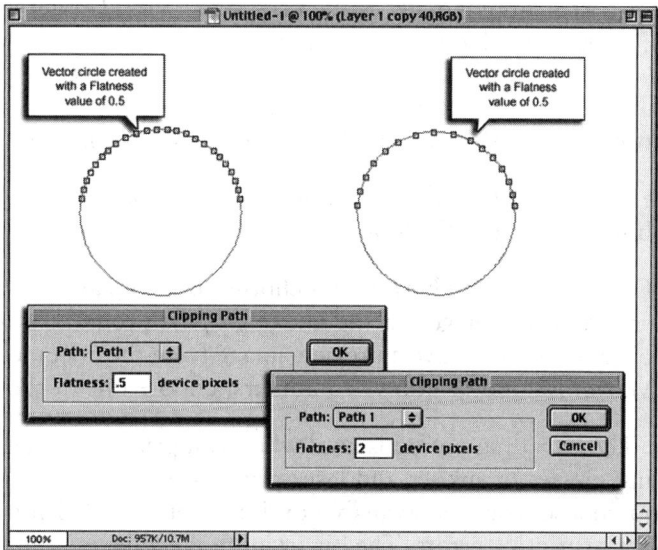

Figure 477.1 Photoshop connects straight-line segments together to create visually curved lines.

Here are some points on the Tolerance setting:

- Values in the Tolerance input field range from 0.2 to 100. The higher the value, the less straight lines are used to create the curved areas of the clipping path. Large values create less complicated clipping paths; however, the curved areas of the path appear blocky. Lower values create smoother-shaped curves; however, the paths contain more line segments and are more complicated to print.

- Leave the Tolerance field blank to let the printer use its default Tolerance value. If you experience printing errors, resave the file with a different Tolerance setting.

- Average Tolerance values for high-resolution printing (1200 dpi to 2400 dpi) range from 8 to 10.

- Average Tolerance values for low-resolution printing (300 dpi to 600 dpi) range from 1 to 3.

Note: In most cases, experimentation is the key to working with the Tolerance value. Try creating a test image using clipping paths with different Tolerance settings and find the value that works best for you and your unique printing situation.

If you work with a publisher or service bureau, contact the press operators and ask them for their recommendation as to the best Tolerance values.

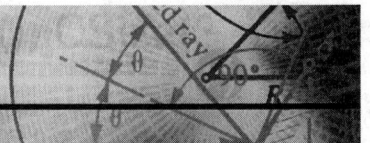

478 *Saving Files with Clipping Paths*

In Tip 476, "Creating Transparency with a Clipping Path," you learned how to create and save an image containing a clipping path. The recommended output format for images with clipping paths is *.eps*. The Encapsulated PostScript format saves pixel-based images with the vector-based clipping path.

If a program supports the *.eps* format, the program creates the transparent areas of the image by interpreting the vector-based clipping path. Some programs like InDesign and QuarkXPress actually let you access and modify the vector-based clipping path.

1. To save a file using the *.eps* format, select the File menu and choose Save As from the pull-down menu. Photoshop opens the Save As dialog box, as shown in Figure 478.1.

2. Click on the Format button, choose Photoshop EPS from the pop-up menu, and click the OK button. Photoshop opens the EPS Options dialog box, as shown in Figure 478.2.

- **Preview:** Click the Preview button and choose from the available options. The Preview is not the printed version of the image but the image graphic programs use to display the image for placement. Choose None to remove a preview image from the document. If you want to share the image between Macintosh and Windows computers, choose one of the TIFF options.

- **Encoding:** The Encoding option is used when you print to a PostScript output device such as high-end printing presses or ink jet and laser printers with a PostScript driver. Click on the Encoding button and choose from the available options. Select ASCII for a generic encoding method or if you experience printing errors. The Binary option produces a smaller and faster printing document but may cause problems with printing to high-end printing presses. The JPEG options create the smallest and fastest printing documents; however, the JPEG options make the file size smaller by removing data from the image.

- **Include Halftone Screen/Include Transfer Function:** Selecting these options saves halftone and image transfer functions for high-end printing presses.

Figure 478.1 The Save As dialog box controls the characteristics of the saved document.

Figure 478.2 The EPS Options dialog box controls the characteristic of the EPS file.

- **PostScript Color Management:** Select this option if you want to convert the file's color data to the printer's color space.

- **Include Vector Data:** Select this option if your image includes vector shapes and type.

- **Image Interpolation:** Select this option if you want to use the Anti-alias option to print your image. Image Interpolation is best used on low-resolution images. Anti-alias helps create a visually smooth appearance to vector shapes when they are converted into low-resolution images.

3. Click the OK button in the EPS Options dialog box to apply the EPS options to the saved file.

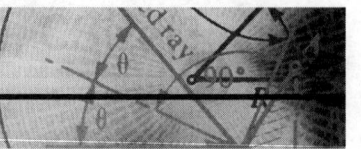

479 *Using Paths with the Stroke Command*

In Tip 476, "Creating Transparency with a Clipping Path," you learned how Photoshop and the *.eps* format work together to create a clipping path. Paths perform many functions in Photoshop, and one of them is the ability to use a path to stroke an area of an image.

Say, for example, you want to use a clipping path to stroke a border around an image. To use the Stroke command with a clipping path, open or create a document with a rectangular path and perform these steps:

1. To access the Paths palette, click the Paths tab or select the Window menu and choose Show Paths from the pull-down menu. Photoshop displays the Paths palette, as shown in Figure 479.1.

2. Move your mouse into the Paths palette and click once on the saved path containing the rectangular border. Photoshop selects the path and displays it on the active document, as shown in Figure 479.2.

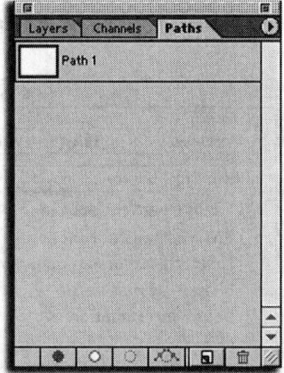

Figure 479.1 The Paths palette in Photoshop displays a saved path with a rectangular vector path.

Figure 479.2 Selecting the saved path causes Photoshop to display the path in the document window.

3. Select the Paintbrush from Photoshop's toolbox and choose an appropriate brush size from the Options bar (refer to Tip 78, "The Paintbrush and Pencil Tools").

4. Click on the Foreground color swatch and select the border color (refer to Tip 221, "Selecting a Foreground and Background Color Swatch").

5. Move your mouse into the Paths palette and click the black triangle in the upper-right corner of the Paths palette. Photoshop opens a fly-out menu displaying the Paths options.

6. Select Stroke Path from the fly-out menu. Photoshop opens the Stroke Path dialog box, as shown in Figure 479.3.

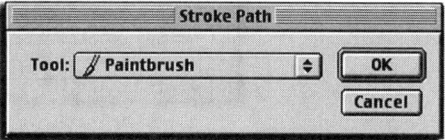

Figure 479.3 The Stroke Path dialog box lets you select the tool to use for the Stroke command.

7. Since you previously selected the Paintbrush from the toolbox, the Paintbrush is the default option. Click the OK button to apply the Stroke to the path. Photoshop strokes the paths using the preselected brush size and color, as shown in Figure 479.4.

Figure 479.4 The Stroke command painted a border around the image based on the previously selected Paintbrush size and color.

480 *Creating Awesome Neon Using Paths*

In the preceding tip, you learned how to use the Paintbrush tools to create a stroke based on a vector-based path. You can use this same Stroke command to create some excellent neon. To create neon using a Photoshop path and the Stroke command, open or create a document with a saved path and perform these steps:

1. To access the Paths palette, click the Paths tab or select the Window menu and choose Show Paths from the pull-down menu. Photoshop displays the Paths palette, as shown in Figure 480.1.

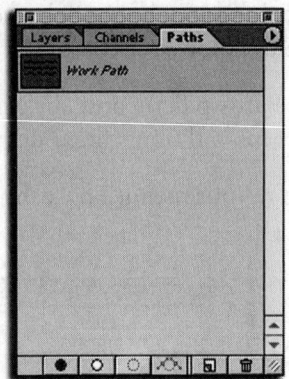

Figure 480.1 The Paths palette in Photoshop displays a saved path containing three separate stroke lines.

2. Move your mouse into the Paths palette and click once on the path containing the vector objects you want to convert into neon. Photoshop selects the path, and in this example, three wavy vector lines display in the document window, as shown in Figure 480.2.

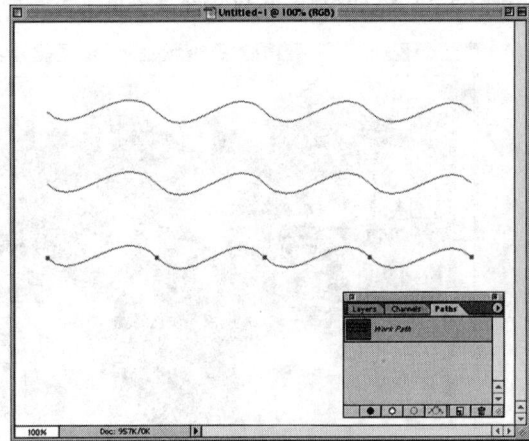

Figure 480.2 The document window displays the vector paths from the work path.

3. Select the Paintbrush from Photoshop's toolbox, choose a soft brush from the Options bar (refer to Tip 78, "The Paintbrush and Pencil Tools"), and change the Opacity setting to 30 percent. In this example, a soft 45-pixel brush is selected from the brush palette options, as shown in Figure 480.3.

4. Click on the Foreground color swatch and select bright yellow (refer to Tip 221, "Selecting a Foreground and Background Color Swatch").

5. Click and hold your mouse on the Selection tool in Photoshop's toolbox. Photoshop displays a fly-out menu with all the available Selection tools, as shown in Figure 480.4.

6. Click once on the Path Component Selection tool. Photoshop closes the fly-out menu and selects the Path Component Selection tool.

7. Move your mouse into the document window and click once on the top wavy line. Photoshop selects the line, as shown in Figure 480.5.

Figure 480.3 A 45-pixel soft brush is selected from the Paintbrush Options bar, and the Opacity input field displays 30 percent opacity.

Figure 480.4 The Selection tool fly-out menu displays a list of all available Selection tools.

8. Move your mouse into the Paths palette and click the black triangle in the upper-right corner of the Paths palette. Photoshop displays a fly-out menu displaying the Paths options.

9. Select Stroke Subpath from the fly-out menu. Photoshop opens the Stroke Subpath dialog box, as shown in Figure 480.6.

10. Since you previously selected the Paintbrush tool, it is the default tool. Click the OK button to apply the stroke to the path, as shown in Figure 480.7.

11. Move your mouse into the Options bar and click once on the icon of the current brush. Photoshop displays a dialog box with the current brush settings, as shown in Figure 480.8.

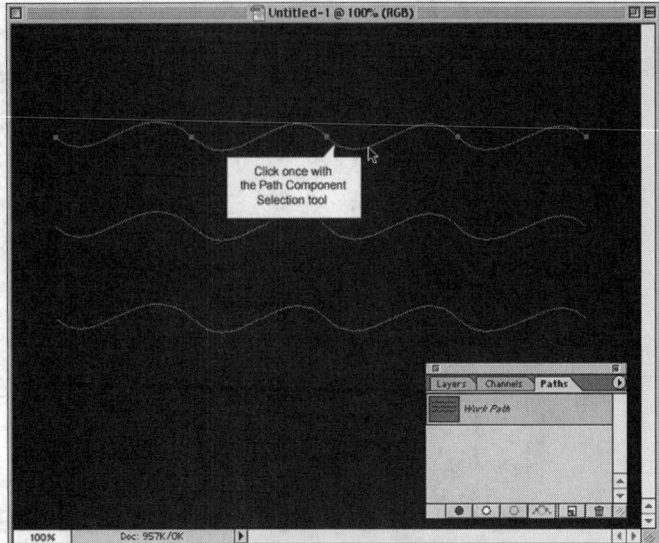

Figure 480.5 Clicking on a vector path with the Path Component Selection tool selects that path.

Figure 480.6 The Stroke Subpath dialog box controls the tool used in the Stroke command.

12. In the Diameter input box, change the value to 25 (the original diameter is 45 pixels).

13. Repeat steps 8 through 10 to apply another stroke to the line. The yellow is reapplied to the wavy line with a 25-pixel brush size.

14. Move your mouse into the Options bar and click once on the icon of the current brush. Photoshop displays a dialog box with the current brush settings (refer to Figure 480.8). In the Diameter input box, change the value to 15 pixels.

15. Repeat steps 8 through 10 to apply another stroke to the line. The yellow is reapplied to the wavy line with a 15-pixel brush size.

16. Move your mouse into the Options bar and click once on the icon of the current brush. Photoshop displays a dialog box with the current brush settings. In the Diameter input box, change the value to 10 pixels.

Figure 480.7 The Stroke Subpath command strokes the wavy line path with the previously selected brush, brush size, opacity, and color.

Figure 480.8 Clicking on the Brush icon displays a dialog box containing the settings for the current brush.

17. Repeat steps 8 through 10 to apply another stroke to the line. The yellow is reapplied to the wavy line with a 10-pixel brush size.

18. Click on the Foreground color swatch and select white (refer to Tip 221, "Selecting a Foreground and Background Color Swatch").

19. Move your mouse into the Options bar and click once on the icon of the current brush. Photoshop displays a dialog box with the current brush settings. In the Diameter input box, change the value to 5 pixels.

20. Repeat steps 8 through 10 to apply another stroke to the line. The white is applied to the wavy line with a 5-pixel brush size.

21. Apply the 5-pixel white brush stroke to the image two or three time, until you like what you see, as shown in Figure 480.9.

Figure 480.9 The wavy vector path with all the yellow and white strokes applied.

Note: Change the Neon color to red and blue and apply the preceding steps to the other two wavy lines, as shown in Figure 480.10.

Figure 480.10 The neon stroke technique applied to all three of the paths within the document.

481 *Using Paths to Control Drawing and Editing Tools*

In the preceding tip, you learned how to use paths with the Stroke command to create neon. To create the neon, Photoshop linked the path to the Paintbrush tool, letting your Paintbrush draw with much more precision and control than could ever be achieved using a mouse or drawing tablet.

Paths control more than the Paintbrush tool; in fact, paths control most of Photoshop's vast arsenal of painting and editing tools.

You can use a vector path to control these tools:

- Pencil
- Airbrush
- Background Eraser
- Pattern Stamp
- Art History Brush

- Paintbrush
- Eraser
- Clone Stamp
- History Brush
- Smudge

- Blur
- Dodge
- Sharpen
- Burn

To control one of Photoshop's painting or editing tools using a vector path, open or create a document containing a vector path and perform these steps:

1. To access the Paths palette, click the Paths tab or select the Window menu and choose Show Paths from the pull-down menu. Photoshop displays the Paths palette, as shown in Figure 481.1.

Figure 481.1 The Paths palette in Photoshop displays a list of all the available paths in the active document.

2. Move your cursor into the Paths palette and click on the path element you want to use to control a painting or editing tool. Photoshop selects the path, and the document window displays the vector-based path (refer to Figure 481.1).

3. Move your mouse into the Paths palette and click the black triangle in the upper-right corner of the Paths palette. Photoshop opens a fly-out menu displaying the Paths options.

4. Select Stroke Path from the fly-out menu. Photoshop opens the Stroke Path dialog box, as shown in Figure 481.2.

Figure 481.2 The Stroke Path dialog box lets you choose the painting or editing tool used to perform the Stroke command.

5. Click on the Tool button. Photoshop displays a list of all available painting and editing tools, as shown in Figure 481.3.

Figure 481.3 Clicking the Tool button displays a list of all the available painting and editing tools.

6. Click on the desired tool. Photoshop closes the pop-up menu and makes your tool selection the default stroke tool.

7. Click the OK button in the Stroke Path dialog box to apply the stroke to the path.

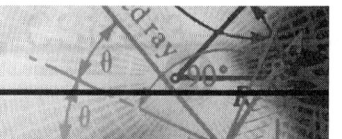

482 *Applying Color to a Vector Path*

In the preceding tip, you learned that you can use any of Photoshop's painting or editing tools to stroke an image. Say, for example, you want to create a dramatic effect in an image by converting the colors in the image to grayscale and then using a vector path to stroke some of the color back into the image.

To apply color to an image using a path, open an RGB or CMYK document in Photoshop and perform these steps:

1. To access the Paths palette, click the Paths tab or select the Window menu and choose Show Paths from the pull-down menu. Photoshop displays the Paths palette, as shown in Figure 482.1.

Figure 482.1 The Paths palette in Photoshop displays a list of all the available paths in the active document.

2. Select the Image menu, select Adjust, and choose Desaturate from the fly-out menu. Photoshop converts the color image into grayscale, as shown in Figure 482.2.

3. Click and hold your mouse on the Pen tool in Photoshop's toolbox. Photoshop displays a fly-out menu with all the available Pen tools, as shown in Figure 482.3.

Figure 482.2 The Desaturate command removes the color from the active image and converts the image into shades of gray.

Figure 482.3 The Pen tool fly-out menu displays a list of all available Pen tools.

4. Click once on the Standard or Freeform Pen tool. Photoshop closes the fly-out menu and selects the tool.

5. Move the Pen tool into the document window and draw a path. For more information on using the Pen tools, refer to Tip 156, "Using the Freeform Pen Tool to Create a Work Path." The Pen path represents where you want to restore the color in the image.

6. Select the History brush from the toolbox (refer to Tip 80, "The History and Art History Brush Tools").

7. Choose a brush size for the History brush from History Options bar. In this example, you selected a 200-pixel soft brush, as shown in Figure 482.4.

Figure 482.4 Clicking the Brush icon in the Options bar lets you select the correct History brush.

8. Move your cursor into the Paths palette and click once on the Work Path. Photoshop selects the work path and displays the vector path within the document window.

9. Move your mouse into the Paths palette and click the black triangle in the upper-right corner of the Paths palette. Photoshop displays a fly-out menu displaying the Paths options.

10. Select Stroke Path from the fly-out menu. Photoshop opens the Stroke Path dialog box, as shown in Figure 482.5.

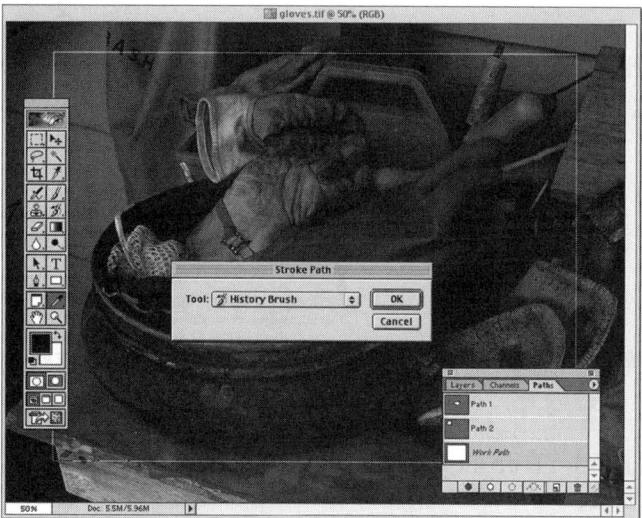

Figure 482.5 The Stroke Path dialog box controls the tool used in the Stroke command.

11. Since you previously selected the History brush, it is the default Tool option. Click the OK button to apply the stroke to the path, as shown in Figure 482.6.

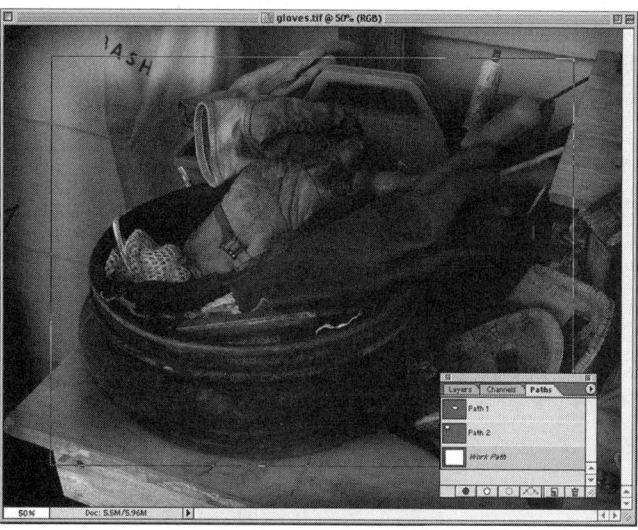

Figure 482.6 The Stroke Path command applies the History brush to the vector path, creating a line of color within a black and white image.

483 *Applying a Fill Using a Vector Path*

In the preceding tip, you learned how to use Photoshop's editing tools and a vector path to create a special effect. Photoshop has the ability to stroke any vector path, and it has the ability to fill an area defined by a path.

To fill an area defined by a vector path, create or open a Photoshop document containing a vector path and perform these steps:

1. To access the Paths palette, click the Paths tab or select the Window menu and choose Show Paths from the pull-down menu. Photoshop displays the Paths palette, as shown in Figure 483.1.

Figure 483.1 The Paths palette in Photoshop displays a list of all the available paths in the active document.

2. Move your cursor into the Paths palette and click on the path element you want to use to control the Fill command. Photoshop selects the path, and the document window displays the vector-based path (refer to Figure 483.1).

3. Click on the Foreground color swatch and select a color (refer to Tip 221, "Selecting a Foreground and Background Color Swatch"). In this example, you selected red as the Foreground color swatch.

4. Move your mouse into the Paths palette and click the black triangle in the upper-right corner of the Paths palette. Photoshop displays a fly-out menu displaying the Paths options.

5. Select Fill Path from the fly-out menu. Photoshop opens the Fill Path dialog box, as shown in Figure 483.2.

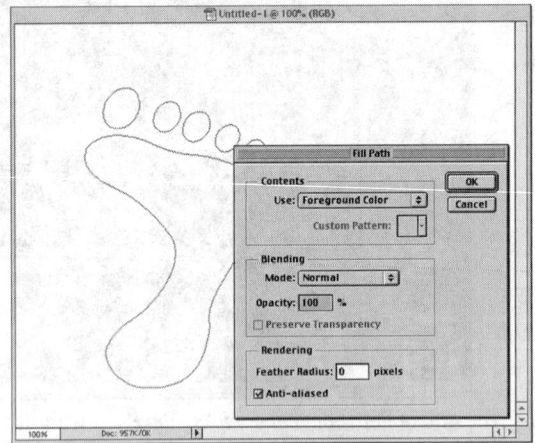

Figure 483.2 The Fill Path dialog box lets you control the characteristics of the fill.

6. If the Use button does not display Foreground Color, click on the Use button and choose Foreground Color from the pop-up menu.

7. Click on the Blending Mode button and choose Normal for the blending mode.

8. In the Opacity input field, enter a value of 100 percent.

9. In the Feather Radius input box, enter a numeric value of 0.

10. Select the Anti-aliased option by clicking once in the check box to the left of the option.

11. Click the OK button to apply the Fill command to the vector shape, as shown in Figure 483.3.

Figure 483.3 The Fill command filled the area defined by the vector shape with the Foreground color.

Note: Refer to Tip 232, "Painting an Image Using the Fill Command," for more information on using the Fill command on a vector shape.

484 *Adding to an Existing Path*

When you draw a vector path (refer to Tip 467, "Creating a New Path"), Photoshop creates a work path in the Paths palette. The work path holds the newly created path. If you have a path selected in the Paths palette and draw a new path, Photoshop places the second path in the same path element.

When you have more than one path in a single element in the Paths palette, Photoshop defines each of the individual paths as subpaths, as shown in Figure 484.1.

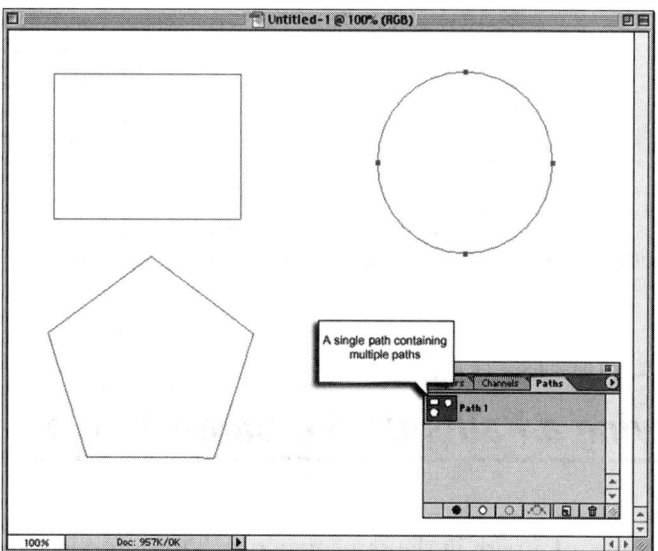

Figure 484.1 When a path element in the Paths palette contains more than one path, Photoshop defines each separate path as a subpath.

When you have multiple paths within a single path element, you instruct Photoshop what path to modify by selecting the path with the Path Component Selection tool, as shown in Figure 484.2.

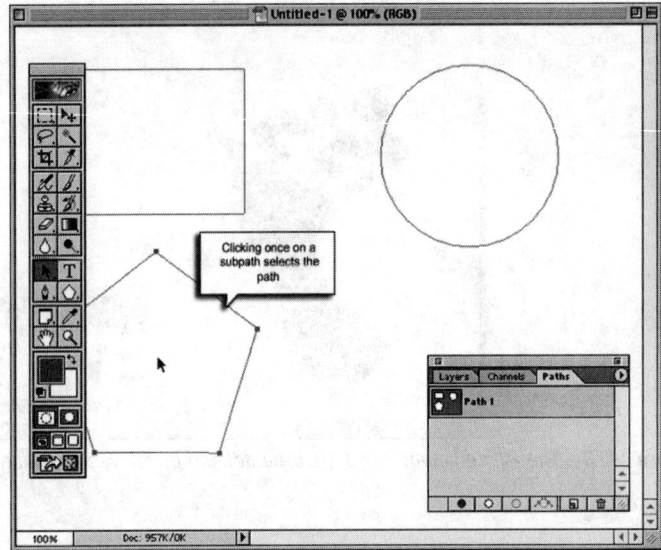

Figure 484.2 Clicking once with the Path Component Selection tool on one of the paths within the path element instructs Photoshop what path to stroke or fill.

To work with more than one subpath at a time, press Shift and click the subpaths you want to select. Holding down the Shift key lets you select as many paths as needed, as shown in Figure 484.3.

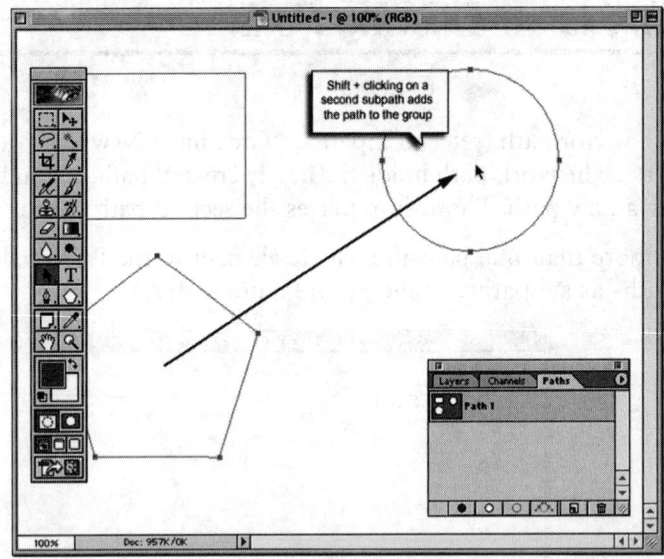

Figure 484.3 Holding down the Shift key and clicking on subpaths lets you control what paths are included in the stroke or fill.

485 *Copying a Path into the Same Image*

You can make copies of a path in the same way that Photoshop lets you make copies of layers or channels. For example, if you experiment with one of the saved paths within the Paths palette, you can save a copy of the original path just in case the experiment does not go as planned.

To make a copy of a path, select the Paths palette by clicking the Paths tab or selecting the Window menu and choosing Show Paths from the pull-down menu. Photoshop displays the Paths palette, as shown in Figure 485.1.

Figure 485.1 The Paths palette in Photoshop displays a list of all the available paths in the active document.

Click and drag the path you want to copy over the Create New Path icon and release your mouse. Photoshop creates a copy of the path and tacks the word "copy" at the end of the path name, as shown in Figure 485.2. Note: When you drag a work path over the Create New Path icon, Photoshop deletes the work path and creates a permanent path.

Figure 485.2 Clicking and dragging a path over the Create New Path icon creates a copy of the original path.

Create as many copies as needed by clicking and dragging the paths over the Create New Path icon. To remove a path from the Paths palette, click and drag the path you want to remove over the Trash Can icon. Photoshop removes the path from the Paths palette.

486 *Moving a Path into Another Photoshop Document*

In the preceding tip, you learned how to create a copy of a path. When you drag a path over the Create New Path icon, you create the new path inside the original document. In Photoshop, it is possible to click and drag a path from one open Photoshop document into another open Photoshop document.

To copy paths between two open Photoshop documents, perform these steps:

1. To access the Paths palette, click the Paths tab or select the Window menu and choose Show Paths from the pull-down menu. Photoshop displays the Paths palette, as shown in Figure 486.1.

2. Click once in the document containing the path or paths you want to move. The Paths palette displays the paths for the selected document (refer to Figure 486.1).

3. Move your cursor into the Paths palette and click and drag a path from the Paths palette into the document window of the other Photoshop image. Photoshop creates a copy of the path in the second document, as shown in Figure 486.2.

Figure 486.1 With two document windows open, the Paths palette displays the paths for the active document.

Figure 486.2 Clicking and dragging a path from the Paths palette of one open document into the document window of another open document creates a copy of the path.

Note: *Since paths are not bound by resolutions or color space, you can copy a path from one Photoshop document into another regardless of the resolution or color space of the two documents.*

487 *Creating Styles from Layers*

One of the new features in Photoshop 6.0 is the ability to create and save graphic styles. Photoshop styles are fills and effects combined into a clickable button. The style buttons reside in Photoshop's Styles palette and are available to any Photoshop document, as shown in Figure 487.1.

Figure 487.1 *The Styles palette contains all the available styles in clickable buttons.*

Say, for example, you want to create a style from a previously created layer effect. To create a style from a layer effect, perform these steps:

1. Select the File menu and choose New from the pull-down menu. Photoshop opens the New dialog box, as shown in Figure 487.2.

Figure 487.2 *The New dialog box controls the settings for the new Photoshop document.*

2. Using the settings from Figure 487.2, create a new file with a width and height of 2 inches, a resolution of 72ppi, a color space of RGB, and Transparent image contents. Click the OK button. Photoshop creates and opens a new document, as shown in Figure 487.3.

Figure 487.3 *A new document window in Photoshop.*

3. Select the Rectangular Marquee tool and draw a small square selection within the document window, as shown in Figure 487.4.

Figure 487.4 Clicking and dragging the Rectangular Marquee tool creates a dotted-line selection.

4. Press the letter "D" on your keyboard to default your Foreground and Background color swatches to black and white.

5. Press Alt+Delete (Macintosh: Option+Delete) to fill the selected area with the default Foreground color.

6. Press Ctrl+D (Macintosh: Command+D) to deselect the Rectangular Marquee.

7. Select the Layer menu, select Layer Style, and choose Drop Shadow from the pull-down menu. Photoshop opens the Layer Style dialog box, as shown in Figure 487.5.

8. Click the OK button to accept the default Drop Shadow settings. Photoshop applies the drop shadow to the box, as shown in Figure 487.6.

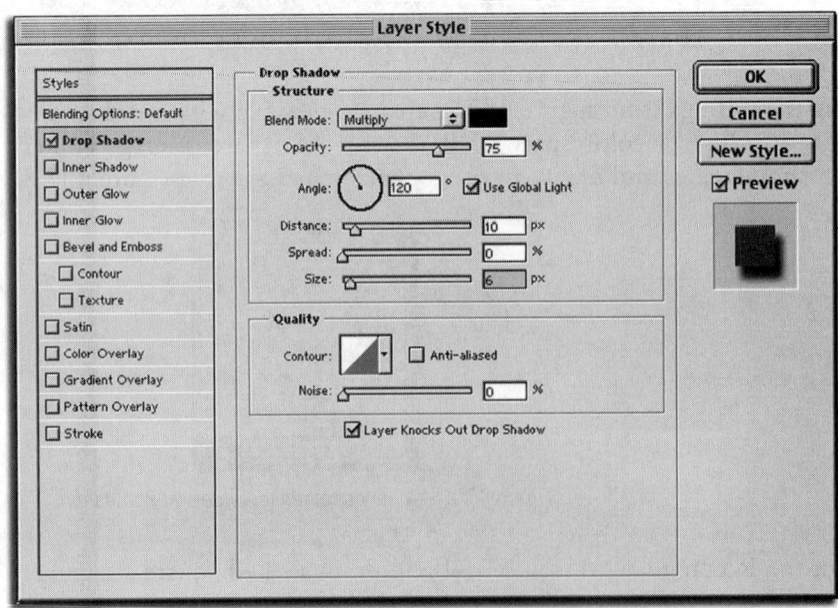

Figure 487.5 The Layer Style dialog box defines the settings for the Drop Shadow style.

Figure 487.6 The Drop Shadow style applied to the black-filled box.

9. If the Styles palette is not visible, click the Styles tab or select the Window menu and select Show Styles from the pull-down menu. Photoshop displays the Styles palette (refer to Figure 487.1).

10. Move your cursor into the Styles palette and click the Create New Style icon at the bottom of the Styles palette. Photoshop creates a new style based on the drop shadow, as shown in Figure 487.7.

Figure 487.7 Clicking the Create New Style icon creates a new style based on the layer effect applied to the black box.

Note: Once you create the style, you can close the document window containing the black drop shadow. The Drop Shadow Style is now available for an open Photoshop document.

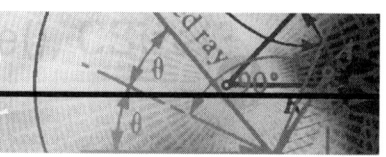

488 *Applying Styles to Text*

In the preceding tip, you learned how add a layer effect to a graphic image and then save the effect as a style. For example, you can apply your new Drop Shadow style to a group of text.

To apply the Drop Shadow style to a group of text, create a new document in Photoshop and perform these steps:

1. Select the File menu and choose New from the pull-down menu. Photoshop opens the New dialog box, as shown in Figure 488.1.

Figure 488.1 The New dialog box controls the settings for the new Photoshop document.

2. Using the settings from Figure 488.1, create a new file with a width and height of 5 inches, a resolution of 72ppi, a color space of RGB, and White Contents. Click the OK button. Photoshop creates and opens a new document.

3. Select the Type tool from the Photoshop toolbox and create a line of text in the new document window, as shown in Figure 488.2. The greater the font size the better the layer style; use font sizes of 30 points or greater. For more information on creating text in Photoshop, refer to Tip 218, "Creating Text in Photoshop 6.0."

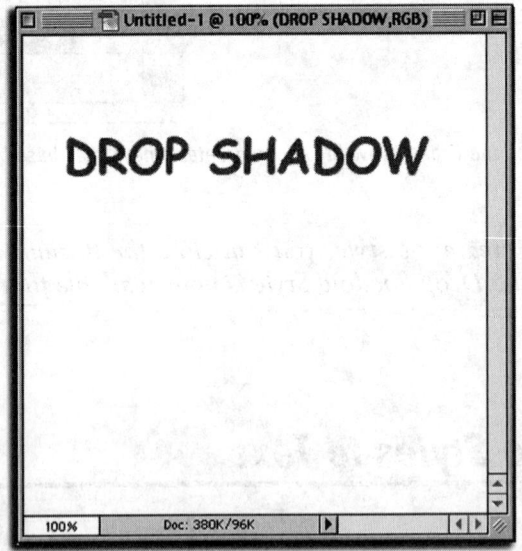

Figure 488.2 Sample text using Photoshop's standard Type tool.

4. If the Styles palette is not visible, click the Styles tab or select the Window menu and select Show Styles from the pull-down menu. Photoshop displays the Styles palette, as shown in Figure 488.3.

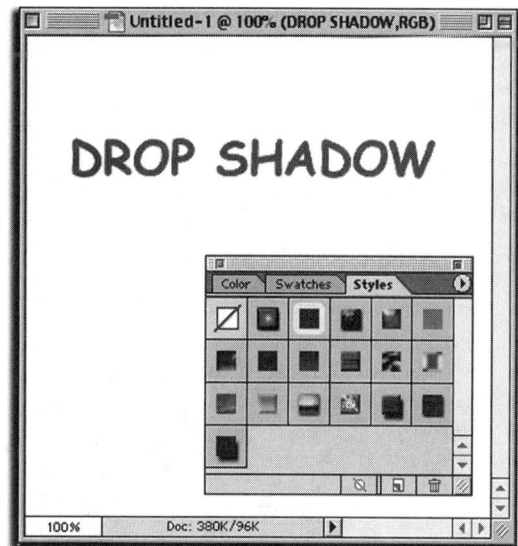

Figure 488.3 The Styles palette in Photoshop displaying all available styles.

5. Move your mouse into the Styles palette and click once on the Drop Shadow icon, which you created in the preceding tip. Photoshop applies the Drop Shadow to the Text layer, as shown in Figure 488.4.

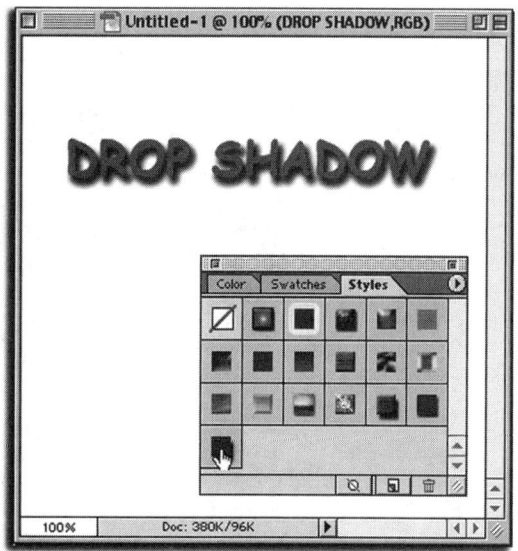

Figure 488.4 The Drop Shadow style applied to a Photoshop Text layer.

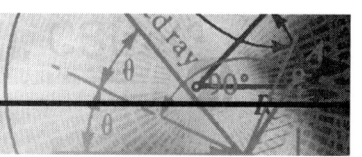

489 *Applying Styles to Selections*

In the preceding tip, you learned how to apply a style to a Photoshop Text layer. Styles can be applied to text or to a selection.

To apply a style to a selected area of an image, open a Photoshop document and perform these steps:

1. If the Styles palette is not visible, click the Styles tab or select the Window menu and select Show Styles from the pull-down menu. Photoshop displays the Styles palette, as shown in Figure 489.1.

Figure 489.1 The Styles palette in Photoshop displaying all available styles.

2. Use the Rectangular Marquee tool to select a portion of the image, as shown in Figure 489.2.

Figure 489.2 Clicking and dragging the Rectangular Marquee tool across the image creates a dotted-line selection.

3. Select the Edit menu and choose Copy from the pull-down menu. Photoshop creates a copy of the selected area and stores the image in Clipboard memory.

4. Select the Edit menu and choose Paste from the pull-down menu. Photoshop places the copied image into a new layer, as shown in Figure 489.3.

Figure 489.3 The Copy and Paste commands created a new layer for the copied information.

5. Move your mouse cursor into the Layers palette and click once on the Drop Shadow style created in Tip 487. Photoshop applies the Drop Shadow style to the copied material, creating a special effect in the image, as shown in Figure 489.4.

Figure 489.4 The Drop Shadow style applied to the copied image data in the new layer.

Note: As you can see, layer effects can be applied to just about any digital information within a Photoshop file, even an entire layer (as demonstrated in the next tip).

490 *Applying a Style to a Layer*

In the preceding tip, you applied a layer style to a selected and copied piece of an image. Photoshop lets you apply layer styles to an entire layer; however, there are a few restrictions. Although layer styles will work on any layer, certain styles such as Drop Shadows and Outer Glow would not be visible. Say, for

example, you want to apply the Drop Shadow style created in Tip 487 to an entire layer; since the Drop Shadow has nowhere to expand, the style would not work, as shown in Figure 490.1.

Figure 490.1 *A Drop Shadow style applied to an entire layer would not work because there is nowhere for the shadow to expand.*

There are, however, several styles that can be successfully applied to an entire layer. These are styles such as Bevel and Emboss or styles that interact with the whole digital image, not just the edges of the image like Drop Shadow. One of the more impressive styles is the Puzzle style. The Puzzle style converts the digital image into a series of puzzle pieces, and it is one of the default styles in the Styles palette.

To apply the Puzzle style to an entire Photoshop layer, open a graphic image in Photoshop and perform these steps:

1. If the Styles palette is not visible, click the Styles tab or select the Window menu and select Show Styles from the pull-down menu. Photoshop displays the Styles palette, as shown in Figure 490.2.

Figure 490.2 *The Styles palette in Photoshop displaying all available styles.*

2. Move your mouse into the default Styles palette and click once on the Puzzle style button. Photoshop applies the Puzzle style to the entire image, as shown in Figure 490.3.

3. To remove the Puzzle style from the image, click once on the Clear Style icon. The Clear Style icon is the leftmost button at the bottom of the Styles palette (refer to Figure 490.2).

Note: *The application of styles to a Photoshop document is one of the few instances in which selection does not work. You cannot select a portion of a layer and apply the style to only the selected area. Photoshop ignores the selection and applies the style to the entire layer.*

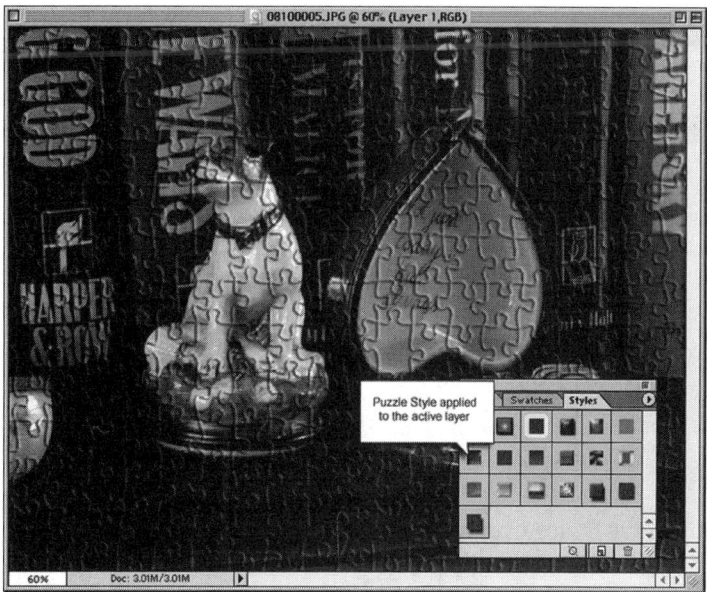

Figure 490.3 The Puzzle style applied to an entire layer.

491 *Saving and Loading Style Sheets*

In the preceding tip, you learned how to apply one of Photoshop's default styles to an entire layer. The default Styles palette contains a group of generic styles. All Photoshop users have access to the same Styles palette the first time they open the program. However, you also have the ability to create new styles and save them.

Say, for example, you want to save the Drop Shadow style you created in Tip 487, "Creating Styles from Layers." To save a style set, open Photoshop, create a new style (refer to Tip 487), and perform these steps:

1. If the Styles palette is not visible, click the Styles tab or select the Window menu and select Show Styles from the pull-down menu. Photoshop displays the Styles palette, as shown in Figure 491.1.

Figure 491.1 The Styles palette in Photoshop displays all available styles, including any newly created styles.

2. Move your mouse into the Styles palette and click once on the black triangle button in the upper-right corner of the Styles palette. Photoshop displays a fly-out menu with the available Styles palette options, as shown in Figure 491.2.

Figure 491.2 The fly-out menu displays a list of all available Styles palette options.

3. Click on the Save Styles option. Photoshop opens the Save dialog box, as shown in Figure 491.3.

Figure 491.3 The Save dialog box defines the name and folder location for the saved style set.

4. The current file name is *Untitled Styles.asi*. In the Name field, rename the file (keeping the *.asi* extension), select a folder, and click the Save button. Photoshop closes the Save dialog box and saves the style set.

5. To load a previously saved style set, click once on the black triangle button in the upper-right corner of the Styles palette. Photoshop displays a fly-out menu with the available Styles palette options (refer to Figure 491.2).

6. Click on the Load Styles option. Photoshop opens the Load dialog box, as shown in Figure 491.4.

7. Click once on the file name for the style set and click the Open button. Photoshop opens the file and appends the new styles to the bottom of the current style set, as shown in Figure 491.5.

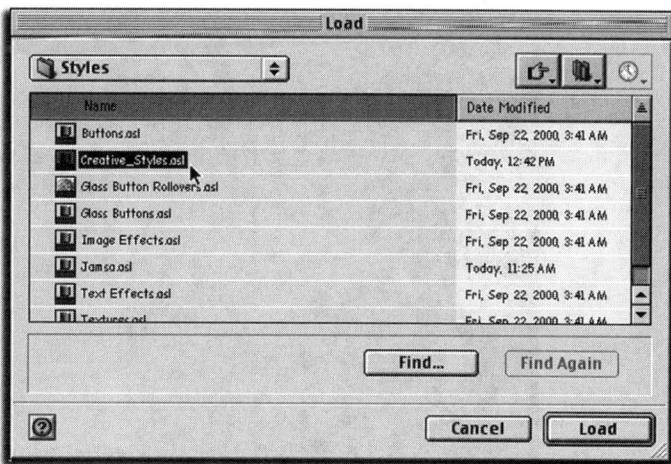

Figure 491.4 The Load dialog box lets you select and load previously saved style sets.

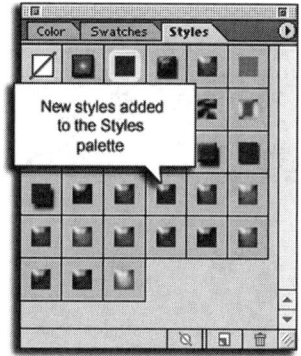

Figure 491.5 Photoshop adds the new styles to the current Styles palette.

492 *Previewing and Applying Filters*

When you work with filters, one of the problems is determining how the filter looks when applied to the image. Photoshop solves this problem by giving you ability to preview the effect of the filter before clicking the Apply button. Some filters, like Blur and Noise, give you a full-screen preview of the filter's effect on the image, as shown in Figure 492.1.

Others, like the Artistic and Brush Stroke filters, do not give you the advantage of a full-screen preview. Instead, they let you view the image through a small window, as shown in Figure 492.2.

Although not as revealing as a full-screen preview, the dialog box preview window gives you a good idea of what the final results will be when applied to the image.

When you work with a dialog box preview, you can change the portion of the image you are currently viewing. Move your cursor into the preview box and then click and drag. When you click and drag, the visible image inside the preview window changes, as shown in Figure 492.3.

Figure 492.1 When you use the Noise filter, Photoshop gives you a full-screen preview of the effect of the filter on the image.

Figure 492.2 The Dry Brush filter lets you view the changes to the image through a small window.

Figure 492.3 Clicking and dragging inside the preview window lets you view different portions of the image.

To increase or decrease the size of the image in the preview window, click once on the plus or minus buttons at the bottom right and the left of the preview window, as shown in Figure 492.4.

Figure 492.4 Clicking the plus and minus buttons increases or decreases the view of the image in the preview window.

Click the OK button to apply the specific filter to the image, as shown in Figure 492.5. In this example, you applied a Dry Brush filter to the image.

Figure 492.5 Clicking the OK button applies the filter effect to the active Photoshop image.

493 *Understanding How Filters Are Applied*

Photoshop comes packaged with over 100 filters and special effects if you add in all the third-party plug-in filters. There are literally hundreds and hundreds of filters available for use in Photoshop. In fact, you can even create your own filters.

When you use a filter on an image, Photoshop physically changes the pixels within the image. Of course, Photoshop gives you the ability to undo any mistakes you might make along the way, but make no mistake, filters physically alter the image, as shown in Figure 493.1.

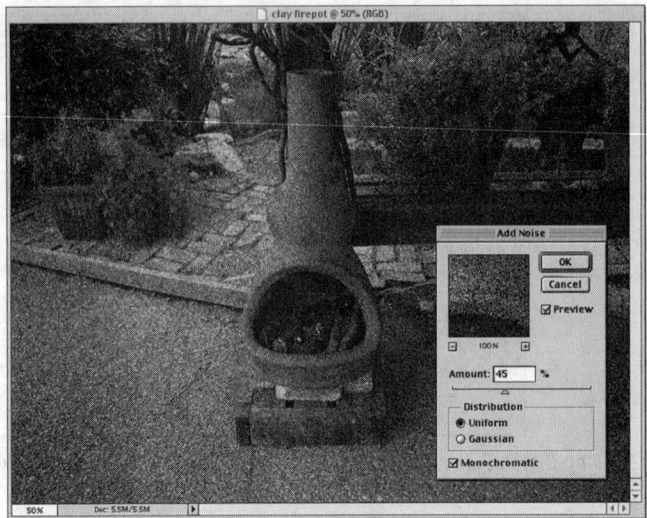

Figure 493.1 The Noise filter, applied to a Photoshop image, alters the image pixels to produce a new (filtered) image.

Photoshop applies some filters in one step and with other filters requires you to modify the filter settings. When you select the Filter menu in Photoshop, filters that have three dots after the filter name define filters that require you to work with the settings in a dialog box before Photoshop applies the filter to the image. Filters without the three dots after the name do not require any further settings and are applied to the image without user interaction, as shown in Figure 493.2.

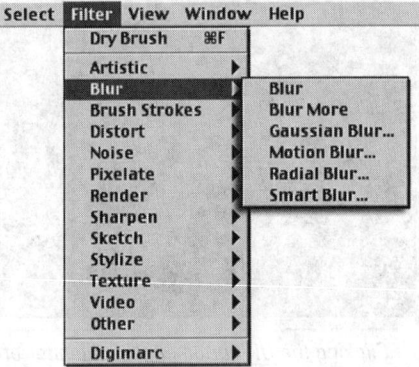

Figure 493.2 The Filter menu displaying the Blur Filter options.

To reapply the last filter you used on an image, select the Filter menu. Photoshop displays a pull-down menu with all the available filters. The first option in the pull-down menu is the last filter you used, as shown in Figure 493.3.

Figure 493.3 The first item in the Filter pull-down menu is the last filter applied to the image.

Click once on the first item in the Filter pull-down menu to reapply the filter. If you hold down the Alt key (Macintosh: Option key) when you select the last filter, Photoshop opens the dialog box for the filter and lets you modify its settings.

Note: All of Photoshop's filters are available for RGB and Multichannel images. Some of the filters are not available for CMYK, Grayscale, and Lab Color images, and no filters are available for Bitmap or Indexed Color images.

494 *Working with Despeckle*

The Despeckle filter finds the edges of an image by identifying significant shifts in color, and then it blurs all of the image except the identified edges. The Despeckle filter is useful for removing noise or small imperfections while still preserving the sharp edges of the image detail. Say, for example, you have an image with a small amount of noise, and you want to remove the noise without losing the sharpness of the image, as shown in Figure 494.1.

Figure 494.1 A Photoshop image that contains small imperfections in the form of digital noise.

To remove the noise from an image, open the image in Photoshop, select Filter menu Noise, and choose Despeckle from the fly-out menu. The Despeckle filter removes most of the noise from the image without losing the sharpness of the image detail, as shown in Figure 494.2.

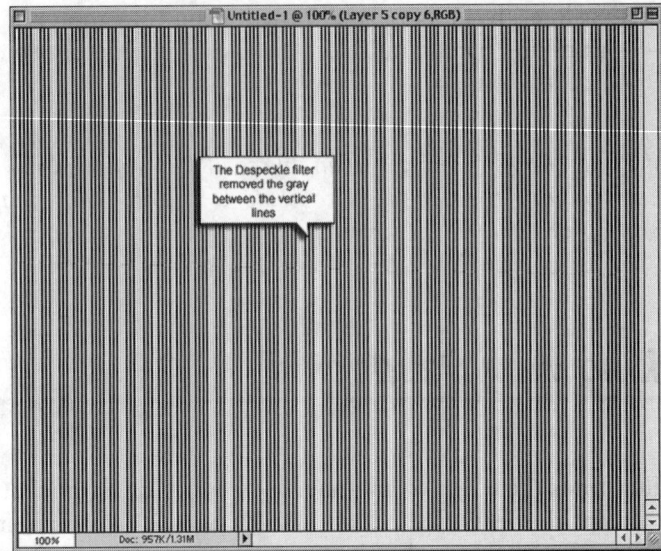

Figure 494.2 *The Despeckle filter removed the noise from the image while successfully maintaining the sharpness of the image detail.*

495 *Using the Median Filter*

In the preceding tip, you learned how to use the Despeckle filter to remove noise from an image. The Median filter also removes noise from an image but using a different technique. Say, for example you have an image that needs some noise reduction. You tried the Despeckle filter (refer to the preceding tip); however, the results are less than satisfactory.

To remove noise from an image using the Median filter, open the document in Photoshop, select the Filter menu, select Noise, and choose Median from the fly-out menu. Photoshop opens the Median dialog box, as shown in Figure 495.1.

Figure 495.1 *The Median dialog box controls how you apply the filter to the image.*

Click on the triangle located under the Radius input box and drag the slider left or right. Dragging the slider to the right increases the Radius and blurs the image. If you drag the slider to the left, the Radius decreases and the image becomes sharper, as shown in Figure 495.2.

Figure 495.2 Clicking and dragging the triangle slider to the right or left correspondingly increases or decreases the blur within the image.

Photoshop searches an image using the value of the Radius. Say, for example, you choose a Radius value of 5. Photoshop creates a grid pattern over the image with each grid having a radius of 5 pixels (10 pixels in diameter). Using the center pixel as its sample value, the Median filter examines the rest of the pixels within a 5-pixel radius and eliminates any colors that radically differ from the sample. It then replaces radically differing pixels with a color based on the median brightness of the pixels defined by the Radius input field, as shown in Figure 495.3.

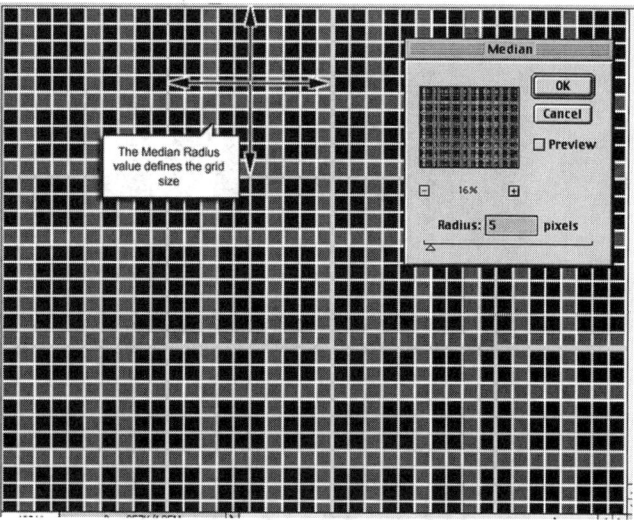

Figure 495.3 The Median filter examines a grid of pixels based on the selected radius.

Note: Because of the way it examines an image, the Median filter is useful for eliminating blur in an image caused by the movement of the camera or the photographed objects.

496 *Working with the High Pass Filter on an Image*

In Tip 494, "Working with Despeckle," you learned how to clean up the noise in an image while retaining the edge sharpness of the image. The High Pass filter works to retain edge details in an image but with a different overall effect to the image.

To use the High Pass filter, select the Filter menu, choose Other and choose High Pass from the fly-out menu. Photoshop opens the High Pass dialog box, as shown in Figure 496.1.

Figure 496.1 The High Pass dialog box controls the application of the filter to the image.

In the Radius input field, enter a value from 0.1 to 250 (or drag the triangular slider left or right to change the Radius value). Photoshop examines the pixels within the value set by the Radius option, looking for sharp transitions of color. It preserves the sharp colors and suppresses the rest of the image.

The lower the Radius value, the less of the image detail is preserved, as shown in Figure 496.2.

Figure 496.2 Choosing a low Radius value creates an embossed look to the image.

Higher Radius values preserve more of the image's detail and create a sharper image, as shown in Figure 496.3.

Figure 496.3 Choosing a higher Radius value creates a sharper graphic with more image detail.

Since the High Pass filter preserves the edges of the image at the expense of detail, it is useful for cleaning up black and white line art, as shown in Figure 496.4.

Figure 496.4 Using the High Pass filter on a black and white piece of line art significantly improves the quality of the image.

497 *Using the Minimum/Maximum Filters on Channels*

The Minimum and Maximum filters are useful for cleaning up a channel mask. Alpha channel masks use black, white, and shades of gray to create a selection (refer to Tip 453, "Creating a Selection with Your Paintbrush").

The Minimum and Maximum filters modify an image by expanding or contracting black and white areas of an image. The Maximum filter works to expand the white areas of an image and contract the black areas. The Minimum filter works to expand the black areas of an image and contract the white areas.

Say, for example, you create an Alpha channel mask. The mask areas, however, contain many unwanted white areas.

To remove the white areas and clean up the Alpha channel mask, select the Filter menu, select Other and choose Minimum from the fly-out menu. Photoshop opens the Minimum dialog box, as shown in Figure 497.1.

Figure 497.1 The Minimum dialog box controls the application of the filter to the image.

In the Radius input field, enter a value from 0.1 to 250 (or drag the triangular slider left or right to change the Radius value). Based on the Radius value, the Minimum filter examines the image in a grid-like pattern and replaces the pixels within the defined grid pattern with black or white.

Click the OK button to apply the Minimum filter to the channel, as shown in Figure 497.2.

Note: If the mask requires more white areas, choose the Maximum filter.

Figure 497.2 Using the Minimum filter on the Alpha channel mask successfully cleaned up the mask.

498 *Using Photoshop's Cutout Filter to Create Artwork*

One of the more creative filters in Photoshop's Artistic series is the Cutout filter. The Cutout filter gives a photographic image a clip art like quality by reducing it into a series of color steps, almost like cutting colored pieces of construction paper and laying them on top of each other to form an image.

To use the Cutout filter, open a graphic image in Photoshop, select Filter menu Artistic, and choose Cutout from the fly-out menu. Photoshop opens the Cutout dialog box, as shown in Figure 498.1.

Figure 498.1 The Cutout dialog box controls the application of the filter to the image.

The Cutout filter gives you three options:

- **No. of Levels:** If you use the analogy of colored paper, the number of levels controls the number of different-colored pieces of color paper used in the application of the Cutout filter. Click in the No. of Levels input field and enter a value from 2 to 8 (or click and drag the triangular slider to the left or right). The higher the value, the more colors the Cutout filter uses, as shown in Figure 498.2.

Figure 498.2 Changing the No. of Levels changes the number of colors used by the Cutout filter.

- **Edge Simplicity:** The Edge Simplicity option controls the complexity of the edge shape. Click in the Edge Simplicity input field and enter a value from 0 to 10 (or click and drag the triangular slider to the left or right). The lower the value, the more complex the edges of the image, as shown in Figure 498.3.

Figure 498.3 Changing the Edge Simplicity value increases or decreases the complexity of the edges in the image.

- **Edge Fidelity:** The Edge Fidelity option controls how close the edges in the Cutout filter relate to the edges within the original image. In the Edge Fidelity input field, enter a value from 1 to 3 (or click and drag the triangular slider to the left or right). The lower the value, the more the edges vary from the original image, as shown in Figure 498.4.

Figure 498.4 Changing the Edge Fidelity value controls how faithfully the edges in the Cutout filter relate to the edges in the original image.

Click the OK button in the Cutout dialog box to apply the filter to the image, as shown in Figure 498.5.

Figure 498.5 The Cutout filter applied to an image, giving the graphic an artistic, clip art look.

499 *Working with the Tiles Filter*

The Tiles filter creates a series of tiles out of the active image. You determine the size of the tiles and the tile offset.

To use the Tiles filter, open an image in Photoshop, select the Filter menu, select Stylize, and choose Tiles from the fly-out menu. Photoshop opens the Tiles dialog box, as shown in Figure 499.1.

Figure 499.1 The Tiles dialog box controls the application of the filter to the image.

The Tile filter options control the operation of the filter:

- **Number of Tiles:** In the input box, enter a value from 1 to 99. Photoshop uses the value to determine the number of tiles created. If the document window is square, then the entered value represents the number of tiles vertically and horizontally. If the document window is a rectangle, Photoshop takes the width or height, whichever of the measurements is smaller, and divides the Number of Tiles into that number. Say, for example, you have an image in a 12-by-6-inch document window. If you choose a value of 3 for the Number of Tiles, Photoshop creates three 2-inch-square tiles (6 divided by 3 equals 2) and fills the image with the tiles.

- **Maximum Offset:** In the input box, enter a value from 1 to 99. Photoshop uses the offset value to nudge the newly created tiles down and to the right. The higher the value, the more offset the tiles.

- **Fill Empty Area With:** Click on a radio button to choose to fill in the offset areas with the current Foreground or Background colors, the Inverse (reverse colors) of the original image, or the original Unaltered image.

Click the OK button to apply the Tile filter to the active image, as shown in Figure 499.2.

Figure 499.2 The Tile filter applied to a Photoshop image.

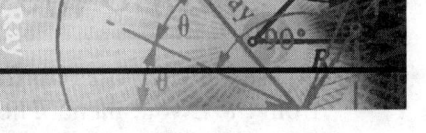

500 *Using the Torn Edges Filter*

Torn Edges modifies the information within an image by giving the edges of the graphic a torn, ragged look. This filter is especially useful on high-contrast images or graphics that contain a lot of text.

To apply the Torn Edges filter to an image, select the Filter menu, select Sketch and choose Torn Edges from the fly-out menu. Photoshop opens the Torn Edges dialog box, as shown in Figure 500.1.

Figure 500.1 The Torn Edges dialog box controls the application of the filter to the image.

Torn Edges modifies an image in much the same way as the Posterize command strips an image into black and white (see Tip 639, "Using the Posterize Command"). The major difference is that the Torn Edges filter gives you more control, and the final image is not reduced to black and white. The Torn Edges filter uses the current Foreground and Background color swatches to reconstruct the image.

The options available for the Torn Edges filter are:

- **Image Balance:** In the Image Balance input field, enter a value from 0 to 50 (or click and drag the triangular slider to the left or right). Image Balance influences the percentage of the Foreground and Background colors used to create the final image. The lower the value, the more the current Background color influences the image; the higher the value, the more the Foreground color influences the final image, as shown in Figure 500.2.

Figure 500.2 Changing the Image Balance value influences the percentage of Foreground and Background colors applied to the image.

- **Smoothness:** In the Smoothness input field, enter a value from 1 to 15 (or click and drag the triangular slider to the left or right). The Smoothness value controls how ragged the line separating the Foreground and Background colors appears in the final image. The lower the value, the smoother the transition from Foreground to Background color; the higher the value, the sharper the edge transition, as shown in Figure 500.3.

Figure 500.3 Changing the Smoothness value influences the transition from Foreground to Background color.

• **Contrast:** In the Contrast input field, enter a value from 1 to 25 (or click and drag the triangular slider to the left or right). The higher the value, the greater the contrast in the image, as shown in Figure 500.4.

Figure 500.4 Changing the Contrast value increases or decreases the contrast in the final image.

Click the OK button in the Torn Edges dialog box to apply the changes to the image, as shown in Figure 500.5.

Figure 500.5 The Torn Edges filter applied to an image.

501 *Applying an Artificial Grain to an Image*

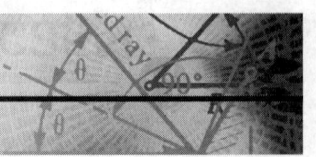

Using Photoshop, it is possible to photograph, process, edit, and print an image without ever once using standard film-to-print techniques. In fact, with the quality of digital cameras, it is not only possible but

commonplace. Working in the digital world lets you avoid the chemicals, the darkrooms, and the light-sensitive films and papers. Digital images do not have a film grain but an ordered number of dots (defined as resolution) that define the image information.

To recapture that nostalgic look, try using the Grain filter to introduce a film-grain appearance to a digital image.

To apply an artificial grain to an image, open a graphic in Photoshop, select the Filter menu, then select Texture, and choose Grain from the fly-out menu. Photoshop opens the Grain dialog box, as shown in Figure 501.1.

Figure 501.1 The Grain dialog box controls the application of the grain to the active image.

The Grain options are:

- **Preview window:** The Grain filter displays the effect of the grain within a preview window. Refer to Tip 492, "Previewing and Applying Filters," for more information on the preview window.

- **Intensity:** In the Intensity input field, enter a value from 0 to 100 (or click and drag the triangular slider to the left or right). The Intensity value controls the amount of grain applied to the image. The greater the value, the more grain is visible.

- **Contrast:** In the Contrast input field, enter a value from 0 to 100 (or click and drag the triangular slider to the left or right). The Contrast value controls the amount of contrast in the image. The greater the value, the more contrast.

- **Grain Type:** Click on the Grain Type option to display a list of available grain options, as shown in Figure 501.2. Choose Regular or Soft to emulate photographic film grain.

An average setting for emulating film grain is an Intensity of 10 to 15, a Contrast of 35 to 45, and a Grain Type of Regular. Click the OK button to apply the Grain filter to the image, as shown in Figure 501.3.

Figure 501.2 Clicking the Grain Type button displays a list of available grains.

Figure 501.3 The Grain filter applied to a Photoshop graphic.

502 *Making Filters Appear Natural*

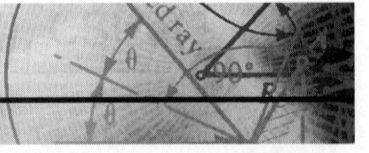

Photoshop's vast array of filters and plug-ins lets you modify, enhance, or otherwise change any digital image. The trick is to make the effect look as natural as possible, especially when the applied filter is supposed to make the image look better, as with the Sharpen filter.

To make filters appear more natural:

- **Slow and easy:** Try applying the filter in stages. Say, for example, you need to apply a Sharpen filter to an image. Try applying the filter in two stages instead of all at once. That helps lessen the impact of the filter against the image.

- **Make a copy:** Before applying a filter to an image, make a copy of the layer (refer to Tip 376, "Making a Pixel-to-Pixel Copy of a Layer"). Apply the filter effect to the original image, then occasionally stop and compare the filtered image to the copy of the original. Sometimes seeing a before and after version of the image gives you insight into how the overall effect is working.

- **Test:** Try different variable settings in the filter dialog box. When you find a successful way to use the filter, save it as an Action (refer to Tip 411, "Creating a New Action").

- **More than one:** Apply more than one filter to the image. Using a single filter creates a canned look; using more than one filter gives you creative control.

- **Order:** If you use more than one filter on an image, try varying the order you use to apply the filters to the image. Since the application of a filter physically changes the image, choosing which filter to use first determines how the final image appears.

Experimentation and knowledge of how Photoshop's filters operate are the keys to using filter creatively and efficiently. When you know what a particular filter is actually doing to the physical image, it gives you more control, and control is what it is all about.

503 *Pushing Filters to the Maximum*

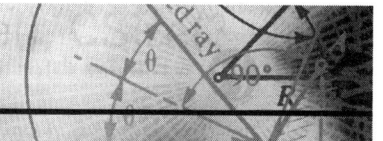

When you apply a filter to an image, the effects of the filter physically modify the pixels within the active layer, as shown in Figure 503.1.

Figure 503.1 The Dry Brush Artistic filter physically changes the pixels in the image to resemble a dry brush painting technique.

To maximize the effect of a filter on an image, you might try increasing the contrast or color within the image using one of Photoshop's adjustment tools.

To increase the contrast of a graphic before applying a filter, select the Image menu, select Adjust and choose Curves from the fly-out menu. Photoshop opens the Curves dialog box, as shown in Figure 503.2.

Figure 503.2 The Curves dialog box adjusts the color and contrast of an image.

Create a reverse "S" curve by clicking once on the middle of the curved graph line. Photoshop places an anchor point on the line. Click again on the upper third of the line to create a second anchor point and drag up, as shown in Figure 503.3. Refer to Tip 205, "Understanding How the Curves Command Adjusts an Image," for more information on using the Curves command.

Figure 503.3 Clicking and dragging the Curve graph line to create a reverse S generates a higher degree of contrast within the image.

Another way to change the image before applying a filter is the Levels command. The Levels command adjusts an image by remapping the brightness of the pixels (refer to Tip 201, "Understanding How the Levels Command Adjusts an Image").

When you change the physical image before applying a filter, you change how the filter affects and changes the image. Using a combination of Photoshop commands before applying a filter effect is the best way to maximize a filter's effect on the image.

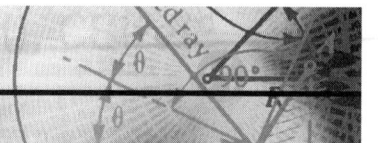

504 *Using Texture Mapping*

Several filters in Photoshop use texture mapping to modify an image. Texture mapping works with the shades of gray within the texture map to create the peaks and valleys of the texture, as shown in Figure 504.1.

Filters using texture maps in Photoshop are:

- Conte Crayon
- Displace
- Glass
- Lighting Effects
- Rough Pastels
- Texture Fill
- Texturizer

Figure 504.1 The shades of gray within a texture map influence how the map distorts the image.

Say, for example, you want to create the effect of an image behind a marbled piece of glass. To create this effect, use the Glass filter. Select the Filter menu, choose Distort and select Glass from the fly-out menu. Photoshop displays the Glass filter dialog box, as shown in Figure 504.2.

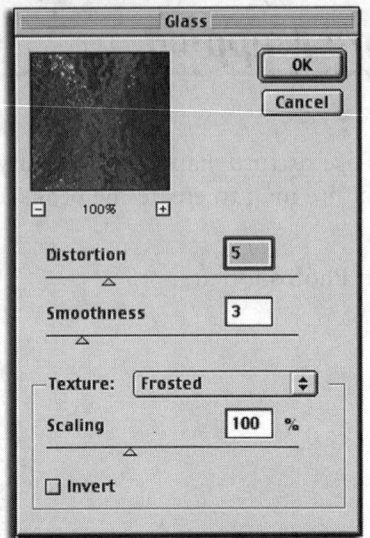

Figure 504.2 Glass distortion works with a texture map to control the effect of the filter.

You control the distortion with the Glass filter options:

- **Distortion:** In the Distortion input field, enter a value from 0 to 20 (or click and drag the triangular slider to the left or right). The Distortion value controls the intensity of the distortion. The greater the value, the more intense the distortion effect.

- **Smoothness:** In the Smoothness input field, enter a value from 1 to 15 (or click and drag the triangular slider to the left or right). The Smoothness value controls how the texture map changes the image. The higher the value, the smoother the application of the texture map.

- **Texture:** Click the Texture option and select an available texture map from the drop-down list, as shown in Figure 504.3. For information on creating your own texture maps, see Tip 505, "Creating Custom Texture Maps."

Figure 504.3 Clicking the Texture button displays a list of available texture maps.

- **Scaling:** In the Scaling input field, enter a value from 50 to 200 percent (or click and drag the triangular slider to the left or right). The Scaling value controls the size of the texture map. Choose a value of 100 percent to apply the map on a one-to-one scale. Choose lower or higher values to enlarge or reduce the size of the map.

- **Invert:** Select the Invert option to reverse the gray values in the image map. Selecting Invert causes the effects of the map to reverse: Peaks become valleys and valleys become peaks.

Click the OK button to apply the Glass filter to the image, as shown in Figure 504.4.

Figure 504.4 The Glass filter applied to an image.

505 *Creating Custom Texture Maps*

In the preceding tip, you learned how the Glass filter uses a texture map to change the physical appearance of an image. Most filters that employ texture maps come with a set of predefined maps; however, it is possible to create your own texture maps. Texture maps are essentially Photoshop documents that are painted or filtered using black, white, and shades of gray. Refer to Figure 505.1 for some examples of texture maps.

When you use a texture map, Photoshop distorts the image based on the shades of gray in the map. To create a texture map, open Photoshop and perform these steps:

1. Select the File menu and choose New from the pull-down menu. Photoshop opens the New dialog box, as shown in Figure 505.2.

2. For this example, create a document with a width and height of 2 inches, a resolution of 72ppi, in Grayscale mode, and with White as the content color (refer to Figure 505.2).

3. Select the Swatches palette by clicking once on the Swatches tab, or select the Window menu and choose Show Swatches from the pull-down menu. Photoshop displays the Swatches palette, as shown in Figure 505.3.

Figure 505.1 Texture maps are Photoshop documents created using black, white, and shades of gray.

Figure 505.2 The New dialog box in Photoshop controls the characteristics of the new document.

Figure 505.3 The Swatches palette displays a list of the available color swatches.

4. Move your mouse into the Swatches palette and click once on one of the light gray color swatches. Photoshop changes the current Foreground color swatch to light gray.

5. Press Alt+Delete (Macintosh: Option+Delete) to fill the new document with the current Foreground color, as shown in Figure 505.4.

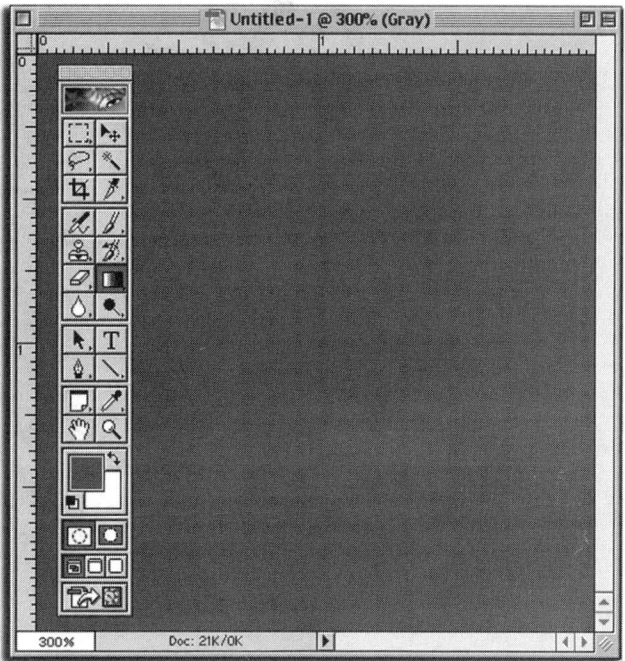

Figure 505.4 Pressing Alt+Delete fills the new document with the current Foreground color.

6. Select the Filter menu, select Sketch and choose Halftone Pattern from the fly-out menu. Photoshop opens the Halftone Pattern dialog box, as shown in Figure 505.5.

Figure 505.5 The Halftone Pattern dialog box creates a halftone pattern in the active image.

7. Choose a Size of 3, a Contrast of 0, and select Dot for the Pattern Type (refer to Figure 505.5).

8. Click the OK button in the Halftone Pattern dialog box. Photoshop applies the pattern to the document, as shown in Figure 505.6.

9. Select the File menu and choose Save As from the pull-down menu. Photoshop opens the Save As dialog box, as shown in Figure 505.7.

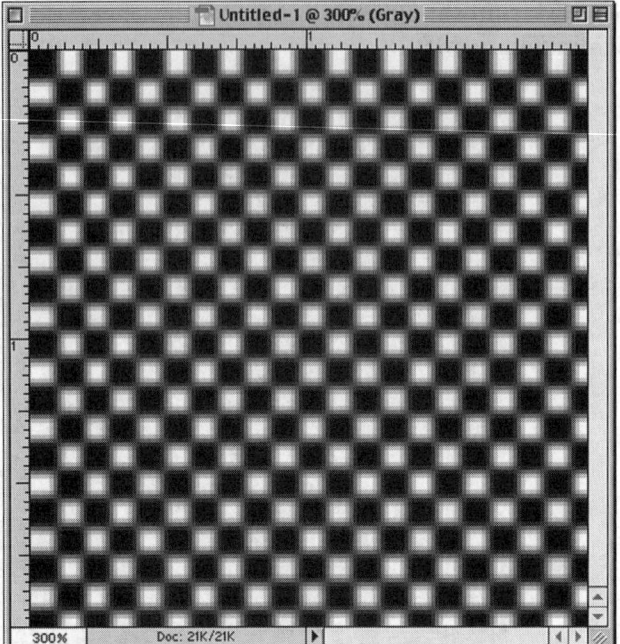

Figure 505.6 The Halftone Pattern applied to the image.

Figure 505.7 The Save As dialog box in Photoshop controls the location, name, and format for the saved image file.

10. In the Name field, assign a name for the document. In this example, the name dots is selected.

11. Click the Format button and select Photoshop for the document's format.

12. Choose a folder for the new texture and click the Save button. Photoshop saves the file and closes the Save As dialog box. To load and apply a custom texture map, see Tip 506, "Working with Customized Texture Maps."

Note: *It is a good idea to create a new folder and place all your textures in that folder. This gives your computer more organization and makes selection of the texture maps easier.*

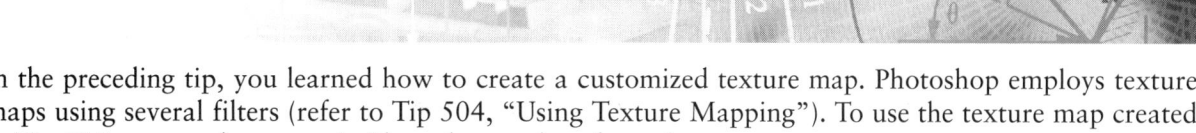

506 *Working with Customized Texture Maps*

In the preceding tip, you learned how to create a customized texture map. Photoshop employs texture maps using several filters (refer to Tip 504, "Using Texture Mapping"). To use the texture map created in Tip 505, open a document in Photoshop and perform these steps:

1. Select the Filter menu, select Distort and choose Glass from the fly-out menu. Photoshop opens the Glass dialog box, as shown in Figure 506.1.

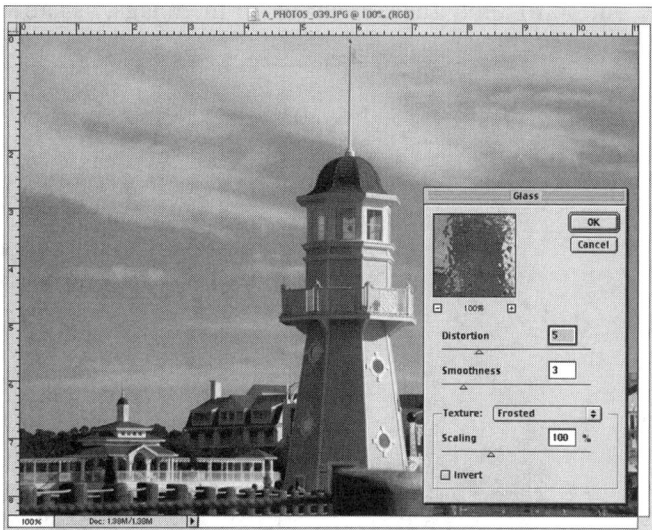

Figure 506.1 The Glass dialog box controls the effects of the distortion on the physical image.

Control the distortion with the Glass filter options:

2. In the Distortion input field, enter a value from 0 to 20 (or click and drag the triangular slider to the left or right). The Distortion value controls the intensity of the distortion. The greater the value, the more intense the distortion effect.

3. In the Smoothness input field, enter a value from 1 to 15 (or click and drag the triangular slider to the left or right). The Smoothness value controls how the texture map changes the image. The higher the value, the smoother the application of the texture map.

4. Click the Texture option and select Load Texture from the drop-down menu. Photoshop displays the Open dialog box, as shown in Figure 506.2.

Figure 506.2 The Open dialog box displays a list of available texture maps.

5. In the preceding tip, you created a texture map named dots. Select the dots texture map file (refer to Figure 506.2) and click the Open button. Photoshop loads the dots texture map into the Glass filter and closes the Open dialog box.

6. In the Scaling input field, enter a value from 50 to 200 percent (or click and drag the triangular slider to the left or right). The Scaling value controls the size of the texture map. Choose a value of 100 percent to apply the map on a one-to-one scale. Choose lower or higher values to enlarge or reduce the size of the map.

7. Select the Invert option to reverse the gray values in the image map. Selecting Invert causes the effects of the map to reverse: Peaks become valleys and valleys become peaks.

8. Click the OK button to apply the Glass filter to the image, as shown in Figure 506.3.

Figure 506.3 The Glass filter applied to an image using a customized texture map.

507 *Using Graduated Values with the Mosaic Filter*

All of Photoshop's filters, not just the Mosaic filter, work with or without the use of selections. However, in this example, you will apply the Mosaic filter to an image using a selection marquee.

When you select an area of an image, Photoshop defines that area as the working area, and with few exceptions, adjustment, commands, and filters only work within the selected area. To influence the Mosaic filter using a selection, open a document in Photoshop and perform these steps:

1. Select the Rectangular marquee from Photoshop's toolbox and create a rectangular selection on the right side of the document window, as shown in Figure 507.1. Refer to Tip 282, "Working with the Marquee Tools," for more information on using the Rectangular marquee.

2. Select the Filter menu, the select Pixelate and choose Mosaic from the fly-out menu. Photoshop opens the Mosaic dialog box, as shown in Figure 507.2.

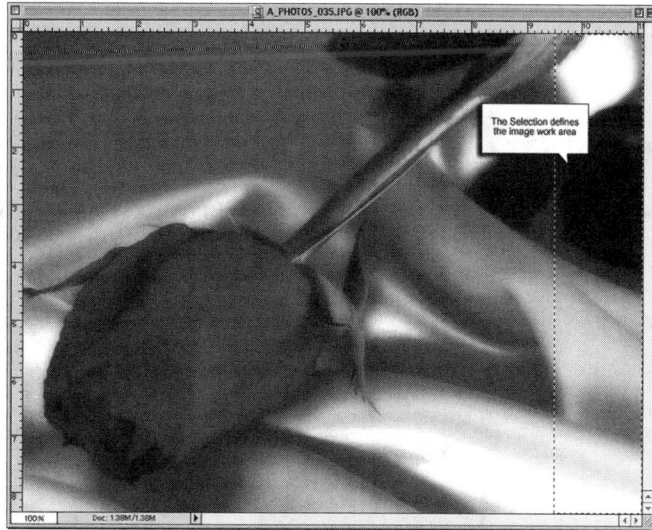

Figure 507.1 A rectangular selection made to the right section of the document window.

Figure 507.2 The Mosaic filter controls the selected portion of the image.

3. In the Cell Size input field, enter a value of 15 (or click and drag the triangular slider left or right until the value 15 appears in the size window).

4. Click the OK button. Photoshop creates a 15-pixel square mosaic within the selected area, as shown in Figure 507.3.

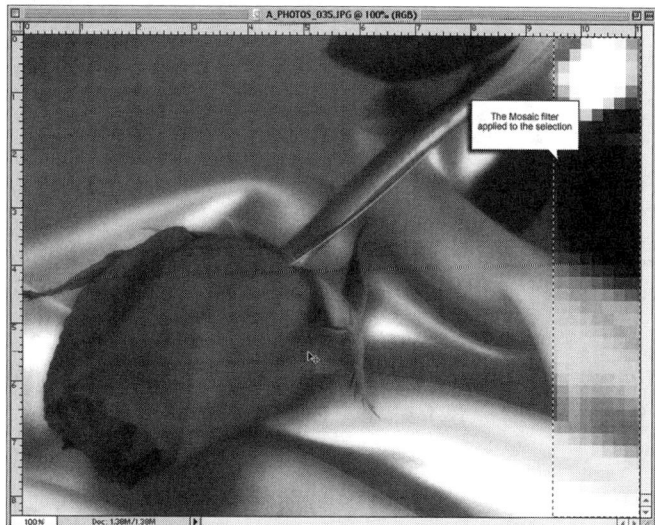

Figure 507.3 The Mosaic filter applied to the selected area of the document window.

5. Move your marquee tool into the selection area and click and drag to the left. Photoshop moves the selection marquee, as shown in Figure 507.4.

Figure 507.4 Click and drag the selection marquee into the adjacent quadrant.

6. Select Filter menu Pixelate and choose Mosaic from the fly-out menu. Photoshop opens the Mosaic dialog box. In the Cell Size input field, enter a value of 12. Click the OK button. Photoshop applies the Mosaic filter to the selected area, as shown in Figure 507.5.

Figure 507.5 The Mosaic filter applied to the next quadrant of the document window.

7. Repeat steps 5 and 6, reducing the Cell Size accordingly until you reach the left side of the image. The image contains a graduated version of the Mosaic filter, as shown in Figure 507.6.

Note: Combining selections with filters is an excellent way to create effects beyond the capabilities of the filter when applied directly to the image.

Figure 507.6 The Mosaic filter gradually applied to the image with the use of a selection marquee.

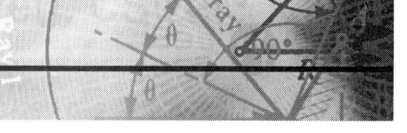

508 *Blending Filter Effects*

In the preceding tip, you learned how to increase the flexibility of a filter with the use of a selection. Another excellent way to increase the flexibility of filters is to combine them with layer blending modes.

To create a special effect using filters and blending modes, open a document in Photoshop and perform these steps:

1. Select the Layers palette by clicking once on the Layers tab, or select the Window menu and choose Show Layers from the pull-down menu. Photoshop displays the Layers palette, as shown in Figure 508.1.

Figure 508.1 The Layers palette displays the layers within the active document.

2. Move your mouse into the Layers palette and click and drag the image layer over the Create a New Layer icon. Photoshop creates a copy of the image layer, as shown in Figure 508.2.

Figure 508.2 Clicking and dragging a layer over the Create a New Layer icon creates an exact copy of the original layer.

3. Click once on the original image layer. In this example, it is the one named Background. Photoshop selects the Background layer.

4. Select the Filter menu, select Stylize and choose Find Edges from the fly-out menu. Photoshop applies the Find Edges filter to the original image layer. To view the Find Edges filter, click once on the visibility icon located to the far left of the copied layer. Photoshop deactivates the copy layer and displays the original image in the document window, as shown in Figure 508.3.

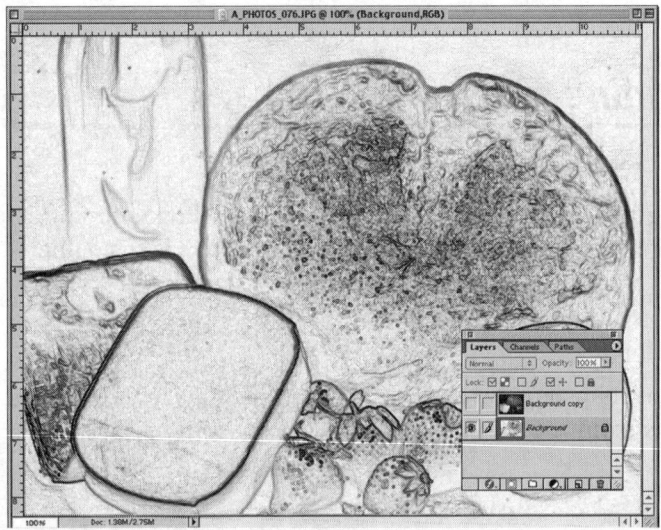

Figure 508.3 The original image layer, displaying the effects of the Find Edges filter.

5. With the original image layer still selected, choose the Image menu, select Adjust and select Threshold from the fly-out menu. Photoshop opens the Threshold dialog box, as shown in Figure 508.4.

6. Click and drag the triangular slider left or right until you achieve a good balance of white and black (refer to Figure 508.4).

7. Click the OK button to apply the Threshold command to the image.

8. Click once on the name of the copied layer. Photoshop reactivates the copy layer, as shown in Figure 508.5.

9. Click once on the Blending Mode button in the upper-left corner of the Layers palette. Photoshop displays a pop-up list of all the available blending modes, as shown in Figure 508.6.

10. Select Multiply from the pop-up menu. Photoshop applies the Multiply blending mode to the image, as shown in Figure 508.7.

For more information on blending nodes, see Tip 687, "Working with Layer Blending Modes."

Figure 508.4 The Threshold dialog box separates the image into black and white.

Figure 508.5 Clicking once on the layer name reactivates the copied image in the document window.

Figure 508.6 The Blending Mode options control how the inks in the two layers mix.

Figure 508.7 Using Layer Blending modes with filters, gives you creative control over the final image.

509 *Using the Torn Edge Filter to Enhance an Image*

In Tip 500, "Using the Torn Edges Filter," you learned how to apply the Torn Edges filter to an image. The Torn Edges filter not only distorts the edges of the image, it replaces the colors in the image with the Foreground and Background color swatches.

The Torn Edges filter maps the image pixels into shades of the Foreground and Background colors based on the original brightness of the image pixels. The darker image pixels favor the Foreground color, and the lighter pixels in the image favor the Background color. Say, for example, you choose blue for the Foreground and yellow for the Background color swatches. When you apply the Torn Edge filter to the image, the darker areas of the image turn blue, and the lighter areas of the image turn yellow.

To use this effect to enhance an image, open a document in Photoshop and perform these steps:

1. Press the letter "D" on your keyboard. Photoshop changes the Foreground and Background color swatches to black and white, as shown in Figure 509.1.

2. Select the Layers palette by clicking once on the Layers tab or by selecting the Window menu and choosing Show Layers from the pull-down menu. Photoshop displays the Layers palette, as shown in Figure 509.2.

3. Move your mouse into the Layers palette and click and drag the image layer over the Create a New Layer icon. Photoshop creates a copy of the image layer, as shown in Figure 509.3.

4. Click once on the copied layer. In this example, it is the one named Background copy. Photoshop selects the Background layer.

5. Select the Filter menu, choose Sketch and select Torn Edges from the pull-down menu. Photoshop displays the Torn Edges filter, as shown in Figure 509.4.

Figure 509.1 Pressing the letter "D" changes the Foreground and Background color swatches to black and white.

Figure 509.2 The Layers palette displays the layers within the active document.

Figure 509.3 Clicking and dragging a layer over the Create a New Layer icon creates an exact copy of the original layer.

Figure 509.4 The Torn Edges dialog box controls the application of the filter to the image.

6. Choose an Image Balance of 25, a Smoothness of 1, and a Contrast of 1. Refer to Tip 500, "Using the Torn Edges Filter," for more information on the filter options.

7. Click the OK button. Photoshop applies the Torn Edges filter to the image copy, as shown in Figure 509.5.

Figure 509.5 The Torn Edges filter applied to an image.

8. Click once on the Blending Mode button in the upper-left corner of the Layers palette. Photoshop displays a pop-up list of all the available blending modes, as shown in Figure 509.6.

9. Select Multiply from the pop-up menu. Photoshop applies the Multiply blending mode to the image, as shown in Figure 509.7.

The final document resembles an image shot through a dark piece of smoky glass. For more information on blending modes, see Tip 687, "Working with Layer Blending Modes."

Figure 509.6 The Blending Mode options control how the inks in the two layers mix.

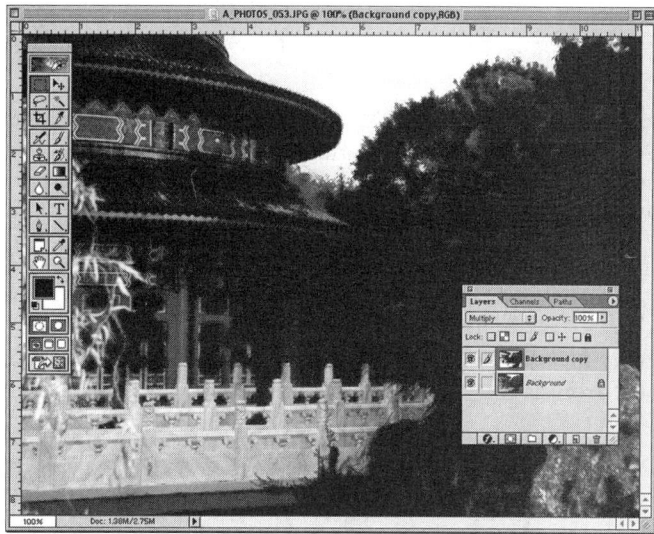

Figure 509.7 Using layer blending modes with filters gives you creative control over the final image.

510 *Loading Images as Texture Maps*

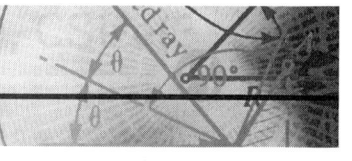

In Tip 505, "Creating Custom Texture Maps," you learned how to create a grayscale Photoshop document to use as a texture map. Another mapping device is to use a graphic image. To use an image as a texture map, open an RGB (red, green, and blue) document in Photoshop and perform these steps:

1. Select the File menu, then select Save As from the pull-down menu. Photoshop opens the Save As dialog box, as shown in Figure 510.1.

Figure 510.1 The Save As dialog box in Photoshop controls the characteristics of the saved document.

2. In the Name field, assign a name for the document. In this example, enter the name *ImageMap*. Make sure you do not use the same name as the original file.

3. Click the Format button and select Photoshop for the document's format (refer to Figure 510.1).

4. Choose a folder for the new image and click the Save button. Photoshop saves the file and closes the Save As dialog box. You are now working on the copied file.

5. Select the Image menu, select Mode, and choose Grayscale from the fly-out menu. Photoshop converts the image from RGB (red, green, and blue) into a grayscale image, as shown in Figure 510.2.

Figure 510.2 The copied file converted into grayscale.

6. Select the File menu and choose Close from the pull-down menu. When Photoshop prompts you to save changes to the document, select Save. Photoshop saves and closes the grayscale copy.

7. Select the File menu and Choose Open. Photoshop displays the Open dialog box.

8. Select the original RGB image from the Open document window and click once on the Open button. Photoshop opens the original RGB image, as shown in Figure 510.3.

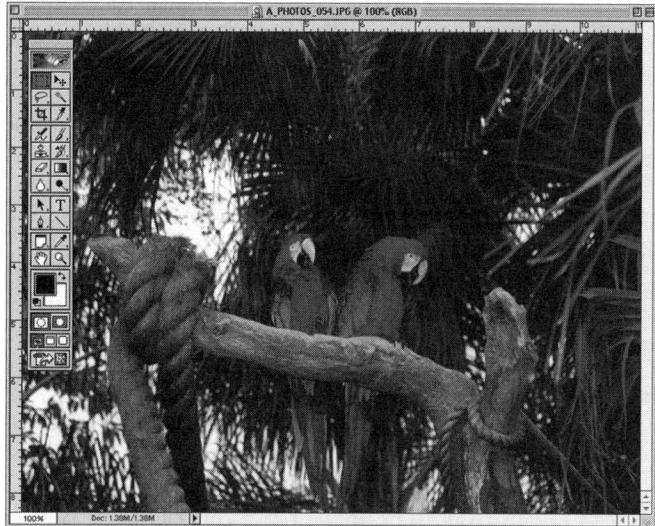

Figure 510.3 The Photoshop document window displays the original RGB image.

9. Select the Filter menu, choose Sketch and select Conté Crayon from the fly-out menu. Photoshop opens the Conté Crayon dialog box, as shown in Figure 510.4.

Figure 510.4 The Conté Crayon dialog box controls the application of the filter to the image.

10. In the Foreground Level input box, enter a value from 1 to 15 (or click and drag the triangular slider to the left or right). The Foreground Level value balances how much of the Foreground is used to produce the final image. The higher the value, the more Foreground color is used; the lower the value, the more Background color is used.

11. In the Background Level input box, enter a value from 1 to 15 (or click and drag the triangular slider to the left or right). The Background Level value balances how much of the Background color is used to produce the final image. The higher the value, the more Background color is used; the lower the value, the more Foreground color is used. Using low values for the Background color produces a mix of the Foreground and Background colors.

12. Click on the Texture button and choose Load Texture from the pop-up menu. Photoshop displays the Open dialog box (refer to Figure 510.2).

13. Select the grayscale copy from the visible list and click the Open button. Photoshop uses your grayscale image as a texture map for the original RGB image.

14. Select a Scaling of 100 percent to match the grayscale texture map to the image.

15. In the Relief input box, enter a value from 0 to 50 (or click and drag the triangular slider to the left or right). The Relief value creates the illusion of a three-dimensional image by lightening and darkening the edges of color in the image. The lower the value, the less pronounced the peaks and valleys. Enter a value of 0 to deactivate the Relief option.

16. Click on the Light Dir button and choose from the available options. In this example, top was chosen for the light direction.

17. Select the Invert option to reverse the shades of gray in the image map.

18. Click the OK button to apply the Conté Crayon filter to the image, as shown in Figure 510.5.

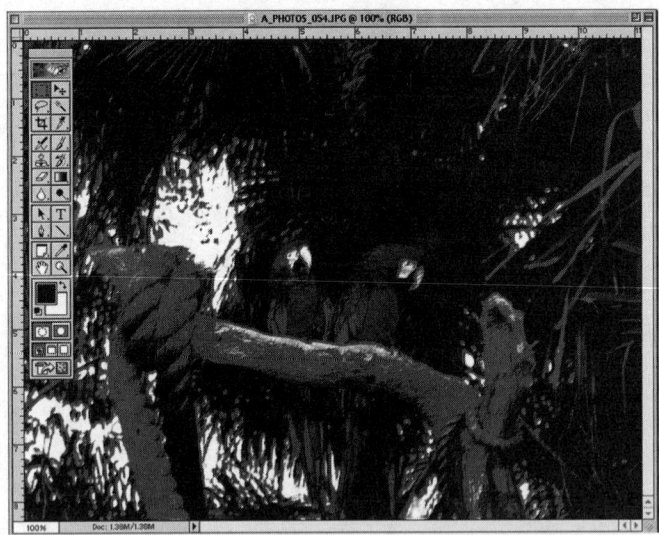

Figure 510.5 The Conté Crayon filter applied to the image using a grayscale image for the texture map.

Note: Using a grayscale texture map instead of the Brick, Burlap, Canvas, and Sandstone texture options converts the image into a softly painted graphic without a rough or bumpy appearance.

511 *Defining the Distortion Area with the Displace Filter*

In Tip 505, "Creating Custom Texture Maps," you learned how to modify an image using a grayscale texture map. The Displace filter uses texture maps to distort an image; however, you control the amount

and direction of the distortion with the use of the Displace filter options and the size and design of the texture map.

As discussed in Tip 505, texture maps are grayscale Photoshop documents. The level of gray in the texture map determines the amount of distortion in the image.

- **Black:** Creating a texture map using black produces the maximum amount of positive displacement within the image.

- **White:** Creating a texture map using white produces the maximum amount of negative displacement within the image.

- **50 percent gray:** A texture map created with 50 percent gray produces no distortion in the image.

Say, for example, you have an image containing a group of straight horizontal lines, and you want to introduce a wave, as shown in Figure 511.1.

Figure 511.1 The document window contains an image with straight horizontal lines.

Photoshop has several filters that will distort an image; however, the Displace filter gives you the most control over the final image. Using Tip 505 as a reference, create a texture map with the same width, height, and resolution as the document in Figure 511.1. Using the Gradient tool, create a texture map similar to Figure 511.2. Save the file with the *.psd* extension and name the file *wave.psd*. You will use this file in step 4.

To apply the texture map to the image, open the horizontal line file (refer to 511.1) and perform these steps:

1. Select the Filter menu, select Distort and choose Displace from the fly-out menu. Photoshop opens the Displace dialog box, as shown in Figure 511.3.

Figure 511.2 The texture map resembles a black and white vertically striped image.

Figure 511.3 The Displace dialog box controls how Photoshop applies the texture map to the image.

2. Choose from these Displace options:

- **Horizontal Scale:** In the Horizontal Scale input box, enter a value from –999 to +999. The Horizontal Scale determines the amount of horizontal distortion within the image. In this example, you enter a value of 50.

- **Vertical Scale:** In the Vertical Scale input box, enter a value from –999 to +999. The Vertical Scale determines the amount of vertical distortion within the image. In this example, you enter a value of 50.

- **Displacement Map:** Click on a radio button to choose how the texture map (the grayscale image) fits the current document. Select Stretch to Fit to stretch a smaller texture map to fit the size of the active document. Select Tile to tile a smaller texture map into the active image. In this example, the texture map is the same size as the active document; therefore, it does not matter which option is chosen.

- **Undefined Areas:** Click on a radio button and choose how the Displace filter handles the distortion of the image at the edges of the document window. Select Wrap Around to wrap the pixels from the opposite side of the image. Select Repeat Edge Pixels to fill the distorted edge areas with similar pixels. In this example, you select Repeat Edge Pixels.

3. Click the OK button. Photoshop displays the Open dialog box, as shown in Figure 511.4.

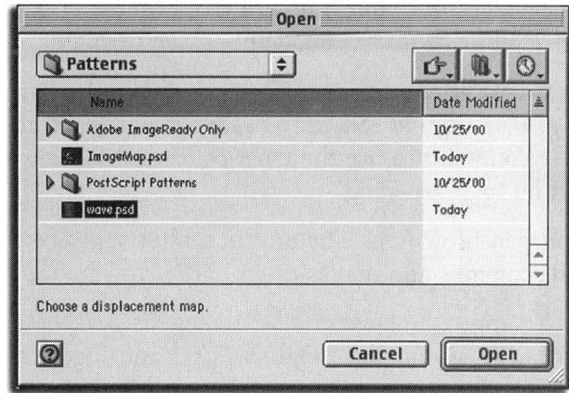

Figure 511.4 The Open dialog box displays a list of all available texture maps.

4. Select the correct texture map. In this example, the file named *wave.psd* contains the texture map shown in Figure 511.2.

5. Click once on the Open button. Photoshop applies the selected texture map to the document, as shown in Figure 511.5.

Figure 511.5 The Displace filter applied to the active Photoshop document.

Notice how the lines bend down where the image matches the darker areas of the texture map and the lines bend up where the image matches the lighter area of the texture map. When you use positive numbers for Horizontal and Vertical Scale, the image distorts down and to the right for shades of gray darker than 50 percent and up and to the left for shades of gray lighter than 50 percent. To reverse how Photoshop applies the texture map to the image, use negative numbers for Horizontal and Vertical Scale.

512 *Understanding How to Apply Filters*

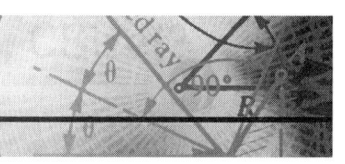

In Tip 502, "Making Filters Appear Natural," you learned that the order in which you apply filters to an image influences the final look of the graphic. Every time you apply a filter to an image, Photoshop

physically changes the image. Since filters do not work on the original image, the effect of a filter is determined by what other modifications the image has gone through.

While applying filters in a different order will help with the natural look of the image, applying filters in the correct order also saves time. Say, for example, you have an image containing a modest amount of dust and scratches. You want to use the Dust & Scratches filter to remove the imperfections, but the image also requires a bit of sharpening.

Do not apply the Sharpen filter first. The Sharpen filter will not only sharpen the image detail, it will sharpen the dust and scratches and makes them harder to remove with the Dust and Scratches filter.

The best technique is to apply the Dust and Scratches filter to the image and then perform image sharpening using Unsharp Mask, as shown in Figure 512.1 and Figure 512.2.

See Tip 599, "Fixing Dust and Scratches," for more information on correcting images with imperfections.

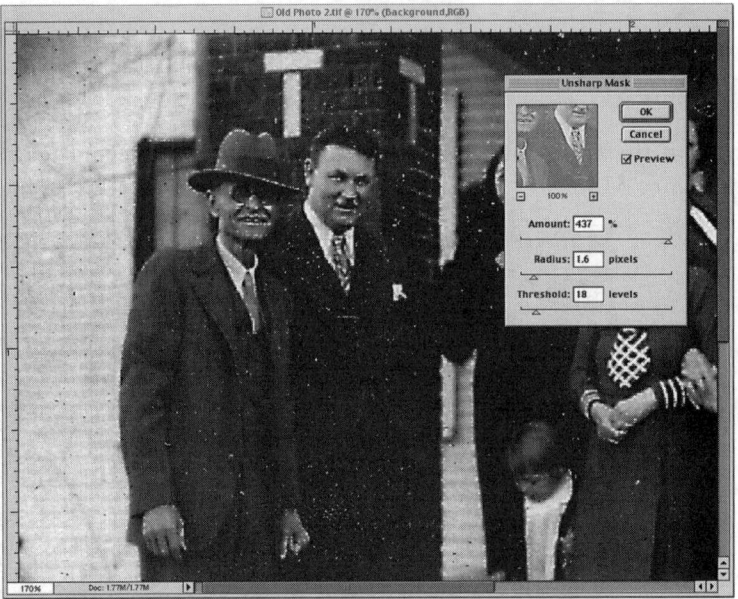

Figure 512.1 Using the Sharpen filter first makes it difficult to remove the dust and scratches from the image.

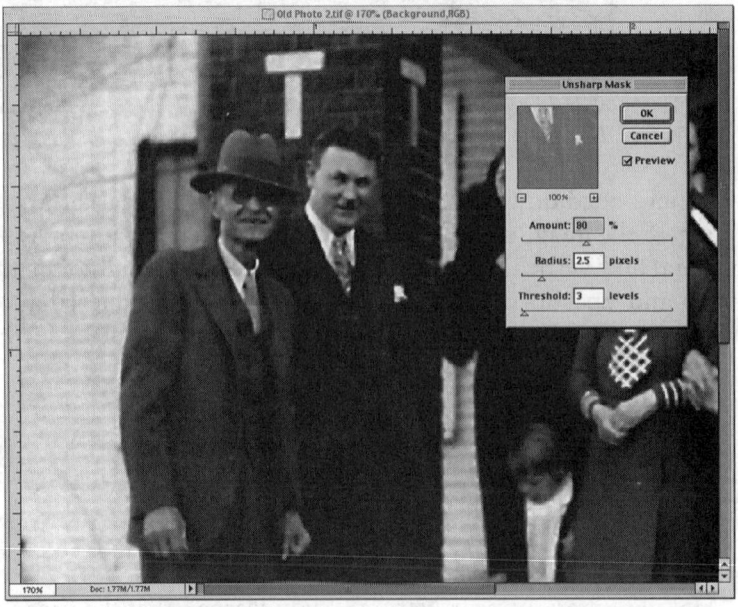

Figure 512.2 Using the Dust and Scratches filter first and then using the Sharpen filter creates a high-quality image.

513 *Improving the Performance of Memory-Intensive Filters*

Although Photoshop's filters are an indispensable tool when working on an image, some of those filters are memory intensive. Any designer who has waited for that obnoxious progress bar to finish understands that some filters take a lot of time, as shown in Figure 513.1.

Figure 513.1 The progress bar in Photoshop indicates how long before a filter completes its operation.

While it is frustrating to wait for a difficult filter to complete its operation, in some cases filters will not work because of a lack of available RAM memory. The solution, of course, is to immediately pick up the telephone and order more memory or, better yet, to order a better computer. However, while you are waiting for FedEx to deliver your additional memory, there are some temporary things you can do to help:

- **Close programs:** If you routinely work with more than one program open, closing the other programs will free up more memory for Photoshop.

- **Reduce History states:** The History palette, by default, holds 20 History States. This enables you to step through the last 20 Photoshop operations performed on the active document. History States consume memory, and lowering the number of History States frees up more memory (refer to Tip 401, "Using Multiple Undos").

- **Cache levels:** Photoshop, by default, holds four cache levels. The cache levels are images of the document saved in memory, and they aid in the redrawing of the your document window. Lowering the number of memory-held images frees up memory that Photoshop can use for other operations (refer to Tip 46, "Determining the Correct Cache Levels Setting").

- **Extensions and plug-ins:** Windows and Macintosh computers use extension files to perform normal computer operations. Your operating system uses extensions and plug-ins to perform network operations and even to control day-planner and calendar programs. If you are not familiar with system operations, check with your system administrator to see if it is possible to deactivate some of the extensions or plug-ins, thereby freeing up valuable RAM memory.

Note: Most of these procedures are temporary fixes at best. However, they may help you get through a difficult part of a design phase until you get that extra memory.

514 *Working with the Artistic Filters*

To make filter selection easier, when you select the Filters pull-down menu, Photoshop displays a list of available filter headings, as shown in Figure 514.1.

The headings define a group of similar filters. Say, for example, you need a Blur filter. You would move your mouse down the Filter menu list until it rested over the Blur heading. Photoshop then would display a fly-out submenu containing a list of all available Blur filters, as shown in Figure 514.2.

Figure 514.1 The Filter pull-down menu displays the headings for all the available filters.

Figure 514.2 The Blur heading displays a list of all the available Blur filters.

Photoshop defines the Artistic filters as a group of image enhancements that apply a painted look to an image. The available Artistic filters are:

- Colored Pencil
- Dry Brush
- Fresco
- Paint Daubs
- Plastic Wrap

- Cutout
- Film Grain
- Neon Glow
- Palette Knife
- Poster Edges

- Rough Pastels
- Sponge
- Watercolor
- Smudge Stick
- Underpainting

The Artistic filters work with images in RGB, Grayscale, Multi-channel, and Duotone color modes. Artistic filters do not work on CMYK, Lab, Indexed, or Bitmap mode images.

In a multi-layered Photoshop document, the Artistic filters modify the active layer. If you have a single channel selected, the Artistic filters will modify the channel instead of the entire image. The Artistic filters work with Photoshop's Native color channels or individual Alpha mask channels.

The Artistic filters do not use texture maps, as do some of Photoshop's distortion filters. They work with and modify the original image without any additional image data.

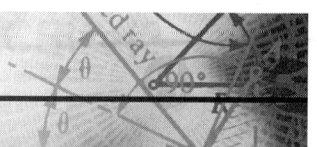

515 *Understanding the Pixelate Facet Filter*

The Facet filter examines an image by grouping same or like-colored pixels. Depending on the image, the Facet filter can make an image appear hand-painted, as shown in Figure 515.1.

Figure 515.1 Applying the Facet filter to a photograph gives the image a hand-painted appearance.

Another use of the Facet filter is in cleaning up a grid or halftone patterns, or in some cases, the Facet filter will clean up the rough edges of a line art image. Say, for example, you scan or create a halftone pattern, but the edges of the pattern appear blurred, as shown in Figure 515.2.

Figure 515.2 The edges of the scanned halftone pattern appear soft.

Using one of the Sharpen filters improves the image, but it creates a halftone pattern within the pattern, as shown in Figure 515.3.

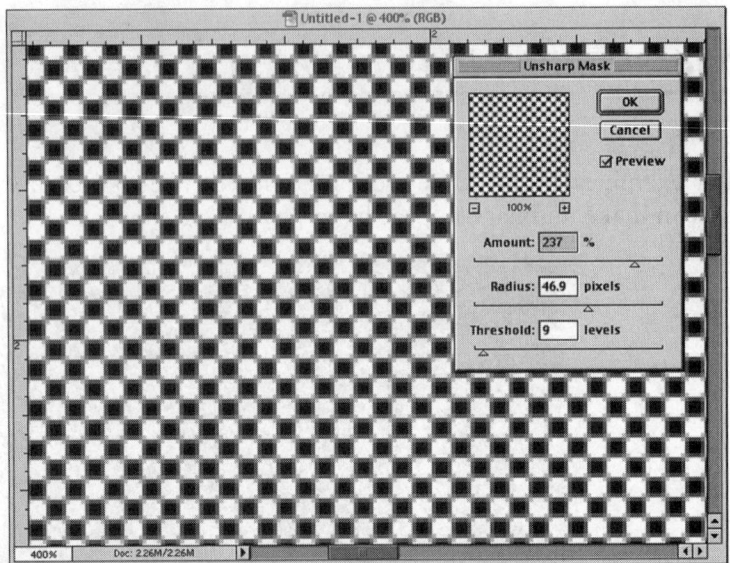

Figure 515.3 Applying the Unsharp Mask filter produces unsatisfactory results.

Since the Facet filter groups similar-colored pixels together, it is ideal for this type of problem. Select Filter menu Pixelate and choose Facet from the fly-out menu. Photoshop applies the Facet filter to the halftone pattern and corrects the image, as shown in Figure 515.4.

Figure 515.4 The Facet filter corrects the problem introduced into the scanned halftone pattern.

516 *Using the Blur and Blur More Filters*

Photoshop's filter palette contains six Blur tools. The Blur and Blur More options are the only two Blur tools that do not contain any user-defined options, as shown in Figure 516.1.

The Blur and Blur More filters differ from the Gaussian Blur filter. While the Gaussian Blur filter applies an average blur to the overall image, the Blur and Blur More filters identify the edges of the image and smooth only the edge colors. This gives the image a more controlled blur, as shown in Figure 516.2.

Figure 516.1 The Blur and Blur More filters execute without user intervention.

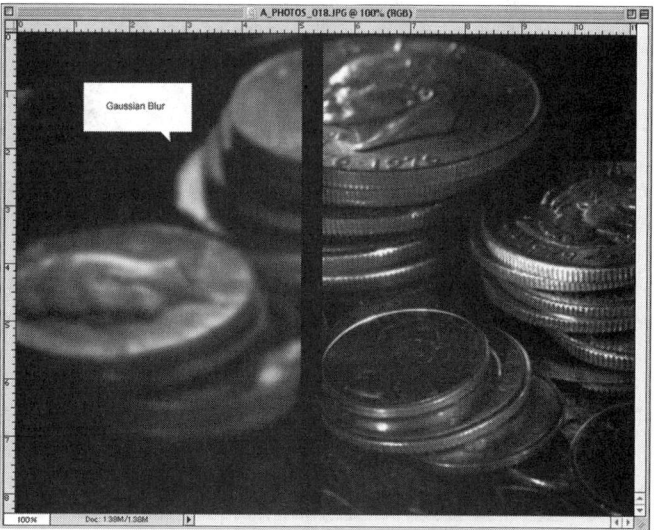

Figure 516.2 The Blur filter and Gaussian Blur filter soften the image's detail using different methods.

The Blur and Blur More filters identify the edges in the image by identifying where large shifts of color or brightness occur. The filters then average the colors together, producing a softer edge. Use the Blur and Blur More filters on images containing details in various stages of focus. Say, for example, you have an image with parts of the image in focus and other parts of the image out of focus, as shown in Figure 516.3. You want to soften the foreground image detail without further blurring the background.

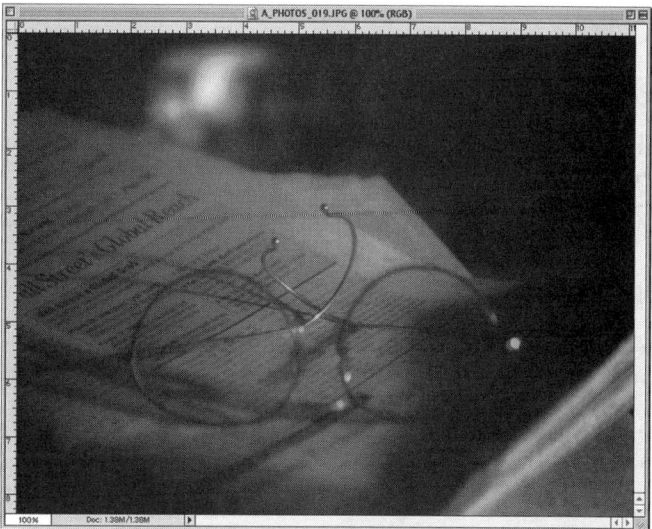

Figure 516.3 Images containing details at various stages of focus are ideal candidates for the Blur and Blur More filters.

Select Filter menu Blur and choose Blur from the fly-out menu. The Blur filter softens the sharp-edged foreground objects without further softening of the background, as shown in Figure 516.4.

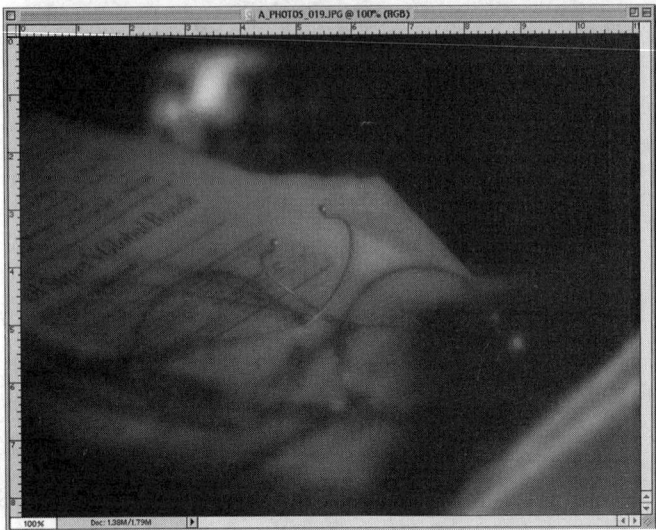

Figure 516.4 The Blur filter softens the foreground objects without changing the background.

Note: The Blur and Blur More filters perform the same function except the Blur More filter produces an effect three to four times stronger than the Blur filter.

517 *Understanding the Brush Strokes Filters*

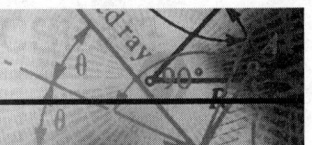

As mentioned in Tip 514, "Working with the Artistic Filters," Photoshop places filters of similar function into groups. The available Brush Strokes filters are:

- Accented Edges
- Angled Strokes
- Crosshatch
- Dark Strokes
- Ink Outlines
- Spatter
- Sprayed Strokes
- Sumi-e

The Brush Strokes filters work with images in RGB, Grayscale, Multi-channel, and Duotone color modes. Brush Stroke filters do not work on CMYK, Lab, Indexed, or Bitmap mode images.

In a multi-layered Photoshop document, the Brush Strokes filters modify the active layer. If you have a single channel selected, the Brush Strokes filters will modify the channel instead of the entire image. The Brush Strokes filters work with Photoshop's Native color channels or individual Alpha mask channels.

The Brush Strokes filters do not use texture maps, as do some of Photoshop's distortion filters. They work with and modify the original image without any additional image data.

Like the Artistic filters, the Brush Strokes filters modify the image, but they create the visual appearance of brush strokes within the image.

Figure 517.1 The Accented Edges filter.

Figure 517.2 The Angled Strokes filter.

Figure 517.3 The Crosshatch filter.

Figure 517.4 The Dark Strokes filter.

Figure 517.5 The Ink Outlines filter.

Figure 517.6 The Spatter filter.

Figure 517.7 The Sprayed Strokes filter.

Figure 517.8 The Sumi-e filter.

518 *Working with the Distort Filters*

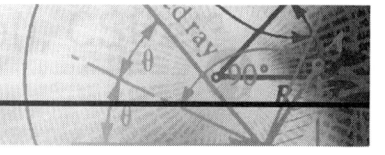

The Distort filters modify the image in such a way as to create a three-dimensional look to the image. The Distort filters are very memory intensive (refer to Tip 513, "Improving the Performance of Memory-Intensive Filters"). The available Distort filters are:

- Diffuse Glow
- Glass
- Pinch
- Ripple

- Displace
- Ocean Ripple
- Polar Coordinates
- Shear

- Spherize
- Wave
- Twirl
- ZigZag

In a multi-layered Photoshop document, the Distort filters modify the active layer. If you have a single channel selected, the Distort filters will modify the channel instead of the entire image. The Distort filters work with Photoshop's Native color channels or individual Alpha mask channels.

Several of the Distort filters use texture maps to change the image (refer to Tip 504, "Using Texture Mapping").

Figure 518.1 The Diffuse Glow filter.

Figure 518.2 The Displace filter.

Figure 518.3 The Glass filter.

Figure 518.4 The Ocean Ripple filter.

Figure 518.5 The Pinch filter.

Figure 518.6 The Polar Coordinates filter.

Figure 518.7 The Ripple filter.

Figure 518.8 The Shear filter.

Figure 518.9 The Spherize filter.

Figure 518.10 The Twirl filter.

Figure 518.11 The Wave filter.

Figure 518.12 The ZigZag filter.

519 *Using the Noise Filters*

Photoshop's Noise filters increase or decrease the noise level within an image. Noise is defined a randomly colored pixels distributed throughout an image, as shown in Figure 519.1.

Figure 519.1 Photoshop defines noise as a single or small grouping of randomly colored pixels.

The available Noise filters are:

- Add Noise
- Dust & Scratches
- Despeckle
- Median

In a multi-layered Photoshop document, the Noise filters modify the active layer. If you have a single channel selected, the Noise filters will modify the channel instead of the entire image. The Noise filters work with Photoshop's Native color channels or individual Alpha mask channels.

The Noise filters do not use texture maps, as do some of Photoshop's distortion filters. They work with and modify the original image without any additional image data.

Figure 519.2 The Add Noise filter.

Figure 519.3 The Despeckle filter.

Figure 519.4 The Dust & Scratches filter.

Figure 519.5 The Median filter.

520 *Applying the Pixelate Filters*

The Pixelate filters change an image by dividing the image into a grid-like pattern and, depending on the Pixelate filter used, merging the colors within the grid. The available Pixelate filters are:

- Color Halftone
- Crystallize
- Facet
- Fragment
- Mezzotint
- Mosaic
- Pointillize

In a multi-layered Photoshop document, the Pixelate filters modify the active layer. If you have a single channel selected, the Pixelate filters will modify the channel instead of the entire image. The Pixelate filters work with Photoshop's Native color channels or individual Alpha mask channels.

The Pixelate filters do not use texture maps, as do some of Photoshop's distortion filters. They work with and modify the original image without any additional image data.

Figure 520.1 The Color Halftone filter.

Figure 520.2 The Crystallize filter.

Figure 520.3 The Facet filter.

Figure 520.4 The Fragment filter.

Figure 520.5 The Mezzotint filter.

Figure 520.6 The Mosaic filter.

Figure 520.7 The Pointillize filter.

521 *Removing the White Halo from an Image Using Defringe*

When you move or paste a selection, the edges of the selection appear to have a dark or white halo, as shown in Figure 521.1.

Figure 521.1 Copying or pasting a selection generates a halo around the copied areas of the image.

Halos appear more often when you select the digital image using the Anti-aliased option (refer to Tip 30, "Placing PostScript Files Using the Anti-alias Option"). The Anti-aliased option is available for all of Photoshop's selection tools. Essentially, anti-alias creates a smoother selection by including some of the pixels on the fringe or edge of the selection border. If the selection is against a white or black background, the Anti-aliased option generates a frustrating halo around the selected image (refer to Figure 521.1).

To remove the halo from a copied or pasted area of an image, select the Layer menu, select Matting and choose Defringe from the fly-out menu. Photoshop opens the Defringe dialog box, as shown in Figure 521.2.

Figure 521.2 The Defringe dialog box controls the amount of halo removed from the edge of the image.

In the Width input field, enter a value from 1 to 200. In most cases, removing the halo generated by the Anti-aliased option requires a value of 1 or 2. Click the OK button to apply the Defringe command to the image.

Based on the value you entered in the Width field, the Defringe command replaces the colors at the edge of the selection with the colors in the surrounding image, effectively eliminating the halo, as shown in Figure 521.3.

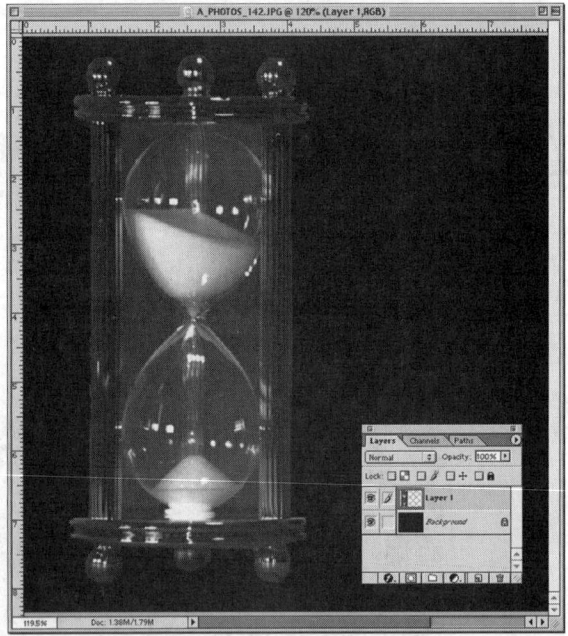

Figure 521.3 The Defringe option replaces the halo edge pixels with the colors of the surrounding image.

Note: The Matting options are not available on a flattened image.

522 *Helping Out a Resized Image*

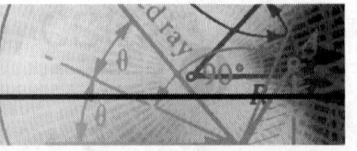

All kinds of things happen when you use Photoshop to change a graphic's width and height. Ideally, you would always scan and work on images at exactly the width and height needed for the final output. Unfortunately, resizing an image is a part of a Photoshop user's life.

When you enlarge an image in a darkroom using real film and photographic paper, the enlarger expands the size of the image in the same way a magnifying glass increases the view of an image. It expands the film's grain to fit the desired size.

Photoshop images are digital and therefore are built using a grid of pixels. Photoshop does not expand or contract the pixels; they always remain the same size. When you enlarge an image, imagine the graphic painted on a brick wall. To expand the size of the brick wall, you do not expand the wall; you need to add more bricks. When you expand a Photoshop image, you have to add more bricks (pixels) to the image. Photoshop does this using a mathematical formula called Interpolation (refer to Tip 22, "Choosing the Correct Interpolation Method").

When you expand the image, Photoshop pulls the pixels apart and adds new pixels to the image. Photoshop decides the colors to paint the pixels based on the colors of the surrounding pixels.

When you expand a Photoshop image, you are not adding detail or image information, you are simply adding colored bricks to the wall. That is why expanding the size of a digital image causes the image to pixelate and lose image detail, as shown in Figure 522.1.

Figure 522.1 Expanding the size of a digital image causes pixelation in the image detail.

When you resize an image, remember these tips:

- The resolution of an image determines the overall quality of the graphic. Although there are many formulas to help you decide on the proper scanning and working resolution, if you are not sure, always err on the high side. Scanning and working on an image at a higher resolution gives Photoshop more image information.

- If you know the resolution of the final image, scan the image at a resolution that evenly divides into the final resolution. Say, for example, you want to scan and work on an image for a Web page. You know the final resolution of the image is 72ppi; however, you need to edit the image, and you want to scan at a higher resolution. Choose a scan resolution of 144ppi, 216ppi, or 288ppi. All of those resolutions divide evenly into the image's final resolution of 72ppi. When Photoshop lowers the image resolution, it removes pixels from the graphic if the resolution is evenly divisible into the final resolution, Photoshop produces a better image visually.

- If you change the width and height of the image, do not simply drag the image into a larger or smaller size. Instead, select Edit menu Transform and choose Scale from the fly-out menu. Resize the image using whole number values such as 10, 15, or 20 percent. When you use the Free Transform command to resize an image, you generate fractional scale number such as 15.7 or 12.3 percent. Since resizing an image adds or subtracts pixels from the visible image, Photoshop does a better job if it has whole numbers to deal with.

523 Resetting Values Within a Dialog Box

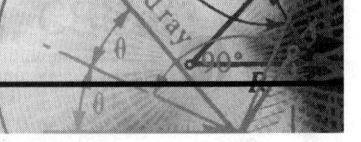

Photoshop is an interactive program. You open a graphic image, and Photoshop edits the image according to your input. If programs like Photoshop ever get to the point that they can think for themselves, it will put everyone out of business.

You interact with Photoshop by opening a document and inputting information into all of the program's various dialog boxes and input fields.

To speed up the entering of information:

- **Tab key:** Once you are in a dialog box, press the Tab key to move quickly through all of the input fields within the open dialog box. Press Shift+Tab to move through the input fields in reverse order.

- **Arrow keys:** Change the value of a selected numeric field by pressing the up and down arrow keys. Pressing the up arrow key increases the input value by one, and pressing the down arrow key decreases the input value by one. In some instances, holding the Shift key and pressing the up or down arrow keys increases or decreases the value by 10.

- **Enter key:** In most cases, unless you are entering text into an input field, the Enter key is linked to the OK or Apply button in a dialog box. Instead of moving your mouse into the dialog box and clicking the OK button, simply press the Enter key.

- **Word games:** When you see an Alert dialog box, pressing the first letter of an Alert option activates that option. Say, for example, you close a document without saving. Photoshop opens an Alert dialog box with the options Cancel, Save, and Don't Save. Pressing the letter "C" cancels the operation and returns you to the document, pressing the letter "S" saves and closes the document, and pressing the letter "D" closes the document without saving.

Note: In most cases, the underlined letter indicates the shortcut to selecting the option (i.e. Cancel).

- **Esc key:** When a dialog box is open, pressing the Esc key closes the dialog box as if you clicked the Cancel button. Clicking the Cancel button or pressing the Esc key closes the dialog box without performing the requested edit.

524 Applying Unsharp Mask

Of all Photoshop's sharpening tools, the one that gives you the best control over the image is Unsharp Mask. The Unsharp Mask corrects blurring introduced during the scan process or after resizing an image.

To sharpen an image, open a graphic in Photoshop, select the Filter menu, select Sharpen, and choose Unsharp Mask from the fly-out menu. Photoshop opens the Unsharp Mask dialog box, as shown in Figure 524.1.

Figure 524.1 The Unsharp Mask dialog box controls the amount of sharpening applied to the image.

It is important to understand that the Unsharp Mask does not actually sharpen the image. It simply creates the illusion of a sharper image by manipulating the available digital information. Therefore, do not use Unsharp Mask if you can first improve the image by rescanning. Then let Unsharp Mask take over from that point. Always start with the best possible image.

The available options for the Unsharp Mask filter are:

- **Threshold:** In the Threshold input field, enter a value from 0 to 255 (or click and drag the triangular slider left or right). Photoshop uses the Threshold option to identify the edges of the image. The higher the Threshold value, the more sensitive Unsharp Mask is to a shift in color or brightness, and more of the image areas sharpen. A value of 0 sharpens all the pixels in the image.

- **Radius:** In the Radius input field, enter a pixel value from 0.1 to 250 percent (or click and drag the triangular slider left or right). Photoshop uses the Threshold option to find the edges within the image, and it uses the Radius value to determine how many pixels on either side of the edges receive sharpening. Unless you intend to sharpen a line art image, normal photographic values are seldom higher than 2 or 3.

- **Amount:** In the Amount input field, enter a value from 1 to 500 percent (or click and drag the triangular slider left or right). The Threshold value identifies the edges within the image, the Radius determines how many pixels to use in the sharpening, and Amount determines how intense the sharpening effect is. The higher the Amount value, the greater the contrast of the sharpened pixels. Values for high contrast printed images range from 150 to 200 percent.

Click the OK button to apply the Unsharp Mask filter to the image, as shown in Figure 525.2.

Note: The Unsharp Mask filter appears sharper on screen than in print. Experiment to see what values work best based on your specific printing devices.

Figure 524.2 The Unsharp Mask filter applied to an image increases the edge sharpness within the image.

525 *Using the Render Filters*

The Render filters are among Photoshop's more creative and memory-intensive filters. The Render filters create three-dimensional shapes, creative cloud patterns, and artificial light sources by mapping the pixels within the image.

The available Render filters are:

- 3D Transform
- Difference Clouds
- Clouds
- Lens Flare
- Lighting Effects
- Texture Fill

All the Render filters work with images in RGB mode. You cannot use the Lens Flare or Lighting Effects filters in Grayscale mode. In CMYK mode, the 3D Transform, Lens Flare, and Lighting Effects filters are disabled, and the Difference Clouds, 3D Transform, Lens Flare, and Lighting Effects filters are not available in Lab color mode.

In a multi-layered Photoshop document, the Render filters modify the active layer. If you have a single channel selected, the Render filters will modify the channel instead of the entire image; however, the Lens Flare and Lighting Effects filters are not available for use on a single channel.

The Render filters do not use texture maps, as do some of Photoshop's distortion filters. They work with and modify the original image without any additional image data.

Figure 525.1 The 3D Transform filter.

Figure 525.2 The Clouds filter.

Figure 525.3 The Difference Clouds filter.

Figure 525.4 The Lens Flare filter.

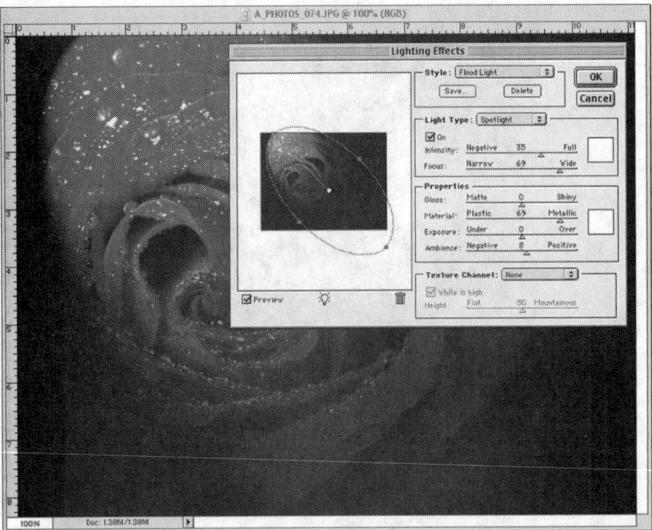

Figure 525.5 The Lighting Effects filter.

Figure 525.6 The Texture Fill filter.

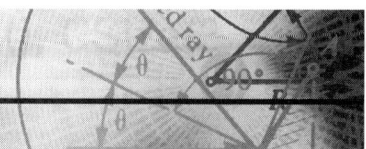

526 *Using the Sketch Filters*

The Sketch filters add texture to an image by applying a hand-drawn effect to the image. The available Sketch filters are:

- Bas Relief
- Charcoal
- Conté Crayon
- Halftone Pattern
- Photocopy
- Reticulation
- Torn Edges

- Chalk & Charcoal
- Chrome
- Graphic Pen
- Note Paper
- Plaster
- Stamp
- Water Paper

The Sketch filters work with images in RGB, Grayscale, Multi-channel, and Duotone color modes. Sketch filters do not work on CMYK, Lab, Indexed, or Bitmap mode images.

In a multi-layered Photoshop document, the Sketch filters modify the active layer. If you have a single channel selected, the Sketch filters will modify the channel instead of the entire image.

The Sketch filters do not use texture maps, as do some of Photoshop's distortion filters. They work with and modify the original image without any additional image data.

Figure 526.1 The Bas Relief filter.

Figure 526.2 The Chalk & Charcoal filter.

Figure 526.3 The Charcoal filter.

Figure 526.4 The Chrome filter.

Figure 526.5 The Conté Crayon filter.

Figure 526.6 The Graphic Pen filter.

Figure 526.7 The Halftone Pattern filter.

Figure 526.8 The Note Paper filter.

Figure 526.9 The Photocopy filter.

Figure 526.10 The Plaster filter.

Figure 526.11 The Reticulation filter.

Figure 526.12 The Stamp filter.

Figure 526.13 The Torn Edges filter.

Figure 526.14 The Water Paper filter.

527 *Working with the Stylize Filters*

The Stylize filters apply a painted or impressionistic look to a Photoshop image. The available **Sketch** filters are:

- Diffuse
- Extrude
- Glowing Edges
- Tiles
- Wind
- Emboss
- Find Edges
- Solarize
- Trace Contour

In a multi-layered Photoshop document, the Stylize filters modify the active layer. If you have a single channel selected, the Stylize filters will modify the channel instead of the entire image.

The Stylize filters do not use texture maps, as do some of Photoshop's distortion filters. They work with and modify the original image without any additional image data.

Figure 527.1 The Diffuse filter.

Figure 527.2 The Emboss filter.

Figure 527.3 The Extrude filter.

Figure 527.4 The Find Edges filter.

Figure 527.5 The Glowing Edges filter.

Figure 527.6 The Solarize filter.

Figure 527.7 The Tiles filter.

Figure 527.8 The Trace Contour filter.

Figure 527.9 The Wind filter.

528 *Using Texture Patchwork*

The Patchwork filter creates a tiled appearance to an image. Say, for example, you want to modify an image to resemble tiles, but you want the image to appear more ordered than the mosaic filter.

The Patchwork filter works with RGB, Grayscale, Duotone, and Multi-channel Photoshop documents. To apply the Patchwork filter to an image, open the graphic in Photoshop, select Filter menu Texture, and choose Patchwork from the fly-out menu. Photoshop opens the Patchwork dialog box, as shown in Figure 528.1.

Figure 528.1 The Patchwork dialog box controls the size of the tiles applied to the active image.

Visual adjustments are performed in the preview window in the Patchwork dialog box (refer to Figure 528.1). Control the application of the filter to the image with the Patchwork options:

- **Square Size:** In the Square Size input box, enter a value from 0 to 10. The greater the value, the larger the individual tiles.

- **Relief:** In the Relief input box, enter a value from 0 to 25. Photoshop shifts the edge colors of the boxes to make them appear at different heights. The greater the value entered in the Relief field, the greater the height and depth of the tiles.

Click the OK button to apply the Patchwork filter to the image, as shown in Figure 528.2.

Figure 528.2 The Patchwork filter applied to a Photoshop image.

529 *Using the Spherize Filter*

The Spherize filter creates a three-dimensional effect by wrapping the active image around a spherical shape. The visual effect is that of looking at the image through a magnifying glass. The Spherize filter is best used on a selected portion of an image. Say, for example, you have an image containing a textured circular area, and you want to modify the shape to resemble a three-dimensional ball.

To apply the Spherize filter to an image, first create a circular area using the Elliptical Marquee tool (refer to Tip 71, "The Marquee Tools") as shown in Figure 529.1. Select the Filter menu, select Distort and choose Spherize from the fly-out menu. Photoshop opens the Spherize dialog box, as shown in Figure 529.2.

Figure 529.1 Create a circular area using the Elliptical Marquee tool..

Visual adjustments are performed in the preview window in the Spherize dialog box (refer to Figure 529.2). Control the application of the filter to the image with the Spherize options:

- **Amount:** In the Amount input box, enter a value from –100 to +100. Higher values increase the depth and height of the spherical distortion.

- **Mode:** Click on the Mode button. Photoshop displays a list of available mode changes to the image. Select Normal to distribute the spherical distortion evenly along the horizontal and vertical axis. Select Horizontal or Vertical to apply the distortion to only one axis of the image.

Click the OK button to apply the Spherize filter to the image, as shown in Figure 529.2.

Figure 529.2 The Spherize filter applied to the selected circle of pixels.

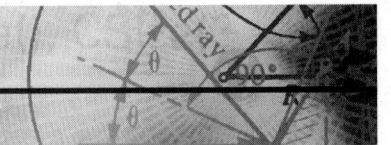

530 *Working with the Fade Command*

Fade is a useful command that gives you final say on exactly how Photoshop applies a filter to the image. When you apply a filter to a Photoshop graphic, imagine the filter applied to a separate layer with the original image directly underneath, as shown in Figure 530.1.

Figure 530.1 When you use the Fade command, Photoshop places the filter effect on a separate layer.

Say, for example, you use the Cutout filter (refer to Tip 498, "Using Photoshop's Cutout Filter to Create Artwork"). However, the effect is too strong, and you want to reduce the filter's effect on the image. To reduce the effect of the Cutout filter, select the Edit menu and choose Fade Cutout from the pull-down menu. Photoshop opens the Fade dialog box, as shown in Figure 530.2.

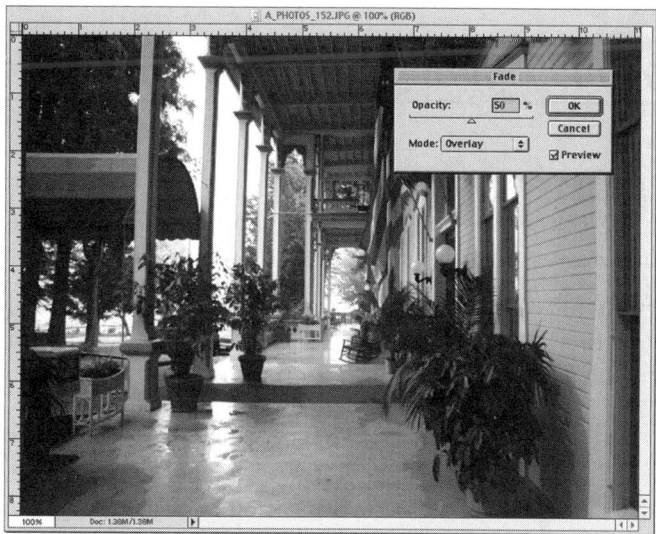

Figure 530.2 The Fade command lets you reduce the intensity of a filter.

You control the intensity of the filter effect using the Opacity and Mode options:

- **Opacity:** In the Opacity input box, enter a value from 0 to 100. A value of 0 removes the effect from the image. The higher the Opacity value, more intense the filter effect.

- **Mode:** Click on the Mode button. Photoshop displays a list of available blending modes. Click on a blending mode to apply that additional effect to the image. See Tip 687, "Working with Layer Blending Modes," for more information on using blending modes with filter effects.

Click the OK button to apply the Fade command to the image, as shown in Figure 530.3.

Figure 530.3 The Fade command reduces the intensity of the Cutout filter.

Note: *The Fade command does not actually reduce the effect of the filter on the image. Changing the Opacity value slowly fades the effect layer and lets the original image show through the filter effect (refer to Figure 530.1). And do not forget those blending mode options; using blending modes with a filter only gives you more control over the final image. Have some fun, experiment, and go where no one has gone before.*

531 *Using the Lighting Effects Filter*

The Lighting Effects filter is one of Photoshop's more creative, as well as memory-intensive, filters. You can use the Lighting Effects filter to create the illusion of a spotlight shining on an image, or you can use it in combination with the Artistic brush filters to create a painterly effect.

The Lighting Effects filter works with RGB color mode images. To apply the Lighting Effect filter to an RGB image, select the Filter menu, select Render and choose Lighting Effects from the fly-out menu. Photoshop opens the Lighting Effects dialog box, as shown in Figure 531.1.

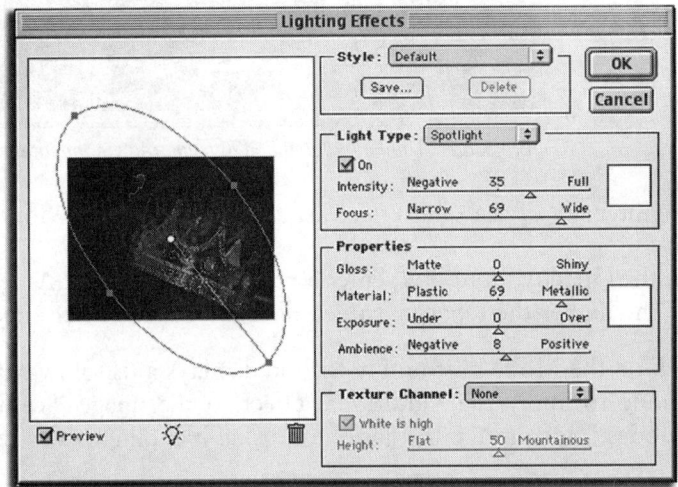

Figure 531.1 The Lighting Effects dialog box controls the application of the filter to the active RGB image.

The left side of the Lighting Effects dialog box contains the image preview. You control the filter by observing the effects of the lighting options in the preview box (refer to Figure 531.1).

- **Preview:** Select the Preview check box to activate or deactivate the image preview. Since the Lighting Effects filter is so memory intensive, occasionally turning off the Preview will significantly speed up your work.

- **Light icon:** Click on the light bulb icon and drag it into the preview window to add additional light sources to the image.

- **Trash Can icon:** To delete a light source, click on a light source in the preview window and drag it over the trashcan icon. You must have at least one light source in the image at all times.

To modify an existing light source, click once on the light source in the preview window. A circle appears around the light source, as shown in Figure 531.2.

- **Anchor points:** Click and drag on any of the four anchor points located around the edge of the circle defining the light source to change the width and height of the source (refer to Figure 531.2).

- **Center point:** Click and drag the center point of the light source to move the location of the light source without changing its size (refer to Figure 531.2).

- **Direction line:** The direction line extends from the center of the light source to the outer edge of the circle. Click on any anchor point and rotate it left or right to change the direction of the light (refer to Figure 531.2).

Figure 531.2 Clicking once on a light source lets you modify the size, direction, and location of the light.

The right side of the Lighting Effects dialog box controls the type of lighting and lets you choose from preset or saved styles.

- **Style:** Click on the Style option. Photoshop displays a drop-down list displaying the available lighting sources. Select from the available options, as shown in Figure 531.3.

Figure 531.3 The Style option lets you choose from the available preset lighting styles.

- **Save:** To save a custom light source, click once on the Save button. Photoshop opens the Save the Style As dialog box. In the Name input field, enter a name for the style. Click the OK button. Photoshop saves the lighting effect and adds it to the Style list.

- **Delete:** Click the Delete button to delete the selected style from the style list.

- **Light Type:** Click on the Light Type button to display a list of available light types. Select one of the available options to change the active light source.

- **On:** Select the On check box to turn the active light source on or off.

- **Intensity:** Click on the Intensity triangular slider and drag it left or right. The maximum values are from –100 to +100. The higher the value, the more intense the active light source.

- **Focus:** Click on the Focus triangular slider and drag it left or right. The maximum values range from −100 to +100. The higher the value, the more unfocused the active light source.

- **Color box:** Click once in the color box located to the far right of the Intensity and Focus sliders. Photoshop opens the Color Picker dialog box. Choosing a new color changes the color of the active light source. Click the OK button in the Color Picker dialog box to record your change to the active light source.

- **Gloss:** Click on the Gloss triangular slider and drag it left or right. The maximum values range from −100 to +100. The higher the value, the harsher the light source; the lower the value, the more muted the light source.

- **Material:** Click on the Material triangular slider and drag it left or right. The maximum values range from −100 to +100. The higher the value, the more metallic; the lower the value, the more plastic the items in the light source appear.

- **Exposure:** Click on the Exposure triangular slider and drag it left or right. The maximum values range from −100 to +100. Similar to Intensity, the Exposure option controls how intense the active light source.

- **Ambience:** Click on the Ambience triangular slider and drag it left or right. The maximum values range from −100 to +100. The Ambience option diffuses the active light source as if there were other light sources in the image.

- **Texture Channel:** Click the Texture Channel to display a pop-up list of all the available channels within the active image. The Texture Channels option uses the selected channel to add texture to the image. Select the White is high option to raise the white areas of the selected channel and lower the darker areas of the selected channel. Click and drag the Height slider left or right. Moving the slider to the right increases the amount of texture applied to the final image.

Click the OK button to apply the lighting effect filter to the image, as shown in Figure 531.4.

Figure 531.4 The Lighting Effects filter applied to a Photoshop image.

532 *Creating a Spotlight to Emphasize an Image Area*

In the preceding tip, you learned how the Lighting Effects filter works with a Photoshop image. In this tip, you will apply a spotlight to an image. Say, for example, you have a graphic image, and you want to emphasize a portion of the image by creating the illusion of a spotlight falling on the selected object, as shown in Figure 532.1.

Figure 532.1 Creating a spotlight will help emphasize the object in the center of the image.

To apply the spotlight to the image, select Filter menu Render and choose Lighting Effects from the pull-down menu. Photoshop opens the Lighting Effects dialog box, as shown in Figure 532.2.

Figure 532.2 The Lighting Effects dialog box controls the characteristics of the light source.

To apply the lighting effect to the image, perform these steps:

1. Select the default light source in the preview window and direct the light source down and to the right (refer to the preceding tip), as shown in Figure 532.3.

2. Click on one of the side anchor points to reduce the width of the light source, as shown in Figure 532.4.

Figure 532.3 Clicking and dragging on the anchor points surrounding the light lets you change the direction of the light source.

Figure 532.4 Clicking and dragging on the anchor points surrounding the light lets you reshape the light source.

3. Move your mouse cursor over to the right side of the Lighting Effects dialog box. Click and drag the Intensity triangular slider and set the Intensity value to +50.

4. Click and drag the Focus triangular slider and set the Focus value to +10. This tightens the focus of the light source and gives you a more definable light.

5. Click and drag the Exposure triangular slider and set the Exposure value to +20. This hits the image with a stronger light source and helps emphasize the selected items.

6. Click the OK button. Photoshop applies the light source to the image and closes the Lighting Effects dialog box, as shown in Figure 532.5.

Figure 532.5 The Lighting Effects filter applied a single light source to the image.

533 *Working with Smart Blur*

The Smart Blur filter works differently than any other Photoshop Blur filter. The Smart Blur filter blurs large sections of an image without distorting or blurring object edges. The Smart Blur filter works great at reducing the colors in a graphic, and it is even used to remove wrinkles from a photographic image. Say, for example, you have an image in which you want to smooth out the large areas of the image without losing the sharpness of the edge pixels, as shown in Figure 533.1.

Figure 533.1 The image requires softening without losing the sharpness of the edge pixels.

Select Filter menu Blur and choose Smart Blur from the fly-out menu. Photoshop opens the Smart Blur dialog box, as shown in Figure 533.2.

Figure 533.2 The Smart Blur options control the application of the blur to the image.

You observe the effects of the Smart Blur filter in the preview window (refer to Figure 533.2). The Smart Blur options control the application of the filter:

- **Radius:** In the Radius input box, enter a value from 0.1 to 100 (or click and drag the triangular slider left or right). The Radius field controls the how many pixels to search for dissimilar values. Say, for example, you set the Radius value to 5. The Smart Blur filter examines pixels using the Radius value of 5. If the pixels are dissimilar, the filter blurs them; if the pixels are relatively the same color and brightness, Smart Blur does not modify them.

- **Threshold:** In the Threshold input box, enter a value from 0.1 to 100 (or click and drag the triangular slider left or right). The Threshold field determines how different the color and brightness values of the pixels need to be before the Smart Blur filter blurs them.

- **Quality:** Click the Quality button and choose the quality of the Smart Blur. High quality requires more processing time.

- **Mode:** Click the Mode button and choose between the available options. Choose Normal to generate a Smart Blur filter based on the colors of the original image. Select Edge Only to create a black and white image with the image being black and the edges white. Select Overlay Edges to overlay the image with white edges.

Click the OK button to apply the effects of the Smart Blur to the image, as shown in Figure 533.3.

Figure 533.3 The Smart Blur filter applied to the image.

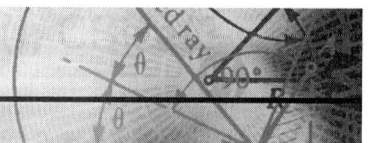

534 *Understanding the Dither Box Filter*

The Dither Box filter lets you create custom patterns and apply them to selected portions of an image. Although the Dither Box filter can create patterns for almost any use, its primary use is in the creation of patterns to be used within Web graphics.

The Dither Box filter only works on images in the RGB color space. To create a New Pattern, select Filter menu Other and choose Dither Box from the fly-out menu. Photoshop opens the Dither Box dialog box, as shown in Figure 534.1.

Figure 534.1 The Dither Box dialog box lets you create and save customized patterns.

The left side of the Dither Box dialog box contains a collection of available color patterns (refer to Figure 534.1). Clicking on any of the available color options applies the selected color to the design box, as shown in Figure 534.2.

Figure 534.2 The design box displays the active color, as selected from the available color patterns.

- **Rename:** Click the Rename button to change the name of the currently active color pattern.

- **New:** Clicking the New button creates a new color pattern icon and resets the design box to blank (refer to Figure 534.2).

- **Fill:** Click the Fill button to fill the active Photoshop document or selection with the current fill pattern.

- **Cancel:** Click the Cancel button to close the Dither Box dialog box without filling the active document or selection with a color pattern.

The design box (refer to Figure 534.2) lets you create your own customized color patterns. Choose the size of the pattern by clicking the radio button to the immediate right of the design box. The 2x2 option creates a pattern 2 pixels wide by 2 pixels tall. You can choose to create a color pattern up to 8 pixels tall by 8 pixels wide (8x8).

The design box is divided into a grid pattern; each one of the grid boxes represents a pixel in the color pattern. To select a color to paint with, move your mouse into the Web Safe Colors box on the far right and click once on a color. Then click once on the pencil tool located underneath the design box. Now select from the available grid patterns. In this example, you choose the 4x4-grid pattern. Each time you click the Pencil tool in a grid box, the box fills with the selected Web Safe Color, as shown in Figure 534.3.

Figure 534.3 Clicking with the pencil tool in a grid box fills the box with the selected Web Safe Color.

Click the Fill button to fill the current selection or layer with the newly created pattern, as shown in Figure 534.4.

For more information on applying a customized pattern to a Web page, see Tip 817, "Applying a Custom Dither Pattern to a Web Background Image."

Figure 534.4 Clicking the Fill button fills the layer or selection with the newly created pattern.

535 *Using Polar Coordinates*

The Polar Coordinates filter is one of those difficult filters to explain, much less figure out what to do with it. Adobe recommends using the filter to create a "Cylinder Anamorphosis." If you are not famil-iar with that term, it defines an 18th-century art technique in which a distorted image (Polar Coordinates), when viewed through a mirrored cylinder, appears normal, as shown in Figure 535.1.

*Figure 535.1 The Polar Coordinates filter, using the Rectangular to Polar option,
takes a flat image and maps the image to the inside of a hollow cylinder.*

To Access the Polar Coordinates filter, select Filter menu Distort and choose Polar Coordinates from the fly-out menu. Photoshop opens the Polar Coordinates dialog box, as shown in Figure 535.2.

Figure 535.2 The Polar Coordinates dialog box controls the effect of the filter on the active document.

The Polar Coordinates dialog box contains two options:

- **Rectangular to Polar:** Select this option to wrap a normal Photoshop image around the inside of a hollow cylinder (refer to Figure 535.2).

- **Polar to Rectangular:** Select this option to reverse the distortion effect Rectangular to Polar. Applying this option to a normal image produces mixed results, as shown in Figure 535.3.

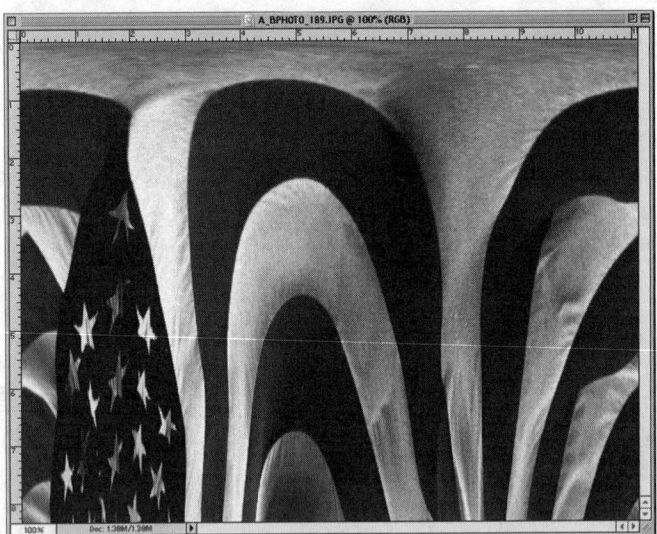

Figure 535.3 Applying the Polar to Rectangular option to a normal image creates a highly distorted image.

Note: Although the Polar Coordinates filter has limited practical use, it can be used to create interesting background patterns. Experimentation is the key to success when working in Photoshop.

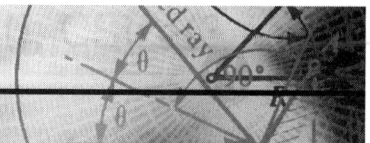

536 *Working with 3D Transformation*

Photoshop's 3D Transform filter lets you manipulate two-dimensional objects, such as cubes, cylinders, or spheres, using wire frame to define the shape. Once you define the initial shape, you can change the form into a more complicated shape using standard Pen tools.

Say, for example, you have a photograph of a box, and you want to create the effect of text wrapped around a cube shape. To wrap text around a cube using the 3D Transform filter, open the image in Photoshop and perform these steps:

1. Select the Type tool and create the text you want to display on the surface of the box. Position it across the center of the box, as shown in Figure 536.1. For more information on using the Type tool, refer to Tip 218, "Creating Text in Photoshop 6.0."

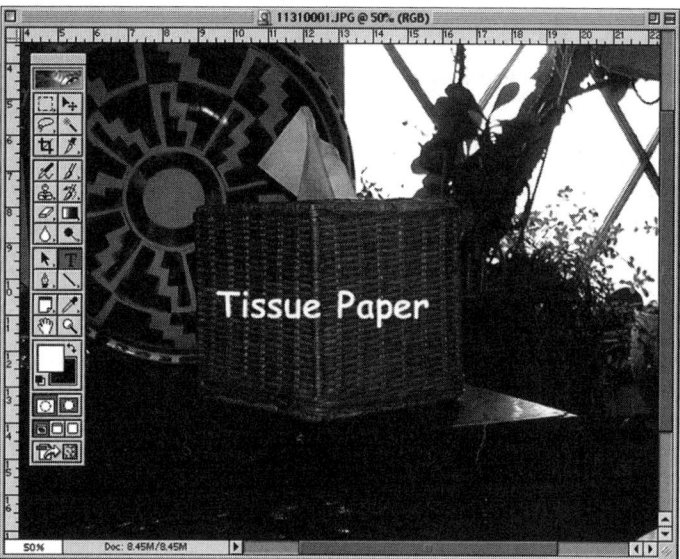

Figure 536.1 Using the Type tool, create the words you want displayed on the surface of the cube.

2. If the Layers palette is not visible, click on the Layers tab or select the Window menu and choose Show Layers from the pull-down menu. Photoshop displays the Layers palette, as shown in Figure 536.2.

Figure 536.2 The Layers palette in Photoshop displays all the layers in the active document.

3. Click on the black triangle button in the upper-right corner of the Layers palette. Photoshop displays the Layers palette options in a pop-up menu. Select Flatten Image from the pop-up menu. Photoshop combines the image layer and text layer into a Background layer.

Note: To flatten the image, you must first select a layer other than the text layer.

4. Select the Filter menu, select Render and choose 3D Transform from the fly-out menu. Photoshop opens the 3D Transform dialog box, as shown in Figure 536.3.

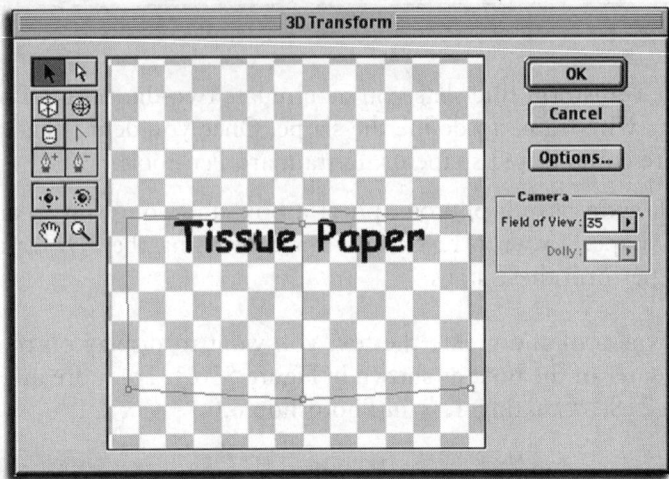

Figure 536.3 The 3D Transform dialog box lets you create three-dimensional objects from two-dimensional photographs.

5. Click once on the Cube tool, located in the toolbox on the left side of the dialog box (refer to Figure 536.3).

6. Move into the preview window and draw a cube shape that closely resembles the box in the photograph. Do not worry if the cube does not line up correctly; you will fix that in the next step.

7. You have two selection tools in the 3D Transform toolbox. The black arrow on the left lets you click and drag the cube shape within the preview box without distorting the shape of the cube. The white arrow on the right lets you click on the anchor points located at the corners of the box and reshape the box. Using the two selection tools, move and reshape the cube to fit the image of the box, as shown in Figure 536.4.

Figure 536.4 The selection tools let you move and reshape the wire frame cube.

8. Once the cube wire frame shape fits the image, select the Trackball tool and rotate the image, as shown in Figure 536.5.

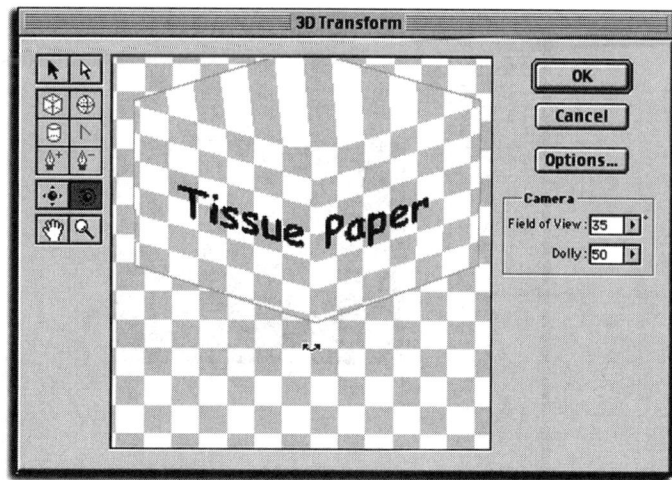

Figure 536.5 *The Trackball tool lets you rotate the cube and text together to produce a 3D box.*

9. Click the OK button to close the 3D Transform dialog box and apply the transformation to the image, as shown in Figure 536.6.

Figure 536.6 *Clicking the OK button applies the transformation to the image.*

Note: The 3D Transform tool works on the active layer within the image. If you want to make the text appear to wrap around a photographic surface without changing the image, skip step 3 and apply the 3D Transform to the text without flattening the document.

537 *Choosing the Correct Render Option in 3D Transform*

In the preceding tip, you learned how to wrap text around the surface of a cube. When you perform a 3D Transform, Photoshop gives you options to control how the transformation is performed. To use the 3D Transform options, open an image in Photoshop, select File menu Render, and choose 3D Transform from the fly-out menu. Photoshop displays the 3D Transform dialog box, as shown in Figure 537.1.

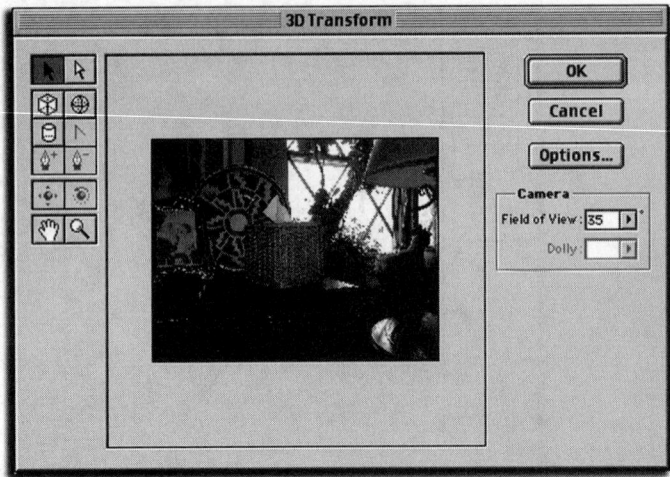

Figure 537.1 The 3D Transform dialog box gives you options to control the results of the transformation.

Using the information from the preceding tip, create a wire frame in the document. Before you apply the transformation, however, click on the Options button. Photoshop opens the Options dialog box, as shown in Figure 537.2.

Figure 537.2 The Options dialog box controls the quality of the transformation.

- **Resolution:** Click on the Resolution option. Photoshop displays a list of available resolutions in a drop-down list. Select High for documents sent to high-end printers and presses, Medium or High for documents printed on laser and ink-jet printers, and Low for images displayed on monitors and Web pages.

- **Anti-Aliasing:** Click on the Anti-Aliasing option. Photoshop displays a list of available options in a drop-down list. Select Low or None for Web documents and Medium or High for documents output to print.

- **Display Background:** Click in the Display Background check box to activate or deactivate this option. If you do not select the Display Background option, the final transformation displays without the background image. Use the option when you want to eliminate the background and preserve only the transformed object.

538 *Creating Custom Filters*

Photoshop lets you create your own customized filter effects by using the Custom filter option. To create you own filter, open an RGB document in Photoshop, select the Filter menu, select Other, and choose Custom from the fly-out menu. Photoshop opens the Custom filter dialog box, as shown in Figure 538.1.

Figure 538.1 The Custom filter dialog box lets you create your own customized filter effects.

The Custom filter dialog box contains a grid of boxes five across and five down. Photoshop lays a grid pattern over the active image and divides the graphic into grid boxes 5 pixels wide by 5 pixels tall.

In the center box, enter a value from –999 to +999. The value represents the amount you want to multiply the brightness value of the center pixel. If you remove all numbers from the grid and enter a 1 in the center box, the visible image appears normal. Positive numbers lighten the image, and negative numbers darken the image.

Each time you enter a numeric value in a grid box, you instruct Photoshop to multiply the brightness value of that pixel by that numeric value. Raising and lowering the brightness values of alternating pixels creates a chiseled look to the image, as shown in Figure 538.2.

Figure 538.2 Alternating positive and negative values creates a chiseled look to the image.

There are two other options controlling the Custom filter: Scale and Offset.

- **Scale:** In the Scale input field, enter a value from 1 to 9999. The Scale value adds to the results of the average values entered in the grid boxes. The higher the value, the darker the image. While the grid boxes manipulate each pixel separately, the Scale value, on average, effects the entire image.

- **Offset:** In the Offset input field, enter a value from –999 to +999. Photoshop adds the Offset value to the results of the Scale value. Negative numbers darken the image, and positive numbers lighten the image.

Click the OK button to record you changes to the active image, as shown in Figure 538.3.

Figure 538.3 A customized filter applied to a Photoshop document.

539 *Applying Filter Effects to Separate Channels*

When you work with the filter options in Photoshop, you typically apply the filter effect to the entire image. When you apply a filter to the image, each color channel within the image changes to reflect the effects of the filter. Applying a filter effect to a single channel creates special effects beyond the normal application of the filter.

Say, for example, you use the Smart Blur on a photograph, but the effect is too pronounced, as shown in Figure 539.1. You want to use the Smart Blur filter in a way that changes the image but retains more detail.

To apply the Smart Blur filter to a separate channel, open a document in Photoshop and perform these steps:

1. If the Channels palette is not visible, click on the Channels tab or select the Window menu and choose Show Channels from the pull-down menu. Photoshop opens the Channels palette, as shown in Figure 539.2.

Figure 539.1 The Smart Blur filter applied to the image.

Figure 539.2 The Channels palette displays the color channels for the active image.

2. Move your mouse into the Channels palette and click once on the Green channel. Photoshop selects the Green channel and deactivates the Red and Blue channels.

3. Select Filter menu Blur and choose Smart Blur from the fly-out menu. Photoshop opens the Smart Blur dialog box, refer to Figure 539.3.

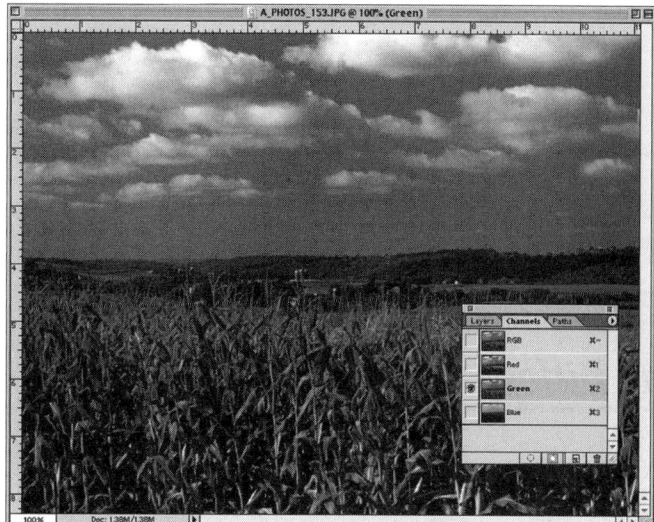

Figure 539.3 The Smart Blur dialog box controls the application of the blur to the Green channel.

4. Refer to Tip 533, "Working with Smart Blur," for information on applying a Smart Blur. Click the OK button. Photoshop applies the Smart Blur filter to the Green channel, as shown in Figure 539.4.

Figure 539.4 The Smart Blur filter applied to the Green channel.

5. Move your mouse into the Channels palette and click once on the RGB composite channel. Photoshop reactivates all the channels and displays the results in the document window, as shown in Figure 539.5.

Figure 539.5 Applying the Smart Blur to the Green channel gives you an image with a detailed, soft appearance.

540 *Using Difference Clouds and Levels to Create Lightning*

A great way to create realistic lightning without going out in the middle of a thunderstorm is by using the Difference Clouds filter with the Levels command.

To create lightning from scratch, open Photoshop and perform these steps:

1. Select File menu New. Photoshop opens the New dialog box, as shown in Figure 540.1.

Figure 540.1 The New dialog box in Photoshop defines the characteristics of the New document.

1. Create a New document with these characteristics:

 • **Width and Height:** 5 inches

 • **Resolution:** 150 pixels/inch

 • **Mode:** RGB

 • **Contents:** White

2. After you enter the changes, click the OK button. Photoshop will close the New dialog box and open the new document.

3. Press the letter "D" on your keyboard. Photoshop changes the Foreground and Background color swatches to black and white.

4. Select the Gradient tool from the toolbox and create a black and white gradient similar to Figure 540.2. For more information on creating customized gradients, refer to Tip 175, "Creating Custom Gradients."

5. Apply the gradient by clicking and dragging the Gradient tool from the upper-left to the lower-right corner of the document window, as shown in Figure 540.3.

Figure 540.2 Create a black and white gradient with two or more black and white transitions.

Figure 540.3 The Gradient applied to the document window produces an angled black and white image.

6. Select the Filter menu, choose Render and select Difference Clouds from the fly-out menu. Photoshop applies the Difference Clouds filter to the gradient in the document window, as shown in Figure 540.4.

Note: Make sure you select the Difference Clouds filter and not the Clouds filter.

Figure 540.4 The Difference Clouds filter applied to the black and white gradient.

7. Select the Image menu, select Adjust, and choose Invert from the fly-out menu. Photoshop inverts the colors in the document window.

8. Select the Image menu, choose Adjust, and then choose Levels from the fly-out menu. Photoshop opens the Levels dialog box, as shown in Figure 540.5.

Figure 540.5 The Levels dialog box controls the brightness levels of the image pixels.

9. Click on the black input slider and drag it to the far right (refer to Tip 201, "Understanding How the Levels Command Adjusts an Image"). As you drag the black slider to the right, you remove the darker pixels from the image and further define the white streaks. Stop dragging the slider when you see something similar to Figure 540.6.

Figure 540.6 *The Levels command eliminates the darker portions of the image, leaving only the lightning.*

Note: *To learn how to use this layer to add lighting to an image, refer to Tip 345, "Working with the Blend If Option to Create Transparency."*

Note: *Since this image is used in a later tip, you may wish to stop and save the image to disk.*

541 *Selecting Colors with the Swatches Palette*

You do not have to work in Photoshop for long before realizing that there are many ways to locate and select colors. One of the easiest ways to select color is with Photoshop's Swatches palette. To view the Swatches palette, click once on the Swatches tab or select the Window menu and choose Show Swatches from the pull-down menu. Photoshop opens the Swatches palette, as shown in Figure 541.1.

Figure 541.1 *The Swatches palette displays a color swatch for each color in the palette.*

To select a specific color from the Swatches palette, move your mouse cursor into the palette and click once in the desired color. Photoshop changes the Foreground color swatch to the selected color, as shown in Figure 541.2.

Figure 541.2 Clicking on a specific color in the Swatches palette changes the Foreground color swatch in Photoshop's toolbox.

The Foreground color swatch represents the current painting color. All of Photoshop's painting, line, and text tools use the Foreground color. In addition, if you create a fill shape using Photoshop's new Shape tools, by default, the fill color is the current Foreground color swatch.

To select a Background color, move your mouse into the Swatches palette, hold down the Alt key (Macintosh: Option key) and click on a color swatch. Photoshop changes the Background color swatch to the selected color, as shown in Figure 541.3.

Figure 541.3 Clicking on a specific color in the Swatches palette while holding down the Alt key changes the Background color swatch in Photoshop's toolbox.

The Background color swatch represents the color used when you use the standard Eraser tool on a Background layer, as shown in Figure 541.4.

Figure 541.4 The standard Eraser tool uses the current Background color swatch as its erasing color.

542 Selecting Colors Using the Eyedropper Tool

In the preceding tip, you learned how easy it is to select colors from the Swatches palette. To add range to the colors you select, use the Eyedropper tool. Say, for example, you want to use a specific color, but the color you want is not part of the current Swatches palette; instead, it is in the current document.

To select a color from the current open Photoshop document, perform these steps:

1. Select and hold your mouse on the Eyedropper tool options. Photoshop opens a dialog box displaying the eyedropper choices, as shown in Figure 542.1.

Figure 542.1 The Eyedropper tool options in Photoshop's toolbox.

2. Select the Eyedropper from the available list. Photoshop selects the Eyedropper tool and makes it the active tool.

3. Move the Eyedropper tool into the document window and click once. Photoshop replaces the current Foreground color swatch with the sample directly underneath the Eyedropper tool.

4. Click the Eyedropper tool in the document window while holding down the Alt key (Macintosh: Option key) to change the current Background color.

5. To change the area the Eyedropper samples, move your mouse into the Options bar and click on the Sample Size option. Photoshop displays a drop-down menu with three Sample Size options:

 • **Point Sample:** Select this option to sample the pixel directly under the tip of the eyedropper.

 • **3 by 3 Average:** When you click the eyedropper tool, the selected color is based on a grid 3 pixels wide by 3 pixels tall, or an average of 9 pixels.

 • **5 by 5 Average:** When you click the eyedropper tool, the selected color is based on a grid 5 pixels wide by 5 pixels tall, or an average of 25 pixels.

Note: Using the 3 by 3 or 5 by 5 Average sampling techniques is useful for selecting flesh tones and diversely colored backgrounds. In both cases, you want an average of the chosen color, not the exact color under the point of the Eyedropper tool.

543 *Using Photoshop's Color Spectrum*

In the preceding tip, you learned how to use the Eyedropper tool to select a color directly from the image. Another way to select a specific color is to use Photoshop's Spectrum palette. The Spectrum palette is located in Photoshop's Color palette.

To view the Color palette, click on the Color tab or select the Window menu and choose Show Color from the pull-down menu. Photoshop opens the Color palette, as shown in Figure 543.1.

Figure 543.1 The Spectrum palette is located at the bottom of Photoshop's Color palette.

Click on one of the two color swatch boxes, located on the left side of the Color palette, to activate the foreground or background color. To select a color, move your mouse into the Spectrum and click once over the desired color. In turn, Photoshop replaces the active color swatch with the selected color.

To change the default Spectrum palette, click once on the black triangle button in the upper-right corner of the Color palette. Photoshop displays the Color palette options, as shown in Figure 543.2.

Figure 543.2 Click on the black triangular button to display a list of options for the Color palette.

At the bottom of the options list are the available Spectrum palettes. Click to select the RGB, CMYK, or Grayscale spectrums. Select Current Colors to display a gradient representing the current Foreground and Background color swatches. Select Make Ramp Web Safe to display only Web Safe colors in the Spectrum palette, as shown in Figure 543.3.

Figure 543.3 Selecting the Make Ramp Web Safe converts the Spectrum palette to Web Safe colors.

544 *Choosing Colors by Their Numeric Values*

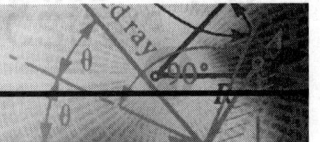

In the preceding tip, you learned how to select colors using the Spectrum palette. The Spectrum palette is part of Photoshop's Color palette. The Color palette lets you select colors by their numeric ink values.

To view the Color palette, click on the Color tab or select the Window menu and choose Show Color from the pull-down menu. Photoshop opens the Color palette, as shown in Figure 544.1.

Figure 544.1 The Color palette lets you select colors based on their numeric ink values.

To change the current color sliders, click once on the black triangle button in the upper-right corner of the Color palette. Photoshop displays the Color palette options, as shown in Figure 544.2.

Select one of the available Slider options from the fly-out menu. Photoshop closes the options menu and changes the Color sliders (refer to Figure 544.1).

- **RGB:** Mixes a color using red, green, and blue ink. In the RGB input boxes, enter a value from 0 to 255 (or click and drag the sliders left or right). Zero indicates none of the selected ink is used to mix the color, and a value of 255 indicates 100 percent of the selected ink is used to mix the color.

Figure 544.2 Click on the black triangular button to display a list of options for the Color palette.

- **CMYK:** Mixes a color using cyan, magenta, yellow, and black ink. In the CMYK input boxes, enter a value from 0 to 100 (or click and drag the sliders left or right). The higher the value, the more of that specific ink is used to mix the color.

- **Grayscale Slider:** Mixes a color using black ink. In the black (K) input box, enter a value from 0 to 100 (or click and drag the sliders left or right). The higher the value, the darker the ink. Entering 100 percent produces black and 0 percent produces white.

- **HSB Sliders:** Mixes a color using hue, saturation, and brightness. To change the values of the HSB input boxes, click in a specific input box and enter a value (or click and drag the sliders left or right). The hue (H) field represents all the colors on the color wheel; use input values from 0 to 360 degrees. The saturation (S) input field represents the saturation of the ink color; click in the input box and enter a value from 0 to 100 percent saturated. The brightness (B) input field represents the brightness of the color. Enter a value from 0 to 100 percent bright.

- **Lab Sliders:** Mixes a color using Lab and a, b channels. In the Lab input boxes, enter a value from 0 to 120 (or click and drag the sliders left or right). The Lab color mode best represents how your eyes view color.

- **HTML:** Mixes a color using red, green, and blue ink. In the RGB input boxes, enter the hexadecimal color code (or click and drag the sliders left or right). The HTML color space functions similar to the RGB color space. However, the only colors available are Web Safe colors.

545 *Using Lab Color to Preserve Image Color*

Photoshop offers you a variety of color modes to choose from:

- Bitmap
- Duotone
- RGB
- Lab

- Grayscale
- Indexed Color
- CMYK
- Multi-channel

Each one of Photoshop's color modes lets you define color using a specific definition of that particular color mode. For example, the RGB color space uses red, green, and blue ink to mix the visible colors in the image, and the CMYK color space uses cyan, magenta, yellow, and black. The color space of a graphic image is determined by where the document is viewed.

The most commonly used color mode in Photoshop is the RGB color space. When you work in Photoshop, you have access to most of the program's tools, adjustments, and filters. In addition, at the end of the editing process, it is a simple matter to convert an RGB image into whatever color mode is required. Because of these reasons, most designers use the RGB color space for most of their editing and design of a Photoshop document.

Photoshop's color modes are unique in the fact that they evolve. As new technologies emerge, it redefines how we use color and how Photoshop applies that color to the digital image. When you work in the RGB color space, be careful how you move the document.

Say, for example, you want to move an RGB Photoshop document from one computer to another. No problem. You save the document to disk and reopen it on the other system. If the two computers are running different versions of Photoshop, you will have a problem.

As the RGB color mode evolves, Photoshop keeps up with the technology by changing the definition of what defines RGB color. That means different versions of Photoshop redefine what constitutes an RGB color. If you move a color-corrected RGB image from Photoshop 6.0 to Photoshop 4.0, the RGB image will shift to the definition of RGB color as defined by Photoshop 4.0. That means the colors in the image shift slightly.

If you do not want this to happen, try converting the image to Lab color before saving and moving the image. The Lab color has not shifted between versions of Photoshop; therefore, every version of Photoshop currently on the market uses the same definition for Lab color.

To move an RGB image between different versions of Photoshop, open the document and perform these steps:

1. Select the Image menu, select Mode and choose Lab Color from the fly-out menu. Photoshop converts the colors in the image from RGB to Lab color.

2. Select the File menu and choose Save As from the pull-down menu. Photoshop opens the Save As dialog box, as shown in Figure 545.1.

3. Select a name and format for the document and save the image. The format of the document is not important; however, if you are reopening the document in Photoshop, the two best formats are *.psd*, and *.tif*.

4. Click the Save button. Photoshop saves the image to disk.

Figure 545.1 The Save As dialog box lets you save a Photoshop document.

Note: *When you reopen the Lab color document, repeat step 1 except choose RGB to return the image to its original colors.*

546 *Working with Pantone Colors*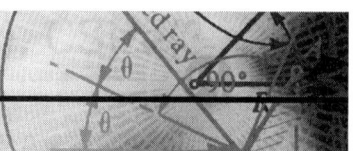

You use the Pantone color-matching system when you work with images that output to four-color press. Each Pantone color has a specified CMYK (cyan, magenta, yellow, and black) equivalent. When you define your colors using the Pantone system, the press operator knows exactly how to mix the ink. This ensures that the colors you select for the document are the colors used to print the document.

The initial selection of a Pantone color is not made using Photoshop but by selecting the color using a Pantone color guide, as shown in Figure 546.1.

Pantone color guides display the Pantone colors on paper stock similar to the stock used to print your document. A color swatch and a number identify each color. Visually select the color from the color guide and write down the corresponding Pantone number. Then select the desired colors using Photoshop's built-in Pantone color palette.

Say, for example, you've designed a brochure. You've identified the color you want to use for the background as a Pantone 298 CV blue. To select the Pantone 298 CV, open Photoshop and perform these steps:

1. Move your mouse into the Photoshop toolbox and click once on the Foreground color swatch. Photoshop opens the Color Picker dialog box. Click the Custom button on the right of the Color Picker dialog box. Photoshop opens the Custom Colors dialog box, as shown in Figure 546.2.

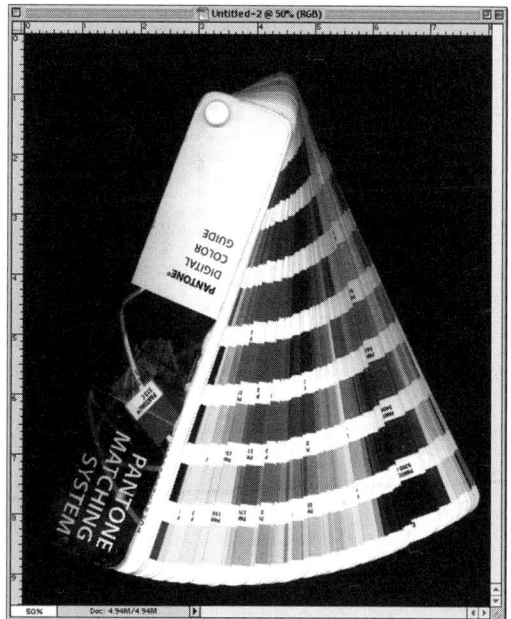

Figure 546.1 *Make the initial selection of a Pantone color using a Pantone color guide.*

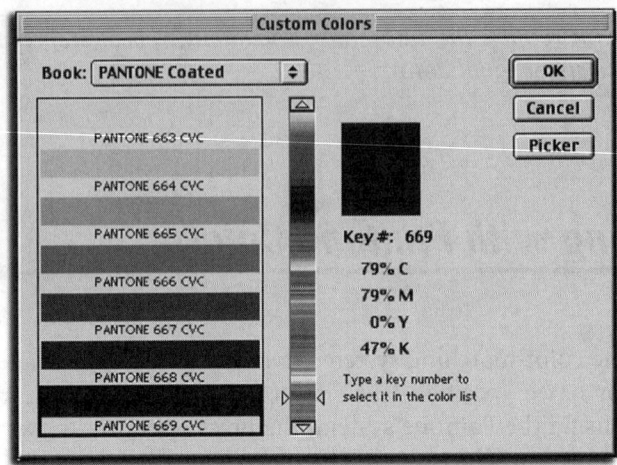

Figure 546.2 The Custom Colors dialog box lets you access all of Photoshop's built-in color palettes.

2. Click once on the Book button. Photoshop displays a list of all available color sets. Since your brochure prints on coated stock paper, select Pantone Coated. Photoshop opens the Pantone Coated color book, as shown in Figure 546.3.

3. The Pantone color you want is the Pantone 298 CV. Type the numbers 2, 9, and 8 on your numeric keypad. Photoshop selects the 298 CV blue color, as shown in Figure 546.4.

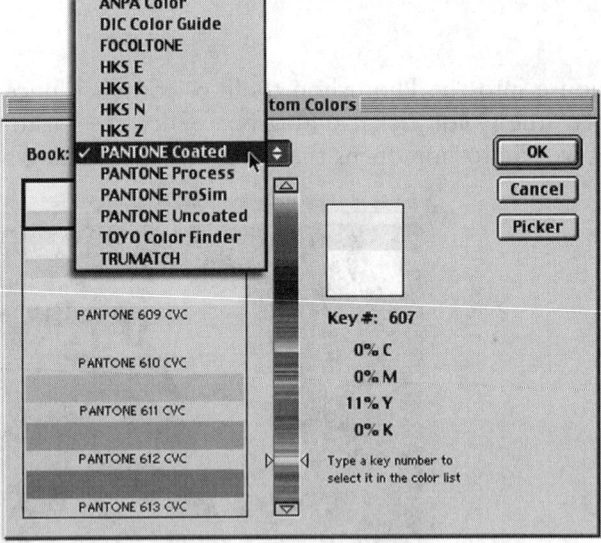

Figure 546.3 The Pantone Coated color book displays a listing of all the Pantone Coated colors.

4. Click the OK button to close the Custom Colors dialog box. The Foreground color swatch now contains the Pantone 298 CV color.

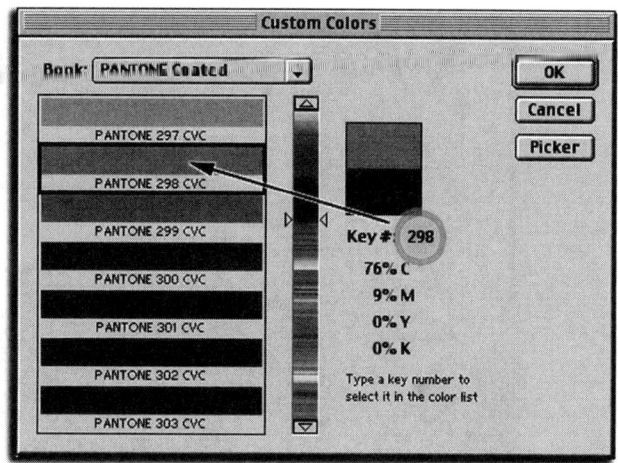

Figure 546.4 To select the 298 CV Pantone colors, enter the numbers 2,9, and 8 on your keyboard.

547 *Adding Individual Colors to the Swatches Palette*

In the preceding tip, you learned how to select a custom Pantone color using the Foreground color swatch. Chances are, however, that you want to save the color so you can access it when needed.

To save a color to the current Swatches palette, open Photoshop and perform these steps:

1. To view the Swatches palette, click once on the Swatches tab or select the Window menu and choose Show Swatches from the pull-down menu. Photoshop opens the Swatches palette, as shown in Figure 547.1.

Figure 547.1 The Swatches palette displays a color swatch for each color in the palette.

2. Using the preceding tip, select the Foreground color swatch and choose a specific Pantone color. In this example, you will use the same Pantone 298 CV. The Pantone color is now the current Foreground color swatch.

3. Move your mouse into the Swatches palette and move below the last swatch. If the Swatches palette is not big enough, click on the lower-right corner of the Swatches palette and drag down to expand the size of the palette. Your cursor resembles a Paint Bucket icon.

4. To add the current Foreground color swatch to the Swatches palette, click once. Photoshop opens the Color Swatch Name dialog box, as shown in Figure 547.2.

Figure 547.2 The Color Swatch Name dialog box lets you define a name for the new color.

5. In the Name input field, enter a name for the color. Click the OK button to save the color swatch to the Swatches palette, as shown in Figure 547.3.

Note: *If the swatch is a Pantone color, use the actual Pantone name. That will help you identify the color later.*

Figure 547.3 The Pantone color is available whenever you open the Swatches palette.

548 *Using the Background Eraser to Erase the Edge of an Image*

One of the more difficult things to do in Photoshop is to precisely select information within an image. Say, for example, you have an image containing an object, and you want to select the object and remove the background. If the background is solid, try using the Background eraser. The Background eraser will not select the object; it will erase the background and leave the image.

In Tip 540, "Using Difference Clouds and Levels to Create Lightning," you created lightning against an opaque background. You want to erase the black background and preserve the lightning.

To erase the background from the Lightning layer, open the document in Photoshop and perform these steps:

1. Click and hold your mouse on the Eraser icon in the Photoshop toolbox. Photoshop opens a pop-up menu containing a list of available Eraser tools, as shown in Figure 548.1.

Figure 548.1 The Eraser options in the Photoshop toolbox.

2. Select the Background Eraser from the available options. Photoshop closes the Eraser options and makes the Background Eraser the default tool.

3. The Options bar displays the available options for the Background Eraser, as shown in Figure 548.2.

4. Click the black triangle to the right of the Brush icon. Photoshop displays a list of available brush sizes. Select a large, soft brush. In this example, you select a 100-pixel soft brush, as shown in Figure 548.3.

Figure 548.2 The Options bar displays the available options for the Background Eraser.

Figure 548.3 The Brush palette displays a list of all the brush sizes available to the Background Eraser tool.

5. Click on the Limits option and select Find Edges from the drop-down menu. The Find Edges option helps the Background Eraser identify the edges of the lightning.

6. In the Tolerance input field, enter a value of 50. Input values range from 1 to 100. The higher the value, the more colors the Background Eraser uses. In this example, you choose a value of 50 percent.

7. Click in the Protect Foreground Color check box and remove the check mark from the box.

8. Click the Sampling button and select Once from the available options. Since you only need to remove the background colors, you only need to sample the image once.

9. Move your cursor into the document window and position the plus sign located in the middle of the brush icon over the area between the rose and the background. These are the colors you want removed from the image.

10. Click and hold your mouse button and drag across the image. Photoshop erases only the background areas of the image. The rose, because of its different color, remains intact.

11. Continue dragging across the image until all the background areas convert to transparent, as shown in Figure 548.4.

Figure 548.4 The Background Eraser tool successfully removed all the black pixels from the image.

549 *Selecting Color with the Foreground Color Button*

In Tip 547, "Adding Individual Colors to the Swatches Palette," you learned how to add a Pantone color to the Swatches palette using the Foreground color swatch. The Foreground color swatch selects more than just Pantone colors. Say, for example, you want to identify a color for use in a Photoshop document. You do not need to use the Pantone colors; you want to identify the color using your monitor.

To select a generic color using the Foreground color swatch, click once on the Foreground color swatch. Photoshop opens the Color Picker dialog box. If the dialog box displays the Custom color set, click once on the Picker button, as shown in Figure 549.1.

Figure 549.1 *The Color Picker dialog box lets you select a color by its numeric values or by using the color preview window.*

To select a color, move your mouse into the color preview window and click once to select the color. Photoshop changes the Current Color box to the selected color, as shown in Figure 549.2. The Original Color box always displays the original Foreground color.

Figure 549.2 *The Current Color box displays the selected color.*

When you select a color, you might see one or two warnings, as shown in Figure 549.3.

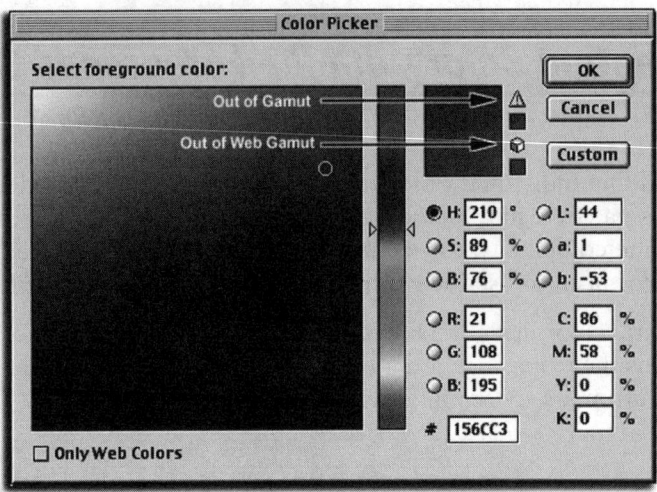

Figure 549.3 The Gamut warning icons let you know when the color you have chosen falls outside a predefined limit.

- **Out of gamut:** The out-of-gamut warning indicates that the color you have chosen falls outside the colors reproducible by a four-color (CMYK) printing press.

- **Out of Web gamut:** The out-of-Web-gamut warning indicates that the color you have chosen falls outside the Web Safe color palette.

Click the OK button to transfer the selected color to the Foreground color swatch.

Note: Clicking once on either the out-of-gamut or the out-of-Web-gamut icons moves the selected color in the preview window to the closest acceptable printing or Web Safe value.

550 *Comparing Corrections in CMYK and RGB Color Space*

Photoshop lets you perform color correction in either the RGB or CMYK color space. However, care should be exercised when choosing a color space. If the Internet is the final destination of the image, then there is no reason to use the CMYK color space.

If the image is destined for use in a magazine and that magazine uses a four-color printing press, then perform the editing of the image in the RGB color space. When the editing process is complete, convert the image to CMYK and perform the final color correction.

The reasons to use RGB as your editing color space are:

- An RGB image is 25 percent smaller than the same image in CMYK. You save memory and filters, and adjustments perform faster.

- The RGB color space is not dependent on a specific ink, so you have more independent control over editing the image.

- Photoshop makes more filters and adjustments available if the image is in the RGB color space.

- Your monitor displays colors using the RGB color space. Although Photoshop displays a preview of CMYK color, colors display more accurately if you use the RGB color space.

If you move an image from the RGB to the CMYK color space, plan to make the conversion only once. Every time you convert an image from RGB to CMYK or vise versa, Photoshop rounds the color values, and important color information is lost every time you move between the color spaces. You have to make the conversion once. Plan ahead and only convert the image one time.

To view the image in CMYK color space while you work in RGB color, select the View menu, choose Proof Setup and select Working CMYK from the fly-out menu. Photoshop displays the colors as close to CMYK as possible.

Note: Choosing Working CMYK from the View menu does not change the colors within the image. Working CMYK only changes the view on your monitor.

551 *Using the Web Safe Color Sliders*

The Web Safe colors are the 216 colors available to browsers like Navigator and Explorer. They are colors that display regardless of the computer or operating system used. Designers created the Web Safe color palette by looking at Windows and Macintosh computers and deciding what colors would display on both systems. Photoshop gives you several ways to select colors for a Web image, and one of those ways is the Color palette.

To select colors using the Web Safe color palette, you need access to the Color palette. To view the Color palette, click on the Color tab or select the Window menu and choose Show Color from the pull-down menu. Photoshop opens the Color palette, as shown in Figure 551.1.

Figure 551.1 The Color palette displays colors for all available color modes.

To change to the Web Safe color palette, click once on the black triangle button in the upper-right corner of the Color palette. Photoshop displays the Color palette options, as shown in Figure 551.2.

Figure 551.2 Click on the black triangular button to display a list of options for the Color palette.

Click on the Web Color Sliders option. Photoshop changes the Color palette to display the Web Safe color sliders, as shown in Figure 551.3.

Figure 551.3 The Color palette displaying the Web Safe color sliders.

Changing a color using the Web Safe color palette changes the current Foreground or Background color swatch. The left side of the Color palette contains two color swatch icons that resemble the Foreground and Background color swatches on Photoshop's toolbox (refer to Figure 551.3). Click once on one of the swatch icons to change the Foreground or Background color swatch.

Click on one of the triangle icons under the sliders and drag left or right to change the current color. Notice that when you drag your mouse, the triangle icon jumps from point to point on the slider. The tick marks, located at the bottom of the slider, indicate the positions of the Web Safe colors, and the slider restricts you to only those marks.

If you want to temporarily override the Web Safe colors, click on one of the triangle icons and drag it left or right while holding the Alt key (Macintosh: Option key). The triangle icon will now move to any position on the slider; however, the color you selected is not a Web Safe color.

Photoshop warns you when you select a color outside the Web Safe palette by displaying a small cube in the lower-left of the Color palette, as shown in Figure 551.4.

Figure 551.4 The small cube icon indicates that the selected color is not a Web Safe color.

Click once on the cube icon to instruct Photoshop to select the closest Web Safe color. The triangle icons under the sliders will shift to the closest Web Safe color match, and the cube icon disappears.

Once you select the color with the Web Safe color palette, it becomes available for use by any of Photoshop's editing or painting tools.

> *Note: If you want to save the color to the Swatches palette, refer to Tip 547, "Adding Individual Colors to the Swatches Palette."*

552 *Converting Colors into Hexadecimal Values*

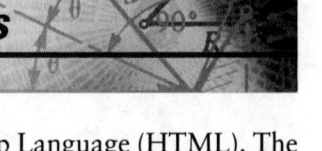

Web pages are constructed using a programming code called Hypertext Markup Language (HTML). The HTML coding language is a universal way to design a Web path that is viewable by any computer or operating system. When you work with color, the HTML code requires the hexadecimal value for that specific value. For example, the hexadecimal value for the color red is: #FF0000. Inserted into an HTML document, the code looks like this: color = "FF0000."

While most Web designers use charts or programs like GoLive and Dreamweaver to assist them in selecting the correct hexadecimal value, Photoshop gives you a quick and easy way to identify the hexadecimal value for any color in a document.

To convert a Photoshop color into its hexadecimal value, open a document in Photoshop and perform these steps:

1. Click and hold your mouse on the Eyedropper icon located in the Photoshop toolbox. Photoshop displays a pop-up list displaying the Eyedropper options, as shown in Figure 552.1.

Figure 552.1 Clicking and holding your mouse on the Eyedropper icon displays a list of all available Eyedropper options.

2. Select the Eyedropper tool from the options list. Photoshop closes the list and makes the Eyedropper the default tool.

3. Move the Eyedropper into the document window and right-click on a color (Macintosh: Ctrl+click). Photoshop opens a context-sensitive menu, as shown in Figure 552.2.

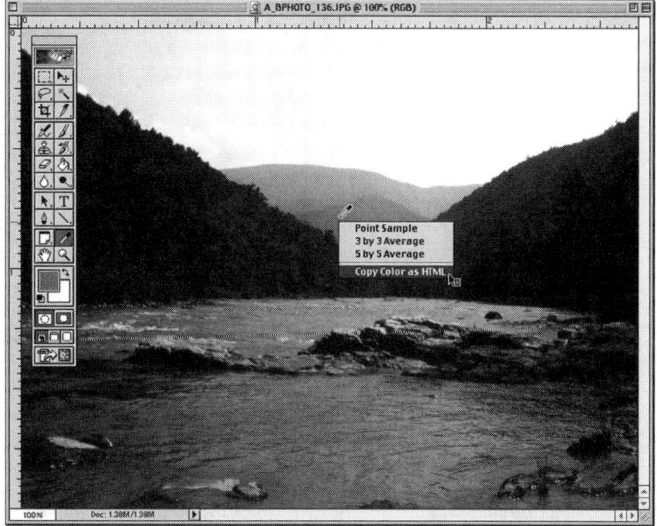

Figure 552.2 Right-clicking your mouse while using the Eyedropper tool displays a context-sensitive menu.

4. Select Copy Color as HTML from the context-sensitive menu. Photoshop copies the hexadecimal value of the selected copy to Clipboard memory.

5. To paste the color value into an HTML document, open the file in a Web or word-processing program and choose Edit menu Paste. The program inserts the information into the text document, as shown in Figure 552.3.

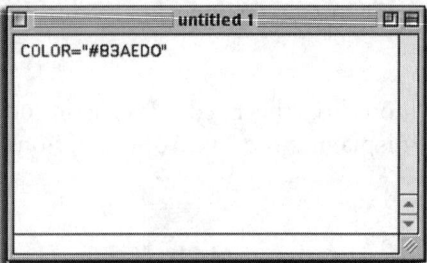

Figure 552.3 The hexadecimal value of the selected color, inserted into a generic text-processing program.

553 *Creating Web Safe Colors from the RGB Color Palette*

In Tip 534, "Understanding the Dither Box Filter," you learned how to create a customized pattern using the Dither Box filter. The primary use of the Dither Box filter is creating a unique color for a Web page using Web Safe colors. Say, for example, you create a Web page, and the color you want to use for the background is not a Web Safe color. You could use the color anyway; but a large percentage of people viewing your Web page would not be able to see the color you have chosen.

The solution is to create a new color from the Web Safe color palette using the Dither Box filter. To create a Web Safe color from an RGB color, open the document in Photoshop and perform these steps:

1. Click and hold you mouse on the Eyedropper icon in the Photoshop toolbox. Photoshop displays a pop-up list displaying the Eyedropper options, as shown in Figure 553.1.

Figure 553.1 Clicking and holding on the Eyedropper icon displays a list of all available Eyedropper options.

2. Select the Eyedropper tool from the options list. Photoshop closes the list and makes the Eyedropper the default tool.

3. Move the Eyedropper into the document window and click once on the RGB color you want to convert into a Web Safe color. Photoshop selects the color and displays it in the Foreground color swatch, as shown in Figure 553.2.

Figure 553.2 The Foreground color swatch displays the color selected from the RGB document.

4. Select Filter menu Other and choose Dither Box from the fly-out menu. Photoshop opens the Dither Box dialog box, as shown in Figure 553.3.

Figure 553.3 The Dither Box dialog box lets you convert an RGB color into a Web Safe Color.

5. The Dither Box dialog box contains two large swatch boxes labeled RGB and Pattern (refer to Figure 553.3). The RGB swatch box represents the color you selected with the Eyedropper tool.

6. Click once on the yellow arrow icon located between the Pattern and RGB swatch boxes. Photoshop creates a New Color in the Collection box and generates a 2-by-2 pattern in the pattern preview box, as shown in Figure 553.4.

7. Click the Rename button. Photoshop opens the Pattern Name dialog box, as shown in Figure 553.5.

Figure 553.4 Clicking the yellow arrow icon creates a Web Safe pattern from an RGB color.

Figure 553.5 The Pattern Name dialog box lets you assign a name to the new pattern.

8. In the Pattern Name input box, enter a name for the new pattern. Click the OK button to record the name change to the Collection box.

9. Click the OK button in the Dither Box filter to save the new pattern and close the Dither box.

If you look closely at the new pattern, you'll notice that the four pixels representing the new pattern are not the same color. What the Pattern Dither filter created was a pattern based on Web Safe colors. When you apply that pattern to an area of an image, the pattern creates the visual appearance of a new color. Photoshop defines this technique as dithering.

In the real world, you can mix two colors together to produce a third, different color. For example, mixing blue and yellow ink produces the color green, or mixing equal amounts of black and white ink creates a mid-tone gray. You cannot create colors on a monitor by mixing inks. What you do is dither, or alternate, different-colored pixels. The Dither Box filter creates a new color by generating an alternating pattern composed of two Web Safe colors. What the eye sees is a new color based on the selected pattern of pixels.

Note: For more information on applying a Dither Box color to an image, see Tip 817, "Applying a Custom Dither Pattern to a Web Background Image."

554 *Understanding the Color Wheel*

When you work with color in Photoshop, it is important to understand that there is more than one way to create a specific color. Photoshop's primary color spaces are RGB and CMYK. The RGB color space mixes colors using red, green, and blue, and it is possible to create billions of colors from those three inks. The CMYK color space mixes colors using cyan, magenta, yellow, and black. Although it would be possible to mix an almost unlimited number of colors with CMYK, you are restricted to a printing safe zone of colors, called the CMYK gamut. The CMYK gamut represents the available colors reproducible on a four-color printing press (see Tip 925, "Recognizing Colors That Will Not Print").

It is a good idea to have a standard color wheel on hand. The color wheel helps you understand, visually, how different colors mix to create new colors, as shown in Figure 554.1.

Figure 554.1 The standard color wheel visually displays how inks mix to produce colors.

Looking at the color wheel in Figure 554.1, you see how colors blend to produce alternate colors. For example, to increase the intensity of a particular color, subtract its opposite color on the color wheel. Conversely, to decrease a particular color, increase its opposite color.

The color wheel also instructs you in how colors blend to form new colors. For example, looking at the color wheel, you see how mixing blue and yellow together produces green.

> **Note:** *Understanding how the color wheel mixes color takes you a long way toward understanding how Photoshop creates colors and how printing presses print color.*

555 *Using Dry Brush and Lighting Effects to Produce a Painting*

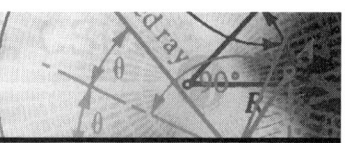

In Tip 448, "Creating a Painted Look with Channels and Filters," you learned how to convert a Photoshop image into a flat painting. Say, for example, you want to create with a greater sense of depth. To convert an RGB photograph into a painting, open the document in Photoshop and perform these steps:

1. Select Filter menu Artistic and choose Dry Brush from the fly-out menu. Photoshop opens the Dry Brush dialog box, as shown in Figure 555.1.

Figure 555.1 The Dry Brush filter modifies the image by reducing the color in large areas of the image while preserving the edge colors.

2. The Dry Brush options control the effects of the filter on the active image:

- **Brush Size:** In the Brush Size input field, enter a value from 0 to 10 (or click and drag the triangular slider left or right). Painting the image with a larger brush reduces the number of colors within large areas of the image. In this example, select a brush size of 3.

- **Brush Detail:** In the Brush Detail input field, enter a value from 0 to 10 (or click and drag the triangular slider left or right). Higher values preserve more of the detail from the original image. In this example, you choose a value of 6 for Brush Detail.

- **Texture:** In the Texture input field, enter a value from 1 to 3 (or click and drag the triangular slider left or right). Higher values generate more texture within the image. Since you are generating the texture of the image using the Lighting Effects filter, select a value of 1 for Texture.

3. Click the OK button to apply the Dry Brush filter to the image, as shown in Figure 555.2.

Figure 555.2 The Dry Brush filter applied to the image.

4. Select the Filter menu, select Render and choose Lighting Effects from the fly-out menu. Photoshop opens the Lighting Effects dialog box, as shown in Figure 555.3.

Figure 555.3 The Lighting Effects filter controls the number and type of light sources used in the image.

5. Click the Style button and select the Default option. Photoshop displays a single light source in the preview window (refer to Figure 555.3).

6. Click and drag one of the anchor points defining the light source and expand the source to light the image, as shown in Figure 555.4.

Figure 555.4 Clicking and dragging the anchor points surrounding a light source let you change the shape and direction of the light.

7. Click on the Texture Channel button at the bottom of the Lighting Effects dialog box and select the Red channel. The Texture Channel option creates a sense of depth in an image by using one of the image's channels to emboss the edge details within the image.

8. Click the OK button. Photoshop closes the Lighting Effects dialog box and applies the Lighting Effect to the image, as shown in Figure 555.5.

Figure 555.5 The Lighting Effects and Dry Brush filters combine to produce an image with a hand-painted appearance.

Note: Experiment with the Lighting Effects options to achieve a new and even better look. For more information on the Lighting Effects filter, refer to Tip 531, "Using the Lighting Effects Filter."

556 *Using Polar Coordinates to Create a Zoom Effect*

In Tip 535, "Using Polar Coordinates," you were introduced to the Polar Coordinates filter. In this tip, you will create a zoom effect using some text and the Polar Coordinates filter.

To create a zoom effect, open Photoshop and perform these steps:

1. Select the File menu and choose New. Photoshop opens the New dialog box, as shown in Figure 556.1.

Figure 556.1 The New dialog box in Photoshop defines the characteristics of the new document.

1. Create a new document with these characteristics:

 - **Width:** 8 inches

 - **Height:** 5 inches

 - **Resolution:** 150 pixels/inch

 - **Mode:** RGB

 - **Contents:** White

2. Click the OK button. Photoshop closes the New dialog box and opens the new document.

3. Press the letter "D" on your keyboard. Photoshop changes the Foreground and Background color swatches to black and white. Use the Paint Bucket tool to fill the background layer with black.

4. Use the Type tool to create some large type (refer to Tip 218, "Creating Text in Photoshop 6.0"). In this example, you created 72-point text using Arial Rounded, as shown in Figure 556.2. If typing black type against a black layer makes it difficult to tell what you are doing, temporarily deactivate the Background layer by clicking once on the eye icon located to the far left of the Background layer.

Figure 556.2 The text for the starburst effect.

5. Move your cursor into the Layers palette and Ctrl+click (Macintosh: Command+click) on the text layer. Photoshop creates a selection boundary around the text, as shown in Figure 556.3.

Figure 556.3 When you Ctrl+click on a layer, Photoshop creates a selection based on the digital information contained within the layer.

6. Choose the Select menu and choose Save Selection from the pull-down menu. Photoshop opens the Save Selection dialog box, as shown in Figure 556.4.

Figure 556.4 The Save Selection dialog box lets you save a selection as an Alpha channel.

7. Click the OK button to save the selection using the default values. Photoshop closes the Save Selection dialog box and saves the selection as a new Alpha channel.

8. Press Ctrl+D (Macintosh: Command+D) to deselect the text.

9. Select the Layer menu, select Rasterize, and choose Type from the fly-out menu. Photoshop converts the text into a raster image. It is no longer text but simply paint in the shape of letters.

10. Select the Filter menu, select Stylize, and choose Find Edges from the fly-out menu. Photoshop converts the text to white and outlines the text with a black line, as shown in Figure 556.5.

Figure 556.5 The Find Edges filter applied to the text layer.

11. Select the Image menu, select Adjust, and choose Invert from the fly-out menu. Photoshop reverses the colors in the text layer.

12. Reactivate the Background layer by clicking on the eye icon located to the far left of the Background layer. Photoshop reactivates the black background layer.

13. Click on the black triangle in the upper-right corner of the Layers palette and choose Flatten Image from the fly-out menu. Photoshop combines the text and background layers into one layer.

14. Select Filter menu Blur and choose Gaussian Blur from the fly-out menu. Choose a radius blur of 2.5 and click OK to apply the blur to the text, as shown in Figure 556.6.

Figure 556.6 The Gaussian Blur filter applied to the Inverted text layer.

15. Select the Filter menu, select Distort, and choose Polar Coordinates from the fly-out menu. Photoshop opens the Polar Coordinates dialog box.

16. Select Polar to Rectangular and click the OK button. Photoshop applies the Polar to Rectangular filter to the image, as shown in Figure 556.7.

Figure 556.7 The Polar Coordinates filter applied to the text layer.

17. Select the Image menu, select Rotate Canvas, and choose 90 CW from the fly-out menu. Photoshop rotates the canvas 90 degrees clockwise.

18. Select the Image menu, select Adjust, and choose Invert from the fly-out menu. Photoshop inverts the colors in the image.

19. Select the Filter menu, select Stylize, and choose Wind from the fly-out menu. Photoshop opens the Wind dialog box. Choose Wind for the Method and From the Left for Direction. Click the OK button to apply the Wind filter to the text, as shown in Figure 556.8.

20. Press Ctrl+F (Macintosh: Command+F) twice to repeat the Wind filter two more times for a total of three applications of the Wind filter.

21. Select the Image menu, select Adjust, and choose Invert from the fly-out menu. Photoshop inverts the colors in the image.

22. Select the Image menu, choose Adjust, and choose Auto Levels from the fly-out menu. Photoshop brightens the whites in the image, as shown in Figure 556.9.

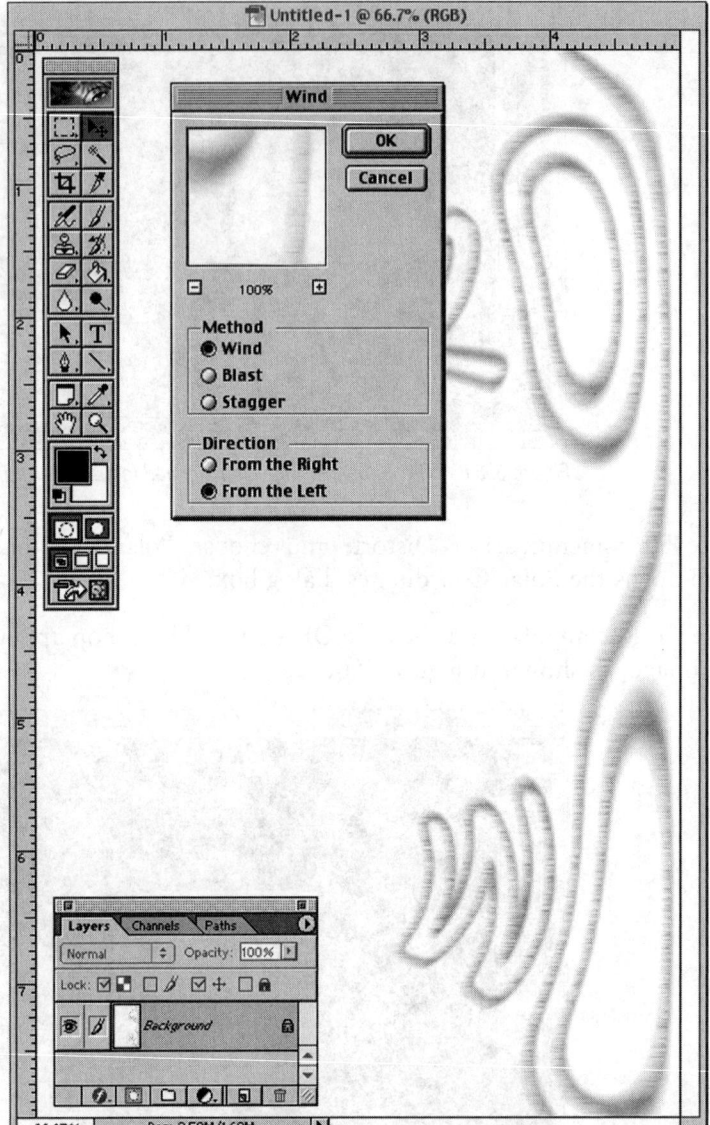

Figure 556.8 The Wind filter applied to the text layer.

23. Press Ctrl+F (Macintosh: Command+F) and repeat the Wind filter three more times.

24. Select Image menu Rotate Canvas and select 90 CCW from the fly-out menu. Photoshop rotates the image 90 degrees counterclockwise. Your image should resemble Figure 556.10.

25. Select Filter menu Distort and choose Polar Coordinates from the fly-out menu. Photoshop opens the Polar Coordinates dialog box. Select Rectangular to Polar and click the OK button. Photoshop applies the Polar Coordinates filter to the text layer, as shown in Figure 556.11.

Figure 556.9 The Auto Levels command applied to the text layer.

Figure 556.10 The text layer rotated 90 degrees counterclockwise.

Figure 556.11 The Polar Coordinates filter applied to the text layer.

26. The Zoom effect is there, but the text is hard to read. Choose the Select menu and choose Load Selection from the pull-down menu. Photoshop opens the Load Selection dialog box. Since this document only contains one Alpha channel, click the OK button. Photoshop loads the selection you created in steps 6 and 7, as shown in Figure 556.12.

Figure 556.12 The Alpha channel selection of the text, loaded back into the image.

27. Click on a dark color in the Swatches palette.

28. Select the Edit menu and choose Fill from the pull-down menu. Photoshop opens the Fill dialog box, as shown in Figure 556.13.

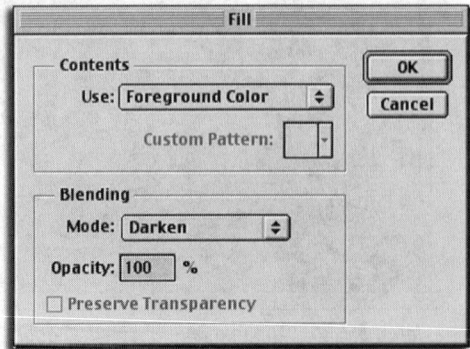

Figure 556.13 The Fill dialog box controls how the selected color fills the image.

29. Select Foreground Color for Contents, a Blending Mode of Darken, and Opacity of 100 percent. Click the OK button to apply the fill to the selected portion of the image, as shown in Figure 556.14.

Figure 556.14 The Fill command applied to the selected portion of the text.

Note: Since this image is used in an upcoming tip, you should save the file using the .psd format.

557 *Using the Adobe Color Picker to Select Web Colors*

In Tip 549, "Selecting Color with the Foreground Color Button," you learned how to select a color by using the Color Picker dialog box. When you use Photoshop's Color Picker, you choose a color visually by clicking within the color preview box, or you type number values into the input fields.

To open the Color Picker dialog box, click once on the Foreground color swatch. Photoshop opens the Color Picker dialog box. If the dialog box displays the Custom color set, click once on the Picker button, as shown in Figure 557.1.

Figure 557.1 The Color Picker dialog box lets you select a color by its numeric values or by using the color preview window.

There are two ways to select a Web color using the Color Picker dialog box:

• **Only Web Colors:** Click once in the Use Only Web Colors check box. Photoshop converts the color preview box to Web Safe colors. Clicking anywhere in the color box produces a Web Safe color, as shown in Figure 557.2.

Figure 557.2 When you select Only Web Colors, Photoshop displays Web Safe colors in the Foreground color box.

• **Hexadecimal values:** If you know the correct hexadecimal value for a specific Web Safe color, click once in the # input field and enter the value. Say, for example, you want a Web Safe red. Enter the value FF0000 into the # input box. Photoshop selects the correct Web Safe red, as shown in Figure 557.3.

Click the OK button to save your change to the Foreground color swatch.

Figure 557.3 To choose a specific Web Safe color, enter the hexadecimal value for a specific color in the hex input box.

558 *Using a Hard Proof to Check for Consistent Color*

Generating a hard proof helps you check the accuracy of your printing devices and helps you create a working profile for your entire workflow. To create a hard proof, you need a color-corrected CMYK image. Do not use an RGB image converted to CMYK.

Photoshop comes with its own CMYK image called Olé No Moiré. You can locate this Photoshop file on the Photoshop installation CD.

To create a hard proof, open the Olé No Moiré image in Photoshop, select the File menu, and choose Print from the pull-down menu. Do not select any special options; simply direct Photoshop to Print the image, as shown in Figure 558.1.

Figure 558.1 The Olé No Moiré image.

If you do not have a suitable image, contact your local printer or service bureau. They keep hard proof image files and will probably let you have one at no charge.

Once you have a hard proof image, it is invaluable for setting up your computer-to-printer workflow. Compare the printed image to the screen image and make corrections using programs like Photoshop's Gamma program (refer to Tip 57, "Calibrating Monitor Color Using the Adobe Gamma Utility").

A hard proof is also useful for producing consistent color between your office and the local printer or service bureau. Use the hard proof to synchronize your system with their printing presses.

Note: Since images fade with time and monitors and printers sometimes lose their calibration, it is a good idea to calibrate your system on a monthly basis.

559 *Creating an ICC Monitor Profile*

The International Color Consortium created the ICC color profile, as shown in Figure 559.1. In essence, it is a standard throughout the professional press industry on how colors print and even how they display on your monitor.

The Adobe Gamma utility (refer to Tip 57, "Calibrating Monitor Color Using the Adobe Gamma Utility") creates an ICC profile to match your hardware and unique workflow. Photoshop, your monitor, and various output devices, from PostScript printers to high-end four-color presses, use this profile to manage the color of the image.

As a designer using Photoshop, proper calibration helps eliminate color cast in your monitor, makes your monitor midtones and grays as neutral as possible, and standardizes image display across different monitors.

Photoshop contains a helper program to assist you in the creation of an ICC profile. The Adobe Gamma resides within the Photoshop application folder.

To load the Adobe Gamma program:

In the Windows operating system, click on the Start button. Move your cursor over the Settings option and click on Control Panels to open the Control Panels folder. Locate the Adobe Gamma utility and double-click to launch the program.

In the Macintosh operating system, click on the Apple icon and move your cursor down to the Control Panels option. Locate and click once on Adobe Gamma to launch the program.

Photoshop opens the Adobe Gamma dialog box, as shown in Figure 559.2.

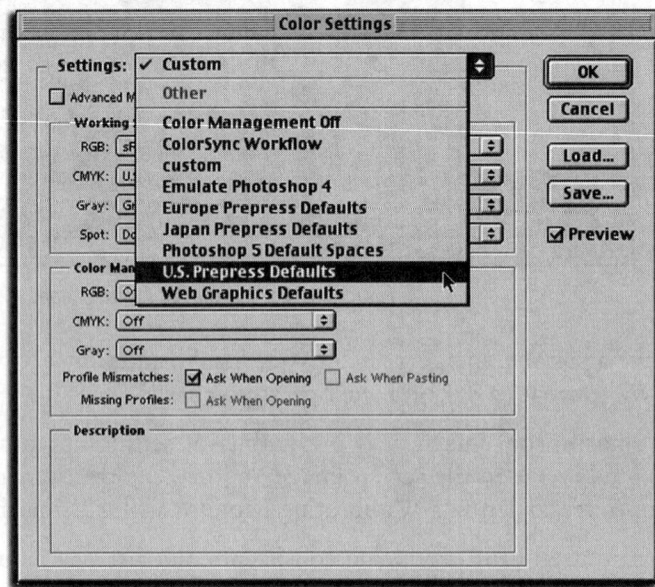

Figure 559.1 ICC profiles standardize color and help to give you consistent results.

To create an ICC profile for your workflow, perform the following steps:

1. If you have never calibrated your monitor, choose the Step by Step option and click on the Next button. The Adobe Gamma utility will take you through a series of screens. At each screen, you stop and evaluate the monitor by adjusting the contrast, colors, and white point of the monitor, as shown in Figure 559.3.

Figure 559.2 The Adobe Gamma program lets you create an ICC color profile.

Figure 559.3 Use the on-screen instructions to step-by-step adjust your computer monitor.

2. To advance to the next screen, click on the Next button. To return to a previous screen, click on the Back button. Click the Cancel button if you wish to end the calibration session without changing your monitor.

3. When you have completed all the adjustments and you are on the last screen, click on the Finish button. The Adobe Gamma utility will open the save dialog box, as shown in Figure 559.4.

4. Give your new profile a name and click the Save button. Adobe Gamma will record your changes to the color settings of your monitor and close the dialog box. You are now ready to work using your new ICC profile.

Note: There are many calibration programs on the market. Be sure to use only one calibration utility to create your profile; using multiple utilities can result in incorrect color data.

Figure 559.4 The last stage of profile creation is to name and save your newly created profile.

560 *Assigning an ICC Color Profile to a Photoshop Document*

In the preceding tip, you learned how the ICC color profile system helps you maintain consistent color from the creation of the image to the printing of the image.

To assign a specific color profile to an image, open the image in Photoshop and perform these steps:

1. Select the Image menu, select Mode and choose Assign Profile from the fly-out menu. Photoshop opens the Assign Profile dialog box, as shown in Figure 560.1.

Figure 560.1 The Assign Profile dialog box lets you assign a specific color profile to an image.

2. The three choices available are:

 • **Don't Color Manage This Document:** Selecting this option removes the color profile from the active image. Choose this option only if you are sure you want to remove the profile.

 • **Working color mode:** This tags the document with the currently active profile.

 • **Profile:** Choose this option to assign a new profile to the working document. Depending on what profile you select, choosing this option may drastically change the appearance of the image. Click the Profile button and select from the list of available profiles, as shown in Figure 560.2.

3. Click the OK button to record the changes to the active document.

Figure 560.2 *Clicking the Profile button lets you choose from the available profiles.*

Note: Since selecting a new profile remaps the physical colors within the active document, it is strongly recommended that you do not change the profile of an image unless you are sure you know what you are doing. Once you save and close the document, the changes cannot be undone.

561 *Previewing Color Adjustments*

When you perform color adjustments within Photoshop, it is important to view colors as accurately as possible. Photoshop gives you the ability to view a color document in one of several different color spaces.

To view an image within a different color space, open the document in Photoshop, select the View menu, choose Proof Setup, and choose from the available options, as shown in Figure 561.1.

- **Working CMYK:** Choosing this option lets you view the colors in the image using the CMYK (cyan, magenta, yellow, and black) color space.

- **Working plates:** Choosing Cyan, Magenta, Yellow, Black, or CMY Plates lets you view the individual color plates used in the production of a four-color print.

- **Macintosh RGB:** Choose this option to view the gamut of color available on a Macintosh monitor.

- **Windows RGB:** Choose this option to view the gamut of color available on a Windows monitor.

- **Monitor RGB:** Choose this option to view the gamut of color available on a generic monitor. Useful for designing images destined for the Internet.

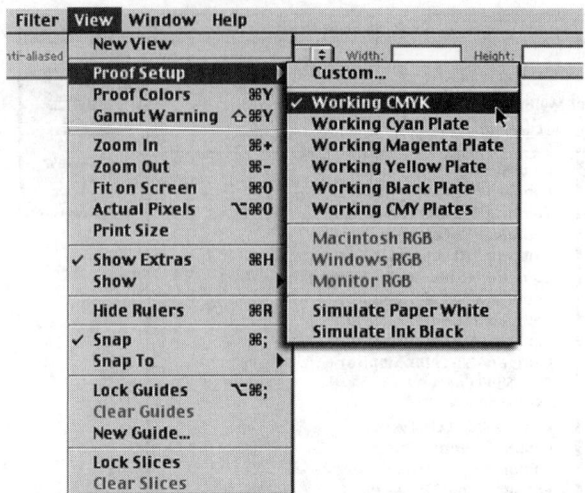

Figure 561.1 Selecting Proof Setup from the pull-down menu lets you choose from several different color spaces.

Note: *Viewing a specific color space also requires a well-calibrated monitor. Refer to Tip 57, "Calibrating Monitor Color Using the Adobe Gamma Utility," for more information on monitor calibration.*

562 *Viewing the Color Values of Pixels*

When you make color corrections, Photoshop lets you view the color values of the pixels using the Info palette. To use the Info palette to view the color values of pixels, open a document in Photoshop, and perform these steps:

1. If the Info palette is not visible, click once on the Info tab or select the Window menu and choose Show Info from the fly-out menu. Photoshop displays the Info palette, as shown in Figure 562.1.

Figure 562.1 The Info palette in Photoshop displays current information on the color values of the active document.

2. Select the Eyedropper tool from the toolbox. Refer to Tip 164, "Using the Eyedropper Tool," for more information on selecting and using the Eyedropper.

3. Move your cursor into the open document. The Info palette displays color information about the pixels directly underneath the Eyedropper tool (refer to Figure 562.1).

4. Make a color adjustment to the image using Curves, Levels, or any of Photoshop's adjustment tools.

5. The Info palette displays two values for the sampled pixels. The value on the left indicates the pixels' original color value, and the value on the right indicates the new color value, as shown in Figure 562.2.

Note: *To change the sample rate of the Eyedropper tool, refer to Tip 335, "Changing the Eyedropper Sample Rate for Greater Accuracy."*

Figure 562.2 The Info palette displays color information concerning the original and new colors' values for the pixels within the current document.

563 *Simulating a Television Image*

Images edited in Photoshop rely on a grouping of pixels. Photoshop groups digital information into a group or raster of pixels. Each pixel represents a dot of information defining the image's detail. An image projects on a television monitor using scan lines. Unless you have a digital video monitor, television images have a subtle left-to-right line quality.

Say, for example, you have a graphic of a television, and you want to insert a photograph onto the monitor. To simulate the look of a television image, open a graphic in Photoshop and perform these steps:

1. If the Layers palette is not visible, click on the Layers tab or select the Window menu and choose Show Layers from the pull-down menu.

2. Move your mouse into the Layers palette and click the New Layer icon. Photoshop creates a new layer, as shown in Figure 563.1.

Figure 563.1 *Clicking the New Layer icon automatically creates a new layer.*

3. Press the letter "D" on your keyboard. The Foreground and Background color swatches default to black and white.

4. Select the Edit menu and choose Fill from the pull-down menu. Photoshop opens the Fill dialog box, as shown in Figure 563.2.

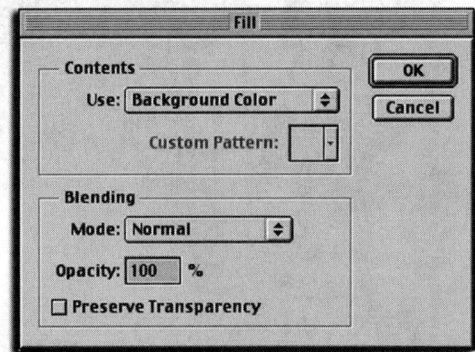

Figure 563.2 *The Fill dialog box controls the characteristics of the fill.*

5. Click the Use button and select Background Color from the pop-up menu. Choose a Blending Mode of Normal and Opacity of 100 percent. Do not choose Preserve Transparency.

6. Click the OK button to apply the Fill command to the image.

7. Select the Filter menu, select Sketch, and choose Halftone Pattern from the fly-out menu. Photoshop opens the Halftone Pattern dialog box, as shown in Figure 563.3.

Figure 563.3 *The Halftone Pattern filter applies uses the fill color within the active layer to create a halftone pattern.*

8. In the Size input field, enter a value of 1.

9. In the Contrast input field, enter a value of 50.

10. Click on the Pattern Type button and select Line for the Pattern Type.

11. Click the OK button to apply the halftone pattern to the image, as shown in Figure 563.4.

12. Move your mouse into the Layers palette and click once on the Blending Mode button. Photoshop displays a list of available blending modes, as shown in Figure 563.5.

13. Select the Soft Light blending mode from the available options. Photoshop applies the Soft Light blending mode to the underlying image, as shown in Figure 563.6.

Figure 563.4 The halftone pattern applied to the white-filled layer.

Figure 563.5 Clicking on the Blending Mode button displays a list of available blending modes.

The Soft Light blending mode blends the inks of the image with the newly created halftone pattern, generating an image with a television-like quality. To complete the effect, place the image in a graphic of a television, as shown in Figure 563.7.

Figure 563.6 *The Soft Light blending mode applied to the image.*

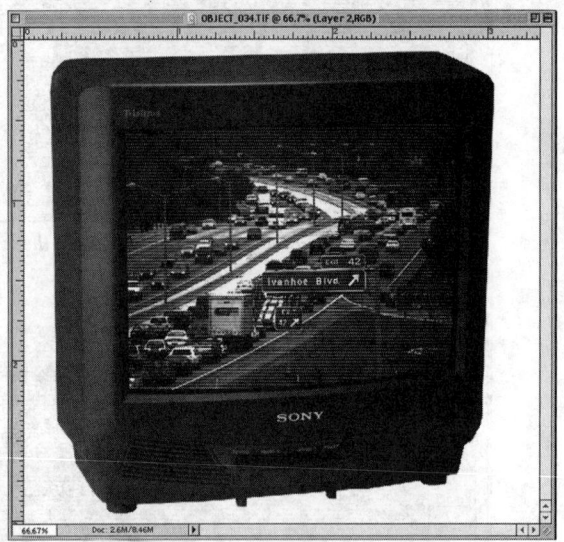

Figure 563.7 *The completed image inserted into the graphic of a television.*

564 *Creating a Star Field with Noise*

In this tip, you will insert a star field behind the text layer. To insert a star field, create the zoom effect in Tip 556 and perform these steps:

1. If the Layers palette is not visible, click on the Layers tab or select the Window menu and choose Show Layers from the pull-down menu. Photoshop displays the Layers palette, as shown in Figure 564.1.

2. Move your mouse into the Layers palette and create a new layer by clicking once on the New Layer icon. Photoshop creates a new layer and places it above the background.

Figure 564.1 The Layers palette displaying the layers from the zoom effect in Tip 556.

3. Press the letter "D" on your keyboard to change the Foreground and Background color swatches to black and white, as shown in Figure 564.2.

Figure 564.2 Pressing the letter "D" changes the Foreground and Background color swatches to black and white.

4. Select the Edit menu and choose Fill from the pull-down menu. Photoshop displays the Fill dialog box. Select Foreground Color as the fill color with a Blending Mode of Normal and Opacity of 100 percent, as shown in Figure 564.3.

Figure 564.3 The Fill dialog box controls the characteristics of the fill.

5. Click the OK button. Photoshop closes the Fill dialog box and fills the new layer with the Foreground color.

6. Select the Filter menu, select Noise, and choose Add Noise from the fly-out menu. Photoshop opens the Add Noise dialog box, as shown in Figure 564.4.

7. In the Amount input field, enter a value of 100 percent. Choose Uniform Distribution by clicking once on the Uniform radio button. Select Monochromatic by clicking once in the check box to the left of the Monochromatic option (refer to Figure 564.4).

8. Click the OK button to close the Add Noise dialog box and apply the Noise command to the active layer, as shown in Figure 564.5.

Figure 564.4 The Add Noise dialog box controls the amount of noise applied to the selected layer.

Figure 564.5 The Noise command applied to the black fill layer.

9. Select the Image menu, select Adjust, and choose Levels from the fly-out menu. Photoshop opens the Levels dialog box.

10. Click and drag the black input slider to the right. The black areas of the layer increase and the white areas decrease, as shown in Figure 564.6.

11. Stop dragging the black slider when your image resembles Figure 564.6. Click the OK button to apply the Levels command to the black layer.

12. Move your mouse into the Layers palette and click on the Blending Mode option. Photoshop displays the Blending Mode options in a drop-down menu, as shown in Figure 564.7.

Figure 564.6 Dragging the black input slider to the right increases the black in the image and decreases the white.

Figure 564.7 The Blending Mode options control how the inks in one layer blend with the inks of another layer.

13. Select Overlay from the fly-out menu. Photoshop overlays the colors in the starburst layer with the colors of the star field layer, as shown in Figure 564.8.

Figure 564.8 Using the Overlay blending mode overlays the colors in the starburst layer and creates the visual effect of the text against stars.

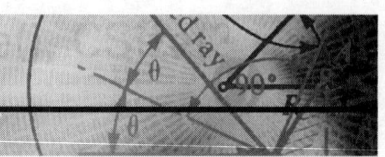

565 *Adjusting Overlapping Spot Colors*

In Tip 258, "Creating a Spot Color Plate in Photoshop," you learned how to use channels to create a separate spot color plate. A printing press uses spot color plates to apply specific colors to a printed document. Correct printing requires correct alignment of each of the plates. Plates that are out of alignment create printed documents in which two colors overlap or in which the two colors fail to meet. When two color plates overlap, they create a third color that usually appears as a dark line or edge around the printed image. When the color plates fail to meet, it creates a white area on the printed document, as shown in Figure 565.1.

Figure 565.1 When color plates fail to align properly, it creates imperfections in the printed document.

To help adjust for the movement of the color plates, your press operator inserts a trap into the image. A trap determines how far overlapping colors spread outward to correct for the movement of the plates on a printing press.

To create a trap in a CMYK image, open the image in Photoshop and perform these steps:

1. Select the Image menu and choose Trap from the pull-down menu. Photoshop opens the Trap dialog box, as shown in Figure 565.2.

Figure 565.2 The Trap dialog box controls the amount of trapping applied to the active CMYK image.

2. Click on the measurement option (refer to Figure 565.2) and select pixels, points, or millimeters from the pull-down menu.

3. In the Width input field, enter a value from 1 to 10. The value represents the amount of trapping applied to the active CMYK image. Your service bureau determines the value for trapping based on its printing presses.

4. Click the OK button. Photoshop closes the Trap dialog box and applies the trap option to the image.

Note: Since service bureaus use the trapping value to create the color plates, applying a trap to a CMYK image does not affect the way the image appears on your monitor or how it prints on your ink-jet or laser printer.

566 *Using a Displacement Map to Distort Text*

In Tip 511, "Defining the Distortion Area with the Displace Filter," you learned how to create and use a distortion map. In this tip, you will learn how to apply a distortion map to bend text. Say, for example, you have an image of a coffee cup, and you want to insert some text onto the curved surface of the cup, as shown in Figure 566.1.

Figure 566.1 The coffee cup needs some text to complete the image.

In order to curve the text onto the coffee cup, you first need to create a displacement map. To make the distortion more effective, create a displacement map with the width, height, and resolution of the coffee cup document. To create the distortion map, open Photoshop and perform these steps:

1. Select the File menu and choose New from the pull-down menu. Photoshop opens the New dialog box, as shown in Figure 566.2.

2. In this example, create a new document with a width of 3 inches, a height of 4 inches, and a resolution of 72 pixels per inch (refer to Figure 566.2).

3. Click the OK button. Photoshop closes the New dialog box and creates the document.

4. Select the Gradient tool from the toolbox and create a linear gradient with white on the left and right and black in the middle, as shown in Figure 566.3. For more information on creating gradients, refer to Tip 175, "Creating Custom Gradients."

Figure 566.2 The New dialog box controls the characteristics of the new document.

Figure 566.3 Use the Gradient Editor to create a white-to-black-to-white linear gradient.

5. Click the OK button in the Gradient Editor. Photoshop closes the Gradient Editor dialog box and saves the gradient to the Presets palette.

6. Move the Gradient tool to the left center of the document window and click and drag your mouse to the right side of the document window. Photoshop creates a white-to-black-to-white gradient across the document, as shown in Figure 566.4.

7. Select the File menu and select Save from the pull-down menu. Photoshop opens the Save As dialog box, as shown in Figure 566.5.

8. Click on the Format button. Photoshop displays a list of available formats. Select Photoshop from the pop-up menu.

9. In the Name input field, enter the name *coffee_d.psd*.

Figure 566.4 Dragging the Gradient tool across the image creates a white-to-black-to-white gradient.

Figure 566.5 The Save As dialog box controls the name, format, and location of the saved file.

10. Click the Save button to save the new document. Photoshop saves the file and closes the New dialog box.

11. Select the File menu and choose Close from the pull-down menu. Photoshop closes the *coffee_d.psd* document.

To place the text onto the cup, open the original document containing the coffee cup and perform these steps:

 1. Select the Type tool from the toolbox and create the text you want on the cup. In this example, you create 24-point text in Britannic Bold, as shown in Figure 566.6. For more information on creating text, refer to Tip 218, "Creating Text in Photoshop 6.0."

2. Select Filter menu Distort and choose Displace from the fly-out menu. Photoshop opens an alert dialog box indicating that a text layer must be rasterized before applying the Distort filter. Click the OK button to close the alert box and open the Displace dialog box, as shown in Figure 566.7.

Figure 566.6 The type "Coffee Mug" is created for placement on the coffee cup.

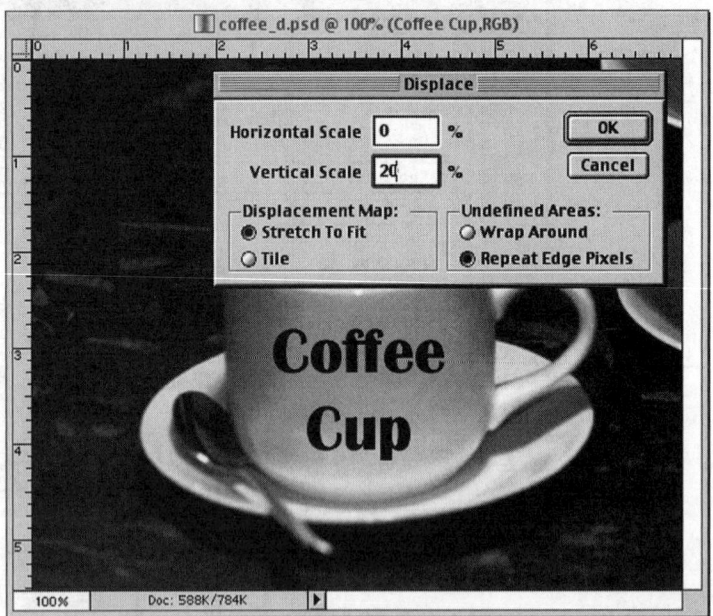

Figure 566.7 The Displace dialog box controls the application of the displacement map to the active image.

3. In the Horizontal Scale input box, enter a value of 0 percent.

4. In the Vertical Scale input box, enter a value of 20 percent.

5. Select Stretch to Fit by clicking once on the radio button to the left of the Stretch to Fit option.

6. Select Repeat Edge Pixels by clicking once on the radio button to the left of the Repeat Edge Pixels option.

7. Click the OK button. Photoshop displays the Open dialog box, as shown in Figure 566.8.

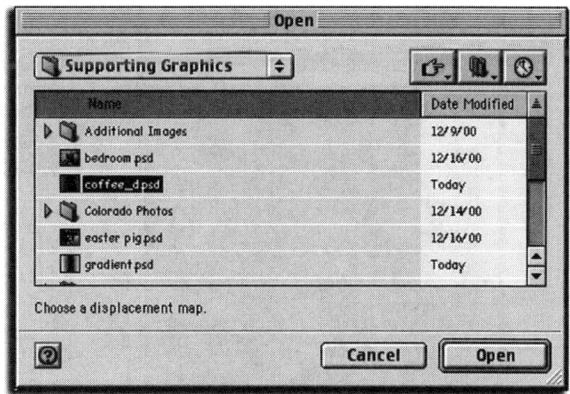

Figure 566.8 The Open dialog box lets you select the displacement map for the Distort filter.

8. Click once on *coffee_d.psd* and click the Open button. Photoshop closes the Open dialog box and applies the displacement map to the text, as shown in Figure 566.9.

Figure 566.9 The coffee displacement map applied to the text layer.

Note: For more information on using the Distort filter, refer to Tip 511, "Defining the Distortion Area with the Displace Filter."

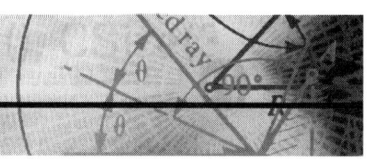

567 *Using Photoshop's Color Sliders*

In Tip 62, "Manually Choosing Colors with the Color Picker," you learned how to select colors with the Color Picker. When you use the Color Picker dialog box to select a color, Photoshop gives you a unique way to choose a color.

To open Photoshop's Color Picker, click once on one of the Foreground or Background color swatches. Photoshop opens the Color Picker dialog box, as shown in Figure 567.1.

Figure 567.1 Photoshop's Color Picker dialog box lets you select colors visually or by their numeric values.

The vertical slider in the middle of the Color Picker dialog box controls the hue of the color. Click on the white triangles, located on either side of the slider and drag up or down to change the hue, as shown in Figure 567.2.

Figure 567.2 The vertical slider controls the hue of the color without modifying its brightness or saturation.

The large color box to the left of the vertical slider controls the saturation and brightness of the color. The small circle within the color box represents the current color pick (refer to Figure 567.1). Click on the circle and drag it to change the saturation and/or brightness of the color.

Drag the slider to the right or left to increase or decrease the saturation of the color, as shown in Figure 567.3.

To increase the brightness of the color, drag the circle icon up; to decrease the brightness of the color, drag the circle icon down, as shown in Figure 567.4.

Click the OK button to apply the color to the Foreground or Background color swatch.

Note: For more information on Photoshop's Color Picker, refer to Tip 62, "Manually Choosing Colors with the Color Picker."

Figure 567.3 Clicking and dragging the color circle to the right or left increases or decreases the saturation of the color.

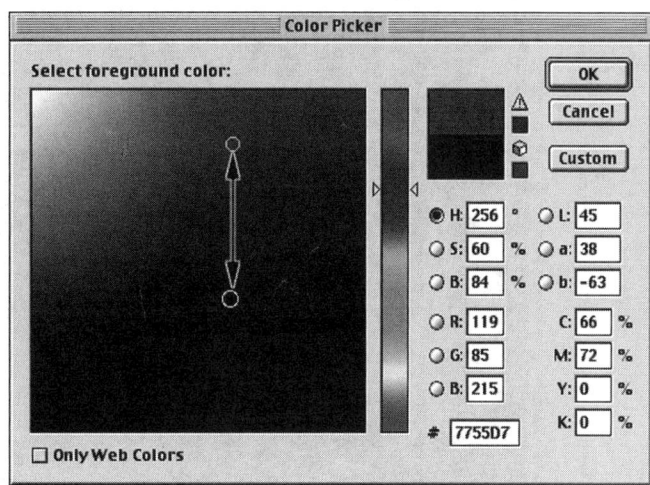

Figure 567.4 Dragging the circle icon up or down increases or decreases the brightness of the color.

568 *Creating a Custom Color Palette from a Photoshop Image*

In the preceding tip, you learned how to use the Color Picker dialog box to select a color using hue, saturation, and brightness. Photoshop gives you many ways to select colors, one of them being the ability to select directly from the image. Say, for example, your work requires you to apply specific colors to several images, and the colors you want come directly from a Photoshop document. To select and save a specific color palette, open the document containing the colors in Photoshop and perform these steps:

1. If the Swatches palette is not visible, click on the Swatches tab or select the Window menu and choose Show Swatches from the pull-down menu. Photoshop displays the Swatches color palette, as shown in Figure 568.1.

Figure 568.1 The Swatches color palette displays individual swatches for the available colors.

2. Move your mouse into Photoshop's toolbox and select the Eyedropper tool by clicking once on the Eyedropper icon. For more information on selecting and using the Eyedropper tool, refer to Tip 164, "Using the Eyedropper Tool."

3. Move the Eyedropper tool into the document window. Move the Eyedropper over a color within the document you want to select and click once. The Foreground color swatch changes to the selected color, as shown in Figure 568.2.

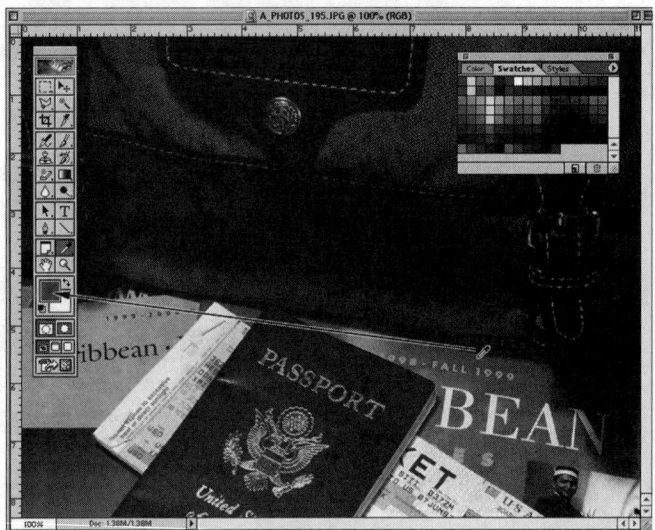

Figure 568.2 The Eyedropper tool lets you select color from within the active document.

4. Move your mouse cursor to the bottom of the Swatches palette. When you move the cursor into the gray area below the color swatches, your cursor turns into a paint bucket. When you see the paint bucket icon, click once. Photoshop opens the Color Swatch Name dialog box, as shown in Figure 568.3.

5. In the Name input field, enter a name for the new color.

6. Click the OK button to close the Color Swatch Name dialog box and add the new color swatch to the Swatches palette, as shown in Figure 568.4.

7. To add additional color swatches to the Swatches palette, move the Eyedropper tool into the open document and repeat steps 3 through 6.

Note: New colors swatches added to the Swatches palette are available for use by any Photoshop documents. For more information on using the Swatches palette, refer to Tip 541, "Selecting Colors with the Swatches Palette."

Figure 568.3 Clicking once at the bottom of the Swatches palette opens the Color Swatch Name dialog box.

Figure 568.4 Clicking the OK button adds the new color swatch to the existing color palette.

569 *Using Color Management with Printed Output*

When you visually edit a color document, you are using the monitor's color space to adjust the color within the image. The configuration and manufacturer of the monitor determine the viewable color space. When you print a color document, different printers use different color spaces.

Photoshop helps you control your printed output by letting you select a different color space to print the image. Having the ability to control the color space of the output document lets you create a multipurpose document that looks good on paper or in a PowerPoint slide presentation.

Say, for example, you create a color document in Photoshop, and you want to print the image on an Epson 1520 Stylus printer.

To set up a normal RGB or CMYK document for printing on an Epson 1520 Stylus, open the document in Photoshop and perform these steps:

1. Select the File menu and choose Print Options from the pull-down menu. Photoshop opens the Print Options dialog box, as shown in Figure 569.1.

Figure 569.1 The Print Options dialog box lets you control the printing of a color document.

2. If you do not see the Color Management options, click in the check box input field to the left of Show More Options. Photoshop displays the Color Management options (refer to Figure 569.1).

3. Choose Document Source Space if you want the image to match its appearance on your monitor or choose Proof if you want the image to match the current soft proof (see Tip 570, "Selecting Soft Proofing Colors").

4. Click on the Profile button and move through the list until you see Epson Stylus Color 1520. Depending on the type of paper used, select one of the 1520 options, as shown in Figure 569.2.

5. Click the OK button. Photoshop closes the Print Options dialog box and applies the output setting to the document.

6. Select the File menu and choose Print from the pull-down menu. Click the Print button to print the document in the selected color space.

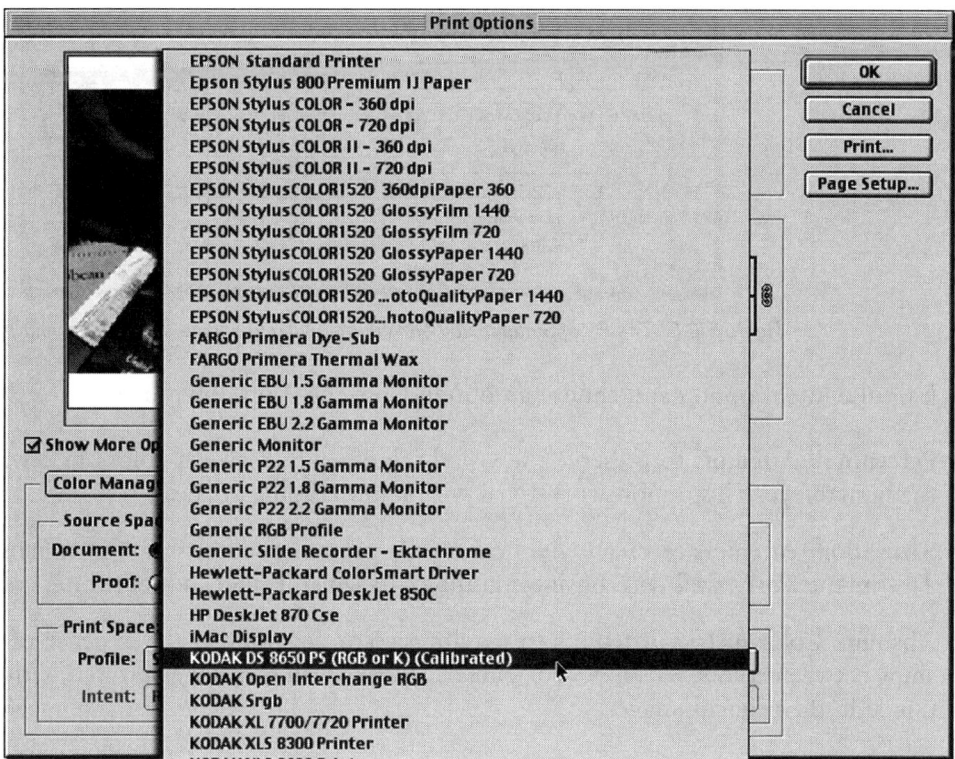

Figure 569.2 The Profile option lets you choose from the available output sources.

570 *Selecting Soft Proofing Colors*

When you print a hard proof, you create a document that prints in the color space of a specific output device. Photoshop users create hard proofs to show a client how an image looks when printed on a specific output device like a four-color press.

Photoshop gives you the ability to generate a soft proof. Soft proofs are not printed documents but documents displayed on your monitor. The Soft Proof option gives you the ability to view an image on your monitor that resembles output on a specific output device.

To create a soft proof, open the document in Photoshop, select the View menu, select Proof Setup, and choose from the available color spaces.

Say, for example, you want to view an RGB image within the CMYK color space. In that case, select Working CMYK from the fly-out menu. Photoshop displays the image using the current CMYK working space.

If you want to view an image using a specific output device, select Custom from the Proof Setup options. Photoshop opens the Proof Setup dialog box, as shown in Figure 570.1.

Say, for example, you want to view the image as it would print on a Hewlett-Packard Color Laser Jet1200/PS. Click on the Profile option. Photoshop displays a list of available options in a drop-down list. Drag your mouse down through the list and click once on Hewlett-Packard Color Laser Jet1200/PS.

Figure 570.1 The Proof Setup dialog box controls how an image displays on your monitor.

Click on the Intent option and choose an option from the drop-down list:

- **Perceptual:** Attempts to preserve the visual relationship between colors in a way that is natural to the human eye. This option works well with photographic images.

- **Saturation:** Attempts to create vivid color in a printed document at the expense of accurate color. This intent works well with business graphics in which bright, not accurate, colors are needed.

- **Absolute Colorimetric:** Attempts to maintain color accuracy at the expense of preserving relationships between colors. Absolute Colorimetric works well on images printed with less color than contained in the original image.

- **Relative Colorimetric:** Compares the white point of the source color space to that of the destination color space and shifts all colors accordingly. Like the Perceptual option, Relative Colorimetric works well on photographic images.

Click on the check box input fields and choose Paper White and/or Ink Black:

- **Paper White:** This option is only available for soft proofs, not actual printing. Checking this option displays the white producible by the selected printing profile.

- **Ink Black:** This option is only available for soft proofs, not actual printing. Checking this option lets you view the dynamic range of the selected printing profile.

Click the OK button to close the Proof Setup dialog box and record your changes to the visible image, as shown in Figure 570.2.

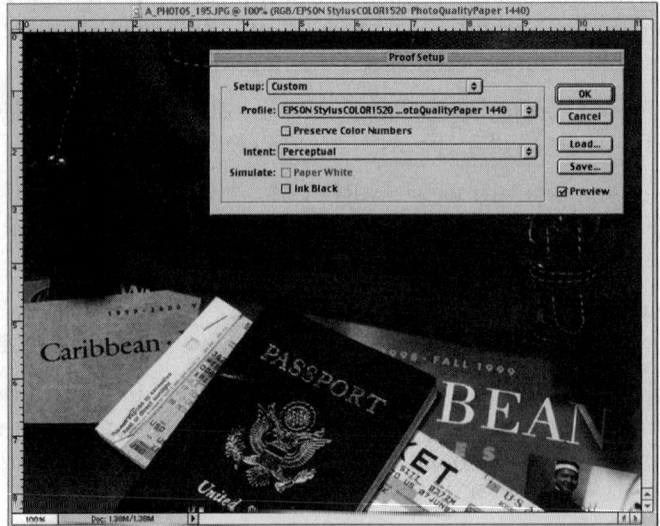

Figure 570.2 The original image, displayed using the Epson Stylus Color 1520 Soft Proofing option.

571 *Matching On-Screen Images to a Color Proof*

In Tip 57, "Calibrating Monitor Color Using the Adobe Gamma Utility," you learned how to calibrate the colors on your monitor. Calibrating monitor color lets you modify the color on your monitor to display correct color balance. The Adobe Gamma utility changes the color characteristics of your monitor and influences the color in an image regardless of the editing program.

Another way to influence the color of an image is to create a specific color settings file. Since a color settings file works with Photoshop, the changes to the monitor colors are temporary and are only in effect as long as Photoshop is open. Say, for example, you want to match color to your Epson 1520 Stylus printer.

To create a new color settings file, first create and print a hard proof (refer to Tip 558, "Using a Hard Proof to Check for Consistent Color"). Then open the RGB hard proof image in Photoshop and perform these steps:

1. Select the Edit menu and choose Color Settings from the pull-down menu. Photoshop opens the Color Settings dialog box, as shown in Figure 571.1.

2. Click on the Settings option at the top of the Settings dialog box. Photoshop displays a drop-down list with the available Color Settings options. Select Custom from the pop-up list.

3. If the Advanced Mode option is not selected, click once in the check box located to the left of the option. Photoshop expands the Color Settings dialog box to include the Advanced Mode options.

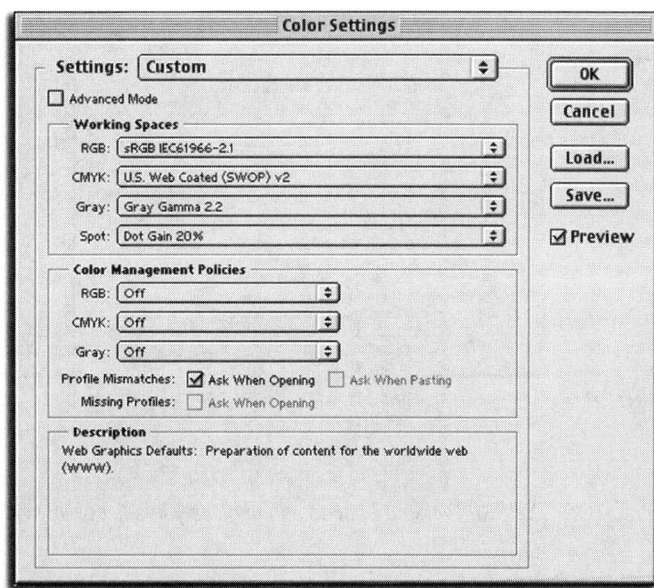

Figure 571.1 The Color Settings dialog box lets you create customized color profiles for use in Photoshop.

4. If the Preview option is not selected, click once in the check box located to the left of the option (refer to Figure 571.1). Selecting the Preview option lets you view changes made to the color settings.

5. Since you printed the hard proof on an RGB printer (Epson 1520), click once on the RGB Working Spaces option. Photoshop displays a drop-down list of available working spaces, as shown in Figure 571.2.

6. Move your cursor down the RGB Working Spaces list until you see the Epson 1520 options. Choose from the available options based on the type of paper used to create the hard proof. In this example, you created the hard proof using photo-quality paper at a printing resolution of 1440. Click once on Epson StylusColor1520 PhotoQualityPaper 1440 option.

7. Compare the monitor image with the hard proof. If you calibrated your monitor (refer to Tip 57, "Calibrating Monitor Color Using the Adobe Gamma Utility"), the hard proof should be relatively close to the image on the monitor.

8. If the hard proof does not resemble the monitor image, try calibrating your monitor using the instructions in Tip 57 and repeating steps 1 through 7.

9. Once you have established a correct color settings file, click the Save button in the Color Settings dialog box. Photoshop opens the Save dialog box, as shown in Figure 571.3.

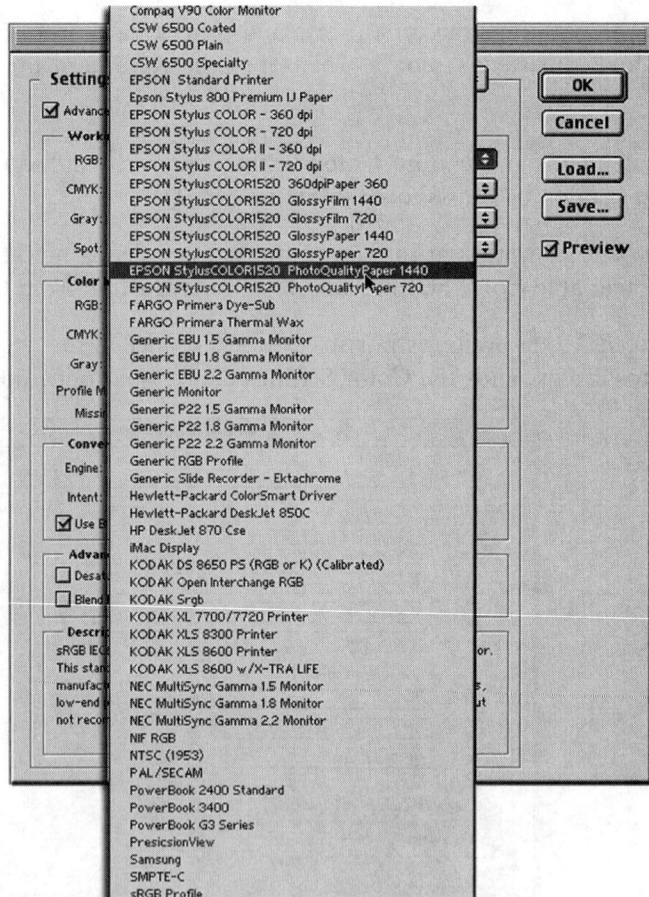

Figure 571.2 The RGB Working Spaces option gives you a list of all available RGB working spaces.

10. In the Name input field, name the new file. In this example, you named the file *Epson1520.csf*.

11. Click the Save button to close the Save dialog box and save the customized settings file. Photoshop opens a Comment dialog box, as shown in Figure 571.4.

12. Enter a description of the new settings file. Comments entered in the Comments dialog box appear in the Description area of the Color Settings dialog box. Click the OK button to close the Comments dialog box and save the file.

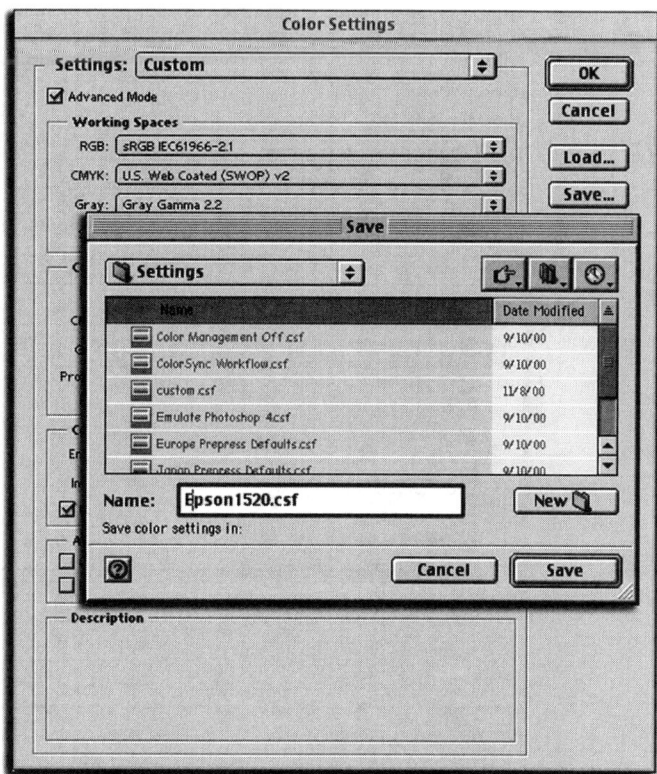

Figure 571.3 The Save dialog box lets you name and save your customized color settings file.

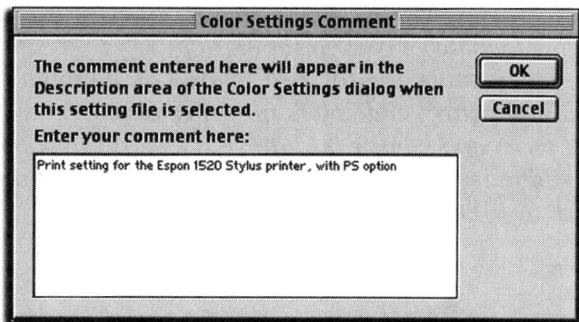

Figure 571.4 The Comment dialog box lets you enter a description of the new customized settings file.

13. To activate a customized settings file, select the Edit menu and choose Color Settings from the pull-down menu. Photoshop opens the Color Settings dialog box (refer to Figure 571.1).

14. Click on the Load button. Photoshop opens Load dialog box, as shown in Figure 571.5.

15. Click once on the *Epson1520.csf* file name and then click the Load button. Photoshop loads the customized settings file into the Color Settings dialog box.

16. Click the OK button to close the Color Settings dialog box and apply the new settings to Photoshop's working space.

Figure 571.5 The Load dialog box lets you select from the available customized settings files.

Note: Attempting to match a color print (hard proof) to the image on your monitor is not an exact science. For example, the colors displayed on a monitor project out of the monitor to your eyes (additive color), and colors on paper require an external light source to reflect off the inks and paper and bounce back to your eye (subtractive color). However, if you understand how to calibrate your monitor to fit a specific workflow, you will have more success when you work on a Photoshop color document.

572 Viewing an Image On-Screen to Evaluate Color Quality

In the preceding tip, you learned how to create a customized color settings file. When you create a custom color settings file, you work visually with the printed hard proof image and the same image displayed in a document window on your monitor. When you evaluate the colors of an image, it is important to understand how Photoshop displays the image on your monitor.

Photoshop uses a grouping of pixels organized into a raster. A raster is a group of pixels that, when assembled in the document window, displays an image. In reality, the image you see on your monitor is a compilation of thousands of tiny dots of ink (pixels).

Adobe Photoshop does not decide the resolution of your monitor. The manufacturer creates a monitor with a specific viewable resolution. The resolution of computer monitors ranges from 72 to 96 pixels pcr linear inch.

When you view an image on your computer monitor, Photoshop creates an image based on the monitor's default resolution. If you view an image at 100 percent zoom, the pixels within the image match the pixels on the monitor. In large images, this creates a document too big to view on the monitor.

However, if you reduce the zoom of the document to fit the available monitor space, Photoshop must remove pixels from the image. While this does not affect the printing of the document, it does affect how the image appears on your monitor. Say, for example, you edit a large image, and the only way to see the entire image is to reduce the zoom size to 50 percent (refer to Tip 183, "Using the Zoom Tool Correctly"). In order for Photoshop to display the entire image, it must remove 50 percent of the pixels from the image.

Viewing a reduced zoom image creates a small shift in the relative colors of the document. Therefore, when you perform color image editing on a Photoshop document, work and edit the image at 100 percent view, as shown in Figure 572.1.

Figure 572.1 *Viewing an image at zoom sizes lower than 100 percent creates shifts in the colors within the document.*

573 *Creating a Noise Gradient*

In Tip 175, "Creating Custom Gradients," you learned how to create a customized gradient from two or more colors. Photoshop lets you create a gradient using solid colors or noise. Noise gradients are useful for special effects and for creating exotic backgrounds.

To create a noise gradient, open Photoshop, and perform these steps:

1. Click once on the Gradient tool in Photoshop's toolbox, as shown in Figure 573.1.

2. Photoshop's Options bar displays the available options for the Gradient tool. Click once on the Gradient sample located on the left side of the Options bar. Photoshop opens the Gradient Editor dialog box, as shown in Figure 573.2.

Figure 573.1 The Gradient tool controls the direction and length of the applied gradient.

Figure 573.2 The Gradient Editor dialog box controls the characteristics of the gradient.

3. Click once on the Gradient Type button. Photoshop displays the two gradient choices in a drop-down list. Click once on the Noise option. Photoshop converts the gradient sample from a solid gradient to a noise gradient, as shown in Figure 573.3.

4. Click on the Color Model button. Photoshop displays a drop-down list with the available color choices. Choose between RGB, HSB, or Lab color. In this example, you choose the RGB color model.

5. In the Roughness input field, enter a value from 0 to 100 percent. The higher the value, the more separation appears between each color in the noise gradient. Lower values create a smoother transition between colors, as shown in Figure 573.4.

Figure 573.3 The Noise gradient creates a random gradient based on RGB (red, green, and blue), HSB (hue, saturation, and brightness), or Lab color models.

Figure 573.4 The Roughness option controls the transition of colors in the noise gradient.

6. Click and drag the RGB triangle sliders left or right to vary the colors in the noise gradient.

7. Select the Restrict Colors options to limit the number of colors available for the noise gradient.

8. Select Add Transparency to create a noise gradient with transparency.

9. Click the Randomize button to generate random color sets for the noise gradient. The Randomize button generates color sets based on the limits you set up with the RGB sliders.

10. To add the gradient to the Preset palette, click in the Name input field, enter a name for the new noise gradient, and click the New button. The result is shown in Figure 573.5.

Note: Refer to Tip 174, "Creating a Gradient Fill Layer," for more information on applying gradients to an image.

Figure 573.5 Clicking the New button adds the noise gradient to the list of Presets.

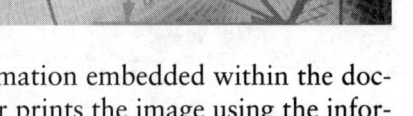

574 *Embedding Color Profiles into an Image*

Photoshop defines a tagged document as having its color profile information embedded within the document. When you open a tagged document, Photoshop displays and/or prints the image using the information contained within the document's embedded profile.

To remove an image's embedded profile or convert the document's profile to the current proof profile, open the document in Photoshop and perform these steps:

1. Select the File menu and choose Save As from the pull-down menu. Photoshop opens the Save As dialog box, as shown in Figure 574.1.

2. Select the Use Proof Setup check box to toggle the document's current color profile. If the box is unchecked, Photoshop removes the current color profile from the image. Selecting this option converts the document's colors to the defined profile space, and this is useful for creating an output file for print. The Use Proof Setup option is available for PDF, EPS, DCS 1.0, and DCS 2.0 file formats.

3. Select the ICC Color Profile (Macintosh: Embed Color Profile) check box to convert the document's colors to the defined proof profile space. The ICC Profile option is available for PSD, PDF, JPEG, TIFF, EPS, DCS, and the Macintosh PICT file formats.

4. Click the OK button to close the Save As dialog box and record your changes to the file.

Figure 574.1 The Save As dialog box controls the embedded color profile for the active image.

Note: *Changing the profile of a document remaps the colors within the image to fit the new profile. Do not change or modify the color profile of a Photoshop document unless you are completely familiar with color management.*

575 *Sorting the Color Table for Optimum Results (ImageReady)*

ImageReady, Photoshop's image-editing program for Web graphics, has its own set of color palettes. ImageReady's Color Table palette displays the colors within the active document. ImageReady lets you sort the color swatches in the Color Table to display by hue, luminance, or popularity.

To access the Color Table in ImageReady, click on the Color Table tab or select the Window menu and choose Show Color Table from the pull-down menu. ImageReady displays the Color Table palette, as shown in Figure 575.1.

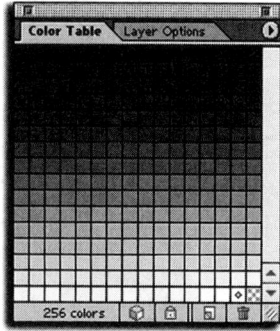

Figure 575.1 The Color Table palette lets you select from the available colors in the active document.

Click once on the black triangle in the upper-right corner of the Color Table palette. ImageReady displays the Color Table options in a pop-up menu, as shown in Figure 575.2.

Figure 575.2 Click the black triangle button to display a list of available options.

To change the sorting order of the colors, select one of the available options:

- **Sort by Hue:** Selecting this option sorts the colors in the color table by their occurrence on the standard color wheel, as shown in Figure 575.3.

Figure 575.3 The Color Table sorted by hue.

- **Sort by Luminance:** Selecting this option sorts the color by brightness from the darkest to the lightest, as shown in Figure 575.4.

Figure 575.4 The Color Table sorted by luminance.

- **Sort by Popularity:** Selecting this option sorts the colors in the active image from most used to least used, as shown in Figure 575.5.

Figure 575.5 The Color Table sorted by popularity.

576 *Creating an Optimized Color Table (ImageReady)*

When you open a document in ImageReady, the Color Table reflects the colors within the image. ImageReady lets you further refine the Color Table by creating an optimized Color Table from the colors in the original image. Optimizing the Color Table of an image reduces the number of colors in the image. Images with fewer colors compress to smaller file sizes.

To optimize the colors within an open ImageReady document, perform these steps:

1. If the Optimize palette is not visible, click on the Optimize tab or select the Window menu and choose Show Optimize from the pull-down menu. ImageReady opens the Optimize palette, as shown in Figure 576.1.

Figure 576.1 The Optimize palette controls the number of colors within the active ImageReady graphic.

2. Click once on the black triangle in the upper-right corner of the Optimize palette. ImageReady displays the Optimize options in a pop-up menu, as shown in Figure 576.2.

Figure 576.2 Click the black triangle button to display a list of available options in the Optimize palette.

3. Click once on the Optimize to File Size option. ImageReady opens the Optimize to File Size dialog box, as shown in Figure 576.3.

Figure 576.3 The Optimize to File Size dialog box controls the number of colors available to the image.

4. In the Desired File Size input field, enter a value from 0 to 999.9. The input value represents the optimized file size in thousands.

5. Click on the radio buttons to select a Start With option:

- **Current Settings:** Select this option to use the current optimization settings. See Tip 730, "Creating Your Own Optimization Settings," for more information on creating and saving custom optimization settings.

- **Auto Select GIF/JPEG:** Select this option to let ImageReady decide the file format.

6. Click on the radio buttons to select a Use option:

- **Current Slice:** Select this option to apply the color optimization to the active image slice.

- **Each Slice:** Select this option to apply optimization to a sliced ImageReady graphic.

- **Total of All Slices:** When you select this option, ImageReady optimizes each slice based on its percentage of the image. Say, for example, you slice an image into three pieces; one slice is 50 percent of the image, and the other two slices are 25 percent each. ImageReady applies 50 percent of the compression to the large slice and 25 percent each to the other two slices.

7. Click the OK button to apply the changes to the active image. ImageReady creates a new Color Table for the image based on the desired file size, as shown in Figure 576.4.

Figure 576.4 The Optimize to File Size command applied to an ImageReady image.

577 *Working with Background Transparency in an Image (ImageReady)*

ImageReady supports transparency in the Graphic Interchange Format (GIF) and the Portable Network Graphic-8 (PNG-8) format. GIF and PNG-8 formats support one level of transparency. That is, the pixels in the image are either fully transparent or fully visible. Web programs such as Dreamweaver and GoLive let you generate transparency in a GIF or PNG-8 graphic; however, using ImageReady gives you more control over the final image.

To preserve the background transparency in a GIF or PNG image, open or create the document in ImageReady, as shown in Figure 577.1, and perform these steps:

Figure 577.1 A graphic image containing transparent pixels.

1. If the Optimize palette is not visible, click on the Optimize tab or select the Window menu and choose Show Optimize from the pull-down menu. ImageReady opens the Optimize palette, as shown in Figure 577.2.

Figure 577.2 The Optimize palette controls the number of colors within the active ImageReady graphic.

2. Click the File Format button (located under the Settings button). ImageReady displays a list of available file formats in a drop-down list. Choose GIF or PNG-8 as the file format, as shown in Figure 577.3.

Figure 577.3 To preserve transparent areas in an image choose the GIF or PNG-8 file format.

3. To save the file with the current settings, select File the menu and choose Save Optimized As from the pull-down list. ImageReady opens the Save Optimized As dialog box, as shown in Figure 577.4.

Figure 577.4 The Save Optimized As box lets you define characteristics of the saved file.

4. In the Name input field, enter a name for the file. If you save the file in the GIF or PNG format, make sure you use the extension at the end of the file. Say, for example, you save a PNG formatted file with the name coffee. The file name would be *coffee.png*.

5. Click on the Format button. ImageReady displays the format options in a drop-down list. Choose from the available options:

 • **Images Only:** Select this option to save the graphic image without any additional HTML code.

 • **HTML and Images:** Select this option to save the graphic images and an HTML document with the code necessary to open the graphics within a Web page, as shown in Figure 577.5.

 • **HTML Only:** Selecting this option generates an HTML document without saving the graphic images.

6. Click the Save button to save the file and close the Save As dialog box.

Figure 577.5 Selecting HTML and Images saves the graphics and creates an HTML document.

578 *Locking Colors into an Image Table (ImageReady)*

In Tip 576, "Creating an Optimized Color Table (ImageReady)," you learned how to reduce the number of colors in an ImageReady document. When you optimize the color table, ImageReady examines the graphic and removes the colors based on a mathematical algorithm. Say, for example, you want to optimize a graphic with specific colors locked into the Color Table. When you perform an Optimize command on a graphic, locked colors remain in the Color Table.

To lock colors into the Color Table of a graphic, open the document in ImageReady and perform these steps:

1. If the Color Table is not visible, click on the Color Table tab or select the Window menu and choose Show Color Table from the pull-down menu. ImageReady displays the Color Table palette, as shown in Figure 578.1.

Figure 578.1 The Color Table palette lets you select from the available colors in the active document.

2. To select a color to lock, move your mouse cursor into the Color Table and click once on a specific color. ImageReady selects the color, as shown in Figure 578.2.

Figure 578.2 Clicking on a color swatch in the Color Table selects the color.

3. To lock the color, click once on the Lock icon. ImageReady locks the color, as shown in Figure 578.3.

Figure 578.3 You identify locked colors by a small white square in the lower-right corner of the color swatch.

4. To unlock the color, click once on the locked color swatch and click once on the Lock icon. ImageReady unlocks the color and removes the white square from the lower-right corner of the color swatch.

5. When you optimize the file (refer to Tip 576), ImageReady preserves the locked colors.

579 *Understanding Color Depth and GIF Images*

In Tip 576, "Creating an Optimized Color Table (ImageReady)," you learned how to create an optimized Color Table for a Web graphic. When you use the Optimize option on a GIF image, Photoshop reduces the colors within an image by reducing the number of bits within a pixel.

The number of bits per pixel determines the number of colors available to the image:

Pixel Depth	Maximum Colors
8 bits	256
7 bits	128
6 bits	64
5 bits	32
4 bits	16
3 bits	8
2 bits	4
1 bit	2

The Optimize by File Size option in ImageReady (refer to Tip 576) determines the number of colors in the image and then creates a bit depth to accommodate the colors.

580 *Using the Hue/Saturation Command*

The Hue/Saturation command lets you adjust the hue, saturation, and lightness of a layer or a selected portion of a layer. Pixel color is composed of three elements:

- **Hue:** The Hue option represents the color of the pixel. Click and drag the Hue slider left or right or click in the Hue input box and enter a number from –180 to +180. The value of Hue represents a move around the color wheel. A positive number indicates clockwise rotation, and a negative number represents a counterclockwise rotation.

- **Saturation:** The Saturation option represents the percentage of color (hue) of the pixels. Click and drag the Saturation slider to the left or right or click in the Saturation input box and enter a value from –100 to +100. The higher the value, the more saturated the ink. Changing the Saturation value to –100 desaturates the colors and produces a grayscale image.

- **Lightness:** To change the lightness value of the pixels, click and drag the Lightness slider to the left or right or click in the Lightness input field and type a value from +100 to –100. The higher the value, the darker the image; the lower the value, the lighter the image.

To access the Hue/Saturation command, open an image in Photoshop, select the Image menu, choose Adjust, and Select Hue/Saturation from the fly-out menu. Photoshop opens the Hue/Saturation dialog box, as shown in Figure 580.1.

In Tip 333, "Using the Hue/Saturation Command to Apply Color to an Image," you learned how to apply color to an image using the Hue/Saturation command using the Master option. You can apply color adjustments to an image using a specific color range.

To apply a color adjustment using a specific color range, click on the Edit button. Photoshop displays a list of available options in a drop-down list, as shown in Figure 580.2.

Figure 580.1 The Hue/Saturation dialog box lets you adjust the colors in an image.

Figure 580.2 The Edit button displays a list of available color preset options.

When you select one of the preset colors, the Hue/Saturation adjustment slider, located at the bottom of the dialog box, lets you modify the selected color (see Figure 580.3).

- Click and drag one of the white triangle sliders to increase the amount of drop off rate of the selected color.

- Click and drag one of the light gray vertical bars to increase the color range without affecting the drop off rate of the color.

- Click and drag the dark gray center to move the entire color slider to a different color.

- Holding the Ctrl key (Macintosh: Command key) lets you move the color bar until a different color is in the center of the bar.

Figure 580.3 The color slider lets you control how the Hue/Saturation command applies the color to the image.

Once you adjust the color slider, use the Hue, Saturation, and Lightness sliders to adjust the color in the image (refer to Tip 333), as shown in Figure 580.4.

Figure 580.4 The Hue, Saturation, and Lightness sliders control the color within the image based on the adjustments made to the color slider.

581 *Using Selection to Influence the Replace Color Command*

In Tip 210, "Using Replace Color," you learned how to use the Replace Color command to adjust the colors within an image. The Replace Color command creates a temporary mask around specific colors within the image and adjusts the hue, saturation, or lightness of the image based on the mask.

Say, for example, you want to use the Replace Color command to adjust an image. However, the image contains several areas of similar color, and you only want to adjust the colors within a specific area of the document, as shown in Figure 581.1.

Figure 581.1 The document contains several areas of similar color.

To use the Replace Color command in a specific area of the document window, open the image in Photoshop and perform these steps:

1. Select one of the available selection tools and create a rough selection area around the area you want to adjust. In this example, you use the Lasso tool to create a rough selection, as shown in Figure 581.2. For more information on the Lasso tool, refer to Tip 73, "The Lasso Tools."

Figure 581.2 The Lasso tool creates a rough selection around the portion of the image you want to adjust.

2. Select the Image menu, select Adjust, and choose Replace Color from the pull-down menu. Photoshop opens the Replace Color dialog box, as shown in Figure 581.3.

Figure 581.3 The Replace Color command adjusts the color in selected areas of the image.

3. Click in the Fuzziness input box and enter a value of 50. The Fuzziness input value controls the number of related colors included in the selection mask. The higher the value (maximum of 200), the more colors are included in the selection mask.

4. Click on the radio button to the left of the Selection option. The Selection option converts the selection preview to a black and white mask.

5. The Replace Color command includes three eyedropper tools. You use the eyedropper tools to select color within the image.

 - **Single Color Eyedropper:** The leftmost eyedropper creates a selection mask based on a single color within the image. Clicking within the document window or image preview selects a single color.

 - **Add Color Eyedropper:** The middle eyedropper lets you increase the selection mask by adding colors. Clicking within the document window or image preview adds additional colors to the selection mask.

 - **Subtract Color Eyedropper:** The rightmost eyedropper lets you remove colors from the selection mask. Clicking within the document window or image preview subtracts colors from the selection mask.

6. Click once on the Single Color Eyedropper and move the eyedropper cursor into the document window. Click once on the color you want to adjust. The image preview creates a mask based on your color selection, as shown in Figure 581.4.

Figure 581.4 *The image preview creates a selection mask based on the color selected with the eyedropper tool.*

7. Click on the triangle slider located under the Fuzziness option and drag it left or right until the mask reflects the colors you want to adjust.

8. If the mask is not correct, use the Add or Subtract Color Eyedroppers to modify the mask.

9. Use the triangular sliders located under the Hue, Saturation, and Lightness options to change the color, the percentage of color, and the brightness of the color within the selection mask.

10. Click the OK button to record the changes to the image, as shown in Figure 581.5.

Figure 581.5 The Replace Color command successfully applied to a Photoshop document.

582 *Using the Gradient Map Command to Create a Sepia Image*

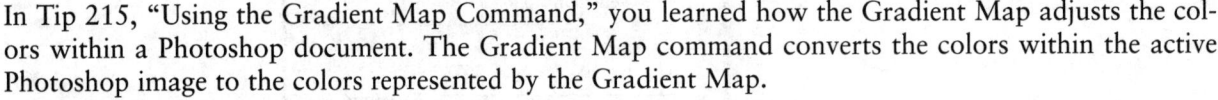

In Tip 215, "Using the Gradient Map Command," you learned how the Gradient Map adjusts the colors within a Photoshop document. The Gradient Map command converts the colors within the active Photoshop image to the colors represented by the Gradient Map.

The Gradient Map tool uses preset or customized gradients to adjust the colors within the image. Say, for example, you want to convert an RGB image into a sepia brown image. To use the Gradient Map command to convert the image, open the document in Photoshop, and perform these steps:

1. If the Swatches palette is not visible, click on the Swatches tab or select the Window menu and choose Show Swatches from the pull-down menu. Photoshop opens the Swatches palette.

2. Select the Image menu, select Adjust, and choose Gradient Map from the fly-out menu. Photoshop opens the Gradient Map dialog box. Position the Gradient Map dialog box so you have access to the Swatches palette, as shown in Figure 582.1.

3. Click on the black triangle to the right of the gradient preview window. Photoshop opens the gradient presets palette, as shown in Figure 582.2.

4. Click and select one of the black-to-white gradients, located at the top and left of the gradient presets palette. Press the Esc key to close the gradient presets palette.

5. Click once in the gradient preview box. Photoshop opens the Gradient Editor dialog box, as shown in Figure 582.3.

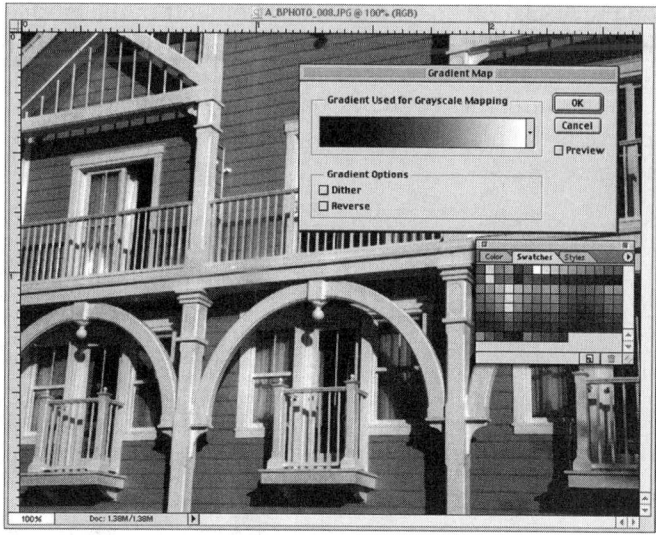

Figure 582.1 The Gradient Map dialog box adjusts the colors in the active document to match the colors in the selected gradient.

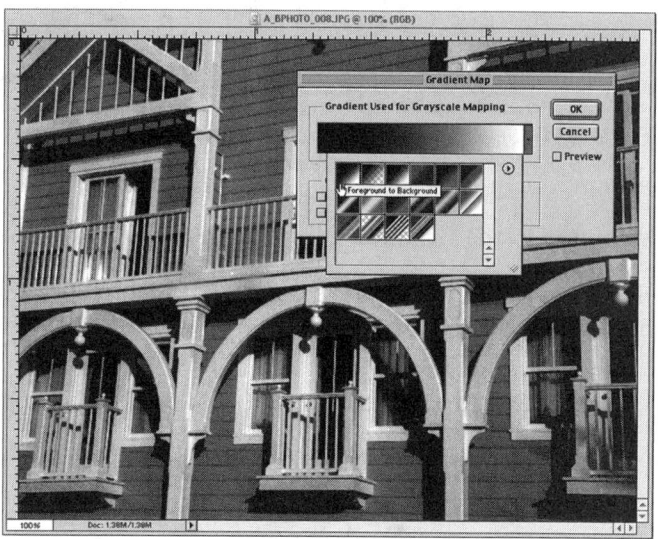

Figure 582.2 The gradient presets palette displays a thumbnail for all the available gradients.

Figure 582.3 The Gradient Editor controls the characteristics of the selected gradient.

6. Click once on the black crayon icon at the bottom left of the gradient adjustment box (refer to Figure 582.3). Photoshop selects the black crayon and lets your change its color.

7. Move your mouse into the Swatches palette and click once on a brown or sepia color swatch. Photoshop converts the black crayon to sepia and maps the colors in the image from sepia to white, as shown in Figure 582.4.

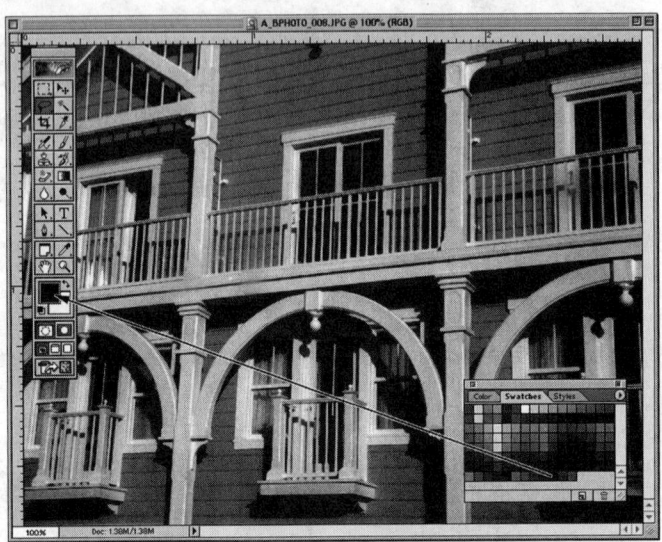

Figure 582.4 Selecting a sepia color from the Swatches palette switches the gradient to sepia and white and converts the active image.

8. Click the OK button in the Gradient Editor to close the dialog box.

9. Click the OK button in the Gradient Map dialog box to record the sepia and white gradient to the image, as shown in Figure 582.5.

Figure 582.5 The sepia to white gradient map successfully applied to the active Photoshop document.

583 *Understanding Native Color Channels*

In Tip 434, "Working with Native Channels and Alpha Masks," you learned how to create an Alpha channel mask using one of Photoshop's Native color channels. When you open a document in Photoshop, the Channels palette displays the Native color channels for that image. Each image, depending on its color mode, has a unique set of Native color channels, as shown in Figure 583.1.

Figure 583.1 Each of Photoshop's color modes create an image with a unique set of Native color channels.

For example, an RGB image contains three Native color channels, one each for the red, green, and blue inks in the image, as shown in Figure 583.2.

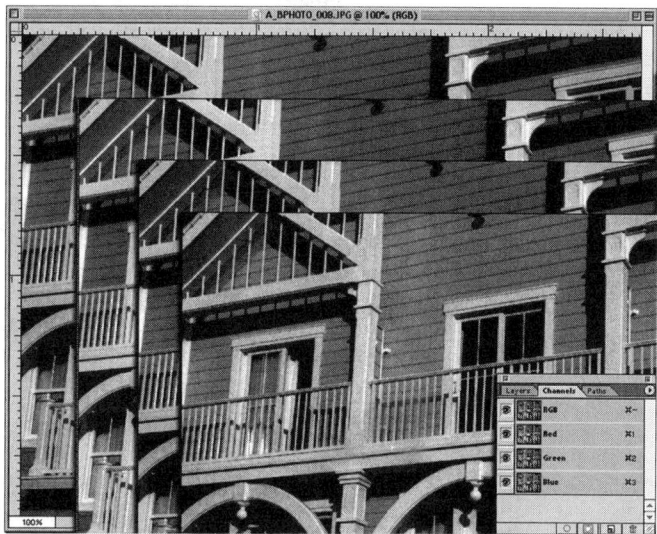

Figure 583.2 The Native color channels in an RGB image represent the percentages of red, green, and blue inks in the image.

Normally, each channel is comprised of 8-bit pixels; therefore, each channel is capable of displaying black, white, and 254 shades of gray. The shades of gray represent the percent of color applied to the image. The darker the shade of gray in a selected channel, the less of that ink is in the active image. To determine the number of colors available to an image, multiply by the number of shades of gray each channel produces. A normal RGB image is capable of producing 16,777,216 separate colors (256×256×256 equal 16,777,216). A normal grayscale image only contains one channel (refer to Figure 583.1); it is capable of producing black, white, and 254 shades of gray.

RGB, CMYK, and Lab color images contain an additional channel, defined as the Composite channel. The Composite channel is located at the top of the Channels palette, and clicking on the Composite channel displays a visual image with all the inks mixed together. Clicking once on an individual color channel deactivates all other channels and displays a visual image of the selected channel in the document window.

584 *Creating Selections with Channel Shortcuts*

In Tip 455, "Turning a Channel into a Selection," you learned how to convert an Alpha channel into a dotted-line selection. When you work in the Channels palette, Photoshop gives you several ways to convert selections into channels and vice versa. One quick way to create and select channels is to use the channel icons located at the bottom of the Channels palette.

If the Channels palette is not visible, click once on the Channels tab or select the Window menu and choose Show Channels from the pull-down menu. Photoshop opens the Channels palette, as shown in Figure 584.1.

Figure 584.1 The Channels palette lets you quickly create and select channel selections.

To convert a selection into an Alpha mask channel, create a selection within an open Photoshop document, as shown in Figure 584.2.

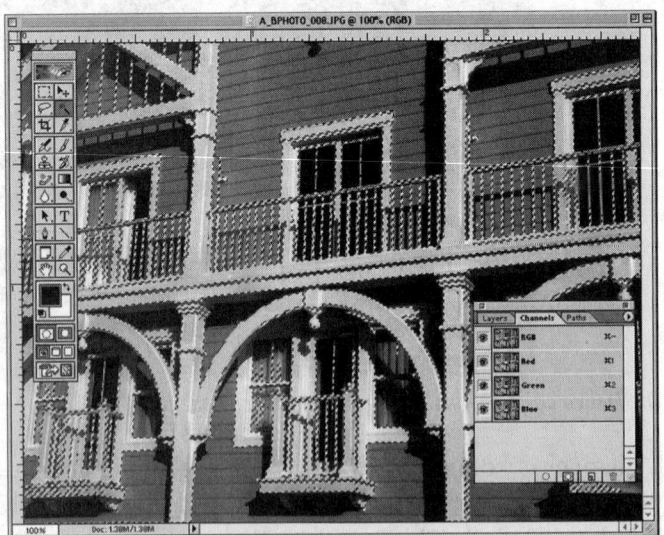

Figure 584.2 The Magic Wand selection tool creates a freeform selection area within the active document.

To convert the selection into an Alpha channel mask, click once on the Save Selection as Channel icon, as shown in Figure 584.3.

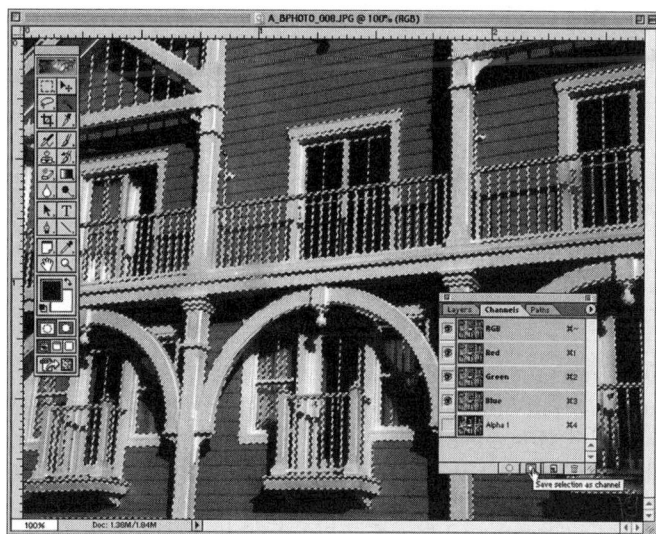

Figure 584.3 Clicking the Save Selection as Channel icon converts the selection into an Alpha mask channel.

To create a selection based on an Alpha channel, click once on the Alpha channel you want to convert into a selection and click once on the Load Channel as Selection icon. Photoshop converts the Alpha mask into a selection, as shown in Figure 584.4.

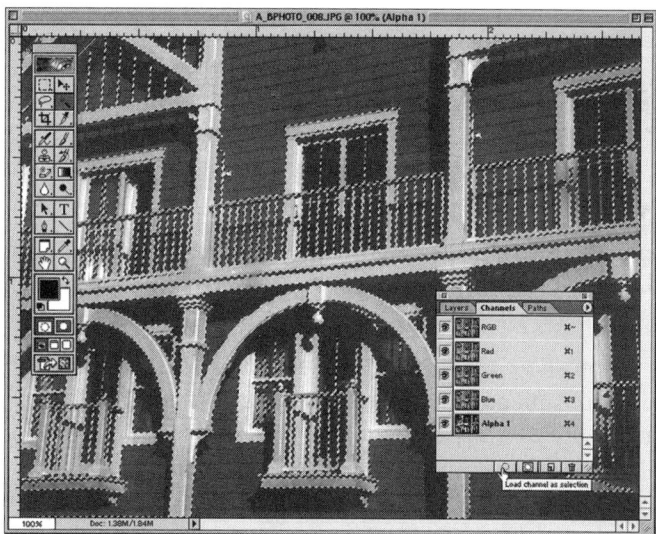

Figure 584.4 Clicking the Load Channel as Selection icon converts the selected Alpha channel into a selection.

Note: Photoshop gives you several ways to perform almost every task. Understanding all the options lets you make a decision as to the best and fastest method.

585 *Working on the Internet*

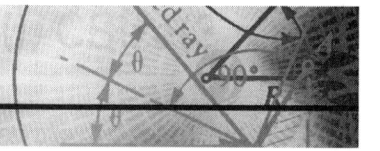

Photoshop is a versatile program. It lets you design and edit images for virtually any output. Photoshop prepares images for high-end printing to color magazines as well as images displayed in newspapers. Each type of photo requires its own unique set of values. Terms like resolution and color space are

important considerations when designing a graphic image. Always have the end of the project in mind before you start. As with all other forms of output, designing images for the Internet has its own set of values.

- **Resolution:** The resolution of an Internet graphic is connected to the output capabilities of a monitor. Typically, the resolution of computer monitors ranges from 72 to 96 pixels per linear inch (ppi). Therefore, the maximum resolution of a computer graphic should not exceed 96ppi. Increasing the resolution of the image only makes a bigger image, not an image with greater detail. For more information on adjusting the size of a Photoshop image, refer to Tip 269, "Changing an Image Using Image Size."

- **View size:** Design images at 100 percent view and then display the image at 100 percent view on the Web document. Modifying the size of Web graphics forces your Web browser to spend time resizing the image, and this slows the load of the page. If the image is not the correct size, return the image into Photoshop and adjust the width and height of the image (refer to Tip 269).

- **File formats:** Save clip art or images containing few colors in the Graphic Interchange Format (GIF). Save photographs in the Joint Photographic Experts Graphic format (JPEG). The Portable Network Graphic (PNG) format is relatively new to computers, and only 30 percent of the Web browsers currently in use support the PNG format. See Tip 852, "Understanding the JPEG File Format," and Tip 853, "Understanding the GIF File Format," for more information on the GIF and JPEG formats.

586 *Additional Measuring Units*

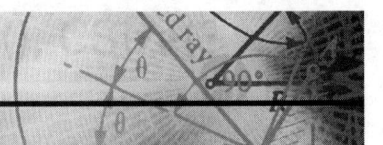

When you edit and work on an image, Photoshop gives you several ways to measure the size of the image. Measurement systems include pixels, inches, centimeters, points, picas, and percent. Understand that changing the measurement units does not affect the document, only the way you measure the document.

To change how Photoshop measures a document, select Edit menu Preferences and choose Units & Rulers from the fly-out menu. Photoshop opens the Units & Rulers options in the Preferences dialog box, as shown in Figure 586.1.

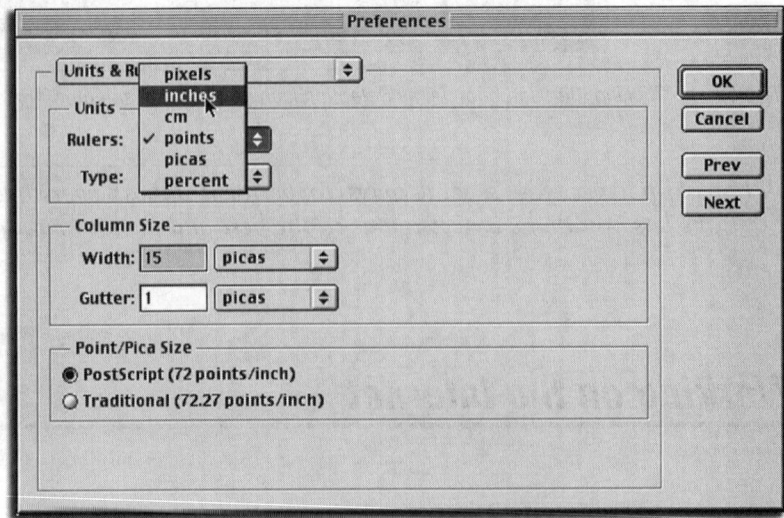

Figure 586.1 The Units & Rulers options in the Preferences dialog box lets you change the measurement system used by Photoshop.

- **Rulers:** Click once on the Rulers button. Photoshop displays the Rulers measurement unit options. Click on an option to change the measurement system used by Photoshop. The choices are pixels, inches, centimeters, points, picas, and percent.

- **Type:** Click once on the Type button. Photoshop displays the Type measurement unit options. Click on an option to change the system Photoshop uses to measure text. The choices are pixels, points, and millimeters.

Click the OK button to close the Units & Rulers dialog box and record your changes to the program.

Note: Changing the measurement units affects all files opened in Photoshop, not just the active Photoshop document.

587 *Using Photoshop's Measurement Units*

In the preceding tip, you learned that Photoshop lets you change the measuring units by accessing the Units & Rulers dialog box. Changing Photoshop's measuring units does not affect the quality of an image. Depending on the type of document, you change the measuring units to reflect the output of the document.

- **Pixels:** Select pixels to work with and edit images destined for the Internet or a computer slide presentation. The pixel measurement unit reflects the measuring units of a monitor.

- **Inches:** Although the United States was supposed to convert to the metric system years ago, it never fully made the conversion. The inches measurement system is the measuring system of our country. Use this system to design and print documents such as posters or small print runs performed at local 24-hour copy stores like Kinko's.

- **Centimeters:** The centimeter measurement system is the normal system for most countries other than the United States.

- **Points:** Use the points measurement system to measure and adjust text. Photoshop uses both standard (72 points per linear inch) and traditional (72.27 points per linear inch) point measurement systems.

- **Picas:** The pica measurement system is used extensively by the professional print industry. Most service bureaus and high-end print houses use picas to do all their measuring.

- **Percent:** Use the percent measurement system to measure images by a percentage of the original document. When you open a document using the percent measurement system, the ruler bars display a width and height from 0 to 100 percent. Expanding or contracting the image size of a graphic is based on a percentage of the whole. For example, to reduce a 10-inch-wide image down to 5 inches, you select a file reduction of 50 percent.

588 *Changing Measurement Units on the Fly*

In Tip 586, "Additional Measuring Units," you learned how to change Photoshop's measurement system by using the Units & Rulers dialog box. Photoshop provides a way to quickly change the current measurement system.

To change to a different measurement system, open a document in Photoshop and right-click your mouse cursor on the ruler bar. Photoshop opens a pop-up menu with the available measurement options, as shown in Figure 588.1.

Figure 588.1 Right-clicking your mouse on Photoshop's ruler bar lets you select from a list of available measurement options.

Click on one of the available options. Photoshop closes the options menu and converts the ruler bar to the new measurement system.

> *Note: If the ruler bar is not visible, select the View menu and choose Show Ruler from the pulldown menu. Photoshop displays the ruler bars at the top and left sides of the document window (refer to Figure 588.1).*

589 *Scanning an Old Image into Photoshop*

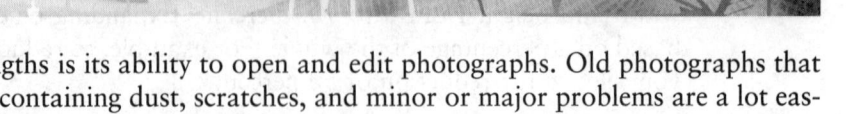

One of Photoshop's greatest strengths is its ability to open and edit photographs. Old photographs that have faded with time and images containing dust, scratches, and minor or major problems are a lot easier to fix than you might think.

The first step to editing an image is the scan of the original document. Continuous-tone images are original documents and images that used traditional darkroom and lab techniques. In order for Photoshop to edit an image, it first must be rasterized, or converted, into pixels. That is the job of your scanner. A scanner takes a continuous-tone image and converts the image into small dots of color. Those dots of color represent the resolution of the scanned image. When you scan an image at a resolution of 150spi (samples per inch), your scanner takes the original image and breaks it into definable dots. At 150spi,

the image contains 150 separate dots of ink per linear inch. A 5×7 image scanned at 150spi contains 787,500 pixels, as shown in Figure 589.1.

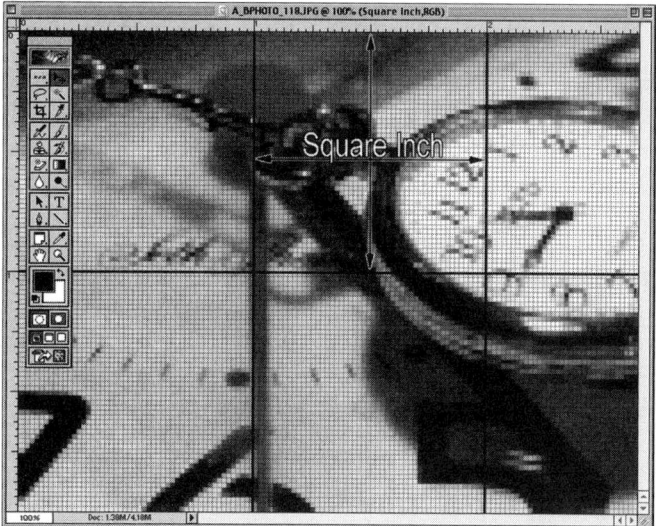

Figure 589.1 The resolution and the number of square inches in the scanned image determine the number of available pixels.

The higher the resolution of the image, the more information Photoshop has to adjust and edit the image. To scan, edit, and print a good-quality image, use optical scan resolutions of 300spi, 600spi, or even higher. Remember that the more digital information Photoshop has, the better job it will do in the editing and printing of the final image.

Another option to consider is the color mode of the scanned document. Old images do not fade to perfect gray; they fade to brown, yellow, or sepia. Do not scan old black and white images as grayscale. You lose too much digital information.

Scan and edit the document using the RGB color space. A normal grayscale image gives you a maximum of 256 steps of gray; an RGB image gives you a maximum of 16,777,216 steps of color. Although the RGB color space is three times bigger than working in grayscale, scanning and working the RGB color space gives Photoshop more digital information to perform the work.

590 *Working Smart to Eliminate Common Scanning Mistakes*

As you learned in the preceding tip, scanning an image is the process of converting the graphic into a form that Photoshop can open and edit. When you scan the image, prepare the image so that you have the best digital information. Remember the phrase "start with a good scan." Do not use the tremendous power of Photoshop to correct the problems introduced by a sloppy scan. Get the scan right and then let Photoshop take over.

- **Stay clean:** Old photos contain more than enough dust and scratches. Keep your scanner bed free of dust by cleaning it regularly with a good commercial glass cleaner. The glass-cleaning products that advertise the use of ammonia are the best because they help eliminate streaking.

- **Compressed air:** Another great product to own is a small can of compressed air. Blowing some air across the scanner bed and the image helps to eliminate those stray particles of dust that always seem to find their way into your scanner.

- **Black cloth:** Sometimes the top portion of the scanner (the part that covers the image before you scan), is less than perfect. Many scanners use a white background, and light leaks in around the edges of the scanner cover. This causes hot spots or uneven lighting on the image. Purchase a small piece of black silk and lay the silk over the image before you close the scanner cover.

- **File formats:** If you do not scan directly into Photoshop, save the files in TIFF format. The TIFF format preserves the color integrity of the image, and Photoshop will not have a problem opening the image. Do not select the LZW compression method or any other compression method. Save the image as an uncompressed TIFF image and then open the image into Photoshop.

- **Scan for detail:** All scanners have the ability to influence the quality of the image. Scan the image using your particular scanning software so that the image contains as much detail as possible. If an area is too light or too dark, Photoshop will correct the problem after the scan. However, areas of a scan that wash out (pure white) or have a deep shadow (pure black) have no digital information. Photoshop needs something to work with. Do not try to make the scan perfect; that is what Photoshop is for. Simply get as much information as possible and let Photoshop do the rest.

591 *Choosing the Correct Color Space for Scanning Old Images*

When you scan an image, you reproduce an image using one of several color spaces. Old images, especially photographs made before the advent of color, do not fade to perfect gray; they fade to brown, yellow, or sepia. A typical response is to scan the image in grayscale. Do not scan old black and white images as grayscale. You will lose too much digital information.

Scan and edit the document using the RGB color space. A normal grayscale image gives you a maximum of 256 steps of gray; an RGB image gives you a maximum of 16,777,216 steps of color. Although the RGB color space produces a file size three times larger than scanning and working in grayscale, the RGB color space gives Photoshop more digital information to perform the work.

If you scan an old black and white image in grayscale, you lose up to 90 percent of the digital information contained in the original image. The tradeoff is speed because RGB images are three times larger, which translates into slower work times in Photoshop. However, in many cases, the final output outweighs the performance loss, as shown in Figure 591.1.

Figure 591.1 Scanning and editing an image using the RGB color space gives Photoshop more digital information to perform the corrections and adjustments.

592 *Identifying Low and High Key Images*

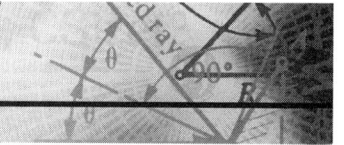

In Tip 590, "Working Smart to Eliminate Common Scanning Mistakes," you learned that Photoshop wants image detail. A scanned image needs sufficient detail in order for Photoshop to perform image editing.

Photoshop's histogram is an excellent way to determine if an image contains enough detail information. To check the digital information in a scanned document, open the image in Photoshop, select the Image menu, and choose Histogram from the pull-down menu. Photoshop opens the Histogram dialog box, as shown in Figure 592.1.

The histogram gives you a quick view of the tonal range of the active image. The left portion of the histogram represents the shadows, the middle portion of the histogram represents the midtones, and the right portion of the histogram represents the highlights (refer to Figure 592.1).

Images with insufficient detail in the highlights are low key images, as shown in Figure 592.2.

Figure 592.1 The histogram displays a graph of the distribution of information in the active image.

Figure 592.2 Images lacking information in the highlights are low key images.

Images with insufficient detail in the shadow areas are high key images, as shown in Figure 592.3.

Figure 592.3 Images lacking information in the shadows are high-key images.

Images with good tonal range contain high numbers of pixels in all areas of the image, as shown in Figure 592.4.

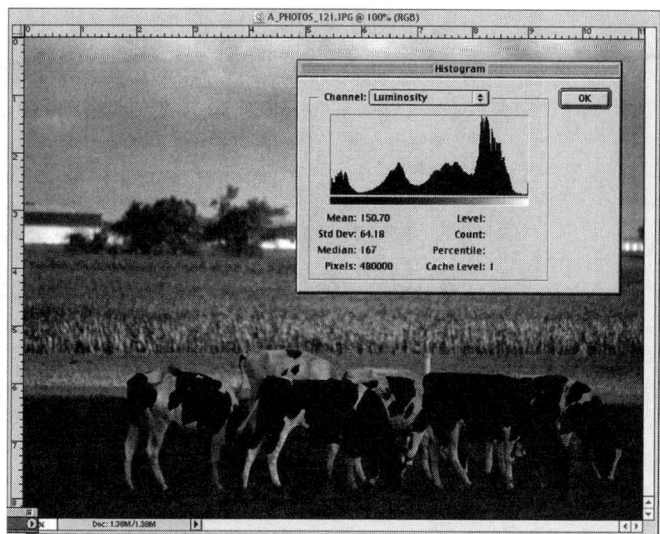

Figure 592.4 Images with good tonal range contain high numbers of pixels in the highlight, midtones, and shadow areas of the histogram.

A lack of tonal range in an image restricts Photoshop's ability to edit and correct the image. While in some cases a lack of tonal range is due to a lack of detail in the original image, in most cases, it indicates a poorly scanned image.

To correct for low or high key images, rescan the image using the scanner's adjustments (refer to your scanner's operating manual for more information on scanning adjustments).

593 *Determining the Best Resolution*

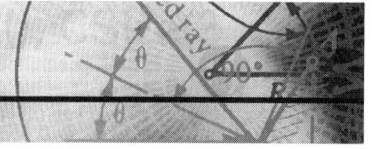

When you scan an image, you want to use the optimal resolution for that particular image. Many formulas help you determine the proper scan resolution. Typically, scanning higher-than-needed resolutions does not hurt the quality of the image; however, it will create a much bigger file. Scanning at resolutions lower than optimal, creates images with less quality. To know the optimal resolution at which to scan an image, you need to know the resolution of the output device.

Say, for example, you want to scan an image, and you know that the final destination of the image is a magazine.

To calculate the optimal scan resolution, you need to know the original width of the image, the width of the image when it prints, and the lines per inch (lpi) of the printing press.

You contacted the service bureau, and their presses run at a line screen of 122lpi (lines per inch). They also informed you that the image print size is 4 by 4 inches. The original image size is 2 by 2 inches.

- Divide the final width by the image's original width (4 divided by 2 equals 2).

- Multiply that result by the lines per inch of the output device (2 multiplied by 122 equals 244).

- Multiply that result by 1.5 (1.5 multiplied by 244 equals 366).

The optimal scan resolution is 366spi (samples per inch), as shown in Figure 593.1.

Figure 593.1 Using the scan formula lets you scan images at the optimal resolution without creating large file sizes.

594 *Scanning Directly into Photoshop*

In Tip 589, " Scanning an Old Image into Photoshop," you learned how to scan and save an image for editing and printing in Photoshop. Photoshop lets you scan directly into the program by way of the Import option.

Scanning directly into Photoshop does not improve the quality of the scanned image; however, it does make you more efficient. Instead of opening your scanner software, scanning and saving the image, closing the scanner software, and then opening the document in Photoshop, you simply scan and edit directly from Photoshop.

To scan directly into Photoshop, perform these steps:

1. Select the File menu and choose Import. Photoshop displays a list of available import devices, as shown in Figure 594.1.

2. Select your scanner from the fly-out menu. Photoshop opens your scanner's software and lets you scan an image (refer to your scanner's operation manual for information on scanning an image).

3. Click the Scan button. Your scanner program scans the image and immediately opens the image in Photoshop, as shown in Figure 594.2.

Note: If you do not see your scanner listed in the Import menu, you will need to install the plug-in file that connects your scanner to Photoshop. Look in your scanner's operations manual for information on linking Photoshop to you scanner. The process involves moving a file on the CD that came with your scanner and placing that file into Adobe's Plug-in folder. Once accomplished, you will be able to access your scanner from the File menu's Import option.

Figure 594.1 Selecting Import from the pull-down menu lets you select from the available import devices.

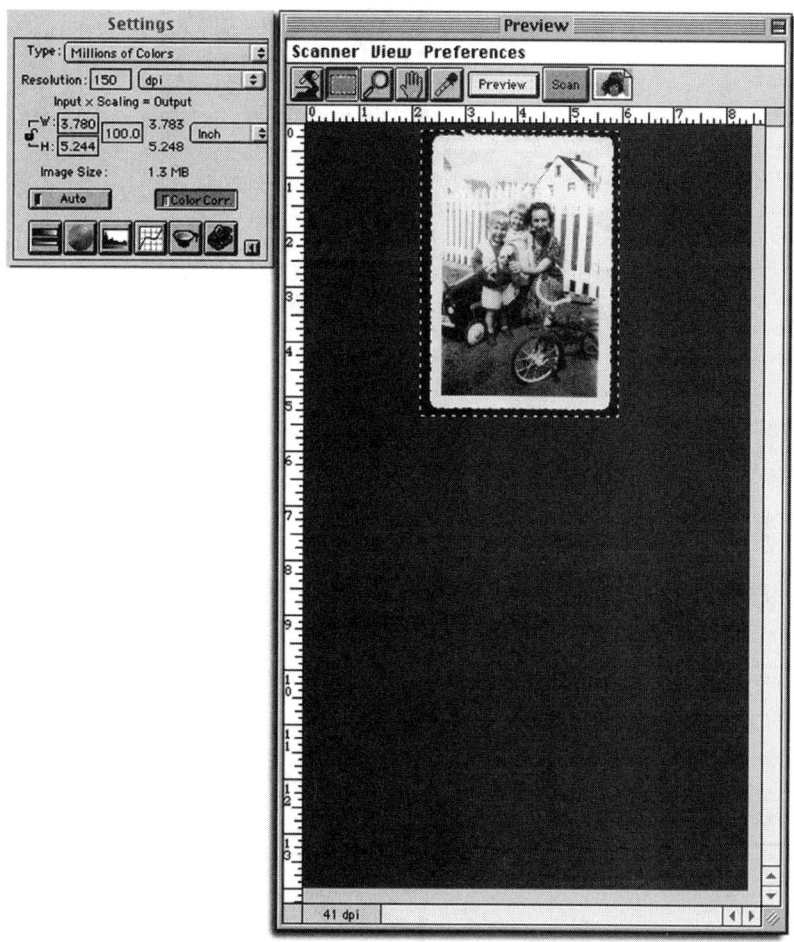

Figure 594.2 Selecting your scanner from the Import menu lets you scan directly into Photoshop.

595 *Using the History to Revert to Previous History States*

In the preceding tip, you learned how to scan an image into Photoshop. Once the image is in Photoshop, the editing process begins. You can use Photoshop's editing tools such as Levels, Curves, and Color Balance, just to name a few of the many ways to correct the image.

As you edit the image, use the History palette to save snapshots of the image at various stages of the editing process.

To save a snapshot of the editing process, open an image in Photoshop and perform these steps:

1. If the History palette is not visible, click once on the History tab or select the Window menu and choose Show History from the pull-down menu. Photoshop opens the History palette, as shown in Figure 595.1.

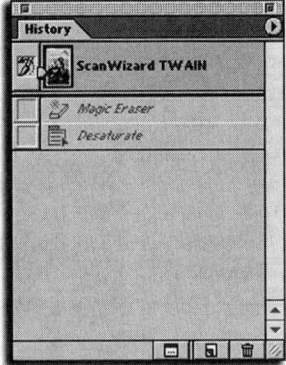

Figure 595.1 *The History palette lets you save snapshots of an image during the editing process.*

2. To save a snapshot of the image, click on the black triangle in the upper-right corner of the History palette. Photoshop displays a pop-up menu with the available History palette options.

3. Click on the New Snapshot option. Photoshop opens the New Snapshot dialog box. Say, for example, you just performed a Levels adjustment to the image. In the Name input box, enter a name for the snapshot. In this example, you named the snapshot Levels Adjustment.

4. Since you want the snapshot taken from the Full Document, click the OK button. Photoshop closes the New Snapshot dialog box and saves the snapshot in the History palette, as shown in Figure 595.2.

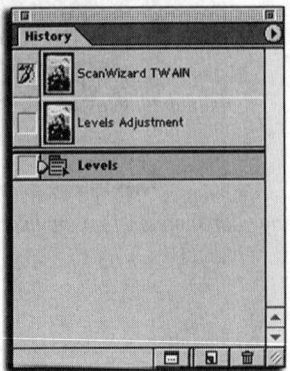

Figure 595.2 *Saving snapshots of the editing process gives you total control over the reconstruction of the image.*

5. At every major change or editing adjustment to the image, stop and create a snapshot.

Note: Creating snapshots of the image gives you the ability to return to any specific development stage in the image. Not only does this help you correct mistakes that go beyond Photoshop's ability to undo, it also lets you be creative by using snapshots for targeted editing of the image. For information on using snapshots to edit an image, see Tip 600, "Using the History Brush to Creatively Edit an Image."

596 *Steps for Scanning Success*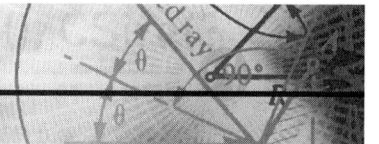

In Tip 590, "Working Smart to Eliminate Common Scanning Mistakes," you learned a few tips to get your scanner ready to scan. Once the scanner is ready to perform the scan, use these steps to ensure a great scan:

1. **Preview the image:** All scanning software lets you view the scan image in a small preview window. Use this opportunity to adjust the image. If the image is at an angle, straighten it. If you scanner has a sweet spot (refer to Tip 198, "Using the Equalize Option"), move the image.

2. **Crop the image:** Use your scanning software's image-sizing tools to crop the image. Scanning a larger image than you need only creates a bigger file and wastes processor time.

3. **Decide the scan mode:** Scanners let you scan images as Line Art, Color, Grayscale, or Halftone.

 - **Line Art** is a 1-bit scan that lets you select high resolutions without a lot of file size. The Line Art mode is useful for scanning logos and sketches.

 - **Halftone** images are 1-bit images that scan a color or black-and-white image using various size halftone dots. Halftone images are useful for printing to low-resolution laser printers and office copiers.

 - **Grayscale** images use an 8-bit pixel to record the grays in the photograph and produce an image with a maximum of 256 steps of gray.

 - **Color** images use a 24- or 32-bit pixel and produce images with millions or billions of colors.

4. **Adjust the image:** Use the built-in controls in your scanning software to produce an image containing detail from highlights to shadows (refer to Tip 592, "Identifying Low and High Key Images").

5. **Scan the image:** Click the Scan button to perform the scan.

6. **Save and edit:** Save the image and begin the editing process.

Note: Always do everything you can to get the best scan possible and then use Photoshop to edit and clean up the rest of the image. If you do not believe you have the best image, rescan and try again.

597 *Scanning Images for the Monitor*

When you work on an image in Photoshop, the output of the image determines how you work. When you scan an image, it is important to know the final output of the image. Images designed for a monitor includes a broad field. Web graphics, Portable Document Files (PDF), interoffice memos, and PowerPoint presentations all have one thing in common: They are all designed for a computer monitor. When you scan images for computer monitors:

- **Color space:** Scan images using the RGB color space. RGB is the color space of a computer monitor.

- **Resolution:** Scan images at a resolution of 72ppi (pixels per inch). The average resolution of a computer monitor is 72ppi.

- **Convert to Indexed color:** The Indexed color space converts an image into a color space acceptable by most older monitors. See Tip 834, "Converting to Indexed Color."

- **Compression:** Do not use compression schemes like LZW and Zip for images designed for multimedia presentations. The compressing and uncompressing of the image slows the presentation.

Note: Because of the number of monitors in the marketplace, images appear differently on different monitors.

598 *Using the Smudge Tool to Blend Pixels*

One of the challenges of merging two images together is the subtle difference between the original image and the copied image. Say, for example, you have two images that you want to combine into one single image. You use the Clone Stamp tool (see Tip 605, "Using the Clone Stamp Tool") to copy the image; however, the rough edge of the copied pixels makes the copied image stand out, as shown in Figure 598.1.

Figure 598.1 The Clone Stamp tool successfully copied the images together, but the edge of the copied pixels makes the image look unrealistic.

To use the Smudge tool to correct the edge of the copied image pixels, open the image in Photoshop, and perform these steps:

1. Click and hold your mouse on the Blur tool or right-click on the Blur tool. Photoshop opens the Blur tool options, as shown in Figure 598.2.

Figure 598.2 Clicking on the Blur tool opens the Blur tool options.

2. Click once on the Smudge tool option. Photoshop selects the Smudge tool.

3. Move your cursor into the Options bar and click on the black triangle to the right of the Brush icon. Photoshop opens the Brush palette, as shown in Figure 598.3.

Figure 598.3 The Brush palette displays a thumbnail of all available brushes.

4. Select a brush size and shape by clicking once on a thumbnail in the Brush palette. Select a small, soft, round brush (refer to Figure 598.3).

5. In the Pressure input field, enter a value of 10 percent (refer to Figure 598.3).

6. Move the modified Smudge tool into the document window. Click and drag the Smudge tool along the edge of the copied pixels. The Smudge tool softly blurs the edge pixels of the copied image into the background of the original image, as shown in Figure 598.4.

Figure 598.4 The Smudge tool successfully blends the edge pixels of the copied image into the original image.

599 *Fixing Dust and Scratches*

Photoshop gives you several ways to correct dust and scratches in an image. One way to correct dust and scratches is to use Photoshop's Dust & Scratches filter.

Say, for example, you scanned an old image into Photoshop, and you want to remove the dust and scratches from the nondetailed areas of the image. To remove the dust and scratches from an old image, open the document in Photoshop and perform these steps:

1. Select the Filter menu, select Noise and choose Dust & Scratches from the fly-out menu. Photoshop opens the Dust & Scratches dialog box, as shown in Figure 599.1.

2. Two options control the Dust & Scratches filter:

 - **Radius:** In the Radius input box, enter a value from 1 to 100 (or click and drag the triangular slider left or right). The Radius value determines the amount of Gaussian blur to apply to the image. The higher the value, the greater the blur, as shown in Figure 599.2.

 - **Threshold:** In the Threshold input box, enter a value from 0 to 255 (or click and drag the triangular slider left or right). The Dust & Scratches filter identifies a scratch or dust mark by a sharp shift in the brightness of the pixels. The Threshold value determines the tolerance that the Dust & Scratches filter applies to the image or how sharp a shift in brightness constitutes a scratch, as shown in Figure 599.3.

3. For light scratches and dust, move the Radius slider to a 2 or 3 and then slowly adjust the Threshold slider until the scratches are removed from the image, as shown in Figure 599.4.

Figure 599.1 *The Dust & Scratches filter helps eliminate dust and scratches from an image.*

Figure 599.2 *The Radius option controls the amount of Gaussian blur applied to the image.*

Figure 599.3 The Radius option controls the amount of Gaussian blur applied to the image.

Figure 599.4 The Dust & Scratches filter successfully removed the scratches from the image.

Note: Since dust and/or scratches on an image are very similar to other normal black and white areas of an image, it is difficult to use the Dust & Scratches filter on the entire image. The best use of the Dust & Scratches filter is to first select small areas of the image one at a time and use the Dust & Scratches filter within those areas.

600 *Using the History Brush to Creatively Edit an Image*

In Tip 595, "Using the History to Revert to Previous Image States," you learned how to save snapshots of an image during the editing and restoration process. Say, for example, you edit an image by performing color correction using the Curves command (see Tip 641, "Using Curves to Increase the Contrast in an Image") and take a snapshot of the image after the Curves adjustment.

Then you perform a Levels adjustment to the image (refer to Tip 201, "Understanding How the Levels Command Adjusts an Image") and take another snapshot after the Levels adjustment.

After performing the Levels adjustment, you realize that certain areas within the image did not require adjustment with Levels. You want to restore the areas of the image that did not require Levels adjustment.

To restore specific parts of an image using the History palette and brush, perform these steps:

1. If the History palette is not visible, click on the History tab or select the Window menu and choose Show History from the pull-down menu. Photoshop displays the History palette, as shown in Figure 600.1.

Figure 600.1 The History palette lets you create snapshots of a document and later use them to restore the image.

2. Move your mouse into the toolbox and click once on the History brush. Photoshop selects the History brush as the active tool (refer to Tip 397, "Understanding How History Operates").

3. Move your mouse into the Options bar and click once on the black triangle to the right of the Brush icon. Photoshop opens the Brush palette, as shown in Figure 600.2.

4. Click once on a brush thumbnail to select a brush. Choose a small, soft brush (refer to Figure 600.2).

5. Move your mouse into the History palette and click once in the source input box to the left of the Curves snapshot, as shown in Figure 600.3.

6. Move your mouse into the document window and use the History brush as you would a paintbrush. When you click and drag your mouse, the History brush restores the image back to the state before you applied the Levels adjustment, as shown in Figure 600.4.

Figure 600.2 The Brush palette displays a list of all available brush sizes.

*Figure 600.3 Clicking in the snapshot source box determines what
snapshot the History brush uses to reconstruct the image.*

Figure 600.4 The History brush successfully restored selected areas of the image.

601 *Using the Dodge Tool to Control Image Exposure*

Photoshop's Dodge tool lightens by withholding light from selected portions of an image. In traditional photography, you lighten an area of a print by inserting a piece of opaque paper between the negative and the image. The paper holds back light from selected portions of the image and thereby lightens the image, as shown in Figure 601.1.

Figure 601.1 In traditional photography, to lighten an image, insert an opaque piece of paper between the enlarger lens and the exposed paper.

When you use the Dodge tool, you essentially place a piece of opaque paper between the enlarger lens and the image. The opaque paper is the brush, and the image lightens depending on how long you drag the brush across the image. Unlike traditional darkroom methods, the Dodge tool lets you lighten only the highlights, midtones, or shadows in the active image.

Say, for example, you have a document that contains dark areas, and you want to lighten selective portions of the image. To use the Dodge tool, open the document in Photoshop and perform these steps:

1. Move your mouse cursor into the toolbox and click and hold (or right-click) on the Toning Tools icon. Photoshop displays a list of available Toning tools, as shown in Figure 601.2.

2. Click once on the Dodge tool. Photoshop closes the Focus options menu and selects the Dodge tool.

3. The Options bar controls the characteristics of the Dodge tool, as shown in Figure 601.3.

4. Click on the black triangle to the right of the Brush icon. Photoshop opens the Brush palette. Select a brush by clicking once on a brush thumbnail. Use soft brushes to apply the Dodge effect to the image.

5. Click once on the Range button. Photoshop displays a pop-up menu with the options Highlights, Midtones, and Shadows. Click once to select a Dodge tool range.

6. In the Exposure input box, enter a value from 1 to 100 percent. The Exposure option controls how fast the Dodge tool performs its operations.

7. In this example, you selected a 35-pixel soft brush, a Range in the Midtones, and an Exposure of 20 percent (refer to Figure 601.3).

Figure 601.2 Right-clicking your mouse on the Toning Tools icon displays of list of available Focus tools.

Figure 601.3 The Options bar controls the characteristics of the Dodge tool.

8. Move your mouse into the document window and place the Dodge tool over the area you want to lighten. Click and drag your mouse over the image. The Dodge tool lightens the image according to how you set up the tool, as shown in Figure 601.4.

Although the Dodge tool lightens image pixels based on Brush size, Range, and Exposure, you control the tool by holding down the mouse button and dragging the Dodge tool across the image. You control the speed of the Dodge tool by increasing or decreasing the Exposure option. Say, for example, you choose a 30 percent Exposure. As long as you continue to hold the mouse button, the brushed areas of the image lighten based on the value entered into the Exposure option. Higher Exposure values lighten the image faster than lower values.

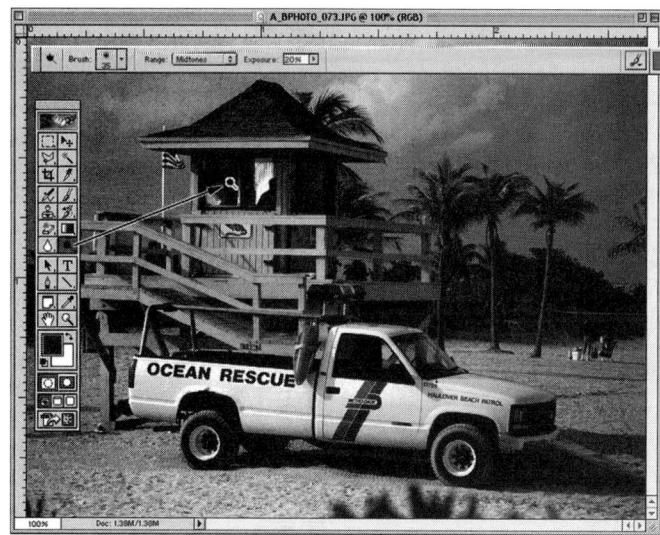

Figure 601.4 The Dodge tool lightens selected areas of the image by reducing the midtones of the image pixels.

602 *Using the Sponge Tool to Control Color Saturation*

Photoshop's Sponge tool works to control the saturation of the inks within a color document. All color pixels within a Photoshop image contain a saturation value from 1 to 100 percent. The higher the value, the greater the saturation of the ink. The Sponge tool works to increase or decrease the saturation of the inks in a Photoshop document.

Increasing the saturation of the inks intensifies the original colors in the image: Reds, greens, and blues become more vivid. When you use the Sponge tool to desaturate the ink colors, reds, greens, and blues become duller and duller until continued use of the Sponge tool finally converts the colors in the image into shades of gray.

Say, for example, you have a color image, and you want to increase the saturation of the inks in selected portions of the image. To use the Sponge tool to control the saturation of the inks in an image, open the document in Photoshop and perform these steps:

1. Move your cursor into the toolbox and click and hold (or right-click) on the Toning tools icon. Photoshop displays a list of available Toning tools, as shown in Figure 602.1.

2. Click once on the Sponge tool. Photoshop closes the Focus options menu and selects the Sponge tool.

3. The Options bar controls the characteristics of the Sponge tool, as shown in Figure 602.2.

4. Click on the black triangle to the right of the Brush icon. Photoshop opens the Brush palette. Select a brush by clicking once on a brush thumbnail. Use soft brushes to apply the Sponge effect to the image. In this example, you choose a soft 27-pixel brush.

5. Click on the Mode button. Photoshop displays a list of available Mode options in a pop-up menu:

 • **Desaturate:** Select the Desaturate option to reduce the saturation of the selected pixels. Continued use of the Desaturate option reduces the color pixels within an image to shades of gray.

 • **Saturate:** Select the Saturate option to increase the saturation of the selected pixels. Since you want to increase the saturation of the inks, you should choose the Saturate option.

Figure 602.1 Right-clicking your mouse on the Toning tools icon displays of list of available Focus tools.

Figure 602.2 The Options bar controls the characteristics of the Dodge tool.

6. In the Pressure input box, enter a value from 1 to 100 percent. The Pressure option controls how fast the Sponge tool performs its operations.

7. To increase the saturation of the inks in the image, move your mouse into the document window and place the Sponge tool over the area you want to increase. Click and drag your mouse over the image. The Sponge tool increases the saturation of the image pixels, as shown in Figure 602.3.

Although the Sponge tool saturates or desaturates image pixels based on Brush size and Mode, you control the tool by holding down the mouse button and dragging the Sponge tool across the image. You control the speed of the Sponge tool by increasing or decreasing the Pressure option. Say, for example, you choose 30 percent Pressure. As long as you continue to hold the mouse button, the brushed areas of the image saturate or desaturate based on the value entered into the Pressure option. Higher Pressure values saturate or desaturate the image faster than lower values.

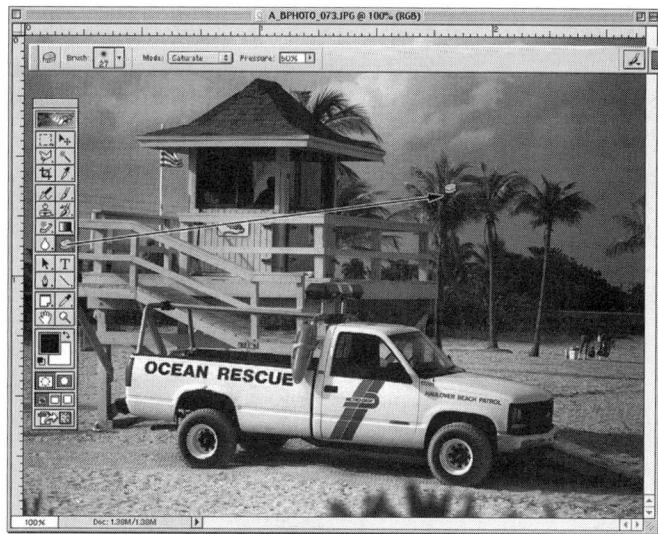

Figure 602.3 The Sponge tool increases the saturation of the color inks in the selected areas of the image.

603 *Using the Dust & Scratches Filter with the History Brush*

In Tip 599, "Fixing Dust and Scratches," you learned how to use the Dust & Scratches filter to reduce the dust and scratches in a photographic image. The problem with using the Dust & Scratches filter is its inability to correct the entire image. The Dust & Scratches filter (refer to Tip 599) corrects scratches by identifying shifts in brightness between the scratch and the surrounding matrix of pixels, as shown in Figure 603.1.

Figure 603.1 The Dust & Scratches filter identifies scratches by a shift in brightness in the image pixels.

Normal photographs contain shifts in brightness along edges or in facial features that are not scratches; however, the Dust & Scratches filter attempts to soften all areas containing shifts in brightness, not just the dust and scratches. To use the Dust & Scratches filter, you have to select areas and apply the filter

selectively to the image. Although this works, it is time-consuming. That is where the History palette can help.

To eliminate dust and scratches from an image using the Dust & Scratches filter and the History palette, open the document in Photoshop and perform these steps:

1. Select Filter menu Noise, and choose Dust & Scratches from the fly-out menu. Photoshop opens the Dust & Scratches dialog box, as shown in Figure 603.2.

Figure 603.2 The Dust & Scratches filter controls the scratches in an image using the Radius and Threshold options.

2. Reduce the dust and scratches in the image using the information contained in Tip 599. The Dust & Scratches filter successfully removes scratches from the several areas of the image; however, it also blurs facial features and graphic items with sharp edges, as shown in Figure 603.3.

Figure 603.3 The Dust & Scratches filter removes scratches and facial features from the image.

3. Click the OK button to close the Dust & Scratches dialog box and apply the changes to the image.

4. If the History palette is not visible, click once on the History tab or select the Window menu and choose Show History from the pull-down menu. Photoshop opens the History palette, as shown in Figure 603.4.

5. To save a snapshot of the image, click on the black triangle in the upper-right corner of the History palette. Photoshop displays a pop-up menu with the available History palette options.

Figure 603.4 The History palette records the last 20 operations performed on the image.

6. Click on the New Snapshot option. Photoshop opens the New Snapshot dialog box. In the Name input box, enter a name for the snapshot. In this example, you name the snapshot "Dust & Scratches."

7. Since you want the snapshot taken from the Full Document, click the OK button. Photoshop closes the New Snapshot dialog box and saves the snapshot in the History palette, as shown in Figure 603.5.

Figure 603.5 Saving snapshots of the editing process gives you control over the reconstruction of the image.

8. Move your mouse into the toolbox and click once on the History brush. Photoshop selects the History brush as the active tool (refer to Tip 397, "Understanding How History Operates").

9. Move your mouse into the Options bar and click once on the black triangle to the right of the Brush icon. Photoshop opens the Brush palette, as shown in Figure 603.6.

10. Click once on a brush thumbnail to select a brush. Choose a small soft brush (refer to Figure 603.6).

11. Move your mouse into the History palette and click once on the original snapshot of the image. The document reverts to the way it looked before you applied the Dust & Scratches filter, as shown in Figure 603.7.

12. Move your mouse into the History palette and click once in the source input box to the left of the Dust & Scratches snapshot, as shown in Figure 603.8.

Figure 603.6 The Brush palette displays a list of all available brush sizes.

*Figure 603.7 Clicking in the family.jpg snapshot of the image reverts the
document back to its original state.*

13. Move your mouse into the document window and use the History brush as you would a paintbrush. When you click and drag your mouse, the History brush paints the image using the Dust & Scratches snapshot. Restore the areas of the image where the Dust & Scratches filter worked, as shown in Figure 603.9.

Note: To further control the History brush, create a new layer and apply the History brush to the new layer. Refer to Tip 233, "Controlling Your Work with Layers."

Figure 603.8 Clicking in the snapshot source box determines what snapshot the History brush uses to reconstruct the image.

Figure 603.9 The History brush successfully restored selected areas of the Dust & Scratches snapshot to the image.

604 *Creating Customized Photo-Restoration Brushes*

All of Photoshop's image-editing tools work according to the size and shape of the brush you choose. Say, for example, you work with the History brush (refer to the preceding tip) to edit an image. The size and shape of the selected brush control how the History brush edits the image. Photoshop comes with a set of default brushes; however, if you do extensive image editing, you will eventually want to create and use your own customized brushes.

To create and save a set of custom image-editing brushes, open Photoshop and perform these steps:

1. Select a tool from the toolbox that requires the use of a brush size. In this example, you should select the Paintbrush, as shown in Figure 604.1.

Figure 604.1 The Paintbrush tool uses a brush to apply ink to the image.

2. The Options bar for the Paintbrush displays a Brush icon. Click once on the small black triangle to the right of the Brush icon. Photoshop opens the Brush palette and displays a list of available brushes, as shown in Figure 604.2.

Figure 604.2 The Brush palette displays a list of all available brush sizes.

3. If you want to create a select set of image-editing brushes, move your mouse into the Brush palette and right-click your mouse on a brush thumbnail. Photoshop displays a list of available options. Click the Delete Brush option to remove the brush from the available list. Continue to remove the brushes until you have a smaller set, as shown in Figure 604.3.

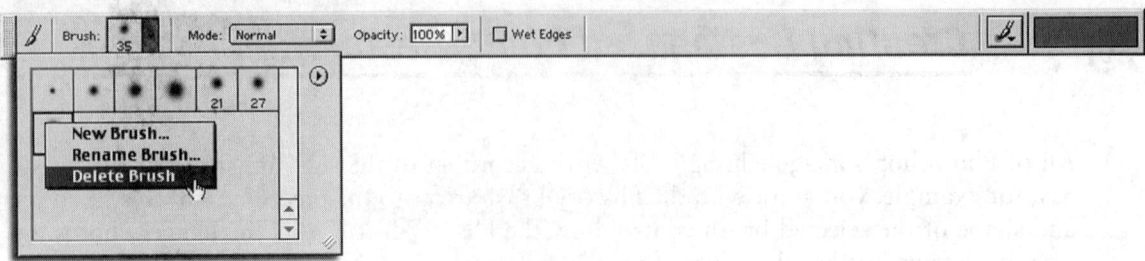

Figure 604.3 Delete the brushes you do not want in your new set.

4. To add a new brush to your set, right-click (Macintosh: Ctrl+click) your mouse in Brush palette and choose New Brush from the pop-up menu. Photoshop opens the New Brush dialog box, as shown in Figure 604.4.

Figure 604.4 The New Brush dialog box controls the characteristics of the new brush.

5. In the Name input field, enter a descriptive name for the new brush.

6. In the Diameter input field, enter a value from 1 to 999. The Diameter field controls the size of the brush in pixels. Image-editing brushes are typically small-diameter brushes: 20 pixels or less.

7. In the Hardness input field, enter a value from 0 to 100 percent. The Hardness option controls the edge of the brush. Image-editing brushes are typically soft brushes: 0 to 20 percent.

8. In the Spacing input field, enter a value from 1 to 999 percent. The Spacing option simulates a solid line by copying the brush image as you drag the mouse. A Spacing value of 25 percent creates a new copy of the brush every 25 percent, which visually simulates a solid line. If you create an oval brush, reduce the spacing value to 10 to 15 percent.

9. In the Angle input field, enter a value from 0 to 180 or 0 to –180. The Angle option controls the angle of the brush around a 360-degree circle. Round brushes are not affected by the Angle option.

10. In the Roundness input field, enter a value from 0 to 100 percent. A 100 percent brush is perfectly round. Lower the value of the Roundness option to create an oval brush.

11. Click the OK button to add the new brush to the Brush palette.

12. Repeat steps 4 through 11 to create as many image-editing brushes as you want in the new palette, as shown in Figure 604.5.

Figure 604.5 The Brush palette containing a new set of image-editing brushes.

13. To save the new Brush palette, click the black triangle, located in the upper-right corner of the Brush palette. Photoshop opens a fly-out menu with the Brush palette options, as shown in Figure 604.6.

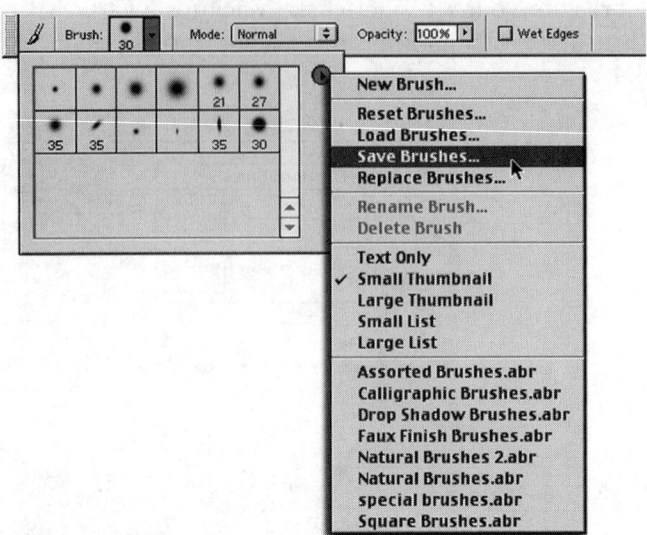

Figure 604.6 Clicking the black triangle displays the options for the Brush palette.

14. Select Save Brushes from the fly-out menu. Photoshop opens the Save dialog box, as shown in Figure 604.7.

Figure 604.7 The Save dialog box lets you name and save your new Brush palette.

15. In the Name input field, enter a name for the brushes. In this example, you named the brushes *restoration.abr.* Click the OK button to save the new brush set.

Note: To access a previously saved brush set, repeat step 14, except select the Load Brushes option. Photoshop opens the Load dialog box. Locate the brush set and click the Load button.

605 *Using the Clone Stamp Tool*

Undoubtedly, the most versatile and widely used image-editing tool is the Clone Stamp tool. The Clone Stamp tool is a paintbrush that selects detailed image information from one part of an image and moves

it to a different portion of the same image. The Clone Stamp tool repairs scratches and imperfections in an image when the Dust & Scratches filter and other editing tools fail. The difference is that the Clone Stamp tool does not blend or blur the image; it paints physical details back into the image.

Say, for example, you have an image that needs some restoration work, as shown in Figure 605.1.

Figure 605.1 The image contains damaged areas that require restoration.

To use the Clone Stamp tool to restore the image, open the document in Photoshop and perform these steps:

1. Click and hold (or right-click) your mouse on the Clone Stamp tool. Photoshop opens the Stamp options, as shown in Figure 605.2.

Figure 605.2 Clicking and holding your mouse on the Stamp tool icon displays the Stamp tool options.

2. Select the Clone Stamp option. Photoshop closes the options menu and makes the Clone Stamp the active tool.

3. Click once on the Clone Stamp icon at the far left of the Options bar. Photoshop opens the Clone Stamp reset options. Select Reset Tool from the pop-up menu. Photoshop resets the Clone Stamp options back to their default values, as shown in Figure 605.3.

Figure 605.3 Selecting the Reset Tool option changes the Clone Stamp options back to their default values.

4. Click on the small black triangle to the right of the Brush icon. Photoshop opens the Brush palette. Select a small, soft brush or choose a customized brush (refer to the preceding tip). In this example, you choose a small, soft, 9-pixel brush, as shown in Figure 605.4.

Figure 605.4 The Brush palette lets you select the size and shape brush to use with the Clone Stamp tool.

5. Move the Clone Stamp tool into the image, position it above the pixels you want to set as the alignment point for the Clone tool, and Alt+click (Macintosh: Option+click) directly over that spot. The alignment point is where the Clone tool begins painting. See Tip 609, "Selecting Information with the Clone Stamp Tool." Examine the image and locate an area of image detail that you believe will successfully cover the damaged portion of the image. That is the area you want to select as your alignment point, as shown in Figure 605.5.

6. Move the Clone tool over the damaged area of the image. Click and drag your mouse slowly over the damaged pixels. Photoshop replaces the damaged pixels with the detail from the alignment point, as shown in Figure 605.6.

7. Move through the image, repeating steps 5 and 6, until you have restored all the damaged areas of the image, as shown in Figure 605.7.

Figure 605.5 *The alignment point represents a detail area of the image that, if moved, would cover the damaged portion of the document.*

Figure 605.6 *The Clone Stamp tool replaces the damaged pixels with the pixels from the alignment point.*

Figure 605.7 *The Clone Stamp tool successfully restored the damaged areas of the image.*

606 *Using the Clone Stamp Tool Between Two Images*

In the preceding tip, you learned how to use the Clone Stamp tool to restore a damaged image. The Clone Stamp tool not only lets you move digital information within a single document, it also lets you open two documents and move information between digital information from one document into another.

Say, for example, you have two images that you want to combine into a single document. To use the Clone Stamp tool to create a single document from two separate images, open the two documents in Photoshop and perform these steps:

1. Position the documents on your monitor so that both images are visible, as shown in Figure 606.1.

Figure 606.1 Position the two open documents so that they are both visible.

2. Using the instructions in the preceding tip, select the Clone Stamp tool and choose the alignment point. In this example, you want to move the image data from *image2.psd* into *image1.psd*. Select the Clone Stamp alignment point from *image2.psd*, as shown in Figure 606.2.

3. Move the Clone Stamp into *image1.psd* and position the tool over the area where you want to begin the cloning process. Click and drag your mouse over the image to copy the digital information from *image2.psd* to *image1.psd*, as shown in Figure 606.3.

Continue to use the Clone Stamp tool until the image is complete, as shown in Figure 606.4.

Figure 606.2 Select the alignment point for the Clone Stamp tool from image2.psd.

Figure 606.3 The Clone Stamp tool moves information from one open document into another.

Figure 606.4 The Clone Stamp tool successfully moved information from image1.psd *to* image2.psd.

607 *Controlling the Clone Stamp Tool Using Multiple Layers*

In Tip 605, "Using the Clone Stamp Tool," you restored the damaged portions of the image using the Clone Stamp tool. To control the image-editing process, create a new layer and perform the image editing in the new layer. When you perform the Clone Stamp operation in a layer, you maintain control of the image. If you make a major mistake, you correct the problem by editing the new layer, not the actual document. Clone Stamping within a new layer gives you control and flexibility over time.

To perform image editing in a new layer, open the document in Photoshop and perform these steps:

1. If the Layers palette is not visible, click once on the Layers tab or select the Window menu and choose Show Layers from the pull-down menu. Photoshop opens the Layers palette, as shown in Figure 607.1.

Figure 607.1 The Layers palette displays a thumbnail image of all the layers within the active image.

2. Click the New Layer icon at the bottom of the Layers palette. Photoshop creates a new layer and places it above the original image layer, as shown in Figure 607.2.

Figure 607.2 Clicking once on the New Layer icon creates a new transparent layer.

3. Select the Clone Stamp tool from the toolbox (refer to Tip 605) and move your mouse into the Options bar. Click to place a check mark in the Use All Layers check box.

4. Refer to Tip 605 and repeat the steps to restore the image. The Clone Stamp tool repairs the image, with one exception. The repairs to the image are performed in the new transparent layer, as shown in Figure 607.3.

Figure 607.3 The Clone Stamp tool works on the image by placing the digital information in the new transparent layer.

Note: The advantage to using a transparent layer is control over the image. Since the information is placed into a separate layer, the original image remains intact. This gives you the control and flexibility needed to do the best job possible.

608 *Moving Information Between Open Documents and Making It Look Realistic*

When you use the Clone Stamp to move information between documents, pay attention to a few points that will help the images appear natural.

- **Document size:** When you move digital information between two documents, it is best if they are both the same resolution. When you Clone Stamp digital information from an image with a resolution of 300 into an image with a resolution of 150, the Cloned Stamp information appears twice as big when moved. For more information on the resolution of an image, refer to Tip 56, "Changing Image Size Using the Pull-Down Menu."

- **Brush size:** The selected brush size determines the size and shape of the Cloned Stamped area. Choose soft brushes to give the information a more realistic look. If you do not have the correct brush for the job, create your own customized brush set (refer to Tip 604, "Creating Customized Photo-Restoration Brushes").

- **Lighting:** When moving images between documents, watch out for conflicting light sources. If the original document contains a light source traveling down and to the right, moving an object with a light source traveling up and to the left will not appear realistic.

- **Color space:** Both open documents must be in the same color space. For example, you cannot Clone Stamp digital information between RGB and CMYK color images. Convert images to the same color space before performing a Clone Stamp operation (refer to Tip 111, "Choosing the Correct Color Space").

Note: The bottom line is to pay attention to the details. If the image does not look realistic to your eyes, it probably will not look realistic to anyone else.

609 Selecting Information with the Clone Stamp Tool

In Tip 605, "Using the Clone Stamp Tool," you learned how to select the alignment point.

- **Brush size:** When you select the alignment point, the size and shape of the brush control the area copied. The best Clone Stamp brushes are small and soft. The soft edge of the brush gives the cloned information a natural look and feel. Since the hardness of the brush (refer to Tip 604, "Creating Customized Photo-Restoration Brushes") determines how the cloned information blends into the original image, experiment with different hardness settings to find the best brush. Since all images are slightly different, you will need different brushes with different hardness settings, as shown in Figure 609.1.

- **Alignment:** You select the alignment point for the Clone Stamp tool by Alt+clicking (Macintosh: Option+clicking) your mouse over the pixels you want to copy. When you begin the painting process, the Clone Stamp tool stays locked to your original alignment point. When you drag your mouse across the image, the alignment point repositions itself according to the Clone Stamp's last position, as shown in Figure 609.2.

Figure 609.1 Different hardness settings produce different effects when coupled with the Clone Stamp tool.

- **Creating a new alignment point:** To create a new alignment point, move your Clone Stamp tool into the image and Alt+click (Macintosh: Option+click) your mouse over another part of the image. The Clone Stamp tool readjusts and begins painting from the new alignment point.

Figure 609.2 The Clone tool readjusts the alignment point according to the last position of the Clone Stamp tool.

610 *Using the Right Color Space*

In Tip 608, "Moving Information Between Open Documents and Making It Look Realistic," you learned that the Clone Stamp tool only moves information between documents if they are both in the same color space. The color space of the documents not only is important when you work between two open images, it also is important to work in the color space that produces the best results.

In Photoshop, RGB and CMYK are the two main color spaces.

When you use the Clone Stamp tool, the best color space to work in is the RGB color space. Three reasons make it the space to work in:

- **Size:** The CMYK color space produces a 25 percent larger file size. Everything works slower on a larger file. Although it is not a good idea to swap speed for image quality, CMYK files are larger and therefore slower.

- **Monitor color:** Your monitor mixes color using three-color guns of red, green, and blue. It does not mix color using four-color guns of cyan, magenta, yellow, and black. In addition, monitors display color using an additive process. The monitor projects the color to your eyes. The CMYK color space is designed for subtractive color. A light source reflects off a paper and returns some of the colors to your eyes.

- **Power:** When you work on an image in CMYK color space, you lose half of Photoshop's filters and several adjustments.

> *Note: For all of these reasons, you will work faster, better, and more accurately if you work in the RGB color space.*

611 *Removing Fringe Pixels*

When you move digital information from one document into another, you typically select the pixels you want to move and then drag them into the other document. Moving selected information sometimes generates a fringe around the edge of the moved pixels, as shown in Figure 611.1.

Figure 611.1 Moving digital information generates a noticeable fringe around the edge of the copied information.

To remove the fringe pixels from a copied image, select the layer containing the copied pixels. Then select Layer menu, select Matting, and choose Defringe from the fly-out menu. Photoshop opens the Defringe dialog box, as shown in Figure 611.2.

Figure 611.2 The Defringe dialog box helps remove fringe pixels from around a copied image.

In the Width input box, enter a value from 1 to 200 pixels. The Defringe option examines the edge pixels based on the Width value and replaces the edge pixels with solid, nonbackground colors.

Click the OK button to apply the Defringe command to the image, as shown in Figure 611.3.

Figure 611.3 The Defringe command successfully removed the white edge pixels from the copied image.

612 *Removing Fringe Pixels Using the Blend If Options*

In the preceding tip, you learned how to remove the fringe pixels from an image using the Defringe command. While the Defringe command does an excellent job of fringe reduction, it does not always work the way you expect. Say, for example, you select a large amount of black text from one document, and you move it into another document.

The original document contained a white background, and your text now has a fringe of white pixels around the text. In the preceding tip, you used the Defringe option, but it left some of the white, as shown in Figure 612.1.

Figure 612.1 The text contains a halo of white pixels that the Defringe command cannot remove.

To remove the fringe pixels, perform these steps to the layer containing the type:

1. If the Layers palette is not visible, click once on the Layers tab or select the Window menu and choose Show Layers from the pull-down menu. Photoshop opens the Layers palette, as shown in Figure 612.2.

Figure 612.2 The Layers palette contains a thumbnail representing each of the layers in the active image.

2. Move your mouse into the Layers palette and double-click on the layer containing the moved text. Photoshop opens the Layer Style dialog box, as shown in Figure 612.3.

3. Move your mouse into the Layer Style dialog box and identify the Blend If options at the bottom center of the dialog box. Locate the Blend If This Layer sliders and slowly drag the white triangular slider to the left. Continue dragging the white slider to the left until the white fringe pixels are no longer visible, as shown in Figure 612.4.

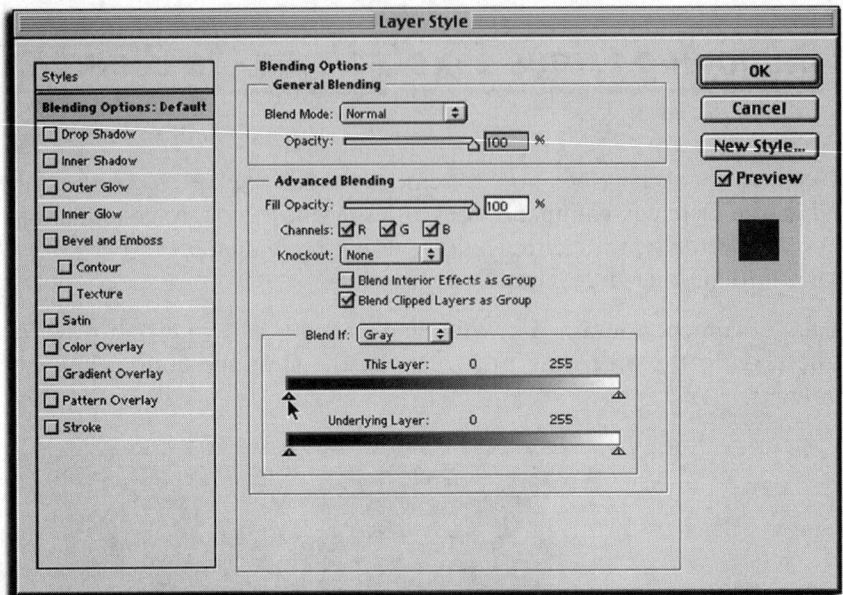

Figure 612.3 *The Layer Style dialog box controls the styles and blending options available to the selected layer.*

Figure 612.4 *Dragging the white slider to the left removes the white pixels from the fringe of the black text.*

Note: *The Blend If options work with the brightness of the image pixels and create transparency in the image, depending on how you move the Blend If sliders. For more information on the Blend If options, refer to Tip 345, "Working with the Blend If Option to Create Transparency."*

613 *Using Curves to Correct High Key Images*

A high key image is defined as a document containing an abundance of digital information in the high light areas of the image. High key images visually appear light.

To check the tonal quality of an image, select Image menu and choose Histogram from the pull-down menu. Photoshop opens the Histogram dialog box, as shown in Figure 613.1.

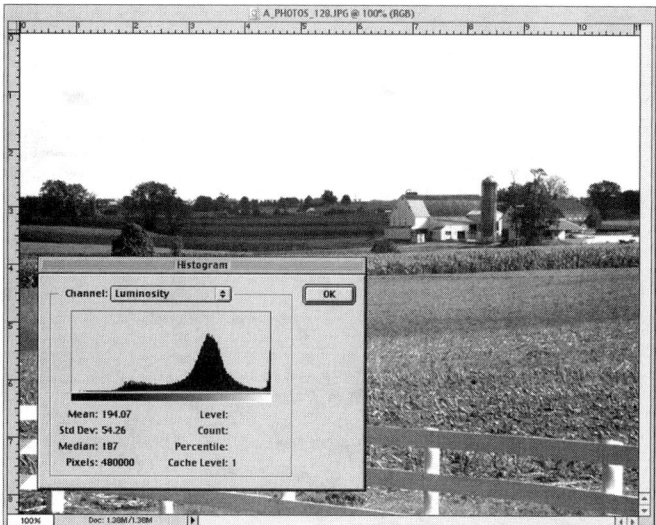

Figure 613.1 The Histogram dialog box displays a graph of the number of pixels within an image.

Say, for example, you have a high key image and you want to correct the document. Correcting the document involves darkening the highlight areas of the image without losing detail in the midtones or shadows.

To correct a high key image, select Image menu Adjust and choose Curves from the fly-out menu. Photoshop opens the Curves dialog box, as shown in Figure 613.2.

Figure 613.2 The Curves dialog box controls the entire tonal range of an image: highlights, midtones, and shadows.

Move your mouse into the Curves dialog box and click three times on the Curves line. Click once on the first third of the curve line, a second time at the midpoint of the line, and a third time on the upper third of the line. Clicking on the Curves line creates an anchor point at the point of the mouse click.

- Leave the first anchor point on the left alone.

- Click and drag the second anchor point up about 10 percent.

- Finally, click and drag the upper third of the line up about 20 percent.

- Click the OK button to apply the Curves adjustment to the image.

Bending the Curves line redistributes the brightness, midtones, and shadows in a high key image and corrects the document, as shown in Figure 613.3.

Figure 613.3 Clicking and dragging the curve redistributes the highlights, midtones, and shadows in a high key image.

614 *Using the Levels Dialog Box to Adjust the Midtones of an Image*

In the preceding tip, you corrected a high key image by using the Curves dialog box. High and low key images have an overabundance of digital information in the highlight or shadow area of the image (refer to the Histogram dialog box in the preceding tip). The Curves dialog box is the best tool to use to correct high and low key images. The Levels command is the best and quickest tool to use when you need to perform modest corrections to the image's midtones.

Say, for example, you have a dark image, as shown in Figure 614.1.

Figure 614.1 The image contains a good distribution of detail, but the image is too dark.

Selecting Image menu Histogram displays the histogram with good distribution of image detail. The image is not considered high or low key; it is just too dark. To adjust the midtones in this image, select Image menu Adjust and choose Levels from the fly-out menu. Photoshop opens the Levels dialog box, as shown in Figure 614.2.

Figure 614.2 The Levels dialog box displays a histogram showing the number and brightness of the pixels in the active image.

Move your cursor into the Levels dialog box and click and drag the middle gray slider to the left, as shown in Figure 614.3.

Figure 614.3 The gray middle slider controls the midtones in the active image.

Moving the middle gray slider to the left increases the brightness of the midtone pixels without affecting the highlights and shadows, and it corrects the image, as shown in Figure 614.4.

*Figure 614.4 Moving the middle gray slider to the left successfully lightens the midtones
of the image without affecting the highlights or shadows.*

615 *Basic Steps for Correcting Images*

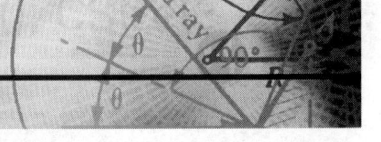

When you perform image editing on a Photoshop document, each editing step alters the image. When you perform additional work, the adjustment is based on the edited image, not the original image. Say, for example, you open an image and use the Curves command to balance the colors in the image and the Levels command to map the brightness of the pixels. The image contains small imperfections, so you use Dust & Scratches and the Sharpen filter to resharpen the image.

Each time you apply a filter or adjustment to the image, the order in which you perform image editing affects the final look of the image.

- **Pixel mapping:** If you need to use the Levels command, use it as one of the first adjustments to the image. The Levels command maps the brightness of the image pixels from black to white. Since mapping the brightness of the pixels in an image changes contrast and color, it is at the top of your "To Do" list for photographic restoration (refer to Tip 201, "Understanding How the Levels Command Adjusts an Image").

- **Pixel saturation:** The Curves command adjusts the hue of the pixels in the image. If you are performing any adjustment to the image with the Curves or Color Balance commands, perform this next. Color correction changes the hue and saturation of the pixels without drastically changing the appearance of the image. If the image contained scratches, color correction shifts the colors in the image; however, the scratches are still part of the image (refer to Tip 205, "Understanding How the Curves Command Adjusts an Image").

- **Restoration:** If you need to perform dust and scratch removal, do it before using any sharpening tools. Dust and scratch removal produces the most physical change to the image. If you perform dust and scratch removal using the Dust & Scratches filter, you may have to rebalance the color in the image using Curves; however, you should wait until you sharpen the image.

- **Sharpening:** If the image requires sharpening, perform this as one of the last stages. Since sharpening an image may cause a shift in color, you may need to use Curves to rebalance the image colors.

Note: Although this is just a small sampling of the adjustments Photoshop performs on an image, attempt to perform adjustments to the color and brightness of the image before performing adjustments that change or paint the image.

616 *Loading and Saving Curves Adjustments*

In Tip 613, "Using Curves to Correct High Key Images," you learned how to correct a high key image by using the Curves command. Say, for example, you scanned a roll of film containing 36 separate images, and all of the images require the same Curves adjustment. However, you do not want to open the Curves palette and re-create the adjustment 36 times. The solution is to create a file based on the Curves command and then apply that adjustment to the images.

To create a saved file based on a specific Curves adjustment, open the first document and perform these steps:

1. Select Image menu Adjust and select Curves from the fly-out menu. Photoshop opens the Curves dialog box.

2. Create an adjustment curve designed to correct a high key image (refer to Tip 613), as shown in Figure 616.1.

3. To save the adjustment curve, click the Save button in the Curves dialog box. Photoshop opens the Save dialog box, as shown in Figure 616.2.

Figure 616.1 The Curves dialog box, displaying an adjustment curve designed to correct a high key image.

4. In the Name dialog box, enter a descriptive name for the custom curve. In this example, you choose the name *highkey.acv.*

5. Click the Save button to save the custom file and close the Save dialog box.

6. Click the OK button to apply the custom curve to the active image.

To apply the custom curve to another image, open the image in Photoshop and perform these steps:

1. Select Image menu Adjust and choose Curves from the fly-out menu. Photoshop opens the Curves dialog box, as shown in Figure 616.3.

Figure 616.2 The Save dialog box lets you name and save customized curve files.

Figure 616.3 When first opened, the Curves dialog box displays a standard curve.

2. Click the Load button in the Curves dialog box. Photoshop opens the Load dialog box, as shown in Figure 616.4.

3. Click once on the *highkey.acv* file and click the OK button. Photoshop loads the *highkey.acv* custom curve and applies it to the image, as shown in Figure 616.5.

4. Click the OK button to apply the custom curve to the second image.

Note: *To learn how to batch process a group of files, refer to Tip 416, "Using Batch Processing to Speed Up Your Work."*

Figure 616.4 *The Load dialog box lets you load custom curves into the Curves dialog box.*

Figure 616.5 *The highkey.acv file loaded into the Curves dialog box.*

617 *Correcting Images with Heavy Foreground Shadows*

Heavy foreground shadows are a common component in photography. Say, for example, you take a photograph. Your subject, because of the surrounding light, appears dark, and you want to lighten the foreground without changing the background, as shown in Figure 617.1.

To reduce dark images in the foreground, open the image in Photoshop and perform these steps:

1. Select from the available selection tools and create a selection marquee around the dark portions of the image. In this example, you used the Magnetic Lasso to select the dark foreground images (refer to Tip 137, "Understanding the Magnetic Lasso Tool"), as shown in Figure 617.2.

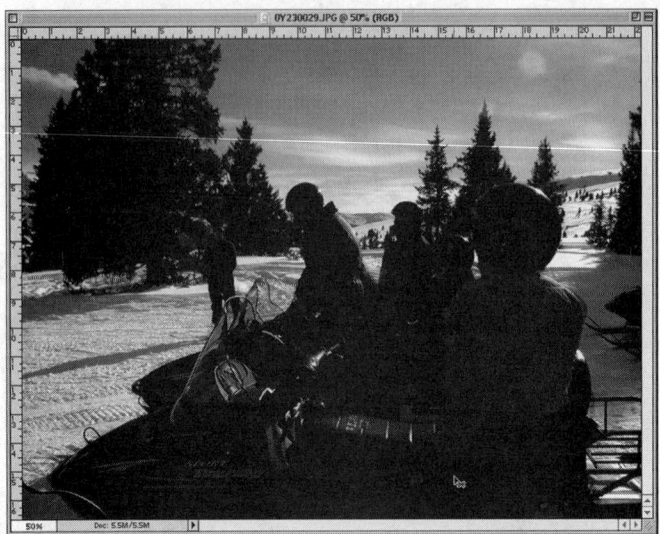

Figure 617.1 A typical image in which the foreground objects are too dark, while the background is in bright sunlight.

Figure 617.2 The Magnetic Lasso tool successfully selected the dark foreground images.

2. Choose Select menu and choose Feather from the pull-down menu. Photoshop opens the Feather Selection dialog box, as shown in Figure 617.3.

Figure 617.3 The Feather Selection dialog box controls the level of transparency at the edge of the selection.

3. In the Radius input field, enter a value from 0.2 to 250 pixels. In this example, you choose a Radius value of 1 to soften the edge of the selection. Click the OK button to apply the feather to the selection.

4. Select Image menu Adjust and choose Levels from the fly-out menu. Photoshop opens the Levels dialog box, as shown in Figure 617.4.

Figure 617.4 The Levels dialog box only adjusts the pixels within the selected area of the image.

5. Click on the gray input slider and slowly drag it to the left, as shown in Figure 617.5.

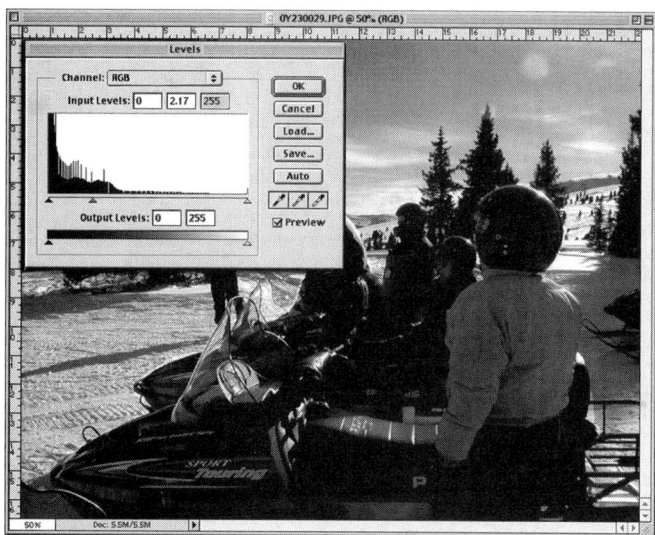

Figure 617.5 The gray input slider controls the midtones of the image. Dragging it to the left lightens the selected pixels.

6. Drag the middle gray slider to the left until the dark foreground images lighten.

7. Click the OK button to apply the changes to the image.

618 *Using Target Values to Set Highlights and Shadows*

When you work with high-end CMYK color images, it's important to set target values for the highlights and shadows in the image. Target values help the printer identify the tonal range of a CYMK image.

To adjust the highlight and shadow target values of a CMYK image, open the image in Photoshop and perform these steps:

1. Select the Eyedropper tool from the toolbox and choose a 3 by 3 Average from the Sample Size drop down list (refer to Tip 335, "Changing the Eyedropper Sample Rate for Greater Accuracy").

2. If the Info palette is not visible, click once on the Info tab or select the Window menu and choose Show Info from the pull-down menu. Photoshop opens the Info palette.

3. Select Image menu Adjust and choose Curves from the fly-out menu. Photoshop opens the Curves dialog box, as shown in Figure 618.1.

4. Move your cursor into the document and move around the image until you locate the lightest and darkest areas of the image. When you locate the light and dark areas of the image, record the X and Y coordinates from the Info palette, as shown in Figure 618.2.

Figure 618.1 The Curves dialog box adjusts the highlight, midtone, and shadow values of the active image.

Figure 618.2 The Info palette shows the X and Y coordinates of the lightest and darkest pixels in the image.

5. Move your cursor back into the Curves dialog box and double-click on the black eyedropper. Photoshop opens the Color Picker dialog box, as shown in Figure 618.3.

6. In the C, M, Y, and K input fields, enter the values 65, 53, 51, and 95. Click the OK button to record the changes to the black eyedropper. You just redefined what the black eyedropper defines as a shadow.

7. Double-click on the white eyedropper. Photoshop opens the Color Picker dialog box, as shown in Figure 618.4.

Figure 618.3 The Color Picker dialog box defines the ink value assigned to the shadow areas of an image.

Figure 618.4 The Color Picker dialog box defines the ink value assigned to the highlight areas of an image.

8. In the C, M, Y, and K input fields, enter the values 5, 3, 3, and 0. Click the OK button to record the changes to the white eyedropper. You just redefined what the white eyedropper defines as a highlight.

9. Using the X and Y coordinates you recorded for the highlights and shadows, select the white eyedropper and move back into the document. Using the Info palette, position the cursor exactly over the X and Y coordinates you choose for the highlight in the image and click the mouse. Photoshop readjusts the highlight.

10. Select the black eyedropper and move into the document. Using the Info palette, position the cursor exactly over the X and Y coordinates you choose for the shadow in the image and click the mouse. Photoshop readjusts the shadow.

11. Click the OK button to record the changes to the image.

Note: Since images display in RGB mode on a monitor, redefining the shadow and highlights of a CMYK image helps a high-end printing press reproduce the image.

> **Note:** *The values indicated for the setting of the black and white eyedroppers are considered norms for printing in the United States. However, since all press operators work differently, it is a good idea to contact your service bureau and verify that the values are consistent with their particular printing presses.*

619 *Using Threshold to Identify Blackpoint and Whitepoint in an Image*

In the preceding tip, you learned how to reset the highlight and shadows of a CMYK image using customized target values. An easier way to identify the highlight and shadow areas of an image is through the Levels dialog box. Say, for example, you want to reset the highlights and shadows of a CMYK image (refer to preceding tip), but you want a better way to identify the highlights and shadows in the image.

To identify the highlights and shadows in an image, open the image in Photoshop and perform these steps:

1. If the Info palette is not visible, click once on the Info tab or select the Window menu and choose Show Info from the pull-down menu. Photoshop opens the Info palette.

2. Select Image menu Adjust and choose Threshold from the pull-down menu. Photoshop opens the Threshold dialog box, as shown in Figure 619.1.

Figure 619.1 The Threshold dialog box splits an image into black and white.

3. Click on the black triangle slider and drag it all the way to the left. The visible image changes to white.

4. Slowly drag the slider to the right until a small portion of the image appears. The black visible portion of the image represents the darkest pixels in the image, as shown in Figure 619.2.

5. Position your cursor over the dark pixels and record the X and Y coordinates from the Info palette.

Figure 619.2 Dragging the black slider slowly to the right reveals the darkest pixels in the image.

6. Click and drag the black Threshold slider all the way to the right. The image turns black. Slowly drag the slider to the left. Small portions of the image begin to turn white. The white areas of the image are the lightest pixels in the graphic, as shown in Figure 619.3.

Figure 619.3 The white portions of the image represent the lightest pixels in the graphic.

7. Position your cursor over the white pixels and record the X and Y coordinates from the Info palette.

8. Click the Cancel button to close the Threshold dialog box.

9. You now have the X and Y coordinates for the lightest and darkest areas on the image.

620 *Correcting Color Using the Individual Color Plates*

When you work on a color image in Photoshop, the channels in the image define the percentage of each ink color used to create the image. Say, for example, you open an RGB image. Photoshop creates red, green, and blue ink plates, as shown in Figure 620.1.

Figure 620.1 The color channels define the percentage of red, green, and blue ink used to create the color image.

Color correction involves adding or subtracting color inks from the image. If an image contains a simple colorcast, it is possible to correct the cast by modifying the appropriate color channel. Say, for example, you have an image that contains too much red. To remove the red from an RGB color image, open the image in Photoshop and perform these steps:

1. If the Channels palette is not visible, click once on the Channels tab or select the Window menu and choose Show Channels from the pull-down menu. Photoshop opens the Channels palette, as shown in Figure 620.2.

Figure 620.2 The Channels palette defines the color inks in the RGB image.

2. Since the image needs a reduction of red, click once on the Red channel. Photoshop selects the Red channel and deactivates all the other channels.

3. Move your mouse up to the RGB channel and click once on the visibility icon to the left of the RGB channel. Photoshop reactivates all the other channels, but it leaves the Red channel as the selected channel, as shown in Figure 620.3.

Figure 620.3 Clicking the RGB visibility icon reactivates the other channels.

4. Select Image menu Adjust and select Levels from the fly-out menu. Photoshop opens the Levels dialog box, as shown in Figure 620.4.

Figure 620.4 The Levels dialog box controls the percentage of midtone gray in the selected Red channel.

5. Since you want to reduce the percentage of red in the image, click on the gray input slider and slowly drag it to the right. When you drag the gray slider to the right, you darken the grays in the Red channel. The darker the shades of gray in the Red channel, the less red in the image, as shown in Figure 620.5.

6. Click the OK button to close the Levels dialog box and record the changes to the image.

Figure 620.5 Dragging the gray input slider to the right darkens the Red channel and reduces the amount of red in the image.

621 *Finding an Image's Midpoint*

In Tip 619, "Using Threshold to Identify Blackpoint and Whitepoint in an Image," you learned to pinpoint the dark and light areas of an image. Images contain three important points: highlights, midtones, and shadows. The Threshold command lets you identify the highs and lows in the image; however, to complete the set, it is important to identify the midtone of the image.

Say, for example, you used the information in Tip 618, "Using Target Values to Set Highlights and Shadows," and you successfully identified and shifted the highlights and shadows in a color image. Unfortunately, shifting the highlights and shadows caused a color cast in the image. While correctly identifying the highlights and shadows in an image usually corrects the image, it sometimes causes a color cast. Remove the color cast using the midtone eyedropper in the Curves dialog box.

To identify the midtone of an image and restore the color balance, open the document in Photoshop and perform these steps:

1. Select Image menu Adjust and choose Curves from the fly-out menu. Photoshop opens the Curves dialog box, as shown in Figure 621.1.

2. Move your mouse cursor into the Curves dialog box and double-click on the middle gray eyedropper (refer to Figure 621.1). Photoshop opens the Color Picker dialog box, as shown in Figure 621.2.

3. In the C, M, Y, and K input fields, enter the values 50, 40, 40, and 10 (refer to Figure 621.2). Click the OK button to close the dialog box and record the changes to the midtone eyedropper.

4. Click once on the middle eyedropper and move your mouse into the document window.

5. The next step requires a bit of experimentation. Move the midtone eyedropper over the area of the image that you believe should be neutral gray. It is possible that the image does not contain any areas that are neutral gray. If that is the case, move the eyedropper to an area of the image that best represents a neutral color (this is why the step requires a bit of experimentation).

Figure 621.1 The Curves dialog box lets you adjust the color balance of the active image.

Figure 621.2 The Color Picker dialog box controls the midtone eyedropper.

6. Click once with the midtone eyedropper. The image colors shift. If the colors in the image look out of sync, move the eyedropper to a different position and click the mouse a second or third time. When you see the colors you want, click the OK button in the Curves dialog box to record your color changes to the image.

Note: While finding the black and white points within an image is easy because of the variables involved in image data, the midtones of a graphic are a bit more of a challenge. However, with enough practice, locating the midtones in an image will become easier.

622 *Making Quick Overall Adjustments to an Image*

Photoshop gives you a quick way to adjust the highlights, midtones, and shadows in an image. The Auto Levels command adjusts an image by examining the document and identifying the lightest and darkest

pixels. Auto Levels then performs a mathematical calculation and maps the brightness of all the pixels to fit what it thinks are the highlights and shadows of the image, as shown in Figure 622.1.

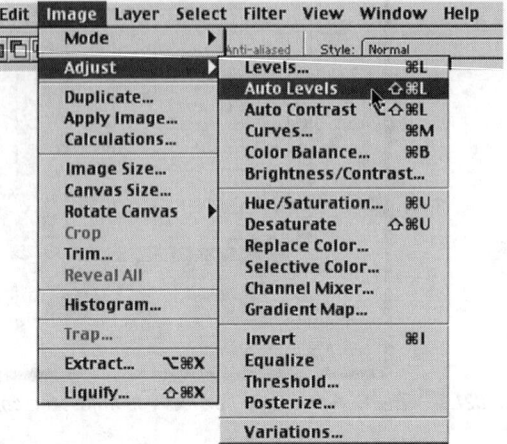

Figure 622.1 The Auto Levels command maps the brightness of the pixels in an image by identifying the document's highlights and shadows.

Say, for example, you have an image that is overly dark, and you want to adjust the image. Select Image menu Adjust and select the Auto Levels command. The Auto Levels command identifies the highlights and shadows in the image and readjusts the image, as shown in Figure 622.2.

Figure 622.2 The Auto Levels command successfully and quickly restored the balance of highlights, midtones, and shadows in the active image.

When you use the Auto Levels command on an average image, the results are quite satisfying. However, Auto Levels does not work with images that do not contain a good highlight or shadow. When the Auto Levels command executes, it looks for the lightest area of the image and identifies that as the highlight. Many images contain scratches. Since scratches are white, Auto Levels defines the scratch as the image highlight and causes an out-of-balance image, as shown in Figure 622.3.

> **Note:** *While the Auto Levels command it is a timesaver when it comes to correcting images, it is not perfect. Use Auto Levels on images containing a normal tonal range from dark to light and without excessive scratches or large white and black borders.*

For more information on controlling the Auto Levels command, see Tip 625, "Using the Auto Levels Command."

Figure 622.3 The Auto Levels command does not work on images with large nondetail areas like scratches or white and black borders.

623 *Using Levels to Adjust Color*

In Tip 618, "Using Target Values to Set Highlights and Shadows," you learned how to perform color correction using the Curves dialog box and the sample eyedropper. In Tip 620, "Correcting Color Using the Individual Color Plates," you learned color correction by directly accessing the color plates of the image. In this tip, you will learn how to perform color correction using the Levels command.

If one thing stands out in your mind, it is that, in Photoshop, there is more than one way to do just about everything. Understanding the available options lets you make a decision on what method produces the best image in the least amount of time.

Say you have an RGB color image with a magenta cast, and you want to remove the cast from the image. To correct the magenta cast using the Levels command, open the image in Photoshop and perform these steps:

1. Select Image menu Adjust and choose Levels from the fly-out menu. Photoshop opens the Levels dialog box, as shown in Figure 623.1.

2. Click once on the Channel button located at the top of the Levels dialog box. Photoshop displays the available channel options in a drop-down list.

3. Since you need to remove the magenta cast from the image, select the Green channel. The Levels histogram adjusts to display the Green channel, as shown in Figure 623.2.

> *Note: Every color in an RGB image has a complimentary color: Red/Cyan, Green/Magenta, and Blue/Yellow. You selected the Green channel because the image contains a magenta cast and the complimentary color to magenta is green.*

4. To remove the magenta cast, you want to add more green to the image. To add more green to the image, click on the middle input slider and drag it to the left. As you drag the middle input slider to the left, release the mouse when you see the correct color in the image, as shown in Figure 623.3.

Figure 623.1 The Levels dialog box controls the mapping of the highlights, midtones, and shadows in the image.

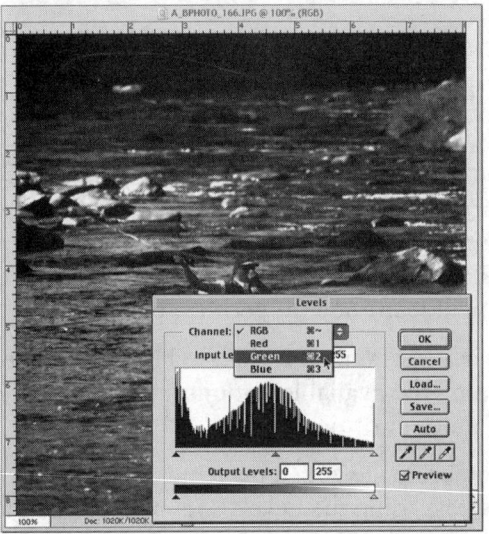

*Figure 623.2 Clicking the Channel button and selecting the Green channel
causes the Levels dialog box to display a histogram of the Green channel pixels.*

5. Click the OK button to close the Levels dialog box and record your changes to the image.

> ***Note:*** *When you drag the middle input slider to the left, you lighten the shades of gray in the Green channel. Since channels are masks (refer to Tip 432, "Understanding Channels and Their Role"), lightening the Green channel increases the percentage of green ink applied to the image. Conversely, dragging the middle input slider to the right darkens the Green channel, reduces the amount of green, and at the same time, proportionally increases the amount of magenta.*

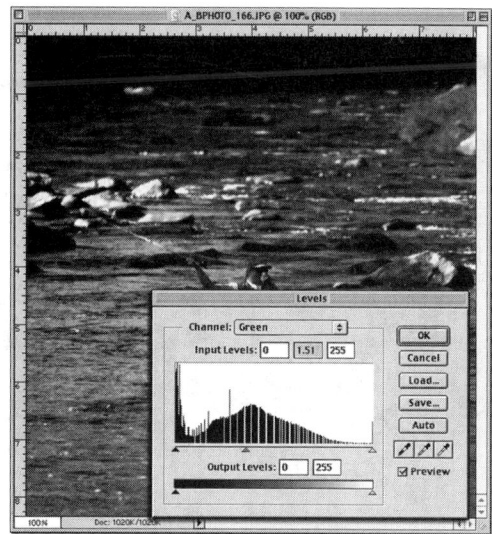

*Figure 623.3 Clicking and dragging the middle gray slider to the left increases
the amount of green in the image and corrects the magenta color cast.*

624 *Using the Brightness/Contrast Command*

The Brightness/Contrast command works to lighten and/or darken the pixels in an image. However, it does not work the same way as Levels or Curves. Brightness/Contrast increases or decreases the brightness of the pixels in an image using a linear average. For example, if you want to darken a faded image using the Brightness/Contrast command, select Image menu Adjust and choose Brightness/Contrast from the fly-out menu. Photoshop opens the Brightness/Contrast dialog box, as shown in Figure 624.1.

*Figure 624.1 The Brightness/Contrast command increases or decreases the
brightness of the pixels in an image using a linear average.*

To darken the image, click on the triangular icon located under the Brightness slider and drag it to the left. As you continue to drag to the left, the pixels in the image become darker, as shown in Figure 624.2.

Unfortunately, the Brightness/Contrast command darkens using an averaging method. The Brightness/Contrast command treats all pixels equally. Say, for example, you drag the Brightness slider 20 percent to the left. All of the pixels in the image darken by 20 percent.

Images are not linear; therefore, you cannot apply a brightness command to the entire image. Images contain highlights, midtones, and shadows. To balance an image, use the Levels command (refer to Tip 201, "Understanding How the Levels Command Adjusts an Image") or the Curves command (refer to Tip 205, "Understanding How the Curves Command Adjusts an Image").

Apply the Brightness/Contrast command to images with a linear color tone, such as clip art, sketch graphics, text, and logos, as shown in Figure 624.3.

Figure 624.2 Clicking and dragging the brightness slider to the left darkens the pixels in the image.

Figure 624.3 The Brightness/Contrast command works successfully on images with a linear color tone, such as sketches or line art.

625 *Using the Auto Levels Command*

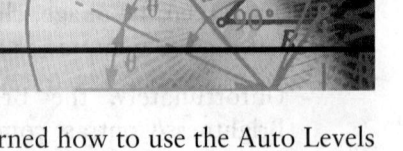

In Tip 622, "Making Quick Overall Adjustments to an Image," you learned how to use the Auto Levels command to adjust the highlights, midtones, and shadows of an image. Since the Auto Levels command adjusts an image based on the available data in the active image, you control the Auto Levels command by selecting the areas of the image you want adjusted.

Say, for example, you have an image surrounded by a large white border. You know if you use Auto Levels, the command will use the white border as the highlight of the image, causing the graphic to be too dark, as shown in Figure 625.1.

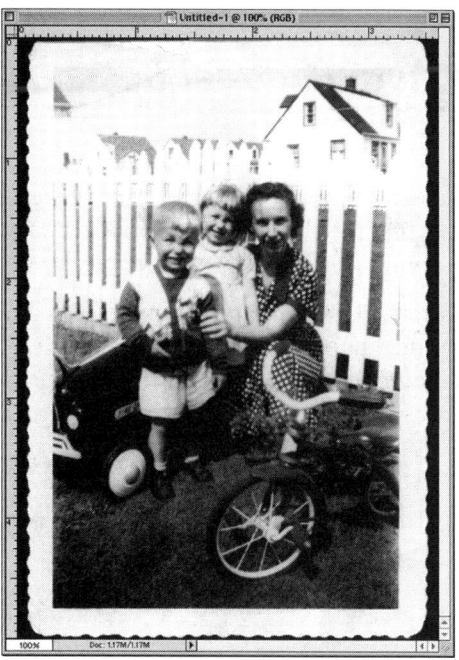

Figure 625.1 The Auto Levels command applied to an image with a large white border overcompensates the highlights and produces a dark image.

To remove the white border from the Auto Levels command, select the Rectangular Marquee tool and select the area of the image you want the Auto Levels command to correct (refer to Tip 71, "The Marquee Tools"). Select Image menu Adjust and choose Auto Levels from the fly-out menu. The Auto Levels command adjust the highlights, midtones, and shadows of the selected portions of the image, as shown in Figure 625.2.

Figure 625.2 The Auto Levels command, applied to a selected portion of the image, successfully corrects the highlights, midtones, and shadows.

626 *Using the Auto Contrast Command*

In the preceding tip, you learned how to use the Auto Levels command to balance the highlights, mid-tones, and shadows of an image. The Auto Contrast command performs a similar function, except it automatically adjust the contrast in a Photoshop image.

When you use Auto Contrast, the command examines the image for the lightest and darkest pixels and then, using that information, maps the image to make the highlights appear lighter and the shadows appear darker. The visual effect is an increase in the contrast of the image, as shown in Figure 626.1.

Figure 626.1 The Auto Contrast command maps the lightest and darkest pixels in the image and lightens the highlights and darkens the shadows.

The Auto Contrast and the Auto Levels commands have the same problem: They map the entire image (refer to the preceding tip). Images containing large black or white borders or heavily scratched graphics throw off the Auto Contrast calculation, as shown in Figure 626.2.

Figure 626.2 The Auto Contrast command applied to an image surrounded by a black border produces an undesirable image.

To use the Auto Contrast command successfully, use your selection tools and identify the portions of the image to which you want to apply the Auto Contrast command, as shown in Figure 626.3.

Figure 626.3 The Auto Contrast command successfully applied to the selected portions of the image from Figure 626.2.

Note: Although the Auto Contrast command is a quick method for increasing the contrast in an image, the best way to boost contrast is with the Curves command (see Tip 641, "Using Curves to Increase the Contrast in an Image").

627 *Sharpening an Image*

Photoshop gives you several ways to sharpen an image. While most Photoshop users prefer working with the Unsharp Mask filter (refer to Tip 524, "Applying Unsharp Mask"), Photoshop has three other sharpening filters. To access the sharpen filters, open Photoshop and select the Filter menu, then choose Sharpen. Photoshop opens a fly-out menu with these sharpen options:

- **Sharpen:** The Sharpen filter does not have any adjustments. When you select the Sharpen filter, it analyzes the image, looking for shifts in brightness. The Sharpen filter interprets brightness shifts as the edges in the image. It sharpens the edges by removing soft shades of color at the edge, giving the image a visually sharper appearance, as shown in Figure 627.1.

- **Sharpen More:** The Sharpen More filter performs sharpening operations similar to the Sharpen filter, except the effect is approximately four or five times greater, as shown in Figure 627.2.

- **Sharpen Edges:** The Sharpen Edges filter attempts to sharpen the edges without affecting other areas of the image, as shown in Figure 627.3.

Figure 627.1 The Sharpen filter applied to a soft-focused image.

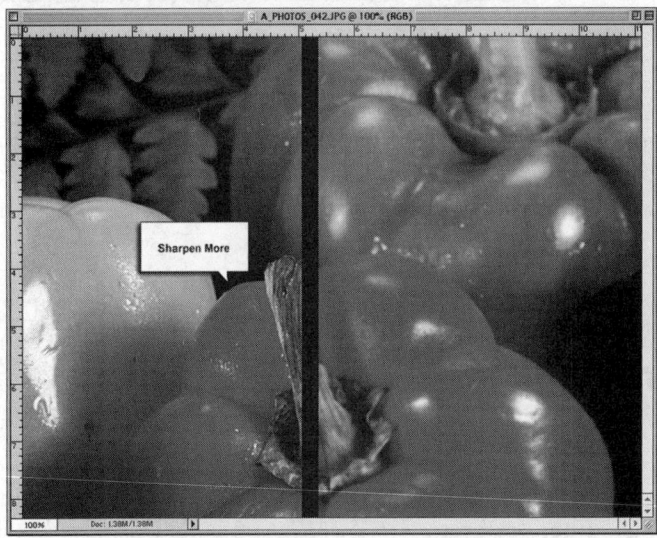

Figure 627.2 The Sharpen More filter applied to a soft-focused image.

Figure 627.3 The Sharpen Edges filter applied to a soft-focused image.

628 *Using the Info Palette to Identify the Tonal Range of an Image*

In Tip 618, "Using Target Values to Set Highlights and Shadows," and Tip 621, "Finding an Image's Midpoint," you learned to identify the tonal range of an image using the Curves dialog box. Say, for example, you want to identify the highlights, midtones, and shadows in an image for use later in image correction.

To identify the tonal range of an image using the Info palette, open the document in Photoshop and perform these steps:

1. If the Info palette is not visible, click once on the Info tab or select the Window menu and choose Show Info from the pull-down menu. Photoshop opens the Info palette, as shown in Figure 628.1.

2. Click the Eyedropper icon in the upper-left color box in the Info palette. Photoshop opens a fly-out menu with the color options, as shown in Figure 628.2.

3. Select Total Ink from the fly-out menu. The Info palette displays Total Ink information in the top-left color box.

4. Move your mouse cursor into the document window and identify the darkest area of the image by watching the Total Ink output in the Info palette. When the Total Ink field displays the highest value, you are over the darkest part of the image. Record the X and Y coordinates of that spot, as shown in Figure 628.3.

Figure 628.1 The Info palette displays color information on the active document.

5. Move your mouse cursor into the document window and identify the lightest area of the image by watching the Total Ink output in the Info palette. When the Total Ink field displays the lowest value, you are over the lightest part of the image. Record the X and Y coordinates of that spot, as shown in Figure 628.4.

Figure 628.2 Clicking on the Eyedropper icon opens a fly-out menu with the available color options.

Figure 628.3 The Info palette identifies the darkest area of the image.

Figure 628.4 The Info palette identifies the lightest area of the image.

Note: By recording the X and Y coordinates of the highlights and shadows, you can return to the image at a later time and perform color correction by adjusting the highlights and shadows of the image with the Curves command (refer to Tip 618).

629 *Using Levels to Set Highlights, Shadows, and Midtones*

In Tip 623, "Using Levels to Adjust Color," you learned how to use the Levels command to adjust the color a Photoshop document. The Levels command also works to identify and set the highlights, midtones, and shadows of an image.

To use the Levels command to adjust the tonal range of an image, open the document in Photoshop and perform these steps:

1. Select Image menu Adjust and choose Levels from the fly-out menu. Photoshop opens the Levels dialog box, as shown in Figure 629.1.

Figure 629.1 The Levels dialog box controls the tonal range of the active image.

2. Move your cursor into the Levels dialog box and click once on the black eyedropper tool. The black eyedropper tool controls the shadow areas of the image.

3. Move the eyedropper tool into the document window and click once on the darkest area of the graphic. If you know the X and Y coordinates of the darkest area (refer to the preceding tip), this will be easy. Move the eyedropper until the X and Y coordinates of the eyedropper match the X and Y coordinates you recorded for the darkest area of the image and click once. This sets the shadows in the image, as shown in Figure 629.2.

4. Move your cursor into the Levels dialog box and click once on the white eyedropper tool. The white eyedropper tool controls the highlight areas of the image.

5. Move the eyedropper tool into the document window and click once on the lightest area of the graphic. This sets the highlight in the image, as shown in Figure 629.3.

6. Using the eyedropper tools readjusts the highlights and shadows to their proper levels and corrects the exposure of the image, as shown in Figure 629.3.

7. Click the OK button to record your changes to the image.

Figure 629.2 Move the black eyedropper into the document window and click once on the darkest portion of the image.

Figure 629.3 Move the white eyedropper into the document window and click once on the lightest portion of the image.

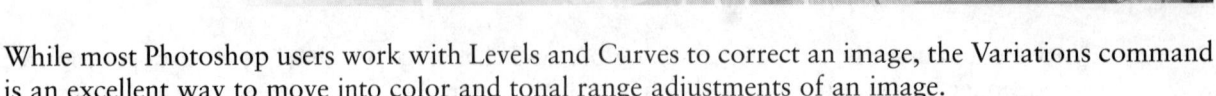

630 *Using the Variations Command*

While most Photoshop users work with Levels and Curves to correct an image, the Variations command is an excellent way to move into color and tonal range adjustments of an image.

To correct the tonal range of an RGB image, select Image menu Adjust and choose Variations from the fly-out menu. Photoshop opens the Variations dialog box, as shown in Figure 630.1.

Choose from the available options to modify an image:

- **Original/Current Pick:** The two thumbnails in the upper-left of the Variations dialog box show the original image and the changed image. During the course of making changes to the image, clicking on the Original thumbnail restores the image to its original settings.

Figure 630.1 The Variations dialog box controls the color and tonal range of the active image.

- **Image adjustment:** Click on the radio buttons to modify the Shadows, Midtones, Highlights, or Saturation of the inks in the active image.

- **Midtonal adjustments:** To adjust the midtone range of the image, use the Lighter and Darker thumbnails on the right of the Variations dialog box. Select the Midtones radio button and click on the lighter and darker thumbnails to lighten or darken the image in the midtonal range.

- **Highlight adjustments:** To adjust the highlights of the image, use the Lighter and Darker thumbnails on the right of the Variations dialog box. Select the Highlights radio button and click on the lighter and darker thumbnails to lighten or darken the image in the highlights.

- **Shadow adjustment:** To adjust the shadows of the image, use the Lighter and Darker thumbnails on the right of the Variations dialog box. Select the Shadows radio button and click on the lighter and darker thumbnails to lighten or darken the image in the shadows.

- **Saturation adjustments:** To adjust the ink saturation of the image, use the Lighter and Darker thumbnails on the right of the Variations dialog box. Select the Saturation radio button and click on the lighter and darker thumbnails to increase or decrease the saturation of the inks.

- **Fine/Course:** Click on the triangular slider and move it left or right to increase (Course) or decrease (Fine) the amount of each adjustment. The finer the setting, the more clicks per adjustment thumbnail are required to produce a change in the image.

- **Show Clipping:** Click in the Show Clipping box to select this option. When selecting the Show Clipping option, the image preview displays a neon color over the areas of the image that, due to the adjustments made to the image, are pure black or white.

- **Variation adjustments:** Click on the thumbnails surrounding the Current Pick thumbnail to add a color adjustment to the image. Clicking on Green, for example, increases the green in the current pick based on the image adjustment and Fine/Course options. The more times you click on the Green thumbnail (or any other thumbnail), the more the image colors will shift.

Click the OK button to record your changes to the image.

Note: The Variations command does not have a preview. Therefore, you perform adjustments to the image by viewing the Current Pick thumbnail.

631 *Using the Desaturate Command*

When you work with the Desaturate command, you need an understanding of what makes up the colors in an image. Every pixel in a Photoshop document is composed of three elements: hue, saturation, and brightness.

- **Hue:** Hue represents the color of the pixel. The value of the hue represents a move around the color wheel from 0 to 360 degrees.

- **Saturation:** Saturation represents the percentage of color (hue) of the pixel. The higher the saturation value (0 to 100 percent), the more saturated the ink.

- **Lightness:** The lightness value of the pixels indicates how bright the color or shade of gray is. Values range from 0 to 255. A 0 brightness pixel is black, and a 255 brightness pixel is white. All numbers in-between represent shades of color or gray, depending on the pixel's hue and saturation.

To use the Desaturate command, open a document in Photoshop, select Image menu Adjust, and select Desaturate from the fly-out menu. Photoshop desaturates the image.

When you apply the Desaturate command to an image or a selected portion of an image, you change the saturation values of all the pixels to 0, while preserving the hue and lightness values. Pixels with a 0 saturation value produce a shade of gray, as shown in Figure 631.1.

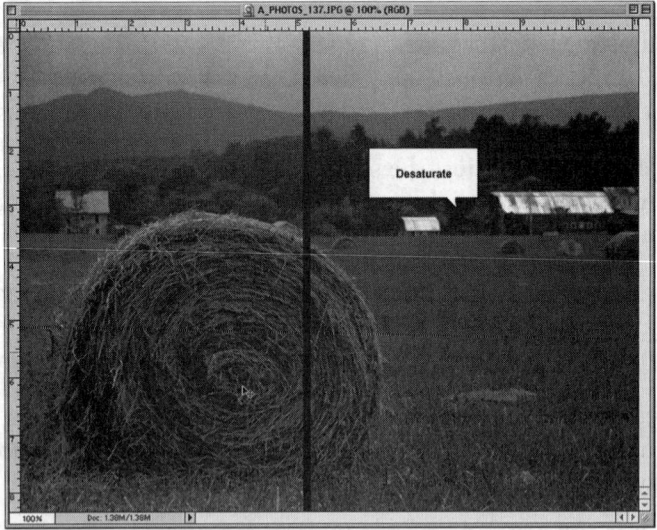

Figure 631.1 The Desaturate command applied to a color image reduces the color pixels to shades of gray.

Note: In Tip 635, "Colorizing a Black and White Image," you learn how to apply color to a grayscale image. Before applying color to an image, it is a good idea to perform the Desaturate command to even the grayscales in the image.

632 *Using the Invert Command*

Photoshop's Invert command reverses the colors or shades of gray in a layer, selection, or channel. When you use the Invert command on a color image, Photoshop examines the brightness value of each pixel and shifts the brightness value to the exact opposite value. The visual effect is that of converting a positive image into a negative or vice versa, as shown in Figure 632.1.

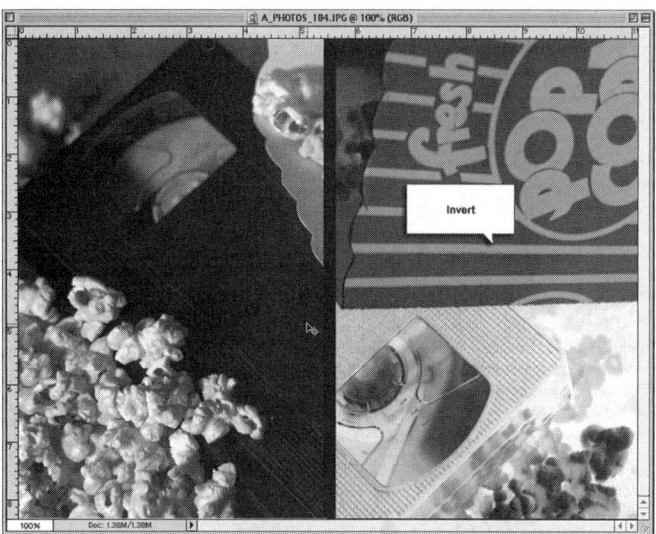

Figure 632.1 *The Invert command reverses the brightness values in the image pixels, creating a negative from an positive or vice versa.*

If you work with black and white negatives, the Invert command successfully converts the scanned negatives into image positives. However, since color negatives contain an orange mask, using the Invert command on a color negative does not work.

The Invert command works on Alpha channels as well as image layers. Say, for example, you created an Alpha channel mask (refer to Tip 307, "Saving a Selection as a Permanent Channel), but you want to reverse the black and white areas of the channel mask. To reverse the mask, select the Alpha channel (refer to Tip 307), select Image menu Adjust, and choose Invert from the fly-out menu. The Invert command reverses the black and white areas of the Alpha mask, as shown in Figure 632.2.

Figure 632.2 *The Invert command successfully reversed the black and white areas of the Alpha channel mask.*

633 *Using the Equalize Command*

The Equalize command redistributes the dark and light areas of the image to reflect the entire range of brightness. The Equalize command does not examine the image to determine the highlights, midtones, and shadows. It looks at the image, and whatever pixels are the brightest it maps to white, and whatever pixels are darkest it maps to black. It then redistributes the image pixels and averages the image. To use the Equalize command on an image, select Image menu Adjust and choose Equalize from the fly-out menu. Photoshop applies the Equalize command to the active layer, channel, or selected area of the image.

When an image does not contain any black or white pixels, the results of the Equalize command can be very disappointing, as shown in Figure 633.1.

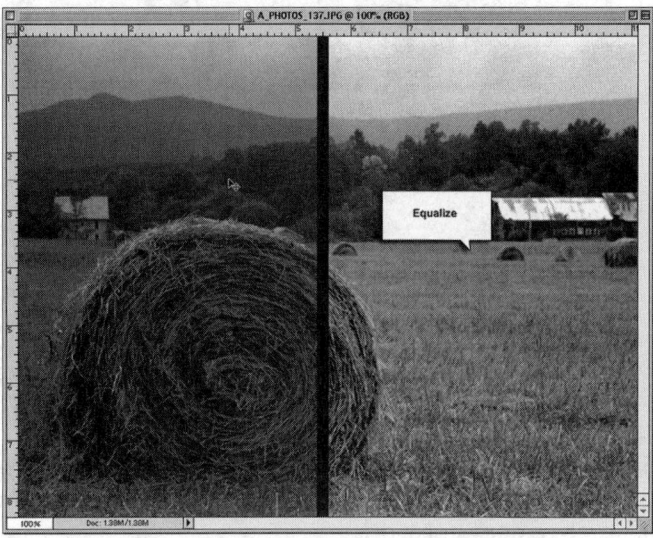

Figure 633.1 Using the Equalize command on a typical image produces varying results.

The Equalize command is not what you use to balance the tonal range of a typical image (refer to Tip 629, "Using Levels to Set Highlights, Shadows, and Midtones"). The Equalize command is a special effects tool used when drastic changes are required of an image.

You used the Equalize command in Tip 556, "Using Polar Coordinates to Create a Zoom Effect," and in Tip 198, "Using the Equalize Option," to set the sweet spot on your scanner.

Whenever you need to map an image's pixels from white to black, the Equalize command is the tool to use.

634 *Using the Threshold Command*

Photoshop's Threshold command converts grayscale or color images into high-contrast black and white graphics. In fact, the Threshold command does not produce any shades of gray in an image; all the pixels map to black or white.

To apply the Threshold command to a black and white or color image, select Image menu Adjust and choose Threshold from the fly-out menu. Photoshop opens the Threshold dialog box, as shown in Figure 634.1.

Figure 634.1 The Threshold dialog box controls the distribution of black and white in the active image.

It is important to understand that a brightness value is assigned to each pixel. Brightness values range from 0 (black) to 255 (white). The Threshold dialog box contains a graph of the image pixels. The graph maps the brightness and number of pixels in the image.

When you first open the Threshold dialog box, the Threshold Level value is set to 128. All pixels with a brightness value of 128 or less are black, and all pixels with a brightness value of 129 to 255 are white.

To increase the number of black pixels in the image, click and drag the triangle slider to the right. To increase the number of white pixels in the image, click and drag the triangle slider to the left, as shown in Figure 634.2.

Figure 634.2 Dragging the triangle slider to the left or right increases or decreases the Threshold Level value and correspondingly increases or decreases the white and black pixels in the image.

Click the OK button to close the Threshold dialog box and record your changes to the image.

Note: The Threshold command is an excellent way to solidify a poorly scanned logo or to create a pen and ink drawing from a photograph.

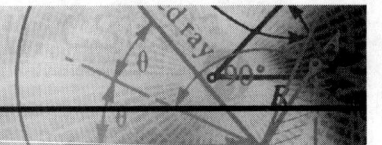

635 *Colorizing a Black and White Image*

An excellent way to colorize an old black and white image is to scan and open the document in Photoshop and perform a few simple steps. Say, for example, you just scanned an old black and white image, and you want to add some color.

To colorize a black and white image, open the document in Photoshop and perform these steps:

1. Select Image menu Mode and choose RGB from the fly-out menu. Photoshop converts the image to the RGB color space. Notice that the image did not change into a color photograph; however, it gives you the ability to add color to the image.

2. If the Layers palette in not visible, click once on the Layers tab or select Window menu Show Layers. Photoshop opens the Layers palette, as shown in Figure 635.1.

Figure 635.1 The Layers palette displays a thumbnail of all the layers in the active document.

3. Click once on the New Layer icon. Photoshop creates a new layer, as shown in Figure 635.2.

Figure 635.2 Clicking the New Layer icon creates a new transparent layer.

4. Click once on the layer blending mode option and choose Color from the pop-up menu, as shown in Figure 635.3.

5. Select the Paintbrush from Photoshop's toolbox. Move your mouse into the Options bar and click on the black triangle located to the right of the Brush icon. Photoshop opens the Brush palette, as shown in Figure 635.4.

6. To apply paint to the image, select small, soft brushes. In this example, you selected a soft 27-pixel brush.

Figure 635.3 Click the blending mode option and change the new layer's blending mode to Color.

Figure 635.4 The Brush palette displays a thumbnail of all the available brush sizes.

7. If the Swatches palette is not visible, click once on the Swatches tab or select the Window menu and choose Show Swatches from the fly-out menu. Photoshop opens the Swatches palette, as shown in Figure 635.5.

Figure 635.5 The Swatches palette displays a color swatch for all the available colors.

8. To select a painting color, move your mouse into the Swatches palette and click once on the selected color. In this example, you selected a light-blue color swatch.

9. If the new layer is not selected, move your mouse into the Layers palette and click once on the new layer (refer to Figure 635.2).

10. Move your mouse into the document and begin painting. As you apply paint to the new layer, you notice the shades of gray in the original image begin changing to blue. The Color blending mode applies the current painting color to the image without covering the details, as shown in Figure 635.6.

Figure 635.6 Selecting the Color blending mode for the new layer lets you apply color to the image without covering the details.

11. To change to a different color, move your mouse to the Swatches palette and select another color. Then return to the image and continue painting.

12. To apply the colors in the new layer to the grayscale image, click once on the black triangle in the upper-right corner of the Layers palette. Photoshop displays the Layers palette options in a pop-up menu.

13. Select Flatten Image from the pop-up menu. Photoshop combines the color layer with the grayscale image, as shown in Figure 635.7.

Figure 635.7 Selecting the Flatten Image option from the Layers palette options combines the color layer with the original grayscale image.

636 *Adjusting Screen Shots for Print*

Making screen shots from your computer monitor can be challenging, but it is an excellent way to instruct someone who is not familiar with a particular computer program. You can create systematic instructions of how to perform a computer task, save a file, or open a program.

Both the Windows and Macintosh operating systems give you ways to generate screen shots. The difficulty is in preparing them for print or for display in a computer presentation.

Say, for example, you used the PrintScreen function in Windows to create a screen shot of the Photoshop workspace, and you want to convert the image for use in print. To prepare the image for printing, open the document in Photoshop.

- **Color space:** To send the image to most ink-jet or laser printers, make sure the image is in the RGB color space. To convert an image to the RGB color space, select Image menu Mode and choose RGB from the fly-out menu. Photoshop converts the image into the RGB color space.

- **Size:** Since screen shots are low-resolution images, do not resize them if you can at all avoid it. One of the major reasons screen shots appear jagged when printed is the designer resized the image. If the image you plan to take a screen shot of is expandable, enlarge the image on the computer monitor before taking the screen shot.

- **File formats:** The most universal file format to save a screen shot is the TIFF format. To save a screen shot in the TIFF format, select File menu Save As from the pull-down menu. Photoshop opens the Save dialog box, as shown in Figure 636.1.

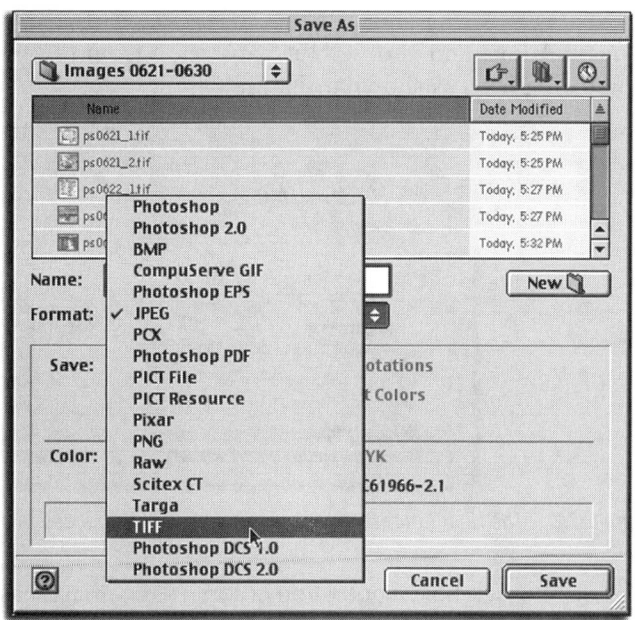

Figure 636.1 The Save dialog box lets you select the name and format of the saved file.

Click on the Format button and choose TIFF from the available options. In the Name input field, give the file a descriptive name. Click the Save button to save the file.

> **Note:** *If you want a great program to help you create screen shots from your monitor, go to **www.tucows.com** and download a program named SnapZ pro. If you generate many screen shots, it is a great timesaver.*

637 *Applying a Tint to an Image*

A great way to attract attention to your images, especially in advertisement, is by applying a unique color tint to the image. When you apply a tint, you essentially remove the original color from the image and replace it with your tint color. Say, for example, you have a color image that you feel would look attractive with a light blue tint.

To apply a light blue tint to the image without having to create a Duotone (see Tip 848, "Manipulating Duotone Images"), open the RGB image in Photoshop and perform these steps:

1. If the Swatches palette is not visible, click once on the Swatches tab or select Window menu Show Swatches. Photoshop opens the Swatches palette, as shown in Figure 637.1.

Figure 637.1 The Swatches palette contains a swatch for all the available colors.

2. Move your mouse into the Swatches palette and select a light-blue color swatch. Photoshop selects the color as the new Foreground color swatch.

3. Select Image menu Adjust and choose Hue/Saturation from the fly-out menu. Photoshop opens the Hue/Saturation dialog box, as shown in Figure 637.2.

Figure 637.2 The Hue/Saturation dialog box controls the application of the blue tint to the image.

4. Click in the Colorize check box. Photoshop colorizes the image based on the current light-blue foreground color, as shown in Figure 637.3.

5. Click and drag the Saturation and Lightness sliders left or right to control the intensity of the color.

6. Click the OK button to close the Hue/Saturation dialog box and record your changes to the image, as shown in Figure 637.4.

Figure 637.3 The Colorize option tints the image based on the current foreground color.

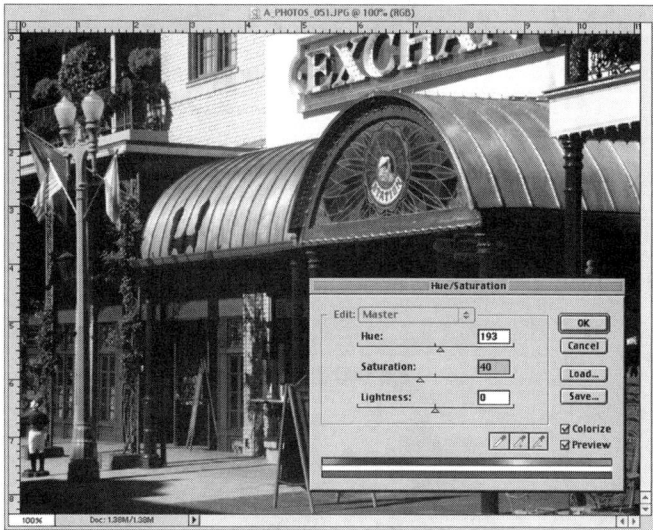

Figure 637.4 The Hue/Saturation command successfully applied a blue tint to the image.

638 *Using Layers to Add Additional Objects to an Image*

When you work on a complicated Photoshop image, remember that the Layers palette helps you control the placement of information in the document. Say, for example, you want to place two people in the same document. By placing the images in two separate layers, you can control how the images interact.

In this example, you have two images in separate layers, and you want one of the images to appear as if it is behind the other, as shown in Figure 638.1.

> *Note: In order for this to work correctly, one or both of the layers need to have transparent backgrounds.*

To make one of the images appear behind the other, perform these steps:

1. If the Layers palette is not visible, click once on the Layers tab or select the Window menu and choose Show Layers from the pull-down menu. Photoshop opens the Layers palette (refer to Figure 638.1).

Figure 638.1 The document contains two images in separate layers.

2. Move your cursor into the Layers palette and click once on the layer containing the image you want to move. In this case, you move the image in Layer_B, and position the image behind the image in Layer_A, as shown in Figure 638.2.

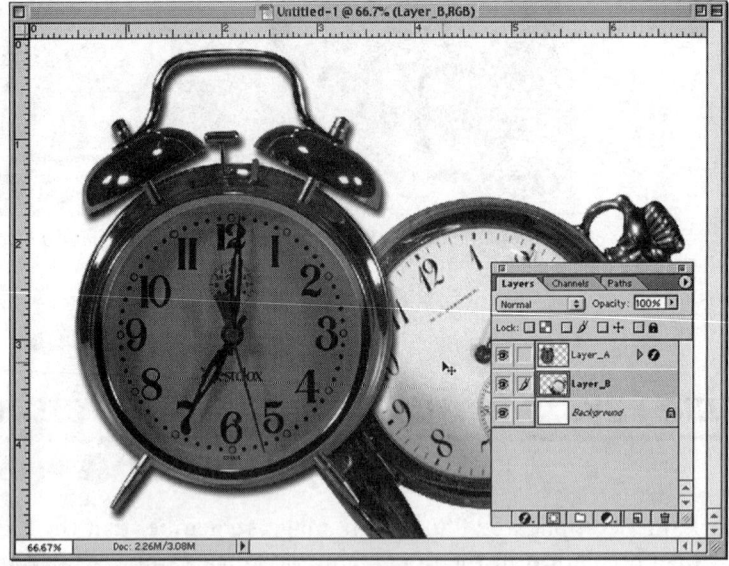

Figure 638.2 Using the Move tool, reposition Layer_B so the image appears behind the image in Layer_A.

3. The image in Layer_B is too large. Select the Edit menu and choose Free Transform from the pull-down menu. Photoshop places a bounding box around the image in Layer_B, as shown in Figure 638.3.

4. Move your mouse to one of the corners of the bounding box until your cursor resembles a diagonal double-pointed arrow. Hold the Shift key to maintain the original proportions of the graphic and drag inward to reduce the size of the image. Press the Enter key to set the transformation, as shown in Figure 638.4.

Figure 638.3 Selecting Free Transform places a bounding box around the image in Layer_B.

Figure 638.4 The Free Transform command successfully reduced the size of the image in Layer_B.

5. Select the Move tool and position the image in Layer_B. When you like what you see, click the black triangle in the upper-right corner of the Layers palette. Photoshop opens the Layers palette options. Select Flatten Image from the pop-up menu. Photoshop combines the two layers together, as shown in Figure 638.5.

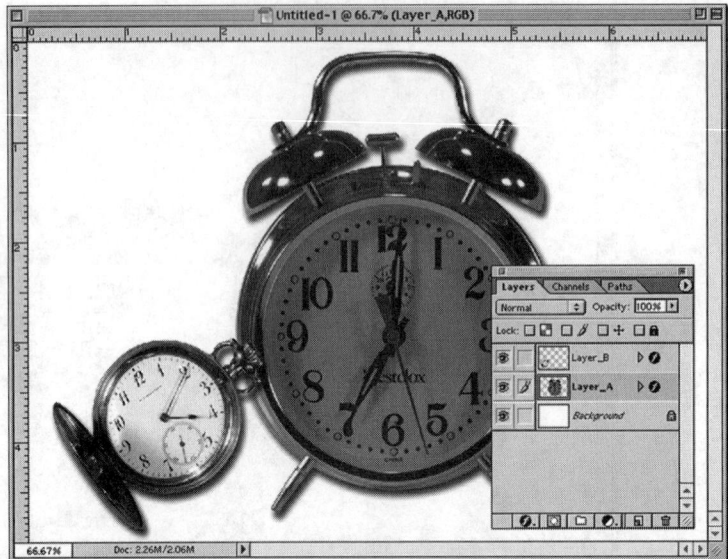

Figure 638.5 The successfully combined images use separate layers to control the effect.

639 *Using the Posterize Command*

The Posterize command works to reduce the available colors within an image by specifying the number of tonal levels. Posterize works with an image's channels to produce a high-contrast image. To apply the Posterize command to an RGB image, select Image menu Adjust and choose Posterize from the fly-out menu. Photoshop opens the Posterize dialog box, as shown in Figure 639.1.

Figure 639.1 The Posterize command creates a high-contrast image by reducing the available colors in the image.

To change the number of colors, click in the Levels input field and enter a value from 2 to 255. Say, for example, you choose a Levels value of 2. The Posterize command generates an image with six colors, two for each of the color channels Red, Green, and Blue, as shown in Figure 639.2.

Note: The Posterize command produces dramatic color shifts in an image. However, like many of Photoshop's filters and commands, try combining the Posterize effect with other filter effects in Photoshop to create the final image.

Figure 639.2 A Posterize value of 2 generates an image with six colors, two for each of the RGB image's color channels.

640 *Using Blending Modes to Reconstruct Faded Images*

Here is a simple trick when performing image editing on old, faded images. Say, for example, you scan an old, faded image. You want to restore the image; however, the image appears too light.

To help restore the image, open the document in Photoshop and perform these steps:

1. If the Layers palette is not visible, click once on the Layers tab or select the Window menu and choose Show Layers from the pull-down menu. Photoshop opens the Layers palette, as shown in Figure 640.1.

Figure 640.1 The Layers palette displays a thumbnail icon for all the layers in the active image.

2. Create a copy of the faded layer by clicking and dragging the layer icon over the New Layer icon, as shown in Figure 640.2.

3. Move your mouse into the Layers palette and click once on the blending mode button. Photoshop displays a list of available blending modes, as shown in Figure 640.3.

Figure 640.2 Clicking and dragging a layer over the New Layer icon creates a copy of the original image layer.

Figure 640.3 The blending mode options control how the inks in two layers mix.

4. Select the Multiply blending mode. Photoshop multiplies the inks in the two layers together, as shown in Figure 640.4.

Figure 640.4 The Multiply blending mode mixed the inks in the two layers, creating a darker image.

5. Select the black triangle in the upper-right corner of the Layers palette and choose Flatten Image from the fly-out menu. Photoshop combines the two layers. You are now ready to restore the image.

Note: With a darker image, you have the ability to reconstruct the image. Refer to Tip 614, "Using the Levels Dialog Box to Adjust the Midtones of an Image," and Tip 589, "Scanning an Old Image into Photoshop," for more information on restoring old images.

641 Using Curves to Increase the Contrast in an Image

In Tip 319, "Using Curves to Adjust an Image," you learned how the Curves command corrects color imbalance in an image. The Curves command is also an excellent way to increase an image's contrast. Say, for example, you have an RGB image, and you want to increase the contrast.

To use Curves to increase the contrast of an image, open the document in Photoshop and perform these steps:

1. Select Image menu Adjust and choose Curves from the fly-out menu. Photoshop opens the Curves dialog box, as shown in Figure 641.1.

Figure 641.1 The Curves dialog box lets you control the entire tonal range of the active image.

2. Move your mouse into the Curves dialog box and click once in the middle of the Curves diagonal line. Photoshop places an anchor point in the middle of the curve, as shown in Figure 641.2.

Figure 641.2 Clicking on the diagonal line creates an adjustable anchor point.

3. Click once halfway up the diagonal line between the middle anchor point and the top point, and drag straight up about 10 percent. Creating a reverse S curve increases the brightness of the highlights and decreases the brightness of the shadow pixels. The overall effect is an increase in contrast, as shown in Figure 641.3.

4. Click the OK button to close the Curves dialog box and record the changes to the active image.

5. If the image requires more contrast adjustment in the highlights, move the center anchor up, as shown in Figure 641.4.

Figure 641.3 Creating an S curve increases the contrast in the image.

Figure 641.4 Click and drag the middle anchor up the line to correct lighter images.

6. If the image requires more contrast adjustment in the shadows, move the center anchor down, as shown in Figure 641.5.

Figure 641.5 Click and drag the middle anchor down to correct darker images.

642 *Blending Two Images Together*

Here is a fast and easy way to create a visually pleasing blend between two images contained within two layers. Say, for example, you have a Photoshop document with images in two separate layers, and you want to blend the image in Layer_A with the image in Layer_B, as shown in Figure 642.1.

Figure 642.1 The document contains two images in separate layers.

To blend the two images, open the document in Photoshop and perform these steps:

1. If the Layers palette in not visible, click once on the Layers tab or select the Window menu and choose Show Layers from the pull-down menu. Photoshop opens the Layers palette.

2. Click once on Layer_A. Photoshop selects Layer_A. In this example, you want to blend the image in Layer_A into the Layer_B image.

3. Click once on the Add a Mask icon at the bottom of the Layers palette. Photoshop creates a layer mask in Layer_A, as shown in Figure 642.2.

Figure 642.2 Clicking on the Layer Mask icon creates a layer mask in the selected layer.

4. Press the letter "D" on your keyboard. Photoshop converts the Foreground and Background color swatches to black and white.

5. Select the Gradient tool from the toolbox and select the Linear Gradient option from the Options bar (refer to Tip 82, "The Gradient Tool").

6. Click once on the layer mask in Layer_A. Photoshop selects the layer mask.

7. Position your mouse cursor to the right side of the visible graphic in Layer_A and drag left across the image. Release the mouse when your cursor reaches the end of the image, as shown in Figure 642.3.

Figure 642.3 Click and drag the Gradient tool across the visible image in Layer_A.

8. When you release the mouse, the Gradient tool creates a black-to-white gradient within the layer mask. Since black generates transparency in a layer mask, the black areas of the mask make the image appear transparent. The image remains visible in the white portions of the mask, as shown in Figure 642.4.

Note: Since the Gradient tool generates a new gradient each time the tool is dragged across the layer mask, if you do not like the mask, drag the Gradient tool a second time across the image. Photoshop removes the original mask and creates a new mask based on the movement of the Gradient tool across the image.

Figure 642.4 The Gradient tool created a black-to-white mask across the image and visually blended the images in Layer_A and Layer_B.

643 *Correcting and Matching the Color Tone of an Image*

Here is an excellent tip for correcting overall color tone in one image by using the color values from another image. Say, for example, you have two RGB images. One of the images has correct color tone, and the other requires adjustment, as shown in Figure 643.1.

Figure 643.1 Two separate RGB images: Image_A contains good color tone, and Image_B requires correction.

To correct the color tone in Image_B, open Image_A and Image_B in Photoshop and perform these steps:

1. If the Color palette is not visible, click once on the Color tab or select Window menu Show Color. Photoshop opens the Color palette, as shown in Figure 643.2.

2. Select the Eyedropper tool from the toolbox and select a 3 By 3 Average Sample Size (refer to Tip 335, "Changing the Eyedropper Sample Rate for Greater Accuracy").

Figure 643.2 The Color palette displays color information on the active image.

3. Move the Eyedropper tool into Image_A. Choose an area of the image similar to an area in Image_B. In this example, you clicked once with the Eyedropper tool over his cheek. The Color palette displays the RGB color information for the Eyedropper sample, as shown in Figure 643.3.

Figure 643.3 The Color palette records the RGB color information from Image_A.

4. Record the RGB color values from the Color palette. You will use them to correct Image_B.

5. Click once in the Image_B document window. Photoshop selects Image_B.

6. Select Image menu Adjust and choose Curves from the fly-out menu. Photoshop opens the Curves dialog box.

7. Click once on the Channels button in the Curves dialog box and select the Red channel. Photoshop displays the color curve for the Red channel, as shown in Figure 643.4.

8. Move your mouse cursor into Image_B and click and hold the mouse button over the cheek area (attempt to locate an area similar to the area you selected in Image_A). The Curves palette displays a small circle on the diagonal line, as shown in Figure 643.5.

9. Remember the location of the circle. Move your mouse into the Curves dialog box and click once on the diagonal line in the same position as the small circle. Photoshop adds an anchor point to the line.

10. In the output field, enter the Red ink value you recorded in step 4. Photoshop moves the curve vertically to match the input number, as shown in Figure 643.6.

11. Click once on the Channels button in the Curves dialog box and select the Green channel. Photoshop displays the color curve for the Green channel.

Figure 643.4 Selecting the Red channel lets you control the values of the red ink in Image_B.

Figure 643.5 To locate a tonal area within a color document, click and hold your mouse button.

Figure 643.6 Changing the Output field to match the Red value from Image_A adjusts the red inks in Image_B.

12. Repeat steps 8 through 10, selecting an area on the cheek (close to the area you selected for the Red channel) and adjusting the Output value to match the Green output value you recorded in step 4. Repeat the process for the Blue channel.

13. Click the OK button to close the Curves dialog box and record your changes to the Image, as shown in Figure 643.7.

Figure 643.7 The color corrected image based on the values recorded by Image_A.

644 *Reducing Blemishes with Smart Blur*

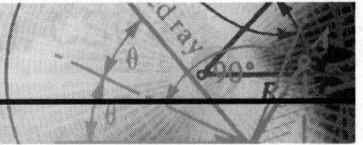

A common problem with close-up portraits is that the camera sometimes gives you too much information. Wrinkles and blemishes or small skin imperfections can ruin an otherwise excellent portrait. Many Photoshop users employ the Airbrush tool and carefully cover facial and skin imperfections. However, another way to remove small imperfections quickly is with the use of the Smart Blur filter.

The Smart Blur filter examines an image and blurs interior areas like a cheek or forehead without softening the edge pixels. Say, for example, you have an old portrait. Time and wear have conspired to roughen some of the facial features, as shown in Figure 644.1.

To correct the blurred areas of the portrait, open the document in Photoshop and perform these steps:

1. Select the Lasso tool from the toolbox and draw a rough selection around the damaged pixels on the cheek area of the image. Refer to Tip 73, "The Lasso Tools," for more information on using the Lasso.

2. Choose the Select menu and choose Feather from the pull-down menu. Photoshop opens the Feather Selection dialog box, as shown in Figure 644.2.

3. In the Feather Radius input field, enter a value of 2. Click the OK button to apply the feather to the selection.

4. Select Filter menu Blur and choose Smart Blur from the fly-out menu. Photoshop opens the Smart Blur dialog box, as shown in Figure 644.3.

Figure 644.1 The old portrait containing minor imperfections.

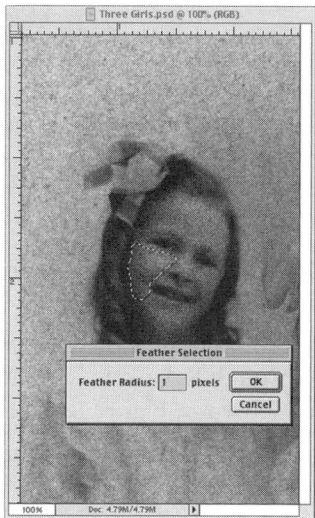

Figure 644.2 The Feather command lets you soften the edges of the selection by increasing the transparency of the selection edge.

Figure 644.3 The Smart Blur filter lets you smooth large areas of an image without affecting the edge pixels.

5. Using the preview window in the Smart Blur dialog box, move the Radius and Threshold triangle sliders until the selected facial features blend properly (refer to Tip 533, "Working with Smart Blur").

6. Click on the Quality button and select High from the drop-down list box.

7. Click on the Mode button and select Normal from the drop-down list box.

8. Click the OK button to apply the Smart Blur to the cheek area of the portrait, as shown in Figure 644.4.

Figure 644.4 The Smart Blur filter applied to the cheek area of the portrait.

9. Select and feather another damaged area of the image using the Lasso tool and the Feather command. Then repeat steps 4 through 8. Continue working through the image until you have removed all of the damaged areas, as shown in Figure 644.5.

Figure 644.5 The Smart Blur filter successfully restored the damaged portions of the image.

645 *Creating the Illusion of a Slide-Mounted Image*

Here is a great way to make your images stand out. Scan an old slide mount and make your images appear inside the mount.

The first step is to find and scan a slide mount. If the slide mount is not perfect, do not worry. It just helps the effect appear more realistic. For information on using Photoshop with your scanner, refer to Tip 594, "Scanning Directly into Photoshop." Scan the slide mount in the RGB color space and open the slide in Photoshop, as shown in Figure 645.1.

Figure 645.1 The image of a slide mount opened in Photoshop.

To insert an image into the slide mount, perform these steps:

1. If the Layers palette is not visible, click once on the Layers tab, or select the Window menu and choose Show Layers from the fly-out menu. Photoshop opens the Layers palette.

2. In the image layer containing the slide as a Background, double-click on the Background layer in the Layers palette. Photoshop opens the New Layer dialog box, as shown in Figure 645.2.

3. In the Name input field, enter Slide Mount. Click the OK button to convert and name the layer.

4. Select the Magnetic Lasso (refer to Tip 137, "Understanding the Magnetic Lasso Tool") and draw a selection defining the inside of the slide, as shown in Figure 645.3.

5. Choose the Select menu and choose Feather from the pull-down menu. Photoshop opens the Feather Selection dialog box, as shown in Figure 645.4.

6. In the Feather Radius input field, enter a value of 2. Click the OK button to apply the feather to the selection. Feathering the selection makes the image blend naturally into the slide mount.

7. Press the Delete key. Photoshop deletes the interior of the slide mount.

8. Press Ctrl+D (Macintosh: Command+D) to deselect the dotted-line marquee.

9. Select File menu Open. Photoshop displays the Open dialog box, as shown in Figure 645.5.

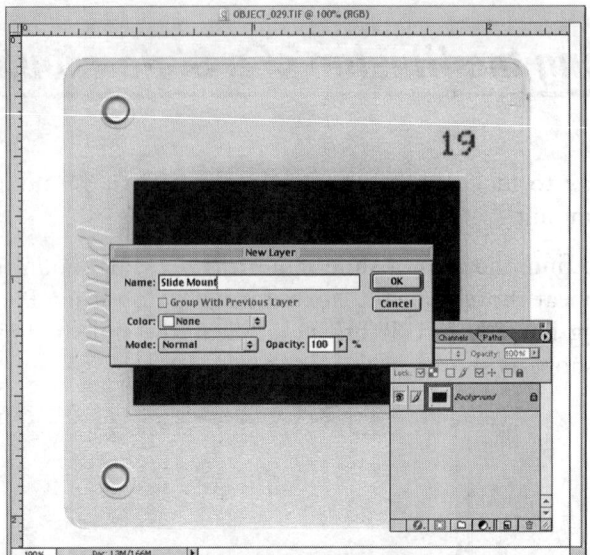

Figure 645.2 The New Layer dialog box lets you convert a Background into a layer.

Figure 645.3 The Magnetic Lasso defines the inside of the slide mount.

*Figure 645.4 The Feather command lets you soften the edges of the selection
by increasing the transparency of the selection edge.*

10. Click once on the file name you want to open and click the Open button. Photoshop opens the second file. In this example, you selected Image_B.

11. To move Image_B into the slide mount document, click on the Image_B layer icon and drag the icon into the slide mount document. Photoshop creates a new layer containing the Image_B graphic, as shown in Figure 645.6.

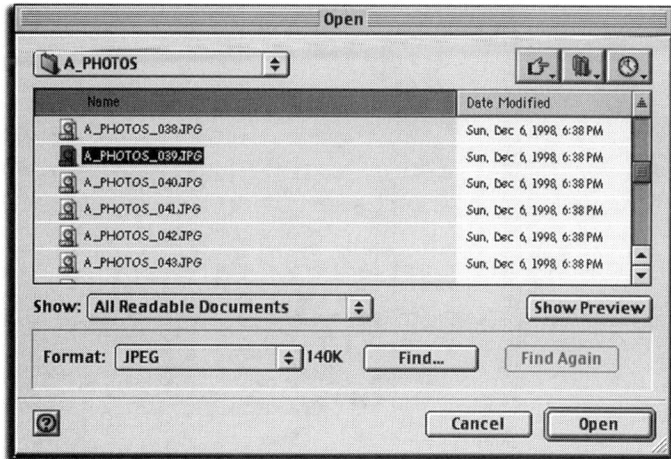

Figure 645.5 The Open dialog box lets you select and open a Photoshop file.

*Figure 645.6 Clicking and dragging a layer icon from one document into another
open document creates of copy of the dragged layer.*

12. Move your mouse into the Layers palette and click and drag Layer_B under the slide mask layer. Image_B is masked by the slide layer and appears to be in the slide mount, as shown in Figure 645.7.

13. To move or resize the Image_B layer, select the Edit menu and choose Free Transform from the pull-down menu. Photoshop places a bounding box around the image. Click in the corner anchor point and drag inward or outward to decrease or increase the image size. Press the Enter key to apply the change to the image. Refer to Tip 227, "Manipulating Shapes with Free Transform," for more information on using the Free Transform command.

Note: To avoid possible color-matching problems, use images in the same color space.

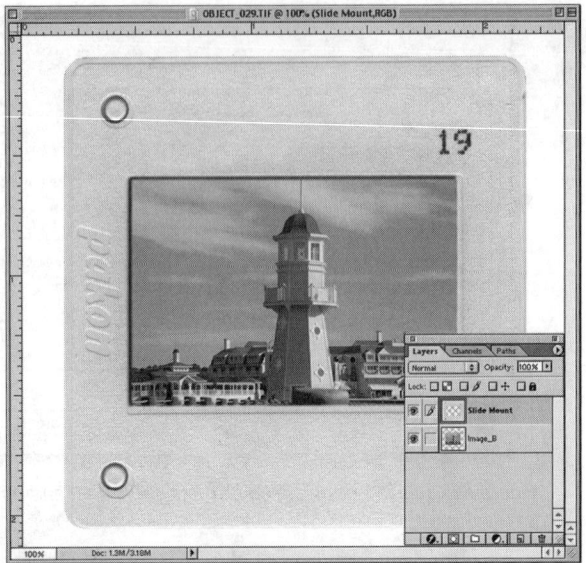

Figure 645.7 The Image_B layer appears in the slide mount.

646 *Putting a Corner Curl on an Image*

If you have ever wanted to place a curled edge onto a graphic image, this is the tip for you. The curled edge is a popular effect, and it is not that difficult to produce.

To apply a curled edge to an RGB image, open the document in Photoshop and perform these steps:

1. Select the Pen tool from the toolbox and create a triangular path similar to the one in Figure 646.1. Refer to Tip 154, "Creating Vector Paths with the Pen Tool," for more information on using the Pen tool.

Figure 646.1 The triangular pen path defines the area of the curl.

2. If the Paths Palette is not visible, click once on the Paths tab or select the Window menu and select Show Paths from the pull-down menu. Photoshop opens the Paths palette.

3. Double-click on the Work Path in the Paths palette. Photoshop opens the Save Path dialog box, as shown in Figure 646.2.

4. In the Name input field, enter the name "curl." Click the OK button to close the Save Path dialog box.

Figure 646.2 The Save Path dialog box defines the name of the new path.

5. Select the Gradient tool from the toolbox. Move your cursor into the Options bar and click once on the black triangle to the right of the gradient preview. Photoshop opens the Gradient palette, as shown in Figure 646.3.

Figure 646.3 The Gradient palette displays a list of available gradients.

6. Click on the small black triangle in the upper-right corner of the Gradient palette. Photoshop displays the Gradient palette options in a pop-up menu.

7. Move your cursor to the bottom of the Gradient options and select *Metals.grd*. Click the Append button in the alert box to add the Metal gradients to the current gradients, as shown in Figure 646.4.

8. Select the Steel Bar gradient from the gradient icons (refer to Figure 646.4).

9. Click once on the Layers tab. Photoshop opens the Layers palette.

10. Click once on the Create a New Layer icon. Photoshop creates a new transparent layer, as shown in Figure 646.5.

Figure 646.4 The Metal gradients displayed the in the Gradients palette.

Figure 646.5 Clicking on the New Layer icon generates a new layer.

11. Click once on the Paths tab. Photoshop opens the Paths palette.

12. Move your mouse into the Paths palette and Ctrl+click (Macintosh: Command+click) on the curl path. Photoshop converts the path into a selection, as shown in Figure 646.6.

13. Select the Gradient tool from the toolbox and click and drag the Metal gradient across the selection from left to right, as shown in Figure 646.7.

14. Click on the Layers tab. Photoshop opens the Layers palette.

15. Click once on the layer containing the image. In the example, the image is contained in the background.

16. Click once on the Create a New Layer icon. Photoshop creates a new layer above the background, as shown in Figure 646.8.

17. Select the Elliptical Marquee tool from the toolbox and draw an oval in the new layer. Then choose Select, Transform Selection from the pull-down menu. Move your cursor outside the defined bounding box and rotate the image clockwise until it resembles Figure 646.9. Press the Enter key to set the transform.

Figure 646.6 *When you Ctrl+click (Macintosh: Command+click) on a path, Photoshop converts the path into a selection.*

Figure 646.7 *The Gradient tool applies the metal gradient to the selected area of the transparent layer.*

Figure 646.8 *Clicking the New Layer icon creates a new transparent layer above the selected layer.*

Figure 646.9 The Elliptical Marquee tool and Transform Selection command create a rotated oval selection.

18. Choose the Select menu and choose Feather from the pull-down menu. Photoshop opens the Feather Selection dialog box, as shown in Figure 646.10.

Figure 646.10 The Feather command lets you soften the edges of the selection by increasing the transparency of the selection edge.

19. In the Feather Radius input field, enter a value of 15. Click the OK button to apply the feather to the selection.

20. Press the letter "D" on your keyboard. Photoshop converts the Foreground and Background colors to black and white.

21. Press Alt+Delete (Macintosh: Option+Delete). Photoshop fills the selection with the Foreground color, as shown in Figure 646.11.

22. Press Ctrl+D (Macintosh: Command+D) to deselect the dotted-line marquee.

23. In the Layers palette, enter a value of 65 percent into the Opacity input box for the black oval layer. Photoshop lowers the opacity of the black oval, and your image now has a curled edge, as shown in Figure 646.12.

Figure 646.11 The oval selection filled with the foreground color.

Figure 646.12 The completed image containing the curled edge.

647 *Creating a Bevel on Any Object with a Gradient*

The Bevel and Emboss filters do an excellent job of placing a 3-D bevel or embossing on a layer. However, the special effects filters require a layer that contains areas of transparency. The filter uses the transparency to apply the bevel or emboss. Here is a way to apply a bevel to almost any object using the Gradient tool.

Say, for example, you have a graphic of a logo, and you want to apply a bevel effect to the image without cutting the logo out of the layer.

To apply a bevel to the logo graphic, open the document in Photoshop and perform these steps:

1. Select the Magic Wand tool from the toolbox and click once on the logo (refer to Tip 170, "Understanding How the Magic Wand Works"). Photoshop selects the logo, as shown in Figure 647.1.

Figure 647.1 The Magic Wand tool selected the single color logo.

2. Choose Select menu Modify and choose Border from the fly-out menu. Photoshop opens the Border Selection dialog box, as shown in Figure 647.2.

Figure 647.2 The Border command converts a dotted-line selection into a border selection.

3. In the Width input field, enter a value of 12. Click the OK button to close the Border dialog box and apply the change to the selection.

4. Select the Gradient tool from the toolbox and, referring to the preceding tip's steps 5 through 8, select the Steel Bar gradient from the Gradient palette.

5. Click and drag the Gradient tool from the top of the selection to the bottom. Photoshop applies the Gradient tool to the selected border area of the logo, creating a bevel, as shown in Figure 647.3.

Figure 647.3 The Steel Bar gradient applied to the selection border, creating a beveled look to the logo.

648 *Creating a Scan Line Effect with Patterns and Channels*

In Tip 563, "Simulating a Television Image," you learned how to create a television quality with the use of a halftone pattern. Here is another way to create a pattern on an image using a pattern fill.

Say, for example, you want to make an image appear as if on a television. To create a scan-line appearance, perform these steps:

1. Select File menu New. Photoshop opens the New dialog box, as shown in Figure 648.1.

2. Create a new document 1 pixel wide and 6 pixels tall with a resolution of 72. Click the OK button to open the new document.

3. Select the Zoom tool from the toolbox and click on the new file until it is big enough to work on, as shown in Figure 648.2.

Figure 648.1 The New dialog box controls the characteristics of the new document.

Figure 648.2 The new document opened in Photoshop.

4. Press the letter "D" on your keyboard. Photoshop converts the Foreground and Background colors to black and white.

5. Select the Pencil tool from the toolbox and carefully paint the top three pixels black, as shown in Figure 648.3.

Figure 648.3 The Pencil tool fills in the top three pixels with black.

6. Select the Edit menu and choose Define Pattern from the pull-down menu. Photoshop opens the Pattern Name dialog box, as shown in Figure 648.4.

7. In the Pattern Name dialog box, enter the name Television. Click the OK button to save the pattern.

Figure 648.4 The Pattern Name dialog box lets you name the new pattern.

8. Select File menu Close. You do not need to save the black and white image file. Select the Close without saving option.

9. Open the document in which you want to apply the line screen (File menu Open).

10. Select the Edit menu and choose Fill from the fly-out menu. Photoshop opens the Fill dialog box, as shown in Figure 648.5.

Figure 648.5 The Fill dialog box controls the application of a fill to the active image.

11. Click on the Use button and select the Pattern option.

12. Click on the Mode button and select the Overlay blending mode.

13. In the Opacity field, enter a value of 40 percent.

14. Click the OK button to apply the effect to the image, as shown in Figure 648.6.

Figure 648.6 The Pattern Fill applied to the image.

***Note:** For even greater control over the image, create a new layer and apply the Pattern Fill to the transparent layer.*

649 *Generating a Carved Look to an Image*

Here is a way to introduce a carved look to an image. To apply a carved look to an RGB image, open the document in Photoshop and perform these steps:

1. If the Layers palette is not visible, click once on the Layers tab or select the Window menu and choose Show Layers from the pull-down menu.

2. Make a copy of the image layer by clicking on the image layer and dragging it down over the New Layer icon. Photoshop creates a copy of the image layer, as shown in Figure 649.1.

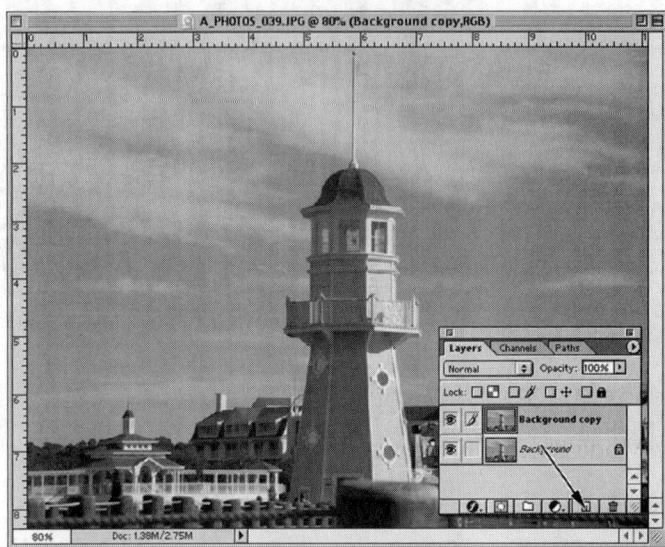

Figure 649.1 Clicking and dragging a layer over the New Layer icon creates a copy of the dragged layer.

3. With the copy layer active, select Filter menu Other and choose High Pass from the fly-out menu. Photoshop opens the High Pass dialog box. Enter a value of 3.0 in the Radius field and click the OK button to apply the effect to the copied layer, as shown in Figure 649.2.

Figure 649.2 The High Pass filter applied to the copied image.

4. Select Image menu Adjust and choose Desaturate from the fly-out menu. Photoshop converts the copied image into shades of gray.

5. Select Image menu Adjust and choose Posterize from the fly-out menu. Enter a value of 2 in the Levels input field and click the OK button to apply the effect to the copied image, as shown in Figure 649.3.

6. Move your mouse into the Layers palette and click on the blending mode button. Choose the Color Burn blending mode from the pop-up menu. Photoshop applies the Color Burn blending mode to the copied layer and completes the carved effect, as shown in Figure 649.4.

Figure 649.3 The Posterize effect applied to the copied image.

Figure 649.4 The Color Burn blending mode mixes the color inks in the original layer with the inks in the modified layer, creating a wood-carved appearance to the image.

650 *Creating Weather in an Image . . . Making It Rain*

If you have ever wanted to control the weather, here is your chance. Say, for example, you want to take a normal photograph and make it appear as if it's raining. To apply some rain to an image, open an RGB document in Photoshop and perform these steps:

1. If the Layers palette is not visible, click once on the Layers tab or select the Window menu and choose Show Layers from the pull-down menu. Photoshop opens the Layers palette.

2. Click once on the New Layer icon. Photoshop creates a new transparent layer, as shown in Figure 650.1.

Figure 650.1 Clicking on the New Layer icon creates a new layer.

3. Press the letter "D" on your keyboard. Photoshop converts the Foreground and Background colors to black and white.

4. Press Alt+Delete (Macintosh: Option+Delete). Photoshop fills the selection with the Foreground color, as shown in Figure 650.2.

Figure 650.2 The new layer filled with the foreground color.

5. Select Filter menu Noise and choose Add Noise from the fly-out menu. Photoshop opens the Add Noise dialog box. In the Amount field, enter a value of 100. Select Uniform Distribution and click to select Monochromatic. Click the OK button to apply the noise to the black layer, as shown in Figure 650.3.

6. Select Filter menu Blur and choose Motion Blur from the fly-out menu. Photoshop opens the Motion Blur dialog box. In the Angle input field, enter a value of 45 degrees. Enter a value of 10 pixels in the Distance input field. Click the OK button to apply the effect to the black layer, as shown in Figure 650.4.

7. Select Image menu Adjust and choose Equalize from the fly-out menu. Photoshop applies the Equalize command to the black layer, as shown in Figure 650.5.

Figure 650.3 The Noise filter applied to the black layer.

Figure 650.4 The Motion filter applied to the black layer.

8. Move your mouse into the Layers palette and click once on the blending mode option and Select Overlay from the drop-down list box.

9. In the Opacity input field, enter a value of 25 percent to lower the opacity of the rain layer and complete the effect (see Figure 650.6).

Figure 650.5 The Equalize command maps an image from black to white and helps highlight the noise.

*Figure 650.6 Selecting the Overlay blending mode and reducing the opacity of the
rain layer, makes it a rainy night in Georgia.*

651 *Enhancing Shadows in Four-Color Printing Presses*

Here is a simple tip to help your shadows print on a four-color printing press. Say, for example, you create a graphic with a drop shadow, and the job outputs to a four-color printing press. The image and the shadow are on separate layers in the document.

To enhance the shadows, open the document in Photoshop and perform these steps:

1. If the Layers palette is not visible, click the Layers tab or select the Window menu and choose Show Layers form the pull-down menu. Photoshop opens the Layers palette, as shown in Figure 651.1.

2. Click once on the layer containing the shadow. In this example, you clicked on the ImageShadow layer.

Figure 651.1 *The Layers palette contains a layer for the image, a layer for the shadow, and a layer for the image background.*

3. Click once on the blending mode button to the left of the Opacity input field. Photoshop displays a list of available blending modes in a drop-down list box. Select the Multiply blending mode option, as shown in Figure 651.2.

Figure 651.2 *The Multiply blending mode blends the background image into the shadow layer, creating a more realistic shadow.*

Note: The Multiply blending mode does not work if the background is white.

652 *Understanding How Photoshop Processes Type*

Photoshop 6.0 made a fundamental change in how the program processes type. Before version 6.0 of the program, you could create, edit, and apply effects to the type layer. Photoshop defines layers containing editable type as Type layers, as shown in Figure 652.1.

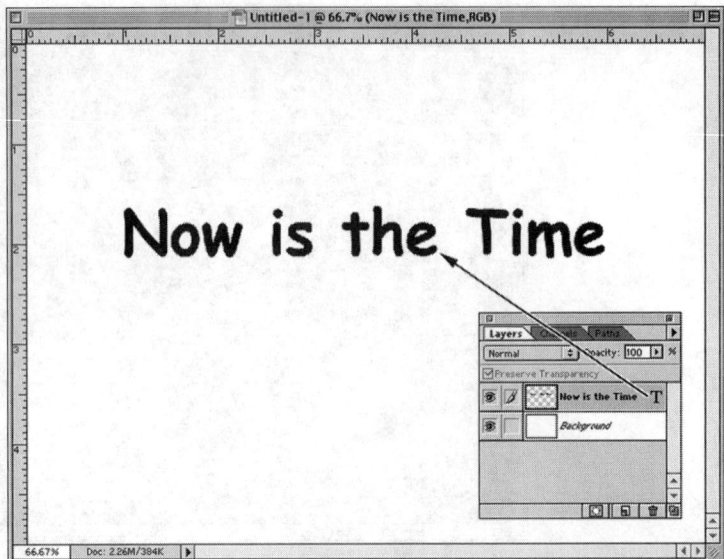

Figure 652.1 In Photoshop 5.0, a bold "T" to the right of a layer containing editable text denotes a Type layer.

If you need to edit the text in a Type layer, double-click your mouse on the bold "T" in the Layers palette. Photoshop opens the Type Tool dialog box, as shown in Figure 652.2.

Figure 652.2 In Photoshop 5.0, the Type dialog box lets you edit the text in a Type layer.

Type layers and the Type dialog box are found in pre-6.0 versions of Photoshop. In Photoshop 6.0, text is typed in the layer without the necessity of using a dialog box, as shown in Figure 652.3.

The most significant change to text processing is how Photoshop handles the text. Before version 6.0, printed Photoshop documents handled text layers as paint; they did not preserve the text. The result to pre-6.0 users of Photoshop shop was jagged or blurry text, especially when you print at low resolutions.

In Photoshop 6.0, text processing changed. Photoshop 6.0 preserves the vector text. Now, when you print a document using Photoshop 6.0, the text prints from the actual PostScript text files. Knowing this about text and Photoshop changes how you use the program.

Now, when you use PostScript fonts in your Photoshop documents, the document text prints clear and crisp whatever the resolution of the digital image. If you process a lot of text, that is a nice thing to know.

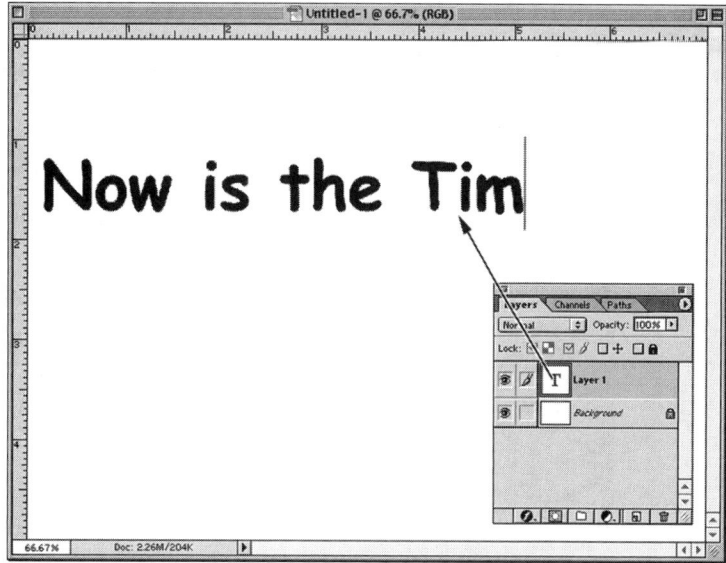

Figure 652.3 Photoshop 6.0 lets you type text directly into the layer.

653 *Working with the Type Mask Tool*

Photoshop has two Type Mask tools. To access the Type Mask tool, click and hold (or right-click) your mouse on the Type tool in Photoshop's toolbox. Photoshop displays the Type tool options in the Options bar, as shown in Figure 653.1.

Figure 653.1 The Type tool options in Photoshop's Options bar.

The Mask tool icon resembles a dotted outline letter T on the left side of the Options bar (refer to Figure 653.1). To use the Mask tool, click once on the Mask tool icon in the Options bar, move your cursor into an open Photoshop document, and begin typing. Photoshop displays the typed text as a red semi-transparent mask, as shown in Figure 653.2.

Figure 653.2 The Mask type tool generates a semitransparent mask of the typed words.

To view the finished type as a mask, move into the toolbox and click once on the Move tool. Photoshop converts the semitransparent text into a selection mask, as shown in Figure 653.3.

Once the text converts into a selection marquee, you can apply all the same editing techniques you use on any standard selection. The difference is that the selection is in the shape and form of text.

Note: See Tip 656, "Using Text Masks," for more information on how to use text masks.

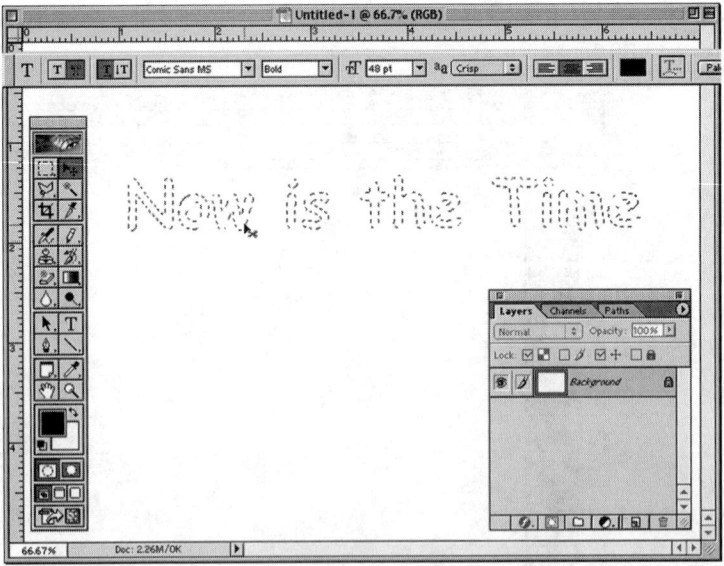

Figure 653.3 The Mask tool creates a selection based on the chosen text size and font.

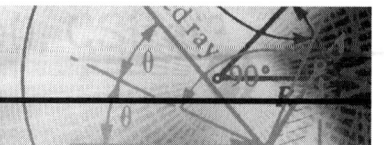

654 *Gaining Flexibility with Type Layers*

When you work with Type layers, it is important to understand that, in version 6 of Photoshop, you are not just working with paint on the screen. You are actually working with and manipulating vector-based text (refer to Tip 652, "Understanding How Photoshop Processes Type").

As long as the layer remains a type layer, you control the font, size, and shape of the words. You can open documents saved with the *.psd* format days, weeks, or months later, and if the document contains a text layer, you can rework the text. Type layers give the Photoshop user tremendous flexibility over the final image.

Before Photoshop 6.0, it was not uncommon to create a graphic image in Photoshop and then move the saved image into Adobe Illustrator to create text and print the document. While there is still a tremendous need for moving Photoshop images into Adobe Illustrator, in many cases, the Photoshop user simply works and prints the document directly from Photoshop.

There are times when you need to convert a text layer into pixels. If you need to convert a text layer into pixels, select Layer menu Rasterize and choose Type from the fly-out menu. Photoshop converts the text layer into pixels.

Rasterized type layers look like text, but they are simply paint in the shape of letters of the alphabet. Rasterized type layers perform and print exactly as any other image layer in Photoshop.

Note: You cannot return a rasterized layer to a vector or type layer. Do not rasterize a type layer until you are sure that is what you want to do.

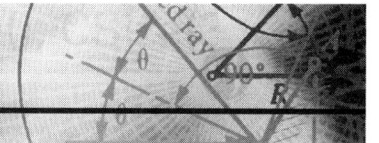

655 *Working with Text and Filters*

You can apply effects to a type layer, such as bevel, emboss, and drop shadow, but you cannot apply a filter to text without first rasterizing the type layer (refer to the preceding tip). Say, for example, you created a Type layer, and you want to apply several effects to the text. You apply a bevel and drop shadow to the type, as shown in Figure 655.1.

After applying the effect to the type layer, you decide to change the font. To change the Font, select the Type tool from the toolbox and double-click with the Type tool on the text, as shown in Figure 655.2.

To modify the font, move your cursor into the Options bar and click once on the black triangle located to the right of Font box. Photoshop displays a list of available fonts in a pop-up menu. Click on a font name to change the selected text, as shown in Figure 655.3.

Now you want to apply a Gaussian Blur to the text. Select Filter menu Blur and choose Gaussian Blur from the fly-out menu. Photoshop opens an alert dialog box, as shown in Figure 655.4.

If you click the OK button, Photoshop lets you apply the Gaussian Blur to the type, but the text is no longer editable.

Figure 655.1 A Bevel and Drop Shadow applied to a type layer.

Figure 655.2 Double-clicking on a section of text with the type tool selects the text.

Note: *Do not apply filters to a text layer unless you are finished editing the text. Once you apply a filter, the text coverts to pixels.*

Figure 655.3 Clicking on a font name changes the font type of the selected text.

Figure 655.4 The alert dialog box warns you that applying the Gaussian Blur filter to the text converts the text into pixels.

656 *Using Text Masks*

In Tip 653, "Working with the Type Mask Tool," you learned how to create a text mask using the new Type Mask tool. Once the Mask tool creates the type mask, all the rules applying to selections are available. Say, for example, you want to create some text and stroke an outline around the selection.

To create a stroked outline of text, open a document in Photoshop and perform these steps:

1. Select the Type tool from the toolbox and select the mask option by clicking the Mask icon in the Options bar, as shown in Figure 656.1.

Figure 656.1 Selecting the Type tool and clicking the Mask icon lets you create a type mask.

2. Click in the document window and create a text mask. In this example, you typed Sky Blue, as shown in Figure 656.2.

Figure 656.2 The text Sky Blue was typed with the Type Mask tool.

3. Move your mouse into the toolbox and select the Rectangular marquee tool. The mask text converts into a selection. Click inside the selection and drag using the marquee tool to position the text, as shown in Figure 656.3.

4. Press the letter "D" on your keyboard. Photoshop converts the Foreground and Background colors to black and white.

5. If the Layers palette is not visible, click once on the Layers tab or select the Window menu and choose Show Layers from the fly-out menu. Photoshop opens the Layers palette.

6. Create a new layer by clicking once on the New Layer icon. Photoshop creates a new layer, as shown in Figure 656.4.

Figure 656.3 Use the marquee tool to reposition the selection.

Figure 656.4 Clicking the New Layer icon creates a new layer.

7. Select the Edit menu and choose Stroke from the pull-down menu. Photoshop opens the Stroke dialog box.

8. In the Width input field, enter a value of 8 pixels. Click the Center radio button. Click the Mode button and choose the Normal blending mode with an Opacity of 100 percent. Do not select Preserve Transparency. Click the OK button to apply the stroke to the selection, as shown in Figure 656.5.

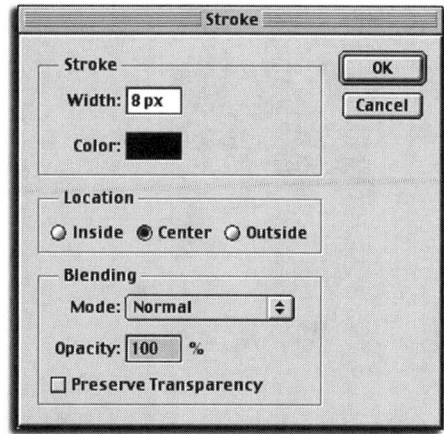

Figure 656.5 The Stroke dialog box controls the characteristics of the stroke.

9. Press Ctrl+D (Macintosh: Command+D) to deselect the text mask and complete the stroke text effect, as shown in Figure 656.6.

Figure 656.6 The Stroke effect applied to the selection mask.

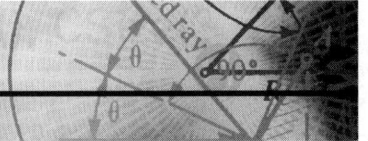

657 *Curving Text in Photoshop*

In Tip 566, "Using a Displacement Map to Distort Text," you curved text to fit the shape of a coffee cup. In Photoshop 6.0, there is an easier way to curve text by using the Text Warp feature.

To curve text onto the surface of a coffee cup, open the document in Photoshop and perform these steps:

1. Select the Type tool from the toolbox and select the text layer button in the Options bar, as shown in Figure 657.1.

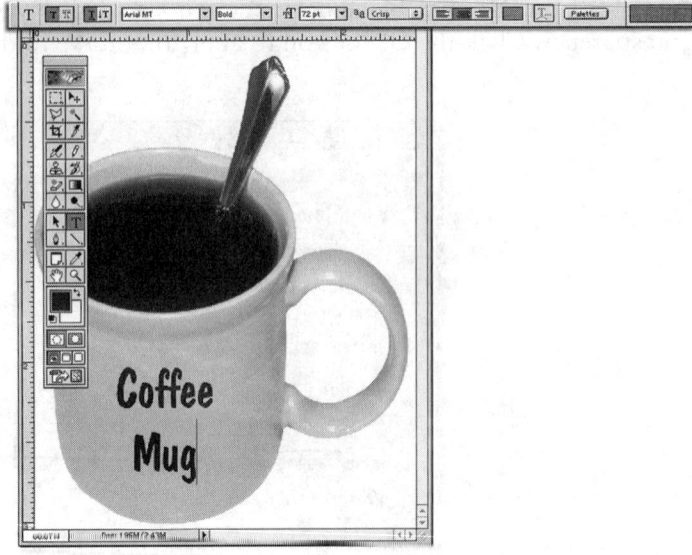

Figure 657.1 Selecting the Type tool from the Photoshop toolbox gives you access to the typing tool options.

2. Click on the black triangle to the right of the font box in the Options bar. Photoshop displays a list of available fonts in a pop-up menu. Click on a font name to select the font. In this example, you choose the font of ChiselD.

3. In the font size input box, enter a font size. In this example, you choose a font size of 24 points.

4. Click once with your Type tool in the document window and enter the text "Coffee Mug."

5. Click on the Warp Text button in the Options bar. Photoshop opens the Warp Text dialog box, as shown in Figure 657.2.

Figure 657.2 The Warp Text dialog box controls the modification of the text layer.

6. Click on the Style button and select Arc from the list of available Warp styles.

7. Select the Horizontal radio button.

8. In the Bend input field, enter a value of –37. Click in the Vertical Distortion input field and enter a value of –28.

9. Click the OK button to apply the distortion to the type layer and complete the effect, as shown in Figure 657.3.

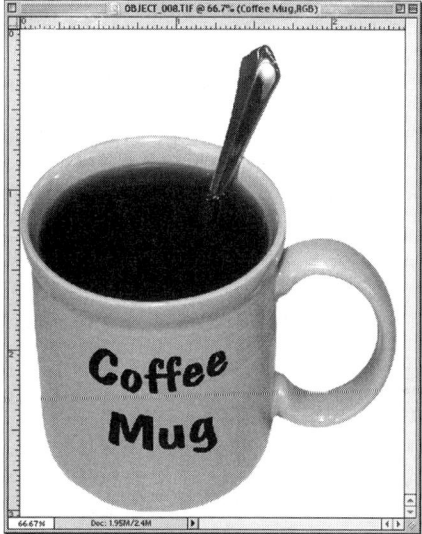

Figure 657.3 The Text Warp effect successfully applied to the type layer.

658 *Manipulating Text Images*

In Tip 653, "Working with the Type Mask Tool," you learned how to create a type mask. You can use type masks to create text images. Say, for example, you have a graphic image, and you want to create text with the image of the text. To manipulate a text image, open a document in Photoshop and perform these steps:

1. Select the Type tool and select mask type tool from the Options bar, as shown in Figure 658.1.

Figure 658.1 Selecting the Type tool from the Photoshop toolbox gives you access to the typing tool options.

2. Click on the black triangle to the right of the font box in the Options bar. Photoshop displays a list of available fonts in a pop-up menu. Click on a font name to select the font. In this example, you choose the font of Impact.

3. In the font size input box, enter a font size. In this example, you choose a font size of 72 points.

4. Click once with your Type tool in the document window and enter the text "BIG BLUE."

5. Move your mouse into the toolbox and select the Rectangular marquee tool. The mask text converts into a selection. Click inside the selection and drag with the marquee tool to position the text selection, as shown in Figure 658.2.

6. Choose the Select menu and choose Inverse from the pull-down menu. Photoshop reverses the selection.

7. Press the Delete key. Photoshop deletes all of the areas surrounding the text and creates an image out of text, as shown in Figure 658.3.

Figure 658.2 Use the marquee tool to reposition the selection.

Figure 658.3 The Type mask creates an image out of a type mask.

659 *Manipulating Text Images with Clipping Groups*

In the preceding tip, you learned how to create an image out of text. When you create a text image using the type mask, you are not creating an image out of text. You create the image using a selection in the shape of text.

The problem with creating a mask and converting the mask into an image is that you lose control over the image and the text. A way to create the same effect as the preceding tip, and maintain control over the text and image, is to use a clipping group.

To manipulate a text image using a clipping group, open a document in Photoshop and perform these steps:

1. Select the Type tool and select the text layer tool from the Options bar, as shown in Figure 659.1.

Figure 659.1 Selecting the Type tool from the Photoshop toolbox gives you access to the typing tool options.

2. Click on the black triangle to the right of the font box in the Options bar. Photoshop displays a list of available fonts in a pop-up menu. Click on a font name to select the font. In this example, you choose the font of Impact.

3. In the font size input box, enter a font size. In this example, you choose a font size of 72 points.

4. Click once with your Type tool in the document window and enter the text "BIG BLUE."

5. Use the Move tool to position the text, as shown in Figure 659.2.

6. If the Layers palette is not visible, click the Layers tab or select the Window menu and choose Show Layers form the pull-down menu. Photoshop opens the Layers palette, as shown in Figure 659.3.

7. Click on the text layer and drag it underneath Layer_A layer.

8. Position your mouse cursor so the tip of the finger icon is touching the edge defining the two layers, as shown in Figure 659.4.

9. Press the Alt key (Macintosh: Option key) and click your mouse. Photoshop creates a clipping group based on the text layer and the image layer, as shown in Figure 659.5.

Figure 659.2 Use the Move tool to reposition the selection.

Figure 659.3 The Layers palette contains a layer for the image and a layer for the text.

Figure 659.4 Position the cursor until the icon appears to touch the line separating the two layers.

10. To reposition the text, click once on the text layer and use the Move tool to click and drag the text layer. When you reposition the text, the image shifts with the text.

> **Note:** *You now have total control over the text layer and the image layer.*

Figure 659.5 Alt+clicking (Macintosh: Option+clicking) on the line separating two layers creates a clipping group.

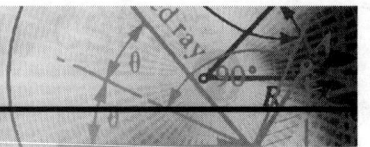

660 *Creating 3-D Text with Layer Effects*

One of the great advantages to creating text with Photoshop's Type tool is the ability to apply layer effects and still preserve the layer as a text layer. Say, for example, you have a document containing a text layer, and you want to apply a drop shadow to the text.

To apply a drop shadow to a text layer, open a document containing text and perform these steps:

1. If the Layers palette is not visible, click the Layers tab or select the Window menu and choose Show Layers form the pull-down menu. Photoshop opens the Layers palette, as shown in Figure 660.1.

Figure 660.1 The Layers palette contains a layer for the image and a layer for the text.

2. Click once on the text layer. Photoshop selects the text layer (refer to Figure 660.1).

3. Click once on the Layer Style button at the bottom left of the Layers palette. Photoshop opens a pop-up menu displaying a list of available layer styles. Click once on Drop Shadow. Photoshop opens the Layer Style dialog box, as shown in Figure 660.2.

4. Select from the available options to control the distance, angle, and characteristics of the text shadow (see Tip 914, "Working with the Layer Style Dialog Box to Create a Shadow").

5. Click the OK button to apply the drop shadow to the text layer, as shown in Figure 660.3.

Note: Even though you applied a drop shadow to the text layer, the layer still contains editable text.

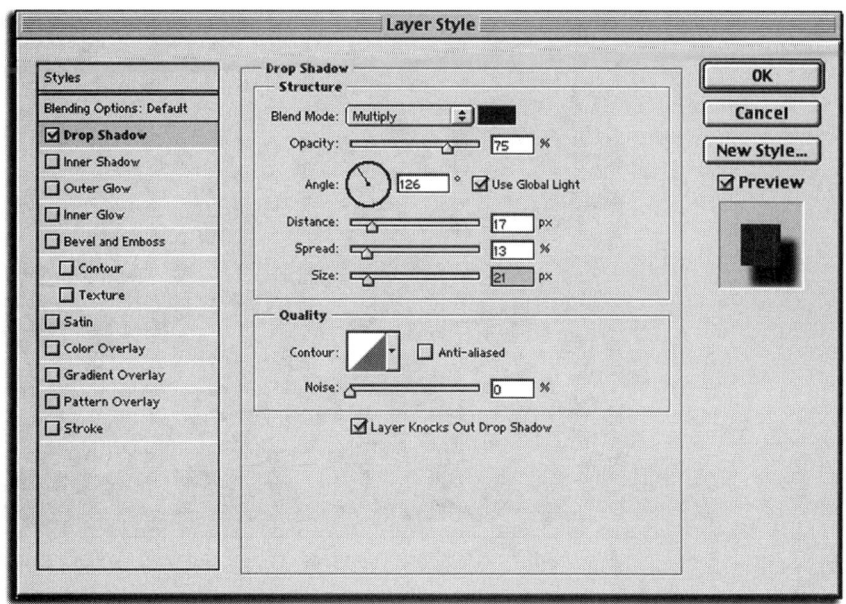

Figure 660.2 The Layer Style dialog box controls the characteristics of the drop shadow.

Figure 660.3 The Drop Shadow Layer effect successfully applied to the text layer.

661 *Working with Text and Graphics in Screen View*

When you work with text in a Photoshop document, you see the type displayed on a standard computer monitor. If the text is sent to a printer, Photoshop creates a digital copy of the type and graphic and sends the file to the printer. The printer interprets the information and creates a document on paper, transparency material, canvas, or whatever output you desire. It is important to remember the differences between a printed document and documents viewed on a computer screen.

Computers define the inks in a document using pixels. Each pixel is a small square of color, as shown in Figure 661.1.

Figure 661.1 Computer monitors define color using square pixels.

Since the corners of each pixel are 90 degrees, they fit together like bricks in a wall. Imagine a large brick wall with each brick having the capability to change to a different color, and you have a good visualization of a computer monitor.

Printers operate by placing dots of ink onto a flat surface. Ink-jet printers, for example, spray dots of ink from different-color nozzles onto the paper's surface (typical ink-jet printers use the colors red, green, and blue). When the inks hit the paper, they blend to form the colors you see when the print job completes, as shown in Figure 661.2.

Figure 661.2 Printers use different color inks to produce the colors you view in a printed document.

Monitors do not mix ink pixels. A typical color monitor is capable of generating over 16 million colors per pixel. Some older monitors cannot produce the millions of colors that newer monitors produce. When an older monitor is required to display a color that is outside its range, the monitor switches the colors of alternating pixels to produce the new color. Say, for example, you need a light blue color, and your monitor cannot produce that exact shade of blue. The monitor alternates darker blue pixels with lighter pixels to produce a visual effect of the light blue color you want. This process of alternating pixel colors is called dithering. Programs like Photoshop help the monitor create the color by instructing the monitor (based on the available colors) exactly what two colors, when dithered, create the visual appearance of the needed color, as shown in Figure 661.3.

Figure 661.3 Monitors alternate pixels in a process defined as dithering to make your eyes see colors that are not there.

662 *Using Type Masks to Create Embossed Text*

In Tip 656, "Using Text Masks," you learned how to create selections from text using the Type Mask tool. Say, for example, you want to create some text with an embossed look, but you do not want to create solid color text with the Type tool. You want to create text using a graphic to fill the text.

To create embossed text using the Text Mask tool, open the document you want to use as a background for the text and perform these steps:

1. Select the Type tool from the toolbox and select the Type Mask icon from the Options bar, as shown in Figure 662.1.

Figure 662.1 The Type Mask tool lets you creates selections from text.

2. Click on the black triangle to the right of the font box in the Options bar. Photoshop displays a list of available fonts in a pop-up menu. Click on a font name to select the font (refer to Figure 662.1). In this example, you chose the font Arial Rounded MT.

3. Click in the font size input box and enter a font size. In this example, you choose a font size of 72 points.

4. Click once with your Type tool in the document window and enter the text "EMBOSS."

5. Move your mouse into the toolbox and select the Rectangular marquee tool. The mask text converts into a selection. Click inside the selection and drag using the marquee tool to position the text, as shown in Figure 662.2.

6. Select the Edit menu and choose Copy from the pull-down menu. Photoshop creates a Clipboard memory copy of the word EMBOSS.

7. Select the Edit menu and choose Paste from the pull-down menu. Photoshop creates a new layer in the Layers palette and places the copied information into the layer, as shown in Figure 662.3.

Figure 662.2 Use the Move tool to reposition the selection.

8. Click the Layer Styles icon located at the bottom left of the Layers palette. Photoshop displays the Layer Styles in a pop-up menu. Select Bevel and Emboss from the pop-up menu. Photoshop opens the Layer Style dialog box and applies an Emboss to the copied text. Change the Structure or Shading of the Emboss and click the OK button to apply the effect to the image, as shown in Figure 662.4.

Figure 662.3 The Copy and Paste commands placed the copied information into a new layer.

Figure 662.4 The Emboss Style successfully applied to the word EMBOSS.

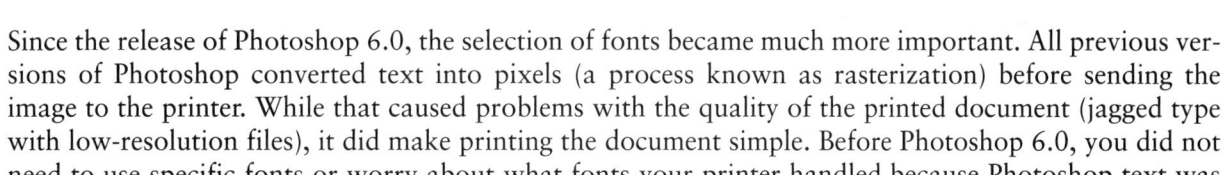

663 *Selecting a Font*

Since the release of Photoshop 6.0, the selection of fonts became much more important. All previous versions of Photoshop converted text into pixels (a process known as rasterization) before sending the image to the printer. While that caused problems with the quality of the printed document (jagged type with low-resolution files), it did make printing the document simple. Before Photoshop 6.0, you did not need to use specific fonts or worry about what fonts your printer handled because Photoshop text was not text; it was simply ink on the paper.

In Photoshop 6.0, things got better. Text now prints using PostScript files, but it requires a bit more thought about the type of fonts you want to use in your documents.

To select a font, open a document in Photoshop and select the Type tool from the toolbox. Photoshop's Options bar now displays all the available type options including the current font, as shown in Figure 663.1.

To select a font, click on the small black triangle to the right of the default font box. Photoshop displays a list of available fonts (refer to Figure 663.1). Move your mouse up and down the list and click once on a font name to select that particular font.

There are many types of fonts in the marketplace today; however, the two major font types are PostScript and TrueType.

- **PostScript:** The PostScript font type is the font of choice for most service bureaus and high-end printing houses. When you purchase PostScript fonts, they come with a file for the monitor and a file for the printer. The monitor file instructs Photoshop how to display the font on your monitor. The print file instructs the printer or printing press how to print the font. PostScript fonts are expensive, but they always produce consistent results between what you see on your computer monitor and what you see on the printed page. PostScript fonts are also faithful when moving documents between Windows and Macintosh versions of Photoshop.

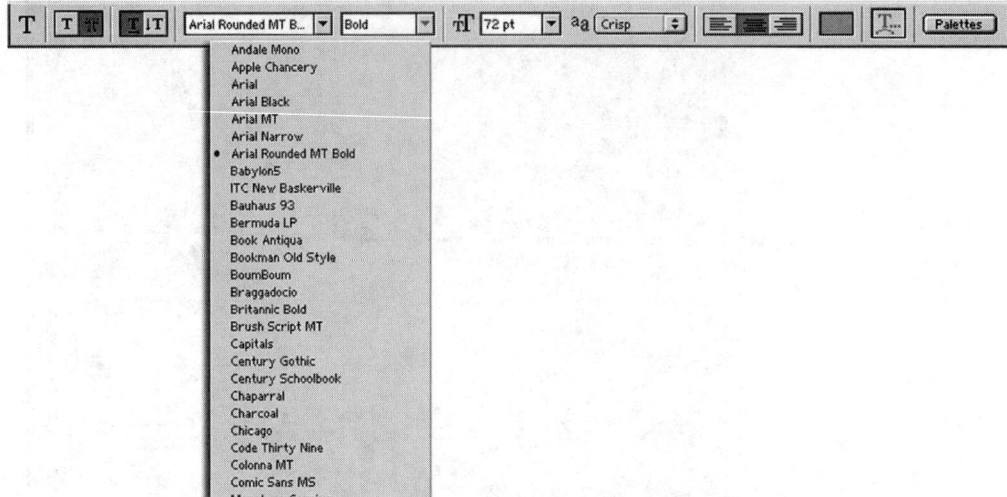

Figure 663.1 The Options bar lets you select from a list of available fonts.

- **TrueType:** The TrueType family does not have the consistency that comes with PostScript. What you see on your monitor may be vastly different from the printed document. Many companies produce TrueType fonts. In fact, if you own a program called Fontographer, you can make your very own fonts. Having so many TrueType fonts on the market generates confusion. For example, the Arial TrueType font you use on your computer may not be the same Arial font the printer uses to print the document.

When working in Photoshop, for the obvious reasons of compatibility, consistency, and look, choose PostScript fonts whenever possible.

664 *Sharpening Text*

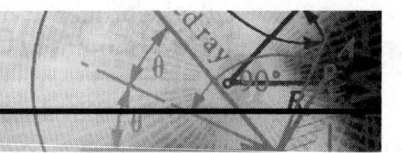

When you sharpen text, you are actually using Photoshop's anti-aliasing option. Anti-aliasing is the term Photoshop uses to describe the sharpening of text on your computer monitor. Text looks jagged when viewed on a monitor because the colors on computer monitors display using small squares, not round dots of ink (refer to Tip 661, "Working with Text and Graphics in Screen View").

Text is especially susceptible to looking jagged on a computer monitor because the type is typically a much different color than the surrounding pixels, causing it to stand out, as shown in Figure 664.1.

When you sharpen the text in Photoshop, you are not actually creating a sharper text. The anti-alias option coats the edges of the text with colored pixels designed to help your eyes blend the text into the background, as shown in Figure 664.2.

To create text with or without the anti-alias feature, open a document containing text and select the Type tool from the toolbox. Move your mouse into the Options bar and click once on the anti-alias button. Photoshop displays a list of available anti-alias options in a drop-down list, as shown in Figure 664.3.

Figure 664.1 Text appears jagged on a monitor due to the square design of the monitor's pixels.

Figure 664.2 The anti-alias option creates a smoother look to text when viewed on a computer monitor.

Figure 664.3 The anti-alias options help to create a visually smoother appearance to text.

Click on None, Crisp, Strong, or Smooth to change the appearance of the text, as shown in Figure 664.4.

Note: *If you use PostScript fonts with Photoshop 6.0, the PostScript font and the printer, not the anti-alias options, control the output of the text.*

Figure 664.4 The anti-alias options visually smooth the text by applying a coating of colored pixels to the edge of the text.

665 *Converting Text into a Freeform Shape with Filters*

In Tip 662, "Using Type Masks to Create Embossed Text," you learned how to use Photoshop's Type Mask tool to create type using a graphic image. In this tip, you will take the Emboss type one step further with the use of Photoshop's filters.

To convert text into a filtered shape, refer to Tip 662, create embossed type, and perform these steps:

1. If the Layers palette is not visible, click the Layers tab or select the Window menu and choose Show Layers from the pull-down menu. Photoshop opens the Layers palette, as shown in Figure 665.1.

Figure 665.1 The Layers palette contains a layer for the image and a layer for the embossed text.

2. Click once on the embossed text layer. Photoshop select the layer (refer to Figure 665.1).

3. Select Filter menu Distort and choose Wave from the fly-out menu. Photoshop opens the Wave dialog box, as shown in Figure 665.2.

Figure 665.2 The Wave dialog box controls the characteristics of the Wave filter.

4. In the Number of Generators field, enter a value of 2.

5. In the Minimum and Maximum Wavelength fields, enter the values of 1 and 13.

6. In the Minimum and Maximum Amplitude fields, enter the values of 1 and 7.

7. In the Horizontal and Vertical Scale input files, enter the values of 100 and 100.

8. Click on the Randomize button until you see a shape you like in the preview window.

9. Click the OK button to apply the effect to the text, as shown in Figure 665.3.

Figure 665.3 The Wave effect successfully converted the standard text into a freeform shape.

Note: *Do not stop with the Wave filter. There are thousands of filter combinations you can use to convert boring text into exciting freeform shapes.*

666 *Creating a Work Path from Type*

In Tip 656, "Using Text Masks," you learned how to create selections based on text. Once you create a text mask, you can convert the mask into a vector path. Photoshop uses paths for a variety of reasons. You can convert a path into a clipping path and maintain transparency in programs like QuarkXPress, PageMaker, and InDesign. Photoshop uses paths to guide tools like the Paintbrush and Airbrush as well as the Clone Stamp and History brush.

To create a path from a type mask, open a document in Photoshop and perform these steps:

1. Select the Type tool from the toolbox and select the Type Mask icon from the Options bar, as shown in Figure 666.1.

Figure 666.1 The Type Mask tool lets you create selections from text.

2. Click on the black triangle located to the right of the font box in the Options bar. Photoshop displays a list of available fonts in a pop-up menu. Click on a font name to select the font (refer to Figure 666.1). In this example, you choose the font Helvetica.

3. Click in the font size input box and enter a font size. In this example, you choose a font size of 72 points.

4. Click once with your Type tool in the document window and enter the text "Path." Click the check mark in the Options bar to set the path.

5. If the Paths palette is not visible, click once on the Paths tab or select Window menu Show Paths. Photoshop opens the Paths palette, as shown in Figure 666.2.

6. Click the black triangle icon in the upper-right corner of the Paths palette. Photoshop displays a pop-up menu with the Paths options. Select Make Work Path from the pop-up menu. Photoshop opens the Make Work Path dialog box, as shown in Figure 666.3.

7. In the Tolerance input field, enter a value of 0.5. Tolerance controls the accuracy of the created path to the dotted-line selection. Values range from 0.5 to 10.0. Low values create paths that conform closely to the original dotted-line selection.

Figure 666.2 The Paths palette displays an icon for all the paths in the active document.

Figure 666.3 The Make Work Path dialog box controls the characteristics of the new path.

8. Click the OK button to close the Make Work Path dialog box and create the new path, as shown in Figure 666.4.

Note: *Once you create the path from the type mask, Photoshop treats the new text path just like any other path.*

Figure 666.4 *Photoshop creates the new path from the dotted-line selection of the type mask.*

667 *Adjusting Text Using Kerning, Tracking, and Leading*

Photoshop has come a long way from the early versions of the program. In early versions of Photoshop, text was a secondary consideration. Photoshop was designed to manipulate graphics. If you wanted to work with large bodies of text, you went to Adobe Illustrator or Adobe PageMaker.

That is no long the case. Photoshop is a graphics and text-processing program. It is true that you would not want use Photoshop to design a brochure or text document, but you have more control over text than you ever have. One of the ways you control text is using kerning, tracking, and leading.

Kerning, tracking, and leading are terms used to define the vertical and horizontal distance between lines and letters of type.

To adjust the kerning, leading, or tracking of Photoshop type, create type in a Photoshop document (refer to Tip 218, "Creating Text in Photoshop 6.0").

If the Character palette is not visible, click on the Character tab or select the Window menu and choose Show Character from the pull-down menu. Photoshop opens the Character palette, as shown in Figure 667.1.

Figure 667.1 *The Character palette controls the format of the selected text.*

- **Leading:** In the Leading input field (refer to Figure 667.1), enter a value from 0 to 5000. The Leading value represents the amount of space allocated to the lines between text. When you press the Enter key to drop to the next line, the leading value determines the amount of space. Normal leading between lines is 125 percent of the font size. When you press the Enter key, by default, Photoshop looks as the font size and adds 125 percent to the leading value. Say, for example, you select a font with a point size of 72. The normal leading value is 90, or 125 percent of 72. Changing the Leading value changes the spacing between the lines of text, as shown in Figure 667.2.

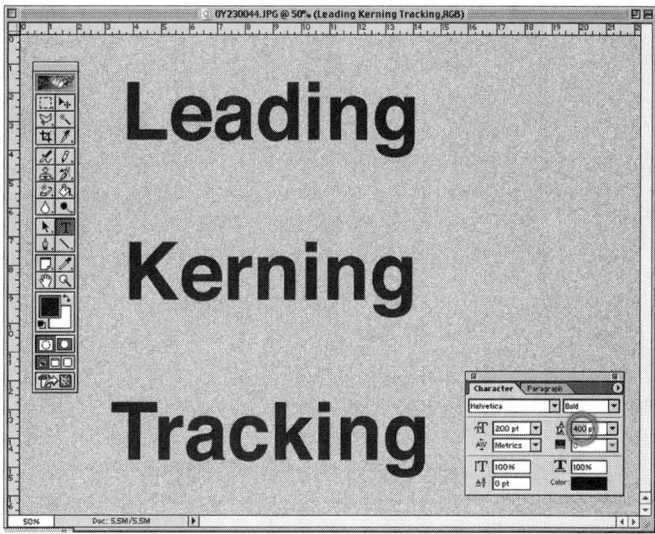

Figure 667.2 The Leading value determines the spacing between lines of text.

- **Kerning:** In the Kerning input field (refer to Figure 667.1), enter a value from −1000 to +1000. Kerning is the measurement of space between individual letters of text. The integer value represents 100th of an em space. Increasing the Kerning value increases the distance between two letters. Decreasing the value brings the two letter closer together, as shown in Figure 667.3.

Figure 667.3 Kerning determines the spacing between two letters.

- **Tracking:** In the Tracking input field (refer to Figure 667.1), enter a value from −1000 to +1000. Tracking is the measurement of space between selected letters of text. The integer value represents 100th of an em space. Increasing the Tracking value increases the distance between selected letters. Decreasing the value brings the selected letters closer together, as shown in Figure 667.4.

Figure 667.4 *Tracking determines the spacing between selected letters.*

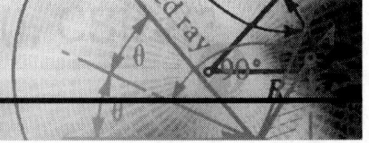

668 *Working with Hyphenation Options*

Although Photoshop is not known as a text-processing program, Photoshop 6.0 goes a long way toward dispelling that myth. One of the new features of text processing is Photoshop's ability to handle hyphenation of large bodies of text.

To control text hyphenation in Photoshop, open the Paragraph palette.

If the Paragraph palette is not visible, click on the Paragraph tab or select the Window menu and choose Show Paragraph from the pull-down menu. Photoshop opens the Hyphenation dialog box, as shown in Figure 668.1.

Figure 668.1 *The Hyphenation dialog box controls the format of large bodies of type.*

- **Words Longer Than:** In the Words Longer Than input field, enter a value from 2 to 25. Photoshop uses this value to determine the length of words to hyphenate.

- **After First:** In the After First input field, enter a value from 1 to 15. Photoshop uses this value to determine the number of letters after which to hyphenate. For example, if you enter a value of 4, Photoshop will not hyphenate any words before the fourth letter in the word.

- **Before Last:** In the Before Last input field, enter a value from 1 to 15. Photoshop uses this value to determine the number of letters before which to hyphenate.

- **Hyphen Limit:** In the Hyphen Limit input field, enter a value from 2 to 25. The Hyphen Limit option controls the maximum number of consecutive lines that can receive a hyphen. For example, if you enter a value of 3, Photoshop will not allow more than three consecutive lines to receive a hyphen.

- **Hyphenation Zone:** In the Hyphenation Zone input field, enter a value from 0 to 720 picas. The Hyphenation Zone option controls the areas at the end of the line where hyphenation occurs. Greater values increase the zone Photoshop uses to look for possible hyphenation.

Click the OK button to record the hyphenation modifications to the Paragraph palette.

Note: Although the extensive use of hyphenation controls may seem out of place in a graphic design program, their entrance into Photoshop 6.0 gives us more control over text and signals a change in how you will use the program in the future.

669 *Working with Character Options*

In Tip 667, "Adjusting Text Using Kerning, Tracking, and Leading," you learned how to control spacing in a text document. Photoshop's Character palette also lets you control the horizontal and vertical size of text.

To adjust the horizontal or vertical size of Photoshop type, create type in a Photoshop document (refer to Tip 218, "Creating Text in Photoshop 6.0").

If the Character palette is not visible, click on the Character tab or select the Window menu and choose Show Character from the pull-down menu. Photoshop opens the Character palette, as shown in Figure 669.1.

Figure 669.1 The Character palette controls the format of the selected text.

- **Horizontal Scale:** In the Horizontal Scale input field, enter a value from 0 and 1000 percent. Entering a value of 100 percent represents the normal horizontal scale of the text. Values greater than 100 percent increase the horizontal scale of the type. Values less than 100 percent decrease the horizontal scale of the type, as shown in Figure 669.2.

Figure 669.2 The Horizontal input field represents the horizontal scale of the selected text.

- **Vertical Scale:** In the Vertical Scale input field, enter a value from 0 and 1000 percent. Entering a value of 100 percent represents the normal vertical scale of the text. Values greater than 100 percent increase the vertical scale of the type. Values less than 100 percent decrease the vertical scale of the type, as shown in Figure 669.3.

Figure 669.3 The Vertical input field represents the vertical scale of the selected text.

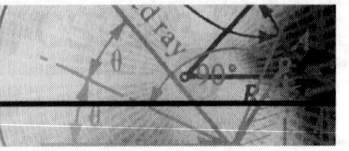

670 *Creating a Multicolor Glow for Text*

In Tip 218, "Creating Text in Photoshop 6.0," you learned how to create type using Photoshop's new Type tools." In this tip, you will apply a multicolor glow to some text using layers and the Gradient tool.

To create a multicolor glow to text, create text in a Photoshop document (refer to Tip 218) and perform these steps:

1. If the Layers palette is not visible, click the Layers tab or select the Window menu and choose Show Layers form the pull-down menu. Photoshop opens the Layers palette, as shown in Figure 670.1.

Figure 670.1 The Layers palette contains a layer for the image and a layer for the text.

2. Move your cursor into the Layers palette and Ctrl+click (Macintosh: Command+click) your mouse on the text layer. Photoshop creates a selection based on the text layer, as shown in Figure 670.2.

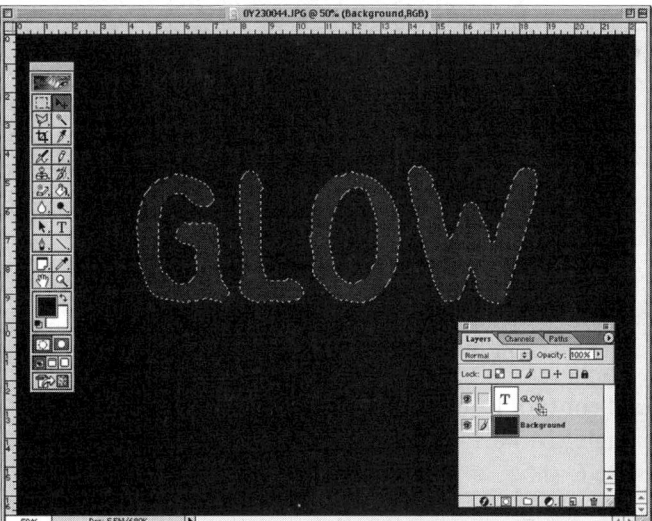

*Figure 670.2 Ctrl+clicking (Macintosh: Command+clicking) your mouse on the text layer creates
a selection based on the type in the layer.*

3. Click once on the Background layer, located directly under the text layer. Photoshop selects the Background layer.

4. Click on the New Layer icon. Photoshop creates a new layer, as shown in Figure 670.3.

Figure 670.3 Clicking the New Layer icon creates a new layer directly above the active layer.

5. Choose Select menu Modify and choose Expand from the fly-out menu. Photoshop opens the Expand Selection dialog box. In the Expand dialog box, enter a value of 8. Click the OK button. Photoshop expands the selection by 8 pixels, as shown in Figure 670.4.

Figure 670.4 The Expand command increased the size of the text selection by 8 pixels.

6. Choose the Select menu and choose Feather from the pull-down menu. Photoshop opens the Feather Selection dialog box. In the Feather Radius input field, enter a value of 8. Photoshop feathers the edge of the text selection by 8 pixels. Click the OK button to record the feather to the selection.

7. Select the Gradient tool from the toolbox. Move your cursor into the Options bar and click once on the black triangle to the right of the gradient preview. Photoshop opens the Gradient palette, as shown in Figure 670.5.

8. Click and choose a colorful gradient thumbnail. In this example, you chose the Spectrum Gradient.

9. Move your mouse into the Layers palette and click once on the new layer created in step 4. Photoshop selects the newly created layer.

10. Move your cursor into the document window and drag it across the expanded text selection. Photoshop creates a spectrum gradient and confines the gradient to the selection, as shown in Figure 670.6.

Figure 670.5 The Gradient palette displays a list of available gradients.

Figure 670.6 The Gradient tool successfully created a multicolor glow behind the text layer.

671 *Extruding Liquid Type from an Image*

In this tip, you are going to create text that has a liquid appearance. This effect goes well against a solid background or, better yet, a background containing an image. To create liquid text, open a document in Photoshop and perform these steps:

1. If the Layers palette is not visible, click once on the Layers tab or select Window menu Show Layers. Photoshop opens the Layers palette.

2. If the Swatches palette is not visible, click once on the Swatches tab or select the Window menu and choose Show Swatches from the pull-down menu. Photoshop opens the Swatches palette. Move your mouse into the Swatches palette and select one of the light-blue swatches, as shown in Figure 671.1.

Figure 671.1 Clicking on a color swatch changes the Foreground color swatch.

3. Select the Type tool from the toolbox and select the Text Layer icon from the Options bar, as shown in Figure 671.2.

Figure 671.2 The Type tool lets you create text in the current foreground color.

4. Click on the black triangle to the right of the font box in the Options bar. Photoshop displays a list of available fonts in a pop-up menu. Click on a font name to select the font (refer to Figure 671.2). In this example, you choose the font Georgia.

5. In the font size input box, enter a font size. In this example, you choose a font size of 72 points.

6. Click once with your Type tool in the document window and enter the text "Liquid."

7. Select the Move tool from the toolbox and position the text in the middle of the document window, as shown in Figure 671.3.

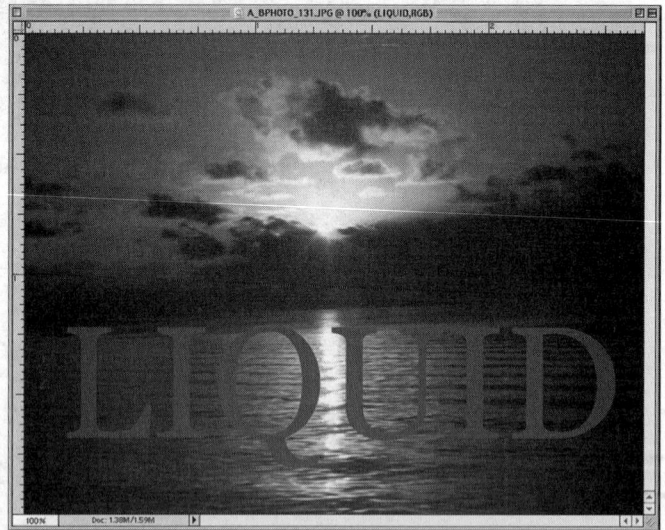

Figure 671.3 The text "Liquid" moved to the middle of the document window.

8. Move your cursor into the Layers palette and Ctrl+click (Macintosh: Command+click) your mouse on the text layer. Photoshop creates a selection based on the text layer, as shown in Figure 671.4.

9. Click once on the New Layer icon. Photoshop creates a new layer, as shown in Figure 671.5.

10. Choose Select menu Modify and choose Contract from the fly-out menu. Enter a value of 2 in the Contract By input field. Click OK to apply the Contract command to the selection.

11. Select Layer menu Type and choose Rasterize from the fly-out menu. Photoshop converts the text into pixels. You need to rasterize the text to perform the next several steps.

*Figure 671.4 Ctrl+clicking (Macintosh: Command+clicking) your mouse on the text layer creates a
selection based on the type in the layer.*

Figure 671.5 Clicking the New Layer icon creates a new layer directly above the text layer.

12. Press the letter "D" on your keyboard. Photoshop converts the foreground and background colors
to black and white.

13. Press Ctrl+Delete (Macintosh: Command+Delete) to fill the contracted selection with the back-
ground color, as shown in Figure 671.6.

Figure 671.6 Pressing Ctrl+Delete (Macintosh: Command+Delete) fills the contracted selection with white.

14. Press Ctrl+D (Macintosh: Command+D) to deselect the text.

15. Select Filter menu Blur and choose Gaussian Blur from the fly-out menu. In the Radius field, enter a value of 1. Click the OK button to apply the blur to the white fill layer, as shown in Figure 671.7.

Figure 671.7 Gaussian Blur filter applied to the white fill layer.

16. Move your mouse into the Layers palette and click once on the blending mode button. Photoshop displays the blending mode options in a pop-up menu. Select Overlay from the available options, as shown in Figure 671.8.

Figure 671.8 The Overlay blending mode applied to the white fill layer.

17. Click once on the visibility icon to the far left of the Background layer. Photoshop deactivates the Background layer.

18. Click once on the black triangle in the upper-right corner of the Layers palette. Photoshop displays the Layers options in a pop-up menu. Select Merge Visible from the available options. Photoshop merges the white fill layer with the text layer, as shown in Figure 671.9.

Figure 671.9 The Merge Visible option merges all visible layers into one.

19. Move into the Layers palette and click once on the text layer.

20. Click the Layer Styles button at the bottom left of the Layers palette and select Bevel and Emboss from the available options. Photoshop opens the Layer Style dialog box. Click the Style option and select Emboss from the pop-up list. Click on the Depth and Size triangle sliders and drag left and right until your text appears rounded. In this example, you used the values of 50 percent for Depth and 10 percent for Size. Click the OK button to apply the effect to the text, as shown in Figure 671.10.

Figure 671.10 The Bevel and Emboss filter applies a rounded effect to the text.

21. Select Filter menu Artistic and choose Plastic Wrap from the fly-out menu. Photoshop opens the Plastic Wrap dialog box. Choose a Highlight Strength of 15, a Detail of 7, and a Smoothness of 8. Click the OK button to apply the effect to the image, as shown in Figure 671.11.

Figure 671.11 The Plastic Wrap applied to the text.

22. Move your cursor into the Layers palette and Ctrl+click (Macintosh: Command+click) your mouse on the text layer. Photoshop creates a selection based on the text layer.

23. Click once on the New Layer icon. Photoshop creates a new layer, as shown in Figure 671.12.

Figure 671.12 Clicking the New Layer icon creates a new layer directly above the text layer.

24. Press Ctrl+Delete (Macintosh: Command+Delete) to fill the contracted selection with the background color.

25. Select Filter menu Sketch and choose Chrome from the fly-out menu. Photoshop opens the Chrome dialog box. Select 10 for Detail and 10 for Smoothness. Click the OK button to apply the effect to the new white filled layer, as shown in Figure 671.13.

Figure 671.13 The Chrome effect applied to the white layer.

26. Press Ctrl+D (Macintosh: Command+D) to deselect the text.

27. Click once on the black triangle in the upper-right corner of the Layers palette. Photoshop displays the Layers options in a pop-up menu. Select Merge Visible from the available options (the background layer is still deselected). Photoshop merges the white fill layer with the text layer, as shown in Figure 671.14.

Figure 671.14 The Merge Visible option merges all visible layers into one.

28. Move into the Layers palette and click once on the visibility icon for the Background. Photoshop reactivates the Background layer.

29. Move your mouse into the Layers palette and click once on the blending mode button. Photoshop displays the blending mode options in a pop-up menu. Select Overlay from the available options to complete the effect, as shown in Figure 671.15.

Figure 671.15 The Overlay blending completes the liquid text effect.

672 *Changing the Perspective of Text to Create a Sense of Depth*

In this tip, you are going to create a blocked look to text by using Photoshop's Perspective filter on a text layer.

To create the block text, open Photoshop and perform these steps:

1. Select the File menu and choose New from the pull-down menu. Photoshop opens the New dialog box. Create a new document with these characteristics.

 - **Width:** 7 inches

 - **Height:** 5 inches

 - **Resolution:** 150 pixels/inch

 - **Color Mode:** RGB

 - **Contents:** White

2. If the Swatches palette is not visible, click once on the Swatches tab or select the Window menu and choose Show Swatches from the pull-down menu. Photoshop opens the Swatches palette. Move your mouse into the Swatches palette and select one of the red swatches, as shown in Figure 672.1.

Figure 672.1 Clicking on a color swatch changes the Foreground color swatch.

3. Select the Type tool from the toolbox, select the Text Layer icon from the Options bar and enter the text, as shown in Figure 672.2.

Figure 672.2 The Type tool lets you create text in the current foreground color.

4. Click on the black triangle to the right of the font box in the Options bar. Photoshop displays a list of available fonts in a pop-up menu. Click on a font name to select the font. In this example, you choose the font Helvetica.

5. In the font size input box, enter a font size. In this example, you choose a font size of 72 points.

6. Click once with your Type tool in the document window and enter the text "Perspective."

7. Select the Move tool from the toolbox and position the text in the middle of the document window, as shown in Figure 672.3.

Figure 672.3 The text "Perspective" moved to the middle of the document window.

8. Select Layer menu Type and choose Rasterize from the fly-out menu. Photoshop converts the text into pixels. You need to rasterize the text to perform the next step.

9. Select Edit menu Transform and choose Perspective from the fly-out menu. Photoshop places a bounding box around the rasterized text.

10. Click on the upper-right corner and drag up. Then click on the upper-left corner and drag down until your text resembles Figure 672.4. Press the Enter key to record the Transform operation.

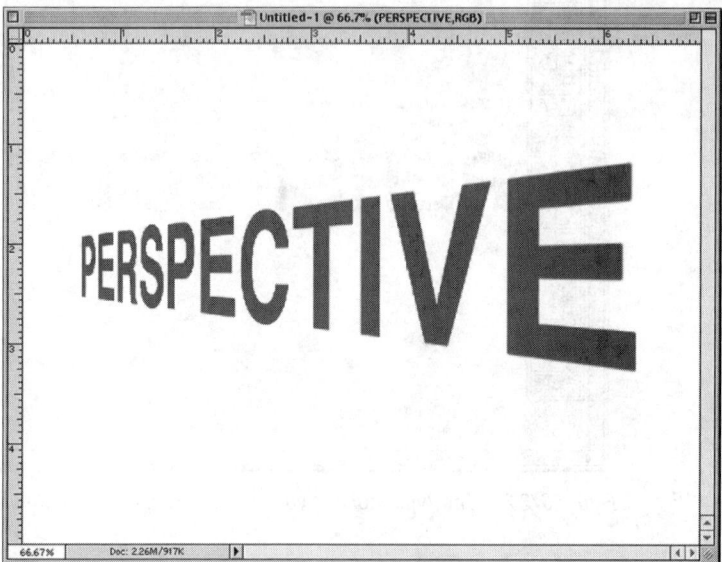

Figure 672.4 The Perspective command lets you distort the rasterized text.

11. Click on the text layer and drag it down over the New Layer icon. Photoshop makes a copy of the original text layer, as shown in Figure 672.5.

Figure 672.5 Dragging a layer over the New Layer icon creates a copy of the dragged layer.

12. Press the letter "D" on your keyboard. Photoshop defaults the Foreground and Background color swatches to black and white.

13. Move your cursor into the Layers palette and click once on the text copy layer.

14. Select the Lock Transparency option and press Alt+Delete (Macintosh: Option+Delete) to fill the copy text layer with the foreground color, as shown in Figure 672.6.

15. Click once in the Lock Transparency check box to deactivate the option.

16. Select Filter menu Blur and choose Motion Blur from the fly-out menu. Select a 30-degree angle and a Distance of 35 pixels, as shown in Figure 672.7.

17. Click once on the visibility icon at the far left of the red layer. Photoshop deactivates the red text layer.

Figure 672.6 Selecting the Lock Transparency option lets you fill the red text with the color black.

Figure 672.7 The Motion Blur filter applied to the black text layer.

18. Click once on the black triangle in the upper-right corner of the Layers palette. Photoshop displays the Layers options in a pop-up menu. Select Merge Visible from the available options. Photoshop merges the black text layer with the background, as shown in Figure 672.8.

19. Select Image menu Adjust and select Levels from the fly-out menu. Photoshop opens the Levels dialog box. Click on the black input slider and drag it all the way to the right. A solid block of black replaces the motion blur. Click the OK button to record the Layers effect to the background, as shown in Figure 672.9.

20. Move into the Layers palette and click once on the red text layer. If the layer is not active, click once on the visibility icon at the far left of the red text layer.

21. Select the Move tool from the toolbox and move the red text layer to fit exactly over the black text, as shown in Figure 672.10.

Figure 672.8 The Merge Visible option merges all visible layers into one.

Figure 672.9 The Levels effect modifies the motion blur into a solid black.

Figure 672.10 The block effect successfully applied to the text layer.

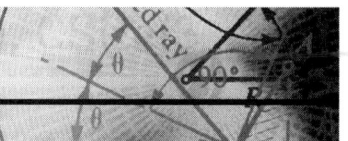

673 *Creating a Beaded Outline Out of Text*

Here is a quick way to create a beaded outline to text. To create a beaded text outline, open Photoshop and perform these steps:

1. Select the File menu and choose New from the pull-down menu. Photoshop opens the New dialog box. Create a new document with these characteristics.

 - **Width:** 7 inches

 - **Height:** 5 inches

 - **Resolution:** 150 pixels/inch

 - **Color Mode:** RGB

 - **Contents:** White

2. Select the Type tool from the toolbox and select the Type Mask icon from the Options bar, as shown in Figure 673.1.

3. Click on the black triangle to the right of the font box in the Options bar. Photoshop displays a list of available fonts in a pop-up menu. Click on a font name to select the font. In this example, you choose the font Arial Rounded MT.

4. In the font size input box, enter a font size. In this example, you choose a font size of 72 points.

5. Click once with your Type tool in the document window and enter the text "BEADED."

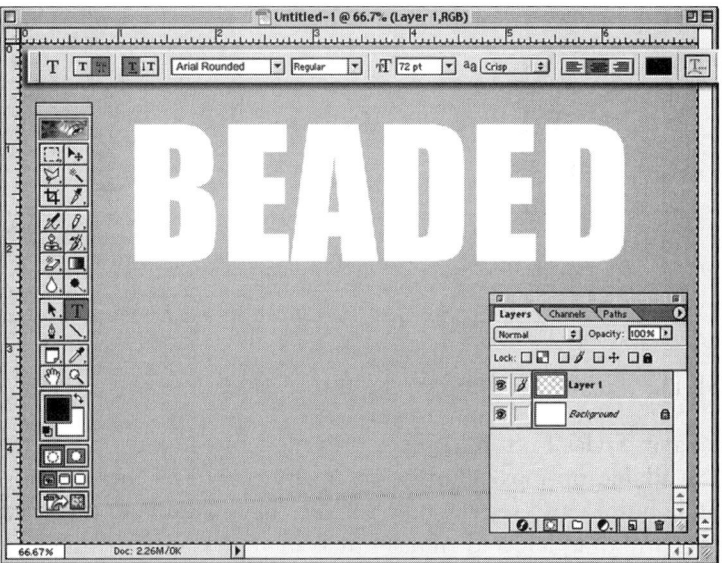

Figure 673.1 The Type Mask option lets you create selections from text.

6. Click on the New Layer icon. Photoshop creates a new layer, as shown in Figure 673.2.

Figure 673.2 Clicking the New Layer icon creates a new layer directly above the Background layer.

7. Choose a color for the stroke by selecting a color from the Swatches palette. In this example a blue color was selected.

8. Select the Edit menu and choose Stroke from the pull-down menu. Photoshop opens the Stroke dialog box. Select a Stroke Width of 6 pixels and a Location of Center. The Blending Mode is Normal with an Opacity of 100 percent. Click the OK button to apply the stroke to the mask outline, as shown in Figure 673.3.

Figure 673.3 The Stroke applied to the masked text.

9. Select Ctrl+D (Macintosh: Command+D) to deselect the text outline.

10. Click the Layer Styles button at the bottom left of the Layers palette and select Bevel and Emboss from the available options. Photoshop opens the Bevel and Emboss Style dialog box. Click the Emboss Style button and select Emboss from the available options. Click on the Depth and Size triangle sliders and drag left and right until your text appears rounded. In this example, you used the values of 200 percent for Depth and 15 percent for Size. Click the OK button to apply the effect to the text, as shown in Figure 673.4.

Figure 673.4 The Bevel and Emboss filter completes the beaded text effect.

674 *Making Quick Chrome Bevels with Text*

To create quick chrome text bevels, open Photoshop and perform these steps:

1. Select the File menu and choose New from the pull-down menu. Photoshop opens the New dialog box. Create a new document with these characteristics.

 - **Width:** 7 inches

 - **Height:** 5 inches

 - **Resolution:** 150 pixels/inch

 - **Color Mode:** RGB

 - **Contents:** White

2. Select the Type tool from the toolbox and select the Type Mask icon from the Options bar, as shown in Figure 674.1.

3. Click on the black triangle to the right of the font box in the Options bar. Photoshop displays a list of available fonts in a pop-up menu. Click on a font name to select the font. In this example, you choose the font Impact.

4. In the font size input box, enter a font size. In this example, you choose a font size of 125 points.

5. Click once with your Type tool in the document window and enter the text "WOW."

6. Click once on the New Layer icon. Photoshop creates a new layer, as shown in Figure 674.2.

Figure 674.1 The Type Mask tool lets you create selections from text.

Figure 674.2 Clicking the New Layer icon creates a new layer directly above the Background layer.

7. If the Swatches palette is not visible, click once on the Swatches tab or select the Window menu and choose Show Swatches from the pull-down menu. Photoshop opens the Swatches palette. Move your mouse into the Swatches palette and select one of the light-brown swatches, as shown in Figure 674.3.

Figure 674.3 Clicking on a color swatch changes the Foreground color swatch.

8. Select the Gradient tool from the toolbox. Move your cursor into the Options bar and click once on the black triangle to the right of the gradient preview. Photoshop opens the Gradient palette, as shown in Figure 674.4.

9. Click and choose the brown-to-white gradient thumbnail (refer to Figure 674.4).

10. Click and drag the Gradient tool across the selection, as shown in Figure 674.5.

Figure 674.4 The Gradient palette displays a list of available gradients.

Figure 674.5 Dragging the Gradient tool across the selected text mask creates a brown-to-white gradient.

11. Choose Select menu Modify and choose Expand from the fly-out menu. Photoshop opens the Expand dialog box. Enter a value of 8 in the Expand By input field. Click the OK button to expand the selection by 8 pixels.

12. Click on the New Layer icon. Photoshop creates a new layer (refer to Figure 674.2).

13. Move your cursor into the Options bar and click once on the black triangle to the right of the gradient preview. Photoshop opens the Gradient palette, as shown in Figure 674.6.

14. Click and choose the Copper gradient thumbnail (refer to Figure 674.6).

15. Click and drag the Gradient tool across the selection, as shown in Figure 674.7.

Figure 674.6 The Gradient palette displays a list of available gradients.

Figure 674.7 Dragging the Gradient tool across the selected text mask creates a brown-to-white gradient.

16. Press Ctrl+D (Macintosh: Command+D) to deselect the type mask.

17. To complete the effect, click and drag the text copy layer underneath the original text layer, as shown in Figure 674.8.

Note: To help the text stand out, select the original text layer and apply a 1-pixel stroke to the outside of the text (Edit menu Stroke), as shown in Figure 674.9.

Figure 674.8 Dragging the copied layer under the original layer creates the illusion of a beveled chrome text layer.

Figure 674.9 Adding a black stroke to the text layer helps the text stand out from the bevel.

675 *Creating Text with a Soft Glow*

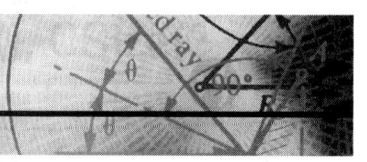

Creating a soft glow around text helps to identify the text against photographic backgrounds. Say, for example, you want to create some text against a photographic backdrop. However, the background makes the text difficult to read. To create a soft glow for text, open a document in Photoshop and perform these steps:

1. Select the Type tool from the toolbox and select the Text Layer icon from the Options bar, as shown in Figure 675.1.

Figure 675.1 The Type tool lets you create text in the current foreground color.

2. Click on the black triangle to the right of the font box in the Options bar. Photoshop displays a list of available fonts in a pop-up menu. Click on a font name to select the font (refer to Figure 675.1). In this example, you choose the font Impact.

3. In the font size input box, enter a font size. In this example, you choose a font size of 72 points.

4. Click once with your Type tool in the document window and enter the text "GLOW."

5. Select the Move tool from the toolbox and position the text against the background, as shown in Figure 675.2.

Figure 675.2 The text "GLOW" moved to the correct position against the background.

6. Click the Layer Styles button at the bottom left of the Layers palette and select Outer Glow from the available options. Photoshop opens the Outer Glow Style dialog box.

 • **Opacity:** Click on the Opacity slider and drag it left or right to increase or decrease the opacity of the outer glow. In this example, you choose an Opacity of 70 percent.

 • **Noise:** Click on the Noise slider and drag it left or right to increase or decrease the noise of the outer glow. The Noise option breaks up the smooth glow appearance. In this example, you choose a Noise value of 0 percent.

 • **Spread:** Click on the Spread slider and drag it left or right to increase or decrease the spread of the glow. In this example, you choose a Spread value of 25 percent.

 • **Size:** Click on the Size slider and drag it left or right to increase or decrease the overall size of the outer glow. In this example, you choose a Size value of 30 percent.

7. Click the OK button to record the changes to the type layer, as shown in Figure 675.3.

Figure 675.3 The Outer Glow style successfully creates a light glow around the text and makes it easier to read.

676 *Identifying Text with Multiple Stroke Lines*

A creative way to help draw a reader's eye to text is to surround the text with multiple stroke lines.

To create text with multiple stroke lines, open Photoshop and perform these steps:

1. Select the File menu and choose New from the pull-down menu. Photoshop opens the New dialog box. Create a new document with these characteristics.

 - **Width:** 7 inches

 - **Height:** 5 inches

 - **Resolution:** 150 pixels/inch

 - **Color Mode:** RGB

 - **Contents:** White

2. Move into the Layers palette and create a new layer by clicking once on the Create a new layer icon, located at the bottom-right of the Layers palette.

3. If the Swatches palette is not visible, click once on the Swatches tab or select the Window menu and choose Show Swatches from the pull-down menu. Photoshop opens the Swatches palette. Move your mouse into the Swatches palette and select one of the blue swatches, as shown in Figure 676.1.

Figure 676.1 Clicking on a color swatch changes the Foreground color swatch.

4. Select the Type tool from the toolbox and select the Type Mask option from the Options bar, as shown in Figure 676.2.

Figure 676.2 The Type Mask lets you create selections based on text.

5. Click on the black triangle to the right of the font box in the Options bar. Photoshop displays a list of available fonts in a pop-up menu. Click on a font name to select the font. In this example, you choose the font Impact.

6. In the font size input box, enter a font size. In this example, you choose a font size of 72 points.

7. Click once with your Type tool in the document window and enter the text "STROKE." Click the check mark in the Options bar to complete the text entry.

8. Press Alt+Delete (Macintosh: Option+Delete) to fill the selection with the foreground color, as shown in Figure 676.3.

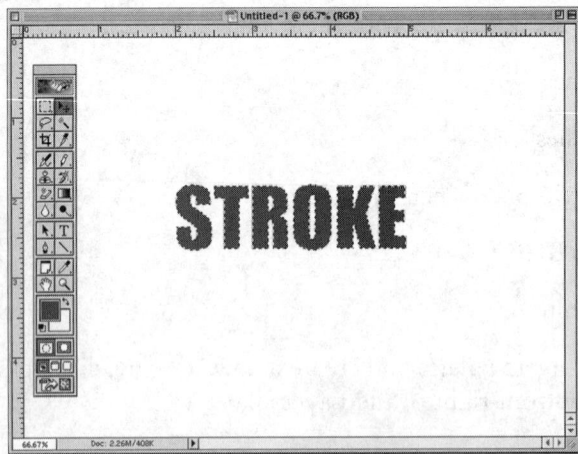

Figure 676.3 Pressing Alt+Delete (Macintosh: Option+Delete) fills the selection mask with the foreground color.

9. Press the letter "D" on your keyboard. Photoshop defaults the Foreground and Background color swatches to black and white.

10. Choose Select menu Modify and choose Expand from the fly-out menu. Photoshop opens the Expand Selection dialog box. Enter a value of 4 in the Expand By input field and click OK to expand the text selection, as shown in Figure 676.4.

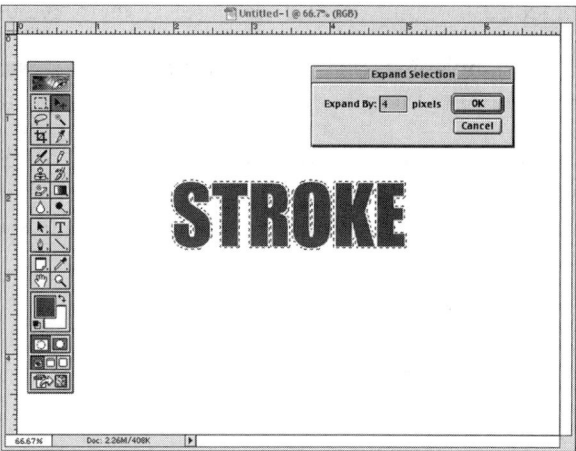

Figure 676.4 The Expand option applied to the text selection.

11. Select the Edit menu and choose Stroke from the pull-down menu. Click in the Width input field and enter a value of 2 pixels. Click the radio button to select the Center Location option. Set the Blending Mode to Normal and Opacity to 100 percent. Do not select Preserve Transparency. Click the OK button to apply the stroke to the expanded selection, as shown in Figure 676.5.

Figure 676.5 The Stroke command applied to the expanded text.

12. Repeat steps 9 and 10 three more times until you have a total of four black stroke lines surrounding the text, as shown in Figure 676.6.

Figure 676.6 The four stroke lines applied to the expanding text selection.

13. Press Ctrl+D (Macintosh: Command+D) to deselect the text outline.

14. Click the Layer Styles button at the bottom left of the Layers palette and select Bevel and Emboss from the available options. Photoshop opens the Layer Style dialog box.

15. Click the Style button and select Emboss from the available options. Click on the Depth and Size triangle sliders and drag left and right until your text appears beveled. In this example, you used the values of 200 percent for Depth and 25 percent for Size. Click the OK button to apply the effect to the text, as shown in Figure 676.7.

Figure 676.7 The Bevel and Emboss filter applies a rounded effect to the text and creates an eye-catching three-dimensional effect.

677 Creating Text with a Background Light Burst

In Tip 535, "Using Polar Coordinates," you were introduced to the Polar Coordinates filter. In this tip, you will create a zoom effect using some text and the Polar Coordinates filter.

To create a starburst effect, open Photoshop and perform these steps:

1. Select File menu New. Photoshop opens the New dialog box, as shown in Figure 677.1.

Figure 677.1 The New dialog box in Photoshop defines the characteristics of the new document.

2. Create a new document with these characteristics:

- **Width:** 8 inches

- **Height:** 5 inches

- **Resolution:** 150 pixels/inch

- **Mode:** RGB

- **Contents:** White

3. Click the OK button. Photoshop closes the New dialog box and opens the new document.

4. Press the letter "D" on your keyboard. Photoshop changes the Foreground and Background color swatches to black and white. Use the Paint Bucket tool to fill the background layer with black.

5. Use the Type tool to create some large type (refer to Tip 218, "Creating Text in Photoshop 6.0"). In this example, you created 72-point text using Arial Rounded, as shown in Figure 677.2. If typing black type against a black layer makes it difficult to tell what you are doing, temporarily deactivate the background layer by clicking once on the eye icon to the far left of the Background layer.

Figure 677.2 The text for the starburst effect.

6. Move your cursor into the Layers palette and Ctrl+click (Macintosh Command+click) on the text layer. Photoshop creates a selection boundary around the text, as shown in Figure 677.3.

Figure 677.3 When you Ctrl+click on a layer, Photoshop creates a selection based on the digital information contained within the layer.

7. Choose the Select menu and choose Save Selection from the pull-down menu. Photoshop opens the Save Selection dialog box, as shown in Figure 677.4.

Figure 677.4 The Save Selection dialog box lets you save a selection as an Alpha channel.

8. Click the OK button to save the selection using the default values. Photoshop closes the Save Selection dialog box and saves the selection as a new Alpha channel.

9. Press Ctrl+D (Macintosh: Command+D) to deselect the text.

10. Select Layer menu Rasterize and choose Type from the fly-out menu. Photoshop converts the text into a raster image. Your text layer is no longer text but simply paint in the shape of letters.

11. Select Filter menu Stylize and choose Find Edges from the fly-out menu. Photoshop converts the text to white and outlines the text with a black line, as shown in Figure 677.5.

12. Select Image menu Adjust and choose Invert from the fly-out menu. Photoshop reverses the colors in the text layer.

13. Reactivate the Background layer by clicking on the eye icon to the far left of the Background layer. Photoshop reactivates the black background layer.

14. Click on the black triangle in the upper-right corner of the Layers palette and choose Flatten Image from the fly-out menu. Photoshop combines the text and background layers into one layer.

15. Select Filter menu Blur and choose Gaussian Blur from the fly-out menu. Choose a radius blur of 2.5 and click OK to apply the blur to the text, as shown in Figure 677.6.

Figure 677.5 The Find Edges filter applied to the text layer.

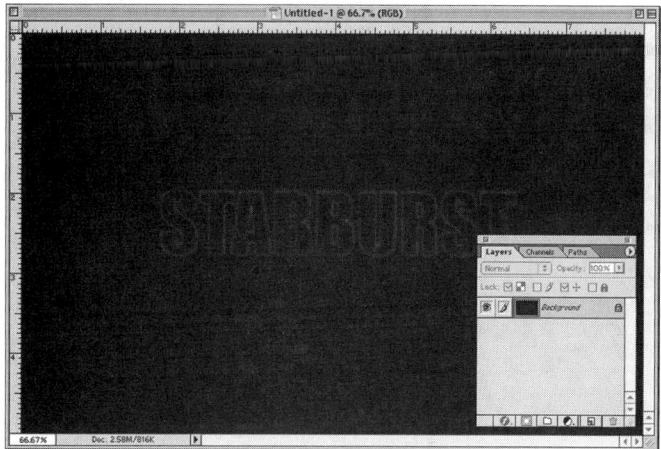

Figure 677.6 The Gaussian Blur filter applied to the inverted text layer.

16. Select Filter menu Distort and choose Polar Coordinates from the fly-out menu. Photoshop opens the Polar Coordinates dialog box.

17. Select Polar to Rectangular and click the OK button. Photoshop applies the Polar to Rectangular filter to the image, as shown in Figure 677.7.

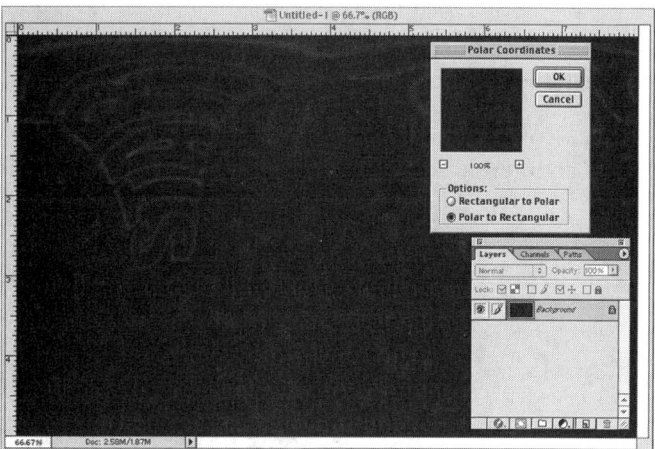

Figure 677.7 The Polar Coordinates filter applied to the text layer.

18. Select Image menu Canvas and choose 90 CW from the fly-out menu. Photoshop rotates the canvas 90 degrees clockwise.

19. Select Image menu Adjust and choose Invert from the fly-out menu. Photoshop inverts the colors in the image.

20. Select Filter menu Stylize and choose Wind from the fly-out menu. Photoshop opens the Wind dialog box. Choose Wind for the Method and From the Right for Direction. Click the OK button to apply the Wind filter to the text, as shown in Figure 677.8.

21. Press Ctrl+F (Macintosh: Command+F) twice to repeat the Wind filter two more times for a total of three applications of the Wind filter.

22. Select Image menu Adjust and choose Invert from the fly-out menu. Photoshop inverts the colors in the image, as shown in Figure 677.9.

23. Select Image menu Adjust and choose Auto Levels from the fly-out menu. Photoshop brightens the whites in the image.

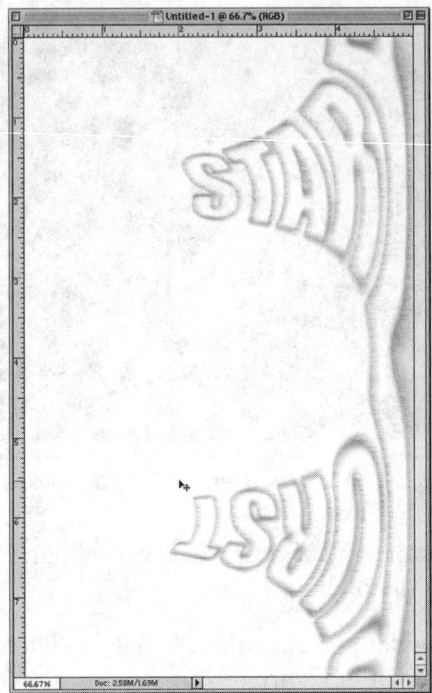

Figure 677.8 The Wind filter applied to the text layer.

24. Press Ctrl+F (Macintosh: Command+F) and repeat the Wind filter three more times.

25. Select Image menu Rotate Canvas and select 90 CCW from the fly-out menu. Photoshop rotates the image 90 degrees counterclockwise. Your image should resemble Figure 677.10.

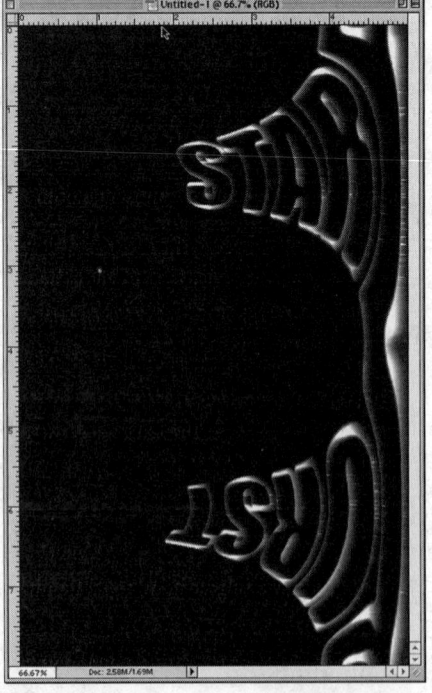

Figure 677.9 The Invert command applied to the text layer.

Figure 677.10 The text layer rotated 90 degrees counterclockwise.

26. Select Filter menu Distort and choose Polar Coordinates from the fly-out menu. Photoshop opens the Polar Coordinates dialog box. Select Rectangular to Polar and click the OK button. Photoshop applies the Polar Coordinates filter to the text layer, as shown in Figure 677.11.

Figure 677.11 The Polar Coordinates filter applied to the text layer.

27. The Zoom effect is there, but the text is hard to read. Choose the Select menu and choose Load Selection from the pull-down menu. Photoshop opens the Load Selection dialog box, as shown Figure 677.12. Since this document only contains one Alpha channel, click the OK button. Photoshop loads the selection you created in steps 6 and 7.

Figure 677.12 The Load Selection dialog box.

28. Click on a dark color in the Swatches palette.

29. Select the Edit menu and choose Fill from the pull-down menu. Photoshop opens the Fill dialog box, as shown in Figure 677.13.

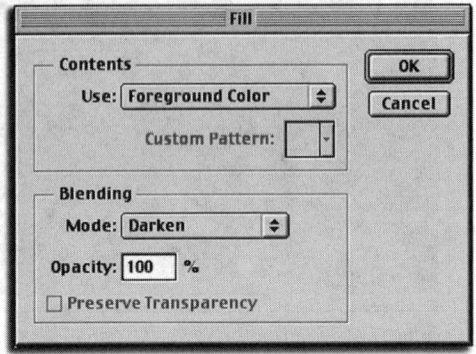

Figure 677.13 *The Fill dialog box controls how the selected color fills the image.*

30. Select Foreground Color for Contents, a Blending Mode of Darken, and an Opacity of 100 percent. Click the OK button to apply the fill to the selected portion of the image, as shown in Figure 677.14.

Figure 677.14 *The Fill command applied to the selected portion of the text.*

678 *Creating a Drop-Shadow Back Screen for Type*

When you incorporate text and graphics, the challenge is to make the text readable without lowering the overall quality of the graphic image. In this tip, you will make a drop-shadow back screen for the text. Say, for example, you have a grouping of text you want to display against a graphic background, as shown in Figure 678.1.

To create a drop-shadow back screen, perform these steps:

1. If the Layers palette is not visible, click once on the Layers tab or select the Window menu and choose Show Layers from the pull-down menu. Photoshop opens the Layers palette.

2. Move your mouse into the Layers palette and select the background by clicking on the Background layer.

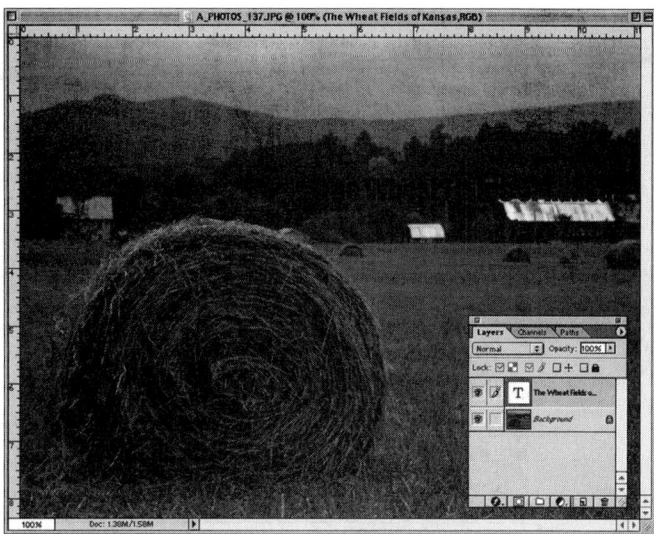

Figure 678.1 The graphic design looks appealing, but the text is difficult to read.

3. Click on the New Layer icon. Photoshop creates a new layer directly above the active layer, as shown in Figure 678.2.

Figure 678.2 Clicking on the New Layer icon places a new layer between the text and background layers.

4. Select the Rectangular Marquee tool from the toolbox (refer to Tip 282, "Working with the Marquee Tools") and create a rectangle section around the visible text.

5. Select the Window menu and choose Show Swatches from the pull-down menu. Photoshop opens the Swatches palette. Move your mouse into the Swatches palette and select a light-blue color swatch. Photoshop changes the Foreground color swatch to light blue, as shown in Figure 678.3.

Figure 678.3 Clicking on a color swatch transfers the selected color to the Foreground color swatch.

6. In the Layers palette, click once on the new layer. Photoshop selects the new layer.

7. Press Alt+Delete (Macintosh: Option+Delete) to fill the rectangular selection with light blue, as shown in Figure 678.4.

Figure 678.4 Pressing Alt+Delete (Macintosh: Option+Delete) fills the selected area of the new layer with light blue.

8. Click the Layer Styles button at the bottom left of the Layers palette and select Drop Shadow from the available options. Photoshop opens the Drop Shadow Style dialog box.

 • **Distance:** Click and drag the triangular slider left or right to increase or decrease the distance of the shadow from the box. In this example, you chose a Distance value of 10.

 • **Spread:** Click and drag the triangular slider left or right to increase or decrease the spread of the shadow. In this example, you chose a Spread value of 10.

 • **Size:** Click and drag the triangular slider left or right to increase or decrease the size of the shadow. In this example, you chose a Size of value of 10.

9. Click the OK button to apply the drop shadow to the image, as shown in Figure 678.5.

Figure 678.5 The drop shadow successfully applied to the box, creating a back screen for the text.

Note: For an added effect, move your mouse into the Layers palette and reduce the opacity of the box layer, as shown in Figure 678.6.

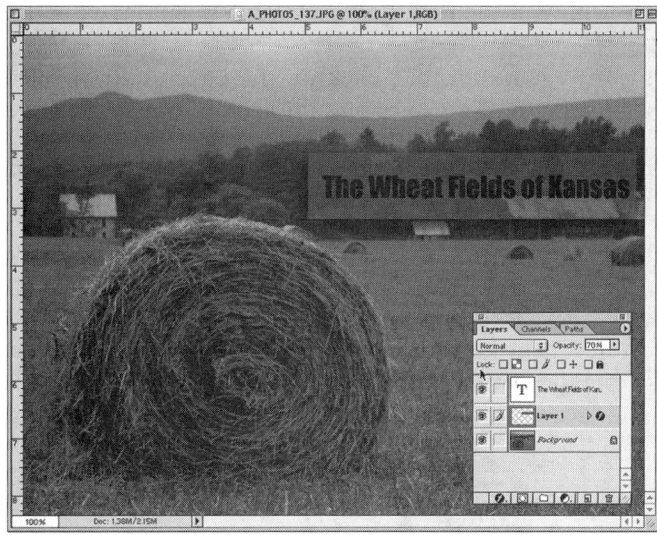

Figure 678.6 Lowering the opacity of the box layer lets some of the background graphic bleed through the layer.

679 *Screening Text Against a Background Using Adjustment Layers*

In the preceding tip, you created a drop-shadow back screen for a grouping of type. Text is always difficult to read against a graphic. However, graphics are a great way to attract the reader's attention. You typically solve this problem by placing the text inside an opaque or semitransparent box and then placing the box on top of the graphic. An excellent way to combine text and graphics is to use Photoshop's Adjustment layers to lighten or darken the background image.

To use an Adjustment layer to fade or darken the background, open a document containing text. In this example, you have a group of words on top of a graphic image, as shown in Figure 679.1.

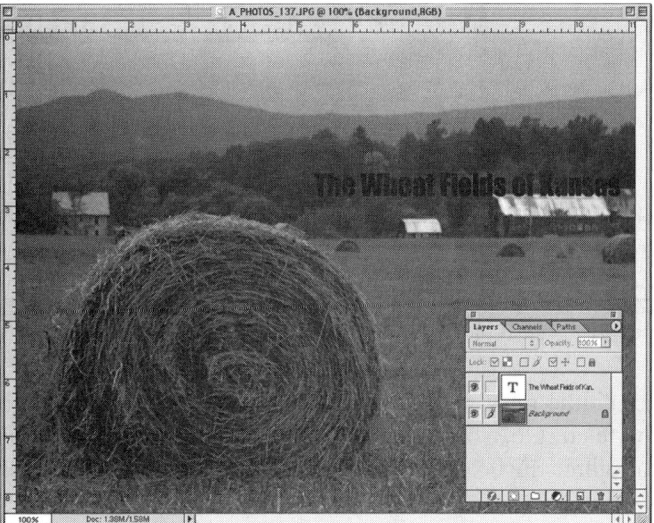

Figure 679.1 The text paragraph is difficult to read against the graphic background.

To correct the problem with the text, using an Adjustment layer, perform these steps:

1. If the Layers palette is not visible, click on the Layers tab or select the Window menu and choose Show Layers from the pull-down menu. Photoshop opens the Layers palette.

2. Move your mouse into the Layers palette and select the background by clicking on the Background layer.

3. Select the Rectangular Marquee tool from the toolbox (refer to Tip 282, "Working with the Marquee Tools) and draw a rectangle selection around the text, as shown in Figure 679.2.

4. Click on the Adjustment Layer icon. Photoshop displays the Adjustment options in a pop-up menu. Select Levels from the available options. Photoshop creates a Levels Adjustment layer directly above the Background layer and opens the Levels dialog box, as shown in Figure 679.3.

Figure 679.2 The Rectangle marquee tool creates rectangular or square selections.

Figure 679.3 The Levels Adjustment layer controls the brightness of the pixels in the Background layer.

5. Click on the middle gray slider and drag it to the right to darken the image or left to lighten the image. In this example, you chose to lighten the background image. Stop when the pixels in the selected area lighten sufficiently, as shown in Figure 679.4.

Figure 679.4 The Levels dialog box controls the lightness or darkness of the pixels within the selected area.

Note: To create a softer edge to the selection box, before performing step 4, choose Select menu and choose Feather from the pull-down menu. Enter a Feather Radius value of 5 or higher to soften the edge of the selection. In this example, you choose a Feather Radius of 10, as shown in Figure 679.5.

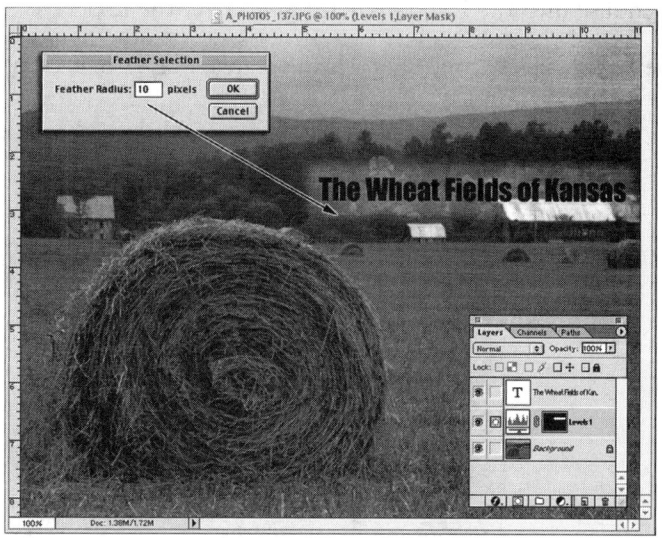

Figure 679.5 Using the Feather command before applying the Levels command creates a softer look to the selection box.

680 *Creating Type that Fades Across the Image*

There are several ways to fade text across an image. In this tip, you will combine a text layer with a layer mask and use the mask to create transparency in the text.

To create transparency in a text layer, open a document containing text (refer to Tip 218, "Creating Type in Photoshop 6.0"). In this example, the Type tool created the word "FADING" in a text layer, as shown in Figure 680.1.

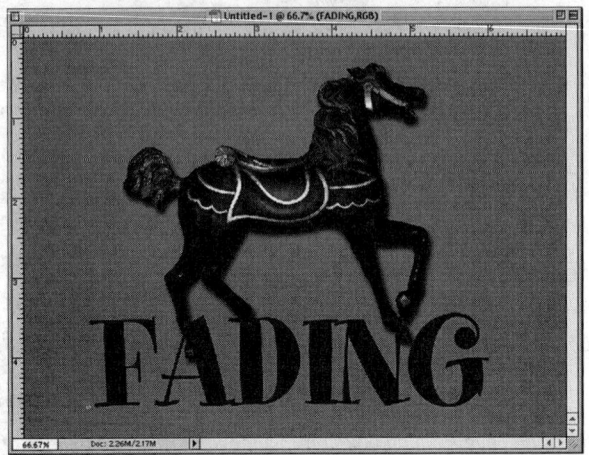

Figure 680.1 The word "FADING" in a text layer.

To create the fade effect, perform these steps:

1. If the Layers palette is not visible, click on the Layers tab or select the Window menu and choose Show Layers from the pull-down menu. Photoshop opens the Layers palette.

2. Move your mouse into the Layers palette and select the text layer by clicking on the text layer.

3. Click on the Layer Mask icon. Photoshop creates a layer mask, as shown in Figure 680.2.

Figure 680.2 Clicking on the Layer Mask icon creates a mask in the active layer.

4. If the Swatches palette is not visible, click on the Swatches tab or select the Window menu and choose Show Swatches from the pull-down menu. Photoshop opens the Swatches palette. Move your mouse into the Swatches palette and select one of the gray swatches. Photoshop changes the Foreground color swatch to gray, as shown in Figure 680.3.

5. Select the Gradient tool from the toolbox. Move your cursor into the Options bar and click once on the black triangle to the right of the gradient preview. Photoshop opens the Gradient palette, as shown in Figure 680.4.

Figure 680.3 Clicking on a color swatch transfers the selected color to the Foreground color swatch.

Figure 680.4 The Gradient palette displays a list of available gradients.

6. Select the Foreground to Background gradient at the top-left of the Gradient palette (refer to Figure 680.4). The first gradient in the Gradient palette reflects the current Foreground and Background color swatches.

7. Move your mouse into the Layers palette and click once on the text layer mask. Photoshop selects the mask. Any editing now performed on the text layer applies to the mask, not the text.

8. Click and drag your mouse across the text from right to left. Photoshop applies a gray-to-white gradient on the layer mask, and the gradient creates transparency in the visible text layer, as shown in Figure 680.5.

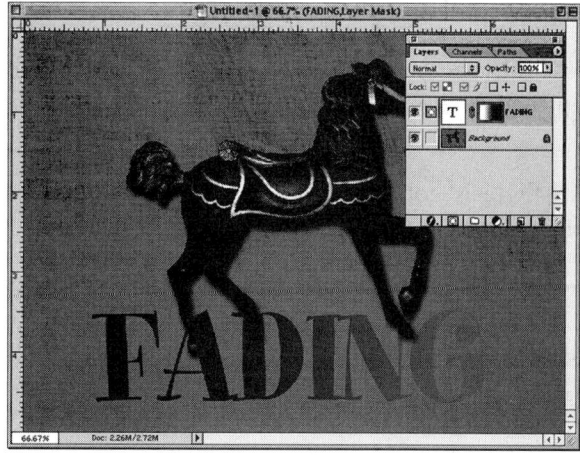

Figure 680.5 Applying the gradient to the layer mask creates transparency in the text layer.

681 *Using Type as a Spot Channel*

Photoshop uses spot color channels to inform a printer about specific colors requirements in your document. Say, for example, that you create a document with graphics and text, and you want the text printed in a specific color. Spot color channels indicate to the printer the color you want and where to print it.

In Tip 449, "Creating Spot Color Channels for Text," you learned how to generate a spot color channel. In this tip, you will learn how to create a spot color channel from previously created text.

To create a spot color channel for text, open a document containing text, as shown in Figure 681.1.

Figure 681.1 A typical Photoshop image contains graphic and text layers.

To create the spot color channel, perform these steps:

1. If the Layers palette is not visible, click on the Layers tab, or select the Window menu and choose Show Layers from the pull-down menu. Photoshop opens the Layers palette.

2. Move your mouse into the Layers palette and Ctrl+click (Macintosh: Command+click) on the type layer. Photoshop then makes a selection, based on the text in the type layer, as shown in Figure 681.2.

3. If the Channels palette is not visible, click on the Channels tab, or select the Window menu and choose Show Channels from the pull-down menu. Photoshop opens the Channels palette.

4. Click on the black triangle icon, located in the upper-right corner of the Channels palette. Photoshop displays the Channels options in the pop-up menu. Select Spot Channel from the pop-up menu. Photoshop opens the New Spot Channel dialog box, shown in Figure 681.3.

5. Click once in the Color dialog box. Photoshop opens the Custom Colors dialog box, shown in Figure 681.4.

Figure 681.2 Ctrl+click (Macintosh: Command+click) on the type layer creates a selection around the text.

Figure 681.3 The New Spot Channel dialog box controls the characteristics of the spot color channel.

Figure 681.4 The Custom Colors dialog box lets you select the color to use with the Spot Color channel.

6. Select the correct color and click the OK button to record your change to the New Spot Color dialog box. Refer to Tip 546, "Working with Pantone Colors," for more information on using the Pantone color system.

7. Click the OK button in the New Spot Color dialog box to apply the color to the spot color channel. Photoshop creates a new spot color channel, as shown in Figure 681.5.

Figure 681.5 *The new Spot Color channel retains the name of the selected Pantone color.*

682 *Choosing the Correct File Type for Images with Spot Color Channels*

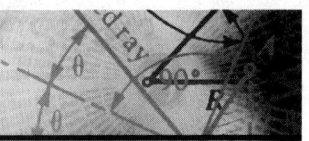

In the previous tip, you learned how to create a spot color channel from an existing layer of text. When you create a document with spot channels, you intend the document to be printed on a color press. When a document containing spot color prints, the printer converts the channels into color plates, and the plates apply the ink to the paper document (refer to Tip 257, "Understanding the Basics of Spot Color Channels").

Documents containing spot colors must be saved using the Desktop Color Separations format (DCS 2.0).

To save a file containing spot color channels, select the File menu and choose Save As from the pull-down menu. Photoshop opens the Save As dialog box, shown in Figure 682.1.

- **Format:** Click on the Format button. Photoshop displays a list of available formats in a pop-up menu. Select DCS 2.0 from the pop-up menu. Since the DCS2.0 format is used to produce color separations, the document must be in the CMYK color space.

- **Spot Colors:** Click in the Spot Colors check box to select the Spot Colors option (refer to Figure 682.1).

- **Color:** If you want the document saved with a color profile, select the Use Proof Setup or Embed Profile options (see Tip 714, "Using the Proof Setup Option").

Click the Save button to close the Save As dialog box and record your changes to the document.

Note: Documents saved as Encapsulated PostScript files (EPS) require a PostScript output device to print properly.

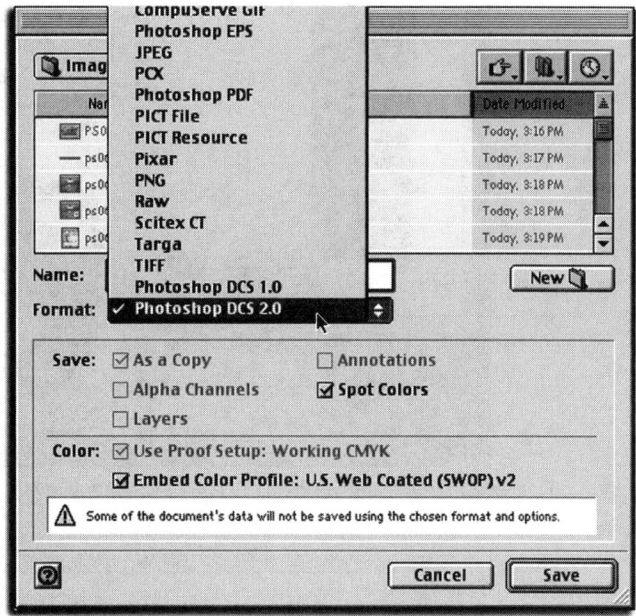

Figure 682.1 The Save As dialog box controls the characteristics of the saved document.

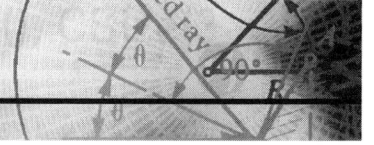

683 *Moving Layers Between Documents*

When you work in Photoshop, each layer represents a specific piece of the image. Photoshop 6.0 lets you create a document with a maximum of 8,000 layers. Although layers give you control over the image, they also increase the size of the file. Say, for example, that you open an image in Photoshop with a file size of 2MB. If you make a copy of the original image layer, the file size expands to 4MB.

The larger the file size is, the slower Photoshop works. To make Photoshop run more efficiently, divide a large document into separate document files and combine them at the end of the project. Say, for example, that you create a 15-layer collage. Instead of trying to work with all 15 layers in a single document, work on the pieces of the collage in separate image files.

To move layers between documents, open two documents in Photoshop and perform these steps:

1. Click in the document window containing the layer that you want to move. Photoshop activates the selected document, as shown in Figure 683.1.

2. Move your mouse into the Layers palettes, and click and drag the layer that you want to move into the second document. Photoshop makes a copy of the dragged layer in the second document, as shown in Figure 683.2.

3. The original image remains unaffected by the move, and the second document contains a copy of the layer.

Figure 683.1 Clicking inside a document window activates the document.

Figure 683.2 Create a copy of a layer by dragging it from the Layers palette into the second document.

Notes on moving layers:

- **Backgrounds:** If you move a background into a second document, Photoshop converts the background into a layer.

- **Color space:** Layers moved from one document window into a second document window take on the color space of the receiving document.

- **Resolution:** Layers moved from one document window into a second document window take on the resolution of the receiving document.

- **Linked layers:** When you move a layer from one document window into a second document window, all linked layers move with the copied layer.

684 *Controlling a Paint Bucket Fill with Layers*

Photoshop's Paint Bucket tool fills a layer or a selected portion of a layer with the current foreground color or pattern. When you fill an area of an image, you replace the original colors with the color or pattern used by the Paint Bucket tool. A better way to control the Paint Bucket tool is by using a separate layer for the fill.

To use a layer to control the Paint Bucket tool, open a document in Photoshop and perform these steps:

1. If the Layers palette is not visible, click on the Layers tab, or select the Window menu and choose Show Layers from the pull-down menu. Photoshop opens the Layers palette.

2. Click once on the New Layer icon. Photoshop creates a new layer, as shown in Figure 684.1.

Figure 684.1 Clicking on the New Layer icon creates a new layer directly above the active layer.

3. Select the area of the image where you want to apply the fill. In this example, you use the Lasso tool (refer to Tip 136, "Using the Standard Lasso Tool") to select the background of the image, as shown in Figure 684.2.

4. Move your cursor into the Layers palette and click on the new layer. Photoshop selects the new layer.

5. Select the Paint Bucket tool from the toolbox and select the color or pattern to fill the selection. In this example, you choose a dark blue color from the Swatches palette.

6. Click once inside the defined selection. Photoshop fills the area with dark blue, as shown in Figure 684.3.

Note: *By filling the transparent layer with the Paint Bucket fill, you effectively control the painting process. Any time that you want to return the image to its original state, simply delete the paint fill layer. Alternatively, you can experiment with blending modes and opacity settings to produce an entirely different image (see Tip 687, "Working with Layer Blending Modes").*

Figure 684.2 The Lasso tool defines the area filled by the Paint Bucket.

Figure 684.3 The Paint Bucket filled the defined area of the new layer with dark blue.

685 *The Photoshop Format*

The Photoshop format (PSD) is unique to Adobe Photoshop. Of all Photoshop's file formats, it is the only one that lets you retain special effects and multiple layers. Say, for example, that you work on a multi-layered image with several effects and adjustment layers. If you want to save the file and reedit the image at a later time, you need to save the image using the Photoshop format.

To save a file using the Photoshop format, select the File menu and choose Save As from the pull-down menu. Photoshop opens the Save As dialog box, shown in Figure 685.1.

Figure 685.1 The Save As dialog box controls the characteristics of the saved file.

- **Format:** Click on the Format button. Photoshop displays a list of the available format options. Select Photoshop from the pop-up list (refer to Figure 685.1).

- **Save:** In the check box fields, deselect Alpha Channels, Layers, Annotations, or Spot Color. If you remove the check mark from the selected items, Photoshop will not save those features with the file.

Click the Save button to save the Photoshop file to disk.

> *Note: Because the PSD format is Photoshop's native file format, save files using the PSD format until the end of the project, and then save them in whatever format the project requires. The PSD format uses a compression scheme that keeps saved file sizes small without removing color information from the file.*

686 *Working with Shape Layers*

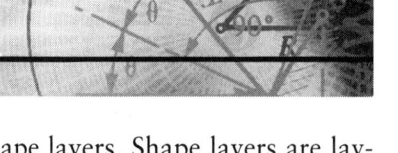

One of Photoshop's new features is the capability to create and edit shape layers. Shape layers are layers that contain vector-based shapes, as opposed to pixel-based shapes (see Tip 844, "Understanding Raster and Vector Images"). Shape layers perform as clipping paths to the information contained in the layer. With the capability to generate and modify vector shapes, Adobe moves closer to combining the features of Illustrator and Photoshop into one program.

To create a shape layer, open an image or create a new document in Photoshop and then perform these steps:

1. If the Layers palette is not visible, click on the Layers tab, or select the Window menu and choose Show Layers from the pull-down menu. Photoshop opens the Layers palette.

2. Select the Pen tool from the toolbox. Photoshop displays the Pen tool options in the Options bar, as shown in Figure 686.1.

Figure 686.1 The Options bar displays the available options for the Pen tool.

3. Move your mouse into the Options bar and click once on the Create New Shape Layer icon (refer to Figure 686.1).

4. Move your Pen tool into the document and click once to set your first anchor point (refer to Tip 154, "Creating Vector Paths with the Pen Tool"). Photoshop sets an anchor point in the document and creates a shape layer, as shown in Figure 686.2.

Figure 686.2 Photoshop generates a shape layer to hold the newly created pen path.

5. Move the pen tool to a different position within the document window, and click once. Photoshop creates a second anchor point and connects the two points with a straight line.

6. Continue to move and click your mouse to create the desired shape. To close the shape, click once with the Pen tool directly above the starting anchor point. Photoshop closes the shape. In this example, you created a diamond shape, as shown in Figure 686.3.

Figure 686.3 Clicking over the starting point closes the vector shape.

7. To modify the selected shape, select the Path Component or Direct Selection tools from the toolbox.

8. The Direct Selection tool lets you click on a specific anchor point and drag the point to a different position, as shown in Figure 686.4.

Figure 686.4 The Direct Selection tool lets you select and move individual anchor points.

9. The Path Component tool lets you click and drag the shape to a different position within the document window without modifying the original shape, as shown in Figure 686.5.

Figure 686.5 The Path Component tool lets you move the vector shape to a different position within the document window.

Note: *For more information on manipulating vector shapes in Photoshop, refer to Tip 155, "Adding, Subtracting, and Converting Anchor Points on a Pen Path."*

687 *Working with Layer Blending Modes*

When you use the blending mode options in Photoshop, you are actually blending the inks of two or more layers, as shown in Figure 687.1.

Figure 687.1 The blending mode options control the mixing of pixels between two or more layers.

When referring to the various blending modes, these terms describe the colors:

- **Base color:** The original colors in the active image layer

- **Blend color:** The colors in the blending layers

- **Result color:** The result of blending the base and blend colors

Depending on the type of blending you want to do, Photoshop gives you up to 17 different blending modes.

- **Dissolve:** The Dissolve option mixes each pixel in the active layer with the pixels in the blending layer using the blend color. The result color is a random replacement of the pixels with the base color or the blend color, depending on the opacity at any pixel location.

- **Multiply:** The Multiply option multiplies the base color by the blend color. The result color is always a darker color. Multiplying any color with black produces black. Multiplying any color with white leaves the color unchanged.

- **Screen:** The Screen option multiplies the inverse of the blend and base colors. The result color is always a lighter color. Screening with black leaves the color unchanged. Screening with white produces white.

- **Overlay:** The Overlay option multiplies or screens the colors, depending on the base color. Patterns or colors overlay the existing pixels while preserving the highlights and shadows of the base color.

- **Soft Light:** The Soft Light option darkens or lightens the colors, depending on the blend color. If the blend color is lighter than 50 percent gray, the image lightens. If the blend color is darker than 50 percent gray, the image darkens. Painting with pure black or white produces a distinctly darker or lighter area but does not result in pure black or white.

- **Hard Light:** The Hard Light option multiplies or screens the colors, depending on the blend color. If the blend color is lighter than 50 percent gray, the image lightens. If the blend color is darker than 50 percent gray, the image darkens.

- **Color Dodge:** The Color Dodge option examines the color information in each channel and brightens the base color to reflect the blend color. Blending with black produces no change.

- **Color Burn:** The Color Burn option examines the color information in each channel and darkens the base color to reflect the blend color. Blending with white produces no change.

- **Darken:** The Darken option examines the color information in each channel and selects the base or blend color (whichever is darker) as the result color.

- **Lighten:** The Lighten option examines the color information in each channel and selects the base or blend color (whichever is lighter) as the result color.

- **Difference:** The Difference option examines the color information in each channel and subtracts either the blend color from the base color or the base color from the blend color, depending on which has the greater brightness value.

- **Exclusion:** The Exclusion option creates an effect similar to but lower in contrast than the Difference mode. Blending with white inverts the base color values. Blending with black produces no change.

- **Hue:** The Hue option creates a result color with the luminance and saturation of the base color and the hue of the blend color.

- **Saturation:** The Saturation option creates a result color with the luminance and hue of the base color and the saturation of the blend color.

- **Color:** The Color option creates a result color with the luminance of the base color and the hue and saturation of the blend color. This preserves the gray levels in the image and is useful for coloring monochrome images and for tinting color images.

- **Luminosity:** The Luminosity option creates a result color with the hue and saturation of the base color and the luminance of the blend color. This mode generates the opposite effect from that of the Color mode.

688 *Choosing Between RGB and CMYK Color Space for Your Output*

Color space is an important part of the design of an image. When you create a graphic image, it is important to save the file in the correct color space. You determine the correct color space by knowing the final destination of the image. Photoshop gives you two major color spaces:

- **RGB:** The RGB color mode displays all the colors within an image using a mix of red, green, and blue pixels. An RGB image is capable of producing 1 of 16.7 million colors per pixel. The RGB mode is the color space of your monitor. Color images display best on a computer monitor if they are in the RGB color space. Also, many inkjet printers use the RGB color space (check with your printer manufacturer) and will print at their best if left in RGB color space, as shown in Figure 688.1.

- **CMYK:** The CMYK color mode displays color information using a mix of cyan, magenta, yellow, and black pixels. Because each color pixel has 8 bits, a CMYK image contains a 32-bit pixel (8 times 4 equals 32). CMYK color mode is the color space of paper. Images destined for high-end printing using a four-color print press use the CMYK color space, shown in Figure 688.2.

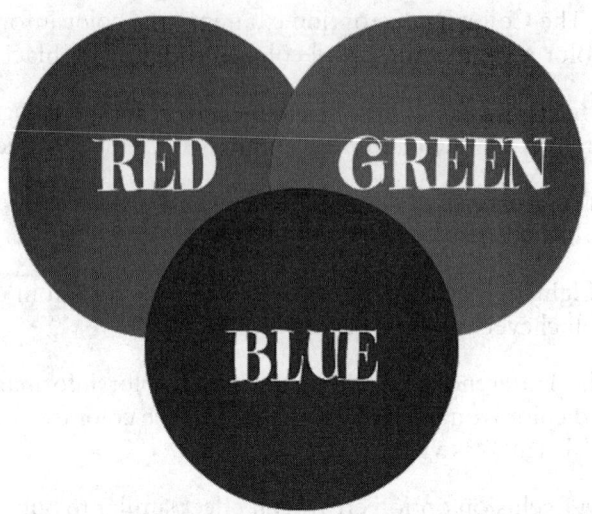

Figure 688.1 RGB is the color space of your computer monitor and many inkjet printers.

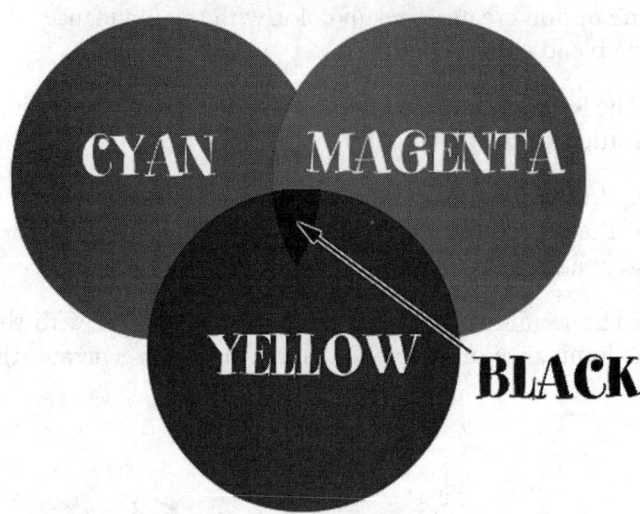

Figure 688.2 Four-color print presses use the CMYK color space.

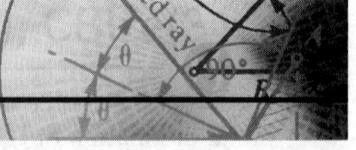

689 *Placing an Image in Adobe Illustrator*

One of the advantages of working on images in Photoshop is the capability to move the image directly into Illustrator. Moving a raster-based (Photoshop) image into a vector program like Illustrator is not done for editing purposes but for the creation of a graphic image combining photos and Illustrator's ability to manipulate vector images. Illustrator contains powerful text-editing tools that go beyond even some of the new features in Photoshop.

Say, for example, that you create a poster. You create the graphic images in Photoshop, but you want to use Illustrator to create the text and print the final document.

To move a graphic image into Illustrator, open the document in Photoshop and perform these steps:

1. Select the File menu, and choose Save As from the pull-down menu. Photoshop opens the Save As dialog box, shown in Figure 689.1.

Figure 689.1 The Save As dialog box defines the name and format for the saved file.

2. Click on the Format button and choose BMP, EPS, JPG, PCT, PSD, or TIFF from the pop-up menu.

3. Click the Save button. Photoshop closes the Save As dialog box and saves the file.

4. Open Illustrator. Select the File menu, and choose Place from the pull-down menu. Photoshop opens the Place dialog box, shown in Figure 689.2.

Figure 689.2 The Place command in Illustrator lets you open a graphic image.

5. Click on the correct graphic image, and click the Place button. Photoshop closes the Place dialog box and opens the document in Illustrator, as shown in Figure 689.3.

Note: After you place the image into Illustrator, you can use the text-editing tools to create the text and print the final document.

Figure 689.3 The graphic image is opened in Adobe Illustrator.

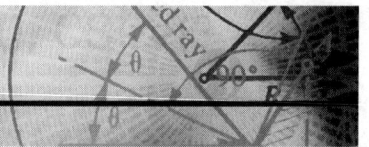

690 *Exporting Paths into Adobe Illustrator*

In the previous tip, you learned how to place a graphic image into Illustrator. With Photoshop's new vector tools, you can create vector paths in Photoshop and then export the paths into Illustrator. When the path is in Illustrator, you can manipulate the image just as you would any vector object.

To export Photoshop paths into Adobe Illustrator, open the document in Photoshop and perform these steps:

1. From the File menu, select Export and choose Paths to Illustrator from the fly-out menu. Photoshop opens the Save dialog box, shown in Figure 690.1.

2. Click on the Write button. Photoshop displays a list of available paths.

3. Click the Save button to close the dialog box and save the document to disk.

4. To open the exported document in Illustrator, open Illustrator, select the File menu, and choose Open from the pull-down menu. Select the exported file from the available list and click the Open button. Photoshop opens the paths in a new document window, shown in Figure 690.2.

Figure 690.1 Select the path that you want to export into Adobe Illustrator from the available options.

Figure 690.2 The exported Photoshop paths document opened in Illustrator.

691 *Saving an Image Using the CompuServe GIF Format*

The Graphics Interchange Format (GIF) is one of the oldest Web file formats. The GIF file format (pronounced *JIFF*) converts text, line art, and clip art into a file size small enough for use on the Internet. To

convert a graphic image directly into the GIF format, open an RGB image in Photoshop and perform these steps:

1. Select the File menu, and choose Save As from the fly-out menu. Photoshop opens the Save As dialog box, shown in Figure 691.1.

Figure 691.1 The Save As dialog box controls the characteristics of the saved document.

2. Click on the Format button. Photoshop displays a list of available formats in a pop-up menu.

3. Select CompuServe GIF from the available format options and click the Save button. Photoshop opens the Indexed Color dialog box, shown in Figure 691.2.

Figure 691.2 The Indexed Color dialog box controls the characteristics of the GIF file.

- **Palette:** Click on the Palette button and choose from the available palette options (see Tip 692, "Choosing the Correct Palette Type for an Indexed File").

- **Colors:** If you selected Uniform, Local, or Master color palettes, the Colors option becomes available. In the Colors input field, enter a value from 8 to 256. The Colors value indicates the number of available colors for the saved GIF file.

- **Forced:** Selecting the Forced option lets you force the inclusion of specific colors into the saved GIF image. The Black and White option forces pure black and white into the image's color table. The Primaries option adds red, green, blue, cyan, magenta, yellow, black, and white to the color table. The Web option adds the 216 Web-safe colors to the color table.

- **Transparency:** Selecting the Transparency option preserves the transparent areas of the image.

- **Matte:** Selecting the Matte option specifies the background color used to fill the anti-aliased edges of the image. When you select the Transparency option, Photoshop applies the matte color to the edges of the transparent areas of the image. When you deselect the Transparency option, Photoshop applies the matte to the entire transparent area of the image.

4. Click the OK button to save the file and close the Indexed Color dialog box.

692 *Choosing the Correct Palette Type for an Indexed File*

In the previous tip, you learned how to convert a Photoshop document into the GIF file format. When you convert an RGB image into the GIF format, Photoshop gives you the option to select the color palette for the saved image. To save a file in the GIF format, open an RGB image in the Photoshop Select File menu, and choose Save As from the fly-out menu. Photoshop opens the Save As dialog box, shown in Figure 692.1.

Figure 692.1 The Save As dialog box controls the characteristics of the saved document.

Select CompuServe GIF from the available format options and click the Save button. Photoshop opens the Indexed Color dialog box, shown in Figure 692.2.

Click on the Palette button and choose from the available palette options:

- **Exact:** Creates a palette using the colors that appear in the active RGB image. This option is available only if the image uses 256 or fewer colors.

- **System (Windows):** Uses Windows' 8-bit palette, based on a uniform sampling of RGB colors.

Figure 692.2 The Indexed Color dialog box controls the characteristics of the GIF file.

- **System (Mac OS):** Uses the Macintosh 8-bit palette, based on a uniform sampling of RGB colors.

- **Web:** Uses the Web-safe 216-color palette. Use this option to maintain color control for Web images.

- **Uniform:** Creates the color palette for the image by sampling colors from the RGB color cube. This option balances the colors in the image to provide an image that displays well on most color monitors.

- **Perceptual:** Creates a custom palette that favors colors viewed by the human eye.

- **Selective:** Creates a color table similar to the Perceptual palette, but favors Web-safe colors. This option usually produces images with the greatest color integrity.

- **Adaptive:** Samples the colors from the visible spectrum of the active image and favors those colors.

- **Custom:** Uses the Color Table dialog box. Edit the color table and save it for later use, or click on the Load button to load a previously created color table.

- **Previous:** Access the Custom palette used in the previous conversion. Use this option to convert several images using the same custom palette.

693 *Opening EPS Files*

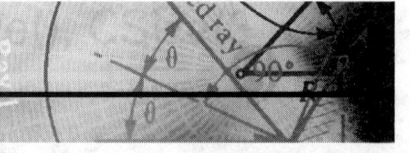

An Encapsulated PostScript file (EPS) incorporates both vector and bitmap data into one file format. Most image-editing and layout programs support the EPS file format. When you open an EPS document, Photoshop converts the image into a pixel-based document.

To open an EPS document in Photoshop, select the File menu and choose Open from the pull-down menu. Photoshop displays the Open dialog box, shown in Figure 693.1.

Select an EPS document and click the Open button. Photoshop opens the Rasterize Generic EPS Format dialog box, shown in Figure 693.2.

- **Width/Height:** Photoshop inserts the default values for the PDF file. In the input fields modify the width and height of the converted PDF document.

- **Resolution:** Files created with the EPS (Encapsulated PostScript) format are resolution-independent. Click in the Resolution input field to choose the correct resolution for the converted PDF document, based on the final resolution.

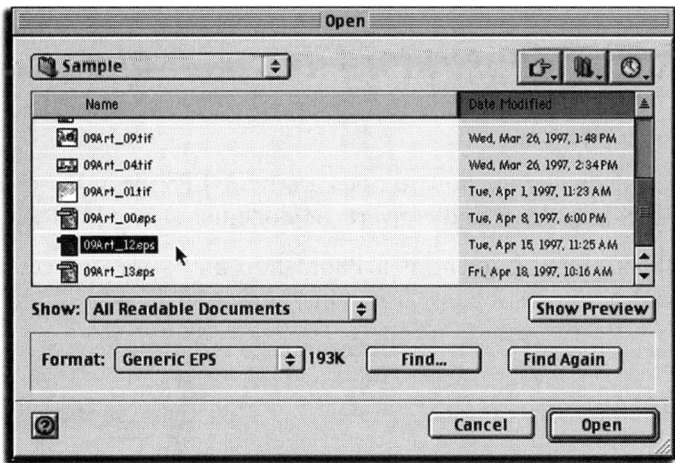

Figure 693.1 The Open dialog box displays a list of all available files.

Figure 693.2 The Rasterize Generic EPS Format dialog box controls the characteristics of the EPS document.

- **Mode:** Click on the Mode button and choose the correct color space from the available options, based on the final output (refer to Tip 111, "Choosing the Correct Color Space").

- **Anti-aliased:** Insert a check mark in the Anti-aliased input box to select this vector conversion option. For more information on this option, refer to Tip 116, "Selecting Anti-aliased for PostScript Images."

- **Constrain Proportions:** Insert a check mark in the Constrain Proportions input box to maintain the width and height proportions of the PDF document.

Click the OK button to close the dialog box and open the document in Photoshop, as shown in Figure 693.3.

Figure 693.3 The EPS document is opened in Photoshop.

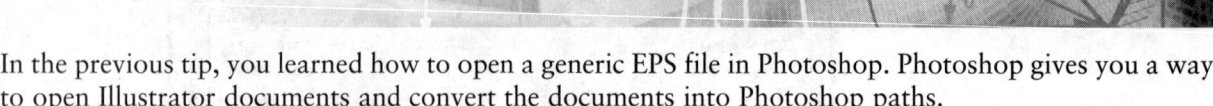

694 *Importing Illustrator Files as Paths*

In the previous tip, you learned how to open a generic EPS file in Photoshop. Photoshop gives you a way to open Illustrator documents and convert the documents into Photoshop paths.

To import an Illustrator document as a Photoshop path, open a vector document in Illustrator and a graphic document in Photoshop, as shown in Figure 694.1.

Figure 694.1 Documents in Photoshop and Illustrator are open at the same time.

Move your mouse into the Illustrator document, and then click and drag the vector path into the Photoshop document window while holding down the Ctrl key (Macintosh: Command key). When you release the mouse, Photoshop converts the Illustrator document into a work path in the Paths palette, as shown in Figure 694.2.

Note: The Paths palette preserves the vector nature of the Illustrator image and lets you edit the shape using the pen tools (see Tip 154, "Creating Vector Paths with the Pen Tool").

Figure 694.2 When you drag a document from Illustrator to Photoshop while holding down the Ctrl key (Macintosh: Command key), Photoshop converts the vector image to a path.

695 JPEG, GIF, and PNG: The Formats of the Internet

The three most common file formats used on the Internet are Joint Photographic Experts Group (JPEG), Graphics Interchange Format (GIF), and the Portable Network Graphic (PNG) file formats. When you save a graphic image for the Internet, the type of image determines the correct file format.

- **Joint Photographic Experts Group (JPEG):** Web designers use the JEPG file format to display photographic images on the World Wide Web. JPEG files use a compression scheme that removes color information from the image to reduce file size. The JPEG format displays colors by alternating different color pixels to fool the eye into seeing colors that are no longer part of the image, in the same way that mixing yellow and blue inks produces the color green. Use the JPEG format for the display of photographic images, as shown in Figure 695.1.

Figure 695.1 The JPEG format performs best with photographic images.

- **Graphic Image File (GIF):** The GIF file format does not remove color from an image; it reduces file size using the Run Length Encoding (RLE) compression scheme. The RLE compression method compresses horizontal lengths of color. Therefore, the fewer colors exist in a GIF image, the smaller the RLE compression method can reduce the size of the file. Use the GIF format for compressing clip art images and for converting text into graphics, as shown in Figure 695.2.

- **Portable Network Graphic (PNG):** The PNG format compresses both photographs and clip art without removing color from the images. It uses RLE compression (refer to the GIF format) to compress large areas of solid color, and it allows the use of an Alpha channel for transparency. However, the popularity of the PNG format for use in normal Web graphics is not as great. Approximately 30 percent of people using the Web have the capability to view PNG-formatted graphics. Use the PNG format for saving images designed for Flash and LiveMotion Web animation, as shown in Figure 695.3.

1180 1001 Photoshop Tips

Figure 695.2 The GIF format compresses text and clip art for use on the Internet.

Figure 695.3 The PNG format creates compressed images for use in Flash and LiveMotion animation.

696 *Creating QuickTime Movies from Animated GIF Files*

One of the little-known features of ImageReady is its capability to generate QuickTime movies from animated GIF files. The QuickTime format is fast becoming the format of choice on Windows and Macintosh for the display of animation and movie sequences. Say, for example, that you want to use an animated GIF sequence within a PowerPoint presentation. To convert an existing animated GIF file into a QuickTime movie, open the file in ImageReady, as shown in Figure 696.1.

Figure 696.1 An animated GIF image is open in ImageReady.

Select the File menu, and choose Export Original from the pull-down menu. ImageReady opens the Export Original dialog box, shown in Figure 696.2.

Figure 696.2 The Export Original dialog box controls the format of the saved file.

Click on the Format button. Photoshop displays a list of available formats. Select QuickTime Movie from the pop-up list and click the Save button. Photoshop opens the Compression Settings dialog box, shown in Figure 696.3.

Click on the Compressor button and select a compression method from the available options. For most QuickTime Movies, choose Photo-JPEG, Sorenson Video, Intel Indeo Video R 3.2, or Cinepak. Then choose Best Depth.

Figure 696.3 The Compression Settings dialog box controls the characteristics of the QuickTime document.

Click on the Quality slider, and drag left or right to select from Least to Best quality. Choosing the Best option creates a full-color image and a large file size. Choosing the Least option creates a smaller file by reducing the number of colors within the image.

Click the OK button to close the Compression Settings dialog box, and save the file (see Figure 696.4).

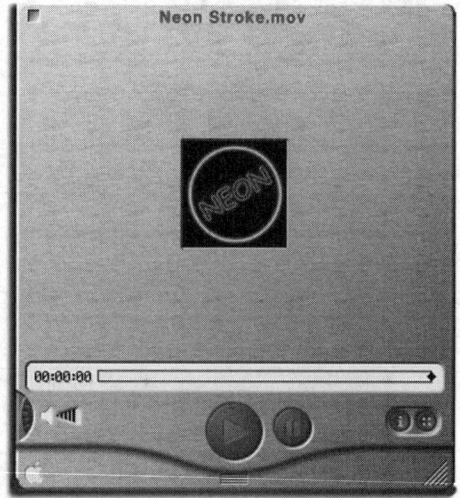

Figure 696.4 The completed QuickTime movie.

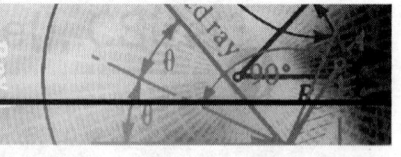

697 *Using the Save As a Copy Option*

When you edit a multi-layered document, Photoshop saves the document in the Photoshop format (PSD), by default. The PSD format is Photoshop's native format. Multi-layered files are unique to the Photoshop program. Although Photoshop 6.0 lets you save multi-layered files in other formats, like Tagged Image File (TIF), and Portable Document Files (PDF) formats, they are limited in their application.

Say, for example, that you want to save a copy of a multi-layered document in the JPG format. The Save a Copy option lets you save a copy of an open Photoshop document and return to work on the original multi-layered image.

To use the Save a Copy option, open a file in Photoshop and perform these steps:

1. Select the File menu, and select Save As from the pull-down menu. Photoshop opens the Save As dialog box, shown in Figure 697.1.

2. Move your mouse into the Save options and select As a Copy by clicking in the As a Copy check box.

3. Click on the Format button and choose the JPEG option from the pop-up menu. A text box located at the bottom of the Save As dialog box warns you that some of the original document's data will not be saved with the file.

4. Click the Save button. Photoshop saves the document and returns you to the original document.

Figure 697.1 The Save As dialog box controls the characteristics of the Save a Copy option.

698 Saving an RGB Image as a BMP or PICT Image

When you save a file, the format that you choose depends on the output of the image. Photoshop lets you save a file in one of two platform-specific formats: BMP and PICT.

- **BMP:** The BMP format is the standard graphic format for Windows and DOS-compatible computers. The BMP format supports grayscale, RGB, indexed color, and Photoshop's bitmap format. Bitmap images do not support the use of Alpha channels. Use the BMP format for images designed specifically for the Windows platform, such as PowerPoint presentations and other Microsoft applications, such as Word, Access, and Excel.

- **PICT:** The PICT format is specifically designed for the Macintosh operating system. Like the BMP format, the PICT format supports grayscale, RGB, indexed color, and the Bitmap color spaces. Use the PICT format for images designed specifically for the Macintosh platform.

Note: *Although the BMP and PICT formats are designed for specific operating systems, with today's documents running on multiple platforms, it is best to use universal formats such as Tagged Image File (TIF) and Portable Document File (PDF) formats.*

699 *Printing Directly from Photoshop Using Default Printing Options*

When you design and edit documents using Photoshop, typically you output and print the images using programs such as QuarkXPress, InDesign, and PowerPoint. To print a document directly from Photoshop, open the document and perform these steps:

1. To view the position of the image on the default printed page, move your mouse down to the information dialog box, and click and hold your mouse inside the dialog box. Photoshop displays a pop-up image displaying the default paper size and the position of the graphic image, as shown in Figure 699.1.

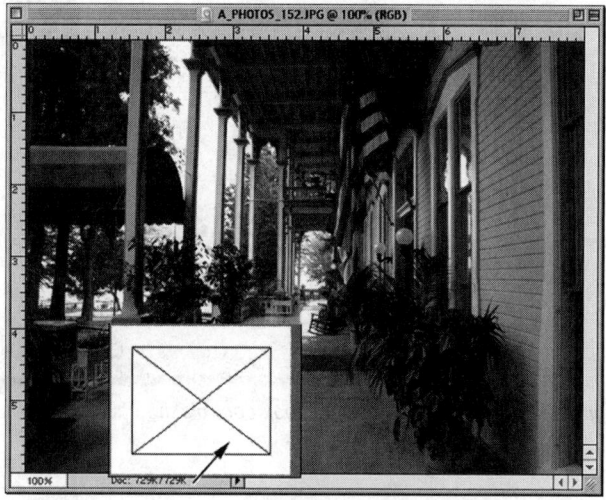

Figure 699.1 Clicking and holding your mouse on the information dialog box displays an image of the default paper size and image position.

2. Release your mouse to collapse the printing view.

3. Hold the Alt key (Macintosh: Option key) and select the File menu; choose Print One from the pull-down menu.

4. Photoshop prints the image, using the default printing options.

> *Note: For information on setting Photoshop's printing options, see Tip 700, "Using Photoshop's Printing Options."*

700 *Using Photoshop's Printing Options*

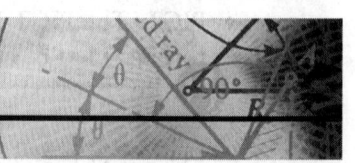

In the previous tip, you learned how to print a document using default values. To change the default print settings, open a document in Photoshop. Select the File menu, and choose Print Options from the pull-down menu. Photoshop opens the Print Options dialog box, shown in Figure 700.1.

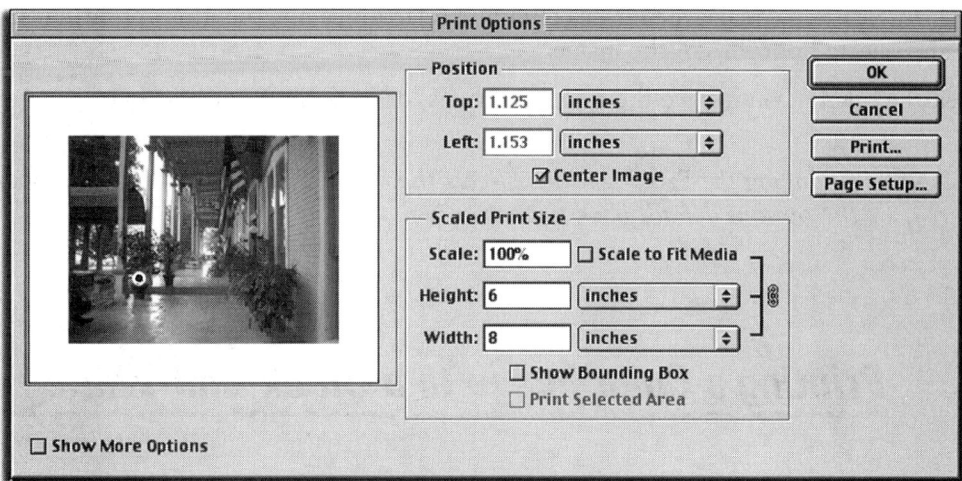

Figure 700.1 The Print Options dialog box controls the characteristics of the printed document.

- **Position:** In the Top and Left input boxes, enter the offset value for the image. The Top value indicates the distance from the top of the graphic image to the top of the paper. The Left value indicates the distance from the left side of the graphic to the left edge of the paper. Activating the Center Image option automatically centers the image on the printed paper and disables the Top and Left input boxes.

- **Scale:** In the Scale input box, enter a value from 3.3 to 20000.00 percent. The Scale option affects the proportional size of the image, based on its original width and height. Activating the Scale to Fit Media option automatically scales the image to the maximum printable size.

- **Height/Width:** In the Height and Width input fields, enter a value for the height and width of the image. Choosing values greater than the size of the image causes Photoshop to crop the image when printing. Because the Height and Width fields are linked together, changing one field automatically adjusts the second field.

- **Show Bounding Box:** When you select this option, a bounding box appears around the image in the preview window. Clicking on and dragging one of the four anchor points proportionally stretches or shrinks the image, as shown in Figure 700.2.

Figure 700.2 Selecting the Show Bounding Box option lets you control the size of the printed document by clicking on and dragging the anchor points.

- **Print Selected Area:** If the image contains a selection, activating this option causes Photoshop to print the selected portions of the image.

Click the OK button to save the current settings, or click the Print button to print the document.

Note: Changing the Print Options affects the active document. When you open a new document, the options default back to their original settings.

701 *Printing a Color Image to a Black-and-White Printer*

When you print a color document to a black-and-white printer, Photoshop, in conjunction with your printer, converts the colors within the document into shades of gray. Photoshop analyzes the red, green, and blue components of the image and then creates a shade of gray based on the results of that calculation. Printing color images directly to a black-and-white printer takes additional processing time, and higher-saturation inks have a tendency to print in dark shades of gray.

To correctly print a color document in black and white, first convert the image to grayscale (refer to Tip 256, "Converting an Image to Grayscale Using Lab Color").

Converting an image to grayscale before printing lets Photoshop gauge the proper density for the shades of gray, as shown in Figure 701.1.

Figure 701.1 Converting an image to grayscale before printing lets Photoshop adjust the density of the gray levels and produces a better printed document.

702 *Printing to a PostScript Color Printer*

When printing a color image to a PostScript printer, you need to set the document for optimum printing. PostScript printers use sophisticated color-measurement systems to accurately reproduce the colors in the original document.

1. PostScript printers mix colors using the CMYK (cyan, magenta, yellow, and black) color space. To convert an image into CMYK color, select Mode from the Image pull-down menu, and choose CMYK from the fly-out menu. Photoshop converts the image into the CMYK color space.

2. Select the File menu, and choose Print from the pull-down menu. Photoshop opens the PostScript printer dialog box, shown in Figure 702.1.

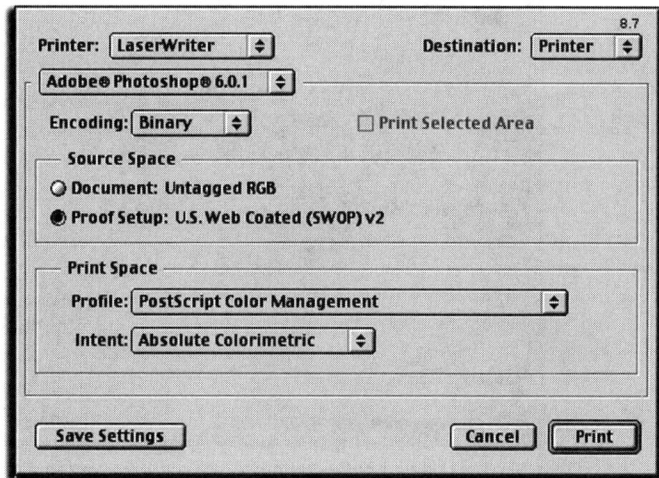

Figure 702.1 The PostScript printer dialog box controls the characteristics of the printed document.

3. Click on the Encoding option and choose Binary from the drop-down list.

4. Click on the Profile option and choose PostScript Color Management, or select a specific output device from the drop-down list.

5. Click on the Intent option and select from the available options in the drop-down list (refer to Tip 253, "Understanding Printer Color Management").

6. Click on the Print button to print the document.

703 *Preparing Images with Clipping Paths for an Imagesetter*

The most common way to create transparency within an image without generating a white box around the graphic is to create a clipping path around the image (refer to Tip 476, "Creating Transparency with a Clipping Path"). Clipping paths are vector-based shapes drawn around a portion of an image. The areas included within the clipping path become visible when printed, and the areas outside the clipping path are transparent, as shown in Figure 703.1.

When an imagesetter prints a graphic containing a clipping path, it uses the vector-based shape to define the visible portions of the image. Complicated images produce paths containing hundreds of separate anchor points. Each one of those points generates a mathematical statement that the imagesetter must interpret. When the complexity of the clipping path exceeds the printer's memory, it generates a Limitcheck error. Limitcheck errors indicate that the printer does not have enough memory to complete the requested job.

When an imagesetter generates a Limitcheck error, you have three choices:

1. **Increase the memory on the imagesetter.** Although this option is possible, it is expensive and not very practical. Because a service bureau or printing house typically owns an imagesetter, it likely will not opt to increase the memory just for your one job.

Figure 703.1 Clipping paths generate transparency within a Photoshop graphic.

2. **Print the document without the clipping path.** Again, this is not a viable option. You created the clipping path to produce transparent areas within the graphic image. Removing the clipping path forces the imagesetter to print the entire image and creates a border or white box around the graphic.

3. **Reduce the complexity of the clipping path.** Of the three options, this is the easiest and most likely option.

To reduce the complexity of a Photoshop clipping path, perform the steps in Tip 476, and create a clipping path. When you first create the path, Photoshop displays the Tolerance option, shown in Figure 703.2.

Figure 703.2 The Tolerance option controls the complexity of the clipping path.

In the Tolerance input box, enter a value from 0.5 to 10. The higher the value is, the less complex the clipping path will be. Experiment with values until you reach a compromise between complexity and printability. Values of 4 or 5 typically generate less complex clipping paths and produce acceptable prints.

704 *Transferring Images to QuarkXPress*

QuarkXPress is a versatile desktop layout program that handles almost any type of graphic format. If your intention is to print color separations using QuarkXPress as the output program, you will need to convert the images into the CMYK color format.

To convert an image to CMYK color space, open the document in Photoshop, select the Image menu, choose Mode, and then choose CMYK Color from the fly-out menu. Photoshop converts the colors in the active document to the CMYK color space, shown in Figure 704.1.

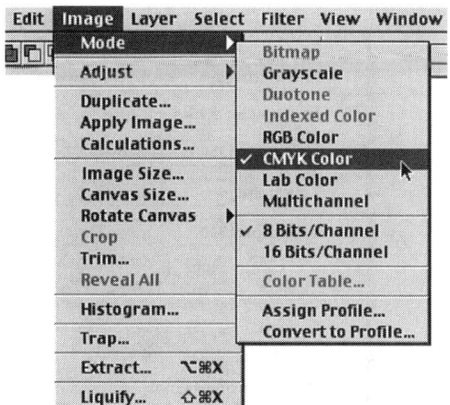

Figure 704.1 Select the CMYK Color option to convert a Photoshop document for printing in QuarkXPress.

When you've converted the image into the CMYK color space, you will need to save the file. Select File menu, and select Save from the pull-down menu. If the job will be printed using a printing press, contact the service bureau and ask what format it requires to correctly separate and print the images. Of all the available formats, the *TIFF*, *EPS*, and *DCS 2.0* are the most common formats used for printing color images in QuarkXPress.

Note: If you use QuarkXPress to output to an inkjet or laser printer, the most common format for saving and printing images is the TIFF format.

705 *Transferring an Image to a Film Recorder*

The publishing industry uses color transparencies to create high-quality images for print. If your printer requires transparencies, you can create them from a Photoshop document using a film recorder. To convert a Photoshop document into a transparency, it is important to know the requirements of the film recorder. It is important to match the pixel count of the image to the pixel count of the specific film recorder.

Say, for example, that you contact your service bureau and ask it to create a transparency, based on a Photoshop image. The service bureau advises you that its film recorder generates a 4-by-5-inch transparency. The service bureau needs an image with the 5-inch measurement to have 2,500 pixels, and the storage size of the file should be at least 10MB. To determine the size of the image, select the File menu and choose New from the pull-down menu. Photoshop opens the New dialog box, shown in Figure 705.1.

1. Click on the Mode option and choose RGB Color from the drop-down list.

2. Click on the Width measurement option and choose Pixels from the drop-down list.

3. Enter a value of 2000 in the Width input field.

4. Click on the Height measurement option and choose Inches from the drop-down list.

5. Enter a value of 4 into the Height input field.

6. In the Resolution input field, enter a resolution value that generates an image size close to but greater than 10MB, as shown in Figure 705.1.

Figure 705.1 The New dialog box controls the characteristics of the new document.

7. Click the OK button to create the image directly in Photoshop.

Note: If you need to scan the image, click the Cancel button in the New dialog box. You now have the information that you need, including the correct resolution to scan the image.

706 *Copying Images into Macromedia Director*

Macromedia Director combines images, text, video and audio files, and a sophisticated interface to produce an interactive multimedia product. When completed, a Director file can be copied onto a CD or run directly from your computer's hard drive.

Director accepts Photoshop images; however, problems occur when moving the image from Photoshop into the Director program. The most common way to move an image into Director is to paste the image from Photoshop.

Say, for example, that you want to move a graphic image into Director. You select the portion of the image that you want to move, select the Edit menu, and choose Copy from the pull-down menu. Photoshop places the copied image into Clipboard memory.

Next, you open Director, select the Edit menu, and choose Paste or Paste Special from the pull-down menu. The image in Clipboard memory is pasted into the Director document. Copying and pasting image information sometimes generates a halo around the pasted image, as shown in Figure 706.1.

To help eliminate the halo effect in a pasted Photoshop image, use the Modify command to contract the selection before performing the Copy command.

1. Select the area of the Photoshop document that you want to paste into Director.

2. Choose Modify from the Select pull-down menu, and choose Contract from the fly-out menu. Photoshop opens the Contract Selection dialog box, shown in Figure 706.2.

Figure 706.1 Copying and pasting information into Director sometimes generates a halo effect around the image.

Figure 706.2 The Contract Selection dialog box lets you shrink the edge of a selected graphic image.

3. Enter a value from 1 to 100 in the Contract By input field. The goal is to contract the selection image and remove the halo, without removing too much of the original image. Typical contraction values are 1 or 2. Click the OK button to record the contraction value to the selection.

4. Select the Edit menu, and choose Copy from the pull-down menu. Then paste the image into Director, as shown in Figure 706.3.

Figure 706.3 The Contract command successfully removed the halo from the copied image.

707 *Transferring Photoshop Images into Adobe After Effects*

The Adobe After Effects program accepts Photoshop documents for the creation of animated effects. The following features are available when moving Photoshop documents into After Effects:

- **Multi-layered:** After Effects accepts multi-layered Photoshop documents.

- **Rendering Text:** After Effects automatically converts Photoshop's text layers into rendered image layers.

- **Layer Masks:** Layer masks automatically apply to the image when moved into After Effects.

- **Clipping Paths:** After Effects preserves Photoshop clipping paths and lets you adjust and move the paths as a unit.

- **Layer Effects:** You need to render all layer effects before moving the image into After Effects.

- **Alpha Channels:** After Effects lets you use Photoshop Alpha channels as transparency masks.

708 *Preparing Images for Screen Display*

Images displayed on a computer monitor require different settings then images sent to print. The following values apply to onscreen images.

- **Resolution:** Windows monitors require a resolution of 96ppi, and Macintosh monitors use the 73ppi standard. To change the resolution of a Photoshop image, select the Image menu and then choose Image Size from the pull-down menu. Photoshop opens the Image Size dialog box, shown in Figure

708.1. In the Resolution input field, enter the correct resolution (based on output) and click the OK button to record the change to the image.

Figure 708.1 *The Image Size dialog box controls the resolution, width, and height of the image.*

- **Color Space:** Image displays on computer monitors use the RGB color space. To change the color space of the active image, select Mode from the Image pull-down menu, and choose RGB Color from the fly-out menu. Photoshop converts the active image into the RGB color space, shown in Figure 708.2.

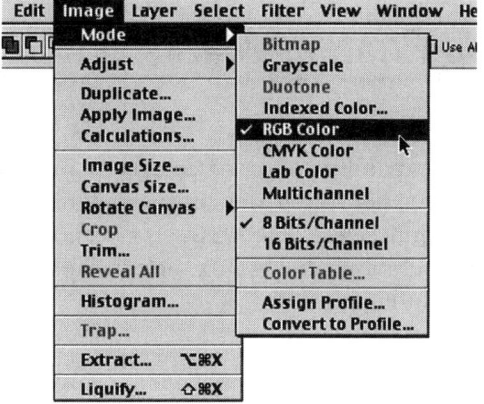

Figure 708.2 *Convert images into the RGB color space for display on a computer monitor.*

- **Format:** The BMP format is the most Windows-friendly format. If you display images on Macintosh monitors, use the PIC file format. To select the format of an image, choose the File menu and then choose Save As from the pull-down menu. Photoshop opens the Save As dialog box. Click on the Format button and select the correct format from the available options, as shown in Figure 708.3.

Note: If you need to display Photoshop images using multiple platforms (Windows and Macintosh), select a resolution of 96ppi and choose the TIFF file format.

Figure 708.3 The Save As dialog box lets you choose the format of the saved file.

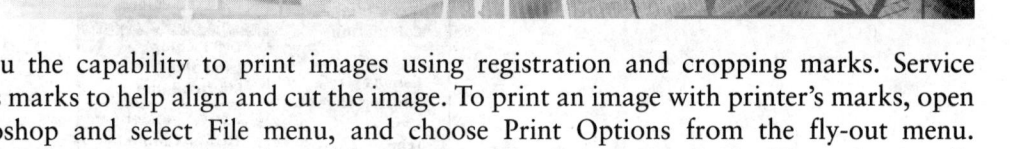

709 *Setting Up Printer's Marks Within an Image*

Photoshop gives you the capability to print images using registration and cropping marks. Service bureaus use printer's marks to help align and cut the image. To print an image with printer's marks, open the image in Photoshop and select File menu, and choose Print Options from the fly-out menu. Photoshop opens the Print Options dialog box. Select Show More Options to display Photoshop's calibration options, as shown in Figure 709.1.

- **Calibration Bars:** Creates a grayscale or color calibration bar outside the image area

- **Registration Marks:** Creates registration marks used by printers to align color separations

- **Corner Crop Marks/Center Crop Marks:** Used to trim the final printed image

- **Caption:** Prints a previously entered caption for the file

- **Labels:** Prints the file name of the image and the names of any additional Alpha channels

Click the OK button to record the changes to the image, as shown in Figure 709.2.

Figure 709.1 Selecting Show More Options displays Photoshop's calibration printing options.

Figure 709.2 An image displaying all the possible cropping and registration marks.

710 *Adjusting Images to Conform to a Web Safe Palette*

In Tip 708, "Preparing Images for Screen Display," you learned how to prepare an image for display on a typical computer monitor. Computer monitors display images by mixing red, green, and blue pixels to produce from hundreds to literally millions of possible color combinations. Therefore, an image may appear different, depending on the monitor. Nowhere is this more important than when displaying images on the Internet. Preparing images for display on a Web page requires specific resolutions, sizes, and color space.

One method for moving an image into the Web Safe color palette is to index the image's colors. To convert an RGB image into the Web Safe color palette, open the document in Photoshop, select Image menu choose Mode, and choose Indexed Color from the fly-out menu. Photoshop opens the Indexed Color dialog box, shown in Figure 710.1.

Click the Palette button and select Web from the available options. Photoshop converts the image colors to conform to the Web Safe color palette. If you have the Preview option selected, the viewable image changes to reflect the new indexed colors, as shown in Figure 710.2.

Figure 710.1 *The Indexed Color dialog box lets you convert an RGB image's colors into the Web Safe color palette.*

Click on the Dither button and select the dither option that best displays the image colors:

- **None:** Turns off the dithering option
- **Diffusion:** Mixes the available colors in a random pattern to produce the displayable image
- **Pattern:** Uses a definable logical pattern to display the image's available colors
- **Noise:** Mixes the colors in the image using a noise-based pattern

Figure 710.2 The Indexed Color option is applied to the active image here.

711 *Deciding File Formats Based on Final Output*

An image's file format depends entirely on the final output of the graphic. When you work on a graphic file in Photoshop, work with the image's final destination in mind. All designers are given images and are asked to prepare them for output to a specific device. The final device determines the file format of the image.

- **Presentations:** Images designed for display using presentation programs such as PowerPoint require image formats that load the images quickly. If the presentation is conducted using the Windows platform, use the BMP file format. Macintosh-based presentation programs work well using the PIC format.

- **Internet graphics:** An image destined for the Internet must load quickly. The three standard Internet formats are the JPEG, GIF, and PNG formats. All three of these formats compress the image information for faster downloads. However, due to their low resolutions, they are not acceptable for printing.

- **Four-color printing:** The type of file format used for color separations is determined by the operator of the printing press. In most cases, the printer will request the image in EPS or DCS file format.

- **Output to inkjet and laser printers (black-and-white or color):** File formats for images sent to inkjet and laser printers are determined by the program sending the information to the printer. However, the TIFF format is widely accepted as a universal file format, especially for images not destined for color separation.

Note: Although choosing the correct file format is determined by the output of the graphic image, it is also true that programs and operating systems control format. Always check with a service bureau before sending any images, and read the user's manuals that come with your programs. In many cases, the manuals recommend the formats that work best with their programs.

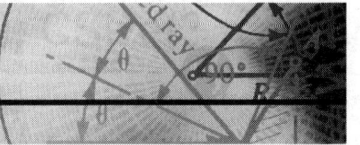

712 *Printing an Image to a PostScript File*

In Tip 702, "Printing to a PostScript Color Printer," you learned how to print a document using PostScript technology. It is also possible to create a PostScript file of the printed document. Say, for example, that you want to print a document, but the printer is not available. You decide to create a file containing the printed document. That way you can send the document to the printer later, when the PostScript printer is available.

To save a PostScript file, open the document in Photoshop and perform these steps:

1. Select the File menu, and choose Print from the pull-down menu. Photoshop opens the Print dialog box, shown in Figure 712.1.

Figure 712.1 *The Print dialog box controls the characteristics of the printed document.*

2. Click on the Destination button and select File from the drop-down list.

3. Click on the Printer button and select an output device from the drop-down list.

4. Click the Save button. Photoshop opens the Save dialog box.

5. In the Name input box, enter a file name. In the example, the file is named image.ps.

6. Click the Save button to save the PostScript printer file to disk.

713 *Selecting and Transferring Halftone Screen Attributes*

The halftone screen attributes include the dot shape and line frequency for each screen used in the printing process. Halftone screens consist of dot patterns that control the amount of ink used per color plate. On a grayscale image, varying the size and number of dots per square inch creates shades of gray in the final image. On a color press, the size and density of the dots control the mixing of the inks.

It is important to note that the printer operating the printing press determines halftone screen attributes. You can contact your printer and request the correct values to use for halftone screen attributes.

To assign halftone screen values to an image, open the graphic in Photoshop and perform these steps:

1. Select File menu and choose Print Options from the pull-down menu. Photoshop opens the Print Options dialog box, shown in Figure 713.1.

Figure 713.1 The Print Options dialog box lets you change the characteristics of the printed image.

2. Click on the Screen button. Photoshop opens the Halftone Screens dialog box, shown in Figure 713.2.

3. Click once on the Use Printer's Default Screens check box to deactivate the option.

4. Click on the Ink button and select Cyan from the drop-down list. Enter the values given to you by your printer in the Frequency and Angle input boxes.

5. Click once on the Shape button and select the required shape from the drop-down list.

6. Click on the Ink button and select the next color from the drop-down list, and repeat steps 4 and 5 for the magenta, yellow, and black inks.

Figure 713.2 The Halftone Screens dialog box controls the values assigned to the active image's halftone screen.

7. Select Use Accurate Screens based on your printer's recommendations.

8. Click the OK button to apply the screens to the active image.

Note: Changing the halftone screen values does not affect the display of the image on your monitor. The halftone values are used by the CMYK printing presses to produce the color-separation plates.

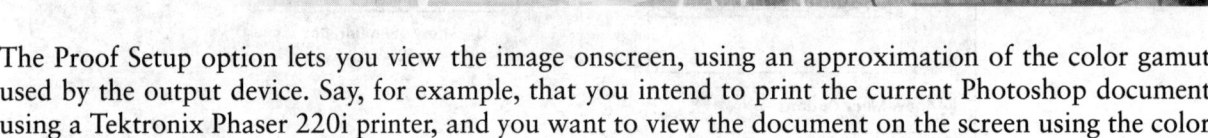

714 *Using the Proof Setup Option*

The Proof Setup option lets you view the image onscreen, using an approximation of the color gamut used by the output device. Say, for example, that you intend to print the current Photoshop document using a Tektronix Phaser 220i printer, and you want to view the document on the screen using the color gamut of the 220i.

To change the proof setting of your monitor, open the document in Photoshop and perform these steps:

1. Select the View menu, choose Proof Setup, and select Custom from the fly-out menu. Photoshop opens the Proof Setup dialog box, shown in Figure 714.1.

Figure 714.1 The Proof Setup dialog box lets you view images on your monitor using the color gamut of a specified output device.

2. Click on the Profile button and select Tektronix Phaser 220i from the drop-down list.

3. Click on the Intent button and select a rendering intent from the drop-down list.

- **Perceptual:** Attempts to preserve the visual relationship between colors in a way that is natural to the human eye. This option works well with photographic images.

- **Saturation:** Attempts to create vivid color in a printed document at the expense of accurate color. This intent works well with business graphics, in cases where bright, not accurate, colors are needed.

- **Absolute Colorimetric:** Attempts to maintain color accuracy at the expense of preserving relationships between colors. This option works well on images printed with less color than that contained in the original image.

- **Relative Colorimetric:** Compares the white point of the source color space to that of the destination color space, and shifts all colors accordingly. Like the Perceptual option, this option works well on photographic images.

4. Select or deselect the Simulate Paper White or Simulate Ink Black options. Selecting either of the options causes the image to display the level of black or paper white of the output device.

5. Click the OK button in the Proof Setup dialog box to record your changes to the image. When you print the image (choose the File menu and select Print), the document will print using your new print options.

Note: Modifying the print options will not change the default color space of the document. It will affect the document only when sent to a printer.

715 *Printing a Portion of an Image*

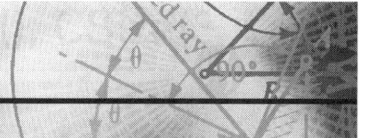

When you print a graphic image in Photoshop, you have the choice of printing the entire graphic image or a selected portion of the active graphic.

To print a portion of a graphic image, open the graphic in Photoshop and perform these steps:

1. Select a portion of an open Photoshop document, as shown in Figure 715.1.

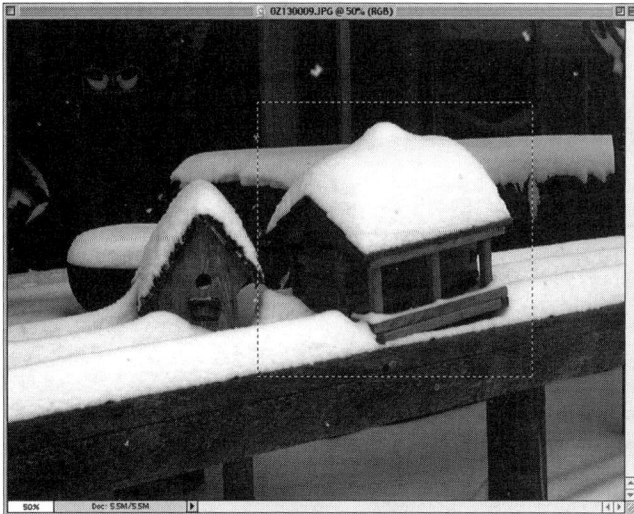

Figure 715.1 The foreground snow-covered birdhouse was selected using the Lasso tool.

2. Select the File menu and choose Print Options from the pull-down menu. Photoshop opens the Print Options dialog box, shown in Figure 715.2.

Figure 715.2 The Print Options dialog box controls the printable area of the image.

3. Click in the Print Selected Area check box.

4. Click the OK button to close the Print Options dialog box.

5. Select the File menu and choose Print from the pull-down menu. Photoshop displays the Print dialog box.

6. Click the Print button to print the selected portions of the Photoshop document, as shown in Figure 715.3.

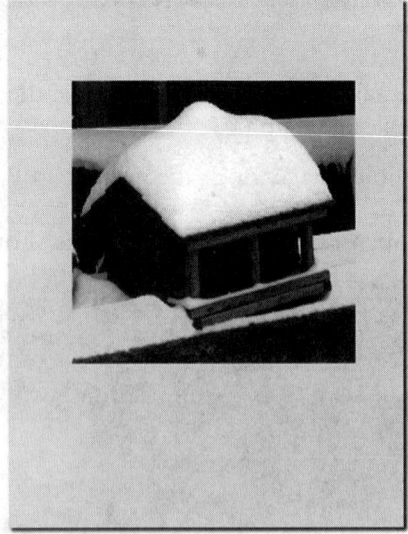

Figure 715.3 The printed graphic displays the selected portions of the original Photoshop image.

716 *Changing the Print Encoding of an Image*

When you send an image to the printer, by default, Photoshop sends the information in a binary format. The binary format is a universal communication language that is accepted by most printers in the United States and Europe. Photoshop offers three encoding schemes:

- **Binary:** This is the most universal encoding scheme. Most printers and output devices accept the binary encoding scheme.

- **JPEG:** The JPEG encoding scheme transfers image information faster by reducing the size of the image data file. Unfortunately, this results in a loss of image data. The JPEG encoding format is used primarily to move large amounts of information across the Internet.

- **ASCII:** This encoding scheme is used by some computers and output devices to move information from computer to computer using Ethernet or Macintosh's AppleTalk network.

To change the print encoding of an image, open the graphic file in Photoshop and perform these steps:

1. Select the File menu and choose Print Options from the pull-down menu. Photoshop opens the Print Options dialog box, shown in Figure 716.1.

Figure 716.1 The Print Options dialog box lets you change the encoding method used by the output device.

2. Click on the Encoding button and select from the available options in the drop down list.

3. Click the OK button to record the changes to the active image.

Note: The Print Encoding options are available only if you output the image to a PostScript printer.

717 *Printing Vector Images*

When you output vector graphics such as type and shapes to a PostScript printer, Photoshop 6.0 gives you the option to send the vector image information to the printer. Photoshop sends a separate image for each type and shape layer to the printer. The printer overlays all the images and clips the data based on the vector data. Photoshop 6.0 is the first version of the program that lets you send PostScript data directly to the printer. This results in cleaner vector shapes and sharper text.

To instruct Photoshop to send the vector data to the printer, open the image in Photoshop and perform these steps:

1. Select the File menu, and choose Print Options from the pull-down menu. Photoshop opens the Print Options dialog box, shown in Figure 717.1.

Figure 717.1 The Print Options dialog box lets you specify whether vector graphics and text layers are sent to the output device.

2. Click in the Include Vector Data check box (this option is not available unless the image contains text or vector shape layers).

3. Click the OK button to record the changes to the image.

4. Select the File menu, and choose Print from the pull-down menu. Photoshop displays the Print dialog box.

5. Click the Print button to print the Photoshop document. Photoshop sends the raster and vector information to the printer.

Note: The Include Vector Image option is available only if you output the image to a PostScript printer.

718 *Saving and Loading Custom Color-Management Settings*

When you create you own customized color-management settings, it is a good idea to save the setting files so that you can use them with other graphic images. Custom color-management files are useable with other applications that share similar management systems, such as Adobe Illustrator.

To create a customized color-management profile, select the Edit menu and then choose Color Settings from the pull-down menu. Refer to Tip 261, "Editing Photoshop's Color Settings," and create a customized color settings file, as shown in Figure 718.1.

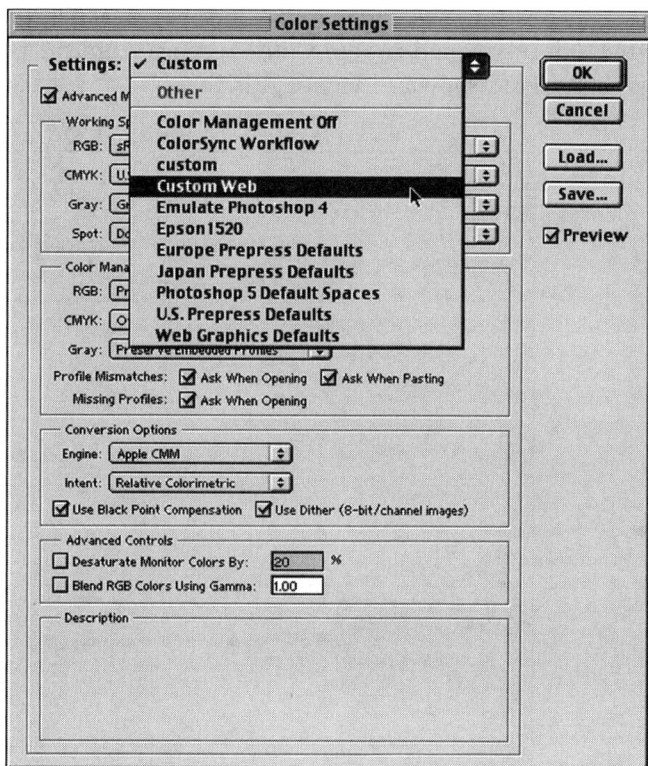

Figure 718.1 The Color Settings dialog box controls the characteristics of the color profile.

To access the customized color-management file from the Color Settings dialog box, it is important to save the file in a specific location:

- **Windows:** Click the Save button in the Color Settings dialog box (refer to Tip 261) and save the file in the Program Files/Common Files/Adobe/Color/Settings folder.

- **Macintosh:** Click the Save button in the Color Settings dialog box (refer to Tip 261) and save the file in the System Folder/Application Support/Adobe/Color/Settings folder.

> *Note: When you save the customized color settings files within the specified folder, the profile will be available whenever you access the Color Settings dialog box.*

719 *Using Color Management Between Photoshop and Illustrator*

In the previous tip, you learned how to create and save a customized color setting file. When the file is saved, it becomes available to all Adobe programs that support color management. Say, for example, that you want to use the same color management file to maintain consistency between images created and printed in Photoshop with images created and saved in Illustrator.

To use a color-management file between Photoshop and Illustrator, create and save the file using the information in the previous tip. Make sure that you save the file in the prescribed folder. Open Adobe Illustrator, select the Edit menu, and choose Color Settings from the pull-down menu. Illustrator opens the Color Settings dialog box, shown in Figure 719.1.

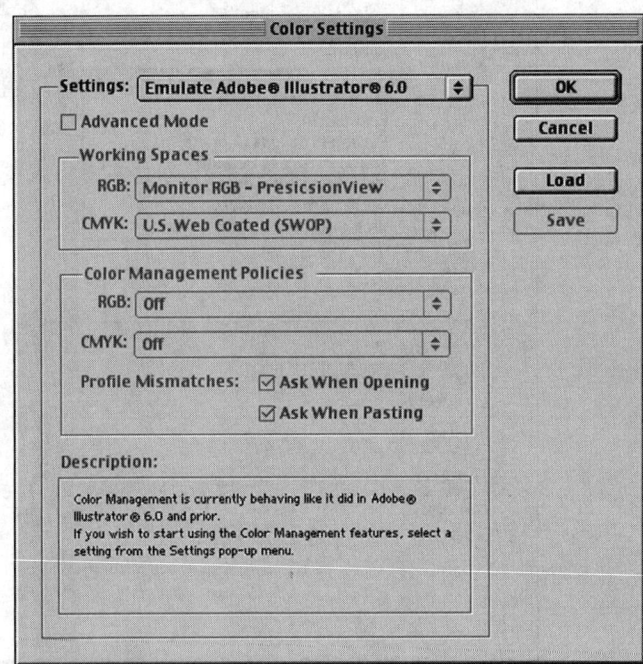

Figure 719.1 The Color Settings dialog box in Adobe Illustrator controls the color settings for the active document.

Click on the Settings button, and select your customized profile from the available options, as shown in Figure 719.2.

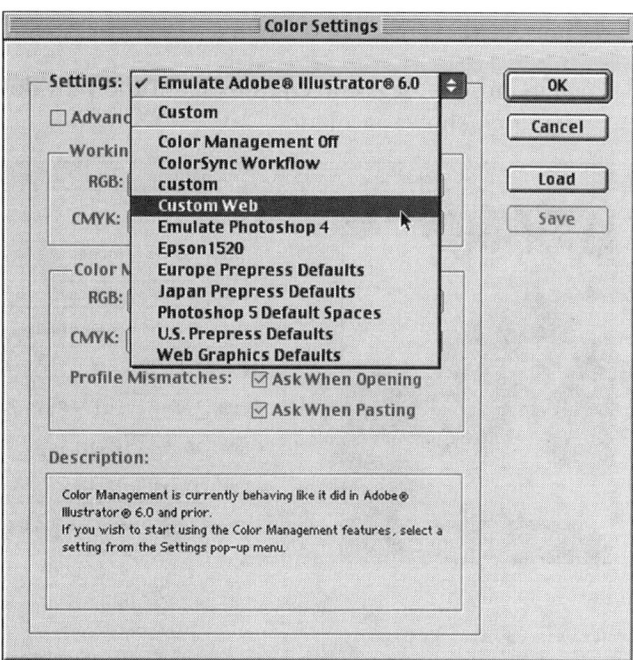

Figure 719.2 The Settings option displays a list of available color setting profiles, including any customized files created in Photoshop.

720 *Understanding Color Management's Role in Printing*

Using color management when you print an image gives you consistent color between image and document. When you use color management in printing, you are instructing Photoshop to print the image using a predefined color space. Photoshop's printing color-management system links the monitor's color-management system with the printer, giving you a constant look from monitor to print.

Different devices operate using different color spaces. The gamut of color viewable on your computer monitor is different from that of your printer. Say, for example, that you have an RGB color image and you want to use your printer to view how the image would print on a Chromax Dye-Sub printer. Select the View menu, choose Proof Setup, and choose Custom from the fly-out menu. Photoshop opens the Proof Setup dialog box, shown in Figure 720.1.

Figure 720.1 The Proof Setup dialog box lets you display the color space of a document based on a specific output device.

Refer to Tip 570, "Selecting Soft Proofing Colors," and set the document to display using the Chromax Dye-Sub printer. Your monitor now proofs the image and displays the color space of the selected output device.

To print the image, perform these steps:

1. Select the File menu, and choose Print Options from the pull-down menu. Photoshop displays the Print Options dialog box, shown in Figure 720.2.

Figure 720.2 The Print Options dialog box controls the color space of the printed document.

2. Click once in the check box to select Show More Options, and choose Color Management from the pop-up menu (refer to Figure 720.2).

3. Select Proof to use the Chromax Dye-Sub Printer color space.

4. Click the Profile button and select Same as Source from the drop-down list.

5. Click the OK button to record your changes to the image.

6. Select the File menu, and choose Print from the pull-down menu. Photoshop displays the Print dialog box.

7. Click the Print button to print the Photoshop document. Photoshop prints the image using the Chromax Dye-Sub Printer color space.

Note: Changing the proof colors does not affect the original color space of the active image. It changes only the color space of the document on your monitor.

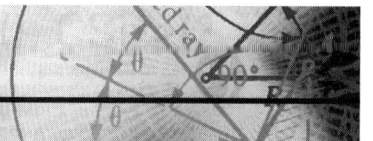

721 *Printing Using Color Traps for Press*

Color traps are used to compensate for the misalignment of the color plates by printing presses. When a CMYK image prints on a four-color press, the press operator creates four ink plates. Each of the plates represents one of the colors used in the printing process. When the paper moves through the press, each plate applies color ink to the paper. At the end of the process, the four ink plates create the final image, as shown in Figure 721.1.

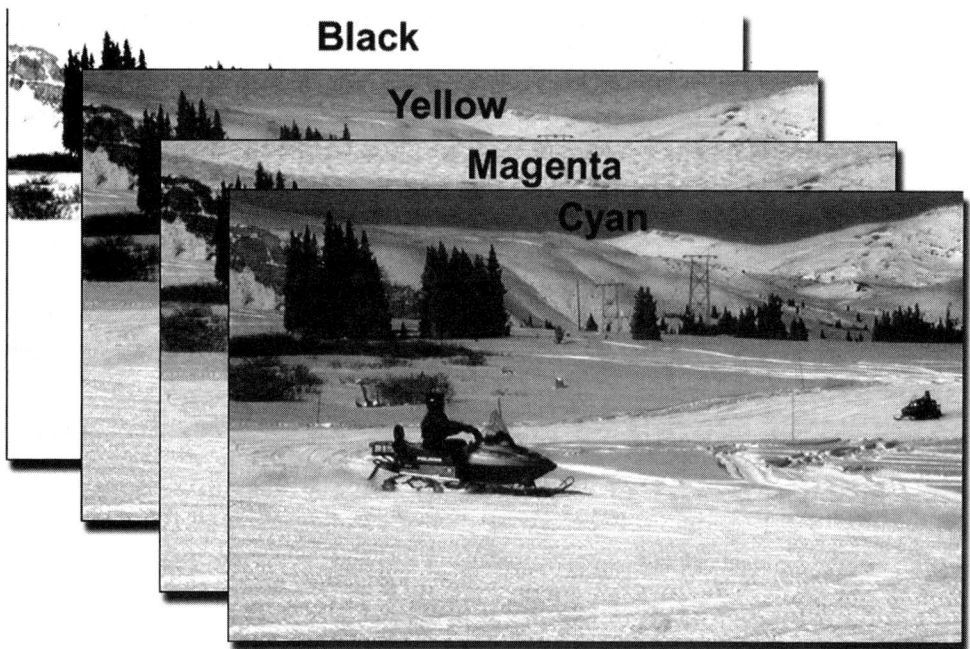

Figure 721.1 The four-color plates represent the percentage of cyan, magenta, yellow, and black applied to the image.

Because the color plates apply ink to the paper, they must be aligned. Unfortunately, it is virtually impossible to achieve a perfect alignment among all four plates. As the paper passes through the press, it can shift, and the rollers that move the paper and support the plates shift slightly as the paper passes through the press. All these factors influence how the ink is applied to the paper.

To correct for the misalignment of the press, Photoshop lets you assign a trap to the image (see Figure 721.2). A trap adds an additional stroke of color around a printed object. When the paper passes through the printing press, the additional stroke of color covers the misalignment of the ink plates.

Figure 721.2 Assigning a trap to a Photoshop image covers the mistakes generated by the misalignment of the plates in a printing press.

Continuous-tone images, such as photographs, typically do not generate solid ink tints; therefore, traps are not applied to photographic images. Traps are used when images generate solid-color tints, as shown in Figure 721.3.

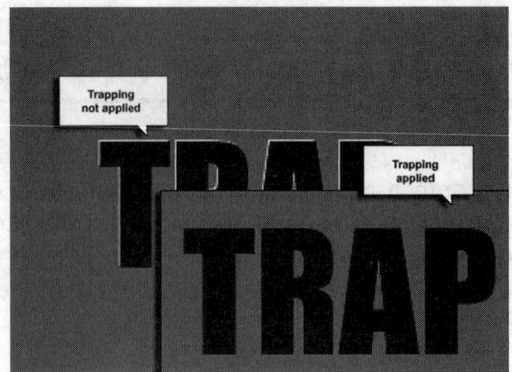

Figure 721.3 Traps are used when images generate solid-color tints between ink plates.

Note: *For more information on applying a trap to a Photoshop image, refer to Tip 339, "Using Photoshop's Trap Option."*

722 *Creating a GIF Animation from a Multi-Layered PS Image*

ImageReady 3.0 lets you create GIF animations directly from a multi-layered Photoshop document (see Figure 722.1).

Each layer within the original Photoshop document becomes one of the cells in the GIF animation.

Figure 722.1 ImageReady lets you convert a multi-layered Photoshop document into an animated GIF file.

To create an animated GIF image, open a multi-layered document in ImageReady and perform these steps:

1. If the Animation palette is not visible, select the Window menu and choose Show Animation from the pull-down menu. ImageReady opens the Animation palette, shown in Figure 722.2.

2. Move your mouse into the Animation palette and click the Duplicate Current Frame button to create a duplicate of the current frame (refer to Figure 722.2).

Figure 722.2 The Animation palette controls the characteristics of the animated GIF file.

3. In this example, there are four layers in the original Photoshop image that controls the animation. Click the Duplicate Current Frame button two more times. The Animation palette shows four frames: the original frame and three new frames, as shown in Figure 722.3.

Figure 722.3 The Animation palette contains a total of four animation sequence frames.

4. If the ImageReady Layers palette is not visible, select the Window menu and then select Show Layers from the pull-down menu. ImageReady opens the Layers palette, shown in Figure 722.4.

Figure 722.4 The ImageReady Layers palette controls the sequence of the animated GIF file.

5. Click once on Frame 1 in the Animation palette. ImageReady selects the first frame. Move your mouse into the Layers palette and deactivate layers 2, 3, and 4, as shown in Figure 722.5. In order to give the image a black background, the Background layer is selected through all the preceding steps.

6. Click on Frame 2 in the Animation palette. ImageReady selects the second frame. Move your mouse into the Layers palette, activate Layer 2, and deactivate layers 1, 3, and 4.

7. Click on Frame 3 in the Animation palette. ImageReady selects the third frame. Move your mouse into the Layers palette, activate Layer 3, and deactivate layers 1, 2, and 4.

8. Click on Frame 4 in the Animation palette. ImageReady selects the fourth frame. Move your mouse into the Layers palette, activate Layer 4, and deactivate layers 1, 2, and 3.

9. Each frame in the Animation palette displays one of the layers from the multi-layered Photoshop document, as shown in Figure 722.6.

Figure 722.5 Frame 1 displays active Layer 1.

Figure 722.6 The Animation palette displays four frames; each representing one layer from the original Photoshop document.

10. Select the File menu, and choose Save Optimized As from the pull-down menu. ImageReady opens the Save Optimized As dialog box, shown in Figure 722.7.

Figure 722.7 The Save Optimized As dialog box, lets you save the animated GIF file.

11. In the Name field, enter a name for the file. In this example, choose the name movement.gif.

12. Click on the Format button and choose Images Only from the pop-up menu.

13. Click the Save button to save the animated GIF file to disk.

Note: When you save an animated GIF image using ImageReady, you can place the file into any HTML document without further changes or modifications.

723 *Cropping an Image for the Web*

When you crop an image in Photoshop, you are essentially reducing the viewable area of the image. In the print industry, cropping is used to focus the reader's attention to a specific area of the image, as shown in Figure 723.1.

Figure 723.1 *Cropping an image helps the reader's eyes focus on specific elements within the image.*

When you crop an image for the Web using ImageReady, not only do you help focus the image, but you also decrease the file size by reducing the number of pixels within the image, so smaller images load faster.

To crop a Web image, open the graphic in ImageReady and perform these steps:

1. Select one of the selection marquee tools from the ImageReady toolbox. In this example, choose the **Rectangular Marquee**, shown in Figure 723.2.

2. Click and drag the Rectangular Marquee tool across the image, and select the portion of the original image that you want to keep.

3. Select the Image menu, and select Crop from the pull-down menu. ImageReady crops the image, based on the Rectangular Marquee selection, as shown in Figure 723.3.

Figure 723.2 *The Rectangular Marquee tool creates square or rectangular selections on the active image.*

Figure 723.3 *The Crop command successfully reduced the size of the original image.*

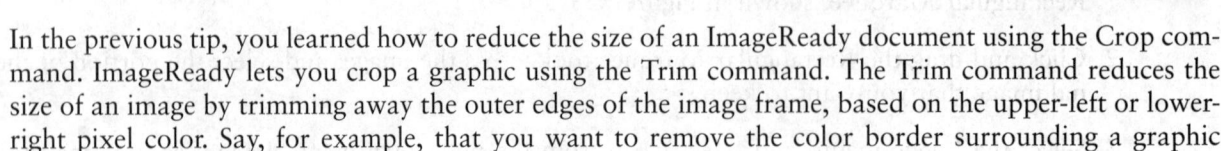

724 *Using the Trim Command in ImageReady*

In the previous tip, you learned how to reduce the size of an ImageReady document using the Crop command. ImageReady lets you crop a graphic using the Trim command. The Trim command reduces the size of an image by trimming away the outer edges of the image frame, based on the upper-left or lower-right pixel color. Say, for example, that you want to remove the color border surrounding a graphic image.

To use the Trim command to remove a colored border, open the graphic in ImageReady and perform these steps:

1. Select the Image menu, and choose Trim from the pull-down menu. ImageReady opens the Trim dialog box, shown in Figure 724.1.

Figure 724.1 The Trim command bases its file reduction on a specific edge color or edge transparency.

2. Click and select the Top Left Pixel Color option.

3. Because you want to remove the entire border surrounding the image, select the Top, Bottom, Left, and Right options.

4. Click the OK button to apply the Trim command to the image, as shown in Figure 724.2.

Figure 724.2 The Trim command successfully removed the solid-color border from the image.

Note: The Trim command works with transparency and solid colors. To preserve specific areas of an image regardless of color, use the Crop command described the in previous tip.

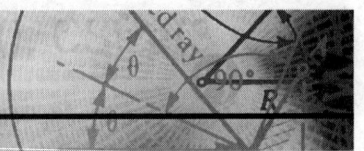

725 *Exporting Images Using ImageReady*

ImageReady is Adobe's Web image-manipulation program. Graphics opened in ImageReady convert easily into Web animations, sliced for display in an HTML table or converted into rollovers. ImageReady lets you create image maps, generate 3-D buttons, and compress images for quick loading onto Web pages. It is a very versatile program.

One more feature of ImageReady is its capability to save files in non-Web formats. Say, for example, that you create a 3-D button using ImageReady and you want to save the file in format useable by PowerPoint, such as TIFF or BMP.

To save an ImageReady graphic in a non-Web format, open the graphic and perform these steps:

1. Select the File menu, and choose Export Original from the pull-down menu. ImageReady opens the Export Original dialog box, shown in Figure 725.1.

Figure 725.1 *The Export Original dialog box controls the format of the saved file.*

2. In the Name input field, enter a name for the graphic.

3. Click on the Format button and select a format from the drop-down list. In this example, you select TIFF as the saved format, as shown in Figure 725.2.

4. Click the Save button to save the file to disk.

Note: ImageReady extends the capabilities of programs such as Photoshop by giving you the option to create and save graphic images in formats other than the standard Web formats of GIF, JPEG, and PNG.

Figure 725.2 Clicking on the Format button displays a list of available file formats.

726 *Viewing Cross-Platform Differences on Your Monitor*

When you display images on the World Wide Web, the output monitor determines the image's color and size. Computer monitors come in all sizes and shapes, from large 21-inch design monitors to small 9-inch grayscale monitors. Not only do you have to take into account monitor size, but you also must understand the difference between the Windows and the Macintosh operating systems.

The average Windows monitor displays images using a gamma of 2.2, and the average Macintosh monitor uses a gamma of 1.8. The gamma rating of a monitor determines the midpoint between light, dark and shades of gray or color. Simply stated, an image displayed on a Windows monitor appears 20 percent darker than the same image viewed on a Macintosh monitor. Macintosh and Windows also use a different color set for displaying images. As a Web designer, you control what the image looks like, but you cannot control how your images are displayed.

To view an image using the Macintosh or Windows display, open the graphic in ImageReady and perform these steps:

1. Move your cursor into the document window and right-click your mouse (Macintosh: Ctrl+click). Photoshop displays a context-sensitive menu displaying the document options, as shown in Figure 726.1.

2. Select Display Preview and choose Standard Windows Color or Standard Macintosh Color from the fly-out menu. ImageReady displays the graphic using the gamma and color set of the selected platform, as shown in Figure 726.2.

3. Select Uncompensated Color to return the image to its original monitor, based on your specific platform and monitor.

Note: View the image using the Macintosh and Windows platforms gives you an idea of how your Web images will look using different operating systems.

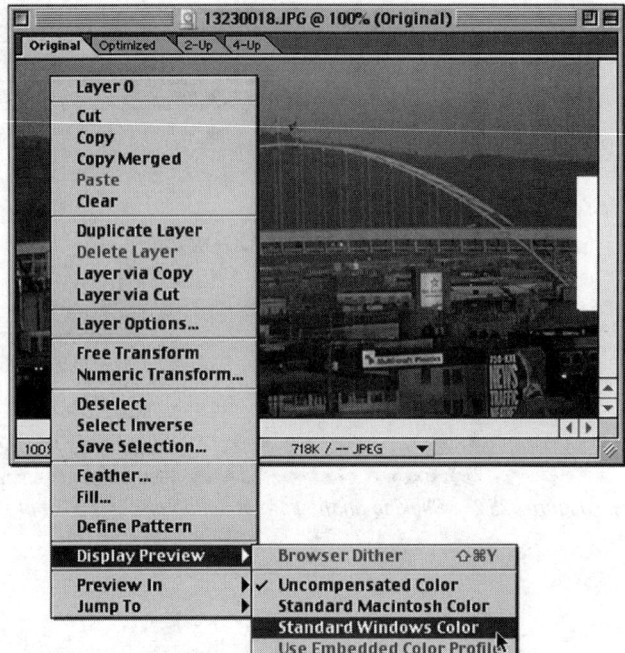

Figure 726.1 Right-clicking your mouse (Macintosh: Ctrl+clicking) displays a context-sensitive menu.

Figure 726.2 An image displayed using the Macintosh and Windows platforms.

727 *Adjusting the Gamma of an Image Using ImageReady*

In the previous tip, you learned how to view an image using the Macintosh and Windows platforms. Viewing the image gives you an idea of whether the graphic works on both systems. Say, for example, that you view an image and realize that the image appears correctly using the Windows platform, but Web browsers using the Macintosh platform cause the image to appear too light, as shown in Figure 727.1.

Figure 727.1 The image appears too light when viewed using the Standard Macintosh Color option.

To adjust the gamma of the image, select the Image menu, choose Adjust, and then select Levels from the fly-out menu. Photoshop opens the Levels dialog box, shown in Figure 727.2.

Figure 727.2 The Levels dialog box controls the relative gamma of the active image.

Click on the middle gamma slider and move to the right. Moving the slider to the right decreases the gamma of the image and darkens the image. Occasionally stop and view the image using the Standard Macintosh Color option (refer to the previous tip). When the image appears acceptable, click the OK button to record the changes to the image, as shown in Figure 727.3.

Note: Because images are viewed using the Macintosh and Windows operating systems, you should lighten or darken the image using levels until the graphic is acceptable for both platforms.

Figure 727.3 The Levels command successfully darkened the image.

728 *Optimizing an Image by File Size*

ImageReady lets you optimize an image by selecting a specific file size. Say, for example, that you need to save an ImageReady file using a specific file size of 15K.

To optimize the image, open the file and perform these steps:

1. If the Optimize palette is not visible, select the Window menu and then choose Show Optimize from the pull-down menu. ImageReady opens the Optimize palette, shown in Figure 728.1.

Figure 728.1 The Optimize palette controls the characteristics of the active file.

2. Click on the black triangle button, located in the upper-right corner of the Optimize palette. ImageReady displays the Optimize options in a fly-out menu.

3. Select Optimize to File Size from the fly-out menu. ImageReady opens the Optimize to File Size dialog box, shown in Figure 728.2.

4. In the Desired File Size box, enter a value of 15.

5. Select Current Settings to maintain the previously selected file format. Select Auto Select GIF/JPEG to let ImageReady decide the best format for the image. In this example, you select Current Settings.

6. Click the OK button to record the change to the image, as shown in Figure 728.3.

Figure 728.2 The Optimize to File Size dialog box controls the size of the active image.

Figure 728.3 The Optimize to File Size command successfully reduced the size of the active image.

Note: *If the new file size creates an unacceptable image, select the Edit menu and choose Undo from the pull-down menu. Then try again using different optimize settings.*

729 *Understanding File Compression in ImageReady*

Due to the slow speeds of most Internet connections, compression of images becomes a part of life as a Web designer. ImageReady uses two standard Web compression schemes: JPEG and GIF. Although the Graphic Interchange Format (GIF) and the Joint Photographic Experts Group (JPEG) formats are commonly thought of as file formats, they are essentially compression schemes.

The GIF format (see Tip 579, "Understanding Color Depth and GIF Images") compresses images using Run Length Encoding (RLE). RLE compression bases file reduction on the number of colors within the original image. The fewer the colors, the smaller the file, as shown in Figure 729.1.

Figure 729.1 GIF images compress based on the number of colors in the original image.

In its pure form, GIF compression is considered lossless, or compression without loss of information. Images compressed using the GIF format uncompress and display exactly like the original image. Because of its compression-by-color method of file reduction, GIF compression is used primarily to reduce the file size of clip art, text, and line drawings.

The JPEG format (see Tip 852, "Understanding the JPEG File Format") reduces file size by removing color from the original image in compression scheme called lossy, or compression by loss of information. Images compressed using the JPEG format are not the same when reopened. The reasoning behind lossy compression deals with the speed of the downloadable image. In the case of JPEG-compressed images, quality is sacrificed for speed in downloading the image, as shown in Figure 729.2.

Figure 729.2 The JPEG format sacrifices quality for download speed.

730 *Creating Your Own Optimization Settings*

In the previous tip, you learned about the two major compression schemes used by ImageReady. When you compress an image using the JPEG or GIF formats, you control the compression using optimizing options. In many cases, the standard compression settings do not fit the current workflow. Say, for example, that you create a customized compression setting for one graphic, and you want to apply the same optimization settings to several more graphics.

To save customized optimization settings and reapply them to another image, open the original image in ImageReady and perform these steps:

1. If the Optimize palette is not visible, select the Window menu and then choose Show Optimize from the pull-down menu. ImageReady opens the Optimize palette, shown in Figure 730.1.

Figure 730.1 The Optimize palette controls the characteristics of the active file.

2. Select the correct optimization settings using the available options (see Tip 731, "Using the Optimize Settings for a JPEG Image"). In this example, you select the JPEG option using Medium quality, and you select the Optimized and Progressive options (refer to Figure 730.1).

3. Click on the black triangle button, located in the upper-right corner of the Optimize palette. ImageReady displays the Optimize options in a fly-out menu.

4. Select Save Settings from the fly-out menu. ImageReady opens the Save Optimizations Settings dialog box, shown in Figure 730.2.

Figure 730.2 The Save Optimization Settings dialog box controls the size of the active image.

5. Click in the Name input box and name the settings. In this example, you name the file "jpeg_medium." The file must be saved in the Optimized Settings folder (refer to Figure 730.2). Saving the settings file in any other folder will prevent you from accessing the file from the Optimize palette pop-up list.

6. Click the Save button to save the file.

To apply the jpeg_medium compression settings to a second image, open the image in ImageReady and perform these steps:

1. Move your mouse into the Optimize palette and click once on the Settings button. ImageReady displays the available options in a pop-up menu.

2. Select jpeg_medium from the pop-up list. ImageReady applies the jpeg_medium compression settings to the active image.

3. Select File menu, and choose Save Optimized to save the file to disk.

Note: After you save an Optimize Settings file, it becomes available every time you open ImageReady.

731 *Using the Optimize Settings for a JPEG Image*

When you save a file using the JPG (Joint Photographic Experts Group) file format, ImageReady lets you control the compression scheme.

If the Optimize palette is not visible, select the Window menu and then choose Show Optimize from the pull-down menu. Photoshop opens the Optimize palette. Click the Optimized File Format option and select JPEG from the drop-down list, as shown in Figure 731.1.

Figure 731.1 The Optimize palette displays the options for JPEG compression.

The following options are available for the JPEG compression scheme:

- **Optimized:** Select the Optimized option to create a smaller enhanced version of the JPEG image. The Optimized option creates a smaller file; however, older browsers do not support the Optimized option.

- **Compression Quality:** Click on the Compression Quality button and select from the available options, or click in the Quality input box and enter a value from 0 to 100 percent. The lower the value is, the more color information is removed from the image. Average Web images compress using values between 20 and 40 percent.

- **Progressive:** The Progressive option displays the JPEG image using three passes. When the image is loaded into the Web browser, every third scan line loads, creating a blurred, quick-loading image. The browser then makes two more passes through the image, filling in the scan lines. The Progressive option does not work on older browsers.

- **Blur:** In the Blur input box, enter a value from 0 to 2. The blur options blurs the image colors, creating an image with a smaller file size.

732 *Using the Optimize Settings for a GIF Image*

When you save a file using the GIF (Graphic Interchange File) format, ImageReady lets you control how the GIF format compresses the image.

If the Optimize palette is not visible, select the Window menu and then choose Show Optimize from the pull-down menu. Photoshop opens the Optimize palette. Click the Optimized File Format option and select GIF from the drop-down list, as shown in Figure 732.1.

Figure 732.1 The Optimize palette displays the options for GIF compression.

The following options are available for the JPEG compression scheme:

- **Lossy:** Select the Lossy option to remove color information from a GIF image. In the Lossy input box, enter a value from 0 to 100 percent. The higher the value is, the greater the loss of image information will be. Normally, the GIF format is considered lossless, or compression without removing color information from the file. The Lossy option lets you remove color from the image to further reduce the size of the file. Remember, lossy compression removes color from the image. After the image is saved, the lost color information cannot be recovered.

- **Selective:** The Selective option lets you control the color gamut of the active image. Click on the Selective option and choose from the available color gamut options.

- **Colors:** Click on the Colors option and choose between 2 and 256 colors for the saved image. Reducing the number of colors in the image further reduces the size of the file.

- **Dither:** Click on the Dither option and choose from the available dither options. The Dither option adds a predefined pattern to the image to reduce color banding. If you select Diffusion as the Dither option, ImageReady lets you choose the amount of diffusion introduced to the image. In the Dither input box, enter a value from 0 to 100 percent. The higher the value is, the more dithering is introduced into the active image.

733 *Using the Optimize Settings for a PNG-8 Image*

When you save a file using the PNG (Portable Network Graphic) file format, ImageReady lets you control the compression scheme of the saved file.

If the Optimize palette is not visible, select the Window menu and then choose Show Optimize from the pull-down menu. Photoshop opens the Optimize palette. Click the Optimized File Format button and select PNG-8 from the list of available file formats, as shown in Figure 733.1.

Figure 733.1 The Optimize palette displays the options for PNG-8 compression.

The following options are available for the PNG-8 compression scheme:

- **Color Reduction:** The Color Reduction option lets you control the colors within the image by the selection of a specific color space. Click on the Color Reduction option and choose from the available color gamut options.

- **Colors:** Click on the Colors option and choose between 2 and 256 colors for the saved image. Reducing the number of colors in the image further reduces the size of the file.

- **Dither:** Click on the Dither button and choose from the available dither options. The Dither option adds a predefined pattern to the image to reduce color banding. If you select Diffusion as the Dither option, ImageReady lets you choose the amount of diffusion introduced to the image. In the Dither input box, enter a value from 0 to 100 percent. The higher the value is, the more dithering is introduced into the active image.

734 *Using the Optimize Settings for a PNG-24 Image*

When you save a file using the PNG (Portable Network Graphic) file format, ImageReady lets you control the compression scheme of the saved file.

If the Optimize palette is not visible, select the Window menu and then choose Show Optimize from the pull-down menu. Photoshop opens the Optimize palette. Click the Optimized File Format option and select PNG-24 from the drop-down list, as shown in Figure 734.1.

Figure 734.1 The Optimize palette displays the options for PNG-24 compression.

The following options are available for the PNG-24 compression scheme:

- **Interlaced:** When selected, the Interlaced option downloads the image using multiple passes. The Interlaced option displays the PNG-24 image using three passes. When the image is loaded into the Web browser, every third scan line loads, creating a blurred, quick-loading image. The browser then makes two more passes through the image, filling in the scan lines. The Interlaced option works with most browsers.

- **Transparency:** When selected, the Transparency option preserves the transparency in the active image. The PNG-24 format supports up to 256 levels of transparency.

- **Matte:** When selected, the Matte option simulates transparency by filling the transparent areas of the original image with a specific color. Click on the Matte button and select None, Foreground Color, or Background Color, or choose from the available color selections. The effect works best when the image loads into a solid-color Web page.

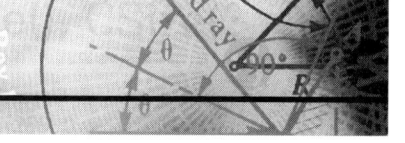

735 *Printing Spot Color Channels*

spot color channels will overprint all other image colors (refer to Tip 258, "Creating a Spot Color Plate in Photoshop"). If your image contains more than one spot color channel, the stacking order of the channels in the Channels palette controls how the colors print on the image.

Sometimes it is necessary to knock out, or remove, a portion of an underlying spot color channel, as shown in Figure 735.1.

Figure 735.1 You create knockouts in underlying spot color channels to prevent the colors from overprinting.

To determine how a multi-channel spot color document will print, it may be necessary to produce a composite proof on a color printer. To create a spot color proof image, open the graphic in Photoshop and perform these steps:

1. If the Channels palette is not visible, select the Window menu and then select Show Channels from the pull-down menu. Photoshop opens the Channels palette.

2. Click on the black triangle button, located in the upper-right corner of the Channels palette. Photoshop displays the Channels options in a pop-up menu. Select Merge Spot Channel from the fly-out menu. Photoshop merges the spot color channels with the other channels in the image, as shown in Figure 735.2.

Figure 735.2 The Channels palette now contains an image with merged spot channels.

3. Select File menu Print from the pull-down menu. Photoshop opens the Print dialog box. Click the Print button to print the image on your color inkjet or laser printer.

> *Note: Because you can not print spot color channels on an inkjet or color laser printer, the Merge Channels options give you the capability to proof the document. Retain a copy of the original image for your service bureau.*

736 *Blending RGB Colors Using the Gamma Option*

To open the Color Settings dialog box select Edit menu and choose Color

Settings from the pull-down menu. The Blend RGB Colors Using Gamma option is located in the advanced mode of the Color Settings dialog box (refer to Tip 261, "Editing Photoshop's Color Settings"), as shown in Figure 736.1.

In the Blend RGB Colors Using Gamma input box, enter a value from 1.00 to 2.20. A value of 1.00 is considered color-correct. When this option is disabled, the RGB color mixes directly on the monitor. Most other applications use this same method of color blending.

In some cases, older graphic programs, such as early versions of CorelDraw!, and the Microsoft Paint program used a different RGB gamma-blending mode, resulting in artifacts surrounding the edge of image colors. If you experience artifacts, or edge colors, when moving Photoshop images into older versions of image-editing programs, activate this option and experiment with different values until the artifact colors in the saved RGB image are removed.

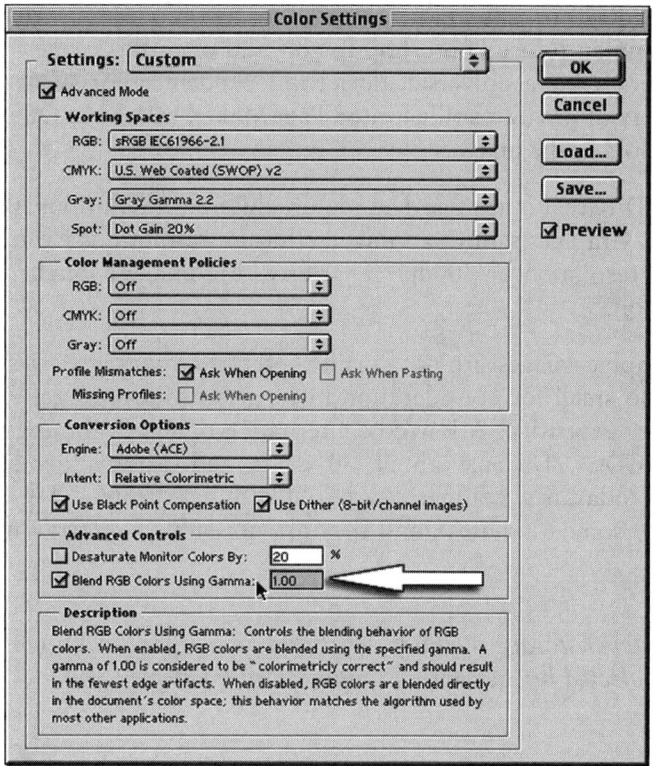

Figure 736.1 The Blend RGB Colors Using Gamma option controls how the colors in the active image are blended.

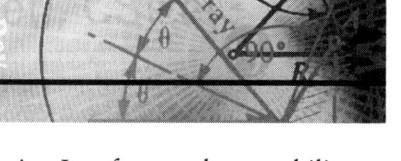

737 *Creating a Master Image*

The word *multi-purpose* is growing in the desktop publishing community. It refers to the capability to save an image and use that image for a variety of purposes. When you create an image in Photoshop and transfer it into another program, it is possible (if not extremely likely) that you will use the image in another program or in another way. Say, for example, that you create a low-resolution image for use within a PowerPoint presentation. Then, two weeks later, you want to use the image in a magazine spread. Unfortunately, you cannot use a low-resolution PowerPoint image in a magazine.

When you set up an image for transfer into multiple programs, it is an excellent idea to have one master image of correct size and resolution to let you transfer the image into any conceivable format.

Use these guidelines when creating a master image:

- **File format:** Save images using the TIFF format. The TIFF format is a universally accepted format, usable on Macintosh and Windows platforms. A typical TIFF image contains a maximum of 17.7 million possible colors per pixel, and almost any image-editing program accepts the TIFF format.

- **Compression:** Avoid compressing the digital images. It is true that compression schemes such as Zip will considerably reduce the size of the stored image. Unfortunately, compression schemes change and evolve just like programs; if you compress the files, you will need the uncompress program to open the files. If you lose the uncompress program, you will not be able to open the image files.

- **Color space:** RGB or Lab color are the two best modes to save and preserve a document's color space. If you plan to use Photoshop to edit and open the images, the Lab color space will save the image's colors using a universal, device-independent color space. If you plan to open the images using a variety of programs (Illustrator, PageMaker, InDesign, Quark), then RGB is a safe bet to preserve the colors in the image.

- **Resolution:** Different output devices require different resolutions. PowerPoint images are saved using 72 to 96ppi. Graphics sent to an imagesetter use resolutions from 120 to 240ppi. Save your master images at a resolution of 300dpi. That gives the image enough pixel information to work in any given situation.

- **Storage:** Graphic images are not small; therefore, saving the files becomes an important decision. Disks are too small for consideration in long-term file storage. Zip and Jaz drives give you more space but are expensive. A low-cost alternative that is becoming popular is storing the images on write-once CDs. CDs cost about 50 cents and store approximately 650MB of information. Increasingly today, new computers are sold with rewriteable CDs. CDs last for many years (25 years or longer, by some estimates), and they are not subject to stray magnetic fields and moisture, like disks.

Note: Whatever storage method you choose, use a good cataloging system that will let you retrieve the selected images with a minimum of hassle.

738 *Regenerating ImageReady's Color Space*

When you open a graphic in ImageReady, the Color Table displays a swatch representing every color within the optimized image, as shown in Figure 738.1.

Figure 738.1 The Color Table displays all the colors in the active ImageReady graphic.

Say, for example, that you want to replace one of the colors in the active image. To replace a color in the active image, open the graphic in ImageReady and perform these steps:

1. If the Color Table is not visible, select the Window menu and then select Show Color Table from the pull-down menu. Photoshop opens the Color Table palette, shown in Figure 738.1.

2. Move your mouse into the Color Table palette and double-click on the color swatch that you want to change. ImageReady opens the Color Picker dialog box, shown in Figure 738.2. Select the Only Web Colors option to display the Web Safe color palette.

Figure 738.2 The Color Picker dialog box displays the Web Safe color palette.

3. Click in the color box and select the color visually, or type in the correct RGB, HSB, or Web code for the color.

4. Click the OK button to close the Color Picker dialog box and record your change to the color swatch.

5. If the Optimize palette is not visible, select the Window menu and then select Show Color Table from the pull-down menu. Photoshop opens the Optimize palette, shown in Figure 738.3.

Figure 738.3 The Optimize palette controls the characteristics of the active image.

6. Click on the black triangle button, located in the upper-right corner of the Optimize palette. ImageReady displays the Optimize options in a pop-up menu. Select Regenerate from the fly-out menu. Photoshop changes the colors in the active image, based on your changes to the color table, as shown in Figure 738.4.

Figure 738.4 The Regenerate command remaps the colors in the active image, based on changes made to the Color Table.

Note: If you want ImageReady to regenerate the colors in the active image automatically, select Auto Regenerate from the Optimize options fly-out menu.

739 Outputting to the Web

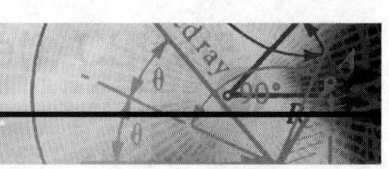

In Tip 737, "Creating a Master Image," you learned how to save Photoshop images for use in a variety of output situations. When you prepare images for the Web, there are certain formatting options to consider before saving the file.

- **File format GIF:** Save clip art text and line art using the GIF file format. GIF images use a color table with a maximum of 256 colors and are ideal for small, quick-loading clip art and text converted into a graphic format.

- **File format JPEG:** Use the JPEG compression format to save photographic images. Photographs typically contain thousands of colors. The JPEG format reduces the number of colors in the image and then uses a dither/blending algorithm to let the eye view the missing colors.

- **File format PNG:** Although the PNG format is a versatile combination of the JPEG and PNG formats, its use on the Internet is limited. Use the PNG format to save images for use in Flash and LiveMotion Web animation.

- **Color space:** RGB is the color space of the World Wide Web. Create the images in the RGB color space, and then use programs such as Photoshop and ImageReady to pull the color table into a Web Safe palette (refer to Tip 553, "Creating Web Safe Colors from the RGB Color Palette").

- **Resolution:** Currently, the Internet is divided into two resolutions: 96ppi for Windows and 72ppi for Macintosh. Most Web designers agree that if you plan for images to be viewed by both the Windows and Macintosh platforms, save the images at a resolution of 72ppi.

Note: The Internet, like most other computer-related devices, is changing on a regular basis. Case in point: The World Wide Web Consortium is considering whether to increase the recommended Internet Web resolution to a 96ppi standard. How this and other changes affect you depends on what you are currently doing with the Internet. It is easy to get left behind in this fast-changing industry. Keep up with changes by research and reading.

740 Printing a Grayscale Image with a Pantone Tint

To apply a Pantone tint to a grayscale image, open the image in Photoshop and perform these steps:

1. Select the Image menu and choose Mode, and then select Duotone from the fly-out menu. Photoshop opens the Duotone Options dialog box, shown in Figure 740.1.

2. Click the Type option and select Monotone from the drop-down list.

Figure 740.1 The Duotone Options dialog box controls the application of color to a grayscale image.

3. Click on the Ink 1 color square. Photoshop opens the Custom Colors dialog box, shown in Figure 740.2.

Figure 740.2 The Custom Colors dialog box gives you access to the Pantone color palette.

4. Select a Pantone color. In this example, you choose a Pantone 492 CVC Brown (refer to Figure 740.2).

5. Click the OK button to record the change to the Ink 1 color box.

6. Click on the Ink 1 Curve box, located to the left of the color box. Photoshop opens the Duotone Curve dialog box, shown in Figure 740.3.

Figure 740.3 The Duotone Curve dialog box controls the amount of the Pantone color applied to the image.

7. In the 100 percent input field, enter the percentage of Pantone 492 CVC that you want to apply to the image. In this example, you choose a percentage of 60 percent; refer to Figure 740.3.

8. Click the OK button to apply the curve adjustment to the ink, and click the OK button in the Duotone Options dialog box to apply the ink to the image, as shown in Figure 740.4.

Figure 740.4 The Duotone option successfully applied 60 492 CVC brown to the grayscale image.

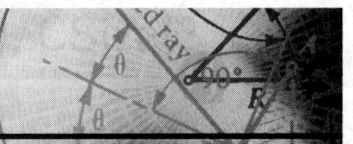

741 *Using Web Snap to Convert an Image into a Web Safe Palette*

When you work on a graphic in ImageReady, the goal is to produce a fast-loading image using colors that conform to the Web Safe color palette. When you use Web Snap, ImageReady lets you control the shifting of the colors within a Web image.

To shift the colors in a graphic image, open the document in ImageReady and perform these steps:

1. If the Optimize palette is not visible, select the Window menu, and select Show Color Table from the pull-down menu. Photoshop opens the Optimize palette, shown in Figure 741.1.

Figure 741.1 The Optimize palette controls the characteristics of the active image.

2. Click on the File Format button and select GIF from the available options (refer to Figure 741.1).

3. Click on the black triangle button, located in the upper-right corner of the Optimize palette. ImageReady displays the Optimize options in a pop-up menu. Select Show Options from the fly-out menu. Photoshop expands the Optimize palette.

4. To remap the colors in the active image, click on the black triangle button, located in the upper-right corner of the Optimize palette. ImageReady displays the Optimize options in a pop-up menu. Select Regenerate from the fly-out menu. Photoshop changes the colors in the image to reflect changes made to the Color Table, as shown in Figure 741.2.

Figure 741.2 The Regenerate command remaps the colors in the active image, based on changes made to the Color Table.

4. In the Web Snap input box, enter a value from 0 to 100 percent. The higher the value is, the greater the shift to the Web Safe palette will be. A value of 100 percent shifts all the colors in the active image. A value of 0 preserves the original colors in the active image.

742 *Setting Up Web Safe Artwork When Using Photoshop*

One of the biggest problems when setting up artwork for display on the Web is keeping the color Web Safe. Maintaining a Web Safe color palette is easy when you create the image in ImageReady. However, you will encounter problems in Photoshop. To maintain consistent Web Safe colors when working in Photoshop, open an RGB document and perform these steps:

1. Select the Image menu and choose Mode, and choose Indexed Color from the pull-down menu. Photoshop opens the Indexed Color dialog box, shown in Figure 742.1.

2. Click on the Palette option and choose Web from the drop-down list. Photoshop converts the color in the image into the Web Safe palette. The Colors counter displays the number 217, or the maximum colors available to an image.

3. Click on the OK button to change the active image, as shown in Figure 742.2.

4. Select the Image menu, choose Mode, and select RGB from the fly-out menu. Photoshop returns the image to the RGB (red, green, and blue) color space.

5. Select the Image menu, choose Mode, and select Indexed Color from the fly-out menu. Photoshop opens the Indexed Color dialog box. The Palette options displays the name Exact, and the Colors counter indicates the exact number of colors in the converted image, as shown in Figure 742.3.

Figure 742.1 The Indexed Color dialog box controls the color space of the active Photoshop document.

Figure 742.2 The Web Safe color palette is applied to the active image.

Figure 742.3 The Indexed Color palette displays an exact color palette.

6. Click on the OK button to record the changes to the image.

Note: Converting and reconverting the image into the Indexed Color space forces Photoshop to reduce the image's file size to the smallest possible value.

743 *Creating a Custom Palette for Indexed Images*

Photoshop lets you create a custom palette based on one or more Photoshop images. Custom palettes are useful for generating consistent color between documents. Say, for example, that you have three images, and you want to create a single color palette, based on the colors within the three images.

To create a custom color palette from three images, perform these steps:

1. Move all three Photoshop images into a newly created folder. In this example, you created a new folder called PS_Images.

2. Open Photoshop and select the File menu, choose Automate, and choose Contact Sheet II from the fly-out menu. Photoshop opens the Contact Sheet II dialog box, shown in Figure 743.1.

Figure 743.1 The Contact Sheet II dialog box controls the characteristics of the contact sheet.

3. Click on the Choose button and select the PS_Images folder. Select a resolution of 72ppi and a color space of RGB (refer to Tip 430, "Generating a Contact Sheet from a Group of Photoshop Images").

4. Click on the OK button to generate the contact sheet, shown in Figure 743.2.

5. Select the Image menu, choose Mode, and choose Indexed Color from the fly-out menu. Photoshop opens the Indexed Color dialog box, shown in Figure 743.3.

6. Click on the Palette option and select Local (Adaptive) from the drop-down list.

7. Click on the Forced option and choose Primaries from the drop-down list.

8. Select the Transparency option.

9. Click on the Dither option and choose None from the drop-down list.

10. Click on the OK button to close the Indexed Color dialog box.

11. Select the Image menu, choose Mode, and choose Color Table from the fly-out menu. Photoshop opens the Color Table dialog box, shown in Figure 743.4.

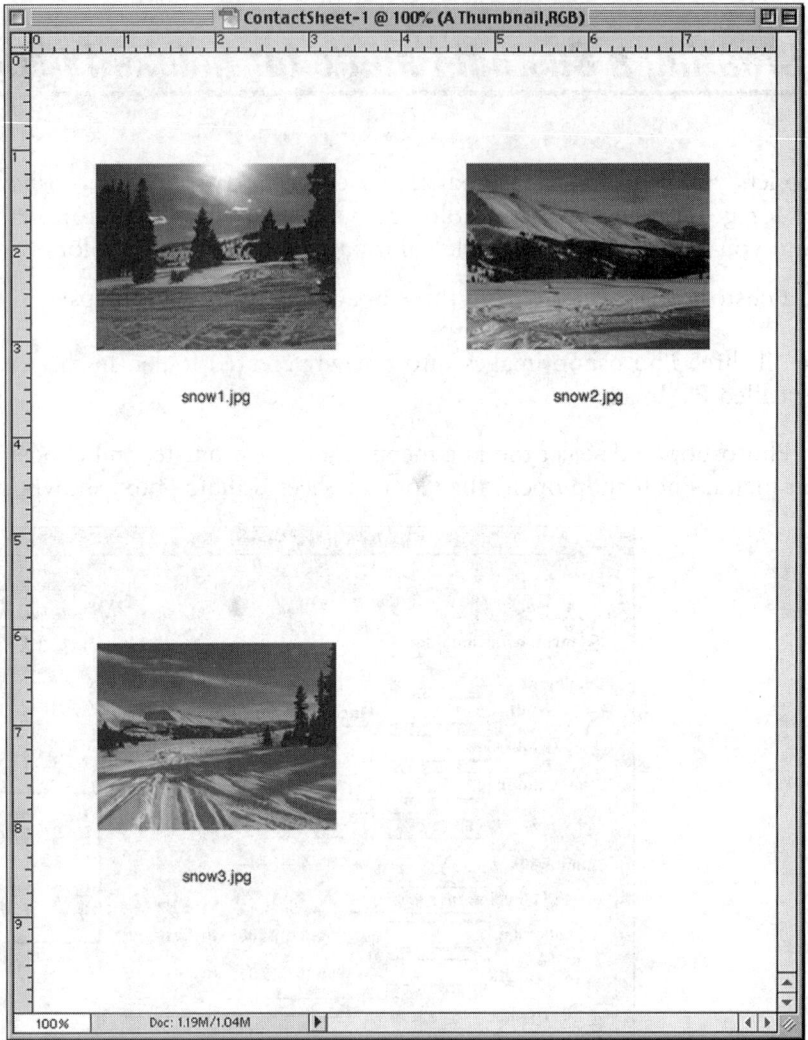

Figure 743.2 The Contact Sheet option creates a contact sheet from graphics in the selected folder.

Figure 743.3 The Indexed Color dialog box lets you create a customized color palette.

12. Click on the Save button. Photoshop opens the Save dialog box, shown in Figure 743.5.

13. In the Name input field, name the file. In the example, you choose the name table_1.act. Click on the Save button to save the file to disk.

Note: Once a color table is saved to disk, you can use the color table to remap the colors in any Photoshop document.

Figure 743.4 The Color Table dialog box displays the customized color table.

Figure 743.5 The Save dialog box lets you save customized color tables.

744 *Using a Custom Color Table*

In the previous tip, you learned how to create a custom color table based on several Photoshop documents. To apply the custom table to another Photoshop document, open the image in Photoshop and perform these steps:

1. Select the Image menu, choose Mode, and choose Indexed Color from the fly-out menu. Photoshop opens the Indexed Color dialog box, shown in Figure 744.1.

2. Click on the Palette option and choose Custom from the drop-down list. Photoshop opens the Color Table dialog box, shown in Figure 744.2.

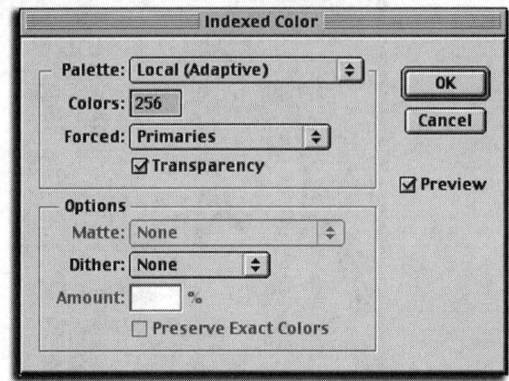

Figure 744.1 The Indexed Color dialog box controls the mapping of the colors in the active image.

Figure 744.2 The Color Table displays the colors available in the active image.

3. Click on the Load button. Photoshop displays the Open dialog box. Select the table_1.act file created in the previous tip.

4. Click on the Open button. Photoshop loads the table_1.act file into the Color Table. Click on the OK button to close the Color Table and apply the color table, as shown in Figure 744.3.

5. Click on the OK button in the Indexed Color dialog box to record the changes to the active image.

Note: Using custom color tables lets you generate a consistent color space for your graphic images. Custom color tables are especially useful when working with Web graphics.

Figure 744.3 The active image displays the colors from the table_1.act color table.

745 *Applying a Gradient to a GIF Image*

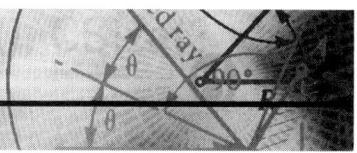

When you create a gradient for use on a Web page, you typically save the image using the GIF format. It is important to understand how the GIF format compresses the image. The GIF format compresses the color in an image by horizontal lengths, as shown in Figure 745.1.

Figure 745.1 The GIF format compresses an image by reducing horizontal lengths of similar color.

When you create a gradient, make sure that the gradient runs top to bottom. GIF images using top-to-bottom gradients compress small than GIF images using gradients at an angle, as shown in Figure 745.2.

Figure 745.2 Top-to-bottom gradients compress smaller than gradients set at an angle.

746 *Adjusting the Color Picker to Display Web Colors*

When you work on Web images, it is important to keep the images within the Web Safe color palette. Photoshop gives you several ways to convert an image into Web Safe colors. However, to create an image from scratch, you want to select colors that represent only the Web Safe colors.

To convert Photoshop's color picker to Web Safe, open an image in Photoshop and perform these steps:

1. Click once on the Foreground Color Swatch, located at the bottom of the toolbox. Photoshop opens the Color Picker dialog box, shown in Figure 746.1.

Figure 746.1 The Color Picker dialog box lets you select colors using the color slider and the color box.

2. Select the Only Web Colors option, located at the bottom left of the Color Picker dialog box, as shown in Figure 746.2.

3. Select a Web Safe color by dragging the color slider up or down and clicking within the color box.

4. Click on the OK button to apply the Web Safe color to the Foreground Color Swatch.

Figure 746.2 Selecting the Only Web Colors option causes the Color Picker to display the Web Safe color palette.

747 *Previewing the Dither of a Web Image*

When a Web image displays on a user's monitor, the colors in the image shift to fit the color space of that particular monitor's color space. Web designers compensate for monitor differences by using the Web Safe color palette. The Web Safe color palette is a gamut of color that displays equally well on Macintosh and Windows monitors. When a monitor cannot display the colors within an image, the computer dithers, or mixes, its available colors to display the missing colors.

Image dithering can produce an undesirable look to an image, especially in a photographic image. To view how an image looks when low-end monitors dither the image colors, open the image in Photoshop and perform these steps:

1. Select the File menu, and choose Save for Web from the pull-down menu. Photoshop opens the Save for Web dialog box, shown in Figure 747.1.

Figure 747.1 The Save for Web dialog box controls the characteristics of the Web graphic.

2. Click once on the triangle button, located in the upper-right corner of the dialog box. Photoshop displays the Preview Mode options, as shown in Figure 747.2.

Figure 747.2 The Preview Mode options let you view the image using different monitor color spaces.

3. Select Browser Dither from the pop-up menu. Photoshop displays the image using an 8-bit Web Safe palette; colors outside the Web Safe palette are dithered, as shown in Figure 747.3.

Figure 747.3 The image displayed using a dithered Web Safe color palette.

748 *Converting an Image into Web Safe Colors with the Click of a Button*

In Tip 742, "Setting Up Web Safe Artwork When Using Photoshop," another way to shift an image into the Web palette is to use Photoshop's Save for Web command.

To shift an image into the Web Safe color palette, open the image in Photoshop and perform these steps:

1. Select the File menu, and choose Save for Web from the pull-down menu. Photoshop opens the Save for Web dialog box, shown in Figure 748.1.

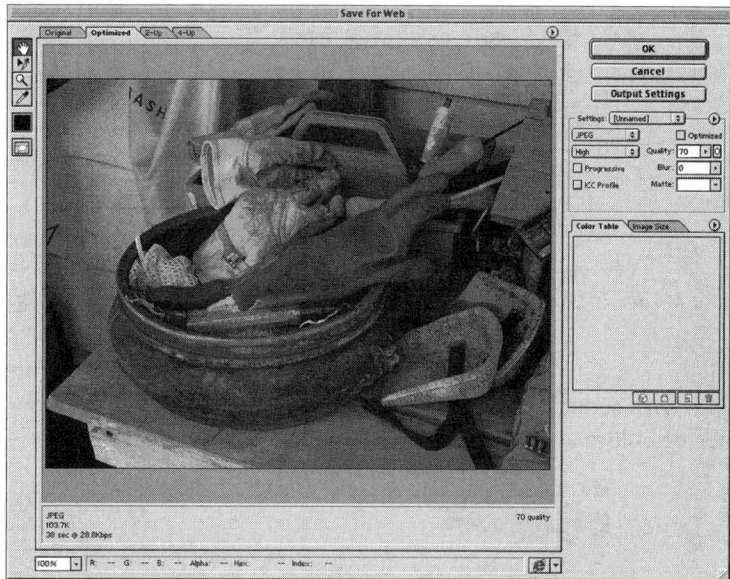

Figure 748.1 The Save for Web dialog box controls the characteristics of the Web graphic.

2. Click on the Color Space option and select Web from the drop-down list, as shown in Figure 748.2.

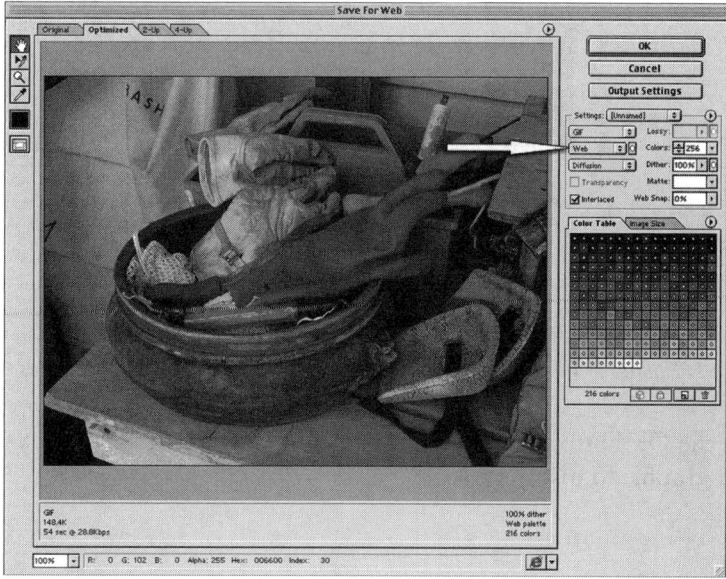

Figure 748.2 The Web option automatically converts the image into the Web Safe color palette.

3. To further reduce the size of the GIF file, click on the Colors option. Photoshop displays a list of numbers from 2 to 256 in a drop-down list. The list represents the maximum number of colors available to the active graphic image, as shown in Figure 748.3.

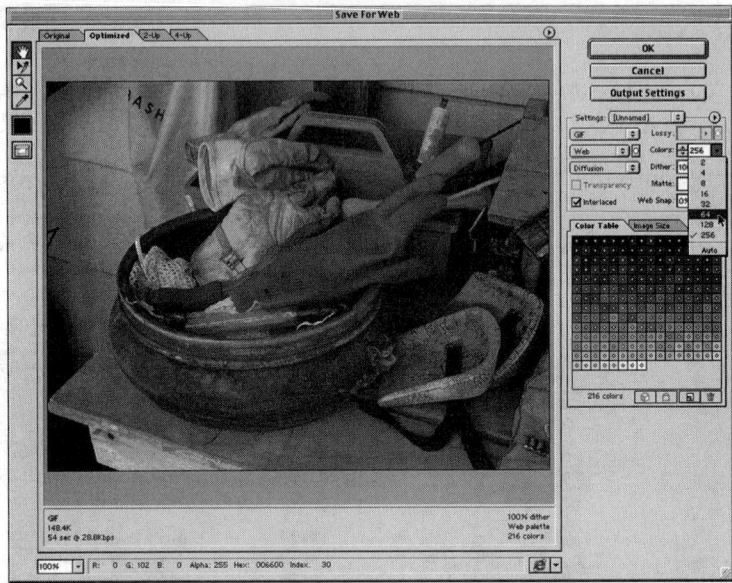

Figure 748.3 The Colors option lets you control the maximum number of colors available to the GIF image.

4. When you save a GIF image, the fewer colors are within the image, the smaller the file size is. Experiment with reducing the number of available colors; stop when the image displays the smallest number of colors and still looks acceptable, as shown in Figure 748.4.

Figure 748.4 Reducing the available color within a GIF image reduces the graphic's file size.

5. Click on the OK button. Photoshop opens the Save dialog box. Click on the Save button to save the modified graphic to disk.

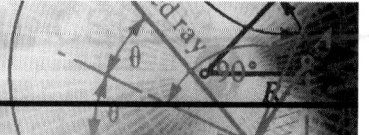

749 *Recompressing a Compressed Image*

When you save images for display on the Internet, the two most common compression formats are JPEG (Joint Photographic Experts Group) and GIF (Graphics Image Format). The JPEG format has always used lossy compression, and now the GIF format lets you employ lossy compression (refer to Tip 732, "Using the Optimize Settings for a GIF Image").

Lossy compression reduces the size of the file by removing color information. After an image compresses using a lossy format, the original data is no longer available to the image. Lossy compression is used for one reason: download speed. Web designers sacrifice some of the quality of the image, as a trade-off for faster downloads of their images.

Lossy compression is progressive compression. Every time you save a lossy compressed image, the compression scheme attempts to compress the image further. Say, for example, that you open a JPEG compressed image in Photoshop. You begin to edit the image, and every few minutes you save the image to disk by selecting File menu's Save command. Resaving the image further degrades the image information, as the JPEG compression scheme attempts to recompress the image information. The more you resave the image, the more the JPEG compression scheme removes color information, creating a poor-quality graphic, as shown in Figure 749.1.

Figure 749.1 Resaving a JPEG or lossy compressed GIF image degrades the quality of the image.

When you work on a graphic image, before you convert the image into a JPEG- or GIF-formatted document, make a copy of the image and convert the copy. That way, if you need to perform additional editing to the image, you can return to the original graphic and perform the necessary editing. When it is time to save the image into the JPEG or GIF formats, make a copy of the original image and then convert the copy.

> *Note: Making copies of an image before a major editing change gives you the capability to return the image to its original state. Try not to burn your bridges; make copies of important images as you work.*

750 *Previewing an Image in a Browser Using Photoshop*

When you work on Web graphics, you want the image to look good on your monitor; however, you also want to see how the image displays using a Web browser such as Navigator and Explorer. To view a Web graphic in a browser window, open the image in Photoshop and perform these steps:

1. Select the File menu, and choose Save for Web from the pull-down menu. Photoshop opens the Save for Web dialog box.

2. The Select Browser button is located on the bottom right of the Save For Web dialog box. Click once on the black triangle located to the right of the Select Browser button. Photoshop displays the available browser options in a pop-up menu, as shown in Figure 750.1.

Figure 750.1 Clicking the Select Browser button displays a list of available browser options.

3. Select one of the available options. In this example, you select the Internet Explorer option. Photoshop opens Internet Explorer and displays the active Photoshop graphic, along with the required HTML (Hypertext Markup Language) for displaying the image, as shown in Figure 750.2.

> *Note: Viewing Web graphics within a browser lets you see the image exactly as it will appear in the completed Web document and gives you total control over the editing process.*

Figure 750.2 The Photoshop graphic is displayed using Internet Explorer.

751 *Selecting the Correct Fill Color When Converting an Image to Transparent*

When you design Web graphics, the GIF compression format lets you create transparent areas within the image, based on a specific color or colors within the image. The most common example of creating transparency in a GIF image is the removal of the background color. Web browsers such as Navigator and Explorer let you open the GIF image and display it with the transparent pixels, as shown in Figure 751.1.

Figure 751.1 A GIF image containing transparent pixels, displayed using Netscape Navigator.

The most common background color used is white. Unless the image displays against a light-colored background, do not use the color white. Choose a background color that exactly or closely matches the background color of the receiving Web page. Generating transparent pixels in a GIF image is not a perfect science. In most cases, artifact colors remain around the edge of the image, creating a halo effect, as shown in Figure 751.2.

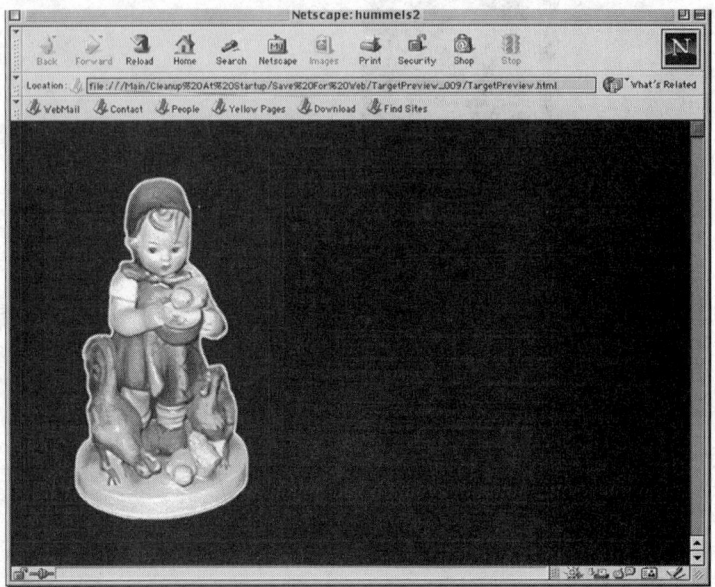

Figure 751.2 Choosing white as the transparent background color creates a halo when the image displays against a dark Web page.

Choosing a color that matches the background of the Web page helps to mask the halo pixels and produces a transparent graphic without the halo, as shown in Figure 751.3.

Figure 751.3 Choosing a similar background color for the original GIF image reduces the halo effect.

Note: Creating GIF images using similar background colors requires project planning. Know where the graphic image will be used before starting the design process. Plan ahead.

752 *Using Onion Skinning on a GIF Animation*

Onion skinning is an animation technique in which you create multiple images, or frames, that combine into animation. Like using onion-skin paper, you use the each frame in the animation to line up the next sequence, as shown in Figure 752.1.

Figure 752.1 Onion skinning uses the underlying frames in the animation to help align each succeeding frame.

In Photoshop, the animation frames are the individual layers. Each layer is a part of the animation. Say, for example, that you want to create a compass with a spinning needle. To create animation using the onion skin technique, open a graphic image of a compass and perform these steps:

1. Create a new layer containing the compass needle, as shown in Figure 752.2.

2. Make a copy of the needle layer by clicking and dragging the needle layer over the New Layer icon, as shown in Figure 752.3.

3. Select the Edit menu, and choose Free Transform from the pull-down menu. Photoshop places an editable bounding box around the needle in the copy layer. Move your cursor outside the bounding box and rotate the copied needle clockwise, as shown in Figure 752.4.

4. Press the Enter key to apply the transform to the needle.

5. Repeat step 2, and make a copy of the rotated needle layer.

6. Repeat step 3 and rotate the copied needle layer, using the previous layer (onion skin) to achieve the correct position.

7. Repeat steps 2 through 4 until you have a Photoshop image similar to Figure 752.5.

Figure 752.2 A Photoshop document containing the image of a compass and a separate layer containing the needle.

Figure 752.3 Clicking and dragging a layer over the New Layer icon creates a pixel-to-pixel copy of the original layer.

Figure 752.4 The Free Transform command lets you rotate the graphic of the copied needle.

Figure 752.5 The completed compass with several layers containing copies of the rotated needle.

Refer to Tip 722, "Creating a GIF Animation from a Multi-layered PS Image," for information on converting the image into an animated GIF file.

Note: Using the onion-skinning technique lets you align and create complex animations, similar to the way old-style animators used colored frames to create cartoons and animated movies.

753 *Creating a "Frame" Look to a Web Page by Creating Directional Tiles*

When you open a Web page containing frames, the browser is actually opening two or more Web documents and is displaying them within separate windows, as shown in Figure 753.1.

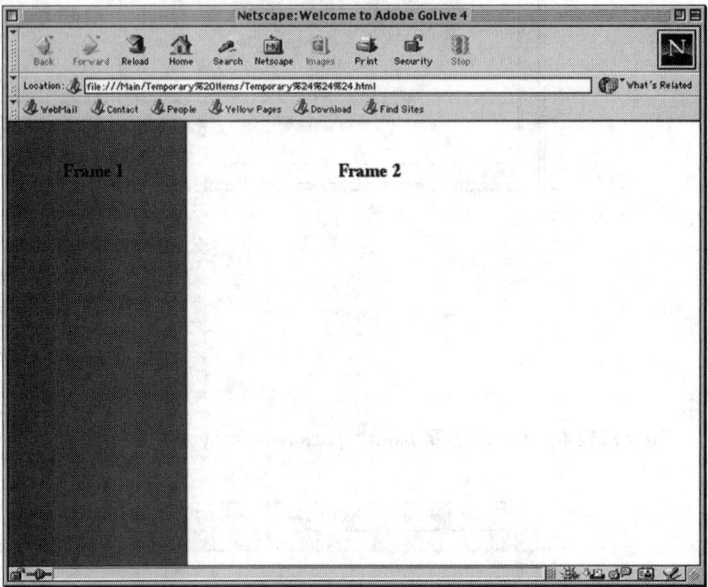

Figure 753.1 Web pages containing frames display two or more Web documents.

Frames present several problems to Web designers: Not all versions of Netscape and Explorer support frame technology, so they take longer to download to the client. Frames can also cause confusion on the part of the user. For example, choosing to print or save a particular Web document saves only the active frame. If the user does not understand this, he may wind up saving the wrong information.

Using Photoshop, you can create background images that simulate the effect of a framed Web document without the associated problems. To create a frame-like graphic image, open Photoshop and perform these steps:

1. Select the File menu, and choose New from the pull-down menu. Photoshop opens the New dialog box, shown in Figure 753.2.

2. Create a document with a width of 800 pixels and a height of 1 pixel. Choose RGB as the color space, and enter a resolution value of 72 (refer to Figure 753.1). Click on the OK button to open the document, as shown in Figure 753.3.

3. Select the Rectangular Marquee selection tool from the toolbox, and then create and select the left quarter of the image, as shown in Figure 753.4.

4. If the Swatches palette is not visible, select the Window menu, and choose Show Swatches from the pull-down menu. Photoshop displays the Swatches palette.

5. Move your mouse into the Swatches palette, and select a color by clicking once on a swatch box. In this example, you choose the RGB blue, as shown in Figure 753.5.

Figure 753.2 The New dialog box controls the characteristics of the new document.

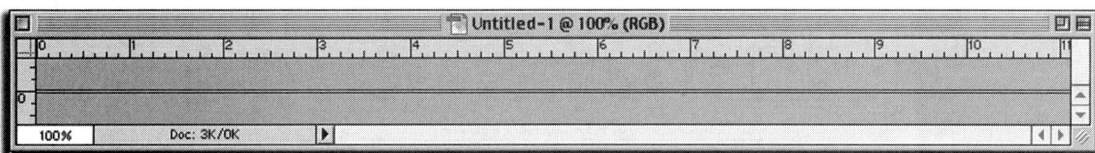

Figure 753.3 The new document opened in Photoshop.

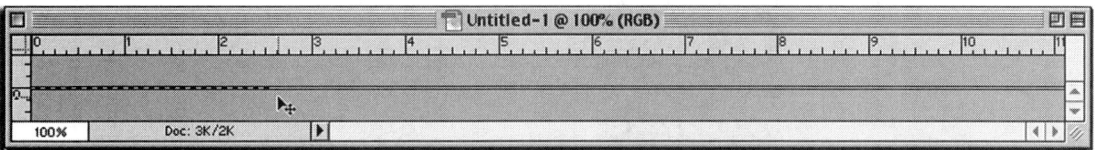

Figure 753.4 Use the Rectangular Marquee tool to select the left quarter of the graphic image.

Figure 753.5 Clicking on a swatch box makes it the default painting color.

6. Press Alt+Delete (Macintosh: Option+Delete) to fill the selected area with the RGB blue color.

7. Select the File menu, and select Save for Web from the pull-down menu. Photoshop opens the Save for Web dialog box, shown in Figure 753.6.

8. Click on the OK button and save the file. In this example, you name the file blue_frame.gif.

9. When you use the file as a tiled background image, the Web browser tiles the image to produce a frame look, as shown in Figure 753.7.

Figure 753.6 The Save for Web dialog box displays the blue-and-white graphic image.

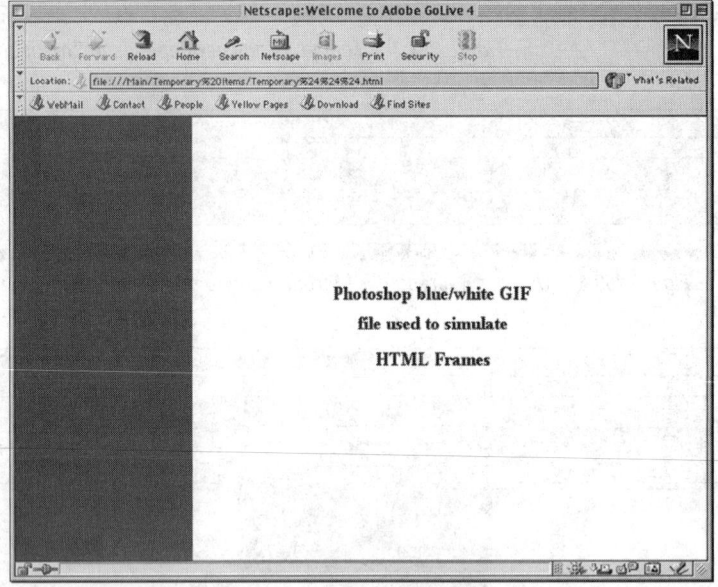

Figure 753.7 The blue_frame.gif file, used as a tiled background on a typical Web page.

754 *Reducing the File Size of a JPEG Image*

Web designers have a problem: They have to create images that look good and load quickly to the client. Sometimes those two goals do not work well together. In most cases, reducing the size of the image file requires lowering the quality of the image. Web artists typically use the JPEG compression format to make their images as small as possible while still preserving some of the quality of the original image. Here are some tips that will help you use the JPEG compression format to its best advantage:

- **Photographic images:** Use the JPEG format on soft images. Unlike the GIF compression scheme that reduces file size by using sharp-edged colors, the JPEG format creates a smaller image if the image is softly blurred.

- **Add Gaussian blur:** Because the JPEG compression works well on softer images, try introducing a measure of Gaussian blur to the photographic image.

- **Recompress the image:** Although Tip 749, "Recompressing a Compressed Image," recommends that you compress a JPEG image only once, performing more than one save on a JPEG image further reduces the image size by removing additional information. Experiment with multiple saves on a JPEG image.

- **Lower the saturation:** Select the Image menu, choose Adjust, and select Hue and Saturation from the fly-out menu. Click and drag the saturation slider to the left, to reduce the saturation of the image. In most cases, reducing the saturation of the image reduces the image's file size.

- **Lower the contrast:** Select the Image menu, choose Adjust, and select Brightness and Contrast from the fly-out menu. Click and drag the contrast slider to the left to lower the contrast in the image. In most cases, reducing the contrast of the image reduces the image's file size.

> *Note: Using one or all of these techniques can significantly reduce the size of your graphic image. However, if reducing the size of the file creates an unacceptable image, back up and start over.*

755 *Reducing the File Size of a GIF Image*

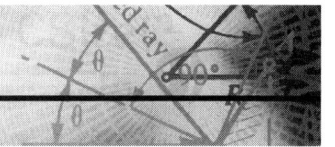

In the previous tip, you learned some tricks to reduce the size of a JPEG image. Because the GIF format is used as much as the JPEG format, here are some tips to help you reduce the size of these images:

- **Solid color:** The GIF format efficiently compresses large areas of solid color. Therefore, GIF images containing solid colors compress smaller than images containing mixed colors.

- **Color reduction:** The GIF format builds a color table with all the colors in the active image. Reducing the number of colors within the image significantly reduces the size of the saved file.

- **Dither reduction:** The dithering process mixes different Web Safe pixels in a pattern to simulate colors that the monitor is incapable of reproducing. One way to reduce the possible effects of dithering is to make sure that the image contains only Web Safe Colors.

- **Lossy compression:** By definition, GIF images are lossless; that is, image information is not removed from the graphic. A new feature in Photoshop is the capability to create a lossy GIF image (refer to Tip 732, "Using the Optimize Settings for a GIF Image").

756 *Reducing the File Size of a PNG Image*

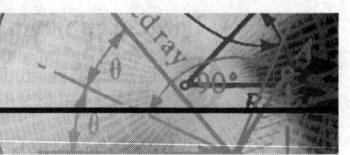

In Tip 754, "Reducing the File Size of a JPEG Image," and Tip 755, "Reducing the File Size of a GIF Image," you learned some tips on reducing the file size of a JPEG and a GIF formatted graphic. The third compression scheme used by the Internet is the Portable Network Graphic, or PNG format. The PNG format was created as an alternative to the GIF format, and it has the advantage of being royalty-free. Technically, you must pay royalty to the Unisys corporation when you use the GIF compression format. The good news is that Adobe Corporation already paid the royalty fee to Unisys, so if you create your GIF compressed images using Photoshop and ImageReady, you do not have to worry about being charged for royalty payments.

Because the PNG format uses the best features of JPEG and GIF, following the hints listed in Tips 754 and 755 will produce small compressed graphic files.

The PNG format works well with all types of images and even creates smaller files sizes than the GIF format. The major problem with the format is its lack of support in the Web community. The two major browsers, Explorer and Navigator, do not openly support the format. Currently, fewer than 30 percent of Web users have the capability to open and view PNG formatted images.

Until support grows for the PNG format, its major use is the creation of images used in Flash and LiveMotion animation. However, keep an eye on the industry. The PNG format is a versatile format, well-suited to the demands of Web designers.

757 *Preparing an Illustrator File for Placement into ImageReady*

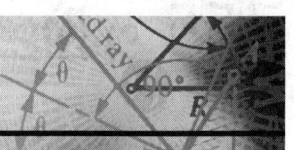

Photoshop is not the only program that creates images for the Internet. Adobe's vector-based program Illustrator is an excellent program for generating clip art and text. The trick is to prepare the image before you exit Illustrator. Say, for example, that you create a clip art piece in Illustrator and you want to move the graphic into ImageReady.

To prepare an image for ImageReady, open the image in Adobe Illustrator and perform these steps:

1. Select the File menu, and choose Export from the pull-down menu. Illustrator opens the Export dialog box, shown in Figure 757.1.

2. Click on the Format button and select Photoshop (PSD) from the list of available options.

3. In the Name input field, enter a name for the image. In this example, you name the file "clipart.psd."

4. Click on the OK button. Illustrator opens the Photoshop Options dialog box, shown in Figure 757.2.

5. Because you will use this image on the Internet, select Screen (72 dpi). To soften the edges of the vector image, choose Anti-Alias. If the image includes additional layers and nested layers, choose to select or discard them.

6. Do not select Embed ICC Profile. Web browsers do not consistently support ICC color profile information. Disabling this option produces a smaller file size.

7. Click on the OK button to convert the Illustrator file into a rasterized Photoshop image.

Figure 757.1 The Export dialog box controls the characteristics of the Illustrator-saved document.

Figure 757.2 The Photoshop Options dialog box lets you control the characteristics of the saved document.

8. Close Adobe Illustrator and open ImageReady.

9. Select the File menu, and select open from the pull-down menu. ImageReady displays the Open dialog box. Locate the clip art.psd file and click on the Open button to move the image into ImageReady, as shown in Figure 757.3.

Figure 757.3 The converted Illustrator document, successfully moved into ImageReady.

Note: Once the image is moved into ImageReady, edit it as you would any other Photoshop graphic image.

758

Converting a QuickTime Movie into an Animated GIF Using ImageReady

In Tip 696, "Creating QuickTime Movies from Animated GIF Files," you learned how to create a QuickTime movie from an animated GIF file. ImageReady lets you reverse the procedure and generate an animated GIF file from a QuickTime movie.

To convert a QuickTime movie into GIF animation, open ImageReady and perform these steps:

1. Select the File menu, and choose Open from the pull-down menu. ImageReady displays the Open dialog box, shown in Figure 758.1.

2. Select a movie file and click on the Open button. In this example, you select compass.mov from the available files. ImageReady opens the Open Movie dialog box, shown in Figure 758.2.

Figure 758.1 The Open dialog box lets you select and open a QuickTime movie.

Figure 758.2 The Open Movie dialog box lets you select what portion of the QuickTime movie that you want to import into ImageReady.

3. In this example, you choose From Beginning to End and every 20th frame. Click on the OK button. Photoshop opens the QuickTime movie frames in ImageReady, as shown in Figure 758.3.

Figure 758.3 The frames of the QuickTime movie successfully moved into the ImageReady Animation palette.

4. To save the selected frames as an animated GIF, select the File menu, save Optimized As (refer to Tip 722, "Creating a GIF Animation from a Multi-layered PS Image").

759 *Using the Tile Maker Filter to Create Seamless Backgrounds*

Designers use graphic images on Web pages to create seamless tiled backgrounds. Images used for Web backgrounds are typically small square or rectangular graphics that, when tiled, create a tiled or seamless background. Say, for example, that you have a small graphic image and you want to use the image as a tiled background. The main concern is achieving a seamless look for the tiled image.

To create a seamless tile background, open a suitable graphic in ImageReady and perform these steps:

1. Select the Filter menu, choose Other, and select Tile Maker from the fly-out menu. ImageReady opens the Tile Maker dialog box, shown in Figure 759.1.

Figure 759.1 The Tile Maker dialog box lets you create seamless background tiles.

2. Select the Blend Edges option. In the Width input field, enter a value from 1 to 20 percent. In this example, you choose a value of 10 percent. The Blend Edges option blends the opposite edges of the image to create a seamless pattern when the image displays as the background on a Web page.

3. Select Resize Tile to Fill Image. Selecting this option causes ImageReady to maintain the original dimensions of the image file.

4. Click on the OK Button to record the changes to the image.

5. Select the File menu, and choose Save Optimized As; save the file to disk.

When you use the image as a background, the Tile Maker filter creates a seamless look for the Web page, as shown in Figure 759.2.

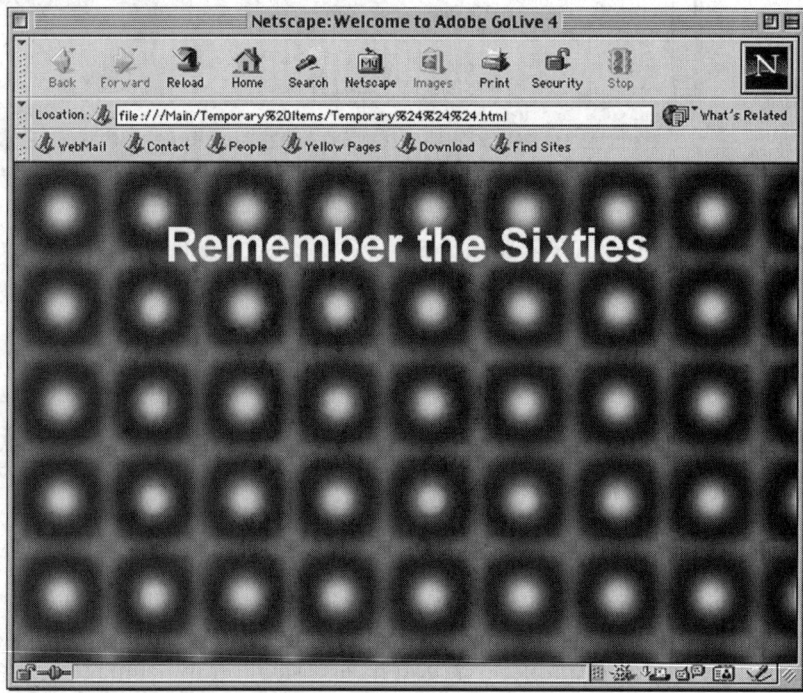

Figure 759.2 The Tile Maker filter successfully created a seamless tile background.

760 *Editing ImageReady Animation Files*

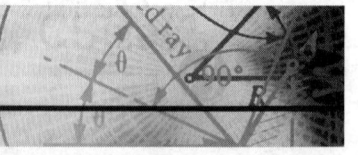

In Tip 722, "Creating a GIF Animation from a Multi-layered PS Image," you learned how to create animation using Photoshop documents. When you create ImageReady animation, the Animation palette gives you options to control how the animation runs on the Web browser.

To edit GIF animation, open the document in ImageReady. If the Animation palette is not visible, select the Window menu and choose Show Animation from the fly-out menu. Photoshop opens the Animation palette, shown in Figure 760.1.

Choose from these options to control the animation file:

- **Timing:** Each frame in the animation sequence is timed. Click on the Timing button and choose from the available timing options, as shown in Figure 760.2.

Figure 760.1 The Animation palette controls the sequence and viewing speeds of each frame in the GIF animation file.

Figure 760.2 The timing options control how long each frame displays.

- **Looping:** Click on the Looping Options button and select the number of times that you want the animation to loop. Selecting Forever (the default option) plays the animation without stopping. Selecting the Other option opens the Set Loop Count dialog box. Enter a value from 1 to 30000 and click the OK button to set the loop count. Each number represents one play of the animation from beginning to end, as shown in Figure 760.3.

Figure 760.3 Set Loop Count controls the number of times that the animation plays.

- **Deleting:** Drag a frame to the trash can icon to delete the frame from the animation sequence.

- **Moving:** Click and drag a frame left or right to change its position within the animation sequence.

- **Tweening:** Click on the Tween button to create smooth animation by adding intervening frames (see Tip 783, "Using the Tween Option to Create Smooth Animation").

- **Adding frames:** Select a frame and click on the Duplicate Frame button to create a pixel-to-pixel copy of the selected frame, as shown in Figure 760.4.

Figure 760.4 The Duplicate Frame button creates a pixel-to-pixel copy of the selected frame.

Select the File menu and choose Save Optimized As to save the editing animation to disk.

761 *Using the Layers Palette as a Storyboard*

When you create animation using a Photoshop document (refer to Tip 722, "Creating a GIF Animation from a Multi-layered PS Image"), the Layers palette holds the individual images that comprise the final animation.

Use the Layers palette in Photoshop as an electronic storyboard. Animators use storyboards to map out a specific animation sequence. Typically, storyboards are hand-drawn images that give the designer a sense and perspective of the actual animation. When you use the Layers palette, you have an electronic storyboard that lets you visualize the final animation.

To use the Layers palette as a storyboard, open a multi-layered document in Photoshop.

- **Show/Hide:** Click on the eye icon to activate or deactivate a specific layer. Tuning layers on and off lets you view different sequences in the file and gives you an idea of the order necessary to produce smooth animation.

- **Layer opacity:** Use a layers opacity setting to roughly view how an animation sequence will fade in and out.

- **Copy layer elements:** Copy elements from individual layers into one layer to maximize the performance of the animation. By viewing the individual layers, you may see how to combine various elements.

- **Moving layer elements:** Use Photoshop's Move tool to select and move a layer element to view the best way to animate the sequence (does that ball need to bounce two times or three times?).

> *Note: Photoshop's Layers palette is a unique storyboard that helps you visualize the final animation. Use that power to create the best animations possible.*

762 *Making Flat-Color Areas Safe for the Web*

When you create Web graphics, specifically GIF clip art, it is important to make the colors in the image Web Safe. Say, for example, that you have a clip art graphic image containing large, flat areas of color and you want to bring those areas into the Web Safe palette.

To move the image colors into the Web Safe palette, open the graphic in ImageReady and perform these steps:

1. If the Color Table is not visible, select the Window menu, and choose Show Color Table from the pull-down menu. Photoshop opens the Color Table palette, shown in Figure 762.1.

Figure 762.1 The Color Table palette in ImageReady displays all the colors in the active image.

2. Select the Eyedropper tool from the ImageReady toolbox.

3. Move the Eyedropper tool into the document window, and click once on a large flat area of color that you want to move into the Web Safe color palette. The corresponding ImageReady highlights the color in the Color Table, as shown in Figure 762.2.

Figure 762.2 The Color Table palette highlights the color selected with the Eyedropper tool.

4. Click once on the Web Snap button, located at the bottom left of the Color Table palette. ImageReady moves the selected color into the Web Safe color palette and changes the color in the active image, as shown in Figure 762.3.

Figure 762.3 The Web Snap button converts the selected color swatch to a Web Safe color.

5. Move the Eyedropper tool back into the document window and repeat steps 3 and 4 for any additional colors that you want to move to the Web Safe color palette. Colors displaying a small diamond in the center of the color swatch indicate a Web Safe color (refer to Figure 762.3).

6. Select the File menu, and select Save Optimized As to save the modified file to disk.

Note: It is not necessary to use the Eyedropper tool to convert a color swatch to the Web Safe palette. If you see a color swatch in the Color Table palette that does not contain a small

white diamond, click once to select the color and then click on the Web Snap button to move the color into the Web Safe palette.

763 *Creating the Illusion of Movement in an Animated GIF*

Creating animation requires separate frames. Each frame in the animation slightly alters the image. Say, for example, that you want to create the illusion of a small toy car moving across the frame. You would open the toy car on a transparent layer in Photoshop and create a nontransparent background on a separate layer behind the car, as shown in Figure 763.1.

Figure 763.1 Creating the illusion of movement in the toy car first requires placing the car and the background on separate layers.

To create the illusion of movement, perform these steps:

1. Create a copy of the car layer by dragging the car layer over the New Layer icon. Photoshop creates a pixel-to-pixel copy of the car layer, as shown in Figure 763.2.

Figure 763.2 Dragging a layer over the New Layer icon creates a copy of the original layer.

2. Select the Move tool from Photoshop's toolbox.

3. Move into the document window and, using the underlying layer to control the move, click and drag the car in the copied layer to the right about a quarter inch, as shown in Figure 763.3.

Figure 763.3 *Use the Move tool to click and drag the copied car to the right.*

4. Repeat steps 1, 2, and 3, until you have a succession of copied layers, with the car in each layer moving increasingly to the right, as shown in Figure 763.4.

Figure 763.4 *The completed multi-layered Photoshop document.*

5. To animate the car sequence, click on the Jump button, located at the bottom of Photoshop's toolbox, to open the multi-layered document in ImageReady, as shown in Figure 763.5.

6. If the Animation palette is not visible, select the Window menu and choose Show Animation from the pull-down menu. Photoshop opens the Animation palette, shown in Figure 763.6.

7. Click on the Duplicate Frame button, and create a separate frame for each of the layers in the Layers palette.

8. Using the Layers palette as a guide, click one at a time on the newly created frames and activate a layer in the Layers palette for each of the frames. For example, click on frame_1 and activate layer_1 by clicking on the Eyeball icon for layer_1. Make sure that all other layers are deactivated with the exception of the background layer. Continue the process until you activate a single layer for each of the frames in the animation, as shown in Figure 763.7.

Figure 763.5 The Photoshop document opened in ImageReady.

Figure 763.6 The Animation palette controls the characteristics of the animation sequence.

9. Play the animation by clicking on the Play Animation icon (refer to Figure 763.7).

10. If you like the animation sequence, select the File menu and then select Save Optimized As. Click on the Save button to save the animation to disk.

Note: To edit the animation, refer to Tip 760, "Editing ImageReady Animation Files."

Figure 763.7 *Each frame in the Animation palette contains one active layer.*

764 *Making an Animation Fade In and Out*

In the previous tip, you learned how to create a simple animation from scratch, using a clip art image of a toy car. Say, for example, that you want to create an animation of a moving car and, at the same time, slowly fade the image.

Open the ImageReady animation created in the previous tips, and perform these steps:

1. If the Animation palette is not visible, select the Window menu and then choose Show Animation from the pull-down menu. Photoshop opens the Animation palette, as shown in Figure 764.1.

Figure 764.1 *The Animation palette controls the characteristics of the animation sequence.*

2. Select Frame_2 in the Animation palette. In the Layers palette, click once in the Opacity input box and enter a value of 95 percent.

3. Select Frame_3 in the Animation palette. In the Layers palette, click once in the Opacity input box and enter a value of 90 percent.

4. Click on each of the frames in sequence and reduce the selected opacity for the layer by 5 percent, until you reach the last frame, as shown in Figure 764.2.

Figure 764.2 The Animation palette showing the frames fading.

5. Click on the Plan Animation icon to view the image. The car moves to the right and slowly fades.

765 *Using Channels to Apply GIF Optimization Settings*

In Tip 755, "Reducing the File Size of a GIF Image," you learned how to reduce the size of GIF image. Compression of files in ImageReady is achieved by limiting the viewable colors in the image, by reducing the image's file size, and by compressing using lossy and lossless file formats. ImageReady lets you control the modification of an image using Alpha channels, as shown in Figure 765.1.

To control the compression of an image using Alpha channels, open the graphic in ImageReady. If the Optimize palette is not visible, select the Window menu and select Show Optimize from the pull-down menu. Photoshop opens the Optimize palette, shown in Figure 765.2.

- **Modifying GIF lossiness:** Select GIF as the optimized file format. Click on the Channel Modification icon, located to the right of the Lossy input field. ImageReady opens the Modify Lossiness Setting dialog box. Click on the Channel button and select the precreated channel mask, as shown in Figure 765.3.

 The white areas of the alpha mask yield the highest levels of quality, and the black areas yield the lowest levels of quality. Use the minimum and maximum slider to further control the application of the mask to the active image.

- **Modifying dither settings:** Select GIF as the optimized file format. Click on the Dither Modification icon, located to the right of the Dither input field. ImageReady opens the Modify Dither Setting dialog box. Click on the Channel button and select the precreated channel mask, as shown in Figure 765.4.

Figure 765.1 Alpha channels control how ImageReady compresses an image.

Figure 765.2 The Optimize palette controls the characteristics of the active image.

Figure 765.3 The Modify Lossiness Setting dialog box controls the application of the Lossy option to the active image.

Figure 765.4 The Modify Dither Setting dialog box controls the application of the Lossy option to the active image.

The white areas of the alpha mask yield the highest levels of image dithering, and the black areas yield the lowest levels of image dithering. Use the minimum and maximum slider to further control the application of the mask to the active image.

766 *Using Channels to Apply JPEG Optimization Settings*

In Tip 754, "Reducing the File Size of a JPEG Image," you learned how to reduce the size of JPEG image. Compression of files in ImageReady is achieved by limiting the viewable colors in the image, by reducing the image's file size, and by compressing using lossy and lossless file formats. ImageReady lets you control the reduction of a JPEG image with the use of selected Alpha channels, as shown in Figure 766.1.

To control the compression of a JPEG image using Alpha channels, open the graphic in ImageReady. If the Optimize palette is not visible, select the Window menu and then select Show Optimize from the pull-down menu. Photoshop opens the Optimize palette, shown in Figure 766.2.

• **Modifying JPEG quality:** Select JPEG as the optimized file format. Click on the Quality Modification icon, located to the right of the Settings input field. ImageReady opens the Modify Quality Setting dialog box. Click on the Channel button, and select the precreated channel mask, as shown in Figure 766.3.

The white areas of the alpha mask yield the lowest levels of quality, and the black areas yield the highest levels of quality (the opposite of GIF compression). Use the minimum and maximum slider to further control the application of the mask to the active image.

Figure 766.1 Alpha channels control how ImageReady compresses an image.

Figure 766.2 The Optimize palette controls the characteristics of the active image.

Figure 766.3 The Modify Quality Setting dialog box controls the application of the Lossy option to the active image.

767 *Using Hexadecimal Values in a Web Color System*

Although most Web image-editing programs create Web Safe color with the click of a button, the Internet defines colors using hexadecimal coding values. Hexadecimal coding is simply a counting system. Everything accomplished in a computer or on the Internet works through numbers, and colors are no exception. Each color in the Web Safe palette is assigned a specific number when that value is entered into an HTML (Hypertext Markup Language) document. Your Web browser interprets the number and displays a color on your monitor. All computers running on the Internet use the same hexadecimal coding system to interpret color information. An example of an HTML document containing a color code follows:

<html>

<body>

This is a <font color = #FF0000<P>red word.

</body>

 </html>

Although this may not seem like much of a Web program, if this piece of code were run in a typical Web browser, the page would be blank except for the sentence "This is a **red** word." The word *red* would display in the color red.

The code color = #FF0000 instructs the Web browser to use the color red when printing the word *red*. The good news is that Photoshop and ImageReady do not require you to know all the hexadecimal values for the colors in the Web Safe palette. All you need to do is select the colors and let Adobe make the changes for you.

768 *Optimizing Individual Image Slices*

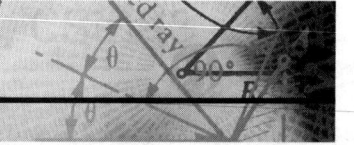

When you slice an image using ImageReady, you essentially cut an image into several pieces and reassemble the pieces in a Web page using a zero-border table, as shown in Figure 768.1.

Slicing an image has several advantages. Individual slices load more quickly than an unsliced graphic. The individual slices can be used as hot links to direct a user to different areas of your Web site. In addition, the individual slices can be compressed to their optimal file size to create a smaller image than the original unsliced graphic.

To optimize an individual image slice, open the sliced graphic in ImageReady and perform these steps:

1. Move your cursor into the toolbox, and then click and hold on the Image Slice tool. ImageReady displays a pop-up menu containing the Image Slice options, as shown in Figure 768.2.

2. Select Slice Select Tool from the available options.

3. If the Optimize palette is not visible, select the Window menu and then choose Show Optimize from the pull-down menu. Photoshop opens the Optimize palette, shown in Figure 768.3.

Figure 768.1 A single Web graphic sliced into several pieces and reassembled in a Web page using a zero-border table.

Figure 768.2 Clicking and holding your mouse on the Image Slice tool lets you view the available Image Slice options.

Figure 768.3 The Optimize palette controls the compression characteristics of the individual slices in the active image.

4. Move into the document window and click once on the slice that you want to optimize. ImageReady selects the slice and dims all the other slices, as shown in Figure 768.4.

5. Using the information in Tip 755, "Reducing the File Size of a GIF Image," move your cursor into the Optimize palette and reduce the size of the selected slice. In this example, the selected slice contains only text. You selected GIF as the file format, optimized, with a quality setting of 20 percent, as shown in Figure 768.5.

Figure 768.4 The Slice Select tool lets you select individual slices within the active image.

Figure 768.5 The selected slice is optimized using the options in the Optimize palette.

Note: *Treat each individual piece of a sliced image as a separate graphic, and use the Optimize palette on each piece of the sliced document. In doing so, you create an image in which the parts, when added up, produce a smaller file size than the original unsliced graphic.*

769 *Using a Temporary Droplet and Using It in ImageReady*

In the previous tip, you learned how to optimize individual slices within an ImageReady document. When you optimize a slice, you use the Optimize palette to create a customized compression setting for the slice. In some cases, you use the GIF compression; in other areas of the image, you use the JPEG

compression format. Each individual slice in the image has the possibility of generating a different set of compression options.

However, it is just as possible that several pieces of the sliced image require the same compression. For example, if you have a sliced image containing text areas and photographic areas, you may want to apply the same GIF settings to all of the text slices and then apply the same JPEG compression setting to all of the photographic slices.

You can accomplish this with the use of droplets. A droplet is a small application that applies settings or actions to one or more images. To use a droplet to apply compression settings to one or more slices within an ImageReady document, open a sliced image and perform these steps:

1. If the Optimize palette is not visible, select the Window menu and then choose Show Optimize from the pull-down menu. Photoshop opens the Optimize palette, shown in Figure 769.1.

Figure 769.1 *The Optimize palette lets you create a temporary droplet and apply it to one or more slices within the active image.*

2. Move your cursor into the toolbox, and then click and hold on the Image Slice tool. ImageReady displays a pop-up menu containing the Image Slice options, as shown in Figure 769.2. Select Slice Select Tool from the available options.

Figure 769.2 *Clicking and holding your mouse on the Image Slice tool lets you view the available Image Slice options.*

3. Click once with the Slice Select tool on the bottom-left text slice. ImageReady selects the text slice.

4. Move into the Optimize palette and apply the GIF compression settings described in step 5 of the previous tip. ImageReady applies the compression settings to the selected text slice.

5. To apply the same settings to the three other text slices, move your cursor into the Optimize palette and then click and drag the droplet icon into the other text slices, as shown in Figure 769.3. If you have not previously saved the droplet settings, ImageReady will prompt you to save the settings as a droplet. Refer to the next tip for information on permanently saving settings as a droplet.

Figure 769.3 The droplet icon applies the compression settings of the selected text slice to other text slices.

Note: The droplet icon in the Optimize palette takes on the characteristics of the selected slice. When you drag the droplet icon onto another slice, the receiving slice takes on the compression settings of the selected slice.

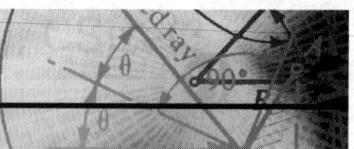

770 *Creating Permanent Droplets*

In the previous tip, you learned how to use a temporary droplet to apply compression settings to individual graphic slices. ImageReady lets you create and save permanent droplets for use whenever needed.

To create a permanent droplet, open a graphic in ImageReady and perform these steps:

1. If the Optimize palette is not visible, select the Window menu and choose Show Optimize from the pull-down menu. Photoshop opens the Optimize palette, shown in Figure 770.1.

2. Use the Optimize palette to create a specific set of compression options for the active image. In the example, you create compression settings for a photograph using the JPEG format (refer to Tip 754, "Reducing the File Size of a JPEG Image").

*Figure 770.1 The Optimize palette lets you create a temporary droplet and apply it to
one or more slices within the active image.*

3. To save the settings in a droplet, move your cursor into the Optimize palette and click once on the droplet icon. ImageReady opens the Save optimized settings as droplet dialog box. Accept the default name, or click in the Name input field and enter a name. In this example, you use the name jpeg (quality2), as shown in Figure 770.2.

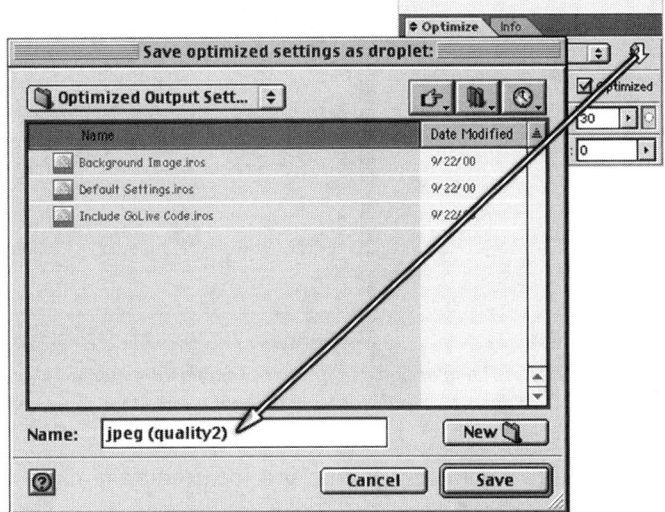

*Figure 770.2 The Save optimized settings as droplet dialog box lets you name and
save customized droplets for use with other graphics.*

4. Click on the Save button to save the droplet to disk.

Note: You can use individual saved droplets to quickly compress and format graphic files. To apply a saved droplet to a Photoshop or ImageReady graphic, refer to the next tip.

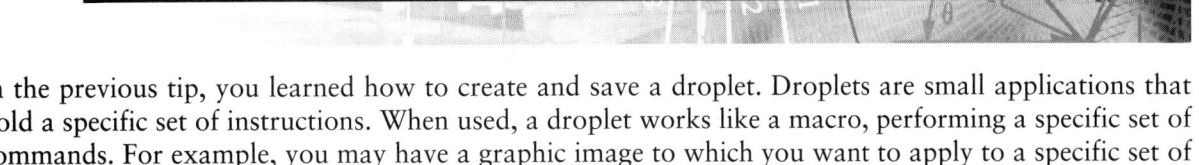

771 *Applying a Droplet to a Graphic*

In the previous tip, you learned how to create and save a droplet. Droplets are small applications that hold a specific set of instructions. When used, a droplet works like a macro, performing a specific set of commands. For example, you may have a graphic image to which you want to apply to a specific set of compression instructions. You previously created and saved a droplet called jpeg (quality2). The saved droplet contains the compression instructions that you want to use on one or more additional graphic images.

To use a droplet on a graphic image, perform these steps:

1. Locate and open the folder containing the droplet named jpeg (quality2).

2. Locate and open the folder containing the graphic file(s) you want to modify with the droplet, as shown in Figure 771.1.

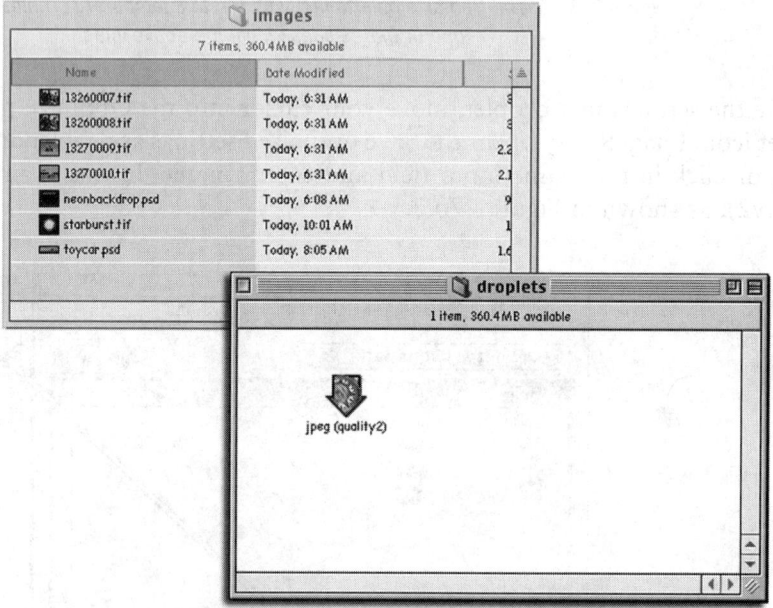

Figure 771.1 *The folder named droplets contains the jpeg (quality2) droplet, and the folder named Images contains the graphic file that you want to change.*

3. Move your cursor into the images folder and locate the file named starburst.tif.

4. Click on and drag the starburst.tif file into the droplets folder, move it directly above the jpeg (quality2) droplet, and release your mouse, as shown in Figure 771.2.

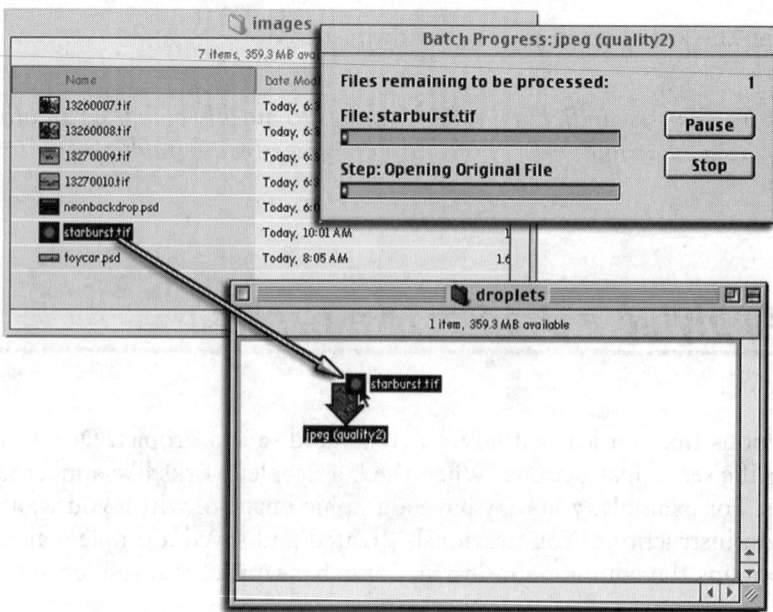

Figure 771.2 *Dragging a graphic file over a droplet activates the droplet.*

5. When you release your mouse, ImageReady opens the graphic file, performs the compression settings defined by the droplet, and saves the file, as shown in Figure 771.3.

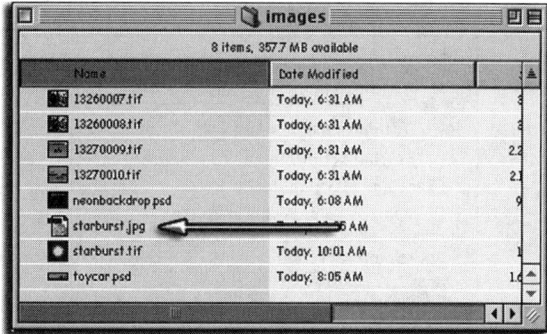

Figure 771.3 The droplet successfully applied the compression settings to the starburst.tif file and saved the file using the name starburst.jpg.

Note: When you drag a file over an ImageReady droplet, the ImageReady program opens, performs the changes to the file, and automatically saves the file according to the droplet settings. Although the ImageReady program remains open, the converted graphic file is closed and saved to disk.

772 *Including an Action in a Photoshop Droplet*

In Tip 770, "Creating Permanent Droplets," you learned how to create and save a simple ImageReady droplet using the Optimize palette to control the compression options. ImageReady and Photoshop let you save droplets that include complicated actions. To create a droplet based on a Photoshop action, you must first create the action (refer to Tip 411, "Creating a New Action").

For example, you can create an action that reduces the size of a digital camera image and converts the color space to CMYK and save the action in Photoshop under the name epson_prep.

To create a droplet from an existing action, open Photoshop and perform these steps:

1. Select the File menu, choose Automate, and then choose Create Droplet from the fly-out menu. Photoshop opens the Create Droplet dialog box, shown in Figure 772.1.

2. Click on the Choose button and select a folder to hold the new droplet. It is a good idea to create a single folder to hold all of your droplets. That makes it easier to access and use the droplets when needed.

3. Click on the Set button and select the active set containing the action that you want to convert into a droplet.

4. Click on the Action button and select one of the default actions.

5. Click on the Destination button and select whether to leave the file open after the action modifies the image (None), to close the file and save it to disk (Save and Close), or to save the converted file into a specific folder (Folder). If you choose the Folder option, you are prompted to select the destination folder (Choose) and to specify whether you want to modify the name and extension of the saved file (File Naming).

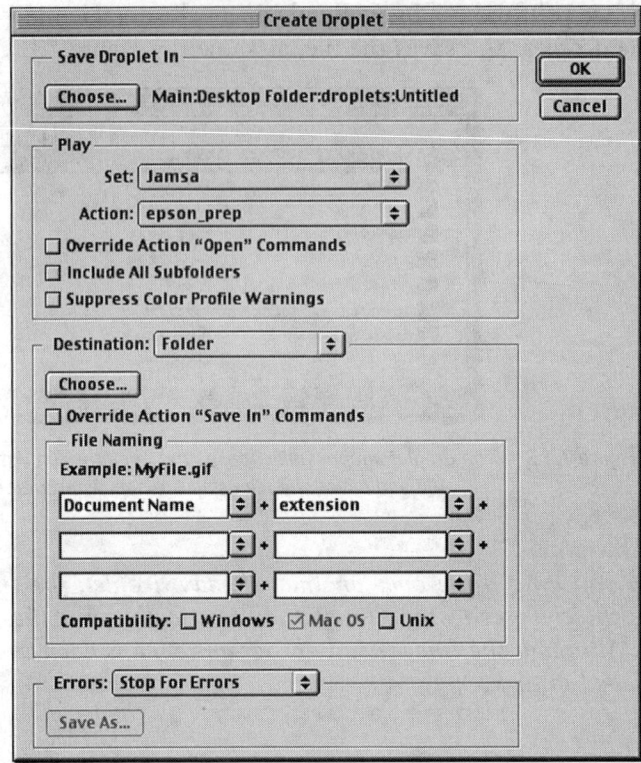

Figure 772.1 The Create Droplet dialog box lets you select the action to use for the droplet.

6. Click on the Errors button and select whether to stop for errors, or log the errors to a file. If you choose to log the errors to a file, you are prompted to name the errors file (Save As).

7. Click on the OK button to save the Photoshop droplet.

Note: To use the Photoshop droplet, refer to Tip 771, "Applying a Droplet to a Graphic."

773 *Creating a JavaScript Rollover*

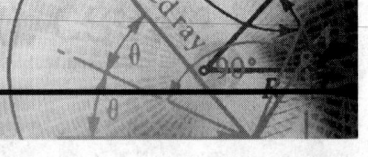

JavaScript rollovers are a great way to help an Internet user navigate through the complexities of a Web page. Rollovers create an interactive environment on a static Web page. Now, instead of the page being flat and lifeless, things happen when the user moves the mouse. The most common application of a rollover is indicating where the interactive buttons are located on a Web page. When the user moves the cursor over a button, the rollover kicks in and changes the graphic displaying the button, as shown in Figure 773.1.

Rollovers trigger as the user moves the cursor across the Web page. The three common states of a rollover are Normal, Up, and Down.

- **Normal:** The Normal rollover state relates to how the image looks when the user's cursor is not directly over the rollover area.

- **Over:** The Over rollover state reacts when the user's cursor moves into the rollover area.

Figure 773.1 A common use of rollovers is changing the look of a graphic button.

- **Down:** The Down rollover state activates when the user's cursor is in the rollover area and then clicks the mouse button.

Creating a rollover with all three states involves the creation of three separate views of the image. Say, for example, that the three rollover states involve creating a button that changes to a drop shadow when the cursor rolls over the button and appears to push in when the user clicks the mouse, as shown in Figure 773.2.

Figure 773.2 The three rollover states for a typical graphic button.

To create the three states for a typical rollover button, open Photoshop and create a document with three layers. Each of the layers should contain one of the rollover states, as shown in Figure 773.3. (See Tip 781, "Creating a JavaScript Rollover in Photoshop," for more information on creating the rollover states.)

To convert the multi-layered document into a JavaScript rollover, perform these steps:

1. Click on the Jump To button, located at the bottom of the Photoshop toolbox. Photoshop opens the multi-layered Photoshop document in ImageReady.

2. If the Rollover palette is not visible, select the Window menu and then choose Show Rollover from the pull-down menu. ImageReady displays the Rollover palette, shown in Figure 773.4.

3. Click on the New Rollover icon twice to create two more rollover states, as shown in Figure 773.5.

4. Click once on the Normal rollover state, and select the Normal layer from the Layers palette. Make sure that the Over and Down layers are deactivated.

Figure 773.3 A Photoshop file containing three layers for the rollover states.

Figure 773.4 The Rollover palette controls the characteristics of each state in the rollover.

Figure 773.5 Clicking on the New Rollover icon creates the Over and Down rollover states.

5. Click once on the Over rollover state, and select the Over layer from the Layers palette. Make sure that the Normal and Down layers are deactivated.

6. Click once on the Down rollover state, and select the Down layer from the Layers palette. Make sure that the Normal and Over layers are deactivated.

7. Select the File menu, choose Preview In, and select from the available options. In this example, you choose Internet Explorer. ImageReady opens Internet Explorer and displays the rollover button, as shown in Figure 773.6.

8. Select the File menu, and choose Quit to close the Internet Explorer program and return to ImageReady.

9. Select the File menu, and choose Save Optimized As from the pull-down menu. ImageReady opens the Save Optimized As dialog box.

Figure 773.6 The rollover button displayed in Internet Explorer

10. Click in the Name input field and enter a name for the JavaScript document.

11. Click on the Format button and select HTML and Images from the available options.

12. Click on the OK button to save the three separate images and a text document containing the prewritten JavaScript code.

774 *Using JavaScript Rollovers with Sliced Images*

In the previous tip, you learned how to create a JavaScript rollover from a multi-layered Photoshop document. JavaScript rollovers can also be used on individual slices to create a totally interactive experience. Say, for example, that you create a Web index page with a black background and a set of buttons on the left side of the page. You want to slice the image, but you also want to use rollovers on some of the individual slices.

When you create rollovers for sliced images, you need the original background image in a layer and the rollover states in individual layers, as shown in Figure 774.1.

To create a rollover state for the image, perform these steps:

1. Click on the Jump To button, located at the bottom of the Photoshop toolbox. Photoshop opens the multi-layered Photoshop document in ImageReady.

2. If the Rollover palette is not visible, select the Window menu and choose Show Rollover from the pull-down menu. ImageReady displays the Rollover palette, shown in Figure 774.2.

3. Move your cursor into the toolbox, and then click on and hold the Image Slice tool. ImageReady displays a pop-up menu containing the Image Slice options, as shown in Figure 774.3.

Figure 774.1 Creating rollover states for a sliced image requires creating the rollover states in separate layers.

Figure 774.2 The Rollover palette controls the characteristics of each state in the rollover.

Figure 774.3 Clicking and holding on the Image Slice tool lets you view the available Image Slice options.

4. Select Slice Tool from the available options.

5. Move the Slice tool into the graphic image and create a rectangular slice around each of the image areas that you want to define as the slices. In this example, you select the button and the data area associated with each of the buttons, as shown in Figure 774.4.

6. Move your cursor into the toolbox, and then click on and hold the Image Slice tool. ImageReady displays a pop-up menu containing the Image Slice options. Choose Slice Select Tool from the available options.

Figure 774.4 The Slice tool creates image slices when you click on and drag the tool across the image.

7. Click once on the slice representing the topmost button. ImageReady selects the slice.

8. Move your cursor into the Rollover palette and click once on the New Rollover icon. ImageReady creates a rollover state called Over.

9. Click once on the Normal rollover state and deactivate all the layers except the background, as shown in Figure 774.5.

Figure 774.5 The Normal rollover state displays only the background layer.

10. Click once on the Over rollover state and activate the Home Over layer, as shown in Figure 774.6.

Figure 774.6 The Over rollover state contains the background and the Home Over layer.

11. Move your cursor into the document and click once to select the second button slice. Repeat steps 8, 9, and 10, but activate the Info Over layer instead of the Home Over layer in step 10.

12. To preview the rollover, select the File menu, choose Preview In, and select from the available options. In this example, Internet Explorer previews the rollover, as shown in Figure 774.7.

13. Select the File menu and choose Save Optimized As. ImageReady opens the Save Optimized As dialog box. Name the file and click the OK button. By default, ImageReady saves the file along with a text document containing the HTML code to run the file.

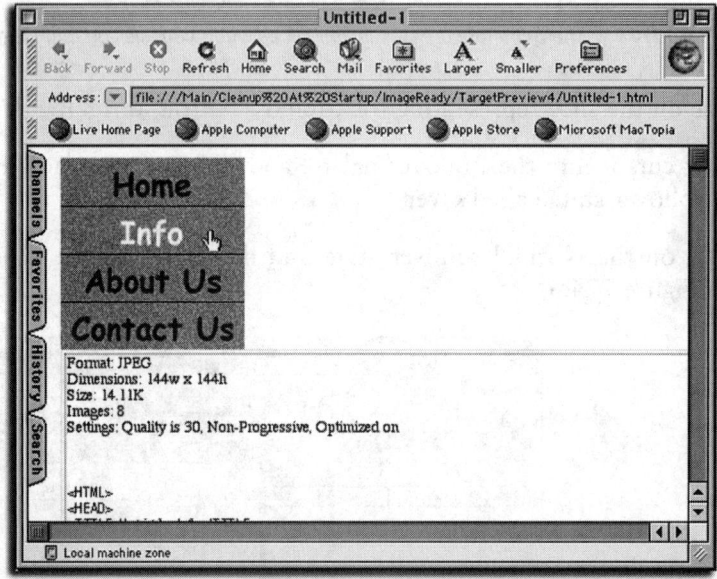

Figure 774.7 The rollover previewed in Internet Explorer.

775 *Working with 2-Up and 4-Up Views*

When you work in ImageReady, the active document opens in a window display. The window display lets you view the original image, the optimized image, or a 2-Up or 4-Up view of the optimized image.

- **Original:** Clicking on the Original tab displays the active image without applying any compression scheme (such as JPEG or GIF), as shown in Figure 775.1.

Figure 775.1 The Original tab displays the original image without compression.

- **Optimized:** Clicking on the Optimized tab displays the active image using the compression options from the Optimize palette, as shown in Figure 775.2.

Figure 775.2 Clicking on the Optimized tab displays the optimized image, based on the settings in the Optimize palette.

- **2-Up:** Clicking on the 2-Up tab displays the original image and the optimized image. This lets you view the original image and, at the same time, view the effects of your current compression settings, as shown in Figure 775.3.

Figure 775.3 With the 2-Up option, you can view the original and optimized images.

- **4-Up:** Clicking on the 4-Up tab lets you view the original image and three versions of the image at different compression settings, as shown in Figure 775.4.

Figure 775.4 With the 4-Up option, you can view the original and three versions of the image at different compression settings.

776 *Using Various File Formats with a Sliced Image*

When you slice an image, each one of the image slices is a separate graphic image. ImageReady creates the illusion of a solid image by reassembling the images into a zero-border table. Because you create individual graphic images using a square or a rectangle shape, the zero-border table assembles the graphics like bricks in a wall, as shown in Figure 776.1.

Figure 776.1 The sliced image reassembles itself into a zero-border table.

For example, you may have a sliced graphic image with areas containing text and areas containing photographic images (refer to Figure 776.1). By compressing the text areas using the GIF format and compressing the photo areas using the JPEG format, you create a small, fast-loading document.

A second trick to creating fast-loading sliced documents is to eliminate solid-color areas. In Figure 776.1, several of the sliced areas contain solid black. When you reassemble the image into a Web page, drop the image onto a black background and delete the portions of the image containing solid black. Because the black background compensates for the missing areas of the image, you have a graphic that loads quickly and looks like a solid image, as shown in Figure 776.2.

Figure 776.2 By removing the black slices from the image table and loading the document against a black background, you create a fast-loading Web image.

777 *Using Logos for Web Backgrounds*

Increasingly today, you see corporate logos used as backgrounds for Web pages. The problem with using a logo is that the image distracts your visitors from focusing on the actual content of the Web page, such as descriptions and linking buttons. If you use a logo as a Web background, it is important to tone down the image so that it does not distract the user from the important areas of the page.

To convert a logo into a Web background, open the logo in Photoshop and perform these steps:

1. Select the Image menu, choose Adjust, and select Levels from the fly-out menu. Photoshop opens the Levels dialog box, shown in Figure 777.1.

Figure 777.1 The Levels dialog box controls the overall lightness and darkness of the logo image.

2. Click on the middle-input slider and drag the slider to the left to lighten the image (refer to Tip 614, "Using the Levels Dialog Box to Adjust the Midtones of an Image").

3. Because you want to create a light, nondistracting image, do not be afraid to drag the slider far to the left, as shown in Figure 777.2.

4. Click the OK button to apply the Levels command to the image.

5. Select the Marquee tool from the toolbox, and draw a perfect square around the image by holding down the Shift key as you click and drag the mouse, as shown in Figure 777.3.

Figure 777.2 The Levels command successfully lightens the logo.

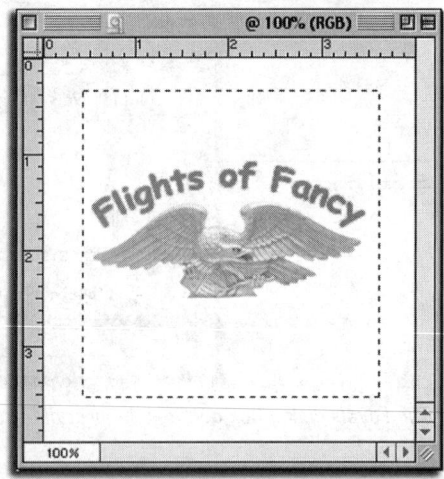

Figure 777.3 The Marquee tool draws a perfect square when you hold down the Shift key as you drag the mouse.

6. Select the Image menu, and choose Crop from the pull-down menu. Photoshop crops the image, based on the square selection marquee.

7. Move the graphic into ImageReady and save the image using the GIF format (refer to Tip 755, "Reducing the File Size of a GIF Image").

8. When the image is used as a Web tile, it presents a nonobtrusive background, as shown in Figure 777.4.

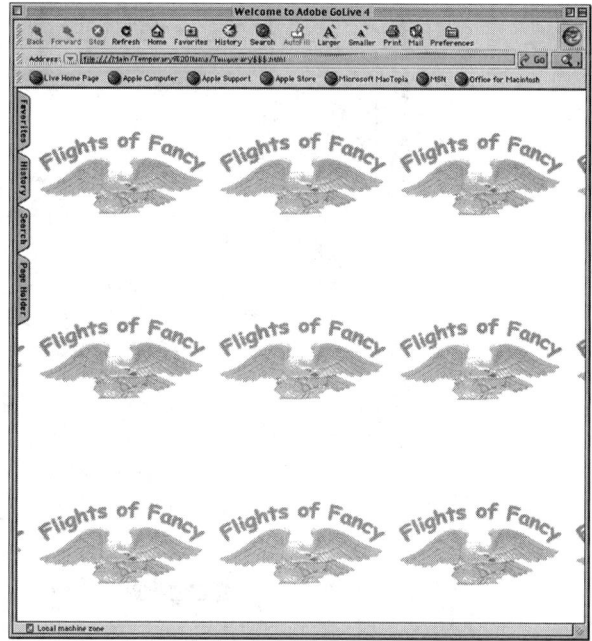

Figure 777.4 The logo displayed as a background tiled graphic.

778 *Creating 3-D Buttons with Copy and Paste*

An excellent way to create buttons that seem to come right out of the surface of a graphic background is to use layer effects combined with copied areas of the original image. Say, for example, that you want to create a button that appears to be part of the surface of a multi-colored background.

To create a 3-D button using copy and paste, open the image that you want to use as the background and then perform these steps:

1. Move your cursor into the toolbox, and click on and hold the Marquee tool, which is located on the top left corner of the toolbox. Photoshop displays the Marquee options in a pop-up menu.

2. Select the Elliptical Marquee tool from the available options.

3. Move your cursor into the document window and draw a small circle. If you want a perfect circle, hold the Shift key as you drag the mouse, as shown in Figure 778.1.

4. Select the Edit menu, and choose Copy from the pull-down menu.

5. Select the Edit menu, and choose Paste from the pull-down menu. Photoshop creates a new layer and places the pasted pixels exactly over the original image pixels, as shown in Figure 778.2.

6. Move your cursor into the Layers palette and click on the Layer Style button, located at the bottom-left of the Layers palette. Photoshop displays a list of available effects.

7. Select Bevel and Emboss from the pop-up menu. Photoshop opens the Layer Style dialog box, shown in Figure 778.3.

Figure 778.1 The Elliptical Marquee tool creates round or oval selections.

Figure 778.2 The Copy and Paste commands created a new layer for the pasted pixels.

8. Select from the available bevel options until you see the type of button you want. In this example, you selected a style of Emboss and a technique of Chisel Hard, as shown in Figure 778.4.

Note: *To use this multi-layered image as a Web button, open the image in ImageReady. Refer to Tip 773, "Creating a JavaScript Rollover," for more information on converting a Photoshop image into a rollover button.*

Figure 778.3 The Layer Style dialog box controls the characteristics of the bevel effect.

Figure 778.4 The Emboss effect created a 3-D button from the copied area of the original image.

779 *Editing Colors Within an ImageReady Color Table*

When you open a graphic in ImageReady, the Color Table palette displays a color swatch for each color in the optimized image, as shown in Figure 779.1.

Figure 779.1 The Color Table displays color information for the active image.

Because the Color Table displays all the colors within the active image, you control the image colors by editing the colors in the table.

- **Selecting:** To select a color in the color table, click once on the selected color.

- **Locking colors:** To lock a color into the color table, select the color and click on the Lock Color icon. ImageReady locks the color into the table. Locked colors will not shift or change, even if you change the Optimization settings in the Optimize palette. Locked colors are identified by a small square in the lower-right corner of the color swatch, as shown in Figure 779.2.

Figure 779.2 Locked colors have a small white square in the lower-right corner of the color swatch.

- **Using Web Safe colors:** Colors identified as Web Safe have a small diamond in the center of the color swatch (refer to Figure 779.3).

- **Web snapping:** To move a color swatch into the Web Safe color palette, click once on the swatch and then click on the Web Snap icon, located at the bottom-left of the Color Table palette. ImageReady converts the selected swatch to the closest Web Safe color and places a small diamond in the center of the color swatch, as shown in Figure 779.3.

Figure 779.3 The Web Snap icon converts the selected color into the Web Safe color palette.

- **Deleting colors:** To delete a color, click on and drag the color swatch to the trash icon, located at the bottom-right of the Color Table. ImageReady removes the color from the color table and the active image.

- **Adding color:** To add the current foreground color to the color table, click on the New icon (second icon from right). ImageReady adds the current foreground color to the end of the Color Table.

- **Editing color:** To edit a color, double-click on a color swatch. ImageReady opens the Color Picker dialog box, shown in Figure 779.4.

Figure 779.4 The Color Picker dialog box controls the color characteristics of the selected color swatch.

Edit the color and click the OK button to apply the change to the color swatch and the active image (refer to Tip 62, "Manually Choosing Colors with the Color Picker").

780 *Creating a Master Color Palette*

ImageReady lets you create a master palette, for use with a group of PNG-8 or GIF images. When you create and use a master palette all images display using the same colors.

To create a master palette, open a graphic that you want to use for the master palette in ImageReady and then perform these steps:

1. Choose the Image menu, select Master Palette, and select Add to Master Palette from the fly-out menu. ImageReady adds the colors from the open image into the master palette.

2. If you want to add colors from more than one graphic image, close the active image and open a second image.

3. Select the Image menu, choose Master Palette, and select Add to Master Palette from the fly-out menu. ImageReady adds the colors from the second image into the master palette.

4. To clear the master palette and start over, select the Image menu, choose Master Palette, and select Clear Master Palette from the fly-out menu. ImageReady clears all the color information from the master palette.

5. When you have completed adding color information to the master palette, select the Image menu, choose Master Palette, and select Build Master Palette from the fly-out menu. ImageReady builds a master palette from the color data.

6. To save the master palette, select the Image menu, choose Master Palette, and select Save to Master Palette from the fly-out menu. ImageReady opens the Save Color Table dialog box, as shown in Figure 780.1.

Figure 780.1 The Save Color Table dialog box lets you save customized color tables.

7. Click in the Name field and enter a name for the color table. In this example, you name the file table1.act.

8. To apply the custom palette to a GIF or PNG-8 image, open the graphic in ImageReady.

9. If the Optimize palette is not visible, select the Window menu and select Show Optimize from the pull-down menu. Photoshop opens the Optimize palette, as shown in Figure 780.2.

Figure 780.2 The Optimize palette controls the characteristics of the active image.

10. Click on the Format button and select GIF or PNG-8 from the available options.

11. Click on the Color Reduction button and select your saved color table (table1.act) from the available options, as shown in Figure 780.3.

Figure 780.3 The Color Reduction button lets you access all the available color tables.

781 *Creating a JavaScript Rollover in Photoshop*

Web designers use JavaScript rollovers to make static Web pages interactive. Rollovers indicate links, trigger animations, or even play sounds and QuickTime movies. In a graphic-related rollover, two or more separate images create the illusion of interactivity. When a user moves the cursor over the area defined by the rollover, it triggers an event. In the case of a graphic rollover, the graphic image changes, depending on how the user moves the mouse, as shown in Figure 781.1.

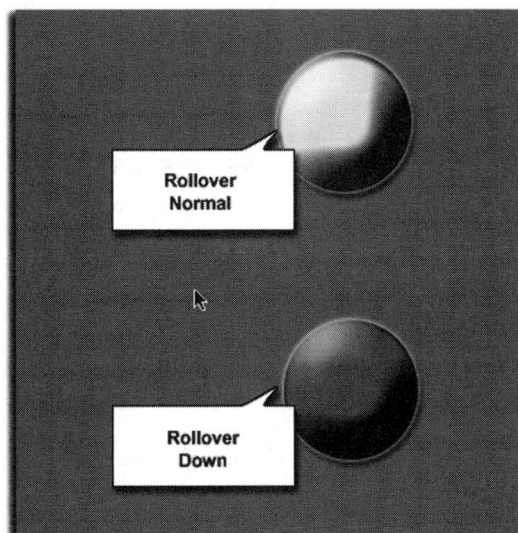

*Figure 781.1 A JavaScript rollover uses two or more graphic images to create
the illusion of movement on a static Web page.*

To create a simple JavaScript rollover using Photoshop, perform these steps:

1. Select the File menu and then choose New from the pull-down menu. Photoshop displays the New dialog box, shown in Figure 781.2.

Figure 781.2 The New dialog box controls the characteristics of the rollover graphic.

2. Create a new document in the size and shape that you want for the JavaScript button. In this example, you create a document with a width and height of 1 inch, a resolution of 72ppi, and the RGB color space. Click the OK button to create the new document.

3. In this example, you will create a simple three-event button. Select the Elliptical Marquee tool from the toolbox, and draw a small circle in the middle of the new document window, as shown in Figure 781.3.

Figure 781.3 The Elliptical Marquee tool creates round or oval selections.

4. Move your cursor into the Layers palette and click once on the New Layer icon. Photoshop creates a new layer, as shown in Figure 781.4.

5. Move your cursor into the Swatches palette and click once on one of the red swatch boxes. Clicking on a swatch box transfers the red color to the foreground swatch, as shown in Figure 781.5.

6. Press Alt+Delete (Macintosh: Option+Delete) to fill the selected area in the new layer with red. Do not deselect the round selection area.

7. Move your mouse into the Layers palette and click once on the New Layer icon. Photoshop creates another new layer.

8. Move your cursor into the Swatches palette and click once on one of the green swatch boxes. Clicking on a swatch box transfers the green color to the foreground swatch.

9. Press Alt+Delete (Macintosh: Option+Delete) to fill the selected area in the new layer with green. Do not deselect the round selection area.

10. Move your cursor into the Layers palette and click once on the New Layer icon. Photoshop creates a third new layer.

Figure 781.4 Clicking on the New Layer icon creates a new layer directly above the background.

Figure 781.5 The foreground color swatch reflects the selection made in the Swatches palette.

11. Move your cursor into the Swatches palette and click once on one of the blue swatch boxes. Clicking on a swatch box transfers the blue color to the foreground swatch.

12. Press Alt+Delete (Macintosh: Option+Delete) to fill the selected area in the third new layer with blue.

13. Press Ctrl+D (Macintosh: Command+D) to deselect the round selection area.

14. You now have a Photoshop graphic image that contains three new layers. Each of the layers contains a circle of color: one of red, one of green, and one of blue, as shown in Figure 781.6.

15. To convert this Photoshop graphic into a JavaScript rollover, open the graphic in ImageReady and perform the steps listed in Tip 773, "Creating a JavaScript Rollover."

Note: This example is a simple illustration of how you might create a JavaScript rollover. By using Photoshop's layer effects and filters, the possibilities of creating exciting, eye-catching rollover buttons is endless.

Figure 781.6 The completed Photoshop graphic containing three colored layers.

782 *Cropping Web Animations*

When you create a moving animation in ImageReady, you essentially use layers to generate the illusion of movement. Each layer in the animation contains a copy of the original image in a different position in the frame. When the layers combine to create the animation, the object appears to move across the screen (refer to Tip 763, "Creating the Illusion of Movement in an Animated GIF"), as shown in Figure 782.1.

Figure 782.1 Separate frames within the animated GIF image create the illusion of movement.

When you create the animation, the portions of the image that fall outside the viewable area of the frame are still part of the image, even though they cannot be viewed, as shown in Figure 782.2.

When you save the animation, the uncropped areas of the image create a bigger file size. To help reduce the file size of an animated GIF image, open the animation in ImageReady and perform these steps:

1. If the Animation palette is not visible, select the Window menu and then select Show Animation from the pull-down menu. Photoshop opens the Animation palette, shown in Figure 782.3.

Figure 782.2 The areas of the image outside the viewable document window are still a part of the image.

Figure 782.3 The Animation palette controls the cropping of the animation frames.

2. Click on the small triangle button located in the upper-right corner of the Animation palette. ImageReady displays the Animation palette options in a pop-up menu.

3. Select Optimize Animation from the pop-up menu. ImageReady opens the Optimize Animation dialog box, as shown in Figure 782.4.

Figure 782.4 The Optimize Animation dialog box lets you reduce the size of the animation file by cropping unneeded areas from the image.

4. Select the Bounding Box option to crop all the areas of the animation that fall outside the viewable image frame.

5. Click the OK button to apply the Bounding Box option to the active image.

> **Note:** *Although the Bounding Box options helps to reduce the file size of the animation file, it is incompatible with earlier versions of GIF editors that do not support the option. You should make a copy of the animation and perform the Bounding Box option on the copy. That way, you always have the original animation if you want to make modifications to the image.*

783 *Using the Tween Option to Create Smooth Animation*

In Tip 763, "Creating the Illusion of Movement in an Animated GIF," you learned how to create an animation sequence by moving an image through a series of separate frames and then combining them into an animated GIF.

ImageReady gives you a much easier way to create straight-line animation using the Tween option. The Tween command lets you add or modify a series of frames between two new frames.

To use the Tween option to create an animation sequence, refer to Tip 763, and create a two-layer file of the toy car. Layer 1 should contain an image of the car at the far left of the viewable frame, and Layer 2 should contain an image of the car at the far right of the viewable frame, as shown in Figure 783.1.

Figure 783.1 The Photoshop document containing two layers of the toy car.

To use the Tween option to animate the car sequence, open the document in ImageReady and perform these steps:

1. If the Animation palette is not visible, select the Window menu and select Show Animation from the pull-down menu. Photoshop opens the Animation palette, shown in Figure 783.2.

Figure 783.2 The Animation palette controls characteristics of the animation frames.

2. Refer to Tip 763, and create an animation sequence with two frames. The frame with the car on the left should be Frame 1, and Frame 2 should contain the layer with the car on the right; refer to Figure 783.2.

3. Click once on Frame 1.

4. Click on the small triangle button located in the upper-right corner of the Animation palette. ImageReady displays the Animation palette options in a pop-up menu.

5. Select Tween from the pop-up menu. ImageReady opens the Tween dialog box, as shown in Figure 783.3.

Figure 783.3 The Tween dialog box controls the characteristics of the Tween option.

- **All Layers:** Select All Layers to perform the Tween option using all of the layers in the image.

- **Selected Layer:** Choose Selected Layer to use the layers selected for the animation. Because the car animation contains only two layers, both of which are used in the animation, it does not matter what option you select.

- **Position:** Select this option to vary the animation from the first cell to the last cell. Because you want to create the illusion of the car moving from left to right, select this option.

- **Opacity:** When you select the Opacity option, the animation slowly fades to zero opacity. Because you want to see the car moving across the frame, do not select this option.

- **Effects:** Select this option to vary any layer effects applied to this image. Because you did not use any layer effects, do not select this option.

- **Tween with:** Click on the Tween with option and select the next frame used to create the animation. Because you selected the first frame in the animation and you want the Tween operation to base the animation on the last frame, select Next Frame from the available options.

- **Frames to Add:** Click in the Frames to Add input box and enter how many frames you want to create between the first frame and the last frame. In this example, you enter a value of 8.

6. Click the OK button to apply the Tween command to the image. ImageReady generates 8 new frames, for a total of 10 animation frames, as shown in Figure 783.4.

Figure 783.4 The Tween command successfully created a straight-line animation.

784 *Using Tween with Layer Effects*

In the previous tip, you learned how to create a simple straight-line animation using the Tween command. The Tween command also creates animation sequences based on layer effect. Say, for example, that you create text with the Text Warp effects and you want ImageReady to animate the text.

To create animation based on warped text, create a Photoshop image with two text layers. Each of the layers should use the Text Warp feature to distort the type (refer to Tip 193, "Warping Text"), as shown in Figure 784.1.

Figure 784.1 A Photoshop document with two type layers containing warped text.

Open the Photoshop document in ImageReady and then perform these steps:

1. If the Animation palette is not visible, select the Window menu and then select Show Animation from the pull-down menu. Photoshop opens the Animation palette, shown in Figure 784.2.

Figure 784.2 The Animation palette controls characteristics of the animation frames.

2. Refer to Tip 763, "Creating the Illusion of Movement in an Animated GIF," and create an animation sequence with two frames. Frame 1 should contain the warped text from Layer 1, and Frame 2 should contain the warped text from Layer 2.

3. Click once on Frame 1.

4. Click on the small triangle button located in the upper-right corner of the Animation palette. ImageReady displays the Animation palette options in a pop-up menu.

5. Select Tween from the pop-up menu. ImageReady opens the Tween dialog box, shown in Figure 784.3.

Figure 784.3 The Tween dialog box controls the characteristics of the Tween option.

6. Select All Layers for the Layers option.

7. Deselect all the Parameters options with the exception of Effects (refer to Figure 784.3).

8. Because you previously selected Frame 1 in the Animations palette, select Next Frame for the Tween with option.

9. Click in the Frames to Add input box and enter a value of 4, to add four additional frames to the animation.

10. Click the OK button to add the Effects frames between the two warp text layers, as shown in Figure 784.4.

Figure 784.4 The Tween command successfully created an animation sequence based on two warp text frames.

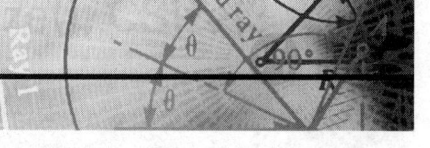

785 *Using Tween to Fade Animation*

In Tip 764, "Making an Animation Fade In and Out," you learned how to control the opacity of an animated GIF file to create the appearance of an image fading in and out. One other feature of the Tween command is its capability to fade an image across a series of frames. Say, for example, that you want the toy car animation created in Tip 783, "Using the Tween Option to Create Smooth Animation," to fade as it moves across the image window.

To use the Tween command to fade and animate the toy car, open the animation sequence created in Tip 783 and perform these steps:

1. Click on the small triangle button located in the upper-right corner of the Animation palette. ImageReady displays the Animation palette options in a pop-up menu.

2. Select Tween from the pop-up menu. ImageReady opens the Tween dialog box, shown in Figure 785.1.

Figure 785.1 The Tween dialog box controls the characteristics of the Tween option.

3. Repeat the steps to create the toy car animation in Tip 783, with one exception: Select the Opacity and Position options.

4. Click the OK button to apply the Tween command to the toy car layers. ImageReady animates the car and, at the same time, lowers the opacity of the car as it travels left to right across the visible frame, as shown in Figure 785.2.

Figure 785.2 The Tween command animated the toy car and lowered the opacity of the image frame by frame.

786 *Resizing an Animated GIF File*

Normally, when you create a graphic animation sequence, the size and resolution of the image has already been determined. Say, for example, that you create an animation sequence using ImageReady, and the image size is incorrect.

To resize animation, open the animation sequence in ImageReady (refer to Tip 763, "Creating the Illusion of Movement in an Animated GIF") and perform these steps:

1. Select Image menu, and select Image Size from the pull-down menu. ImageReady opens the Image Size dialog box, shown in Figure 786.1.

Figure 786.1 The Image Size dialog box controls the size and resolution of the active animation file.

2. Click in the Width and Height fields to define the size of the animation file in pixels. Because animated GIF images typically display on the Web, the pixel system is the measurement system of the Internet.

3. Click in the Percent input field and enter a value to increase or decrease the size of the file, based on a percentage of its original size.

4. Select the Constrain Proportions option to keep the width and height of the animation in proportion.

5. To create a smooth image, click on the Quality button and select Smooth (Bicubic) from the drop-down list.

6. Select Action Options to include the Image Size command in an action (refer to Tip 411, "Creating a New Action").

7. Click the OK button to apply the Image Size command to the animation. ImageReady resizes each frame in the animation.

Note: Although this tip centered on changing the size of an animation file, the Image Size command works to resize any graphic opened in ImageReady.

787 *Forcing a Rollover to Trigger an Animation Sequence*

In Tip 781, "Creating a JavaScript Rollover," you learned how to convert a multi-layered Photoshop document into a JavaScript rollover. Moving your cursor into the area controlled by the rollover changes the state of the graphic image, such as identifying where to click on a button. Say, for example, that when you roll your cursor onto a graphic image of a button, the rollover graphic says "Click Here," as shown in Figure 787.1.

Figure 787.1 The JavaScript rollover indicates where the button is by displaying the words "Click Here."

Say, for example, that you want the toy car animation created in Tip 763, "Creating the Illusion of Movement in an Animated GIF," to be triggered when the user moves the cursor over a graphic containing the word "Start."

To use a JavaScript rollover to trigger an animated sequence, open the Photoshop image containing the two toy cars created in Tip 783, "Using the Tween Option to Create Smooth Animation," as shown in Figure 787.2.

Create two more layers in the toy car graphic. One layer contains the word "Start," and the second layer contains the word "Go" (refer to Tip 218, "Creating Text in Photoshop 6.0"), as shown in Figure 787.3.

Figure 787.2 The original Photoshop image containing two toy car layers.

Figure 787.3 The Type layers Start and Go, added to the Photoshop file.

To create the final animation sequence, perform these steps:

1. Click on the Jump To button, located at the bottom of the Photoshop toolbox. Photoshop opens the multi-layered Photoshop document in ImageReady.

2. If the Rollover palette is not visible, select the Window menu and choose Show Rollover from the pull-down menu. ImageReady displays the Rollover palette, shown in Figure 787.4.

Figure 787.4 The Rollover palette controls the characteristics of each state in the rollover.

3. Click on the New Rollover icon to create one more rollover state, as shown in Figure 787.5.

Figure 787.5 Clicking on the New Rollover icon creates the Over rollover state.

4. Click once on the Normal rollover state, and select the Start layer from the Layers palette. Make sure that all other layers are deactivated.

5. Click once on the Over rollover state, and select the Go layer from the Layers palette. Make sure that all other layers are deactivated.

6. If the Animation palette is not visible, select the Window menu and then select Show Animation from the pull-down menu. Photoshop opens the Animation palette, shown in Figure 787.6.

Figure 787.6 The Animation palette controls characteristics of the animation frames.

7. Refer to Tip 763, and create an animation sequence with two frames. The frame with the car on the left should be Frame 1, and Frame 2 should contain the layer with the car on the right. Both of the animation frames should contain a version of the car, and both layers should contain the layer with the word "Go." (Refer to Figure 787.5.)

8. Click once on Frame 1.

9. Click on the small triangle button located in the upper-right corner of the Animation palette. ImageReady displays the Animation palette options in a pop-up menu.

10. Select Tween from the pop-up menu. ImageReady opens the Tween dialog box, shown in Figure 787.7.

11. Select All Layers, and choose the Position option. Because you previously selected Frame 1, select Next Frame from the Tween with option.

12. Click in the Frames to Add input field, and enter 6.

13. Click the OK button to apply the Tween command to the image. ImageReady creates the animation. The car moves from the left to right of the image window, and the word "Go" is at the top of every frame, as shown in Figure 787.8.

14. To preview the animation sequence, select the File menu, choose Preview In, and select from the available options. In this example, you select Internet Explorer to preview the animation, as shown in Figure 787.9.

Note: The JavaScript rollover triggered the animation sequence because you linked the Over rollover state to the animation in step 7. When you create a rollover, if you click on a particular rollover state and then create animation, the animation is automatically linked to the selected rollover state.

Figure 787.7 The Tween dialog box controls the characteristics of the Tween option.

Figure 787.8 The Tween animation applied to the two car frames.

Figure 787.9 Internet Explorer displays the animation sequence.

788 *Creating Background Transparency in GIF and PNG Images*

Since the introduction of Photoshop 6.0 and ImageReady 3.0, creating transparent areas in a Web image just got a whole lot easier. As a matter of fact, creating transparency within an image destined for the Internet is as simple as erasing the areas of the image you want transparent and saving the file through Photoshop's Save For Web option, or ImageReady.

To generate transparent areas in an image, open the graphic in Photoshop, and perform these steps:

1. If the Layers palette is not visible, select the Window menu and then choose Show Layers from the pull-down menu. Photoshop opens the Layers palette, shown in Figure 788.1.

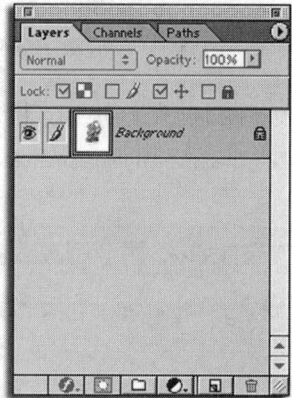

Figure 788.1 The Layers palette defines all the layers within the active document.

2. The major obstacle to creating transparency in an image is layer type. If the image layer is a background, double-click on the background layer name. Photoshop opens the New Layer dialog box, shown in Figure 788.2.

Figure 788.2 The New Layer dialog box lets you convert a background into a layer.

3. A background layer does not support transparency. Click in the Name input field and enter a name for the layer.

4. Click the OK button to convert the background into a layer.

5. You want to leave the object on a transparent background. Select the Lasso tool from the toolbox, and select all the areas around the object, as shown in Figure 788.3.

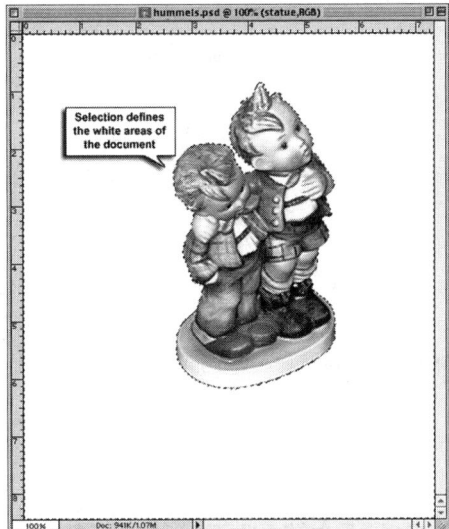

Figure 788.3 Use the Lasso tool and select all the areas of the image that you want to make transparent.

6. Press the Delete key. Photoshop converts the selected areas of the image to transparent, as shown in Figure 788.4.

Figure 788.4 The document window containing the object against a transparent background.

7. Select the File menu, and choose Save for Web from the pull-down menu. Photoshop opens the Save For Web dialog box, as shown in Figure 788.5.

8. Click on the Format button and select GIF, PNG-8, or PNG-24 (JPEG images do not support transparent pixels), and select the Transparency option (refer to Figure 788.5).

9. Click the OK button to save the image (see Tip 830, "Changing Image Size Using Save For Web," for more options in the Save For Web dialog box).

Figure 788.5 The Save For Web dialog box controls the format of the transparent image.

789 *Applying Layer Effects Within ImageReady*

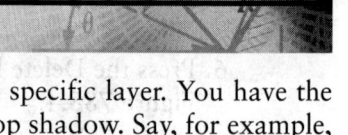

When you work on an image, Photoshop lets you apply a layer effect to a specific layer. You have the capability to generate complicated bevel and emboss, as well as a simple drop shadow. Say, for example, that you create an image in Photoshop and then move the graphic into ImageReady. Once in ImageReady, you decide to add a shadow effect to the image.

It is not necessary to return to Photoshop simply to apply a shadow effect; ImageReady is also capable of performing layer effects. To apply a layer effect to an ImageReady document, open the graphic in ImageReady and perform these steps:

1. If the Layers palette is not visible, select the Window menu and choose Show Layers from the pull-down menu. ImageReady opens the Layers palette, shown in Figure 789.1.

Figure 789.1 The Layers palette defines all the layers within the active document.

2. Click on the Layer Effect icon, located at the bottom-left of the Layers palette. Photoshop displays a list of available layer effects in a pop-up menu.

3. Select Drop Shadow from the pop-up menu. ImageReady applies a generic drop shadow to the selected layer, as shown in Figure 789.2.

Figure 789.2 Selecting Drop Shadow automatically applies a drop shadow to the selected layer.

Note: Where Photoshop gives you the option to control the drop shadow, ImageReady applies the effect automatically to the selected layer. To modify a layer effect, refer to the next tip.

790 *Modifying a Layer Effect in ImageReady*

In the previous tip, you learned how to apply a layer effect using ImageReady. Say, for example, that you apply a drop shadow to a graphic. However, after you create the drop shadow, you want to modify the generic effect created by ImageReady.

To modify a generic layer effect, open an ImageReady document containing a layer with an applied layer effect and then perform these steps:

1. If the Layer Options/Style palette is not visible, select the Window menu and choose Show Layer Options from the pull-down menu, as shown in Figure 790.1.

2. Move your cursor into the Layers palette and click once on the layer containing the layer effect. The Layer Options/Style palette displays layer information on the selected layer. If you click on a layer containing a drop shadow, the palette displays the name Drop Shadow and lets you modify the shadow effect.

 • **Blending Mode:** Click on the Blending Mode button and choose a blending mode from the drop-down list. The most common blending mode for shadows is the Multiply mode.

 • **Opacity:** Click in the Opacity input field and enter a value from 0 to 100 percent. The lower the value is, the more transparent the shadow will be. The shadow input field defaults to 75 percent.

Figure 790.1 The Layer Options palette lets you modify the layer effects created in Photoshop or ImageReady.

- **Distance:** Click in the Distance input field and enter a value from 0 to 300. The Distance input value represents the distance of the shadow from the object.

- **Color:** Click in the color box and choose the shadow color. The most common color for shadows is the default value of black.

- **Angle:** Click in the Angle input field and enter a value from +180 to –180. The Angle value sets the angle of the light source.

- **Global Angle:** Select the Global Angle option to use the same light source for all effects in all layers.

- **Spread:** Click in the Spread input field, and enter a value from 0 to 100 percent. The Spread value determines the size of the mask used to blur the shadow effect.

- **Size:** Click in the Size input field, and enter a value from 0 to 250. The Size value determines the size of the shadow.

- **Layer Knocks Out Drop Shadow:** Select this option to eliminate the shadow effect where it interacts with transparent areas of the image.

Note: When you apply a layer effect to a layer in Photoshop or ImageReady, the Layer Options/Style palette is where you apply modifications to the effect.

791 *Choosing a Frame Disposal Method Within an Animation*

The frame disposal method specifies whether ImageReady should keep the current frame in the animation before displaying the next frame, as shown in Figure 791.1.

Figure 791.1 Choosing a frame disposal method determines the frame-by-frame view of animation.

To select a frame disposal method, open an animation sequence in ImageReady and perform these steps:

1. If the Animation palette is not visible, select the Window menu and choose Show Animation from the pull-down menu. ImageReady opens the Animation palette, shown in Figure 791.2.

2. Right-click (Macintosh: Ctrl+click) on a frame. ImageReady displays a pop-up menu displaying the frame disposal options. Select from the available options:

 - **Automatic:** Choose this option to discard the previous frame if the current frame contains transparent pixels.

 - **Do not dispose:** Choose this option to preserve the previous frames in the animation.

 - **Restore to background:** Chose this option to display one frame at a time. When you select this option, previous frames do not display through the transparent areas of the image.

Figure 791.2 The Animation palette controls the frame disposal method used by ImageReady.

Note: The frame disposal method is useful only with animations containing transparent frames. Nontransparent animation does not require a frame disposal method.

792

Creating an Image with a Matted Background

When you create a GIF or a PNG image with transparency, you have the capability to place nonrectangular objects onto a solid or multi-colored Web background, as shown in Figure 792.1.

Figure 792.1 Transparency lets you control what you see in a Web image.

The background matting option lets you fill in the transparent areas of an image with a specific Web color. Background transparency is especially useful with JPEG images because they do not support transparency. The Matte options work best when the Web background is a solid color.

Say, for example, that you modify a photograph in Photoshop to contain transparent areas and you want to place the image on a Web page. Because the JPEG format does not support transparency, you decide to fill the transparent areas of the image with the same color as the background of the Web page.

To use the matte option, open the graphic in ImageReady and perform these steps:

1. If the Optimize palette is not visible, select the Window menu and choose Show Optimize from the pull-down menu. ImageReady opens the Optimize palette, shown in Figure 792.2.

Figure 792.2 The Optimize palette controls the characteristics of the matting command.

2. Click once on the image format button and select JPEG as the file format.

3. Click once on the triangle button located to the right of the Matte color box. ImageReady opens the matte options, as shown in Figure 792.3.

Figure 792.3 The Matte options control the fill color for the active image.

- **None:** Select None to fill the transparent areas of the JPEG image with white.

- **Foreground/Background:** Select Foreground Color or Background Color to fill the transparent areas of the image with the current foreground or background color.

- **Color swatch:** Select a color swatch to fill the area with a predefined Web Safe matte color.

- **Other:** Click on Other to select a color from the ImageReady Color Picker, as shown in Figure 792.4.

Figure 792.4 Selecting Other from the pop-up menu lets you select the matte color using the Color Picker.

4. The selected color fills the transparent areas of the image, as shown in Figure 792.5.

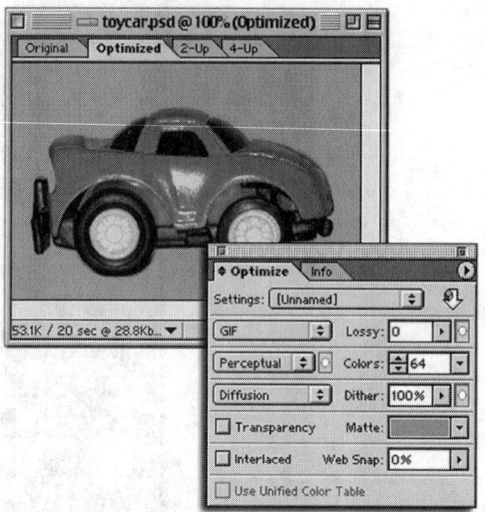

Figure 792.5 The Matte option fills the transparent areas of the image with the selected color.

793 *Identifying Non-Web Colors Using ImageReady*

When you open a graphic in ImageReady, the Color Table defines all of the colors within the image. Each color swatch containing a small white triangle identifies the swatch as a Web Safe color.

To identify where a specific color occurs within the image, open a graphic in ImageReady and perform these steps:

1. If the Color Table palette is not visible, select the Window menu and choose Show Color Table from the pull-down menu. ImageReady opens the Color Table palette, as shown in Figure 793.1.

Figure 793.1 The Color Table palette identifies all the colors within the active GIF and PNG-8 image.

2. Select the Eyedropper tool from the toolbox.

3. Move the Eyedropper tool into the document window, and click once to sample a color from the image. The Color Table palette selects the sampled color from the image, as shown in Figure 793.2.

Figure 793.2 The Color Table palette displays the selected color.

4. To bring the selected color into the Web Safe palette, click once on the Web Snap button, located at the bottom-left corner of the Color Table. ImageReady selects the closest Web Safe match and converts the color, as shown in Figure 793.3.

> *Note:* Colors outside the Web Safe palette do not display correctly on old color monitors. Placing the colors into a Web Safe palette ensures that the image displays correctly on all monitors, old or new.

Figure 793.3 The Web Snap button converts the selected color into the Web Safe color palette.

794 *Creating Seamless Background Images Using the Offset Option*

Creating seamless background tiles just got easier with the Offset command. For example, you have a logo that you want to convert into a seamless background tile. In this example, you open a 200-by-200 pixel graphic in ImageReady, as shown in Figure 794.1.

To convert the logo into a seamless background tile, perform these steps:

1. Select the Filter menu Other, and select Offset from the fly-out menu. ImageReady opens the Offset filter, shown in Figure 794.2.

Figure 794.1 The logo graphic open in ImageReady.

Figure 794.2 The Offset filter controls the offset of the active image.

2. Click on the Offset by button and choose Percent from the drop-down list.

3. Click in the Horizontal and Vertical input fields, and enter a value of 50 percent (refer to Figure 794.2).

4. Click the OK button to apply the offset to the active image, as shown in Figure 794.3.

Figure 794.3 The Offset filter applied to the active image.

5. As an added feature, select the logo before performing the Offset command and paste it back into the center of the image, as shown in Figure 794.4.

6. Select the File menu, and choose Save Optimized As from the pull-down menu. ImageReady opens the Save Optimized dialog box.

7. Name the file and save it to disk. When you use the image as a tile on a Web page, the background image appears seamless, as shown in Figure 794.5.

Figure 794.4 *The original logo pasted back into the image after performing the Offset command.*

Note: *Centering the image within the document window makes it easier to control the offsetting of the graphic, and produces a more consistent tile.*

Figure 794.5 *The Offset image used as a background tile.*

795 *Determining Whether a Background Is Really Seamless*

A quick way to determine whether a graphic image produces a seamless tile effect is to open the image in Photoshop and use the Pattern Fill option. Say, for example, that you create a background tile in Photoshop and you want to see if the image produces a seamless appearance, as shown in Figure 795.1.

To determine whether a graphic image produces a seamless tile pattern, open the graphic in Photoshop and perform these steps:

1. Select the Edit menu and choose Define Pattern from the pull-down menu. Photoshop displays the Pattern Name dialog box, shown in Figure 795.2.

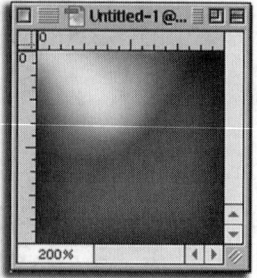

Figure 795.1 A potential background tile, opened in Photoshop.

Figure 795.2 The Pattern Name dialog box lets you name and save a graphic image as a pattern.

2. Click in the Name input field and name the new pattern. In this example, you select Tile Pattern 1 as the name.

3. Click the OK button to save the tile pattern.

4. Select the File menu and choose New from the pull-down menu. Photoshop opens the New dialog box, shown in Figure 795.3.

Figure 795.3 The New dialog box lets you create a new document to view the tile pattern.

5. Select a width and height large enough to display several tiles the size of the original pattern. Because the original tile that you saved as a pattern contain a width and height of 1 inch, you create the new document with a width and height of 5 inches by 5 inches.

6. The resolution and color space of the new document should match that of the tile pattern document. In this example, the color space is RGB and the resolution is 72 ppi.

7. Click the OK button to open the New document.

8. Select the Edit menu and then choose Fill from the pull-down menu. Photoshop opens the Fill dialog box, shown in Figure 795.4.

Figure 795.4 The Fill dialog box controls the characteristics for the Fill command.

9. Click on the Use button and select Pattern from the available options.

10. Click on the Custom Pattern button and select Tile Pattern 1 from the list of available patterns.

11. Select a blending mode of Normal and an opacity of 100 percent. Do not select Preserve Transparency (refer to Figure 795.4).

12. Click the OK button to apply the pattern to the new document window, as shown in Figure 795.5.

Figure 795.5 The Fill command successfully filled the document window with the saved pattern.

***Note:** The Fill command is an excellent way to view how a tile pattern appears in a Web document. If the pattern is seamless, delete the new document and then save the original pattern.*

796 *Creating a Seamless Background Using a Photograph*

Photographic images typically do not produce a seamless background, but with a little help from ImageReady and the Tile Maker filter, even photographic images make seamless tiles.

Say, for example, that you have a small graphic image that you want to use as a background tile; however, the image appears blocky, as shown in Figure 796.1.

Figure 796.1 The graphic tile appears blocked, and the edges are easy to identify.

To correct the problems with the photographic tile, open the graphic in ImageReady and perform these steps:

1. Select the Filter menu, choose Other, and choose Tile Maker from the pull-down menu. ImageReady opens the Tile Maker dialog box, shown in Figure 796.2.

Figure 796.2 The Tile Maker filter helps to create seamless tiles from clip art and photographic images.

2. Select the Blend Edges option, and enter 10 percent in the Width input field. The Width field determines how much of the image edge is modified to produce a smooth tile.

3. Select the Resize Tile to Fill Image option. When deselected, the original image resizes based on the value entered in the Width input field.

4. Click the OK button to apply the Tile Maker filter to the image.

5. View the image as a tile to determine the actual effects of the Tile Maker filter, as shown in Figure 796.3.

Figure 796.3 The Tile Maker filter creates a smoother appearance to the graphic tile background.

Note: *Experiment with the Kaleidoscope Tile option in the Tile Maker filter to create some interesting special-effects background tiles, as shown in Figure 796.4.*

Figure 796.4 The Kaleidoscope Tile option creates special-effects background images.

797 *Using a Full-Screen Image as a Background*

Full-screen backgrounds are created using a single, nontiled image. Although creating full-screen backgrounds makes for a large image, if it's done properly, you can make a background from a single graphic and still make it small enough to load quickly.

To create a full-screen background, do not use a photograph; instead, create a multi-colored background image using flat color areas. Because the compressed image uses the GIF format, large, flat areas of color compress more efficiently.

To create a full-screen background, open Photoshop and perform these steps:

1. Select the File menu and chose New from the pull-down menu. Photoshop opens the New dialog box, shown in Figure 797.1.

Figure 797.1 The New dialog box lets you define the characteristics of the new document.

2. Create a document with a width of 1,024 pixels and a height of 768 pixels, in the RGB color mode and with a resolution of 72 ppi (refer to Figure 797.1). Using 1,024 by 768 gives the image enough size to work with lower and higher resolution monitors.

3. If the Swatches palette is not visible, select the Window menu and choose Show Swatches from the pull-down menu. Photoshop opens the Swatches palette.

4. Click on the black triangle button located in the upper-right corner of the Swatches palette. Photoshop displays a pop-up menu containing the Swatches options, as shown in Figure 797.2.

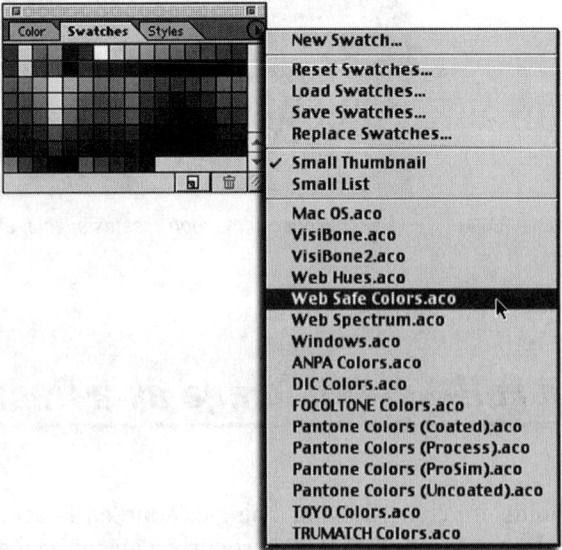

Figure 797.2 Clicking on the black triangle displays a pop-up menu containing the Swatches options.

5. Select Web Safe Colors from the Swatches options, and click the OK button to convert the Swatches palette to the Web Safe Color palette.

6. Experiment using your painting tools and create a background containing large flat areas of Web Safe colors, as shown in Figure 797.3.

Figure 797.3 An example of a full-screen image containing large flat areas of Web Safe color.

7. To save the image, select the File menu and choose Save For Web from the pull-down menu. Photoshop opens the Save For Web dialog box, shown in Figure 797.4.

Figure 797.4 The Save For Web dialog box lets you control the compression of the active image.

8. Click on the Format button and select GIF from the available options.

9. Because the image contains four colors, click on the Colors option and select 4 from the pop-up list (refer to Figure 797.4).

10. Click the OK button to save the file to disk. You now have a large full-screen background with an image size of only 12.6K, as shown in Figure 797.5.

Figure 797.5 The completed image displayed using Internet Explorer.

798 *Creating a Browser Size Template*

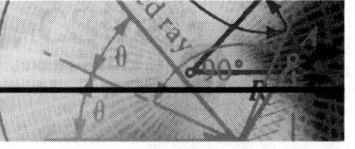

When you design images destined for the Web, you should understand that the images display on all types of monitors. Different monitors display color differently, so you use a Web Safe palette to control the colors in your images. Monitors also have different resolutions. The resolution of a monitor determines the width and height of a browser window. Typical monitor resolutions are listed here:

- 640×480

- 800×600

- 1024×768

- 1152×870

- 1280×960

Say, for example, that you design a graphic image using a width and height of 800×600 pixels. The image fits perfectly on an 800×600 monitor, is too big for a 640×480 monitor, and fits with room to spare on a larger monitor, as shown in Figure 798.1.

Compensate for different monitor resolutions by creating a browser size template. Use the template on your monitor to view how different monitors view different resolution images.

To create a browser template, open Photoshop and perform these steps:

1. Select the File menu and choose New from the pull-down menu. Photoshop opens the New dialog box, shown in Figure 798.2.

2. Create a document with a width and height that matches the resolution of your monitor. Use the RGB Color mode and a resolution of 72ppi (refer to Figure 798.1). In this example, you create a new document with a size of 1280 by 960.

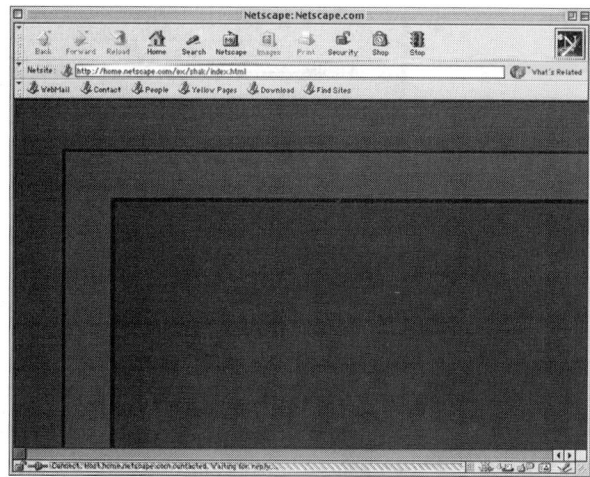

Figure 798.1 The resolution of a monitor determines what the user sees on the Web browser.

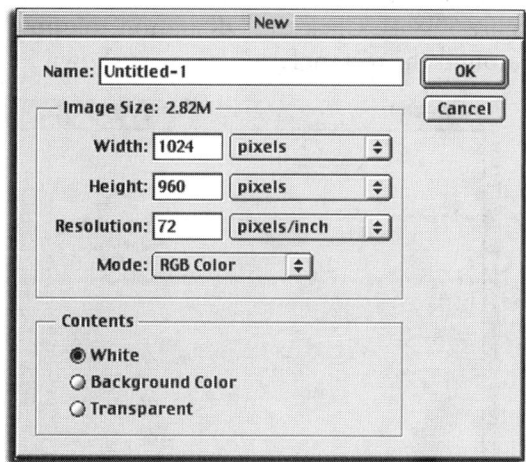

Figure 798.2 The New dialog box lets you define the characteristics of the new document.

3. Select the Rectangular Marquee tool from the toolbox.

4. Move into the Options bar, click once on the Style button, and select Fixed Size from the drop-down list.

5. Click in the Width input field and enter a value of 1024 pixels. In the Height input field, enter a value of 768 pixels, as shown in Figure 798.3.

Figure 798.3 The Option bar controls the characteristics of the Rectangular Marquee tool.

6. Move the Marquee tool to the upper-left corner of the document window, and click your mouse. The Marquee tool generates a 1024-by-768 selection. If the selection is not in the exact upper-right corner of the document window, click on it and drag it to the corner.

7. Select the Edit menu and choose Stroke from the pull-down menu. Photoshop opens the Stroke dialog box, shown in Figure 798.4.

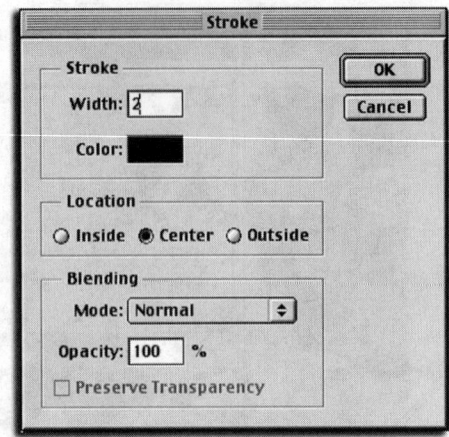

Figure 798.4 The Stroke box creates a stroke of color around a preselected area of a Photoshop image.

8. Select a stroke of 2 pixels, and select Center for the location. Leave the other options at their default values (refer to Figure 798.4). Click the OK button to apply the Stroke command. Photoshop creates a stroke line around the rectangle selection, as shown in Figure 798.5.

Figure 798.5 The Stroke command created a stroke line around the selection marquee.

9. Repeat steps 5 through 8 by creating and stroking two more marquee selections: one with a value of 800×600, and a second with a value of 640×480, as shown in Figure 798.6.

Open and use the template to match your graphic images to the various sizes on the template. That way, you have a good idea of how the images appear at different resolutions.

Note: If the image size matches the resolution of your monitor, use the template as a desktop image. Refer to the Windows or Macintosh operation manual to learn how to convert a photograph into a background image.

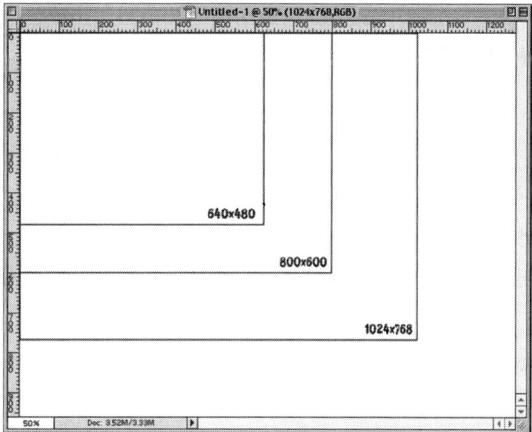

Figure 798.6 The finished template contains a rectangle representing all of the major browser sizes.

799 *Moving a Photoshop Image into ImageReady*

Photoshop and ImageReady are two programs that work together to produce graphics for anything from Web pages to four-color magazines. When you work between Photoshop and ImageReady, Adobe gives you a way to jump between the two programs using the Jump To button. The Jump To button lets you move an image from Photoshop directly into ImageReady, and vice versa. The Jump To button is located at the bottom of the Photoshop and ImageReady toolboxes, as shown in Figure 799.1.

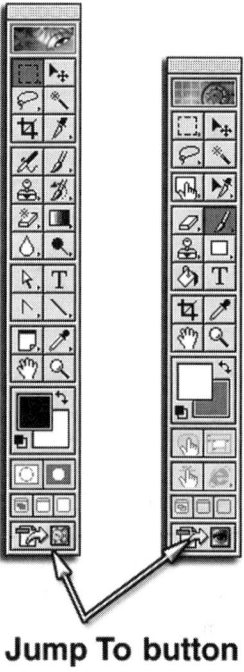

Jump To button

Figure 799.1 The Photoshop and ImageReady toolboxes contain a button that lets you move an image between the two programs.

Because ImageReady is primarily a Web-editing program, moving a graphic into ImageReady modifies the image to conform to certain Web standards:

- **Color space:** Images in Photoshop contain millions of possible colors. Images moved into ImageReady and saved using the GIF and PNG-8 formats knock the color table to a maximum of 256 colors.

- **Resolution:** Although ImageReady lets you open an image at any resolution, Web images are typically 72ppi or 96ppi. Any graphic with a larger resolution simply wastes space and processor time.

- **Lossy Compression:** ImageReady saves photographic images using the JPEG format (refer to Tip 754, "Reducing the File Size of a JPEG Image"). JPEG compression reduces file size by removing color information from the image.

When you jump an image into ImageReady and then jump it back into Photoshop, the image returns to Photoshop with the modifications made in ImageReady, and vice versa. Because ImageReady modifies the image's color table and performs lossy compression, take care when moving an image into ImageReady and then back into Photoshop.

800 *Working with Transparency in the GIF Format*

When you create a transparent area in an image, saving the file in the GIF format lets you preserve the transparency on a Web page, as shown in Figure 800.1.

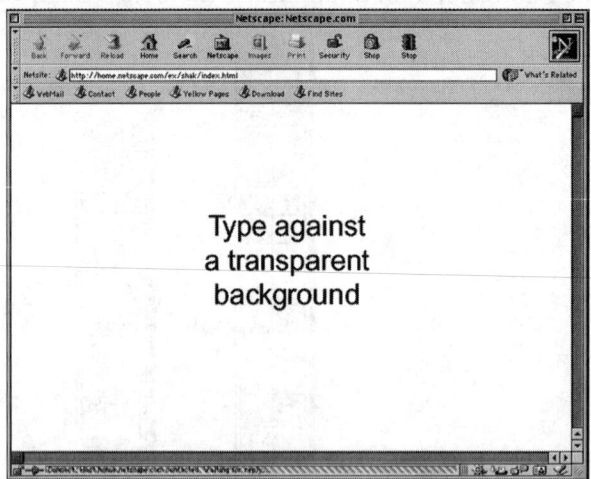

Figure 800.1 Creating an image with transparent areas and saving the image using the
GIF format lets you view the image in a Web browser with the transparent areas intact.

GIF images have one problem: They are limited to 1-bit transparency, which does not let you create soft-edged looks to the image. In Photoshop, you create soft-edged transparency effects such as drop shadows and bevels. Unfortunately, saving the image using the GIF format creates a hard-edged look to the image, as shown in Figure 800.2.

Although there are not a lot of options, one workaround is to create the image and then use ImageReady's Matte option to fill in the areas with a Web Safe color matching the background of the Web page.

Figure 800.2 The Photoshop drop shadow creates a hard edge when converting the image to the GIF format.

To use the Matte option to create the illusion of a soft drop shadow, open the graphic in ImageReady and perform these steps:

1. If the Optimize palette is not visible, select the Window menu and choose Show Optimize from the pull-down menu. ImageReady opens the Optimize palette, shown in Figure 800.3.

Figure 800.3 The Optimize palette controls the characteristics of the matting command.

2. Click once on the image format button and select GIF as the file format.

3. Deselect the Transparency option.

4. Click once on the triangle button located to the right of the Matte color box. ImageReady opens the Matte options, as shown in Figure 800.4.

5. Select Other from the available options. Photoshop opens the Color Picker dialog box, shown in Figure 800.5.

6. Select the exact background color used on the Web page. The best way to select the color is to know the color's hexadecimal code and type the code into the # input box, located at the bottom right of the dialog box (refer to Figure 800.5). In this example, you enter the value of 999999.

7. Click the OK button to apply the matte color to the transparent areas of the image, as shown in Figure 800.6.

8. Select the File menu and then choose Save Optimized As from the pull-down menu. ImageReady opens the Save Optimized As dialog box. Name the file and click on the Save button to save the file to disk.

9. When the image opens on a Web page containing the same background color, the Matte option blends the image into the background and creates the illusion of a soft drop shadow, as shown in Figure 800.7.

Figure 800.4 The Matte options control the fill color for the active image.

Figure 800.5 The Color Picker dialog box lets you choose the color for the matte fill command.

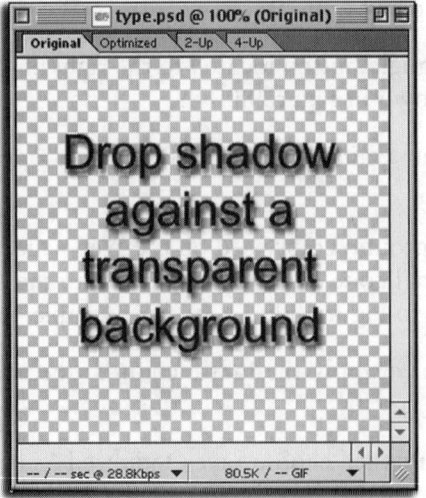

Figure 800.6 The matte color applied to the transparent areas of the active image.

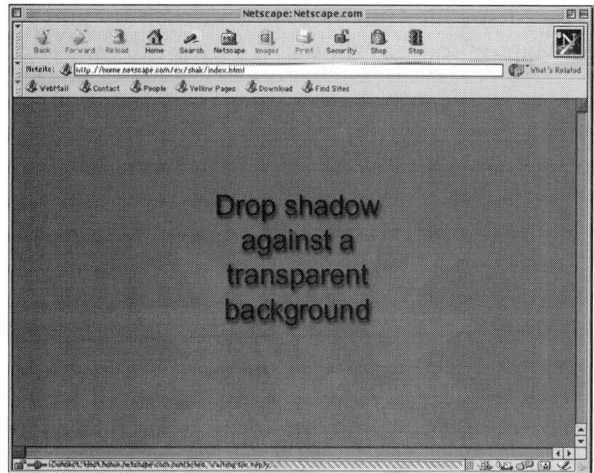

Figure 800.7 The drop shadow successfully used on a Web page.

801 *Creating an Image Map*

Image maps are graphic images that contain invisible hot spots. When the Web surfer's cursor enters a hot spot, the image icon switches from a selection arrow to a hand icon. When the user clicks inside the defined hot spot, it triggers a Web event. That event might be a link to another page or the download-ing of a file, or the action could even trigger a sound or play a QuickTime Movie.

Image maps differ from sliced images in that the graphic used for the image map is not sliced into sep-arate image pieces. You create an image map using the whole image. Say, for example, that you have a graphic of the United States, and you want to create links to all the states in the union. A user would click on the state of California, for example, and the map event would send that user to a Web page with information on California.

To create a simple image map, open the graphic in ImageReady and perform these steps:

1. If the Image Map palette is not visible, select the Window menu and choose Show Image Map from the pull-down menu. Photoshop opens the Image Map palette, shown in Figure 801.1.

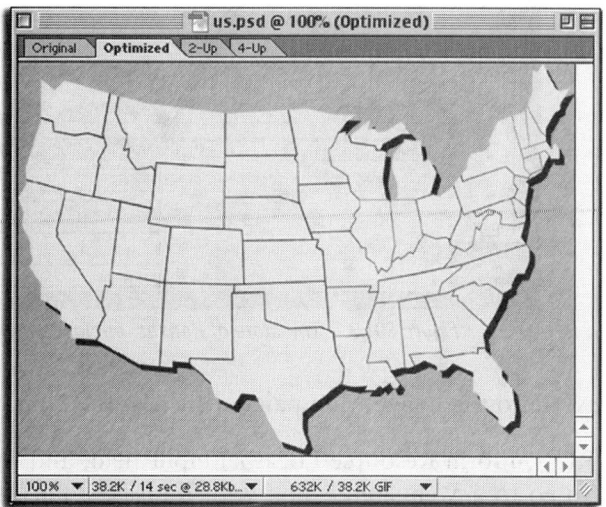

Figure 801.1 The Image Map palette lets you control the map events.

2. Move your mouse cursor into the toolbox and click on and hold the Image Map tool. Photoshop opens the Image Map options, as shown in Figure 801.2.

Figure 801.2 The Image Map tools let you create invisible hot spots in the active image.

3. Select the Polygon Image Map tool from the available options.

4. Move into the graphic and click once with the Polygon tool in the upper-left corner of Kansas. The Polygon tool creates an anchor point.

5. Move to each corner of the state of Kansas and click. Each time you click, the Polygon tool creates a direct line from the previous point.

6. Click once on the starting point. The Polygon tool closes the shape, as shown in Figure 801.3.

Figure 801.3 The state of Kansas, enclosed in a polygon.

7. Move your cursor into the Image Map palette, click in the Name field and enter the name Kansas.

8. Click in the URL (Uniform Resource Locator) input field, and enter an event. In this example, you want the user to go to a Web site dealing with Kansas. Enter http://www.kansasinfo.com into the URL field. Clicking the mouse triggers the event.

9. Use the Target option if you want the user placed within a particular frame. Because the kansasinfo site does not contain frames, leave this field blank.

10. Click in the Alt field and enter "Kansas Info" into the input field. The Alt text displays for users employing nongraphical browsers.

11. To complete the map, you need to create a separate image map shape for each of the 50 states. Refer to Figure 801.2, and select the best tool to create the necessary shapes. Use the Image Map Selection tool to select and reshape a previously created hot spot.

12. After completing all the necessary hot spots, select the File menu and choose Save Optimize As. ImageReady opens the Save Optimized As dialog box, shown in Figure 801.4.

Figure 801.4 The Save Optimized As dialog box lets you control the characteristics of the Image Map file.

13. Click on the Format button and select HTML and Images.

14. Click in the Name field and name the HTML document file.

15. Click on the Save button to save the file and images to disk.

> *Note: When you save the file, ImageReady creates a folder called Images and an HTML document. In this example, the folder contains the graphic image of the United States, and the HTML document contains all the code necessary to run the file in a standard Web browser.*

802 *Moving ImageReady Rollovers into GoLive*

In Tip 773, "Creating a JavaScript Rollover," you learned how to create a JavaScript rollover button. After you create the rollover, you want to move the rollover into a preexisting HTML document. The steps for moving a rollover into GoLive are different than the steps involved with other HTML editors. The important thing about moving the image and the code is to define the save options. This tip assumes that you know your way around GoLive and are looking for the best way to incorporate ImageReady coding into the GoLive document.

To move a rollover created in ImageReady into GoLive, open the rollover in ImageReady (refer to Tip 773) and perform these steps:

1. Select the File menu and choose Save Optimized As. ImageReady opens the Save Optimized As dialog box, as shown in Figure 802.1.

Figure 802.1 The Save Optimized As dialog box lets you control the characteristics of the Image Map file.

2. Click on the Format button and select HTML and Images.

3. Click in the Name field and name the HTML document file. In this example, you enter the name rollover.html.

4. Select the Include GoLive Code option.

5. Click on the Save button to save the file and images to disk.

> *Note: GoLive and ImageReady are both made by Adobe. By selecting the option to include GoLive code within the ImageReady document, you now have a rollover that can be translated by GoLive and inserted into any active GoLive Web document.*

803 *Moving ImageReady Rollovers into Generic Web-Editing Programs*

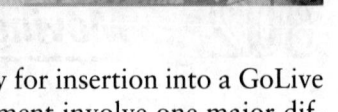

In the previous tip, you learned to how prep a rollover created in ImageReady for insertion into a GoLive document. The steps for moving a rollover into a generic Web-editing document involve one major difference from moving the rollover into GoLive.

To move a rollover created in ImageReady into a generic Web-editing program, open the rollover in ImageReady (refer to Tip 773, "Creating a JavaScript Rollover") and perform these steps:

1. Select the File menu and choose Save Optimized As. ImageReady opens the Save Optimized As dialog box, shown in Figure 803.1.

2. Click on the Format button and select HTML and Images.

Figure 803.1 The Save Optimized As dialog box lets you control the characteristics of the Image Map file.

3. Click in the Name field and name the HTML document file. In this example, you enter the name generic.html.

4. Do not select the Include GoLive Code option. This is important. If you select the Include GoLive option, the coding will not work in other Web-editing programs.

5. Click on the Save button to save the file and images to disk.

Note: The definition of "generic Web-editing programs" includes names such as Dreamweaver and Cold Fusion. Do not mistake the word generic *to mean a lesser-quality program; many people prefer Dreamweaver to GoLive. This term is used only to define Web-editing programs other than GoLive.*

804 *Choosing GoLive or ImageReady When Saving Web Images*

In the previous two tips, you learned how to prepare ImageReady JavaScript code documents for use in GoLive or any other Web-editing program. The question of whether to include GoLive coding in the saved HTML document is relevant only if the document requires insertion into a preexisting Web page.

When you save a rollover using ImageReady, many times the document is complete and ready to run. If your intention is to create the rollover document in ImageReady and run the created code without modification, then the GoLive/No GoLive question is not necessary to answer.

The saved ImageReady code works fine in any standard browser with or without the Include GoLive code option selected, as shown in Figure 804.1.

In addition, if you intend to only save the images, then deciding whether to select the GoLive option does not influence the saving of the graphic files.

Figure 804.1 The Include GoLive Code option is necessary only if the HTML code is edited by another Web-editing program.

805 *Performing a Digital Emboss with Lighting Effects*

One of the interesting things to note about the lighting effects filter is that it sculpts light based on a previously created alpha channel.

Say, for example, that you want to create a cool embossing effect for a logo. To use the Lighting filter to create an embossed look to a logo, open the logo in Photoshop and perform these steps:

1. If the Layers palette is not visible, select the Window menu and choose Show Layers from the pull-down menu. Photoshop opens the Layers palette, shown in Figure 805.1.

Figure 805.1 The Layers palette shows the logo against a transparent background.

2. Move your cursor into the Layers palette and Ctrl+click (Macintosh: Command+click) on the Logo layer. Photoshop coverts the layer into a selection, as shown in Figure 805.2.

Figure 805.2 Ctrl+clicking (Macintosh: Command+clicking) on a layer converts the visible pixels into a selection.

3. Choose the Select menu and then select Save Selection from the pull-down menu. Photoshop opens the Save Selection dialog box, shown in Figure 805.3. Click on OK to save the selection as a new channel.

Figure 805.3 The Save Selection dialog box lets you save the logo as an alpha channel.

4. Click on the Channels tab. Photoshop displays the Channels palette. Click once on the Alpha channel created in step 3. Photoshop selects the alpha channel and displays it in the document window.

5. Select the Filter menu, choose Blur, and choose Gaussian Blur from the pull-down menu. Photoshop opens the Gaussian Blur dialog box, shown in Figure 805.4.

6. Enter a value of 3 in the Radius input field, and click the OK button to apply the blur to the logo channel. The Lighting Effects filter, to create a softer edge to the bevel, uses the Gaussian blue.

7. Click on the Layers tab, and click once on the layer containing the logo. Photoshop selects the original logo layer.

8. Because you created an alpha channel with a copy of the original logo, you no longer need the logo layer. Select a color from the Swatches palette, and press Alt+Delete (Macintosh: Option+Delete) to fill the layer with the selected color.

9. Select the Filter menu, choose Render, and choose Lighting Effects from the fly-out menu. Photoshop opens the Lighting Effects dialog box, shown in Figure 805.5.

Figure 805.4 The Gaussian Blur filter applies a soft blur to the selected alpha channel.

Figure 805.5 The Lighting Effects filter uses the logo alpha channel to apply a bevel to the blue layer.

10. Click on the Texture Channel button and select the alpha channel created in step 3 from the drop-down list (refer to Figure 805.5).

11. Leave the rest of the Lighting Effects options on their default values.

12. Move over to the Preview dialog box and readjust the light to move across the document (refer to Figure 805.5).

13. When you like what you see, click the OK button to apply the lighting effects to the active image, as shown in Figure 805.6.

Note: *For more information on using the Lighting Effects filter, refer to Tip 531, "Using the Lighting Effects Filter."*

Figure 805.6 The Lighting Effects filter successfully applied an embossed look to the logo.

806 *Working with Sliced Images*

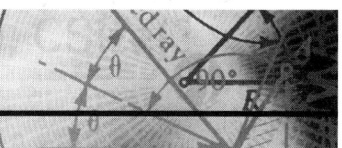

In Tip 768, "Optimizing Individual Image Slices," you learned how to create a sliced graphic document and optimize the individual slices. When you slice an image, you divide the graphic into separate pieces and then reassemble them using an HTML tag called a table. A table is similar to a spreadsheet. Each cell in the table holds a piece of the divided image. When done correctly, the image appears to be a solid graphic.

You might wonder why you want to slice an image in the first place. Because each slice of the image represents a separate piece of the whole graphic image, you use slices to trigger specific events. For example, clicking on a specific slice sends the user to a different part of a Web document (see Tip 809, "Linking Slices in a Web Image").

Another reason to generate multiple sliced images is to squeeze every compression bit possible out of each individual slice. For example, slices containing solid colors compress smaller than slices containing images (refer to Tip 768).

Sliced images are also more compatible with older browsers, unlike creating image maps (refer to Tip 801, "Creating an Image Map").

Several Web studies indicate that loading small graphic images is faster on computers using slow modems, as opposed to downloading the entire graphic image.

As you can see, using sliced images can tremendously speed up download times and can create interactivity in a seemingly solid image.

807 *Working with Type in ImageReady*

Like Photoshop, Adobe ImageReady lets you create and modify text. The process of creating text in ImageReady is the same as that of creating text in Photoshop.

In ImageReady, you type text directly into the document window in a type layer, and the text retains its vector format when printed. New features in ImageReady 3.0 now let you warp and bend text to fit a specific shape, just as in Photoshop 6.0.

To create text in ImageReady, select the Type tool from the toolbox. The Options bar displays the options available for the Type tool, as shown in Figure 807.1.

Figure 807.1 Selecting the Type tool from the ImageReady toolbox causes the Options bar to display all the available typing options.

Modify the Type tool by choosing from the available options on the Options bar.

- **Reset:** Click on the Type icon, located on the far left of the Options bar, to reset the current tool, or to reset all tools, back to the default setting.

- **Horizontal/vertical type:** Click on the Horizontal or Vertical buttons to generate horizontal or vertical type or type masks.

- **Font family:** Click on the black triangle to the right of the font box to select from the list of available fonts.

- **Font style:** Click on the black triangle to the right of the style box to select from the available font styles.

- **Font size:** Click on the black triangle to the right of the font size box to set the size (in points) of the type.

- **Anti-aliasing method:** Click on the anti-aliasing button to display a list of available anti-aliasing methods. The Crisp option creates a hard, sometimes ragged appearance to text, while the Smooth option helps smooth out the visual appearance of the text.

- **Left/center/right alignment:** Click on the Left Align, Center Align, or Right Align button to format the structure of multi-line text layers to left, center, or right alignment.

- **Text color:** Click on the black triangle to the right of the text color box to display the Color Picker dialog box (refer to Tip 62, "Manually Choosing Colors with the Color Picker") to choose a default type color.

- **Warped text:** Click on the Text Warp button to modifying any pre-existing type. Refer to Tip 193, "Warping Text," for more information on warping text.

- **Palettes:** Click on the Palettes button to display the Character and Paragraph dialog boxes. For more information on using the Character and Paragraph palettes, refer to Tip 669, "Working with Character Options."

After selecting from the available options, move your cursor into the document window and begin typing, as shown in Figure 807.2.

To modify preexisting text, select the text using the Type tool and modify it using the previous options.

Note: *With the exception of creating a type mask, ImageReady's typing tools perform like their counterparts in Adobe Photoshop 6.0.*

Figure 807.2 The Type tool in ImageReady creates text directly in the document window.

808 *Moving Type from Photoshop into ImageReady*

In the previous tip, you learned about ImageReady's Type tool. In essence, creating text in ImageReady is a simple as creating text in Adobe Photoshop. Previous versions of ImageReady did not handle text exactly the same way as Photoshop did. For example, Photoshop 5.5 still required you to type text into a Type dialog box, as shown in Figure 808.1.

At the same time, the version of ImageReady that shipped with Photoshop 5.5 let you create the text directly in the document window, as shown in Figure 808.2.

Photoshop 6.0 and ImageReady come closer to making the job of creating and editing text easier. Both programs let you type directly in the document window, and, with the exception of generating a type mask (Photoshop 6.0), both programs handle text the same way.

Therefore, when you create a document in Photoshop containing type layers, the type layers remain intact when the image moves into ImageReady. That includes any warping or layer effects added to the layer.

If you convert the type layer into a normal pixel-based layer (select the Layer menu, choose Rasterize, and select Type), the layer remains rasterized. As in Photoshop, once a type layer converts into a pixel-based layer, it remains as pixels, not text, regardless of the program.

Figure 808.1 The Type Tool dialog box in Photoshop 5.5 required that all text be first typed
into the box before rendering the text in the document window.

Figure 808.2 ImageReady 2.0 let you enter text directly in the document window.

809 *Linking Slices in a Web Image*

In Tip 768, "Optimizing Individual Image Slices," you learned how to optimize individual pieces of a sliced image. When you optimize a slice in ImageReady, you select the slice and compress the slice using the options from the Optimize palette, shown in Figure 809.1.

Figure 809.1 *The Optimize palette controls the compression options for the selected image slice. This image contains several slices that require the same compression settings.*

Say, for example, that you have a sliced document open in ImageReady (refer to Tip 768), and several of the image pieces require the same compression settings.

To speed up the optimization process, open the graphic in ImageReady and link the slices together by performing these steps:

1. If the Slice palette is not visible, select the Window menu and choose Show Slice from the pull-down menu. ImageReady opens the Slice palette, shown in Figure 809.2.

Figure 809.2 *The Slice palette controls the characteristics of the slices in the active document.*

2. Move your cursor into the toolbox, and then click on and hold the Image Slice tool.

3. Choose Slice Select Tool from the available options.

4. Move the Slice Select tool into the document window and Shift-click on the slices that you want to link. Holding down the Shift key adds the selected slices to the previously selected slices.

5. After you select all the slices, right-click (Macintosh: Ctrl+click) on one of the selected slices. ImageReady displays a context sensitive menu, as shown in Figure 809.3.

6. Select Link Slices from the available options. ImageReady links all the selected slices into one set.

7. When you optimize the set (refer to Tip 768), the compression options affect all the slices in the selected set.

Figure 809.3 Right-clicking (Macintosh: Ctrl+clicking) on a selected slice opens a context-sensitive menu.

Note: *To unlink the set, right-click (Macintosh: Ctrl+click) on one of the selected slices and then select Unlink Slices, Unlink Set, or Unlink All.*

810 *Attaching the Alt Tag to a Sliced Image*

The Alt tag is an important part of a Web image. Web browsers use the Alt tag when they are incapable of displaying graphics or when Web users disable the loading of your graphic images. According to studies, 30 percent of Web users turn off the loading of graphic images. These people are the information surfers of the Internet. They are not interested in your fun images or your rollover buttons; their interest is in data and information, and images to them are only the fluff of a Web page (they may not be too far from the truth).

The Alt tab becomes particularly important when you slice an image. The user may not be able to see your images, but at least he can see the text associated with the graphic.

To add an Alt tag, open the sliced document in ImageReady and perform these steps:

1. If the Slice palette is not visible, select the Window menu and choose Show Slice from the pull-down menu. Photoshop opens the Slice palette, shown in Figure 810.1.

Figure 810.1 The Slice palette controls the options for all the slices within the active document.

2. Move your cursor into the toolbox, and then click on and hold the Image Slice tool. ImageReady displays a pop-up menu containing the Image Slice options.

Figure 810.2 Clicking on and holding your mouse on the Image Slice tool lets you view the available Image Slice options.

3. Choose Slice Select Tool from the available options.

4. Move the Slice Select tool into the document window and click on one of the image slices.

5. If the Alt option is not visible in the Slice palette, click on the black triangle located in the upper-right corner of the Slice palette, and select Show Options from the fly-out menu, as shown in Figure 810.3.

Figure 810.3 Selecting Show Options lets you view additional options for the Slice palette.

6. Click in the Alt field, and enter an appropriate Alt for the selected slice.

7. Move back to the document window, and, one at a time, select a slice and enter the Alt tag text.

8. Select the File menu and choose Save Optimized As to save the images and file to disk (refer to Tip 768, "Optimizing Individual Image Slices").

Note: Generating Alt tags is good Web-programming etiquette. It helps people using nongraphic browsers identify the graphics on a Web page, and it might entice users who turned off their graphics to turn them back on.

811 *Compressing QuickTime Movies*

In Tip 696, "Creating QuickTime Movies from Animated GIF Files," you learned how to create a QuickTime movie using ImageReady. When you save a QuickTime movie, ImageReady lets you decide on a specific compression scheme. The compression scheme that you use depends on where the movie plays.

To save and compress a QuickTime movie, open the animation in ImageReady, select the File menu, and choose Export Original from the pull-down menu. ImageReady opens the Export Original dialog box, shown in Figure 811.1.

Figure 811.1 The Export Original dialog box lets you control the compression of the QuickTime movie.

Click on the Format button, and select QuickTime from the drop-down list. Click on the Save button to open the Compression Settings dialog box. The Compressor drop-down list displays all the available compression options. The following compression schemes work best when saving QuickTime movies:

- **Cinepak:** This compresses video using a 20:1 ratio. The Cinepak compression is capable of playing back 320×240–formatted video at 30 frames per second.

- **DV-NTSC:** The National Television Standards Committee (NTSC) format compresses video for use in broadcast television in North America, Japan, Korea, Surinam, and Taiwan. Use the format to compress video for replay using the new DV format.

- **DV-PAL:** The PAL (Phase Alternate Line) format compresses video for use in broadcast television in Australia, Europe, Hong Kong, Singapore, and Thailand. Use the format to compress video for replay using the new DV format.

- **Intel Indeo®Video R3.2:** A versatile compression scheme. Use this format to compress QuickTime movies for running off an interactive CD or from a hard drive.

- **Motion JPEG A & B:** The JPEG compression schemes use lossy compression. Use these formats to create small movies by sacrificing image quality. This is useful for running QuickTime movies from the Internet on slower-speed computers.

- **None:** Choose this option to disable compression of the image.

- **Sorenson Video:** This option compresses video at low data rates while maintaining excellent image quality. Use the Sorenson compression rate with medium to low quality for use on the Internet.

812 *Designing a Web Interface*

When you use Photoshop and ImageReady to design a Web interface, design using these rules:

- **Screen resolution:** The interface needs to fit on the user's monitor. Design the interface with a width of 800 pixels and a height of 600 pixels, the size of the average user's monitor. Although you can exceed the maximum height, try not to create the interface with a width exceeding 800 pixels. Exceeding the maximum width forces users to scroll left and right to view all the elements on the page.

- **Download speeds:** The index page to a Web site should load to a user's computer in a maximum of 30 seconds. Studies show that 30 seconds is the average time that users are willing to wait for a page to download. It requires 20 seconds to download 36K of information using a 28.8 modem. Because the average modem used in the United States is only 28.8, design the index page to a maximum file size of 36K.

- **Backgrounds:** Do not create highly textured backgrounds for your Web pages; they make it difficult to read overlaid text. In addition, because backgrounds use the GIF compression format, solid-color backgrounds compress smaller than backgrounds containing multiple colors.

- **Buttons:** Photoshop and ImageReady create excellent buttons. Design buttons with an intuitive look. If the button is designed to move the user to the next page, use a right-facing arrow, and add the word "Next" to the graphic. To return to the previous page, use a left-facing arrow and include the word "Prev" or "Previous."

- **Consistency:** Use the same interface on each page of your Web site. Do not create a new set of buttons for each page. This only confuses users and forces them to relearn the rules of the game.

- **Colors:** Always use Web Safe colors for any graphics involved in the interface; this creates sharp-looking buttons. Using non-Web Safe colors causes colors to dither (mix) on older monitors, creating a fuzzy appearance to the interface.

- **Animation:** ImageReady creates animation with the click of a button. Unfortunately, excessive animation is distracting to the user. To keep the user focused, do not overdo animation.

813 *Using Photoshop to Create an Interactive Button List*

An interactive button is a graphic image on a Web page that changes. It is a button that appears pushed in when the user moves the cursor over the graphic, or it is a button that plays a sound. Interactive buttons help a new user understand how to maneuver your Web site. In this example, you will create an interactive button list using Photoshop, as shown in Figure 813.1.

To create an interactive button list, open Photoshop and perform these steps:

1. Select the File menu and choose New from the pull-down menu. Photoshop opens the New dialog box. Create a new file with a width and height of 150 pixels in the RGB color space, with a resolution of 72 ppi, as shown in Figure 813.2.

Figure 813.1 This four-button interactive button list employed Photoshop and ImageReady in its construction.

Figure 813.2 The New dialog box controls the characteristics of the New document.

2. Click the OK button to open the new document.

3. If the Swatches palette is not visible, select the Window menu and then choose Show Swatches from the pull-down menu. Photoshop opens the Swatches palette.

4. Click on the black triangle located in the upper-right corner of the Swatches palette, and select Web Safe Colors from the available options.

5. Select a color from the Swatches palette, and press Alt+Delete (Macintosh: Option+Delete) to fill the new document with the selected color. In this example, you select a dark blue, as shown in Figure 813.3.

Figure 813.3 The new document layer filled with dark blue.

6. Move your cursor into the Swatches palette and select white from the swatch boxes.

7. Select the Type tool from the toolbox. Select a font and size from the Options bar (refer to Tip 218, "Creating Text in Photoshop 6.0"), and type the words "Home," "Site Map," "Search," and "Help." To create a separate layer for each word, click the check mark from the Options bar after typing each word. Position the words so that they evenly divide the document window, as shown in Figure 813.4.

Figure 813.4 The Type tool lets you create text in a predefined size and font.

8. Click on the black triangle located in the upper-right corner of the Layers palette, and select Flatten Image from the available options. Photoshop combines the text layers with the blue background, as shown in Figure 813.5. Be sure to position the text using the Move tool before flattening the layer.

Figure 813.5 The Flatten Image option combines all the layers within the active image.

9. Move your cursor into the Swatches palette and select yellow from the swatch boxes.

10. Select the Type tool from the toolbox (refer to Tip 218), and type the word "Home." Select the exact font and size used to create the original word "Home" in step 7, as shown in Figure 813.6.

Figure 813.6 The yellow word "Home" matches the original word typed in white.

11. Select the Move tool from the toolbox and position the yellow word "Home" directly above the original word typed in white. The white text is obscured by the yellow text.

12. Repeat steps 10 and 11, by typing, one at a time, the words "Site Map," "Search," and "Help." Each time you type the next word, stop, select the Move tool, and position to text to fit over the white text. You now have a background layer containing the blue background with the white words, and four text layers containing the yellow text, as shown in Figure 813.7.

Figure 813.7 The Layers palette holds the background and four separate text layers.

Note: When you create an interactive button set, the first stage is to separate the individual elements into separate layers. Photoshop lets you create these interactive layers, but it cannot build the actual Web interface. For that part of the design, you need ImageReady. The next tip shows you how to generate the interactive list using the multi-layered image created in Photoshop.

814 *Building an Interactive Button List Using ImageReady*

In the previous tip, you learned the first steps in creating an interactive button list. When the multi-layered list is complete, you need ImageReady to finish the process. Although ImageReady is quite capable of performing all the steps from beginning to end, it is easier to start in Photoshop and move into ImageReady because of Photoshop's graphic-oriented interface.

Complete the steps in the previous tip, and click on the Jump To button, located at the bottom of the Photoshop toolbox. The image created in Photoshop transfers to ImageReady, as shown in Figure 814.1.

Figure 814.1 Clicking on the Jump To button automatically opens the Photoshop multi-layered graphic image in ImageReady.

To create the interactive list, perform these steps:

1. If the Slice palette is not visible, select the Window menu and choose Show Slice from the pull-down menu. ImageReady opens the Slice palette (refer to Figure 814.1).

2. Move your cursor into the toolbox, and then click on and hold the Image Slice tool. ImageReady displays a pop-up menu containing the Image Slice options. Choose the Slice Tool from the available options.

3. Move your cursor into the Layers palette, and deactivate all the layers except the background layer.

4. Click in the upper-left corner of the document window, and drag down and to the right until you create a slice that defines the section of the document window containing the word "Home," as shown in Figure 814.2. To make the creation of the slice easier, use the Zoom tool to increase the view of the document.

Figure 814.2 The Slice tool creates rectangular slices by clicking and dragging your mouse across the document window.

5. Use the Slice tool three more times, each time selecting an area containing the other three words. You now have four image slices, each one containing one text word, as shown in Figure 814.3.

Figure 814.3 The Slice tool created four slices in the document window.

6. Move your cursor into the toolbox, then click and hold on the Slice tool. ImageReady displays a pop-up menu containing the Image Slice options. Choose the Slice Select tool from the available options.

7. Click once on the slice defining the "Home" text.

8. Move into the Slice palette, click once in the Name field, and enter the name Home.

9. Click in the URL input field and enter http://www.homepage.com (the fictitious name for your home page).

10. Click on the Rollover tab to access the Rollover palette, shown in Figure 814.4.

Figure 814.4 The Rollover palette controls the actions of the inactive rollover button list.

11. Click on the New Rollover State icon to create a second rollover state, as shown in Figure 814.5.

Figure 814.5 Clicking on the New Rollover State icon creates a second rollover state called Over.

12. Move your cursor into the Layers palette, and activate the text layer containing the word "Home." The Rollover palette now contains a Normal rollover state with white text and a second rollover state with yellow text, as shown in Figure 814.6. Make sure to leave the background layer active.

13. Move into the document window and select the slice containing the words "Site Map." Repeat steps 11 and 12, but activate the layer containing the words "Site Map."

14. Move into the document window and select the slice containing the word "Search." Repeat steps 11 and 12, but activate the layer containing the word "Search."

15. Move into the document window and select the slice containing the word "Help." Repeat steps 11 and 12, but activate the layer containing the word "Help."

Figure 814.6 The Rollover palette contains two rollover states with white and yellow text.

16. Click on the Slice tab, to access the Slice palette. One at a time, click on the individual slices and repeat steps 8 and 9. Name each slice using the appropriate text words from the document window (Site Map, Search, and Help). In addition, click in the URL fields and enter the location for each of the slices.

17. Select the File menu and choose Save Optimized As to save the graphics and HTML document.

18. Each individual slice now contains a unique name and URL, and the Rollover palette now shows a Normal and Over rollover state for each slice, with white text for the Normal state and the appropriate yellow overlaid text for the Over state. To preview the completed button list, select File menu Preview In, and choose a browser from the available options.

> *Note: When you open this saved document in any Web browser or editing program, moving your cursor over one of the words triggers the yellow text. Clicking on the yellow text sends the document to the predefined URL, as shown in Figure 814.7.*

Figure 814.7 The completed button list, displayed using Internet Explorer

815 *Understanding Dithering in a Web Image*

Dithering involves intermixing two Web Safe colors to produce the illusion of a third color. Dithering occurs in a Web document when the selected colors of a graphic file do not match the capabilities of the receiving computer monitor. Although even older monitors display a maximum of 256 colors, the differences between Macintosh and Windows monitors force the Web designer into a definable Web Safe palette of 216 colors.

When you create Web graphics, be sure to use the Web Safe palette. When you use ImageReady, by default, the Swatches palette is set to Web Safe colors. In Photoshop, to access the Web Safe colors, open the Swatches palette, click on the black triangle in the upper-right corner of the palette, and select Web Safe Colors.aco from the available options, as shown in Figure 815.1.

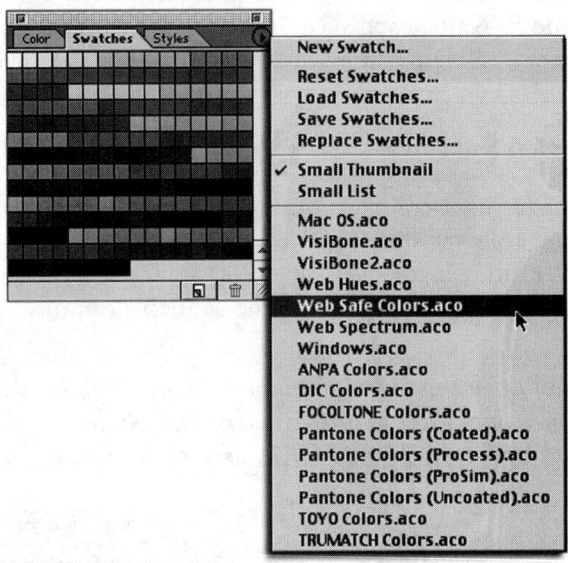

Figure 815.1 *The Web Safe color palette ensures that Web graphics display without dithering.*

Dithering presents a problem when displaying continuous-tone images. The abundance of colors in a photograph forces older computer monitors to dither the image to increase its tonal range. If taken to extremes, the dithering process makes an image look noisy, as shown in Figure 815.2.

If everyone who views your images uses a high-resolution monitor capable of viewing millions of colors, then dithering does not occur and you do not have any problems. Unfortunately, life is not quite that simple. The average Internet user has a computer monitor capable of displaying thousands of colors. That is a lot of color, but it's not enough to prevent some images from dithering.

When you save a file using ImageReady, the Optimize palette gives you the option of dithering the image, as shown in Figure 815.3.

Click in the Dither input field and enter a value from 0 to 100 percent. The greater the amount is, the more dithering takes place and the grainier the image appears on older computer monitors. Unfortunately, turning off the option is not the answer. Creating a photographic image with a 0 dither value creates an image with stepped areas where the colors mix.

The average dither value for a photographic image is from 65 to 85 percent. However, you should evaluate images on a case-by-case basis. Choose the correct dither option based on how the image appears on your monitor.

Figure 815.2 The dithering process applied to a continuous-tone image makes the photograph appear grainy.

Figure 815.3 The dithering option in ImageReady controls the amount of pixel mixing used in the image.

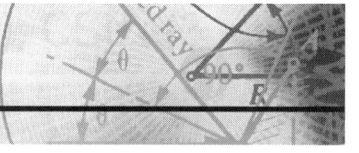

816 *Printing ImageReady Documents*

ImageReady, like Photoshop, is a fully functional image-editing program. ImageReady lets you create graphics and text, and then apply special effects and filters to the image. However, you cannot print a document from ImageReady. This is because ImageReady designs images for the Internet, not images for output to print.

Say, for example, that you create a Web interface or some other Internet graphics, and you want to print the images for viewing by a client (not an unreasonable assumption). To print graphics from ImageReady, move the image into Photoshop.

ImageReady and Photoshop work back and forth using the Jump To button, located at the bottom of the Photoshop and ImageReady toolboxes. To print an ImageReady graphic, move your cursor into to the ImageReady toolbox and click on the Jump To button, as shown in Figure 816.1.

Figure 816.1 The Jump To button lets you open an ImageReady graphic in Photoshop.

When the graphic file is in Photoshop, select the File menu and then select Print. The image prints just like any other Photoshop graphic image (refer to Tip 699, "Printing Directly from Photoshop Using Default Printing Options").

817 *Applying a Custom Dither Pattern to a Web Background Image*

In Tip 534, "Understanding the Dither Box Filter," you learned how to create customized patterns using the Dither Box filter. Another way to create a customized dither pattern is to create the pattern in Photoshop and use the pattern as a Web background tile.

To create a customize dither pattern, open Photoshop and perform these steps:

1. Select the File menu and choose New from the pull-down menu. Photoshop opens the New dialog box. Create a new file with a width and height of 2 pixels in the RGB color space, with a resolution of 72ppi, as shown in Figure 817.1. Click the OK button to open the new document.

Figure 817.1 The New dialog box controls the characteristics of the New document.

2. Select the Zoom tool from the toolbox, and click on the document window to expand the size of the small image.

3. If the Swatches palette is not visible, select the Window menu and choose Show Swatches from the pull-down menu. Photoshop opens the Swatches palette.

4. Click on the black triangle located in the upper-right corner of the Swatches palette, and select Web Safe Colors.aco from the available options.

5. Select the Paintbrush tool from the toolbox.

6. Move into the Options bar, and click once on the black triangle located to the right of the Brush palette option. Select a 1-pixel brush from the available options (refer to Tip 78, "The Paintbrush and Pencil Tools").

7. Select a color from the Swatches palette, and fill the upper-left and lower-right pixels with the color. In this example, you select a dark blue color, as shown in Figure 817.2.

Figure 817.2 The upper-left and lower-right pixels filled with dark blue.

8. Select a second color from the Swatches palette, and fill the upper-right and lower-left pixels with the color. In this example, you select a lighter blue color, as shown in Figure 817.3.

Figure 817.3 The upper-right and lower-left pixels filled with light blue.

9. Select the File menu and choose Save For Web from the pull-down menu. Photoshop opens the Save For Web dialog box, shown in Figure 817.4.

Figure 817.4 The Save For Web dialog box controls the compression format used by the active image.

10. Click on the Format button and select GIF as the file format.

11. In the Dither input field, enter a value of 0.

12. Click the OK button to save the file to disk. Name the file pattern_1.gif.

Note: When you use the image as a tiled background, the dark and light blue colors visually blend to produce a nondithered blue. Creating custom dither patterns lets you move your graphics outside the normal 216 Web Safe color palette, as shown in Figure 817.5.

Figure 817.5 The newly created Photoshop pattern used as a background on a Web page.

818 *Creating a Web Image Gallery*

Photoshop's Web Gallery command lets you create a Web site containing a thumbnail page with all your images. Say, for example, that you have a Web site containing many images. You want to guide your users to a single Web page containing a thumbnail of all your graphic images. When a user clicks on one of the thumbnails, a full-size image loads on a secondary page.

The Web Gallery command in Photoshop lets you accomplish this task with a minimum of effort. To create a Web gallery, perform these steps:

1. Move your cursor onto the desktop, right-click (Macintosh: Ctrl+click), and select New Folder from the context-sensitive menu. Name the new folder Web Images, and move all the images that you want to include in the Web gallery into the folder.

2. Open Photoshop and select the File menu, choose Automate, and choose Web Photo Gallery from the fly-out menu. Photoshop opens the Web Photo Gallery dialog box, shown in Figure 818.1.

3. Click on the Styles option and select a style from the drop-down list. The preview box lets you observe how the Web gallery looks, based on your style selection. In this example, you select Vertical Gallery (refer to Figure 818.1).

4. Click on the Options button and select from the available options:

 - **Banner:** The Banner options let you select the site name, photographer, and date.

 - **Gallery Images:** The Gallery Images option lets you choose the size and compression quality of the images.

 - **Gallery Thumbnails:** The Gallery Thumbnail option lets you select the size of the thumbnails and specify whether to use the file names or caption information.

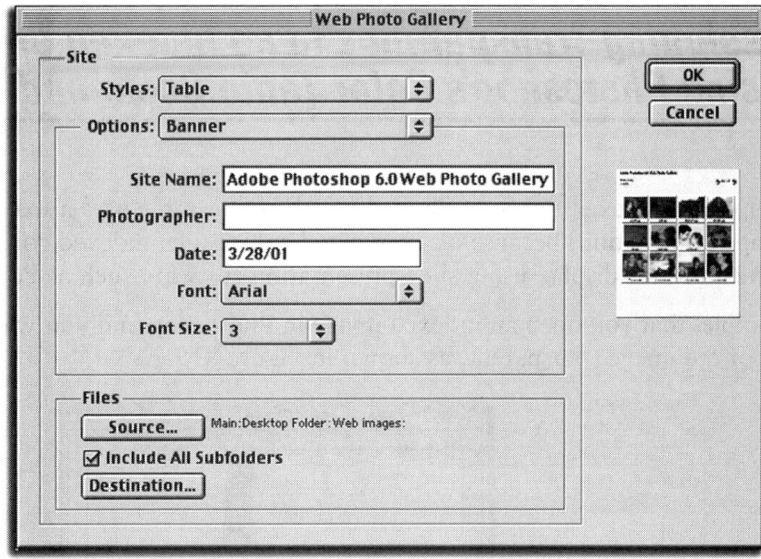

Figure 818.1 The Web Photo Gallery dialog box controls the creation of the Web Gallery.

- **Custom Colors:** The Custom Colors option lets you change the color of the background, banner, text, and links.

5. Click on the Source button and select the Web Images folder. The Source button defines the location of the images.

6. Click on the Destination button and select a folder to hold the Web Gallery. The Destination button defines where you want Photoshop to save the Web Gallery.

7. Click the OK button to create the Web Gallery, as shown in Figure 818.2.

Figure 818.2 The Web Gallery displayed using Netscape Navigator.

819 Assigning Transparency to an Indexed Color Image Using Photoshop's Color Table Command

When you open an indexed image in Photoshop, the color table uses a maximum of 256 colors to display the image information. Because of a restricted color table, indexed color images are used primarily on the Internet and for display using slide-presentation software such as PowerPoint.

Say, for example, that you open an indexed image in Photoshop and you want to make the surrounding white areas of the image transparent, as shown in Figure 819.1.

Figure 819.1 A typical indexed color graphic containing a solid-white background.

To define a transparent color within an indexed color image, open the image in Photoshop and perform these steps:

1. Select the Image menu, choose Mode, and then choose Color Table from the fly-out menu. Photoshop opens the Color Table dialog box, shown in Figure 819.2.

2. Click once on the Eyedropper tool, located at the bottom-right of the Color Table dialog box.

3. Locate the white color swatch in the color table and click once. The Color Table renders the selected color transparent, as shown in Figure 819.3.

4. Click the OK button to apply the changes to the active image.

The Color Table dialog box lets you select one transparent color. Selecting a second color only switches transparency from the previously selected color swatch. This option works when you want to make one single color in the image transparent. If you need to make more than one color transparent, convert the image into the RGB color space (select the Image menu, choose Mode, and then choose RGB). When you're finished converting, use traditional selection and deletion methods to remove as many colors from the image as needed (refer to Tip 477, "Setting Up for Transparency").

Figure 819.2 The Color Table dialog box defines all the colors within the indexed color image.

Figure 819.3 Selecting a color using the Eyedropper tool renders the selected color transparent.

820 *Moving Photoshop Images into Adobe LiveMotion*

LiveMotion is Adobe's answer to Macromedia's Flash program. Both LiveMotion and Flash create inactivity and movement inside a user's Web document. They bring a Web site alive with sound, animation, and movement (some say too much sound, animation, and movement). Whatever you think about Web page construction, LiveMotion and Flash have forever changed how you look at the Internet.

When moving Photoshop files into LiveMotion, you should remember that LiveMotion is a construction program, not necessarily an editing program. Before you open the graphic files in LiveMotion take a few moments to prepare the image.

- **Resolution:** Unless you are using vector-graphic images, the standard resolution for Web images is 72ppi. Prepare images for use in LiveMotion by selecting Image menu, choosing Image Size, and verifying that the image resolution is 72ppi (refer to Tip 269, "Changing an Image Using Image Size").

- **Color space:** Web images (as repeatedly stated) work best when converted into the Web Safe color palette. Before moving an image into LiveMotion, make sure that your color falls into the Web Safe color palette (refer to Tip 742, "Setting Up Web Safe Artwork").

- **Image size:** On the Internet, size matters, especially images used in LiveMotion animation sequences. Large image sizes take longer to download and result in jerky, distracting animation. Check to ensure that the image is compressed to its smallest possible file size (refer to Tip 4, "Choosing the Correct Compression Scheme to Fit the File").

- **Format:** LiveMotion accepts the standard Web formats of GIF and JPEG, and it even accepts the newer PNG format. Each format has its own advantages; choose the best format for the image before moving the graphic into LiveMotion (refer to Tip 695, "JPEG, GIF, and PNG: The Formats of the Internet").

Note: When the image opens in LiveMotion, you might want to edit the image. To do so, select (from LiveMotion) the Edit menu and choose Edit Original from the pull-down menu. The image opens in Photoshop, and any editing changes performed on the image automatically apply to the LiveMotion copy.

821 *Creating Ragged Text Using Layer Masks*

Photoshop lets you modify text in a variety of ways. Creative uses of text, such as drop shadows and bevels, draw the reader's attention to your Web site or advertisement. Ragged text, if not overdone, creates interest and directs the eye to where you want the reader to focus his attention.

To create text with a ragged appearance, open Photoshop and perform these steps:

1. Select the File menu, and choose New from the pull-down menu. Photoshop opens the New dialog box. Create a new file with a width of 7 inches and a height of 5 inches in the RGB color space, with a resolution of 72ppi, as shown in Figure 821.1. Click the OK button to open the new document.

Figure 821.1 The New dialog box controls the characteristics of the new document.

2. If the Swatches palette is not visible, select the Window menu and choose Show Swatches from the pull-down menu. Photoshop opens the Swatches palette.

3. Click on the black triangle located in the upper-right corner of the Swatches palette, and select Web Safe Colors.aco from the available options.

4. Select a color from the Swatches palette, and press Alt+Delete (Macintosh: Option+Delete) to fill the new document with the selected color. In this example, you select a dark blue, as shown in Figure 821.2.

5. Select the Filter menu, choose Noise, and select Add Noise from the fly-out menu. Photoshop opens the Noise dialog box, shown in Figure 821.3.

Figure 821.2 The new document layer filled with dark blue.

Figure 821.3 The Noise dialog box randomly generates different brightness levels for the blue pixels.

6. In the Amount field, enter a value of 20 percent. Choose Uniform distribution, and select the Monochromatic option. Click the OK button to apply the noise to the active document (refer to Figure 821.3).

7. Move your mouse into the Layers palette and double-click on the Background layer. Photoshop opens the New Layer dialog box.

8. In the Name input box, enter the name "ROUGH." Click the OK button to convert the background into a layer.

9. Select the Type tool from the toolbar, and create a type mask for the word "ROUGH" (refer to Tip 656, "Using Text Masks"). In this example, you use the CrossantD font, with 100-point size, as shown in Figure 821.4.

Figure 821.4 The Type Mask tool created the word "ROUGH" as a selection mask.

10. Move your cursor into the Layers palette and click once on the Add a Mask icon. Photoshop creates a mask and displays the word "ROUGH," as shown in Figure 821.5.

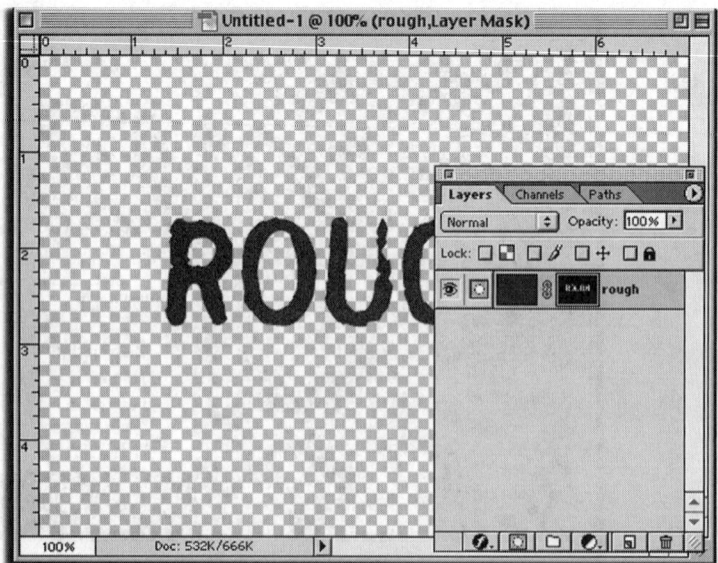

Figure 821.5 Clicking on the Add a Mask icon creates a layer mask based on the type mask.

11. Select the Filter menu, choose Brush Strokes, and choose Sprayed Strokes from the fly-out menu (make sure that the Layer mask is selected). Photoshop opens the Sprayed Strokes dialog box, shown in Figure 821.6.

Figure 821.6 The Sprayed Strokes dialog box controls the application of the filter to the layer mask.

12. Edit the stroke length and spray radius until you see a ragged appearance to the layer mask. Changing the layer mask changes the text. In this example, you use a value of 12 in Stroke Length, and a value of 7 in Spray Radius.

13. Click the OK button to apply the Sprayed Strokes filter to the layer mask, as shown in Figure 821.7.

Figure 821.7 The Sprayed Strokes filter, when applied to the layer mask, gives the text a ragged appearance.

Note: To further spice up the look of the text, try applying a bevel or emboss to the image (refer to Tip 674, "Making Quick Chrome Bevels with Text"), as shown in Figure 821.8.

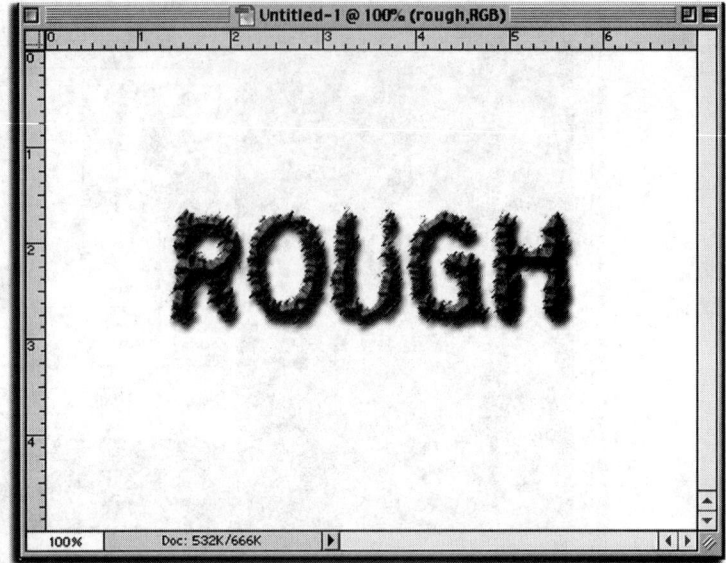

Figure 821.8 The "ROUGH" text with a hard bevel applied to the layer mask.

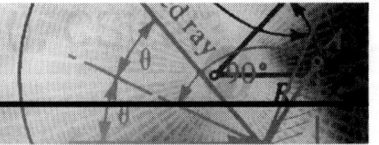

822 *Saving Recurring Web Settings*

In Tip 770, "Creating Permanent Droplets," you learned how to save time by creating droplets. Droplets are storage devices for repeated ImageReady and Photoshop operations. Droplets commonly are used to store and reuse compression settings for groups of images.

ImageReady gives you another way to store popular settings. Say, for example, that you create many graphic images with the same color table. In Tip 744, "Using a Custom Color Table," you learned how to create a customized color table. Color tables are saved using the *.act* extension. Color tables saved with the *.act* extension are always available for ImageReady.

To save a popular color table, open ImageReady and perform these steps:

1. If the Color Table palette is not visible, select the Window menu and select Show Color Table from the fly-out menu. ImageReady opens the Color Table palette, shown in Figure 822.1.

Figure 822.1 The Color Table palette defines the colors within the active image.

2. Use the Color Table palette to create a unique-set color table (refer to Tip 744).

3. To save the Color Table, click once on the black triangle located in the upper-right corner of the Color Table palette, and select Save Color Table from the fly-out menu. ImageReady opens the Save dialog box, shown in Figure 822.2.

Figure 822.2 The Save dialog box controls the name and location of the new color table.

4. If you want to access the color table from ImageReady, you need to save the file in the Optimized Colors folder. The Optimized Color folder is located in the Photoshop applications folder, inside a subfolder named Presets. Saving the file in the Optimized Colors folder lets you access the file directly from the Color Table palette, as shown in Figure 822.3.

Figure 822.3 The Color Table palette lets you access customized color tables.

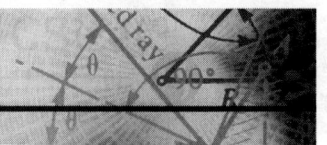

823 _Opening Photoshop Files as Animations_

In Tip 722, "Creating a GIF Animation from a Multi-layered PS Image," you learned how to create an animated GIF file using a multi-layered Photoshop document. ImageReady gives you an easier way to convert a Photoshop document. Say, for example, that you have a multi-layered document and you know that you want to create an animated GIF from the individual layers.

To create an instant animation file, open ImageReady and perform these steps:

1. Select the File menu, and select Open from the pull-down menu. ImageReady displays the Open dialog box, shown in Figure 823.1.

Figure 823.1 The Open dialog box lets you select documents for editing in ImageReady.

2. Select the appropriate Photoshop document and click on the Open button. ImageReady opens the image in a document window, as shown in Figure 823.2.

Figure 823.2 The multi-layered Photoshop document open in ImageReady.

3. If the Animation palette is not visible, select the Window menu and choose Show Animation from the fly-out menu. ImageReady opens the Animation palette (refer to Figure 823.2).

4. Click on the black triangle located in the upper-right corner of the Animation palette, and select Make Frames from Layers. ImageReady places each individual layer in a separate animation frame. The frame sequence follows the order of the layers, as displayed in the Layers palette, shown in Figure 823.3.

Figure 823.3 The Make Frames from Layers option successfully converted the multi-layered Photoshop document into animation.

To modify and save the animation, refer to Tip 722.

824 *Creating Animations from Separate Images*

In the previous tip, you learned how to create animation automatically, using a multi-layered Photoshop document. ImageReady also lets you create animation using separate documents. Say, for example, that you have six separate graphic images and you want to combine them into an animation sequence. The first step is to create a folder for the images.

Move your mouse onto the desktop, right-click (Macintosh: Ctrl+click), and select New Folder from the context-sensitive menu. Name the new folder Animation, and move all the images that you want to include in the Web gallery into the folder. ImageReady imports the images according to their file names. To make the frame sequencing correct, name the files using an alphabetic or numeric sequence, such as image01, image02, image03, and so on.

Open ImageReady and Select the File menu, choose Import, and then choose the Folder As Frames option. ImageReady opens the Choose a Folder dialog box, shown in Figure 824.1.

Select the Animation folder and click on the Choose button. ImageReady opens the separate images and places them one at a time into the Animation palette, as shown in Figure 824.2.

To modify and save the animation, refer to Tip 722, "Creating a GIF Animation from a Multi-layered PS Image."

Figure 824.1 The Choose a Folder dialog box lets you select the folder containing the separate images.

Figure 824.2 The Animation palette displays a separate frame for each of the separate graphic images.

825 *Changing the Size of Background Tiles to Produce Different Effects*

Graphic images used for Web background tiles size to any dimensions. The larger the tile size is, the fewer tiles are needed to produce the background image, as shown in Figure 825.1.

A larger tile creates a larger file size and takes longer to download. A smaller tile creates a smaller file size, but it takes longer to tile the background. Within reason, what counts is not a matter of tile size, but the effect that you want to generate.

Smaller tiles create a group of small repeating patterns. If the graphic tile contains a lot of color, the pattern tends to be distracting, especially if there is text lying over the background, as shown in Figure 825.2.

Enlarging the tile creates a background with fewer repetitions and makes the image less distracting, as shown in Figure 825.3.

The important consideration, therefore, is not the size of the graphic tile (within reason), but what you want to accomplish with the Web page. Pages containing large groupings of text need larger, less distracting backgrounds. Web pages, like the index page, can use smaller colorful backgrounds to attract attention to the site.

Figure 825.1 Different tile sizes produce different looks to the background of a Web page.

Figure 825.2 The small tile creates a distracting background.

Figure 825.3 Enlarging the tile creates a less distracting background.

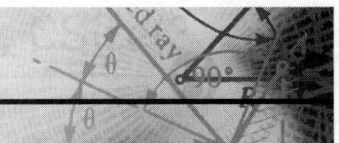

826 *Reasoning for Using Web Safe Colors*

When you design graphics for the Internet, two things happen if you move out of the Web palette. One problem is color shifting. If you do not use Web Safe colors, older monitors using only 256 colors shift the colors. In some cases, text colors shift to the point that the type becomes unreadable, as shown in Figure 826.1.

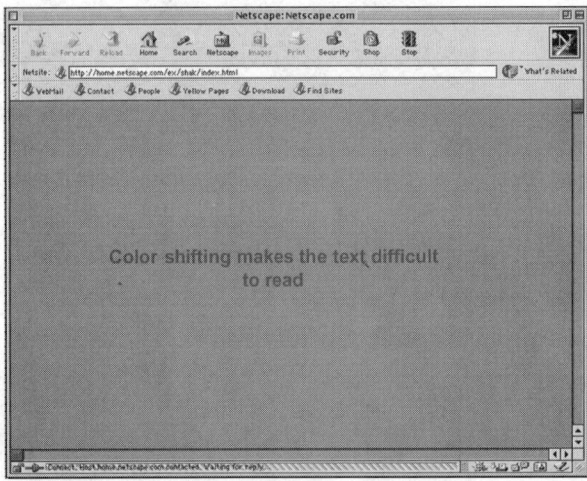

Figure 826.1 Color shifting causes text and background colors to shift, making the text difficult to read.

The second problem deals with the dithering of the graphic image colors. When you design a graphic without using the Web Safe color palette, the solid-color portions of the image begin to dither on older monitors, as shown in Figure 826.2.

Figure 826.2 Designing images using colors outside the Web Safe color palette causes unwanted dithering.

Note: The bottom line is that you should not design Web images unless you use the Web Safe color palette. There is too much to lose in the overall quality of the image.

827 *Making GIF Images Small*

Making GIF images small is easy, if you follow a few basic steps.

- **Solid areas of color:** GIF images compress smaller when the image contains large flat areas of color, as shown in Figure 827.1.

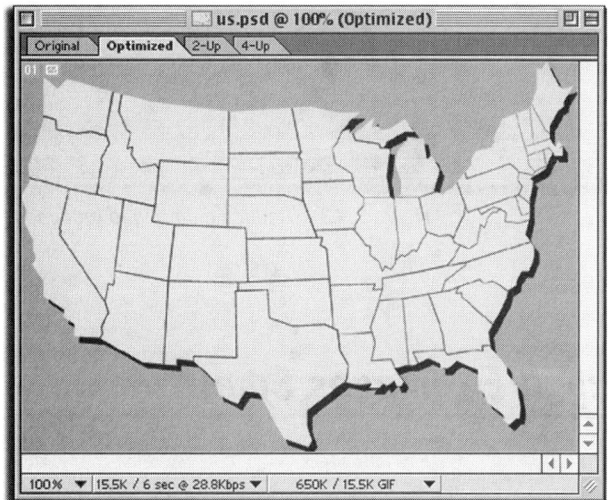

Figure 827.1 Large solid areas of color produce smaller GIF file sizes.

- **Number of colors:** Using fewer colors produces smaller files. The number of colors in the image determines the size of a GIF pixel. If a GIF image contains four colors, the image holds the information using a 2-bit pixel. If the image contains a maximum of 256 colors, the GIF format requires an 8-bit pixel. Create GIF images using fewer colors, as shown in Figure 827.2.

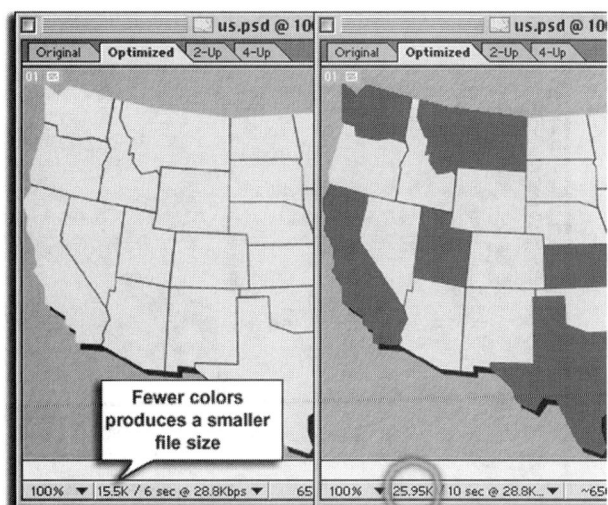

Figure 827.2 Using fewer colors creates smaller file sizes.

- **Reduced dithering:** Dithering mixes two colors to produce a third color. Dithering creates a file with more colors and makes it difficult for the GIF format to compress the image, as shown in Figure 827.3.

Figure 827.3 Reduce dithering to reduce file size.

828 *Making JPEG Images Small*

In the previous tip, you learned some techniques on reducing the size of a GIF image. To reduce the file size of a JPEG, follow these tips:

- **Soft tonal qualities:** JPEG images compress smaller when they contain soft shifts of color. Sharpening an image is counter-productive when the image is compressed using the JPEG format, as shown in Figure 828.1.

- **Additional blurring:** Although blurring is not the best way to handle photographic images, applying a soft blur to background areas creates a smaller file size, as shown in Figure 828.2.

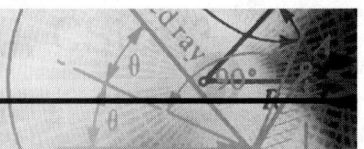

Figure 828.1 Soft images compress smaller than images containing sharp color edges.

- **Decreased saturation:** While not always effective, decreasing the saturation of a photographic image can create smaller file sizes, as shown in Figure 828.3.

Figure 828.2 Blurring an image creates a smaller file size.

Figure 828.3 JPEG images compress smaller when the image contains less saturation.

- **Reduced image contrast:** Not always effective, reducing the contrast in an image (similar to blurring) usually creates smaller file sizes, as shown in Figure 828.4.

Figure 828.4 Decreasing contrast creates smaller file sizes.

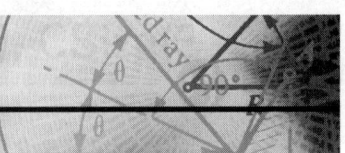

829 *Converting from Grayscale to Bitmap*

The Bitmap mode converts an image into a 1-bit black-and-white image, as shown in Figure 829.1.

Figure 829.1 A grayscale image converted into a bitmap graphic.

The bitmap format creates a small file by reducing the depth of the image's pixels. A normal grayscale image contains an 8-bit pixel capable of producing 256 shades of gray. A bitmap image contains a 1-bit pixel capable of producing only two colors. That is why bitmap images produce a stark black-and-white image (refer to Figure 829.1).

The bitmap format is useful for converting color and grayscale images into pen-and-ink drawings, or converting single-color logos into small images capable of fast downloads on the Internet.

To convert a grayscale image into a bitmap image, open the image in Photoshop (color photographs must convert to grayscale) and perform these steps:

1. Select the Image menu, choose Mode, and select Bitmap from the fly-out menu. Photoshop opens the Bitmap dialog box, shown in Figure 829.2.

Figure 829.2 The Bitmap dialog box controls the application of the bitmap format to the active grayscale image.

2. In the Output field, enter a new resolution for the bitmap conversion.

3. Click on the Method button and select from the available options:

- **50% Threshold:** Divides the tonal range into black and white

- **Pattern Dither:** Converts the image using a predefined pattern

- **Diffusion Dither:** Converts the image using a predefined pattern

- **Halftone Screen:** Converts the image by simulating a halftone dot pattern

- **Custom Pattern:** Converts the image using a customized halftone dot pattern

4. Click the OK button to apply the bitmap conversion to the active image.

Note: Bitmap images are restricted to a single flattened layer. In addition, bitmap images do not have the capability to generate transparency.

830 *Changing Image Size Using Save for Web*

Photoshop gives you the capability to change the size of an image. When you select Image menu and choose Image Size, Photoshop opens the Image Size dialog box, shown in Figure 830.1.

Figure 830.1 The Image Size dialog box lets you change the size of the active image.

When you work on Web graphics, you typically save the images using Photoshop's Save for Web option. The Save for Web option not only lets you save the image using the standard Web compression formats, but it also lets you resize the image before saving it. To select the Save for Web option, open a file in Photoshop and select the File menu, and choose Save for Web from the pull-down menu. Photoshop opens the Save for Web palette, shown in Figure 830.2.

Click on the Image Size tab to display the current size of the image in pixels. To resize the image, click in the Width and Height input fields, and enter new values in the input fields. Alternately, you can enter a percentage value in the Percent input field. Select the Constrain Proportions option to maintain the proportions of the original image.

Click on the Apply button to apply the image size modifications to the active image.

Figure 830.2 The Save for Web palette lets you save and resize the active digital image.

831 Locking Colors Using Save for Web

In Tip 578, "Locking Colors into an Image Table (ImageReady)," you learned how to lock colors using the ImageReady color table. Photoshop gives you the same capability to lock specific colors into an indexed color table. Say, for example, that you have a clip art image and you want to convert the image into the GIF format. Converting a typical image into the GIF format reduces the color table to a maximum of 256 colors. To convert the image into the GIF format without using ImageReady, open the image in Photoshop, select the File menu, and choose Save for Web from the pull-down menu. Photoshop opens the Save for Web dialog box, shown in Figure 831.1.

Figure 831.1 The Save for Web dialog box compresses Photoshop documents into standard Web formats.

To lock colors into the image color table, perform these steps:

1. Click on the Format button and select GIF from the available options.

2. Click on the Color Table tab. Photoshop displays the Color Table palette. The Color Table displays a color swatch for the colors in the active image (refer to Figure 831.1).

3. To change the numbers of colors within the active document, click on the Colors button. A drop-down list box displays the available color options, as shown in Figure 831.2.

Figure 831.2 The Colors pop-up menu lets you select how many colors appear in the GIF image.

4. Select 4 from the available options. The image converts to four colors. The Save for Web option selects the four colors based on the average colors within the image, as shown in Figure 831.3.

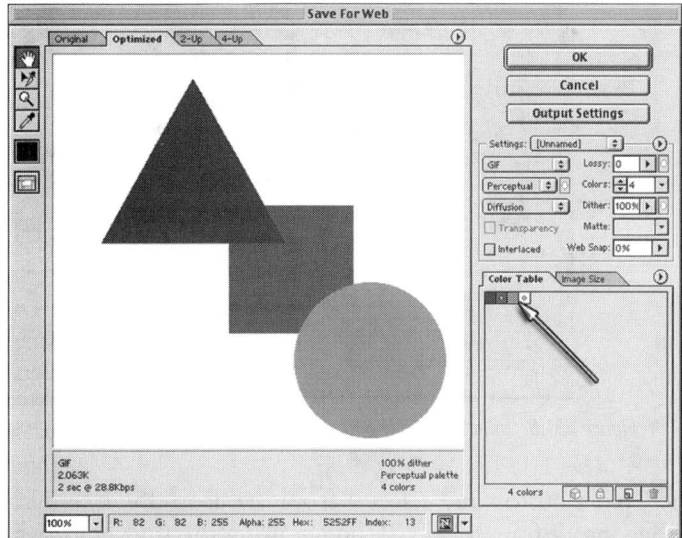

Figure 831.3 Selecting four colors converts the active image into a four-color document.

5. Click on the Colors options and select 128 from the available option. Photoshop colors the image using 128 separate colors. Changing the Colors option changes the number of colors within the active image.

Say, for example, that you want to convert a GIF image into four colors; however, *you* want to select the colors, not let the computer do so. To select the colors for the Web conversion, perform these steps:

1. Move your mouse into the Color table and Ctrl+click (Macintosh: Command+click) on the four colors that you want to preserve, as shown in Figure 831.4.

2. Click on the Lock icon, located at the bottom of the Color Table. The Save for Web dialog box locks the selected colors into the table, as shown in Figure 831.5.

Figure 831.4 *Ctrl+clicking (Macintosh: Command+clicking) the color swatches within the Color Table lets you select noncontiguous colors.*

Figure 831.5 *Clicking on the Lock button locks the selected colors into the Color Table.*

3. Click on the Colors button and select 4 from the drop-down list. The Save for Web dialog box converts the image into a four-color GIF image using the four colors, as shown in Figure 831.6.

4. Click the OK button in the Save for Web dialog box to save the converted image to disk.

*Figure 831.6 The Save for Web dialog box used the locked colors in the Color
Table to perform the four-color conversion of the image.*

832 *Using Layers to Generate Motion in a Photoshop Image*

The ImageReady program lets you create animation using multi-layered Photoshop documents. In addition, ImageReady lets you convert QuickTime movies into animation files. Animation works well on the Internet but falls short if you are attempting to place the animation into a printed document. Of course, animations do not work on paper, but there are ways to simulate motion without actually animating the image. Say, for example, that you want to simulate motion in an image and place that image within a printed document.

To create the illusion of movement in an image, open the document in Photoshop and perform these steps:

1. If the Layers palette is not visible, select the Window menu and then choose Show Layers from the pull-down menu. Photoshop opens the Layers palette, shown in Figure 832.1.

Figure 832.1 The Layers palette displays a thumbnail of each layer in the active document.

2. Make a copy of the car layer by clicking and dragging the car layer over the New icon, as shown in Figure 832.2.

Figure 832.2 Clicking and dragging a layer over the New icon creates a copy of the dragged layer.

3. Repeat step 2 and make four more copies of the original car layer.

4. Rearrange the car layers in the Layers palette from first to last, as shown in Figure 832.3.

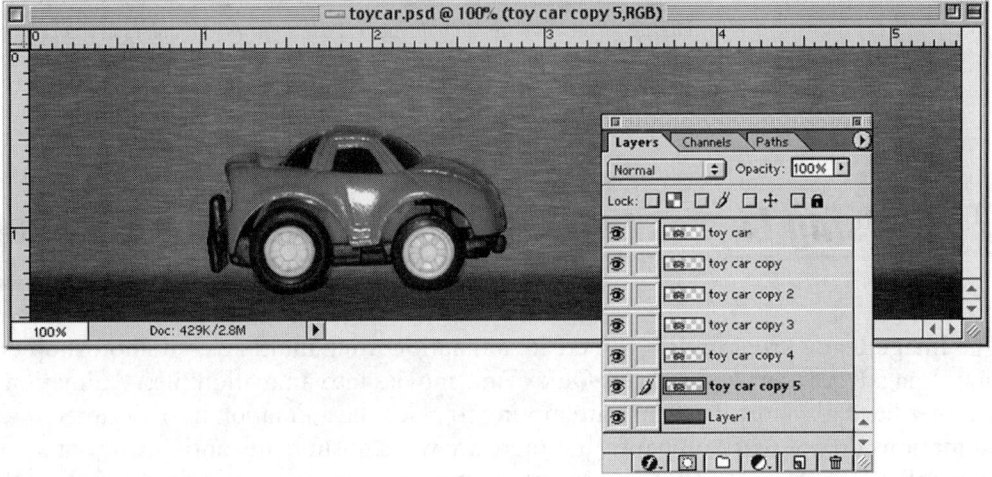

Figure 832.3 Click and drag the copied layers from top to bottom.

5. Select the Move tool from the toolbox.

6. Click once on the car copy layer. Photoshop selects that layer.

7. Move your Move tool into the document window, and drag the car copy layer to the right, exposing one quarter of the car body, as shown in Figure 832.4.

Figure 832.4 Click and drag the car copy layer to the right.

8. One at a time, click on copies 2, 3, and 4, and move each layer to the right, as shown in Figure 832.5.

Figure 832.5 All five-car copy layers are proportionally moved to the right.

9. Click on the car copy layer.

10. Click in the Opacity input box and enter a value of 80 percent opacity.

11. One at a time, select copy layers 2, 3, and 4, and reduce the opacity of each layer by another 20 percent (60, 40, 20).

12. Select copy layer 5, and reduce the opacity to 10 percent, as shown in Figure 832.6.

Figure 832.6 The car copy layers, with reduced opacity settings.

13. Select the car copy layer.

14. Select the Filter menu, choose Blur, and select Radial Blur from the fly-out menu. Photoshop opens the Radial Blur dialog box, shown in Figure 832.7.

15. Select a radial blur amount of 8, and set the Blur Method option to Spin. In the Quality box, select Good. Click the OK button to apply the radial blur to the car copy layer.

16. One at a time, select the copy layers, 2, 3, 4, and 5, and apply the same radial blur.

17. The image now gives the appearance of movement, as shown in Figure 832.8.

Figure 832.7 The Radial Blur filter applies a blur to the selected car copy layer.

Figure 832.8 The completed image gives the impression of movement.

833 *Understanding Black Point Compensation*

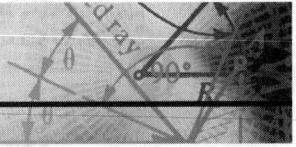

The Black Point Compensation options let you control the mapping of images converted into different color spaces. When you select Black Point Compensation, the full dynamic range of the original image is mapped to the full dynamic range of the destination color space.

When you deselect Black Point Compensation, Photoshop simulates the full dynamic range of the original image. Deselecting Black Point Compensation causes blocky or gray shadows in the destination image, as shown in Figure 833.1.

To change the Black Point Compensation option, open Photoshop, select the Edit menu, and choose Color Settings from the pull-down menu. Photoshop opens the Color Settings dialog box, shown in Figure 833.2.

A check mark in the Black Point Compensation option enables this feature. Clicking once in the check box disables this option. In most cases, you should leave this option selected. However, if you notice overly sharp shadows when converting an image to a different color space, open the Color Settings dialog box and disable the Black Point Compensation option.

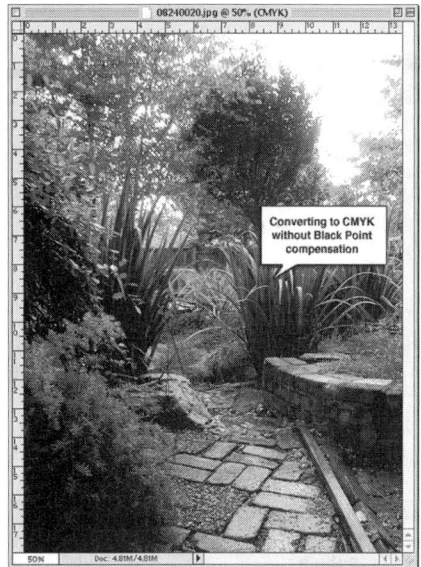

Figure 833.1 *Deselecting Black Point Compensation causes blocky or gray shadows in the destination color space.*

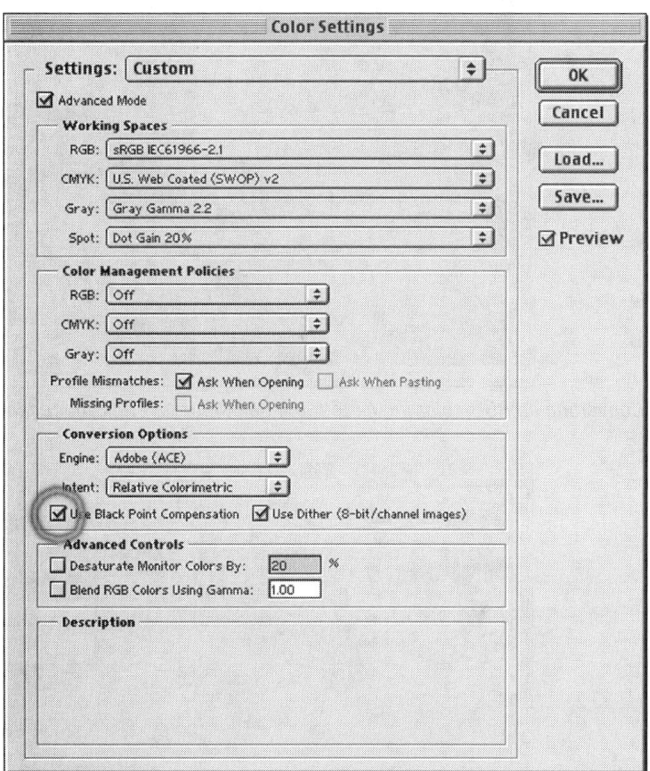

Figure 833.2 *The Color Settings dialog box controls the Black Point Compensation option.*

Note: *The Black Point Compensation option affects all images opened in Photoshop, not just the active image.*

834 *Converting to Indexed Color*

When you convert an image into the indexed color space, the active image converts into a single 8-bit color image. Other formats that use an 8-bit pixel are the GIF and PNG-8 Web compression formats.

In essence, converting an image to indexed color reduces the maximum colors available to the color palette to 256. If you convert an image RGB to indexed color, Photoshop examines the millions of colors available to an RGB image and reduces the color palette. In most cases, this produces a color document with fewer colors and lower image quality, as shown in Figure 834.1.

Because clip art typically has far fewer then the maximum allowable 256 colors, converting a generic clip art piece reduces the size of the file without sacrificing image quality, as shown in Figure 834.2.

Figure 834.1 Converting an RGB color image to the Index Color palette reduces the color and quality of the original image.

Figure 834.2 Clip art converted into the indexed color space produces small images without loss of quality.

RGB images contain a red, green, and blue pixel, and indexed color images contain 1 color pixel. Therefore, when you convert an image from RGB to indexed color, the file automatically shrinks by one third.

Use the indexed color space to convert when you plan to convert a color photograph into the GIF format. Although most images compress smaller and look better when you use the JPEG format, sometimes the GIF format creates a good-looking photographic image. When you first convert the image into the indexed color space, you reduce the image into an 8-bit pixel, the same size used by the GIF format. The indexed color space preserves the original colors in the image better than doing a direct GIF save of an RGB image.

If you create computerized presentations, the indexed color space preserves essential color information while significantly reducing the file size of the image. One of the big problems with using large images in a presentation, as with PowerPoint, is large file sizes. Large file sizes cause the image to load with a jerky animation, especially if you use slide display techniques such as zooming. By indexing the colors in the image, you create a smaller file that loads smoothly, thus creating a seamless animation for your presentation.

835 Specifying the Correct Indexed Color Palette

In the previous tip, you learned about the indexed color space. Understand that the indexed color space is not a file format, but a storage space for the colors in the active image. When you convert an image into the indexed color space, it is important to use the correct color palette. Choose a color palette to match where the image will be displayed.

To convert an image to indexed color, open the document in Photoshop, select Image menu and choose Mode, and choose Indexed Color from the pull-down menu. Photoshop opens the Indexed Color dialog box, shown in Figure 835.1.

Figure 835.1 The Indexed Color dialog box lets you choose from a list of available color tables.

- **Exact:** Create a color tablet from the color in the original image. This option is available only if the original image contains 256 or fewer colors.

- **System (Mac OS):** Selecting this option converts the colors in the original image to a color table matching the Macintosh operating system.

- **System (Windows):** Selecting this option converts the colors in the original image to a color table matching the Windows operating system.

- **Web:** Selecting this option converts the colors in the original image into the Web Safe color palette.

- **Uniform:** Selecting this option converts the colors in the original image into a uniform color palette, based on the RGB color cube. No specific colors in the original image take precedence over any other colors.

- **Perceptual:** Selecting this option converts the colors in the original image to a color set more pleasing to the human eye. High- and low-saturation colors blend to produce softer color percentages.

- **Selective:** Similar to the Perceptual color table, selecting this option converts the colors in the original image while favoring Web Safe colors.

- **Adaptive:** Selecting this option converts the colors in the original image, based on the color within the original image. For example, images containing a lot of red and blue produce a palette favoring red and blue.

- **Custom:** Selecting this option converts the colors in the original image, based on a predefined color table (refer to Tip 743, "Creating a Custom Palette for Indexed Images").

- **Previous:** Selecting this option creates a custom palette for indexed images, based on the last color conversion performed.

Click the OK button to apply the Indexed Color table to the active image.

836 *Changing the Bit Depth of an Indexed Color Image*

In the previous tip, you learned that converting an RGB image to indexed color transforms the image from a 24-bit pixel to an 8-bit pixel. The reduction of the pixel restricts the image to a maximum of only 256 colors.

Say, for example, that you convert an RGB image using the indexed color format, but the file size is still too big. Another way to convert the image is to reduce the bit size of the pixel. The following chart shows how color relates to bit size:

8-bit pixel	256 colors
7-bit pixel	128 colors
6-bit pixel	64 colors
5-bit pixel	32 colors
4-bit pixel	16 colors
3-bit pixel	8 colors
2-bit pixel	4 colors
1 bit pixel	2 colors

Unfortunately, the indexed file creates an 8-bit pixel. You can reduce the number of colors within the image, but you cannot reduce the bit size of the pixel. To work around this restriction, first open the image in Photoshop and perform these steps:

1. Select the Image menu, choose Mode, and choose Indexed Color from the pull-down menu. Photoshop opens the Indexed Color dialog box, shown in Figure 836.1.

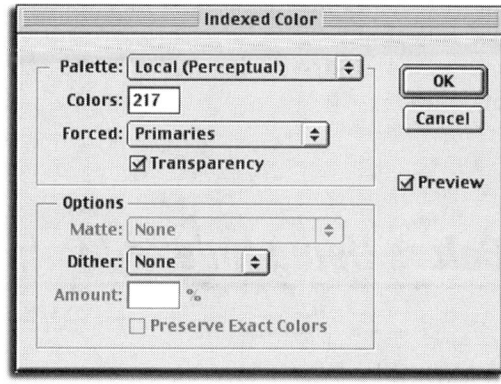

Figure 836.1 The Indexed Color dialog box lets you select the number of colors within the active image.

2. Click on the Palette option and choose Uniform, Selective, Adaptive, or Perceptual from the list of available options. In this example, you select Perceptual (refer to Figure 836.1).

3. Click in the Colors input box and enter a color value lower than 256. The lower the value is, the smaller the file size will be; however, you have to get below the numbers listed in the previous table. In this example, you select 64 colors. Anything lower makes the image look too blocky.

4. Looking at the previous table, an image containing only 64 colors sustains a 6-bit pixel.

5. Click the OK button to apply the changes to the image. At this point, the image still has an 8-bit pixel.

6. Select the File menu and choose Save for Web from the pull-down menu. Photoshop opens the Save for Web dialog box, shown in Figure 836.2.

Figure 836.2 The Save for Web dialog box controls the compression format for the active document.

7. Click once on the Format option and select GIF from the drop-down list (refer to Figure 836.2).

8. Click in the Colors dialog box, and enter a value of 64 (refer to Figure 836.2).

9. Click the OK button to save the file, using the GIF compression.

10. The GIF compression at 64 colors further reduces the size of the indexed color image, without removing additional colors.

837 *Forcing Colors Using Indexed Color*

In the previous tip, you learned how to reduce the size of an indexed color image using the GIF compression format. When you use perceptual palettes to convert an image, Photoshop converts the colors within the original image, based on an average weighting system. Say, for example, that you want Photoshop to give more weight to the Web Safe color palette.

To force Photoshop to convert the image using a predefined weighting average, open the image and perform these steps:

1. Select the Image, choose menu Mode, and choose Indexed Color from the pull-down menu. Photoshop opens the Indexed Color dialog box, shown in Figure 837.1.

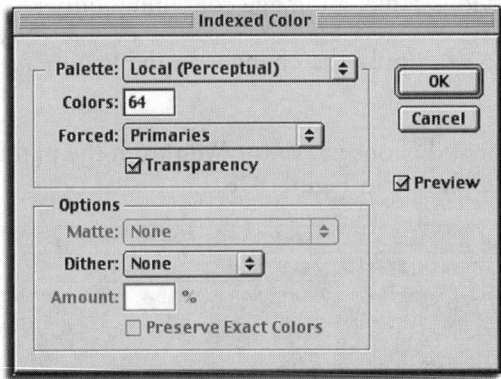

Figure 837.1 *The Indexed Color dialog box lets you select the number of colors within the active image.*

2. Click on the Palette option and choose Perceptual from the list of available options (refer to Figure 837.1).

3. Click once on the Forced button, and select from the available options.

- **None:** Selecting this option converts the colors in the original image, using an average of all the colors within the original image.

- **Black and White:** Selecting this option converts the colors in the original image and forces black and white into the color table.

- **Primaries:** Selecting this option converts the colors in the original image and forces the primary colors of red, green, blue, cyan, magenta, yellow, black, and white into the color table.

- **Web:** Selecting this option converts the colors in the original image and forces the 216 Web Safe colors into the color table.

- **Custom:** Selecting this option converts the colors in the original image, based on a customized color table (refer to Tip 743, "Creating a Custom Palette for Indexed Images").

4. Click the OK button to apply the changes to the active image.

838 *Choosing the Correct Dither Options for an Indexed Color Palette*

In the previous tip, you learned how to force specific color into an indexed color table. One other option in converting indexed color images is the inclusion of dithering. The dithering option mixes pixels together to create color unavailable to the color table. In the printing industry, color inks mix to produce different colors on the printed page. On a computer, pixels cannot mix, so the dither option alternates different color pixels to create the illusion of color.

To use the dither option on an indexed image, open the image in Photoshop, select the Image menu, choose Mode, and choose Indexed Color from the pull-down menu. Photoshop opens the Indexed Color dialog box, shown in Figure 838.1.

Figure 838.1 The Indexed Color dialog box lets you select the number of colors within the active image.

Click on the Dither button and choose from the available options:

- **None:** Selecting this option turns off the Dither command. In photographs, this creates a blocky appearance in the image. In clip art, turning off dithering helps to keep the image colors sharp, as shown in Figure 838.2.

Figure 838.2 Selecting None turns off the Dither option.

- **Diffusion:** This option blends the pixels using error diffusion. This dither method is less structured than pattern dither, as shown in Figure 838.3. Click in the Amount field and enter a value from 1 to 100 percent. Higher values apply more diffusion to the image.

Figure 838.3 The Diffusion dither method produces a more natural look to photographic images.

- **Pattern:** This option blends the pixels using a predefined pattern. This method is more structured than diffusion, as shown in Figure 838.4.

Figure 838.4 The Pattern dither option mixes image colors using a predefined pattern.

- **Noise:** This option mixes pixels by using a random noise pattern. Use this option if you intend to slice the image (refer to Tip 806, "Working with Sliced Images").

839 *Editing Specific Colors Within the Indexed Color Palette*

When you use the Index Color option, Photoshop reduces the number of colors to a maximum of 256. In Tip 835, "Specifying the Correct Indexed Color Palette," you learned how to control the conversion of the image. However, sometimes you want more control. Say, for example, that you convert an RGB image using the indexed color space, and you want to modify the colors in the Indexed Color table.

To modify an image using the color table, open an indexed color image in Photoshop and perform these steps:

1. Select the Image menu, choose Mode, and choose Color Table from the fly-out menu. Photoshop opens the Color Table dialog box, shown in Figure 839.1.

Figure 839.1 The Color Table dialog box displays all the available colors in the indexed color image.

2. To change a color in the image, move your mouse into the Color Table dialog box, and click once on a color swatch. Photoshop opens the Color Picker dialog box, shown in Figure 839.2.

Figure 839.2 The Color Picker dialog box lets you change the colors in the active image.

3. Click in the color box, or move the color slider to select a color (refer to Tip 62, "Manually Choosing Colors with the Color Picker").

4. Click the OK button to apply the change to the color table and to the active image, as shown in Figure 839.3.

5. Move through the color table and change as many colors as needed. Click the OK button to close the Color Picker dialog box and record the changes to the active image.

Figure 839.3 Changing a color in the Color Table changes the related color in the active image.

840 *Working with Color-Matching Options for an Indexed Color Image*

In the previous tip, you learned how to convert the colors in an indexed image using the Color Table option. Say, for example, that you want to convert certain colors in an indexed color image to a specific color system. The Color Table gives you access to all the available color-matching systems, such as Pantone, Trumatch, and Toyo.

To change the colors in an indexed color image to a specific matching system, open the indexed color image in Photoshop and perform these steps:

1. Select the Image menu, choose Mode, and choose Color Table from the fly-out menu. Photoshop opens the Color Table dialog box, shown in Figure 840.1.

Figure 840.1 The Color Table dialog box displays all the available colors in the indexed color image.

2. To change a color in the image, move your mouse into the Color Table dialog box, and click once on a color swatch. Photoshop opens the Color Picker dialog box, shown in Figure 840.2.

Figure 840.2 The Color Picker dialog box lets you change the colors in the active image.

3. Click on the Custom button. Photoshop opens the Custom Colors dialog box, as shown in Figure 840.3.

Figure 840.3 The Custom Colors dialog box lets you select colors from industry-standard color-matching systems.

4. Click on the Book button and select from the available color-matching options. In this example, you select the Pantone Coated color-matching system (refer to Figure 840.3).

5. Select a specific color using the Pantone thumbnails and the vertical color slider (refer to Tip 546, "Working with Pantone Colors").

6. Click the OK button to apply the Pantone color change to the table and to the active image.

7. Click the OK button to close the Color Table and record the colors to the active image.

841 *Changing the Colors of a Simple Background Image*

Graphic images used as Web backgrounds create fast-loading, attractive backdrops for your Web pages. One way to create consistency among the pages on your Web site is to use the same graphic image, but with different Web Safe colors. Say, for example, that you create a two-color background tile, and you want to use the same design on all your Web pages. To make the image unique, you want to change the colors from page to page, as shown in Figure 841.1.

Figure 841.1 A typical two-color background tile.

To change the colors of the image, open the graphic in Photoshop and then perform these steps:

1. Move your mouse into the toolbox, and click on and hold the Eraser tool.

2. Select Magic Eraser Tool from the available options. Move the Magic Eraser into the document window, and click once on the gray background (refer to Tip 165, "Working with the Magic Eraser"). The Magic Eraser removes the gray and makes the pixels to transparent, as shown in Figure 841.2.

3. If the Swatches palette is not visible, select Window menu and choose Show Swatches from the pull-down menu. Photoshop opens the Swatches palette.

4. Click on the black triangle button, located in the upper-right corner of the Swatches palette. Photoshop displays the Swatches palette options in a pop-up menu. Select Web Safe Colors.aco from the available options, and click OK to replace the current colors with the Web Safe palette, as shown in Figure 841.3.

5. Select the color that you want to use for the graphic image (not the background) by clicking once on the desired color. In this example, you choose a light blue Web Safe color.

6. Move your mouse into the Layers palette and select the Lock Transparent Pixels option, as shown in Figure 841.4.

Figure 841.2 The Magic Eraser tool makes the sampled color to transparent.

Figure 841.3 The Swatches palette displaying the Web Safe color palette.

Figure 841.4 The Lock Transparent Pixels option prevents the modification of any transparent pixels in the active layer.

7. Press Alt+Delete (Macintosh: Option+Delete). Photoshop replaces the color of the graphic with the selected Web Safe color. Because you selected Lock Transparent Pixels, the transparent areas of the image remain transparent, as shown in Figure 841.5.

8. Move your cursor into the Layers palette and click on the New Layer icon. Photoshop creates a new layer. Click on the new layer, and drag it underneath the image layer, as shown in Figure 841.6.

9. Move to the Swatches palette and select a color for the background. In this example, you select a light yellow.

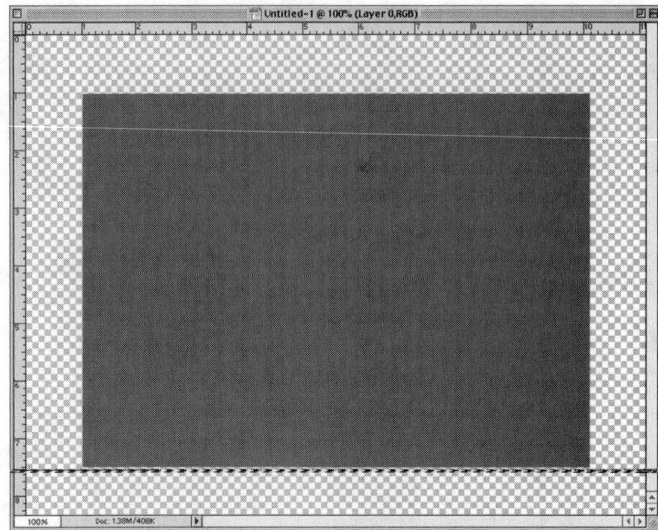

Figure 841.5 Selecting Lock Transparent Pixels lets you change the image colors without changing the transparent background.

Figure 841.6 The new layer dragged under the image layer

10. Press Alt+Delete (Macintosh: Option+Delete). Photoshop fills the new layer with the Web Safe color, as shown in Figure 841.7.

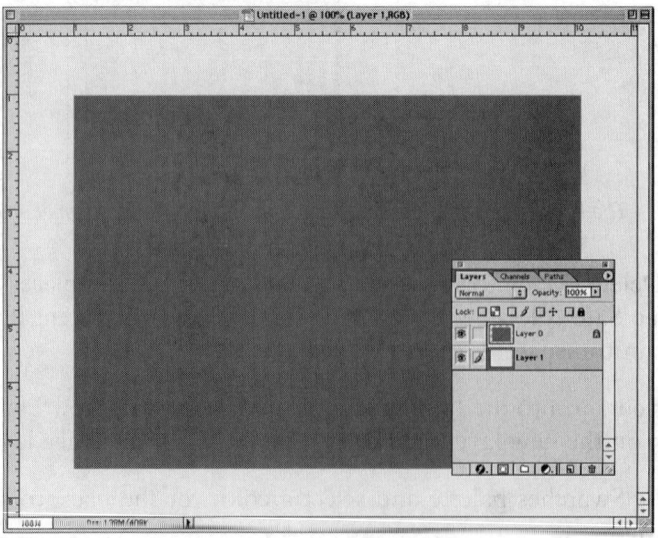

Figure 841.7 The yellow-filled layer replaces the transparent areas of the image.

11. Click on the black triangle button, located in the upper-right corner of the Layers palette. Photoshop displays the Layers palette options in a pop-up menu. Select Flatten Image from the available options. Photoshop flattens the image into a single background, as shown in Figure 841.8.

Figure 841.8 The Flatten Image option combines the two layers into a single background.

12. You now have a copy of the original graphic tile with a different Web Safe color scheme. Repeat this process and create as many different tiles as needed.

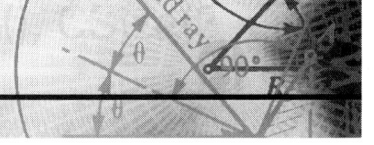

842 *Working in Lab Color Mode*

Lab color mode is the only color space in Photoshop considered device-independent. Every version of Photoshop uses the same Lab color system. In addition, other graphic-editing and layout programs use the same definition as Photoshop, if they support the Lab color mode. This alone makes the Lab a versatile color space (refer to Tip 545, "Using Lab Color to Preserve Image Color").

To convert a Photoshop graphic into the Lab color space, select the Image menu, choose Mode, and select Lab from the fly-out menu. Photoshop converts the colors in the image into the Lab color space.

If you convert an RGB image to Lab color, Photoshop translates the red, green, and blue channels into Lab channels of lightness, hue, and saturation. Because Lab and RGB use a similar perceptual color table, converting an image from Lab to RGB, or vice versa, does not change the visual look of the image.

If you convert a CMYK image to Lab color, Photoshop must translate four-color channels of cyan, magenta, yellow, and black. Conversion of a CMYK image is not perfect, and when you reconvert a Lab image back into a CMYK image, the original image loses some of the saturation of the Lab image.

When you work in the Lab color space, there are some restrictions on what you can do.

- **Adjustments:** When you work on a Lab color image, the Selective Color, Channel Mixer, and Variations adjustments are unavailable.

- **Filters:** When you work on a Lab color image, the Artistic, Brush Stroke, Sketch, and Texture filters are unavailable. In addition, you do not have access to Smart Blur or several Distort and Stylize filters. Most of the Render options also are unavailable.

When you save a Lab color image, keep in mind that Lab is a color space, not a file format. The best formats for saving Lab images are TIF, EPS, and PSD; however, you also can save a Lab image in PDF and in Photoshop's DCS format.

843 *Choosing an Index Color Table*

In Tip 835, "Specifying the Correct Indexed Color Palette," you learned how to modify the color palette when converting an image to indexed color. When you convert an image into indexed color, the Color Table option lets you select any available color table.

To convert the color table of an indexed color graphic, open the image in Photoshop and perform these steps:

1. Select the Image menu, choose Mode, and select Color Table from the fly-out menu. Photoshop opens the Color Table dialog box, shown in Figure 843.1.

Figure 843.1 The Color Table dialog box lets you select a predefined color table.

2. Click on the Table button to select a color table from the available list. Understand that selecting a new color table does not normally map the colors in the image as you might expect. For example, selecting Grayscale from the available options does not convert the image into a perfect grayscale image, as shown in Figure 843.2.

3. To load a saved color table, click on the Load button. Photoshop opens the Load dialog box, shown in Figure 843.3.

4. You can load any saved color table from ImageReady or Photoshop. Select the .aco color table from the available list, and click on the Load button to apply the color table to the active image.

Note: In most cases, changing a color table produces a change in the image that borders on a special effect.

Figure 843.2 The grayscale color table produces a black-and-white image, but not in the way you might expect.

Figure 843.3 The Load dialog box lets you select a previously saved color table.

844 *Understanding Raster and Vector Images*

Image-editing programs store graphics in two major forms: vector and raster. Raster images use a grouping, or raster, of pixels to define the image. Each pixel represents a piece of color information that, when added together, produces a photograph or a clip art piece, as shown in Figure 844.1.

Scanned images are raster-based. A scanner creates a raster image by dividing the graphic into a group of pieces, similar to the organized layout of the bricks in a wall. Each brick represents a piece of information from the original image. Raster-based programs like Photoshop use that information to display the image within a document window.

Vector graphics define the image using a series of anchor points. The computer draws lines between each anchor point; depending on the type of points used, you can create very impressive clip art designs, as shown in Figure 844.2.

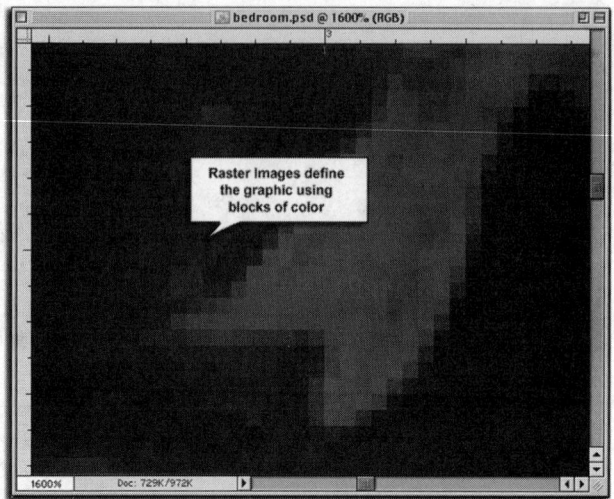

Figure 844.1 Raster images use a group of pixels to define image information.

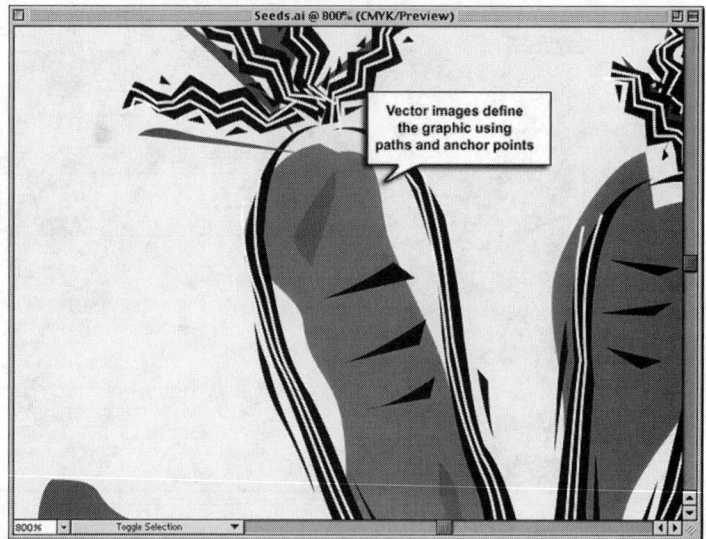

Figure 844.2 Vector images use a series of anchor points connected by straight or curved lines.

Adobe's image-editing programs utilize vector, raster, or a combination of both.

- **Illustrator:** Illustrator is primarily a vector-based program. However, you can open Photoshop "raster" images and perform some simple filter effects.

- **Photoshop:** Photoshop's main advantage is its capability to manipulate and enhance raster-based images. However, Photoshop has the capability to work with basic vector-editing tools such as the Pen tool, and Photoshop 6.0 has the capability of preserving vector-based PostScript text.

- **ImageReady:** Because the Internet is primarily a raster-based world, ImageReady is a raster-based program.

845 *Converting Bitmap Images into Halftone Images*

A Photoshop halftone image is a 1-bit image converted into black-and-white dots. When you create a halftone image, Photoshop spaces the dot patterns to simulate dark and light image areas, as shown in Figure 845.1.

*Figure 845.1 A halftone pattern generates a pattern of black-and-white dots.
The concentration of dots creates tonal areas in the image.*

Photoshop uses Bitmap mode to convert an image into a halftone. To convert a grayscale image into a halftone, open the image in Photoshop and perform these steps:

1. Select the Image menu, choose Mode, and choose Bitmap from the fly-out menu. Photoshop opens the Bitmap dialog box, shown in Figure 845.2.

Figure 845.2 The Bitmap dialog box lets you select a specific halftone pattern.

2. Click on the Method option and select Halftone Screen from the drop-down list (refer to Figure 845.2).

3. Click the OK button. Photoshop opens the Halftone Screen dialog box, shown in Figure 845.3.

 • **Frequency:** Click in the Frequency input field, and enter a value between 1.000 and 999.999. Frequency corresponds roughly to the resolution of the image. Smaller values produce larger dots.

- **Angle:** Click in the Angle input field and enter a value from –180 to +180 degrees. The Angle option determines the angle of the dot lines. For example, a value of 90° produces the dots in a left-to-right straight line.

Figure 845.3 The Halftone Screen dialog box lets you control the frequency, angle, and shape of the halftone screen.

- **Shape:** Click on the Shape option and select a shape from the drop-down list.

4. Click the OK button to apply the halftone screen to the image, as shown in Figure 845.4.

Note: If you create halftone screens for your service bureau, contact the press operator to give you the values for the best frequency, angle, and shape.

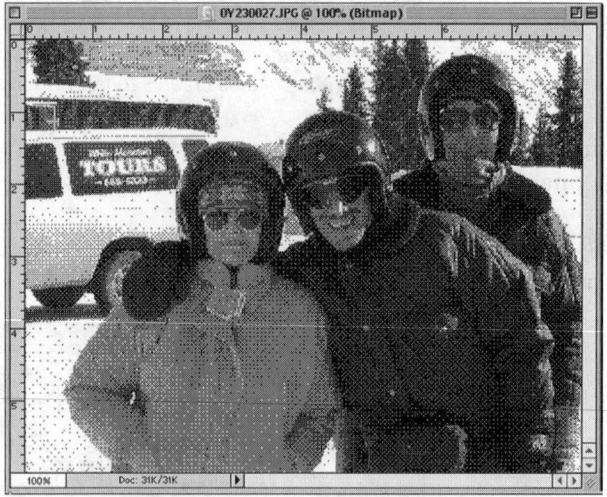

Figure 845.4 The halftone screen applied to the image.

846 *Working with Additional Bitmap Conversion Options*

In the previous tip, you learned how to create a halftone screen from a bitmap image. The Bitmap option provides more options then the creation of halftone screens.

To explore the other Bitmap options, open the grayscale image in Photoshop and perform these steps:

1. Select the Image menu, choose Mode, and choose Bitmap from the fly-out menu. Photoshop opens the Bitmap dialog box, shown in Figure 846.1.

2. Click on the Method option and select an option from the drop-down list (refer to Figure 846.1).

Figure 846.1 The Bitmap dialog box lets you select a specific halftone pattern.

- **50% Threshold:** Selecting this option converts the image into a black-and-white image, resembling a pen-and-ink drawing. The Bitmap command converts all pixels by dividing the image from midtone to light and midtone to dark. The lighter shades of gray go white, and the darker shades of gray go black, as shown in Figure 846.2.

Figure 846.2 The 50% Halftone option converts an image into black and white.

- **Pattern Dither:** Selecting this option converts the image into black and white using a predefined pattern, as shown in Figure 846.3.

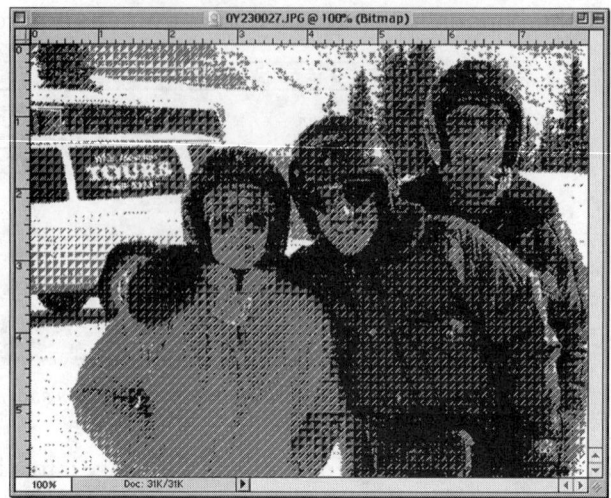

Figure 846.3 The Pattern Dither option applied to a typical grayscale image.

- **Diffusion Dither:** Selecting this option converts the image into black and white using an error diffusion pattern. The effect appears more natural when applied to photographic images, as shown in Figure 846.4.

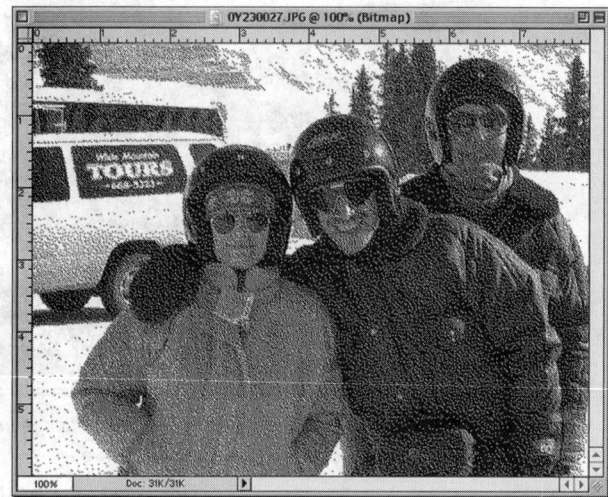

Figure 846.4 The Diffusion Dither option applied to a photographic image.

- **Custom Pattern:** Selecting this option converts the image into black and white using a customized diffusion pattern. Click on Custom Pattern and choose from a list of available patterns, as shown in Figure 846.5.

3. Click the OK button to apply the Bitmap command to the active image.

Figure 846.5 *The Custom Pattern option applied to a grayscale image.*

847 *Working with Monotone Images*

Photoshop creates monotone images from 8-bit grayscale images. Instead of applying a shade of gray, the Monotone command uses the 8-bit pixel to produce a shade of a particular color. Because the image contains an 8-bit pixel, the maximum steps of color in a monotone image are 256.

To create a monotone image, first convert the image to grayscale (select the Image menu, choose Mode, and choose Grayscale), and perform these steps:

1. Select the Image menu, choose Mode, and then choose Duotone from the fly-out menu. Photoshop opens the Duotone Options dialog box, shown in Figure 847.1.

Figure 847.1 *The Duotone Options dialog box controls the application of color to the image.*

2. Click on the Type option and select Monotone from the drop-down list.

3. Select the monotone color by clicking once on the color square (refer to Figure 847.2).

4. Select the color using Photoshop's Customs Colors, or click on the Picker Button and select a color from the Color Picker dialog box. In this example, you opt to select a Pantone Coated 492 CVC brown (refer to Tip 546, "Working with Pantone Colors").

Figure 847.2 Clicking on the color square opens the Custom Color dialog box.

5. Click the OK button to close the Custom Colors dialog box and record the color in the Duotone Options dialog box.

6. Click the OK button to close the Duotone Options dialog box and apply the color to the image, as shown in Figure 847.3.

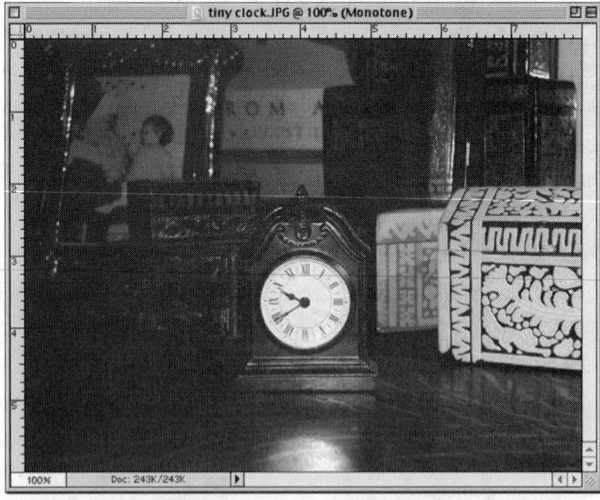

Figure 847.3 The monotone color successfully applied to the original grayscale image.

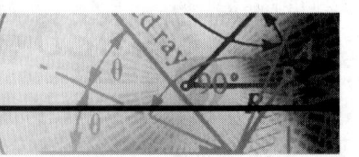

848 *Manipulating Duotone Images*

In the previous tip, you learned how to apply a single color to a grayscale image. The duotone options lets you select up to four colors. To apply more than one color to a grayscale image, open a grayscale image in Photoshop and perform these steps:

1. Select the Image menu, choose Mode, and choose Duotone from the fly-out menu. Photoshop opens the Duotone Options dialog box, as shown in Figure 848.1.

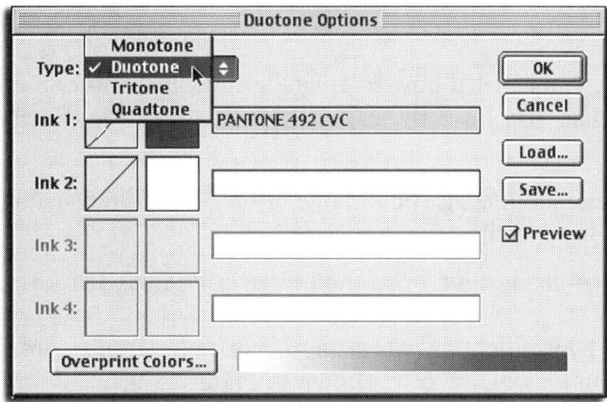

Figure 848.1 The Duotone Options dialog box controls the application of color to the image.

2. Click on the Type option and select Duotone from the drop-down list. The Duotone dialog box now lets you manipulate two inks (refer to Figure 848.1).

3. When you work with two or more inks, the darkest color is the top color; succeeding color boxes receive lighter colors until the lightest color is on the bottom, as shown in Figure 848.2.

4. To select the colors, click one at a time on the color squares (refer to Figure 848.1) and choose the colors from the Custom Colors dialog box, or the Color Picker dialog box.

Figure 848.2 For best results, run multiple colors from dark on top to light on bottom.

Note: *Use multicolor duotones to increase the tonal range of images printed on professional presses. Duotone images printed on ink-jet and laser printers usually require the use of single-color inks.*

849 _Changing the Curves of a Duotone Image_

In the previous tip, you learned how to create a multi-ink duotone image. When you select the inks for a duotone image, you also have the capability to control the distribution of the ink using the Curves palettes.

Using curves, you can modify the tonal range of the ink and redistribute the ink according the highlights, midtones, and shadows in the original image.

To access the Curves dialog box, open the image in Photoshop and perform these steps:

1. Select the Image menu, choose Mode, and choose Duotone from the fly-out menu. Photoshop opens the Duotone Options dialog box, shown in Figure 849.1.

Figure 849.1 The Duotone Options dialog box controls the application of color to the image.

2. To modify the color, click on the Curves box. Photoshop opens the Duotone Curve dialog box, shown in Figure 849.2.

3. Adjust the curve by clicking on and moving the curve line (refer to Tip 205, "Understanding How the Curves Command Adjusts an Image").

4. Click the OK button to apply the Curves option to the ink.

Figure 849.2 The Duotone Curve dialog box redistributes color according to highlights, midtones, and shadows in the original image.

Say, for example, that you use the Duotone Options dialog box to apply a sepia tone to an image (refer to Tip 847, "Working with Monotone Images"). However, the ink oversaturates the shadows of the image.

Select the Curves option for the brown ink (refer to step 2), and reduce the application of brown by lowering the curve, as shown in Figure 849.3.

Figure 849.3 Lowering the curve reduces the application of the selected color in the shadow areas of the image.

850 *Converting an Image to Multichannels*

When you work on an image, Photoshop defines the colors in the image using the graphics channels. Say, for example, that you work on an RGB image. Photoshop defines the visible colors in the image by using the image's native color channels, as shown in Figure 850.1.

Figure 850.1 The native color channels of an RGB image define the mixing of the image's inks.

Each channel in an RGB image represents a percentage of red, green, and blue. Mixing channels produces the visible colors in the document (refer to Tip 432, "Understanding Channels and Their Role").

Converting an image using the multichannel option converts the image into separate spot channels.

To separate an image into multichannels, open the image in Photoshop and select the Image menu, choose Mode, and choose Multichannel. Photoshop removes the composite channel and converts the remaining channels into spot color channels, as shown in Figure 850.2.

Figure 850.2 The Multichannel command converts the native color channels to spot color channels.

- **RGB:** Selecting the Multichannel command on an RGB image converts the channels from red, green, and blue to cyan, magenta, and yellow.

- **CMYK:** Selecting the Multichannel command on a CMYK image converts the channels from cyan, magenta, yellow, and black into separate channels of the same colors.

- **Channel deletion:** When you delete a channel from an RGB or CMYK image, Photoshop automatically converts the remaining channels into a multichannel document.

To save multichannel images, select the File menu, choose Save, and use the DCS 2.0 format.

Note: Multichannel images have limited use in specialized printing applications. One application, according to Photoshop, is the conversion of a duotone image for printing in the Scitex CT format.

851 *Using the Original and Optimized Views in ImageReady*

When you edit a graphic in ImageReady, the document window lets you select what view you want to see while you work. Clicking on the Original and Optimized buttons lets you see the original, uncompressed image or the optimized version of the file. To change the current view, click on the Optimized or Original tab, as shown in Figure 851.1.

When you are in the editing phase, stay in the original view. The optimized view optimizes the image every time you make an editing change. In some cases, this can take 5 or 10 seconds for each modification to the image, as shown in Figure 851.2.

Another reason to use the Original window is that you have the capability to use the drawing and type tools. You cannot perform drawing and type editing while in the Optimize window. Therefore, for all these reasons, stay in the Original window and occasionally move to the Optimize window to view the effects of your editing on the image.

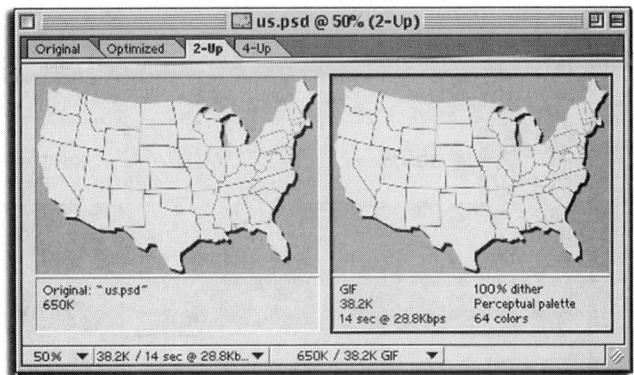

Figure 851.1 The ImageReady document window lets you view the original or optimized version of the image.

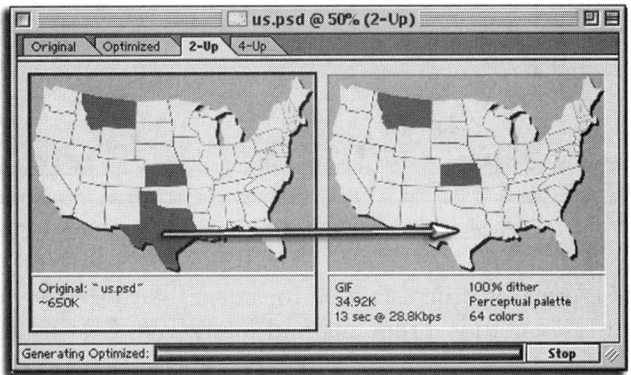

Figure 851.2 The Optimize window optimizes the image every time an editing change is made to the image.

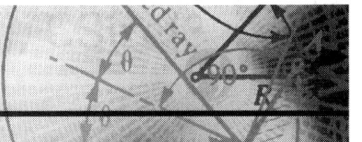

852 *Understanding the JPEG File Format*

The JPEG (Joint Photographic Experts Group) format was created to handle the unique problems associated with using images on the Internet. The major problem with photographic images is their file size. It is not uncommon for a saved graphic file to be in the million bytes or higher category. On the Internet, attempting to move a million-byte file could take 20 minutes or longer.

The JPEG format solves this problem by significantly reducing the file size of photographic images. It accomplishes file reduction by selectively removing colors from the image and replacing the missing information by mixing the remaining colors in a dither pattern. When you save the file, the JPEG format still uses a 24-bit pixel, but by reducing the number of colors, the file size goes way down. It is not uncommon to see a JPEG image 100 times smaller than the original image.

JPEG files define color reduction with the term *lossy*. When you apply the JPEG compression scheme to a photographic image (refer to Tip 754, "Reducing the File Size of a JPEG Image"), the information removed cannot be recovered.

In addition, the JPEG format reduces the visual quality of the original image. Designers consider loss of quality a necessary part of life on the Internet and attempt to balance the loss of quality with the speed of the download, as shown in Figure 852.1.

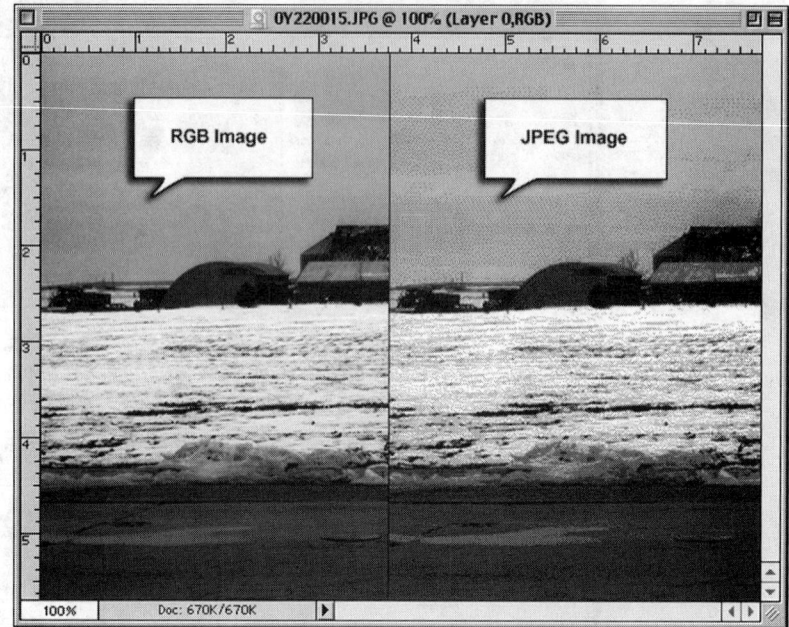

Figure 852.1 The JPEG format reduces file size and image quality.

Although the JPEG format is primarily used for images destined for the Internet, the format works well for images used in presentation programs and interactive CDs using programs such as Director and iShell.

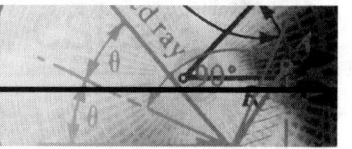 *Understanding the GIF File Format*

In the previous tip, you learned about the JPEG file format. GIF (Graphics Interchange Format) is another format that works its magic on images intended for display on the Internet. The GIF format works best on clip art, text, and logos, or images that contain a lot of sharp edges and few colors.

When you convert an RGB image into the GIF format (refer to Tip 755, "Reducing the File Size of a GIF Image"), the conversion process reduces the depth of the pixel from 24 bits to 8 bits. An 8-bit pixel is capable of displaying a maximum of only 256 colors. When the image contains more than 256 colors, the GIF format reduces the colors to 256 by retaining a representative sample of the major color areas in the original image's color table.

When you apply the GIF format to a photographic image, it has a tendency to make the soft color areas of the image appear blocky, as shown in Figure 853.1.

GIF images reduce file size by reducing the depth of the image's pixel and by compressing the remaining colors in the image using RLE (Run Length Encoding). RLE is a lossless compression scheme that compresses large areas of flat color. Because clip art, logos, and text contain large, flat areas of color, the GIF format is ideal for compressing these images.

Like the JPEG format (refer to the previous tip), the GIF format is a Web compression format. However, the GIF format is becoming increasingly popular for use in computerized slide presentations such as PowerPoint. Check your presentation application and see if it accepts the GIF file format.

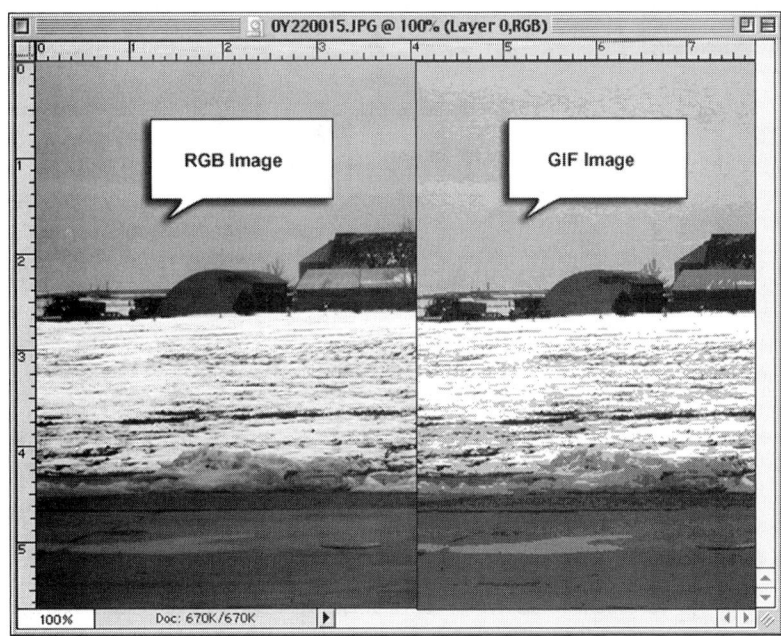

Figure 853.1 The GIF format applied to a photograph creates a block or stepped appearance to the soft area of the image.

854 *Understanding the PNG-8 and PNG-24 File Formats*

The PNG (Portable Network Graphic) format is the newest addition to the list of Web compression formats. As the newest format, it is the most versatile.

The PNG-8 format performs compression similar to the GIF format. It reduces the original image's pixel depth to 8 bits, and it retains a maximum of 256 colors. In addition, it uses the RLE compression scheme to reduce the size of the file (refer to the previous tip). The PNG-8 format reduces the file size in clip art, logos, and text by compressing large, flat areas of color.

The PNG-24 format performs compression on photographic images. However, unlike the JPEG format (refer to Tip 852, "Understanding the JPEG File Format"), it uses lossless compression techniques. The PNG-24 format uses a 24-bit pixel and RLE compression to reduce the size of the file without reducing the quality of the image, as shown in Figure 854.1.

The PNG format performs the duty of the JPEG and GIF formats, and it reduces file size without removing color. It is an excellent format, but it's ahead of its time. Although the PNG format works great, it is not yet supported by the major browsers Netscape Navigator and Internet Explorer. Less than 30 percent of Internet surfers have the capability to open PNG-formatted images. Therefore, the word on the PNG format is to wait and watch the industry. It does not make sense to use a format, no matter how good, if the majority of Web users cannot access it.

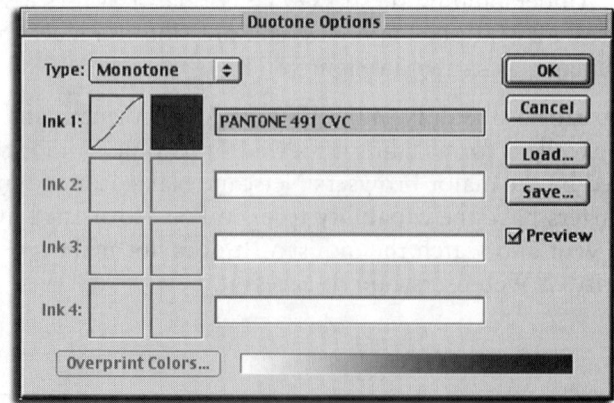

Figure 854.1 The PNG-24 format reduces file size without sacrificing image quality.

855 *Exporting a Duotone Image into Another Application*

In Tip 848, "Manipulating Duotone Images," you learned how to colorize an 8-bit grayscale image using the Duotone command. Duotone images present an excellent method for moving a small, colorized image into layout programs such as InDesign, PageMaker, and QuarkXPress.

To prepare a duotone image for use in another application, open the image in Photoshop and perform these steps:

1. Select the Image menu, choose Mode, and choose Duotone from the fly-out menu. Photoshop opens the Duotone Options dialog box, shown in Figure 855.1.

Figure 855.1 The Duotone Options dialog box lists all the colors used to create the duotone image.

2. Verify that the name of the specific Pantone color appears in the Color name box. This helps the layout program identify the correct color.

3. Click the OK button to close the Duotone Options dialog box.

4. Select the File menu and choose Save As from the pull-down menu. Photoshop opens the Save As dialog box, shown in Figure 855.2.

Figure 855.2 The Save As dialog box lets you specify the format for the saved duotone image.

5. Click on the Format option and select the EPS format from the drop-down list. Of all Photoshop's formats, the EPS format preserves the content of the image along with the specific Pantone colors.

6. Click the OK button to save the file to disk.

Note: If your layout program does not accept the EPS format, you can use the PDF format. However, because the PDF format uses lossy compression methods to save the file, pay attention to the PDF options (see Tip 859, "Saving a PDF File"), for more information on saving PDF documents.

856 *Saving Files with the DCS Format for Color Separations*

In the previous tip, you learned how to save a duotone image for printing in another application. If your duotone image contains spot color, you need to use another format. Say, for example, that you create a duotone image that includes one or more spot color channels. To save the image for printing, open the document in Photoshop and perform these steps:

1. Select the Image menu, choose Mode, and choose Duotone from the fly-out menu. Photoshop opens the Duotone Options dialog box, shown in Figure 856.1.

2. Verify that the name of the specific Pantone color appears in the Color name box. This helps the layout program identify the correct color.

Figure 856.1 The Duotone Options dialog box lists all the colors used to create the duotone image.

3. Click the OK button to close the Duotone Options dialog box.

4. If the Channels palette is not visible, select the Window menu and choose Show Channels from the pull-down menu. Photoshop opens the Channels palette, shown in Figure 856.2.

5. Verify that the name of the specific Pantone colors appears as the name of each spot color channel. This information is crucial to the printing press.

6. Select the File menu and choose Save As from the pull-down menu. Photoshop opens the Save As dialog box, shown in Figure 856.3.

Figure 856.2 The Channels palette displays an icon for each spot color in the image.

7. Click on the Format button and select the Photoshop DCS 2.0 format. The DCS format creates the separation plates necessary for printing a spot color document on a printing press.

8. Click the OK button to save the file to disk.

Figure 856.3 The Save As dialog box lets you specify the format for the saved duotone image.

Note: When you create a document using spot color channels, your intent is to print the document using a separation press. Any time your work involves a service bureau, contact the press operator and ask for specific instructions on preparing the document.

857 *Printing the Color Separation Plates*

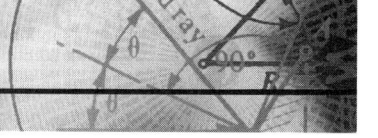

In the previous tip, you learned how to prepare a spot color document for use on a printing press. Although the press operator typically prepares the separate plates for processing on the press, you can print a copy of the plates using an ink-jet or laser printer.

Some printers ask you to print plate copies so that they can observe how the inks on the separate plates mix to produce the colors in the image. Printing color plates generates black-and-white images. The shades of gray on the image represent the percentage of ink applied to the image. The darker the shade of gray is, the less ink there is, as shown in Figure 857.1.

To print copies of the color separation plates, open the document in Photoshop and perform these steps:

1. Select the File menu and choose Print Options from the pull-down menu. Photoshop opens the Print Options dialog box, shown in Figure 857.2.

2. Select Show More Options.

3. Click on the Option button, located under Show More Options, and choose Color Management from the drop-down list (refer to Figure 857.2).

4. Click once on the Profile button and select Separations from the pop-up menu.

5. Click the OK button to close the Print Options dialog box and apply the changes to the active image.

Figure 857.1 Printing the separation plates on an ink-jet or laser printer produces black-and-white copies of the original image.

6. Select the File menu and choose Print from the pull-down menu.

7. Click on the Print button. Photoshop prints out separate pages for each native color and spot color channel in the active document.

Figure 857.2 The Print Options dialog box lets you print separation color plates.

858 *Working with Color Separation Tables*

When you design images for printing on a four-color press, before the press operator separates the image into color plates, the document must first be converted into the CMYK color space (refer to the previous tip).

When you convert an RGB (red, green, and blue) image into CMYK, Photoshop looks at the original RGB image colors and decides the percentages of cyan, magenta, yellow, and black to apply to the color plates. Photoshop makes this conversion based on a color-conversion table.

The color-conversion table instructs Photoshop how to convert the inks, based on the type of press used in the printing process. To access the color-conversion table, select the Edit menu and choose Color Settings from the pull-down menu. Photoshop opens the Color Settings dialog box, shown in Figure 858.1.

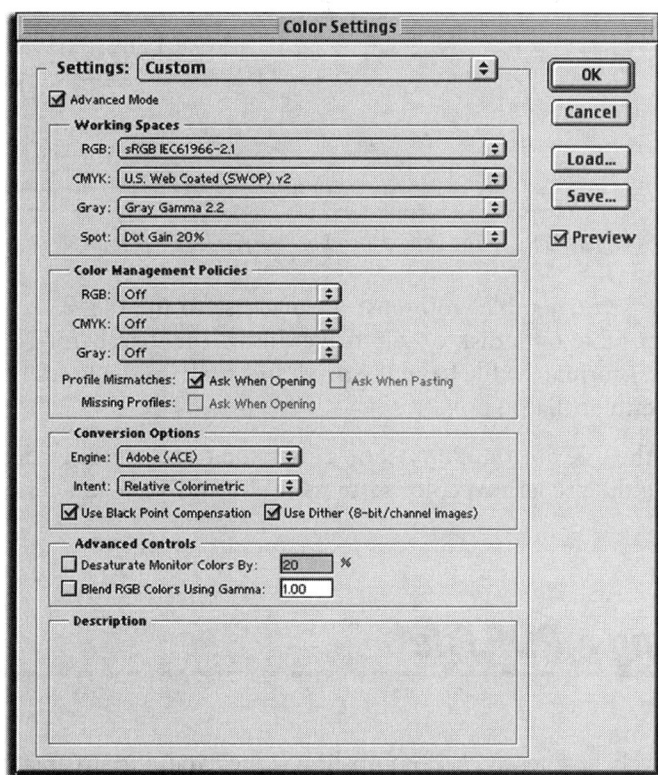

Figure 858.1 The Color Settings dialog box controls the conversion of an RGB image into the CMYK color space.

To select one of Photoshop's preloaded setting files, click on the Settings button and choose a color set from the drop-down list (refer to Tip 52, "Using the Predefined Color Settings Within Photoshop"). The preset files help you define the color space that Photoshop uses to make the conversion of the image. However, they do not handle every situation. Say, for example, that your CMYK images are printing with unacceptable color shifts. Your press operator informs you that she has a specific color-conversion table for Photoshop that describes the conversion method used by the presses that print your images.

To load a predefined color setting file into Photoshop, click on the Load button in the Color Settings dialog box. Photoshop opens the Load dialog box, shown in Figure 858.2.

Figure 858.2 The Load dialog box lets you load a previously saved color settings file.

To load the color settings table, you must have access to the file. The most common transfer method is to place the color table on a disk or Zip drive. Insert the disk before opening the Color Settings dialog box. Select the *.csf*-formatted file from the disk, and click on the Load button. The color setting file loads into the Color Settings dialog box.

When you click the OK button, Photoshop closes the Color Settings dialog box. Now images converted in Photoshop use the predefined color settings table, and your images print correctly.

859 *Saving a PDF File*

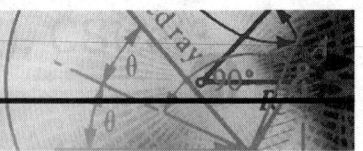

One of the relatively new features of Photoshop is the capability to create documents and save them using the universal PDF (Portable Document File) format. The PDF format is a Macintosh/Windows-compatible format. The primary use of the PDF format is the creation of documents that are readable by virtually any computer and operation system. Say, for example, that you create a graphic poster and you want to give the file to your customers. However, some of your customers use Macintosh and some use Windows. By saving the file using the PDF format, you instantly solve your viewing problems.

To save a file in the PDF format, open the image in Photoshop and perform these steps:

1. Select the File menu and choose Save As from the pull-down menu. Photoshop opens the Save As dialog box, shown in Figure 859.1.

2. Click on the Format button and choose Photoshop PDF from the drop-down list.

3. Click on the Save button. Photoshop opens the PDF Options dialog box, shown in Figure 859.2.

Figure 859.1 The Save As dialog box lets you choose the format for a saved document.

- **Encoding:** Select Zip or JPEG encoding. JPEG is the most common encoding scheme. When you select JPEG, choose the Quality setting by clicking in the Quality input field and entering a value from 0 to 12. The larger the value is, the less compression will occur (refer to Tip 754, "Reducing the File Size of a JPEG Image"). If you select the Zip format, the user opening the file needs an Unzip program to open the file.

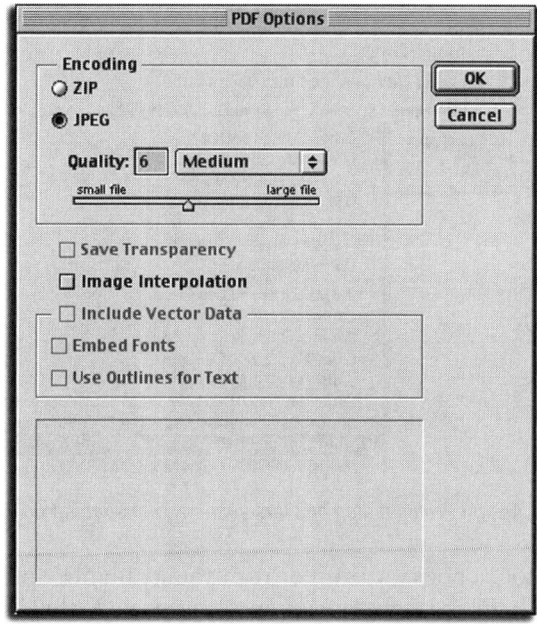

Figure 859.2 The PDF Options dialog box lets you control the options for the saved file.

- **Save Transparency:** Select this option to preserve the transparency in the image. This option is not available if the image does not contain transparent pixels.

- **Image Interpolation:** Select this option to apply anti-alias techniques to low-resolution images (refer to Tip 30, "Placing PostScript Files Using the Anti-alias Option").

- **Include Vector Data:** If the image contains vector data in the form of paths, selecting this option preserves the vector data.

- **Embed Fonts:** Selecting this option creates a bigger file, but the fonts used to create the image save along with the file. This guarantees that the text prints exactly as designed.

- **Use Outlines for Text:** Selecting this option converts the text in the image to vector outlines. This option saves space, but you cannot return to the image and edit the text.

4. Click the OK button to record the changes and save the file to disk.

860 *Embedding ICC Profiles into PDF Graphics*

When you design PDF documents in Photoshop, the colors that you see depend on your monitor, operating system, and active program. Even if you calibrate your system (refer to Tip 57, "Calibrating Monitor Color Using the Adobe Gamma Utility"), the person viewing your PDF file might be (and probably is) using a different setup.

The ICC color profile system embeds information into the image, instructing the computer on what system created the image and the best way to display the graphic on other systems (refer to Tip 249, "Understanding ICC Profiles").

To assign an ICC profile to a PDF document, select the Image menu, choose Mode, and select Assign Profile from the fly-out menu. Photoshop opens the Assign Profile dialog box, shown in Figure 860.1.

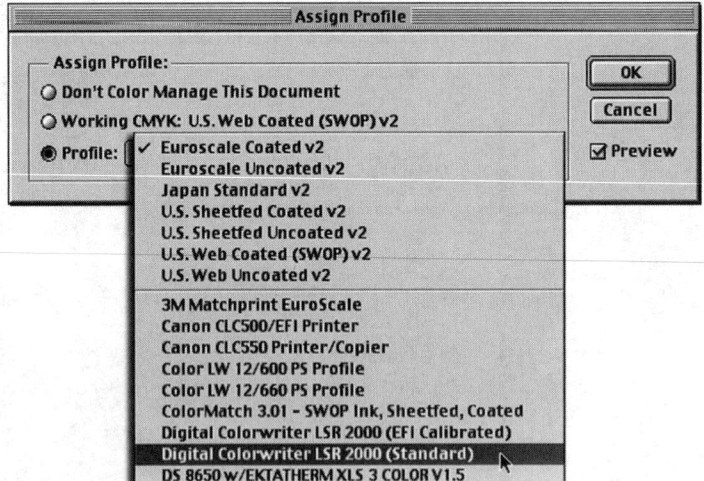

Figure 860.1 The Assign Profile dialog box lets you assign a specific color-management profile to the active image.

Select the Profile button, choose a profile from the available options (refer to Tip 560, "Assigning an ICC Color Profile to a Photoshop Document"), and click the OK button to apply the profile to the image. Then perform the steps in the previous tip to save the PDF document file.

Note: *Images using the ICC Profile command display correctly on all ICC-friendly systems and programs. The Acrobat Reader program is ICC-friendly, as is the latest version of the Macintosh and Windows operating systems. Embedding ICC profiles does not handle all image problems, but it goes a long way toward helping your images look their best, regardless of computer or operating system.*

861 *Understanding File Formats and Color Spaces*

When you edit an image in Photoshop, you pass through two development stages: designing the image and saving the image.

The design phase involves editing the image, using a particular color space.

- **Bitmap:** 1-bit images. Used for scanning and printing fine line-art and sketches.

- **Grayscale:** 8-bit images. Used primarily for editing black-and-white images, transferring image into colored duotones, and working with Photoshop's Bitmap options.

- **RGB:** 24-bit color images. Used primarily for Web images and graphics displayed using a computer monitor. RGB is Photoshop's most versatile color space.

- **CMYK:** 32-bit color images. Used primarily for editing images for four-color printing presses.

- **Lab:** 24-bit color images. A unique device-independent color space. Use Lab to move Photoshop images between different versions of Photoshop.

The working color space depends on the final output of the image. Use the RGB color space if the document will be used for several different applications, such as the Internet and print.

The saving phase involves saving the image using a particular file format. Some formats are more forgiving than others. When you save a file, the output of the image determines how the file is saved.

You should understand the difference between lossy and lossless compression. When a format uses lossy compression, it removes color information to reduce its file size. The JPEG format employs lossy compression. The GIF and PNG-8-formats are defined as lossless, however they only contain a maximum of 256 colors, Since the RGB, CMYK, and Lab formats can hold millions of possible colors, be wary of using the GIF and PNG-8 formats with these color spaces.

Lossless formats save the file without removing color information. The most universal formats are TIF, EPS, PIC and BMP. All four of these formats save the image information without removing color in the process.

> *Note: Do not confuse color space with file format. Both items are important to the image, but file format does not necessarily determine color space, and color space does not determine file format. File format and color space work together to define what the image is and where it will be used.*

862 *Choosing Size and Color Space for Presentations*

When you use Photoshop to design presentation graphics, you have an advantage over designing images for the Internet: You know the output device used to display the information. In today's technical world, presenters do not use old-fashioned overhead slides (at least, most do not); they use the new-style LCD projection systems. LCD projectors take the slide presentation as it appears on your computer monitor and project the information onto a wide-format screen. In additions, LCD projectors use the same color space as your monitor: additive RGB.

With this information, you can use Photoshop to create stunning presentation graphics.

- **Color space:** Always design color graphics using the RGB color space. As previously stated, the RGB color space is the color space of your monitor and projection system. When the design phase is complete, try indexing the colors in the image (refer to Tip 834, "Converting to Indexed Color"). Color indexing reduces the file size to one third of the original RGB image, as shown in Figure 862.1.

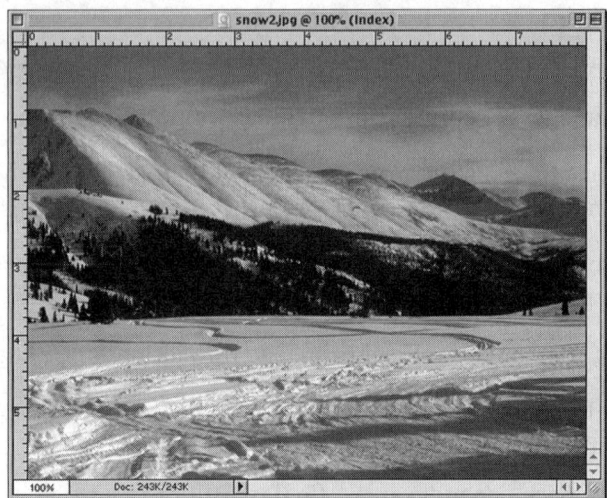

Figure 862.1 Indexing an RGB image reduces the file size by two thirds.

- **Image size:** This part of the design phase is very important. Create the graphic image the exact size that it needs to be in the presentation program. Say, for example, that you require the size of the graphic image to be exactly 200 × 150 pixels. When you create the graphic in Photoshop, open a new file with a width and height of 200 × 150, or select the Image menu, choose Image Size, and change the size of the existing graphic to 200 × 150 (refer to Tip 269, "Changing an Image Using Image Size").

The object is not to resize the image in the presentation program. Resizing an image in the presentation program forces the application to resize the image on the fly every time that the presentation is run. This causes jerky animation, and poor-quality images, as shown in Figure 862.2.

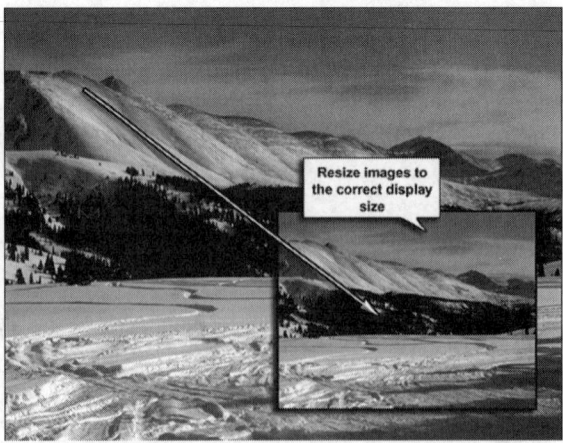

Figure 862.2 Resizing images in the presentation program causes jerky animation and poor-quality output.

863 *Using Quick Mask for Complicated Transparency Effects*

The most common method of generating transparent pixels is with the use of Photoshop's standard selection and Eraser tools. Say, for example, that you want to create an area of transparency in an image. You select the Eraser tool from the toolbox and use it like a paintbrush. As you click and drag, the areas that you move over in the image change to transparent, as shown in Figure 863.1.

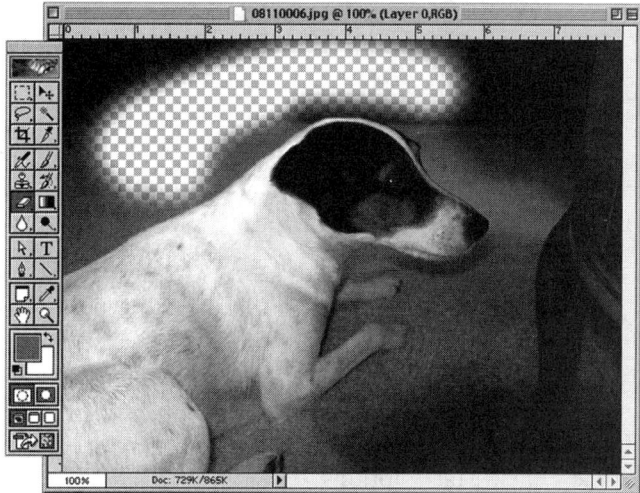

Figure 863.1 The Eraser tool creates transparent areas in a Photoshop document.

Using the Eraser tool works well on simple images, but when you work on complicated images, Photoshop's Quick Mask option can help you create flawless transparency in an image.

To use the Quick Mask option to create transparency, open a document in Photoshop and perform these steps:

1. Select the Paintbrush tool from the toolbox and choose a soft brush from the Options bar, as shown in Figure 863.2.

Figure 863.2 Select a soft-edged brush from the Paintbrush Options bar.

2. Press the letter "D" on your keyboard to default the foreground and background colors to black and white.

3. Double-click on the Quick Mask icon, located at the bottom of the toolbox. Photoshop opens the Quick Mask options, as shown in Figure 863.3.

Figure 863.3 Double-clicking on the Quick Mask icon opens the Quick Mask options.

4. Select Color Indicates Masked Areas, and choose 50 percent opacity. Click the OK button to record the changes to the Quick Mask options.

5. Use the Paintbrush tool to begin creating a mask for the areas of the image that you want to convert to transparent. Use different sizes of brushes for the tight areas, as shown in Figure 863.4.

Figure 863.4 The Quick Mask option converts paint strokes into a semitransparent mask.

6. If you painted too much, use the Paintbrush with the color white to erase areas of the mask.

7. Occasionally click on the Standard mode button to observe the selection process, as shown in Figure 863.5.

Figure 863.5 The Standard icon converts the masked areas into a selection.

8. When the mask covers the area that you want to make transparent, click on the Standard Mode icon and press the Delete key. The selected areas convert into transparent pixels, as shown in Figure 863.6.

> *Note: Using the Quick Mask option gives you control over the image. You press Delete when the mask exactly matches the areas that you want transparent.*

Figure 863.6 The selected areas of the image successfully converted into transparent pixels.

864 *Compression of Graphics*

One consideration for presentation graphics is to use standard compression formats. Never use compression on a graphic intended for display in a presentation program.

Say, for example, that you create several graphic images for a PowerPoint presentation and you use TIFFs to save the files. PowerPoint accepts the TIFF format, and it has the advantage of being easy to transport between the Windows and Macintosh formats.

To save an image as a TIFF, open the graphic in Photoshop and perform these steps:

1. Select the File menu and choose Save As from the pull-down menu. Photoshop opens the Save As dialog box, shown in Figure 864.1.

Figure 864.1 The Save As dialog box controls the format of the saved graphic file.

2. Click on the Format button and select TIFF from the drop-down list.

3. Click on the Save button. Photoshop opens the TIFF Options dialog box, shown in Figure 864.2.

Figure 864.2 The TIFF Options dialog box lets you control the compression of the TIFF image.

4. Select IBM PC or Macintosh, depending on the destination operating system.

5. Do not select LZW Compression (refer to Figure 864.2).

Note: LZW compression compresses the file on disk and forces the presentation program to uncompress the image every time it displays. The compressing and uncompressing of the image slows the software and causes the animation to display with a jerky movement.

865 *Creating a Soft-Edged Shadow in a GIF Transparent Image*

The GIF format lets you select one color for transparency. While this works fine for images with a hard shadow, it makes images with drop shadows unacceptable, as shown in Figure 865.1.

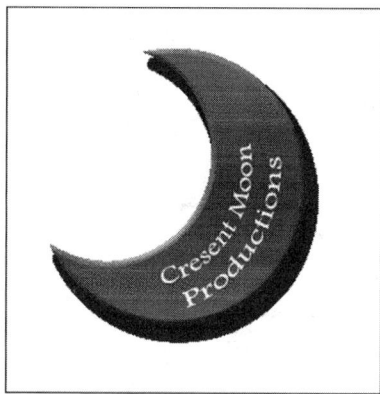

Figure 865.1 Drop shadows applied to a GIF image create a hard edge to the shadow.

Drop shadows do not work on GIF images because there is no way to create gradual transparency. However, with knowledge of the background that the image displays and the GIF Matting option, you can create a believable soft shadow using the GIF format.

Say, for example, that you have a logo with a drop shadow, and you want to convert the image into a GIF image, as shown in Figure 865.2.

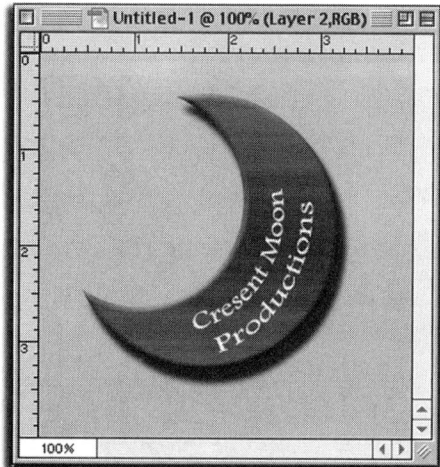

Figure 865.2 An image containing a logo with a drop shadow.

To create a drop shadow using a GIF image, open an graphic containing a drop shadow in Photoshop and perform these steps:

1. Select the File menu and choose Save for Web from the pull-down menu. Photoshop opens the Save for Web dialog box, shown in Figure 865.3.

2. Click on the Format button and choose GIF from the drop-down list (refer to Figure 865.3).

3. Make sure that the Transparency option is selected.

4. Click on the Matte button, and select Other from the drop-down list. Photoshop opens the Color Picker dialog box, shown in Figure 865.4.

Figure 865.3 The Save for Web dialog box controls the format of the active image.

5. Select a Web Safe color from the Color Picker that matches the background color of the Web page. This is the secret to making the shadow look soft. The matte color matches the color of the Web page. The matte fills the semitransparent areas of the image and gives the impression of a soft drop shadow.

Figure 865.4 The Color Picker dialog box lets you select the matte color.

6. Click the OK button to save the file to disk. When you use it against a background with the same color as the matte, it creates a soft appearance, as shown in Figure 865.5.

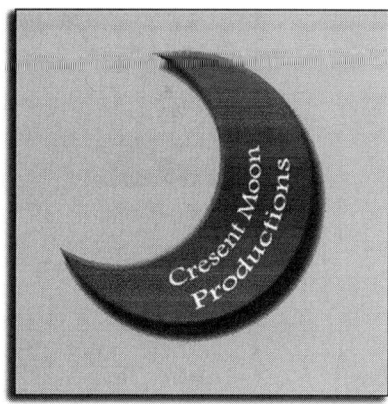

Figure 865.5 The matte color makes the drop shadow appear soft.

866 *Applying Filters with the History Brush*

When you apply a filter to an image, Photoshop modifies the image according to what filters, if any, were previously applied to the image and the type of filter chosen. You apply filters to individual layers or selections within the layer. In addition, the intensity of the effect is controllable using the Fade command (refer to Tip 508, "Blending Filter Effects").

Another way to control the effect of a filter is using the History Brush. Say, for example, that you have a landscape image, and you want to apply a Glass filter to a portion of the image. You could select the portion of the image that you want the filter to modify; however, a selection does not really illustrate the application of the filter to the image, as shown in Figure 866.1.

Figure 866.1 A selection does not indicate how a filter looks when applied to the image.

To use the History Brush in conjunction with the Glass filter, open the document in Photoshop and perform these steps:

1. Select the Filter menu, choose Distort, and choose Glass from the fly-out menu. Photoshop opens the Glass dialog box, shown in Figure 866.2.

Figure 866.2 The Glass dialog box lets you control the application of a filter to the active image.

2. Modify the Distortion options. In this example, you enter a distortion value of 5, a smoothness value of 3, and a scaling value of 100 percent.

3. Click on the Texture button and select from the available options. In this example, you select the Frosted option.

4. Click the OK button to apply the Glass distortion to the image, as shown in Figure 866.3.

Figure 866.3 The Glass distortion filter applied to the active image.

5. If the Layers palette is not open, select the Window menu and choose Show Layers from the pull-down menu. Photoshop opens the Layers palette.

6. Move your cursor into the Layers palette and click on the New Layer icon. Photoshop creates a new layer, as shown in Figure 866.4.

7. Select History Brush tool from the toolbox and choose a medium, soft brush, as shown in Figure 866.5.

8. Move your cursor into the Layers palette and click once on the new layer. Photoshop selects the new layer.

Figure 866.4 Clicking on the New Layer icon creates a new layer.

Figure 866.5 The History Brush lets you restore selected portions of the image.

9. Using the History Brush like a paintbrush, restore selected portions of the image by painting them back into the document window (see Figure 866.6).

10. Using a new layer with the History Brush gives you the control that you need to be creative, as well the capability to edit mistakes quickly.

Note: A second way to approach the application of a filter is to take a snapshot of the image after you apply the filter and use the History Brush with the snapshot (refer to Tip 400, "Painting with a Snapshot").

Figure 866.6 The History Brush restores the original portions of the image.

867 *Using Duotone and Noise to Create the Appearance of Age in an Image*

Not every image that you create in Photoshop needs to look brand new. Sometimes you want to add some age an image. Say, for example, that you want to give the appearance of age to a new color photograph.

To age an image, open the RGB document in Photoshop and perform these steps:

1. Select the Image menu, choose Mode, and choose Grayscale from the fly-out menu. Photoshop converts the image into an 8-bit grayscale document.

2. Select the Image menu, choose Mode, and choose Duotone from the fly-out menu. Photoshop opens the Duotone Options dialog box, as shown in Figure 867.1.

3. Perform the steps in Tip 847, "Working with Monotone Images," to apply a sepia tone to the image, as shown in Figure 867.2.

4. Select the Filter menu, choose Noise, and select Add Noise. Photoshop opens the Add Noise dialog box, shown in Figure 867.3.

5. In the Amount field, enter a value from 0.10 to 400. In this example, you select a value of 6.

6. Select Gaussian and deselect the Monochromatic option.

7. Click the OK button to apply the Noise filter to the image, as shown in Figure 867.4.

Figure 867.1 The Duotone Options dialog box lets you apply up to four colors to an 8-bit grayscale image.

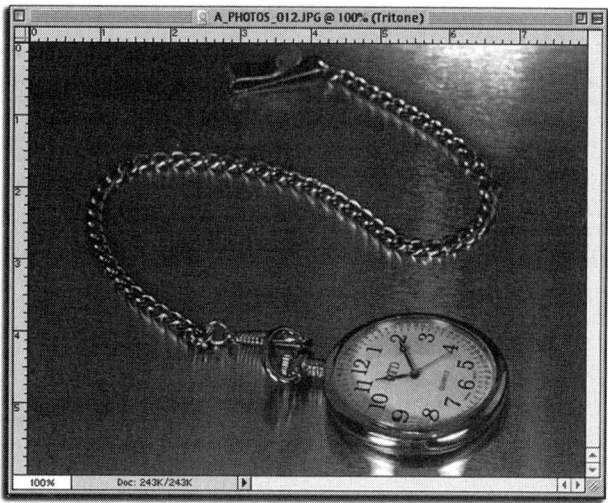

Figure 867.2 Perform the steps in Tip 847 to apply the sepia tone to the image.

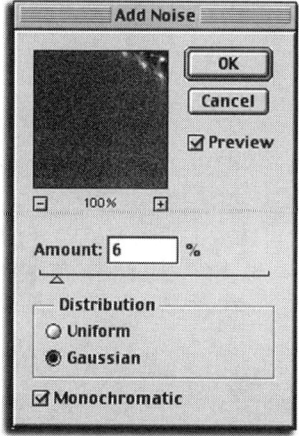

Figure 867.3 The Add Noise filter introduces random noise to the active image.

Figure 867.4 When applied to the image, the Noise filter gives the impression of age.

868 *Using Gaussian Blur to Create a Sense of Depth in an Image*

Graphic images displayed on a computer monitor are flat. Photoshop lets you manipulate the width and height of an image, but there is no option for controlling the depth of the image because there is no depth. One effective way to create a sense of depth within an image is to blur outside areas while leaving the central portion of the image in focus.

Say, for example, that you have a group shot of some people and you want to generate a sense of depth in the image by blurring selected areas of the image.

To create a sense of depth in an image, open the document in Photoshop and perform these steps:

1. Select the Filter menu, choose Blur, and then choose Gaussian Blur from the fly-out menu. Photoshop opens the Blur dialog box, shown in Figure 868.1.

Figure 868.1 The Blur dialog box controls the amount of blurring applied to the image.

2. In the Radius input field, enter a value of 4. Click the OK button to apply the blur to the image.

3. If the Layers palette is not open, select the Window menu and choose Show Layers from the pull-down menu. Photoshop opens the Layers palette.

4. Move your cursor into the Layers palette and click on the New Layer icon. Photoshop creates a new layer, as shown in Figure 868.2.

Figure 868.2 Clicking on the New Layer icon creates a new layer.

5. Select the History Brush from the toolbox and choose a small, soft brush, as shown in Figure 868.3.

Figure 868.3 The History Brush lets you restore selected portions of the image.

6. Move to the Layers palette and click once on the new layer. Photoshop selects the new layer.

7. Move the History Brush in to the document window and restore the portions of the image that you want in focus, as shown in Figure 868.4.

> **Note:** *Using the History Brush with a new layer gives you total control over the image. If you make a mistake or just want to start over, simply drag the new layer to the trash, create another new layer, and start all over.*

Figure 868.4 The History Brush restored portions of the original image and created a visual sense of depth.

869 *Weaving Color and Black and White into the Same Image*

In the previous tip, you learned how to create the illusion of depth in an image using the Blur filter and the History Brush. Using a combination of color and black and white is an excellent way to attract attention. Say, for example, that you want to emphasize a specific area of a graphic image.

To use color and black and white to generate attention, open a color image in Photoshop and perform these steps:

1. Select the Image menu, choose Adjust, and choose Desaturate from the fly-out menu. Photoshop removes the color from the image, as shown in Figure 869.1.

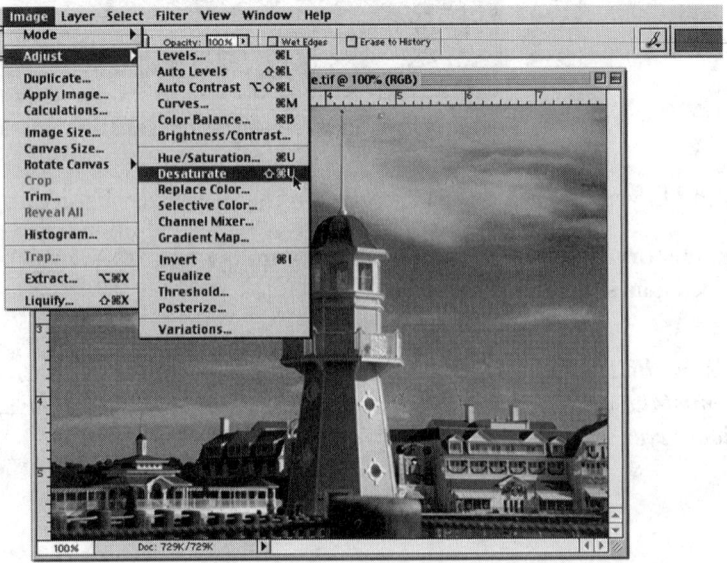

Figure 869.1 The Desaturate selection removes the color from an image by reducing the saturation of the pixels to 0 percent.

2. Select Image menu Mode, choose Adjust and choose Levels from the fly-out menu. Photoshop opens the Levels dialog box, shown in Figure 869.2.

Figure 869.2 The Levels dialog box lets you adjust the shadows, midtones, and highlights of the active image.

3. Click on the middle input slider and drag it to the right. The active image darkens in the midtones, as shown in Figure 869.3.

Figure 869.3 Dragging the middle slider to the right darkens the midtones of the image.

4. Click the OK button to apply the changes to the image.

5. If the Layers palette is not open, select the Window menu and then choose Show Layers from the pull-down menu. Photoshop opens the Layers palette.

6. Move your cursor into the Layers palette and click on the New Layer icon. Photoshop creates a new layer, as shown in Figure 869.4.

7. Select the History Brush from the toolbox and choose a small, soft brush, as shown in Figure 869.5.

8. Move to the Layers palette and click once on the new layer. Photoshop selects the new layer.

9. Move the History Brush in to the document window and restore the portions of the image that you want in color, as shown in Figure 869.6.

Figure 869.4 Clicking on the New Layer icon creates a new layer in the active image.

Figure 869.5 The History Brush lets you restore selected portions of the image.

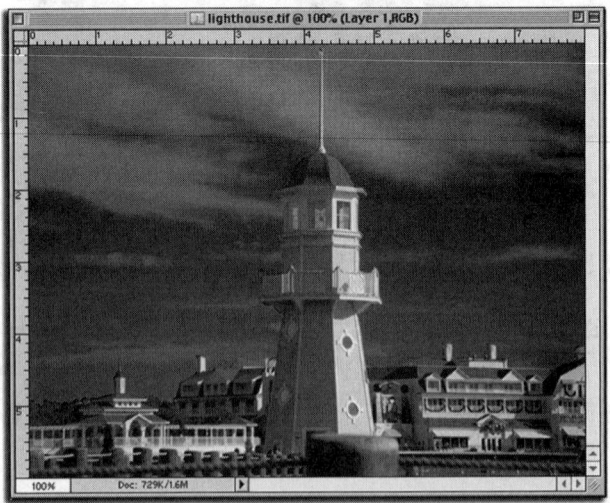

Figure 869.6 The History Brush restores selected portions of the original image and creates a visually attractive image.

870 *Using Filter Techniques to Attract Attention*

In Tip 868, "Using Gaussian Blur to Create a Sense of Depth in an Image," you learned how to give your images a visual feeling of depth. You can experiment with other filters to produce eye-catching images.

For example, repeat the steps in Tip 868, but instead of using the Blur filter in steps 1 and 2, select the Filter menu, choose Artistic, and choose the Cutout filter, as shown in Figure 870.1.

Figure 870.1 The Cutout filter combined with the History Brush creates a whole new look.

Alternatively, replace the Blur filter in Tip 868 by selecting the Image menu, choosing Adjust, and choosing Threshold, as shown in Figure 870.2.

Note: As you can see, the possibilities are endless. With a bit of experimentation, you can create some interesting, attention-grabbing images.

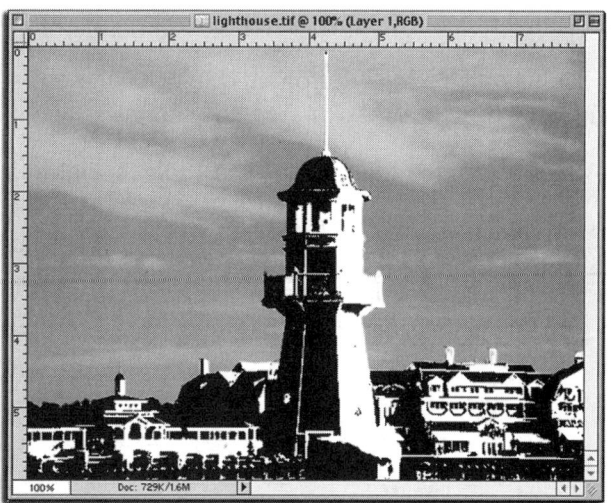

Figure 870.2 The Threshold command replaces the Blur filter to create a black-and-white ink drawing mixed with color.

871 *Using the Screen Blending Mode to Generate Transparency*

It was a dark and stormy night, or that's how the story goes. Of course, it wouldn't be so dark with a little lightning. In Tip 540, "Using Difference Clouds and Levels to Create Lightning," you learned how to combine the Clouds filter with levels to create lightning. In this tip, you combine the lightning with an image and then use the Screen blending mode to generate transparency in the lightning layer.

Say, for example, that you want to add lightning to an image containing clouds. To add lighting to an image, create a new layer and then perform the steps in Tip 540 to create the lightning.

To create the transparency, perform these steps:

1. If the Layers palettes in not open, select the Window menu and choose Show Layers from the pull-down menu. Photoshop opens the Layers palette, shown in Figure 871.1.

Figure 871.1 The Layers palette displays lightning and clouds layers.

2. Click once on the lightning layer. Photoshop selects the lightning layer.

3. Click once on the Blending Mode button, and select Screen from the pop-up menu. The black areas of the lightning layer convert to transparent, as shown in Figure 871.2.

4. Select the Move tool from the toolbox to reposition the lightning, as shown in Figure 871.3.

Note: The Screen blending mode converts pixels to transparent when the brightness of the pixels in the Screen layer is equal to or darker than that of the pixels in the underlying layer. Because pure black has a brightness value of 0, all the black pixels convert to transparent.

Figure 871.2 The Screen blending mode converts the black areas of the lightning layer into transparent pixels.

Figure 871.3 Reposition the lighting layer to fit the image of the clouds.

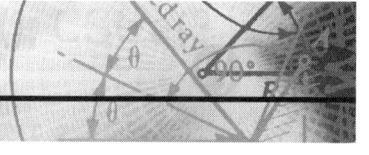

872 *Creating Textured Backgrounds*

Textured backgrounds are not just for Web pages, they can be used for posters, letterheads, and even for customized desktop patterns.

To create a textured background, open Photoshop and perform these steps:

1. Select the File menu and choose New. Photoshop opens the New dialog box. Create a new document with a width of 8 inches, a height of 8 inches, a resolution of 150ppi in RGB mode, as shown in Figure 872.1.

2. If the Layers palette is not open, select the File menu and choose Show Layers from the pull-down menu.

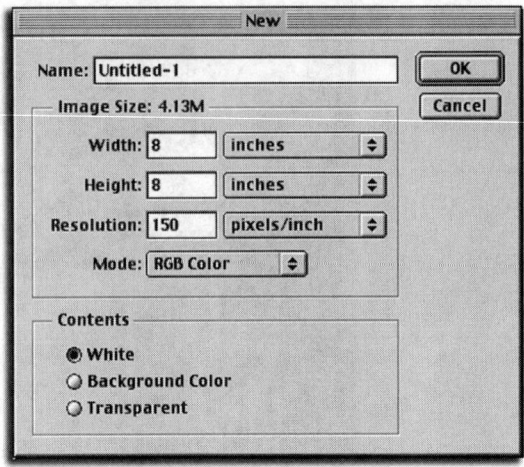

Figure 872.1 The New dialog box defines the characteristics of the new document.

3. Double-click on the background layer. Photoshop opens the New Layer dialog box, shown in Figure 872.2.

4. In the Name input field, enter the name "Texture." Click the OK button to close the New Layer dialog box.

5. Click once on the Layers Effects icon, located at the bottom left of the Layers palette, and select Bevel and Emboss from the pop-up menu. Photoshop opens the Layer Style dialog box.

6. Select Texture from the Styles options. The Layer Style dialog box displays the Texture options, as shown in Figure 872.3.

7. Click on the Pattern box to display the available layer styles, as shown in Figure 872.4.

8. Click on an available pattern. Photoshop applies the pattern to the open document, as shown in Figure 872.5. Refer to Tip 133, "Creating and Saving Patterns," for information on creating customized patterns.

9. Click the OK button to close the Layer Style dialog box.

Note: After you apply the pattern to the open document, experiment by selecting a different color from the Swatches palette and applying the new color to the document with the Paint Bucket tool.

Figure 872.2 The New Layer dialog box lets you convert a background into a layer.

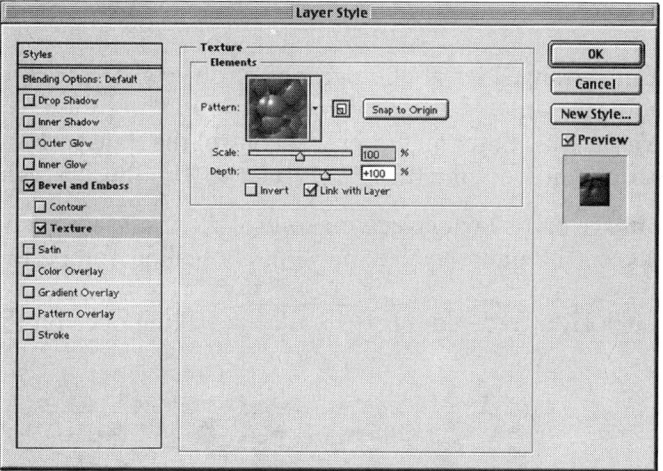

Figure 872.3 The Layer Style dialog box controls the characteristics of the Texture option.

Figure 872.4 Clicking on the Pattern box displays a list of available patterns.

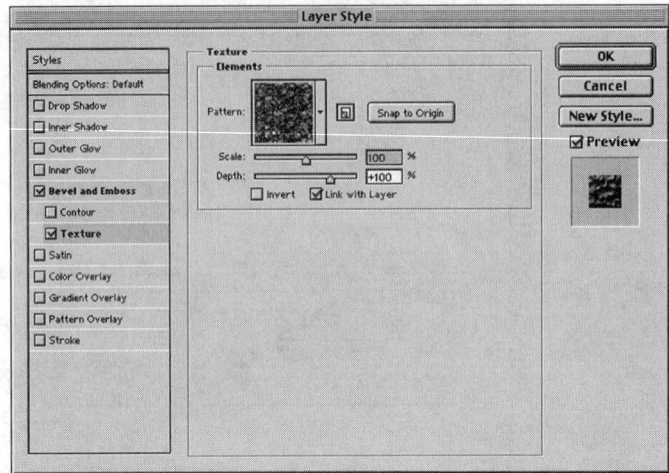

Figure 872.5 Click on a pattern sample to apply the pattern to the document.

873 *Creating a Photo Collage with Layer Masks*

A collage is a neatly arranged set of photographs or objects. The trick to creating great-looking collages is to make the individual images blend softly together. In Photoshop, you can make awesome photo collages by using layer masks. Layer masks let you control the transparency of the pixels within the selected layer, without permanently erasing the image (refer to Tip 386, "Creating a Layer Mask").

By placing each image on its own layer, you control the transparency of each image. To create a collage using layer masks, open a multi-layered image in Photoshop and perform these steps:

1. Select the watch layer and add a layer mask by clicking once on the Layer Mask icon, as shown in Figure 873.1.

Figure 873.1 Clicking on the Layer Mask icon creates a layer mask for the selected layer.

2. Press the letter "D" on your keyboard to default the foreground and background colors to black and white.

3. Select the Gradient tool from the toolbox, and choose the Foreground to Background linear gradient from the available options (refer to Tip 172, "Working with the Gradient Options"), as shown in Figure 873.2.

Figure 873.2 The foreground to background linear gradient.

4. Click once on the layer mask attached to the watch layer.

5. Click and drag the Gradient tool from the bottom to the top of the watch. In this example, you want the watch to fade from solid to transparent, as shown in Figure 873.3.

Figure 873.3 Dragging the Gradient tool across the mask creates transparency in the watch layer.

874 *Creating Brushed-Metal Text*

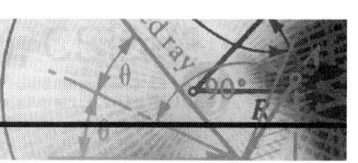

Here is a cool tip for generating a brushed-metal appearance to any text, using the type mask tool.

To create brushed type, open Photoshop and perform these steps:

1. Select the File menu and choose New from the pull-down menu. Create a new document 3 inches square with a resolution of 150ppi, as shown in Figure 874.1.

Figure 874.1 The New dialog box controls the characteristics of the new document.

2. If the Layers palette is not open, select the Window menu and choose Show Layers from the pull-down menu.

3. Create a new layer by clicking on the New Layer icon. Photoshop creates a new layer, as shown in Figure 874.2.

Figure 874.2 Clicking on the New Layer icon generates a new layer.

4. Select the Type tool from the toolbox, and choose the Mask icon from the Options bar.

5. Create a letter or letters within the newly created layer. In this example, you create a mask using the letters HOT, as shown in Figure 874.3.

6. Press the letter "D" on your keyboard to default the background and foreground colors to black and white.

7. Select the Gradient tool from the toolbox, and choose the linear Black, White gradient preset from the gradient options, as shown in Figure 874.4.

8. Click and drag the Gradient tool from the top to the bottom of the masked letters. Photoshop creates a black to white gradient in the shape of the word HOT, as shown in Figure 874.5.

9. Choose the Select menu, choose Modify, and select Contract from the fly-out menu. Enter a value of 4 and press the OK button. Photoshop contracts the selection mask by 4 pixels.

Figure 874.3 The masked letters HOT created in the new layer.

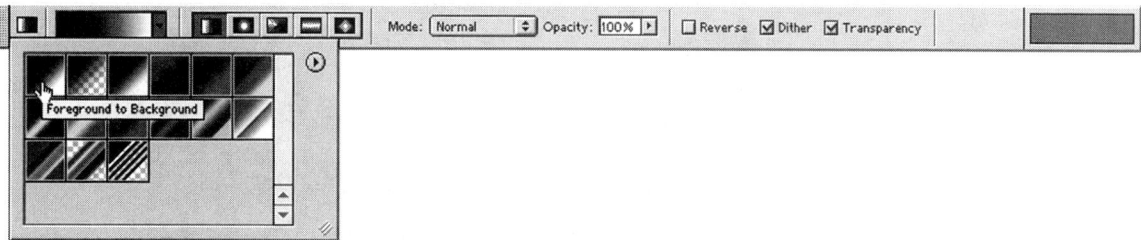

Figure 874.4 The Black, White gradient draws a linear gradient.

Figure 874.5 The Black, White gradient applied to the masked text.

10. Click on and drag the Gradient tool from the bottom to the top of the masked letters. Photoshop creates a Black, White gradient in the shape of the contracted word HOT, as shown in Figure 874.6.

11. Select the Filter menu, choose Texture, and choose Grain from the fly-out menu. Enter an Intensity value of 30 and a Contrast value of 60. Click the OK button to apply the Grain filter to the selected text, as shown in Figure 874.7.

Figure 874.6 The white to black gradient applied to the contracted text mask.

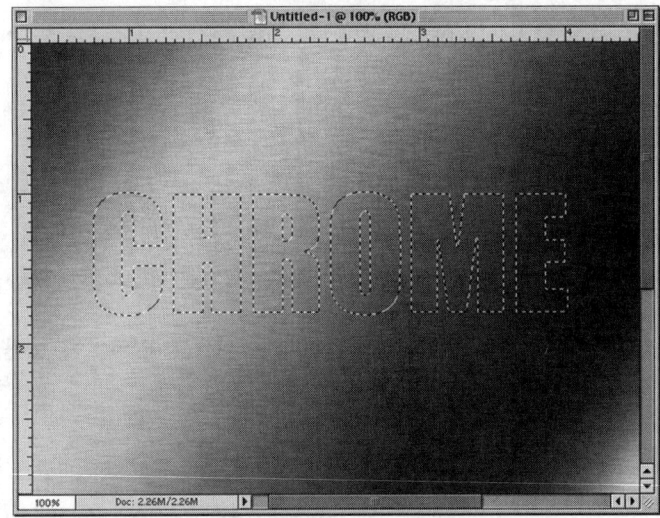

Figure 874.7 The Grain filter applied to the masked text.

12. Select the Filter menu, choose Noise, and choose Add Noise from the fly-out menu. Enter a value of 12 and select Gaussian and Monochromatic, as shown in Figure 874.8. Click the OK button to apply the Add Noise filter to the selected text.

13. Select the Filter menu, choose Sharpen, and choose Unsharp Mask from the fly-out menu. Enter an Amount of 350, a Radius of 2, and a Threshold of 50. Click the OK button to apply the Unsharp Mask filter to the selected text, as shown in Figure 874.9.

14. Select the Filter menu, choose Blur, and choose Motion Blur from the fly-out menu. Enter a value of 0 in the Angle input field and enter 12 in the Distance input field. Click the OK button to apply the Motion Blur filter to the selected text, as shown in Figure 874.10.

15. Click on the Layers Effects icon, located at the bottom of the Layers palette, and select Drop Shadow to add a standard drop shadow to the image, as shown in Figure 874.11.

Figure 874.8 The Add Noise filter applied to the masked text.

Figure 874.9 The Unsharp Mask filter applied to the masked text.

Figure 874.10 The Motion Blur filter applied to the masked text.

Figure 874.11 The completed brushed metal text.

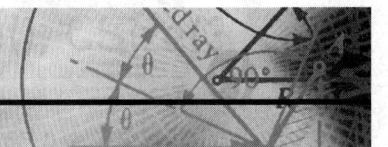

875 *Applying a Chrome Look to Text*

Nothing looks cooler than bright chrome text, and, with Photoshop, creating cool-looking chrome is a snap. To create chrome text, open Photoshop and perform these steps:

1. Select the File menu and choose New. Photoshop opens the New dialog box. Create a new document with a width of 7 inches, a height of 5 inches, and a resolution of 150ppi in RGB mode, as shown in Figure 875.1.

Figure 875.1 The New dialog box defines the characteristics of the new document.

2. Select the Gradient tool from the toolbox.

3. Move your cursor into the Options bar and click on the Gradient options button. Photoshop opens the default gradient options, as shown in Figure 875.2.

Figure 875.2 Clicking on the Gradient options button lets you select from a variety of preset gradients.

4. Select the Copper Gradient (refer to Figure 875.2).

5. Move into the document window and drag the gradient tool from the upper-left corner to the lower-right corner of the document window, as shown in Figure 875.3.

Figure 875.3 Dragging the Gradient tool across the document window applies the gradient to the image.

6. Select the Filter menu, choose Noise, and choose Add Noise from the fly-out menu. Photoshop opens the Add Noise dialog box, shown in Figure 875.4.

Figure 875.4 The Add Noise dialog box controls the application of the filter to the image.

7. Select a Noise Amount of 10 and choose Uniform and Monochromatic. Click the OK button to apply the Noise filter to the image (refer to Figure 875.4).

8. Select the Filter menu, choose Blur, and choose Motion Blur from the pull-down menu. Photoshop opens the Motion Blur dialog box. Enter a value of 0 in the Angle input field and enter 14 in the Distance input field, shown in Figure 875.5.

Figure 875.5 The Motion Blur filter controls the amount of motion blur applied to the image.

9. Select the Image menu, choose Adjust, and choose Desaturate from the fly-out menu. Photoshop converts the copper gradient into grayscale, as shown in Figure 875.6.

Figure 875.6 The Desaturate command removes the color from the active layer.

10. Select the Type Mask tool and create the text that you want to convert into chrome (refer to Tip 218, "Creating Text in Photoshop 6.0"). In this example, you select Impact font at 72 points, as shown in Figure 875.7.

11. Select the Edit menu and choose Copy from the pull-down menu.

12. Select the Edit menu and choose Paste from the pull-down menu. Photoshop places the copied pixels into a separate layer, as shown in Figure 875.8.

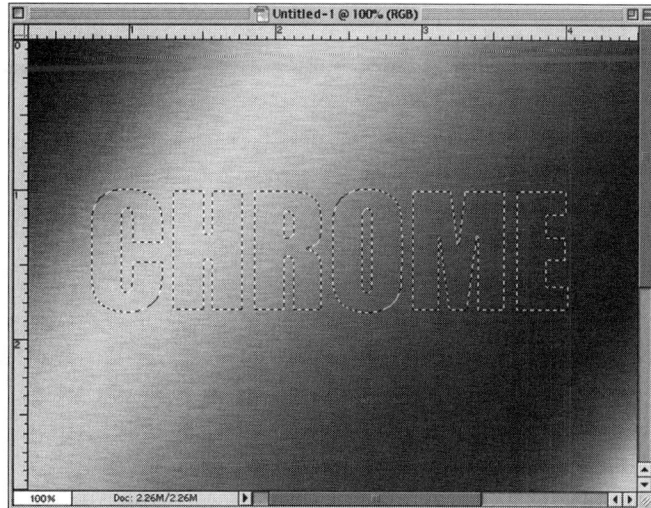

Figure 875.7 The Type Masking tool creates a selection based on the outline of a font.

Figure 875.8 The new layer contains the copied text.

13. Move your mouse into the Layers palette, select the Effect button, and select Bevel and Emboss from the available options. Photoshop opens the Layer Style dialog box, shown in Figure 875.9.

14. Click on the Style list box and select Inner Bevel from the available options.

15. Click on the Technique list box and select Chisel Hard from the available options.

16. Click the OK button the apply the bevel to the image (refer to Tip 674, "Making Quick Chrome Bevels with Text"), as shown in Figure 875.10.

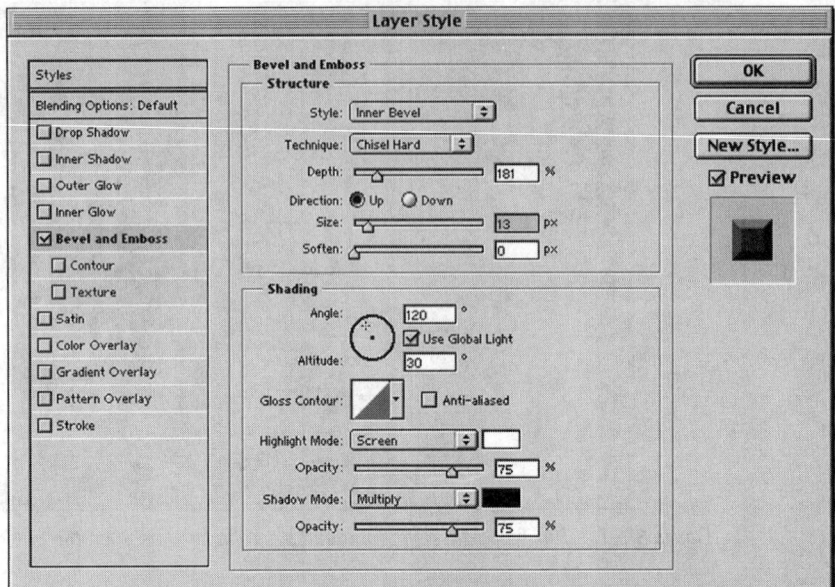

Figure 875.9 The Layer Style dialog box controls the application of the Bevel and Emboss filter to the copied text.

Figure 875.10 The completed chrome text.

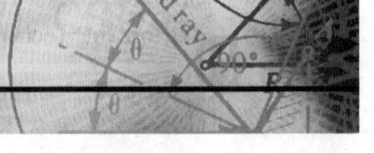

876 *Creating a Metallic Texture*

Creating a metal look to an object is a snap in Photoshop. To apply a brushed-metal look to an image, open a graphic in Photoshop containing transparent and non-transparent areas (refer to Figure 876.1) and perform these steps:

1. Click once on the sun layer.

2. Select the Preserve transparency option for the sun layer, as shown in Figure 876.1.

Figure 876.1 The Preserve Transparency option prevents the transparent areas of the sun layer from being modified.

3. Move your mouse into the Swatches palette and click once on a light gray. Photoshop converts the foreground color swatch to light gray.

4. Select the Gradient tool from the toolbox.

5. Move your cursor into the Options bar and click on the Gradient options button. Photoshop opens the default gradient options, as shown in Figure 876.2.

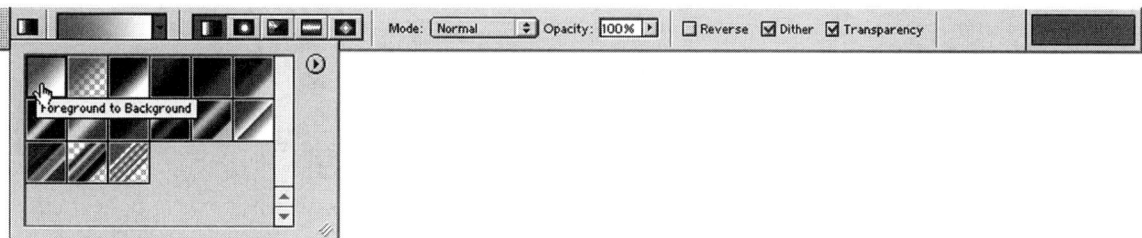

Figure 876.2 Clicking on the Gradient options button lets you select from a variety of preset gradients.

6. Select the Foreground to Background preset gradient (refer to Figure 876.2).

7. Move into the document window and drag the gradient tool from the upper-left to lower-right corner of the sun graphic, as shown in Figure 876.3.

Figure 876.3 Dragging the gradient tool across the sun graphic applies the gradient to the image.

8. Select the Filter menu, choose Texture, and choose Grain from the fly-out menu. Enter an Intensity value of 75 a Contrast value of 50, and a Grain Type of Regular. Click the OK button to apply the Grain filter to the selected text, as shown in Figure 876.4.

Figure 876.4 The Grain filter applied to the masked text.

9. Select the Filter menu, choose Noise, and choose Add Noise from the fly-out menu. Enter a value of 14 and select Uniform and Monochromatic. Click the OK button to apply the Add Noise filter to the layer, as shown in Figure 876.5.

Figure 876.5 The Add Noise filter applied to the sun image.

10. Select the Filter menu, choose Sharpen, and choose Unsharp Mask from the fly-out menu. Enter an Amount of 400, a Radius of 2, and a Threshold of 30. Click the OK button to apply the Unsharp Mask filter, as shown in Figure 876.6.

11. Select the Filter menu, choose Blur, and choose Motion Blur from the fly-out menu. Enter a value of 0 in the Angle Input box, and enter 14 in the Blur input field. Click the OK button to apply the Motion Blur filter, as shown in Figure 876.7.

12. To complete the effect, click on the Layers Effects icon, located at the bottom of the Layers palette, and select Bevel and Emboss. Select a Chisel Soft bevel, as shown in Figure 876.8.

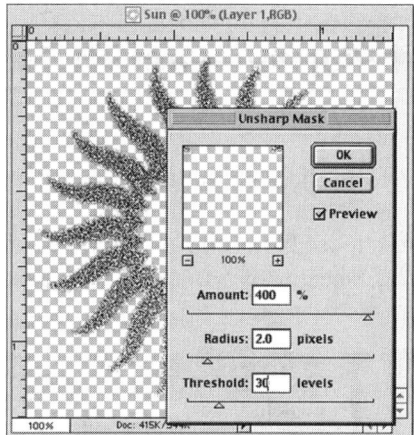

Figure 876.6 *The Unsharp Mask filter applied to the sun graphic.*

Figure 876.7 *The Motion Blur filter applied to the sun image.*

Figure 876.8 *The completed sun image.*

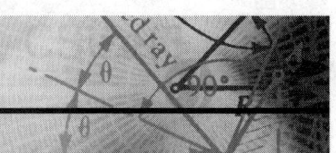

877 *Applying a Futuristic Look to Text*

To create futuristic text, perform these steps:

1. Select the File menu and choose New. Photoshop opens the New dialog box. Create a new document with a width of 6 inches, a height of 5 inches, and a resolution of 150ppi, in RGB mode, as shown in Figure 877.1.

Figure 877.1 The New dialog box defines the characteristics of the new document.

2. Select the Type tool and create a text layer containing the text that you want to convert into futuristic text. In this example, you type the word FUTURE, as shown in Figure 877.2.

Figure 877.2 The Type tool created the word FUTURE.

3. Press the Ctrl key (Macintosh: Command key) and click once on the text layer. Photoshop creates a selection around the text.

4. If the Channels palette is not open, select the Windows menu and choose Show Channels from the fly-out menu.

5. Create a new channel by clicking once on the New Channel icon, as shown in Figure 877.3.

Figure 877.3 Clicking on the New Channel icon creates a new channel.

6. Press the Delete key to fill the selected text with white, as shown in Figure 877.4.

Figure 877.4 Pressing the Delete key fills the selected text with white.

7. Create another new channel by clicking once on the New Channel icon.

8. Press the Delete key to fill the selected text of the second new channel with white.

9. Select Filter menu Blur, and choose Gaussian Blur from the pull-down menu. Enter a value of 12 in the Radius input field and click the OK button. Photoshop applies the blur to the Alpha 1 copy channel, as shown in Figure 877.5.

10. Select the Filter menu, choose Pixelate, and choose Color Halftone from the fly-out menu. Photoshop opens the Color Halftone dialog box. Enter a value of 5 in the Max Radius input field, and click the OK button. Photoshop applies the Color Halftone filter to the Alpha 1 copy channel, as shown in Figure 877.6.

Figure 877.5 The Gaussian Blur filter controls the amount of blur applied to the image.

Figure 877.6 The Color Halftone filter applied to the image.

11. Click once on the Layers tab to access the Layers palette and select the text layer as the active layer..

12. Press the Ctrl key (Macintosh: Command key) and click once on the text layer. Photoshop creates a selection around the original text.

13. Choose the Select menu, choose Modify, and select Contract from the fly-out menu. Enter a value of 4 and press the OK button. Photoshop contracts the selection mask by 4 pixels.

14. Select the Filter menu, choose Render, and choose Lighting Effects from the fly-out menu. Click the OK button in response to the alert dialog box, warning you that the text must be rasterized. Photoshop opens the Lightning Effects dialog box, shown in Figure 877.7.

15. Click once on the Texture Channel option and select the Alpha 1 copy channel from the drop-down list.

16. Select the White Is High option, as shown in Figure 877.8.

17. Click the OK button to apply the lighting effects to the image, as shown in Figure 877.9.

Figure 877.7 The Lighting Effects dialog box controls the characteristics of the lighting filter to the image.

Figure 877.8 The Lighting Effects filter dialog box controls the application of the filter to the active image.

Figure 877.9 The Lighting Effects filter applied to the text.

878 *Creating a Mound Button*

A mound button is a combination of two images placed together in a JavaScript rollover. A mound button changes shape, displaying a pushed-in button as the Web user moves the cursor over the button. Mound buttons are a popular effect on a Web page. The steps below show how to make your own personal mound buttons.

1. Select the File menu and choose New. Photoshop opens the New dialog box. Create a new document with a width of 5 inches, a height of 5 inches, and a resolution of 150ppi in RGB mode, as shown in Figure 878.1.

Figure 878.1 The New dialog box defines the characteristics of the new document.

2. If the Layers palette is not open, select the Window menu and choose Show Layers from the pull-down menu. Photoshop opens the Layers palette.

3. Click on the New Layer icon. Photoshop creates a new layer, as shown in Figure 878.2.

Figure 878.2 The Layers palette displays a thumbnail for each layer in the image.

4. Choose the color for the button by selecting a color box from the Swatches palette (refer to Tip 221, "Selecting a Foreground and Background Color Swatch"). In this example, you select a light blue color.

5. Select the Elliptical Marquee tool from the toolbox and draw a circular selection on the screen. The circle selection represents the size and shape of the mound button.

6. Select the Edit menu and choose Stroke from the pull-down menu. Photoshop opens the Stroke dialog box.

7. Select a Stroke width of 12 pixels and choose Center Location. Click the OK button to apply the stroke to the selection, as shown in Figure 878.3.

Figure 878.3 The blue stroke applied to the selection.

8. Press Ctrl+D (Macintosh: Command+D) to deselect the Elliptical Marquee tool.

9. Select the Filter menu, choose Blur, and choose Gaussian Blur from the fly-out menu. Choose a blur radius of 5 pixels. Click the OK button to apply the Gaussian blur to the blue stroke, as shown in Figure 878.4.

Figure 878.4 The Gaussian Blur filter applied to the blue stroke.

10. Click once on the Layers Effects icon, located at the bottom left of the Layers palette, and select Bevel and Emboss from the pop-up menu. Photoshop opens the Layer Style dialog box.

11. Click in the Depth field and enter a value of 150 percent. Click the OK button to apply the smooth bevel to the blue stroke, as shown in Figure 878.5.

Figure 878.5 The Layer Style dialog box controls the characteristics of the bevel option.

12. Select the Magic Wand tool from the toolbox and click once in the middle of the elliptical blue stroke. Photoshop selects the transparent area in the middle of the stroke ellipse.

13. Choose the Select menu, choose Modify, and choose Expand from the fly-out menu. Enter a value of 8 in the Expand input box, and click the OK button to apply the expansion to the Magic Wand selection.

14. Click on the New Layer icon. Photoshop creates a new layer.

15. Press Alt+Delete (Macintosh: Option+Delete) to fill the selection with the blue color, as shown in Figure 878.6.

Figure 878.6 Pressing Alt+Delete (Macintosh: Option+Delete) fills the selected area with the foreground color.

16. Click once on the Layers Effects icon, located at the bottom left of the Layers palette, and select Bevel and Emboss from the pop-up menu. Photoshop opens the Layer Style dialog box.

17. Click once on the Style option and select Inner Bevel from the drop-down list.

18. To complete the mound button, click the OK button to apply the inner bevel to the new layer, as shown in Figure 878.7.

Figure 878.7 The completed mound button

879 *Applying Rust to a Background Surface*

To create a rusted-looking background, perform these steps:

1. Select the File menu and choose New. Photoshop opens the New dialog box. Create a new document with a width of 150 pixels, a height of 150 pixels, and a resolution of 150ppi in RGB mode, as shown in Figure 879.1.

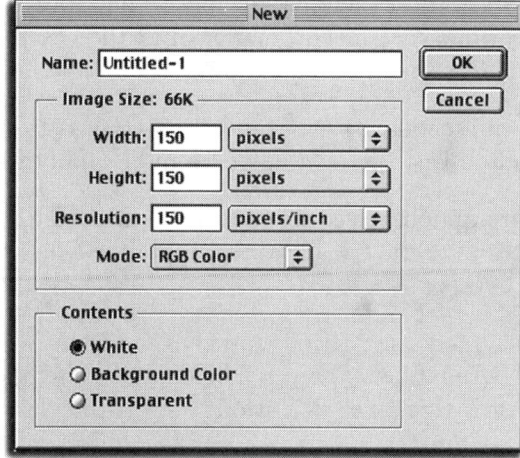

Figure 879.1 The New dialog box defines the characteristics of the new document.

2. Select a shade of brown from the Swatches palette.

3. Press Alt+Delete (Macintosh: Option+Delete) to fill the background layer with the brown color, as shown in Figure 879.2.

Figure 879.2 Pressing Ctrl+Delete (Macintosh: Command+Delete) fills the selected area with the foreground color.

4. Select the Filter menu, choose Texture, and choose Grain from the fly-out menu. Enter an Intensity value of 35 and a Contrast value of 65. Click the OK button to apply the Grain filter to the background layer, as shown in Figure 879.3.

Figure 879.3 The Grain filter applied to the background layer

5. Select the Filter menu, choose Noise, and choose Add Noise from the fly-out menu. Enter a value of 10 and select Uniform and Monochromatic. Click the OK button to apply the Add Noise filter to the background layer, as shown in Figure 879.4.

6. Select the Filter menu, choose Distort, and choose Glass from the fly-out menu. Photoshop opens the Glass filter. Enter a Distortion value of 14 and a Smoothness value of 8.

7. Click on the Texture option, select the Canvas texture from the drop-down list, and enter a Scaling value of 50 percent. Click the OK button to apply the Glass filter to the image, as shown in Figure 879.5.

8. Select the Filter menu, choose Artistic, and choose Plastic Wrap from the fly-out menu. Photoshop opens the Plastic Wrap filter. Enter a Highlight Strength of 20, a Detail value of 15, and a Smoothness value of 3. Click the OK button to apply the Plastic Wrap filter to the background layer, as shown in Figure 879.6.

Figure 879.4 The Add Noise filter applied to the background layer

Figure 879.5 The Glass filter applied to the background layer

Figure 879.6 The Plastic Wrap filter applied to the background layer

9. Make a copy of the background layer by moving your mouse into the Layers palette and dragging the background layer over the New Layer icon, as shown in Figure 879.7.

Figure 879.7 Dragging a layer over the New Layer icon creates a copy of the dragged layer.

10. Select the Filter menu, choose Sketch, and choose Reticulation from the fly-out menu. Photoshop opens the Reticulation filter. Enter a Density value of 50, a Black Level value of 0, and a White Level value of 50. Click the OK button to apply the Reticulation filter to the copy layer, as shown in Figure 879.8.

Figure 879.8 The Reticulation filter applied to the copy layer

11. Select the Image menu, choose Adjust, and choose Invert from the fly-out menu. Photoshop inverts the colors in the copied layer.

12. To complete the effect, click on the Blending Mode option and select Color Burn from the drop-down list, as shown in Figure 879.9.

Figure 879.9 The Color Burn blending mode blends the two layers and creates a rusted appearance to the image.

880 *Converting Common-Looking Text to Gold*

To convert text into gold onscreen, perform these steps:

1. Select the File menu and choose New. Photoshop opens the New dialog box. Create a new document with a width of 175 pixels, a height of 175 pixels, and a resolution of 150ppi in RGB mode, as shown in Figure 880.1.

Figure 880.1 The New dialog box defines the characteristics of the new document.

2. Press the letter "D" on your keyboard to default the foreground and background colors to black and white.

3. Select a dark brown color from the swatches palette and press Ctrl+Delete (Macintosh: Command+Delete) to fill the background with brown.

4. If the Channels palette is not open, select the Window menu and choose Show Channels from the pull-down menu.

5. Click once on the New Channel icon to create a new channel.

6. Select the Type tool from the toolbox and type a white letter *g* in the middle of the new channel, as shown in Figure 880.2.

Figure 880.2 The new channel containing the letter g

7. Create a copy of the new channel by clicking on and dragging the channel over the New Channel icon.

8. Select the Filter menu, choose Blur, and choose Gaussian Blur from the fly-out menu. Choose a blur radius of 4 pixels. Click the OK button to apply the Gaussian blur to the copied channel, as shown in Figure 880.3.

Figure 880.3 The Gaussian Blur filter applied to the copied channel.

9. Ctrl+click (Macintosh: Command+click) on the original Alpha 1 channel. Photoshop converts the letter *g* into a selection in the Alpha 1 copy channel.

10. Choose the Select menu, and choose Inverse from the pull-down menu. Photoshop reverses the selection.

11. Press the Delete key to convert the area surrounding the letter *g* with white, as shown in Figure 880.4.

Figure 880.4 Pressing the Delete key fills the selected area with white.

12. Move your cursor into the Layers palette and click once on the New Layer icon. Photoshop creates a new layer.

13. Select a bright yellow color from the Swatches palette.

14. Press Alt+Delete (Macintosh: Option+Delete) to fill the selection with the yellow foreground color.

15. Select the Filter menu, choose Render, and choose Lighting Effects from the fly-out menu. Photoshop opens the Lighting Effects dialog box, as shown in Figure 880.5.

Figure 880.5 The Lighting Effects dialog box controls the characteristics of the lighting filter to the image.

16. Click once on the Texture Channel option, select the Alpha1 copy channel from the drop-down list, and choose a Height of 15 percent. Select the White Is High option.

17. Refer to Figure 880.5 and adjust the Light Type and Properties values. Click the OK button to apply the Lighting Effects filter to the image, as shown in Figure 880.6.

Figure 880.6 The Lighting Effects filter applied to the text.

18. Choose the Select menu and choose Load Selection from the pull-down menu. Photoshop opens the Load Selection dialog box.

19. Click the Channel button and select the Alpha 1 channel.

20. Select the Invert option, and click the OK button to apply the selection to the new layer.

21. Press the Delete key to remove the white areas from the text.

22. Click on the Layers Effects icon, located at the bottom of the Layers palette, and select Drop Shadow to add a standard drop shadow to the text.

23. If you wish, you can delete the brown background layer, leaving just the gold text against a transparent background, as shown in Figure 880.7

Figure 880.7 The completed gold text

881 *Creating a Multicolor Pushbutton for the Internet*

To create an attractive pushbutton for a Web document, perform these steps:

1. Select the File menu and choose New. Photoshop opens the New dialog box. Create a new document with a width of 3 inches, a height of 3 inches, and a resolution of 72ppi in RGB mode, as shown in Figure 881.1.

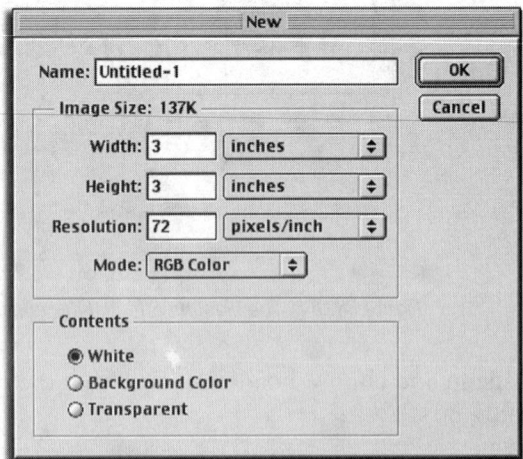

Figure 881.1 The New dialog box defines the characteristics of the new document.

2. If the Layers palette is not open, select the Window menu and choose Show Layers from the pulldown menu. Photoshop opens the Layers palette.

3. Create a new layer by clicking once on the New Layer icon.

4. Select the Elliptical Marquee tool from the toolbox, and draw a circular selection in the size that you want your pushbutton. Hint: Hold down the Shift key while you use the Elliptical Marquee tool to draw a perfect circular selection, as shown in Figure 881.2.

Figure 881.2 The Elliptical Marquee tool created a circular selection in the new layer.

5. Press the letter "D" on your keyboard to default the foreground and background colors to black and white.

6. Press the letter "X" on your keyboard to reverse the foreground and background colors.

7. Select the Gradient tool from the toolbox and choose the Foreground to Background radial gradient from the available options (refer to Tip 172, "Working with the Gradient Options"), as shown in Figure 881.3.

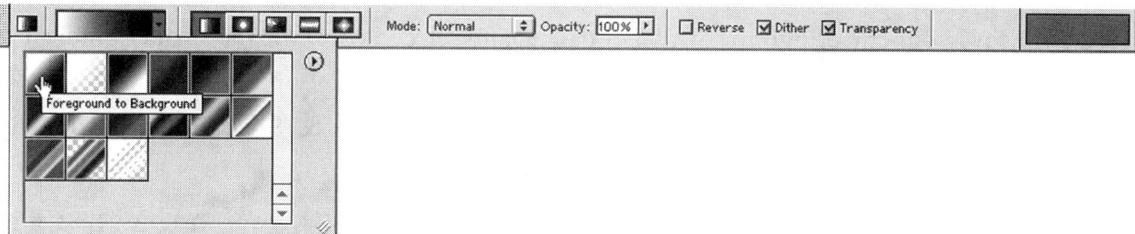

Figure 881.3 The foreground to background radial gradient

8. Move the radial gradient tool into the circular selection, and drag from the inside upper-left corner to the lower right of the selection marquee, as shown in Figure 881.4.

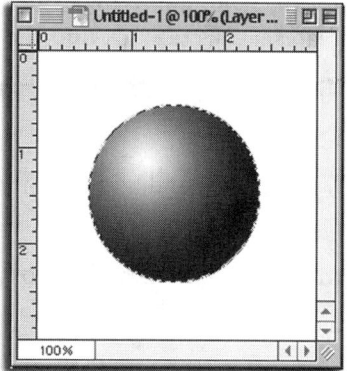

Figure 881.4 The radial selection tool creates a white to black gradient inside the selection marquee.

9. Press Ctrl+D (Macintosh: Command+D) to deselect the circular selection.

10. Move into the Layers palette and create a copy of the layer containing the circular gradient by clicking on and dragging the layer over the New Layer icon.

11. Select the Edit menu and choose Free Transform from the pull-down menu. Photoshop places a bounding box around the gradient circle.

12. Move to a corner of the bounding box until your cursor resembles a diagonal arrow. Hold the Shift and Alt keys (Macintosh: Shift and Option keys) and drag inward, as shown in Figure 881.5.

Figure 881.5 The Free Transform command lets you reduce the size of the copied gradient circle.

13. Continue to drag inward until you reduce the size of the copied gradient circle by 20 or 25 percent. Press the Enter key to apply the Free Transform command to the copied layer.

14. Press the letter "D" on your keyboard to default the foreground and background colors to black and white.

15. Move your cursor into the Swatches palette and select a color for the smaller gradient circle. In this example, you select a dark blue.

16. Select the Image menu, choose Adjust, and choose Hue & Saturation from the fly-out menu. Photoshop opens the Hue/Saturation dialog box.

17. Select the Colorize option. Photoshop colorizes the small circle, as shown in Figure 881.6.

18. Click the OK button to apply the Hue & Saturation adjustment to the active layer.

19. Press the letter "D" on your keyboard to default the foreground and background colors to black and white.

20. Press the Ctrl key (Macintosh: Command key) and click once on the copied layer containing the small circle. Photoshop creates a selection around the circle.

21. Choose the Select menu, choose Modify, and choose Border from the fly-out menu. Photoshop opens the Border dialog box.

22. Enter a value of 3 in the Width Input field and click the OK button. Photoshop creates a 3-pixel border from the selection.

23. Select the Gradient tool from the toolbox and choose the Foreground to Background radial gradient from the available options (refer to Figure 881.3).

Figure 881.6 The Colorize option colors the selected layer using the current foreground color.

24. Move the radial gradient tool into the document window and drag from the upper-left corner to the lower right of the border marquee. Photoshop creates a black to white gradient defined by the border selection.

25. Press Ctrl+D (Macintosh: Command+D) to deselect the circular selection, as shown in Figure 881.7.

Figure 881.7 The completed multicolor button

882 *Creating a Studio Backdrop*

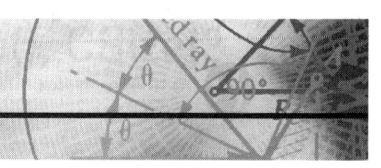

Have you ever wanted to create a backdrop for a product but lacked the budget to perform the shoot in a studio? To create a professional backdrop for a product, open a backdrop and perform these steps:

1. Select the Rectangular Marquee tool from the toolbox, and select the lower half of the backdrop image, as shown in Figure 882.1.

Figure 882.1 Use the Rectangular Marquee tool to select the lower portion of the image.

2. Select the Edit menu, choose Transform, and choose Perspective from the fly-out menu. Photoshop places a bounding box around the selected area of the image.

3. Move to the lower-right corner of the bounding box until your cursor resembles a diagonal arrow. Click and drag to the right, as shown in Figure 882.2.

Figure 882.2 The Perspective command lets you readjust the corners of the selection.

4. Press the Enter key to apply the Transform command to the selection.

5. Choose the Select menu and choose Inverse from the pull-down menu. Photoshop reverses the selection.

6. Choose the Select menu and choose Feather from the pull-down menu. Photoshop opens the Feather dialog box. Enter a value of 40 and click the OK button to apply the feather to the selection.

7. Select the Image menu, choose Adjust, and choose Levels from the fly-out menu. Photoshop opens the Levels dialog box.

8. Click on and drag the middle gray slider to the right to darken the selected portion of the image, as shown in Figure 882.3.

Figure 882.3 The Levels command darkens the selected portion of the background.

9. Press Ctrl+D (Macintosh: Command+D) to deselect the rectangular selection.

10. By reactivating the product layer, the studio backdrop is complete, as shown in Figure 882.4.

Figure 882.4 The backdrop adds depth to the image and gives a studio quality to the image.

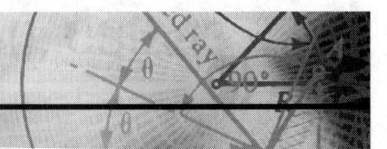

883 *Designing Realistic Screw Heads*

Realistic-looking screw heads are a great final touch to a Photoshop graphic containing a metallic background. To create a realistic screw head, open a Photoshop document containing a metallic background (refer to Tip 876, "Creating a Metallic Texture") and perform these steps:

1. Select the Elliptical Marquee tool from the toolbox, and draw a circular selection in the size that you want the screw head, as shown in Figure 883.1.

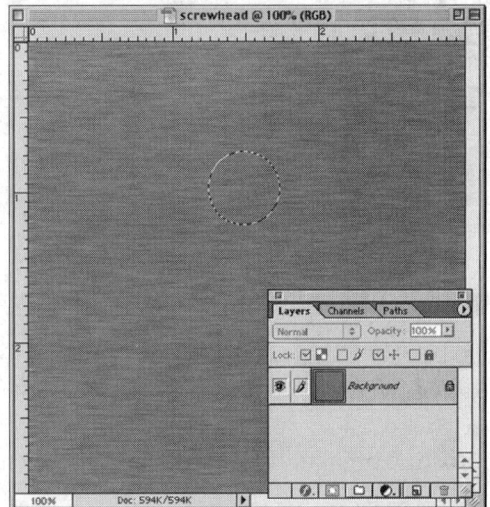

Figure 883.1 *The Elliptical Marquee tool created a circular selection in the new layer.*

2. Select the Edit menu and choose Copy from the pull-down menu. Photoshop makes a copy of the selected pixels and stores them in Clipboard memory.

3. Select the Edit menu and choose Paste from the pull-down menu. Photoshop pastes the selected pixels into a separate layer, as shown in Figure 883.2.

Figure 883.2 *The Copy/Paste command creates a new layer for the pasted pixels.*

4. If the Layers palette is not open, select the Window menu and choose Show Layers from the pull-down menu. Photoshop opens the Layers palette.

5. Click once on the Layer Effects icon, located at the bottom left of the Layers palette, and select Bevel and Emboss from the pop-up menu. Photoshop opens the Layer Style dialog box.

6. Click once on the Style option and select Pillow Emboss from the drop-down list.

7. Click once on the Technique option and select Chisel Emboss from the drop-down list.

8. Enter a Depth value of 200 and a Size value of 5. Click on the Enter key to apply the bevel to the selected layer, as shown in Figure 883.3.

Figure 883.3 The Layer Style dialog box controls the characteristics of the bevel option.

9. Select the Rectangular Marquee tool from the toolbox, and draw a rectangular selection in the size that you want for a screw slot, as shown in Figure 883.4.

Figure 883.4 The Rectangular Marquee tool created a selection screw slot.

10. Select the Edit menu and choose Copy from the pull-down menu. Photoshop makes a copy of the selected pixels and stores them in Clipboard memory.

11. Select the Edit menu and choose Paste from the pull-down menu. Photoshop pastes the selected pixels into a separate layer.

12. Click once on the Layers Effects icon, located at the bottom left of the Layers palette, and select Bevel and Emboss from the pop-up menu. Photoshop opens the Layer Style dialog box.

13. Click once on the Style option and select Inner Bevel from the drop-down list.

14. Click once on the Technique option and select Smooth from the drop-down list.

15. Click once on the Down Direction option.

16. Click the OK button to apply the layer style to the copied layer, as shown in Figure 883.5.

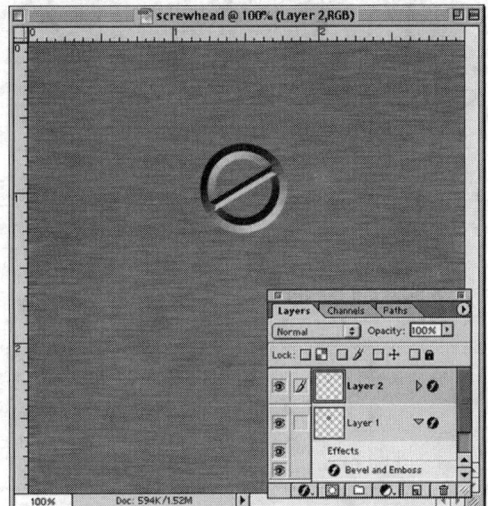

Figure 883.5 The layer style applied to the copied layer gives the impression of a slot in the screw head and completes the image.

884 *Designing a Logo Pattern*

This might seem simplistic, but creating a logo pattern is an excellent way to attract attention to a brochure or a bland Web page. The key to successful text logo patterns is not to overdo the text. Use soft shades of blue or gray so that the background does not overwhelm the rest of the document.

To create a logo pattern, perform these steps:

1. Select the File menu and choose New. Photoshop opens the New dialog box. Create a new document with a width of 2 inches, a height of 2 inches, and a resolution of 72ppi in RGB mode, as shown in Figure 884.1.

2. Move your cursor into the Swatches palette and select a color for the text logo. In this example, you select a light blue.

3. Select the type tool from the toolbox and create the logo text (refer to Tip 218, "Creating Text in Photoshop 6.0"). In this example, you select Book Antigua, at 36 points, as shown in Figure 884.2.

Figure 884.1 The New dialog box defines the characteristics of the new document.

Figure 884.2 The Type tool created the logo text.

4. Select the Edit menu and choose Free Transform from the pull-down menu. Photoshop places a bounding box around the logo text.

5. Move outside the bounding box until your cursor resembles a bent arrow. Click to rotate the selected text 45° counterclockwise, as shown in Figure 884.3.

Figure 884.3 The Free Transform command lets you rotate the logo text.

6. Press the Enter key to apply the Free Transform command to the logo text.

7. Move into the Layers palette and create a copy of the layer containing the logo text by clicking on and dragging the layer over the New Layer icon.

8. Select the Edit menu and choose Free Transform from the pull-down menu. Photoshop places a bounding box around the copied text.

9. Move to a corner of the bounding box until your cursor resembles a diagonal arrow. Hold the Alt+Shift (Macintosh: Option+Shift) key and drag inward, as shown in Figure 884.4.

Figure 884.4 The Free Transform command lets you reduce the size of the copied logo text.

10. Continue to drag inward until you reduce the size of the copied circle by 40 to 50 percent. Press the Enter key to apply the Free Transform to the copied layer.

11. Select the Move tool from the toolbox and reposition the reduced logo text, as shown in Figure 884.5.

Figure 884.5 The Move tool relocated the second text layer.

12. Click on the black triangle in the upper-right corner of the Layers palette and select Flatten image from the pull-down menu. Photoshop combines the image into a single background layer.

13. Select the File menu and choose Save to save the image (refer to Tip 133, "Creating and Saving Patterns").

14. When you apply the pattern to a brochure or a Web page, it creates an eye-catching background, as shown in Figure 884.6.

Figure 884.6 The logo pattern applied as a tiled background

885 *Creating a Spherical Shadow*

When you work with spherical objects, creating realistic shadows is not as easy as using the drop shadow effects (see Tip 912, "Understanding the Visual Perception Created by Offset Shadows"). In most cases, using the drop shadow layer effect simply will not work. Creating a realistic spherical shadow is easy when you use Photoshop.

To create a spherical shadow, open an image containing a spherical object on a transparent background and perform these steps:

1. If the Layers palette is not open, select the Window menu and choose Show Layers from the pull-down menu. Photoshop opens the Layers palette, shown in Figure 885.1.

Figure 885.1 The Layers palette identifies each layer within the active document.

2. Move into the Layers palette and create a copy of the sphere layer by clicking on and dragging the layer over the New Layer icon. Photoshop creates a pixel-to-pixel copy of the sphere layer.

3. Select the Move tool from the toolbox.

4. Move into the document window, and click and drag down and to the right. Photoshop offsets the copied layer.

5. Click on and drag the sphere copy layer underneath the sphere layer.

6. Select the Preserve Transparency option for the copied layer, as shown in Figure 885.2.

Figure 885.2 The Preserve Transparency option prevents the modification of the transparent pixels in the selected layer.

7. Press the letter "D" on your keyboard to default the foreground and background colors to black and white.

8. Press Alt+Delete (Macintosh: Option+Delete) to fill the copied sphere with the current foreground color, as shown in Figure 885.3.

Figure 885.3 Pressing Alt+Delete (Macintosh: Option+Delete) fills the copied sphere with the foreground color.

9. Deselect the Preserve Transparency option for the copied layer.

10. With the sphere copy layer selected, choose the Filter menu, choose Blur, and select Gaussian Blur from the fly-out menu.

11. Enter a value of 30 in the Radius input field, and click the OK button to apply the Gaussian Blur to the active layer. Since the resolution of an image effects the application of the Gaussian Blur filter, experiment with Radius values, as shown in Figure 885.4.

Figure 885.4 The Gaussian Blur filter applied to the active image.

12. Select the Edit menu and choose Free Transform from the pull-down menu. Photoshop places a bounding box around the blurred circle.

13. Move to the bottom center anchor point of the bounding box until your cursor resembles a vertical arrow. Drag up until you have reduced the vertical size of the black shadow by 50 to 60 percent, as shown in Figure 885.5.

Figure 885.5 The Free Transform command lets you reduce the vertical size of the black circle.

14. Press the Enter key to apply the Free Transform to the shadow image.

15. Select the Move tool from the toolbox and move the black shadow under the sphere layer.

16. To complete the effect, move your cursor into the Layers palette and reduce the opacity of the shadow layer to 75 percent, as shown in Figure 885.6.

Figure 885.6 The complete spherical shadow

886 *Creating a Shadow in Front of an Object*

Here is another effect that cannot be accomplished using the standard drop shadow layer effects: creating a shadow in front of an object. Say, for example, that you want to create a shadow in front of a piece of text. To create the shadow, open a document in Photoshop containing text on a transparent background, and perform these steps:

1. Move into the Layers palette and create a copy of the layer containing the text by clicking on and dragging the layer over the New Layer icon, as shown in Figure 886.1.

Figure 886.1 Clicking on and dragging the text layer over the New Layer icon creates a pixel-to-pixel copy of the text layer.

2. Select the Move tool from the toolbox and move the copied layer directly under the original text.

3. With the copied text layer selected, choose the Edit menu, select Transform, and choose Flip Vertical from the fly-out menu. Photoshop flips the copied text layer, as shown in Figure 886.2.

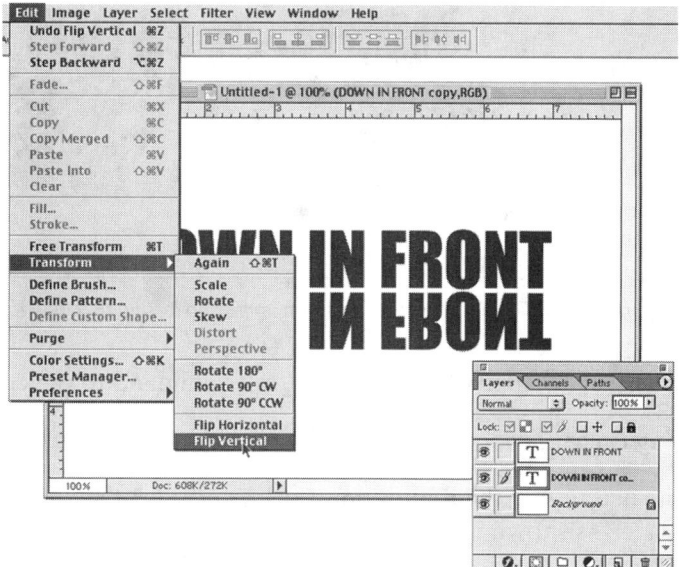

Figure 886.2 The Flip Vertical command reversed the copied text layer.

4. With the copied text layer selected, choose the Layer menu, select Rasterize, and select Type from the pull-down menu. Photoshop converts the type layer into a raster paint layer.

5. With the copied text layer selected, choose the Edit menu and select Free Transform from the pull-down menu. Photoshop places a bounding box around the reversed text.

6. Move to the bottom center anchor point of the bounding box until your cursor resembles a vertical arrow. Drag down until you have increased the vertical size of the text by 50 to 60 percent, as shown in Figure 886.3.

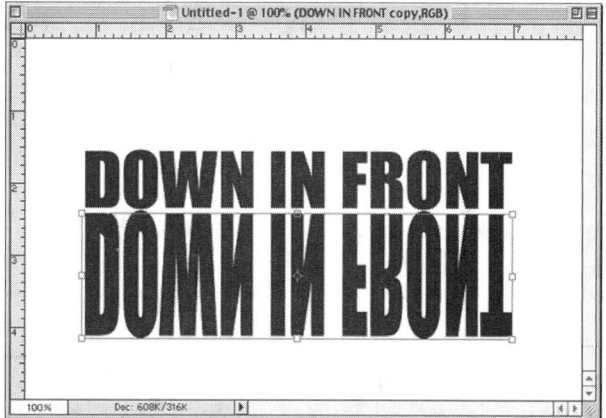

Figure 886.3 The Free Transform command lets you increase the vertical size of the text.

7. Right-click (Macintosh: Ctrl+click) inside the bounding box and select Perspective from the pop-up menu.

8. Move to the bottom right anchor point of the bounding box until your cursor resembles a gray arrow. Drag to the right until you have increased the perspective of the text, as shown in Figure 886.4.

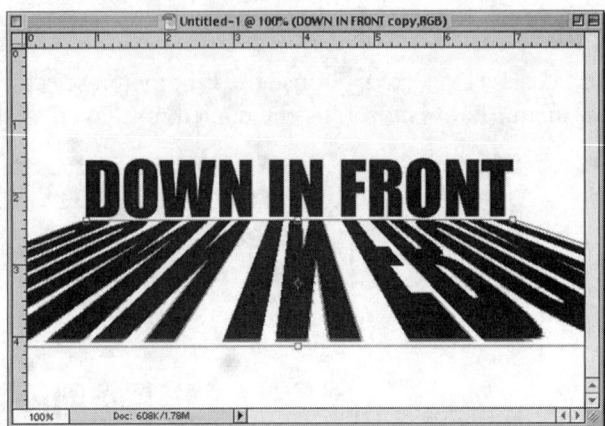

Figure 886.4 The Perspective Transform command lets you change the perspective of the text.

9. Press the Enter key to apply the Free Transform command to the copied layer.

10. Select the Filter menu, choose Blur, and choose Gaussian Blur from the fly-out menu.

11. Enter a value of 3 or 4 in the Radius input field, and click the OK button to apply the Gaussian Blur to the text layer, as shown in Figure 886.5.

Figure 886.5 The Gaussian Blur filter applied to the active image

12. Select the Rectangular Marquee tool from the toolbox and select the lower half of the shadow text, as shown in Figure 886.6.

13. Choose the Select menu and choose Feather from the fly-out menu.

14. Enter a value of 30 to 35 in the Feather input field, and click the OK button to apply the feather to the selection.

15. Press the Delete key. Photoshop deletes the portions of the text covered by the rectangular marquee. However, because you chose the Feather command, the effect softly fades from dark to light, creating a believable front shadow, as shown in Figure 886.7.

Figure 886.6 Use the Rectangular Marquee tool to select the lower portion of the image.

Figure 886.7 The completed front shadow

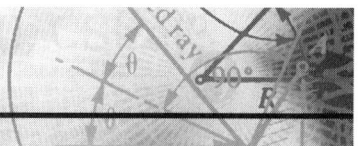

887 *Working with Cast Shadows*

Cast shadows go beyond what the Photoshop layers effects are capable of creating. A cast shadow fits the relative size and shape of the object and fades with distance. To create a cast shadow on an object, open a document in Photoshop containing an image on a transparent background, and perform these steps:

1. If the Layers palette is not open, select the Window menu and choose Show Layers from the pull-down menu. Photoshop opens the Layers palette.

2. Ctrl+click (Macintosh: Command+click) on the clock layer. Photoshop creates a selection based on the visible pixels in the image layer, as shown in Figure 887.1.

3. Move into the Layers palette and create a new layer by clicking once on the New Layer icon, as shown in Figure 887.2.

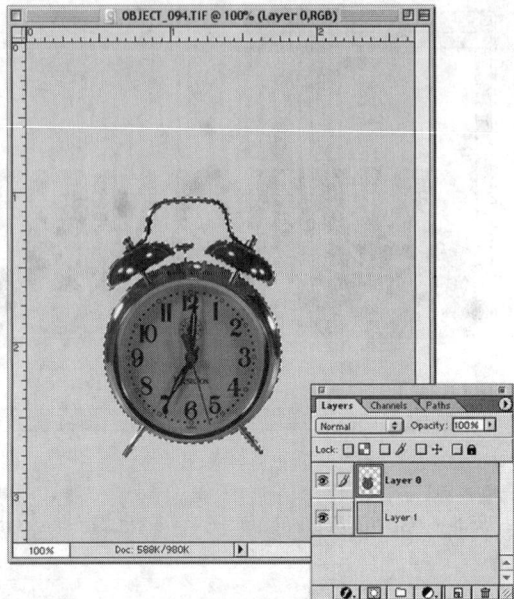

Figure 887.1 Ctrl+clicking (Macintosh: Command+clicking) on a layer thumbnail in the Layers palette creates a selection based on the visible pixels within the layer.

Figure 887.2 Clicking on the New Layer icon creates a new layer directly above the active layer.

4. Press the letter "D" on your keyboard to default the foreground and background colors to black and white.

5. Press Alt+Delete (Macintosh: Option+Delete) to fill the selected area with the current foreground color, as shown in Figure 887.3.

6. Press Ctrl+D (Macintosh: Command+D) to deselect the selection.

7. Move into the Layers palette and drag the black layer underneath the original watch layer.

8. With the shadow layer selected, choose the Filter menu, select Blur, and select Gaussian Blur from the fly-out menu.

9. Enter a value of 15 in the Radius input field, and click the OK button to apply the Gaussian Blur filter to the copy layer, as shown in Figure 887.4.

Figure 887.3 Pressing Alt+Delete (Macintosh: Option+Delete) fills the selected area with the foreground color.

Figure 887.4 The Gaussian Blur filter applied to the active image

10. With the shadow layer selected, choose the Edit menu and select Free Transform from the pull-down menu. Photoshop places a bounding box around the shadow.

11. Move to the top center anchor point of the bounding box until your cursor resembles a vertical arrow. Drag up until you increase the vertical size of shadow by 10 to 20 percent, as shown in Figure 887.5.

12. Right-click (Macintosh: Ctrl+click) inside the bounding box, and select Perspective from the pop-up menu.

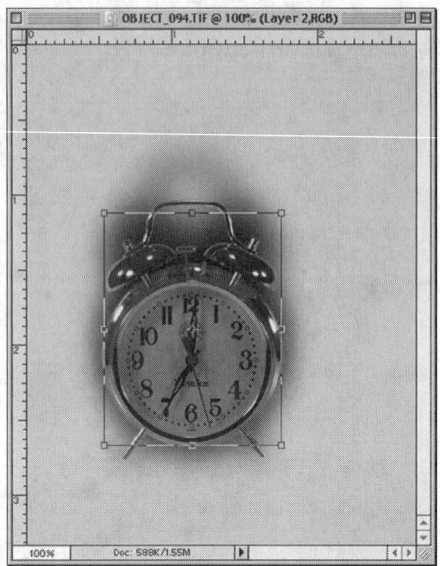

Figure 887.5 The Free Transform command lets you increase the vertical size of the shadow.

13. Move to the top-right anchor point of the bounding box until your cursor resembles a gray arrow. Drag to the right until you have increased the perspective of the shadow, as shown in Figure 887.6.

Figure 887.6 The Perspective Transform command lets you change the perspective of the shadow.

14. Right-click (Macintosh: Ctrl+click) inside the bounding box and select Rotate from the pop-up menu.

15. Move outside the bounding box until your cursor resembles a bent arrow. Click to rotate the shadow counterclockwise until it resembles the shadow in Figure 887.7.

16. Press the Enter key to apply the Free Transform command to the copied layer.

17. Move into the Layers palette and select the Preserve Transparency option for the shadow layer, as shown in Figure 887.8.

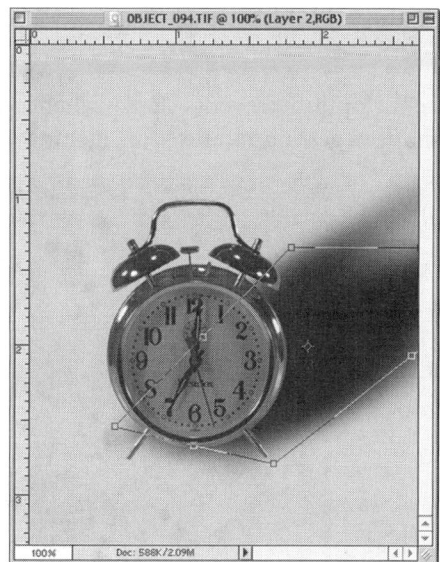

Figure 887.7 The Free Transform command lets you rotate the shadow layer.

Figure 887.8 The Preserve Transparency option prevents the modification of the transparent pixels in the shadow layer.

18. Select the Gradient tool from the toolbox and choose the Foreground to Background linear gradient from the available options (refer to Tip 172, "Working with the Gradient Options"), as shown in Figure 887.9.

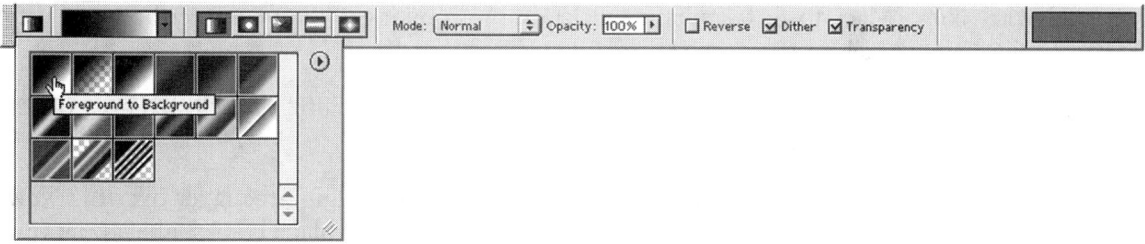

Figure 887.9 The Foreground to Background radial gradient

19. Move the Linear Gradient tool into the document window, and drag from the bottom to the top of the watch copy layer.

20. The Preserve Transparency option prevents the Gradient tool from covering the entire layer and creates the effect of the shadow getting lighter with distance, as shown in Figure 887.10.

Figure 887.10 The linear selection tool creates a black to white gradient inside the selection marquee and completes the cast shadow.

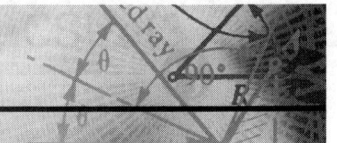

888 *Creating a Shadow on a Curved Surface*

Creating a shadow on a flat surface (refer to the previous tip) is easy. Creating shadows that fall across curved surfaces requires more thought. Say, for example, that you want to insert a shadow for an object next to a wall. In this example, you have a background layer and a transparent layer containing the object.

To create a shadow, open the document in Photoshop and perform these steps:

1. Move into the Layers palette and create a copy of the layer containing the object by clicking on and dragging the layer over the New Layer icon.

2. Press the letter "D" on your keyboard to default the foreground and background colors to black and white.

3. Ctrl+click (Macintosh: Command+click) on the copy layer. Photoshop creates a selection based on the visible pixels in the image layer.

4. Press Alt+Shift+Delete (Macintosh: Option+Shift+Delete) to fill the selected area of the image with the foreground color, as shown in Figure 888.1.

5. Create a copy of the shadow layer by clicking on and dragging the layer over the New Layer icon. You should have the original layer with the object and two black copies labeled figure copy and figure copy 2.

Figure 888.1 Pressing Alt+Shift+Delete (Macintosh: Option+Shift+Delete) fills the nontransparent pixels in the copied layer with the current foreground color.

6. Select the Lasso tool from the toolbox and select the portion of the figure copy layer that runs from the bottom of the figure to the edge of the wall, as shown in Figure 888.2.

Figure 888.2 The Lasso tool selected the bottom portion of the figure copy layer, stopping at the bottom edge of the wall.

7. Press the Delete key to remove the pixels from the figure copy layer. Because the other object layer lies underneath the deleted pixels, you will not notice any change within the image.

8. Move your cursor into the Layers palette and click once on the figure copy 2 layer.

9. Choose the Select menu, and choose Inverse from the pull-down menu. Photoshop reverses the selection.

10. Press the Delete key to remove the pixels from the figure copy 2 layer. Press Ctrl+Delete (Macintosh: Command+Delete) to deselect the selected areas of the image.

11. Move your cursor into the Layers palette and click once on the figure copy layer.

12. Select the Edit menu, choose Transform, and select Distort from the fly-out menu. Photoshop places a bounding box around the figure copy pixels.

13. Here is the tricky part. Click on and drag the corners of the bounding box until the shadow looks stretched to the edge of the wall, as shown in Figure 888.3.

Figure 888.3 Use the Distort Transform command to move the object shadow down and to the right.

14. Press the Enter key to apply the Free Transform command to the copied layer.

15. Move your cursor into the Layers palette and click once on the figure copy 2 layer.

16. Select the Move tool from the toolbox and position the top portion of the shadow over the distorted portion. If the distorted portion of the shadow does not fit, repeat steps 11 and 12 until they match.

17. When the layers line up correctly, deactivate all layers except the two shadow layers.

18. Click on the black triangle button, located in the upper-right corner of the Layers palette, and select Merge Visible from the pop-up menu. Photoshop merges the two shadow layers.

19. Click and drag the merged shadow layer (figure copy) underneath the original figure layer.

20. With the merged layer selected, choose the Filter menu, select Blur, and select Gaussian Blur from the fly-out menu.

21. Enter a value of 10 in the Radius input field, and click the OK button to apply the Gaussian Blur filter to the merged layer, as shown in Figure 888.4.

Figure 888.4 The Gaussian Blur filter applied to the active image completes the effect.

Note: *To enhance the visual effect, try lowering the opacity of the merged layer containing the shadow.*

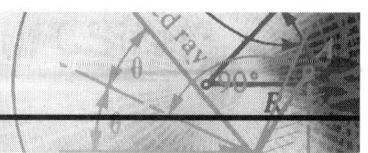

889 *Creating Quick Neon*

In Tip 480, "Creating Awesome Neon Using Paths," you learned how to manipulate a path to create realistic neon. The steps below demonstrate a quick, down-and-dirty way to generate fast neon.

1. Select the File menu and choose New. Photoshop opens the New dialog box. Create a new document with a width of 6 inches, a height of 4 inches, and a resolution of 150ppi in RGB mode, as shown in Figure 889.1.

Figure 889.1 The New dialog box defines the characteristics of the new document.

2. Press the letter "D" on your keyboard to default the foreground and background colors to black and white.

3. Press Alt+Delete (Macintosh: Option+Delete) to fill the background with the current foreground color, as shown in Figure 889.2.

Figure 889.2 Pressing Alt+Delete (Macintosh: Option+Delete) fills the background with the foreground color.

4. Select the Type tool from the toolbox, and create a type mask (refer to Tip 653, "Working with the Type Mask Tool"). In this example, you selected Comic Sans, at 72 points, as shown in Figure 889.3.

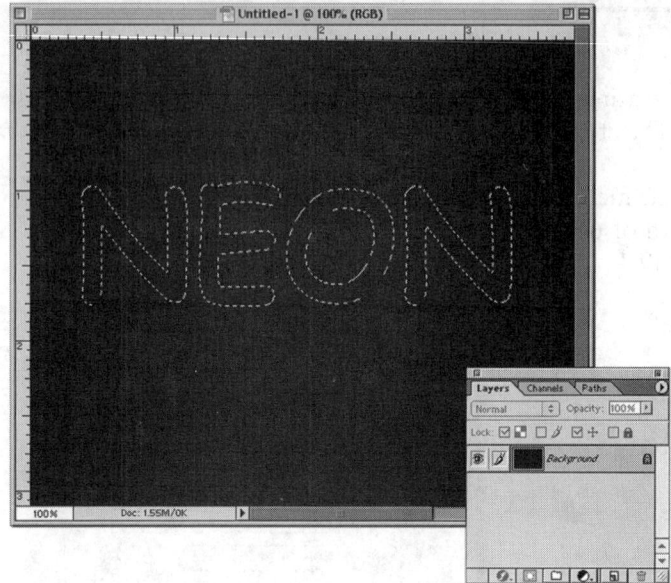

Figure 889.3 The Type Mask tool created the word NEON in the Comic Sans font.

5. Choose the Select menu, choose Modify, and choose Border from the fly-out menu. Photoshop opens the Border dialog box. Enter a value of 10 in the Width input field, and click the OK button to apply the border to the selected text, as shown in Figure 889.4.

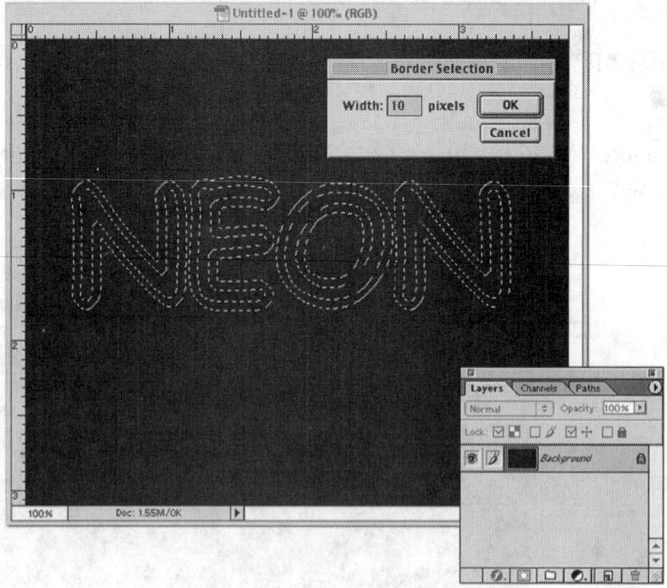

Figure 889.4 The Border command applied to the selected type mask

6. Choose the Select menu and choose Feather from the fly-out menu. Photoshop opens the Feather dialog box. Enter a value of 2 in the Radius input field, and click the OK button to apply the Feather command to the selected text.

7. Move your cursor into the Swatches palette and select a bright neon color. In this example, you select the color yellow.

8. Press Alt+Delete (Macintosh: Option+Delete) to fill the selected type mask with the current foreground color, as shown in Figure 889.5.

Figure 889.5 Pressing Alt+Delete (Macintosh: Option+Delete) fills the text mask with the foreground color.

890 *Colorizing Line Art*

Typically, a line-art graphic consists of a white background with a line drawing in black, as shown in Figure 890.1.

Figure 890.1 Line-art drawings consist of black lines against a white background.

The trick to colorizing a line-art graphic is to color the image using separate layers to control the process.

To colorize a piece of line art, open the image in Photoshop and perform these steps:

1. If the image is a Bitmap graphic, select the Image menu, choose Mode, and choose Grayscale from the fly-out menu. Photoshop opens the Grayscale dialog box, shown in Figure 890.2.

Figure 890.2 The Grayscale dialog box controls the size ratio of the converted bitmap image.

2. Enter a value of 1, and click the OK button to convert the image.

3. To colorize a grayscale image, you must first convert the image into the RGB color space. Select the Image menu, choose Mode, and choose RGB from the fly-out menu. Photoshop converts the image into the RGB (red, green, and blue) color space.

4. Select the Magic Eraser tool from the toolbox (refer to Tip 165, "Working with the Magic Eraser").

5. Click once in the white area of the line-art image. Photoshop converts the white pixels into transparent pixels. Continue to click in all the white areas of the image until you convert all the white pixels to transparent, as shown in Figure 890.3.

Figure 890.3 The Magic Eraser tool converts the selected pixels to transparent pixels.

6. Create a new layer by clicking once on the New Layer icon.

7. Click and drag the new layer underneath the line-art layer.

8. Select a light gray color from the Swatches palette.

9. Press Alt+Delete (Macintosh: Option+Delete) to fill the new layer with the current foreground color, as shown in Figure 890.4.

10. Move into the Layers palette and click once on the bottom layer. Photoshop selects the bottom layer.

11. Create a new layer by clicking once on the New Layer icon. Photoshop creates a new layer directly above the bottom layer in the Layers palette.

12. You now have three layers: the original line-art layer (on top), a new transparent layer (in the middle), and a bottom, gray-filled layer.

Figure 890.4 Pressing Alt+Delete (Macintosh: Option+Delete) fills the selected area with the foreground color.

13. Click once on the line art layer.

14. Select the Magic Wand tool from the toolbox, and click once inside one of the line art areas that you want to colorize. Photoshop selects the area, as shown in Figure 890.5.

Figure 890.5 The Magic Wand tool selects an enclosed area of the line-art drawing.

15. Click once on the transparent (middle) layer. Photoshop selects the transparent layer.

16. Move your cursor into the Swatches palette and select a color from the Swatches palette.

17. Select the Paintbrush from the toolbox and choose a brush size from the Options bar (refer to Tip 78, "The Paintbrush and Pencil Tools").

18. Move into the document window and begin painting the selected area of the image, as shown in Figure 890.6.

19. After completing the first section of the line art, create a new layer and repeat steps 13–18 until all the interior areas of the line art are complete, as shown in Figure 890.7.

Figure 890.6 *The Paintbrush tool applies color to the selected portion of the image.*

Figure 890.7 *The completed line art image*

Note: Using the Magic Wand tool keeps you painting within the lines and places the paint layer underneath the line art, which helps to define the original black lines in the image.

891 *Creating Beads on a String*

To create the visual effect of beads linked together on a string, perform these steps:

1. Select the File menu and choose New. Photoshop opens the New dialog box. Create a new document with a width of 4 inches, a height of 4 inches, and a resolution of 150ppi in RGB mode, as shown in Figure 891.1.

2. Select the Paintbrush tool from the toolbox.

Figure 891.1 The New dialog box defines the characteristics of the new document.

3. Move your cursor into the Options bar and click once on the black triangle, located to the right of the Brush palette. Photoshop opens the Brush dialog box.

4. Click on the black triangle located in the upper-right corner of the brush palette, and select the New Brush option from the pop-up menu. Photoshop opens the New Brush dialog box, shown in Figure 891.2.

Figure 891.2 The New Brush dialog box controls the characteristics of the new brush.

5. Create a new brush with a diameter of 20 pixels, 100 percent hardness, and a spacing of 120 percent (refer to Figure 891.2).

6. Click the OK button to save the new brush.

7. To select the new brush, click once on the New Brush icon in the Brush palette.

8. If the Channels palette is not open, select the Window menu and choose Show Channels from the pull-down menu. Photoshop opens the Channels palette.

9. Create a new channel by clicking once on the New Channel icon.

10. Select the Freeform Pen tool and create a path for the beaded chain by clicking on and dragging in the open document window, as shown in Figure 891.3.

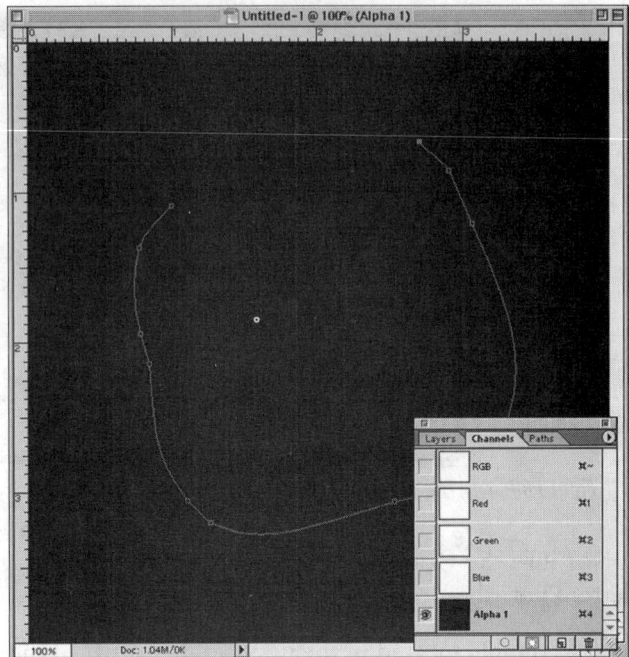

Figure 891.3 The Freeform Pen tool creates a path based on the movement of your mouse.

11. Press the letter "D" on your keyboard to default the foreground and background colors to black and white.

12. If the foreground color is not white, press the letter X on your keyboard to reverse the foreground and background colors.

13. Move into the document window and right-click (Macintosh: Ctrl+click). Select Stroke Path from the context-sensitive menu. Photoshop displays the Stroke Path dialog box (you must have the Freeform Pen tool selected for this step to work).

14. Select Paintbrush from the available tool options, and click the OK button to apply the stroke to the pen path, as shown in Figure 891.4.

15. Select the Paintbrush tool from the toolbox.

16. Move your cursor into the Options bar and click once on the black triangle, located to the right of the Brush palette. Photoshop opens the Brush dialog box.

17. Select the small hard brush in the upper-left corner of the Brush palette (refer to Figure 891.2).

18. Select the Freeform Pen tool from the toolbox to reactivate your path.

19. Move into the document window and right-click (Macintosh: Ctrl+click). Select Stroke Path from the context-sensitive menu. Photoshop displays the Stroke Path dialog box (you must have the Freeform Pen tool selected for this step to work).

20. Select Paintbrush from the available tool options, and click the OK button to apply the stroke to the pen path, as shown in Figure 891.5.

21. Create a copy of the alpha channel (Alpha 1) containing the beads by dragging the channel thumbnail over the New Channel icon. Photoshop creates a copy of the Alpha 1 channels and names the channel Alpha 1 copy.

Figure 891.4 The Stroke Path command created a beaded outline based on the brush created in step 5.

Figure 891.5 The Stroke Path command creates a white line between the beads with the small white brush selected in step 17.

22. With the Alpha 1 copy channel selected, choose the Filter menu, select Blur, and select Gaussian Blur from the fly-out menu.

Enter a value of 3 in the Radius input field and click the OK button to apply the Gaussian Blur filter to the active channel, as shown in Figure 891.6.

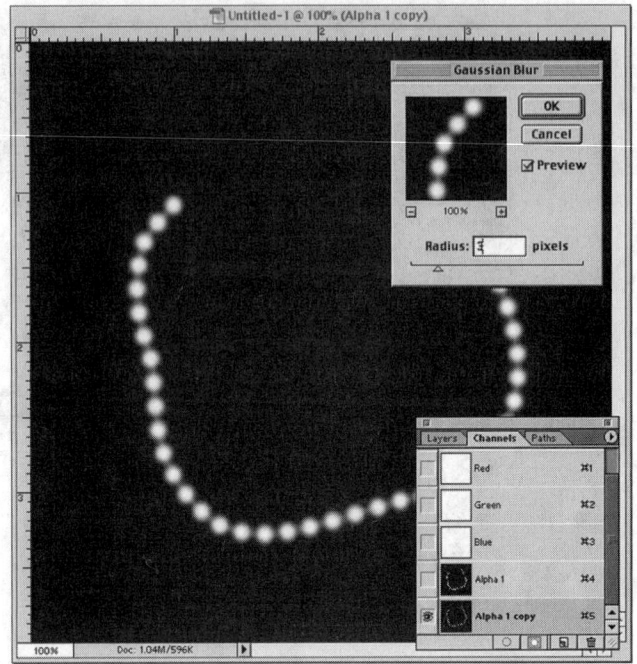

Figure 891.6 The Gaussian Blur filter applied to the active channel

23. Click once on the Layers tab. Photoshop displays the Layers palette.

24. Create a new layer by clicking once on the New Layer icon.

25. Choose Select menu and choose Load Selection from the pull-down menu. Photoshop opens the Load Selection dialog box.

26. Click on the Channel option and select Alpha 1 from the drop-down list. Click the OK button to apply the selection to the new layer, as shown in Figure 891.7.

Figure 891.7 The Load Selection dialog box lets you choose from the available Alpha channels.

27. Click on a color in the Swatches palette to select a color for the beads. In this example, you select a light gray.

28. Press Alt+Delete (Macintosh: Option+Delete) to fill the selected area with the current foreground color, as shown in Figure 891.8.

Figure 891.8 *Pressing Alt+Delete (Macintosh: Option+Delete) fills the copied spheres with the foreground color.*

29. Select the Filter menu, choose Render, and choose Lighting Effects from the fly-out menu. Photoshop opens the Lighting Effects dialog box, shown in Figure 891.9.

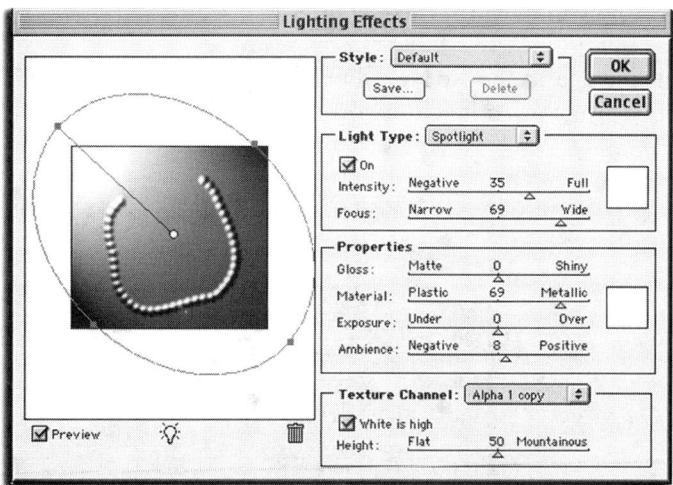

Figure 891.9 *The Lighting Effects dialog box controls the effect of the filter on the active layer.*

30. Click once on the Texture Channel option and select Alpha 1 copy from the drop-down list.

31. Refer to Figure 891.9 and set the light source to the upper-left corner of the preview window (refer to Tip 531, "Using the Lighting Effects Filter").

32. Click the OK button to apply the Lighting Effects filter to the image and complete the effect, as shown in Figure 891.10.

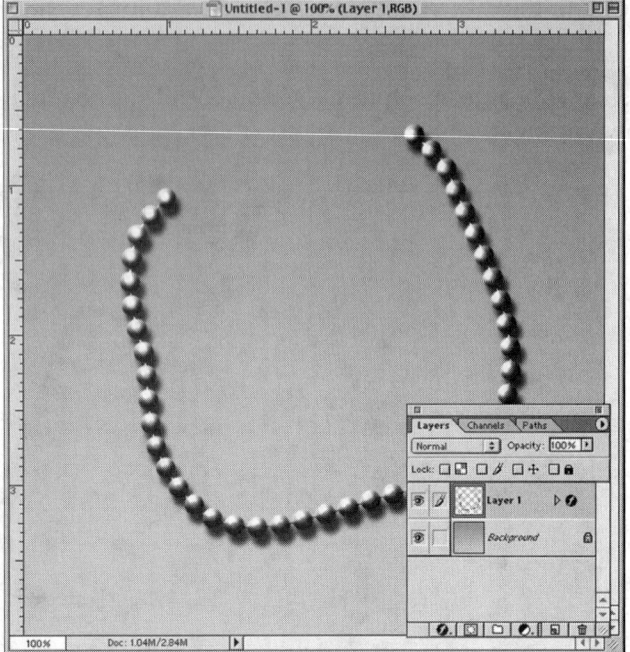

Figure 891.10 The Lighting Effects filter completes the effect.

892 *Wrapping an Image Around a Sphere*

This simple trick creates the illusion of a spherical pattern. To wrap a pattern around a spherical surface, open Photoshop and perform these steps:

1. Select the File menu and choose New. Photoshop opens the New dialog box. Create a new document with a width of 4 inches, a height of 4 inches, and a resolution of 150ppi in RGB mode, as shown in Figure 892.1.

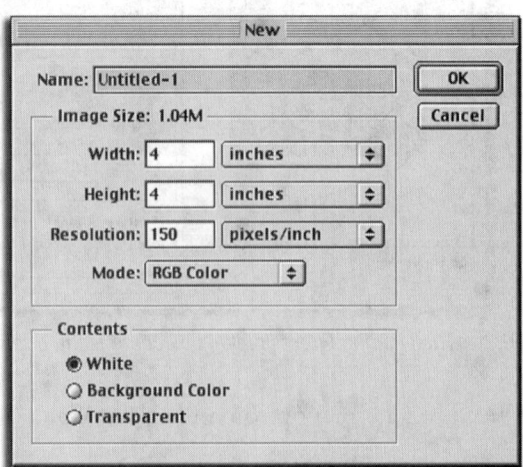

Figure 892.1 The New dialog box defines the characteristics of the new document.

2. Select the Elliptical Marquee tool from the toolbox and draw a circular selection in the size that you want your sphere. Hint: Hold down the Shift key while you use the Elliptical Marquee to draw a perfect circular selection, as shown in Figure 892.2.

Figure 892.2 The Elliptical Marquee tool created a circular selection.

3. Select the Edit menu and choose Fill from the pull-down menu. Photoshop opens the Fill dialog box, shown in Figure 892.3.

Figure 892.3 The Fill dialog box lets you fill the selection with a predefined pattern.

4. Click on the Use option and select Pattern from the drop-down list.

5. Click on the Custom Pattern option and select a pattern from the drop-down list. In this example, you select one of the standard Photoshop patterns (refer to Figure 892.3).

6. Click the OK button to apply the pattern to the circular selection, as shown in Figure 892.4.

7. Select the Filter menu, choose Distort, and choose Spherize from the fly-out menu. Photoshop opens the Spherize dialog box.

8. Click in the Amount input field and enter a value of 100 percent.

Figure 892.4 The Fill dialog box filled the selected area with a predefined pattern

9. Click on the Mode option and select Normal from the drop-down list.

10. Click the OK button to apply the Spherize filter to the selection, as shown in Figure 892.5.

Figure 892.5 The Spherize filter creates the illusion of a pattern wrapped around a sphere.

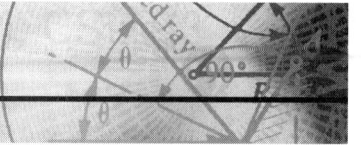

893 *Creating a Stone Background*

There are two ways to work with a stone background: Take a digital picture, or create your own using Photoshop. These steps show how to use Photoshop to create a stone background resembling gray slate.

1. Select the File menu and choose New. Photoshop opens the New dialog box. Create a new document with a width of 6 inches, a height of 4 inches, and a resolution of 150ppi, in RGB mode, as shown in Figure 893.1.

Figure 893.1 The New dialog box defines the characteristics of the new document.

2. If the Channels palette is not open, select the Window menu and choose Show Channels from the pull-down menu. Photoshop opens the Channels palette.

3. Create a new channel by clicking once on the New Channel icon.

4. Press the letter "D" on your keyboard to default the foreground and background colors to black and white.

5. Select the Filter menu, choose Render, and choose Clouds from the fly-out menu. Photoshop applies the Clouds filter to the new channel, as shown in Figure 893.2.

Figure 893.2 The Clouds filter applied to the new channel

6. Select the Image menu, choose Adjust, and choose Equalize from the fly-out menu. Photoshop applies the Equalize command to the new channel, as shown in Figure 893.3.

Figure 893.3 The Equalize filter applied to the new channel

7. If the Layers palette is not open, select the Window menu and choose Show Layers from the pull-down menu.

8. Move your cursor into the Layers palette and click once on the background layer.

9. Select the Filter menu, choose Render, and choose Lighting Effects from the fly-out menu. Click once on the Texture Channel option and select Alpha 1 from the drop-down list. Photoshop applies the Lighting Effects filter to the new channel, as shown in Figure 893.4.

Figure 893.4 The Lighting Effects dialog box

10. Expand the light source, and change the direction to the upper left (refer to Figure 893.4).

11. Change the focus option to a value of 1, and set the exposure value to −65 (refer to Tip 531, Using the Lighting Effects Filter").

12. Click the OK button to apply the Lighting Effects filter to the image, as shown in Figure 893.5.

Note: If you create stone as a background tile for the Internet, repeat the steps in this tip, using a new document with a width and height of 1 inch and a resolution of 72ppi.

Figure 893.5 The Lighting Effects filter creates the effect of gray slate.

894 *Creating Realistic Water Droplets on an Image*

Here is a quick and easy way to create the effect of water droplets on an image.

1. Select the File menu and choose New. Photoshop opens the New dialog box. Create the new document with the same width, height, resolution, and color space of the image document. In this example, you create a new document with a width of 6 inches, a height of 4 inches, and a resolution of 150ppi in RGB mode, as shown in Figure 894.1.

Figure 894.1 The New dialog box defines the characteristics of the new document.

2. If the Swatches palette is not open, select the Window menu and choose Show Swatches from the pull-down menu.

3. Move your cursor into the Swatches palette and click once on a medium, dark-gray color box. Photoshop converts the foreground color to dark gray. Hold the Alt key (Macintosh: Option key) and click once on a light-gray color box. Photoshop converts the background color to dark gray, as shown in Figure 894.2.

Figure 894.2 The foreground and background color swatches display dark and light gray colors.

4. Select the Gradient tool from the toolbox and choose the Foreground to Background linear gradient from the available options, as shown in Figure 894.3.

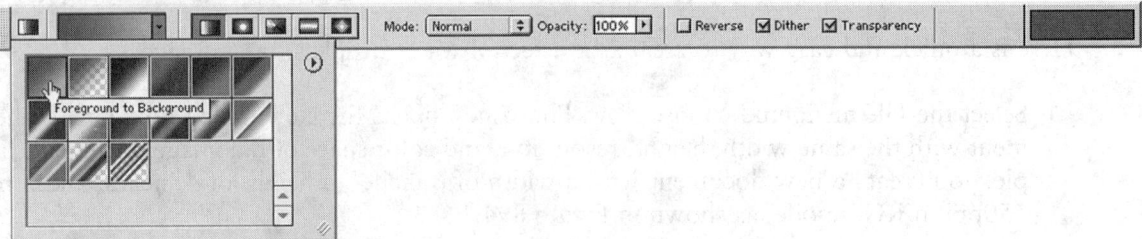

Figure 894.3 The foreground to background linear gradient

5. Move the linear gradient tool into the document window, and drag from the upper left to the lower right, as shown in Figure 894.4.

Figure 894.4 The linear selection tool creates a Foreground to Background gradient inside the document window.

6. Select the Filter menu, choose Noise, and select Add Noise to the image. Photoshop opens the Add Noise dialog box, shown in Figure 894.5.

Figure 894.5 The Add Noise filter introduces random noise to the active image.

7. Click in the Amount field and enter a value of 400. Choose the Distribution option of Gaussian, and choose Monochromatic.

8. Choose the Filter menu, choose Blur, and select Gaussian Blur from the fly-out menu.

9. Enter a value of 5 in the Radius input field and click the OK button to apply the Gaussian Blur filter to the active layer, as shown in Figure 894.6.

Figure 894.6 The Gaussian Blur filter applied to the image

10. Select the Image menu, choose Adjust, and choose Threshold from the fly-out menu. Click on the Threshold slider and drag it to the right until you produce rounded spots as shown in Figure 894.7.

11. Choose the Filter menu, choose Blur, and select Gaussian Blur from the fly-out menu. Enter a value of 5 in the Radius field, and click the OK button to apply the blur to the image.

12. Select the Image menu, choose Adjust, and choose Threshold from the fly-out menu. Click on the Threshold slider and drag to the right until you produce even larger rounded spots, as shown in Figure 894.8.

Figure 894.7 The Threshold command converts the image into black and white.

Figure 894.8 The Threshold command creates large rounded black-and-white drops.

13. Select the Magic Eraser tool from the toolbox (refer to Tip 165, "Working with the Magic Eraser").

14. Click once in the white area of the image. Photoshop converts the white pixels into transparent pixels, as shown in Figure 894.9.

15. Move into the Layers palette and Ctrl+click (Macintosh: Command+click) on the water drops layer. Photoshop creates a selection based on the visible pixels in the image layer.

16. Select the Gradient tool from the toolbox and choose the Foreground to Background linear gradient from the available options.

17. Move the linear gradient tool into the document window and drag from the upper-left corner to the lower-right corner, as shown in Figure 894.10.

18. Click once on the Layers Effects icon, located at the bottom left of the Layers palette, and select Bevel and Emboss from the pop-up menu. Photoshop opens the Layer Style dialog box.

19. Click once on the Style option and select Inner Bevel from the drop-down list.

20. Enter an Opacity value of 100 percent, and click on the Enter key to apply the bevel to the selected layer, as shown in Figure 894.11.

Figure 894.9 The Magic Eraser tool converts the selected pixels into transparent pixels.

Figure 894.10 The linear selection tool creates a foreground to background gradient inside the selected portions of the image.

21. Move into the Layers palette and create a new layer by clicking on the New Layer icon.

22. Click once on the black triangle, located in the upper-right corner of the Layers palette, and choose Merge Visible from the available options. Photoshop merges the water drop layer and the transparent layer. This prevents further changes to the bevel and emboss effect.

23. Press the letter "D" on your keyboard to default the foreground and background colors to black and white.

24. Move into the Layers palette and Ctrl+click (Macintosh: Command+click) on the water drops layer. Photoshop creates a selection based on the visible pixels in the image.

25. Select the Edit menu and choose Stroke from the pull-down menu.

26. Enter a Stroke Width value of 2, and choose the Center Location option. Click the OK button to apply the stroke to the image, as shown in Figure 894.12.

Figure 894.11 The Layer Style dialog box controls the characteristics of the bevel option.

Figure 894.12 The stroke applied to the water drops

27. Choose the Filter menu, choose Blur, and select Gaussian Blur from the fly-out menu. Enter a value of 3 in the Radius input field, and click the OK button to apply the Gaussian Blur filter to the water drops.

28. To use the water drops, move the image into the water drops document (refer to Tip 683, "Moving Layers Between Documents").

29. To make the drops appear transparent, select the water drops layer and choose the Hard-Light blending mode, as shown in Figure 894.13.

Figure 894.13 The Hard Light blending mode creates the illusion of transparent water drops.

895 *Working with the Lens Flare Filter*

The Lens Flare filter creates the illusion of an image containing a reflection from a camera lens. To generate a lens flare, open an image in Photoshop. Select the Filter menu, choose Render, and choose Lens Flare from the pull-down menu. Photoshop opens the Lens Flare dialog box, shown in Figure 895.1.

Figure 895.1 The Lens Flare filter lets you create the illusion of a lens flare on an open graphic image.

- **Brightness:** Click in the Brightness input field and enter a value from 10 to 300 percent. The Brightness value controls the intensity and width of the lens flare.

- **Lens Type:** Select a lens flare representing a 50-300mm zoom, 35mm prime, or 105mm prime. Each option creates a slightly different lens flare.

- **Image preview:** The image preview box contains a preview of the lens flare. Click on and drag the small plus sign to relocate the lens flare within the image.

Click the OK button to apply the lens flare to the image, as shown in Figure 895.2.

Figure 895.2 The Lens Flare filter applied to the active image

896 Creating a Moveable Lens Flare on a Separate Layer

In the previous tip, you learned how to create a lens flare. The one major obstacle to creating a lens flare is moving the effect after applying it to the image. Typically, you apply the lens flare directly to the active image. Although this creates a great-looking lens flare, you cannot relocate it.

To create a moveable lens flare, open an image in Photoshop and perform these steps:

1. If the Layers palette is not open, select the Window menu and choose Show Layers from the pull-down menu.

2. Move your cursor into the Layers palette and click once on the New Layer icon. Photoshop creates a new layer, as shown in Figure 896.1.

Figure 896.1 Clicking once on the New Layer icon creates a new transparent layer.

3. Press the letter "D" on your keyboard to default the foreground and background colors to black and white.

4. Press Alt+Delete (Macintosh: Option+Delete) to fill the new layer with the current foreground color, as shown in Figure 896.2.

Figure 896.2 Pressing Alt+Delete (Macintosh: Option+Delete) fills the new layer with the foreground color.

5. Select the Filter menu, choose Render, and choose Lens Flare from the pull-down menu. Photoshop opens the Lens Flare dialog box, shown in Figure 896.3.

Figure 896.3 The Lens Flare filter lets you create the illusion of a lens flare on an open graphic image.

6. Refer to the previous tip, and create a lens flare in the black-filled layer. Hint: Because you plan to move the lens flare, locate the flare near the center of the image preview box (refer to Figure 896.3). Click the OK button to apply the lens flare to the image.

7. Move into the Layers palette and click on the Blending Mode option. Select the Screen blending mode from the drop-down list. The black portions of the new layer turn transparent, exposing the lens flare, as shown in Figure 896.4.

8. To relocate the lens flare, select the Move tool from the toolbox. Then click on and drag the lens flare layer, as shown in Figure 896.5.

Figure 896.4 The Screen blending mode removes the black portions of the layer, exposing the lens flare.

Figure 896.5 Use the Move tool to relocate the lens flare.

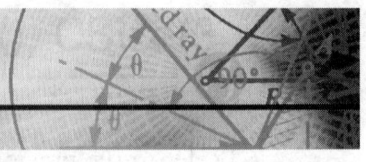

897 *Creating a Chiseled Edge*

In Tip 893, "Creating a Stone Background," you learned how to create the illusion of a gray slate surface. You can generate a chiseled edge to that surface by performing these steps:

1. Select the Freeform Lasso tool from the toolbox, and create a jagged edge selection, as shown in Figure 897.1.

Figure 897.1 The Lasso tool created a freeform jagged selection.

2. Move to the keyboard and press Ctrl+J (Macintosh: Command+J). Photoshop creates a new layer containing the selected pixels, as shown in Figure 897.2.

Figure 897.2 Pressing Ctrl+J (Macintosh: Command+J) creates a new layer from the selected area of the active layer.

3. Click once on the Layers Effects icon, located at the bottom left of the Layers palette, and select Drop Shadow from the pop-up menu. Photoshop opens the Layer Style dialog box.

4. In the Size input field, enter a value of 15. This increases the blur of the drop shadow.

5. Click the OK button to apply the drop shadow to the layer, as shown in Figure 897.3.

6. Move into the Layers palette and click once on the background layer.

7. Press the letter "D" on your keyboard to default the foreground and background colors to black and white.

8. Press Ctrl+Delete (Macintosh: Command+Delete) to fill the selected area with the current background color, as shown in Figure 897.4.

Figure 897.3 The drop shadow layer style applied to the copied layer.

Figure 897.4 Pressing Alt+Delete (Macintosh: Option+Delete) fills the background with white and completes the effect.

898 Creating Credit-Card Text with the Effects Layers

Everyone has seen a credit card with its punched-out text. If you create a graphic of a credit card and you want to generate the illusion of punched-out text, perform these steps:

1. Select the Type tool from the toolbox.

2. Move into the Options bar and select the Type Mask option, as shown in Figure 898.1.

3. The font is very important to the effect. In this example, you select the Lcd D font and choose a font size of 18 points (refer to Figure 898.1). The Lcd D font and other designer fonts can be downloaded from text sites on the Internet, or purchased from companies like Adobe.

4. Move into the document and enter the numerical text that appears at the bottom of a credit card.

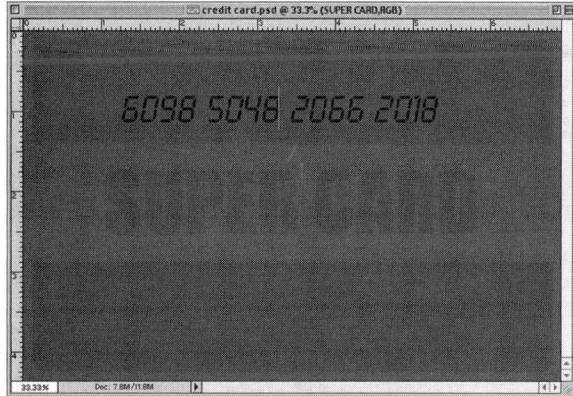

Figure 898.1 The Type Mask option creates a selection based on the outline of the active font.

5. Select the Move tool from the toolbox, and position the outline text as shown in Figure 898.2.

Figure 898.2 The Move tool lets you reposition the masked font.

6. Move to the keyboard and press Ctrl+J (Macintosh: Command+J). Photoshop creates a new layer containing the selected pixels.

7. Click once on the Layers Effects icon, located at the bottom left of the Layers palette, and select Bevel and Emboss from the pop-up menu. Photoshop opens the Layer Style dialog box.

8. Click once on the Style option and select Emboss from the drop-down list.

9. Click once on the Technique option and select Smooth from the drop-down list.

10. Enter a Depth value of 200 and a Size value of 5. Click on the Enter key to apply the bevel to the type mask, as shown in Figure 898.3.

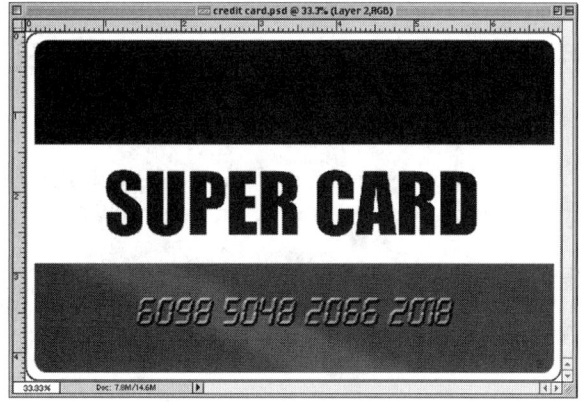

Figure 898.3 The Emboss effect applied to the text mask.

11. Repeat steps 3–10 for the name on the credit card, using a slightly larger point size for the type mask, as shown in Figure 898.4.

Figure 898.4 The finished credit card containing the illusion of punched-out text.

899 *Using the Pastels Filter with the History Brush*

Photoshop's Rough Pastels filter modifies the image by creating the illusion of a pastel brush applied to the image, as shown in Figure 899.1.

Figure 899.1 The Pastels filter applied to an image creates the illusion of using pastel brush strokes.

For example, you have a portrait that you want to apply the Rough Pastel filter to, but you do not want the filter to distort the face. You can apply the Rough Pastel filter without losing the details of the face, by performing these steps:

1. Select the Filter menu, choose Artistic, and choose Rough Pastels from the fly-out menu. Photoshop opens the Rough Pastels dialog box, shown in Figure 899.2.

2. In this example, you select a Stroke Length value of 30, a Stroke Detail value of 4, and a Light Direction value of Top Right (refer to Figure 899.2). The remainder of the options you can leave at their default values.

Figure 899.2 The Rough Pastels dialog box controls the application of the filter to the image.

3. Click the OK button to apply the Rough Pastels filter to the image, as shown in Figure 899.3.

Figure 899.3 The Rough Pastels filter applied to the image

4. Move into the Layers palette and click once on the New Layer icon. Photoshop creates a transparent layer.

5. Select the History brush from the toolbox (refer to Tip 143, "Using the History Brush with a Transparent Layer").

6. With the new layer selected, move into the document window and use the History brush to restore the face by painting with the History brush, as shown in Figure 899.4.

Note: Always use a new transparent layer when using the History brush. The new layer gives you control over the image and the capability to start over (throw away the layer).

Figure 899.4 The History brush uses a snapshot to restore the facial areas of the image.

900 *Creating a Colorized Mezzotint*

A typical mezzotint is an image constructed using a halftone screen with custom dot shapes. To create a colorized mezzotint, open an image in Photoshop and perform these steps:

1. Move into the Layers palette and create a copy of the image layer by clicking on and dragging the image layer over the New Layer icon. Photoshop creates a pixel-to-pixel copy of the image layer, as shown in Figure 900.1.

Figure 900.1 Dragging a layer over the New Layer icon creates a copy of the dragged layer.

2. With the copied layer selected, choose the Filter menu, select Pixelate, and choose Mezzotint from the fly-out menu. Photoshop opens the Mezzotint dialog box, shown in Figure 900.2.

3. Click on the Type option and choose a mezzotint from the drop-down list. In this example, you selected Long Lines. Click the OK button to apply the mezzotint to the copied layer, as shown in Figure 900.3.

4. To colorize the image, select the copied layer and choose the Multiply blending mode, as shown in Figure 900.4.

Figure 900.2 The Mezzotint dialog box controls the application of the filter to the image.

Figure 900.3 The Mezzotint filter applied to the copied image.

*Figure 900.4 The Multiply blending mode blends the colors from the original
image layer and successfully colorizes the image.*

901 *Using the Audio Annotation Tool*

Photoshop contains a new tool for creating audio notes. The Audio Annotation tool lets you create audio notes and attach them to the active document. Photoshop saves audio notes with the document so that when the file is reopened, the notes can be replayed.

To create an audio note, open a document in Photoshop and select the Audio Annotation tool from the toolbox, as shown in Figure 901.1.

Figure 901.1 The Audio Annotation tool lets you create, save, and replay audio notes.

Move the Audio Annotation tool into the document window and click once. Photoshop opens the Recording dialog box, shown in Figure 901.2.

Figure 901.2 The Recording dialog box lets you create audio messages.

Click on the Start button (Macintosh: Record button) and begin the message. You will need a microphone connected to your computer (refer to your computer's user manual for information on connecting a microphone).

Click on the Stop button to stop the recording and save the message. To replay a previously saved message, double-click on the speaker icon, shown in Figure 901.3.

Figure 901.3 *Double-click on the speaker icon to replay the audio message.*

902 *Ghosting an Image to Generate Attention*

Creating a ghosted background in an image focuses attention on a specific area of a graphic. Say, for example, that you want to generate attention to a specific portion of an image. To ghost the background, open the image in Photoshop and perform these steps:

1. Select the Freeform Lasso tool from the toolbox and select the area of the image that you want to preserve (refer to Tip 280, "Selection Methods"), as shown in Figure 902.1.

2. Move to the keyboard and press Ctrl+J (Macintosh: Command+J). Photoshop creates a new layer containing the selected pixels, as shown in Figure 902.2.

3. Move your cursor into the Layers palette and click once on the background layer. Photoshop selects the background layer.

4. Select the Image menu, choose Adjust, and choose Hue/Saturation from the fly-out menu (refer to Tip 580, "Using the Hue/Saturation Command"). Photoshop opens the Hue/Saturation dialog box, as shown in Figure 902.3.

5. Click on the Saturation slider and drag to the left to reduce the saturation of the background layer. In this example, you select a saturation value of 30 percent.

6. Click the OK button to apply the Hue/Saturation command to the background layer, as shown in Figure 902.4.

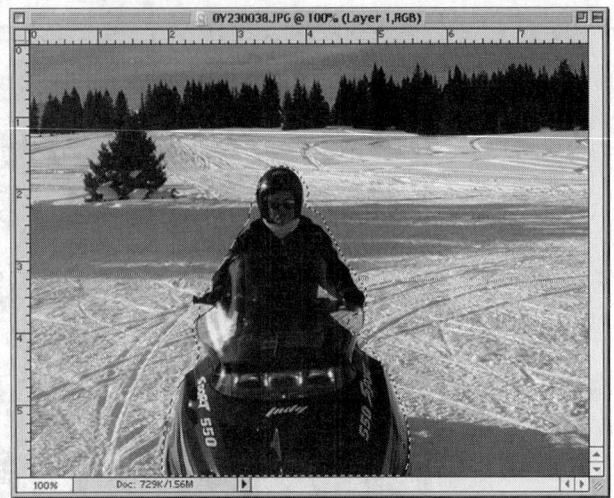

Figure 902.1 The Lasso tool created a freeform selection.

Figure 902.2 Pressing Ctrl+J (Macintosh: Command+J) creates a new layer from the selected area of the active layer.

Figure 902.3 The Hue/Saturation dialog box controls the color content of the active layer.

Note: *By reducing the saturation of the background layer, you draw attention to the portions of the image in the copied layer. This is an excellent way to direct viewers to the portions of the image that you want them to see.*

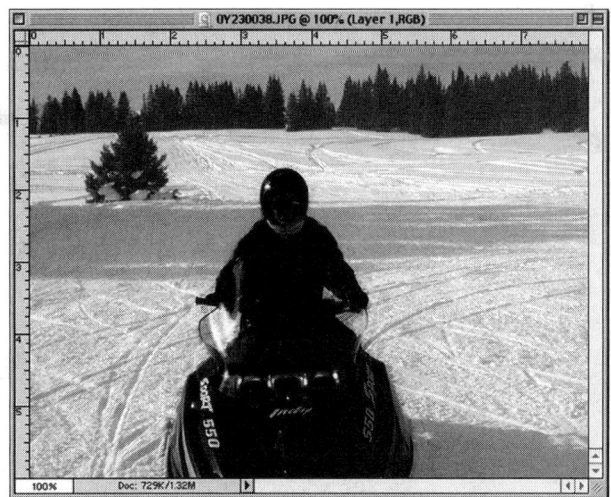

Figure 902.4 The Hue/Saturation command successfully reduced the color of the background layer.

903 *Softening an Image Using Multiple Layers*

For years, portrait photographers have created soft-focused photos, using camera and darkroom techniques. Say, for example, that you want to apply a soft focus to an image.

To generate a soft focus, open an image in Photoshop and perform these simple steps:

1. If the Layers palette is not open, select the Window menu and choose Show Layers from the pull-down menu.

2. Move into the Layers palette and create a copy of the background layer by clicking on and dragging the layer over the New Layer icon. Photoshop creates a pixel-to-pixel copy of the layer, as shown in Figure 903.1.

3. Choose the Filter menu, select Blur, and select Gaussian Blur from the fly-out menu.

4. Enter a value of 10 in the Radius input field and click the OK button to apply the Gaussian Blur filter to the copied layer, as shown in Figure 903.2.

5. To create the soft-focus effect, move into the Layers palette, click on the Blending mode button, and select Lighten from the available options.

6. To soften the effect further, click in the Opacity input field and lower the opacity of the Gaussian blurred layer. In this example, you select an opacity setting of 75 percent, as shown in Figure 903.3.

Figure 903.1 Dragging a layer over the New Layer icon creates a copy of the dragged layer.

Figure 903.2 The Gaussian Blur filter applied to the image

Figure 903.3 Lowering the opacity and selecting the Lighten blending mode creates a softly focused image.

904 *Solarizing an Image*

The solarization process partially reverses the positive to negative portions of the image. If, for example, you want to solarize a graphic image, but the Photoshop Solarize filter causes the image to lose too much detail. You can control Photoshop's Solarize filter, by performing these steps:

1. If the Layers palette is not open, select the Window menu and choose Show Layers from the pull-down menu.

2. Create a copy of the background layer by clicking on and dragging the layer over the New Layer icon. Photoshop creates a copy of the layer, as shown in Figure 904.1.

3. Choose the Filter menu, select Blur, and select Gaussian Blur from the fly-out menu.

4. Enter a value of 1 in the Radius input field and click the OK button to apply the Gaussian Blur filter to the copied layer, as shown in Figure 904.2. Using the Gaussian Blur filter helps to mute the effects of the Solarize filter.

5. With the copied layer selected, choose the Filter menu, choose Stylize, and choose Solarize from the fly-out menu. Photoshop solarizes the copied image layer, as shown in Figure 904.3.

6. To influence the Solarize filter, move into the Layers palette, click on the Blending mode button and select Hard Light, Darken, or Luminosity from the available options. In this example, you select the Hard Light blending mode, as shown in Figure 904.4.

Figure 904.1 Dragging a layer over the New Layer icon creates a copy of the dragged layer.

Figure 904.2 The Gaussian Blur filter applied to the copied image layer.

Figure 904.3 The Solarize filter applied to the active image layer.

Figure 904.4 The Hard Light blending mode restores some of the detail lost by using the Solarize filter.

905 *Creating an Assembled Image from Multiple Layers*

When you work on multi-layered Photoshop documents, such as photo collages, you could have 15 or more separate layers within a single document. When you add image layers to a Photoshop document, you increase the size of the file according the amount of detail within the new layer, as shown in Figure 905.1.

Figure 905.1 Adding detail layers to a Photoshop document increases the image file size.

In Photoshop, the larger the file size is, the more RAM memory the program requires to run efficiently (refer to Tip 16, "Understanding How Photoshop Uses Your Hard Drive and RAM Memory"). A great tip for working in multi-layered documents is *not* to work in multi-layered documents.

If you intend to create a complicated multi-layered document, create separate documents for each individual layer in the final collage. Then open one document at a time, work on that portion of the image, and move to the next document. When all the separate documents are complete, open a new document in Photoshop and, one at a time, open the separate document files and drag them into the final document file, as shown in Figure 905.2.

Figure 905.2 Move the completed layers into the final document by clicking on and dragging from one open document window into the final document file.

The suggestion here is not to make the image better, but to increase your efficiency when you work. Single-layer documents are smaller and, therefore, operate faster. By working on individual document files, you increase your efficiency: You get more work done in the same amount of time.

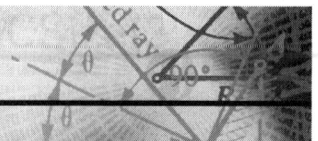

906 *Using Lens Flare to Create a 3-D Globe*

Here is an easy way to generate a three-dimensional sphere using Photoshop's Lens Flare filter.

1. Select the File menu and choose New. Photoshop opens the New dialog box. Create a new document with a width of 4 inches, a height of 4 inches, and a resolution of 150ppi in RGB mode, as shown in Figure 906.1.

Figure 906.1 The New dialog box defines the characteristics of the new document.

2. Select the Elliptical Marquee tool from the toolbox and draw a circular selection in the size that you want your sphere. Hint: Hold down the Shift key while you use the Elliptical Marquee tool to draw a perfect circular selection, as shown in Figure 906.2.

Figure 906.2 The Elliptical Marquee tool created a circular selection in the new layer.

3. If the Swatches palette is not open, select the Window menu and choose Show Swatches from the pull-down menu.

4. Move into the Swatches palette and select a color for the sphere. Choose a dark color to interact with the Lens Effect filter. In this example, you select a dark green.

5. Press Alt+Delete (Macintosh: Option+Delete) to fill the selection with the current foreground color, as shown in Figure 906.3.

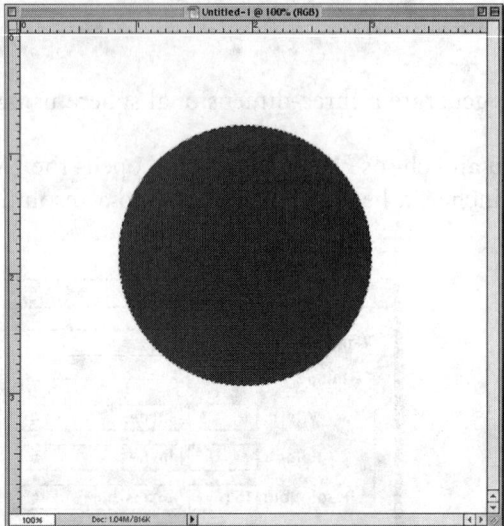

Figure 906.3 Pressing Alt+Delete (Macintosh: Option+Delete) fills the new layer with the foreground color.

6. Select the Filter menu, choose Render, and choose Lens Flare from the pull-down menu. Photoshop opens the Lens Flare dialog box, shown in Figure 906.4.

Figure 906.4 The Lens Flare filter lets you create the illusion of a lens flare on an open graphic image.

7. Click in the Flare Center preview box and drag the flare center to the upper left.

8. Select the 105mm Prime Lens Type.

9. Click in the Brightness input field and enter a value from 10 to 300. In this example, you select a value of 135.

10. Click the OK button to apply the lens flare to the image, as shown in Figure 906.5.

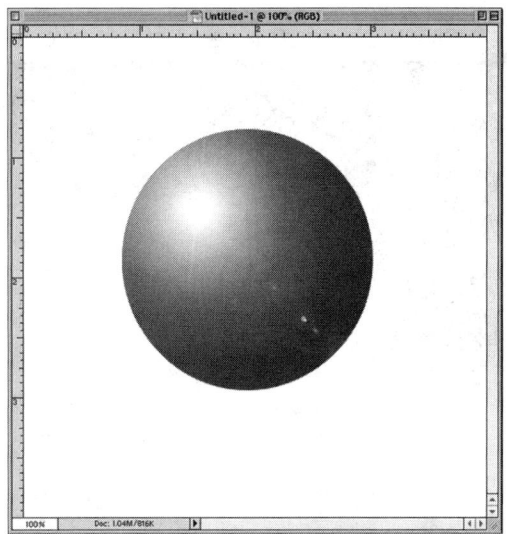

Figure 906.5 The Lens Flare filter applied to the active image

907 *Using Multiple Colors to Create a Text Glow*

In Photoshop 6, not only do you have the capability to generate a glow around an object using Layer Effects, but you also can modify the effect using predefined gradients.

To generate a multiple-color glow around text, open a document containing a text layer and perform these steps:

1. If the Layers palette is not open, select the Window menu and choose Show Layers from the pull-down menu.

2. Move into the Layers palette and click once on the layer containing the text.

3. Click once on the Layers Effects icon, located at the bottom left of the Layers palette, and select Outer Glow from the pop-up menu. Photoshop opens the Layer Style dialog box, shown in Figure 907.1.

4. Click in the Size input field and enter a value 20.

5. Click once on the black triangle located to the right of the gradient preview box (refer to Figure 907.1). Photoshop opens the gradient options (see Figure 907.2).

6. To change the glow around the text, click on the available options or create your own customized gradients (refer to Tip 175, "Creating Custom Gradients"). The outer glow surrounding the text is influenced by the different gradients, as shown in Figure 907.3.

7. Click the OK button to apply the Outer Glow effect to the text layer.

Figure 907.1 The Layer Style dialog box controls the characteristics of the Outer Glow effect.

Figure 907.2 The gradient options influence the application of color to the Outer Glow effect.

Figure 907.3 The gradient options influences the glow surrounding the text.

908 *Using the Gradient Tool to Generate Spheres*

In Tip 906, "Using Lens Flare to Create a 3-D Globe," you learned how to create a sphere using the Lens Flare filter. Another way to create convincing spheres is with the Gradient tool.

 1. Select the File menu and choose New. Photoshop opens the New dialog box. Create a new document with a width of 5 inches, a height of 5 inches, and a resolution of 150ppi in RGB mode, as shown in Figure 908.1.

Figure 908.1 The New dialog box defines the characteristics of the new document.

2. Select the Elliptical Marquee tool from the toolbox and draw a circular selection in the size that you want the sphere, as shown in Figure 908.2.

Figure 908.2 The Elliptical Marquee tool created a circular selection in the background layer.

3. If the Swatches palette is not open, select the Window menu and choose Show Swatches from the pull-down menu.

4. Move your cursor into the Swatches palette and click once on a light-gray color box. Photoshop converts the foreground color to light gray. Hold the Alt key (Macintosh: Option key) and click once on a medium blue color box. Photoshop converts the Background color to medium blue, as shown in Figure 908.3. The foreground color represents the sphere highlight, and the background color represents the color of the sphere.

Figure 908.3 The foreground and background color swatches display light gray and medium blue.

5. Select the Gradient tool from the toolbox and choose the Foreground to Background radial gradient from the available options, as shown in Figure 908.4.

6. Move the radial gradient tool into the document window and drag from the upper-left corner to the lower-right corner.

Figure 908.4 The Foreground to Background radial gradient.

7. The starting point and distance that you drag the radial gradient tool determine the placement and size of the highlight, as shown in Figure 908.5.

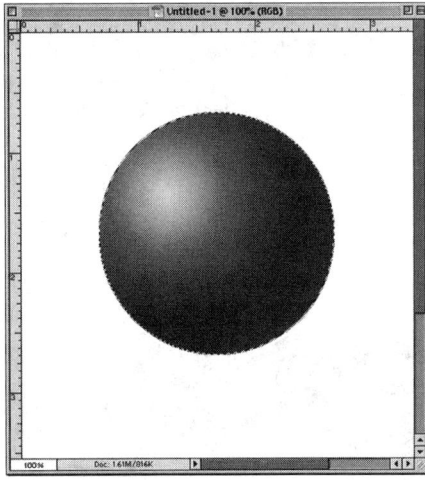

Figure 908.5 The linear selection tool creates a foreground to background gradient inside the circular selection.

909 *Using Threshold to Create a Pen-and-Ink Drawing*

The Threshold command converts a grayscale or color image into a black-and-white image. The Threshold command makes the decision to convert an image pixel to black or white based on the brightness level of the pixel (refer to Tip 634, "Using the Threshold Command").

To convert an image into a pen-and-ink drawing and still maintain some of the original image details, open the image in Photoshop and perform these steps:

1. Select the Image menu, choose Adjust, and choose Desaturate from the fly-out menu. Photoshop converts the image into shades of gray.

2. If the Layers palette is not open, select the Window menu and choose Show Layers from the pull-down menu.

3. Create a copy of the background layer by clicking on and dragging the layer over the New Layer icon. Photoshop creates a copy of the layer, as shown in Figure 909.1.

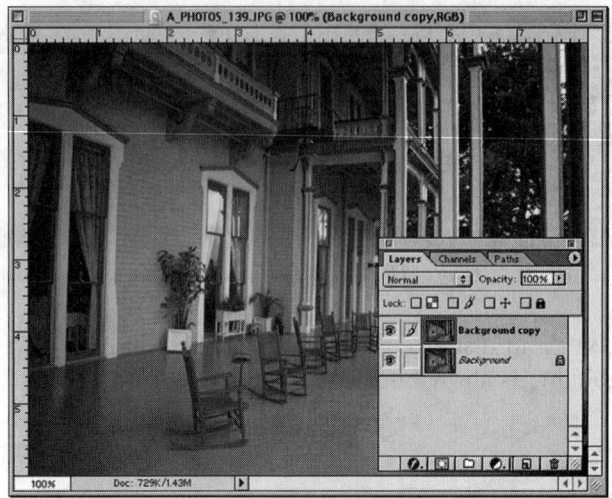

Figure 909.1 Dragging a layer over the New Layer icon creates a copy of the dragged layer.

4. Select the Image menu, choose Adjust, and choose Threshold from the fly-out menu. Photoshop opens the Threshold dialog box, shown in Figure 909.2.

Figure 909.2 The Threshold dialog box controls where black and white occur within the image.

5. Move the Threshold slider left or right until you achieve a good balance of black and white within the image. In this example, you selected a Level of 145. Click the OK button to apply the Threshold command to the copied layer (refer to Figure 909.2).

 If you want more image detail, move into the Layers palette, click on the Blending mode button, and select Multiply from the available options.

6. To soften the effect further, click in the Opacity input field and lower the opacity of the copy layer. In this example, you select an opacity setting of 60 percent, as shown in Figure 909.3.

Figure 909.3 Lowering the opacity and selecting the Multiply blending mode creates a detailed pen-and-ink drawing.

910 *Creating Separate Layers from Layer Effects*

When you use the Layer Effects options, Photoshop creates everything from drop shadows to bevels using a single layer. Creating the same effect manually would require two or more separate layers. Say, for example, that you create a drop shadow on a group of text, and you want to convert the drop shadow into a fallback shadow. The Layer Effects do not let you create a fallback shadow, but you can separate the shadow from the effect and create the new shadow with the transform tool.

To separate a drop shadow from its effects, open an image containing a drop shadow effects layer and perform these steps:

1. If the Layers palette is not open, select the Window menu and choose Show Layers from the pull-down menu.

2. Move into the Layers palette and click once on the text layer containing the drop shadow effect. Photoshop selects the text layer, as shown in Figure 910.1.

3. Select the Layer menu, choose Layer Style, and choose Create Layer from the fly-out menu. Photoshop separates the shadow and places it on a separate layer, as shown in Figure 910.2

4. Move into the Layers palette and click once on the drop shadow layer. Photoshop selects the layer.

5. Choose the Edit menu and select Free Transform from the pull-down menu. Photoshop places a bounding box around the drop shadow, as shown in Figure 910.3.

6. Hold down the Ctrl key (Macintosh: Command key) and move your cursor over the top-center anchor point until it resembles a gray arrow.

7. Click on and drag the top-center anchor up and to the right to create a drop-back shadow, as shown in Figure 910.4.

Figure 910.1 Clicking on a layer in the Layers palette selects the layer.

Figure 910.2 The Create Layer option separates the effects from the original image layer.

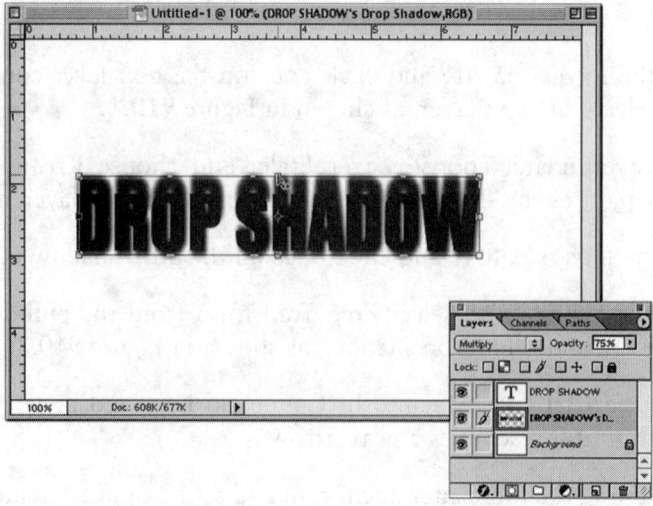

Figure 910.3 The Free Transform command encloses the shadow within a bounding box.

Figure 910.4 The Free Transform command converted the separated shadow into a drop-back shadow.

Note: When you select the Create Layer option, you might see an alert box warning you that not all layer effects convert to separate layers. To continue the separation of the layer effect, click the OK button. Photoshop converts the layer effect into separate layers.

911 *Using the Global Angle Command*

When you work with multiple layers, each containing its own layer effect, it is important to maintain a consistent light source (see Tip 912, "Understanding the Visual Perception Created by Offset Shadows"). To access the Global light source command without returning to the Layers palette, select the Layer menu, choose Layer Style, and select Global Light from the fly-out menu. Photoshop opens the Global Light dialog box, shown in Figure 911.1.

Move your cursor in the light circle and drag the plus sign to reposition the light source for the entire document, or click in the Angle input box and enter a value from 0 to 360°. Click in the Altitude box and enter values from 0 to 90°.

Note: To lock the light source of one or more layer effects, deselect the Global Angle option in the Layer Style dialog box.

Figure 911.1 *The Global Light option in the Layer Style dialog box controls the light source for all the layers in Photoshop containing layer effects.*

912 *Understanding the Visual Perception Created by Offset Shadows*

When you create visual perspective within a Photoshop document, you create depth by design techniques and the use of Photoshop's powerful layer effects. An important point to remember is that a Photoshop document contains width and height, but there is no depth associated to a graphic image. An obvious point is to never take image depth for granted. Although we know images do not contain depth, we perceive depth by changing the image.

For example, when you use a drop shadow layer effect, the object appears to hover over the surface of the paper, as shown in Figure 912.1.

Figure 912.1 *The drop shadow gives the impression of depth to the image.*

Although the image is just as flat as it was before you applied the drop shadow, your mind is forced into seeing depth. Did Photoshop create the depth? No, your mind created the depth. Photoshop just gave it the cues that it needed.

Depth and perception depend on how you look at the real world. For example, objects get smaller with distance, as shown in Figure 912.2.

Figure 912.2 *Reducing the size of an object makes it appear farther away.*

Try placing your hand over your left eye. When you look around, the world still looks three-dimensional. However, because you covered one of your eyes, you are actually looking at the world in a two-dimensional view. You still see three dimensions because your mind understands how the world works, and it believes that the laws of the physical universe cannot change (at least, you hope they do not change).

When you create three-dimensional and perspective designs in Photoshop, do not just click on the buttons, sit back, and say, "Wow, that looks good." Understand why you see what you see. Understand that you are taking a flat surface and painting three dimensions using color, shadows, size, angles, and everything else that works to create depth and perception.

When you understand what you are doing, you gain control over the process. You become a designer instead of a button pusher. Do not just click on buttons.

913 *Understanding Adobe's Open Architecture Programming*

When Adobe designed Photoshop, it created the program using an open architecture. Translated, that means that the program grows in two ways. One way is to create an update to the program and then sell it to you. Another way is to create plug-ins and sell them to you.

Open architecture programming is like plugging a light into the electrical socket in your home. If you want a better lamp, unplug the old lamp and plug in another, or leave the original lamp plugged in and add another lamp. It's up to you.

Plug-ins enhance the operation of Photoshop with everything from color correction to photo restoration. When you purchase plug-ins, you are actually buying a program that plugs into Photoshop and extends the features of the program.

When you purchase plug-ins, remember a few points:

- **Compatibility:** Because a plug-in is essentially program code, it must be written for a specific program. When you purchase a plug-in, make sure that it is compatible with your version of Photoshop. In addition, plug-ins that you purchased for Photoshop 5, might not work correctly with version 6. Furthermore, some plug-ins run on the Macintosh platform, and some run only on Windows. Check before you purchase a plug-in.

- **Enhancement:** Although plug-ins can save you lots of time, many plug-ins do not introduce a new feature to Photoshop. For example, you can purchase plug-ins that perform color correction. Photoshop also performs color correction, and it performs it just a good as those high-priced plug-ins if you understand how to use the curves and levels dialog boxes. Ask yourself when you purchase a plug-in if you are getting an additional feature or whether the plug-in is just making the process go faster. If faster is the answer, is it worth the cost? Only you can answer that question.

- **Plug-in creation:** If you have knowledge of programming languages such as C++, you can design and create your own plug-ins. Contact Adobe through its Web site (www.adobe.com) and apply for a software developer's license. Many programmers/designers create plug-ins for specific Photoshop functions without ever intending to market or sell them to other users. Be wary of homemade plug-ins: In many cases, they work well only on the designer's computer.

- **Actions:** The Actions palette in Photoshop (refer to Tip 410, "Using the Actions Palette") lets you create shortcuts to complicated Photoshop procedures. Before you purchase a specific plug-in, it is possible that you will be able to replicate the plug-in using Photoshop's existing features and create an action to run the procedure.

Note: There are a lot of excellent plug-ins in the marketplace, but let the buyer beware. Look and ask questions before purchasing any enhancements to Photoshop. You will be far happier and probably will wind up with more money in your pockets.

914 *Working with the Layer Style Dialog Box to Create a Shadow*

The Layer Style dialog box creates one type of shadow: a drop shadow. Drop shadows are essentially a shadow in the shape of the original image, offset and dropped behind the image. When you create a drop shadow, the object first must be on a transparent layer. The drop shadow effect creates the shadow at the edge of the object; the transparent pixels surrounding the image define the image edge, as shown in Figure 914.1.

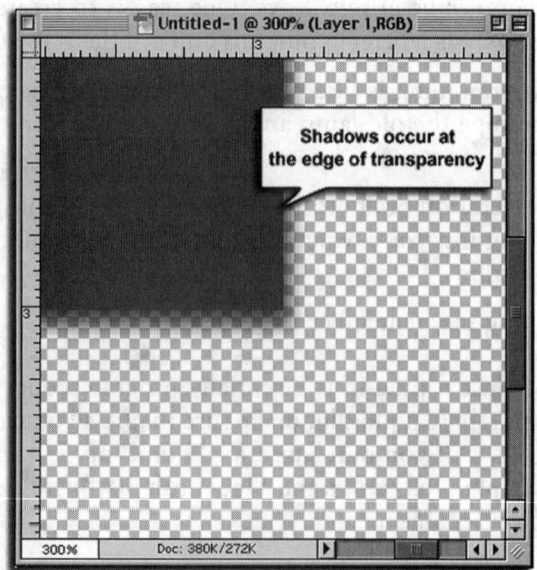

Figure 914.1 The transparent pixels at the edge of the image define the shape of the drop shadow.

To create a drop shadow, select a layer containing transparent and nontransparent pixels, and click once on the Layers Effects icon, located at the bottom left of the Layers palette. Select Drop Shadow from the pop-up menu. Photoshop opens the Layer Style dialog box, shown in Figure 914.2.

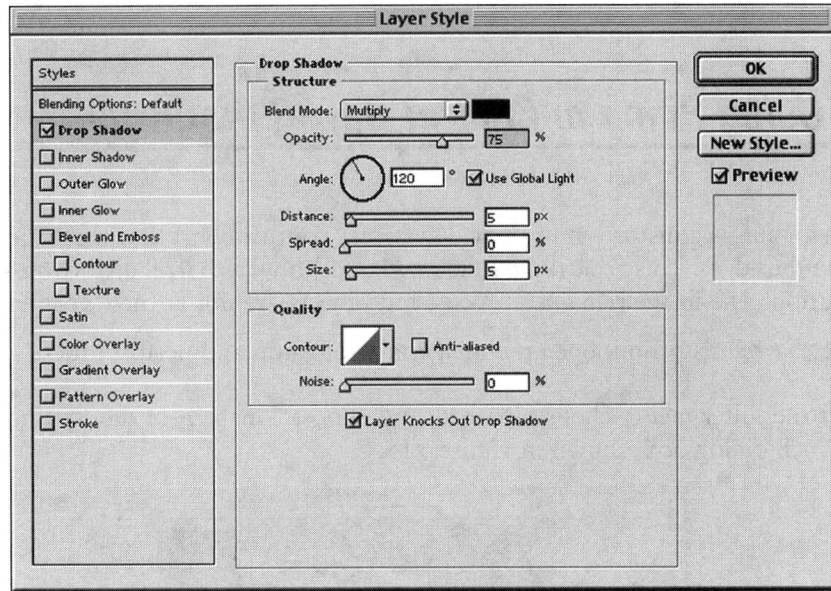

Figure 914. 2 The Layer Style dialog box controls the application of all layer effects.

- **Blend Mode:** The Blend Mode option controls the blending mode of the shadow with the background layer. Click on the button and choose from the available options. The default blending mode is Multiply.

- **Shadow Color:** Click on the small color box, located to the right of the Blend Mode option, to select a different color for the shadow. The default color is black.

- **Opacity:** Click in the Opacity input field and enter a value from 0 to 100 percent. The lower the value is, the more transparent the drop shadow is. The default value is 75 percent.

- **Angle:** The Angle option controls the direction of the light source and therefore the direction of the shadow. Click in the Angle input field and enter a value from –360 to +360 degrees. Select the Global Light option to adjust all the effect layers to conform to a single angle.

- **Distance:** Click in the Distance input field and enter a value from 0 to 30,000 pixels. The greater the value is, the greater the offset of the shadow is.

- **Spread:** Click in the Spread input field, and enter a value from 0 to 100 percent. The greater the value is, the greater mask controlling the shadow is.

- **Size:** Click in the Size input field, and enter a value from 0 to 250 pixels. The greater the value is, the greater the Gaussian blur applied to the shadow is.

- **Quality:** Click on the Quality button to remap the brightness levels of the shadow using a Curves dialog box (refer to Tip 205, "Understanding How the Curves Command Adjusts an Image").

- **Noise:** Click in the Noise input field, and enter a value from 0 to 100 percent. The greater the value the more noise mixes with the shadow. The default value is 0.

Click the OK button to apply the drop shadow to the image.

Note: *Refer to Tip 912, "Understanding the Visual Perception Created by Offset Shadows," to understand how shadows affect our visual perception.*

915 *Using Pinch to Control Barrel Distortion*

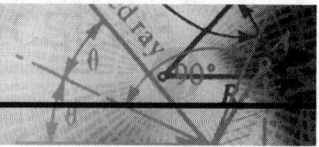

Barrel distortion is a distortion in optical systems (your camera) that magnifies the center of the image more than the edges. This typically results in what is know as barrel distortion—or, correctly stated, barrel aberration. The image remains in focus, but objects are not at their proper size.

To correct barrel distortion, open the image in Photoshop and perform these steps:

1. Select the Filter menu, choose Distort, and choose Pinch from the fly-out menu. Photoshop opens the Pinch dialog box, shown in Figure 915.1.

Figure 915.1 *The Pinch dialog box controls the application of the filter to the active image.*

2. Click in the Amount field and enter a value from –100 percent to +100 percent. Positive numbers generate a pinch, and negative numbers generate a bloat.

3. Because there is no live preview of the image, it is best to work slowly. In this example, you enter a value of 5 percent.

4. Click the OK button to apply the Pinch filter to the image, as shown in Figure 915.2.

Figure 915.2 *The Pinch filter reduced the barrel distortion.*

5. To reapply the Pinch filter, press Ctrl+F (Macintosh: Command+F) to repeat the last filter, as shown in Figure 915.3.

Figure 915.3 A reapplication of the Pinch filter using a 5 percent value corrected the barrel distortion within the image.

916 *Using the Scratch Compression Plug-in*

Photoshop uses an area of your hard drive defined as the scratch disk (refer to Tip 45, "Using More Than One Scratch Disk"). During the editing process, Photoshop uses the scratch disk to store digital information. By default, Photoshop performs compression when it stores the information, and it therefore must decompress to access the information. The process of compression and decompression slows down the program.

If your computer contains a fast hard drive, install the Disable Scratch Compression plug-in. Installation of the plug-in stops Photoshop from compressing and uncompressing the hard drive information.

To install the Disable Scratch Compression plug-in, place the Photoshop 6.0 CD in your CD drive, and locate and open the Optional Extensions folder. Click on and drag the Disable Scratch Compression file into the Plug-ins folder in the Photoshop applications folder, as shown in Figure 916.1.

Figure 916.1 Click on and drag the Disable Scratch Compression file into the Photoshop Plug-ins folder.

To use the new plug-in, close and restart Photoshop. The Disable Scratch Compression plug-in does not change how you work in Photoshop, but you should see an improvement in overall speed performance, especially when you edit large graphic images. If you want to return Photoshop to its normal compression of the scratch disk information, remove the plug-in from the Plug-ins folder and restart Photoshop.

917 *Working with Unlimited Clipboard Size*

In the previous tip, you learned how to enhance Photoshop by modifying how Photoshop works with the scratch disk. If needed, the Unlimited Clipboard Size plug-in lets you change how Photoshop uses the Clipboard. Photoshop uses the Clipboard to store normal copy and paste functions, performed while editing a document. When you close Photoshop, you have the option of saving the copied material in the Clipboard RAM memory (refer to Tip 40, "When to Use the Export Clipboard Option"). Photoshop restricts the Export Clipboard command to a maximum of 4MB of RAM. It does this to prevent other open programs that need RAM memory from crashing. Typically, low RAM memory causes programs to crash.

If you have additional RAM memory (256MB or more) and you typically copy and paste Photoshop information from one document to another, installing the Unlimited Clipboard Size plug-in disables Photoshop's 4MB maximum export size.

To install the Unlimited Clipboard Size plug-in, place the Photoshop 6.0 CD in your CD drive, and locate and open the Optional Extensions folder. Click on and drag the Unlimited Clipboard Size file into the Plug-ins folder in the Photoshop applications folder, as shown in Figure 917.1.

Figure 917.1 Click on and drag the Unlimited Clipboard Size file into the Photoshop Plug-ins folder.

To use the new plug-in, close and restart Photoshop. The Unlimited Clipboard Size plug-in does not change how you work in Photoshop. However, you should now be able to copy large image areas of a document, close Photoshop, and paste the exported data into a document in another open program. If you experience frequent program crashes and want to return Photoshop to its normal 4MB limitation of exported data, remove the plug-in from the Plug-ins folder and restart Photoshop.

918 *Installing the Unlimited Preview Plug-in*

In the previous tip, you learned how to add functionality to Photoshop by adding the Unlimited Clipboard Size plug-in. The Unlimited Preview plug-in modifies saved Photoshop documents and lets you increase the preview size of a saved file.

When you save a file in Photoshop, you have the option of saving the file with a full size preview (refer to Tip 61, "Saving Files with Image Previews"). Layout programs such as InDesign and QuarkXPress use image previews to display the file on the layout screen.

When you select the Full Size preview option (refer to Tip 61), Photoshop limits the maximum size of the image preview to 512 by 512 pixels. For large Photoshop images, this causes the graphic to appear pixilated.

In most cases, image previews are use for placement only (FPO); the layout program does not use the image preview for print. However, sometimes you want large Photoshop images to display well in the layout document. The Unlimited Clipboard Size plug-in, when installed, removes the 512-by-512 pixel limit from image previews.

To install the Unlimited Preview plug-in, place the Photoshop 6.0 CD in your CD drive, and locate and open the Optional Extensions folder. Click on and drag the Unlimited Preview Size file into the Plug-ins folder in the Photoshop applications folder, as shown in Figure 918.1.

Figure 918.1 Click on and drag the Unlimited Preview Size file into the Photoshop Plug-ins folder.

To use the new plug-in, close and restart Photoshop. The Unlimited Preview plug-in does not change how you work in Photoshop. However, you should now be able to use better-quality previews in layout programs such as InDesign and QuarkXPress. If you want to return Photoshop to its normal 512-by-512 limitation for image previews, remove the plug-in from the Plug-ins folder and restart Photoshop.

919 *Using the Force VM Compression Plug-in*

In Tip 916, "Using the Scratch Compression Plug-in," you learned how to disable the compression of Photoshop's scratch disk information. The Force VM Compression plug-in modifies the way Photoshop saves scratch disk information to further compress the data.

Say, for example, that you work on a laptop computer without a lot of available hard drive space. Your problem is not speed, but simple usability. Every time you attempt to save a file on your laptop's hard drive, you receive an out-of-disk-space error. You can correct the problem by removing information from the laptop's hard drive, but you need everything that is on the drive.

The problem is not just the lack of space on your hard drive; it is also a problem with how Photoshop uses the scratch disk. By default, Photoshop uses five times the size of your image file in scratch disk space. Say, for example, that you edit a 25MB document; Photoshop requires 125MB of free hard drive space. You might be able to work on the image, but when you try to save the file, Photoshop still holds on to the additional 125MB, and you do not have the room to save the file.

The Force VM Compression plug-in performs aggressive compression of the scratch disk space during a file save command, and the compression of the scratch disk should free up enough hard drive space to enable you to save the file.

To install the Force VM Compression plug-in, place the Photoshop 6.0 CD in your CD drive, and locate and open the Optional Extensions folder. Click on and drag the Force VM Compression file into the Plug-ins folder in the Photoshop applications folder, as shown in Figure 919.1.

Figure 919.1 Click on and drag the Force VM Compression file into the Photoshop Plug-ins folder.

To use the new plug-in, close and restart Photoshop. The Force VM Compression plug-in does not change how you work in Photoshop. However, you should now be able to save files without receiving an out-of-disk-space error. If you want to return Photoshop to its normal operation, remove the plug-in from the Plug-ins folder and restart Photoshop.

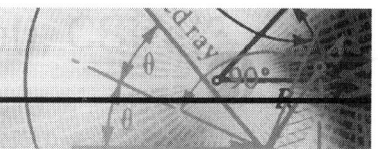

920 *Working with Text Annotations*

Photoshop contains a new tool for creating text notes. The Notes tool lets you create one or more text-based notes and attach them to the active document.

To create a text note, open a Photoshop document and select the Notes tool from the toolbox, as shown in Figure 920.1.

Figure 920.1 The Notes tool lets you create text-based annotations.

Move the Notes tool into the document window and click once. Photoshop opens the text input box, shown in Figure 920.2.

Move your mouse into the text input box and enter the text (refer to Figure 920.2). To modify the author name, font, and font size, move your mouse into the Options bar, shown in Figure 920.3.

- **Author Name:** In the Author Name field, enter a title for the text note.

- **Font:** Click the Font button and choose from the available fonts.

- **Size:** Click the Size button and choose from the available size options.

- **Color:** Click on the color box to select a different color for the note icon.

- **Clear All:** Click on the Clear All button to delete the current note.

To collapse the note, click once on the Collapse button in the upper-left corner of the note. Photoshop collapses the note and displays a note icon. To reopen the note, double-click on the Note icon, as shown in Figure 920.4.

Figure 920.2 *Click in the text input box to create a text-based note.*

Figure 920.3 *The Options bar controls the characteristics of the text note.*

Figure 920.4 *The Note icon indicates a previously saved text note.*

921 *Experimenting with the Use All Layers Option*

The Use All Layers option lets you control editing effects in a Photoshop document by placing the modifications to the document within a separate layer.

The Use All Layers option is located in the Options bar. To activate the Use All Layers option, select one of the editing tools from the toolbox, move into the Options bar, and select the Use All Layers option, as shown in Figure 921.1.

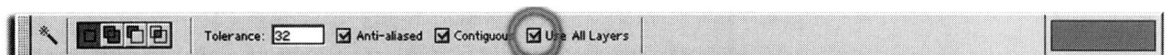

Figure 921.1 The Use All Layers option lets you control or edit a document using one or more layers.

The following Photoshop tools let you modify the document within a separate layer:

- **Magic Wand:** Selecting Use All Layers lets you select information within a Photoshop multi-layered document based on where you click within the visible image, not the active layer.

- **Clone Stamp:** Selecting Use All Layers lets you modify a document by using one or more transparent layers. Although using transparent layers with the Clone Stamp tool is not a requirement, it gives you flexibility and control over the image.

- **Magic Eraser:** Selecting Use All Layers lets you erase areas of an image based on where you click in the document window, not the active layer.

- **Blur/Sharpen/Smudge:** Selecting Use All Layers lets you modify a document by using one or more transparent layers.

922 *Creating Quick Marbleized Text*

To create quick marbleized text, open Photoshop and perform these steps:

1. Select the File menu and choose New. Photoshop opens the New dialog box. Create a new document with a width of 5 inches, a height of 5 inches, and a resolution of 150ppi in RGB mode, as shown in Figure 922.1.

2. Select the Type tool from the toolbox, and create a type mask (refer to Tip 653, "Working with the Type Mask Tool"). In this example, you select Impact at 60 points, as shown in Figure 922.2.

3. Move into the Layers palette and create a new layer by clicking on the New Layer icon, as shown in Figure 922.2.

4. Press the letter "D" on your keyboard to default the foreground and background colors to black and white.

5. Select the Filter menu, choose Render, and choose Clouds from the fly-out menu. Photoshop fills the type mask using the Clouds filter, as shown in Figure 922.3.

Figure 922.1 The New dialog box defines the characteristics of the new document.

Figure 922.2 The Type Mask tool created the word MARBLE in the Impact font.

Figure 922.3 The type mask filled with the Clouds filter.

6. Select the Filter menu, choose Stylize, and choose Find Edges from the fly-out menu.

7. Select the Image menu, choose Adjust, and choose Invert from the fly-out menu. The image turns black, as shown in Figure 922.4.

Figure 922.4 The Find Edges and Invert commands applied to the text mask.

8. Select the Image menu, choose Adjust, and select Equalize from the pull-down menu. The document now resembles Figure 922.5.

Figure 922.5 The Equalize command brings out the marble look in the type mask.

9. To colorize the marble text, select the Image menu, choose Adjust, and select Hue & Saturation from the fly-out menu. Photoshop opens the Hue/Saturation dialog box, shown in Figure 922.6.

10. Select the Colorize option, and enter a Hue value of 150 and a Saturation value of 40 (refer to Figure 922.6). Click the OK button to apply the Hue & Saturation filter to the type mask.

11. To complete the effect, click once on the Layers Effects icon, located at the bottom left of the Layers palette, and select Bevel and Emboss from the pop-up menu. Photoshop opens the Layer Style dialog box.

Figure 922.6 The Hue/Saturation dialog box.

12. Click once on the Style option and select Inner Bevel from the drop-down list.

13. Click once on the Technique option and select Chisel Hard from the drop-down list.

14. Enter a Depth value of 200 and a Size value of 5. Press the Enter key, or click OK to apply the bevel to the selected type mask, as shown in Figure 922.7.

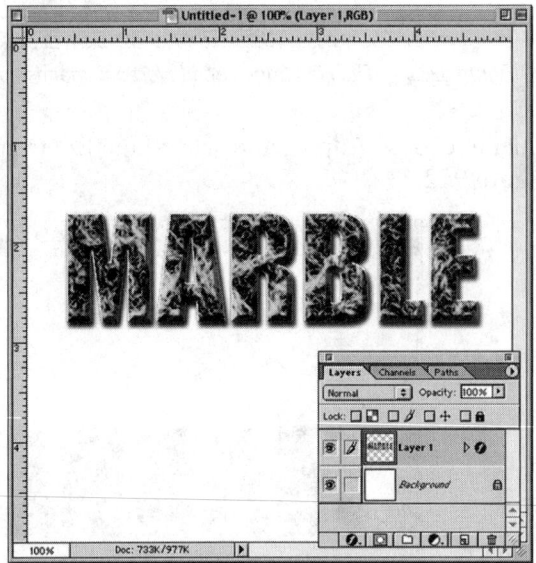

Figure 922.7 The completed image with the bevel option applied to the text.

923 *Working with Color Reproduction Basics*

When you work on an image using your monitor, you view the image using additive RGB (red, green, and blue) pixels. When sent to an offset press, that same image prints the image using subtractive CMYK (cyan, magenta, yellow, and black) inks. The color spaces of monitors and printing presses are different; however, they are not incompatible.

When you work on a CMYK image, calibrate the RGB monitor to the press (refer to Tip 57, "Calibrating Monitor Color Using the Adobe Gamma Utility"). In addition, you need a good color proof

using the calibration settings (refer to Tip 558, "Using a Hard Proof to Check for Consistent Color"). However, before you send the image to the service bureau, call the printer and ask these questions:

- **The lines per inch (LPI) used by the printing press:** Knowing the LPI of the press helps you determine the best resolution to use for scanning and saving documents.

- **Paper stock dot gain:** The dot gain of the paper represents how much the inks spread when they hit the paper. Knowing this value lets you compensate for the dot gain using Photoshop's Printer Setup (refer to Tip 108, "Understanding Dot Gain and Ink Coverage").

- **Printing methods (UCR/GCR):** The GCR (Gray Component Removal) printing method produces better color printing. The UCR (Under Color Removal) printing method works best on images with deep shadows (refer to Tip 11, "Setting Up Photoshop's Color Settings").

- **File formats:** Save the file in the format recommend by your service bureau (refer to Tip 711, "Deciding File Formats Based on Final Output").

Note: Color reproduction is not an exact science. Staying informed of the process is your best bet to reproducing consistent color.

924 *Creating Wire-Frame Text*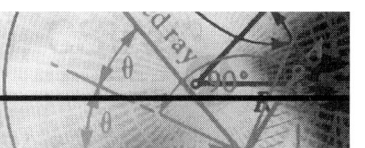

To create some cool-looking wire-frame text, open Photoshop and perform these steps:

1. Select the File menu and choose New. Photoshop opens the New dialog box. Create a new document with a width of 5 inches, a height of 5 inches, and a resolution of 150ppi in RGB mode, as shown in Figure 924.1.

Figure 924.1 The New dialog box defines the characteristics of the new document.

2. Move your mouse into the Swatches palette and select a color to fill the background layer. In this example, you select a light gray.

3. Press Alt+Delete (Macintosh: Option+Delete) to fill the background with the current foreground color.

4. If the Layers palette is not open, select the Window menu and choose Show Layers from the pull-down menu. Photoshop opens the Layers palette.

5. Create a new layer by clicking once on the New Layer icon, as shown in Figure 924.2.

Figure 924.2 Clicking once on the New Layer icon creates a new transparent layer.

6. Select the Type tool from the toolbox, and create a type mask using the word "WIRE" (refer to Tip 653, "Working with the Type Mask Tool"). In this example, you select Impact at 72 points, as shown in Figure 924.3.

Figure 924.3 The Type Mask tool created the word "WIRE" in the Impact font.

7. Move your mouse into the Swatches palette and select a color to use for the wire-frame text. In this example, you select a bright yellow.

8. Select the Edit menu and choose Stroke from the pull-down menu. Photoshop opens the Stroke dialog box, shown in Figure 924.4.

9. Click in the Width input field and enter a value of 5. Select the Center Location option. Click the OK button to apply the stroke to the image (refer to Figure 924.4).

10. Click once on the Layers Effects icon, located at the bottom left of the Layers palette, and select Bevel and Emboss from the pop-up menu. Photoshop opens the Layer Style dialog box, shown in Figure 924.5.

11. Click once on the Style option and select Inner Bevel from the drop-down list.

12. Click once on the Technique option and select Smooth from the drop-down list.

Figure 924.4 The Stroke dialog box controls the application of the stroke to the type mask.

Figure 924.5 The Layer Style dialog box controls the characteristics of the bevel option.

13. Add a drop shadow by clicking once on the Drop Shadow Style (refer to Figure 924.5).

14. Click in the Distance input field and enter a value of 10.

15. Click the OK button to add the bevel and drop shadow to the stroked type, as shown in Figure 924.6.

Figure 924.6 The completed wire-frame text.

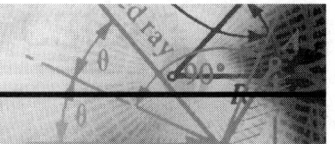

925 *Recognizing Colors That Will Not Print*

In Tip 923, "Working with Color Reproduction Basics," you learned that monitors and printing presses use different color systems. In reality, your monitor can displays millions more colors than a printing press is capable of printing. RGB colors that do not reproduce on a printing press are defined as out of gamut. The term *gamut* describes the printable color within a specific color space.

Photoshop lets you view out-of-gamut colors by placing a mask over the nonprintable areas of the image.

To identify the out-of-gamut areas within an RGB image, open the document in Photoshop, select the View menu, and select Gamut Warning from the pull-down menu. By default, Photoshop places a 100 percent gray mask over the out-of-gamut colors, as shown in Figure 925.1.

Figure 925.1 The gray areas of the image represent the out-of-gamut colors within the active image.

To modify the opacity and color used by the Gamut Warning command, select the Edit menu, choose Preferences, and choose Transparency & Gamut from the fly-out menu. Photoshop opens the Transparency & Gamut Preferences dialog box, as shown in Figure 925.2.

Figure 925.2 The Transparency & Gamut Preferences dialog box lets you control the color and opacity of the gamut warning.

Click once in the Color box and select a different gamut color using Photoshop's color picker (refer to Tip 62, "Manually Choosing Colors with the Color Picker"). In the Opacity input box, enter a value from 1 to 100 percent. The lower the opacity value is, the more transparent the gamut warning slider will be. Click the OK button to apply the changes to the Photoshop program, as shown in Figure 925.3.

Figure 925.3 The Gamut Warning command modified to use a 75 percent bright yellow.

Note: Changing the Gamut preferences changes the preferences for all Photoshop documents, not just the open document.

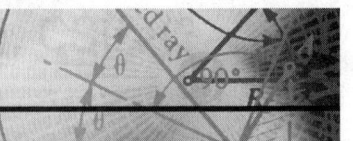

926 *Quickly Editing Out-of-Gamut Colors*

In the previous tip, you learned how to identify the out-of-gamut colors within an RGB image. If you convert an RGB image containing out-of-gamut colors into the CMYK color space, Photoshop will, by default, move the colors into the CMYK color palette. The image then shifts color.

Although color shifting is inevitable, it is possible to correct the image before converting into the CMYK color space.

To quickly correct out-of-gamut colors, open the RGB image in Photoshop and perform these steps:

1. Select the View menu and select Gamut Warning from the pull-down menu. Photoshop places a mask over the out-of-gamut colors, as shown in Figure 926.1.

Figure 926.1 The masked areas of the image represent the out-of-gamut colors within the active image.

2. Choose the Select menu and choose Color Range from the pull-down menu. Photoshop opens the Color Range dialog box, shown in Figure 926.2.

Figure 926.2 The Color Range dialog box lets you select the out-of-gamut colors in the active image.

3. Click on the Select option and choose Out of Gamut from the drop-down list. Click the OK button to apply the selection to the image. Photoshop creates a selection around the out-of-gamut color, as shown in Figure 926.3.

Figure 926.3 The Color Range command selected the out-of-gamut colors.

4. Select the Image menu, choose Adjust, and choose Hue & Saturation from the pull-down menu. Photoshop opens the Hue/Saturation dialog box, as shown in Figure 926.4.

Figure 926.4 The Hue/Saturation dialog box controls the saturation of the selected areas of the image.

5. The problem with out-of-gamut colors is not the color, but the saturation of the ink. Click on the Saturation slider and drag to the left until the gamut warning disappears from the image. In this example, you successfully correct the image by reducing the saturation of the out-of-gamut pixels by –30 percent, as shown in Figure 926.5.

Note: Reducing the saturation of the inks is not always successful, but when it works, it is a quick and easy way to bring the colors within an image into CMYK gamut.

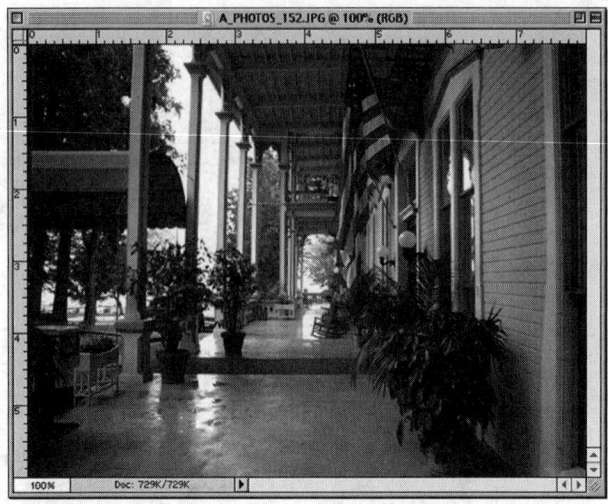

Figure 926.5 *Reducing the saturation of the selected areas of the image brought the colors back into CMYK gamut.*

927 *Working with the Twain Interface*

When Photoshop 6.0 hit the market, it changed how we deal the Twain interface. Before Photoshop 6.0, you had Twain Select and Twain Acquire options. To select an input device, you selected the File menu and chose Import.

The Twain function is important because it lets you access your scanners, digital cameras, and other input devices. The most common use of the Twain function is to scan images directly into Photoshop without having to save the image and reopen the saved image in Photoshop (refer to Tip 119, "Importing Images Directly from a Scan").

When you select the File menu and choose Import, Photoshop 6.0 does not display an Acquire and Select option; your input devices appear directly in the fly-out menu, as shown in Figure 927.1.

Figure 927.1 *The Import fly-out menu displays a list of available input devices.*

To have an input device appear in the Import menu, check with the user's manual that came with the device and follow the installation instructions. The installation procedure places a file in the Twain preferences folder that instructs Photoshop to access that particular device.

Note: Not every input device is Photoshop-compliant. If you have question concerning a specific scanner or digital camera, a good place to start is the company's Web site. In many cases, the software that you need is on the site and can be downloaded free.

928 *Adjusting the Dot Gain of a Grayscale Image*

If you view grayscale images on a monitor, adjusting dot gain is not necessary. The dot gain option defines the amount of spread that the inks experience when applied to paper. Both inks and papers are responsible for dot gain, but low-quality printing paper is the biggest offender when it comes to large dot gains.

Because your monitor does not experience dot gain, images printed on low-quality paper have a tendency to appear darker than the same image viewed on a computer monitor. Photoshop lets you compensate for the dot gain of paper by giving you an adjustment feature.

To access Photoshop's dot gain options, open a grayscale image, select the Edit menu, and choose Color Settings from the fly-out menu. Photoshop opens the Color Settings dialog box, shown in Figure 928.1.

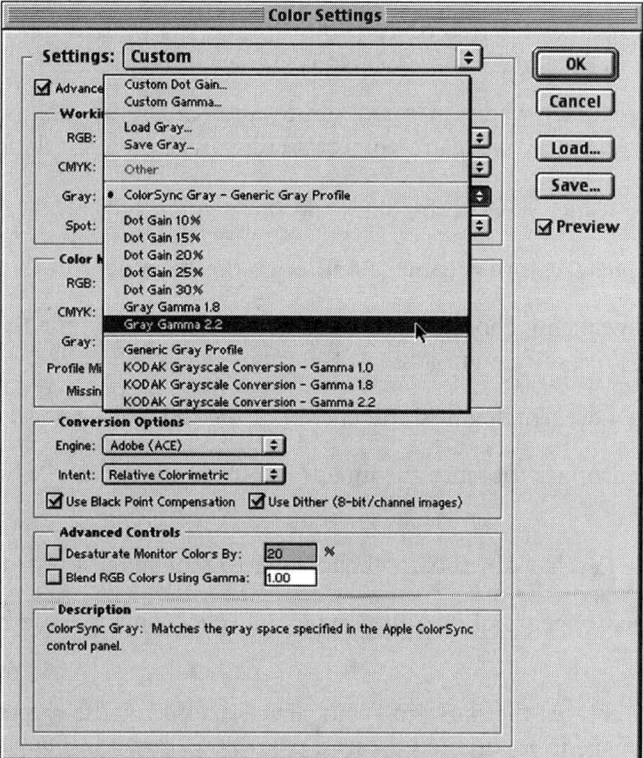

Figure 928.1 The Color Settings dialog box lets you control the dot gain of a printed image.

Click on the Gray option, located under Working Spaces, and select a dot gain from the drop-down list:

- **Dot Gains 10–30 Percent:** Click on one of the preset dot gain options. Lower dot gain values produce a lighter image. If you have the Preview option selected, you see the change occur to the image.

- **Gray Gamma 1.8:** Select the 1.8 Gamma option to view the image as it displays on an average Macintosh monitor.

- **Gray Gamma 2.2:** Select the 2.2 Gamma option to view the image as it displays on an average Windows monitor.

- **Custom Gamma and Custom Dot Gain:** Select the Custom options to create a customized dot gain or gamma value.

Click the OK button to apply the changes to the Photoshop program.

> *Note: For correct adjustments, contact your printer and ask for advice on setting the dot gain value for grayscale images.*

929 *Quickly Removing Color Casts Introduced by a Scanner*

A common problem with scanning images is that sometimes the scanner introduces a color cast to the image. Although this is frustrating, it is not difficult to correct.

The first step to correcting the color cast introduced by a scanner is to purchase an 11-step gray wedge. A gray wedge, sometimes referred to as a color target, is a piece of photographic paper exactly matched to black to white in 10 percent increments, as shown in Figure 929.1.

You can purchase a gray wedge at many photo and camera stores, as well as from computer product magazines. To use the gray wedge to correct a color cast, perform these steps:

1. Place the gray wedge next to the photo on the scanner bed, as shown in Figure 929.2.

2. Perform a normal scan of the image and open the document in Photoshop.

3. Select the Image menu, choose Adjust, and select Levels from the fly-out menu. Photoshop opens the Levels dialog box, shown in Figure 929.3.

4. Move into the Levels dialog box and click once on the white Eyedropper tool (refer to Figure 929.3).

5. Move the Eyedropper tool into the image and click once on the white box at the bottom of the gray wedge.

6. Move into the Levels dialog box and click once on the black Eyedropper tool (refer to Figure 929.3).

7. Move the Eyedropper tool into the image and click once on the black box at the top of the gray wedge.

8. Photoshop calibrates the dark and light levels based on the target values of the gray wedge, and restores the image to its original prescan colors, as shown in Figure 929.4.

Figure 929.1 *An 11-step gray wedge contains white to gray to black in 10 percent increments.*

Figure 929.2 *Place the gray wedge adjacent to the image on the scanner bed.*

Figure 929.3 *The Levels dialog box controls the shadows, highlights, and midtones of the active image.*

Figure 929.4 Sampling black and white using the gray wedge restored the original color values of the scanned image.

930 *Using Lab Color to Sharpen an RGB Image*

In Tip 256, "Converting an Image to Grayscale Using Lab Color," you learned the best way to move an image into the grayscale color mode. Another application of the Lab color space is the sharpening of an RGB (red, green, and blue) color image.

To sharpen an RGB image, open the document in Photoshop and perform these steps:

1. Select the Image menu, choose Mode, and choose Lab from the fly-out menu. Photoshop converts the RGB colors into the Lab color space.

2. If the Channels palette is not open, select the Window menu and choose Show Channels from the pull-down menu. Photoshop opens the Channels palette, shown in Figure 930.1.

Figure 930.1 The Channels palette identifies each color channel within the active document.

3. Click once on the Lightness channel. Photoshop activates that channel, which contains the brightness values for the image, as shown in Figure 930.2.

Figure 930.2 The Lightness channel controls the brightness values for the Lab color image.

4. Select the Filter menu, choose Sharpen, and select Unsharp Mask from the fly-out menu. Photoshop opens the Unsharp Mask dialog box.

5. Sharpen the visible image using the Unsharp Mask options (refer to Tip 524, "Applying Unsharp Mask"). In this example, you choose an amount of 45, a radius of 1.2, and a threshold of 12. Click the OK button to apply the Unsharp Mask to the Lightness channel.

6. Move into the Channels palette and click once on the Lab channel. Photoshop reactivates all the image channels.

7. Select the Image menu, choose Mode, and choose RGB from the fly-out menu. Photoshop returns the image to RGB color space, as shown in Figure 930.3

Figure 930.3 The sharpened image returned to the RGB color space.

Note: *When you use the Unsharp mask on an RGB image, you sharpen the entire image. Because RGB channels record percentages of ink in addition to sharpening the image, you lose image detail and shift image color. When you convert the image into Lab and sharpen the Lightness channel, you sharpen the image without overly affecting the detail or the color. This is a better way to work.*

931 *Why Scanned Images Appear Dull*

Flatbed scanners are tremendous devices: They let you convert a continuous-tone image into a rasterized image or an image composed of pixels. The scanner maps the pixels and Photoshop reorganizes the data into a photograph. In that sense, a scanner is simply the device that you use to move the image into Photoshop.

Although scanners have greatly improved over the last few years, the best advice about reflective scanners is this: Do not use one unless necessary. If possible, use a slide or a negative scanner to access the original image data.

Flatbed or *reflective* scanners use two steps to retrieve the image data. They shine a light source on the object, and then the image reflects some of the light back to the scanner's input, as shown in Figure 931.1.

Figure 931.1 Flatbed scanners record the reflected light from the scanned object.

The light source must travel to the object and bounce back to the scanner's input array. Traveling that distance has a tendency to flatten and dull the colors within an image. One of the biggest complaints about scanned images is that they lose some of their sharpness. That loss is due to the distance traveled to and from the scanned object.

When you scan the original negative or slide, the scanner projects light *through* the image and immediately captures the light on the other side of the slide or negative. Because the light source does not have to travel very far, the scanned image appears sharper and the colors look more vivid, as shown in Figure 931.2.

One other reason to scan a negative or slide is that you are working with the original image. A print is not the original image. No matter how well prepared they are, copies cannot compete in quality with the original image. Therefore, using the original negative or slide is the way to go.

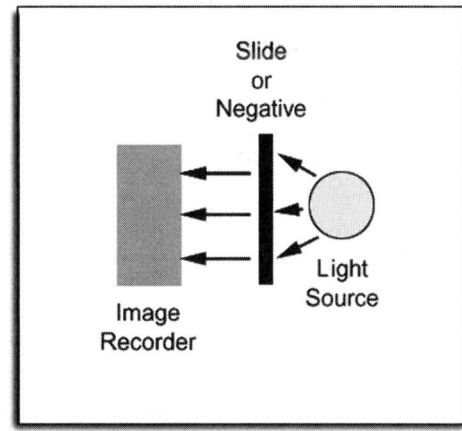

*Figure 931.2 Using a slide or negative scanner produces a crisper, brighter image because
the light does not have far to travel.*

932 *Using Transform on Linked Layers*

When you work on a multi-layered document, Photoshop lets you control each layer individually. As a designer, you keep an eye on the Layers palette. When you want to work on a specific portion of an image, you select the correct layer and begin working.

One of the biggest frustrations is not paying attention to the Layers palette and realizing that you made the editing modification in the wrong layer. Of course, that is when Photoshop's wonderful History palette and multiple undoes come in handy (refer to Tip 397, "Understanding How History Operates").

Say, for example, that you want to move or transform objects on two or more layers. Photoshop's layer-linking option lets you link several layers and move or transform the objects within the selected layers.

To use Photoshop's linking feature, open a multi-layered document and perform these steps:

1. If the Layers palette is not open, select the Window menu and choose Show Layers from the pull-down menu. Photoshop opens the Layers palette, shown in Figure 932.1.

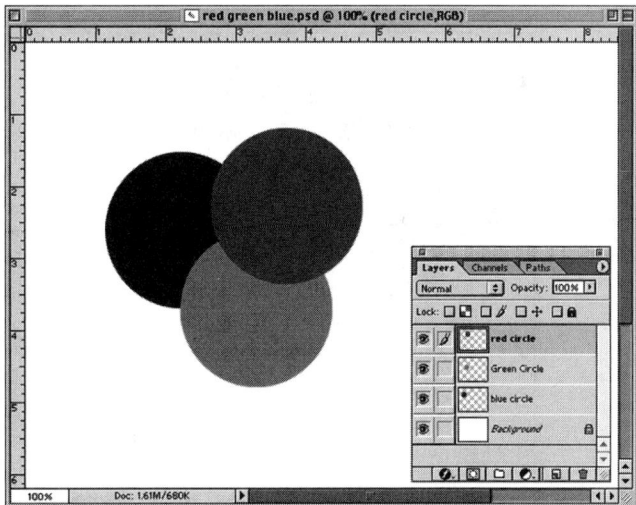

Figure 932.1 The Layers palette displays a thumbnail for all the active layers in the open document.

2. To move the elements within a single layer, move into the Layers palette and click once on a layer. In this example, you select the blue circle layer.

3. Select the Move tool from the toolbox.

4. To relocate the blue circle, move into the document window and click and drag your mouse. Photoshop moves the blue circle.

5. To move the blue circle and the red circle at the same time, leave the blue circle selected and click once in the Layers linking box, as shown in Figure 932.2.

Figure 932.2 Clicking once in the Layers linking box adds a chain icon to the red circle layer.

6. Move the cursor into the document window and click and drag your mouse. You move the blue and red circles.

7. Leave the blue and red circles selected.

8. Select the Edit menu and choose Free Transform from the pull-down menu. Photoshop places a bounding box around the blue and red circles.

9. Transform the two objects by clicking on and dragging any of the bounding box anchor points, as shown in Figure 932.3.

Figure 932.3 The Free Transform option works on linked layers.

10. To deactivate the link, click once on the link icon. Photoshop removes the link between the two layers.

933 *Flipping Photoshop Images*

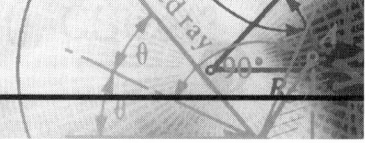

Photoshop gives you the option to flip an image vertically or horizontally. Say, for example, that you have a portrait of someone and you want to place a flipped version into another layer to create a mirror image.

To flip a Photoshop image, open the document in Photoshop and perform these steps:

1. If the Layers palette is not open, select the Window menu and choose Show Layers from the pull-down menu. Photoshop opens the Layers palette.

2. Select the Move tool from the toolbox.

3. Move into the Layers palette and click once on the layer containing the image that you want to flip.

4. To make a copy of the image layer, move into the document window, hold the Alt key (Macintosh: Option key) and drag to the left. Photoshop makes a copy of the selected layer, as shown in Figure 933.1.

Figure 933.1 Clicking and dragging while holding down the Alt key (Macintosh: Option key) makes a copy of the selected pixels or layer.

5. Move into the Layers palette and click once on the copied layer.

6. Select the Edit menu, choose Transform, and choose Flip Horizontal from the fly-out menu. Photoshop flips the copied layer, as shown in Figure 933.2.

Figure 933.2 The Flip Horizontal command flips the image and creates a mirror image of the original.

934 *Managing Your Workflow*

When you work in Photoshop, the term *workflow* defines how you work. Say, for example, that you scan an image using a Microtek ScanMaker 4, move into Photoshop and edit the document using Photoshop 6 on a Diamond 21-inch color monitor, and print using an Epson 1520 Stylus Color printer. The history of working on that particular document defines the image's workflow.

Workflow is not some button that you push in Photoshop; it is how you do things. Most Photoshop users have more than one workflow. You might work from scan to ink-jet printer, or scan to four-color press. When you create an image, edit the image, and finally print or display the image, you created a workflow. If you generate more than one document using the same options, you can create consistency by using the same workflow (this is where the button pushing comes into play).

In Photoshop, workflow is knowledge of the devices that define the workflow environment. For example, you should know the scanner that you use to access pixel information, the programs that you use to edit the document, and the capabilities of the output device. Photoshop lets you combine this information into a profile.

Using Photoshop, you can define a workflow for each specific type of job you perform. Photoshop defines a workflow as a document profile (refer to Tip 560, "Assigning an ICC Color Profile to a Photoshop Document").

To create a profile, select the Edit menu and choose Color Settings from the pull-down menu. Photoshop opens the Color Settings dialog box.

Note: The key to efficiency in Photoshop is to watch how you work and create a Color Settings profile for each definable workflow (refer to Tip 261, "Editing Photoshop's Color Settings"). Then load the correct profile to match your workflow.

935 *Creating Carved Text*

In this tip, you create carved text from a specific background. In this example, you want to create carved text from the stone graphic created in Tip 893, "Creating a Stone Background". Open the image in Photoshop and perform these steps:

1. If the Layers palette is not open, select the Window menu and choose Show Layers from the pull-down menu. Photoshop opens the Layers palette.

2. Select the Type tool from the toolbox, and create a type mask (refer to Tip 653, "Working with the Type Mask Tool"). In this example, you select Impact at 150 points, as shown in Figure 935.1.

Figure 935.1 The Type Mask tool created the word "CARVED" in the Impact font.

3. Press Ctrl+J (Macintosh: Command+J) on your keyboard. Photoshop makes a copy of the masked layer based on the background texture, as shown in Figure 935.2.

Figure 935.2 Pressing Ctrl+J (Macintosh: Command+J) creates a copy based on the selected type mask.

4. Move into the Layers palette and create a new layer by clicking once on the New Layer icon. Photoshop creates a new layer directly above the text copy layer in the Layers palette.

5. Press the letter "D" on your keyboard to default the foreground and background colors to black and white.

6. Press the letter "X" on your keyboard to reverse the foreground and background colors.

7. Press the Ctrl key (Macintosh: Command key) and click once on the copied layer containing the copied text (the middle layer). Photoshop creates a selection based on the type mask.

8. Select the Edit menu and choose Stroke from the pull-down menu. Photoshop opens the Stroke dialog box, shown in Figure 935.3.

Figure 935.3 The Stroke dialog box controls the application of the stroke to the type mask.

9. Click in the Width input field and enter a value of 4. Select the Center Location option. Click the OK button to apply the stroke to the image (refer to Figure 935.3).

10. You now have three layers: the original stone graphic layer (on the bottom), the copied type layer (in the middle), and white-stroked layer (on top).

11. Click once on the white stroke layer (the top layer).

12. Click once on the Layers Effects icon, located at the bottom left of the Layers palette, and select Bevel and Emboss from the pop-up menu. Photoshop opens the Layer Style dialog box, shown in Figure 935.4.

13. Click once on the Style list box and select Outer Bevel from the available options.

14. Click once on the Technique list box and select Smooth from the available options.

15. Enter a Depth value of 200 and a Size value of 10.

16. Select the Down option to complete the carved Effect.

17. Click OK or press the enter key to apply the bevel to the selected layer, as shown in Figure 935.5.

Figure 935.4 The Layer Style dialog box controls the application of the bevel to the white stroke layer.

Figure 935.5 The completed effect resembles text carved into stone.

936 *Choosing Serif or Sans Serif Fonts*

Although Photoshop is not a text-processing program, you can generate and manipulate text in a number of creative ways. Understand that it is not just the typing of the text that makes a document; you also want to consider the type of font.

Fonts fall into two categories:

- **Serif:** *Serif* is the Latin word for "feet." You identify serif fonts by the small extensions (feet) at the end of the lines that define the letter, as shown in Figure 936.1.

- **Sans serif:** Sans serif fonts do not have small lines or extensions at the end of the lines defining the text, as shown in Figure 936.2.

Sans serif fonts work best for large body text such as headlines and short sections of large point-size text, as shown in Figure 936.3.

**Serif fonts have extensions
at the end of the lines that
define the letters**

Figure 936.1 Serif fonts have small feet at the end of the lines defining the text.

Sans serif fonts do not
have extensions at the end
of the lines that define the
letters

Figure 936.2 Sans serif fonts do not have extensions at the ends of the lines defining the text.

**SANS SERIF FONTS
MAKE
GREAT HEADLINES**

Figure 936.3 Use sans serif fonts for large attention-grabbing text.

Serif fonts use the design of the font to help guide the eye from word to word. Therefore, they are ideal for paragraph text or bodies of text, as shown in Figure 936.4.

Serif fonts work well for large areas
of body text. Serif fonts work well for large areas
of body text. Serif fonts work well for large areas
of body text. Serif fonts work well for large areas
of body text. Serif fonts work well for large areas
of body text. Serif fonts work well for large areas
of body text. Serif fonts work well for large areas
of body text. Serif fonts work well for large areas
of body text. Serif fonts work well for large areas
of body text.

Figure 936.4 A serif font works best with large bodies of text.

Most graphic designs are more than images; a firm knowledge of fonts and their proper use goes a long way to making your designs a success. Fonts are not an afterthought. Select a serif or sans serif font to enhance the overall design of image, not just to place words on a page.

937 *Indexing Your Images Using Contact Sheets*

Nothing is more frustrating than trying to locate one specific image from the thousands of images in your files. I hate to use a timeworn phrase, but it is like trying to find a needle in a haystack. In Tip 100, "Working with Contact Sheets," you learned how to generate a contact sheet from your graphics. A practical way to use the contact sheet option is to create folders of your images and generate contact sheets for each folder.

Say, for example, that you want to organize your graphic images, and you own a rewriteable CD drive. To organize your graphic images, place selected groups of graphics on a rewriteable CD and then use Photoshop to create a contact sheet of the graphics. Each CD contains a specific group of images, such as sunsets, portraits, or backgrounds.

To organize your CD, place a group of images in a folder and write them to a CD, as shown in Figure 937.1.

Figure 937.1 Organizing your images by placing specific graphics on a rewriteable CD.

To print a contact sheet of the images, open Photoshop and select File menu Automate, and choose Contact Sheet II from the pull-down menu. Photoshop opens the Contact Sheet dialog box, shown in Figure 937.2.

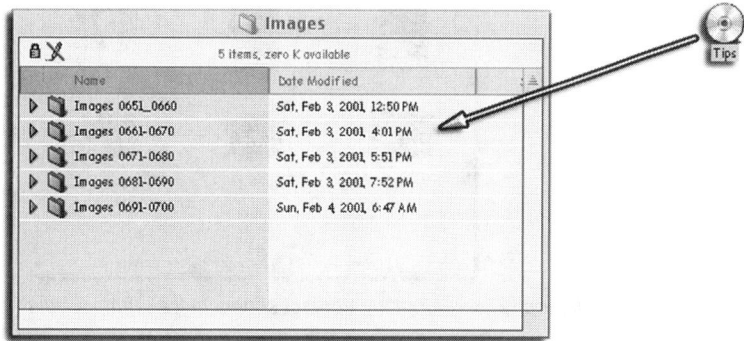

Figure 937.2 The Contact Sheet II dialog box lets you create a contact sheet from a group of graphic images.

Select the CD containing the selected graphics and use the Contact Sheet command to generate a print-out of the images. One at a time, create CDs and generate contact sheets for the graphic images, as shown in Figure 937.3.

The key to success is organizing the images into definable categories. Now when you need a specific image, all you have to do is access the graphic by referencing the contact sheet.

Note: Using organizational tricks will not make you a better designer, but it will give you more time to design.

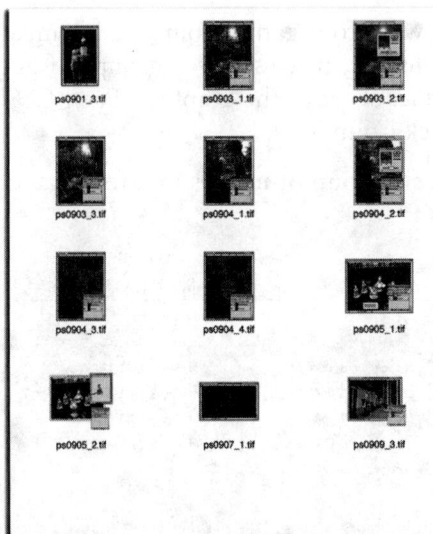

Figure 937.3 Creating contact sheets helps organize your image files.

938 *Redefining an Image Using Columns*

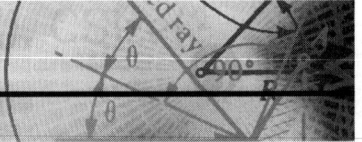

Photoshop lets you generate columns within a document window. The Columns command defines the width of the image based on traditional pica, points, inches, or centimeters.

Say, for example, that you are designing a graphic image that will appear within a newspaper. The newspaper uses 200-point-wide columns with 15-point gutters. The final image needs to fit across two columns, as shown in Figure 938.1.

To select the correct image width, open Photoshop and perform these steps:

1. Select the Edit menu, choose Preferences, and choose Units & Rulers from the fly-out menu. Photoshop opens the Units & Rulers Preferences dialog box, shown in Figure 938.2.

2. Move to the Column Size options and change the Width and Gutter measuring options to points.

3. In the Width input field, enter a value of 200.

4. In the Gutter input field, enter a value of 15.

5. Click the OK button to close the Units & Rulers dialog box.

6. Select the File menu and choose New. Photoshop opens the New dialog box, shown in Figure 938.3.

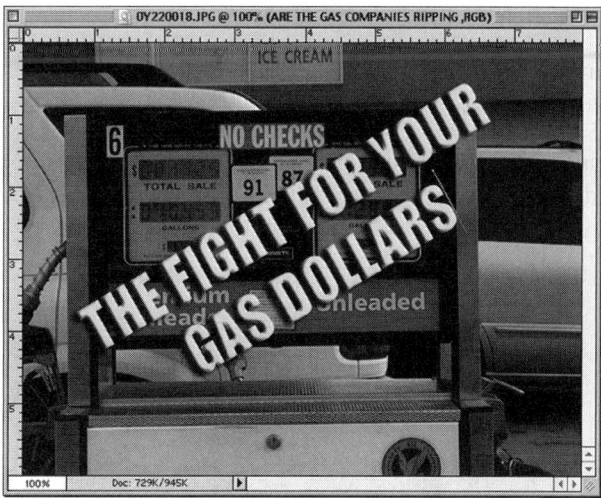

Figure 938.1 The image needs to fit a 200-point-wide column with 15-point gutters.

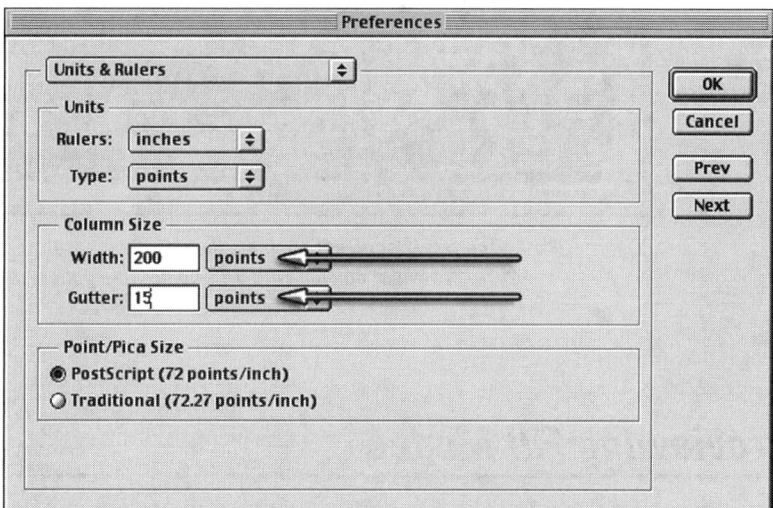

Figure 938.2 The Units & Rulers Preferences dialog box lets you define the dimensions of a column and a gutter.

Figure 938.3 The New dialog box defines the characteristics of the new document.

7. Click once on the Width measuring option and select Columns from the drop-down list.

8. Click on the Height measuring option and select Points from the drop-down list.

9. In the Width input field, enter a value of 2.

10. In the Height input field, enter a value representing the height of the image in points. In this example, you enter a value of 250 (refer to Figure 938.3).

11. Select a color space for the document and click the OK button. Photoshop uses the Units & Ruler preferences and creates a document with a two-column width plus a gutter measurement of 15, as shown in Figure 938.4.

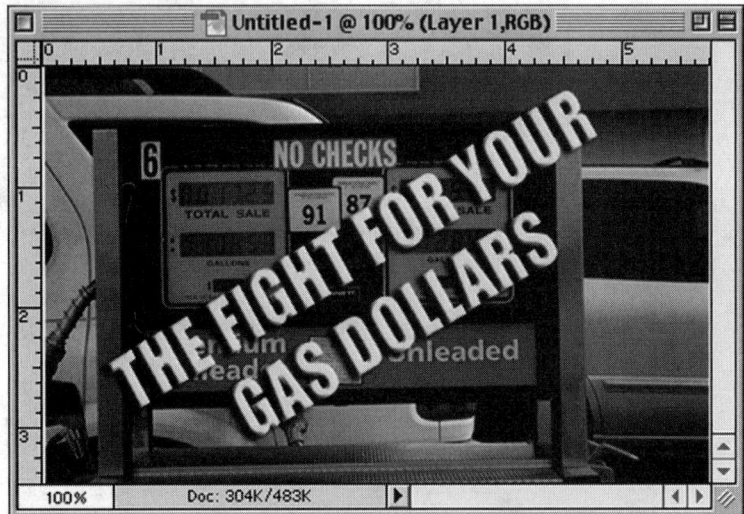

Figure 938.4 The New document contains the correct measurements to fit a 200-point-width column with a 15-point-wide gutter.

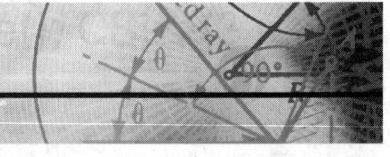

939 *Previewing Fill Modes*

Photoshop's Fill command lets you fill a layer or selection with a predefined pattern or color (refer to Tip 232, "Painting an Image Using the Fill Command"). When you use the fill command, you have the option of selecting the source, blending mode, and opacity of the fill.

A better way to use the Fill command is to apply the fill on a separate layer and then use the opacity and blending modes options of the layer to control the final application of the fill command.

To use a layer to preview the Fill command, open an image in Photoshop and perform these steps:

1. Use Photoshop's selection tools to select the portion of the image that you want to fill (refer to Tip 280, "Selection Methods"). In this example, you select the Lasso tool and select the background of the image, as shown in Figure 939.1.

2. If the Layers palette is not open, select the Window menu and choose Show Layers from the pull-down menu. Photoshop opens the Layers palette.

3. Move into the Layers palette and click once on the New Layer icon. Photoshop creates a new transparent layer.

4. Select the Edit menu and choose the Fill command. Photoshop opens the Fill dialog box, shown in Figure 939.2.

Figure 939.1 The selected portions of the image control the application of the Fill command.

Figure 939.2 The Fill command lets you choose a blending mode and opacity for the fill source.

5. Click once on the Use option and select Pattern from the drop-down list.

6. In this example, you want to fill the selected areas of the image using one of Photoshop's predefined patterns. Click once on the Custom Pattern option and select from the available options in the drop-down list.

7. Make sure that the blending mode is set to Normal, and the opacity is set to 100 percent. Do not select Preserve Transparency.

8. Click the OK button to apply the fill to the new layer, as shown in Figure 939.3.

9. To adjust the image, click on the Blending Mode option and experiment with different blending modes, as shown in Figure 939.4.

10. To adjust the opacity of the fill layer, click in the Opacity input field and enter values from 0 to 100 percent, as shown in Figure 939.5.

11. When you like the results of your experimentation, press Ctrl+E (Macintosh: Command+E). Photoshop merges the fill layer with the image layer, as shown in Figure 939.6.

Figure 939.3 The Fill command applied to the selected portion of the new layer.

Figure 939.4 The Blending Mode option changes how the inks of the fill layer mix with the inks of the original image.

Figure 939.5 The Opacity slider controls the transparency of the pixels in the fill layer.

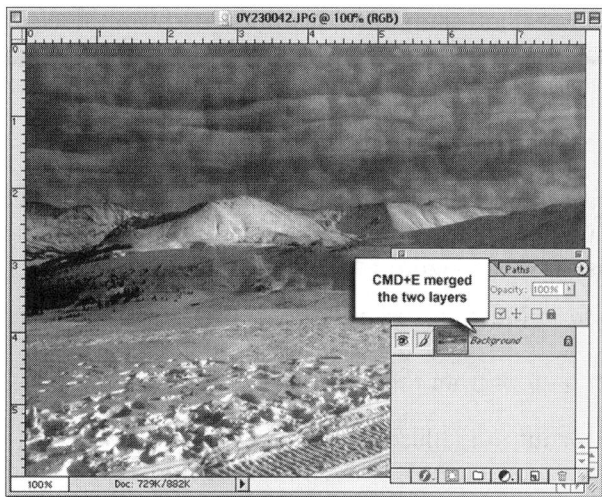

Figure 939.6 Pressing Ctrl+E (Macintosh: Command+E) lets you merge the fill layer with the image layer.

Note: Creating preview layers for the Fill command gives you control over the image and gives you the flexibility to experiment.

940 *Using Drag-and-Drop to Copy Between Applications*

One of the advantages to using Adobe products is the capability to move graphic information between open programs using a method called drag and drop. Say, for example, that you create a graphic design in Photoshop and want to move the image into Illustrator. When in Illustrator, you will enhance the image using Illustrator's vector tools.

To drag and drop Photoshop and Illustrator images, arrange the Illustrator and Photoshop windows to display equally on the monitor, as shown in Figure 940.1.

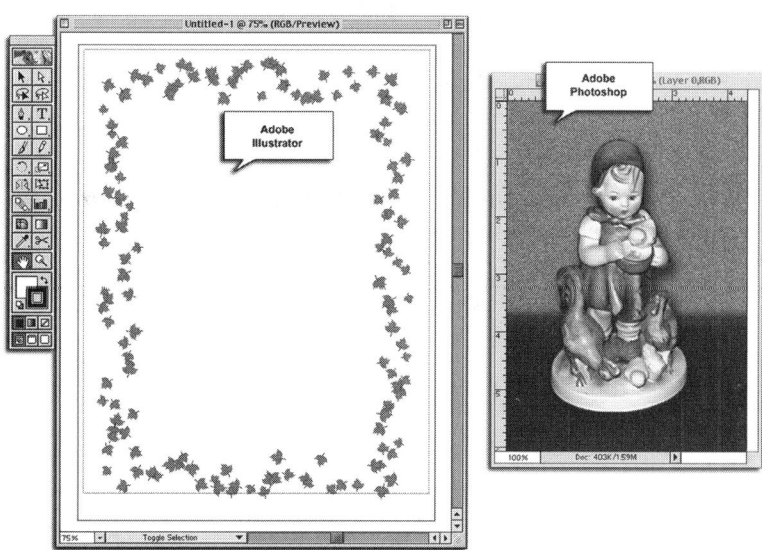

Figure 940.1 The Illustrator and Photoshop document windows.

To move an image from Photoshop into Illustrator, perform these steps:

1. Click in the Photoshop Layers palette and click once on the layer that you want to move.

2. Select the Move tool from the Photoshop toolbox.

3. Move your cursor into the Photoshop document window, and click on and drag the image from the Photoshop document window into the Illustrator document window. A copy of the layer is created in Illustrator, as shown in Figure 940.2.

To move an image from Illustrator into Photoshop, perform these steps:

1. Select the Selection tool from the Illustrator toolbox.

2. Move your cursor into the Illustrator document window, and click on and drag the vector graphic from the Illustrator document window into the Photoshop document window. A copy of the vector graphic is created in Photoshop, and the graphic is placed within a bounding box, as shown in Figure 940.3.

Figure 940.2 Clicking on and dragging a Photoshop layer into the Illustrator document window creates a copy of the layer in Illustrator.

3. Press the Enter key to remove the bounding box, or resize the image by clicking on and dragging the bounding box anchor points.

Note: In addition to Photoshop and Illustrator, the drag-and-drop feature also works with Adobe PageMaker and InDesign.

Figure 940.3 Clicking on and dragging an Illustrator vector graphic into the Photoshop
document window creates a copy of the graphic in Photoshop.

941 *Using Drag-and-Drop to Copy Information with a Layer*

In the previous tip, you learned how to move digital information between programs using the drag-and-drop feature. In Photoshop, an excellent way to make a quick copy of a layer or a selected portion of a layer is to use the drag-and-drop method inside Photoshop.

Say, for example, that you have an image on a single layer, and you want to create another copy of the image and place the copied pixels on a separate layer. To use drag and drop in Photoshop, open an image and perform these steps:

1. If the Layers palette is not open, select the Window menu and choose Show Layers from the pull-down menu. Photoshop opens the Layers palette.

2. Move your cursor into the Layers palette and click once on the layer containing the pixels that you want to copy. In this example, you want to make a copy of the layer containing the blue ball, as shown in Figure 941.1.

3. Select the Move tool from the Photoshop toolbox.

4. Hold the Alt key (Macintosh: Option key), and click on and drag the blue ball to the right. Photoshop creates a copy of the blue ball and places the copy on a new layer named Blue Ball Copy, as shown in Figure 941.2.

> *Note: If you use the drag-and-drop method on a selected an area of an image, Photoshop generates a copy based on the pixels within the selection.*

Figure 941.1 The blue ball layer contains the image pixels that you want to copy.

Figure 941.2 Holding the Alt key (Macintosh: Option key) while you click on and drag the
Move tool creates a copy of the image pixels in the selected layer.

942 *Using the Paste Into Command*

In Photoshop, you have the option of performing a standard Copy and Paste command. When you copy an area of an image (Edit menu, Copy), Photoshop hold the copied pixels in Clipboard memory. When you perform a Paste command (Edit menu, Paste), Photoshop creates a transparent layer and places the copied pixels within the new layer.

Photoshop has a second Paste option called the Paste Into command. Say, for example, that you copy a background image by selecting the Edit menu and choosing Copy, and you want to paste the pixels back into a Photoshop graphic. However, you want the graphic area pasted into a circular area. The Paste Into command creates a new layer and adds a layer mask to control the shape of the pasted information.

To use the Paste Into command, open a Photoshop document and perform these steps:

1. Use the Photoshop Rectangular Marquee tool to select a large portion of the background image, as shown in Figure 942.1.

Figure 942.1 The Rectangular Marquee tool selected a large portion of the background image.

2. Select the Edit menu and choose Copy from the pull-down menu. Photoshop copies the selected pixels and places them in Clipboard memory.

3. Close the open Photoshop document (File menu, Close), and open the document that you want to insert the copied pixels into (File menu, Open), as shown in Figure 942.2.

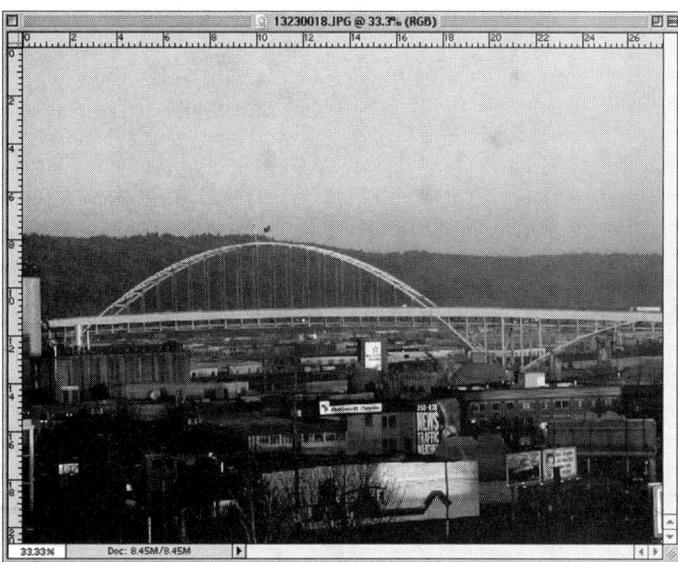

Figure 942.2 When you close a Photoshop document, the Clipboard memory retains the copied pixel information.

4. Select the Lasso Marquee tool from the Photoshop toolbox, and draw a selection the size and shape that you want for the background image, as shown in Figure 942.3.

Figure 942.3 The Lasso Marquee tool creates a selection within the open document window.

5. Select the Edit menu and choose Paste Into from the pull-down menu. Photoshop creates a new layer with a layer mask. The layer mask is the size and shape of the selection, as shown in Figure 942.4.

Figure 942.4 The Paste Into command created a layer mask and pasted the image pixels into the mask.

Note: Modify the layer mask, if necessary, by referring to Tip 387, "Editing a Layer Mask." Using the Paste Into command gives you the flexibility to copy large areas of a Photoshop document and paste that information into a predefined space. The layer mask gives you the control that you need to be creative.

943 *Using the Cut and Copy Commands, and Their Effect on RAM Memory*

In the previous tip, you learned how to use the Copy and Paste Into commands to move copied information into a predefined shape. Photoshop's Cut command, just like the Copy command, places the pixel information into your computer's RAM memory. RAM (Random Access Memory) is where your computer stores information about any open programs. In addition, your operating system (Macintosh or Window) uses RAM memory to perform all its operations.

Think of RAM memory as a box. As you open programs, the box begins to fill. In addition to the memory used by programs when you use the Copy or Cut command in Photoshop.

Photoshop images are not small; using the Copy or Cut command makes the box fill quickly, and that slows Photoshop and can even cause the program to crash. Say, for example, that you use the Copy command to move some digital information into another Photoshop image. After you move the information, you no longer need it in the Clipboard memory.

To remove the unneeded information from the Clipboard, select the Edit menu, choose Purge, and select from the available options:

- **Undo:** Selecting this option removes the last Photoshop undo from RAM memory.

- **Clipboard:** Selecting this option removes any copied information from RAM memory.

- **Histories:** Selecting this option clears the History palette.

- **All:** Selecting this option clears Undo, the Clipboard, and the History.

A word of caution: When you use the Purge command, the operation cannot be undone. Be certain that you want perform a purge before executing the command.

944 *Cropping Pixels Outside the Viewable Image*

When you move a layer from one Photoshop document into a second document window, Photoshop creates a transparent layer and places the image in the new layer (refer to Tip 349, "Adding Layers to an Image from Another Document"). If the layer that you moved contains a larger width or height, Photoshop visibly clips the image to fit the new document window, as shown in Figure 944.1.

The process of visible clipping does not remove the image information from the file; it only restricts the portion of the image that you see. Although this feature lets you move the layer for accurate positioning, it creates large file sizes.

To clip the image layer to match the width and height of the document window, perform these steps:

1. If the Layers palette is not open, select the Window menu and choose Show Layers from the pull-down menu. Photoshop opens the Layers palette.

2. Move into the Layers palette and click once on the layer containing the visibly clipped information.

3. Press Ctrl+A (Macintosh: Command+A) on your keyboard. Photoshop places a selection marquee around the image.

Figure 944.1 *Photoshop clips moved layers that are larger than the receiving document.*

4. Select the Image menu and choose Crop from the pull-down menu. Photoshop removes the image areas outside the document window and creates a smaller file, as shown in Figure 944.2.

Figure 944.2 *The Crop command effectively removed the visibly clipped areas of the image and reduced the file size.*

945 *Using Clipboard Memory to Copy Between Applications*

Photoshop lets you move digital information to any program with the capability of performing a Copy and Paste command. Say, for example, you want to move a portion of a Photoshop image into Illustrator; however, you do not have enough RAM memory to open both Photoshop and Illustrator at the same time.

To use Copy and Paste between Photoshop and Illustrator, open Photoshop and perform these steps:

1. Select the File menu, choose Preferences, and choose General from the fly-out menu. Photoshop opens the General Preferences dialog box, as shown in Figure 945.1.

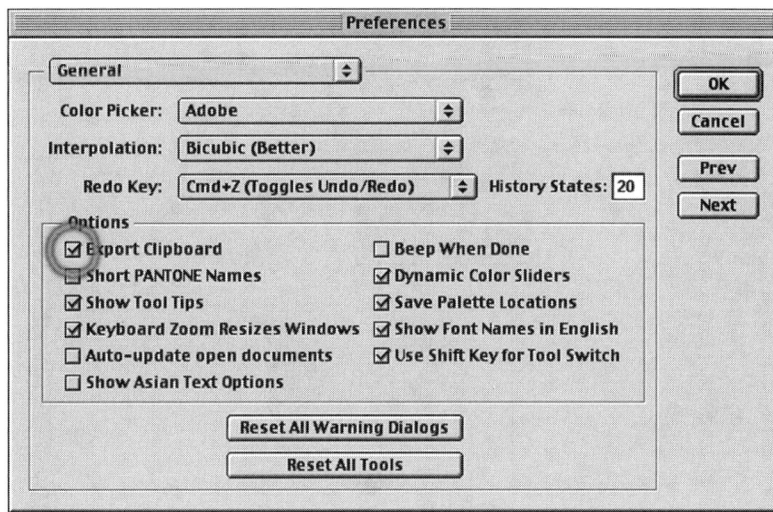

Figure 945.1 The General Preferences dialog box lets you save information in Clipboard memory after closing Photoshop.

2. Select the Export Clipboard option (refer to Figure 945.1), and click the OK button to close the General Preferences dialog box.

3. Use Photoshop's selection tools to identify the area of the image that you want to move into Illustrator. In this example, you use the Rectangular Marquee tool to select a portion of the visible image, as shown in Figure 945.2.

Figure 945.2 The Rectangular Marquee tool selects a portion of the open document.

4. Select the Edit menu and choose Copy from the pull-down menu. Photoshop places the selected pixels into Clipboard memory.

5. Close Photoshop (File menu, Close) and open Illustrator.

6. Select the Edit menu and choose Paste from the pull-down menu. Illustrator pastes the Photoshop information into the Illustrator document, as shown in Figure 945.3.

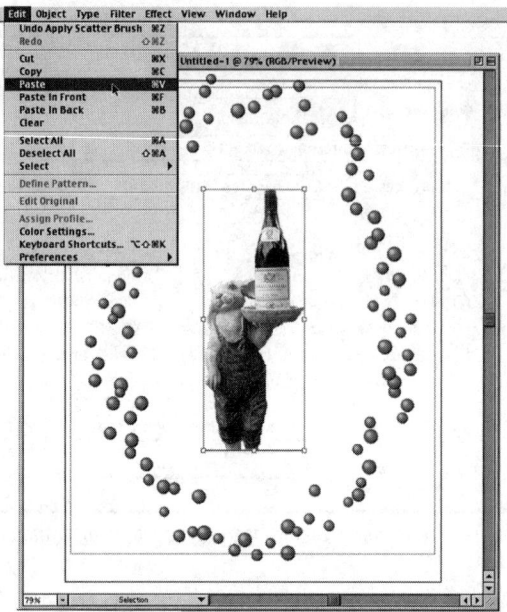

Figure 945.3 The Paste command successfully copied the Photoshop information into a document in Illustrator.

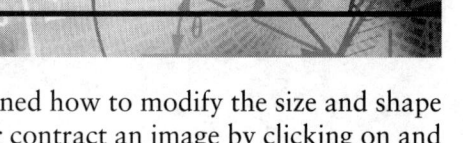

946 *Using the Scale Tool Correctly*

In Tip 227, "Manipulating Shapes with Free Transform," you learned how to modify the size and shape of a Photoshop image. The Free Transform tool lets you expand or contract an image by clicking on and dragging the bounding box anchor points created with the Free Transform command, as shown in Figure 946.1.

Figure 946.1 The Free Transform command lets you modify the size of a digital image.

Although the Free Transform command is a quick way to resize an image, it leads to image quality problems. When you resize an image, Photoshop must insert or remove pixels to fit the new size of the image. Photoshop defines this process as digital interpolation (refer to Tip 13, "Understanding How Photoshop Transforms an Image"). Clicking on and dragging a Free Transform slider generates fractional expansions such as 120.2 percent or 85.5 percent. When you use fractional sizes, it results in a reduction of image quality and a jagged appearance to the resized image.

To resize a graphic correctly, open the image in Photoshop and perform these steps:

1. If the Layers palette is not open, select the Window menu and choose Show Layers from the pull-down menu. Photoshop opens the Layers palette.

2. Move your mouse into the Layers palette and click once on the layer containing the information that you want to resize. In this example, you select the layer containing the rabbit.

3. Select the Edit menu and choose Free Transform from the pull-down menu. Photoshop places a bounding box around the image pixels (refer to Figure 946.1).

4. To change the size of the image, move your mouse into the Options bar, and click in the Width or Height input fields. To increase the image size, enter percentage values higher than 100 percent. To reduce the image size, enter values lower than 100 percent, as shown in Figure 946.2.

Figure 946.2 The Free Transform options let you select a specific percentage value to increase or reduce the size of the selected image.

5. Press the Enter key to record the changes to the selected image.

> *Note: Using whole number percentage values to resize an image helps the Photoshop Interpolation command create a better-quality image.*

947 *Using De-interlace to Remove Horizontal Line Jitter*

Creating graphic images for television is different than creating images for print. The main difference is the display of the graphic. Televisions use scan lines running left to right to paint the image onto the phosphors of the screen, and printers use dots of ink to reproduce the image on a piece of paper.

Television images create line jitter when the graphic contains horizontal lines. As the image processor paints the alternate lines of the graphic onto the screen, the thin horizontal lines appear to jump up and down.

It would be impossible to avoid any horizontal lines in a graphic image; however, Photoshop gives you a way to reduce the jitter effect by applying the De-interlace command to the image before saving it for television.

To apply the De-interlace command, open the image in Photoshop and select the Filter menu, choose Video, and choose De-interlace from the fly-out menu. Photoshop opens the De-interlace dialog box, shown in Figure 947.1.

- **Eliminate Odd/Even:** Images used for television display better by eliminating the odd scan lines. Choose Even Fields for graphics displayed on the European television system.

Figure 947.1 The De-interlace command lets you control line jitter in graphics designed for display on a television screen.

- **Create Fields Duplication/Interpolation:** Select the Duplication option for clip art images, and use Interpolation for photographic image.

Click the OK button to apply the changes to the image.

948 *Using a Table to Determine Scan Resolutions*

The resolution of a Photoshop image determines the number of dots of ink in the image. When you scan an image using a resolution of 72ppi, the image contains 72 dots of information per linear inch, as shown in Figure 948.1.

Figure 948.1 The resolution of an image determines the number of ink dots per linear inch.

To be accurate, they are not always dots of ink. For example, images displayed on a monitor use small brick-like pixels, and offset presses use ovals, squares, and even crosses to define the inks in the image. After all is said and done, the resolution of an image in Photoshop determines the amount of information that you have to perform editing, or whatever else you plan to do to the image. To Photoshop, a pixel is simply a piece of math defining the hue, saturation, and brightness of the color. The more pixels Photoshop has, the more information it has and the more it can do to the image.

When you work in the printing industry, however, high resolutions only slow the process; besides, after you send the image to your printer, all the service wants to do is print the image, not edit the image.

The following table gives some recommended scan resolutions:

Printed Resolution	*Offset Press lpi*	*Scan Resolution spi (lines per inch)*
300dpi	45lpi	100spi
600dpi	85lpi	180spi
1200dpi	125lpi	225spi
2400dpi	133lpi	266spi

949 *Switching to the NTSC Color Palette for Television*

In Tip 947, "Using De-interlace to Remove Horizontal Line Jitter," you learned how to remove the annoying line bounce from an image displayed on a television screen. Although television monitors use a set of the RGB (red, green, and blue) color space, they cannot display a variety and intensity of color available on a computer monitor. Using the RGB color space to design television images results in over-saturated images that seem to bleed together on the screen.

To prepare an image for display on a television, open the image in Photoshop and select the Filter menu, choose Video, and choose NTSC color from the fly-out menu. Photoshop converts the image into the NTSC color space, as shown in Figure 949.1.

Figure 949.1 Use the NTSC color space for images displayed on a television monitor.

The NTSC (National Television Systems Committee) created a standardized color system for North American television. Use the NTSC color option to convert any RGB images designed for display on a television monitor used in the United States, Canada, and Mexico.

> *Note: After you convert and save the file using the NTSC color space, the document cannot be converted back into normal RGB color space. If you plan to use the image in other areas besides television, make a copy of the original and convert the copy into NTSC color.*

950 *Reducing Print Size Without Reducing Image Quality*

When you print an image directly from Photoshop, the program sends the digital information to your printer and the image prints. However, if the image is too big to fit on the paper, you receive an error message, as shown in Figure 950.1.

Figure 950.1 Attempting to print an image larger than the printable area of your image produces this warning.

Say, for example, that you have an image with a width and height of 12 × 14, and you want to reduce the image size to fit on an 8 × 11-inch sheet of paper.

To reduce the image size without removing pixels from the image, select the Image menu and choose Image Size from the pull-down menu. Photoshop opens the Image Size dialog box, shown in Figure 950.2.

Figure 950.2 *The Image Size dialog box controls the width, height, and resolution of the active document.*

Select the Constrain Proportions option, and deselect the Resample Image option (refer to Figure 950.2) In this example, you select the Document Size Height input field and enter a value of 9. The Width input field displays the closest proportional value of 7.714, and the Resolution value changed from 150 to 233.333 pixels per inch, as shown in Figure 950.3.

Figure 950.3 *When you deselect Resample Image, reducing the image size correspondingly increases the image's resolution.*

The Resample option uses Photoshop's Interpolation command to add or subtract pixels from the image. When you reduce the width and height of the image, Photoshop removes pixels from the image to fit the smaller document size.

When you deselect the Resample option, Photoshop does not remove pixels from the image; it resizes the pixels to fit the new width and height. Therefore, there is no loss of digital information. Although your printer discards information that it does not need, the extra resolution is still embedded within the file. Later, if you choose to return the image to its original 12 × 14-inch size, Photoshop restores the image without any loss of digital information. It simply restores the pixels back to their original size values.

Note: Because the average resolution of a Web graphic is 72ppi, when you resize images for the Internet, make sure that you select the Resample option.

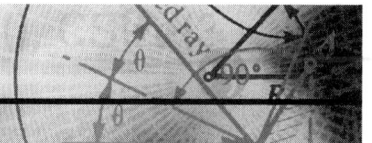

951 *Using the Jump To Button*

The Photoshop and ImageReady Jump To option lets you move a graphic image back and forth between Photoshop and ImageReady. In Photoshop 6.0 and ImageReady 3.0, the Jump To button is located at the bottom of the Photoshop and ImageReady toolboxes, as shown in Figure 951.1.

Figure 951.1 The Jump To button lets you move a graphic image between Photoshop and ImageReady.

Say, for example, you begin work on a graphic Internet button in Photoshop and want to move the image into ImageReady to complete the design, as shown in Figure 951.2.

Figure 951.2 The graphic image requires moving into ImageReady.

To move the document into ImageReady, click once on the Jump To button (refer to Figure 951.1). Photoshop opens the graphic image in ImageReady, as shown in Figure 951.3.

Figure 951.3 The graphic image reopens in ImageReady.

Note: Using Jump To is an excellent way to edit documents quickly. However, unless you have a fast computer (500MHz or faster) and a lot of RAM memory (256MB or more), using the Jump To option slows editing operations in both programs.

952 Resetting Preferences in ImageReady

When you open ImageReady, the setup of the options reflects the last time that you used the program. Say, for example, that you used the Magic Wand tool and changed the default tolerance from 32 to 100 (refer to Tip 170, "Understanding How the Magic Wand Works"). The next time you use ImageReady, the Tolerance value will be 100. Although one option might not present a problem, ImageReady contains dozens of options.

ImageReady stores the Option setting within a preference file. To reset ImageReady's preference file, open Photoshop, hold down the Shift+Alt+Ctrl keys (Macintosh: Shift+Option+Command keys), and click on the Jump To button (refer to the previous tip). ImageReady displays an alert box asking if you want to erase the ImageReady preferences, as shown in Figure 952.1.

Figure 952.1 Resetting ImageReady's preferences returns the program's options and palette locations to their original values.

To reset ImageReady's preferences, click once on the Erase button. ImageReady opens with all palettes and options set to their default values.

953 *Adding Applications to the Jump To Button*

When you use the Jump To option (refer to Tip 951, "Using the Jump To Button"), Photoshop moves your graphic images back and forth from Photoshop to Illustrator. Say, for example, that you want to move a Photoshop document into Adobe Streamline, or you want to move an ImageReady document into GoLive. Adobe lets you add programs to the Jump To option by adding shortcuts (Macintosh: create an alias) to the Jump To Graphics Editor or the Jump To HTML Editor folders.

Say, for example, that you want to access Adobe Streamline from Photoshop. To add Streamline to the Jump To options, perform these steps:

1. Reference your Windows or Macintosh operations manual and create a shortcut (Macintosh: alias) for Streamline, as shown in Figure 953.1.

Figure 953.1 A Windows shortcut for Adobe Streamline.

2. Move the shortcut into the Jump To Graphics Editor folder, as shown in Figure 953.2.

Figure 953.2 Move the Streamline shortcut into the Jump To Graphics Editor folder.

3. Open a graphic file in Adobe Photoshop and select the File menu, choose Jump To, and select Adobe Streamline from the fly-out menu. The Jump To option opens the active Photoshop document in Streamline.

To use the Jump To option to move an ImageReady document into GoLive, perform these steps:

1. Reference your Windows or Macintosh operations manual and create a shortcut for Adobe GoLive.

2. Move the shortcut into the Jump To HTML Editor folder, as shown in Figure 953.3.

3. Open a graphic file in Adobe ImageReady and select the File menu, choose Jump To, and select Adobe GoLive from the fly-out menu. The Jump To option opens the active Photoshop document in GoLive.

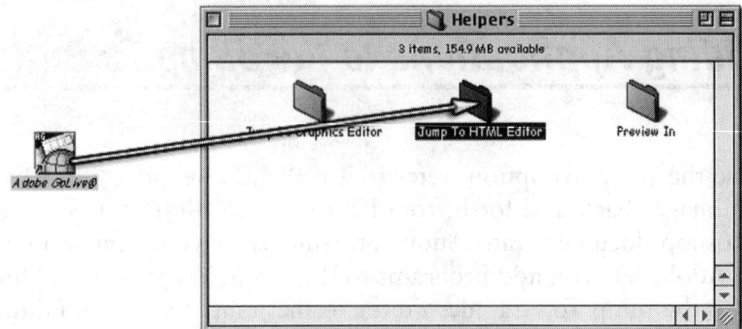

Figure 953.3 Move the Streamline shortcut into the Jump To HTML Editor folder.

954 *Using Automatic Update with the Jump To Option*

In the previous tip, you learned how to move graphic images between programs using the Jump To option. When you move the document between programs, Adobe gives you the options of automatically updating the image on the fly.

Say, for example, that you move a Photoshop graphic into ImageReady, perform some editing of the image, and then want to return to Photoshop with the editing changes intact.

To use the Auto Update option, open Photoshop and select the Edit menu, choose Preferences, and select General from the fly-out menu. Photoshop opens the General Preferences dialog box, shown in Figure 954.1.

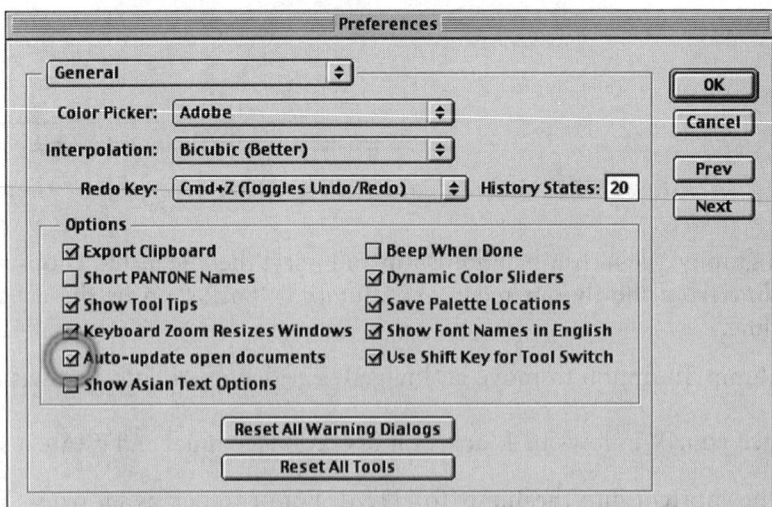

Figure 954.1 The General preferences dialog box lets you control whether the Jump To option updates the image.

Select the Auto-update open documents option, and click the OK button to close the General Preferences dialog box. Now, when you use the Jump To option, Photoshop or ImageReady automatically updates the image as you move between the two programs.

If you do not want the graphic image updated, open the General Preferences dialog box and deselect the Auto-update open documents option.

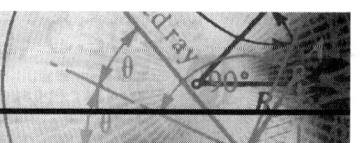

955 *Changing an Image's Print Dimensions*

In Tip 950, "Reducing Print Size Without Reducing Image Quality," you learned how to adjust the size of a Photoshop image without reducing the quality of the image. If your intent is simply to print the document, there is an easier and quicker way to fit the image onto the default paper size of your printer. Say, for example, that you select the File menu, choose Print, and receive an error stating that the image to too big for the current paper size of your printer, as shown in Figure 955.1.

The image is larger than the paper's printable area; some clipping will occur.

Cancel Proceed

Figure 955.1 The alert box warns you that the image is too big to print.

To change the size of the active Photoshop image, click on the Cancel button in the Alert dialog box (refer to Figure 955.1), select the File menu, and choose Print Options from the pull-down menu. Photoshop displays the available print options for your default printer, as shown in Figure 955.2.

Figure 955.2 The Print Options dialog box lets you change the printable size of the active document.

In the Scale box, enter a percentage value to reduce the image size. For example, if you want to reduce the size of the image by half, enter the value 50 percent. Click the OK button to record the changes to the image. Now, when you select the File menu and choose Print, the image prints at 50 percent of its original value.

Modifying the Scale value changes the printing size of the image without affecting the actual width and height of the original image.

Note: When you change the printing size of the image using the Reduce or Enlarge option, the new printing size is saved with the file. To change printing size of the image back to full size, select the File menu, choose Print Options, and change the value back to 100 percent.

956 *Monitoring Work in Progress*

When you perform editing and adjustment commands in Photoshop, the program display a progress bar, indicating the amount of time left to perform the particular adjustment. Say, for example, that you perform a Lighting Effects filter on a large image (refer to Tip 531, "Using the Lighting Effects Filter"). During the application of the effect, Photoshop displays a Progress bar, shown in Figure 956.1.

Figure 956.1 The Progress bar indicates the amount of time left to perform the Lighting Effects filter.

Although in most instances you want to continue the process, if you choose to end the editing procedure, click on the Cancel button. Photoshop ends the editing procedure and returns the document to the editing state before performing the Lighting Effects filter.

In some cases, a particular editing command or adjustment does not display the Progress bar. To cancel a Photoshop operation when you do not have access to the Progress bar, press Ctrl+period (Macintosh: Command+period).

To monitor the amount of time that it took to complete a specific operation, click once on the black triangle, located to the right of the information box, and select Timing from the available options, as shown in Figure 956.2.

Figure 956.2 The Timing option lets you view the amount of time required to perform the last Photoshop operation.

957 *Changing Photoshop Screen Mode for Color Correction*

In Tip 53, "Changing Photoshop's Screen Display Mode," you learned how to change the default background when using Photoshop. When you perform color correction in Photoshop, any colors surrounding the image affect your perception of color.

Say, for example, that you want to color-correct an image. The best way to view the image is on a neutral or black background. To change Photoshop's background, open the image in Photoshop and perform these steps:

1. Move into the toolbox and select the available screen modes, as shown in Figure 957.1.

958 *Creating 3-D Packaging*

Photoshop gives you several ways to create 3-D objects. Here is a quick way to produce a package using Photoshop and the Free Transform option. Say, for example, that you have a rectangular illustration that you want to convert into a front-view package, as shown in Figure 958.1.

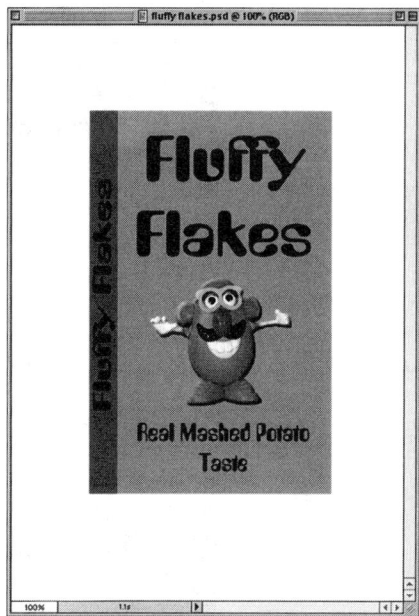

Figure 958.1 You want to convert this image into a three-dimensional package.

To create a quick 3-D package, open the image in Photoshop and perform these steps:

1. If the Layers palette is not open, select the Window menu and choose Show Layers from the pull-down menu. Photoshop opens the Layers palette.

2. Click once on the layer containing the graphic image. In this example, you click on the package layer (refer to Figure 958.1).

3. If the Ruler bar is not visible, select the View menu and choose Show Rulers from the pull-down menu.

4. Create a guide by clicking your mouse in the horizontal ruler bar and dragging down until the guide is approximately a quarter-inch below the top of the graphic image, as shown in Figure 958.2.

5. Select the Rectangular Marquee tool from the toolbox, and create a selection defining the front of the box, as shown in Figure 958.3.

6. Select the Edit menu, choose Transform, and choose Perspective from the fly-out menu. Photoshop places a bounding box around the graphic image.

7. Click and drag the upper-right anchor point down until it intersects the guide, as shown in Figure 958.4.

8. Press the Enter key to apply the transform to the image.

9. Select the Rectangular Marquee tool from the toolbox, and create a selection defining the left side of the box, as shown in Figure 958.5.

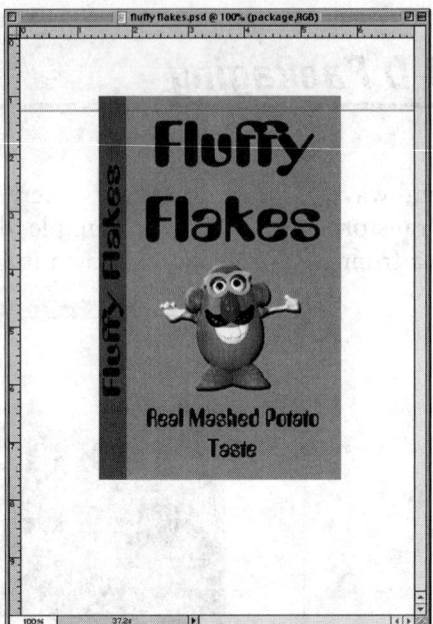

Figure 958.2 Move the guide directly below the top of the graphic image.

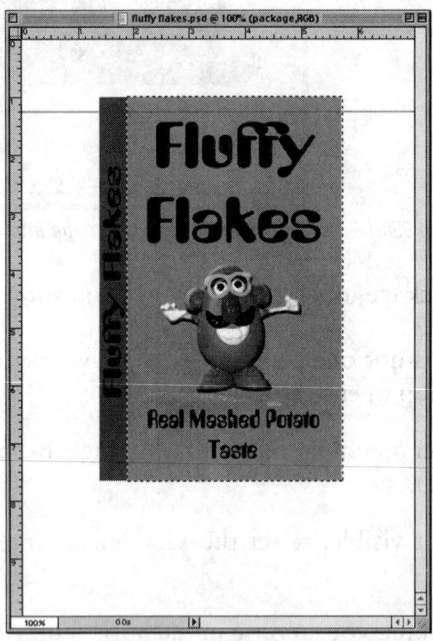

Figure 958.3 Use the Rectangular Marquee tool to select the portion of the image that represents the front of the package.

10. Select the Edit menu, choose Transform, and choose Perspective from the fly-out menu. Photoshop places a bounding box around the graphic image.

11. Click on and drag the upper-left anchor point down until it intersects the guide, as shown in Figure 958.6.

12. Press the Enter key to apply the transform to the image.

13. The Perspective Transform command converted the flat image into one resembling a 3-D box, as shown in Figure 958.7.

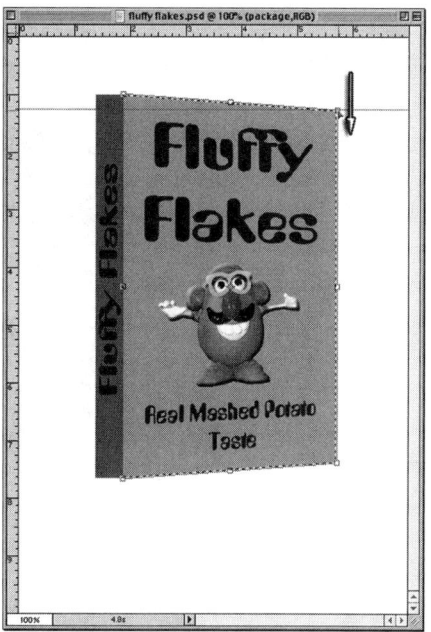

Figure 958.4 Click on and drag the upper-right anchor down to match the guide.

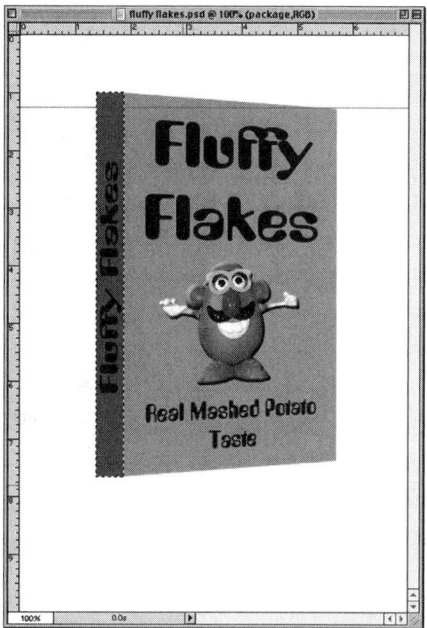

Figure 958.5 Use the Rectangular Marquee tool to select the portion of the image that represents the left side of the package.

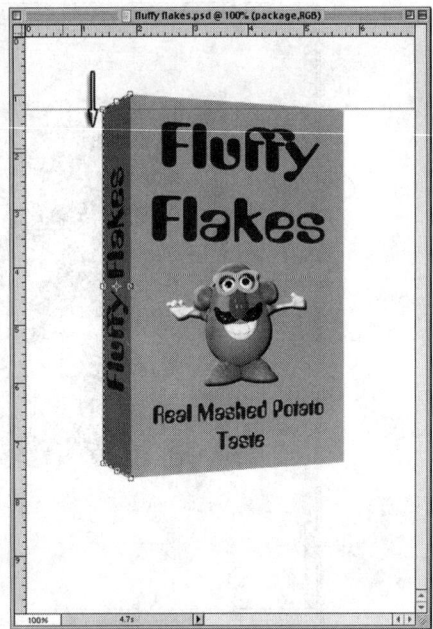

Figure 958.6 Click on and drag the upper-left anchor down to match the guide.

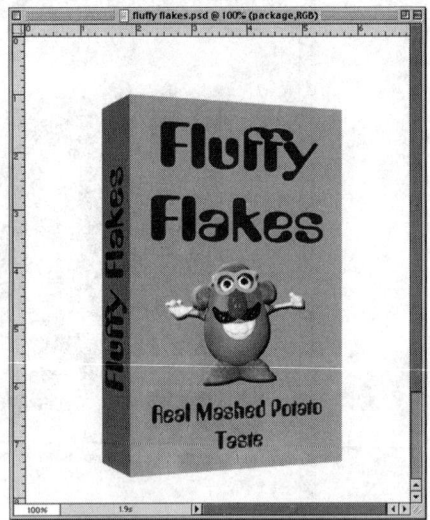

Figure 958.7 The flat box resembles a 3-D package, thanks to Photoshop and the Perspective Transform command.

959 *Creating Realistic Shadows for 3-D Packaging*

In the previous tip, you learned how to create a 3-D package out of a single graphic image. To add some depth to the image, you need to apply a drop shadow.

To apply a drop shadow to a 3-D image, open the package created in the previous tip and perform these steps:

1. If the Layers palette is not open, select the Window menu and choose Show Layers from the pull down menu. Photoshop opens the Layers palette.

2. Move your mouse into the Layers palette and click once on the layer containing the 3-D package.

3. Click once on the Layers Effects icon, located at the bottom left of the Layers palette, and select Drop Shadow from the pop-up menu. Photoshop opens the Layer Style dialog box, shown in Figure 959.1.

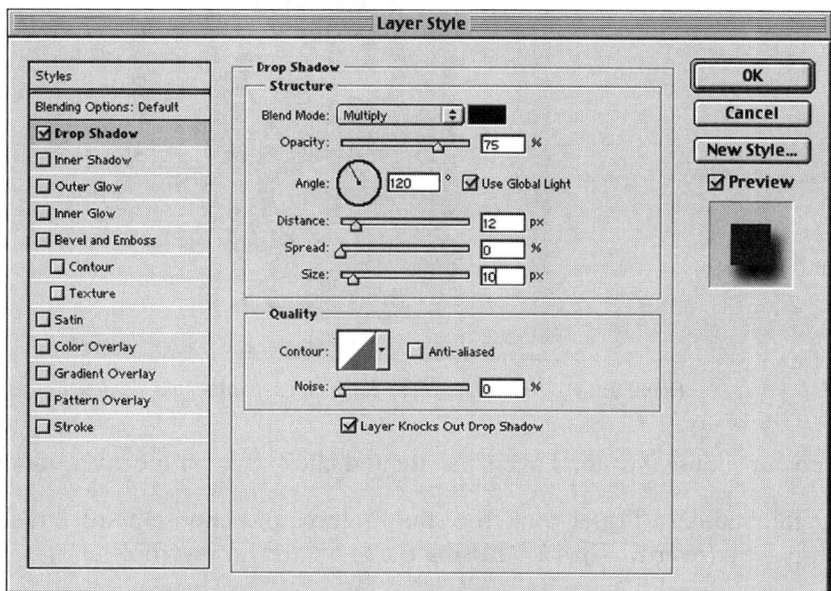

Figure 959.1 *The Layer Style dialog box controls the characteristics of the bevel effect.*

4. In the Distance input box, enter a value of 12.

5. In the Size input box, enter a value of 10.

6. Click the OK button to apply the drop shadow to the image, as shown in Figure 959.2.

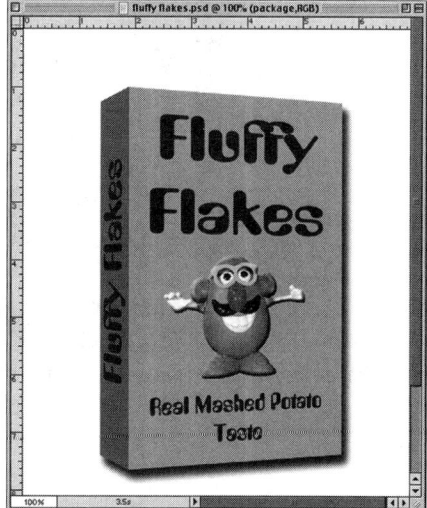

Figure 959.2 *The Drop Shadow applied to the 3-D package.*

7. Select the Layer menu, choose Layer Style, and choose Create Layer from the fly-out menu. Photoshop separates the shadow effect from the 3-D package and places the shadow on a separate layer, as shown in Figure 959.3.

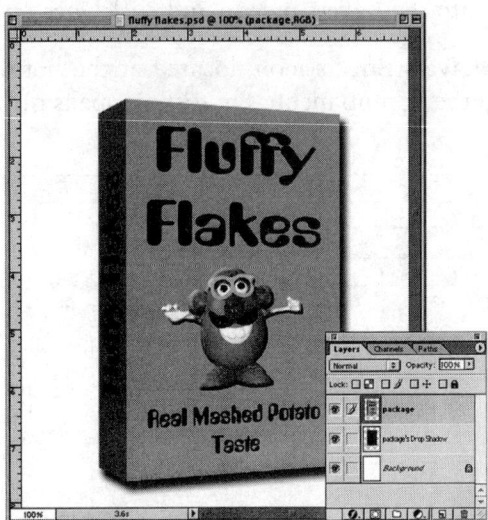

Figure 959.3 The Create Layer command separated the shadow from the object.

8. Move your mouse into the Layers palette and click once on the layer containing the shadow.

9. Select the Standard Eraser tool from the toolbox and choose a soft brush from the Options bar's Brush palette (refer to Tip 169, "Using the Standard Eraser Tool").

10. Move into the document window and erase the left and bottom portions of the shadow, as shown in Figure 959.4.

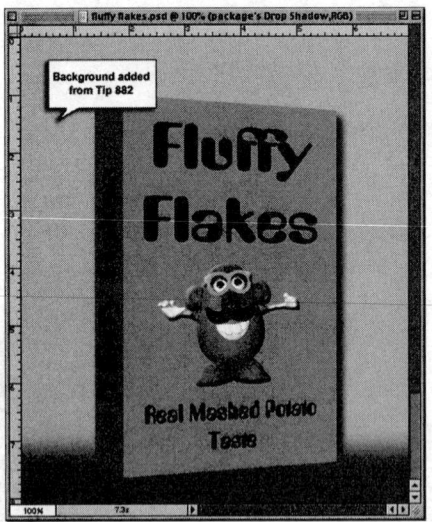

Figure 959.4 The Standard Eraser tool removed the left portion of the drop shadow, creating a realistic 3-D shadow.

960 *Backlighting an Image*

In Tip 958, "Creating 3-D Packaging," you leaned how to create a three-dimensional package. In the previous tip, you learned how to create a realistic drop shadow for the package. Another way to display a product is to use a single spotlight on a background.

To create backlighting for the product, open Photoshop and perform these steps:

1. Select the File menu and choose New. Photoshop opens the New dialog box. Create a new document with a width of 5 inches, a height of 5 inches, and a resolution of 150ppi in RGB mode, as shown in Figure 960.1.

Figure 960.1 The New dialog box defines the characteristics of the new document.

2. Press the letter "D" on your keyboard to default the foreground and background colors to black and white.

3. Press Alt+Delete (Macintosh: Option+Delete) to fill the background with the current foreground color (black).

4. Select the Elliptical Marquee tool from the toolbox, and draw a circle in the middle of the document window, as shown in Figure 960.2.

Figure 960.2 The Elliptical Marquee tool created a circle in the middle of the document window.

5. Press Ctrl+Delete (Macintosh: Command+Delete) to fill the circle with the current background color (white).

6. Press Ctrl+D (Macintosh: Command+D) to deselect the circle marquee.

7. Select the Filter menu, choose Blur, and select Gaussian Blur from the fly-out menu. Photoshop opens the Gaussian Blur dialog box.

8. Enter a value of 90 in the Radius field and click the OK button to apply the blur to the image, as shown in Figure 960.3.

Figure 960.3 The Gaussian Blur filter applied to the active image.

9. Select the Image menu, choose Adjust, and choose Hue & Saturation from the fly-out menu. Photoshop opens the Hue/Saturation dialog box, as shown in Figure 960.4.

Figure 960.4 The Hue/Saturation dialog box controls the color of the active image.

10. Select the Colorize option and drag the Hue slider to the right until the input value displays 180 (refer to Figure 960.4). This places a blue/green tinge to the blurred image.

11. Select the Rectangular Marquee tool from the toolbox and draw a rectangle enclosing the bottom half of the document window, as shown in Figure 960.5.

12. Press Ctrl+J (Macintosh: Command+J). Photoshop makes a copy of the selected portion of the image and places the copied pixels in a separate layer, as shown in Figure 960.6.

13. Select the Move tool from the toolbox, and drag the image in the copied layer down until it resembles Figure 960.7.

14. Now, when you move an object such as the 3-D book into the document, it appears backlit, as shown in Figure 960.8.

Figure 960.5 The Rectangular Marquee tool created a selection from the bottom half of the document window.

Figure 960.6 The selected portion of the image resides in a separate layer.

Figure 960.7 Use the Move tool to drag the copied pixel down.

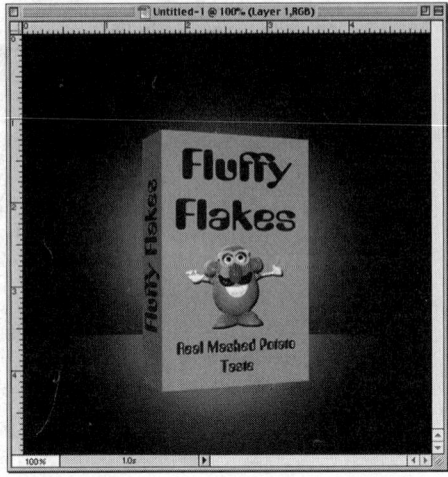

Figure 960.8 The 3-D package appears backlit using a studio background.

961 *Fixing the Edges of a Motion-Blurred Object*

When you use the Motion Blur filter on an image, the effect falls off sharply before it reaches the edge of the image, as shown in Figure 961.1.

Figure 961.1 The effect of the Motion Blur filter falls off as it approaches the edge of the image.

To correct this problem, select the Rectangular Marquee tool from the toolbox and create a selection around the good portion of the motion blur, as shown in Figure 961.2.

Now select the Edit menu and choose Free Transform from the pull-down menu. Photoshop places a bounding box around the selected portion of the image. Click on the center-right anchor point and drag to the right until you reach the edge of the document window, as shown in Figure 961.3.

Figure 961.2 *The Rectangular Marquee tool selected the good portions of the Motion Blur filter.*

Figure 961.3 *Drag the center-right anchor to the right to correct the fall off of the motion blur.*

To complete the correction, click on the center-left anchor point and drag to the left until you reach the edge of the document window, as shown in Figure 961.4.

Press the Enter key to apply the Free Transform command to the image.

Figure 961.4 Drag the center-left anchor to the left to correct the fall off of the motion blur.

962 *Creating Finely Chiseled Text*

Here is an excellent way to create eye-catching finely chiseled text using Photoshop and the Emboss filter. To create chiseled text, open Photoshop and perform these steps:

1. Select the File menu and choose New. Photoshop opens the New dialog box. Create a new document with a width of 5 inches, a height of 5 inches, and a resolution of 150ppi in RGB mode, as shown in Figure 962.1.

Figure 962.1 The New dialog box defines the characteristics of the new document.

2. Press the letter "D" on your keyboard to default the foreground and background colors to black and white.

3. Select the Type tool from the toolbox and enter the word "CHISEL" in a nice serif font (refer to Tip 218, "Creating Text in Photoshop 6.0"). In this example, you choose Apple Chancery at 72 points, as shown in Figure 962.2.

Figure 962.2 The word "CHISEL" typed using 72-point Apple Chancery.

4. Move your mouse into the Swatches palette and click once on a midgray color box. Photoshop changes the foreground color to gray.

5. Select the Layer menu, choose Rasterize, and choose Type from the fly-out menu. Photoshop converts the text layer into a normal ink layer (you need to rasterize the text for the next step).

6. Select the Edit menu and choose Stroke from the pull-down menu. Photoshop opens the Stroke dialog box, shown in Figure 962.3.

Figure 962.3 The Stroke dialog box controls the application of the stroke to the converted type layer.

7. The width of the stroke depends on the text and type size. In this example, you select a width value of 4.

8. Select Inside for the Location, and click the OK button to apply the stroke to the text, as shown in Figure 962.4.

9. Select the Filter menu, choose Stylize, and choose Emboss from the fly-out menu. Photoshop opens the Emboss dialog box.

10. Enter an Angle value of 140°, a Height value of 2 pixels, and an Amount value of 120 percent. Click the OK button to apply the Emboss filter to the converted type layer, as shown in Figure 962.5.

Figure 962.4 The Stroke command applied to the converted type layer.

Figure 962.5 The Emboss filter applied to the converted type layer.

11. To add color to the image, select the Image menu, choose Adjust, and choose Hue & Saturation from the fly-out menu. Photoshop opens the Hue/Saturation dialog box, shown in Figure 962.6.

Figure 962.6 The Hue/Saturation dialog box controls the color of the active image.

12. Select the Colorize option.

13. Choose a Hue value of 75 percent and a Saturation value of 45. Click the OK button to apply the color to the image (refer to Figure 962.6).

14. To complete the effect, click once on the Layers Effects icon, located at the bottom left of the Layers palette, and select Drop Shadow from the pop-up menu. Photoshop opens the Layer Style dialog box.

15. Click the OK button to apply the drop shadow to the image, as shown in Figure 962.7.

Figure 962.7 The completed image of chiseled text.

963 *Viewing the Effects of a Feather Using Quick Mask*

One of the problems associated with the Feather command is viewing the feather before applying the effect to the image. The Feather option works to soften the edge of a selection by reducing the opacity of the pixels along the selection edge. Unfortunately, you cannot view the effects of a feather until after the effect has been applied to the image (refer to Tip 304, "Understanding How Feathering Operates").

Say, for example, that you want to create a vignette border around an image (refer to Tip 305, "Feathering a Selection to Create a Vignette Border"). When you create a selection defining the border, you apply a feather to the selection, as shown in Figure 963.1.

To view the effects of the Feather command before applying the vignette to the image, first create and feather an oval selection (refer to Tip 305). Before you press the Delete key, move to the toolbox and press the Quick Mask button. Photoshop displays a mask based on the applied Feather command, as shown in Figure 963.2.

To apply the vignette, click on the View button and press the Delete key. Photoshop creates a soft border around the image, exactly matching the Quick Mask preview, as shown in Figure 963.3.

Figure 963.1 A selection marquee cannot display the amount of feather applied to the edge.

Figure 963.2 The Quick Mask option gives you a preview of the vignette.

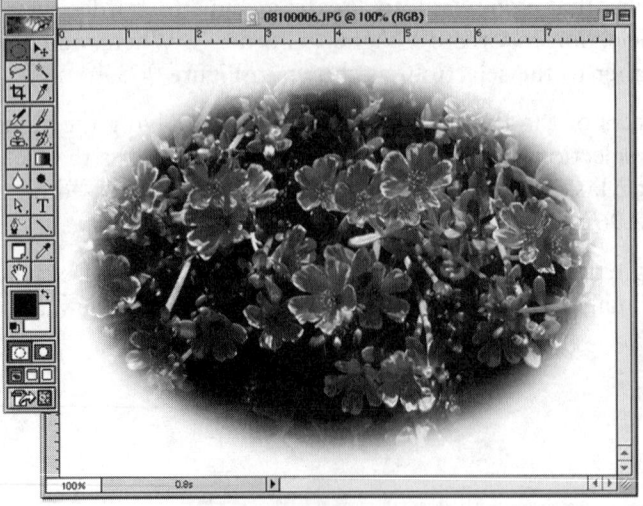

Figure 963.3 The completed vignette matches the Quick Mask preview.

964 *Creating Backgrounds with Depth Using the Lighting Effects Filter*

In Tip 148, "Creating Fast Backgrounds Using Filters," you learned how to create backgrounds using the Clouds filter. In this example, you will create a background and add depth to the image using the Lighting Effects filter.

To create a background with depth, open Photoshop and perform these steps:

1. Select the File menu and choose New. Photoshop opens the New dialog box. Create a new document with a width of 6 inches, a height of 6 inches, and a resolution of 150ppi in RGB mode, as shown in Figure 964.1.

Figure 964.1 The New dialog box defines the characteristics of the new document.

2. Press the letter "D" on your keyboard to default the foreground and background colors to black and white.

3. Move your mouse into the Swatches palette and select a color for the background. In this example, you select a light blue.

4. Select Filter menu Render, and select Clouds from the fly-out menu. The background layer fills with blue and white clouds, as shown in Figure 964.2.

5. Select the Filter menu, choose Distort, and select Glass from the fly-out menu. Photoshop opens the Glass dialog box.

6. Enter a Distortion value of 5 and a Smoothness value of 4, and choose Frosted in the Texture option. Click the OK button to apply the Glass filter to the background layer, as shown in Figure 964.3.

7. Select the Filter menu, choose Render, and select Lighting Effects from the fly-out menu (refer to Tip 531, "Using the Lighting Effects Filter"). Photoshop opens the Lighting Effects dialog box, shown in Figure 964.4.

Figure 964.2 The Clouds filter applied to the background layer.

Figure 964.3 The Glass filter applied to the background layer.

Figure 964.4 The Lighting Effects dialog box.

8. Choose an upper-left, elongated light source (refer to Figure 964.4).

9. Click on the Texture Channel option and select Blue from the drop-down list. Click the OK button to apply the Lighting Effects filter to the image, as shown in Figure 964.5.

Figure 964.5 The Lighting Effects filter applied to the background layer.

10. When you apply an image to the background, use a drop shadow that follows the direction of the light source. In this example, you created some text and added a drop shadow moving down and to the right, as shown in Figure 964.6.

Figure 964.6 The text and drop shadow, combined with the Lighting Effects filter, generate a sense of depth within the image.

965 *Correcting Out-of-Gamut Colors with the Sponge Tool*

In Tip 926, "Quickly Editing Out-of-Gamut Colors," you learned how to bring out-of-gamut colors into the CMYK (cyan, magenta, yellow, and black) color range by using the Hue & Saturation command.

Although Hue & Saturation is a quick way to move colors into CMYK, it does not let you selectively change color. To correct color on a selective basis, open an out-of-gamut image in Photoshop and perform these steps:

1. Select the View menu and select Gamut Warning from the pull-down menu. Photoshop places a mask over the out-of-gamut colors, as shown in Figure 965.1.

Figure 965.1 The masked areas of the image represent the out-of-gamut colors within the active image.

2. Choose the Select menu and choose Color Range from the pull-down menu. Photoshop opens the Color Range dialog box, shown in Figure 965.2.

Figure 965.2 The Color Range dialog box lets you select the out-of-gamut colors in the active image.

3. Click on the Select option and choose Out of Gamut from the drop-down list. Click the OK button to apply the selection to the image. Photoshop creates a selection around the out-of-gamut colors, as shown in Figure 965.3.

4. Select the Sponge tool from the toolbox.

5. Move into the Options bar and select a small, soft brush. Choose the Desaturate blending mode, as shown in Figure 965.4.

Figure 965.3 The Color Range command selected the out-of-gamut colors.

Figure 965.4 The Sponge tool controls the saturation of the selected areas of the image.

6. Click and drag the Sponge tool over the out-of-gamut areas of the image, until the gamut warning color disappears. In this example, you successfully correct the image by desaturating the out-of-gamut pixels, as shown in Figure 965.5.

Note: The Sponge tool gives you an advantage over the Hue & Saturation method (refer to Tip 926), the ability to desaturate color areas based on the needs of the image.

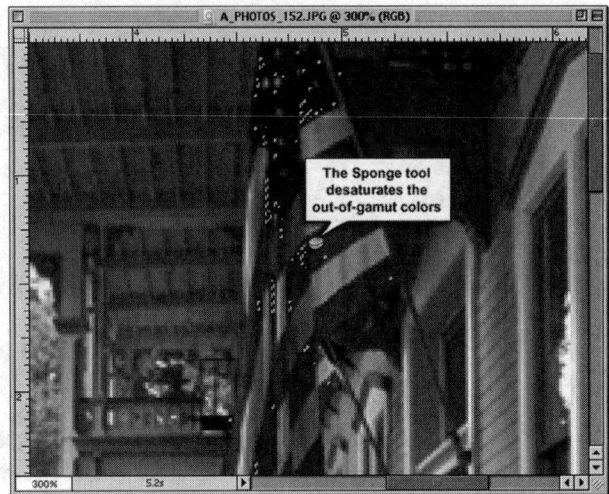

Figure 965.5 Reducing the saturation of the selected areas of the image brought the colors back into the CMYK gamut.

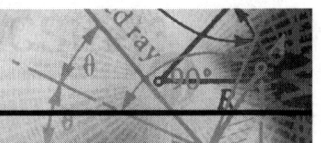

966 *Creating a Cool-Looking Web Interface*

To create an interface, open Photoshop and perform these steps:

1. Select the File menu and choose New. Photoshop opens the New dialog box. Create a new document with a width of 4 inches, a height of 3 inches, and a resolution of 72ppi in RGB mode, as shown in Figure 966.1.

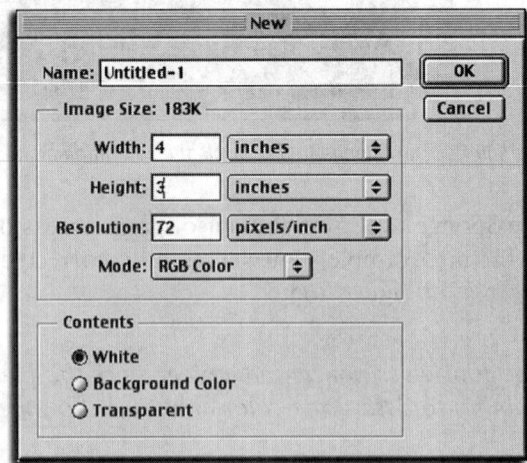

Figure 966.1 The New dialog box defines the characteristics of the new document.

2. If the Layers palette is not open, select the Window menu and choose Show Layers from the pull-down menu. Photoshop opens the Layers palette.

3. Create a new layer by clicking once on the New Layer icon.

4. Select the Rectangular Marquee tool from the toolbox, and draw a rectangular marquee in the size that you want your interface, as shown in Figure 966.2.

Figure 966.2 The Rectangular Marquee tool created a selection in the new layer.

5. Move your cursor into the Swatches palette and select a color for the interface. In this example, you select a light blue.

6. Press Alt+Delete (Macintosh: Option+Delete) to fill the selection with the current foreground color, as shown in Figure 966.3.

Figure 966.3 Pressing Alt+Delete (Macintosh: Option+Delete) fills the selection marquee with the foreground color.

7. Press Ctrl+D (Macintosh: Command+D) to deselect the rectangular marquee.

8. Click once on the Layer Effects icon, located at the bottom left of the Layers palette, and select Bevel and Emboss from the pop-up menu. Photoshop opens the Layer Style dialog box.

9. Click once on the Style option and select Inner Bevel from the drop-down list.

10. Click once on the Technique option and select Chisel Hard from the drop-down list.

11. Enter a Depth value of 100 percent and a Size value of 7. Click the OK button to apply the bevel to the selected layer, as shown in Figure 966.4.

12. Make a copy of the new beveled layer by dragging the new layer over the New Layer icon, as shown in Figure 966.5.

13. Move into the Layers palette and click once on the new copied layer.

14. Select the Edit menu and choose Free Transform from the pull-down menu. Photoshop places a bounding box around the copy of the layer box.

15. Move down to the lower-right corner anchor, then click and drag up and to the left to reduce the size of the box. Hint: Hold the Alt+Shift (Macintosh: Option+Shift keys) while dragging the box to maintain the original proportions of the box.

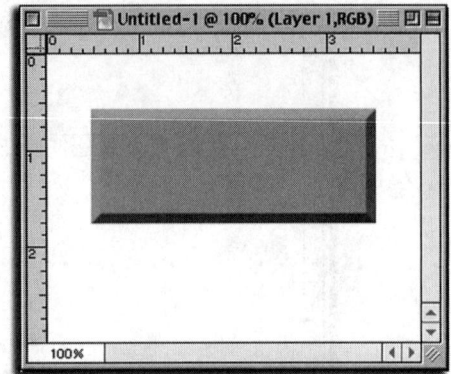

Figure 966.4 The bevel style applied to the image.

Figure 966.5 Dragging a layer over the New Layer icon creates a copy of the dragged layer.

16. Press the Enter key to apply the Free Transform command to the image, as shown in Figure 966.6.

Figure 966.6 The Free Transform command applied to the copy of the box layer.

17. Click once on the Layer Effects icon, located at the bottom left of the Layers palette, and select Bevel and Emboss from the pop-up menu. Photoshop opens the Layer Style dialog box.

18. Click once on the Down option.

19. Click the OK button to apply the change to the image, as shown in Figure 966.7.

Figure 966.7 Clicking on the Down button gives the impression of a border surrounding the box.

20. Select the Type tool from the toolbox and create the interface text (refer to Tip 218, "Creating Text in Photoshop 6.0"), as shown in Figure 966.8.

Figure 966.8 The Type tool created the interface text.

967 *Creating Spherical Buttons*
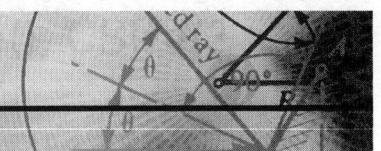

To create a spherical text button, open Photoshop and perform these steps:

1. Select the File menu and choose New. Photoshop opens the New dialog box. Create a new document with a width of 3 inches, a height of 3 inches, and a resolution of 72ppi in RGB mode, as shown in Figure 967.1.

Figure 967.1 The New dialog box defines the characteristics of the new document.

2. If the Layers palette is not open, select the Window menu and choose Show Layers from the pull-down menu. Photoshop opens the Layers palette.

3. Create a new layer by clicking once on the New Layer icon.

4. Select the Elliptical Marquee tool from the toolbox, and draw a circular selection in the size that you want your spherical text button. Hint: Hold down the Shift key while you use the Elliptical Marquee tool to draw a perfect circular selection, as shown in Figure 967.2.

Figure 967.2 The Elliptical Marquee tool created a circular selection in the new layer.

5. Move your mouse into the Swatches palette and select a color for the button. In this example, you selected an orange from the standard color palette.

6. Hold the Alt key (Macintosh: Option key) and select a slightly darker version of the orange that you selected in step 5. Photoshop's foreground and background colors are now light and dark orange.

7. Select the Gradient tool from the toolbox and choose the Foreground to Background radial gradient from the Options bar (refer to Tip 172, "Working with the Gradient Options"), as shown in Figure 967.3.

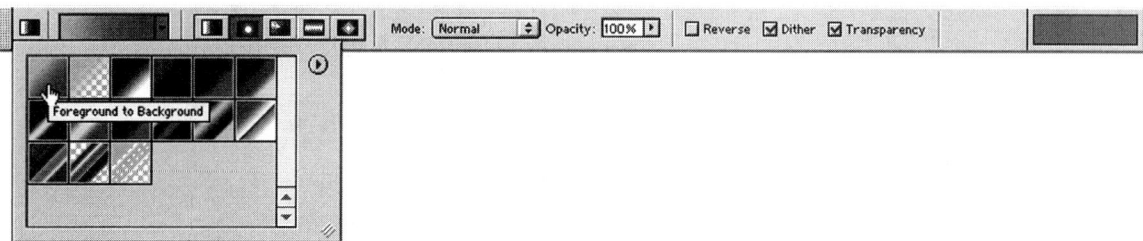

Figure 967.3 The foreground to background radial gradient.

8. Move the Radial Gradient tool into the circular selection, and drag from the center of the circle to the edge of the selection marquee, as shown in Figure 967.4.

Figure 967.4 The Radial Gradient tool creates a light to dark orange radial gradient inside the selection marquee.

9. Press Ctrl+D (Macintosh: Command+D) to deselect the circular selection.

10. Click once on the Layer Effects icon, located at the bottom left of the Layers palette, and select Bevel and Emboss from the pop-up menu. Photoshop opens the Layer Style dialog box.

11. Click once on the Style option and select Inner Bevel from the drop-down list.

12. Click once on the Technique option and select Smooth from the drop-down list.

13. Enter a Depth value of 100 percent and a Size value of 30. Click on the Enter key to apply the bevel to the selected layer, as shown in Figure 967.5.

Figure 967.5 The bevel style applied to the image.

14. Select the Type tool from the toolbox and create the button text (refer to Tip 218, "Creating Text in Photoshop 6.0"). In this example, you type the word "HOME" at 14 points using Comic Sans font. Center the text on the orange button, as shown in Figure 967.6.

Figure 967.6 The Type tool created the button text.

15. Move into the Layers palette and Ctrl+click (Macintosh: Command+click) on the layer containing the orange circle. Photoshop creates a circular selection based on the orange button.

16. Move into the Layers palette and click once on the layer containing the text.

17. Select the Filter menu, choose Distort, and select Spherize from the fly-out menu. Photoshop opens the Spherize dialog box, shown in Figure 967.7.

Figure 967.7 The Spherize command applied to the word Home.

18. Enter a distortion amount of 90 percent, and click the OK button to apply the Spherize filter to the text layer (refer to Figure 967.7).

19. Move into the Layers palette and create a new layer by clicking once on the New Layer icon (the circular selection marquee is still selected).

20. Select the Edit menu and choose Stroke from the pull-down menu. Photoshop opens the Stroke dialog box, shown in Figure 967.8.

Figure 967.8 The Stroke dialog box controls the application of the stroke to the circular selection in the new layer.

21. Enter a Width value of 4, and select Outside for the Location.

22. Click the OK button to apply the stroke to the selection.

23. Click once on the Layers Effects icon, located at the bottom left of the Layers palette, and select Bevel and Emboss from the pop-up menu. Photoshop opens the Layer Style dialog box.

24. Click once on the Style option, and select Emboss from the drop-down list.

25. Click once on the Technique option, and select Smooth from the drop-down list.

26. Click the OK button to apply the bevel to the stroke, as shown in Figure 967.9.

Figure 967.9 The Emboss style applied to the stroke layer completes the effect of a spherical text button.

968 *Adding Depth with Drop Shadows*

To create a sense of depth using a drop shadow, open an image in Photoshop containing a solid shape or tiled background. In this example, you open an image containing a textured background, as shown in Figure 968.1.

Figure 968.1 A Photoshop image containing a simple background.

To use the drop shadow style to generate a sense of depth, perform these steps:

1. Select the Polygonal Lasso from the toolbox and create a diagonal selection across the image, as shown in Figure 968.2.

Figure 968.2 The Polygon Lasso created a diagonal selection across the document window.

2. Press Ctrl+J (Macintosh: Command+J). Photoshop makes a copy of the selected area and places it in a separate layer.

3. Click once on the Layers Effects icon, located at the bottom left of the Layers palette, and select Drop Shadow from the pop-up menu. Photoshop opens the Layer Style dialog box.

4. In the Distance input box, enter a value of 12.

5. In the Size input box, enter a value of 10.

6. Click the OK button or press the enter key to apply the Drop Shadow to the copied layer, as shown in Figure 968.3.

Figure 968.3 The drop shadow applied to the copied layer.

7. Move your mouse into the Layers palette and click once on the background layer.

8. Select the Image menu, choose Adjust, and choose Levels from the fly-out menu. Photoshop opens the Levels dialog box, shown in Figure 968.4.

Figure 968.4 The Levels dialog box controls the shadows, midtones, and highlights of the original layer.

9. Click on and drag the middle gray slider to the right. Photoshop darkens the pixels in the original image layer (refer to Figure 968.4).

10. Complete the effect by adding some type between the top and bottom layers, as shown in Figure 968.5.

Figure 968.5 The effect of depth is enhanced by adding an object or, in this example, some text, between the two layers.

969 *Creating Custom Shadows Without Using Layer Effects*

Photoshop's Layer effects create great drop shadows. However, your creative limit is controlled by the options in the Layers Styles dialog box, as shown in Figure 969.1.

To create your own customizable shadow, open an image containing a text layer and perform these steps:

1. Move into the Layers palette and create a copy of the layer containing the text by clicking on and dragging the text layer over the New Layer icon, as shown in Figure 969.2.

2. Select the Move tool from the toolbox and drag the copied text layer off and to the right (refer to Figure 969.2).

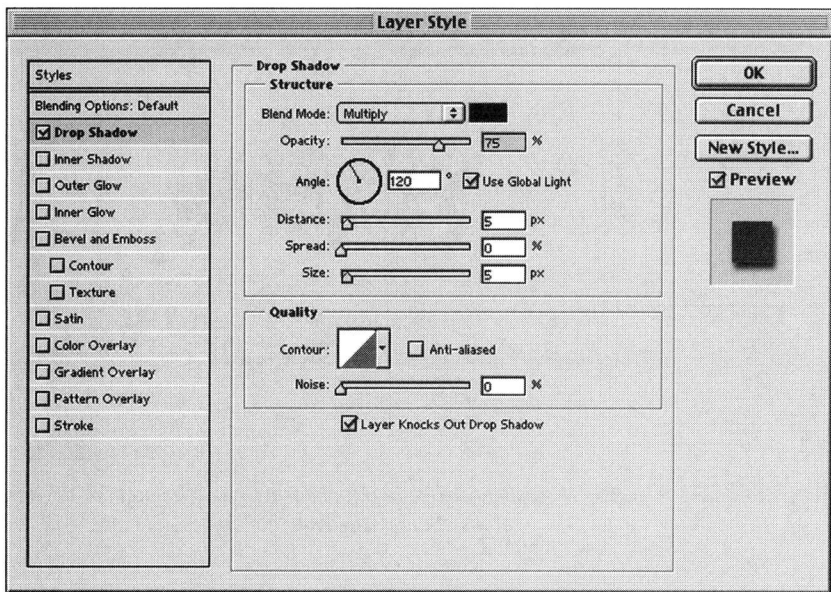

Figure 969.1 The options in the Layer Style dialog box control the application of the style to the image.

Figure 969.2 Clicking on and dragging the Text layer over the New Layer icon creates a copy of the text layer.

3. Press the letter "D" on your keyboard to default the foreground and background colors to black and white.

4. Press Alt+Delete (Macintosh: Option+Delete) to fill the copied text layer with the current foreground color. Because the layer is a text layer, only the text converts to black, as shown in Figure 969.3.

5. With the copy layer selected, choose the Filter menu, select Blur, and select Gaussian Blur from the fly-out menu. Photoshop will warn you in an alert dialog box that the text must be rasterized. Click the OK button. Photoshop opens the Gaussian Blur dialog box.

6. Enter a value of 15 in the Radius input field and click the OK button to apply the Gaussian Blur to the shadow copy layer, as shown in Figure 969.4.

7. Move into the Layers palette and drag the black copy layer underneath the original image layer.

8. Select the Move tool from the toolbox, and position the shadow layer off and to the right of the original image layer.

Figure 969.3 Pressing Alt+Delete (Macintosh: Option+Delete) fills the nontransparent areas of the image with the foreground color.

Figure 969.4 The Gaussian Blur filter applied to the active image.

9. Finish the effect by clicking in the Opacity input field for the copied layer and entering a value of 75 percent, as shown in Figure 969.5.

Figure 969.5 The finished shadow with a Gaussian Blur filter and reduced opacity.

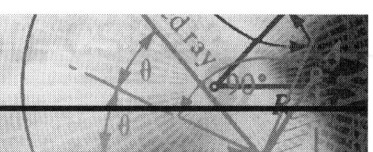

970 *Getting Started with WebDAV*

Photoshop uses WebDAV (Web Distributed Authoring and Versioning) technology to help you manage projects and workflow across the Internet or using a local area network (LAN). To create a workflow using the WebDAV technology, you must first be connected to a WebDAV server. For information on WebDAV, refer to www.webdav.com, as shown in Figure 970.1.

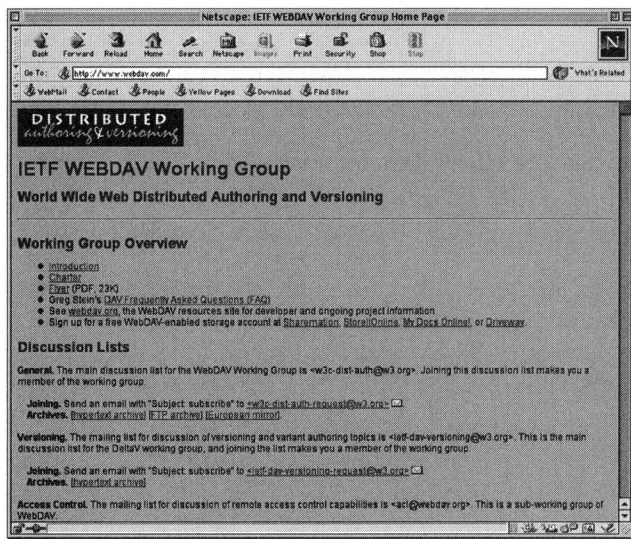

Figure 970.1 The WebDAV Web site contains information on setting up and using the WebDAV technology.

After your organization has set up the WebDAV site, it is a simple matter to load images on the site, which gives access to the images to anyone authorized to use the site. This lets you create a workflow that extends as far as the Internet.

Designers working in different parts of your company or different locations in the world have access to the files. You also can grant people access to particular areas of the site while restricting them from other areas. In addition, when you access a document, the WebDAV site restricts others from accessing the same file.

971 *Operating in the WebDAV Environment*

In the previous tip, you learned about the WebDAV (Web Distributed Authoring and Versioning) management software. To use WebDAV to manage your workflow, you must first be able to log on to a WebDAV server (refer to the previous tip). The WebDAV server plays the part of a central storage device for all your Photoshop images. When connected, anyone involved in the workflow of a specific project has access to the information on the WebDAV server.

Because Photoshop files tend to have large file sizes, all designers linked into a WebDAV server need to have high-speed access to the Internet. Suggestions range from DSL (Direct Service Line) to Roadrunner (high-speed fiber optics). Whatever your choice is, the value of WebDAV is in its capability to access the information quickly. If it takes hours just to download a single file, there is no benefit to the system.

To access information from an active WebDAV server, open Photoshop and select the File menu and choose Manage Workflow from the fly-out menu.

- **Open from Workflow:** Select this option to receive a local copy of the Photoshop file. You are required to enter the URL (uniform resource locator), including the file name of the file that you want to access. Say, for example, that you want a local copy of the Photoshop file named image3b.psd, located on the WebDAV server www.design.org.

 To access the file, select the Open from Workflow option and enter http//:www.design.org/ image_folder/image3b.psd. Click the OK button to retrieve the file. When the file is open, you have access to all the other WebDAV options.

- **Check Out:** When you retrieve a file from the server, selecting the Check Out option prevents other users from accessing the same file and making changes while you are working.

- **Check In:** Selecting the Check In command writes any changes made to the document back to the server. Not only does this rewrite the changes to the server, but it also disables your exclusive lock to the file. To relock the file, reselect the Check Out option.

- **Upload to Server:** Selecting this option uploads the current editing changes to the server and maintains your exclusive lock on the file.

- **Add to Workflow:** Selecting this option lets you add a new document to the WebDAV server. You are required to enter the URL, including the file name of the file that you want to upload to the server.

972 *Choosing Options for WebDAV*

To access the WebDAV options, select the Edit menu, choose Preferences, and select Workflow options from the fly-out menu. Photoshop opens the Workflow Options dialog box, shown in Figure 972.1.

Figure 972.1 The Workflow Options dialog box controls access to the WebDAV server.

You have these options in the Download from Server area:

- **Always:** Choose this option to automatically update the latest version of the file from the server.

- **Ask:** Choose this option to display a dialog box if the file has been updated.

- **Never:** Choose this option to download a file without the display of a dialog box and without downloading the latest version of the file.

You have these options in the Check Out from Server area:

- **Always:** Choose this option to automatically check out the file when you open it.

- **Ask:** Choose this option to display a dialog box if you open a file that is not checked out.

- **Never:** Choose this option to open the file without a dialog box and without checking out the file.

973 *Viewing and Working with Copyright Information*

When you work on previously designed Photoshop documents, the possibility exists that the document contains a copyright. Copyright information is your way of protecting your designs and artwork from illegal use.

To scan a Photoshop document for embedded copyright information, open the document and select the Filter menu, choose Digimarc, and choose Read Watermark from the fly-out menu. Photoshop examines the active document for copyright information, as shown in Figure 973.1.

Figure 973.1 The Read Watermark option scans an image for embedded copyright information.

Copyright information is added to the image in the form of background noise that is not visible to the viewer. This means that an image containing a digital copyright can be printed and rescanned back into Photoshop, and the copyright information will still be readable.

When you check an image for a digital watermark, understand that lack of a digital watermark does not indicate that the image is not copyrighted. The application of Photoshop filters to an image containing a digital watermark affects the capability of the Read Watermark command to find the watermark; however, it does not eliminate the copyright.

To add copyright information to your own Photoshop document, refer to Tip 99, "Inserting Digital Copyright Information into a Photoshop Image."

974 *Converting an Animation into an Image Suitable for Printing*

ImageReady lets you open and select a specific cell from an animation or a QuickTime movie, and Photoshop helps you prepare the image for printing. Say, for example, that you want to remove a single frame from a digital movie and prepare that frame for printing.

To prepare a digital animation frame for printing, open ImageReady and perform these steps:

1. Select the File menu and select Open from the pull-down menu. ImageReady displays the Open dialog box, shown in Figure 974.1.

Figure 974.1 The Open dialog box lets you select a movie file and select a specific cell within the animation.

2. Select the movie file, and click on the Open button. ImageReady displays the Open Movie dialog box, shown in Figure 974.2.

Figure 974.2 The Open Movie dialog box lets you select a specific frame from the movie file.

3. Select the Selected Range Only option.

4. Click on the movie slider button and drag left or right to select the frame that you want to print.

5. Click the OK button to move the selected frame into ImageReady, as shown in Figure 974.3.

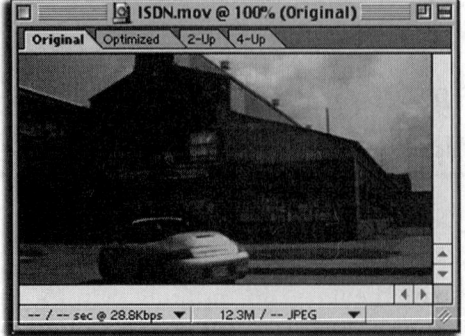

Figure 974.3 The selected frame opened in ImageReady.

6. Click the Jump To button, located at the bottom of the ImageReady toolbox. The selected frame opens in Photoshop, as shown in Figure 974.4.

Figure 974.4 Clicking on the Jump To button moves the selected frame into Photoshop.

7. Select the Image menu and choose Image Size from the pull-down menu. Photoshop opens the Image Size dialog box, shown in Figure 974.5.

Figure 974.5 The Image Size dialog box controls the width, height, and resolution of the selected movie frame.

8. Select the Constrain Proportions and Resample Image options (refer to Figure 974.5).

9. In this example, you want to print the image as close to 5 by 7 inches as possible. Click in the Width input field and enter a value of 7. The Height field automatically modifies the Width field to maintain the proportions of the image.

10. Most movie files have a resolution of 72ppi. Although this works well for displaying a movie on a computer monitor, it is too low for printing. Click in the Resolution input field and enter a value of 150.

11. Click the OK button to apply the changes to the image, as shown in Figure 974.6.

12. To print the image, select the File menu and select Print from the pull-down menu (refer to Tip 699, "Printing Directly from Photoshop Using Default Printing Options").

Note: If the image requires additional enhancement, refer to Tip 636, "Adjusting Screen Shots for Print."

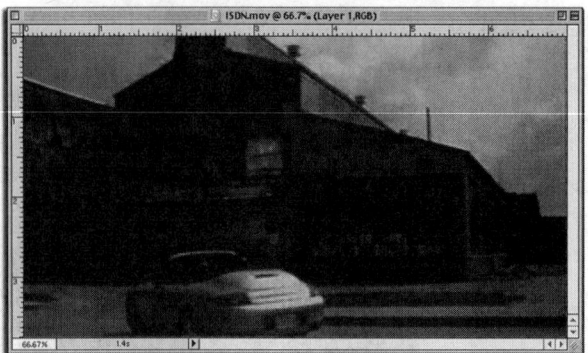

Figure 974.6 The modified movie cell.

975 *Simulating Motion in an Image*

In Tip 832, "Using Layers to Generate Motion in a Photoshop Image," you learned how to generate motion in an image using multiple layers. Another efficient way to generate motion within an image is with the Motion Blur filter and the History brush.

To simulate motion in an image, open the graphic in Photoshop and perform these steps:

1. Select the Filter menu, choose Blur, and choose Motion Blur from the fly-out menu. Photoshop opens the Motion Blur dialog box, shown in Figure 975.1.

Figure 975.1 The Motion Blur dialog box controls the amount and angle of the motion blur.

2. In the Angle input field, enter a value from –360 to +360°. In this example, you enter a value of 20°.

3. In the Distance field, enter a value from 1 to 999 pixels. In this example, you enter a value of 60 pixels.

4. Click the OK button to apply the Motion Blur filter to the active image (refer to Figure 975.1).

5. If the Layers palette is not open, select the Window menu and choose Show Layers from the pull-down menu. Photoshop opens the Layers palette.

6. Create a new layer by clicking once on the New Layer icon, as shown in Figure 975.2.

Figure 975.2 Clicking on the New Layer icon creates a new transparent layer.

7. Select the History brush from the toolbox and select a small, soft brush from the Options bar, as shown in Figure 975.3.

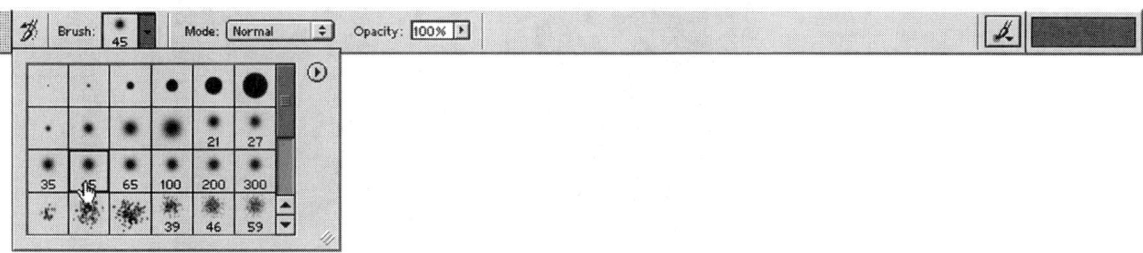

Figure 975.3 Select a small, soft brush from the Options bar.

8. Move your mouse into the Layers palette, and click once on the new transparent layer.

9. Move into the document window and use the History brush to repaint the areas of the image that you want to restore, as shown in Figure 975.4.

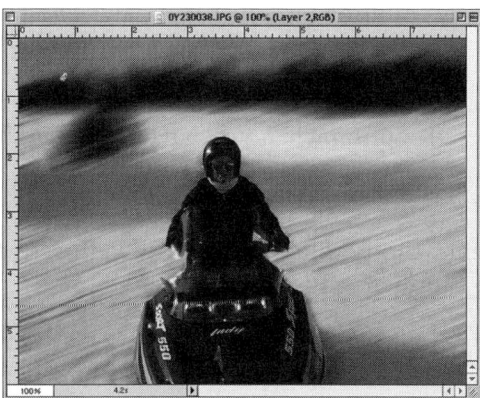

Figure 975.4 The restored portions of the image give the impression of movement in the background.

976 *Focusing Attention Using Adjustment Layers*

An excellent way to focus attention to a specific portion of an image is with the use of adjustment layers. Say, for example, that you create the cover to restaurant menu, and you want to focus attention to the image. However, you want the customers to be able to read the words on top of the graphic.

To focus attention using adjustment layers, open the graphic image in Photoshop and perform these steps:

1. If the Layers palette is not open, select the Window menu and choose Show Layers from the pull-down menu. Photoshop opens the Layers palette.

2. Select the Rectangular Marquee tool from the toolbox and select the center area of the image, as shown in Figure 976.1.

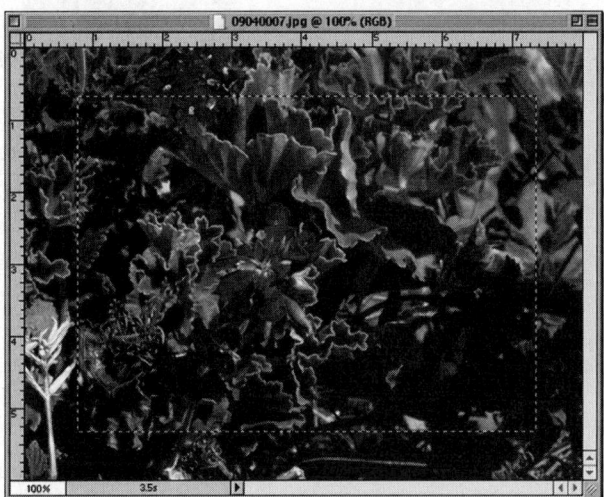

Figure 976.1 The Rectangular Marquee tool selected the center section of the active image.

3. Click once on the New Adjustment Layer icon, and select Levels from the pop-up menu, as shown in Figure 976.2.

4. Click on the middle-gray input slider and drag to the left. The selected portions of the image begin to lighten. Click the OK button when you have an image that resembles Figure 976.3.

5. Move into the Layers palette and click once on the Levels Adjustment layer.

6. Select the Filter menu, choose Blur, and choose Gaussian Blur from the fly-out menu. Photoshop opens the Gaussian Blur dialog box.

7. In the Radius input field, enter a value of 10. The Gaussian Blur filter softens the edge of the Levels mask. Click the OK button to apply the Gaussian Blur filter to the image, as shown in Figure 976.4.

8. Add some text to complete the image (refer to Tip 218, "Creating Text in Photoshop 6.0"), as shown in Figure 976.5.

Figure 976.2 The Levels dialog box controls the adjustment of the selected areas of the document window.

Figure 976.3 The Levels dialog box lightened the selected areas of the document window.

Figure 976.4 The Gaussian Blur filter applied to the layer mask.

Figure 976.5 The Type tool added text and completed the restaurant cover.

977 *Moving Photoshop's Brushes Palette*

Photoshop 6.0 changed the location of several of its standard palettes. The most noticeable was the elimination of the Options palette, when it became the Options bar, as shown in Figure 977.1.

Figure 977.1 In Photoshop 6.0, the Options palette became the Options bar.

Another drastic change (to some Photoshop users) was the elimination of the Brush palette. When you select a tool requiring a brush size, the Brush palette appears to the left of the Options bar, as shown in Figure 977.2.

Figure 977.2 The Brush palette is now a part of the Options bar.

Although the design of the Options bar is an excellent feature, many users do not like accessing the Brush palette from the top of the screen. That is not a problem because the designers at Adobe gave you a way to change the Brush palette location.

To change the Brush palette location, select a tool requiring the use of the Brush palette (in this example, you select the Paintbrush tool).

To change the location of the Brush palette, Shift+right-click (Macintosh: Ctrl+Shift-click) where you want the palette to move, as shown in Figure 977.3.

Figure 977.3 Shift+right-clicking (Macintosh: Ctrl+Shift-clicking) moves the Brush palette to the new location.

978 *Understanding Object Linking (Windows Only)*

Photoshop supports linking images using an OLE (object linking and embedding) container application. Container applications are programs that support object linking and embedding, such as Adobe PageMaker and Microsoft Word.

To copy an image into an OLE-compliant program, first open the image in Photoshop. Then choose the Select menu and choose All from the pull-down menu. Select the Edit menu and choose the Copy command. Photoshop places the image in Clipboard memory.

Now open an OLE-compliment program (in this example, the PageMaker program was used), select the Edit menu, and choose Paste Special from the pull-down menu. The copied image is pasted into the OLE-compliant program, as shown in Figure 978.1.

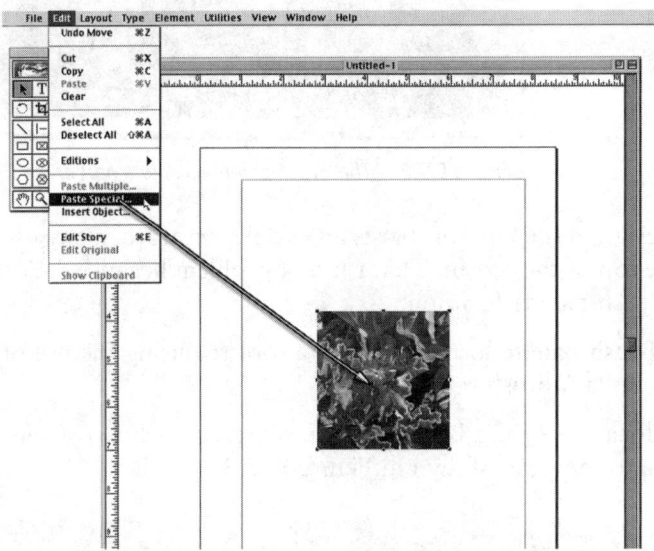

Figure 978.1 Using the Paste Special option lets you paste OLE documents into the active document window.

The OLE linked image gives you access to the original editing program. Say, for example, that you insert an OLE image into PageMaker and you want to edit the image. Open PageMaker and double-click on the image. The OLE document reopens in the original editing program (in this example, Photoshop), and you can edit the document. When you save and close the file in Photoshop, the image will be updated in the OLE program (in this example, PageMaker).

Note: If you update the original file directly from Photoshop, the next time the OLE-compliant document is opened, the file will be updated.

979 *Creating a Pill-Shaped Button*

Creating a pill-shaped button has never been easier when you use Photoshop 6 and the new Styles palette.

To create a quick pill-shaped button, open Photoshop and perform these steps:

1. Select the File menu and choose New. Photoshop opens the New dialog box. Create a new document with a width of 4 inches, a height of 2 inches, and a resolution of 72ppi, as shown in Figure 979.1.

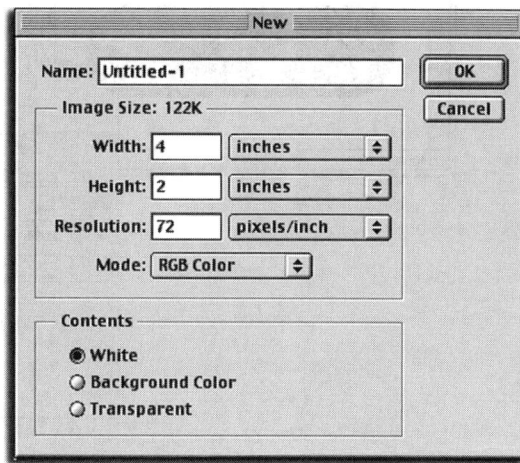

Figure 979.1 The New dialog box defines the characteristics of the new document.

2. If the Layers palette is not open, select the Window menu and choose Show Layers from the pull-down menu. This opens the Layers palette.

3. Create a new layer by clicking once on the New Layer icon.

4. Select the Rounded Rectangle tool from the toolbox, as shown in Figure 979.2.

Figure 979.2 Select the Rounded Rectangle tool from the available drawing tools.

5. Move into the Options bar, select the Create Filled Region button (third button from the left), and enter a value of 35 in the Radius field, as shown in Figure 979.3.

Figure 979.3 The Options bar lets you modify the characteristics of the Rounded Rectangle tool.

6. Draw a selection in the size that you want your button, as shown in Figure 979.4.

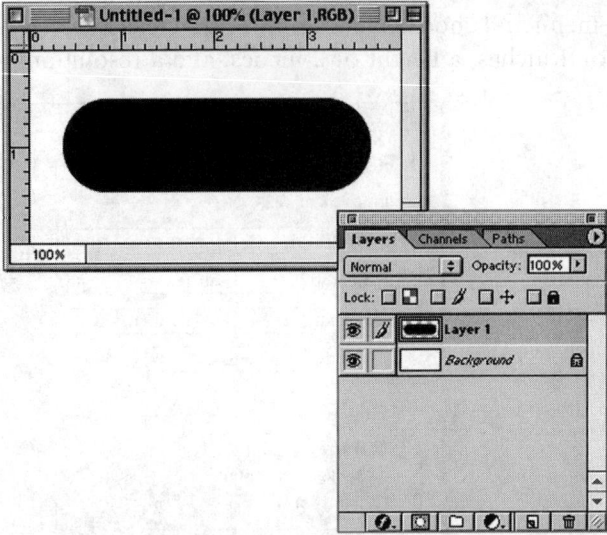

Figure 979.4 The Rounded Rectangle tool created a pill-shaped button in the new layer.

7. If the Styles palette is not open, select the Window menu and choose Show Styles from the pull-down menu. Photoshop opens the Styles palette.

8. Click once on the black triangle, located in the upper-right corner of the Styles palette, and select Glass Buttons.asl from the available Style options, as shown in Figure 979.5.

Figure 979.5 Clicking on the black triangle button lets you select from the available Styles options.

9. To add the glass styles to your palette, click the OK or Append buttons.

10. Select a style for your button by clicking one at a time on the available options, as shown in Figure 979.6.

Figure 979.6 The Blue Glass style applied to the rounded rectangle layer creates a great-looking pill-shaped button.

980 *Creating a Smooth Selection Using Noise*

Photoshop lets you select information using a variety of selection tools and methods (refer to Tip 280, "Selection Methods"). Say, for example, that you use the Magic Wand tool to create a selection (refer to Tip 170, "Understanding How the Magic Wand Works"), but the selection boundary is jagged, as shown in Figure 980.1.

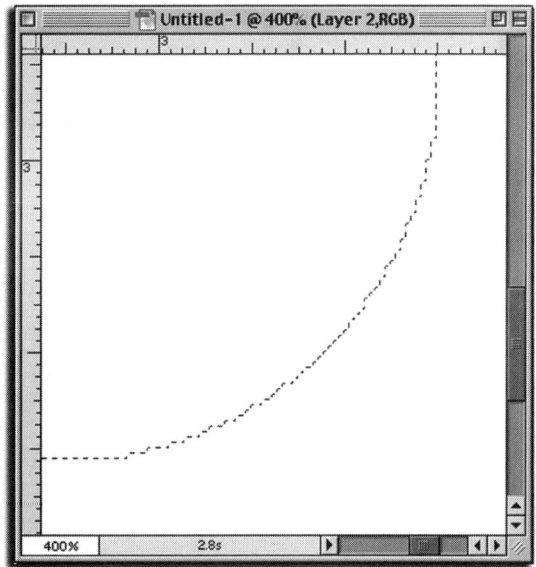

Figure 980.1 The Magic Wand tool makes quick work of complicated selections, but the selection edge is usually jagged.

To help smooth out the selection, perform these steps:

1. Select the Quick Mask option from the toolbox. Photoshop converts the Magic Wand selection into a red mask, as shown in Figure 980.2.

Figure 980.2 The Quick Mask option creates a mask from a selected portion of the image.

2. Select Filter menu Noise, and choose Median from the fly-out menu. Photoshop opens the Median dialog box, shown in Figure 980.3.

*Figure 980.3 The Median filter blends the brightness of pixels within an image.
The effect applied to a selection mask smoothes out the jagged edge.*

3. Click on and drag the Radius slider to the right until the mask appears smooth. In this example, you select a value of 15. Click the OK button to apply the Median filter to the Quick Mask, as shown in Figure 980.4.

4. Click on the Standard Mode button to restore the selection, as shown in Figure 980.5.

Figure 980.4 The Median filter applied to the Quick Mask.

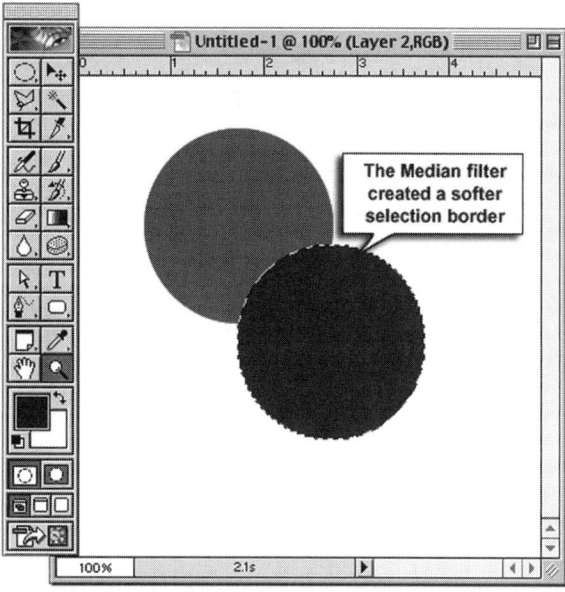

The Median filter
created a softer
selection border

Figure 980.5 Clicking on the Standard Mode button returns you to the original image with a much smoother selection.

981 *Creating a Transparent Image for PowerPoint*

Without a doubt, PowerPoint is one of the most popular presentation programs in today's marketplace. Everybody from families showing off their vacation photos to corporate executives use PowerPoint.

Say, for example, that you want to prepare a graphic image for a PowerPoint presentation. However, when you open the image in PowerPoint, you see a big white box surrounding the graphic, as shown in Figure 981.1.

Figure 981.1 If not saved correctly, Photoshop images appear in PowerPoint surrounded with a white box.

Unfortunately, what you want is a graphic image against a transparent background. To prepare an image for PowerPoint with a transparent background, open the image in Photoshop and perform these steps:

1. Select the File menu and choose Save for Web from the pull-down menu. Photoshop opens the Save for Web dialog box, shown in Figure 981.2.

Figure 981.2 The Save for Web dialog box controls the transparent pixels in the active image.

2. Select the GIF format, and select the Transparency option. In this example, you leave the other options at their default values (refer to Tip 853, "Understanding the GIF File Format").

3. Click the OK button to save the file.

4. When you open the image in PowerPoint, the transparent areas of the original graphic remain transparent, as shown in Figure 981.3.

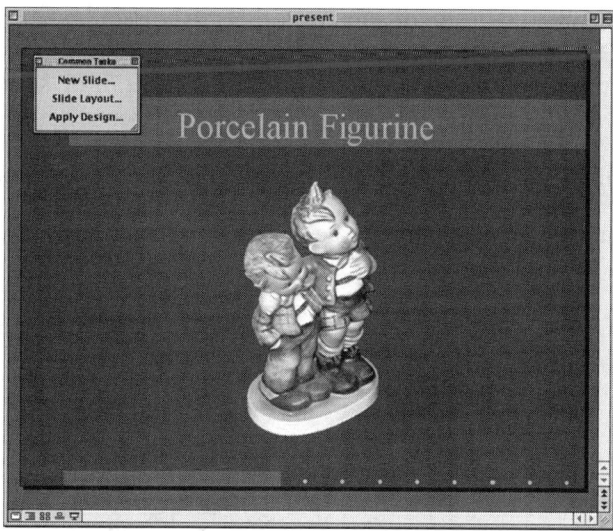

Figure 981.3 The GIF file format preserves the transparency of the original image.

982 *Locating the Exact Center of a Graphic Image*

When you align and move an object in Photoshop, it is important to locate the exact center of the image. The Photoshop Ruler bar helps, but to find the exact center, you have to know the exact width and height of the graphic. If the image fills the document window, that might not be very difficult; however, if you want to find the center of a single object, it can become a problem. Say, for example, that you want to find the center of a red circle that you just created in a separate layer. It might be easy to approximate, but if you are centering other objects on top of the circle, do not try to estimate the center, as shown in Figure 982.1.

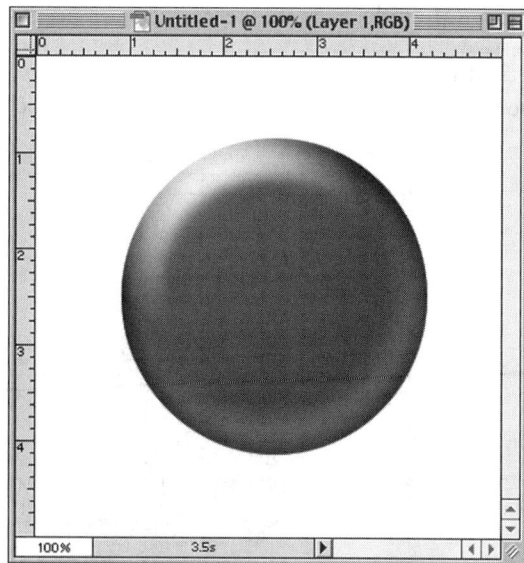

Figure 982.1 Finding the exact center of a circle is not as easy as it might seem.

To find the exact center, open the document in Photoshop and perform these steps:

1. If the Layers palette is not active, click on the Layer tab or select the Window menu, and choose Show Layers from the pull-down menu. Photoshop opens the Layers palette.

2. Move your cursor into the Layers palette and click on the layer containing the red circle.

3. Select the Edit menu and choose Free Transform from the pull-down menu. Photoshop places a bounding box around the red circle, as shown in Figure 982.2.

Figure 982.2 The Free Transform command places a bounding box around the red circle.

4. If the Ruler bar is not visible, select the View menu and select Show Rulers from the pull-down menu.

5. To create a guide, move into the horizontal ruler bar, and then click and drag into the document window. Drag the horizontal guide over the center anchor points on the Transform bounding box.

6. Move into the vertical ruler bar, and then click and drag into the document window. Drag the vertical guide over the center anchor points on the Transform bounding box, as shown in Figure 982.3.

Figure 982.3 The vertical and horizontal guides marked the center point of the selected graphic.

7. Press the Esc key to remove the bounding box from the graphic.

Note: Because the guidelines, by default, snap to the anchor points on the Transform bounding box, you have the exact center of the selected object.

983 *Quickly Opening and Closing Layers in Photoshop*

One of the most frustrating aspects of working on a multi-layered Photoshop document is accessing a specific layer. Say, for example, that you have a 10-layer Photoshop document and you want to work on 1 layer without the distraction of the other 9 layers, as shown in Figure 983.1.

Figure 983.1 Multi-layered documents are difficult to work on in Photoshop.

To quickly activate and deactivate layers, open the document in Photoshop. If the Layers palette is not open, select the Window menu and choose Show Layers from the pull-down menu. Move your cursor into the Layers palette, hold down the Alt key (Macintosh: Option key), and click once on the Eyeball icon of the layer that you want to edit. Photoshop deactivates all the other layers in the document, leaving you free to perform editing, as shown in Figure 983.2.

Figure 983.2 Holding down the Alt key (Macintosh: Option key) while clicking on a layer.
Eyeball icon deactivates all the other layers in the active image.

To reactive all the layers, hold down the Alt key (Macintosh: Option key) and click once on the Eyeball icon for the active layer. Photoshop reactivates all the layers in the selected document.

Note: Having the capability to quickly open and close groups of layers saves time in the editing process and lets you accomplish more work in the same amount of time.

984 Determining the Dynamic Range of a Scanner

The two most import features of a scanner are the resolution and the dynamic range. The optical resolution of a scanner defines how much information transfers from the original scan into Photoshop. Photoshop breaks the image into small pieces that you define as the resolution of the image. Photoshop then reassembles those pieces and displays the image.

Resolution is good. You want a lot of resolution, but you also want a scanner with good dynamic range. Dynamic range is the total amount of optical density that the scanner is capable of delivering to Photoshop. Using a measurement system from 0 to 4, it describes the maximum achievable shadow. In dynamic range, 0 equals white and 4 equals pure black. High dynamic ranges on scanners are important because each increase in numerical value represents 10 times more data for Photoshop.

Here is the problem: In most flatbed scanners, the higher the optical resolution is, the less the dynamic range is. Most entry-level scanners have a dynamic range from 2.3 to 2.9. A midrange scanner delivers a 3.0 to 3.3 dynamic range, and high-end scanners costing tens of thousands of dollars can achieve a full dynamic range all the way to 4.0. Most of the time, a scanner with a dynamic range up to 3 or 3.2 is fine. In fact, few images exceed a dynamic range of 3.2.

When a scanner analyzes an image that exceeds its dynamic range limitation, the first area to suffer is the dark shadow. Although in most cases this is not a problem, you run into trouble scanning old, dark images. The lack of dynamic range forces loss of information in the dark areas of the image, as shown in Figure 984.1.

Figure 984.1 A lack of dynamic range causes a loss of information starting in the shadow areas of the image.

When your scanner has a greater dynamic range, information in the darker areas of the image is preserved, as shown in Figure 984.2.

Figure 984.2 Scanners with a greater dynamic range pick up more detail in the shadow areas of the image.

Note: *When you purchase a scanner for use with Photoshop, look for more than the optical resolution: Check the dynamic range. A dynamic range that runs close to 3.0 to 3.2 is excellent for most scanning situations.*

985 *Viewing Images Intended for the Internet*

Images created for viewing on Web pages have one major problem: the user's computer system. The two major platforms on the Internet are Macintosh and Windows. Although both systems perform well, images displayed on Macintosh or Windows machines appear different, as shown in Figure 985.1.

Figure 985.1 The same image displayed on a Macintosh and a Windows monitor appears different.

One problem is the color set: Windows machines display images using a slightly different color set than Macintosh machines. The other problem involves the Gamma of the monitor. Gamma measures the brightness of the midtone values produced by your monitor. The average Gamma value for a Windows monitor is 2.2, and the average value of a Macintosh monitor is 1.8. This results in an image displaying 20 percent darker on a Windows monitor.

Say, for example, that you have a graphic image that you want to display in a Web document, but you are not sure how the image appears on Macintosh or Windows monitors.

To view the Gamma of a photographic image, open the graphic in ImageReady. Select the View menu, choose Preview, and select Standard Macintosh Color or Standard Windows Color from the fly-out menu.

- **Standard Macintosh Color:** Selecting this option from a Windows computer displays the image using a 1.8 Gamma.

- **Standard Windows Color:** Selecting this option from a Macintosh computer displays the image using a 2.2 Gamma.

Note: The best method for adjusting the Gamma of an image is with the Levels command (refer to Tip 727, "Adjusting the Gamma of an Image Using ImageReady").

986 *Previewing Images in a Browser*

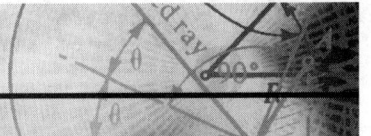

In the previous tip, you learned how to view the gamma range of an image when viewed on a Macintosh or a Windows monitor. Web browsers also add their own personal modifications to an image. Say, for example, that you want to view a Web graphic using one or more different Web browsers.

To view an image in a Web browser, open the graphic in ImageReady. Select the File menu, choose Preview In, and choose from the available options, as shown in Figures 986.1 and 986.2.

Figure 986.1 The Web image displayed using Internet Explorer 4.5.

Because the marketplace typically uses more than one version of Explorer and Navigator, it is an excellent idea to keep several versions of each browser. Figure 986.3 shows a graphic image displayed in Navigator 6.0.

Figure 986.2 The Web image displayed using Netscape Communicator 4.75.

Figure 986.3 The Web image displayed using Netscape Navigator 6.0.

987 *Updating Existing HTML Files*

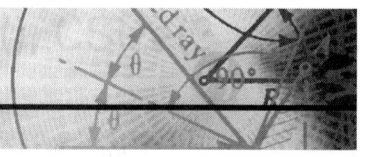

When you save graphics using ImageReady, the program generates any associated HTML code necessary to run the file. Say, for example, that you slice a graphic image and save the file. ImageReady saves the slices and generates the HTML table document needed to reload the sliced image into a Web document, as shown in Figure 987.1.

Say, for example, that you access the original image and modify the number of slices (refer to Tip 806, "Working with Sliced Images"). When you resave the document, you want ImageReady to modify the original HTML code to comply with your modifications to the image.

To update existing HTML code, open and make changes to the graphic in ImageReady. Select the File menu and choose Update HTML from the pull-down menu. ImageReady opens the Update HTML dialog box, shown in Figure 987.2.

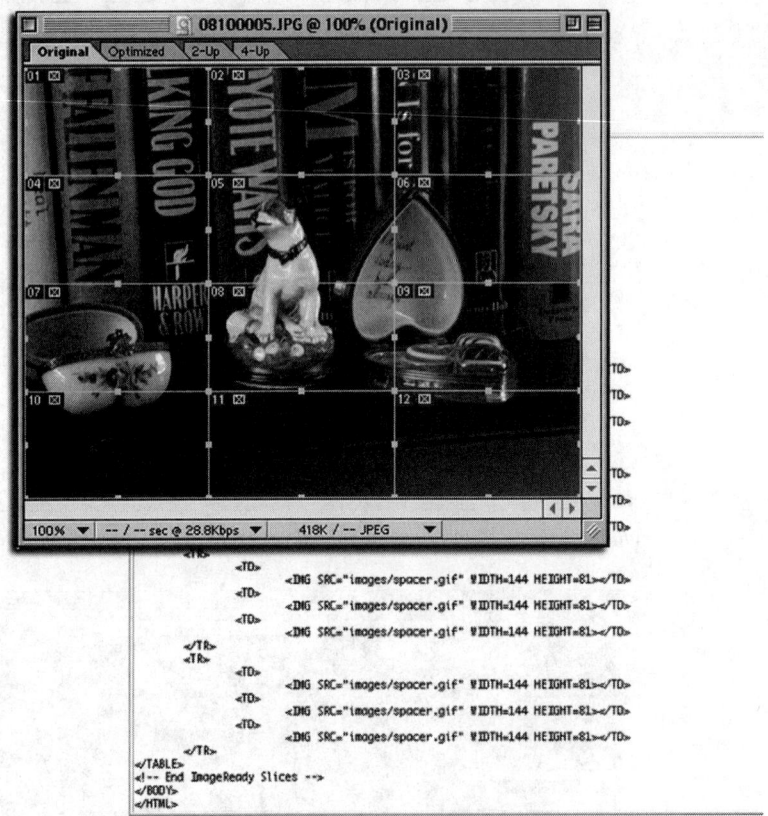

Figure 987.1 ImageReady saves a sliced image and the HTML necessary to open the file in a Web browser.

Figure 987.2 The Update HTML dialog box lets you select the HTML document requiring modification.

Locate and select the correct HTML document, and click on the Open button. ImageReady opens the HTML document and updates the code to correspond to your modifications of the graphic.

Note: If no modifications are required, ImageReady display an alert box indicating that no changes were made to the original code.

988 *Creating a Hybrid Graphic in ImageReady*

A hybrid graphic is combination of a continuous-tone image and clip art, as shown in Figure 988.1.

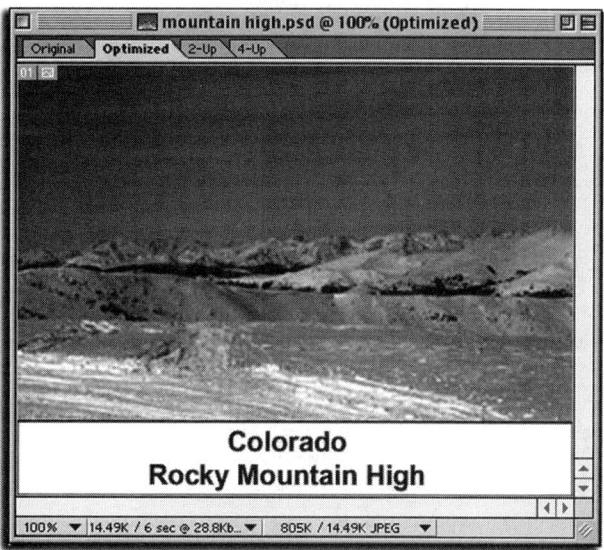

Figure 988.1 A hybrid image contains photographic and clip art elements.

Although this does not present any particular design problems, it presents an opportunity when the image is used on the Internet. The two most common file formats used on the Internet are JPEG (Joint Photographic Experts Group) and GIF (Graphics Interchange File).

The JPEG format is used exclusively for photographs, and the GIF format is used for clip art. To obtain the best of both worlds, slice the image and compress each piece to its optimum compression.

To slice the image, open the graphic in ImageReady and perform these steps:

1. Move your mouse into the ImageReady toolbox and select the Slice tool.

2. If the Optimize palette is not visible, select the Window menu and choose Show Optimize from the pull-down menu. Photoshop opens the Optimize palette, shown in Figure 988.2.

Figure 988.2 The Optimize palette controls the compression characteristics of the individual slices in the active image.

3. Move into the image, and then click and drag your mouse from the upper-left corner to the right middle of the document window. ImageReady creates a slice for the upper half of the document window, as shown in Figure 988.3.

Figure 988.3 The Slice tool created a slice from the upper half of the image.

4. Move into the image, and then click and drag your mouse from the middle-left to the bottom-right corner of the document window. ImageReady creates a second slice for the lower half of the document, as shown in Figure 988.4.

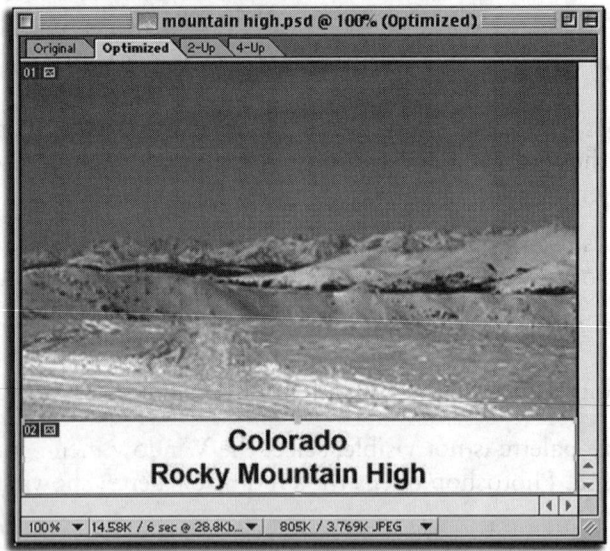

Figure 988.4 The Slice tool created a slice from the lower half of the image.

5. Move your mouse into the ImageReady toolbox, and select the Slice Select tool.

6. Move into the document window and click once on the top slice. ImageReady selects the slice and dims all the other slices, as shown in Figure 988.5.

7. Using the information in Tip 754, "Reducing the File Size of a JPEG Image," move your mouse into the Optimize palette and reduce the size of the selected slice. In this example, the selected slice contains a graphic image. You select JPG as the file format and choose Optimized, with a quality setting of 40 percent, as shown in Figure 988.6.

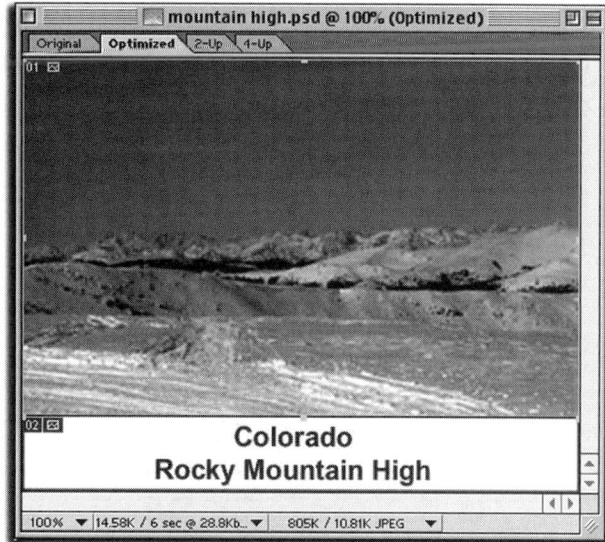

Figure 988.5 The Slice tool lets you select individual slices within the active image.

Figure 988.6 The selected slice is optimized using the options in the Optimize palette.

8. Move into the document window and click once on the bottom slice. ImageReady selects the slice and dims all the other slices.

9. Using the information in Tip 755, "Reducing the File Size of a GIF Image," move your mouse into the Optimize palette and reduce the size of the selected slice. In this example, the selected slice contains a text image. You select GIF as the file format and choose Optimized, with a color setting of 4, as shown in Figure 988.7.

Figure 988.7 The selected slice is optimized using the options in the Optimize palette.

989 *Reducing Step Gradients with Noise*

In Tip 985, "Viewing Images Intended for the Internet," you learned how to view images using a Macintosh and Windows gamma. The preview option in Photoshop lets you observe images using both operating systems and correct the image based on information from both the Macintosh and Windows operating systems. Another problem with Internet graphics is a stepped appearance to images containing a gradient, as shown in Figure 989.1.

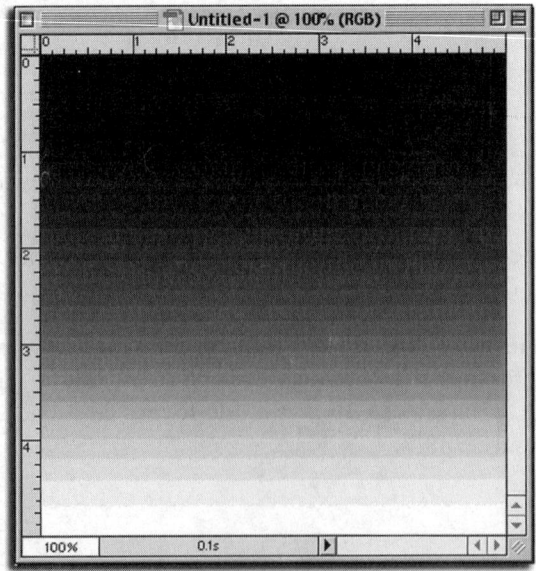

Figure 989.1 When viewed on the Internet, images containing a gradient have a tendency to appear stepped.

Gradients appear stepped because not all monitors display the same number of colors. Most designer make the mistake of viewing their Web images on their high-end, billion-color monitors. The gradient

looks correct because the monitor has enough color variation to display the gradient correctly. Problems occur when the image displays on an older monitor that is not capable of producing all the same colors.

To help correct stepped gradients, open the image in Photoshop, select the Filter menu, choose Noise, and choose Add Noise from the fly-out menu. Photoshop opens the Add Noise dialog box, shown in Figure 989.2.

Figure 989.2 The Add Noise dialog box adds random noise to the active image.

Select Uniform Distribution, and do not select Monochromatic.

Click on the Amount slider and drag to the right until the noise causes the step to be less obvious (refer to Figure 989.2). In this example, you select a value of 15.

Now select the Filter menu, choose Blur, and select Gaussian Blur from the fly-out menu. Photoshop opens the Gaussian Blur dialog box. Increase the radius to soften the effect of the Add Noise filter, and click the OK button to apply the Gaussian Blur filter to the image, as shown in Figure 989.3.

Figure 989.3 The Add Noise and Gaussian Blur filters effectively removed the stepped appearance to the gradient.

Note: Using the Add Noise and Gaussian Blur filters typically does not eliminate the stepped appearance to the gradient, but it will soften its effect.

990 Customizing an Action to Create a New Photoshop Document

When you select the File menu and choose New in Photoshop, the resulting dialog box displays a width, height, color space, and resolution for the last graphic that you opened. The situation is further complicated when you save something to the Clipboard. Photoshop thinks that you want to open a document with the dimensions of the image inside Clipboard memory. Although this is frustrating, it is actually easy to fix. If you have a common size of new document that you want to open, use the Action palette to create an action for the event.

To create a file open action, open Photoshop and perform these steps:

1. If the Actions palette is not visible, click on the Actions tab or select the Window menu, and choose Show Actions from the pull-down menu. Photoshop displays the Actions palette, as shown in Figure 990.1.

Figure 990.1 The Actions palette displays all the available actions.

2. Click on the New Action icon, located at the bottom of the Actions palette. Photoshop opens the New Action dialog box, shown in Figure 990.2.

Figure 990.2 The New Action dialog box defines the initial characteristics of the file.

3. In the Name input field, enter a name for the action. In this example, the name of the file is New Document.

4. Click on the Function Key option and select an open function key from the drop-down list. In this example, you select the F2 function key (refer to Figure 990.2).

5. Click on the Record button. Photoshop closes the New Action dialog box and begins recording the action.

6. Select the File menu and choose New from the pull-down menu. Photoshop opens the New dialog box, as shown in Figure 990.3.

Figure 990.3 The New dialog box defines the width, height, resolution, and color space of the new document.

7. Click on the Stop Recording icon. Photoshop stops recording the action and saves a file named New Document in the Actions palette, as shown in Figure 990.4.

Figure 990.4 Clicking on the Stop Recording icon ends the action and saves the file in the Actions palette.

Note: To try out your new action, simply press the F5 function key. This is a quick and easy way to open a standard new Photoshop document.

991 *Using Merge Visible to Lock Layer Effects*

When you add a layer effect to an image, Photoshop adds the effect to the active layer. Photoshop 6 identifies each layer effect by its own element, as shown in Figure 991.1.

When you add an effect to a layer, any previous effects influence the new effect. For example, adding a drop shadow to an image containing an inner bevel appears different than applying a drop shadow to a layer without a bevel. An addition, when you convert an image containing layer effects into another color space, it can affect how the effects appear after the conversion.

Figure 991.1 Photoshop identifies each effect applied to a layer with its own element.

To lock layer effects into a layer, open a Photoshop multi-layered document containing layer effects, and perform these steps:

1. If the Layers palette is not visible, click once on the Layers tab, or select the Window menu and choose Show Layers from the pull-down menu. Photoshop opens the Layers palette, shown in Figure 991.2.

Figure 991.2 The Layers palette displays information on all the layers in the active image.

2. Move your cursor into the Layers palette and click once on the button layer (refer to Figure 991.2).

3. Create a new layer by clicking once on the New Layer icon.

4. Click on the new layer and drag it below the button layer, as shown in Figure 991.3.

5. Click once on the button layer. Photoshop selects the button layer.

6. Select the Layer menu and choose Merge Down from the pull-down menu. Photoshop merges the button layer (and all the attached effects) into the new layer. The result is a new layer containing the original graphic with the effects merged into the image, as shown in Figure 991.4.

Figure 991.3 Drag the New Layer icon below the button layer.

Figure 991.4 The Merge Down option combined the effects layer with the new layer.

992 *Adding the GIF89a Format to Photoshop 6.0*

One of the questions concerning Photoshop 6 is, what happened to the GIF89a format? The answer to that question is that Photoshop merged the features of the GIF89a format into the Save for Web command (refer to Tip 830, "Changing Image Size Using Save for Web") and Adobe's Web editing program, ImageReady.

That might be fine, but some people still miss the old GIF89a format. To restore the GIF89a format to Photoshop 6.0, perform these steps:

1. Make a copy of the GIF89a Export file in Photoshop 5.5. The file is located in the Adobe Applications folder, inside a folder named Import/Export, as shown in Figure 992.1.

Figure 992.1 The GIF89a Export file is located in Photoshop 5.5's Import/Export folder.

2. Drag the GIF89a Export file into the Import/Export folder in the Photoshop 6.0 application folder, as shown in Figure 992.2.

Figure 992.2 Drag the copy of the GIF89a Export file into the Photoshop 6.0 Import/Export folder.

3. Restart Photoshop and open a document that you want to convert into the GIF89a format.

4. Select the File menu, choose Export, and select GIF89a Export from the fly-out menu. Photoshop opens the GIF89a Export dialog box, shown in Figure 992.3.

Figure 992.3 The GIF89a Export dialog box open in Photoshop 6.0.

Note: Although Adobe has not commented on using the GIF89a Export command with Photoshop 6.0, it seems to function correctly on both the Macintosh and Windows platforms.

993 *Creating an Instant Neon Glow*

The artistic filter Neon Glow works great to create a Neon Glow around an image, but most Photoshop users choose other methods to create a neon glow, simply because they do not understand how to correctly apply the filter. Say, for example, that you have some text on a flattened layer, as shown in Figure 993.1.

Figure 993.1 A flattened Photoshop graphic image containing some text.

To create a soft neon glow around the text, open the image in Photoshop and perform these steps:

1. If the Layers palette is not open, select the Window menu and choose Show Layers from the pull-down menu. Photoshop opens the Layers palette.

2. Press the letter "D" on your keyboard to default the foreground and background colors to black and white. The Neon Glow filter uses the foreground color to fill the areas outside the glow effect.

3. Select the Magic Wand tool from the toolbox, and deselect the contiguous options in the Options bar (refer to Tip 181, "Using the Contiguous Option with the Magic Wand").

4. Click once in the white area surrounding the text. Photoshop selects all the white areas in the document window, as shown in Figure 993.2.

5. Select the Filter menu, choose Artistic, and choose Neon Glow from the fly-out menu. Photoshop opens the Neon Glow dialog box, shown in Figure 993.3.

6. In the input box for Glow Size, enter a value of 7.

7. In the input box for Glow Brightness, enter a value of 20.

8. Click once on the Glow Color box, and select a bright yellow from Photoshop's color picker (refer to Tip 62, "Manually Choosing Colors with the Color Picker").

Figure 993.2 The Magic Wand tool selected all the white areas within the document window.

Figure 993.3 The Neon Glow dialog box controls the size and color of the neon glow filter.

9. Click the OK button to apply the Neon Glow filter to the image, as shown in Figure 993.4.

Figure 993.4 The Neon Glow filter applied to the active document.

994 *Setting Text on Fire*

Here is a cool tip to create hot text. To set some text on fire, open Photoshop and perform these steps:

1. Select the File menu and choose New. Photoshop opens the New dialog box. Create a new document with a width of 6 inches, a height of 3 inches, and a resolution of 150ppi in RGB mode, as shown in Figure 994.1.

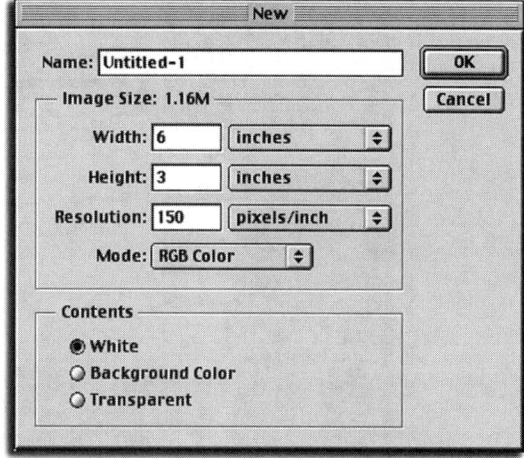

Figure 994.1 The New dialog box defines the characteristics of the new document.

2. Press the letter "D" on your keyboard to default the foreground and background colors to black and white.

3. Select the Type tool from the toolbox, and create the flaming text (refer to Tip 218, "Creating Text in Photoshop 6.0"). In this example, you select Impact at 60 points and type the word "FLAMES," as shown in Figure 994.2.

FLAMES

Figure 994.2 The Type tool created the text.

4. If the Layers palette is not open, select the Window menu and choose Show Layers from the pull-down menu. Photoshop opens the Layers palette.

5. Click once on the black triangle button, located in the upper-right corner of the Layers palette, and choose Flatten Image from the pull-down menu. Photoshop flattens the text layer into the background layer.

6. Select the Image menu, choose Adjust, and choose Invert from the fly-out menu. Photoshop inverts the colors in the image.

7. Select the Image menu, choose Rotate Canvas, and select 90CW from the fly-out menu. Photoshop rotates the document 90° clockwise.

8. Select the Filter menu, choose Stylize, and select Wind from the fly-out menu. Photoshop opens the Wind dialog box, shown in Figure 994.3.

9. Select Wind from the Method options and direct the wind to move from the left. Click the OK button to apply the Wind filter to the image.

10. Press Ctrl+F (Macintosh: Command+F) to reapply the Wind filter to the image.

11. Select the Image menu, choose Rotate Canvas, and select 90CCW from the fly-out menu. Photoshop rotates the document 90° counterclockwise.

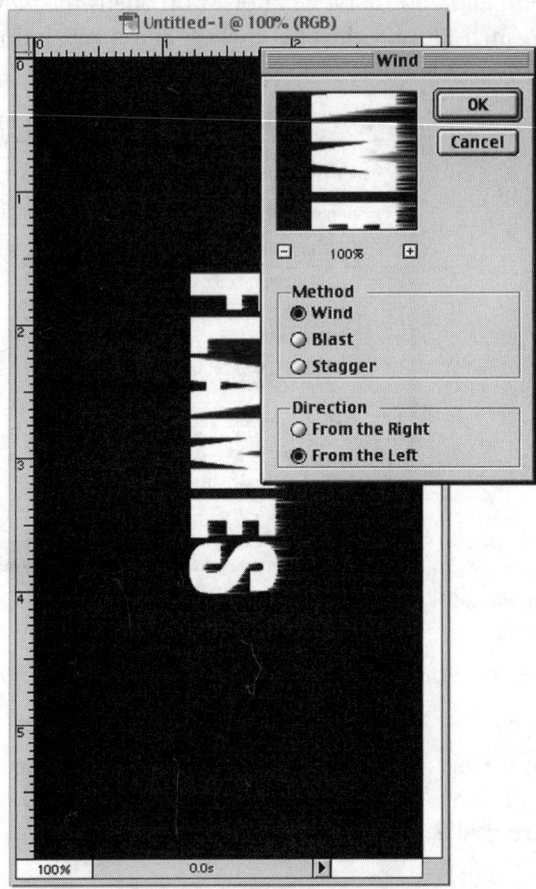

Figure 994.3 The Wind filter lets you approximate the effect of wind blowing across the image layer.

12. Select the Filter menu, choose Stylize, and choose Diffuse from the fly-out menu. Photoshop opens the Diffuse dialog box. Select a Mode of Normal, as shown in Figure 994.4.

Figure 994.4 The Diffuse filter softens the effect of the Wind filter.

13. Select the Filter menu, choose Blur, and choose Blur More from the fly-out menu. Photoshop softens the edge of the white text.

14. Select the Filter menu, choose Distort, and choose Ripple from the fly-out menu. Photoshop opens the Ripple dialog box, shown in Figure 994.5.

Figure 994.5 The Ripple filter distorts the text by creating a wave pattern.

15. In the Amount field, enter a value of 100 percent.

16. Choose Small from the available Size options.

17. Click the OK button to apply the ripple to the text (refer to Figure 994.5).

18. Select the Image menu, choose Mode, and choose Indexed Color from the fly-out menu. Use the default options and click the OK button to convert the image into the indexed color space.

19. Select the Image menu, choose Mode, and choose Color Table from the fly-out menu. Photoshop opens the Color Table dialog box.

20. Click on the Table button and choose Black Body from the available options. Photoshop converts the text into flaming text, as shown in Figure 994.6.

Figure 994.6 Selecting the Black Body color table converts the text into flames.

995 *Creating Wild Backgrounds with the Gradient Tool*

Here is a quick way to generate a colorful background—and it will be different every time you make one.

To create a colorful background, open Photoshop and perform these steps:

1. Select the File menu and choose New. Photoshop opens the New dialog box. Create a new document with a width of 4 inches, a height of 4 inches, and a resolution of 150ppi in RGB mode, as shown in Figure 995.1.

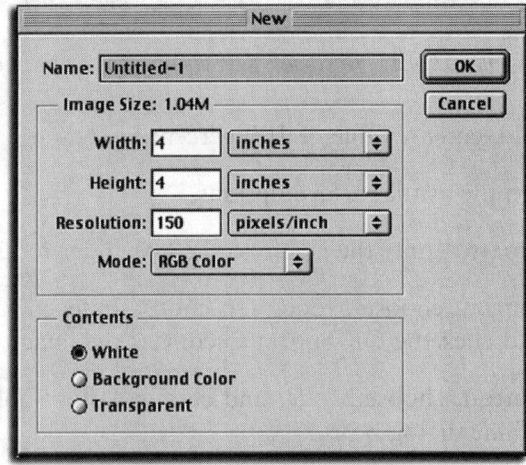

Figure 995.1 The New dialog box defines the characteristics of the new document.

2. Select the Gradient tool from the toolbox (refer to Tip 82, "The Gradient Tool").

3. Move your cursor into the Options bar and click once on the black button to the right of the gradient preview box. Photoshop displays a list of gradients, as shown in Figure 995.2.

Figure 995.2 Clicking on the black triangle button displays a list of available gradients.

4. Choose the Linear gradient tool and select one of the gradients from the default gradient styles. In this example, you select the Spectrum gradient (refer to Figure 995.2).

5. Click and drag the gradient tool from the upper-left corner to the lower-right corner of the document window. The Gradient tool generates a linear gradient using the Spectrum gradient, as shown in Figure 995.3.

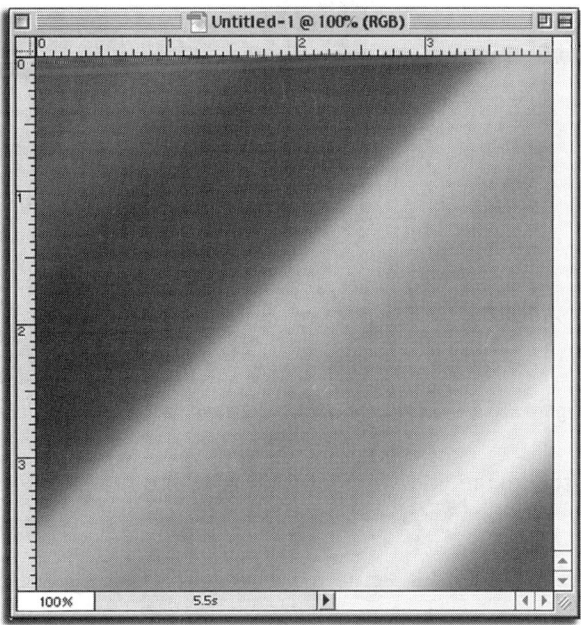

Figure 995.3 The Spectrum gradient applied to the document window.

6. Move into the Options bar, click once on the Mode option, and select Difference from the drop-down list.

7. Click and drag the Gradient tool from the upper-right corner to the lower-left corner of the document window. Photoshop creates a second gradient based on the Spectrum colors and the Difference blending mode, as shown in Figure 995.4.

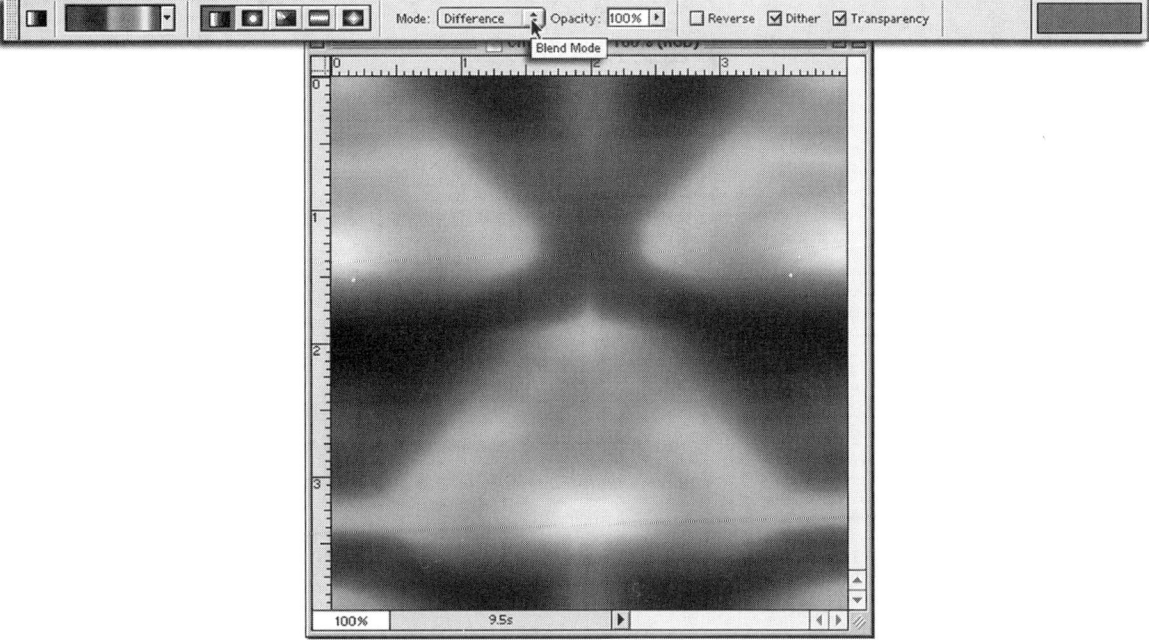

Figure 995.4 The Difference blending mode created a mixed, or blended, image in the document window.

8. Experiment with different gradient options, and drag in different directions. Every time you click and drag across the screen, the Difference blending mode changes the visible image, as shown in Figure 995.5.

Figure 995.5 Every time you click on and drag the gradient tool, it changes the image.

9. When you like the image you see, stop and save the file.

996 *Creating Stacked Text*

To create a stacked look to text, open Photoshop and perform these steps:

1. Select the File menu and choose New. Photoshop opens the New dialog box. Create a new document with a width of 6 inches, a height of 3 inches, and a resolution of 150ppi in RGB mode, as shown in Figure 996.1.

Figure 996.1 The New dialog box defines the characteristics of the new document.

2. If the Layers palette is not open, click once on the Layer tab, or select the Window menu and choose Show Layers from the pull-down menu. Photoshop opens the Layers palette.

3. Select the type tool from the toolbox, and create some text in the document window (refer to Tip 218, "Creating Text in Photoshop 6.0"). In this example, you select Impact at 72 points, as shown in Figure 996.2, and type the word "STACKED."

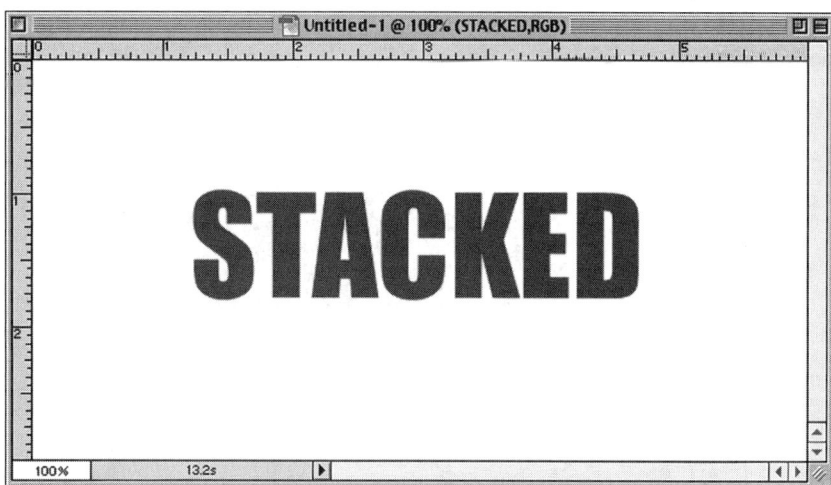

Figure 996.2 The Type tool created the logo text.

4. Click once on the Layer Effects icon, located at the bottom left of the Layers palette, and select Drop Shadow from the pop-up menu. Photoshop opens the Layer Style dialog box.

5. Enter a value of 10 for distance and a value of 8 for size. Click the OK button to apply the drop shadow to the image, as shown in Figure 996.3.

Figure 996.3 The drop shadow applied to the image.

6. Move your mouse into the Layers palette and Ctrl+click (Macintosh: Command+click) on the text layer. Photoshop creates a selection based on the visible text, as shown in Figure 996.4.

7. Move into the Layers palette and create a new layer by clicking once on the New Layer icon, as shown in Figure 996.5.

8. Choose the Select menu, choose Modify, and select Contract from the fly-out menu. Photoshop opens the Contract Selection dialog box.

9. Enter a value of 5 in the Contract By input box, and click the OK button to apply the Contract command to the selected text, as shown in Figure 996.6.

Figure 996.4 Ctrl+clicking (Macintosh: Command+clicking) on a layer thumbnail in the Layers palette creates a selection based on the visible pixels within the layer.

Figure 996.5 Clicking on the New Layer icon creates a new layer directly above the active layer.

Figure 996.6 The Contract command reduces the dimensions of the selected text.

10. Move your mouse into the Swatches palette and select a color for the contracted text. In this example, you select a light gray.

11. With the new layer selected, press Alt+Delete (Macintosh: Option+Delete) to fill the selected text with the current foreground color, as shown in Figure 996.7.

Figure 996.7 Pressing Alt+Delete (Macintosh: Option+Delete) fills the selected area with the foreground color.

12. Press Ctrl+D (Macintosh: Command+D) to deselect the text marquee.

13. To complete the effect, click once on the Layer Effects icon, located at the bottom left of the Layers palette, and select Bevel and Emboss from the pop-up menu. Photoshop opens the Layer Style dialog box.

14. Click once on the Style option and select Inner Bevel from the drop-down list.

15. Click once on the Technique option and select Chisel Hard from the drop-down list.

16. Enter a Depth value of 110 and a Size value of 6. Click on OK to apply the bevel to the selected layer, as shown in Figure 996.8.

Figure 996.8 The bevel effect applied to the contracted text layer completes the effect.

997 *Restoring the Input Setting in the New Dialog Box*

Photoshop 6.0 added a handy new feature: the capability to restore the File New dialog box to the last-used settings. When you create a new document in Photoshop (File menu, New), Photoshop uses the setting from the last new document—that is, unless you have something in Clipboard memory. Using the Clipboard memory (Edit menu, Copy) places portions of a Photoshop document into the Clipboard memory. This is normally a good thing, unless you want to attempt to open a new document in Photoshop: Then you get the width and height (usually in pixels) of the information contained in the Clipboard memory, as shown in Figure 997.1.

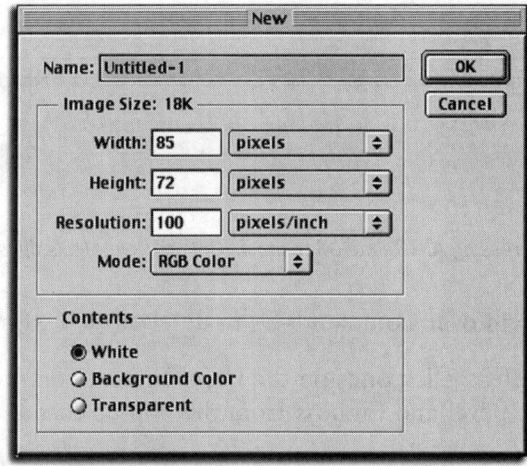

Figure 997.1 The New Document dialog box reflects the width, height, and
resolution of the information held in Clipboard memory.

Photoshop thinks that you want to create a new document and paste the Clipboard memory into the document window, so it uses the width, height, and resolution of the copied information. Sometimes this is exactly what you want to do; however, when you want to create a new document, having to change the information back to the old setting is frustrating and time-consuming.

In Tip 990, "Customizing an Action to Create a New Photoshop Document," you learned how to create an action to open a document based on a previously defined image. However, if all you want to do is open a new document based on the last new document, hold down the Ctrl+Alt keys (Macintosh: Command+Option keys), select the File menu, and choose New. Photoshop opens the New dialog box with the values from the last new document, as shown in Figure 997.2.

Figure 997.2 Holding the Ctrl+Alt keys (Macintosh: Command+Option keys), selecting the File menu, and choosing
New restores the new values from the last new document.

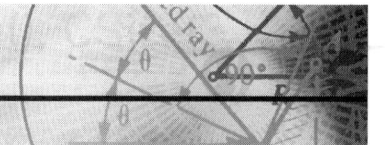

998 *Creating a Unique Lens Flare*

Photoshop's Lens Flare filter creates realistic lens flares (refer to Tip 895, "Working with the Lens Flare Filter"). However, sometimes you want a simple flare without the colors and overlapping levels that the Lens Flare filter produces, as shown in Figure 998.1.

Figure 998.1 The Lens Flare filter creates realistic lens flares in any Photoshop document.

To create your own lens flare, open the image that you want to apply the lens flare to, and perform these steps:

1. If the Layers palette is not open, select the Window menu and choose Show Layers from the pull-down menu. Photoshop opens the Layers palette.

2. Create a new layer by clicking once on the New Layer icon.

3. Press the letter "D" on your keyboard to default the foreground and background colors to black and white.

4. Press Alt+Delete (Macintosh: Option+Delete) to fill the new layer with the current foreground color, as shown in Figure 998.2.

5. Select the Elliptical Marquee tool from the toolbox, and draw a circular selection in the size that you want the lens flare, as shown in Figure 998.3.

6. Select the Filter menu, choose Artistic, and select Plastic Wrap from the fly-out menu. Photoshop opens the Plastic Wrap dialog box, shown in Figure 998.4.

7. Enter a Highlight Strength value of 15, a Detail value of 8, and a Smoothness value of 1. Click the OK button to apply the Plastic Wrap filter to the new layer, as shown in Figure 998.5.

8. Press Ctrl+D (Macintosh: Command+D) to deselect the circular marquee.

9. To apply the new lens flare to the image, move into the Layers palette, click on the blending mode button, and select Screen blending mode from the available options. The Screen blending mode removes the black from the layer, leaving only the new lens flare.

10. Select the Move tool from the toolbox and drag the lens flare to the correct image position, as shown in Figure 998.6.

Figure 998.2 Pressing Alt+Delete (Macintosh: Option+Delete) fills the new layer with the foreground color.

Figure 998.3 The Elliptical Marquee tool created a circular selection in the new layer.

Figure 998.4 The Plastic Wrap dialog box controls the application of the filter to the new layer.

Figure 998.5 The Plastic Wrap filter applied to the black-filled layer.

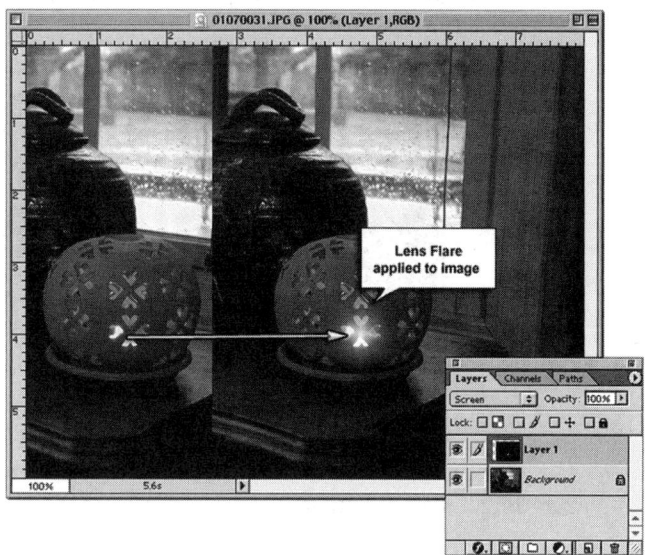

Figure 998.6 The new lens flare applied to the image.

999 *Finding the Big Electric Cat*

In the strictest sense, this is not exactly a tip. However, most people who have used Photoshop over the years have followed the evolution of the Big Electric Cat. The Electric Cat has been in Photoshop for most of its version upgrades, and every time, Adobe changes the look of the cat.

To find the Electric Cat windows, hold the Ctrl+Alt+Shift keys, select the Help menu, and choose About Photoshop. (On a Macintosh, hold down the Command key, select the Apple menu, and choose About Photoshop.) Photoshop changes the normal screen shot to that of the Big Electric Cat. This version of the Big Electric Cat is a take-off on Adobe's move toward making Photoshop more of a vector program. The Big Electric Cat resembles (and I use the word *resembles* in a very loose way) the Adobe Illustrator Venus splash screen, as shown in Figure 999.1.

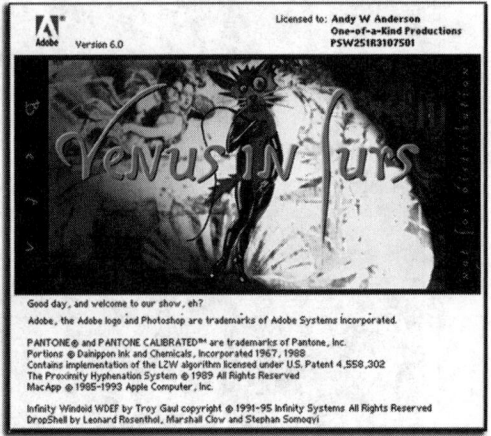

Figure 999.1 The Big Electric Cat in Photoshop 6.0.

When the scrolling credits go through one complete cycle, Shift-click directly on the Venus image (Macintosh: click below Venus, no Shift key) to display a list of crazy sayings, as shown in Figure 999.2.

Figure 999.2 A list of crazy sayings appears after the credits complete one cycle.

1000 *Making Things Explode*

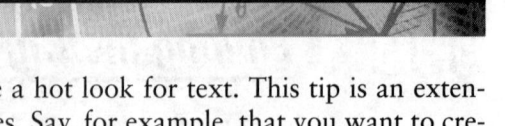

In Tip 994, "Setting Text on Fire," you learned how to create a hot look for text. This tip is an extension of the flaming text tip and lets you create exploding shapes. Say, for example, that you want to create a flaming or exploding sun.

To create a flaming sun, open Photoshop and perform these steps:

1. Select the File menu and choose New. Photoshop opens the New dialog box. Create a new document with a width of 4 inches, a height of 4 inches, and a resolution of 150ppi in RGB mode, as shown in Figure 1000.1.

2. Press the letter "D" on your keyboard to default the foreground and background colors to black and white.

Figure 1000.1 The New dialog box defines the characteristics of the new document.

3. Press Alt+Delete (Macintosh: Option+Delete) to fill the background layer with the current foreground color.

4. Select the Elliptical Marquee tool from the toolbox, and draw a circular selection in the size that you want your exploding sun. Hint: Hold down the Shift key while you use the Elliptical Marquee tool to draw a perfect circular selection, as shown in Figure 1000.2.

Figure 1000.2 The Elliptical Marquee tool created a circular selection in the new layer.

5. Press Ctrl+Delete (Macintosh: Command+Delete) to fill the circular selection with the current background color.

6. Press Ctrl+D (Macintosh: Command+D) to deselect the circular selection.

7. Select the Filter menu, choose Stylize, and select Wind from the fly-out menu. Photoshop opens the Wind dialog box, shown in Figure 1000.3.

Figure 1000.3 *The Wind filter lets you approximate the effect of wind blowing across the image layer.*

8. Select Wind for the Method, and direct the wind to move from the left. Click the OK button to apply the Wind filter to the image (refer to Figure 1000.3).

9. Select the Image menu, choose Rotate Canvas, and select 90CW from the fly-out menu. Photoshop rotates the document 90° clockwise.

10. Press Ctrl+F (Macintosh: Command+F) to reapply the Wind filter to the image.

11. Select the Image menu, choose Rotate Canvas, and select 90CW from the fly-out menu. Photoshop rotates the document 90° clockwise.

12. Press Ctrl+F (Macintosh: Command+F) to reapply the Wind filter to the image.

13. Select the Image menu, choose Rotate Canvas, and select 90CW from the fly-out menu. Photoshop rotates the document 90° clockwise.

14. Press Ctrl+F (Macintosh: Command+F) to reapply the Wind filter to the image. Your image now resembles Figure 1000.4.

Figure 1000.4 *The circular selection with the Wind filter applied four times.*

15. Select the Filter menu, choose Stylize, and choose Diffuse from the fly out menu. Photoshop opens the Diffuse dialog box. Select the Normal Mode, shown in Figure 1000.5.

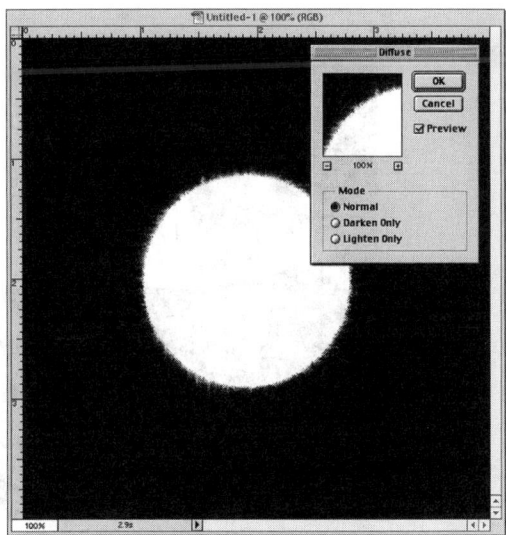

Figure 1000.5 The Diffuse filter softens the effect of the Wind filter.

16. Select the Filter menu, choose Blur, and choose Blur More from the fly-out menu. Photoshop softens the edge of the circle.

17. Select the Filter menu, choose Distort, and choose Ripple from the fly-out menu. Photoshop opens the Ripple dialog box, shown in Figure 1000.6.

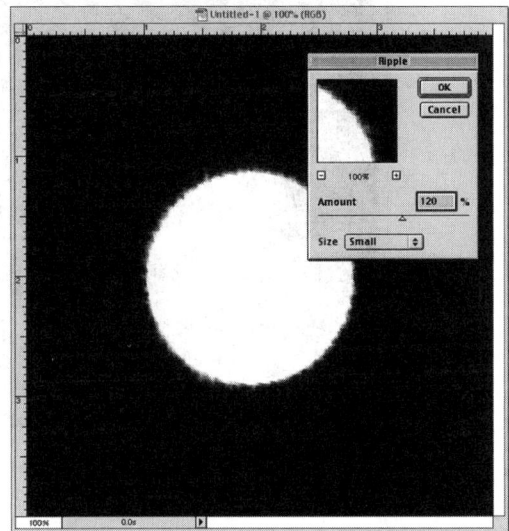

Figure 1000.6 The Ripple filter distorts the text by creating a wave pattern.

18. In the Amount field, enter a value of 120 percent.

19. Choose Small from the available Size options.

20. Click the OK button to apply the ripple to the circle (refer to Figure 1000.6).

21. Select the Image menu, choose Mode, and choose Indexed Color from the fly-out menu. Use the default options and click the OK button to convert the image into the indexed color space.

22. Select the Image menu, choose Mode, and choose Color Table from the fly-out menu. Photoshop opens the Color Table dialog box.

23. Click on the Table list box and choose Black Body from the available options. Photoshop converts the circle into a flaming, exploding ball, as shown in Figure 1000.7.

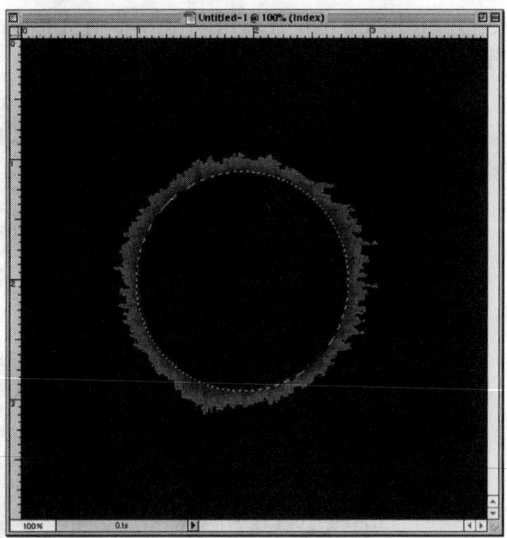

Figure 1000.7 Selecting the Black Body color table converts the circle into an exploding ball of flames.

24. Select the Elliptical Marquee tool, and draw a circular selection defining the center of the ball, as shown in Figure 1000.8.

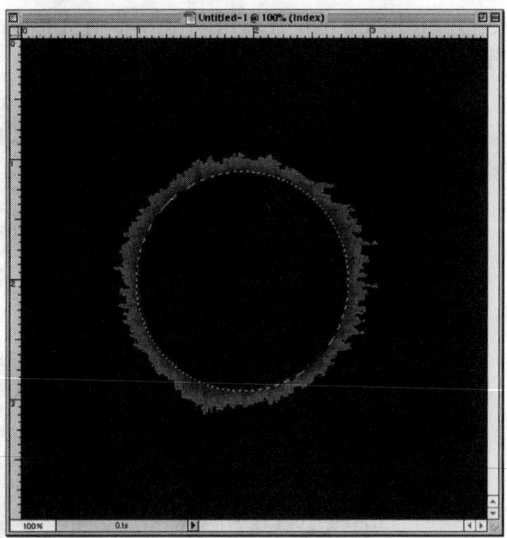

Figure 1000.8 The selection marquee covers the exact center of the exploding ball.

25. Select a bright yellow from the Swatches palette, and press Alt+Delete (Macintosh: Option+Delete) to fill the background layer with the current foreground color (yellow).

26. Select Image menu Mode and choose RGB from the fly-out menu. Photoshop converts the image into the RGB color space.

27. Select the Filter menu, choose Noise, and select Add Noise from the fly-out menu, as shown in Figure 1000.9.

28. In the Amount field, enter a value of 20 percent. Use Uniform Distribution, and select Monochromatic. Click the OK button to apply the Noise filter to the selected area of the image.

29. To complete the effect, select the Filter menu, choose Distort, and select Spherize from the fly-out menu.

Figure 1000.9 The Noise filter applies noise to the yellow-filled area of the image.

30. Select Normal for the Mode, and enter 100 percent in the Amount field. Click the OK button to apply the Spherize filter to the image, as shown in Figure 1000.10.

Figure 1000.10 The Spherize filter completes the effect of an exploding sun.

1001 *Wrapping Text Around a Globe*

Photoshop 6.0 and the new Text Warp command let you create text running around the surface of a globe. Say, for example, that you have an image containing a graphic of a world globe, and you want to wrap text around the globe.

To create globe-circling text, open an image containing a globe on a transparent layer, and perform these steps:

1. If the Layers palette is not open, select the Window menu and choose Show Layers from the pull-down menu. Photoshop opens the Layers palette, shown in Figure 1001.1.

Figure 1001.1 *The Layers palette contains a layer for the background and a layer for the globe.*

2. Click once on the layer containing the globe. Photoshop selects the globe layer.

3. Click once on the Layers Effects icon, located at the bottom left of the Layers palette, and select Drop Shadow from the pop-up menu. Photoshop opens the Layer Style dialog box.

4. Enter a Distance value of 10 and a Size value of 8. Click the OK key to apply the drop shadow to the globe, as shown in Figure 1001.2.

Figure 1001.2 *The drop shadow applied to the globe.*

5. Select the Type tool from the toolbox, and create wrap text (refer to Tip 218, "Creating Text in Photoshop 6.0"). In this example, you select ITC Officina Sans at 18 points, as shown in Figure 1001.3.

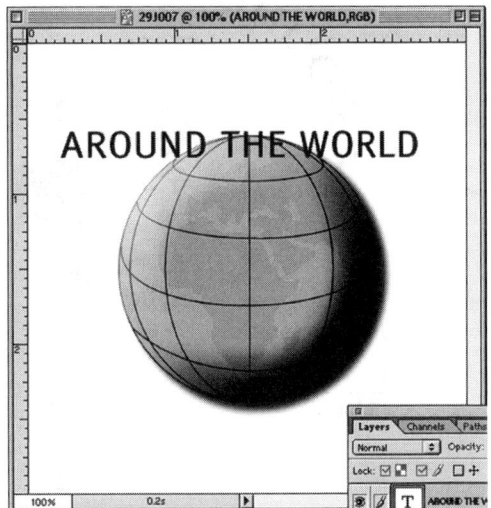

Figure 1001.3 The Type tool created the text.

6. Move your cursor into the Options bar and click once on the Warp Text button (located to the left of the Palettes button). Photoshop opens the Warp Text dialog box, as shown in Figure 1001.4.

Figure 1001.4 The Warp Text dialog box lets you modify the text in the active layer.

7. Select the Style option and choose Arc from the drop-down list. Enter a Bend value of +100 percent, and enter Horizontal Distortion and Vertical Distortion values of 0. Click the OK button to apply the Warp Text command to the text, as shown in Figure 1001.5.

8. Make a copy of the warp text layer by dragging the layer icon over the New Layer icon, as shown in Figure 1001.6.

9. With the copy layer still selected, click on the Text Warp button. The Text Warp dialog box opens with the Bend value set to +100 percent (refer to Figure 1001.4).

10. Change the Bend value to a –100 percent, and click the OK button to apply the warp to the copied layer.

11. Select the Move tool from the toolbox and position the two text layers so that they form a circle, as shown in Figure 1001.7.

Figure 1001.5 The Warp Text command applied to the text layer.

Figure 1001.6 Clicking on and dragging a layer over the New Layer icon creates a copy of the dragged layer.

Figure 1001.7 Use the Move tool and select one text layer to position them into a circle.

12. Create a new layer by clicking once on the New Layer icon.

13. Click once on the Eyeball icon, to deactivate the globe and background layers.

14. Click once on the layer created in step 12. Photoshop selects the new layer.

15. Select the Layer menu and select Merge Visible from the pull-down menu. Photoshop merges the two text layers. Because you selected the new transparent layer, Photoshop automatically rasterized the text.

16. Reactivate the globe and background layers by clicking once on the Eyeball icon.

17. Click once on the merged text layer. Photoshop selects the text layer.

18. Select the Edit menu and choose Free Transform from the pull-down menu. Photoshop places a bounding box around the circular text.

19. Click on the corners of the bounding box and resize the text until it fits around the globe, as shown in Figure 1001.8.

Figure 1001.8 The Free Transform tool modifies the text to fit around the globe.

20. Press the Enter key to apply the Free Transform command to the text layer.

21. Select the Edit menu and choose Free Transform from the pull-down menu. Photoshop places a bounding box around the circular text.

22. Move up to the Options bar and enter a value of 40 percent in the H (Height) field, and enter a value of −30 degrees in the Rotation input field, as shown in Figure 1001.9.

Figure 1001.9 The Height and Rotation fields modify the selected text.

23. Press the Enter key to apply the transformation to the text layer (refer to Figure 1001.8).

24. To complete the effect, select the Eraser tool from the toolbox and erase the portions of the text that go behind the globe, as shown in Figure 1001.10.

Figure 1001.10 The Eraser tool created the illusion of the text going behind the globe.

Note: *To gain more control over the text layer, create a layer mask to generate the transparent areas of the text (refer to Tip 386, "Creating a Layer Mask").*

Index

A

accenting areas of image, channels for, 463

.act extension, 822

Action, 410–431
 for batch processing of images, 416
 button, converting into, 414
 command converted into, 431
 command inserted into existing, 421, 423
 command playback, excluding/including single, 415, 417
 copying/moving steps between, 425
 creating, 410–411, 990
 deleting, 413
 dialog settings, recording with different, 418
 droplet created from, 772
 menu items inserted into, 421
 modal control, activating, 424
 modifying existing, 415, 417–423
 nesting, 426
 for opening files, 990
 Playback options, execution using, 412
 plug-ins replicated by, 913
 predesigned, 410, 413
 shortcut keys, 431
 stop commands inserted into, 422
 viewing individual steps of, 417

Action set
 deleting, 413
 opening/closing, 413
 saving Actions into, 419
 saving into folders, 420

Actions palette
 button set, converting into, 414
 using, 410

Add Anchor Point tool, 87, 155

Add blending mode, 266

Add to Selection option, 136–137, 170, 282–284

Adjustment layers, 141, 322, 327, 341, 347, 392
 blending modes combined with, 326
 built-in masks, controlling with, 370
 clipping groups, 378–379
 creative use of, 323
 focusing attention using, 976
 lens flare, correcting, 331
 masks, 325, 327, 331, 370
 merging, 324, 371
 order of stack, 372
 Pass Through option, 390
 portability, 327
 screening text against background, 679

adjustments. *See* editing

Adobe (ACE) color engine, 254, 261

Adobe After Effects, transferring images to, 707

Adobe Gamma utility, 559
 calibrating monitor color using, 57, 241, 249
 white point of monitor, measuring, 240

Adobe Illustrator, 844
 Clipboard, copying to, 945
 customized color settings, 719
 exporting/importing images to, 115, 689, 940, 951, 953–954
 exporting/importing paths to, 690, 694
 opening files, 5, 116
 preparing file for ImageReady, 757
 RAM used by, 18

Adobe LiveMotion, moving Photoshop images into, 820

Adobe Web site, 26–27

age, creating appearance of, 867

Airbrush tool, 41, 77, 191, 217, 221, 279
 Paintbrush differentiated from, 222
 path used to control, 481

Alert dialog box, 523

alignment
 grids for, 104, 106
 guides for, 103
 ImageReady, 807
 of layers, 287, 354
 of paths, 471
 point (Clone Stamp), 605, 609
 of spot colors, 339, 565, 721
 of text, Type tool used for, 218

Alpha channels, 152, 257, 259, 289, 432, 434. *See also* channels
 changing color of, 457
 cleaning up, 497
 difficult selections held by, 445
 editing, 443
 file compression, controlling, 765–766
 file size and, 433
 filters and, 461, 497, 514, 517–520
 Invert command, use of, 632
 Lighting Effects filter, performing digital emboss with, 805
 multiple channels loaded as selections, 456
 painting to create mask, 453
 removing selected channels, 458
 selections created from, 309, 311, 455–456, 584
 Spot color channels, conversion into, 450
 tracing paper, converting into, 452, 457
 vignette, creation of, 446

anchor points, 465, 844
 adding to existing path, 87, 155
 Auto Add/Delete, Freeform Pen tool, 156
 converting straight/curved, 87, 155
 creating, 154, 465–466
 curved, 154–155, 465–466
 deleting, 87, 155
 drawing lines between, 73, 124
 moving, 85, 308, 314, 466, 470
 number on path, 137, 140, 474, 703
 straight, 154–155, 465
 temporary, 137

animation, 812. *See also* GIF (Graphics Interchange Format) animation; QuickTime movies
 Adobe LiveMotion, moving images into, 820
 compressing files, 132
 converting for printing, 974
 cropping Web animations, 782
 editing ImageReady files, 760
 fade in/fade out of, 764, 785
 file size, reducing, 782
 frame disposal method, 791
 ImageReady to create instant animation file, 823
 layer effect, based on, 784
 layers, use of, 782
 from multi-layered documents, 823
 onion skimming, 752
 separate images, creating from, 824
 sequence triggered by JavaScript rollover, 787
 storyboard, Layers palette as, 761
 straight-line, 783
 text, animating, 784
 video LUT (lookup table), 44

annotations
 audio, 901
 text, 89, 121, 920

Anti-aliased option
 GIF files, 691
 halos, removing using Defringe, 521
 ImageReady, 807
 Lasso tools, 283
 Magic Eraser tool, 165, 229
 Magic Wand tool, 170, 284
 Magnetic Lasso tool, 137
 Marquee tool, Elliptical, 282
 Paint Bucket tool, 167
 Pen tools, 285
 PICT files, 120
 PostScript/PDF images, 30, 116–118, 693
 Standard Lasso tools, 136
 text sharpening, 664
 Type tool, 218

Append File Extension option, 33–34

Apply Image command, 264

Area option, Art History Brush, 144
arrowhead lines, creating, 126
Arrow key, 523
Art History Brush tool, 41, 80, 144, 217, 481
artifacts, removing, 736, 751
Artistic filters, 492, 514, 555, 671, 842, 870, 899, 993
ASCII encoding system, 716
Audio Annotation tool, 89, 901
Auto Contrast command, 626
Auto Erase option, 228
Auto Levels command, 204, 622, 625
Auto Resolution dialog box, 269
Auto Select Layer option, 287, 350
Auto Update option, 954

B
background
 Adjustment layer used to lighten/darken, 679
 complicated, removing, 291
 with depth, creating, 964
 dither pattern, applying, 817
 diversely colored, selecting, 542
 erasing on, 221
 filters used to create, 148
 flattening layers into (See Flatten Image option)
 full-screen image as, 797
 ghosted, 902
 Gradient tool used for, 995
 layer, converted into, 394
 layers compared, 346
 logos for web backgrounds, 777
 Magic Eraser tool to remove, 229
 masks and, 388
 matting option, 792
 moving into second document as layer, 683
 rusted-looking, 879
 seamless background, creating, 794–796
 selections used to control filter/adjustment effects, 315
 for sliced images, 776
 stone, 893
 studio backdrop, 882
 text, Adjustment layers for screening, 679
 text, background light burst for, 677
 textured, 872
 tiles (See tiles)
 transparency in, 751, 788, 792
 Web page, design for, 812
 Web page frame look, directional tiles for, 753
Background color
 Auto Erase of line, effect of, 228
 default, 221
 Eyedropper tool used to change, 90, 164
 filling area with, 161, 232
 reversing, 221
 simple background, changing color of, 841

Background Color Swatch, 94, 306, 346, 541
 Auto Erase of line, effect of, 228
 black and white default, 306
 reversing box, 306
 selecting, 221, 279
 Torn Edges filter, use of, 500, 509
Background Eraser tool, 41, 81, 168, 481, 548
backlighting an image, 960
backwards compatibility, 36
barrel distortion, Pinch for, 915
Base Name input field, 117
batch processing of images, 416
beads on string, creating, 891
Behind blending mode, 234
Bevel and Emboss filters, 647
Bevel and Emboss layer style, 384, 391, 490
 3-D buttons, creating, 778
 text, embossing, 671, 673, 676
bevels, Gradient tool used for, 647, 674
Bicubic pixel interpolation, 13, 22
Big Electric Cat, finding, 999
Bilinear pixel interpolation, 13, 22
Binary encoding system, 716
Bitmap color mode, 111, 246–247, 255, 829, 845–846
black
 adding to image, 332
 channels, use in, 432, 434–435, 452, 461, 497
 layer mask, 387
 Overlay blending mode, 366
 Screen blending mode, 366
 in texture maps, 505, 511
black and white
 Color Swatch default, 306
 weaving with color into image, 869–870
black-and-white images
 Channel Mixer command, 212–213
 colorizing, 635
 converting bitmaps to, 846
 converting image to, 236
 converting to negative, 216
 fading from color to black and white, 173
 Invert command, use with negative, 632
 Threshold option to create, 199
black-and-white printer, printing color to, 701
Black channel
 editing, 438–439
 viewing, 436
Black or White Matte preview option, 145
black point compensation, 254, 261, 833
blemishes, removing, 644
Blend If option, 345, 612
blending, 160. See also Blur tool.
 channels (See channels, blending)
 colors by dithering (See dithering)
 RGB colors, gamma used for, 261

two images, 642
two objects, 160
blending modes, 361
 Add, 266
 Adjustment layers combined with, 326
 base color, 234, 361, 687
 Behind, 190, 234
 black and white, converting image to, 236
 blend color, 234, 361, 687
 Color, 192, 234, 368
 Color Burn, 234, 363, 649
 Color Dodge, 234, 363
 Darken, 234, 364, 904
 Difference, 234, 367
 Dissolve, 234, 365
 Exclusion, 234, 367
 faded images, reconstructing, 640
 filters combined with, 508, 530
 Gradient options, 172–174, 177
 Hard Light, 234, 326, 362, 904
 Hue, 192, 234, 368
 Layers, 171, 174, 177, 508, 687
 Lighten, 234, 364
 Luminosity, 234, 368, 904
 Multiply, 171, 234
 Normal, 369
 options available, list of, 173, 234
 Overlay, 234, 366, 671
 painting tools influenced by, 234
 Pass Through option for layers, 390
 result color, 234, 361
 Saturation, 192, 234, 368, 687
 Screen, 171, 234, 366
 smoothness of blend, 175, 180
 Soft Light, 234, 362, 563
 Subtract, 266
block effect, text, 672
Blur and Blur More filters, 492, 516, 533, 539, 644, 842, 961, 975. See also Gaussian Blur filter
blurring, correcting. See sharpening of image
Blur tool, 41, 83, 158, 191, 217
 dust and scratches corrected with, 159
 multilayer editing, 233
 path used to control, 481
 two objects blended with, 160
BMP file format, 698, 708, 711
borders. See edges
bounding box
 cropping Web animations, 782
 Free Transform command to create, 227
 showing, 287, 700
Brightness/Contrast command, 207, 624, 754
brightness (luminosity). See also tonal range
 blending mode, 234, 368, 904
 channels, values of colors in, 442
 Color Picker to control, 567
 Difference blending mode, blend color adjusted with, 367

HSB color model, brightness channel of, 239
HSB color slider, adjustment using, 544
ImageReady Color Table, sorting by luminance in, 575
pixel value (*See* brightness (luminosity) value of pixels)
brightness (luminosity) value of pixels, 361, 442
 Add/Subtract blending modes, adjustment using, 266
 Blend If option selection based on, 345
 Burn tool, selecting pixels to change with, 162
 Difference blending mode and, 367
 Equalize option, redistribution by, 198
 gradient fill, brightness mapped to, 215
 histogram of, 201
 Invert command, use of, 216
 Posterize option to control, 200, 219
 Preserve Luminosity option, Color Balance command, 206
 Replace Color command to adjust, 210
 selection based on, 73–74, 170
 Sharpen tool, effect of, 290
 Threshold option, effect of, 199
browsers. *See also* Web
 preview of image in, 750, 986
 size template, creating, 798
 transparent pixels, image displayed with, 751
Brush Dynamics, 101, 191, 279
 Fade option, 197
 Stylus option to link drawing tablets, 191, 196
brushed-metal image/text, 874, 876
brushes, 160, 162
 Clone Stamp tool, 608–609
 creating (*See* brushes, creating)
 deleting, 188
 drawing tablet used with, 101, 196
 fade rate, 197
 Foreground Color Swatch, color controlled by, 306
 icons for cursors, 64
 pastel, 899
 selecting, 41, 159
 shapes and sizes, 64, 101, 185–186, 223, 230, 289
brushes, creating
 angle, 185, 223–224
 calligraphic, 223
 circle, defining with, 185
 diameter, 185, 223–224
 dotted-line, 224
 drawn objects, defining from, 186
 hardness, 185, 223–224
 modifying existing to create new, 230
 photo-restoration, 604
 roundness, 185, 223–224
 single-use, 195

spacing, 185, 223–224
Sparkle, 189
Wet Edges option used with, 194
Brush palettes. *See also* brushes
 creating custom, 187
 loading palettes, 187–188
 moving, 977
 Preset Manager to control default, 188
 tools using, 41 (*See also specific tools*)
Brush Size cursor option, 64
Brush Strokes filter, 492, 517, 842
Brush tools, 41. *See also* brushes; *specific tools*
bug fixes, 26–27, 48
Burn tool, 41, 84, 95, 191, 217
 blown-out highlights, restoring, 162
 path used to control, 481
buttons. *See also* JavaScript rollovers
 Actions converted to button set, 414
 3-D, creating with copy and paste, 778
 list, creating, 813–814
 mound, 878
 multicolor push, 881
 pill-shaped, 979
 spherical text, 967
 style, 487 (*See also* Styles palette)
 Web interface, design for, 812

C
Cache Levels settings, correct, 46, 513
Calculations command, 265, 267
calibration bars, 709
calligraphic brush, creating, 223
canvas
 adjusting size of, 270
 Cropping tool used to expand, 274
 rotating, 271
captions, file, 709
carved look, 649
case sensitivity
 file names, 35
 Web pages, default option for, 33
CDs
 compressing files for, 132
 for file storage, 737
center
 drawing image from, 128
 locating exact center of image, 982
centimeter measurement system, 587
Channel list, 319
channel masks. *See* Alpha channels
Channel Mixer command, 212, 435, 842
 color tinting, 338
 converting image to grayscale, 213
 preset options, 214
channels, 8–9, 432–463. *See also* Alpha channels; Composite channels; Native color channels; Spot color channels
 accenting areas of image, 463
 8-bit and 16-bit channels, working with, 10, 97, 442

blending, 264–265, 267
blending mode options used for, 234, 266
color defined by, 432, 442
correcting color using individual plates, 620
creating, 443
current channels used to modify (*See* Channel Mixer command)
difficult selections held by, 445
duplicating, 460
editing, 438–439, 444, 457
eye icon, 436
file size, relationship to, 433
filter intensity influenced by, 461
filters used to modify, 446, 514, 517–520, 527, 539
layers compared, 434
Magnetic Lasso used in, 141
merging multiple channels, 441
mixing (*See* Channel Mixer command)
moiré patterns, removing, 462
Multichannel command to separate, 850
multiple channels loaded as selections, 456
number of, displaying, 21
Paintbrush tool used on, 444
painterly look created with, 448
Posterize option, use of, 200, 219
Quick Mask saved as permanent, 451
removing selected channels, 458
selections converted to/from, 307, 309, 311, 453–456, 584
sharpening image with, 447
splitting into individual images, 459
stacking order, rearranging, 440
television image, simulating, 648
viewing, 21, 37, 436
Channels palette, 37, 432
 correcting color using, 620
 display, changing, 437
 options, changing, 457
 thumbnails, creating, 437
Character options, 218, 667, 669
chiseled edge, creating, 897
Choose Folder dialog box, 117
circle, drawing, 128
circular selections, 71
Cleanup tool, 289
clip art, 844
 Cutout filter used to create, 498
 hybrid graphic, creating, 988
 Web Safe GIF flat-color, 762
Clipboard, 40, 942–943, 990, 997
 copying between applications, 945
 Unlimited Clipboard Size plug-in, 917
clipping groups, 152
 adjustment layers controlled by, 378
 deactivating, 378
 exotic edges created with, 379
 manipulating text images with, 659

clipping paths
Imagesetter, preparing images for, 703
Layer (*See* Layer clipping path)
saving files with, 476, 478
shape layers as, 686
transparency created with, 476
Clone Stamp tool, 79, 130
alignment point, 605, 609
brushes for, 608–609
color spaces, 608, 610
multiple layers used to control, 233, 607
Opacity setting, 191, 217
path used to control, 481
restoring damaged image with, 605–609
two images, using between, 606
CMYK channel, 436. *See also* Composite channel
CMYK color model, 238–239
CMYK color mode/space, 9, 98, 111, 244, 255, 554, 688
converting to, 111, 250, 255, 704, 858
files, size of, 347
PostScript printers, used by, 702
RGB color space corrections compared, 550
size of, 610
Trap option, using, 339, 565, 721
viewing color information, 96
viewing image in (Working CMYK), 550, 561, 570
CMYK colors, used for selective color correction, 211
CMYK Color Sliders, 211, 544
CMYK gamut, 62, 549, 554, 925–926, 965
CMYK image
channels in, 433, 436
editing Black channel of, 439
color(s). *See also* Color Picker
accuracy, print options for, 253–254
background (*See* Background color; channels)
blending (*See* blending modes)
brightness (*See* brightness (luminosity))
correction (*See* color correction)
Curves command to adjust (*See* Curves command)
darkening (*See* darkening an image)
desaturating (removing), 209, 334, 602, 631
displayable colors, increasing number of, 97
of grid, 106
hue (*See* hue)
masks (*See* Alpha channels; masks)
monitor, colors on (*See* monitor)
multicolor gradient pattern or wash (*See* Gradient tool)
open document, color information on, 21, 96

out of gamut, 62, 549, 925–926, 965
Paintbrush tool used to change, 236
path, applying to, 482
printing (*See* color management system (CMS); printing)
reducing available color, 200, 219, 533, 576, 579, 639, 731–734, 748, 754–756, 827, 834, 836
sampling color information (*See* color selection methods; Extraction tools)
saturation (*See* saturation)
selected areas, removing, 334
simulating unavailable colors (*See* dithering)
single color applied using Paint Bucket tool, 82, 166
spot, 31, 565, 721 (*See also* Spot color channels)
of text, 218, 807
viewing channels in, 37
weaving with black and white into image, 869–870
color balance
Color Balance command, 206, 318
Levels command to adjust, 201–202, 204
restoring, 621
Variations command to adjust, 220
Color blending mode, 192, 234, 368
Color Burn blending mode, 234, 363, 649
color casts
Auto Levels, effect of, 204
correcting, 620–621, 623, 929
Hue/Saturation Colorize option, effect of, 208
color channels. *See* channels
color-conversion table, 858
color correction, 316. *See also* color balance; color management system (CMS); color selection; Curves command; Extraction tools; Hue/Saturation command
CMYK and RGB color spaces, comparing corrections in, 550
color measurement points, setting/monitoring, 330
color tone, correcting and matching, 643
hard proof for, 558, 571
individual channels used for, 620
Levels command used for, 623
order of adjustments, 615
Replace Color command, 210, 581
Selective Color command, 211, 842
soft proofing colors, choosing, 570
Variations command used for, 630
viewing, 561, 571–572, 957
color definitions, pixel, 237
Color Dodge blending mode, 234, 363
color engine, 237, 254, 261
Colorize option, Hue and Saturation command, 208

colorizing
black and white image, 635
line art, 890
mezzotint, 900
color lookup table. *See* color tables
Color Management Off color settings option, 11, 52
color management system (CMS), 11, 237, 252, 316. *See also* color settings
hard proof, 558, 571
printing, role in, 253, 569, 720
soft proofing colors, choosing, 570
color measurement points, setting/monitoring, 330
color models, 238–239
color modes/spaces, 1, 98, 861. *See also* Bitmap color mode; CMYK color mode/space; Duotone color mode/space; Grayscale color mode/space; Indexed color mode/space; Lab color mode/space; RGB color mode/space
additive, 238
changing using Conditional Mode Change, 427
choosing correct, 111, 116–118, 120, 608, 610, 688
converting between, 255, 371
filters and, 514, 517, 525–526, 528, 531, 534
ImageReady, 738, 799
Info palette, on, 329
layers moved between documents, 683
master image, 737
monitor, 242, 250, 610, 708
PDF document, 429
PICT files, 120
for picture package, 102
for presentations, 862
for printers, 569–570, 720
subtractive, 238
for Web, 739, 799, 820 (*See also* Web Safe colors)
color numbers. *See* color values
Color option
blending mode, 192, 234, 368
Brush Dynamics, 191, 196
Gradient Editor, 175
Color palette. *See also* Swatches palette
custom palette, creating, 568, 743
foreground/background colors, selecting/changing, 221
ImageReady master palette, creating, 780
Indexed color, 691–692, 743–744, 835, 838–839
numeric ink value, choosing colors by, 544
Spectrum palette, 543
Web Safe Color Sliders, 551

Color Picker, 29
 Foreground/Background Color Swatch, selecting, 221, 549
 Gradient Editor used with, 175
 hue, saturation, and brightness, controlling, 567
 manually picking colors with, 62
 Web colors selected with, 557, 746
color plates. *See* channels
color profiles, 237
 current proof profile, changing document profile to, 574
 ICC Color Profile, 249
 mismatch, working with, 248
 permanent change of document profile, 254
 profile-to-profile conversion, performing, 251
 removing profile, 574
 Spot color channels, images with, 682
Color Range command, 145, 280
Color scan mode, 596
color selection methods. *See also* color correction; Color Picker; Extraction tools
 choosing best method, 29
 Eyedropper tool (*See* Eyedropper tool)
 Foreground color swatch (*See* Foreground color swatch)
 numeric ink value, 544
 out-of-gamut warning, 62, 549, 925–926, 965
 out-of-web gamut warning, 549
 Spectrum palette, 543
 Swatches palette (*See* Swatches palette)
color settings
 color-conversion table, 858
 customizing settings, 11, 571, 781
 editing, 261
 matching on-screen settings to color proof, 571
 Photoshop and Illustrator, using between, 719
 predefined settings, 11, 52, 858
 setting up, 11
color spaces. *See* color modes/spaces
Color Stops option, 175, 178
ColorSync Workflow option, 11, 52
color tables, 39
 assigning transparency to indexed color image, 819
 color-conversion table, 858
 color-matching options, 840
 creating custom table, 743
 ImageReady (*See* ImageReady)
 Index color table, 834–835, 843
 locking colors on, 578, 831
 saving custom table, 822
 using custom table, 744
 video lookup table, 44
 Web Safe table, 243, 834–835
 Windows *vs.* Macintosh tables, 243, 835

color tinting, 338, 637. *See also* colorizing; sepia tint
color tone, correcting and matching, 643. *See also* tonal range
color transparencies, creating, 705
color trap, 339, 565, 721
color values, 166, 182, 243, 252. *See also* brightness (luminosity) value of pixels; Info palette
 Curves command used to adjust, 319
 hexadecimal values, 552, 557, 767
 highlights/shadows, target values for, 618
 saturation value, 631
 selecting colors by numeric ink values, 544
 Selective Color command, effect of, 211
 viewing, 562
color wheel, 554
 adjusting colors to standard, 208
 Curves command used with, 319
columns
 redefining image using, 938
 width, defining image using, 42
comet tails, creating, 197
commands. *See also specific commands*
 channels, effect of, 461
 converted into Action, 431
 modal controls for, 424
 placed within Action, 423
Composite channels, 8, 37, 211, 432, 436, 444, 583
compressing files, 754–756, 864
 Alpha channels to control image modification, 765–766
 choosing correct scheme for, 4, 132
 Disable Scratch Compression plug-in, 916
 Force VM Compression plug-in, 919
 in ImageReady, 729–734, 765
 lossy/lossless, 4, 729, 732, 749, 755, 765, 799, 861
 master image, 737
 QuickTime movies, 811
 recompressing compressed image, 749, 754
 scanned images, 590, 597
 sliced images, 806
CompuServe GIF. *See* GIF (Graphics Interchange Format)
computer monitor. *See* monitor
computer presentations. *See* presentations
Concavity option (arrowhead lines), 126
Conditional Mode Change command, 427
Constrain Proportions option, 114, 116, 118, 120, 269, 950
contact sheets
 creating, 100, 430
 custom palette, used to create, 743
 indexing images using, 937
context-sensitive menus, quickly accessing information with, 63

Contiguous option
 Background Eraser tool, 170
 Magic Eraser tool, 165
 Magic Wand tool, 170, 181, 284
 Paint Bucket tool, 167
contrasts. *See also* brightness (luminosity); tonal range
 Auto Contrast command, 626
 Brightness/Contrast command, 207, 624, 754
 Curves command to adjust, 503, 641
 Edge Contrast option for selection tools, 137, 140
 reducing to reduce file size, 754
 Threshold conversion for high, 199
 Variations command to adjust, 220
Convert Anchor Point tool, 87, 155
copying. *See also* Clone Stamp tool; exporting files
 Action steps, 425
 between applications, 940, 945
 Apply Image command, 264
 Calculations command, 265, 267
 channels, 460
 color separation plates, 857
 Copy and Paste command, 40, 393, 778, 943, 945
 drag-and-drop, 383, 405, 940–941
 Duplicate command, 263
 element within layer, 377, 940
 History states, 405, 407–408
 layer effects, to create, 383, 393
 layers, 376, 940
 Paste Into command, 942
 paths, 485–486
 prior to editing, 263, 749
 recompressed images, 749
copyrights, 48, 99, 321, 973
corner curl on image, putting, 646
Craquelure filter, 148
cropping
 animations, 782
 crop marks, printed image, 709
 with Cropping Tool, 75, 272
 pixels outside viewable image, 944
 Trim command, 275
 for Web, 723–724, 782
 without Cropping tool, 273
Cropping tool
 cropping images with, 75, 272
 expanding canvas using, 274
cross-platform compatibility, 34
 monitor, viewing differences on, 726, 985
 RGB images, adjusting, 243
cursors. *See* tools
curved lines. *See also* anchor points
 changing curve in, 466
 creating, 476–477
 distorting image along, 149
curved surface, bending text to fit, 150, 536, 566, 657, 1001
Curve Fit option, 140, 156
Curves Adjustment layer, 324

Curves command, 205
 to adjust color, 319, 613, 615–616, 618, 621
 to correct high-key/low-key images, 613–614
 duotone image, changing tonal range of, 849
 to increase contrast, 503, 641
 loading and saving adjustments, 616
 order of use of, 615
Custom Shape Drawing tool, 88, 125, 128, 221, 226
custom shapes, paths used to define and save, 129
Cut command, 943
Cutout filter, 498, 870
Cylinder Anamorphosis, 535

D

Darken blending mode, 234, 364, 904
darkening an image, 624, 679. See also Burn tool; shadows; tonal range
DCS. See Desktop Color Separations (DCS 2.0)
default image characteristics, modifying, 33, 61
defragmentation, 17
Defringe command, 611
De-Interlace option, 260, 947
deleting
 Action or Action set, 413
 background, Delete command used on, 306
 Cut command, 943
 Delete Anchor Point tool, 87, 155
 restoring deleted images, 142
depth in image. See perspective
Desaturate command, 209, 334, 631
Desaturate option, Sponge tool, 602
Desktop Color Separations (DCS 2.0), 682, 711, 856
Despeckle filter, 494, 519
dialog boxes. See also specific dialog boxes
 closing, 523
 default positions, restoring to, 70
 modal controls for, 424
 new dialog box, restoring input settings for, 997
 opened by Stop command, 422
 shortcuts for entering information into, 523
Difference blending mode, 234, 367
Difference Clouds filter, 525, 540
Diffusion dither option, 39, 262, 710, 838, 846
Digimarc watermark, 48, 99, 320–321, 973
direction lines, 308
Direct Selection tool, 85, 308, 314, 470, 686
Disk Defragmenter utility, 17
Displace filter, 504, 511, 518, 566
Display & Cursors option, 64
Dissolve blending mode, 234, 365

distortion
 bending text with distortion map, 566
 Distort filters, use of, 518, 556, 842 (See also Displace filter)
 texture maps used for, 504–506
Distribute commands, 353
dithering, 39, 661
 custom pattern, creating, 817
 Dither Box filter, 534, 553
 GIF file size reduction, dither reduction for, 755
 GIF optimization settings, modifying dither for, 765
 Web image, 534, 553, 747, 815, 817
Dither options. See also Diffusion dither option; Pattern dither option
 color profile of document, converting, 254
 customized color settings file, creating, 261
 GIF Optimize settings, 732, 765
 Gradient tool, 172
 Indexed color palette, 262, 710, 838
 Noise option, 262, 710, 838
 PNG Optimize setting, 733–734
Document Size. See also Image size
 information field, 19
 options (paper output), 269
document windows, 54
 grids, 104, 106
 guides, vertical/horizontal, 103
 multiple windows, use of, 54
Dodge tool, 41, 84, 95, 191, 217, 601
 image exposure, controlling, 601
 multilayer editing, 233
 path used to control, 481
dot gain, 108, 203, 923, 928
dotted line, selection defined by, 303, 317
dotted-line brush, creating, 224
dpi (dots per inch), 105
drag-and-drop, 383, 405, 940–941
drawing tablet. See also Stylus option
 Airbrush tool used with, 279
 Brush Dynamics, 191
 Brush tools used with, 101, 196
Drawing tools, 88, 126, 138. See also Art History Brush tool; Custom Shape Drawing tool; History Brush tool
 Layer Styles palette, 123
 measurement information, 96
 options, Option Bar, 128
 Shape Layer/Work Path options, 127
droplets
 Action included in, 772
 graphics, applying to, 771
 permanent, 770
 temporary, 768
drop shadow
 adding depth with, 968
 as back screen for text, 678
 ImageReady, applying within, 789
 separating from its effects, 910

 text layer, applied to, 660
 in transparent GIF images, 800
Drop Shadow style, 382, 384, 391, 487–490
Dry Brush filter, 492, 514, 555
Duotone color model, 239
Duotone color mode/space, 111, 246, 255
duotone images
 changing curves of, 849
 exporting, 855
 manipulating, 848
Duotone options, 740, 847, 849, 867
duplicating. See copying
Durability (watermark), 99, 321
dust, Blur tool to correct, 159
Dust & Scratches filter, 512, 519, 599, 603, 615

E

edges
 blending using Smudge tool (See Smudge tool)
 chiseled edge, creating, 897
 clipping paths used to stroke, 479
 creating (See edges, creating)
 defining edge of selection, Edge Contrast option, 137, 140
 edge color in moved images, removing, 736
 Edge Touchup tool, 289
 erasing using Background Eraser, 548
 feathering (See feathering)
 filters, effect on edges of, 494, 496, 498, 500, 527
 fringe pixels, removing, 611–612
 hiding selection border while working, 297
 modifying selection border, 298
 motion-blurred object, fixing edges of, 961
 Noise filter used to smooth, 980
 path snapped to edge, 139
 Sharpen Edge filter, 627
 smoothing, 289, 296
 Trim command to crop, 275, 724
edges, creating
 corner curl on image, 646
 exotic edges, clipping groups used for, 379
 from selection, 317
 sharp edge, Layer clipping path to create, 312–314
 slide-mounted image, illusion of, 645
 vignette border, 305, 410, 446
editing. See also Gradient Editor; specific commands
 basic steps for, 615
 channels, 212–214, 433, 438–439, 444, 446–447, 457
 in CMYK color space, 250
 copying file prior to, 263, 749
 histograms, use of (See histograms)
 History states, use of, 407, 595
 ImageReady animation files, 760

ImageReady Color Table, colors in, 779

Indexed Color Palette, colors in, 839

Layer clipping path, 314

layers, 233

multiple windows, use of, 54

New View feature to control, 288

order of adjustments, 615

out-of-gamut colors, 926, 965

path used to control, 481

in Quick Mask mode (*See* Quick Mask mode)

repeatable sequences, storing (*See* Actions palette)

in RGB color space, 250, 550

selections used to control effects of, 315

shape layers, 686

spot color channels, 259

in work area, 303

Effects layers, 341, 347. *See also* layer effects

converting to regular layers, 385

credit-card text, creating, 898

efficiency information field, 19

efficient use of Photoshop, 17, 905, 934. *See also* file size

8-bit channels, working with, 51, 97. *See also* Duotone color model; Indexed color model

Ellipse Drawing tool, 88, 128

Elliptical Marquee tool, 71, 281–282

embedded profiles. *See* color profiles

embosses, 235, 527. *See also* Bevel and Emboss filters; Bevel and Emboss layer style

Effects layers, 341

Lighting Effects filter, performing digital emboss with, 805

text, embossed, 662, 676

Emulate Photoshop 4 color settings option, 52

Encapsulated PostScript files (.eps), 711. *See also* PDFs (Portable Document Files)

Anti-alias option used with, 30, 116.693

clipping paths, saving files with, 476, 478

importing, 115

opening, 116, 693

repurposing images for, 98

saving files in, 476, 478

text printed from, 652

Enter key, 523

EPS files. *See* Encapsulated PostScript Files (.eps)

Equalize option, 198, 633

Eraser tools, 41, 81, 169, 191, 217, 289. *See also* Background Eraser tool; Magic Eraser

Auto Erase feature, 228

Background Color Swatch, use of, 221, 306, 346

History brush, turning into, 409

layer, pixels converted to transparent on, 346

path used to control, 481

Erase to History option, 409

errors, batch processing, 416

Esc key, 523

Europe Prepress Defaults, 11, 52

Exclusion blending mode, 234, 367

exploding shapes, creating, 1000

Export Clipboard. *see* Clipboard

exporting files. *See also* Clipboard; importing files

Adobe Illustrator, moving images to, 689, 940, 951, 953–954

Adobe Illustrator, moving paths to, 690

to Adobe LiveMotion, 820

duotone image, 855

generic web-editing programs, moving JavaScript rollovers to, 803

GoLive, moving JavaScript rollovers to, 802

ImageReady, moving image to, 799

ImageReady, moving text to, 808

Lab color mode/space used for, 111, 245, 545

non-Web formats, exporting ImageReady files to, 725

to OLE-compliant program, 978

transparent areas, maintaining, 476, 478, 691, 734

exposure, Dodge tool to control, 601

Exposure option, 162, 217

extension files, deactivating, 513

Extract command, 280, 289, 291

Extraction tools, 166, 289, 291. *See also* Eraser tools; Eyedropper tool; Magic Wand tool; selection tools

Eyedropper tool, 90, 164, 289, 542

color measurement points, setting, 330

foreground/background colors, changing, 90, 148, 221

Gradient Editor used with, 178

highlights/shadows, setting, 328

Levels command, image balancing with, 202

red eye correction, 336

Replace Color command, 581

sample rate, changing, 335, 542

single color, 581

subtract color, 581

F

Facet filter, 515, 520

Fade command, filters used with, 530

faded images, reconstructing, 640

fade in/fade out of animation, 764, 785

Fade rate of brush, changing, 197

feathering of selection border

Feather command, 304–305, 315, 334, 963

Feather Radius input field, 137, 282–283, 285, 304

filters used for, 171

Pen tools, selections made with, 285

viewing, 963

vignette border, creating, 305, 410, 446

Fidelity option, Art History Brush, 144

file(s). *See also* importing files; opening files

compressing (*See* compressing files)

displaying information on open file, 19–21

fragmentation/defragmentation, 17

saving (*See* saving)

file extension option, use of, 34

file formats, 861. *See also* BMP file format; Desktop Color Separations (DCS 2.0); GIF (Graphics Interchange Format); JPEG (.jpg) format; PDFs (Portable Document Files); PICT files; PNG (Portable Network Graphic); PSD (.psd) format; Tagged Image Format (.tif)

displaying for current file, 112

ImageReady, saving files in non-Web formats in, 725

for monitor, 708, 711

native format, 4

for presentations, 711

for printing, 711, 923

for scanned images, 590, 597

selecting with Show button, 112

for sliced image, 776

for Spot color channels, 682

for Web (*See* Web)

file names, 3

as contact sheet captions, 430

converted PDF file, 117

labels, printer's mark, 709

renaming, 3

sliced images, separate names for, 76

upper or lower case, 35

file size. *See also* compressing files; image size

animation file size, reducing, 782

in Bitmap mode, 829

channels, effect of, 433

color space size, effect of, 610

high resolution, effect of, 107

ImageReady file, Image Size command to resize, 786

Indexed Color, effect of, 742

for Internet, 723–724, 748, 754–756

multiple layers, effect of, 344, 347, 683, 905

number of colors available, effect of, 576, 579

optimizing image by file size, ImageReady, 728

for presentations, 834

of sliced images, 806

fill. *See also* styles

Extract command, use of, 289

Gradient Map command, use of, 215

Gradient tool, use of, 172, 174, 177, 221

history state/snapshot, use of, 161, 404

Paint Bucket tool, use of (*See* Paint
 Bucket tool)
Web graphics, converting GIF trans-
 parency for, 751
Fill command, 161, 232
 Background Color Swatch, use of,
 221
 customized pattern, use of, 340
 Foreground and Background Color
 Swatches, 221, 306
 path, filling area defined by, 483
 seamless background, checking, 795
 text layer, use with, 359
filled regions/shapes
 with Drawing tool, 138, 226
 Free Transform, manipulating with,
 227
Fill tool, 289, 291
film recorder, transferring image to, 705
filters, 28, 347. *See also* Artistic filters;
 Blur and Blur More filters;
 Displace filter; Noise filters; plug-
 in modules; Polar Coordinates fil-
 ter; Render filters; Shear tool
 active layer, work in, 514, 517–520,
 525–527
 applying, 492–493, 507, 512, 655,
 866, 870
 backgrounds created with, 148
 blending modes combined with, 508
 Brush Strokes, 492, 517, 842
 channels and (*See* channels)
 color modes and (*See* color
 modes/spaces)
 custom filters, creating, 538
 Cutout, 498, 870
 Distort (*See* distortion)
 Dither Box, 534, 553
 Fade command, use of, 530
 filter sandwich, creating, 171
 gradients, controlling with, 171
 Grain, 501
 High Pass, 496
 intensity, controlling, 461, 530
 masks and, 152, 171
 maximizing effect of, 503
 memory-intensive filters, improving
 performance of, 513
 Minimum/Maximum, 497
 natural appearance, tips for, 502
 painterly look, creating, 448
 Patchwork, 528
 Pixelate, 515, 520
 previewing, 44, 492, 531
 selections combined with, 315, 507,
 529
 Sharpen, 447, 512, 627
 Sketch, 526, 671, 842
 Spherize, 529, 582
 Stylize, 527, 842
 text, used with, 655, 665
 texture mapping, use of, 504–506,
 510, 842
 Tile Maker, 759, 796

Tiles, 499, 527
Torn Edges, 500, 509
Find dialog box/button, 2, 112
Finger Painting option, 147
Fit on Screen view option, 56
fixes, 26–27, 48
flaming sun, creating, 1000
Flatten Image option, 254, 343,
 373–374, 536
flesh tones, 542
flipping. *See* inverting
Focus tools, 83. *See also* Blur tool;
 Sharpen tool; Smudge tool
folders
 Action set, 420
 choosing, 117
 Plug-Ins, 28, 50
 texture maps, 505
fonts, 12, 218, 652
 changing, 655
 ImageReady, 807
 selecting, 663
 serif/sans serif, 936
Foreground color
 changing, 148
 default, 148, 221
 filling area with, 161
 Force Foreground option, Extract
 command, 289
 mask, black, white, or gray to create,
 151–152
 Pencil tool, line drawn by, 228
 Protect Foreground Color option,
 168
 reversing, 221
 Soft and Hard Light blending modes,
 362
 transferring sampled color to, using
 Eyedropper, 164
Foreground Color Swatch, 94, 306, 541
 black and white default, 306
 filled regions, 226
 Pantone colors, working with,
 546–547
 reversing, 306
 selecting color with, 221, 546–547,
 549
 Torn Edges filter, use of, 500, 509
Format button, 112
4-bit color, 51
four-color printing, 238–239, 241, 244,
 249, 721. *See also* CMYK color
 mode/space; Pantone colors
 file formats for, 711
 out-of-gamut colors, 62, 549,
 925–926, 965
 shadows, enhancing, 651
fragmentation/defragmentation, 17
Freeform Lasso tools. *See* Lasso tools
Freeform Pen tool, 87, 139, 156
freeform shape, text converted to, 665
Free Transform command
 linked layers, used on, 932
 manipulating shapes with, 227

manual modification of selection,
 293
 numerically adjusting selection, 292
 shadow created with, 299, 910
 size of image, modifying, 946
Freeze tool, 278
Frequency option (anchor points)
 Magnetic Lasso tool, 137
 Magnetic Pen tool, 140
fringe pixels, removing, 611–612
Full Screen Modes (screen display), 53
Full Size option, image display, 33, 61
Fuzziness input box, 581

G

gamma, adjusting using ImageReady,
 727, 985
Gamma option, blending RGB colors
 using, 261, 736
gamut warnings, 62, 549, 925–926, 965
Gaussian Blur filter, 180, 462–463, 516,
 655, 754, 868, 989
GCR printing method, 923
ghosted background, 902
GIF (Graphics Interchange Format), 98,
 132, 585, 691, 695, 711, 739,
 853
 compressing files, 729–730, 732,
 748, 751, 755, 765, 797, 827
 flat-color clip art, Web Safe, 762
 full-screen image background, 797
 GIF89a format, 992
 gradient applied to, 745
 ImageReady Optimize option, use of,
 576–577, 579
 indexed color space, use of, 834
 master color palette, creating, 780
 recompressing compressed image,
 749
 soft-edged shadow in transparent
 image, 865
 text slices, applying settings to, 769,
 776
 transparency in, 577, 788, 792, 800
GIF (Graphics Interchange Format)
 animation
 Adobe LiveMotion, 820
 converting QuickTime movie into,
 758
 editing, 760
 illusion of movement, creating, 763
 multi-layered image, created from,
 696
 onion skimming, 752
 QuickTime movies created from, 696
 resizing file, 786
Glass filter, 504, 506, 518
Global Light option, 384, 911
glow, applying to text, 670, 675, 907
GoLive
 JavaScript rollovers moved into, 802
 saving Web images with, 804
Gradient Editor
 creating custom gradients, 175

document image, custom gradient color selected from, 178
saving and loading custom gradients, 176
smoothness of gradient, 175
Gradient Map command, 215, 582
Gradient Presets, 176
gradients, 306
filters controlled with, 171
GIF image, applying to, 745
layers for, 341
noise gradient, creating, 573
smoothness of, 175, 180
stepped gradients, reducing, 989
Gradient tool, 82, 217. *See also* Gradient Editor
Background Color Swatch, 221
bevel applied with, 647
Blending Mode options, effect of, 173
blending two images together, 642
colorful background created with, 995
filters, controlling, 171
Foreground Color Swatch, 221
Metal gradient, curl created with, 646
multicolor wash created with, 179
options, working with, 172
spheres generated with, 908
Grain filter, 501
gray
channels, use in, 432, 434–435, 438, 452, 461
layer mask, 387
in texture maps, 505, 511
viewing channels in, 37
Grayscale color mode/space, 10, 111, 246, 255
converting to Bitmap, 829
printing in, 246
Grayscale color slider, 544
grayscale images. *See also* brightness (luminosity)
black-and-white images created from, 199
Calculations command to create, 267
Channel Mixer command to convert color image to, 213
Colorize option to add color, 208
Desaturate command to convert color image to, 209
dot gain, adjusting, 928
gradient fill, grayscale range of image mapped to, 215
Invert command used to convert, 216
merging, using Merge Channels option, 441
Pantone tint, printing with, 740
printers, resolution for, 107, 110
RGB image converted to, 245, 256
scan mode for, 596
texture maps as, 505, 510–511
viewing, 37, 145
grayscale values, channel pixels, 442

grid patterns, cleaning up, 515
grids (document windows), 104, 106
Grow command, 303, 431
guides, vertical/horizontal, 103

H
halftone images, 247, 845
halftone patterns
cleaning up, 515
television image, simulating, 563
Halftone scan mode, 596
halftone screen attributes, selecting and transferring, 107, 713
halos
background color to mask, 751
removing using Defringe, 521
hand-tinted appearance, 212
Hand tool, 91, 289
hard drive, 16–17. *See also* scratch disks
file fragmentation/defragmentation, 17
saving space, 36
hard light, correcting, 315
Hard Light blending mode, 234, 326, 362, 904
height, document
Canvas Size command to modify, 270
converted PDF documents, 116, 118
imported PICT files, 120
height, image, 1, 22, 292
changing, 114, 269, 522
for printing, 700
hexadecimal color values, 552, 557, 767
Hide/Show Preview button, 112
High Color monitor color option, 51
high-key images
correcting, 613–614
identifying, 592
Highlighter tool, 289, 291
highlights. *See also* high-key images; tonal range
Auto Contrast command, use of, 626
Auto Levels command, use of, 204, 622, 625
Color Balance command to adjust, 206
Dodge tool to control, 601
Extract command, use of, 289
Eyedropper tool to adjust, 202
gradient map, image map areas mapped to, 215
Levels command to identify/adjust, 201–202, 629
restoring blown-out, 162
setting within image, 328
Sharpen tool, use of, 290
target values to set, 618
Threshold used to identify, 619
Variations command to adjust, 220, 630
High Pass filter, 496
histograms
accuracy of, 47
examining image using, 276, 613–614
Image Cache, effect of, 47

Levels dialog box, 201–202
scanning, use for, 592
History Brush tool, 41, 80, 191, 217, 397–398, 400, 409
brush size, selecting, 142
complicated background, removing, 291
Dust & Scratches filter used with, 603
editing image with, 600
filters applied with, 866
path used to control, 481
restoring images with, 142
Rough Pastels filter used with, 899
simulating motion with, 975
transparent layer, use with, 143
History palette, 397
creating document snapshot, 398, 403, 595
linear or nonlinear histories, using, 399
memory impacted by, 401, 403, 513
number of operations in, 401, 513
painting with document snapshot, 400
History states, 397, 399–400, 595
creating new document from, 402
dragging between windows, 405
duplicating, 407
Erase to History option, 169
filling with, 161, 404
number of, 401, 403
previous state, snapshot created from, 408
RAM used by, 401, 403, 513
stepping through, 406
horizontal line jitter, removing, 947
hot spots, 801
HSB color model, 239
HSB color slider, 544
HTML
color code, example of, 767
color slider, 544
hexadecimal values, use of, 552, 557, 767
ImageReady format, 577
Save for Web feature, 135
table, 806
updating existing files, 987
hue, 361, 442, 631. *See also* Curves command; Hue/Saturation command
Color Picker to control, 567
HSB color model, hue channel of, 239
HSB color slider, adjustment using, 544
ImageReady Color Table, sorting in, 575
Replace Color command to change, 210
Hue blending mode, 192, 234, 368
Hue/Saturation command, 208, 580, 926
Adjustment layers, use with, 323

color applied with, 333
red eye correction, 336
sliders used to modify colors, 580
hybrid graphic, creating, 988
hyphenation options, 668

I
ICC Color Profile, 249
assigning to document, 560
creating, 559
embedding into PDF graphics, 860
icons
preview, 33, 61
standard/precise, switching between, 64
tool icons, changing, 64
Image Attributes (watermark), 99, 321
Image Cache
Cache Levels settings, 46
Histogram, effect on, 47
Use cache for histogram option, modifying, 47
viewing and modifying, 46
image maps
Black Point Compensation, 833
creating, 801
image previews. *See* previews
ImageReady, 14, 844. *See also* Optimize palette
animations, 696, 758, 760, 782–787, 791, 812, 823–824
background transparency, working with, 577
Color Table, 575–576, 578, 738, 779, 793, 799, 822
converting image to Web Safe palette, 741
cropping images, 723–724
droplet, use of, 769–772
exporting images using, 725
file compression in, 729–734
gamma, adjusting, 727
GoLive used with, 804
hybrid graphic, crating, 988
Illustrator file, preparing, 757
Image Size command to resize file, 786
interactive button list, creating, 814
layer effects, using, 789–790
locking colors into Color Table, 578
master color palette, creating, 780
moving Photoshop image into, 799
original image, view of, 775, 851
printing documents in, 816
regenerating color space, 738, 741
resetting preferences in, 952
rollovers (*See* JavaScript rollovers)
sliced images, 768–769, 776
text in, 807–808
Web interface, 812
Imagesetter
clipping paths, preparing images with, 703
Limitcheck error, 703

image size, 1, 13, 22. *See also* height, image; width, image
Fixed Size option, 128
Image Size dialog box, using, 269
imported images, resizing, 115
Navigator palette to resize, 55
for presentations, 862
print size reduced without quality reduction, 950
Proportional size option, 128
pull-down menu to resize, 56
resized image, tips to help, 522, 524, 946
resolution increased by changing, 114
Save for Web to resize, 830
screen shots, resizing, 636
selection, resizing, 294–295
View input box, changing percentage in, 184
Web images, 585, 820, 830
Zoom tool to resize, 92, 183
image transformation in Photoshop, 13
importing files. *See also* exporting files
Adobe Illustrator, 115, 694, 940
Lab color mode used for, 245
PDF files, 117–118, 429
PICT files, anti-alias, 120
PICT Resources, 122
Place option used for, 115
scanning into Photoshop, 119, 594
text annotations, 121
inches measurement system, 109, 587
Index color table, choosing, 843
indexed color images
assigning transparency to, 819
changing bit depth of image, 836
color-matching options for, 840
forcing colors using indexed color, 837
Web Safe colors and, 710, 742
Indexed color model, 239
Indexed color mode/space, 111, 255, 597
color palette for, 691–692, 743–744, 835, 838–839
converting to, 834
Dither options, 262, 838
editing colors, 839
Indexed Color option, 710, 742, 744
indexing of images, 937
Info palette, 96, 328, 330, 562
changing displayable options, 329
shortcuts, 329
tonal range identified using, 628
information dialog box
open graphic file, information on, 19, 21
print preview, 20
ink
coverage, 108
dot gain, 108, 203, 923, 928
saturation (*See* saturation)
inkjet printers, 661
characterizing monitor for, 241

CMYK color mode, 244
color separation plates, printing, 857
file formats for, 711
RGB color mode, 242
Inner Shadow option, 391
intent options, printer, 253–254, 714
interactive buttons. *See* buttons
interactive media. *See also* Web
hot spots, 801
Layer clipping paths, use of, 312–314
Macromedia Director, copying images into, 706
International Color Consortium (ICC). *See* color management system (CMS); ICC Color Profile
Internet. *See* Web
interpolation of pixels, 13, 22, 522, 946, 950
Intersect with Selection option, 136–137, 170, 282–284
inverting
Foreground and Background colors, 221
Foreground and Background Color Swatches, 306
horizontal/vertical flipping of images, 933
Invert command to reverse color, 216, 632
Reverse option for gradient colors, 172
selection area, Invert option to reverse, 311

J
Japan Prepress Defaults, 11, 52
JavaScript rollovers
animation sequence, triggering, 787
creating, 773, 781
generic web-editing programs, moving into, 803
GoLive, moving into, 802
mound buttons, 878
saving, 804
sliced images, using, 774
JPEG encoding system, 716
JPEG (.jpg) format, 98, 585, 695, 711, 739, 852
Adobe LiveMotion, 820
compressing files, 4, 34, 132, 729–731, 754, 766, 828
file size of image, reducing, 754
photographic slices, applying settings to, 769, 776
recompressing compressed image, 749, 754
Jump To button, 799, 951, 953–954

K
Kaleidoscope option, 796
kerning, 667
Kodak Photo CD
destination, choosing, 302
opening images saved in, 6
source, choosing, 301

L

Lab color mode/space, 111, 239, 245, 255, 842. *See also* Composite channels
 converting RGB image to grayscale, 245, 256
 image color preserved by, 545
 image sharpening, 245, 930
 transporting an image, 111, 245, 545
Lab color slider, 544
laser printers
 characterizing monitor for, 241
 CMYK color mode, 244
 color separation plates, printing, 857
 file formats for, 711
 RGB color mode, 242
Lasso tools, 73, 124, 153, 283, 296
 creating straight lines using, 283
 Magnetic Lasso, 73, 137, 280
 Standard Lasso, 73, 136, 280
Layer clipping path
 creating, 312
 editing, 314
 style applied to, 313
layer effects. *See also* Bevel and Emboss layer style; Effects layer; Layer Style dialog box; Styles palette
 applying, 382
 copy and paste, creating via, 393
 drag and drop, moving with, 383
 3-D text created with, 660
 editing, 392
 global light applied to multilayers, 384
 ImageReady, use in, 789–790
 locking, 991
 perspective, creating, 391
 separate layers, creating, 910
 style created from, 487–489
 Tween option used with, 784
layer masks, 152
 blending two images together, 642
 creating, 386
 duplicating, 388
 editing, 387
 linking and unlinking from image, 389
 photo collage created with, 873
 ragged text, creating, 821
 text layers combined with to fade type, 680
 transparency, 352, 387
Layer Properties dialog box, 381
layers, 347, 905. *See also* Adjustment layers; Effects layers; shape layers; Text layers; Type layers; Use All Layers option
 adding from another document, 327, 349
 aligning, 287, 354–355
 animations, 696, 782, 823
 assembled image created from multiple layers, 905
 Auto Select Layer option, use of, 287, 350
 background converted into, 394

backgrounds compared, 346
Blend If option, using, 345
blending modes (*See* blending modes)
blending two images/layers together, 264, 642
channels compared, 434
Clone Stamp tool, controlling, 607
concept of, 341
controlling work with, 233
copying, 940
distributing, 287, 353
element within layer, copying, 377
file size, multilayered documents, 344, 347, 683, 905
filling, 939
filters, active layer modified by, 514, 517–520, 525–527
Flatten Image option, use of (*See* Flatten Image option)
Gradient fill layer, creating, 174, 177
hiding/showing, 343
Invert command, use of, 632
JavaScript rollover, multilayers converted into, 773
lens flare, moving, 896
linked (*See* linked layers)
locking, 358, 991
magnifying lens effect, use for, 396
masking transparent areas of, 352
masks (*See* layer masks)
maximum number of, 392
merging, 374–375, 385
motion simulated using, 832
moving between documents, 683, 905
multi-layered document converted to single layer, 254, 343, 373–374
multi-layered documents, saving in non-PSD formats, 697
naming, 381
nontransparent areas, selecting, 351
objects added using, 638
opacity, controlling, 357
opening and closing quickly, 983
Paint Bucket fill controlled with, 684
pixel-to-pixel copy, making, 376
regular, 341, 385
restacking, 342, 372
sampling image information from all layers, 395
selecting, 348
softening an image using multiple layers, 903
style applied to, 488, 490 (*See also* Layer Style dialog box; Styles palette)
styles created from, 487
transparency (*See* transparency, layer)
viewing, 348
visible information, selecting, 360
visible layers, merging, 375, 385
layer sets, 392
 creating, 380, 385
 Pass Through option, 390
Layers palette, 174, 177, 324, 348–349
 backgrounds *vs.* layers, 346

clipping group, creation/use of, 378–379
layer effects and Adjustment layers, control over, 392
layer names in, 381
stacking order of layers in, 342
storyboard, use as, 761
Layer Style dialog box, 345, 382, 392, 487, 914
Layer Styles palette. *See* Styles palette
leading value, 667
Lemple-Zif-Welch compression. *See* LZW compression
lens flare
 correcting, 331
 creating custom, 998
Lens Flare filter, 525
 creating a lens flare, 895
 3-D globe created with, 906
 moving on separate layer, 896
Levels Adjustment layer, 331, 378, 463
Levels command, 201
 Adjustment layer, use as, 322
 Auto Levels command, 204, 622, 625
 color correction using, 623
 eyedroppers used to balance image, 202
 filter use and, 503
 highlights, shadows, and midtones, identifying and setting, 629
 input sliders, 201–202, 204
 to lighten background, 315
 lightning, creating, 540
 midtones, adjusting, 614
 order of use of, 615
 output sliders, controlling output with, 203
Lighten blending mode, 234, 364
Lighting Effects filter, 504, 525, 531–532
 backgrounds with depth, 964
 digital emboss, 805
 painterly effect, 555
lightness of image/pixels, 580, 631. *See also* Brightness/Contrast command; brightness (luminosity); highlights; Hue/Saturation command; Lab color mode/space
 blending mode options for, 234
 Dodge tool to control, 84, 601
 Replace Color command, 210
lightning, creating, 540, 871
light source, 384, 608, 911, 960
Limitcheck error, 703
line art
 colorizing, 890
 printers, resolution for, 107, 110
 printing, 247
Line Art scan mode, 596
Line Drawing tool, 88, 126
lines, 465. *See also* anchor points; curved lines
 arrowhead lines, creating, 126
 Auto Erase feature to erase, 228
 Custom Shape tool, 226

drawing straight, 88, 283
 selection based on lines between user-
 defined points, 73, 124
lines per inch (lpi), 923
linked layers
 aligning, 354
 distributing, 353
 linking layers together, 356
 moving between documents, 683
 selection marquee, alignment to, 355
 Transform used on, 932
Liquefy command, 277–278
liquid type extruding from image, 671
Load Selection command, 311
locking layers, 358, 991
lockups, system, 24
logos
 designing a logo pattern, 884
 web backgrounds, used for, 777
low-key images
 correcting, 614
 identifying, 592
luminosity. *See* brightness (luminosity)
Luminosity blending mode, 234, 368,
 904
LZW compression, 4, 132, 597

M
Macintosh
 Adobe Gamma utility, calibrating
 monitor color using, 57, 241
 allocating memory to Photoshop, 18
 ColorSync Workflow color settings,
 11, 52
 color table, 243
 corrupt settings files, 24
 Find button, 2, 112
 finding misplaced image on hard
 drive, 2, 112
 Full Size option to display image, 33
 Hide/Show Preview button, 112
 importing anti-aliased PICT files, 120
 installed memory, determining
 amount of, 18
 monitor screen display, 726, 985
 PICT Resources, importing, 122
 special occasion settings files, saving,
 25
 Thumbnail, 33, 61
 video LUT animation, problems with,
 44
 virtual memory, running Photoshop
 with, 15
Macromedia Director, copying images
 into, 706
Magic Eraser tool, 41, 81, 165, 229
Magic Wand tool, 74, 95, 153, 170,
 280, 284, 296
 Contiguous option used to change
 selection by, 181
 multiple layers, use with, 395
 Tolerance option, 170, 182, 284, 303
Magnetic Lasso tool, 73, 137, 280
Magnetic Pen tool, 139–141, 156
magnifying lens effect, 396, 529
marching ant marquee, 303

Marquee tools, 71, 280–282. *See also*
 Rectangular Marquee tool
masks, 152. *See also* Alpha channels;
 Gradient Editor; Gradient tool;
 Quick Mask mode
 Adjustment layers, 325, 327, 331,
 370
 background and, 388
 Constant option, Channel Mixer, 212
 cropped areas, 272
 layers (*See* layer masks)
 selection, 280, 289
 text (*See* text masks)
 transparency, 151–152, 352, 387
master image, creating, 737
Matte option, 521, 691, 735, 792, 800
Maximize Backwards Compatibility
 option, 36
Maximum filter, used on channels, 497
measurement systems. *See also* ruler bar
 changing measuring units, 586–588
 Info palette, measurement informa-
 tion on, 96
 information dialog box, 21
 resolution, measurement of, 110
 Units & Rulers options, 586
 width and height measurement sys-
 tem, choosing, 109
Measure tool
 Info palette information, 96
 straightening image with, 146
Median filter, 495, 519
menu bar, displaying, 53
menu items inserted into Action, 421
Merge Channels option, 441, 735
Merge Visible option, 324, 374–375,
 385, 991
Metal gradient, curl created with, 646
metallic textured object/text, creating,
 674, 874–876
mezzotint, colorized, 900
midtones
 Auto Levels command, use of, 622,
 625
 Color Balance command to adjust,
 206
 Curves command used to identify,
 621
 Dodge tool to control, 601
 gradient map, image map areas
 mapped to, 215
 Levels command to identify/adjust,
 201, 614, 629
 Variations command to adjust, 220,
 630
Minimum filter, used on channels, 497
misplaced image on hard drive, finding,
 2, 112
modal controls, activating in Action,
 424
Mode option (blending). *See* blending
 modes
Mode option (color space), 116–118,
 120
modes, color. *See* color modes/spaces

moiré patterns, removing from scanned
 images, 300, 462
monitor. *See also* presentations
 calibrating color on, 57, 241, 249,
 316, 559
 characterizing, 241
 color depth of, 51
 color saturation, changing, 261
 color space, 242, 250, 610, 708
 cross-platform differences, viewing,
 726, 985
 display modes, changing, 53, 957
 file format for, 708
 Fit on Screen view option, 56
 perception of color on monitor, fac-
 tors affecting, 316, 572
 preparing images for screen display,
 708
 print, adjusting screen shots for, 636
 Proof Setup option, 714
 resolution, 572, 708, 798, 812
 scanning for, 597
 text, screen view of, 661
 white point, measuring, 240
Monochrome option, Channel Mixer
 command, 212–213
monotone images, 847
Mosaic filter applied to selection, 507,
 520
motion, animated. *See* animation
motion, simulating for print, 832, 975
Motion Blur filter, 961, 975
mound buttons, 878
Move tool, 72, 268
 linked layers, use with, 353–356
 Lock Position option blocking use of,
 358
 options, 287
moving. *See also* exporting files; Move
 tool
 Action steps, 425
 anchor points (*See* anchor points)
 Brush palette, 977
 Clone Stamp tool to move data
 between images, 606, 608
 History states, 397, 405
 within image, Navigator palette used
 for, 55
 images within document, Use Pixel
 Doubling used for, 38
 image with/without mask, 389
 layer effects, 383
 layers between documents, 683, 905
 lens flare, 896
 viewable area of image, 91
multimedia projects, resolution for, 113
Multiply blending mode, 171, 234

N
Native color channels, 432, 434–435,
 850
 filters and, 514, 517–520
 understanding, 583
native format, saving in, 4
natural appearance, 502, 608, 894, 959

Navigator palette, moving around in image using, 55
Nearest Neighbor pixel interpolation, 13, 22
negatives
 converting to negative image, 216
 Invert command, use of, 632
 scanning, 301
neon, creating, 480, 514, 889, 993
Neon Glow filter, 993
New dialog box, 1
new document, setting up, 1
New Selection option, 136–137, 170, 282–284
New View command, 288
Noise dither option, 262, 710, 838
Noise filters, 148, 492, 494–495, 519
 age, creating appearance of, 867
 smooth selection, creating, 980
 star field created with, 564
 stepped gradients, reducing, 989
 weather created with, 650
noise gradient, creating, 573
Normal blending mode, 369
Notes tool, 89, 920
NTSC (National Television Systems Committee), 98, 260, 949

O

object, wrapping text around, 536, 566, 657, 1001
object linking, 978
objects, adding to image, 638
Offset option to create seamless background, 794
Olé No Moiré color correction image, 558
OLE (object linking and embedding), 978
onion skimming, 752
online. See Web
opacity. See also transparency
 channel mixing, 212
 layers, controlling in, 357
 reducing, 171
Opacity option, 144, 217
 Brush Dynamics, 191, 196
 Eraser tool, 169
 for fill, 161, 232
 filter intensity, controlling, 530
 Gradient Editor, 175
 Gradient tool, 172, 177
 Magic Eraser tool, 165, 229
 Paintbrush tool, 222
 Paint Bucket tool, 167
 Quick Mask, 151
Opacity Stops option, 175
open architecture programming, 913
Open dialog box, 112
opening files
 Action for, 990
 Adobe Illustrator, 5, 116
 EPS files, 116
 Kodak Photo CD format, 6
 PDF files, 116

Photoshop opened with other Adobe programs, 14
 preexisting images, 112
Optimize palette. See also ImageReady
 channels, optimization settings applied with, 765–766
 creating optimization settings, 730
 file size, optimizing image by, 728
 image slicing, 768–769
 using optimize settings, 731–734
 view of optimized image, 775, 851
Options bar, 65. See also blending modes; Exposure option; Opacity option; Pressure option; Use All Layers option
 Blur tool, 158
 Burn tool, 162
 Drawing tools, 128, 138
 Free Transform mode, 292
 History and Art History Brush tools, 142, 144
 Lasso tools, 136–137, 283
 Magic Eraser tool, 229
 Magic Wand tool, 181, 284
 Marquee tools, 282
 modifying tool options, 101, 225
 Move tool, 287
 Paintbrush tool, 190
 Pen tools, 139–140
 resetting tools to default values, 140, 225
 Sample Size, 335
 Sharpen tool, 290
 Smudge tool, 147
 Type tool, 218
Outer Glow style, 490
out-of-gamut warning, 62, 549, 925–926, 965
out-of-web-gamut warning, 549, 925–926, 965
Output option, 117
oval selections, 71
Overlay blending mode, 234, 366, 671
overlays, Effect layers, 341
overprinting two colors, 339, 735

P

Page Range option, 117
Paintbrush tool, 41, 78, 191, 217. See also brushes
 Airbrush differentiated from, 222
 blending modes used with, 190
 channels, modifying, 444
 color changed with, 236
 creating patterns with, 133
 Fade rate option for comet tails, 197
 Foreground Color Swatch, use of, 221
 path used to control, 481
 Quick Mask, use of, 93, 151
 resizing brushes, 230
 selecting area using Channels palette and, 453
 shadows created with, 235
 spot color channels, painting on, 259
 Stroke command used with, 479–480

Paint Bucket tool, 82, 166, 306
 controlling, 167, 684
 Foreground Color Swatch, use of, 221
painterly effect, creating
 Art History brush, 144
 channels, 448
 filters, 448, 515, 531, 555, 899
 texture map, 510
painting cursors. See brushes
painting tools. See also brushes; Brush palette; specific tools
 blending modes used to influence, 234
 paths used to control, 481
palettes. See also Options bar; pop-up palettes; specific palettes
 customized palettes, creating, 60
 default positions, restoring, 70
 docking palettes together, 69
 grouping item tabs, 60
 for indexed files, 691–692
 library items, adding, 66
 linking palettes together, 68
 locations, changing/saving, 32, 60
 modifying, 66
 renaming items in, 67
 showing/hiding, 53, 58
Pantone colors
 in duotone images, 855–856
 Pantone Color Matching System, 244, 546, 840
 saving to Swatches palette, 547
 shortening names of, 31
 tinting grayscale image, 740
 working with, 546
Paragraph options, 218
Pass Through option, 390
paste. See copying
Paste Into command, 942
patches, 26–27, 48
Patchwork filter, 528
Path Component tool, 85, 470–471, 484, 686
Path elements, 467, 471, 484
paths, 308, 464–486. See also anchor points; clipping paths; Layer clipping path; Paths palette; Pen tools; Saved Paths; Work Paths
 Adobe Illustrator, exporting to, 690
 aligning, 471
 closed shape, 156
 color applied to, 482
 combining multiple paths, 469
 copying, 485–486
 creating, 87, 127, 138–140, 154, 156, 465, 467–468
 Curve Fit option, 140
 custom shapes, defining and saving, 129
 drawing/editing tools controlled by, 481
 filling area defined by, 483
 Illustrator files imported as, 694
 modifying, 155, 308, 470

moving, 85, 470
neon created with, 480
open shape, 156
saving, 468
selections, paths created from, 286,
 473–474
selections created from paths, 285,
 475
smoothness of path, controlling, 129,
 473–475, 477
Stroke command used with, 479–480
subpaths, working with, 484
path segments, 308, 465, 474, 477
Paths palette, 464
 Magnetic Pen tool, path created by,
 139
 Path elements in, 467, 471, 484
 work paths stored in, 157
Path tools. *See* Direct Selection tool;
 Path Component tool
Pattern dither option, 262, 711, 838,
 846
patterns
 cleaning up, 515
 creating and saving, 133, 337, 359,
 534–535
 custom, 846
 dithering (*See* dithering)
 filling with, 161, 232, 340
 logo, 884
 predefined, selecting, 79, 131, 167
 selected areas, applying to, 534
 television image, simulating, 648
 text, 359
Pattern Stamp tool, 79, 131, 191, 217
 multi-layer editing, 233
 path used to control, 481
PDFs (Portable Document Files), 597
 Anti-alias option used with, 30, 116
 compressing files, 132
 converting to Photoshop files, 429
 embedding ICC Color Profile into,
 860
 importing, 115, 117–118
 opening, 116–117
 saving, 697, 859
pen-and-ink drawings, 829, 846, 909
Pencil tool, 41, 78, 191, 217
 Auto Erase used with, 228
 Foreground Color Swatch, use of,
 221
 path used to control, 481
Pen tools, 87, 154, 156, 465–468. *See
 also* Magnetic Pen tool
 converting Pen paths to permanent
 paths, 157
 options, changing, 140
 selections made with, 285
 shape layers created with, 686
percent measurement system, 587
perspective
 of cropped area, changing, 272
 drop shadow, adding depth with, 968
 Effects layer, creating with, 391
 Gaussian blur to create depth in
 image, 868

offset shadows, 912
of text, changing, 672
photo collage created with layer masks,
 873
photographic filters, 28. *See also* plug-in
 modules
photographs, packaging (Picture
 Package option), 102
Photoshop, earlier versions of
 color settings, 11, 52
 opening documents in (backwards
 compatibility), 36
 RGB image moved between versions,
 545
 type, treatment of, 808
Photoshop file format (.psd), 4, 307,
 685
Photoshop product registration, 48
Photoshop Slices, 134
pica measurement system, 587
PICT files, 708, 711
 anti-alias PICT files, importing, 120
 PICT Resources, importing, 122
 saving RGB image, 698
Picture Package option, 102, 428
Pinch filter, 915
Pixelate filters, 515, 520
Pixel Dimensions, 269
pixels, 661, 948. *See also* rasters; resolu-
 tions; Tolerance option
 bit depth and color, 8–9, 442, 836
 brightness of, brightness (luminosity)
 value of pixels
 changing from 8-bit to 16-bit pixels,
 97
 color, elements of, 580 (*See also*
 hue; lightness of image/pixels;
 saturation)
 color definitions, 237
 converting type layer into, 654
 fringe pixels, removing, 611–612
 Histogram display, 47, 276
 ImageReady Optimize option, pixel
 depth and, 579
 image size and, 1, 13, 22
 interpolation (*See* interpolation of
 pixels)
 mapping using Levels command, 615
 measurement system, 109, 587
 Move tool to move pixel informa-
 tion, 72
 as numeric values (*See* color values)
 ppi (pixels per inch), 105, 110
 removed by Magic Eraser tool (*See*
 Magic Eraser tool)
 single vertical or horizontal pixel,
 selection based on, 71
 text converted to, 12
 Threshold option to control lumi-
 nance values, 199
 Use Pixel Doubling option, using, 38
PKZIP, 132
Place option, importing images with,
 115
plates. *See* channels
Playback options, Action, 412

plug-in modules, 28, 50, 913
 additional plug-in folders, use of, 28,
 50
 compatibility, 913
 creating, 913
 deactivating, 513
 default, in plug-in folder, 28
 Disable Scratch Compression, 916
 Force VM Compression, 919
 loading select set of, 50
 scanner, 119
 third-party plug-ins, purchase of, 50
 Unlimited Clipboard Size, 917
 Unlimited Preview, 918
PNG (Portable Network Graphic), 98,
 132, 577, 585, 695, 711, 739,
 854
 background transparency, creating in
 PNG images, 788, 792
 compressing files in, 733–734, 756
 master color palette, creating, 780
points measurement system, 43, 587
Polar Coordinates filter, 518, 535, 556,
 677
Polygon Drawing tool, 88
Polygon Lasso tool, 73, 124
pop-up palettes
 changing view from icon to text, 66
 library items, adding, 66
 modifying, 66
 renaming items in, 67
Pop-up sliders, using, 95
Posterize Adjustment level, 322–324
Posterize option, 200, 639
 Adjustment level, used within, 323
 colors in image, controlling number
 of, 219
PostScript files. *See also* Encapsulated
 PostScript files (.eps)
 printing image to, 712
 text printed from, 652
PostScript fonts, 652, 663
PostScript measuring system, 43
PostScript printers, 244, 702
 color management, 253
 printing vector images, 717
PowerPoint. *See* presentations
ppi (pixels per inch), 105, 110
Precise tool icons, 64
preexisting images, opening, 112
prepress process, 244
presentations. *See also* monitor
 Color Management Off setting, 11,
 52
 color space, 862
 compressing files for, 132, 864
 file formats, 711
 file size, 132, 344, 834, 862
 indexed color images, 819, 834
 RGB color, 242
 transparent image, 819, 981
Preserve Transparency option, 161, 232,
 359, 734
Preset Manager, Brush palette, 188
Pressure option, 217
 Airbrush tool, 222

Blur tool, 158
Brush Dynamics, 191
Sharpen tool, 290
Smudge tool, 147
Sponge tool, 163
previews, 20. *See also* monitor; views
in browser, 750, 985–986
characteristics, modifying settings for, 61
color corrections, 561
Color Range, options for, 145
dithering, Web image, 747
Extract command, 289
feathering, 963
Fill command, 939
filters, 492, 531
Hide/Show Preview button, 112
Internet, images for, 750, 985–986
Navigator proxy preview area, using, 55
saving, Image Preview options, 33, 61
saving files with, 61
scans, 596
Unlimited Preview plug-in, 918
Variations command, 220
video lookup table, Preview option, 44
printers. *See also* inkjet printers; laser printers
operation of, 661
Print Options, 253
printing. *See also* four-color printing
color management for, 253, 569, 720
color reproduction basics for, 923
color space used by, 98, 569–570, 720 (*See also* CMYK color mode/space)
color to black-and-white printer, 701
converting animation for, 974
default options, changing, 700
default options, printing directly from Photoshop using, 699
dimensions, changing print, 955 (*See also* image size)
file formats for, 98, 711
ImageReady documents, 816
motion simulated in, 832, 975
portion of image, 715
print encoding of image, changing, 716
printer's marks, within image, 709
reducing print size without reducing quality, 950
resolutions, 98
screen shots, 636
spot color channels (*See* spot color channels)
text, 652
Print Size view option, 56
process colors, 211, 244
product registration, 48
profiles. *See* color profiles
progress bar, 956
Proof Setup option, 714
Proportional size option, 128

proportions. *See* Constrain Proportions
proxy preview area, using, 55
PSD (.psd) format, 4, 307, 685, 697
Pucker tool, 277
Puzzle Style, 490

Q
QuarkXPress, transferring images to, 704
Quick Mask mode, 93, 151–152, 280
complicated transparencies, used for, 863
feathering, viewing effects of, 963
preview option, 145
saved as permanent channel, 451
traditional selection methods combined with, 153
QuickTime movies
from animated GIF files, 696
compressing, 811
converting into animated GIF, 758
quitting Photoshop, 3

R
rain, creating, 650
RAM (random access memory)
additional RAM modules, installing, 18
allocating to Photoshop, 18
Cache Levels option use and, 46
Clipboard use and, 40, 943
efficiency information, open file, 19
filters, improving performance of, 513
History states, RAM used by, 401, 403, 513
installed memory, determining amount of, 18
Photoshop use of, 14, 16, 18
plug-ins, used by, 28
thumbnails, creation of, 437
Range option (pixel brightness range), 162
Raster Image Processor (RIP), 244
Rasterize Generic EPS Format dialog box, 116
Rasterize Generic PDF Format dialog box, 118
rasterizing
by scanner, 589
text, 359, 654
rasters, 5, 7, 13, 563, 572, 844
Rectangle Drawing tool, 88, 128
rectangles
Cropping tool, use of, 75
selections based on, 71, 281
Rectangular Marquee tool, 71, 129, 133, 281–282
aligning layer to selection marquee, 355
cropping image with, 273
red eye, correcting, 336
redraws
high resolution and speed of, 107
monitor color depth and rates of, 51
number allowed per open image, 46
Regenerate command, 738, 741

registration marks, printer, 709
Render filters, 525, 531–532, 536–537, 540, 555, 842
repetitive operations, storing. *See* Actions palette
Replace Color command, 210, 581
repurposing images, 98
Resample Image option, 114, 269, 950
Reset Palette Locations option, 70
resolutions, 1, 7, 13
Auto Resolution dialog box, 269
changing, 114, 269
correct resolution, choosing, 107, 110
dpi/ppi and, 105
EPS files, 693
final output, determining resolution based on, 113
halftone screen frequency and, 107
high-end printing press, 107
image size changed to increase, 114
inkjet printer, 110
layers moved between documents, 683
master image, 737
monitor, 572, 708, 798, 812
multimedia projects, 113
open graphic file, 21
PDF documents, converted, 116, 118
picture package, 102
print graphics, 98
redraws, low-resolution images for, 46
resized image and, 522
scan (*See* scan resolutions)
Use Pixel Doubling option, 38
Web, 98, 113, 585, 739, 799, 820
restoring images. *See also* Dust & Scratches filter
Blur tool, 159
Clone Stamp tool, 79, 130, 605–609
customized brushes, 604
highlights, restoring blown-out, 162
History Brush, 142
Levels command, use of, 201–202, 204
Reverse option (gradient colors), 172
RGB color model, 238–239
RGB color mode/space, 8, 111, 242, 255, 554, 610, 688
Channels palette tab, use of, 37
CMYK, converting to, 250
CMYK color space corrections compared, 550
cross-platform display, adjusting images for, 243
editing in, 550
indexed color, converting to, 834
moving between Photoshop versions, 545
for repurposing images, 98
scanning in, 250, 589, 591, 597
television, use for, 260
viewing color information, 96
viewing image in, 561
for Web, 739

RGB colors, gamma used to blend, 261, 736
RGB color slider, 544
RGB images. *See also* Composite channels
 channels in, 432–433
 CMYK, converting to, 858
 Colorize option for duotone, 208
 file size, 347
 grayscale, converting to, 245, 256
 Native color channels, 583
 selective color correction, 211
 sharpening of, 245, 930
RGB Working Spaces, 571
rollovers. *See* JavaScript rollovers
Rotate Canvas command, 271
rotating selection, 292, 300
Rough Pastels filter, 899
Rounded Drawing tool, 88, 123, 128
Rubber stamp/Pattern Stamp, 41
ruler bar, 103, 109
Rulers measurement unit options, 586

S

sampling tools. *See* Extraction tools
saturation, 361, 442, 580, 631. *See also* Curves command; Hue/Saturation command
 Color Picker to control, 567
 Desaturate command, 334, 631
 Desaturate option, Sponge tool, 602
 file size and, 754, 828
 HSB color model, saturation channel of, 239
 HSB color slider, adjustment using, 544
 monitor color saturation, changing, 261
 printer color management, 253
 Replace Color command to change, 210
 Sponge tool to control (*See* Sponge tool)
 value, 631
 Variations command to adjust, 220, 630
Saturation blending mode, 192, 234, 368, 687
Save As option, 3
Saved Paths (Paths palette), 472. *See also* paths
Save for Web command, 135, 748
 image size changed using, 830
 locking colors using, 831
saving. *See also* Clipboard; file formats
 Action sets into folders, 420
 Actions into set, 419
 audio or text note, 89
 BMP or PICT image, RGB image as, 698
 clipping paths, files with, 476, 478
 color tables, 822
 color to Swatches palette, 547
 Curves adjustments, 616
 custom color settings, 718
 DCS format files, 856

default options for saved files, 33
 .eps files, 478
 GIF (Graphics Interchange Format) files, 691
 History, 397
 image previews, saving files with, 61
 Internet, recurring settings for, 822
 Kodak Photo CD documents, 302
 master image, 737
 multi-layered documents, Save a Copy option, 697
 in native format, 4
 new files, 3
 palette locations, 32
 paths, 468
 PDFs (Portable Document Files), 859
 Quick Mask as permanent channel, 451
 for repurposed use, 98, 737
 Saving File options, setting default, 33
 screen shots, 636
 selection as permanent channel, 307
 selection using Save Selection command, 454
 sliced images, 135
 Snapshot image, 142
 Spot color channels, 682
 styles, 491
 Swatch custom palette, 231
 Web images, 804 (*See also* Save for Web command)
Scale option, printing, 700
scan-line appearance, creating, 648
scanning. *See also* Kodak Photo CD
 color casts introduced by, removing, 929
 directly into Photoshop, 594
 dullness of scanned images, reason for, 931
 dynamic range, 984
 file formats, 590, 597
 histogram, use of, 276, 592
 importing images directly from, 119
 low- and high-key images, identifying, 592
 mistakes, avoiding, 590
 mode for, 596
 moiré patterns, removing, 300, 462
 for monitor, 597
 old images, 589
 previews, 596
 repurposing scanned images, 98
 RGB color space, use of, 250, 589, 591, 597
 selective color correction, 211
 steps for success in, 596
 straightening scanned image, 146
 Trim command to crop, 275
 Twain interface, 927
 Unsharp Mask to correct blurring, 524
scan resolutions, 113, 589, 593, 948, 984
Scratch compression plug-in, 916

scratch disks, 16
 Disable Scratch Compression plug-in, 916
 Force VM Compression plug-in, 919
 multiple disks, use of, 45
scratches
 Auto Levels options, effect on, 622
 Blur tool to correct, 159
 Clone Stamp tool to repair, 605
 Dust & Scratches filter to correct (*See* Dust & Scratches filter)
scratch size, open file information, 19
Screen blending mode, 234, 366, 871
screen display. *See* monitor
screw heads, designing realistic, 883
scroll bars, displaying, 53
segment lines. *See* path segments
selections, 280. *See also* bounding box; color selection methods; Extract command; Free Transform command; Transform Selection command
 adjustments, to control effects of, 315
 aligning layer to selection marquee, 355
 borders/edges (*See* edges)
 channels, difficult selections held by, 445
 channels, removing selected, 458
 channels converted to/from, 307, 309, 311, 453–456, 584
 Color Range command, use of, 145, 280
 contracting a selection, 295
 dotted line, defined by, 303, 317
 element within layer, copying, 377
 expanding selection area, 294
 filters combined with, 315, 507, 529
 Grow command, 303
 history state/snapshot, filling with, 404
 of layers, 348
 Load Selection command to control, 311
 manual modification of, 293
 masks, 280, 289 (*See also* Alpha channels; Quick Mask)
 multiple channels loaded as, 456
 Noise filter used to smooth, 980
 nontransparent areas of layer, 351
 numerically adjusting selection, 292
 paths, selections created from, 285, 475
 paths created from, 286, 473–474
 patterns applied to, 534
 pen path converted into selection, 285
 printing portion of image, 715
 printing selected area, 700
 removing color from, 334
 Replace Color command influenced by, 581
 reversing selection, 145

Save Selection command to convert to channel, 454
saving as permanent channel, 307
Similar command, 303
Stroke command to paint, 310
styles applied to, 489
visible information in layer, 360
selection tools, 280, 470. *See also* Extraction tools; *specific tools*
freeform, 73
options for, 136–137, 170, 282–284
path selection (*See* Direct Selection tool; Path Component tool)
work area, creation of, 303
Selective Color command, 211, 332, 842
sepia tint
Channel Mixer, 212
Color Balance command, 318
Gradient Map command, 582
Hue/Saturation command, 333
settings files, 23. *See also* Action set; color settings
corruption of, 24
restoring to control Photoshop, 24
special occasions, saving separate files for (Macintosh only), 25
shadows. *See also* drop shadow; low-key images
Auto Contrast command, use of, 626
Auto Levels command, use of, 622, 625
Black Point Compensation and, 833
cast shadows, working with, 887
Color Balance command to adjust, 206
creating, 190
curved surface, creating on, 888
custom shadows created without layer effects, 969
Dodge tool to control, 601
for 3-D packaging, 959
Effect layers, 341
filters and adjustments, selection to control effects of, 315
four-color printing presses, enhancing in, 651
freestanding shadow created with Free Transform, 299
in front of object, creating, 886
gradient map, image map areas mapped to, 215
heavy foreground shadows, correcting, 617
Inner Shadow option, 391
Layer Style dialog box, creating with, 914
Levels command to identify/adjust, 201–202, 204, 629
offset shadows, visual perception created by, 912
Paintbrush tool, created with, 235
Selective Color to increase/decrease, 332
setting within image, 328

Sharpen tool, use of, 290
soft-edged shadow in GIF transparent image, 865
spherical shadow, creating, 885
target values to set, 618
Threshold used to identify, 619
Variations command to adjust, 220, 630
shape layers, 226, 392. *See also* clipping paths
creating, 127, 138, 140, 156, 686
modifying, 686
shapes. *See also* Custom Shape Drawing tool
Free Transform, manipulating with, 227
multiple paths to form, 469
sharpening of image. *See also* Sharpen tool
filters to preserve edge sharpness, 494, 496
RGB image, Lab color used with, 245, 930
Sharpen filters, use of, 447, 512, 524, 627
timing of, 615
Unsharp Mask, applying, 524
sharpening of text, 664
Sharpen tool, 41, 83, 191, 217, 290
multilayer editing, 233
path used to control, 481
Shear tool, 149–150
shortcuts
Alert dialog box, 523
channels converted to/from selections, 584
converting commands into Actions, 431
Show button (file format), 112
Similar command, 303
Single Column/Row Marquee tools, 71
16-bit channels, working with, 97
size of image. *See* image size
Size option, Brush Dynamics, 191, 196
sketches, printing, 247
Sketch filters, 526, 671, 842
sliced images, 806
Alt tag, attaching, 810
droplet, use of, 769
file formats for, 776
GIF/JPEG settings applied to multiple slices, 769
JavaScript rollover, using, 774
linking slices, 809
optimizing individual, 768
solid-color areas, eliminating, 776
Slice tool, 76, 134–135
slide-mounted image, creating illusion of, 645
slide presentations. *See* presentations
Smart Blur filter, 533, 539, 644, 842
Smudge tool, 41, 83, 147, 191, 217, 481, 598
snapshot of document, 142
creating, 398, 403

dragging between windows, 405
filling selection with, 404
painting with, 400
previous History state, creating from, 408
saving, 595
Snap To option, document window grid, 104
softening an image using multiple layers, 903
Soft Light blending mode, 234, 362, 563
Soft Proof option, 570
Solarize filter, 904
Source PDF option, 117
Spacing option, Art History Brush, 144
Sparkle brush, defining, 189
special-effects filters. *See* filters
Spectrum palette, 543
speed of computer processor, 14
spheres
Gradient tool, generated with, 908
Lens Flare filter, 3-D globe created by, 906
spherical buttons, creating, 967
spherical shadow, creating, 885
Spherize filter, 529, 892
wrapping image around, 892
wrapping text around, 1001
Split Channels command, 459
Sponge tool, 41, 84, 163, 191, 217, 602, 965
spot color channels, 432, 434
Alpha channel converted into, 450
basics of, 257
converting image into, 850
creating, 258
knockouts to prevent overprinting, 735
painting on, 259
printing, 735, 856–857
saving, 682, 856
text, creating channel from existing, 681
text, creating channels for, 449
spot colors, 31. *See also* Pantone colors
creating a spot color plate, 258
overlapping colors, adjusting, 339, 565, 721
spotlight effect, 463, 532
Square option, 128
squares, selections based on, 71
Stamp tools, 79, 130–131
Standard Lasso tool, 73, 136, 280
Standard Mode (screen display mode), 53
Standard tool icons, 64
starburst effect, creating, 556
star field, inserting with Noise filter, 564
status bar, 59
current image, information on, 19
showing/hiding, 59
stone background, creating, 893
stop commands, inserting into Action, 422

storyboard, Layers palette used as, 761
straightening scanned image, 146
Stroke command, 310
 Foreground Color Swatch, use of,
 221
 neon created with, 480
 paths, use with, 479–480
 text, multiple stroke lines for, 676
stroked outline of text, 656
studio backdrop, creating, 882
styles. *See also* Bevel and Emboss layer
 style; Drop Shadow style
 creating, 491
 layer, applied to, 488, 490
 Layer clipping path, applied to, 313
 layers, created from, 487
 loading, 491
 saving, 491
 selections, applying to, 489
 text, applying to, 488
Styles palette, 138, 487–490
 adding styles to, 491
 default, 491
 Drawing tools used with, 123
Stylize filters, 527, 842
Stylus option, 137, 140, 191, 196, 279
Subtract from Selection option,
 136–137, 170, 282–284
sunlight effect, 463
Swatches palette, 541. *See also*
 Background Color Swatch;
 Foreground Color Swatch
 adding colors to, 547
 backgrounds, creating, 148
 custom palette, creating, loading, and
 saving, 231, 568
 default palette, 231
 Gradient Editor used with, 175
system crashes, 24

T

Tab key, 523
table, HTML, 806
tagged graphics, 237, 248, 574. *See also*
 color profiles
Tagged Image Format (.tif), 4, 98, 307
 ImageReady, saving files in, 725
 LZW compression, 4
 master image, saving, 737
 multi-layered documents, Save a
 Copy option for, 697
 scanned images, 590
 screen shots, saving, 636
 Zip compression, 4
Target (for watermark), 99, 321
television
 color palette for, 949
 color space, 98
 preparing images for, 260, 947
 resolutions, 98
television image, simulating, 563, 648
text, 218. *See also* fonts; Type tool
 animating, 784
 background, Adjustment layers used
 to screen against, 679
 background light burst for, 677

beaded outline of, 673
brushed-metal, 874
carved, 935
character options, 218, 667, 669
chiseled, 962
chrome look, 674, 875
clipping group, manipulating text
 images with, 659
color, 807
credit-card text, creating, 898
drop-shadow back screen for, 678
3-D text created with layer effects,
 660
embossed, 662, 676
fading across image, 680
filters applied to, 655
fire surrounding, 994
Foreground Color Swatch, color con-
 trolled by, 306
freeform shape, filters used to con-
 vert to, 665
futuristic look, 877
glow, applying, 670, 675, 907, 993
gold, converting to, 880
hyphenation options, 668
in ImageReady, 807–808
kerning used to adjust, 667
leading used to adjust, 667
liquid type extruding from image,
 671
marbleized, 922
multiple stroke lines, identifying
 with, 676
patterns, creating unusual, 359
perspective, changing for depth, 672
printing, 652
processing of, 652
ragged, 821
rasterizing, 359, 654
sharpening, 664
slices, 769, 776
spaces between letters/lines, 667
spherical text buttons, 967
Spot color channels created for/from,
 449, 681
stacked look, 996
stroked outline of, 656
styles applied to, 488
tracking used to adjust, 667
transparency in, 680
type measurement unit options, 586
warping/bending, 86, 150, 193, 218,
 536, 566, 657, 784, 807, 1001
wire-frame, 924
zoom effect, creating, 556
text annotations, 89, 121, 920
text layers, 341, 488, 536, 652, 654
 drop shadow applied to, 660
 to fade type, 680
text masks, 653, 656. *See also* Type
 Mask tool
 embossed text, creating, 662
 manipulating text images with, 658
 Work Path created from, 666
textured backgrounds, 872

Texture filters, 842
texture maps, 504, 506
 creating custom map, 505
 distortion, 504–506, 511
 folder for, 505
 loading graphic image as, 510
Thaw tool, 278
three-dimensional effects, 235
 backlighting for 3-D packaging, 960
 buttons, creating with copy and
 paste, 778
 creating 3-D packaging, 958
 3D Transform filter, 525, 536–537
 Layer clipping paths, 312–314
 shadows for 3-D packaging, 959
 spheres (*See* spheres)
 text, creating with layer effects, 660
Threshold option, 171, 199, 619, 634,
 870, 909
TIFF. *See* Tagged Image Format (.tif)
tiled appearance for image, 528
tiles, background
 changing size of, 825
 logo pattern, 884
 seamless, 794–796
 Tile Maker filter, 759, 796
 Tiles filter, 499, 527
 Web page frame look, directional
 tiles for, 753
timing, open file information, 19
title bar, displaying, 53
Tolerance option
 Background Eraser tool, 168
 Magic Eraser tool, 165, 229
 Magic Wand tool, 170, 182, 284,
 303
 Paint Bucket tool, 166–167
Tolerance value, path creation,
 473–474, 477, 703
tonal range. *See also* brightness (lumi-
 nosity); highlights; midtones;
 shadows
 Color Balance command to adjust,
 206
 duotone image, adjusting in, 849
 histogram to view, 592, 613
 Info Palette to identify, 628
 Levels command to identify/adjust,
 201–202, 204, 629
 Posterize option to specify, 200, 219
 Variations command to adjust, 630
Toning tools, 84, 95. *See also* Burn tool;
 Sponge tool
toolbar
 showing/hiding, 53, 58
 use of, 49
tool icons, changing, 64
tools. *See also specific tools*
 Background color box, 94
 Brush palette, used in, 41
 current tool, information on, 19
 cursor position information, 96
 Foreground color box, 94
 hidden, 49
 hotspots, 64

modifying options for, 101, 225
Options bar, use of, 65
paths used to control, 481
pop-up sliders, use of, 95
resetting to default values, 140, 225
selecting, 49
shortcut keystrokes, 49
Tool Tips option, 49
Torn Edges filter, 500, 509
tracing paper, converting channels into, 452, 457
Tracking value, 667
Traditional measuring system, 43
Transform Selection command, 293, 298
transparency. *See also* opacity; Opacity option
background transparency, Web, 577
Behind mode to paint transparent pixels, 190
clipping path to create, 476, 703
complicated, Quick Mask used for, 863
cropping from border, 275
exported files, maintaining in, 476, 478, 691, 734
feathering and, 304
of fill, 161, 172, 175, 177
GIF images, 788, 792, 800
indexed color image, assigning to, 819
layers (*See* transparency, layer)
masks, 151–152, 352, 387
for presentations, 981
preserving transparent pixels (*See* Preserve Transparency option)
soft-edged shadow in GIF transparent image, 865
in text, 680
in Web graphics, 751
transparency, layer, 233
Blend If option to create, 345
editing transparent layer, 233
History Brush used with transparent layer, 143
within layer, creating transparent areas, 345
layer mask, transparent area created by, 387
locking transparent pixels, 358
masking transparent areas of layer, 352
merged layers, retaining in, 374
nontransparent areas, selecting, 351
patterns, used to create, 359
preserving in, 359
Screen blending mode to generate, 871
Transparency option, Gradient tool, 172
Trap option, using, 339, 565, 721
Trim command, 275, 724
True Color monitor color option, 51
TrueType fonts, 663
Twain interface, 927
Tween option
to fade animation, 785

layer effect, animation base on, 784
straight-line animation, 783
Twirl tool, 277
type. *See* text
Type layers, 652, 654–655
Type Mask tool, 653, 874–875
embossed text created using, 662
Work Path created from, 666
Type measurement unit options, 586
Type tool, 86, 218, 807–808

U
UCR printing method, 923
Unconstrained option, 128
undo
History brush used for, 142 (*See also* History palette)
multiple undos, using, 401
U.S. Prepress Defaults, 11, 52
Units & Rulers options, 43, 586
Unsharp Mask, applying, 524
updating Photoshop
automatic updates, 27
product registration for, 48
from Web site, 26
Use All Layers option, 147, 233, 921
Blur tool, 158, 160
Magic Eraser tool, 165, 229
Magic Wand tool, 170, 284
Paint Bucket tool, 167
Sharpen tool, 290
Smudge tool, 147
Use Lower Case default option, 33
Use Pixel Doubling option, 38
User Slices, 134

V
Variations command, 220, 630, 842
vector images, 844
Adobe Illustrator, 5, 115, 689, 844
importing, 115
printing, 717
shapes, vector-based (*See* shape layers)
vector paths. *See* paths
vector text
Anti-alias option, use of, 116
converting to pixels, 12
printing, 652
vector tools. *See* Pen tools
video LUT (lookup table) animation, working with, 44
View input box, percentages in, 184
View pull-down menu, 56
views. *See also* previews
Action, individual steps of, 417
changing image view size, 55–56, 92, 585
channels, 436
CMYK color space (Working CMYK), 550, 561, 570
cropping pixels outside, 944
cross-platform differences, 726
ImageReady, 775
layers, 348

moving viewable area of image, Hand tool used for, 91
multiple views of same image, opening, 54
RGB color space, 561
screen display mode, changing, 53
View pull-down menu, options of, 56
vignette border, creating
Action, 410
Alpha channel, 446
Feather command, 305
virtual memory, running Photoshop with, 15
Visibility icon, 343

W
warping text. *See* text
Warp tool, 277
wash (Wet Edges option), 169, 194
washed-out image, correcting, 326
water droplets, creating, 894
watermark. *See* Digimarc watermark
weather in image, creating, 540, 650, 871
Web. *See also* HTML; ImageReady; indexed color images; Indexed color mode/space; Web Safe colors
Adobe Web site, 26–27
animation, compressing files for, 132
buttons for (*See* buttons)
color settings for, 11
color space, 739, 799, 820
compressing files for, 132 (*See also* compressing files)
cropping image for, 723
customized patterns for, 534
dither of image (*See* dithering)
download time, 812
file extensions, use of, 34
file formats, 98, 585, 695, 711, 738 (*See also* GIF (Graphics Interchange Format); JPEG (.jpg) format; PNG (Portable Network Graphic))
file names, case sensitivity of, 33, 35
file size and, 344
fill color when converting image to transparent, 751
frame look, directional tiles used for, 753
image gallery, creating, 818
interface, creating, 812, 966
Layer clipping paths, use of, 312–313
logos for web backgrounds, 777
out-of-web gamut warning, 549, 925–926, 965
previewing images for, 750, 985–986
resolutions for, 98, 113, 585, 739, 799, 820
Save for Web feature, 135, 748, 830–831
saving recurring settings, 822
slicing images for (*See* sliced images)
splitting channels for, 459
stepped appearance of gradients, reducing, 989

Tile Maker filter for seamless background, 759
transparent areas, creating, 233, 788
WebDAV, 970–927
working on, 585
Web Graphics Default color settings option, 52
Web Safe colors, 551, 779, 812, 826. *See also* Web Snap
adjusting colors to conform, 710
Color Picker, selecting with, 557
color table, 243
converting Color Picker to, 746
converting image to, 741–742, 748
dithering and, 534, 553, 747, 815, 817
flat-color areas, 762
non-web colors, identifying, 793
Save for Web command, 748
Web Snap, 741, 779, 793
Weight option (arrowhead lines), 126
Wet Edges option, 169, 194

white. *See also* black and white
channels, use in, 432, 434–435, 452, 461, 497
layer mask, 387
in texture maps, 505, 511
width, document
Canvas Size command to modify, 270
converted PDF documents, 116, 118
imported PICT files, 120
width, image, 1, 22, 292
changing, 114, 269, 522
for printing, 700
Width option
arrowhead line, 126
Magnetic Lasso, 137
Magnetic Pen, 140
windows, document. *See* document windows
Windows Thumbnail, 33, 61
work area, 303, 507
workflow, management of, 834

Work Paths, 472, 484. *See also* paths
converting to permanent paths, 157
creating, 468
Freeform Pen tool, created using, 156
saving, 468, 472
selection, creating from, 473
text mask, created by, 666
World Wide Web. *See* Web
wrinkles, removing, 533, 644
www.adobe.com. *See* Adobe Web site

X

X and Y coordinates, Info palette, 329

Z

zero-border table, 776
Zip file compression, 4, 132, 597
zoom effect, creating, 556, 677
zoom in/out methods, 55–56, 572
zoom percentages, changing, 184
Zoom tool, 92, 183, 288–289